THE BUILDINGS OF ENGLAND
FOUNDING EDITOR: NIKOLAUS PEVSNER

LONDON 6: WESTMINSTER
SIMON BRADLEY AND NIKOLAUS PEVSNER

London
6
Westminster

BY
SIMON BRADLEY
AND
NIKOLAUS PEVSNER

YALE UNIVERSITY PRESS
NEW HAVEN AND LONDON

YALE UNIVERSITY PRESS
NEW HAVEN AND LONDON
302 Temple Street, New Haven CT 06511
47 Bedford Square, London WC1B 3DP
www.yale.edu/yup
www.yaleup.co.uk
www.pevsner.co.uk

Published by Yale University Press 2003
2 4 6 8 10 9 7 5 3 1

ISBN 0 300 09595 3

Printed in China
through World Print
Set in Monotype Plantin

CONTENTS

LIST OF TEXT FIGURES AND MAPS

Every effort has been made to contact or trace all copyright holders. The publishers will be glad to make good any errors or omissions brought to our attention in future editions. Drawings from *The Survey of London* are reproduced by kind permission of English Heritage.NMR.

PHOTOGRAPHIC ACKNOWLEDGEMENTS

A special debt is owed to English Heritage photographers Derek Kendall and Nigel Corrie for taking most of the photographs for this volume (© English Heritage Photo Library).

The sources for the remaining photographs are shown below. We are grateful for permission to reproduce them as appropriate.

Simon Bradley: 33
Martin Charles: 17, 52, 69
The Conway Library, Courtauld Institute of Art: 38, 65, 66, 113
Crown Copyright: Historic Royal Palaces: 27
Crown Copyright.NMR: 15, 56
The Crown Estate: 86
DTZ Debenham Tie Leung: 55
Anthony Kersting: 2, 26, 28, 46, 48, 53, 58, 105
Edifice Photo Library: 35, 68, 119
English Heritage Photo Library: 1, 7, 62, 74, 75, 80, 102, 103, 104, 114, 115, 116
The Dean and Chapter of Westminster: 6, 8, 9, 10, 11, 12, 13, 14, 16, 18, 21, 22, 23, 24, 25, 29, 30, 31, 43, 44, 45, 63, 64, 77
Paul Mellon Centre for Studies in British Art / Courtesy of Malcolm Baker: 47
National Trust Photographic Library / Photo: Geoff Morgan: 36
William Pye Partnership / Photo: Edward Woodman: 122
The Ritz Hotel: 98
The Royal Collection © 2002 HM Queen Elizabeth II / Photo: Derry Moore: 81
Spencer House: 49, 57
Warburg Institute: 54, 79
Reproduced by kind permission of English Heritage.NMR: 5, 19, 20, 61, 67, 82, 91, 95, 96, 97, 99, 108, 109, 112

ABBREVIATIONS AND
LISTS OF LONDON ARCHITECTS

Area Authorities

MBW Metropolitan Board of Works (1855–88)
LCC London County Council (1888–1965)
GLC Greater London Council (1965–86)
GLA Greater London Authority (2000–)

Other Abbreviations

NMR National Monuments Record
RCHM/RCHME Royal Commission on Historical
 Monuments (of England)
RIBA Royal Institute of British Architects
SPAB Society for the Protection of Ancient
 Buildings

Surveyors to the Fabric, Westminster Abbey

Sir Christopher Wren 1698–
 1723
Nicholas Hawksmoor 1723–36
John James 1736–46
James Horne 1746–52
Henry Keene 1752–76
James Wyatt 1776–1813
B.D. Wyatt 1813–27
Edward Blore 1827–49
Sir George Gilbert Scott
 1849–78

J.L. Pearson 1878–98
J.T. Micklethwaite
 1898–1906
W.R. Lethaby 1906–28
Sir Walter Tapper 1928–35
Sir Charles Peers 1935–51
S.E. Dykes Bower 1951–73
Peter Foster 1973–1988
Donald Buttress 1988–95
John Burton 1995–

*Architects to the Metropolitan Board of Works, the London County
Council and the Greater London Council*

Superintending Architects

Frederick Marrable 1856–61
George Vulliamy 1861–87
Thomas Blashill 1887–99
W.E. Riley 1899–1919
G. Topham Forrest 1919–35
E.P. Wheeler 1935–9
F.R. Hiorns 1939–41
J.H. Forshaw 1941–6
(Sir) Robert Matthew 1946–53
(Sir) Leslie Martin 1953–6

(Sir) Hubert Bennett
 1956–71
(Sir) Roger Walters 1971–8
F.B. Pooley 1978–80
P.E. Jones 1980–6

Fire Brigade Branch

Edward Cresy 1866–70
Alfred Mott 1871–9
Robert Pearsall 1879–99
Owen Fleming 1900–

Housing of the Working Classes Branch

Owen Fleming 1893–1900
John Briggs 1900–2
Rob Robertson 1902–10

Education Branch (until 1904 architects to the School Board for London)

E.R. Robson 1871–84
T.J. Bailey 1884–1910
Rob Robertson 1910–

The Constructional Division

(absorbed the Fire Brigade Branch and the Housing of the Working Classes Branch from 1910, the Education Branch from 1920. Housing was placed under the valuer's Department from 1946 until 1950, when the whole of the Architect's Department was reorganized under Sir Robert Matthew, with separate heads of department for housing and education.)

Housing

H.J. Whitfield Lewis 1950–9
K.J. Campbell 1959–74
G.H. Wigglesworth 1974–80

Education

S. Howard 1950–5
M.C.L. Powell 1956–65
Schools: C.E. Hartland 1965–72
Education: M.C.L. Powell 1965–71
G.H. Wigglesworth 1972–4
P.E. Jones 1974–80

Special Works (a separate department responsible for fire and ambulance stations, magistrates' courts, civic buildings, etc.)

G. Horsfall 1960–76 (also senior architect Civic Design, 1965–70, and Thamesmead Manager from 1970)
R.A. Michelmore 1977–80 (from 1980, principal Construction Architect)

Surveyors to the Metropolitan Police

Charles Reeves 1842–66
Thomas Charles Sorby 1867–8
Frederick Caiger 1868–81
John Butler Sen. 1881–95
John Dixon Butler 1895–1920

G. Mackenzie Trench 1921–47
J. Innes Elliott 1947–74
M. Belchamber 1974–88
T. Lawrence 1988–2002
A. Croney 2002–

Chief architect, City of Westminster, from 1964 (various titles)

A.F.G. West 1964–74
J.M. Hirsh 1974–8

A. Selman 1978–84

FOREWORD

Westminster – that is, the area that was merged in 1965 with the Boroughs of Paddington and Marylebone into the present, expanded City of Westminster – was first surveyed by the *Buildings of England* in Nikolaus Pevsner's *London 1: the Cities of London and Westminster*, 1957. A revised edition followed in 1962, a further revision (by Bridget Cherry) in 1973, but most of the 1950s text remained. The present division reflects the much fuller overhaul and expansion of the London volumes that began in 1983 with Bridget Cherry's *London 2: South* (*see* map, p. 1). *London 3: North West*, the new *London 1: The City of London* (by Simon Bradley) and *London 4: North* followed in 1991, 1997 and 1998 respectively. The first includes the present-day City of Westminster N and NW of the area described between these covers, as well as the little outlying district s of Hyde Park and Kensington Gardens. *London 5: East and Docklands*, by Bridget Cherry and Charles O'Brien, will complete the revised London series, by which time more than half a century will have passed since Pevsner's first research forays into its bomb-scarred streets.

The arrangement of the book is as follows. A general introduction gives an account of the growth and development of Westminster from prehistoric times to the present. Its eight broadly chronological chapters explore the development of building types, architectural styles and methods and principles of planning, in their social and political context.* The gazetteer follows, treated in eleven areas each with its own brief introduction and summary of contents. Churches come first, with Anglican ones ahead of the rest (except for the special case of Westminster Cathedral); then public buildings, here arranged alphabetically; then streets or groups of streets, also in alphabetical order. The chief exceptions are: Whitehall (area one), where the Government buildings are described as they occur on the ground, with lesser buildings slotted in between; the Nash route along Regent Street etc., and Oxford Street (areas four and five), both of which have linear treatments; and Belgravia and Pimlico (areas ten and eleven), the central expanses of which are covered by perambulations. The only street that has had to be split is Victoria Embankment (sections one and two), which is also shared with *London 1: The City of London*. Other streets necessarily shared between volumes are Drury Lane, Kingsway and Neal Street (with *London 4*), and Regent Street and Knightsbridge (with *London 3*).

* The geology, prehistory, vernacular architecture and industrial archaeology of Greater London are covered more fully in the introductions to Vols. 2–5.

The principles of the series otherwise remain. Certain church furnishings (notably bells, plate and most moveable furniture) and moveable furnishings in secular buildings are omitted. Buildings from before *c.* 1700 are almost always mentioned, along with most Georgian ones. Victorian, C20 and C21 architecture is more selectively treated. Public statues and monuments are included, residence plaques and other commemorative inscriptions generally excepted. Street numbers are usually given preference over names or commercial occupants, though for many important buildings both are supplied. Where a pair of dates is given for a post-war building, the first is generally that for the acceptance of the design, the second for completion. For pre-war buildings, paired dates cover the span from the start of work to the finish. Brackets are used for interiors that were not inspected; description of an interior does of course not imply that the building is open to the public. Research and visiting began in 1997, so a few interiors may have been altered by the time this book appears. Buildings known to be threatened have been pointed out, as well as a few proposed for major alteration. As ever, information from readers on errors and omissions is always welcome.

ACKNOWLEDGEMENTS

As with Vol. 1 in the revised series, the greatest debt is owed to Sir Nikolaus Pevsner's old *London 1* volume. The text of that wonderful book, including Bridget Cherry's entries for the 1973 revision, has been kept as the basis of the new edition whenever possible. For the present volume, my first thanks are due to its three expert contributors, all of whom have helped lighten the load of research and writing. John Schofield of the Museum of London Archaeology Service provided the first Introduction chapters, a few detailed architectural paragraphs excepted, and also contributed gazetteer accounts of some early buildings and archaeological discoveries. Alexandra Wedgwood revised the Palace of Westminster entry, and John Newman performed the same service for Somerset House. I am extremely grateful to all three. The book also builds on two earlier contributions to the *Buildings of England* series. Malcolm Tucker's entries on Thames crossings in *London 2: South* form the basis of the present bridge descriptions. For Westminster Abbey, the revised text incorporates many of the late Priscilla Metcalf's amendments for *The Cathedrals of England and Wales* anthology, 1985.

Next come my colleagues at the *Pevsner Architectural Guides*, past and present. As Editor of the series until 2002, Bridget Cherry was an unfailing source of wise advice and guidance. Research assistance was ably supplied by Charles O'Brien, without whose patient work identifying dates and architects this book would have taken much longer to appear. Emily Rawlinson kept a close eye on the illustrations, and Sally Salvesen oversaw the production of the book, which is the first in the series to be prepared entirely by Yale University Press. Other, invaluable assistance within the Penguin office was supplied by Sabrina Needham and Susan Machin, within the Yale office by Ruth Applin and Emily Winter. Stephany Ungless proved an expert copy editor, and Judith Wardman a no less expert indexer. The drawn plans are the work of Alan Fagan and Christopher Woodward, the maps of Reg and Marjorie Piggott. Once again, most of the photographs were specially taken by the National Monuments Record (English Heritage), by Derek Kendall and Nigel Corrie. I am deeply grateful for their efforts, and it is very pleasing that the transfer to Yale has made it possible to reproduce them in colour. A hidden debt is owed to the authors of volumes in progress, for their draft texts and their instructive companionship in other cities: an invaluable source of parallels or contrasts with the London scene. Lucky readers will discover their names as their books begin to appear.

Others very kindly undertook to read the text in draft, and their

comments and corrections were invaluable; many also helped with numerous other research questions. At the head of the list is John Newman, who worked patiently through the whole, and Bridget Cherry, who read only slightly less. For Westminster Abbey I was very lucky to receive stimulating comments and suggestions from Tim Tatton-Brown, Carol Davidson Cragoe, John Goodall, John Physick and Geoffrey Fisher (whose attributions are initialled GF in the gazetteer), as well as from Tony Trowles, Christine Reynolds and Tony Platt on the Abbey's side, and from Eddie Smith at Westminster School. John Phillips and Patrick Rogers performed a similarly helpful service for Westminster Cathedral. The Whitehall section benefited from close attention by Richard Hewlings, a constantly stimulating source of information and ideas, and the expert comments of Steven Brindle and Neil Cooke; Paul Britton also read much of the text, and kindly organized a specially rewarding site visit. John Earl did the same service of reading for the theatres, and Graeme Cottam of the Thorney Island Society for the whole of area nine. David G.C. Allan and Susan Bennett (Royal Society of Arts), Patricia Croot (parish churches), Simon Danischewsky (Bridgewater House), Hermione Hobhouse (Belgravia and Pimlico), Peter Howell (Roman Catholic buildings), Jonathan Ray (Albany), Peter Schmitt (Burlington House), Michael Turner (St James's Palace and Marlborough House) and Prof. H.J.V. Tyrrell (Royal Institution) also kindly shared their expertise. Others who have been especially helpful on a great many matters include Susie Barson, Sir Howard Colvin, Richard Garnier, Elain Harwood, Frank Kelsall, Michael Kerney, Rory O'Donnell, Michael Preston, Steven Robb, Robert Thorne, Paul Waite, Philip Ward-Jackson, Christopher Stell, Gavin Watson and Elizabeth Williamson.

Much invaluable information came in addition from the great constellation of experts at English Heritage, both from unpublished reports and from conversations and correspondence. Besides those already mentioned, I am especially grateful to Roger Bowdler, Emily Cole and David M. Robinson; to Peter Guillery at the National Monuments Record, to John Greenacombe and the *Survey of London* staff; to Geoff Noble (to whom I owe many useful visits with the London Advisory Committee); and to Paul Calvocoressi, James Edgar, Tim Jones, Delicia Keate, Treve Rosoman and Paul Velluet. A corresponding debt is owed to Westminster City Council, where Rosemarie MacQueen and her colleagues in the planning department, especially Robert Ayton, Mike Grey, Michael Lowndes and Isla Macneal, fielded a great many queries on the post-war developments.

Then there is a mighty list of those who supplied information on particular research problems, whether by letter, telephone or in person. Clergy and Religious who helped with the church entries include the late Rev. W.M. Atkins, Rev. Michael Barney, Rev. F. Davis, Rev. Ralph Godsall, Rev. Dr Peter Graves, Fr Geoffrey Holt, Rev. Nicholas Holtam, the Venerable William Jacob, Canon Paul Jobson, Fr Thomas M. McCoog, Rev. Mark Panton, Sr Marie Paul, Fr Michael Seed and Fr Desmond Tillyer.

Architects who kindly took the time to help include Peter Ahrends, John Bancroft, Charles Broughton, Martin Bryant, Peregrine Bryant, Donald Buttress, Nicholas Colwyn-Foulkes, David de Cobain, Lyn Edwards, John Forde, Nadine Fowler, Simon Francis, Matthew Goulcher, the late Roderick Gradidge, Julian Gregson, Steve Hood, Jonathan Howe, Paul Humphreys, Peter Inskip, Edward Jamilly, Tom Jestico, Tim Kempster, Jeremy Lever, Alex Lifschutz, Robert Maguire, Francis Maule, Robin Moore Ede, Nathalie Morton, Mike Moxley, Bernard Parker, Steven Pidwill, Mark Pinney, Peter Sanders, Arthur Shannon, David Snaith, Quinlan Terry, Mary Thum, Tony Tugwell, John Warren, John Whiles, Sir William Whitfield, Jack Wood and Julia Wright. The artists Jane Ackroyd, Robyn Denny, Alfred Fisher, Giuseppe Lund and William Pye were helpful in similar ways.

The largest group of all is made up of scholars, archivists, churchwardens and other people in the know: James Anderson, Lord Astor of Hever, Rosemary Baird, David Baldwin, Tabitha Barber, Alan Baxter, Vivien Beavis, Alan Bell, Susan Bennett, David Bieda, Neil Bingham, Catriona Blaker, Chris Bond, John Bos, Martin Bradley, David Brady, the late John Brandon-Jones, Geoff Brandwood, Kerry Bristol, Alan Brooks, Sandie Browne, John Carbis, Ursula Carlyle, Sebastian Carter, Christine Casey, Phillip Chancellor, Sue Cliveden, Thomas Cocke, Diana Coke, Mark Collins, Simon Constable, John Cornforth, David Crellin, Robert Cripps, Nicole Croft, Kate Crowe, Margaret Daly, Gillian Darley, Ann Davis-Thomas, Ptolemy Dean, Paul Dew, Dale Dishon, Mary Dobson, Sarah Dodgson, Sue Donnelly, Ian Dungavell, Shirley Durgan, Diana Eccles, Lewis Eldridge, David Esterley, Karen Evans, Philip Evans, Clara Farmer, David Foreman, R.A.M. Forrest, Celina Fox, Jonathan Foyle, Jenny Freeman, Cyril Gander, Claire Gapper, Paul Gardner, Anthony Geraghty, Nigel Green, Ray Green, Stephen Halliday, Roger Harding, Eileen Harris, Clare Hartwell, Richard Haslam, Kate Hay, Maria Hellman, Kathryn Hiesinger, Gordon Higgott, Dennis Hill, Rosemary Hill, Judy Hillman, Sir Christopher Howes, Jonathan Hughes, Penelope Hunting, Ralph Hyde, William Ingrey, Alastair A. Jackson, Neil Jackson, Sally Jeffery, Peter Jefferson-Smith, Chris Johnson, Reg Jones, Derek Keene, Mary Kool, Adrian Last, Peter Leach, Phillip Lindley, Anne Locker, Peter Lockyer, Peter Longman, Todd Longstaffe-Gowan, Floramae McCarron-Cates, Kieran McCarthy, Andrew MacGregor, Barry MacIntyre, Peter Maplestone, Patricia J. Methven, Chris Miele, Richard Mole, Sam Mullins, Virginia Murray, Mary Nixon, Aidan O'Boyle, Stephanie Pattenden, David Peace, M.H. Port, Ken Powell, Alan Powers, Carol Price-Brown, Margaret Hayden Prince, Paul Pritchard, Thyrza Radley, Pat Reed, Edith Reilly, Harriet Richardson, Margaret Richardson, Jackie Riding, John Martin Robinson, Andrew Saint, Ann Saunders, Susan Scott, Valerie Scott, Peyton Skipwith, Michael Snodin, Julian Spicer, Gavin Stamp, Maryanne Stevens, Damie Stillman, Elisabeth A. Stuart, June Stubbs, Caroline Swash, Paul Taylor, Alan Thacker, Colin Thom, Robert Thornton, John Thorneycroft, Julia Thrift, John Tiltman, Ian Toplis, George Toynbee-Clark, Valerie Tufnell, Catherine Wakeling, Frank

Arneil Walker, Richard Wenley, Capt. M. Whatley, Lucy Whitaker, Christopher White, C. Whitlock, Bill Wilson, Michael Winner, Alan Winter, Philip Winterbottom, Roger Woodley, Giles Worsley and James Yorke. Information from unpublished theses by Kerry Bristol (James Stuart), Tara Draper (Robert Adam) and Eitan Carol (Charles Holden) is gratefully acknowledged. More generally, I am indebted to the library staff of the Bishopsgate Institute, British Library, Council for the Care of Churches, Courtauld Institute, English Heritage Library (Savile Row), Guildhall Library, Institute of Historical Research, National Monuments Record, Society of Antiquaries, Southwark Local Studies Library and Westminster Archives Centre; also to the Grosvenor Estate, for permission to consult its records.

There is also of course an inherited debt from those who helped prepare the three earlier editions. Initial research was carried out in 1950–3 by Mrs K. Michaelson. Sir Nikolaus recorded his gratitude to a long list of helpers and correspondents, many of whom assisted with more than one edition. Several of these names recur in turn in the list of correspondents whose helpful letters to the old *Buildings of England* office have shaped the present edition: Betty Carvalho, John Charlton, P. Cormack, John Fisher, Christopher Honey, Rodney Hubbuck, S.F. Marriott, H.V. Molesworth Roberts, C. Monkhouse, Alan Mould, Leslie A. Perowne, the late Frank Scarlett, the late Hans Schmoller, Tanya Steading, Alan E. Teulon and Margaret Walk. Detailed contributions from R.H. Harrison, Sir Thomas Kendrick, George McHardy, Ian Nairn and Nicholas Taylor, which were marked with names or initials in earlier editions, have been incorporated in the revised text.

Finally, my apologies to anyone inadvertently left out above, and my heartfelt thanks to the many others who showed me around and inside the buildings of Westminster.

INTRODUCTION

Westminster is a slippery term in the C21. For non-Londoners the name is shorthand for the institutions of Government. A glance at the tube map, where Westminster station sits between St James's Park and Embankment, seems to bear this out. But these neighbouring stations, and another twenty-seven on the system, are in the present City of Westminster too. However, only sixteen of these fall within the area covered by this book. The explanation lies with the reforms of local government in 1965, when the old City of Westminster was grouped with the boroughs of St Marylebone and Paddington. The results can confuse the uninitiated: for instance, Westminster's present City Hall is included here, but not its Council House on the Marylebone Road, which is treated in *London 3: North West*.

What the present book covers is effectively the West End – one of those terms which everyone recognizes without being able to

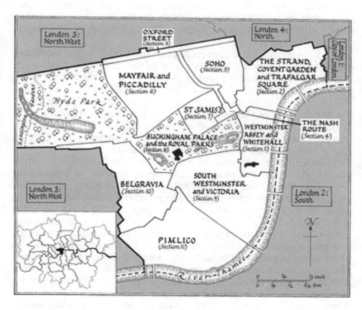

Westminster showing area divisions used in this book

define exactly – along with the Royal Parks and Government quarter to the s and w, and the mostly residential districts s of that. The treatment in eleven divisions reflects many other differences, deriving from history, function and architectural character. First comes Westminster Abbey and Whitehall, including the Palace of Westminster: the historical nucleus and raison d'être of Westminster as a settlement distinct and apart from the City. Architecturally it is also of course almost all plums and no pudding. Next is the Strand, Trafalgar Square and Covent Garden, of which the Strand represents the ancient Thames-side link between the axis of Whitehall and the City. The third area, w and nw of the second, is Soho, which introduces the theme of large-scale Georgian development. Its w boundary is shared with part of the fourth section, which covers *Nash*'s great new early c19 route in sequence from Carlton House Terrace, n up Regent Street, and on to the edge of Marylebone. Fifth comes Oxford Street, the boundary between old Westminster and Marylebone to its n, intersecting with the fourth area at Oxford Circus. Mayfair, the sixth area, lies w of Soho, and has always been socially and architecturally superior to it. Piccadilly forms its s boundary, and also the n boundary of St James's, the seventh section. This small enclave is enclosed on the s and w by St James's Park and Green Park, which form the e part of the eighth division. Its other components are Buckingham Palace, Hyde Park, The Mall and Hyde Park Corner. The ninth area, South Westminster and Victoria, is a highly unpredictable mixture. Aristocratic Belgravia and bourgeois Pimlico, the tenth and eleventh areas, are by contrast thoroughly planned Late Georgian to mid-Victorian quarters, in which *Thomas Cubitt*'s input still far outweighs those of all other builders and developers put together.

So here we have the greater part of the London that outsiders come to see. Indeed, only 5 per cent of the capital's visitors were estimated *not* to have set foot in Westminster in 2000. That most of them could have identified Big Ben, Nelson's Column and Westminster Abbey without much difficulty is a fairly safe guess. As for the rest of the area, it is worth pausing to consider what a first-time visitor interested in architecture and history would make of Westminster, considered in isolation from the City to the e and the great built-up expanse all around.

Here and there, around the Abbey or off the Strand, our visitor might still sense the pragmatically loose growth of a medieval city. Elsewhere, the regular street layouts centred on garden squares would certainly suggest the planner's hand; but the areas covered are not huge, and the grid often fails to carry on from part to part. It is all very different from, say, the concentric planning of c16–c17 Amsterdam or the absolutist realignment of c18 Lisbon: a sign of development by powerful private estates rather than a single controlling authority. Then there are the great c19 thoroughfares cut through the grid. Some are very impressive, but others were obviously done on the cheap, and there is hardly a suggestion of consistent replanning to match Papal Rome or Napoleon III's Paris. That the monarchy was not specially ambitious or rich would be a reasonable conclusion, and the situation

of its palaces on the western edge of the capital might seem to underline it. Yet the Crown also managed to preserve an amazing extent of green, wild-looking space, stretching for miles from St James's Park to Kensington Gardens: a precious resource that is unique amongst major capitals. Social inequality in general must have been very great for some centuries, though few of the big houses qualify as palaces, and from the mid C19 to the 1970s a good deal of model or municipal housing was erected. Older buildings are generally well looked after, extreme decay or neglect almost unknown. As for the average person, he or she obviously likes shopping and drinking a lot, and about a hundred years ago seems to have been obsessed with theatre-going. A horde of uninteresting commercial buildings went up in the 1950s–60s in a scattered sort of way, perhaps as a result of air-raid damage, perhaps not. Surprisingly little has been built since then; the most striking recent arrival is the giant observation wheel on the South Bank near Westminster Bridge, opened in 2000. A ride on this wheel (the London Eye, by *Marks Barfield Architects*) is an excellent introduction to the architecture and topography of Westminster; armchair users who want a more detailed account should read on below.

PREHISTORIC, ROMAN AND MEDIEVAL WESTMINSTER

BY JOHN SCHOFIELD AND SIMON BRADLEY

The Prehistoric and Roman Periods

There has been so much building work in Westminster, particularly for royal and Governmental complexes over the last five hundred years, that much of the archaeological evidence for the landscape even up to the C18 has been destroyed. Palaeolithic and Mesolithic flint tools, dating roughly from 440,000 B.C. onwards, have been recovered from sites in Westminster, as in other London boroughs, but there is no certain evidence of settlement or habitation. Elephant remains from the last interglacial period (130,000–110,000 B.C.) were reported from Pall Mall and St James's Square in 1758, and several more findings of a variety of prehistoric animal bones have been made around Trafalgar Square: they include lions, hippopotami and rhinoceros. But no buildings have been recorded. By the time of the Bronze Age, starting *c.* 2000 B.C., there is evidence of small settlements or farms in several inner London boroughs, but hardly anything in Westminster. A piled structure like a jetty and dating to *c.* 1600 B.C. was identified in 1993 on the s bank at Vauxhall, but it probably went out only to an island in the river. Another timber structure of uncertain purpose found behind Richmond Terrace in 1983 has been dated by Carbon-14 probably to the band 660–520 B.C., and layers which might be from human occupation have been identified at a site E of St Margaret's church. From the Bronze Age, also, much of the Thames including the

stretch at Westminster was used for ritual depositing of weapons, offerings and perhaps human burial. A stream later called the Tyburn, which rose in Hampstead and flowed S through what is now Regent's Park, near to Buckingham Palace and so to St James's Park, split into two as it neared the Thames and thus encircled a gravel island, Thorney. This small island is the origin of the modern settlement of Westminster.

In the mid CI the ROMAN TOWN of Londinium was established on the N bank of the Thames, immediately E of the area covered by this book. It became the medieval and modern City of London (*see London 1: The City*). Roman roads led to it from all directions; from its beginning, London was, as now, difficult to avoid. One major road led W along the present Oxford Street; there seems to have been a small hamlet near the present Bond Street underground station, where (as the dip in the road shows) the highway crossed the Tyburn stream. Another led W from Ludgate in the City, but its course is not certain. In the 1960s it was thought that there might have been a Roman crossing of the Thames at Westminster, with roads leading to it on either bank; but since then negative evidence for such a crossing has continued to accumulate. Roman finds in the Westminster area include cremation burials, boundary ditches, a boat at Storey's Gate (presumably from the branch of the Tyburn going N round Thorney Island), a building under St Martin-in-the-Fields and possible remains of another under Westminster Abbey (ironically, found when digging the grave of Sir George Gilbert Scott in 1878), along with a C3 stone sarcophagus found to its N. Another sarcophagus was found in Surrey Street off the Strand in 1741, and a tombstone showing a child holding a ball comes from somewhere in Great College Street.

Anglo-Saxon and Early Medieval Westminster

After the C5, when Roman London and other Roman settlements in the region were abandoned, there were no towns until the middle of the C7, and even then people continued to live mostly in hamlets or rural estates. What 'London' meant in the few documents of the time was totally uncertain until in 1984 two scholars working independently, Martin Biddle and Alan Vince, simultaneously proposed that plotting all previous C7–C9 finds showed a concentration in the area W of the City, around the present Aldwych and Covent Garden. Excavation since on many sites has confirmed that this was the extensive SAXON SETTLE-MENT OF LUNDENWIC: over 150 acres (60 hectares), with roads, lanes, houses and industrial buildings. It stretched from the contemporary waterfront inland of the Embankment probably to the old Roman road beneath Holborn and Oxford Street on the N, and from Aldwych in the E to Trafalgar Square in the W. A wide range of Continental trading contacts, from Norway to France, is indicated by imported objects. Two cemeteries have been found, one under what is now St Martin-in-the-Fields, and another to the N in Covent Garden; the latter may have included burial mounds. The Saxon town, which may have gone through several phases of development, seems to have been occupied from

shortly after 600 to some time after 850. The main excavation, at the Royal Opera House in Covent Garden, found traces of timber buildings nearly 40 ft (12 metres) long, with lanes, industrial workshops and many signs of a thriving, congested urban space. Some way to the S lay Thorney Island, with the Benedictine foundation of Westminster Abbey on it; beyond it to the S were open fields until the C17. Just N of the Abbey in Whitehall were two successive C9 buildings, the later a timber-framed hall, recorded in 1960 at the Old Treasury site.

Little can be said of ANGLO-SAXON ART AND ARCHITEC-TURE. The origins of Westminster Abbey are obscured by legend and the later efforts of monkish forgers to enhance its age and authority. It may have been established or refounded by King Offa in the C8: not Offa the Great of Mercia, as is often thought, but probably Offa, king of the East Saxons in the early C8. It was certainly there by the later C10, and was rebuilt by Edward the Confessor from *c.* 1050. But rather than build in a native tradition, Edward gave his church the plan and forms of the most recent buildings in Normandy. Westminster is therefore the starting point in England of the new Romanesque or NORMAN way of building. The Abbey had an apsed E end, an internal elevation with alternating piers, and a crossing tower. Two W towers were raised later, quite probably to Edward's plans. The towers remain, entirely refaced, along with some of the monastic buildings added from *c.* 1065. The groin- or barrel-vaulted spaces under much of the E range of the cloister can still be walked through, and other parts show walls and openings treated in alternating stones or stone and tile.

p. 110

It was also Edward the Confessor who established the first royal palace, next to the Abbey which was to be his own mausoleum. It was enclosed with a defensive wall, but was never military in character (contrast the Norman foundation of the Tower of London in the SE corner of the Roman City, with its great C11 keep and concentric C12–C14 fortifications). The earliest standing structure here is Westminster Hall, built in stone for William II to the present dimensions in 1097–9 and completely remodelled three centuries later. Like the Confessor's Abbey it was built on the grandest scale. The windows were arranged with a wall-passage in the stepped tripartite rhythm familiar from Norman clerestories, such as at Winchester cathedral. Some detached capitals from this work, carved with very early examples of figure scenes, may be seen at the Jewel Tower (*see* below). Other figured capitals, of mid-C12 date, have been discovered at the Abbey, probably from work in the cloisters. Otherwise the more developed and ornate Late Norman style is represented only by the Abbey's infirmary chapel, a fine but ruinous aisled building of *c.* 1160.

The Later Middle Ages

MEDIEVAL WESTMINSTER was a straggling one-street town. From the City, the riverside street called the Strand curved round SW with the bank of the Thames to form a junction with roads coming in from the N. From this junction King Street, on the

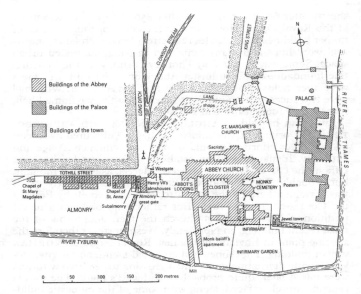

Westminster Abbey and its surroundings in the later Middle Ages.
Map (adapted from Barbara Harvey, *Living and Dying in England
1100–1540*, 1993)

line of the present Whitehall, went s to the N gate of the Abbey
precinct. From the other, w gate, Tothill Street (developed by
the Abbey in the C14) struck out to the w, but quickly became a
road between fields. In terms of communication, Westminster
was more used by river traffic. Most riverside houses had private
wharves or watergates, but the town never developed port
facilities; that was left to the City, which from *c.* 1130 onwards
received charters guaranteeing its independence. The riverfront
of Westminster and along the Strand was no doubt reclaimed
spasmodically by individual houses and institutions, but archaeo-
logical work here has not been as intense as in the City, so the
chronology is not yet specified.

The City's priority in economic activity would hardly have
seemed the case under Henry III (1215–72), when both Abbey
and palace were one vast building site. Most of the remains of
MEDIEVAL ARCHITECTURE in Westminster belong to these two
complexes, and in each case the earliest major structures that
survive are of C13 date. After the late C13 the focus of interest
and innovation tends to shift back and forth between Abbey and
palace, so the account that follows is largely chronological.

The C13 work at WESTMINSTER ABBEY began in 1220, when
a new Lady Chapel was added E of the Norman church. This
was demolished in the early C16, but something of its plan is
known, and it is a reasonable guess that it would have had

windows of lancet form, the usual kind of the Early English
GOTHIC style. Lancets can be seen in London in the retrochoir
of Southwark Cathedral and the choir of the Temple Church (*see
London 2: South* and *London 1: The City*), both of the first half of
the C13. The next development in terms of windows was plate
tracery, a late C12 French invention that is another missing link
in the existing building record at Westminster. What we have
instead is the Abbey church itself, begun for Henry III in 1246 2,6,
as a synthesis between carefully selected French elements and p.
English traditions. The Master Mason was *Henry of Reynes*, and 121
there are good reasons for identifying Reynes with Reims, the site
of the French coronation church. Compared with preceding
Gothic cathedrals such as Wells, Lincoln and Salisbury, West-
minster Abbey is French in its plan, elevation and tall propor-
tions. The plan has a polygonal apse with polygonal chapels p.
radiating off the ambulatory, just like Reims. Moreover, the 125
chapels have a wall-passage in front of their windows, as at
Reims; bar tracery of Reims pattern is used everywhere; the piers
are of the same type as at Reims; and foliage appears for the first
time in England carved naturalistically, as can also be found at
Reims, rather than stylized with stiff-leaf shapes. But Reims was
begun as long before as 1210, and Henry of Reynes clearly
wanted to temper his borrowings with more up-to-date French
innovations. His two most important sources were Amiens, where
windows had recently been made of four lights with bar tracery
of three foiled circles, and the Sainte Chapelle in Paris, begun
c. 1241–3, which for instance has tracery of unencircled trefoils. p.
Both motifs are repeated in the earliest phase at Westminster, 188
that is before Henry of Reynes was succeeded by *John of
Gloucester* in 1253: the first in the Chapter House, the second in 7
the cloister.

But in other respects the Abbey shows its English roots, and
in such a range of devices great and small that it is clear that the
designer must have learned his craft in England. To begin with,
its second storey is a full gallery, a Romanesque tradition which
the French gave up once the High Gothic style took over from
the Early Gothic at Chartres after 1194. Instead, Chartres (and
also Reims and Amiens) has a triforium, that is a shallower storey
contained within the thickness of the wall. Westminster, and
England generally, remained faithful to galleries. Also English
is the polygonal plan of the Chapter House, a form established 7
at Lincoln and Beverley and unknown in France. Even more
remarkable is the use of a ridge rib in the high vaults, a tradition 6
begun at Lincoln earlier in the C13 and also unknown in France.
At Westminster a further step down the English road of elabo-
rated rib vaults was taken when the E bays of the nave were rebuilt
up to 1272, when a tierceron rib was introduced, on the pattern
of the most recent works at Lincoln and Ely. The effect of all-
over richness depended also on such innovations as the diaper
pattern carved on the spandrels, the use of Purbeck marble for
the piers and other details, and the plentiful population of
SCULPTURE, from large figures such as the angels in the transepts 9
or the Annunciation in the Chapter House, to the exquisite small
carvings of bosses, corbels, etc. The best are equal in quality to 8

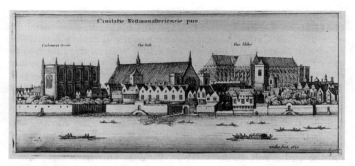

Westminster from across the Thames, showing (left to right)
St Stephen's Chapel, Westminster Hall, Westminster Abbey
Engraving by Wenceslas Hollar, 1647

any contemporary work on the Continent, with which they share
a preference for lifelike facial types and expressions.

Some of the lesser motifs of Henry III's Abbey were also
used in his residential additions to WESTMINSTER PALACE,
which was firmly established by the C13 as the primary royal
residence. Splendid though we know these to have been, they
were eclipsed in purely architectural terms by the greater marvels
of St Stephen's Chapel. This was begun in 1292 for Edward I
and embellished up to 1363, by which time it had been made col-
legiate. It was a tall, aisleless building with four angle turrets,
foreshadowing the much later royal chapels of Eton and Cam-
bridge, but much more richly and colourfully decorated. Like
many larger domestic chapels it was two-storeyed, taking its
proportions from the Sainte Chapelle. Only the lower storey of
15 1292–7 survives (properly, the Chapel of St Mary Undercroft),
much restored after the fire of 1834. This is enough to show how
revolutionary the chapel was, for it has both lierne vaults and
ogee arches in the tracery, the earliest appearances in England of
motifs which were both to be fundamental to the later develop-
ment of the DECORATED style. They can be attributed to *Michael
of Canterbury*, who initially had charge of the work. Similar in
spirit is the net-like tracery and lierne vaulting in the S part of
the E range of the Abbey cloister, work traditionally dated to
the 1340s, but more likely to have followed soon after a fire of
1298 in the monastic quarters. Here the tracery openings have
split cusps, a device associated with the Kentish masons, which
was to prove less popular and enduring in England than the
ogee. Ogee arches also appear on several tombs in the Abbey (*see*
below, p. 12), and formerly on the last in the chain of Eleanor
Crosses erected by Edward I, *c.* 1293, at the W end of the Strand
(whence the name Charing Cross).*

The succeeding, PERPENDICULAR style also derived some-
thing from St Stephen's Chapel, and specifically from the upper

* The present cross there is a Victorian re-creation, not on the original site.

level. This was built from the 1320s to 1348, first under *Thomas of Canterbury* (son of Michael), succeeded by *William Ramsey III.* Here motifs of panelling and especially the so-called descending mullion appeared, closely related to the work of the 1330s at Gloucester and at Ramsay's new cloister of St Paul's Cathedral. These were the two key buildings for the later course of the style, early examples of which can also be identified at the Abbey. First came the porch of the w front, which appears to have been added in connection with refacing of the lower w towers *c.* 1338–43. It is of the spreading or 'welcoming' type, with mullions of Perp character in the blind tracery of the inside. Work then switched to the Great Cloister, where the s and w walks were rebuilt in 1344–65. The details of the cloister are close to those at St Paul's, another work by *William Ramsey III* (†1349), and it may be that it and the w porch were designed by him too. His successor at the cloister was the Abbey's own Master Mason *John Palterton,* who also undertook the rebuilding of the abbot's house, courtyard and associated buildings to the w, and of the Little Cloister to the E (mostly replaced since).

p. 188

What this account leaves out is the nave of the Abbey church itself, on which Palterton resumed work in 1375–6. Progress was slow; none of Henry III's successors was willing or able to spend as much, and the monks' attentions tended to turn away towards their other buildings. Only in 1506 were the last bays of the high vault finished. So it is all the more remarkable that the C13 design was continued in all essentials. The result is a building more homogeneous in appearance than any of the medieval cathedrals except Salisbury. Only at the w end, as has already been mentioned, do Perp forms appear fully fledged. The upper stages here are C15 or early C16, though the towers were incomplete when the Abbey was dissolved as such in 1540.

2

p.8

Of the C14 works at Westminster Palace we have two very different survivals. The little Jewel Tower of 1365–6 by *Henry Yevele,* at what was the sw corner of the palace precinct, is the only work of medieval military architecture remaining in Westminster, necessary by virtue of its function as a store for the king's treasure. The other work is the reconstruction of the C11 Westminster Hall, begun in 1394 and finished in 1401. Here again is a work of great splendour that was also widely influential: less so for *Yevele*'s much-restored elevations, handsome though these are, than for *Hugh Herland*'s mighty hammerbeam roof. As the earliest large-scale exposed example in England it is the parent of a splendid progeny, especially in East Anglia. As at the Abbey, SCULPTURE was an important part of the effect, though just five of the many original statues of kings survive inside.

p.8

17

There is much less to report for the C15, when royal patronage tended toward Windsor, and the Abbey mostly pressed on with its unfinished business in the nave. Worth mention here as an ornate and imaginative instance of the Perp style is the Chantry Chapel of Henry V, built across the E side of the ambulatory like a bridge from *c.* 1438. But the early C16 was rather more productive, so that TUDOR GOTHIC can be seen at Westminster at its best. The outstanding example is the resplendent Henry VII's Chapel, a giant aisled structure which

replaced the C13 Lady Chapel of the Abbey in 1503–*c*. 1510. It
18 has England's most ingenious Late Gothic vault, a fan vault of
pendant type diversified by interpenetrating cross-arches. The
closely panelled exterior has polygonal turrets for buttresses,
framing windows curving and jutting forward in lively movement,
a pattern more like those of some great houses of the time than
of any other church or chapel. Frustratingly, no designer is doc-
umented for the work; the prime candidates are *Robert Janyns*
Jun. for the lower parts, *William Vertue* for the upper storey and
vault. Sculpture was an essential part of the original effect inside
p. and out, and though the exterior figures have now all gone there
139 is still a very full complement of highly individual statues within.
 The Abbot in the early C16, John Islip, was also a great builder
in his own right. Besides completing the high vault, he carried
on the work of the W towers and added a wing to the abbot's
house. It seems appropriate that his own, two-storey chantry
tomb of *c*. 1523 should be the largest of any ecclesiastic in the
Abbey. As for the palace, a fire in 1512 put an end to it as the
pre-eminent royal residence, but the collegiate chapel carried on,
and in 1526–9 it undertook the two-storey St Stephen's Cloister.
This survives, heavily reconstructed, within the Victorian Palace
of Westminster.
 On the small island which formed the basis of Westminster,
there was some jostling for space between the two complexes.
Edward III built his Jewel Tower at the SW corner of his palace,
invading the monks' garden by about 40 ft (12 metres). The
Abbey demanded and won compensation, but accepted the *fait*
accompli by rebuilding their wall around the intrusion. Much of
the C14 Abbey wall remains, and can be seen from Great College
Street and Old Palace Yard.
 There were a few PARISH CHURCHES and also some hospi-
tals, but nothing like the concentration in and around the City
to the E. For much of the medieval period, St Margaret, in the
Abbey precinct, was the main parish church. Possibly built in
the late C11, the church at first stood rather by itself, like today;
later came trading stalls of a fair established in 1248 within the
precinct, and a street of housing which came up to it. It was
totally rebuilt *c*. 1482–1523, but has been restored many times
since, so that the medieval exterior of ragstone and Caen is now
replaced by Portland stone. Things are different inside, where the
16 even, slender arcades or four-centred arches remain, the work of
the Abbey's mason *Robert Stowell*. The original parish stretched
from the Thames to Oxford Street, and from the Tyburn E to St
Giles-in-the-Fields, N of St Martin-in-the-Fields (*see London 4:*
North). New parishes were also created, sometimes on the basis
of older chapels. They included St Mary-le-Strand and St
Clement Danes by 1222 (the former mentioned as a church in
1150, the latter possibly as old as the C9–C10), and St Martin
itself, which took away much of the N and E parts of the parish.
We might suppose that in the Middle Ages these churches looked
like the scores of others in the City, with aisles and chapels
and W towers. St Martin-in-the-Fields was totally rebuilt in
the 1720s, but the lower part of the C15 tower survives within
the C17 rebuilding of St Clement Danes. For a fuller discus-

sion of medieval parish church types in London, *see London 1: The City*.

Of the HOSPITALS, The Hospital of St James, for leprous women, is known by the mid C12; it was never rich. The Hospital of St Mary Rouncevall, an offshoot of the priory of that name in Navarre, was founded in 1222 by William Marshal, Earl of Pembroke, suppressed after 1432 but revived in 1476; its site is now covered by Northumberland Avenue. Next to it was a hermitage dedicated to St Katherine. In 1505 Henry VII ordered the rebuilding of the derelict Savoy Palace off the Strand (*see* below) as a hospital for the poor with a hundred beds. He obtained information about the C14 hospital of S. Maria Nuova in Florence, with results which were evident in the Savoy's new cruciform layout. It had three chapels; one remains, much restored, as the Savoy Chapel of 1510–16, which stood W of the main buildings.

Between the City and Westminster, along the Strand, SECULAR MANSIONS AND PALACES were established mostly in the C12 and C13, settling down near the royal palace and the organs of Government. Nearly all lay on the river side, and had river access. From engravings and a little excavation we know about the Bishop of Bath's Inn (later Arundel House, modified by *Inigo Jones*): a C14 hall at the back of a large courtyard, and extensive gardens down to the Thames. Neighbours were the Bishops of Exeter, Llandaff and Carlisle; the town houses of the Bishops of Norwich and Durham (under the Adelphi) were further W, nearer Charing Cross. In 1245 the Archbishop of York established his official residence 'in the street of Westminster', and this became York Place, which was extended by Wolsey as archbishop in 1514–29. Among the ecclesiastical palaces were some, though not many, houses of secular nobles: in 1245 Henry III granted to his relation Peter of Savoy the land which became the great private palace of the Savoy, which was sacked by the rebels in 1381.* On the N side of the Strand, near the Temple, were some of the outlying smaller legal inns, whose concentration was in the City suburb of Holborn and Fleet Street. The present enclave of Clement's Inn preserves the name of one of them. All these mansions would have been fronted by smaller houses of tradesmen and shops.

By 1200 some ORDINARY HOUSES of this kind no doubt stood at the S end of King Street, next to a corner where there were two gates: E into the palace, and S into the Abbey precinct. By 1300 most of King Street was built up, though less on the W side. Westminster, like many other towns, suffered a recession in the first half of the C15, but from *c.* 1450 there are signs of new building and prosperity. William Caxton had a shop within the precinct, next to the Chapter House; here he set up the first printing press in England in 1476. Some lanes down to the Thames from King Street had speculative cottages along them. King Street itself was full of taverns (fifty-eight by the mid C16) and inns, serving the needs of many coming to Parliament, the many legal offices, or the royal court. A plan made in 1611 of the

* It seems then to have lain waste for 120 years, and some of its stone was taken to build Eton College in 1444.

Sun Tavern on the W side (where the present Parliament Street,
the S part of Whitehall, now meets Parliament Square), by Ralph
Treswell, shows a long and narrow property, just as in any other
medieval town; two main drinking rooms on the ground floor
and a parlour behind, and two storeys above. Such houses, need-
less to say, were timber-framed, a manner of building that went
on well into the C17. The surviving examples and the later devel-
opment of the type are discussed below, *see* pp. 17–18.

Medieval Art, Monuments and Church Fittings

The use of the Abbey as the royal burial church for most of the
period means that its medieval treasures far outshine those of any
other site in England. Even by Continental standards the works
are often superlative. It is right to think of them in international
terms because several of the royal commissions were by artists
from abroad, whose works sometimes proved too exotic to inspire
domestic imitation. Other embellishments, including those done
for the Abbey community or for non-royal courtiers, tend to be
more typically English. Outside the Abbey there is little; brought-
in pieces include a carved Spanish C14 crucifix at St Matthew
Great Peter Street and a C15 English alabaster Madonna and
Child at Westminster Cathedral.

MONUMENTS deserve the first place. The story begins with
the early effigial slabs to three C12–C13 abbots in the cloister, all
very damaged. Next comes the group of *c.* 1270 that includes the
shrine base of Edward the Confessor and Henry III's own tomb
to its N. These stand outside English traditions by virtue of their
classicizing design and the use of Italian mosaic decoration of
Cosmati type. (The same visiting craftsmen also made mosaic
12 PAVEMENTS at the E end of the church, works which look aston-
ishingly exotic even today.) Henry's effigy proper was commis-
10 sioned rather later, in 1291, from *William Torel*; he also made the
effigy of Eleanor of Castile. Both are of bronze gilt and belong
firmly to the English Gothic school, as do the late C14 bronze-
11 gilt effigies of Edward III and of Richard II and his queen. A
rival material after the C14 was alabaster, used for the effigies of
John of Eltham (†1336, made by *William Ramsey III*) and Queen
Philippa (†1369). The sculptor of Philippa's tomb was *Jean de
Liège* of Brabant, a forerunner of the 'Dutch' artists – that
is, Netherlanders or Germans – who were so much employed
in England in the C15–C16. Philippa's effigy is incidentally
accounted the first portrait, rather than ideal likeness, at the
Abbey. A technique less widely imitated was that of metal plates
on a wooden core, whether of enamelled copper (William de
Valence †1296) or silver gilt (Henry V †1422, now robbed away).

Most of these tombs stand around the shrine, and have
canopies in the shape of flat testers so as to allow a better view
of it. The canopies of tombs placed further away could afford
to make a bigger display. The two that stand out are of Edmund
Crouchback (†1296) and Aymer de Valence (†1324), spectacular
14 works both by *Michael of Canterbury*. Crouchback's already uses
ogee arches, which are fully developed in Aymer's, along with the
split-cusped motifs already noted in the cloisters. Crouchback's

tomb is also the first in the Abbey to have little mourning figures or weepers on the chest. Lesser tombs include a good population of abbots and courtiers, some with simple chests, others with the oversailing arched canopies of the C15–C16, whether placed like free-standing screens or set against a wall. The last in a wholly Gothic idiom is that erected in 1556 to Chaucer, though this may be a reused older piece.

BRASSES are less conspicuous, but a good many survive in whole or part. The origin of memorial brasses in England is sometimes traced to the inlaid tombstones to John and Margaret de Valence (†1277, 1276) in the pavement of the shrine, though these are without images. The best of the rest are the two big late C14 examples in St Edmund's Chapel. p. 162

For the history of English PAINTING in the C13 and C14 the treasures of the Abbey are unparalleled. They begin with the retable, only fragmentarily preserved, but perhaps the most exquisite piece of late C13 panel painting in Europe. Next are the noble over-life-size wall paintings of saints in the S transept 13 and St Faith's Chapel, of c. 1300, and the slightly later figures on the sedilia. The sedilia are of wood, so these also have the character of panel paintings. Also on wood is the giant portrait of Richard II, datable to the mid 1390s. Somewhat earlier, and of a much lower standard, are the poorly preserved scenes of the Apocalypse in the Chapter House. In addition many of the monuments and some of the architectural sculpture retain original colouring, and a few tombs have (very faded) painted scenes on the lower ranges. Of lost works, the great cycles of painting at Westminster Palace, in the Painted Chamber and St Stephen's Chapel, lasted long enough to be recorded. The chamber, of the late C13, showed the arrival of a new, French-derived figure style; a century later, the chapel included some sophisticated attempts at illusionistic perspective in the Italian manner. The destruction of all but fragments of these schemes in 1834 was undoubtedly the greatest single loss to English art in the C19 or C20.

TILES can be seen to best advantage in the Chapter House, which has one of the best mid-C13 floors anywhere. The STAINED GLASS is disappointing. A few reassembled C14–C15 figures remain, without much character. The best C13 pieces are detached and in the Abbey museum; the C16 sequence of Henry VII's Chapel is entirely lost. Good windows of the early C16 can however be seen at St Margaret and St George Hanover 23 Square, though neither is of English manufacture and both have been reworked to fit. WOODWORK includes the sedilia already mentioned, the near-contemporary Coronation Chair, some big robust furniture in the Muniment Room, and the stalls of c. 1512 in Henry VII's Chapel, with their Flamboyant, rather Flemish canopies and perky misericords. METALWORK is especially well 22 represented. Highlights include the grate of Queen Eleanor's tomb, of 1293–4, and the grand brazen screen round the monument of Henry VII and his queen. This is of 1505–c. 1512 and still entirely in Perp forms, although the monument inside marks the memorable moment when the court of Henry VIII took up the new style of the Renaissance (see p. 16, below).

WESTMINSTER FROM THE REFORMATION
TO THE COMMONWEALTH

BY JOHN SCHOFIELD AND SIMON BRADLEY

The Impact of the Reformation

Westminster in the C16 changed dramatically, as so much power
and property passed out of the hands of the church. In 1530, just
before the Reformation began in earnest, Henry VIII acquired
York Place, the residence of the disgraced Wolsey as Archbishop
of York. Henry rebuilt and extended it to become Whitehall
Palace, similar in ambition though not size to Hampton Court:
a large hall, galleries and courts, tennis courts, orchard and
banqueting house, partly on the other, w side of King Street. The
N half of the street thus traversed the enlarged palace, between
two gatehouses built across it. St James's Park was created N of
Tothill Street and w of King Street; Henry turned the former
hospital into a manor house which became St James's Palace. Of
Whitehall a few early C16 fragments remain, including Wolsey's
wine cellar and parts of Henry's tennis courts, both incorporated
within C18–C20 buildings and not normally visitable; much can
also be learned from archaeology and other records. St James's
20 Palace keeps its C16 gate-tower and chapel and parts of several
ranges, though much more has been lost or refaced. In both cases
the material is largely brick, which had become normal for the
more expensive kinds of secular work in London by the early C16.

The suppression of the Hospital of St James for a royal palace
is symptomatic of the English Reformation, which was directed
very decidedly from above. The other hospitals and religious
houses were also seen off in the 1530s–40s, though their relative
scarcity in Westminster meant that the effects were less drastic
than in and around the City. The exception is Westminster Abbey
itself, which was protected from much spoliation by its unique
role in royal burials and coronations. Henry VIII gave it cathe-
dral status, but his daughters had other ideas: Mary I re-founded
it as a Benedictine abbey, then in 1560 Elizabeth I made it a
collegiate church directly under the Crown.

Nor was Henry the only one with drastic intentions. Under
Edward VI (1547–52), St Mary-le-Strand was demolished to
make way for Somerset House; Protector Somerset promised
to rebuild the church, but nothing was done until the 1710s.
Somerset also wanted to demolish St Margaret for building
materials, but the parishioners turned out with weapons and
prevented him. Also during the C16, the bishops were gradually
ejected from their Strand residences. Noble houses such as
Bedford House appeared on the N side. The BIG MANSIONS
towards the river stayed on, but with new owners and some
replacements. The most important, already mentioned, was
Somerset House, built in 1547–52. It was a courtyard house in
the medieval and Tudor tradition with a gatehouse to the Strand
and a great hall on the inner side of the court, but in its orderly
courtyard plan and classical decoration it was more consistently
of the new, Renaissance world than anything done in England

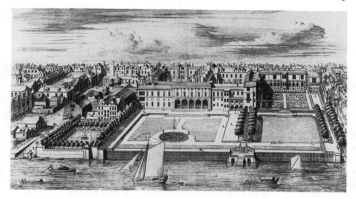

Somerset House from across the Thames,
showing (centre) the Queen's Gallery added in 1662–3.
Engraving by J. Kip after Leonard Knyff, 1714

before (*see* below). Between it and the Temple were Arundel House of the Howards (who displayed a collection of antique sculptures in their gallery, which ran down to the river), and Essex House of the Devereux. Further w, Salisbury House was rebuilt in 1599–1603 by Sir Robert Cecil, the future 1st Earl of Salisbury, with a courtyard open to the street (except for a set of railings) instead of the usual range of separately let buildings: another innovation. To the w, by Charing Cross, Northumberland House of *c*. 1605–12 was one of the biggest; like the others, it had extensive gardens down to the Thames. The large and rambling precinct of the Savoy also became a favoured spot for houses of noblemen and high-ranking clergy in the C16 and C17, then in the later C17 a centre for Nonconformity and French Protestants (*Wren* rebuilt the Little Chapel for them), and a haunt of criminals claiming sanctuary until 1697.

These great houses were often short-lived; Essex House, replaced by the present Essex Street in the 1660s–70s, was an early casualty, and the demolition of Northumberland House in 1874 extinguished the breed. Now there is nothing to show for them apart from street names and a few fragments: a C16–C17 brick-built plunge bath from Arundel House off Surrey Street, p. and the watergate of 1626–7 from the 1st Duke of Buckingham's 378 work at York House (not Wolsey's, but another so called after the then Archbishop bought it in 1557), now landlocked in the gardens of the Victoria Embankment (central section). Hardly more enduring were the detached, compact mansions of the earlier C17, such as Goring House and Arlington House on the site of Buckingham Palace, which belong in a larger category of country houses built within easy reach of London. Nor is there much to show for the ALMSHOUSES of the C16 and C17, a medieval tradition that continued in Protestant form. Of the foundations w or sw of the Abbey, all were either relocated or

consolidated in one new building in Rochester Street in the later
C19.

More lasting in their impact on the character of Westminster
were the ROYAL PARKS, the outlines of which were also estab-
lished in the first half of the C16 (some modest realignments and
encroachments excepted). The area affected, w of the built-up
parts, was anciently three parts of the manor of Westminster:
Neyte, approximately from the site of Kensington Palace to the
Serpentine, further E (*see London 3: North West*); Hyde on its E
side, forming the majority of Hyde Park and some land to the
s; and Eybury, which stretched s from the site of Grosvenor
Square down to the Thames at Pimlico. Hyde was extracted by
Henry VIII from Wolsey; Henry straightened up the N boundary
by adding part of the manor of Paddington, to form a park for
hunting. A royal banqueting house, with kitchens for roasting,
was built in the new park in 1551 (so, a piece of royal building
under Edward VI). Green Park, between St James's Park and
Hyde Park to its NW, appears also to have been acquired in
Henry's reign. Elizabeth liked to walk in St James's Park, and
gates to the park, along with numerous other gates and bridges
in the surrounding fields, were constructed for her.

The Renaissance Style

Alongside these changes in ownership, planning and religious
practice came a shift in art and architecture from Gothic to
RENAISSANCE or classical forms. The status of Westminster as
the centre of power and fashion ensured that the new styles and
devices appeared here extremely early on. Their progress can be
now traced only in the CHURCH MONUMENTS at the Abbey,
where they begin with the employment of the Italian *Pietro
Torrigiano* in Henry VII's Chapel. He made the effigy of Lady
Margaret Beaufort in 1511–13, followed by the entire monument
to Henry VII and his queen in 1512–*c.* 1518. Both are of an
exquisitely calm beauty, from which all the angularity and rest-
less tension of Gothic sculpture have vanished.

Torrigiano's complete control over the later tomb is also a sign
of his high status as an artist, an idea which took many more
years to catch on in England. This was due in part to the way in
which decorative 'antique' forms were taken over and combined
with native Gothic traditions, rather than treated as an all-
embracing style. But it also points to the fracture with Mediter-
ranean Catholic culture caused by the Reformation, which
excluded all but North European craftsmen for most of the C16.
So the English scene from the 1560s into the C17 was dominated
by Flemings or Dutchmen, who brought their native fashions with
them. The Duchess of Suffolk's tomb (†1563) shows these fully
fledged: classical, arcaded tomb-chest, strapwork decoration in
the Antwerp manner. Later tombs filled the abandoned chapels
of the Abbey with canopies or tiers, whether set against a wall or
free-standing. Effigies begin to appear reclining on an elbow as
well as fully recumbent (Lord Russell, †1584), or kneeling (Sir
Richard Pecksall †1571), or with children shown smaller and

also kneeling (Lady Burghley †1589). The columns, pilasters, entablatures, obelisks and coffered arches of these tombs constitute the greatest display of early Renaissance architectural forms in Westminster. Their profuse heraldry also advertised the entrenchment of so many new governing families. The genre culminates in the early C17 with two free-standing royal monuments, to Mary Stuart and Elizabeth I, respectively by *Cornelius Cure* and *William Cure II*, and *Maximilian Colt*, both with effigies well above the usual Late Tudor standard. They also show the movement away from dazzling colours to the monochromes of the C17, though with areas still picked out in pigment and gilding.

ARCHITECTURE proper has little to show by comparison, and any account must lean heavily on demolished buildings. The two gatehouses of Henry VIII's Whitehall neatly demonstrate the early progress of classical ideas. The Holbein Gate of the early 1530s used terracotta portrait roundels of emperors to add antique pomp to a Tudor Gothic structure (as still appears at Hampton Court). But when the King Street Gate was built in the 1540s, a distinctive French classicism was adopted, with domed turrets and tiers of thin pilasters. The greatest monument of this style was old Somerset House, which displayed such novelties as conjoined windows under one pediment and a frontispiece of superimposed orders. Complete innovations like this were deliberately created by advanced Protestant reformers to mark a break with the past; hence the immediate popularity of Serlio's treatise in architecture, published gradually in Italy and France from 1537 to the 1550s, which must have been in the hands of Somerset or his architect. The later turn towards Netherlandish motifs was still in force when Northumberland House was built, where the façade was decorated in strapwork. Serlio was also the model for the tessellated ceiling at St James's Palace chapel, dated 1540, which retains some original PAINT- 19 ING. There are also striking grisaille schemes of the mid C16 at No. 20 Dean's Yard. Lost works are headed by *Holbein*'s great dynastic mural of 1537 at Whitehall, burnt with the palace in 1698 but known from drawings and copies.

Lesser Houses of the Sixteenth and Earlier Seventeenth Centuries

While timber-framing remained the norm, there was little common ground between the great houses, with their elaborate displays of classical ornament and broad spreading fronts, and the ordinary HOUSES of the citizenry. Their timber-framed dwellings tended to be built up extremely high on major streets, with jettied upper storeys, but on lesser streets could be just two-storeyed. One example of each remains, both probably C17: a tall, p. narrow-fronted house at No. 229 Strand, and a two-storey house 363 at Nos. 13–14 Portsmouth Street (the so-called Old Curiosity Shop). Also timber-framed is the E range of the Deanery court-yard at Westminster Abbey, partly of 1606, and part of the Seven Stars pub in Carey Street, probably no earlier than the 1680s. In addition, good pictorial records exist of typical C16–C17

timber-framed houses, some with enriched bargeboards and vigorously carved classical ornament.

Many of these houses stood in the district around the present Drury Lane, Kingsway and Aldwych, which was mostly subjected to slum clearance in the later C19, and also on the N side of the Strand towards the E, an area razed a little earlier to build the Royal Courts of Justice. These districts were built up by the mid C17, representing a significant expansion of the urban area. In the C16 the open space started on the N side of St Martin-in-the-Fields, but by 1600 the population of London had swelled to *c.* 200,000, and the pressure to build new streets of houses was immense. Such rapid growth here and outwards from the City alarmed the authorities, who in the later C16 and C17 made several attempts to halt, restrict or at least control the builders (1580, 1593, 1602, 1625, 1630, 1657, 1661, 1671). None was properly enforced, especially once the Crown realized that fines for non-compliance amounted to a useful new tax. The planned private developments of the C17 (*see* below) were able to evade these prohibitions by creating select, well-built new districts that would not fill up with the disorderly and dangerous poor.

Several of the Proclamations against new construction are also important for the story of the replacement of fire-prone timber-framing with BRICK. In 1605, timber was prohibited for house fronts, though it was not given up for decades afterwards. Further Proclamations from 1615 tried to regulate floor heights and to enforce the use of vertical rather than horizontal windows. Behind the front, timber-framing disappeared very gradually: framed houses of *c.* 1635 remain, refaced, in Maiden Lane; Park Place and St James's Place have 1680s–90s houses with timber-framed back walls or wings; a house with a jettied and weatherboarded flank in Charles Street dates from as late as the 1750s. Of newer kinds of C17 house, nothing remains of the advanced fashion for giant-pilastered fronts that came in with the 1630s (still represented by Lindsay House in Lincoln's Inn Fields, *see London 4: North*; also by a near-facsimile Victorian elevation in Covent Garden, *see* p. 20, below). The transitional C17 brick-fronted types with shaped or half-hipped gables, once commonplace, have also disappeared, though late examples of rear gables remain, e.g. in Old Queen Street, *c.* 1700. The few intact domestic interiors from before the Restoration are concentrated in the Abbey precinct, including some panelling in the Deanery, and (in the Jerusalem Chamber) a typically ostentatious overmantel of the 1620s.

The Crown's wavering attitude to the growth of London outside the City also showed in its endorsement of the New Exchange, a speculation by the Earl of Salisbury, opened in 1609 next to his house in the Strand. This courtyard building was modelled on the Royal Exchange in the City, whose Corporation was violently opposed to Salisbury's project. His understanding of the importance of luxury trades to the burgeoning West End was prescient, even if the building proved the first of many white elephants in Westminster. Amongst those concerned with its design was *Inigo Jones*, and his name opens a new chapter.

The Seventeenth Century: Inigo Jones and Nicholas Stone

The central figure in English architecture during the years between *c.* 1615 and the 1640s is *Inigo Jones* (1573–1652). Yet we do not possess many buildings by him, and his influence was at first confined to a narrow circle of Court and courtiers. He is first recorded, as a painter, in 1603. From 1605 he was engaged as a designer of masques, and in 1610–12 he was Surveyor to Henry, Prince of Wales. In the 1600s and again in 1613–14 he travelled in Italy, and on his return was promised the Surveyorship of the King's Works, a post he took up in 1615. Except for the Queen's House at Greenwich and his alterations to St Paul's Cathedral, all his most important works lie or lay in Westminster: the Banqueting House in Whitehall, begun 1619, the Queen's Chapel at St James's Palace, begun 1623, and then St Paul's church (faithfully rebuilt in the late C18) and the Piazza at Covent Garden, after 1629. In all these works there appears an attitude to architecture new to England. Many of their individual motifs had already been used by Elizabethan and Jacobean designers – e.g. superimposed orders, pediments above windows – but they were disjointed members before Inigo Jones came. He considered a building as a whole, following a system of proportions which cannot be modified in any one place without destroying the controlling harmony. It is based on systems worked out by the architectural theorists of the Italian Renaissance, on Serlio and Palladio, whose writings and works Jones knew well. They ensure a nobility and orderliness in plan and elevations which permitted no compromise with the Jacobean past, which Jones's early masque drawings seem already to be struggling away from. Especially new were the use of the giant order in a portico, as at St Paul Covent Garden, and the renunciation of the orders in favour of a sober pedimented block, as at the Queen's Chapel. The radically plain Tuscan design of St Paul illustrates the side of Jones most remarkable in European terms: namely, his interest in the direct re-invention of Antique buildings, at a time when the Renaissance tradition of the Continent was increasingly overlaid by the Baroque.

Technically, too, Jones was an innovator, in ways that would hardly have been possible for a designer who had risen through the building trades in the usual way. The Banqueting House (since refaced) seems to have been the first major use in London of Portland stone, the fine white Dorset limestone that became the dominant stone in the capital after 1660. The great flat span of its ceiling (with *Rubens*'s glorious paintings in the compartments) depended on the use of kingpost trusses, an Italian carpentry technique previously untried in England. Such trusses also made possible the shallow roof pitch of the Queen's Chapel, whose Romanizing coffered barrel vault would have been no less unfamiliar to native eyes. Only with the new churches of Wren, built after the Great Fire of 1666, would anything comparable be attempted again in English church architecture; the Broadway Chapel off the present Victoria Street (*c.* 1638–42, dem.), though of a decidedly post-medieval cross-in-square plan, still clung to Tudor Gothic externally.

26, 27, 28
p. 341

p. 341

26

27

28

p. More important still than any one of these innovations for the
341 future shape of the capital was the PLANNING of Covent Garden,
N of the Strand, which had passed into the hands of the Dukes
of Bedford. It counts as the earliest of the squares of London,
laid out by Jones on the example of the piazza at Livorno, with
house elevations suggestive of the Place des Vosges in Paris.
The design made one composition, with the existing mansion,
Bedford House, taking charge of the S side, and with streets
entering at the middle of the N and E sides and to N and S on the
W side, where the centre was taken by St Paul's church. The
houses had uniform façades, to make them individually incon-
spicuous and give them all together a palace air, a uniformity not
achieved again in London housing until the C18. Their elevations
– hipped-roofed, with pilaster strips over a recessed arcade – were
less influential than the means by which they were built, which
provided a template for wholesale development in London into
the C19. The owner cleared the land and laid out streets (and, in
this instance, built cellars too), but the houses were put up by
agreements with speculating builders, who were then permitted
to sell them on long fixed-term leases. The landlord thus acquired
the reversion of the properties and kept control over quality and
design, without the cost of building them himself. Jones's plan
also included London's first mews, that is streets meant for
stabling and services (Maiden Lane, Floral Street): a device
which encouraged the fronts of even very large houses to face
directly on the street. And so, for all its quirks, Covent Garden
begins the story of what we now think of as Georgian London.

The story of SCULPTURE in the first half of the C17 lacks a
comparably abrupt break. The key figure here is *Nicholas Stone*
29 (1587–1647), a Devonshire man who learned his art from two
Dutch sculptors, the London-based Isaac James, followed by
Hendrik de Keyser of Amsterdam. As his career began, the late
C16 stereotypes in church monuments were giving way to a much
wider range of poses, conceits and religious images, many of
which first appeared in England at the Abbey. By *c.* 1620 there
were for instance seated effigies (Elizabeth Russell †1601) as well
as the more familiar kneeling ones, kneelers supporting a slab
25 rather than set on top (Sir Francis Vere †1609), tombs incorpo-
rating relief panels showing the deeds of the deceased (Lord
Norris, *c.* 1611 by *Isaac James* himself), and attendant angels
(Lady Fane †1618). Stone himself not only brought liveliness to
old forms, such as the tomb-chest with reclining effigy (Viscount
Dorchester, 1640), but also introduced new types, most notably
compositions with a standing portrait statue (Sir George Holles,
c. 1632). He may also have helped develop the cartouche, the
favourite later C17 and C18 type of wall monument (Grace Scot
†1645/6).

Further innovations in sculpture were due to two Continental
artists active in the 1620s–30s, *Hubert Le Sueur* from France and
Francesco Fanelli from Italy. They preferred bronze, a material
neglected at the Abbey since Torrigiano's day. *Le Sueur*'s best-
32 known work is the equestrian statue of Charles I in Trafalgar
Square, the oldest survivor of the hundreds of public monuments
in Westminster. He also designed two spectacular installations in

the Abbey, the Richmond and Lennox monument (†1624 and 30
1639) with its huge corner caryatids, and the Buckingham
monument (†1628), which combine bronze with black and white
marble. Le Sueur's several bust monuments are eclipsed by that
to Sir Robert Aiton (†1638), attributed to *Fanelli*, who was by far
the better portraitist. At about this time the circular recesses used
for busts since the late C16 begin to give way to oval ones; an
early example is Sir Richard Tufton †1631. Another early C17
treatment was to set the bust on a tall pedestal, such as that
to Camden, the antiquary (†1623). The bust also emerged as a
form of portrait in its own right, e.g. *Le Sueur's* of James I at the
Banqueting House.

In terms of their ARCHITECTURE, monuments of this period
show an advance towards a vocabulary derived from the high
Italian Mannerism of Michelangelo and his imitators, whether
directly or via the Netherlands. This new, post-Jacobean manner
shades off into the robust and ornate classicism christened by
Sir John Summerson 'Artisan Mannerism', a style associated
with London builders such as the master bricklayer Peter Mills,
and especially prevalent in the City. Its characteristic features
are eared and lugged surrounds, blocked half-pilasters and curly
open pediments, and a general preference for flattened rather
than rounded members. A more sophisticated understanding of
the classical style is shown at the watergate of York House p.
mentioned above, a fully-fledged classical building of 1626–7, 378
of uncertain authorship; the mason was *Stone* himself, but *Jones*
and *Sir Balthazar Gerbier*, another courtier-architect, are also
candidates.

The COMMONWEALTH of the 1650s must have been an inter-
esting time to visit Westminster. Some reminders of the old order
had been destroyed in the 1640s – the windows of Henry VII's
Chapel, the late C13 Eleanor Cross at Charing Cross – but the
chief monuments of Inigo Jones stood largely unharmed. The
greatest recent changes were the DEFENCES built by the Parlia-
mentarians in 1643–4, during the Civil War. These comprised
earthworks with forts at various points, enclosing both the City
and Westminster, with most of the existing suburbs. Redoubts
or forts punctuated the earthwork at Southampton House in
Holborn, at what is now Rathbone Place (N of Oxford Street,
at the top of Wardour Street) and another is remembered in
the name of Mount Street, Mayfair. The earthwork then went
via Constitution Hill, through the site of Victoria Station, and
through Tothill Fields to the river. None of it can be seen above
ground today, nor was it tested in battle.

The wars of the 1650s were rather with Continental powers,
the exactions for which help to explain the scarcity of public
improvements.* Ordinary building naturally went on, for instance
in Great Newport Street, where an altered house remains.
Cromwell himself ruled from semi-royal state in Whitehall, where
Charles I had been fantasizing even up to his last months about

*The gateway dated 1655 from the bridewell or prison near Francis Street,
now reset behind the former Middlesex Guildhall, was an addition to an early C17
establishment.

building a gargantuan new palace to designs by *Jones* and his pupil *John Webb*. Other Parliamentarians lived close by, such as John Bradshaw, ensconced in the Deanery of the Abbey. A stone's throw away was the Royalist enclave of Westminster School, which had taken over much of the monastic quarters at the Reformation. Its Head Master Dr Busby added a Library in 1657–9 (rebuilt after war damage). The school community still lived almost on the edge of the country: even as late as 1675, virtually all the land now comprising Victoria and Belgravia, up to Hyde Park Corner, was pasture, meadow or gardens.

WESTMINSTER FROM THE RESTORATION TO AROUND 1815

The Restoration and the English Baroque

The Restoration of Charles II in 1660 is the great watershed in the architectural history of the West End in the C17, as the Great Fire of 1666 is for that of the City. The king and his reinstated court brought with them from France new ideas of architectural style, palace planning, gardening and recreation. The concept also became established of 'the season', recognized months of the year in which the upper classes would remove to London. The capital thus became more than ever the fountainhead of offices, sinecures, marriages and mistresses, entertainments, and goods of luxury and culture. Also on hand was a new generation of educated, gentlemanly architects, to supply any wants in building. Several such men were employed within the revivified Office of Works, which entered its greatest period as a powerhouse of new ideas and a school of craftsmanship. The resulting architectural culture proved broader, deeper and more robust than that of Inigo Jones and his circle.

The focus of fashionable life was more than ever at the 'West End' of the built-up area, a shift only accelerated by the Great Fire; after the 1670s the struggle to put a limit to London's growth was effectively abandoned. The BUILDING BOOM saw St James's, most of Soho, and the S part of Mayfair built over, as well as much land W of old Westminster and to the S of St James's Park; there was also expansion outside our area, e.g. in Seven Dials, N of Covent Garden. Great houses for the élite were provided along the broad streets of Pall Mall and Piccadilly and around Whitehall, and in several new squares: St James's Square from 1661, Leicester Square from 1670, Golden Square from 1675, Soho Square from 1677 (also to the N, in Holborn: Bloomsbury Square from 1661, and in the 1680s Red Lion Square and Queen Square). St James's Square has the plan of Italian squares, with the major streets entering in the middle of each side, not at the ends. Not all the others were so regular; for instance, Leicester Square, alias Leicester Fields, is an irregular quadrangle, originally with a great mansion off-centre on one side. But the mass of new construction was for people of the middling sort, in streets of brick-built terraces of increasingly

standardized design. Most were built on open land, others on the sites of former mansions and their gardens, especially along the Strand.

By 1700 London was already the largest city in Europe, with up to 600,000 inhabitants: an amazing increase from *c*. 200,000 in 1600. The early 1700s saw a slight slackening, but after the peace of 1714 things picked up again. Mayfair acquired its three squares, N of the C17 strip along Piccadilly: Hanover Square from *c*. 1717, Grosvenor Square – the largest and most regular – from *c*. 1725, and Berkeley Square from *c*. 1738. Like St James's Square, and the contemporary Cavendish Square N of Oxford Street (*see London 3: North West*), they formed the centrepieces of new districts provided with lesser streets and mews. Grosvenor Square and Berkeley Square were built on private or freehold land, rather than on leased Crown land like St James's, as also were smaller, square-less Mayfair districts such as the Burlington Estate N of Burlington House. Somewhat less select housing was built S of the Abbey precinct in the 1720s, in and around Smith Square. A fuller account of this growth will be found in the relevant area introductions. Here it is worth bearing in mind two things: that the aristocratic model of estate development went on side by side with smaller-scale speculative building, where all that really mattered was to join on to the street plan and to get out with a profit; and that the grid-plan of streets, with or without mews and focused on squares of (usually) greater houses, nonetheless remained the ideal for estate development well into the C19. A market and even a parish church might also be provided, on the model of Covent Garden and St James's, though this was less common; church-room was more usually supplied in the C18 by proprietary chapels, that is private Anglican foundations with rented pews. The Grosvenor Chapel of 1730–1 is an intact and unusually ambitious survivor. (The oldest surviving place of worship after that is Roman Catholic: *Bonomi*'s Chapel of Our Lady, Warwick Street, 1789–90.)

p. 475

39

ROYAL PATRONAGE began in St James's Park, which was laid out in the French taste, with a great canal running E–W and a broad avenue to its N (The Mall, for the newly imported equestrian sport of *palle-maille*). Such works could be done relatively cheaply, but a great new urban palace in the French manner was less within the means of the English crown. Modifications and extensions were naturally easier; the most significant was the gallery for Charles I's widow added to Somerset House in 1662–3, probably by *Webb*. It was another example of the influential formula with a giant order embracing two diminishing storeys above a rusticated ground floor. The great project of designing a new Whitehall, which Webb had spent long years working up, soon passed to the coming man *Dr* (soon *Sir*) *Christopher Wren*. Nothing substantial was done until after 1685, however, and even then the constricted sites of most of Wren's new ranges, and their preference for interior over exterior effects, gave them an unimpressive look in external views. These parts of the palace were casualties of the fire of 1698, and all that can be seen today is part of a riverside terrace or quay. The same plain manner was used for the brick-built State Rooms of 1703

p. 235

p. 15

p. 235

at St James's Palace, by *Wren* or his office. There are also minor but characteristic works there by the two greatest architects of Wren's school, *Nicholas Hawksmoor* (stables) and *Sir John Vanbrugh* (kitchens), both 1710s.

Wren had more enduring successes with CHURCHES. His ideas were distilled by the demand for half a hundred new designs for the City after the Great Fire. Many of those were necessarily built on congested sites, or reused old fabric; but at St James Piccadilly (1676–84) Wren provided the new suburb of St James's with a free-standing building, which by his own, later account also epitomized his ideal for the Protestant Church of England. It is an aisled oblong with shallowest of chancels, with a tunnel vault over the central space and galleries with columns at the upper level along each side. Wren's other surviving Westminster church, St Clement Danes in the Strand (1680–2), is also aisled, but here he resolved a clipped-off corner of the plot into a unique and highly Baroque double-apsed E end. St Clement is also of interest for its tower, rebuilt a dozen years or so before Wren came, which still exhibits the heavy, ornate classicism of mid-C17 London. Wren's third and least interesting church, St Anne Soho (1677–86), was a casualty of the Second World War. None of the three belongs with the centralizing plans that are a feature of many City churches, although St James did originally have entrances on a central cross-axis, nor did any have a spire that can be firmly attributed to Wren.

The next great leap in church architecture came with the so-called Fifty Churches Act in 1711. This was framed to bring London's burgeoning suburbs back to the bosom of the Church, with free-standing, Portland stone buildings of a greater rhetorical power than the churches of Wren, to be paid for by a tax on coal. Three of the dozen or more that followed were built in Westminster, all of immense interest: *Thomas Archer*'s wild and wonderful St John Smith Square, close in spirit to Central European Baroque; *John James*'s St George Hanover Square, more hesitant but with the great asset of a full temple portico; and *James Gibbs*'s St Mary-le-Strand, also Continental Baroque, but this time after the Roman school. The last is of course right in the heart of old Westminster, for the Act was soon modified to allow funding for older parishes. Gibbs went on to add a steeple to St Clement Danes, and to rebuild the old St Martin-in-the-Fields. This too has a great temple portico, combined with a tower and stone steeple in a way that was very influential, especially (via Gibbs's publications) in North America.

The architect most closely associated with the Fifty Churches was *Nicholas Hawksmoor*, Wren's most brilliant pupil; his greatest work in Westminster was the completion from 1735 of the W towers of the Abbey. These are also the greatest work of the GOTHIC REVIVAL in London before the C19. The design is inaccurate in almost every archaeological point, but – as with some earlier Neo-Gothic works by Wren, in London and Oxford – their general effect is extraordinarily convincing. They were completed after Hawksmoor's death by *John James*, whose Portland stone refacing of the tower of St Margaret in 1735–7 is in a similar but less powerful idiom. By that time, the star of

p. 585

33

p. 680

37

38

p. 293

2

Neo-Palladianism had long been in the ascendant. But before exploring the Georgian architectural scene more fully, the story of London's houses needs to be taken up again.

Domestic Architecture, 1660–1760

The GREAT HOUSES of Restoration London were often closer in character to country houses than to any preceding urban traditions. Particularly influential was *Sir Roger Pratt*'s short-lived Clarendon House (1664–7), one of several mansions of the 1660s–70s set back on the N side of Piccadilly, which had a winged double-pile plan, astylar façades and a hipped roof. Another trend-setter was *Hugh May*'s Berkeley House (1665), the first in London to have quadrant-shaped links to service wings in its forecourt. All that survives of these Piccadilly houses is the shell of the contemporary Burlington House, remodelled beyond recognition; it was of a more conservative mid-C17 type, with slight projections within the angles of the wings. Another quasi-country house which lingers on as a name and an engulfed carcase is Buckingham House (now Palace), of 1702–5 probably by *William Winde*, W of St James's Park. This gave London its first sight of the new, Baroque formula for great houses, with a full attic storey instead of a hipped roof, and pilasters rising from the ground. The earliest great house to survive reasonably intact is Marlborough House, of 1709–11 by *Wren* and his son *Christopher Wren Jun.*, which also has the straight-topped attic (here disguised by later heightening), but which uses angle piers of even quoins instead of a true giant order. Quoins also appear on two façades preserved from greater houses of the 1690s, Schomberg House in Pall Mall and Harrington House in Craig's Court, off Whitehall; the former shows the Clarendon House formula of projecting wings and pedimented central emphasis compressed to fit into a row of street fronts. p. 593 34

The number of such one-off commissions was always relatively small, however. There are several reasons for this. Building was costlier in London, and freehold sites scarce. There was in addition a lively market in renting houses. Ministers or senior courtiers could also expect to be provided with official apartments, most of which were made by adapting and extending older structures. The few Restoration INTERIORS that survive in Westminster include one of this type: a big open-well stair of the mid 1670s in the complex off Whitehall known as Dorset House, which began as a conversion of one of Henry VIII's tennis courts. A still finer staircase remains at Ashburnham House, now part of Westminster School, a drastic reconstruction of the medieval abbot's house, effected *c.* 1662. Its complex, toplit arrangement with many short flights must have been influenced by the demands of the site. The compartmented ceilings with their thick, wreathed plasterwork and such details as the elegant turned balusters make Ashburnham House one of the best instances of Inigo Jones's influence on the succeeding generation. p. 203

For original interiors in newly built houses there is nothing until Marlborough House, where the hall and staircases have PAINTINGS of battle scenes by *Laguerre*. The next, Venetian

generation of mural painters working in England is represented by *Sebastiano Ricci*'s mythological scheme of 1712–15 at Burlington House, but his canvases were dispersed through several rooms in C19 alterations. Other major C17–C18 mural schemes are destroyed, but the fashion spread downwards, and some early C18 terrace houses were adorned in this way. Finest

40 by far is the illusionist Baroque scheme at No. 8 Clifford Street, in the manner of Sir James Thornhill's great compositions at Greenwich or St Paul's; less ambitious work remains at e.g. No. 76 Dean Street and No. 60 Carey Street.

TERRACE HOUSES great and small were the usual London type after 1660. Even dukes did not scorn them: the plainness of the St James's Square elevations is especially striking, and the influence of such an easily adopted treatment was clearly all-pervasive. It was a markedly different convention from that in many Continental cities, where those who could not afford a family palace often took apartments in larger, shared properties. The type also tended to blur distinctions between classes: a nice reflection of an urban culture that was in some respects more socially flexible and less cringingly hierarchical than that of other European capitals.

So much of Westminster still consists of terraces that their evolution is worth tracing in some detail, starting with the ELEVATION. The vertical, plain and narrow-fronted house type was already the norm by the time of the Great Fire of 1666, and the Rebuilding Act which followed in 1667 can be seen as a codification of 'best practice'. What it could not do was enforce uniformity of design on the City's proprietors and builders, who necessarily set to work at different times and with different ends in view, on sites that frequently varied in size and shape from house to house. There was therefore a marked contrast between

p. the City or Westminster's ancient thorough-fares such as the
363 Strand, with their mixed house heights and proportions, and the newer districts to the W and NW, with their more uniform terraces on plots of matching size (the 1667 Act did not apply here, but its provisions were generally influential on London's builders). Standardization was also encouraged by large-scale developers such as the Machiavellian *Dr Nicholas Barbon*, who built over several aristocratic properties with new streets of houses (Essex House, Newport House, Carew House).

Many early terraces were not well built, and wholesale replacement was common once the first, sixty-year leases expired in the 1730s–40s (*see* especially Soho, e.g. Dean Street and Greek Street). But elsewhere quite long stretches of after 1670 remain, mostly of small to middling size: St James's Place, Buckingham Street, Newport Court, Essex Street, Litchfield Street, and so on. The last three were all *Barbon* creations; the surviving houses are often disguised by later heightening and refacing. Three bays was the customary width, three storeys the customary height (often set over a sunk or half-sunk basement storey, lit when possible by a front 'area' or light well). The storey heights are usually even, at least between ground floor and first floor, with brick bands at the divisions. Windows have sash-boxes set almost flush (many of which must have replaced casement windows), and

large, straight- or segmental-headed windows, often with key blocks.

The late C17 London house type lasted well into the early C18: the least-altered group is in Queen Anne's Gate, of *c.* 1704–5. Here the fronts are pieced out with an extra half-bay, and embellished with exuberantly carved door-hoods and timber eaves cornices. Such cornices were banned by the Building Act of 1707, aimed at reducing the risk of fire, and another Act of 1709 required that window-frames be recessed into the brickwork. This seems to not to have taken effect until the 1720s–30s (decades in which segment-headed windows were back in fashion); carved timber door-hoods of the Queen Anne's Gate type also remained common into those decades (Meard Street, Broadwick Street, Smith Square). Other embellishments were achieved in brick or stone. Fine rubbed red brick was used contrastingly for window dressings, or for panels below the windows, sometimes linking them vertically; giant pilasters or angle piers were fashionable in the 1710s–20s, under the influence of the Baroque (Clifford Street, Frith Street). These pilasters could also be of stone or stucco, sometimes rusticated or treated as even quoins (Hanover Square, St George Street). A rarer, more extrovert Baroque type appears at *Archer*'s No. 43 King Street (Covent Garden), 1716–17. The same advance from the plain wall of the late C17 to something bolder can be seen at two early SCHOOLS: the Grey Coat Hospital of 1698–1701 (partly rebuilt), and the Bluecoat School in Caxton Street of 1709, a single schoolroom fortified by stout angle pilasters.

The years around 1720 also saw a revival of PALLADIAN INFLUENCE on the West End terraced house front. This generally meant subjecting the proportions to an implied order rising through the first and second floors, with the ground floor visually treated as a basement. The first floor is taller than the second and (usually) ground floors, forming a *piano nobile* in the Italian sense, i.e. the storey in which the greatest rooms were normally placed. Windows become smaller in area in relation to the wall, and the absent order is often signalled by horizontal mouldings. Early and influential examples include houses by the Palladian pioneer *Colen Campbell* in Brook Street and Old Burlington Street; the latter in particular show how a continuous façade could be achieved by suppressing any emphasis on the party wall (as also at e.g. *Henry Flitcroft*'s Nos. 9–10 St James's Square). By the 1740s this type of house had effectively replaced the kind with taller, narrower proportions and segment-headed windows. Other, more gradual C18 changes included the use of grey or yellow stock brick in place of the warmer red shades, and the tendency to treat the ground floor with rusticated or channelled stucco or stone.

A harder change to effect was the grouping of individual façades into a larger, palace-like front. The first attempt, by *Colen Campbell* in Grosvenor Square (1725, demolished), aimed with incomplete success at making one entire side into a single composition. (The idea took root and flourished faster elsewhere in Britain: immediately in Bath, and later on in, e.g., Edinburgh.) More modest imitations followed, such as a terrace built *c.* 1738

35

41,
p.
28

37

36

p.
28

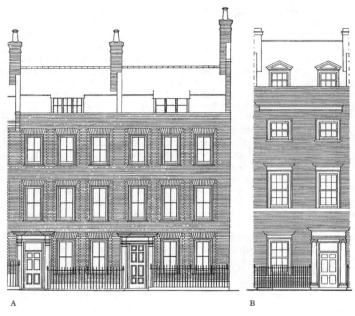

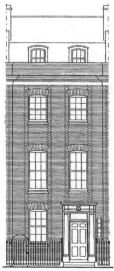

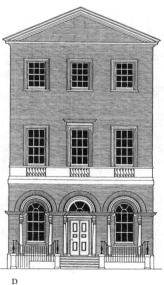

A

B

C

D

Georgian house elevations.
A, Nos. 19–21 Meard Street; B, No. 76 Brook Street,
by Colen Campbell; C, No. 48 Upper Grosvenor Street; D,
No. 33 Upper Brook Street, by Sir Robert Taylor
(*The Survey of London*; not to scale)

in the Strand with a pedimented centre and ends (also demol-
ished), and the twin ranges of the 1750s by *Sir Robert Taylor* in
Great George Street (all but demolished). The oldest examples
which can still be appreciated are remnants of the Adelphi
scheme of 1768–74 (*see* p. 39, below). By the early C19 the prin-
ciple was generally accepted; the streets off Grosvenor Place,
built up around that time, show grouped terrace compositions
finally superseding individual house fronts. It was much easier to
achieve symmetry on a smaller scale, whether by mirrored pairs
(Nos. 35–36 Upper Brook Street, Nos. 45–46 Berkeley Square,
1730s–40s), or by placing the entrance centrally (Charles Street,
Hill Street, Chesterfield Street, 1750s), usually in connection
with a front-hall staircase (*see* below).

Much of the interest of such houses derives from their
various EXTERIOR FEATURES. Ornament is often restricted to
the DOORCASE, some early types of which have already been p.
335
described. After *c.* 1720 they survive in great quantities, often as
additions to older houses. Pilastered kinds are common in the
first half of the C18 (Nos. 67–68 Dean Street), used more often
than not with pediments (Nos. 13–19 Cowley Street); engaged
columns are reserved for grander houses (No. 9 Clifford Street).
Variants include a frieze with an upswept cornice, a fashion of
c. 1720–30 (No. 17 Buckingham Street), and blocked piers of
Gibbs type (Nos. 35–36 Upper Brook Street). One mid-C18
introduction which remained popular has a semicircular fanlight
rising into an open pediment, often supported on columns or
half-columns rather than pilasters, with sections of entablature
to make up the height (No. 43 Parliament Street, Nos. 5–13
Queen Anne's Gate). FANLIGHTS became increasingly delicate
and ornate as the C18 progressed, especially the radial or semi-
circular type (No. 20 St James's Square). The oblong form also
persisted (No. 10 Downing Street), commonly used in conjunc-
tion with another durable doorcase type: a straight hood resting
on consoles, often of carved stone (Nos. 31–32 Old Burlington
Street, Nos. 9–10 St James's Square). It can be regarded as a
Palladian updating of the older, bracketed variety.

To take the story on through the C18 and into the early C19,
mention should be made of the much-imitated Neoclassical inno-
vations by *Robert Adam*, such as sunk reliefs on pilaster-shafts
(Adelphi), and of the recessed round-arched doorways encour-
aged by the Building Act of 1774, which limited exposed timber-
work even further. The latter tend to appear in ones and twos,
due to the shortage of large-scale late C18 development in West-
minster to match that in Bloomsbury or Marylebone; Craven
Street, extended and updated in *c.* 1792, has the longest run. But
the early C19 fashion for deep columned porches of stucco is fully
represented, in the new districts of Belgravia and Pimlico.

WINDOWS offer less variety. The fashion for segmental heads
has already been pointed out. The Palladian fondness for little
window pediments was generally confined to greater houses,
but other Palladian variants are recognizable even when the
openings are plain: the Venetian window, that is a triple opening
with a taller, round-headed central light (No. 71 South Audley p.
426
Street, No. 26 Soho Square) and the less common Diocletian or

thermal window, a part-circle with two plain uprights (No. 9 St James's Square). Bay windows occur with increasing frequency after c. 1730, usually on garden or parkside elevations (No. 16 Arlington Street), but sometimes on side elevations, with columns over the roadway (No. 9 St James's Square, Nos. 9 and 71 South Audley Street). Canted shapes are most common, but seg-mental bows were also known; after the mid C18 these became the norm for houses with appealing back views (Park Lane, Queen Anne's Gate, Old Queen Street), often in combination with the more adventurous plans of the Neoclas-sical period (*see* below). The thick glazing bars of the late C17 and early C18 have usually been replaced by the lighter, thinner pattern pre-ferred by the later Georgians, or else by Victorian or C20 plate glass. The thinning look was boosted by the Act of 1774, which required sash frames to be set more deeply into the wall.

From the later C18, windows were often modernized by cutting down first-floor sills, usually with the addition of a balcony or individual balconettes. The Adelphi houses are early examples of the latter, which soon became second in importance only to the doorcase as the standard embellishment of the London house front. Other IRONWORK includes railings of wrought or cast iron, with more elaborate displays reserved for overthrows or torch-holders. Behind the house, architectural features were occasion-ally built to improve the view from the rear windows (No. 71 South Audley Street, No. 32 Curzon Street).

The PLANS of the houses, or at least of the common three-bay type, stayed rather more constant. The greatest change con-cerned the placing of the staircase. In the mid C17 this was usually set between the front and back rooms, sometimes accom-panied by a light well; it was often of open-well plan rather than the more compact dog-leg (No. 10 Buckingham Street, No. 34 Essex Street). The type lingered into the C18 (No. 36 Gerrard Street, 1737), but after c. 1680 the more familiar plan with a staircase alongside the back room was customary: 'the common forme of all late built houses', according to the gentleman-architect Roger North in the mid 1690s. This more space-efficient arrangement makes an early appearance at No. 8 Buckingham Street, c. 1675–80. It is generally found together with a closet wing opening off the rear room, in which are smaller rooms suited to more private uses. Good examples from the early C18 include houses associated with the Soho builder *John Meard Jun.* (Meard Street, Nos. 67–68 Dean Street, Nos. 48–58 Broadwick Street). The smallest house type has just one room per floor, with the staircase tucked in one corner (No. 4 Lower John Street, off Golden Square, c. 1685; No. 5 Avery Row, c. 1725). Fireplaces were placed in the angles, often in pairs (Nos. 31–41 Craven Street, 1730–1), or in the centre of party walls or cross walls. Internal partitions were often of timber studwork.

Larger houses might have a grand open-well staircase in the front hall, rising to a first-floor landing, and a more simply treated back stair for access to the basement and top storeys (No. 31 Old Burlington Street, Nos. 31 and 36 Hill Street). Another type of plan has a toplit central staircase with flights above the first floor placed outside the well, and a second-floor

78,
p.
714

61

41

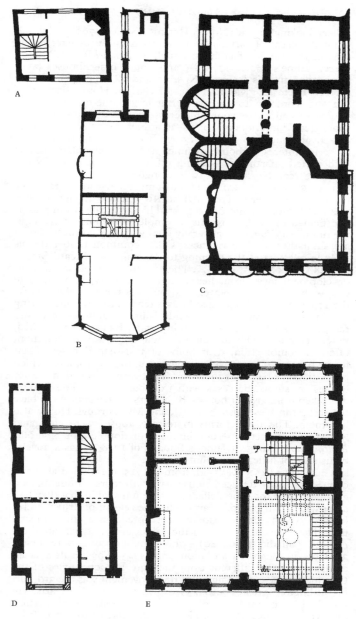

Late seventeenth- and eighteenth-century house plans.
A, No. 4 Lower John Street, first floor; B, No. 10 Buckingham
Street, first floor; C, No. 3 Robert Street, by the Adam Brothers,
first floor; D, No. 46 Queen Anne's Gate, ground floor; E, No. 31
Old Burlington Street, by Colen Campbell, first floor (A, courtesy
of English Heritage; B to E, *The Survey of London*; not to scale)

gallery looking into it (No. 18 Hertford Street, 1760s). Central, toplit staircases of various kinds returned to favour later in the
p. 714 c18, in the hands of architects such as *Samuel Wyatt* (No. 14 Queen Anne's Gate, 1775–8), and some older houses were remodelled in this fashion (Nos. 15 and 18 Upper Grosvenor Street). Even the gigantic houses of Carlton House Terrace, of 1827–33, conform to this type. But larger one-off houses are harder to generalize about in terms of plan: witness e.g. the sophisticated interiors of *c.* 1728–30 at Nos. 11–12 North Audley Street, attributed to *Edward Lovett Pearce*. The 1770s–90s saw flickering interest in houses planned as flats or chambers, that is with paired apartments opening off a shared staircase (No. 1 Robert Street, Nos. 14 and 19 Buckingham Street).

The ARCHITECTURAL DETAILS of most house interiors follow recognizable patterns. The PANELLING that was the normal wall treatment until the mid c18 is treated hierarchically, from raised-and-fielded in the best rooms to simple sunk compartments in the humblest. Panelling generally goes with box cornices, which are similarly varied in richness. Other common timber details include pilasters at the opening to the staircase (Meard Street; No. 48 Greek Street, 1741–2). The STAIRCASE itself saw a rapid development away from heavy, closed-string types of the late c17, with their square newels and bulbous turned balusters. By the 1720s even medium-sized houses tended to have open-string staircases with carved tread ends, slim column newels, and ramped rails with spirally sweeping ends. Balusters diversified; fluted, spiral-fluted and spiral-twisted types are all common, often in combination, with bulb- or urn-shaped bases. Their forms became progressively elongated until *c.* 1770, after which plain stick-like balusters took over. Timber was rivalled in greater houses by stone staircases with iron balustrades. The fashion was taken from greater houses: St James's Palace appears to have the earliest in Westminster (1703), and Marlborough House also has them. The usual forms in terrace houses were elongated lyre shapes, sometimes superimposed or doubled, or S-scrolls. *Brettingham's* No. 5 St James's Square, of 1748–9, has a novelty balustrade of little brass columns.

The PALLADIAN REVIVAL from *c.* 1715, mentioned above in connection with terraced houses, was of course influential on greater houses too. The Palladians were unusual in that they had a conscious patriotic programme for the reform of British architecture, which they considered corrupted since Inigo Jones's time; like Jones, they revered the works of the Italian architect Andrea Palladio (1508–80), whose publications were newly available in English translation after 1715. The result was an architecture very different from the Late Baroque styles of the Continent. The central figure in this movement was the 3rd Earl of Burlington, greatest of all Georgian patrons of the arts. He
p. 490 signalled his intent by employing *Colen Campbell* to modernize his own Burlington House on Piccadilly, where he took over from *Gibbs*. Campbell's broad spreading two-storey façade was heightened by the Victorians, but several of the remaining c18 rooms may be his (or else by Burlington's later protégé *William Kent*). Their chaste architectural decoration shows a significant advance

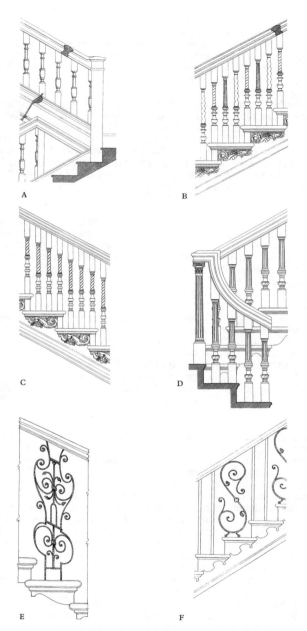

Late seventeenth- and eighteenth-century balustrades.
A, No. 15 Soho Square; B, No. 31 Old Burlington Street; C, No. 18
Clifford Street (Buck's Club); D, No. 29 Sackville Street; E, No. 16
Upper Grosvenor Street; F, No. 11 Golden Square
(*The Survey of London*; not to scale)

towards the later C18 ideal of unified, coherent interiors, though
large inset paintings still played a considerable part. They also
demonstrated the Palladian liking for full-scale pedimented door-
cases, which effectively brought an outdoor or 'public' feature
inside the house.

Another Palladian innovation was the villa, a more compact,
four-square type of house with rural or semi-rural associations.
Villas spread like floating seeds up the Thames, but they also put
down roots in Whitehall; several reconstructed interiors from
the earliest there, Pembroke House, remain within the present
Ministry of Defence building. The type is still represented in
Whitehall by Dover House, by the latter-day Palladian *James
Paine* (1754–8, altered; Gwydyr House of *c.* 1772 has about as
much frontage to Whitehall, but lacks the compact plan of a true
villa).

Burlington's own enthusiasm for architecture soon led him into
design himself, and he was lucky to have land N of Burlington
House to lay out as a kind of ideal suburb, with pedimented
elevations closing the views. The much-altered No. 1 Savile Row
is all that remains of these; its design may have been a collabo-
ration with *William Kent*, who became the leading London archi-
tect of the 1730s and 1740s. Kent did some work at St James's
Palace, but his domestic masterwork is No. 44 Berkeley Square,
the most poetic and inventive three-bay terrace house in London.
Its astonishing staircase, with twin wings returning round the
sides of a circular well, was influential on later Georgian gener-
ations, though the Baroque complexities of its upper parts
were more admired than imitated. Fellow Palladians include
the Italian *Giacomo Leoni*, and the Englishmen *John Vardy Sen.*,
Henry Flitcroft (who began as Burlington's assistant), and *Roger*
and *Robert Morris*. Leoni is represented by two houses, includ-
ing the former Queensberry House in Burlington Gardens
(1721–3, altered), which revived the formula of two storeys with
giant pilasters over a rusticated ground floor. Of the English
contingent, several found places within the Office of Works,
completing the eclipse of the Baroque school led by Wren,
Vanbrugh and Hawksmoor.

HOUSES from the 1720s until at least the 1760s therefore
usually show the influence of Palladianism, whether in style, pro-
portion or detail. In such a climate it was possible for a depend-
able but uninspired architect such as *Matthew Brettingham Sen.*
to build up a big practice. Egremont House and No. 106 in
Piccadilly and Nos. 5 and 13 St James's Square are documented
or attributed mid-C18 works by him which survive. But plenty of
novelties were brought forth behind the rather conservative house
façades of these years, especially where plans and fashions in
decoration were concerned.

As for HOUSE PLANS, the rigid symmetries of the palazzo
model were unsuited to fashionable entertaining, not least
because the owners' apartments could not be fitted on to the
same floor. So a new layout was devised in which a circuit of con-
trastingly decorated public rooms could be made from the head
of the staircase. Brettingham's Norfolk House in St James's
Square (1748–52; dem.) is accounted the first; his Egremont

House preserves something like the same arrangement. An innovation nowadays less obvious, because it concerns function rather than plan, was the establishment of a dedicated dining room; *Kent*'s Devonshire House in Piccadilly (dem.), a severely plain Palladian mansion begun in 1734, seems to have had one of the first. Later C18 houses tended to have ground-floor dining rooms, with suites for larger parties above.

Any account of DECORATION should begin with PLASTER-WORK, the native traditions of which were refreshed by Swiss-Italian *stuccatori* such as *Giuseppe Artari* and *Giovanni Bagutti*. They often worked with *Gibbs*, with results that may be seen in his St Martin-in-the-Fields. The trails, scrolls and foliage motifs developed by the 1730s into something looser and less constrained by moulded compartments, without taking the leap into Rococo asymmetry. Some of the best work was done by *Edward Shepherd*, on the Grosvenor Estate in the 1720s–30s (No. 66 Brook Street, No. 71 South Audley Street; also the stairhall of No. 4 St James's Square, a ducal house of 1726–8). This late Baroque style combines or collides in various ways with the explicitly Palladian manner associated with *Kent*: a more strongly architectural idiom, with a fondness for compartmented ceilings, swags, masks, frontal and profile caryatids, and large volutes. Good examples remain e.g. in Kent's No. 22 Arlington Street and No. 44 Berkeley Square, *Gibbs*'s house of 1734–40 in Park Place, and *Flitcroft*'s Nos. 45 and 46 Berkeley Square of a decade later. In his facility for designing smaller details, including furniture, Kent also anticipated the all-encompassing interior designs of the later C18: a natural gift, perhaps, for an architect who began as a painter (albeit a feeble one, as the reredos of St George Hanover Square shows only too well). p. 507

53

For full-blown ROCOCO, the French-influenced interiors of *Isaac Ware*'s Chesterfield House and the Franco-Italian work at Norfolk House stood out until their demolition or dismantling in the 1930s, if only by virtue of their rarity in London. Less dazzling English parallels included foliage used in big ceiling roses (No. 44 Parliament Street, No. 17 Charles Street), or flatter compositions including birds, masks, dragons and inset relief scenes (No. 1 Greek Street (Soho Square), No. 12 South Audley Street). The secular Gothic Revival produced one freakish house in Arlington Street, of uncertain authorship (1756–60, dem.); the briefer vogue for Chinoiserie has left balustrades, such as at *Sir R. Taylor*'s No. 43 Parliament Street, of the 1750s, and wallpapered interiors such as at No. 39 Charles Street. pp. 429, 573

The autonomous craftsman-builder of the kind represented by Edward Shepherd – a man with schemes as substantial as Shepherd Market and Crewe House (Curzon Street) to his credit – pass into eclipse in the mid C18, and plasterers of the later C18 such as *Joseph Rose Jun.* tended to wait on architects' drawings for instruction. The same fate overtook the carvers of the FIRE-PLACES that are the finest ornaments of so many C18 interiors. In the late C17 and early C18, a simple shoulder-arched marble surround was common even in quite large houses, but in the 1720s the fashion for console brackets, herms, friezes and other carved ornament spread rapidly, along with the use of white 54

statuary marble rather than the grey 'dove'. Decorative potential also increased with the return to fashion of the overmantel, around 1730. The results include works by sculptors of the calibre of *J.M. Rysbrack* (Foreign and Commonwealth Office, *ex situ*) and *Sir Henry Cheere*, as well as much anonymous work of the highest quality; even in the later C18, a sculptor of the calibre of *Joseph Wilton* was prepared to supply chimneypieces for Somerset House. Timber was also used, such as in more economical versions of the two-stage chimneypiece, popular with the Palladians; plaster could be employed for the upper part (No. 31 Old Burlington Street, No. 46 Berkeley Square). A common late C18 stone type used side columns and a central relief tablet, often diversified with coloured marbles.

New Building Types of the Eighteenth Century

The growth and consolidation of the C18 state, and the increasingly sophisticated and complex commercial and social circles of London life, went hand in hand with a great increase in new types of building. The most important by far are GOVERNMENT OFFICES, of which several remain along Whitehall. Senior officials commonly lived and worked in the same building, so the type detached itself only gradually from the domestic tradition. The extensions to No. 10 Downing Street, built by the Office of Works for Sir Robert Walpole in 1732–5, are effectively a wing of apartments in the older, palace style. By contrast, *Thomas Ripley*'s Admiralty of 1723–6 housed both apartments for the Sea Lords and a panelled board room (reassembled from the previous building of 1693–4), in a ponderous U-shaped building whose giant portico is an unmistakable sign of state. Also very unlike a

p. 259

private house is *Kent*'s Treasury of 1733–7, tall and stilted in its proportions, with carefully graduated rustication and several tucked-in mezzanine storeys. Kent made designs for new Houses of Parliament too, but C18 rebuilding of the Palace of Westminster got no further than a range of law courts designed by *Vardy Sen.* (1755–70). More domestic in character are *John Lane*'s office of the Paymaster General, 1732–3, and the twin official houses at Nos. 6–7 Old Palace Yard, of 1754–6, where the pedimented Palladian villa is the obvious model; *S.P. Cockerell*'s Admiralty House, built on to the Admiralty in 1786–8, was meant from the start as an official residence. A convincing break with such domestic reminiscences came with *Sir William Chambers*'s new

pp. 319, 321

Somerset House (1776–1801, with later additions), which also abandoned the traditional location along Whitehall in favour of the river side of the Strand. This huge courtyard building housed official bodies such as the Navy Office and Exchequer, as well as the newly founded Royal Academy and two other Learned Societies.

BARRACKS were another official building type scarcely known before the mid C17, and Westminster has the finest of them: the Horse Guards in Whitehall of 1750–9. It seems to have been

48

designed by *Kent*, but he died before work started. A very Kentian design was nonetheless executed, with modifications due probably to *Stephen Wright*. Its motifs come from the main-

stream of Anglo-Palladian design, but its picturesque silhouettes are a world away from the chilly austerity of such earlier Palladian landmarks as *Burlington*'s Dormitory at Westminster School (1722–30). Other C18 barracks have disappeared, as have the various C18 HOSPITALS; the St George's Hospital at Hyde Park Corner, an older house adapted in 1733 by *Isaac Ware*, was architecturally the most impressive.

THEATRES come top of the list of buildings for recreation. Fully enclosed, purpose-built theatres date from after the Restoration. Theatres catch alight easily, but the three great stages of Westminster were always rebuilt when this happened, and all are in use today. The oldest is the Theatre Royal in Drury Lane, originally of 1662–3, and finally rebuilt in 1810–12 by *Benjamin Dean Wyatt*. Its exterior is altered, but Wyatt's nobly Neoclassical foyer remains. Her Majesty's Theatre in Haymarket began as *Vanbrugh*'s Opera House of 1704–5; it was rebuilt in 1790–4 by *M. Novosielski* with Britain's first horseshoe-shaped auditorium, and again in the late C19. Youngest of the three sites is the Royal Opera House, originally of 1731–2 by *Edward Shepherd*, and burnt and rebuilt in 1808–9 by *Robert Smirke*. For the present, Victorian theatre there *see* p. 70.

Vanbrugh's Opera House also featured an ASSEMBLY ROOM, an institution which proved very popular. The various C18 establishments culminated in *James Wyatt*'s Pantheon of 1769–72 on Oxford Street, which in its first incarnation had a sensational hybrid of the Roman Pantheon and S. Sophia in Constantinople as its main space. All that is now left of these places of resort is No. 48 Great Marlborough Street, of 1774, which seems to be no different from an ordinary house. The one surviving COFFEE HOUSE, the former Adelphi Tavern in John Adam Street (1771), is of much more consequence internally; like the Royal Society of Arts there, it formed part of the *Adam* brothers' Adelphi development. 59

CLUBS are another C18 invention. As exclusive or semi-public establishments they emerged first in St James's, by evolution from the many coffee houses, chocolate houses, taverns, assembly rooms and gambling dens there. Several are still named after early proprietors: Boodle's, Brooks's, White's, Pratt's. The first three all have purpose-built premises, of which Boodle's and Brooks's retain their C18 form. In plan these C18 clubs are not so different from a greater town house meant for entertaining, except that private apartments were not necessary.

Other C18 INSTITUTIONS are harder to pigeonhole. Westminster lacked a powerful municipal body comparable to the City Corporation, for whom the younger *George Dance* produced some of the most original public commissions in England in the later C18. Only the reworked portico remains of Dance's largest Westminster commission, the Royal College of Surgeons in Lincoln's Inn Fields (1806–13, with *James Lewis*). More self-consciously novel in design was Dance's Shakespeare Gallery, a paying attraction in Pall Mall (1782–3, dem.). It was lined with dramatic and historical canvases by British artists: 'history painting' of the most prestigious kind, for which the public market remained disappointingly small. *James Barry*'s allegorizing canvases of 1777–83

in the Great Room of the Royal Society of Arts are the chief
surviving example in Westminster. The Society itself, which
aimed at raising the standard of British arts and manufactures
by a programme of prizes, exhibitions and lectures, has some-
what club-like premises in John Adam Street (1772–4), designed
by the *Adams*. Disinterested scientific knowledge was promoted
by the Royal Institution, established in Albemarle Street in 1799
in an adapted older house; its façade of Herculean columns is
later, of 1837–8 by *Lewis Vulliamy*.

The most common attractions, however, were SHOPS. C18
England is accounted the world's first consumer society, and
London was the chief outlet for its products. Purpose-built rows
of shops are not unknown, such as *Sir R. Taylor*'s Nos. 165–167
New Bond Street of the early 1770s, but the conversion of
ordinary houses was more common; Oxford Street is the most
famous of many streets gradually taken over in this way. Enough
of the original SHOPFRONTS remain to give an idea of their
variety. No. 34 Haymarket is the oldest, of the mid C18, with
double bows of a degree of projection outlawed by the 1774 Act.
The shallower bows of the later C18 can be seen in Goodwin's
Court, off St Martin's Lane. One-off fronts might be Gothick
(No. 15 Frith Street) or even latter-day Rococo (No. 88 Dean
Street, 1791). Rows of engaged columns appeared in the early
C19 (No. 37 Soho Square, before 1812). The arrangement was
often associated with BANKS, of which the pioneering examples
stood in the Strand or Charing Cross. All that remain of these
are a few C18 fireplaces and other fixtures, reset in successor
premises (Coutts', Strand; Drummond's, Trafalgar Square).

Finally to BRIDGES. The first Westminster Bridge, constructed
alongside the Houses of Parliament in 1738–50, was only the
second Thames crossing after the ancient London Bridge in the
City: a telling sign of the maturity of Westminster as a distinct
settlement. The round-arched design, by the Swiss *Charles
Labelye*, also transformed England's backward traditions of
bridge-building.

Neoclassical Influences

The half-century or so after 1760 proceeds under an art-
historical banner labelled NEOCLASSICISM, a term which
implies a renewed appreciation and imitation of classical Anti-
quity. Its effects are commonly diagnosed as a greater plainness
and severity in exteriors, a thinner and more delicate handling of
decorative work inside and out, and a keenness to display novel
Antique motifs derived from domestic or non-Italian architec-
ture. Publications by a new generation of architectural travellers
– Robert Wood, James Stuart, Nicholas Revett, Robert Adam –
made motifs of this kind increasingly familiar from the 1750s
onwards. As a blanket term, Neoclassicism masks a number of
complexities, including the strong Neo-Palladian strain in later
C18 architecture, stylistic cross-currents from the Continent and
especially from France, and many earlier evocations of classical
models (for instance, the coffered and painted ceilings of the
1740s designed by or attributed to *Kent*, at No. 44 Berkeley

60
p.
407

Square and No. 22 Arlington Street). But it is all the same not
hard to point out the chief innovators and innovations.

James 'Athenian' Stuart (1713–88), who travelled widely in
Greece in the 1750s, makes a good introduction. At No. 15 St
James's Square, 1764–6, he used a Greek Ionic order in an
applied temple front wholly of stone: a new and influential
marker for sophisticated display on a terrace house front. New
motifs inside include ceilings with coffering derived from 55
Palmyra, and an early use of little inset pictures: a characteristic
instance of the growing control of artists in other media by the
designing mind of the architect. Stuart's gift for interior design
also appears at Spencer House in St James's Place, a Palladian 49
mansion of 1756–8 by *Vardy Sen.* His contributions include the
Palm Room, which mixes Roman and c17 English ideas, and a 57
pioneering Painted Room of a type destined for a pan-European
vogue.* But Stuart was too lazy, or too often drunk, to follow up
his early lead. The potential of Palmyrene coffering was exploited
more effectively after 1768 in Grafton Street, a late enterprise by
Taylor (1714–88); his houses also show a talent for tight planning, 51
with interlocking rooms of various shapes.

More famous and productive than Stuart or Taylor was *Robert
Adam*, a Scottish architect who belonged to a younger genera-
tion (1728–92). Adam settled in London in 1758 after four years'
travel in Europe and the Near East. His calling card was the
Admiralty Screen of 1760–1, with its stern colonnade placed
directly on the ground. But his hopes of further public com-
missions were thwarted, even if the Adelphi scheme of 1768–74
(a speculation with his brothers *William* and *James*) gave the
Thames its first great embanked classical composition. Adam
had much more success with luxury houses for aristocratic
patrons, of which Nos. 20 and 33 St James's Square, the muti-
lated former Lansdowne House off Berkeley Square, and Apsley
House at Hyde Park Corner are the chief survivors. Here Adam's
genius for taking pains with every detail of the interior, from cor-
nices to carpets, could be given free rein. The *grottesche*, painted
and stucco decoration in Roman buildings, were his chief model.
Under their influence, plasterwork and carved details became
ever thinner and more refined, with trails of husks, fluted or
ribbed circles and part-circles, and little inset paintings by such
artists as *G.B. Cipriani* and *Angelica Kauffmann*. The result was
a style that lesser architects found irresistible to imitate – *see* for
instance *John Crunden* at Boodle's Club in St James's Street, or
Richard Edwin's Stratford House off Oxford Street, both 1770s –
but very hard to equal. Adam also had much work remodelling
older houses, especially in Mayfair. Interiors remaining there
range from whole suites to individual ceilings (No. 106 Piccadilly,
No. 30 Curzon Street, No. 10 Hertford Street, No. 17 Hill
Street, No. 29 Sackville Street). Such adapted houses tend to
lack the adventurous play with room plans – apsed-ended with p.
column-screens, circular, octagonal – of his all-new houses, as 39
well as their carefully calculated programme of uses for each

* A slightly earlier example, by *J.-F. de Clermont* at No. 5 St James's Square, does
not survive.

interior, whether public or private. No. 20 St James's Square is
an outstanding example: a full first-floor circuit of public rooms,
with private apartments in an elongated rear wing placed to one
side, all fitted behind a three-bay front. Adam was also swift to
use new INDUSTRIAL MATERIALS, such as *Wedgwood* plaques for
fireplaces (No. 20 St James's Square), *Liardet*'s stucco (No. 11 St
James's Square), and the artificial marble called scagliola, made
of coloured and polished plaster, perfected in the mid C18.
(Another material worth mention is *Eleanor Coade*'s imperishable
cast stone, which appeared in many exterior roles from the late
C18.)

Adam's most enduring rival was *Sir William Chambers*
(1723–96). Chambers's architectural education included a term
in the official École des Arts in Paris, and his style remained
coloured by mid-C18 French ideas. These are well to the fore at
p. his great work, Somerset House, appearing in numerous details
321 as well as in such spaces as the beautiful vaulted vestibule by
the Strand. Other influences include the dark spirit of Piranesi,
seen in the huge rusticated arches of the river front, and
much from both the Italian Cinquecento and from the Anglo-
Palladian tradition, including a reminiscence of Webb's gallery
at Somerset House for the Strand elevation. Chambers's other
Westminster works have suffered badly; casualties include Gower
House in Whitehall of 1765–74, extensive improvements for
George III's family at Buckingham House, and the chief inte-
riors of his own Melbourne House of 1771–5, the Palladian shell
of which survives as Albany. Interior works within earlier houses
remain at Marlborough House, at No. 21 Arlington Street,
and in reconstructed rooms from Pembroke House within the
Ministry of Defence building.

A more domestic French idiom was developed by *Henry
Holland* (1745–1806), who worked typically for Francophile Whig
clients. Its spareness and reserve by comparison with Adam's
58 all-over effects can be seen inside his Brooks's Club in St James's
Street, of 1776–8. More radical still is his remodelling of the
50, present Dover House in Whitehall, after 1787, with its toplit
p. columned rotunda of advanced Parisian type. Other surviving
256 Holland interiors are minor; his greatest work, the profligate
transformation of Carlton House for the Prince of Wales after
1783, is destroyed. Holland's own speculative undertaking in
Westminster, at Hertford Street, is uninteresting. More distinc-
tive is the long plain courtyard of bachelor chambers hidden
behind Albany, built when Holland converted the main house to
this unusual use in 1802–3. There is less to show from Holland's
prolific contemporary *James Wyatt* (1746–1813), who also devel-
oped a more reserved interior style: modifications to older build-
ings, including Jones's Banqueting House; the recasting of No. 9
Conduit Street (another instance of a terrace house with a giant
order); and attributed works including the much-altered White's
Club in St James's Street, already mentioned, and the Powder
Magazine in Hyde Park. Wyatt's smooth interior manner is best
represented by his less inventive elder brother *Samuel*'s works, at
56 No. 20 Hanover Square, No. 15 St James's Square, and No. 14
Queen Anne's Gate.

The wilder side of Neoclassicism showed a fascination with abstracted, elemental forms, but this is harder to find in Westminster. Something close to the younger Dance's iconoclastic simplifications can be seen in *S. P. Cockerell*'s weird steeple at St 70 Anne Soho, of 1801–3. *John Soane* (1753–1837), Dance's greatest pupil, had a late flowering in Westminster. His work is distinctive for its combination of severity and delicacy, with a preference for planar surfaces or simple grooved patterns, interrupted by small areas of high-relief carving or modelling. What remains is largely interior, and largely concentrated on the w side of Whitehall: at Nos. 10 and 11 Downing Street, which demonstrate 79 his fascination with shallow-domed or cross-vaulted spaces, at the minimal stairhall inside William Kent's Treasury, and at the Privy Council wing of 1824–6, a fragment of a larger, columned office range for the Board of Trade that was otherwise reconstructed twenty years later. Losses include his Law Courts of 1822–5 at the Palace of Westminster, which old views suggest were as startling internally as any of his major designs. These late works were created within a very different architectural culture, of which more is said on pp. 44–52 below.

Sculpture in Westminster, c. 1660–c. 1815

WESTMINSTER ABBEY remained the most important site for sculptural commissions in Britain well into the early C19. The biggest change after the Restoration was that royal patronage no longer signified much (though royal burials continued well into the C18). Another absence is the late C17–early C18 kind of monument with life-size portrait statues in contemporary dress. Apart from that, most of the fashions are illustrated. Reclining effigies remained in favour after 1660, often accompanied by allegorical figures or delicate reliefs. Smaller monuments were treated as exercises in bravura carving, even as a kind of still life, with urns, trophies and festoons. Some are by native artists such as *John Bushnell*, but Netherlandish sculptors, *Grinling Gibbons* and *Arnold Quellin* foremost, usually carried off the prize commissions (Thomas Thynn †1682). The best English sculptor at that 31 time was the Roman-trained *Francis Bird* (1667–1731), who rises here and there to a convincing Baroque swagger (Dr Busby, 1702–3, with *Edward Chapman*; Dr Grabe, †1711).

Bird's chief work in London was the exterior sculpture on St Paul's in the City. The buildings of Westminster had no ARCHITECTURAL SCULPTURE to compare with this, or with the giant commemorative relief on Wren's Monument, also in the City. The most important work of sculpture outside the Abbey was short-lived: a great altarpiece in the Roman Catholic chapel at Whitehall Palace, erected in 1686 for James II's queen, Mary of Modena, by *Gibbons* and *Arnold Quellin*. It survives in a few fragments, including ruined figures in the Abbey gardens. Gibbons is seen at his best not in stone but in his peerless WOOD p. CARVING, such as the reredos and organ at St James Piccadilly, 585 festoons at St James's Palace, and the refixed overmantel at the Admiralty board room. (A later work in carved timber is the pictorial reredos in St Margaret, *c.* 1758.)

Illusionistic carving in wood did not come high up the hierarchy of sculpture from a Continental point of view, nor was English sculpture around 1700 in the forefront of the art in any other respect. By the 1720s the picture was wholly different, thanks to fresh talent from abroad, attracted by a new interest in sculpture on the part of the English aristocracy. The leading figures were the Flemings *Peter Scheemakers, Laurent Delvaux, Denis Plumier* and *J.M. Rysbrack*, and the Italian *G.B. Guelfi* (another Burlington protégé). All have significant works at the Abbey. The Buckingham monument of *c.* 1721, by *Plumier* with *Delvaux* and *Scheemakers*, shows several trends dominant until after the mid C18: a reclining effigy in the Flemish manner, elements of architecture around the sarcophagus, allegorical attendants derived from late Baroque Roman sculpture, and large but finely carved trophies or drapery. It also anticipates the fashion for portraits in Roman Republican style, with togas or armour and close-cropped hair. Such monuments were often designed in collaboration with London architects: Rysbrack with *Gibbs* (Matthew Prior, 1721–3), who also worked with *Guelfi* (James Craggs, 1724–7); Rysbrack also with both *Leoni* (Daniel Pulteney †1731) and with *Kent* (Newton, 1731, and Stanhope, 1733), who in turn also designed with *Scheemakers* (Shakespeare, 1740–1). The last illustrates another, very attractive feature of these years, the portrayal of historical figures in period costume (also Ben Jonson, *c.* 1723, *Gibbs* with *Rysbrack*). Imported busts or statues also appear by artists such as *Coysevox* (Matthew Prior) and *Filippo della Valle* (Lady Walpole, 1740–1).

The greatest C18 sculptor of all those working at the Abbey was the Frenchman *L.-F. Roubiliac*. He arrived in the 1730s, and came of a younger generation with affinities to the Rococo school. This comes out more in his portrait busts than in his major monuments, including the three great melodramatic masterpieces of the 1740s–50s, to the Nightingales, the Duke of Argyll, and General Hargrave. The prettiness of the ROCOCO is best illustrated by the works of *Sir Henry Cheere* in mid-century, who specialized in Rococo compositions of coloured marble (Admiral de Sausmarez, *c.* 1757). There is also Cheere's pupil *(Sir) Robert Taylor*, whose later career was in architecture; his Cornewall monument of 1744, now banished to the Abbey cloister, is the biggest display in the Abbey of rocaille or rockwork.

The Cornewall monument is of special importance as the first giant patriotic monument voted by Act of Parliament. Its successors in the Abbey demonstrate a progressive calming of gesture, drapery and composition, a movement associated with the more reserved emotional range of the NEOCLASSICAL era. Representative works include *Joseph Wilton*'s Wolfe monument of 1760–72, *Joseph Nollekens*'s Three Captains of 1784–93, and the monument by *John Flaxman* to Lord Mansfield, 1793–1801, where stasis is complete. Other changes include an abandonment of Roman armour for heroic figures (as still worn by Wolfe) in favour of togas or bared flesh, and a general preference for sharp outlines over broken or fluttering ones. The predictable concern to keep in step with fashions in architectural details was some-

times met by further collaborations between architects and sculptors. *James Stuart*'s design for Rear-Admiral Watson was executed by *Scheemakers* (1760–3, partly dismantled), *Chambers*'s for Lord Mountrath by *Wilton* (1766–71). *Adam* worked with 64 several sculptors, including *Nicholas Read*, a pupil of Roubiliac (Duchess of Northumberland, 1778) and the Dane *M.H. Spang* (James Thomson, 1762); his Townshend monument of 1760, one 63 of several in the Abbey to portray non-European figures, was a combined effort by *John Eckstein* with *L.-F. Breton* and *Thomas (Sen.) & Benjamin Carter*.

After the 1760s works by foreign sculptors are less common, given the growing numbers of able native-born artists. The consolidation of a national school is also reflected in the founding of the Royal Society of Arts and Royal Academy in the 1760s–70s. The most common signatures in these years are therefore English, including *Thomas Banks, John Bacon Sen.* and *Jun.*, 65 the last two especially telling in their works in relief. (Banks and the elder Bacon, along with Wilton and Nollekens, were also employed at Somerset House, the greatest location for architectural sculpture in C18 London.) The Abbey can also show such interesting one-hit wonders as *Henry Webber*, a pupil of the elder Bacon (Garrick monument, 1797). By the time of *Westmacott*'s and *Chantrey*'s contributions in the early C19 the Abbey was increasingly full, and so space-saving bust monuments or standing statues came to be preferred; also a few seated statues (Raffles, *c.* 1832 by *Chantrey*, Wilberforce, 1835–40 by *Samuel Joseph*). The last show the return to naturalism from ideal form that is particularly associated with Chantrey, whose portraiture was a great inspiration to his Victorian successors.

Another source of patronage was for PUBLIC STATUES, typically in the form of figures of the reigning monarch placed in town squares. Standing statues were usual until the mid C18, such as *C.G. Cibber*'s Charles II in Soho Square, the anonymous Queen Anne at Queen Anne's Gate (originally Queen Square), or *John Nost*'s George II introduced to Golden Square. After the mid C18 stone figures began to give way to bronze or lead, a change prefigured by *Gibbons*'s bronze James II of 1686, now in front of the National Gallery. This is so superior to other works by him that it is generally attributed to two Flemish sculptors in his workshop, *Laurens van der Meulen* and one *Dievot*. Equestrian figures were preferred after the early C18. The earliest, in Berkeley, Leicester and Grosvenor Squares, are lost. William III remains in St James's Square, a late addition by *John Bacon Sen. & Jun.* (1794–1808), and also *Matthew Cotes Wyatt*'s George III at Cockspur Street, and – finest of all – *Chantrey*'s George IV in Trafalgar Square. Of these, George III was paid for by public subscription, a device extended to commemorative figures of political leaders (Pitt at Hanover Square, also *Chantrey*, 1825–31). But these belong to the period after the Napoleonic Wars, which changed the climate for art and architecture so much that it needs a chapter of its own.

METROPOLITAN IMPROVEMENTS,
c. 1815–c. 1840

London in the years after the Battle of Waterloo regarded itself
as the greatest city in the world, or at least as the only worthy
rival to Paris: an impression flatteringly reinforced by streams
of visitors from the newly pacified Continent. Arrival was eased
by newly improved roads and fast river steamers; gas lighting,
begun experimentally in Pall Mall in 1807, made the streets feel
safer after dark. The resident population grew enormously, from
960,000 for the inner parishes in 1801 to 1,950,000 in 1841, the
date of the next census; of these, 161,000 lived in Westminster in
1801, 229,000 forty years later.* There was as yet no representa-
tive body for the West End, the refashioning of which was due
to direct intervention by the State in its various guises. The City,
too, began to cut broad new highways through its ancient matrix
of lanes and courts. Chateaubriand, returning in 1822 thirty
years after his first London visit, could only marvel at these 'wide
streets lined with palaces'. The new streets, and the arcades,
bridges, clubs, gateways and theatres of the period, still deter-
mine much of the character of Westminster.

The REPLANNING of the West End was the greatest single
achievement of these years. The shortcomings of the Georgian
city had been a source of complaint for years, voiced most lucidly
in 1766 by the architect *John Gwynn*, whose proposals included a
new highway running N from the N end of Haymarket. This idea
went through several incarnations before the plan by the engag-
ing *John Nash* was enacted in 1813. What made the project urgent
was the reversion of the lands of the present Regent's Park to the
Crown, combined with the Prince Regent's own longings both
for a more fitting approach to Carlton House from the N and for
another pleasure-palace to be placed somewhere in the park. The
new Regent Street had therefore to start at Carlton House, and
in order to keep down land costs it also had to reconcile this axis
with a continuation to the N along the W margin of Soho.

p. 437

Nash was sixty-one years old in 1813, and had been architect
to the Department of Woods and Forests since 1806. His subse-
quent work in London showed an astonishing creative flowering.
In Nash's hands, the obstacles of changed direction became some
of the finest and most Picturesque effects, including the great
sweeping Quadrant and the circular crossing at Oxford Circus.
By 1820, when the buildings of Regent Street were finished, Nash
was already in the toils of new schemes. Streets were cut through
on cross-axes, so that St James's Square now confronts the
Theatre Royal, Haymarket across the line of Regent Street. Just
E of Haymarket, the blind turning of Suffolk Street was entirely
rebuilt. Next came Trafalgar Square, for which plans were pub-
lished in 1826, replacing what was merely a vaguely triangular
junction; it took until the 1840s to attain its familiar form. The
area to its E was also remade as the West Strand Improvements,

p. 481

* The larger figure for each year covers the areas later enclosed by the London
County Council boundary.

including the present Adelaide Street and the N side of the Strand at its W end (completed 1832). Meanwhile Carlton House itself had been pulled down, after the Prince of Wales became King George IV, and Carlton House Terrace was built across its site in 1827–33. All these changes encouraged others to agitate for their own pet schemes; Colonel Sir Frederick Trench MP's Thames embankment and *Soane*'s triumphal royal route linking Windsor and the Houses of Parliament are the best known, but neither came to anything (though Soane did intend his Board of Trade in Whitehall and new Law Courts to play their part).

The ARCHITECTURE of Nash's streets was almost invariably finished in stucco (originally coloured and scored to look like stone), with little domed incidents, long pilastered expanses, and a general rejection of the plain neutral aesthetic of the late C18 terrace front. Nash's own designs, with their nodding familiarity with recent Parisian ideas, were diversified by works from others such as *Soane*, *Decimus Burton* and *C.R. Cockerell*. Regent Street itself was almost entirely rebuilt in the earlier C20, but Nash's Carlton House Terrace remains – a coda to his mighty palace-fronted sequence around Regent's Park – along with most of his West Strand Improvements and much of the many-authored Suffolk Street. Another area largely rebuilt in the early C19 lay E of Whitehall, where *Henry Harrison*'s Richmond Terrace remains, a brick-and-stone composition of 1822–5. A smaller enterprise in a style closer to that of Nash is Victoria Square near Buckingham Palace, a speculation of 1838–42 by *Matthew Wyatt*. p. 448 68 p. 431

New BRIDGES were another key improvement. The first Vauxhall Bridge opened in 1816, approached by the new Vauxhall Bridge Road across the largely open area SE of the historic core of Westminster. Waterloo Bridge followed in 1817, making a short cut to the Surrey side from off the Strand.

Next in order of display come the enterprises associated with the ROYAL PALACES and PARKS, along with various monuments to the Napoleonic Wars. A crucial part of these changes was the transformation of Hyde Park Corner, between Green Park and Hyde Park at the W end of Piccadilly. Its possibilities had excited many C18 architects, although they wished to stress that it marked the point of arrival in London from the W. When *Decimus Burton*'s buildings finally rose in the 1820s – a column-screen and two great triumphal arches, of which one has since been shifted slightly – their main axis was instead turned to face S, where *Nash* was busy from 1825 aggrandizing Buckingham House as Buckingham Palace. This troubled project was meant as the new chief residence of George IV, but it was not occupied until long after his death in 1830, after several changes to the design including corrective surgery by *Edward Blore*. The stupendous interiors are mostly as Nash conceived them, with vast coffered ceilings and some of the deepest and richest cornices ever created in English architecture. There are even some Chinese interiors made up of parts from Nash's Brighton Pavilion, reassembled in a new wing added by *Blore* in the 1840s which turned Nash's three-sided palace into the courtyard-plan building familiar today. Nash had less trouble when the Office of Works came to upgrade St James's Palace in the 1820s, with remodelled p. 646 81

interiors, modest additions in a cheap brick Neo-Tudor style, and the boxy stucco residence of Clarence House at one corner.

The PARKS themselves have changed little since the early C19, the age in which the English Picturesque became the dominant landscape style throughout Europe. Its advance within Westminster can be traced from *Henry Wise* and *Charles Bridgeman*'s

p. 661 creation of the Serpentine in Hyde Park as an irregular lake in 1727–31, to the free, park-like replanting of Berkeley Square

p. 437 garden in the late C18, and on to *Nash*'s informal reshaping of St James's Park and the Buckingham Palace gardens in the 1820s (the last with *W.T. Aiton*). Both works feature an irregular lake and cunningly contrived paths and planting, making the whole seem much larger. Hyde Park and Green Park had no formal landscaping to undo, but Hyde Park did acquire several elegant new buildings: entrance lodges, the fine Serpentine Bridge and (later) *Nash*'s Marble Arch, resited from the forecourt of Buckingham Palace to make way for Blore's wing. Marble Arch was meant to commemorate the Napoleonic Wars, but little of the sculpture intended was ever affixed (though pieces were thriftily reused on Buckingham Palace and the new National Gallery). So much marble must have contrasted strikingly with the honey-coloured Bath stone of Nash's new palace. Bath stone was incidentally a distinctive fashion of the 1820s (also at Richmond Terrace, and Lancaster House and Apsley House, for which *see* p. 48 below). It had been introduced by Lord Burlington at his Westminster School dormitory a century before, which made it the first of many post-medieval alternatives to Portland stone for major buildings in London.

Other MONUMENTS to the wars and wartime commanders

p. 441 include the Duke of York's Column of granite by *B.D. Wyatt*,

1 between the two halves of Carlton House Terrace, *Sir Richard Westmacott*'s Achilles statue in Hyde Park (a tribute to the Duke of Wellington), and less exalted oddities such as the dragon-

62 shaped Cadiz Memorial on Horse Guards Parade. Nelson's Column in Trafalgar Square also belongs with this group, though *William Railton*'s design was built under Queen Victoria (1839–43), and its fine bronze sculpture was not completed until 1867.

All these new works imposed a kind of narrative on the fabric of Westminster, speaking of patriotic triumph and dynastic power, and organized around routes and spaces of promenade, consumption and display. The genteel public of this new West End, or rather its masculine half, was also catered for by a new generation of CLUBS in or near St James's. Another reason for the club boom was the realization that members could found a club collectively, bypassing the proprietary system of the older, political-aristocratic houses in St James's Street. This encouraged clubs of a more specialized type to form, whether for travellers, scholars, graduates, or half-pay officers left kicking their heels by the ending of the wars. Men of the last stamp flocked to the first of the new generation, the United Service Club in Regent Street, of 1817–19 by *Robert Smirke* (demolished). Later clubhouses that survive are, in order of completion: Arthur's, St James's Street, by *Thomas Hopper* (now the Carlton), Crockford's in the same

street, by *B.D.* and *Philip Wyatt* (now a casino), and the Union, Trafalgar Square by *Smirke* (now part of Canada House), all 1827; the second United Service Club, Waterloo Place, 1828 by *Nash* (later remodelled by *Decimus Burton*, and now the Institute of Directors); the Athenaeum opposite it, 1830, by *Burton*; the Travellers', Pall Mall, 1832 by *Charles Barry*; the Oxford and Cambridge, also Pall Mall, 1838 by *Sir Robert & Sydney Smirke*; the Reform, another in Pall Mall by *Barry*, 1841; and the Conservative, St James's Street, 1845 by *George Basevi* and *Sydney Smirke* (now offices). Features that recur include a block-like two-storey composition with a single-storey columned porch, a preference for corner sites, and (inside) at least one large room with column-screens or pilasters making tripartite divisions. Many also have a main staircase which breaks at right-angles at the half-landing, returning by symmetrical arms with a further right-angled break to a landing against the entrance wall* (Crockford's, Athenaeum, United Service; also Arthur's, where the lowest flight splits at the bottom into two more).

p. 612
p. 613

The clubhouses also illustrate the proliferation of alternative CLASSICAL STYLES in the early C19. No longer was there a single dominant style, such as Palladianism, which gradually overcame older modes; instead, different styles were cultivated as alternatives, even for separate interiors within one building. A brief survey is enough to show that the 1820s and 1830s were the key decades for diversification, and it would certainly be a mistake to think of the change as 'Victorian'.

First the GREEK REVIVAL, that is the literal imitation of forms derived especially from Greek temples of the C4 and C5 B.C. The foremost English architect of this pan-European phenomenon was *Robert Smirke*, who made a big splash in London after his Grecian travels with the very severe Theatre Royal in Covent Garden (1808–9, *see* Royal Opera House). *Decimus Burton's* Athenaeum is gentler externally, with a version of the Parthenon frieze as a sign of high Hellenic culture; Smirke's own Union Club is also milder, with a giant Greek Ionic order, but its status as part of a larger building (shared with the Royal College of Physicians; now Canada House) makes it atypical. Another quirk of the club is that one room abandons Grecian severity in favour of a mid-C18 French or LOUIS XIV style. The label is deceptive: motifs from the reign of Louis XV and even later in the C18 were often hybridized, quite apart from the many fashions of the Sun King's own reign (1643–1715). The style was confined to interiors, at least until the 1850s, and was considered especially aristocratic. It appears in full spate in the white-and-gold main rooms at Crockford's by the brothers *B.D.* and *Philip Wyatt*, the leading promoters of the style in England.

A little later came the ITALIANATE manner pioneered by *Barry* at the Travellers' and Reform clubs, a style by contrast more influential on exteriors. The Florentine and Roman High Renaissance inspired their quoins, aedicules, and a deep,

p. 612

*The oldest of this type in Westminster seems to be at No. 21 Albemarle Street (now Royal Institution), of *c.* 1775, attributed to the great northern house architect *John Carr*; the earlier staircase at *Chambers*'s Gower House was similar.

elaborated main cornice used without a controlling order (an English echo of Klenze's Munich works of the 1810s–20s). The higher relief of the Reform Club demonstrates the greater rich-
69 ness of surface preferred by the Victorians, just as its interiors pointed the way to the rich motifs waiting to be quarried from the Italian Renaissance.* A fourth, more conservative strain that might be called LATE CLASSICAL is illustrated by the former Arthur's and Conservative clubs, with their essentially Palladian formulae of applied order and rusticated ground floor.

The period also saw a revival of the GREAT HOUSE. Greatest of all was Lancaster House, alias York House or Stafford House, begun 1825. This was another French-accented undertaking by the *Wyatt* brothers, with later interiors and alterations by *Smirke, Barry,* and the decorators *Morel & Seddon* – a reminder of the growing importance of 'upholsterers' and other room-furnishers for the story of the C19 interior. The results are rivalled only by Buckingham Palace, an appropriate comparison for a house begun for the royal Duke of York and used since the early C20 as a public museum or for Government functions. More typical are such medium-sized examples as Forbes House in Halkin Street, off Grosvenor Place (*c.* 1810 by *Smirke,* with later enlarge-ments), the three detached houses in the corners of Belgrave Square, or Dudley House in Park Lane, of 1827–8 by *William Atkinson.* The last is especially interesting as the only survivor of the great parkside mansions there; its interiors are of a refined classical strain that is neither Grecian, modern French, Louis XIV, nor Neo-Palladian.

Many of the most splendid INTERIORS of the period belonged rather to extensions or modernizations of older houses, to suit the latest ideas of luxurious entertainment. The best place to experience these is Apsley House, which the *Wyatt* brothers transformed in 1826–30 for the 1st Duke of Wellington. The greatest new room was a giant picture gallery, an advanced exercise in the revived Dixhuitième. The early C19 was something of a golden age for such galleries, especially once the art market began to swell with the spoils of recent Continental upheavals. They often doubled as banqueting rooms or ballrooms, like the room added to Northumberland House as early as the 1750s. *Adam's* Lansdowne House was also planned with one, though the space was not fitted up as a gallery until 1816–19 (by *Smirke,* and for sculpture, not painting). Other noted galleries of the 1810s–20s belonged to enlargements of lost houses on Park Lane: Londonderry House (yet another by *B.D.* and *Philip Wyatt*) and Grosvenor House (begun by *William Porden,* com-pleted by *Thomas Cundy II*). One ballroom that does survive is that created by *Samuel Ware's* sensitive Neo-Palladian remodel-ling of Burlington House in 1815–18.

A rarer type is the ARCHITECT'S HOUSE, which by the 1820s might include an office-cum-gallery to display the master's col-

*To anticipate the Victorian story, two Pall Mall clubs, both demolished, showed the coming embrace of the later Cinquecento: the Carlton, 1846–56, and Army and Navy, 1848–51. *C.O. Parnell's* former Whitehall Club in Parliament Street, 1864–6, is interesting as a surviving example from outside clubland.

lections. *Nash*'s house in Regent Street had one, as did *Decimus Burton*'s in Spring Gardens. Their destruction makes Soane's house in Lincoln's Inn Fields seem an even more precious survival (*see London 4: North*). *Edward Cresy*'s house, a self-advertising imitation of the so-called House of Palladio in Vicenza, remains at No. 6 Suffolk Street; also *Wyatville*'s remodelling of No. 39 Brook Street for himself, with its long gallery. p. 431

Before going on to the mass-produced new houses of the period, it is worth taking a quick tour of the other MAJOR BUILDINGS. The best-known CHURCHES of this period nationally tend to be those funded by the New Churches Acts of 1818 and 1824, which were meant especially to secure newly built-up areas for the Establishment. Six were built in Westminster under these Acts in the 1820s–30s, of which only two remain: *J.P. Gandy Deering*'s St Mark North Audley Street in Mayfair, and *Henry Hakewill*'s St Peter Eaton Square in Belgravia. Both are Grecian, with porticoes and columned steeples (those at St Peter in the familiar juxtaposition derived from St Martin-in-the-Fields), and both have been rebuilt internally. After that there is a break until the Victorian Gothic of the 1840s. The same Acts also effectively discouraged the building of proprietary chapels, the last of which seem to have gone up in the early 1810s. One other official project that deserves mention is the unusually scrupulous refacing of Henry VII's Chapel in 1809–22.

Another Government enterprise was *William Wilkins*'s NATIONAL GALLERY in Trafalgar Square, of 1833–8. Its weaknesses as a design are thrown into relief by comparison with the vastly more potent British Museum in Bloomsbury, by Wilkins's fellow Greek Revivalist Robert Smirke (*see London 4: North*). Also Grecian is Wilkins's other major work in Westminster, the former St George's Hospital of 1827–33, at the E end of Knightsbridge facing Hyde Park Corner. Further HOSPITALS include *Decimus Burton*'s former Charing Cross Hospital and Ophthalmic Hospital in Adelaide Street, architecturally subordinated to Nash's West Strand Improvements, and the old Westminster Hospital of 1831–4 in Broad Sanctuary (demolished), a harbinger of the secular Gothic Revival, by *W. & H.W. Inwood*. SCHOOLS had yet to catch the Gothic bug, and surviving examples are stuccoed, classical and compact: the St Martin's Schools in Adelaide Street by *Nash*, and the former Pimlico Grammar School in Ebury Street by *Gandy Deering*. *Smirke*'s King's College (1829–35), which was built as an Anglican university for London, was planned as part of the Somerset House complex and was thus necessarily classical. p. 307

BARRACKS are represented by Wellington Barracks S of St James's Park (1833–4), another formal exercise in pilastered stucco, with elevations by *Philip Hardwick*; the buildings, heavily reconstructed, have outlasted those of the Victorian barracks at Chelsea and Knightsbridge. The most notable PRISON was the long-demolished Millbank Penitentiary, completed in 1821 by *Smirke* as a modified version of polygonal designs by *Thomas Hardwick*. Intended as a model for the nation, its construction and design caused endless distress in practice, though it deserves to be remembered for pioneering mass-concrete foundations.

Local felons were confined in the short-lived Westminster Bridewell of 1834, s of the present Victoria Street. But the future story of such space-hungry institutions, as with cemeteries and lunatic asylums, lay on cheaper land outside Westminster.

COMMERCIAL ARCHITECTURE naturally offered more opportunities for small-scale display. Two especially valuable survivals are the toplit SHOPPING ARCADES of the 1810s, the earliest

67 of their kind in Britain: the Burlington Arcade off Piccadilly by *Samuel Ware*, and the Royal Opera Arcade off Haymarket, by *Nash* and *G.S. Repton*. The first is especially appealing, with shops along both sides and architectural detail reminiscent of Ware's Neo-Palladianizing at Burlington House itself. Also worth seeking out are what remains of *Joseph Jopling*'s two buildings of 1830 in Motcomb Street, Belgravia: the Pantechnicon, originally a compound of warehouse, shops and showrooms behind a giant Greek Doric façade, and its pilastered counterpart opposite, which had a bazaar for small shops on its upper floors. *Pennethorne*'s No. 10 St James's Street is another former bazaar building of the period.

For foodstuffs, a roomier and more open type of MARKET

p. BUILDING was required. One of the best anywhere in Britain is
342 *Charles Fowler*'s Covent Garden Market of 1828–30, built in a severe classical style with a perimeter of primitive Doric colonnades. The Victorians roofed over Fowler's two market courtyards, which were planned with extreme care for handling everything from garden plants to potatoes. His no less sophisticated Hungerford Market of 1831–3 was sacrificed to build Charing Cross Station. INDIVIDUAL SHOPS meanwhile grew ever larger, e.g. Fortnum & Mason in Piccadilly, 1834–5 (demolished); early survivors include *J.B. Papworth*'s No. 10 Charles II Street, 1833, off St James's Square. This is to leave out the many speculative houses built with shops below, or adapted with SHOPFRONTS. The last remain in considerable numbers, especially in St James's Street and Soho (Beak Street, Carnaby Street, Greek Street).

Finally, the TERRACE HOUSES. New building naturally continued within areas settled earlier, where older leases were falling in or where land became available. One example is the little enclave of houses with shops E of Carnaby Street, 1820–5. An important change to house elevations of the period concerns the doorway, which for ease of arrangement inside is often no longer aligned with the window above in the C18 way. The countervailing movement towards symmetrical, grouped compositions of houses has already been noted. An active area for new developments in the 1810s–30s lay SW of the historic core of Westminster, on land made newly accessible by Vauxhall Bridge Road. Its character was at best respectable rather than fashionable, and much deteriorated into slums and was swept away. Maunsel Street off Vincent Square, with its houses just one broad bay wide, is typical. Similar terraces can be seen further W on the

82 fringes with Chelsea, e.g. in Ebury Bridge Road or Bourne Street. Vincent Square also has a few villas of suburban type, designed in symmetrical pairs under a single broad pedimental gable. Another Late Georgian suburban formula appears in

Bloomfield Terrace in NW Pimlico, with its quasi-semi-detached rows of the 1840s.

Westminster was rescued from too much of this kind of small-scale, fragmented development by the great builder *Thomas Cubitt*, working with the Grosvenor Estate in the planned districts of BELGRAVIA and PIMLICO. The Grosvenors' holdings here were larger even than their huge enclave in Mayfair, stretching as they did from the margins of Knightsbridge all the way SE to the river. Very little of this had been built on before the 1810s. Plans were in the offing from c. 1812 for what was to become the very select district of Belgravia, that is the northern part, between Buckingham Palace and Sir Hans Sloane's late C18 developments at the N end of Chelsea. Something close to the executed plan was adopted in 1821, featuring squares of various shapes, with the first true crescent in Westminster (Wilton Crescent) to the N.* Its realization would have been impossible without Cubitt's abilities as architect-contractor. Cubitt pioneered the role of the super-builder with his own workshops and army of employees, but he was also adept at co-opting fellow builders, and *George Basevi*'s designs for the main ranges of Belgrave Square are one of several major features of the agreed plan undertaken by others. Socially the new district was an instant success, rivalling Mayfair as a fashionable address. Cubitt's earlier undertakings in North Bloomsbury and the contemporary development of Tyburnia N of Hyde Park had nothing like the same cachet, though squares and crescents are plentiful in both areas (*see London 4: North* and *London 3: North West*).

Houses in Belgravia range from large to gigantic, except for those of the many mews streets (often screened by giant arches, imitated from Nash's Regent's Park terraces). The material is stucco or stucco and brick, the style classical, with a fondness for long symmetrical compositions and giant orders that take after the work of Nash. Greek or Roman models give way after c. 1840 to the new Italianate fashion, by which time Cubitt was already beginning on his plan for PIMLICO to the S. This was a less select district in social terms, and its squares and terraces took much longer to build. Their average size is also smaller, at least outside the three main squares and their connecting streets. The latest, of the 1870s, are amongst the last of the stucco era in London.

The INDUSTRIAL BUILDINGS that sustained this urban boom have almost completely vanished. In an age before railways, water transport was the cheapest method for building materials, which naturally favoured sites along the river. The Office of Works used land E of Somerset House, later taken to build King's College. Cubitt's own depot and dock, off Grosvenor Road on the Pimlico shore, have also been completely overbuilt. One relic of the period lies further W on the same road: the reception basin of the Grosvenor Canal, the banks of which attracted many more contractors' yards and workshops. As completed in 1825 the canal ran only a short distance NE, through waterlogged land that since 1724 had been utilized for reservoirs by the Chelsea Water

*Discounting Alderman Pickett's crescent-shaped widening of the Strand by St Clement Danes, c. 1789–96.

Company, one of several private concerns that kept Westminster supplied with tolerable piped water. A later utility was gas for lighting, produced from 1812 from a pioneering gas works in Marsham Street. Londoners also needed vast supplies of beer, and from the later C18 BREWERIES became the first civilian factories to be built on a giant scale. The chief survivor in Westminster is Combe & Co.'s hulking 1830s premises of plain brick, N of Long Acre.

The impact of industry is inescapable in other ways, however. Ever bolder uses were found for CAST IRON, which in the 1810s was already employed as a cheaper alternative to stone for the new Vauxhall Bridge. Such buildings as St George's Hospital made inventive use of cast-iron girders, and by the 1830s some very large architectural features were being cast, including Doric half-columns at Carlton House Terrace and the side colonnade added by *Samuel Beazley* to the Theatre Royal in Drury Lane. How iron framing might be expressed structurally was left for the Victorians to sort out.

VICTORIAN AND EDWARDIAN WESTMINSTER

Westminster lost none of its established functions or building types in the C19, unlike the City, where old habits of 'living above the shop' made way for commercial monocultures. The population figures speak for themselves: Westminster had 241,000 in 1841, rising to 254,000 ten years later, before declining to 183,000 in 1901. For the City, the numbers are 123,000, 129,000, then a mere 27,000. But the overall number of Londoners grew astonishingly, reaching six and a half million in the built-up area by 1901, and many of their needs and pleasures were satisfied in Westminster. By the early C20 its fabric was more varied than at any time before or since, enriched by many new Victorian building types and sub-types and by examples of most of the succeeding stylistic fashions. Some districts had undergone violent change, but others had barely been disturbed since Georgian days. Heavy industry fumed near idyllic parkland; acres of profligate wealth lay a few streets from pockets of desperate poverty.

Victorian ARCHITECTURE is hard to address chronologically, whether in local or national terms. Too much starts happening at once, and new pressures and demands crowd in, and fresh novelties in style or technique seem always to be arriving, like trains drawing into one of the giant new railway termini. Ideas of progress and change also flavour much Victorian architectural writing, in which innovations tend to be discussed less as enduring models than as pointers into the mists of the future. The story of this diversification must begin with the most important architectural competition of the C19, for the new Houses of Parliament. Its style, ornament, construction and siting all raise essential themes in the architectural history of Victorian Westminster, which are here followed in turn. Other building types are then rounded up, and a final survey taken of the years before the First World War.

*The Houses of Parliament, the Gothic Revival and
Church Architecture*

In 1834 the PALACE OF WESTMINSTER burned down. A great
effort saved Westminster Hall, the Law Courts, and enough of
St Stephen's Cloister and the lower part of St Stephen's Chapel
to justify their restoration. The design of the replacement was
put out to competition, a sign of the discredit into which the
system of nominated 'Official Architects' had recently fallen. The
winner, *Sir Charles Barry*, was assisted in the details by *A. W. N.
Pugin*, the young genius of the Gothic Revival, for whom the style
was at once universally valid and morally and spiritually impera-
tive. Their new building began to rise alongside the Thames in 3,
the 1840s, and was completed in the early 1860s. The result, in 90,
Pevsner's judgement of 1957, is 'the most imaginatively planned pp.
and the most excellently executed major secular building of the 220
Gothic Revival anywhere in the world'. –1

The GOTHIC REVIVAL was the most vital and original move-
ment within Victorian high architecture, and the Palace of West-
minster marked its early maturity. It showed first of all that the
style could give convincing form and an enviable freedom in plan
and silhouette even to the most complex secular buildings.
Thanks to *Pugin*'s tireless draughtsmanship, it also achieved the
direct and scrupulous imitation of medieval forms which anti-
quarian critics had long been demanding: an antidote to the
loose, associative Gothic that ran back through James Wyatt and
Horace Walpole to Kent, Hawksmoor and Wren. But the period
chosen was Tudor, and Tudor and Perpendicular Gothic were
passing out of vogue almost before the building rose above
ground. Pugin soon declared himself exclusively in favour of the
later C13 and early C14. The coming generation of the Cambridge
Camden Society – mostly very young, and (unlike the Roman
Catholic Pugin) staunchly Anglican – were of a similar mind, and
argued for the perfection and correctness of this 'Middle Pointed'
style in bossy little pamphlets that sold in tens of thousands.

The reformation in Gothic taste that resulted is visible
almost immediately in the CHURCHES of Victorian Westminster.
Their numbers were swelled partly to supply the new districts
of Belgravia and Pimlico, partly due to the zealous missionary
impulse to poorer or slummy areas. The earliest Victorian church
to survive is of 1840–3: St Paul Wilton Place by *Thomas Cundy
II*, of the cheap-looking, historically inaccurate Gothic which
Pugin and the Camdenians were eviscerating in print. *Ambrose
Poynter*'s Christ Church, Victoria Street (1841–4, demolished),
came closer to the Middle Ages externally. The full triumph of
archaeology arrived later in the 1840s, from a repentant *T. Cundy
II* (St Barnabas, Pimlico, 1847–50), and from two of the rising 71
generation of Gothic specialists, *Benjamin Ferrey* (St Stephen
Rochester Row, also 1847–50), and *George Gilbert Scott* (St
Matthew Great Peter Street, 1849–51, altered). All are in versions
of C13 or C14 English Gothic, planned on roomy sites, and exe-
cuted in the same Kentish ragstone of which London's medieval
churches were built; all also have, or were meant to have, stone
steeples. *Cundy*, who was Surveyor to the Grosvenor Estate,

supplied three more in this tradition in the 1850s–60s: St Michael Chester Square in Belgravia, St Saviour and St Gabriel Warwick Square in Pimlico. The deep chancels favoured from the later 1840s helped to accommodate a more dignified and elaborate liturgy, in line with the urgings of the Oxford Movement from the 1830s onwards; St Michael took the rival, Low Church plan form with broad transepts, since disguised by enlargement. Tighter sites elsewhere entailed more compressed, space-efficient plans, omitting balancing transepts and other projections. Two
73 examples are the Jesuit church of the Immaculate Conception in Farm Street by *J.J. Scoles*, of 1844–9 (with a *Pugin* high altar, and many extensions by other hands), and *F. & H. Francis*'s Christ Church Down Street in Mayfair of 1865–72.

It is a huge leap from such exercises in native archaeology to
72 *G.E. Street*'s St James-the-Less of 1859–61. By that time the idea had taken hold that C19 Gothic could and should stride forward from medieval precedent. The result is one of the most original churches of the Revival in its fusion of Continental sources and candid display of polychromatic brick construction. A later mission church is *R.J. Withers*'s St Mary Bourne Street of 1873–4, also of red brick and also with a long un-English roof-line and semicircular apse. Further mission churches were founded rather optimistically even into the 1880s–90s, not one of which survives. Of the other architects in the pantheon of High Victorian Gothic, only *J.L. Pearson* produced a major new work in Westminster, the early masterpiece of Holy Trinity Bessborough Gardens (1849–52, demolished).

CHURCH RESTORATIONS are only slightly less important than new buildings in the story of the Gothic Revival. The restorers' greatest prize in London was of course Westminster Abbey, where most of the important work coincided with the Surveyorship of *Sir George Gilbert Scott*, between 1849 and 1878. Scott inevitably made mistakes here and there, but nothing too destructive befell the interior or the monuments, while the restored Chapter House is the greatest possible testament to his scholarship and aesthetic judgement. His successor was *Pearson*, unfortunately a much less skilled archaeologist, who left his fingerprints all over the restored N transept after 1884. Westminster's parish churches represented a different kind of challenge, since almost all were post-medieval, classical designs. Those of the late C17 and earlier C18 underwent minor changes by *William Butterfield* and others, many of which have been reversed since. The despised classicism of the early C19 could expect no quarter: *Sir Arthur Blomfield* rebuilt the insides of St Peter Eaton Square (since replaced) and St Mark North Audley Street in the 1870s, in a stripy round-arched style that was recognizably medieval without clashing with the original window shapes. *Scott* had earlier done something similar to the chapel of King's College; the task of restoring St Margaret, Westminster's
16 only medieval parish church, also fell to him.

The churches and chapels of OTHER DENOMINATIONS are wonderfully diverse, especially in the immigrants' district of Soho. Variants of the round-arched, Neo-Romanesque style were used for the two greatest Nonconformist meeting houses in West-

minster, *W.F. Poulton*'s vast Westminster Chapel of 1864–5 and *Alfred Waterhouse*'s King's Weigh House Chapel of 1889–91. Each has a rounded or part-rounded plan with galleries, which by then were almost unheard of in new Anglican churches. *James Cubitt*'s polygonal Welsh Presbyterian Church of 1886–7 in Charing Cross Road, also galleried, is another logical expression of a centralized preaching interior. Other non-English Protestant congregations seem to have given up on a church-like image, to judge by the French Protestant Church in Soho Square (1891–3 by *Aston Webb*, with the minister's house at the front), or *Balfour & Turner*'s reclusive National Scottish Church in Crown Court, Covent Garden, 1909. p. 427

By contrast, the eucharistic worship of the ROMAN CATHOLIC CHURCH imposed a preference for longitudinal plans, and its traditions decidedly favoured architectural display. Where style was concerned, however, its Italian roots often tripped up those, like Pugin, who wanted to steer its buildings exclusively towards the Gothic Revival. The only Gothic example in Westminster after 1850 is *F.H. Pownall*'s Corpus Christi, Maiden Lane (1873–4). *W.W. Wardell*'s former Chapel of St Peter and St Edward off Palace Street, 1856–8, and *Henry Clutton*'s convent of 1862–3 and later in Carlisle Place are by contrast round-arched and plain, while *Kelly & Birchall*'s St Patrick Soho Square of 1891–3 is a modern Italian basilica complete with campanile. Then in 1895 a Neo-Byzantine design by *J.F. Bentley* was chosen for the new Roman Catholic cathedral for Westminster. This established straight away a new style for churches that was at once historically respectable and wholly distinct from Gothic, although nothing on the scale of its hauntingly cavernous, shallow-domed interior was built anywhere else. p. 427 93, p. 675

Official Architecture and the 'Battle of the Styles'

This glance over the ranks of Victorian churches begins to suggest how many ARCHITECTURAL STYLES passed in and out of favour in the period, as well as how styles were deployed to suggest particular moods, messages or affiliations. The practice was well established by 1834, when the Houses of Parliament competition stipulated home-grown 'Gothic or Elizabethan'. But the issue of the appropriate style for GOVERNMENT BUILDINGS would not go away. That *Barry*'s reconstruction of Soane's Board of Trade wing in Whitehall (1844–7) was classical in style can have surprised no one. Then in the 1850s the Crimean War and Indian Mutiny exposed glaring shortcomings in the machinery of Government, and efficient new premises were prescribed as part of the solution. Their procurement was the subject of another public competition, for which Gothic, classical and modern French designs contended for first place. Medievalist hopes seemed vindicated when the initial victor was jilted in favour of a Gothic design by *Scott*, but a change of ministry abruptly killed it. The pragmatic Scott then came up with the present, thoughtfully planned Cinquecento palace, designed in collaboration with *Matthew Digby Wyatt* and built in 1862–75. Its variety, relief and multiplication of motifs and materials make Barry's building 92, p. 268

alongside look quiet and sober, a telling sign of a shared High Victorian aesthetic that cut across stylistic divisions.

The University of London headquarters behind Burlington House, of 1867–70, saw a similar to-ing and fro-ing: a Gothic design was begun, but was made classical once the academics had wrested control from the medievalist faction in Government. Its architect was the remarkable and versatile *Sir James Pennethorne*, whose surviving Westminster works include additions to Buckingham Palace and the Duchy of Cornwall Office in Buckingham Gate. The result shares a family likeness with Scott's Foreign Office. Variants of this same North Italian style were preferred when *Sydney Smirke* and *Banks & Barry* converted and extended Burlington House for the Royal Academy and Learned Societies in 1866–74, and for *E.M. Barry*'s lavish new interiors at the National Gallery in 1872–6. The National Portrait Gallery and Tate Gallery, 1890s designs by architects chosen by private benefactors, are in a less precedent-bound Neo-Renaissance, with smaller-scale motifs. A similar turn away from High Victorian drama marks *Leeming & Leeming*'s Admiralty Extension and *Norman Shaw*'s daringly domestic New Scotland Yard, both of which were begun in 1888. The next additions to the Government buildings of Whitehall really belong to the Edwardian story, for which *see* p. 73 below. Only at the Royal Courts of Justice on the Strand was a Gothic design implemented, after another painfully protracted public competition. *G.E. Street*'s palace of law, built 1871–82, is Early English with a definite French accent, with a greater freedom in elevation and massing than even the new Foreign Office had achieved. But after this high-water mark it was once more the religious and historical associations of Gothic, rather than its claims to be a universal way of building, that determined when the style was used.

p. 249

91

Victorian Fine Art, Decorative Art and Sculpture

The age of Metropolitan Improvement up to *c.* 1840 generated surprisingly little public sculpture or decorative painting. The PALACE OF WESTMINSTER was to change all that. Not only was its exterior carved with masses of figures in the medieval way; its interiors were deliberately conceived both as a stimulus to the national school of fine art and as a didactic sequence telling of British history and destiny. The committee in charge was chaired by Prince Albert, whose enthusiasm for recent German mural painting was influential. The results include major works by such artists as *Daniel Maclise* and *William Dyce*, besides a great population of portrait statues. These paintings proved rather less influential in national terms than the decorative arts that seem to cover every surface all around them. The combinations have a flavour all of their own, neither entirely churchy nor Old English-baronial, that no visitor ever forgets. These decorations were *Pugin*'s territory, and he enlisted such trusted collaborators as *John Hardman* for metalwork and stained glass and *Herbert Minton* for encaustic tiles.

90

Minton and Hardman are associated nationally with CHURCH FURNISHINGS, the highlights of which deserve a summary here. St Barnabas and St Stephen Rochester Row were both fitted out in the late 1840s according to the Cambridge Camden Society's preferences, but as usual these sequences have lost coherence. The font, pulpit and other details of St James-the-Less show the hard, massive and forthright taste of the mid-Victorian years, when period precedent counted for less. It also has a notable mosaic based on a short-lived fresco by *G.F. Watts*, one of several attempts to follow up the less-than-triumphant use of fresco techniques at the Palace of Westminster (where pictorial mosaic was also revived). The later C19 return to a gentler late medieval aesthetic appears in abundance at St Matthew Great Peter Street, St Paul Wilton Place and (especially) St Barnabas, which have chapels, screens, windows, reredoses and other embellishments by such fluent designers and artists as *G.F. Bodley*, *Sir Ninian Comper* and *C.E. Kempe*. STAINED GLASS is rarely outstanding, with many big names represented by minor or damaged works. Two exceptions are *Clayton & Bell* at St James-the-Less, and *Henry Holiday* at St Margaret Westminster (1883) and Westminster Abbey (1868); the Abbey also has fine work by *Burlison & Grylls* in the S transept rose. Its main reredos of 1866–73, the greatest collaborative work of church art in Westminster, was designed by *Scott*, who employed several artists and manufacturers from his contemporary Albert Memorial: *Clayton & Bell*, the sculptor *H.H. Armstead* and the Venetian mosaicists *Salviati & Co*. Mosaics mostly of a very different, Byzantinizing type are amongst the glories of Westminster Cathedral, where various artists worked on the side chapels provided for in Bentley's plan. One of these also has stalls of *c*. 1912 by *Ernest Gimson*, the finest Arts-and-Crafts WOODWORK in any Westminster church.

The path of Victorian SECULAR DECORATION is more faltering, in Westminster as in the rest of Britain. In the 1840s–50s Italian Renaissance *grottesche* were in favour, imitated far more literally than in their Neoclassical foreshadowings. The taste was a pan-European one, and its most notable early practitioners were Germans: *Frederick Sang* (Travellers' Club, Pall Mall, and former Conservative Club, St James's Street) and *Ludwig Grüner* (Buckingham Palace; destroyed). Full-scale mural painting includes ambitious symbolic work of *c*. 1856–64 at Bridgewater House in Cleveland Row by another German, *Jakob Götzenberger*; fragments of *Watts*'s murals in No. 7 Carlton House Terrace, also 1850s, and *Clayton & Bell*'s hieratic figure painting over the State Stair of Scott's Foreign Office, of a decade later. Other interior schemes owed more to the collaboration of artists and architects, an ideal carried over from the Gothic Revival to the Aesthetic Movement and Queen Anne schools of the 1860s–80s; for instance, *Lord Leighton* and *Walter Crane* worked at No. 1 South Audley Street in the 1880s. Such houses remained rare in Westminster, as the upper middle classes and the artists they patronized drifted westward to Chelsea or Kensington (the only purpose-built artist's house in Westminster, *George Morgan*'s No. 33 Warwick Square of 1860–1,

is in bourgeois Pimlico). When painted interiors returned to favour amongst the very rich around 1900, Parisian decorating firms such as *Brémond & Tastemain* were called in (e.g. at No. 10 Carlton House Terrace, 1905–7); or paintings were brought in from elsewhere (No. 75 South Audley Street, No. 3 Grafton Street). But this is to stray too far into the subject of interior design, which is discussed further below (p. 63).

SCULPTURE diversified considerably from the 1840s, as public statuary took over from church monuments as a source of prize commissions. The last multi-figure memorial at Westminster Abbey, *E.H. Baily*'s Lord Holland, dates from *c.* 1847. After that, less space-hungry busts or individual statues were the norm, focusing attention more narrowly on portraiture. The best places to see the works of Victorian sculptors in marble are the 77 'Statesmen's Aisle' at the Abbey and the corridors of the Palace of Westminster. The statues also show the abandonment of Roman dress – used for *John Gibson*'s Peel at the Abbey as late as 1853 – in favour of modern or period costume, preferably involving robes.

The PUBLIC STATUES which began to appear everywhere in the second half of the C19 are almost always of bronze. The Victorians enjoyed debating heatedly about their character and quality, and more than once a despised statue was melted down and replaced. The subjects, no longer restricted to monarchs or prime ministers, include medieval rulers, soldiers, explorers, poets, and philanthropists and reformers of both sexes, as well as a few symbolic figures. Their plinths were often designed by 76 architects, and many are diversified with inventive relief sculpture. The best hunting grounds are the Victoria Embankment gardens, Waterloo Place and Parliament Square. Here there is space only to point out a few highlights: *John Bell*'s sombre 74 Guards' Crimean Monument of 1858–61 at Waterloo Place, the first war memorial in Westminster to honour the dead of all 75 ranks; *Marochetti*'s spirited equestrian Richard I of 1860 by the Palace of Westminster; two by *Sir Hamo Thornycroft*, the introspective General Gordon of 1885–8 (Victoria Embankment, Whitehall section), and the leonine figure of Gladstone, Gordon's nemesis, with four allegorical supporters (1899–1905, outside St Clement Danes).

London's most famous work of sculpture lacks a portrait statue: it is *Alfred Gilbert*'s Shaftesbury Monument ('Eros') at Piccadilly Circus, a large fountain of 1886–93. This is the greatest work in Westminster of the so-called NEW SCULPTURE of the late C19, a French-influenced movement marked by a new sensitivity of modelling and expression and a fondness for allegories and symbols that owed little or nothing to classical or Christian traditions. *Gilbert*'s Fawcett monument at the Abbey, 1885–6, is an exceptionally intense work in the style; *Rodin*, Gilbert's greatest single influence, is represented by The Burghers of Calais group erected in Millbank Gardens in 1914–15. The new manner appears diluted in several wall monuments by *Sir George Frampton* along the Victoria Embankment, showing the smaller scale favoured for so much late C19 commemorative sculpture. The Embankment also incidentally has the oldest monument

in London: Cleopatra's Needle, the Egyptian obelisk of *c.* 1468 B.C., set up in 1877.

ARCHITECTURAL SCULPTURE is plentiful, but less striking. The Palace of Westminster has a huge complement of kings and queens carved by *John Thomas* and assistants, and Thomas's name crops up for small-scale and relief sculpture on other mid-C19 buildings. Buildings as grandiose as the new Foreign Office, the remodelled Burlington House or the University of London offices required something weightier; one common solution was that 'art' sculptors took on the isolated statues, and large statuary workshops such as *Farmer & Brindley*'s the lesser carving.

Victorian Innovations in Building

By the time the Palace of Westminster was fully under way, much had already been done to exploit IRON as a hidden element of major buildings, both for its strength and as a precaution against fire. The palace followed suit, using floors of iron joists with shallow brick arches, and galvanized cast-iron roof plates. *Sir Joseph Paxton*'s Crystal Palace of 1851 – a structure almost entirely of mass-produced iron and glass, which stood in Hyde Park for a year before reconstruction elsewhere – demonstrated what could be done where function overruled questions of architectural style. Surviving buildings in Westminster that show its influence include *E.M. Barry*'s barrel-vaulted Floral Hall of 1858–60 (now reconstructed as part of the Royal Opera House), all glass and iron apart from its side walls, and the former Flower Market in Covent Garden, of 1871–87 (now London Transport Museum). Smaller-scale iron-framed structures are not uncommon, including the roof over the Durbar Courtyard in *M.D. Wyatt*'s India Office, 1868, and a drill hall of 1882–6, reconstructed in Horseferry Road. But the nervousness of fire-insurance companies deprived London of full cast-iron façades, of the type seen here and there in Liverpool or Glasgow and all over the United States. Instead, iron construction spread invisibly by means of various patent building systems combining iron joists and uprights with brick, concrete and other incombustible materials.

The most celebrated iron and glass roofs were of course at RAILWAY STATIONS. The high cost of reaching Westminster from across the Thames delayed the arrival of these until the 1860s, and limited their number to the termini at Victoria (a rare double terminus, with two separate companies side by side) and Charing Cross. *John Fowler*'s train shed for the London, Chatham & Dover Railway at Victoria remains; its two spans of sickle-trusses are less impressive-looking but more stable than the single span at Charing Cross, which had to be taken down after structural failure in 1905. Underground railways are described below.

The mainline railways also encouraged a wider choice of BUILDING MATERIALS. Already in the 1820s Welsh slate was replacing local clay tile for roofing, while canal-borne Bath stone had become a new status symbol. After the 1830s it was joined by cheaper West Country sandstones carried on the Great Western Railway. The revival of ragstone for churches in the

1840s has already been noted. The Palace of Westminster was faced in a Yorkshire limestone that did not wear well. Caen stone, another ill-advised fashion, was used in the 1840s at Buckingham Palace, the Conservative Club, and for repairing Westminster Abbey, failing rapidly at all three. A longer-lasting combination on many Victorian buildings was Portland stone with a ground floor or lower courses of polished granite, of which many types and colours were available, and often also some dressings of red Mansfield sandstone. Red brick came back into fashion for houses in the 1870s, demoting the yellow London stock brick to less visible elevations. Further diversity came from the harder and brighter red bricks of the Midlands and NW and from the increasing use of terracotta, as seen in many buildings by *Waterhouse*. In the latest C19 and early C20 colour-glazed or white faience also became popular.

Planning and Municipal Reform

3 Barry's Palace of Westminster rests on a long embankment built out into the river. The potential of a much longer embankment for improving the transport and utilities of London was often discussed in the first half of the C19, but nothing happened in the absence of an independent body powerful enough to carry it through. The shortcomings of planning in the 1840s are illustrated by the failure of *Pennethorne*'s proposals for a new E–W route N of the Strand, of which Cranbourn Street (1843–5) is a fragment. More successful was Victoria Street, a broad highway driven by the Westminster Improvement Commissioners through the slummy area W of the Abbey in 1847–51. Things moved faster after the Metropolitan Board of Works (MBW) was founded in 1855. Its responsibilities included new street improvements and the transformation of London's choking sewerage system, objectives which fused magnificently in the new VICTORIA EMBANK-
4 MENT. As executed in 1864–70 by *Sir Joseph Bazalgette*, this stretches all the way N and E from Westminster Bridge to the Temple, from which the route continues into the City. Beneath were sewers, water and gas mains, and the new Metropolitan District Railway, the first underground railway to reach Westminster; to their landward side were plots for new buildings and wide strips of public garden. New sewage pumping stations were provided in connection, including one in Westminster on Grosvenor Road; the wharves and jetties along Millbank, s of the Houses of Parliament, were swept away in further embankment-making of the 1880s and 1900s. Road circulation was helped by two new BRIDGES of the 1850s–60s, Chelsea Bridge and Lambeth Bridge (both since replaced).

None of the MBW's other schemes in Westminster was quite so impressive, though most did achieve a modicum of slum clearance. The first was Garrick Street, a short cut through the E part of Covent Garden, in 1859–61. Then in the 1870s–80s came Northumberland Avenue, for better access to the Embankment from Whitehall, and the intersecting routes of Shaftesbury Avenue and Charing Cross Road, which speeded E–W traffic through Soho and made a N–S link from Trafalgar Square to

Tottenham Court Road. The latter two followed winding routes in order to save money, and the relatively shallow plots on either side fostered a cheap, feebly picturesque red brick architecture. Only after the London County Council replaced the MBW in 1888 did replanning return on a scale Nash would have saluted or Paris admired, in the form of the Aldwych crescent and Kingsway, its continuation to the N (1898 and later). Their wider highways were accompanied by wider clearance on either side, allowing new buildings of a much more imposing scale.

Westminster's own LOCAL GOVERNMENT coexisted with these over-arching authorities. Some kind of civic administration dated back as far as 1585, when a Court of Burgesses was enacted to administer the local powers of the Abbey, which was effectively independent of the county authorities of Middlesex. However, most administration effectively devolved upon the parishes as the West End was built up, tempered in many areas by the power and influence of great estates such as the Grosvenors'. Then in the C19 certain functions were centralized under new authorities: the police in 1828, followed by the Metropolitan Board of Works itself, and ten years after that by the fire brigade, as a department of the MBW (1865). The new authorities rapidly standardized their buildings. Rochester Row has the best cluster built for the POLICE (future uncertain): magistrates' offices of 1845 in the usual brick Italianate of *Charles Reeves* (facing Vincent Square), stables by *T.C. Sorby*, 1867–8, and a police station and magistrates' court by *J. Dixon Butler*, 1900–4. Butler's distinctive work, much rehearsed throughout London, varied in formality according to status: big pediments and bracketed doorcases for courthouses, unadorned brick Free Style for police section houses, like that in Beak Street (1909–10). A former FIRE STATION of 1883, in the Renaissance style of *Alfred Mott*, survives in Great Scotland Yard.

Other resources were often pooled by the parishes, arrangements reflected in certain MUNICIPAL BUILDINGS built or planned before the City of Westminster was chartered in 1900. Caxton Hall in Caxton Street, built in 1882–3 for St Margaret's and St John's (which had formed a Poor Law Union in 1832), was large enough to serve as Westminster's City Hall for much of the C20. Rather smaller is the office of 1857–8 in Tavistock Street for the Strand District Board of Works, set up by the Metropolitan Management Act of 1855. It served St Anne Soho, St Clement Danes, St Mary-le-Strand and St Paul Covent Garden. Such fragmentation between smallish vestries gave a very different architectural picture from the rest of inner London, with its competitive display of late C19 town halls.

PUBLIC LIBRARIES and BATHS were provided at first at the discretion of the local authority, with several Westminster parishes in the vanguard. Baths started early with buildings of 1846–7 in Orange Street (demolished). The front range remains of those by *F.J. Smith* in Great Smith Street, which were built integrally in 1891–3 with a public library. This in turn replaced Westminster's first municipal library, instituted in 1857 by adopting premises of 1840 from an independent working men's foundation. The style of the late C19 libraries, including those in

Buckingham Palace Road and South Audley Street, is the usual friendly gabled red brick.

Victorian Domestic Architecture

Great stand-alone MANSIONS continued to be built, but in diminishing numbers. The greatest survivor is *Barry*'s Bridgewater House in Cleveland Row, finished externally in 1848, where the Italianate manner of his Reform Club is taken to a higher pitch of ornament and texture. Others have gone, including one other great palazzo, *Lewis Vulliamy*'s Dorchester House on Park Lane (1849–53), and *William Burn*'s Montagu House (1859–62), the last new private palace in Whitehall, in the mansarded French C17 style.

A similar progression from Italianate or palazzo-style stucco to French 'Second Empire' can be traced in TERRACE HOUSING. Italianate terraces were of course going up all the time in Belgravia and Pimlico. The style was stretched to fit *Thomas Cubitt*'s two giant houses of 1843–5 flanking Albert Gate in Knightsbridge, the tallest London had yet seen, and Italianate terraces filled up Buckingham Gate after *Pennethorne* realigned it in 1853–9. As late as the 1870s the Grosvenor Estate was still enforcing Italianate refacings on its Mayfair tenantry. Earlier terrace house styles which failed to take include Elizabethan – by *Lewis Cubitt* in Lowndes Square, 1837–9 – and English Gothic, of which *Scott*'s spectacular terrace of 1852–4 at The Sanctuary is significant as one of London's earliest C19 buildings to dramatize its roofscape. But the mansard-roofed French Renaissance ('Second Empire') of *Thomas Cundy III*'s rebuilt Grosvenor Place and Grosvenor Gardens suggested after 1865 that the days of Italianate stucco were numbered.

Things moved on again in the 1870s with the advent of the QUEEN ANNE style. This misleading term yokes together the revivals of English mid-C17 domestic forms and of Northern Renaissance styles, especially as used on the tall gabled town houses of the Low Countries, whether expressed in carved red brick or in terracotta. The traditional London house plan and flat-fronted elevation relaxed under their influence into a wide variety of arrangements, often aimed at making better use of light, including single, double or triple-storey bows of every shape. The results can be seen in all their russet splendour in the N part of the Grosvenor Estate in Mayfair, where architects had to be chosen from the Duke's 'approved list'; the lucky candidates included *Ernest George*, *R.W. Edis*, *J.E. Trollope* and *J.T. Wimperis*. Commercial versions were not far behind; Agnew's in Old Bond Street, 1876–8 by *E. Salomons & R.S. Wornum*, is an early example. The N part of Mayfair also has some marvellous fin-de-siècle houses by *Eustace Balfour* and *H. Thackeray Turner*, in an inventive Arts-and-Crafts style (Mount Street, Brook Street). *W.D. Caröe*'s flats in Duke Street and *J.F. Bentley*'s Archbishop's House at Westminster Cathedral share a certain kinship of fine red brick and stone. The 1890s also saw a rally of stone-built Tudor Gothic and Elizabethan, including two major houses, *W.H. Romaine-Walker*'s

85

p.
541

Stanhope House in Park Lane and *J. L. Pearson*'s house and office for Viscount Astor on (of all places) the Victoria Embankment.

Fashionable INTERIORS often, but not always, kept pace with what was happening on the outside. More generally, the principle of period imitation and the mass of competing practitioners – both architects and superior decorating firms – made available a vast choice of styles and combinations of styles. Industry, finance and the colonies meanwhile generated legions of the newly rich eager to move in alongside, or in place of, the older social and governing élites. Architects and interior decorators were on hand to guide them in the delicate matter of taste, usually towards some version of the Louis XIV and Dixhuitième styles. Superior examples from the 1890s–1900s include the Astors' glittering rooms at No. 18 Carlton House Terrace, Lord Revelstoke's strongly contrasting suite at No. 37 Charles Street, and *Ernest George & Peto*'s work for a mineral-water baron at No. 47 Berkeley Square. The endless salons and boiseries elsewhere tend to blur together in the memory's eye, especially when commercial uses have banished the intended furnishings and fabrics. Rather more engaging are some of the less Francophiliac sequences, such as the Italian Renaissance work at No. 6 Carlton House Terrace (*Ernest George* again), *Blow & Billerey*'s dark wooded rooms at No. 46 Grosvenor Street, or Lord Howard de Walden's naïvely operatic transformation of Seaford House in Belgrave Square. Another style worth watching is Neo-Adam, which begins proliferating around 1870 (No. 60 Green Street, No. 11 St James's Square). In the early C20 it approaches direct imitation through a process of thinning and flattening (No. 30 Curzon Street, by *H. T. Hare*; No. 17 Hill Street). Most exciting of all to modern eyes are Westminster's two schemes by the most enduringly famous mid-C19 designers, both of whom refused the crutch of period imitation. One is *William Morris*, whose firm adorned two rooms of St James's Palace in 1866–7 with patterns devised by *Philip Webb*; *Owen Jones* is the other, represented by an amazing Graeco-Moorish sequence of 1866–70 at No. 16 Carlton House Terrace. Both 86 make unforgettable use of colour, especially of close bright patterns on a dark ground.

Individual houses for the wealthy were supplemented by residential chambers and mansion blocks. CHAMBERS were a speciality of St James's and its fringes, where bachelors-about-town tended to live. The earliest survivors, *Decimus Burton*'s No. 15 Regent Street of 1838–9 and No. 18 St James's Square of 1846–7, do not look much different from big stucco houses. Later examples usually incorporate shops, such as *Butterfield*'s Nos. 37–38 Bury Street, 1870, or *Reginald Morphew*'s two in Jermyn Street, some of the most original creations in Westminster in the Free Style of *c.* 1900. MANSION BLOCKS have larger, family-sized accommodation fitted on to a single floor, often with separate quarters for servants; some included shared dining rooms and other facilities. Storeys of even height are another 88 distinguishing feature. The type is discussed in more detail in the introduction to South Westminster (p. 667), its chief stronghold

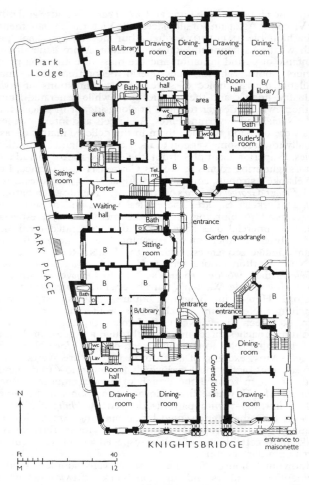

Wellington Court, Knightsbridge, 1893–5. First-floor plan
(*The Survey of London*)

in central London from its first massed appearance in the
1850s. Concentrations can also be found in Mayfair and along
Knightsbridge, one of several main roads out of London to the
N and W which attracted them. The greatest of all is Whitehall
Court, *Archer & Green*'s French Renaissance pavilions of splen-
dour built on the Victoria Embankment in 1886–92. Others in
Westminster were intricately planned to extract maximum value
from irregular sites, with results that are less predictable than
the rigid oblong blocks of Marylebone or Baker Street. Queen

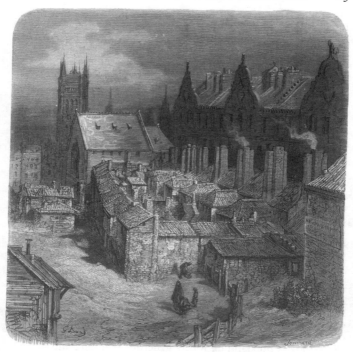

Westminster, north of Great Peter Street, showing (left) Rochester Buildings, 1862. Engraving by Gustave Doré, 1872

Anne's Mansions in Queen Anne's Gate, 1873–89 (demolished), was of this type; its fourteen unadorned storeys caused such offence that the Building Acts were revised in 1894 to enforce a normal height limit of 80 ft (24.4 metres) – ten below the maximum fixed in 1862 – plus another 20 ft (6 metres) for set-back upper storeys.

WORKING-CLASS HOUSING showed a similar movement towards larger and taller blocks, though of course nothing near the same quality of accommodation was provided. Its importance in the complete architectural picture has generally been over-looked in Westminster. The 1840s saw a few reforms aimed at improving housing standards, and some early 'model housing' – so called because it was hoped that other builders would follow its lead – followed in the 1850s. The earliest survivor, of the gallery-access type, is on the Grosvenor Estate: St George's Buildings in Bourdon Street, of 1852–3. It was built for a parochial organization by the housing specialist *Henry Roberts*. Another important figure in model housing was *H.A. Darbishire*, who began with a Guardsmen's lodging block of 1853–4 in Francis Street (demolished); his later Guards' Institute and Orphanage buildings in the same street give an idea of its gritty

p. character. His gabled Rochester Buildings off Great Peter Street,
65 built with a private benefaction in desperate slums, followed
in 1862. These have affinities with Darbishire's first, experi-
mental blocks of 1863–4 for the Peabody Trust, the wealthiest
of the private housing associations, on Commercial Street in
Spitalfields (*see London 5: East and Docklands*). Darbishire then
developed a standardized yellow brick block, first used in 1865
in Islington. Versions up to six storeys high were deployed in
the 1870s–80s to get the maximum accommodation out of the
Peabody estates in Westminster (Drury Lane, Grosvenor Road,
Great Peter Street). The other great provider of housing was
Sir Sydney Waterlow's *Improved Industrial Dwellings Company*,
founded in 1863 and meant to run at a profit. It too developed
a standard style, based on an early model-dwelling design by
Henry Roberts. The chief differences from Peabody's are
recessed staircases left open to the air and self-contained dwelling
plans without shared lavatories or sculleries. Those in Westmin-
ster vary in their architectural handling: the blocks on Grosvenor
land, such as at Duke Street (Mayfair) and Ebury Street, have a
few decorative touches, but the rest are of the usual harsh and
unadorned type (Charing Cross Road, Francis Street, Ebury
Bridge Road).

Much of this housing was built for the MBW, which preferred
to co-opt other bodies to discharge its obligation to rehouse those
displaced by new streets. The national mood changed from the
later 1880s, when some provincial cities initiated house-building
on their own account. London more than caught up with them
due to the energy of the young *LCC*, whose Millbank Estate of
89 1897–1902 is outstanding for its generous planning and gabled,
consciously domestic image. Westminster City Council's first
estate followed in 1902–4, to a more regimented parallel-block
plan by *Joseph & Smithem* (Page Street). It has decorative details
reminiscent of mansion flats. The list of providers could be
expanded with the Metropolitan Association for Improving the
Dwellings of the Industrious Classes (Gatliff Buildings, Ebury
87 Bridge Road, 1865–7), Watney's Brewery (Palace Street, 1882–3,
a rare example in London of employers' housing), St James's
Vestry (Ingestre Place off Broadwick Street, 1886–7), the
Artizans', Labourers' and General Dwellings Co. (Lees Place,
1887–91), and so on into the early C20.

Schools, Hospitals and Other Philanthropic Buildings

Victorian priorities put education before housing, and despite
much demolition there is no shortage of C19 SCHOOLS in
Westminster. The key division is between church schools and the
non-denominational Board Schools established by the Education
Act of 1870. The former, usually Gothic, often sit next to their
parent churches or chapels. Those at *Thomas Cundy II*'s St
Barnabas (1846–7) and *G. E. Street*'s St James-the-Less (1861–4)
are the most striking; the former balances Westminster's first
CLERGY HOUSE, a satellite building type associated with High
Church parishes (compare St Paul Wilton Place, St Matthew
Great Peter Street). After 1870 Gothic persisted as a kind of

denominational signal, as at *R.R. Arntz*'s Westminster City School of 1876–7. Meanwhile the School Board for London under *E.R. Robson* began to develop the familiar compact, tall-windowed red brick premises, usually in some version of Queen Anne. St George's School in Mayfair (1897–8), by Robson's son *Philip*, shows the Church of England coming round to the arrangement. The latest Board Schools in Westminster are of 1901, planned integrally with the LCC's Millbank Estate; three years later the LCC absorbed the Schools Board and its architectural responsibilities. The boarding houses of Westminster School also abandoned churchiness for Queen Anne; compare *Sir G.G. Scott*'s No. 1 Dean's Yard, 1862, with Rigaud's in Little Dean's Yard, 1896–7 by *T.G. Jackson*.

The profusion of small HOSPITAL BUILDINGS from before 1914 in Westminster is explained by the tendency of specialist centres, supported by unco-ordinated charitable initiatives, to gravitate to the capital. Scarcely one remains in use, but few of the survivors have been much altered; the biggest concentrations are in Vincent Square and in Soho Square and Dean Street. Most are by specialist architects, and are more striking for their styles and individual histories than for any innovations in planning. These tended to come from larger, general hospitals such as the former Queen Alexandra Military Hospital on Millbank, now part of the Tate Gallery (1903–6); its special feature was the unusual use of day rooms on the ward pavilions. PRIVATE CHARITY produced such buildings as *Joseph Clarke*'s miniature French Gothic chapel of 1862–4 for the House of St Barnabas at No. 1 Greek Street (Soho Square), or the girls' club of 1883–4 across the way in Greek Street. The Royal Parks were increasingly open for popular recreation, suitably embellished with new fountains and bandstands, and so new MUNICIPAL PARKS were limited to the modest riverside strips along Victoria Embankment and Millbank. Several churchyards and burial-grounds were also turned into gardens.

Victorian Commercial Architecture

The Great Exhibition of 1851 permanently increased tourism in London, and together with the growth in railway travel this created a great mid-C19 boom in HOTELS. Accommodation before the 1850s was provided by inns, a hangover from the old coaching days, or private hotels that were almost always adapted from terraced houses. Their successors included several giants, built to overawe guests and shareholders, and equipped with suites of public rooms rivalling those of the Pall Mall clubs. The first half of the 1860s produced those at the two railway termini, *James Knowles Jun.*'s Grosvenor Hotel at Victoria and *E.M. Barry*'s at Charing Cross, and also *W. & A. Moseley*'s Westminster Palace Hotel in Victoria Street (demolished) and *James Murray*'s former Buckingham Palace Hotel in Buckingham Gate. The railway hotels adopt versions of the fashionable French C17 style, disguised at Charing Cross by post-war rebuilding of the mansard roof. A similar French style was used for the many former hotels built along Northumberland Avenue in the years

p. 738

1878–87, and for the huge Hotel Cecil off the Strand, opened in 1885 (demolished). External display was no guarantee of profitability, however: the Savoy, a more utilitarian structure which opened alongside in 1889, stole a lasting march on its rival by providing bathrooms in unprecedented numbers. Two other famous Victorian hotels are in Mayfair: Claridge's in Brook Street and the Connaught in Mount Street, big red brick 1890s buildings of the kind favoured by the Grosvenor Estate.

Accommodation for non-residents was swelled by a new wave of CLUBS equipped with bedroom floors, and usually also a 'strangers' room' for non-members. Some were built as junior branches of established clubs, others for newer political or social groupings. A shortage of sites in St James's scattered them further afield, and the most imposing survivor is on the Victoria Embankment: *Waterhouse*'s National Liberal Club of 1884–7, in the mixed quasi-Romanesque style of his later years. Piccadilly has three late C19 former clubs in a row at Nos. 96–104, which likewise abandon the palazzo model for something taller and looser. By the early C20 there were over two hundred clubs in London, of which the purpose-built minority included ladies' establishments such as *Wimperis & Arber*'s Empress Club in Dover Street and minnows like *Frank Verity*'s Beefsteak Club, little more than a big dining room on Charing Cross Road.

SHOPS are another great Victorian theme. DEPARTMENT STORES emerged gradually from the ranks of the larger bazaars and drapers' shops, of which *James Murray*'s palazzo of 1866 for Lewis & Allenby remains in Conduit Street. Others commonly expanded by knocking through into adjacent houses, replacing their premises with something more coherent when funds permitted. Later rebuilding has left only one Victorian department store trading in Westminster, *C. W. Stephens*' Harvey Nichols in Knightsbridge (1889–94), though *Lockwood & Mawson*'s Civil Service Supply Association of 1876–7 survives in other uses in Bedford Street. Some stores specialized in mail-order and overseas business; the chain of huge warehouses for the Army & Navy Stores in Francis Street and Greycoat Place is in its way as impressive a relic of maritime empire as the Chatham boatyards.

SMALLER SHOPS are best seen *en masse* in Oxford Street, and also in New and Old Bond Street. The stylistic succession is like that of houses, from Italianate to Queen Anne or Northern Renaissance, with occasional diversions into Gothic or Elizabethan. Many are no wider than a single house plot, but extra space was provided by building upwards, giving a characteristic tall gabled silhouette with storeys diminishing above a first-floor display window (comparable to the entresols of commercial Paris). Old Bond Street also has Westminster's only remaining Victorian SHOPPING ARCADE on the Regency model, *Archer & Green*'s Royal Arcade of 1879–80. Specialized shops include ART GALLERIES, for which natural light was essential. This favoured toplit interiors placed in the rear, as at Agnew's in Old Bond Street and the Fine Art Society and the former Colnaghi's in New Bond Street. Toplit galleries also appear at Thomas Goode's china shop of 1875 and later in South Audley

Street, an early Queen Anne venture by *Ernest George*, with ambitious Aesthetic decoration.

SHOPFRONTS are less well preserved, and many important types have almost disappeared. Asprey's in New Bond Street, *c.* 1865 and later, shows what could be done with cast iron and the new material of plate glass. A more old-fashioned mid-C19 type with columns or pilasters and subdivided glazing appears at Nos. 8 and 26 Old Bond Street and No. 25 New Bond Street. Later C19 and Edwardian fronts often tempered plate glass with delicate leading or glazing bars in upper areas (F. Pinet's, New Bond Street; Nos. 93–95 Strand). SHOP INTERIORS include Floris in Jermyn Street, a wonderful mahogany-fitted parfumier's of 1850s origin. Other old interiors, nothing much in aesthetic terms, are steeped in the special masculine atmosphere that comes with tradition and gradual change (Trumper, Curzon Street; Bates, Jermyn Street; Purdey's, Mount Street).

OFFICES are everywhere, but generally make a less impressive effect than in the City. The post-medieval street plan of Westminster also provided few irregular sites of the kind that enforced such variety on the City's office architecture. Only the shipping-company premises of Cockspur Street can offer comparison with the competitive riches of Cornhill or Threadneedle Street. Even in the new streets, office buildings tend to take a back seat. In Victoria Street they blended with giant mansion flats and hotels, almost all now demolished; in Garrick Street, commerce is subordinate to *Frederick Marrable*'s Garrick Club of 1864; in Northumberland Avenue it is the hotels that stand out, in Shaftesbury Avenue and Charing Cross Road the theatres. One interesting theme elsewhere is the eclectic Gothico-Italianate style developed by *Charles Gray* in the 1850s–60s (Tavistock Street, No. 34 Bedford Street), when architects began mixing features derived from various older styles in the hope of achieving some new fusion. The normal level of eclecticism around 1900 is represented by the very prolific *E.K. Purchase* all over Soho and the E parts of Mayfair. A more creative use of Arts-and-Crafts and Art Nouveau idioms was made by *Treadwell & Martin*, who specialized in narrow office fronts of marvellous variety.* Nos. 41–43 Whitehall and the adjoining Old Shades pub show something of their marvellous repertoire. *Caröe*'s headquarters for the Church Commissioners on Millbank (1903–6) have the space to be even more freewheeling.

The best cluster of BANKS, most now in other uses, is in their traditional stronghold at the N end of Whitehall and S side of Trafalgar Square. In the square, *F.W. Porter*'s Union Bank (1870–2) shows the durable fashion for polished granite columns; in Whitehall, *R.W. Coad*'s Cocks & Biddulph's Bank of 1873–4 reaches after something more domestic, while *Ewan Christian*'s bank of 1884 for Cox & Co. adopts an unusual Neo-Elizabethan style. The more conservative palazzo tradition, so strong in City bank architecture throughout the C19, is represented by

*The familiar seaweedy style of Art Nouveau first appears on balconies designed by *A.H. Mackmurdo* at the Savoy Hotel (1885–9).

branches by *John Gibson* (No. 212 Piccadilly, 1873) and *F. W. Porter* (Nos. 62–64 Knightsbridge, 1884–5). Other banks made use of the plentiful supply of big c18 houses; *P. C. Hardwick*'s transformation of Queensberry House for the Bank of England is the most notable. INSURANCE OFFICES are much less common. Several set up in Pall Mall; *David Brandon*'s Eagle Insurance is in the round-arched Italian fashion of the 1860s, *Norman Shaw*'s magnificent Alliance Assurance at the corner with St James's Street is a gabled Queen Anne composition with strong Continental motifs.

Entertainment and Recreation

THEATRES come top of the entertainment programme. Britain lacked the equivalent of the Continental 'civic theatre', and those of London were built entirely by private enterprise. Westminster's grandest Victorian example, and the only one from the mid c19, is *E. M. Barry*'s porticoed Royal Opera House of 1857–8. Other entertainment could be had at music halls and concert halls, none of which survives intact. Of full-scale theatres, the 1870s–80s have left two intact auditoria by *Thomas Verity*: the Criterion at Piccadilly Circus, a small basement venue, and the Comedy in Panton Street. Then in the 1890s–1900s substantial new theatres started opening almost every year. The rise in the social standing of playgoing was partly responsible; other factors were improvements in fire safety and the capacity of some new houses for spectacles such as circuses and aquatic displays (as at *Frank Matcham*'s Hippodrome in Charing Cross Road, 1898–1900). The glut of suitable sites along the new streets also helped, though much ingenuity was needed to squeeze the most out of them. This favoured a select group of expert theatre designers, headed by *C. J. Phipps*, *W. G. R. Sprague* and *Matcham* himself, joined in the early c20 by *Bertie Crewe*. Externally, theatres follow fashion in turning from red brick and terracotta mixed Renaissance to stone-faced Baroque in the 1900s, as seen at *Sprague*'s non-identical twins in Aldwych (the Aldwych and the Strand). The usual mood inside is an intensified or Anglicized version of the French styles popular in private houses, executed more summarily and often topped off with painted figure scenes by specialists such as *Felix de Jong* or *Herbert van Hooydonck*. *Matcham*'s splendid Coliseum in St Martin's Lane is one of the most singular, planned as an all-day venue, with tier upon tier of tearooms at the front. Other theatres worth seeking out include two in Shaftesbury Avenue designed largely by non-specialists, *T. E. Collcutt*'s broad-fronted Palace Theatre of 1888–91 and *Lewen Sharp*'s Apollo of 1900–1 (an unusual Hapsburg Baroque design), and two that were updated with exceptionally beautiful Edwardian interiors: Nash's Theatre Royal, Haymarket, by *S. D. Adshead*, and the Playhouse in Northumberland Avenue, Dixhuitième work by *Fernand Billerey*, 1906–7. MUSIC HALLS, a type not always easily distinguishable from theatres, are represented by the big London Pavilion complex of 1885 at Piccadilly Circus, now in other uses. The London Palladium in Argyll Street is *Matcham*'s music-hall

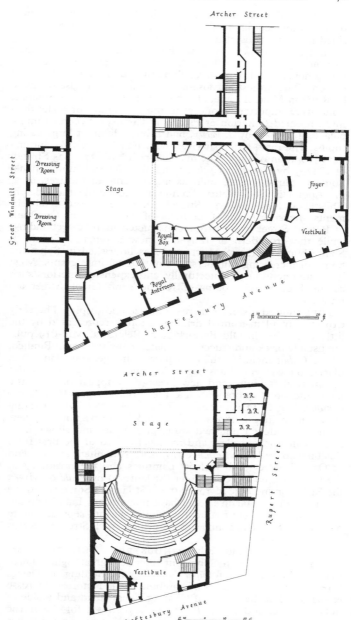

Theatre plans, Shaftesbury Avenue. A, Lyric Theatre; B, Apollo Theatre (*The Survey of London*)

conversion of exhibition rooms built in 1867–8: the chief survivor
of the various commercial EXHIBITION BUILDINGS that diver-
sified the attractions of the C19 West End.

RESTAURANTS were another booming business in the later
C19, emerging as something distinct from the older inns and
eating houses, and flourishing along the Strand and at the S end
of Soho. The earliest purpose-built example still in use seems to
be Rules in Maiden Lane, of 1873. The railway caterers Spiers &
Pond were important pioneers in the economies of scale: their
multi-roomed Criterion at Piccadilly Circus, a Second Empire
palace of 1871–4 by *T. Verity*, had several different large eating
rooms. The main space survives, with *Frank Verity*'s Byzantiniz-
ing decoration of 1899. The majolica-rich Nos. 222–225 Strand,
of 1882–3 by *Goymour Cuthbert* and *W. Wimble*, is now a bank.
Some restaurants were built as attachments to theatres, as at
the Apollo in Shaftesbury Avenue and alongside the Adelphi
Theatre at Nos. 409–410 Strand. Of more famous establish-
ments, *Archer & Green*'s Café Royal of 1865–72 in the Quadrant
of Regent Street was partly reconstructed in 1920s rebuilding,
while the Trocadero of 1895–6 is now a retained façade in
Shaftesbury Avenue. Smaller concerns flourished in Soho, the
home of increasing numbers of Continental immigrants. Most
were unpretentious architecturally, and expensive interiors such
as the French-style rooms of Kettner's off Greek Street are
unusual.

PUBS showed a similar increase in size and display. The early
C19 style of plain-fronted drinking shop is represented by the
little Grenadier in Old Barrack Yard, Belgravia. Mid-C19 pubs
are usually brick and stucco Italianate; many survive in Pimlico,
where *Cubitt* included them as part of his general plan, often
placed on corners. Pubs generally tend to lag behind wider
commercial fashions, and new ideas often appear first as little
half-understood quotations, like the sunflower panels at *Henry
Cotton*'s Sun & 13 Cantons in Beak Street, 1882. Accelerating
competition in the 1890s, encouraged by restrictions on new
licences, produced polished stone pub fronts and showy inte-
riors of mirror, cut glass and mahogany. Two of the best from
this binge decade are *Saville & Martin*'s Tottenham at the E end
of Oxford Street (still with its paintings and tiles inside), and
the Golden Lion in King Street (St James's) by *Eedle & Myers*;
the Red Lion in Duke of York Street (St James's Square) and the
97 Salisbury in St Martin's Lane have magnificent Late Victorian
interiors. These were frequently subdivided into separate, more
or less select bars and snugs; the Argyll in Argyll Street preserves
this arrangement.

WAREHOUSES and other INDUSTRIAL BUILDINGS are
common, especially in Soho, but offer few great sights. Three
that stand out are *J. T. Wimperis*'s factory for Boldings in Davies
Street, 1889–91, the cluster of warehouses and factories of Crosse
p. & Blackwell at the N end of Charing Cross Road and E side of
426 Soho Square, and *Frank L. Pearson*'s premises for the music
publishers Novello, of 1898 and later, less for its printing house
than for the splendid Northern Renaissance showroom on
Wardour Street.

Edwardian Westminster

So many trends begin or finish in the first decade and a half of the C20 that the period deserves a brief account of its own. As the penny-pinching Victorian spirit abated, the desire was commonly voiced that Westminster should become a capital worthy of the British Empire and comparable in splendour to Paris, Vienna or Berlin. The big bold scheme already mentioned for Kingsway and Aldwych was one consequence; another was the chastely classical rebuilding of Waterloo Place by *Sir William Emerson* from 1902, the first major part of Nash's Regent Street route to be replaced. A third, more consciously Imperial piece of window-dressing was *Sir Aston Webb*'s refronting of Buckingham Palace in late C18 French style, with a new ceremonial setting and approach made up of the Victoria Memorial, the widened 103 Mall, and Admiralty Arch at its Trafalgar Square end (1905–13). The scale and vision of such schemes were worthy of Nash; in terms of consistent craftsmanship, the new works surpassed any period of English building before or since.

The predominant official idiom in these years was EDWAR- DIAN BAROQUE, a stone-built style that was patriotic without falling for the domesticity of much later C19 home-grown revivalism. The greater works of Wren and Vanbrugh were its most important source, and versions of the domed towers of Greenwich Hospital proliferated; giant columns replace the all-over Late Victorian effect of superimposed orders, with heavy rustication and blocked openings taking care of the lowest storeys. The style appeared simultaneously at the Old War Office of 1899–1906, designed by *William Young*, and the New Government Offices of 1899–1915, designed by *J.M. Brydon*. Both make a more extensive use of stone SCULPTURE than Scott had allowed at the Foreign Office, by such accomplished Imperial mood-setters as *Alfred Drury*, *Paul Montford* and *Sir Bertram Mackennal*. But for high Imperial swagger, sculpture in bronze cannot be matched; the greatest example in Westminster is *Adrian Jones*'s quadriga of 1907–12 on the Wellington Arch, 102 meant to symbolize Peace, with a close second in the optimistic figure groups by *Sir Thomas Brock* on the Victoria Memorial. 103

The range of ALTERNATIVE ARCHITECTURAL STYLES available to architects up to 1914 appears just s of Whitehall and w of Parliament Square. *James Miller*'s Institution of Civil Engineers in Great George Street (1910–13) is an orthodox giant-column design (a contrasting companion for the Chartered Surveyors' and Mechanical Engineers' headquarters, 1890s works still in domesticated brick, respectively by *Waterhouse* and *Basil Slade*). The square-domed Methodist Central Hall in 100 Storey's Gate, 1905–11 by *Lanchester & Rickards*, adopts a rarer, Viennese Baroque, with highly secular sculpture by *Henry Poole*: a sign of the Methodists' proud independence from Anglican Gothic traditions. But the former Middlesex Guildhall of 1912–13 in Parliament Square, by *J.G.S. Gibson & Partners*, goes instead for a kind of Art Nouveau Gothic Revival, with a very successful integration of relief sculpture (by *H.C. Fehr*): a worthy, if eccentric finish to the tradition of Gothic public building in

Westminster. A gentler, more domestic Neo-Wren style akin to the brick architecture of Hampton Court appears a little to the E at the railway offices of 1905 at No. 6 Cowley Street, by *Horace Field*; his earliest Westminster work in this vein is the publishers' offices at Nos. 6–7 Portugal Street, 1903.

There are also some outstanding examples of a short-lived style which has been called NEO-MANNERIST or Secessionist, characterized by fractured rectilinear forms and a rejection of the curves of Art Nouveau. *J.J. Joass*'s Royal Insurance in Piccadilly and Mappin & Webb in Oxford Street, both of 1906–8, show a fascination with the nervous, inverted classicism of Michelangelo's Florentine interiors. *Charles Holden*'s British Medical Association on the Strand, also completed in 1908, goes further in casting off classical precedent in favour of subtle horizontal set-backs, punctuated by figure sculptures (now mutilated) by the young *Jacob Epstein*. In the same years an alternative squared-off style, more conventional and assimilable, was imported from recent work in Paris; it made its entrée at *Frank Verity*'s mansion blocks at Nos. 25–26 Berkeley Square and Nos. 3–7 Cleveland Row. These trends share a movement away from curved profiles and mouldings towards something more rectilinear. The shift became general *c.* 1910, when building revived after a downturn in the later 1900s. It appears in the later phases of the Regent Street rebuilding and of the new Kingsway and Aldwych, dominated respectively by the uninspired modern-French architecture of *Sir Henry Tanner* and *Trehearne & Norman*. Even Whitehall was not exempt: *J.W. Murray*'s Office of Woods and Forests, 1906–9, and *H.N. Hawkes*'s Board of Agriculture, 1912–14, abandon turrets and sculpture for reined-in, grid-like elevations.

The fine Portland stone of these buildings concealed an increasing use of NEW MATERIALS. Concrete framing was used for official architecture after *c.* 1910, for instance, and concrete and steel were deployed together at Methodist Central Hall. But the greatest instances of STEEL FRAMING belong with commercial architecture. Steel rather than iron was increasingly used from the late C19; *Waterhouse*'s National Liberal Club of 1884–7 is largely steel-framed within, and *Matcham*'s theatres used it to make clear-span balconies without visual obstructions. The next step was to make the steel frame structurally independent of the walls, which the London Building Acts still required to be of a thickness compatible with old-fashioned load-bearing construction. Central to this development were *Mewès & Davis*, 98 the Anglo-French partnership responsible for the Ritz Hotel in Piccadilly (1903–6), the former Morning Post building in Aldwych (1906–7), and the Royal Automobile Club in Pall Mall (1908–11). All three have precisely engineered steel frames, which are however entirely concealed by elevations in the latest fashion of French C18 revival, in the manner of A.-J. Gabriel or Bélanger. Shortly after, the building regulations were relaxed enough to allow some external expression of the steel frame, commencing at Selfridge's new store in Oxford Street (begun 1908). Here the giant columns are divided by recessions with cast-iron panels marking the floor divisions, a treatment influen-

tial well into the interwar years. The result is the first major build-ing in London that is unequivocally American in character, and some of the designers were American or American-based too: *Albert D. Millar* of *Daniel Burnham*'s famous Chicago practice for the elevations, *Sven Bylander* for the frame (as also at the Ritz).

Selfridge's, the Ritz and the Royal Automobile Club all repre-sent the summation of their building types in the years up to 1914. But this is not to say that their rivals were unworthy. Of other DEPARTMENT STORES, *Frank Atkinson*'s Waring & Gillow in Oxford Street, 1901–6, made inventive play with Wren's Hampton Court elevations, while *Walter Cave*'s Burberry's in 99 Haymarket, 1911–13, tempers the Selfridge pattern of columns overlaid on steel framing with a subtler classical vocabulary. HOTELS were transformed as older establishments closed in favour of smart new ones such as the Ritz; in 1913 it was esti-mated that London had spent £10 million on them over the pre-vious decade. The Piccadilly Hotel of 1905–8 shows the elderly 107 *Norman Shaw* throwing his weight behind the Baroque revival; it is also a key work in the rebuilding of Nash's Regent Street. Less sumptuous accommodation was provided by Messrs Salmon & Gluckstein, at the Strand Palace Hotel (1907–9) and Regent Palace Hotel in Glasshouse Street (1912–15), both by *Sir Henry Tanner* and *W. J. Ancell*. Their white faience cladding recurs as the hallmark of another Salmon & Gluckstein venture, the RESTAU-RANTS of J. Lyons & Co. The first Lyons' tearoom opened in 1894, in older premises in Piccadilly. By 1904 *Ancell* was build-ing restaurants for them (No. 94 New Bond Street). The first Lyons' Corner House, also by *Ancell*, opened in Coventry Street in 1909. With their standardized architecture (as developed in the 1920s by *F. J. Wills* and the interior designer *Oliver Bernard*) and dependable menus, they were the first true catering chains in London: a counterpart to the uniform designs for railway com-panies, police stations and other public buildings.

HOUSES were less affected by new building methods. Gabled, bow-fronted houses remained common in Mayfair, as also in Marylebone; *R. G. Hammond* was responsible for many, often as speculations on his own account. The most potent new style was NEO-GEORGIAN, characterized by less eventful fronts of red brick, with upright sashes and a more direct imitation of C18 English precedents. It appeared fully formed in 1902–3 at *Detmar Blow*'s No. 28 South Street on the Grosvenor Estate, where Blow went on to wield much influence as Surveyor. A more original take on the style was provided by *Edwin Lutyens*. His earliest London work was the *Country Life* offices in Tavistock Street (1904–5), a ludic variation on Hampton Court themes. Lutyens's Neo-Georgian houses followed in the early 1910s, stripped down to a minimum of finely proportioned red brick, with ornament restricted to the doorcase: No. 7 St James's Square, the pair including No. 10 Great Peter Street, and No. 36 Smith Square. The last addresses show that the area s of Westminster Abbey was returning to fashion, both for new houses and for refurbished older ones: the first instances in Westminster of what the post-war age would call GENTRIFICATION. Other favoured areas were

Queen Anne's Gate and Old Queen Street and the more modest
enclave of Catherine Place and Buckingham Place.

Always in the background was the progress of ELECTRICITY,
which was first generated commercially at the Grosvenor Gallery
in New Bond Street in the mid 1880s. The big power stations
that succeeded it lay outside Westminster, although a giant sub-
station did appear in Duke Street (Mayfair) in 1903–5, under
a raised terrace with Baroque detailing designed by *Stanley
Peach* and *C.H. Reilly*. By then electric lighting was common in
houses and theatres, joined from 1910 by the first purpose-built
CINEMAS. The oldest of these is Nos. 19–23 Oxford Street, with
a ordinary-looking street front by *Gilbert & Constanduros*. *Horace
Gilbert* of the firm went on to design the inside of the former
Rialto Cinema in Coventry Street (1912–13), whose scale and
materials rival those of a theatre. Cinema and theatre design
would remain closely linked until the 1930s (*see* pp. 79–80
below). Electricity also allowed a revival of SHOPPING ARCADES,
built without top-glazing; *G. Thrale Jell*'s Piccadilly Arcade of
1909–10 is the first of this type.

TRANSPORT was also revolutionized by electricity. It made
possible a new generation of UNDERGROUND RAILWAYS, begin-
ning in 1890 with the City & South London. These ran much
deeper than their mid-Victorian predecessors, built mostly on the
'cut and cover' method. The Central London Railway (Central
Line), opened in 1900 between Marble Arch and the Bank of
England in the City, was the first into Westminster. *Harry Mea-
sures* designed its surface buildings as single-storey halls equipped
with subterranean lift equipment, allowing commercial develop-
ment on top. The arrangement survives at Tottenham Court
Road (Nos. 9–15 Oxford Street); at Oxford Circus station the
offices on top are the company's own. Next came the present
Bakerloo, Piccadilly and Northern lines, opened 1906–7. These
were conceived as one great project by the American C.T. Yerkes,
and shared a standard station design by *Leslie W. Green*. They too
had space for office-building on top, but used a more recogniz-
able image of uniform arcading clad in oxblood faience. Oxford
Circus, Covent Garden (Long Acre) and Leicester Square
(Charing Cross Road) are amongst those still in use. Electrifica-
tion of the District Railway in 1905 was followed by rebuilding
at several of its stations: Embankment and Temple by *H.W. Ford*,
Victoria to designs by *George Sherrin*, with a shopping arcade
(cf. his South Kensington and Liverpool Street, *London 3: North
West* and *London 1: The City*).

Another new conveyance was the ELECTRIC TRAM. The first
appeared in Westminster in 1903, four years after the LCC took
over most of the old horse-drawn network; a special electric tram
tunnel down to the Victoria Embankment was therefore included
within the new Kingsway. The replacement of horse buses by
motorized ones after 1907 completed the revolution in public
mobility. Journeys by public transport in 1911 had already
doubled from ten years before, and the way was clear for the great
suburban expansion of the interwar years. By the 1910s the
PRIVATE CAR was also generating its own building types: No. 4
Hay's Mews is a private 'motor house' (1904, by *J. Leonard*

Williams); a commercial garage of *c.* 1907, purely utilitarian, survives in Richmond Buildings, off Dean Street; No. 21 Pall Mall is an early car showroom, of 1911 by *E. Boehmer* for Renault, inevitably in an C18 French style.

WESTMINSTER BETWEEN THE WARS

All non-essential building was banned in 1916, during the First World War. A boom in commercial architecture followed as soon as peace returned; Kingsway was finished in 1922, Regent Street in 1927–8, both without much change from the squared-off manner of the early 1910s. This prosperity ended suddenly at the end of the 1920s, and 1930s buildings are less common. The slump also marks the main turning point in style, after which the many historical styles begin to dwindle away.

The most conspicuous new works of the 1920s in Westminster generally adopted a revivified CLASSICAL STYLE, characterized by a proud display of giant columns and often accompanied by the stripping of mouldings from windows and entablatures. The greatest influence here came from the École des Beaux-Arts in Paris and the ateliers of its associated architects, whether experienced directly or transmitted by its American adherents. American influence has already been mentioned in connection with Selfridge's, which took until 1928 to complete. Other US-designed works include *Helmle & Corbett*'s Bush House 108 (1920–35), the last part of Aldwych to be finished, followed later by *J. Russell Pope*'s extension to the Tate Gallery (1935–7, with *Romaine-Walker & Jenkins*). Both evoke the grandeur of the Roman baths, a favourite model of the Beaux-Arts school. American architects also returned to Italian Renaissance themes; *Thomas Hastings*'s Devonshire House, a mixed-use block of 1924–6 in Piccadilly, shows the style stretched to cover a very large building, planned with the rising set-backs characteristic of New York. Another transatlantic fashion, suited to very large office buildings with passenger lifts, was to set a giant order high up above evenly treated storeys. *Sir Frank Baines*'s twin blocks of 1927–30 on Millbank are the chief examples, enhanced by the rebuilding of Lambeth Bridge on the main axis between them (1929–32): the final instalment of formal classical planning in Westminster.

The architectural consultant for the new Lambeth Bridge was the combative *Sir Reginald Blomfield* (1856–1942), a senior member of the knighted élite who tended to receive the lion's share of official or Imperial projects in the early C20. His chief interwar work was the rebuilding of the Regent Street Quadrant 107 (1923–8), a chaster and more French derivation of Norman Shaw's Piccadilly Hotel with which the destruction of Nash's stucco had begun. *Sir Herbert Baker* (1862–1946), a younger man less in thrall to all things French, specialized in IMPERIAL GOVERNMENT HEADQUARTERS. The genre began properly with *A.M. & A.G.R. Mackenzie*'s Australia House in Aldwych, 101 1913–18, a conventionally besculpted giant-column design with

a forceful Beaux-Arts plan, finished with fine Antipodean
109 marbles and woods. Baker's India House in Aldwych (1928–30)
and South Africa House in Trafalgar Square (1930–3) both
attempt a deeper fusion of native motifs with a smooth European
classicism, aided by mural schemes from indigenous artists
and by sculpture from Baker's indispensable collaborator *Sir
Charles Wheeler*. (Canada made do with Smirke's Union Club in
Trafalgar Square, refaced and enlarged by *Septimus Warwick* in
1924–5.) Baker's Ninth Church of Christ Scientist in Marsham
Street (1926–30) is the only large religious building in Westmin-
ster from between the wars, in a classicized version of the Early
Christian style that interwar church architects found so irre-
sistible. A late work is Church House in Dean's Yard, 1936–40,
an inflated essay in Neo-Georgian. Another architect with a
non-English background was *Sir John J. Burnet* (1857–1938),
a Scot who trained in Paris. His first Westminster work, the
very original No. 99 Aldwych (1909–11), has affinities with the
Neo-Mannerist school. His New Gallery range in Regent Street,
1920–5, is the best example in Westminster of 'stripped classical',
preserving the dignified proportions of a traditional façade
without using a controlling order.

Most interesting of all are the many works, large and small, by
Sir Edwin Lutyens.* He carried on a dual practice, split between
official projects in India and an omnivorous list of domestic,
commercial and monumental work. Lutyens's commercial build-
ings include the toy-like former Midland Bank in Piccadilly,
Neo-Wren of 1922–4, No. 120 Pall Mall (for which *see* Cockspur
Street), a rare English appearance by his invented Delhi
Order (1929–31), and the quizzically classical Nos. 67–68 Pall
Mall (1930–1). He also supplied classical trimmings to raise
the tone of some large commercial schemes on the Grosvenor
Estate, where the massing and planning was worked out by
others. At Grosvenor House in Park Lane (1926–9), designed
with *L. Rome Guthrie* of *Wimperis, Simpson & Guthrie*, the new
architecture of big blocks establishes an interesting tension
with Lutyens's rooftop pavilions; at the former Gamage's at
Nos. 499–521 Oxford Street (1928–30), the effect is merely a
face-saving veneer.

A more celebrated work by *Lutyens*, the hauntingly reticent
Cenotaph in Whitehall (1919–20), heads the list of MEMORIALS
which proliferated after the First World War. A more pictorial
formula combined naturalistic bronze figures and simplified
Portland stone architecture. The finest example is *C.S. Jagger*'s
105 Royal Artillery Monument of 1921–5 at Hyde Park Corner,
designed with the architect *Lionel Pearson*, a work comparable to
Lutyens's own war memorials in its deployment of traditional
forms in an original and moving way. Architects engaged on this
kind of monument include *Sir R. Blomfield, H.C. Bradshaw* and
Sir J.J. Burnet, sculptors *Gilbert Ledward, Victor Rousseau, Adrian
Jones* and *Sir William Reid Dick. Sir George Frampton*'s Edith
Cavell monument in St Martin's Lane is unusually a solo effort,
entirely of stone.

* For his earlier houses in Westminster *see* p. 75 above.

The stylistic limits of London's PUBLIC SCULPTURE between the wars are represented on the traditional side by *Alfred Gilbert*'s Queen Alexandra Memorial alongside Marlborough House (1927–32), a final, heady flowering of the New Sculpture, on the Modernist side by *Epstein*'s Rima of 1925 in Hyde Park, a primitivist relief. This has lettering by *Eric Gill*, whose own Stations of the Cross at Westminster Cathedral (1913–18) was the first sculptural commission in the city in a post-naturalistic manner. The tradition of ARCHITECTURAL SCULPTURE was rejuvenated at *Charles Holden*'s No. 55 Broadway (1927–9), which has sturdy abstracted nudes in relief by Epstein, Gill, and other artists including the young *Henry Moore*. Recent Swedish sculpture pointed out a less radical path away from naturalism, followed by *Sir Charles Wheeler* – already mentioned for his collaborations with Sir Herbert Baker – and *William McMillan* in their cheerful merfolk for *Lutyens*'s fountains in Trafalgar Square (1939). Official taste in PAINTING remained more conservative, best seen in the bright academic sequence of 1926–7 in St Stephen's Hall, the last major instalment of patriotic decoration at the Palace of Westminster.

The ANGLICAN CHURCH limited itself to embellishing or adapting older buildings. The most interesting are St Michael Chester Square, to which *Sir Giles Gilbert Scott* added a tall spare Gothic chapel in 1920–1, and St Mary Bourne Street, extended in 1925–8 by *H.S. Goodhart-Rendel* in an intensely personal version of High Victorian Gothic. Inside, *Martin Travers*'s Anglo-Catholic fittings explore the potential of Continental Baroque. The Abbey too disengaged itself from Gothic traditions, and *Comper*'s war-memorial St George's Chapel there (1925–32) is Early Renaissance.

The Growth of Non-Traditional Styles in Architecture

Architecture ran parallel to sculpture in its abandonment of past convention in favour of something simpler. It would be misleading to bracket every path or stage of this trend under the heading of the Modern Movement, which made a late and limited impact on Westminster. More popular in every sense were the stylistic trends loosely labelled ART DECO, after the Exposition des Arts Décoratifs held in Paris in 1925. Cubic massing, stepped profiles, metallic surfaces and exotic ornament in flattened or summary patterns are its common currency.

These themes and variations can be followed by looking closely at theatre and cinema architecture. The surprise here is that THEATRES rather than cinemas took up the new approaches soonest; their interiors are also much more likely to have survived. Edwardian opulence bows out at *Robert Cromie* and *Emblin Walker & F.E. Jones*'s new auditorium within the Theatre Royal, Drury Lane (1921–2). The first new West End theatre after that, tiny by comparison, was *Ernest Schaufelberg*'s Fortune Theatre in Russell Street (1922–4): a blockish, concrete-framed building which abandoned boxes, curved balconies and traditional ornament all together. Later 'little theatres' include *E.A. Stone &*

Partners' Whitehall Theatre, 1929–30, with a more suavely treated cubic exterior and a restrained Deco interior by *Marc-Henri & Laverdet*. Of contemporary work, *Basil Ionides*'s Art Deco interior at the Savoy in the Strand (recreated in facsimile after a fire in 1990) is both more spectacular and more classicizing, while *Schaufelberg*'s Adelphi Theatre in the same street goes all out for a kind of jagged geometrical treatment with Expressionist undertones. A similar style appears at the auditorium of *E. Wamsley Lewis*'s Apollo Victoria Theatre of 1928–30 in Vauxhall Bridge Road. This belongs to the class of ciné-theatres, equipped for films or live performances; its exterior, with plain streamlined horizontals, is perhaps the earliest interwar building in Westminster in step with advanced Continental taste. Its auditorium can compare with the 'atmospheric' craze of *c.* 1930, seen in strength in suburban picture houses.

Earlier CINEMAS and ciné-theatres tended to hold on to historicist trappings: Adamesque and Renaissance at *Frank Verity* and *Sam Beverley*'s former Carlton Theatre in Haymarket, 1926–7; Quattrocento at the American architect *Thomas W. Lamb*'s façade for the Empire in Leicester Square, 1927–8. *E.A. Stone*'s Prince Edward Theatre in Old Compton Street, 1929–30, is classical externally but Art Deco within, another job by *Marc-Henri & Laverdet*. The ciné-theatre hybrid disappeared soon after, with the advent of talking pictures and national cinema chains by specialist architects. *Mather & Weedon*'s Odeon of 1937 in Leicester Square shows a mature super-cinema house style of simplified forms with a trademark tower. A more serious-minded approach, derived from the plain, horizontal brick architecture of Dutch designers such as W.M. Dudok (1884–1974), marked *Francis Lorne*'s design for the first Curzon Cinema in Curzon Street (1934, demolished); the same architect's Mount Royal, a big block of small flats on Oxford Street, 1933–4, survives to represent the style. The streamlined, all-white cinema interior appeared at the Paris by *Robert Cromie*, within the basement of Nos. 4–12 Regent Street (1939, destroyed during alterations, 2000).

Other building types showed a tendency towards increasing size and bulk. Giant OFFICES rose along the Victoria Embankment in the 1930s, including Brettenham House in Lancaster Place and Shell-Mex House, both of plain stone with repeated set-backs, and *Collcutt & Hamp*'s New Adelphi, of another common 1930s type with strong uprights. The last also has large areas of metal framing, as allowed by revised building regulations after 1932. The most radical use of set-backs was at *Holden*'s No. 55 Broadway, the London Underground headquarters (1927–9), already mentioned in connection with its sculptural decoration. Its bold cross-plan owed much to Holden's experience in hospital design, where the white-tiled light wells usual in big London offices were unacceptable. Another well-planned work by Holden is the Underground ticket hall at Piccadilly Circus (1925–8); but the new UNDERGROUND STATIONS for which Holden is best known all lie outside Westminster. EXHIBITION BUILDINGS, an important interwar type in outer London, are represented by *Easton & Robertson*'s audacious

elliptical-arched New Building for the Royal Horticultural 111
Society off Vincent Square, 1926–8. Designed with the engineer
Oscar Faber, it illustrates the maturity of REINFORCED CON-
CRETE CONSTRUCTION once the dominance of early, patent
systems had been shaken off. *Rendel, Palmer & Tritton*'s new
Waterloo Bridge (1937–44) used concrete box-girders in a can-
tilevered structure, disguised by *Sir Giles Gilbert Scott*'s arching
spandrels. Another replaced BRIDGE was Chelsea Bridge, by
the same engineers but using high-tensile steel (1934–7, with
G. Topham Forrest).

DEPARTMENT STORES, like theatres, also abandoned tradi-
tional styles after the 1920s. The last giant-column designs in-
clude the former Peter Robinson in Oxford Street (1921–c. 1926)
and Liberty's Regent Street wing (*E. T. & E. S. Hall*, designed
1914, built 1925–6). Liberty's earlier side wing along Great
Marlborough Street (1922–3) relapsed into defiantly nostalgic 106
timber-framed construction. By 1935–7, the date of *Louis Blanc*'s
D.H. Evans's in Oxford Street, a German model of vertical
stone uprights without period precedent was preferred. The
simple, logical treatment of unadorned horizontals first appears
at *Joseph Emberton*'s shop for Simpson's in Piccadilly of 1935–6,
which was also innovative for its welded construction (though
less novel all over than Peter Jones's curtain-walled store in
Chelsea, opened 1937).

Medium-sized SHOPS include *Emberton*'s for His Master's
Voice at Nos. 363–367 Oxford Street (1938–9), the first in
London with a big display of glass-brick windows, and Drage's
by *Gordon Jeeves* at Nos. 73–89 in the same street (1929–30, with
matching extension), with the waves and zigzags of Paris in 1925.
Jeeves was also the executant for the American architect *Raymond
Hood*'s Ideal House in Great Marlborough Street (1927–9, also
with a matching extension). This black granite-faced showroom
and office makes the most discerning use in Westminster of
the freedom with colours introduced by the Paris Exhibition.
Smaller, more select shops often advertised themselves with
architect-designed SHOPFRONTS: three nice 1930s examples are
Nos. 21 and 26 Bruton Street, respectively Neo-Georgian (*Basil
Ionides*) and Modernistic (*Gerald Lacoste*), and No. 15 North
Audley Street, Neo-Gothick by *Richardson & Gill*.

HOTELS show a similar story. *Sir Henry Tanner*'s Park Lane
Hotel in Piccadilly, 1925–7, keeps up the display of columns,
and has one of the last displays of contrasting 'period' interiors;
but its ballroom extension of 1930–1 goes headlong for Art
Deco inside. Other, older hotels with Deco updatings include
Claridge's in Brook Street and the Savoy in the Strand, the work
respectively of *Oswald Milne* and *Easton & Robertson*. The most
important new hotel was the Dorchester in Park Lane, of 1930–1,
where *Owen Williams*'s brilliantly engineered but aesthetically
ruthless concrete frame is softened by *W. Curtis Green*'s Deco
details. Curtis Green had a freer hand at Nos. 63–65 Piccadilly,
one of the best interwar BANKS outside the City of London,
which shows how much life was left in classical design even as
late as 1926–8. But the 1930s slump dried up the supply of new
or rebuilt branches soon after.

PUBS, like cinemas, fell under the sway of house styles. Neo-Tudor or Neo-Georgian were preferred, meant as wholesome antidotes to the bad associations of Victorian gin palaces. Many breweries retained their own architects to rebuild and upgrade older premises. Youngers' half-timbered pubs by *J.S. Quilter & Son* are one instantly recognizable type (Pillars of Hercules, Greek Street; Coach and Horses, Bruton Street), *Alfred W. Blomfield*'s rather grudging red brick Neo-Georgian for Watney Combe Reid is another (French House, Dean Street).

GARAGES by contrast had no need to look to the past. *J.J. Joass*'s Lex Garage in Brewer Street (1928–9, with *Robert Sharp*) has a Byzantine-cum-Deco front. At the Victoria Coach Station in Buckingham Palace Road (1931–2), *Wallis, Gilbert & Partners* were employed, a commercial firm adept at streamlined Deco image-making. The former Imperial Airways terminal in the same street, 1937–9 by *A. Lakeman* and *W. H. Williams*, is even more theatrical.

Domestic Architecture

Neo-Georgian weathered the First World War with little difficulty. Practised hands such as *Gervase Bailey* and *Wimperis, Simpson & Guthrie* made it the standard manner for PRIVATE FLATS, the dominant domestic type in Westminster after *c.* 1920. That is the date of the first Neo-Georgian block in Grosvenor Square, only seven years after its last new private house went up. Later examples often disengaged from classical proportions, retaining the domestic imagery of red brick and white-painted sash windows. The genre culminates gigantically in *Gordon Jeeves*'s Dolphin Square in Grosvenor Road (1935–7), 1,236 flats in a continuous block equipped with underground car parking and mechanical ventilation. By the mid 1930s Neo-Georgian was in competition with various stripped-down styles, represented by *Thomas Tait*'s Chelsea House in Lowndes Street, Belgravia (1934–5), or *Michael Rosenauer*'s Arlington House in Arlington Street (1934–6), planned with a set-back centre to give the best views of Green Park. More routine are the streamlined blocks by *T.P. Bennett & Son*, offices as well as flats, that went up in Marsham Street, where a private firm undertook large-scale clearances from *c.* 1934.

The chief visual distinction between such private blocks and the PUBLIC HOUSING of the day is the use of external galleries for access, usually on high-density blocks of around five storeys. Westminster Council's were designed by *Ashley & Newman* (Willow Place, off Francis Street; Page Street; Ebury Bridge Road) or *A.J. Thomas* (also Ebury Bridge Road). Similar buildings were put up for the Peabody Trust (Great Peter Street; also Vauxhall Bridge Road, 1910s); for the Westminster Housing Trust, a private charitable body (Tachbrook Estate, Grosvenor Road, with an unusually free plan); and by *Lutyens* for Grosvenor Estate tenants near Millbank (Page Street). The last, which replaced sub-standard housing damaged in the disastrous Thames flood of 1928, have the most immediate appeal, with chequerwork outer elevations and little classical shop pavilions between. Other charities provided

lodgings for single people; Murray House off Caxton Street (1928) was one of several designed for women, who by 1931 already made up 35 per cent of London's workforce.

The movement away from large households and lavish entertainment on the part of the rich was not immediate: balls were still given and salons maintained, though both declined drastically after the 1920s. The difference from the years before 1914 was that the supply of BIG HOUSES exceeded the number of householders willing or able to keep them up. Very few new ones were therefore built. The last mansions in Mayfair – the E part of which was becoming ever more commercialized – were Nos. 42–44 Hill Street, finished 1919, and No. 38 South Street, begun in the same year. A Rothschild house, No. 23 St James's Place (1929–30), was the last in St James's. The obverse of this over-supply was the demolition of many great houses for their valuable sites, often hurried on by bills for death duties. Devonshire House and Grosvenor House went in the 1920s; Chesterfield House, Norfolk House, Dorchester House in the 1930s, along with the front part of Lansdowne House, half of Berkeley Square, and most of the Adelphi terraces: a depressing list.* The rescue of Adam's No. 20 St James's Square with a matching office extension in 1936–7 pointed the way to more creative reuses.

SMALLER PRIVATE HOUSES continued to be built, especially outside Mayfair. Smith Square and its environs maintained their appeal. No. 37 Tufton Street, 1936, is the closest pre-war Westminster can show to a Modern Movement private house. The flatter, sparer look required by 1930s fashion was supplied less iconoclastically by adjusting the Neo-Georgian style towards the later C18 or the Regency. *Oliver Hill*, one of the most modish house architects, designed elegantly spare Neo-Georgian groups at the corner of Lord North Street and Great Peter Street (College House) and at No. 40 Smith Square. It also became smart to live in a MEWS, from which the reek of horses had been banished by the private car. Some Mayfair mews were broad enough to permit new houses of considerable size, and the seclusion encouraged a certain stylistic playfulness: Neo-Georgian for *Philip Tilden*'s The Lodge in Hay's Mews, Tudor or half-timbering for *Frederick Etchells*'s Nos. 6–10 Mount Row and *T.P. Bennett & Son*'s No. 22 Farm Street.

The most original private INTERIORS of the time have proved fragile; again and again, the mirrored bathrooms or silvered saloons photographed for *Country Life* or *Vogue* turn out to have disappeared. Many were the work of a new, socialite breed of professional interior decorator, a familiar presence in novels and satires of the day. Reasonably complete sequences remain by *Syrie Maugham* at No. 48 Upper Grosvenor Street and by *Lord Gerald Wellesley* at No. 4 Grosvenor Square; fragments remain of *Oliver Hill*'s work at College House. *Rex Whistler*'s fairytale murals survive better; No. 19 Hill Street and Nos. 11–12 North

* Listing of buildings judged worth preserving began in London in 1938, though statutory protection had to wait until the Town and Country Planning Acts of 1944 and 1947. The list for Westminster was not officially endorsed until 1958. Garden squares were protected earlier, by an Act of 1931.

Audley Street have examples, besides the sequence of 1926–7 at the Tate Gallery Restaurant. *Albert Speer*, a rather unexpected name, needs mentioning for his chillingly masculine remodelling of the former German Embassy at Nos. 7–9 Carlton House Terrace, 1937.

WESTMINSTER FROM *c.* 1940 TO *c.* 1975

The city approached the Second World War fully alert to the dangers of air attack. Britain's first municipal air-raid shelters were made at Caxton Hall in 1938, and *Adams, Holden & Pearson*'s new Westminster Hospital in Horseferry Road (1935–9) was the first hospital to be poison-gas proof. The (civilian) gas-holders in nearby Marsham Street had their lower stages adapted as part of the Whitehall SHELTER system, of which two important parts can still be seen: the block-faced Citadel of 1939 by the Admiralty Extension, and the basement shelters of the New Government Offices, now open to the public.

The Blitz began in Westminster on the night of 30th August 1940, when four incendiaries fell on Belgravia. By May 1945, 1,104 people had been killed in our area, and a great deal of physical damage inflicted. The debate on PLANNING for London started during the war, when the Modernists of the *MARS Group* proposed a giant functionalist masterplan, published in outline in 1942. The *Royal Academy Planning Committee* aimed by contrast to revive the Edwardian tradition of grand axes and formal intersections, on a scale expanded to suit motor traffic. Both were overtaken by *J.H. Forshaw* and *Sir Patrick Abercrombie*'s *County of London Plan* (1943), which led on to the official County Plan of 1951. This was region-wide planning of the largest scale, fulfilling more than half a century of discussion and debate. Much of the new agenda – separation of industrial and residential zones, a legally protected Green Belt, satellite towns, ring roads – had little direct impact on Westminster. This was due in part to its good housing stock, the worst slums having already been cleared and rebuilt, and in part to the even scatter of bomb damage, so unlike the concentrated wastelands of the City and East End. These areas, and the industrialized riverside s of the Thames, were the first priority in the late 1940s and 1950s. Strategic planning issues in Westminster came up later, often in connection with the road improvements which the growth of car use was thought to require.* One large-scale scheme was the *LCC*'s replanning of Hyde Park Corner, Park Lane and Marble Arch (1958–62), which removed some notorious bottlenecks at the expense of much parkland and several fine Piccadilly houses.

Other schemes tended to falter in a quagmire of broader questions of urban design: planning literature from the later 1950s to

* Westminster did however produce its own *City of Westminster Plan* in 1946 (by J. Rawlinson and W.T. Davidge), as officially requested; it generally endorsed the 1943 plan, e.g. in the idea of a dedicated Government precinct in Whitehall.

the early 1970s is dominated by forthcoming transformations that never actually arrived. Planning history therefore tends to march out of step with architectural history, and the most contentious schemes are best understood retrospectively from the mid 1970s, when many post-war trends halted or went into reverse (*see* pp. 92–3, below). The other great landmark is 1965, when the LCC gave way to the GLC, under REORGANIZATION which grouped the former boroughs of St Marylebone and Paddington in an expanded City of Westminster.

Post-War Restorations

Restoration of damaged buildings got under way almost immediately and did not finish until the 1960s. National and institutional pride and the like-for-like provisions of the rebuilding fund ensured that the results were generally conservative. Two of the three burnt-out Wren CHURCHES were restored in near-facsimile, like their City sisters: St James Piccadilly by *Sir Albert Richardson*, St Clement Danes by *Antony Lloyd*, as the RAF church (an especially good job). Archer's St John Smith Square was eventually resurrected as a concert hall (1965–9), with a reconstruction by *Marshall Sisson* of Archer's original design. At the Abbey, which had escaped serious harm, memorial chapels in traditional styles were created in the later 1940s, followed by an unswerving campaign by *Stephen Dykes Bower* to clean and redecorate the interior (1953–64). Damaged areas of the close were rebuilt, mostly by *Seely & Paget* and in replica or traditional styles.

SECULAR RESTORATIONS are headed by the new House of Commons by *Sir Giles Gilbert Scott*, opened in 1950; its well-crafted but underpowered Tudor Gothic forms have finally come into their own with the televising of proceedings, in which they look nicely restful. Parsimony and antiquarian prejudice ruled the *Ministry of Works'* repair of the bomb-damaged Old Treasury complex in Whitehall, which exposed the Tudor remains at the cost of much later fabric. The neighbouring Nos. 10 and 11 Downing Street were reconstructed concurrently by *Raymond Erith*, who could at least be creative on his own, Neo-Georgian account, as the new No. 12 shows. Elsewhere, some bombed Georgian houses were re-created to give the effect of complete runs (Smith Square, Queen Street Mayfair); gaps in the stucco of Pimlico and Belgravia were usually filled with plain brick flats (Eaton Place, Chester Square, St George's Square).

Official Architecture

Government buildings, exempted from strict post-war controls on new construction, at first showed no sign of wanting to break with tradition. Work pressed on in Whitehall until 1959 with *Vincent Harris's* Ministry of Defence, a stripped-classical giant on a tapering light-well plan, with only slight revisions from the pre-war design (which in turn derived from competition-winning proposals of 1913–15). Astylar classicism, slightly updated by

set-back planning, was chosen for *C.E. Mee*'s Ministry of Agriculture extension in New Scotland Yard, finished 1952, and for *Thomas Tait*'s Colonial Office in Broad Sanctuary, abandoned unfinished in the same year. By the 1960s, the tables were turned in favour of complete replanning, whatever the cost to Whitehall's older architecture; but *Sir Leslie Martin*'s masterplan of 1964–5 mercifully remained on paper. Martin's career path from public service (with the LCC) to private practice was typical of several senior architects of the early post-war generation, who tended to share the Modernist ideal of an architecture generated by a rational analysis of need in which stylistic expression could be left till last. *Eric Bedford*'s ruthlessly logical Department of the Environment complex in Marsham Street (1963–71, demolished 2002–3), a raised precinct of concrete-framed slabs, and the flexibly planned Tate Gallery extension of 1973–9 by *Llewelyn-Davies, Weeks, Forestier-Walker & Bor* were arrived at by this kind of design process. A more consciously aestheticized or expressive official architecture appears at *Sir Basil Spence*'s chunky Home Office block in Queen Anne's Gate (1972–6, with the *Fitzroy Robinson Partnership*), with its composition of fat-topped slabs and towers and at the National Gallery extension of 1970–5, where the top storey echoes a giant cornice.

Housing after 1945

As with official architecture, housing took a while to shake off pre-war norms. Sash windows were used on the first schemes to be completed, Russell House in Alderney Street, Pimlico, 1946–50, and *T.P. Bennett*'s little square towers in Ebury Street, 1950–2, built respectively for Westminster City Council and the Grosvenor Estate. PUBLIC HOUSING up to the 1970s was chiefly the City Council's, LCC efforts being concentrated elsewhere. As in most boroughs, private firms were employed until the reorganization of 1965, after which the Council depended more on its own Architect's Department. The results have endured exceptionally well. Westminster's proudest effort was *Powell & Moya*'s Churchill Gardens Estate on Grosvenor Road (1947–62), conceived in fulfilment of a pre-war clearance scheme. It was designed to conform with the high density of 200 persons per acre stipulated in the 1951 plan, leaving a few selected Victorian buildings on the margins. Its combination of airy parallel slabs and more loosely planned lower blocks in a generous landscaped setting was influential on public housing for the rest of the 1950s. *Riches & Blythin*'s Abbots Manor Estate at the opposite end of Pimlico began in 1952–5 with lower slabs, but its 1960s extension includes one of the TOWER BLOCKS that proliferated in British cities from the later 1950s. These are represented elsewhere in Westminster by four one-off designs, three of them in Soho: in Berwick Street, Broadwick Street, and Ingestre Court off the same street. All three rise from podiums housing commercial units, which in turn integrate the blocks into the streetscape. The fourth and earliest tower is fully detached: Hide Tower in Regency Street, by *Stillman & Eastwick-Field* (1959–61), a pioneering instance of pre-cast concrete facing.

Two rebuilt BARRACKS also made use of residential towers. *Tripe & Wakeham*'s Chelsea Barracks, 1960–2, is a spare, neutral design; *Basil Spence*'s Knightsbridge Barracks, 1967–70, is typical of the later 1960s in its more expressive concrete language, a derivation from late Corbusier which Spence had earlier explored to great effect at the University of Sussex. Its 320-ft (97.5-metre) high barrack tower is the only 1960s high-rise overlooking Hyde Park that earns its place. The low-rise, intricately planned HOUSING ESTATES that succeeded the tower-block type were pioneered at *Darbourne & Darke*'s Lillington Gardens Estate, Vauxhall Bridge Road (1964–72). At 210 persons per acre it was even denser than Churchill Gardens. Non-residential parts – pubs, a library – were more fully integrated within the ranges, and traffic rigorously excluded. Also influential was its use of red brick facing instead of concrete, a friendlier way of achieving the tough, dark finishes increasingly preferred by the mid 1960s.

116, p. 784

PRIVATE HOUSING was much less ambitious in scale. Two Neo-Georgian works that shine out from an increasingly thin stream are *Goodhart-Rendel*'s No. 1 Dean Trench Street (1951–5), a blithe evocation of the Arts-and-Crafts manner of half a century before, and *Claud Phillimore*'s No. 23 St Anselm's Place off Davies Street (1966–7), a pied-à-terre for the 4th Duke of Westminster. The Duke's Grosvenor Estate shrank considerably when Pimlico was sold to pay death duties in the early 1950s, but a programme of profitable flat conversions, combined with an influx of embassies and other non-commercial bodies, saved its terraces in Belgravia from the decay that overtook so much of Kensington or Paddington. A Modernist aesthetic appeared dramatically at *Denys Lasdun & Partners*' flats at No. 26 St James's Place (1959–60), an important work in the development of Lasdun's own style, which made full use of split-level planning. *Peter Moro* and *Walter Greaves*'s Audley Court in Hill Street (1960–2) represents a more conventional type of upmarket private flats; Grosvenor Hill Court in Bourdon Street, 1962–8 by *B. & N. Westwood, Piet & Partners*, shows the private sector catching on to the tower-and-podium formula. One-off architects' houses are not common; infill schemes include *Peter Foggo & David Thomas*'s concrete-framed No. 78 Cambridge Street in Pimlico and the more defensive-looking No. 35 Kinnerton Street in Belgravia, 1975, by *John Taylor* of *Chapman Taylor Partners*.

Commercial Architecture

The Blitz left Westminster with a large and immediate demand for office space, much of which was met by change-of-use permits for residential buildings old and new. The changeover undoubtedly saved numerous older houses, especially those which had suffered bomb damage; Bridgewater House, converted in 1948–9, heads the list.

NEW OFFICES were limited by building licences favouring the residential and industrial sectors, which remained in force until 1954. The only showpiece from before then is *Michael Rosenauer*'s Time & Life headquarters in New Bond Street (1951–3), paid for by American money, planned around a fine circulation

route, and adorned inside and out with works in many media by Festival of Britain artists. Other early newcomers were the so-called Lessor Scheme blocks, more traditional in style and for the most part notoriously bland in expression, which were privately built for immediate Government occupation. The most interesting is *Curtis Green, Son & Lloyd*'s Fortress House in Savile Row (1949–50), composed and classically detailed to suggest stern authority. The great surge in office permissions in 1954–5 included much else in a pre-war image, whether Neo-Georgian or merely plain and small-windowed. A few architects could still make such traditions interesting: *Sir Albert Richardson*'s classically proportioned AEI building in Grosvenor Place (with *Wimperis, Simpson & Fyffe*) is nicely unorthodox in detail; *Donald McMorran*'s Nos. 100–109 Pall Mall (with *D. Armstrong Smith*) has something of the eerie simplicity of Mussolini's best monuments. Architects more in step with wider trends included *Trehearne & Norman, Preston & Partners*, much employed in the City for office blocks in the lighter, more colourful style associated with the Festival; their No. 2 Regent Street, designed with *Leslie C. Norton*, combines traditional ashlar with an openwork top canopy. Until its recent refacing, the partnership's Nos. 32–50 Strand was a conspicuous example of the post-war chequerboard elevation as pioneered by Lubetkin and Tecton. But the greatest pattern-making façade in Westminster is *Eero Saarinen*'s eagle-topped US Embassy in Grosvenor Square (1957–60). This broad elevated block represents an American development of Modernist themes towards conscious formality which found more echoes behind the Iron Curtain than it did in Welfare State Britain. At *Ernö Goldfinger*'s Nos. 45–46 Albemarle Street the influence is pre-war France and the expressive, carefully proportioned concrete framing of Auguste Perret, though West End politesse required a facing of Portland stone.

The offices so far mentioned fall in with the old street plan; elsewhere there was scope for more radical replanning. Stag Place, a private development planned by *Howard, Fairbairn & Partners* on the Watney's brewery site (1959–64, reconstruction in progress 2003), was a fully fledged precinct of the kind encouraged by the 1951 plan, with traffic banished to the edges. The pedestrianized central space was bleak, however, and the architecture mediocre apart from the dominant shaped tower. Stag Place belongs with the rebuilding of VICTORIA STREET from the mid 1950s as a stronghold of offices, and most of these are thoroughly mediocre too. New Scotland Yard is worth singling out (1962–6 by *Max Gordon* of *Chapman Taylor Partners*), for its smooth detail and a rigorously expressed frame. Things improved after the lifting of a general Government ban on new office permissions imposed in 1964, and the 1970s blocks are more interesting in profile and more attractive in materials. Dark polished stone and stainless steel appear on *Elsom, Pack & Roberts*'s Ashdown House and BP House, 1971–5, which climb irregularly up to make a piazza in front of Westminster Cathedral. Polished granite was also used for *Seifert & Partners*' No. 50, 1971–7, a medium-height tower with flat triangular bays; it makes a group with No. 65 Buckingham Gate, also by *Elsom, Pack & Roberts*, which has dark bronze curtain

walling in the late manner of Mies van der Rohe. Mies and the post-war American serviced office are amongst the influences on London's best precinct development of the 1960s, *Alison & Peter Smithson*'s Economist group in St James's Street (1962–4). Its 114 irregular grouping of three towers of different heights also explores the architects' internationally important ideas about place-making and the inspiration of the established urban context. Elsewhere, the new breed of secretive and predatory private developer often held the best cards. The most egregious example in Westminster is *Guy Morgan & Partners*' Bowater House, Knightsbridge (1956–8), a dreary mixed-height assemblage concocted by Harold Samuel in connection with LCC road improvements. At Piccadilly Circus, the focus after 1959 of the first great post-war planning controversy, the conflicting demands of private owners, road engineers and local authorities ended only in deadlock.

The TALL OFFICE BUILDINGS mentioned above exploited the plot-ratio planning permitted by the 1951 plan, which was fixed at 5:1 for central London. After 1956 a policy prevailed of considering each tall building on its merits; new techniques of bored piles overcame the insecure foundations of London's clay soils. Lever House in New York was the forefather of the basic tower-and-podium office type, which was especially favoured by London clients seeking a technocratic image. Castrol House on Marylebone Road (*see London 3: North West*) and *Andrew Renton*'s Thorn House in St Martin's Lane (since refaced) follow the Lever House model; variants from the early 1960s include *Robert* p. *Matthew, Johnson-Marshall & Partners*' New Zealand House, 416 Haymarket, with a square instead of a slab-like tower, and *Ronald Ward & Partners*' elegantly shaped Millbank Tower, with its sweep- 115 ing, irregular forebuilding. The Millbank Tower group also illustrates the official preference after 1957 for a residential element in big commercial schemes, which in this case is placed apologetically at the back; the Economist precinct, where the smallest tower is residential, is the most creative response to the problem.

Other high-rises were built for HOTELS, a type subsidized by a Government hungry for tourists' hard currency and boosted after 1964 by the ban on new offices. *Michael Rosenauer*'s low-rise Westbury Hotel in New Bond Street, 1953–6, was the first to adopt American principles of room service over communal dining rooms; the 1960s hotels in Grosvenor Square follow the grandiose columned Neo-Georgian templates established by *Fernand Billerey* as far back as 1932. The first hotel tower is also the tallest: *Lewis Solomon, Kaye & Partners*' London Hilton of 1 1961–3 (405 ft, 123.4 metres), an insultingly mediocre design for such a prominent site. Later hotels on Park Lane were less tall; *Sir Frederick Gibberd & Partners*' Inter-Continental at the Hyde Park Corner end of Piccadilly, 1971–5, is low-rise. The Knightsbridge side of the park did better: *Brian O'Rorke*'s Berkeley Hotel of 1965–72 is a well-crafted traditional design that escapes period imitation, *Seifert & Partners*' Grand Metropolitan Hotel of 1968–73 a good bit of pop architecture with a circular tower modelled like a corncob stump.

Other building types showed a definite falling off from pre-war norms, whether in terms of number, expressiveness or quality.

Oxford Street's DEPARTMENT STORES adopted curtain walling as soon as building resumed, but the medium-sized blocks that resulted are of little interest. Much better is *Slater & Uren*'s John Lewis (1958–60), a strongly modelled block which makes bold use of colour. The department-store tradition ends in Oxford Street in the ugly concrete shape of Debenhams, of 1968–71 by *Adrian V. Montagu & Partners*. Contemporary BANKS are rather better; *Seifert & Partners*' former National Westminster branch at Nos. 354–358 and *Burnet, Tait & Partners*' Lloyds at Nos. 399–407 both play off a large-windowed banking space against office floors above. Of SHOPS elsewhere, the only one to stand out is *Peter Moro*'s Hille showroom at No. 41 Albemarle Street (1961–3), a very refined exercise in curtain walling.

Planning policy protected THEATRES from commercial redevelopment (which was not the same thing as encouraging new ones). The bomb-damaged Queen's Theatre in Shaftesbury Avenue was partially remodelled in 1957–9 (*Westwood, Sons & Partners*, with *Sir Hugh Casson*), a sombre end to the long story of updating West End theatres to suit architectural fashion. Away from theatreland, *John & Sylvia Reid* refaced the Westminster Theatre in Palace Street in 1965–6 (demolition proposed). The story of CINEMAS is more eventful, though the popular exoticism of the 1930s did not return. The only really interesting example is the rebuilt Curzon in Curzon Street (1963–6), by *H. G. Hammond* of *Burnet, Tait & Partners*, where the abstract artists *W. Mitchell & Associates* and *Victor Vasarely* created a genuinely memorable interior. The Curzon's combination of cinema with an office block on top, permitted by the invention of non-flammable film, was pioneered rather less crisply at the same architects' Wingate House in Shaftesbury Avenue, 1957–9.

A few PUBS were built in the 1950s, but Modernist forms could do little to keep the type distinctive; *T. P. Bennett & Son*'s glazed-fronted house for Whitbread at Nos. 17–18 Leicester Square, 1956–8, illustrates the problem. RESTAURANTS, so easily accommodated within an older or larger building, likewise dwindled as a separate type. *Guy Morgan*'s café for J. Lyons at Nos. 184–190 Oxford Street, 1959, is no more memorable than the food must have been; Stone's Chop House in Panton Street (1961–3), a very late work by *Sir A. Richardson* (*Richardson & Houfe*), illustrates the lasting associations between traditional fare and Neo-Georgian architecture. *Philip Jebb*'s Neo-Georgian-Gothick restaurant pavilion behind No. 44 Berkeley Square (1963–4), for the gambling den established by John Aspinall, suggests a deeper aversion to Modernism in certain aristocratic circles. On the opposite side architecturally and culturally is *Patrick Gwynne*'s The Dell Restaurant in Hyde Park (1964–5), a crystalline lotus-like structure with something of Frank Lloyd Wright's feeling for architecture in landscape.

Other Public Buildings

The prefabricated SCHOOLS for which post-war England became internationally famous do not appear in Westminster, and the first significant new building, *John Bancroft*'s Pimlico School of

1966–70, belongs to the post-1965 era of the GLC and the Inner
London Educational Authority. The cramped site led to its orga-
nization along an internal multi-level 'street', a more influential
model for subsequent school design than its inflexible classroom
layout, or the greenhouse-type glazing derived from James
Stirling's Cambridge History Faculty. FURTHER EDUCATION
produced similarly uncompromising work in the Strand block
for King's College (*Troup & Steele* with *E.D. Jefferiss Mathews*,
1966–71), with its restlessly Brutalist concrete frame. Contempo-
rary blocks for the London School of Economics are only slightly
less disappointing than its interwar ranges. MULTI-STOREY
CAR PARKS deserve mention as a building type embraced by the
planners, who foresaw rising demand as bomb sites steadily
disappeared (South Audley Street; Selfridge's, Oxford Street).

The most interesting new CHURCHES both replaced war-
damaged buildings. *H.O. Corfiato*'s Notre Dame de France
(1951–5) took over the circular plan of its predecessor, but was
too early for a free-standing central altar of the kind permitted
by Roman Catholic liturgical reform. *Bruce George*'s Guards'
Chapel at Wellington Barracks, 1961–3, is a strongly masculine
block on a traditional longitudinal plan. It makes creative use of
natural light, and surviving parts of its C19 predecessor, includ-
ing *Street*'s fine mosaic-filled apse, are convincingly incorporated.

p. 770

113

Public Art from 1945 to the Present

Public art in Westminster, like official architecture, carried over
a great deal from interwar tradition. New STATUES continued the
sequence of monarchs, by *Sir William Reid Dick* (George V, Old
Palace Yard) and *W. McMillan* (George VI, Carlton Gardens);
Reid Dick also sculpted Roosevelt for Grosvenor Square. Each
is honoured with a formal architectural setting. *Epstein*'s nimble
Smuts in Parliament Square, 1956, appears a work of levity by
comparison. Churchill's figure alongside him, by *Ivor Roberts-
Jones* (1973), is a weightier, more Rodinesque presence. *Oscar
Nemon*'s Viscount Portal on Victoria Embankment (1975) moves
further towards a simplified or abstracted handling. After that
naturalism returns in force, for statues of Second World War
commanders or to represent regiments and divisions collectively;
Nemon and *Roberts-Jones* were joined on this kind of work by
Franta Belsky and by younger sculptors including *James Butler*,
Faith Winter and *Angela Conner*. The Grosvenor Estate has also
fostered statues in traditional styles, and Belgrave Square now
has a large cluster. Writers have inspired less precedent-bound
treatments, including *Maggi Hambling*'s freakish Oscar Wilde
monument in Adelaide Street, 1998. The Royal Parks favoured
the Festival of Britain style of happy nude figures, notably *T.B.
Huxley Jones*'s fountain in Hyde Park (1963). The Canada Memo-
rial in Green Park, 1994 by *Pierre Granches*, represents a North
American genre of water-sculpture inspired by landscape;
Gustafson Porter's proposed Diana, Princess of Wales Memorial
Fountain in Hyde Park is of this school.

The best CHURCH ART of the 1950s–60s adopts Modernist
principles: a reduction to line at *Jean Cocteau*'s murals in Notre

Dame, bold figurative colour at *Evie Hone*'s stained glass at the Immaculate Conception, pure abstraction at *John Piper*'s windows at St Margaret. At Westminster Cathedral, where *Boris Anrep* continued working on mural mosaics into the early 1960s, the mood is closer to Byzantine revival. Major new mosaics are again being installed at the cathedral (2003), after a long pause while the marble facing was completed. Of church work elsewhere, the most interesting is *Roderick Gradidge*'s weird columbarium at St Mary Bourne Street, 1999.

ABSTRACT ART elsewhere came in with sculptural commissions for new private buildings, beginning with *Henry Moore*'s stone shapes at the Time & Life Building in New Bond Street. Works in bronze arrived in the late 1950s, from *Geoffrey Clarke* at Thorn House in St Martin's Lane and *Barbara Hepworth* at John Lewis in Oxford Street, neither of them as well integrated as Moore's. Mural reliefs and collages by the prolific *William Mitchell* appeared in the new subways at Marble Arch around the same time. Free-standing abstract sculpture begins as late as 1968 with *Moore*'s Locking Piece on Millbank, and has remained surprisingly scarce. *Patrick Heron* and *Julian Feary*'s Big Painting Sculpture at Stag Place (1998), the biggest example by far, does its best in unpromising surroundings. More common are works commissioned to adorn new structures. *Eduardo Paolozzi*'s reliefs of 1982 for the Pimlico Underground air vent off Vauxhall Bridge Road are an unusually successful example. Recent policy of Westminster City Council has been to require artworks on even quite modest new buildings. The results sometimes look like tokenism, but *Langlands & Bell*'s stone relief map at Nos. 110–116 Strand (2002), an echo of the *Forma Urbis* of Ancient Rome, shows a fresh approach. The best instance in Westminster of art conceived within architectural constraints is *William Pye*'s giant fountain called Chalice (1991), suspended from the atrium frame of *Arup Associates*' office blocks on Buckingham Palace Road.

WESTMINSTER AFTER 1975: ARCHITECTURE, PLANNING AND CONSERVATION

Few of the hopes and assumptions of the mid-C20 architectural scene were still in place by European Architectural Heritage Year, 1975. Popular revulsion from top-down planning and from a great deal of recent architecture, especially office blocks and public housing, had become almost universal; even the architectural press mostly read like a conservationist manifesto. Never had old buildings been so much preferred over new ones, which were perceived all too often as impositions by faceless moneymen or implacable and insensitive bureaucracies. Protests from campaigning journalists and architectural societies were joined by those of a new generation of residents' associations (whom the authorities found especially hard to ignore). In Westminster, the Covent Garden Community Association, Soho Society and Thorney Island Society, founded respectively in 1971, 1972 and

1985, were in the forefront. Changes in legislation also helped, especially the Civic Amenities Act of 1967. This allowed the designation of conservation areas, where new development had to be in keeping; after 1974, special permission was required to demolish characterful old buildings within them that were thought not quite good enough for listing. By the end of the C20 there were fifty-one such areas in the expanded City of Westminster, thirty-two of which lie wholly or partly within the area covered by this book; only Pimlico and South Westminster now contain large undesignated areas.

Two protracted West End battles stand out in the years up to the mid 1970s. PICCADILLY CIRCUS came in the sights of the developer Jack Cotton, who in 1959 presented a mediocre scheme that would have allowed road-widening in the bomb-damaged NE corner. Rejected after a public enquiry, it was succeeded by a string of more drastic plans incorporating elevated pedestrian decks and privately financed office towers, before the GLC finally gave up in 1974. Pedestrian decks of this kind ('vertical segregation') are a common feature of large-scale planning in 1960s London, mostly on housing estates, but also in some commercial parts of the City (*see London 1*). At one period it looked as if Regent Street might be rebuilt with them. Pedestrian decks also featured in the COVENT GARDEN plan, first drafted in 1968 jointly by Westminster and Camden councils and the GLC, which began the second and greater conservation battle. The plan, which anticipated the market's closure in 1974, embraced several other received ideas of post-war planning: new main roads, zoning of commercial and residential areas, and a new public open space. But almost nobody wanted these supposed benefits, and even a reduced version was rejected by public enquiry in 1973. The GLC then discovered a new talent, for what would soon become known as urban regeneration. The market buildings were restored: Fowler's for small shops, an outstanding project by the *GLC Historic Buildings Division* (1977–80), the Victorian halls for museums to London's transport and theatres. The surrounding streets came back to life, with small shops (some with replica Georgian shopfronts), residential conversions and all manner of other new uses. And the idea that an 'obsolete' district should be replaced wholesale was killed at a stroke.

Adapting Older Buildings

What might be called conservation architecture is an important theme from the 1970s, after which adaptations of older buildings become as important as wholly new ones. They include some distinguished RESTORATION SCHEMES, many of them meticulously researched and painstakingly executed by new generations of specialist architects. One of the largest projects concerned the Foreign Office (1984–97), by the *Property Services Agency* with *Cecil Denny Highton* (later merged in *HOK*), who reversed decades of neglect and unfeeling alteration and brought London's finest sequence of mid-Victorian interiors back to life. Another sleeping beauty, the Strand block of Somerset House, was adapted for the Courtauld Institute of Art by *Green Lloyd* in

1987–9, with public access to galleries in the restored C18 rooms. External cleaning in Whitehall, at the Palace of Westminster and elsewhere has allowed a new appreciation of the beauties of older architecture; at the Abbey, the clean effect is due to large-scale refacing in 1973–95. The rising standards of commercial restoration can be tracked from *Sir Basil Spence* and *Anthony Blee*'s hit-and-miss renovation of No. 100 Park Lane (1969–70), through *Stone, Toms & Partners* and *Donald W. Insall & Associates*' work at No. 22 Arlington Street (1977–81), where the restored interiors are let down by dreary new offices facing the street, to *Rolfe Judd*'s impeccable transformation of Spencer House in 1987–90. Also worth mention are some restorations of Georgian terrace houses which have illuminated their history and function (Nos. 23 and 25 Brook Street and No. 36 Craven Street, for new museums; also No. 68 Dean Street). Theatres have benefited too, expertly encouraged since 1976 by the Theatres Trust. The Royal Opera House, Palace Theatre and Theatre Royal, Haymarket, stand out from the list of recent restorations; in addition, the Whitehall Theatre, the Playhouse in Northumberland Avenue and the Lyceum have been recovered for theatrical use.

Other ADAPTATIONS have been bolder in their juxtaposition of old and new. *Sir Frederick Gibberd & Partners*' conversion of the main West Strand Improvements block for Coutts' bank, 1973–8, restored the Nash façades at the cost of cutting a big glazed centrepiece into one side. It also introduced Westminster to the atrium block, the most important innovation in office design since air conditioning became general in the 1960s. Wellington Barracks, another stuccoed Nash-era design, was reworked in 1979–85 by *George Trew Dunn Beckles Wilson Bowes*, with restored elevations screening dumpy new blocks behind. At Richmond House in Whitehall, mostly converted from older buildings in 1983–7, the chief new element is a historically evocative entrance section of brick and stone by *Whitfield Partners*. Warehouse conversions by *Bowerbank, Brett & Lacey* (Floral Street), *Hawkins/Brown* (Beak Street, Marshall Street) and *CZWG* (Wardour Street) demonstrated in the 1980s–90s that late C19 buildings could be brusquely treated without destroying character. A more ambitious scheme by *Ronald Green* of *Casson, Conder & Partners*, 1974–9, transformed the 1820s warehouses of Whitcomb Street by means of selective demolition, making an appealing public space on unpromising back land. The gentler renovation of Lancashire Court off Avery Row (1998–9) shows a similar concern with place-making within the existing urban grain. Finally CHURCH ARCHITECTURE, of which the two most important projects were due to rebuilding after ruinous fires. At St Matthew Great Peter Street, *Donald Buttress* created a smaller church by stitching together the C19 tower and reoriented chancel (1982–4). St Peter Eaton Square was resurrected by the *Braithwaite Partnership* (1988–91), as a cool, rational space within the old silhouette.

Less interesting is the common type of 'FAÇADE JOB', in which only the shell or front is kept as a mask for a new framed structure. Isolated Westminster examples can be traced back to Harrington House off Whitehall, converted to a telephone

exchange in 1927–30. When Schomberg House in Pall Mall was treated in 1956–8, the lost part of the front was re-created in excellent facsimile. The modern wave seems to have begun in Mayfair in 1971, when the fronts of No. 78 South Audley Street and Nos. 5–6 Stanhope Gate were incorporated in larger office developments. Another early example is Waring & Gillow in Oxford Street, 1977–8. Council policy since at least *c.* 1982 has usually required that the front range of rooms be kept in addition, preventing the night-time resemblance to back-lit theatre flats. Combined façades are also rarer than in the City; the group at Nos. 14–26 Great Smith Street, an atrium block built in 1988–92 behind four retained commercial elevations, seems to be the largest. Façadism was also adopted at the new Trocadero in Coventry Street and London Pavilion at Piccadilly Circus, Victorian fun palaces updated in the 1980s with shops, amusement arcades, a cinema and other attractions. Such buildings invariably try to disguise their increased bulk with big sloping mansards.

New Buildings Since c. 1975

PUBLIC HOUSING responded to the crisis of architectural confidence by reverting to a more domestic image, invariably of red or brown brick. The resulting NEO-VERNACULAR style left its mark on *Westminster City Council Architects'* Longmoore Gardens estate on Vauxhall Bridge Road, finished 1980, where pitched roofs replace the flattened profiles of the adjacent Lillington Gardens complex. A more interesting and less economical development of the ideas of Lillington Gardens is the citadel-like Odhams Walk in Long Acre (1974–81), by *Donald Ball* for the GLC. Its exploration of introverted, interlocking plan forms recurs on a smaller scale in later GLC schemes around Covent Garden, represented by Cambridge Court in West Street of 1984, two years before the GLC was abolished. Westminster's flat-building programme in our area ended with *Lee, Goldfinger & Miles's* small blocks on Vauxhall Bridge Road (1984–7). A proud tradition of new municipal housing expired miserably shortly afterwards, with 'targeted sales' calculated for political advantage. A new wave of housing associations did something to fill the gap, led by the Soho Housing Association; their first completed scheme was John Broadwood House in Bridle Lane (Brewer Street), 1976–80 by *Simon Crosse* of *Feilden & Mawson*, followed by projects from *Peter Mishcon & Associates, CGHP Architects* and others. Such schemes tend to be of modest size, and are carefully planned to make the most of unpromising sites. The most interesting is the wholly unique attachment to St Anne's church, of 1989–91 by the *Westwood Partnership* (*Jan Piet* and *Julian Luckett*); the outline of the demolished church was re-created, together with community facilities and a small worship space. Outside the West End, the Sanctuary Housing Association renovated or reinstated several terraces in Pimlico in 1983–92; C19 stucco outlines were respected, with simplified ornamental detail.

The story of PRIVATE HOUSING is dominated by the two great remaining landlords, the Grosvenor Estate and Crown Estate, and

by one firm, *Chapman Taylor Partners*. The Grosvenor Estate commissioned a strategic plan from Chapman Taylor, published in
1971, which rivalled the best local-authority plans in its scale and
scope. Some inventive infill and restoration followed, especially
in Kinnerton Street and the defile of little closes and courts off
it – a rare exception to the generally dull pattern of post-war
mews development. *Chapman Taylor Partners* were also engaged
by the Crown Estate at its holdings at the river end of Vauxhall
Bridge Road, general plans for which were settled in 1976. The
118 first and best of three residential phases there is Crown Reach,
completed in 1983 by *Nicholas Lacey* and *Maguire & Murray*; its
broken outlines suggest the influence of unplanned vernacular
forms, even as its aspect looks forward to the great wave of
1980s–90s private flats in the London docklands. The second
phase, around Bessborough Gardens, is Cubitt pastiche; the
third, to its w, smaller-scale, mews-like terraces with Post-modern
detailing (1987–9). The biggest concentration of more recent
private housing is on former industrial land along Grosvenor
Road. The *Halpern Partnership*'s Eagle Wharf there (2000–2)
shows the return to a plain white Modernist vocabulary for expensive inner-city flats; *Koski, Solomon & Ruthven*'s flats of 1995–8 in
Bourchier Street (Wardour Street), Soho, launched the trend in
Westminster.

OFFICES continue to be the most common building type. The
designation of conservation areas meant a widespread return to
brick in sensitive contexts. The results are often merely dull, but
interesting paraphrases of nearby buildings sometimes resulted:
Early Georgian for *Ansell & Bailey* at No. 31 St George Street,
Waterhouse for *Ronald Ward & Partners* at Colette House, Piccadilly. Where context mattered less, the most common fashion
from the later 1970s was for ribbed or vertical proportions, often
diversified with little oriels high up. *Ian Fraser & John Roberts
Partners*' block in Charing Cross Road, 1982, uses rough red
brick; stone was preferred for *Chapman Taylor Partners*' expressionistic Caxton House, Tothill Street, 1974–9, and *Casson,
Conder & Partners*' No. 11 Strand, 1981–5. *Whitfield Partners*'
No. 2 Bessborough Street, 1983, reverts to load-bearing brick,
used in a massively sculptural way. Further away from the main
119 stream, *Quinlan Terry* attempted a Neo-Georgian multi-storey
idiom at Dufour's Place (Broadwick Street), 1983–4.

By that time the first POSTMODERN architecture was going
up, and several of the best early examples are in Westminster.
Rock Townshend's Nos. 62–65 Chandos Place, *Chapman Taylor
Partners*' Agar Street extension of Charles Holden's block on
the Strand, and the *Rolfe Judd Group Practice*'s Nos. 27–28 Soho
Square, all completed 1984–5, combine a feeling for context
with a vocabulary of insouciantly simplified classical references.
An influential designer in this style was *Terry Farrell*; his parodic
temple for Clifton Nurseries appeared temporarily in Covent
Garden in 1981, the year after the Venice Biennale at which Postmodernism first appeared as a global phenomenon. Farrell's
4, chief work in this vein in Westminster is Embankment Place,
p. the giant atrium block built over the platforms of Charing
301 Cross Station in 1986–91: a supremely confident work which

earns its prominent place on the river front. Flashy, formulaic Postmodern blocks appeared too (Duke Street, St James's; Broadwick Street), but the less said about these the better.

Other new ATRIUM BLOCKS appeared from the early 1980s, beginning rather apologetically with *Chapman Taylor Partners'* West One Shopping Centre in Oxford Street (1977–81). West-minster lacks the sudden exuberant burst created in the City by the Big Bang of 1986, but the type is represented by such build-ings as the new Lansdowne House in Berkeley Square, 1987–8 (*Chapman Taylor* again, but now with wallclimber lifts and Post-modern styling). Air-rights atrium blocks over Victoria Station and its railway approaches opted instead for a modern image: mirror glass for *Elsom Pack Roberts* in 1981–4, a more rigorous steel exoskeleton for *Peter Foggo* (*Arup Associates*) in 1988–91. 122 *Sidell Gibson Partnership*'s atrium block at the corner of Northum-berland Avenue, 1986–90, took the coward's way out by rebuild-ing its C19 predecessor in external facsimile. By way of extreme contrast, the *Richard Rogers Partnership*'s glittering Channel 4 120 headquarters in Horseferry Road, 1991–4, represents the High-Tech school of dramatized minimal construction at its most poetic; the firm's less complex office in Broadwick Street, 1998–2000, shows no decline in quality. *James Stirling*, another international superstar, is commemorated in Stirling House in Carlton Gardens (1998–9), a Postmodern design posthumously revised by the successor practice of *Michael Wilford & Partners*. The most arresting refurbishment is *Avery Associates'* Neathouse Place in Vauxhall Bridge Road (1996–7, on a 1960s frame), where angled glass cladding creates a different aesthetic for front and back.

Speculative office commissions in the early C21 tend to go to a few well-established practices. *Elsom Pack Roberts* (now *EPR*) often work in steel and glass, dramatically composed at Eland House, 1994–5, and its forthcoming companions at Stag Place. *Michael Squire*'s firm favours a Modernist idiom of simple rectangular forms, often tempered by traditional materials (Nos. 279–295 Vauxhall Bridge Road). *Rolfe Judd* are usually more contextual, both in materials and in echoes of Postmodern cornices or mansards (Curzon Street, Nos. 2–4 Cork Street). *Tre-hearne & Norman*'s friskier Postmodernism is represented by Nos. 44–47 Pall Mall, 1996–7, and No. 9 South Street.

The tally of OFFICIAL ARCHITECTURE since 1975, discount-ing restorations and conversions, is small. The broken profiles of *Powell Moya & Partners'* Queen Elizabeth II Conference Centre (1981–6) suggest a concern to fit in that stops just short of palpable loss of nerve. The bolder Portcullis House (1998–2001), *Michael Hopkins & Partners'* Parliamentary offices on the no less sensitive riverside site N of the Palace of Westminster, is given form by its external expression of load-bearing construction and 'green' services. Acclaim was more general for the astonishing Jubilee Line station in its basement void, one of the best new sights of the Millennium year 2000. C20 ministry buildings in Whitehall are being updated by means of glazed-over courtyards, a process not yet complete in 2003; *HOK* have the Ministry of Defence, *Foster & Partners* the New Government Offices.

123 (Foster had more leeway remodelling the London School of Economics Library in Portugal Street in 1999–2001, where the spiral access ramp echoes his earlier renovation of the Berlin Reichstag.)

RETAIL ARCHITECTURE is now largely an affair of refurbishments and interior-making. Most of the big Regent Street and Oxford Street stores have been overhauled, often with new atria. Amongst smaller shops, the prevailing late C20 fashion for all-white Minimalist interiors is represented by *John Pawson*'s Jigsaw at Nos. 126–127 New Bond Street, 1996. The reaction in favour of bold colour blocks will be obvious to anyone exploring the shopping thoroughfares by the time this book appears. Some globalized labels now replicate their boutique designs internationally, so that clones of e.g. *Jean-Michel Wilmotte*'s Cartier at No. 40 Old Bond Street will be found in other countries. The 'flagship stores' of mass-market brands sometimes aim instead at spectacular sensory overload, as at *BDP Design*'s Niketown at Oxford Circus (1999). RESTAURANT INTERIORS have also attracted much architectural talent. The giant establishments of Sir Terence Conran, beginning with Quaglino's in Bury Street (1993, *CD Partnership*) were an influential late C20 model; *David Chipperfield*'s hard-edged Wagamama in Lexington Street, 1995–6, is the chief work in Westminster by this influential architect. The ranks of THEATRES have recently increased: *Paxton Locher Architects* have converted a Soho synagogue in Dean Street for the Soho Theatre, 1999–2000, and an extra performance space was included at *Jeremy Dixon/Edward Jones*'s remodelling of the Royal Opera House in 1997–9, with *Charles Broughton* of *BDP*, which is also of note as the greatest Postmodern-classical work in Westminster.

New work at the MUSEUMS AND GALLERIES of Westminster began with three privately funded projects. At the Tate, *James*
121 *Stirling, Michael Wilford & Associates*' Clore Gallery of 1982–6 houses some quite conventional galleries within a colourful Postmodern appendage whose motifs include half-hidden references to its older neighbours. *Venturi, Rauch & Scott Brown*'s Sainsbury Wing at the National Gallery, 1987–91, is a larger building in which the riddles are more insistent, and the forms derive from wider historical precedents as well as the urban context. *Norman Foster & Partners*' cool Sackler Galleries at Burlington House (1989–91) are a brilliant improvisation approached by lifts and staircases made in the gulf between the C17–C18 and C19 blocks, all in a minimal late C20 vocabulary. Underused back land was also the starting point for *Dixon/Jones*'s Ondaatje Wing at the National Portrait Gallery (1998–2000), which went further in reforming visitor circulation; *John Miller & Partners*' alterations to the Tate (1998–2001) have a similar end in view, though the effects are less far-reaching; both projects were partly funded by the National Lottery. The sequence looks likely to continue, with plans under discussion in 2003 for opening up the basement storey of the National Gallery (by *Dixon/Jones*), and for further work at Burlington House, where *Michael Hopkins & Partners* will annex the old University of London headquarters behind. A different tradition is represented by *John Simpson*'s Queen's Gallery

of 1999–2002 at Buckingham Palace: a work of modern rather than Postmodern classicism, though too gleefully done to seem entirely straight-faced.

In terms of broader PLANNING, the built-up area of 'old' West-minster, excepting Pimlico, most of Belgravia and the district around Vincent Square, is designated part of London's Central Activities Zone. This also extends into the City, the s part of the Borough of Camden, and part of the South Bank. Selected areas within it are identified with particular uses and activities, without being exclusively 'zoned' for them: state institutions along Whitehall and in the N and E parts of South Westminster and Victoria; arts, culture and entertainment in Soho and Covent Garden; academic institutions at the E end of the Strand. In addition, Oxford Street, Regent Street, the Bond Streets and part of Knightsbridge are protected as 'International Centres' for shopping. Special care is now given to the free movement of pedestrians within the city, and the various traffic-control measures mean that Westminster is a much more comfortable place to walk in than even ten years ago. Three large-scale inter-ventions deserve mention: the Strand pedestrian refuge, part of improvements completed in 1997; the closure of the N side of Trafalgar Square under *Norman Foster & Partners*' new plan, under way in 2003; and *Lifschutz Davidson*'s suspended walkways at Hungerford Bridge, completed the year before.

WESTMINSTER IN THE EARLY C21 therefore seems set for steady evolution rather than drastic change. The future for the wider Westminster City Council area looks more eventful; in particular, giant office developments with high-rises are under way at Paddington, NW of the area covered in this book. But ex-industrial land is almost used up in our area, and the 1950s–70s buildings are now the usual sacrificial victims. The process is nothing like as advanced as in the City of London, but the demo-lition in 2002 of a big 1970s complex on Buckingham Palace Road is certainly a sign of the times. Replacements tend to be more reticent than in the City, where new skyscrapers are once again rising to strengthen the intoxicating mixture of styles and shapes. Of course this is by no means always a bad thing; for instance, buildings such as *Trehearne & Norman*'s Georgian facsimiles at Nos. 6–7 Clifford Street (1997) are healing some of the wounds left over from the two get-rich-quick decades after *c.* 1954, and little that has come down from that time is especially memorable or appealing.* The very best are increasingly likely to be listed, a process begun in 1988 with the Time & Life Building, the Economist group and *Goodhart-Rendel*'s No. 1 Dean Trench Street. Numbers have swelled since 1995 under the scrupulously researched national programme of thematic listings, with Churchill Gardens and Lillington Gardens in the forefront.

Whether the early C21 will produce buildings that future gen-erations may want to protect will surely hinge on how far archi-tects and developers are willing to go beyond the safety-first rule in terms of design. If present trends continue, there should at

*The worst loss so far is *Denys Lasdun*'s store for Peter Robinson at Nos. 65–72 Strand, 1957–9 (demolished 1996).

least be more residents to argue the case: the population of the whole City of Westminster increased to 244,597 in 2000, up from 190,661 in 1981. Besides the recent tendency to convert anything and everything into flats, new housing ('social' as well as private) is officially required as an element in most larger commercial schemes; even *Terry Farrell & Partners'* proposed Home Office complex in Marsham Street will include some flats, and a new residential quarter planned by *Broadway Malyan* is under construction around the Grosvenor Canal basin (Grosvenor Road). Parts of Mayfair are also being quietly reclaimed for private households, as temporary office permissions expire. Residential areas are also protected from the steady creep of hotels that is sterilizing cities such as Prague and Venice.

It may seem far-fetched to bracket Westminster with smaller historic cities of this type; but on present form it is unlikely that a user of this book in twenty years' time will find many new landmarks, or miss many old ones – a claim that could not be made for the City of London or the East End. This stasis, which will seem timid to many, undoubtedly reflects the affection in which 'Visitor's London' is held in the wider world. How far things continue on this even course will depend in part on the new Greater London Authority, whose *London Plan* appeared in first draft as this book was on its way to press.

FURTHER READING

The literature is vast. The *Bibliography of Printed Works on London History to 1939*, ed. Heather Creaton, 1994, lists nearly 22,000 items on the capital. Other bibliographies include the same author's *London* (vol. 189 in the *World Bibliographical Series*), 1996, a shorter guide with longer citations including some postwar items. Many relate in some way to Westminster. Anything specific to an individual building or area, including seventeen volumes of the indispensable *Survey of London*, is listed under the area introductions; key works for Westminster Abbey, Palace of Westminster and Whitehall are covered at the end of those entries. The fullest collection of relevant material, published and unpublished, is at the Westminster Archives Centre; the Guildhall Library also has strong holdings. For all-purpose reference, the best book is the *Encyclopaedia of London*, edited by B. Weinreb and C. Hibbert, 1992 (2nd edn). S.E. Rasmussen, *London, the Unique City* (revised edn 1967) is still an invaluable introduction to topography and development up to the C20. Good general or single-volume histories include Roy Porter, *London, a Social History*, 1994, Stephen Inwood, *A History of London*, 1999, and Peter Ackroyd, *London, the Biography*, 2000.

After that come histories and surveys for particular periods. Several of those for the earlier period cover Westminster as well as the City. The standard account of Saxon and early medieval London is C.N.L. Brooke and G. Keir, *London 800–1216*, 1975, but this was written before the arrival of proper archaeological resources. For the discovery of *Lundenwic see* A. Vince, *Saxon*

London, 1990, and Martin Biddle in the introduction to M.D. Lobel (ed.), *The British Atlas of Historic Towns*, vol. 3, *The City of London*, 1989, are also useful. John Stow's *Survey of London*, 1603, is available in several editions, the best by C.L. Kingsford, 1908 (reprinted 1971). Secular properties are surveyed by John Schofield in *Medieval London Houses*, 1995, with a gazetteer of sites, and *The London Surveys of Ralph Treswell* (London Topographical Society), 1987, which makes available an important collection of house plans of *c.* 1600. The same author's *The Building of London*, 1999 (3rd edn) is a succinct account of sacred and secular buildings between the Conquest and Great Fire. Recent archaeological discoveries are published yearly in the *Transactions of the London and Middlesex Archaeological Society*, quarterly in the *London Archaeologist*. The *London Topographical Record*, published every five years or so, covers matters from a less archaeological perspective; the *Westminster History Review* (1997–) is more local in its focus.

Essential topographical tools for the post-medieval period are B. Adams, *London Illustrated, 1604–1851*, 1983, and the five volumes of historic map facsimiles produced by the *London Topographical Society*, 1982–92. Other maps are catalogued by J. Howgego, *Printed Maps of London* c. *1553–1850*, 1978 (2nd edn) and R. Hyde, *Printed Maps of Victorian London 1851–1910*, 1975. F. Barker and P. Jackson, *The History of London in Maps*, 1990, makes illuminating use of a wide range of sources. Of historical and architectural studies, N.G. Brett-James, *The Growth of Stuart London*, 1935, holds its place. Craig Spence, *London in the 1690s, a Social Atlas*, 2000, is a statistical survey that brings the city wonderfully to life. Contemporary topographical accounts include Edward Hatton, *A New View of London*, 1708, and Strype's revision of Stow's *Survey*, 1720.

For the late C17 to the early C19 the central modern work is Sir John Summerson's *Georgian London*, first published 1945; a new edition by Sir Howard Colvin will appear in 2003. For a critical re-examination of Summerson's story for the period *c.* 1660–1720 *see* Elizabeth McKellar, *The Birth of Modern London*, 1999. On the urban fabric there is *Good and Proper Materials, the Fabric of London since the Great Fire*, ed. Ann Saunders (London Topographical Society), 1989. C.C. Knowles and P.H. Pitt, *The History of Building Regulations in London 1189–1972*, 1972, deserves mention in this connection. Also useful are G. Rudé, *Hanoverian London*, 1971, and Celina Fox (ed.), *London, World City 1800–1840*, 1992, with essays by Andrew Saint and J.M. Crook. For the latter period, James Elmes's profusely illustrated *Metropolitan Improvements*, 1829, and *London and its Environs in the Nineteenth Century*, 1831, and John Tallis, *London Street Views*, 1838–47, are available in modern facsimile. J. Britton et al., *Illustrations of the Public Buildings of London* (3 vols.), 1825–38, contains good measured drawings. Rev. M.E.C. Walcott, *The Memorials of Westminster*, 1851, and E. Walford, *Old and New London*, 1872–8, are amongst the best Victorian accounts. Retrospective accounts include F. Sheppard, *London 1808–1870, the Infernal Wen*, 1971. K. Young and P. Garside, *Metropolitan London, Politics and Urban Change 1837–1981*, 1982,

gives the wider political story, and A. Service, *London 1900*, 1979, provides an engaging account of Westminster's golden age. The agenda for post-war planning was set by Forshaw and Abercrombie's *County of London Plan*, 1943, Abercrombie's *Greater London Plan*, 1944, and their summation in the *County Development Plan* of 1951. In 1960 *The London Plan, First Review* gave a survey of progress. Two outstanding recent books, Michael Hebbert, *London, More by Fortune than Design*, 1998, and Jerry White, *London in the Twentieth Century*, 2001, investigate the failure of so much of the planners' vision. Lionel Esher's national survey, *A Broken Wave, the Rebuilding of England 1940–1980*, 1980, is also valuable for Westminster. The chief periodical for post-war issues is the *London Journal*.

General surveys of buildings and monuments include the RCHME volumes of 1924 (on Westminster Abbey) and 1925, from the five-volume set covering all London, although these exclude anything later than 1714. Details of the many listed buildings are given in the DCMS's *Lists of Buildings of Historic and Architectural Interest*, issued as six spiral-bound paperbacks in 1987–8. On demolished buildings there is Hermione Hobhouse, *Lost London*, 1971.

Buildings of national importance in Westminster are covered by general architectural histories. Good starting points are Summerson's *Architecture in Britain 1530–1830* (Pelican History of Art), last revised 1991 (and now counterbalanced by Giles Worsley, *Classical Architecture in Britain, the Heroic Age*, 1995); *Victorian Architecture* by R. Dixon and S. Muthesius, 1978; and *Edwardian Architecture* by A. Service, 1977. Royal and Governmental buildings are surveyed in *The History of the King's Works*, ed. H.M. Colvin, 1963–82 (6 vols.). G. Stamp and C. Amery, *Victorian Buildings of London 1837–1887*, 1980, includes many Westminster examples. Elain Harwood, *England, A Guide to Post-War Listed Buildings*, 2000, includes sharp portraits of a dozen or more examples from Westminster.

As for domestic architecture, houses are well served by D. Cruickshank and P. Wyld, *London, the Art of Georgian Building*, 1975, A. Byrne, *London's Georgian Houses*, 1986, and D. Cruickshank and N. Burton, *Life in the Georgian City*, 1990; C. Saumarez Smith, *The Rise of Design*, 2000, is of interest for interiors. For artisan and early council housing *see* J.N. Tarn, *Five Per Cent Philanthropy*, 1973, and Susan Beattie, *A Revolution in London's Housing* (on the LCC), 1980. *Public Housing* by Alan Cox, 1993, is a guide to the relevant London archives. At the opposite end of the social scale are David Pearce, *London's Mansions*, 1986; C.S. Sykes, *Private Palaces*, 1985, and J. Cornforth, *London Interiors, from the archives of Country Life*, 2000. Two entertaining accounts of élite patronage are J.M. Crook, *The Rise of the Nouveau Riches*, and Peter Thorold, *The London Rich*, both 1999. The Queen Anne movement is covered by Mark Girouard, *Sweetness and Light*, 1977.

For other building types and themes important for Westminster it is enough to name some standard works. J. Booker, *Temples of Mammon, the Architecture of Banking*, 1990, and M. Girouard, *Victorian Pubs*, 1975, have transformed understanding of their

subjects. A. Eyles and K. Skone, *London's West End Cinemas*, 1991, J. Earl and M. Sell, *Guide to British Theatres, 1750–1950* (Theatres Trust), 2000, and M. MacKeith, *The History and Conservation of Shopping Arcades*, 1986, are excellent introductions, all with gazetteers. D. Taylor and D. Bush, *The Golden Age of British Hotels*, 1974, has much on the West End. M.H. Port, *Imperial London*, 1995, covers Victorian and Edwardian official architecture, supplemented by his article 'Government and the Metropolitan Image', in Dana Arnold (ed.), *The Metropolis and its Image*, 1999. Two survey volumes published through English Heritage, *English Hospitals 1660–1848* (ed. Harriet Richardson) and James Douet, *British Barracks 1600–1914*, both 1998, put in context two important Westminster building types. For art galleries *see* Giles Waterfield (ed.), *Palaces of Art*, 1991. The impact of railways is surveyed in T.C. Barker and M.R. Robbins, *A History of London Transport*, 1963–74 (2 vols.); H.P. White, *A Regional History of the Railways of Great Britain*, vol. 3, *Greater London*, 1971 (2nd edn), and A.A. Jackson, *London's Termini*, 1983 (2nd edn). For the Underground, *see* D. Lawrence, *Underground Architecture*, 1994, and J. Glover, *London's Underground*, 1996 edn; for horticultural matters, Mireille Galinou (ed.), *London's Pride, The Glorious History of London's Parks and Gardens*, 1990, Todd Longstaffe-Gowan, *The London Town Garden 1700–1840*, 2001, and the annual *London Gardener* (1995–).

Individual architects can be followed in H.M. Colvin, *Biographical Dictionary of English Architects 1600–1840*, 1995 (3rd edn), the *Directory of British Architects 1834–1900* (British Architectural Library), 1993 (expanded edn 2001, up to 1914), and A.S. Gray, *Edwardian Architecture, A Biographical Dictionary*, 1985. A. Service, *The Architects of London*, 1979, is a series of pithy essays on leading figures up to the late C20. Monographs of particular significance for Westminster include Eileen Harris, *The Genius of Robert Adam, His Interiors*, 2001; R.A. Fellows, *Sir Reginald Blomfield*, 1986; J. Harris, *Sir William Chambers*, 1970; J. Harris and M. Snodin, *Sir William Chambers, Architect to George III*, 1996; Hermione Hobhouse, *Thomas Cubitt, Master Builder*, 1971 (new edn 1995); T. Friedman, *James Gibbs*, 1984; J. Summerson, *Inigo Jones*, 1966 (latest edn, 2000); A.G.S. Butler, *Sir Edwin Lutyens* (3 vols.), 1950 (reissued 1984); B.M. Walker (ed.), *Frank Matcham, Theatre Architect*, 1980; J. Summerson, *The Life and Work of John Nash*, 1980; G. Tyack, *Sir James Pennethorne*, 1992; and A. Saint, *Richard Norman Shaw*, 1976.

For sculpture, the standard work is Margaret Whinney, *Sculpture in Britain 1530–1830* (Pelican History of Art), revised by John Physick, 1988. There is a biographical survey of London tomb sculptors by Adam White for *c*. 1560–*c*. 1660 in *Walpole Society* 61, 1999, and R. Gunnis, *Dictionary of British Sculptors 1660–1851*, revised 1968 (3rd edn forthcoming) covers the succeeding period. Benedict Read, *Victorian Sculpture*, 1982, and Susan Beattie, *The New Sculpture*, 1983, bring the story up to the early C20. The journal *Church Monuments* contains many relevant articles. Scholarly monographs on individual British sculptors are still uncommon; artists treated include Alfred Gilbert (by Richard Dorment, 1985), Roubiliac (by M. Baker and D.

Bindman, 1995) and Westmacott (by Marie Busco, 1994). For statues *see* J. Blackwood, *London's Immortals*, 1989. Painted interiors are covered by E. Croft-Murray, *Decorative Painting in England 1537–1837* (2 vols.), 1962–70, and Claire A.P. Willsdon, *Mural Painting in Britain 1840–1940*, 2000. Geoffrey Beard, *Craftsmen and Interior Decoration in England, 1660–1820*, 1981, covers the applied arts.

Individual buildings can often be investigated in contemporary periodicals, the *Illustrated London News*, *The Builder* and *Building News* (later *Architect and Building News*) for the C19, the *Architectural Review*, *Architects' Journal* and *RIBA Journal* for the C20. *Country Life* also covers London houses and other matters. A database of periodical articles is available at the British Architectural Library (RIBA), and on-line at *www.architecture.com*. Westminster City Council's planning database from 1983 onwards is also accessible, at *www.westminster.gov.uk/planningandlicensing/index/cfm*.

Finally a list of guides and surveys suitable for immediate reference. Official publications that can be recommended are Gillian Darley (ed.), *The Living Heritage of Westminster*, 1985 (2nd edn), and Tony Aldous, *A Prospect of Westminster*, 1989. E. and W. Young, *London's Churches*, 1986, and B.F.L. Clarke, *Parish Churches of London*, 1966, are self-explanatory. For especially lively accounts of selected buildings, *see* E. Harwood and A. Saint, *London*, 1991 (English Heritage), and Ian Nairn, *Nairn's London*, 1966 (revised 1988); Ann Saunders, *The Art and Architecture of London*, 1988, covers the whole capital rather more comprehensively. For newer buildings there is Samantha Hardingham, *London, A Guide to Recent Architecture* (latest edition 2001).

A much fuller bibliography of general works, including much on individual architects and artists, can be found at the Reference section of the *Pevsner Architectural Guides'* website, *www.lookingatbuildings.org.uk*.

WESTMINSTER

WESTMINSTER ABBEY, WHITEHALL AND SURROUNDINGS

INTRODUCTION

Three great institutions or clusters dominate this, the oldest district of Westminster: the Abbey and its precinct at the S end, the first to colonize or recolonize the riverside island of Thorney; the Palace of Westminster immediately E of the Abbey, built originally from the C11 in intimate connection; and to their N the sequence of government buildings great and small that line the modern street of Whitehall. Separate introductions are provided for each, so here there is no need to do more than outline the topography and explain a few essential points.

The most important street in the area by far is Whitehall itself, which runs N–S a little way inland of the Thames. It is

thus the counterpart and complement of the Strand, further E, which forms part of the same route connecting the City with Westminster. The buildings on the w side of Whitehall are bounded chiefly by St James's Park, and park and river between them give the precinct its strongly defined linear character. Whitehall is therefore treated as a single, subdivided section, with greater and lesser buildings taken together. A separate entry deals with the mid-Victorian foundation of Victoria Embankment, which severed the direct link with the river that had for centuries made Whitehall a favoured site for the houses of the great. At the s end of Whitehall and of the Embankment is the approach to Westminster Bridge, London's second Thames bridge, built first in the mid C18 in this convenient situation for Parliament and the Abbey. Of the area to its s, the riverside is occupied by the Palace of Westminster, the land further w chiefly by the Abbey and its enclosed and peaceful precinct. The N–S route that includes Old Palace Yard makes the division. N of the Abbey and its daughter church of St Margaret are Parliament Square, E, with the former Middlesex Guildhall on its E side, and Broad Sanctuary, w, with the Methodist Central Hall just off its w side and the Queen Elizabeth II Conference Centre on its N.

The Abbey is of course the 'West Minster' itself, and the medieval town grew up along its approach roads from the w and N. So it is worth a few lines on what became of this early settlement. The only area which now has any feeling of antiquity is the Abbey precinct, where many medieval buildings remain, several in the use of Westminster School. As for the rest, the key events

100
p.6,
p.8
2

WESTMINSTER ABBEY, WHITEHALL and surroundings

CHURCHES
- ① St Margaret Westminster
- ② Methodist Central Hall

PUBLIC BUILDINGS
- Ⓐ Jewel Tower
- Ⓑ Middlesex Crown Court
- Ⓒ Queen Elizabeth II Conference Centre

OFFICIAL BUILDINGS, WHITEHALL
- ⓘ Department for the Environment, Food and Rural Affairs
- ⓘⓘ Old War Office
- ⓘⓘⓘ Banqueting House
- ⓘⓥ Gwydyr House
- ⓥ Ministry of Defence
- ⓥⓘ Queen Mary's Steps
- ⓥⓘⓘ Richmond House

- ⓥⓘⓘⓘ Cenotaph
- ⓘⓧ Portcullis House
- ⓧ New Scotland Yard
- ⓧⓘ Police Station
- ⓧⓘⓘ Old Admiralty
- ⓧⓘⓘⓘ Admiralty House
- ⓧⓘⓥ Admiralty Extension
- ⓧⓥ The Citadel
- ⓧⓥⓘ Paymaster General's Office (former)
- ⓧⓥⓘⓘ Horse Guards
- ⓧⓥⓘⓘⓘ Dover House
- ⓧⓘⓧ Old Treasury, with Dorset House and Privy Council
- ⓧⓧ Nos. 10–12 Downing Street
- ⓧⓧⓘ Foreign and Commonwealth Office
- ⓧⓧⓘⓘ New Government Offices

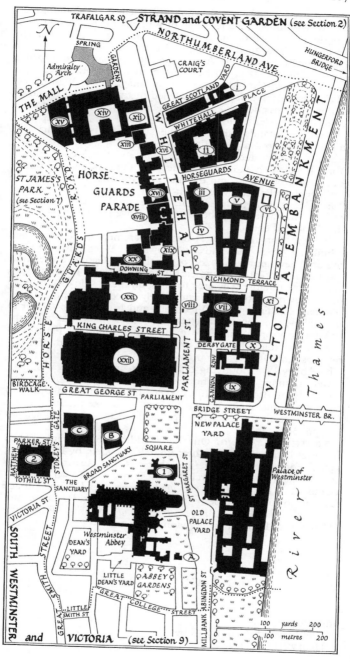

TRAFALGAR SQ. **STRAND and COVENT GARDEN** (see Section 2)

NORTHUMBERLAND AVE.

SPRING GARDENS

CRAIG'S COURT

HUNGERFORD BRIDGE

Admiralty Arch

THE MALL

GREAT SCOTLAND YARD

PLACE

WHITEHALL

WHITEHALL

HORSEGUARDS

HORSE GUARDS PARADE

ST JAMES'S PARK (see Section 7)

GUARD'S ROAD

AVENUE

VICTORIA EMBANKMENT

DOWNING ST.

KING CHARLES STREET

RICHMOND TERRACE

PARLIAMENT ST.

DERBY GATE

CANNON ROW

BIRDCAGE WALK

GREAT GEORGE ST.

PARLIAMENT

BRIDGE STREET

WESTMINSTER BR.

NEW PALACE YARD

Thames

PARKER ST.

STOKEY'S GATE

SQUARE

MATTHEW

TOTHILL ST.

BROAD SANCTUARY

THE SANCTUARY

ST MARGARET ST.

Palace of Westminster

VICTORIA ST.

SOUTH

Westminster Abbey

DEAN'S YARD

OLD PALACE YARD

GREAT SMITH STREET

LITTLE DEAN'S YARD

ABBEY GARDENS

River

LITTLE SMITH ST.

GREAT COLLEGE STREET

MILLBANK ABINGDON ST.

WESTMINSTER and VICTORIA (see Section 9)

100 yards 200

100 metres 200

are the two fires of 1512 and 1698 which led to the abandonment first of Westminster Palace, then of Whitehall Palace, as the chief London residence of the monarch. Some parts of Westminster Palace which escaped the flames in 1512 continued in use as law courts or by Parliament. A medieval nucleus survived a further conflagration in 1834, to be incorporated, suitably restored, in the great Neo-Gothic successor: the magnificent Westminster Hall, a late C11 structure remodelled in the C14–C15; the lower storey of St Stephen's Chapel, of the late C13; and the associated early C16 cloister. A fourth surviving part, the little C14 Jewel Tower, now stands isolated to the SW. After 1512 Henry VIII made do without a great London house of his own until 1530, when he confiscated the riverside palace of the Archbishops of York. It was then expanded to the W, at the expense of ordinary streets and buildings, and old and new together became known as Whitehall Palace. Most of it burnt in 1698, and only *Inigo Jones's* Banqueting House and some modest C16 fragments remain; the carve-up of the site that followed is described under the Whitehall entry.

For the rest, the story is one of incremental clearance and rebuilding from the mid C18 onwards. Westminster Bridge required new approach roads, of which Great George Street, now a stronghold of late C19 and early C20 professional headquarters, is the most notable. The area to its N, on the W side of Whitehall up to Downing Street, was completely razed to build giant government buildings by the Victorians and Edwardians. Closer to the Abbey, the dense old streets and alleys made way after the C18 for new open spaces or institutional buildings; Parliament Square was made by steady enlargements of this kind, and C18 terraces S of Old Palace Yard were levelled as late as the 1960s. The Abbey's own outlying buildings on this side – gates, bell-tower, almonry and almshouses – were early casualties. A few streets W of Broad Sanctuary keep their medieval names and alignments, but their character is now so unlike that of the rest of old Westminster that they are included in a separate section (*see* pp. 665–726).

FURTHER READING. One book addresses these interlinked histories better than any other: *Royal Westminster*, by P. Hunting, 1981. For the earlier period there is G. Rosser, *Medieval Westminster* (1989). All archaeological discoveries on Thorney Island since the C19, and especially those ahead of the Jubilee Line extension, are to be reported in C. Thomas, R. Cowie and J. Sidell, *The Royal Palace, Abbey and Town of Westminster* (Museum of London, in preparation).

WESTMINSTER ABBEY

INTRODUCTION

We are largely in the dark regarding the earliest history of Westminster Abbey. A Roman structure found in 1878 when Sir George Gilbert Scott's grave was dug in the nave may indicate that this part of Thorney Island was inhabited then. The Abbey's own, dubious traditions dated the foundation to 604 and claimed a miraculous consecration by St Peter, to whom it is dedicated. Firm evidence begins with the grant of land to an existing community by King Offa, probably the East Saxon king of the early C8 rather than his famous namesake of Mercia (757–96). Then in the later C10 St Dunstan re-endowed the monastery, as part of his great enterprise of reviving the Benedictine rule in England. With only twelve monks, Westminster was not one of the largest; in the mid C11 it was called a 'monasteriolum' (little

monastery). By that time the Abbey was attracting royal notice. The first connection recorded is the burial of Harold I in its precincts in 1040.

The Eleventh-Century Abbey

Edward the Confessor began to build a new church and monastic buildings on a much greater scale *c.* 1050, and lived to see the consecration in 1065. He also built a palace for himself, on the riverside land to the E. Edward had been raised in exile in the vigorous court of Normandy, and brought with him its new, Romanesque way of building. The abbey which he planned as his burial place thus came a generation ahead of the architecture that followed the Norman Conquest, when every other great English church was rebuilt. The difference showed in size as well as style, and at 322 ft (98 metres) the completed church was even longer than any remaining Norman church in Normandy. None of its fabric remains exposed above ground, but piecemeal excavations, references and the very helpful Bayeux Tapestry reveal much about its form. The E end was short (two bays long), with aisles and an apsed ending to the central vessel. The crossing had a tower; the transepts, two-storey apse-ended chapels; the nave, twelve bays with alternating piers, indicated by square and cruciform plinths found below the present nave floor in 1930. Twin

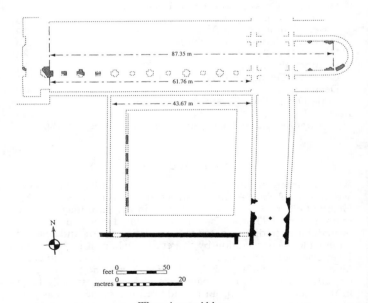

Westminster Abbey.
Plan of the eleventh-century church and cloister
(Eric Fernie, *The Architecture of Anglo-Norman England*, 2000)

towers were added at the w end, the lower stages of which survive within the present towers, as was demonstrated conclusively in the early 1990s. The many parallels with the near-contemporary abbey of Jumièges in Normandy point to a connection with its abbot, Robert, who was Bishop of London in 1044–51. But the stone was English, from Reigate, and the masons sound English too – *Leofsi Duddesunu*, *Godwin Gretsyd* and *Teinfrith* are named. The completion date is uncertain. The nave may have been finished as early as 1065, or left to William the Conqueror. The w towers must have been later; the remaining interior stonework suggests a date *c.* 1100.

A good deal more survives of the Norman monastery buildings, built probably from *c.* 1065, i.e. once the new church was functioning. Besides rediscovered c11–c12 fragments, parts remain above ground of the undercroft of the e cloister range, the Dormitory on its first floor, the Reredorter or latrines to its s, and the s range, which contained the Refectory. Work on the cloister itself can be dated to the period 1087–1100, from an inscribed capital recorded in the c19. Next in date comes the ruinous Infirmary Chapel off the e side of the Little Cloister, in a typical Late Norman style of *c.* 1160. Some remodelling of the e end may also have gone on in the c12, especially in or around 1161–3, when Edward the Confessor became St Edward and his body was translated to a new shrine.

Henry III's Abbey

The new Abbey of Henry III was anticipated by a building now lost to us: the Lady Chapel of 1220–45, added beyond the Norman e end in a way familiar from many great English churches. It stood, suitably modified to join on to the new work, until replaced by Henry VII's Chapel in the 1500s. Excavations in 1875 indicated a plan with a polygonal apse, like that of Amiens also started in 1220, but longer. The rebuilding of the rest was a separate, personal initiative, paid for by the King himself and meant from the start as his own burial place (the abbey at Fontevrault, the mausoleum of his Angevin predecessors, had been lost to the French by King John). Building proceeded very fast, under the close eye of Henry's Clerk of Works, Edward of Westminster, and not without financial extortion from any source to hand. In 1245 the old church was demolished, in 1246 the new foundation stone was laid, and by 1252 timber was already being prepared for the new stalls. The e end, transepts and crossing must have been finished by 1259, when the order came to make a start in earnest on the nave. Four more nave bays were built up to Henry's death in 1272, three years after the body of the canonized Confessor was translated to its resting place e of the high altar. The total royal expenditure on church and shrine was vast, at some £45,000.

Henry III was a pious but status-conscious and cosmopolitan monarch. His upbringing was French, and his sense of rivalry with the French royal house and royal cult was acute. His new Abbey is therefore the most French of all English Gothic churches in its proportions, and in many features of its plan. It

2

thus sidesteps the Englished Gothic tradition that had developed
so rapidly after 1175, when the new style of the north French
cathedrals was introduced at Canterbury. Not that the Abbey
lacks English features – they will be pointed out as we go on –
but in other ways it is quite unlike recent native work at, e.g.,
Lincoln. French are the plans of the E end, with polygonal apse,
ambulatory and radiating chapels all similar to Reims, and of the
double-aisled transepts, with the triple portal to the N. French
and also dependent on Reims are the wall-passages at the
foot of the aisle and chapel windows, as well as these windows
themselves with their bar tracery, and many smaller details of
piers, plinths and bases. French also are the proportions. The
maximum interior height of 102 ft (31 metres) is greater than at
any other medieval English church. Lincoln choir is 74 ft (22.5
metres) high, Salisbury 84 ft (25.5 metres); but the height at
Reims is 125 ft (38 metres), at Amiens 144 ft (43.9 metres). This
altitude is achieved without a corresponding increase in width;
at 38 ft 6 in. wide (11.8 metres), the central vessel at Westminster
is just 6 in. wider than that at Lincoln. Also French, and of course
a consequence of the great height, is the abutment with flying
buttresses in two upper tiers.

The sources for other distinctive features at Westminster
can also be found in recent French work. From Amiens and
the Sainte Chapelle in Paris come the windows in the form of
so-called spherical triangles (i.e. with convex-curved triangular
frames), the consistent diapering of such flat surfaces as span-
drels, the capitals with naturalistic foliage (also at Reims), the
spandrels with censing angels (transepts), the four-light windows
with geometrical tracery (Chapter House), and the tracery of
unencircled trefoils and quatrefoils (cloister). The S transept rose
comes from another Parisian work, the N transept of Notre
Dame. This dates from the late 1240s, the commencement of the
Sainte Chapelle from *c.* 1241–3, i.e. a few years either side of the
start of work at Westminster. But Reims, the French coronation
church, was begun as long before as 1210. Many of the less up-
to-date features that derive from it, especially the insistent two-
light bar-traceried windows, must therefore have been meant as
a deliberate evocation by the master of Westminster Abbey.*

The name of this man was *Master Henry*, also called *Henry of
Reynes*. It would be asking a great deal to presume that the ref-
erence is to Rayne or Raynes in Essex rather than Reims itself.
Whether he was born at Reims, was trained there, or simply made
a study of the church there has been the subject of much con-
jecture. The influence of Reims can certainly be detected in his
earlier work for the King at the Chapel of St Edward at Windsor,
begun in 1240. His hand has also been suspected at Binham
Abbey in Norfolk, completed by 1244, which has the earliest
four-light window with bar tracery known in England. But in
1243–5 Henry disappears from the records, reappearing in 1246,

*For a more detailed analysis of the architectural sources *see* P. Binski,
Westminster Abbey and the Plantagenets, 1995. By contrast, R. Branner's *St Louis
and the Court Style*, 1965, sees Westminster as much more deferential to the
Rayonnant manner of recent royal work in France.

when a house was bought for him in London. So it may be that he was travelling in France in those years, spying out the latest ideas and motifs for use in the great impending work. That these were blended with so many English techniques and conventions is the strongest argument that the master was a native son, a Henry and not an Henri. Thus the cell-filling of the vaults is managed in the English manner (*see* p. 126), and the chancel vault has a ridge rib, an English fashion deriving from Lincoln. Even more conspicuously, the whole ambulatory with its radiating chapels has a full gallery over, where Reims and Amiens have mere triforium passages. Measured against this fusion of traditions, the cathedrals at Strasbourg, Cologne and Léon, all begun in the 1240s–50s, appear much more imitative of France. And the English Gothic tradition stood fast in turn against many Westminster innovations: only two cases followed of radiating chapels built integrally with the E end (Hailes, Gloucs., and Battle, Sussex), and not one of such tall, flying-buttressed proportions. It was rather the more easily assimilated motifs, especially bar tracery, that were avidly taken up.

Work appears to have started at the E end and transepts, the NE corner of the Great Cloister, and the Chapter House crypt all at the same time, in 1246. By 1253, when Henry of Reynes was succeeded by *John of Gloucester*, the Chapter House was nearly complete and work was well advanced on the church. John carried on Henry's design with minor changes, but changed to a tierceron vault for the new nave. This must have been determined by 1259, when the order to demolish the E part of the old nave was made, because the E bay itself had to be put up at least partly when the crossing was erected. John of Gloucester is not recorded after 1260, and his replacement *Robert of Beverley* implemented further changes to the nave. Five bays of this – enough for the new monks' choir – were standing when Henry III died in 1272, three years after the body of St Edward the Confessor had been translated to its present resting place E of the high altar. The variations between and within these phases of work will be pointed out as we come to them, outside and (especially) inside.

The Completion of the Abbey

We can be briefer here for the rest. None of Henry III's successors proved as generous, and work went on more fitfully. Following a fire in 1298 much of the Great Cloister E walk was rebuilt, in the Dec style which plays such a small part in the whole of the Abbey. The S and W walks followed in 1344–65, in early Perp style. Much of this was due to Nicholas Litlyngton, first prior (1350–62) then abbot (1362–86), as also was the rebuilding of the Infirmary and of the abbot's house S of the W front (the present Deanery). p. 188

The C14–C16 rebuilding of the W END began *c.* 1338–43, when 2 the Norman W towers were recased and the outward-spreading porch inserted between them. Work continued on the W front for another two centuries (though even this was not enough to finish it), and here the Perpendicular style was given its due,

with consistent grating-like panelling over wall surfaces as well as windows. But the W part of the NAVE is self-effacing to an amazing degree, with only minor modifications of the system laid down in the C13. Such a respectful continuation had been done in England at least once before, in the nave of Beverley Minster in the C14. But it is all the same extremely rare, and a mixture of styles is more common (St Alban's, Ely). A start was made in 1375–6 under Litlyngton, on the generous initiative of Cardinal Langham, his predecessor as abbot. The first master mason here was the Abbey's own *John Palterton*, responsible for the aisle walls (though Norman work may remain in their lower courses). After 1387/8 the great royal master mason *Henry Yevele* (†1400) was in charge, under the patronage of Richard II. To Yevele are due the arcades, finished *c.* 1404. The galleries were built and the aisles vaulted in 1413–81 and the clerestory was then begun, all under the master mason *William Colchester*, but after 1422 progress slowed sharply. A new high roof was not begun until the decade after 1468, the flying buttresses not added until 1477–83, the high vault not finished until 1506. For most of this period the master mason was *Robert Stowell* (†1505). The last initiator of major work was Abbot Islip (1500–32). Besides completing the nave, he carried up the W towers, built his own chantry chapel near the high altar, and enlarged the abbot's house, including a 'pew' or gallery looking from it into the S nave aisle. The building of Henry VII's Chapel (1503–*c.*1510), the greatest single work of Tudor Gothic, also took place in his time. But in 1534 work on the NW tower ceased, and things rested until the C17.

18

The Abbey after the Sixteenth Century

We are so used to this cathedral-like building in the middle of London that we may forget to ask how it endured when so many great English abbeys were ruined. The answer is its unique connection with Crown and state. Henry III may have meant the Abbey as a personal project, but the consolidation of Westminster as the centre of government made further royal burials here all but inevitable. The consequence was that it became the Reims and the S. Denis of England put together, that is coronation church as well as royal mausoleum. After the 1220s the Abbey was exempt from episcopal jurisdiction, even from Canterbury, and secular uses flourished. The Chapel of the Pyx was used for the King's Treasury, the Chapter House and Refectory by the medieval House of Commons. Then at the REFORMATION it became one of Henry VIII's six new cathedrals, and in 1540 the first and last bishop was appointed for the newly elevated City of Westminster. Briefly restored to the Benedictines under Mary I, the Abbey was handed back to the Crown on the accession of Elizabeth I. Its charter as a collegiate foundation directly under the sovereign – a so-called Royal Peculiar – was granted in 1560. Also in the mid C16 Westminster School was refounded and several redundant monastic buildings allotted to it.

But the Abbey was meanwhile stripped of much property, and before long the Dean and Chapter identified a useful source of revenue in burial and monument fees. So the medieval and royal

tombs were augmented with a great accumulation of sculpted 24
marble and alabaster, which spilled into the transepts and nave
after the E end filled up. Royal burials ceased in the C18, but
in the same century national monuments, initially to naval and
military heroes, began to be voted by Parliament. In the C19
burials of nonentities ceased and the idea of the Abbey as a kind
of national shrine took hold. The process of retrospective com- 77
memoration, in Poets' Corner and elsewhere, continues down to
this day. The story is told in more detail below (pp. 139–43).

The special status of the Abbey also helps explain its external
appearance, for the uncompleted towers were patently unsatis- p.8
factory for the chief royal church. Any money that was available
in the C17 and C18 was swallowed up by restoration (*see* below).
Then in 1731 a Parliamentary grant was obtained, and the W
front finished and the present towers added in 1735–45, to 2
designs by *Nicholas Hawksmoor* (finished by *John James*, his
successor as Surveyor). The designs look back to proposals for
Gothic towers made in a memorandum of 1713 by the previous
Surveyor, *Sir Christopher Wren*. He wrote of the building in a
businesslike way, neither with enthusiasm nor with antipathy, but
did allow that any other style would make 'a Disagreeable
Mixture, which no person of good Taste could relish'. A model
and variant illustrations exist of Wren's proposal for a tall cross-
ing spire, and also drawings for towers, spires or elongated domes
by *Hawksmoor* and by *William Dickinson*, Wren's deputy at the
Abbey, both of whom were seriously interested in Gothic. But
work at the crossing got no further than the present low stump,
of 1725–6.

The RESTORATIONS of the older fabric are a more contentious
story. Builders and restorers have often been unlucky or unwise
in their choice of stone, and many areas have now been refaced
three times over. Sometimes piecemeal repair has been pursued,
sometimes wholesale replacement. But what hurts more than the
heedless destruction of original fabric, however pugnaciously
recorded, are the needless changes to the design. Much rebuild-
ing and refacing of the nave was done by Dean Williams
(1620–44), and more work after 1662, which already tended to
simplify or shave off older details. In 1697 money was diverted
to the Abbey from the Coal Tax that was paying for St Paul's,
and a year later *Wren* was appointed its Surveyor. His work
included drastic but well-meaning alterations to the N transept
in 1719–22, for which *Dickinson* provided detailed designs. Under
Hawksmoor much was done to the W front, quite apart from the
new towers. *Henry Keene*, Surveyor in 1752–76, did little exter-
nally. Under *James Wyatt*, 1776–1813, a new crossing roof
was provided and a start made on refacing Henry VII's Chapel,
finished under *B.D. Wyatt*, 1813–27. *Edward Blore*, 1827–49,
started the N side of the nave, continued by *Sir George Gilbert
Scott*, 1849–78. Scott also restored the Chapter House and S
transept and began work on N transept portals, finished in
1878–85 by his son *J. Oldrid Scott*. The parts above were done
over in 1884–92 by *J.L. Pearson*, Surveyor in 1878–98. They
were much criticized, and a great change of heart from restoring
to preserving came with *J.T. Micklethwaite*, 1898–1906, and

W.R. Lethaby, 1906–28. Lethaby was both a sensitive medi-evalist and an ardent and highly intelligent disciple of William Morris, who had protested vainly against Pearson's work. *Sir Walter Tapper*, 1928–35, and *Sir Charles Peers*, 1935–51, were similarly gentle. Peers, who cleaned the inside of Henry VII's Chapel, also had to put right bomb damage of 1940–1, which took the lantern roof over the crossing; other architects made good the destruction within the precincts. *S.E. Dykes Bower*, Surveyor in 1951–73, was less tentative. He cleaned and decorated the main interior in 1953–64, recoloured many C15–C17 monuments, and destroyed most of the ancient timber roofs, stopping only when antiquarian protests could no longer be ignored. The exterior was cleaned or refaced in 1973–95, under *Peter Foster* (to 1988) and *Donald Buttress* (to 1995), finishing with Henry VII's Chapel. The present Surveyor is *John Burton*.

The Building Stones

Over a dozen stones can be identified at Westminster, in major or supporting roles. The remaining late C11 walls use blocks of chalk, tufa and Reigate stone. Caen stone from Normandy was used for some C12 work. The great rebuilding begun in the C13 used Reigate stone with some Caen for carved work, and also much Purbeck marble (piers, shafts, paving, etc.). Reigate was a poor choice, some needing renovation as early as the 1370s. The biggest area left is low down on the SW tower. Late medieval times saw Kentish ragstone introduced for plinths (Henry VII's Chapel), parapets, etc., and some white magnesian limestone from South Yorkshire (S transept recasing). The upper parts of Henry VII's Chapel used such a limestone, from Huddleston, along with Caen stone and with Reigate for some interior work. Wren used Burford or Taynton stone from Oxfordshire, but the early C18 went over to Portland stone instead. The Wyatts used Bath stone for most of the upper parts of Henry VII's Chapel, but Scott and Pearson switched to the less durable Chilmark stone from Wiltshire (sound at Salisbury after seven centuries, decaying in the London air after one). Restoration since the early C20 has reverted to Portland stone, with lapses into Clipsham stone, e.g. in the S cloister.

EXTERIOR

Westminster Abbey is excellently placed, at the S end of Whitehall, with the widening of Parliament Square in front, and the trees and St Margaret's church to give scale, and with the Houses of Parliament on the l. to lead on into a larger picture. Only the skyline is disappointing. The W towers and the low, temporary-looking pyramid-roofed crossing tower lack strength to counterbalance the body of the building. When approached from the W along Victoria Street or Tothill Street, the W front would seem a little too slight to impress if it were not for its narrow height – the tallest of any English church front, at 225 ft

(68.6 metres). The internal length with Henry VII's Chapel is 511 ft (155.6 metres), 4 ft less than Canterbury, longer than Lincoln or York or Peterborough, shorter than Ely, St Alban's, Winchester or Old St Paul's.

This picture of the Abbey as it appears today has little relation to that which a traveller before the C16 would have seen. Then the surrounds were fields, with streets and houses only on the smallest scale to the N and W, and the Palace of Westminster, a complicated, not at all orderly group of structures, to the E and NE. The Abbey had its precinct and monastic ranges on the S and SW, its close, known as The Sanctuary, on the N. Palace, church and monastery would have formed one whole to the eye. 2

Before starting to study the exterior in detail one ought to remember that it is, as Lethaby put it, 'so completely recased that to describe it will be to describe a series of modern works'. We begin at the E end, leaving Henry VII's Chapel until last.

The East End

Here the French-derived plan is evident at once, the ambulatory with its radiating polygonal chapels, the buttresses and flying buttresses, and the windows with their bar tracery. The lower windows are of two lights below a six-foiled circle, fitted into the top arch. The same Reims-derived tracery pattern repeats high up in the tall clerestory windows, though the circle has a cinque-foil here. Many of the surrounds at both levels were simplified under *Wren*, with plain concave sides and strange acorn-like stops to the arch heads. Between these levels is an extra window tier. It belongs to the gallery, which in a unique way extends outwards from the ambulatory over the radiating chapels. This surprising feature may owe less to English tradition generally and more to the particular needs of the coronation ritual, of which more below. But the windows themselves are mostly of an explicitly French type, in the shape of a convex triangular frame with an eight-foiled circle. Windows like this were first introduced in the W front at Amiens, c. 1225–30, and more prominently at the Sainte Chapelle, begun c. 1241–3. At the latter they are used in conjunction with two-light windows in the narrower bays, a feature copied at Westminster, which was of course begun just three years later. So here is an impressive reminder of how up-to-date *Henry of Reynes* could be. The windows retain framing arches on nook-shafts, arches of a typically depressed two-centred shape which repeats in other parts of the Abbey. The high vaults are supported by flying buttresses in two tiers, the only examples in medieval England, with tall pinnacles rising over them. PARAPETS are castellated, that over the clerestory being a 1970s replacement for a pierced parapet mistakenly introduced by *Blore* in the C19. The design, if it is original, was probably the first castellation on an English church.

Where the E chapels end there is space for just one bay before the transepts. That on the N SIDE has a four-light Perp window to Abbot Islip's Chapel, c. 1523, inserted below.

p. 121

The Transepts

The transepts are three bays long, a decidedly English feature (cf. Salisbury, Lincoln). Their juxtaposition with the apse and its chapels is therefore quite unlike that at Reims, which has the shallow transepts usual in France.

The N TRANSEPT is fully exposed. Its sides continue the system of the E end, except that on the W side the window surrounds retain their nook-shafts. The N FRONT was the principal façade of Henry III's Abbey, serving as the state entrance from West-minster Palace and facing the land approach from London. It is tripartite, expressing the fact that the transepts have E and W aisles. The pattern is such French fronts as those of Amiens or the S transept of Chartres, and it shows off the two-tiered flying buttresses to great effect. But it is also the most altered part of the C13 design. A large porch added *c.* 1358–62 was removed in brutal simplifications from *c.* 1662 by the mason *Edward Woodroffe*, who cut away many decorative features. In 1719–22 the wounded front was re-embellished, along the lines of designs pre-pared before 1713 by *William Dickinson*, under *Wren*. This work was Neo-Gothic in spirit but unarchaeological in detail. The C19 transformation fell to *Sir G.G. Scott* and *J.L. Pearson* (1875–92). Scott and his son *J. Oldrid Scott* were responsible for the porches, Pearson for later work on the parts higher up. The result was much more of a new, Victorian design than it need have been. Here there is space only to re-evoke its C13 appearance, and to attribute responsibility for other parts. Latest restoration 1980–1.

There are three ample PORCHES, under gables set flush with the buttresses. The central porch has a double doorway in a deep arch of five orders, the side porches are vaulted and have door-ways of three orders (the E one blind, with trefoiled arcading). Door surrounds and shafts are of strongly contrasting Purbeck marble (largely *Scott*'s work), a material also of vital importance internally. The chief difference from the French arrangement at this level is the low priority given to sculpture. The largest statues, now lost, were fitted into trefoil-headed niches within and between the porches, and not used in overlapping ranks or in lieu of columns. English preferences also show in the decora-tion of the tympana. In France they had figure scenes in tiers or strips, full of drama. Here in the side porches and their lateral arches are four tiers of cinquefoiled circles, geometrical patterns on flat surfaces rather than human action. The pattern is cut by the arch rather than arranged to fit it, anticipating the net-like English tracery of half a century later. The central portal had an even stranger blind-traceried pattern of a flattened quatrefoil over rows of arches in two sizes. Small sculpted scenes must have fitted into it, with St Peter probably at the top. Dickinson replaced all this with his own design, erased in turn for *Scott*'s earnest programme of SCULPTURE (by *William Brindley*). Christ in Majesty on top, attended by angels. Two levels below, with Apostles above two symbolic processions: E, Arts, History and Philosophy led by the Church; w, Law, Legislation and Science

led by the royal builders of the Abbey. Virgin and Child on the central pier. Also Scott's the little Lincoln-type canopies set within the niches, and (more authentic) the three straight-sided gables. The boss of the w porch is original, with stiff-leaf decoration and half-figures. Other sculpted details, e.g. the shields and the angel busts in roundels, are copied from the interior.

Above and behind the gables are recessed triplets of lancet windows, under depressed pointed arches: one to each aisle (with the outer lights blind), two in the middle. Above these, i.e. at gallery level, a tier of twin openings with bar tracery all of even height and design, three to each aisle, five in the middle. These features are C13. Above that stage the flying buttresses of the aisles appear, of which the taller, upper pair enclose staircases. The rose window in the middle is entirely from *Pearson*'s work of 1884–92. It is not much like the window shown in Hollar's engraving of 1654, and even less like Dickinson's more reliable survey drawing, first published in 1888. Scott, a better archaeologist than Pearson, might have changed his mind at that point; Pearson chose to carry on regardless. So much for Pearson. The C13 design was of great beauty and daring. It had spandrels glazed above as well as below, an innovation made in France and known first from St Germain-en-Laye, begun *c.* 1238. The whole design was considerably closer to the N transept rose of Notre Dame, begun *c.* 1246, which makes it the most advanced feature of the Abbey from the French point of view. Both windows have or had sixteen lancet lights radiating from the hub, encircled by thirty-two lancet lights in twin groups. That the Westminster design was original is indicated by the close version of it on certain tiles in the Chapter House, datable to *c.* 1255. Also *Pearson*'s are the gable (replacing partly pierced tracery of six-foiled circles within a big arch), double figure-niches on the buttresses, blind tracery on the flying buttresses and pinnacles.

The S TRANSEPT is much harder to see, as the S front is partly hidden by the monastic ranges to its S. (From the exterior point of view the journey is most worth making to see the Chapter House (*see* below).) The E side is like that on the N. The largely unrestored doorway in the far S bay was the King's private entrance from the Palace of Westminster. It has a depressed pointed head, a variation of the form already seen framing the gallery windows. The S FRONT is best viewed from Abingdon Street, or obliquely from the cloister S walk. The top gable with its crowded tracery is a design from *Scott*'s restoration of *c.* 1870, as are the great spiky pinnacles of the turrets. But the rose must be very close to the C13 design, though several times renewed (1451–62, 1814, 1901–2). Below it the two-light windows of the gallery. A row of lancets below that, those of the w bay obscured by a big plain round arch added in mid-C15 recasing. Buttresses much plainer than on the present N front, and perhaps closer to the C13 pattern there; top pair of flying buttresses of normal type, i.e. not stair-enclosing. Last restored 1981–2, when a STATUE of Christ in Majesty by *Arthur Ayres* was put in the gable.

Chapter House

The CHAPTER HOUSE is an octagon adjoining the S transept. It must also have been begun in 1246 and have been largely complete by 1250. Here the design of two-light windows with bar tracery of one circle is enlarged to much broader, more generous windows of four cusped lights, with unenriched quatrefoils above each pair and a six-foiled circle at the top. This enrichment of the Reims scheme was invented at Amiens after 1220 and used at the Sainte Chapelle, begun *c*. 1241–3. So here again the master of Westminster was keenly up-to-date. Low, plain openings to the crypt. The tall flying buttresses were added as necessary strengthening in the C14, probably in 1377–8. The furthest N dates from *Scott*'s restoration in 1866–73, as does the tracery. His upper parts are more speculative: ornamented parapet, long French-type gargoyles and steep tent-like roof. The original roof was very likely flat-topped, like that at Salisbury.

The Nave

The NAVE continues the system of the E parts. The first four bays represent the last phase of Henry III's work, up to 1272, under *John of Gloucester*. The most noticeable change is at gallery level, where the convex-sided triangles give way to windows with straight not convex bases, filled with three small cinquefoiled circles instead of one large eight-foiled one. Other differences include the nook-shafts and sills carried down towards the aisle window heads; the aisle window tracery with cinquefoils instead of six-foils; and the buttresses with stepped offsets and statuary niches (the saddleback tops are due to *Blore*'s restoration in the 1840s). After 1272, building was not resumed until 1375–6, and not completed until 1506.* But the changes were so small – hardly greater, in fact, than those made between the 1240s–50s and 1260s – that the whole looks to this day pretty much as if built in one campaign. The main differences are visible externally in the fifth bay from the E. In aisle and clerestory the lancet lights become cusped instead of plain, and unencircled quatrefoils replace foiled circles; at gallery level, the window arches become more gently curved. There are also taller pinnacles, and further changes to the buttresses. Perhaps the strangest thing is that these small innovations do not really depart from C13 precedent. The closest to anything Perp is the little frieze above the gallery, from the sixth bay onwards (built 1416–18). The small DOOR in the fifth bay led originally to a long-demolished L-shaped wing that joined up with the N transept, built soon after 1250–1 and sometimes identified as a sacristy. STATUES in the buttress niches: the w four added, surprisingly, in Dean Williams's repairs of the 1620s, the rest by *Blore*.

2 From the S or cloister side similar observations can be made. The main difference is that the flying buttresses have three tiers to allow a free run for the N cloister walk, i.e. they carry the thrust

* For the separate phases *see* below, pp. 133–5.

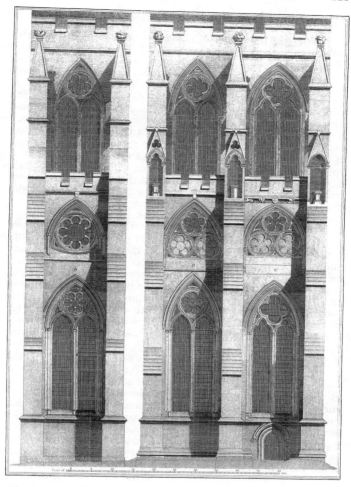

Westminster Abbey. Elevations on the north side, showing (left)
east end bay, (right) nave, fourth and fifth bays from the east
(J.P. Neale, *The History and Antiquities of the Abbey Church of
St Peter, Westminster*, 1818–23)

of the aisle vault as well as that pressing down from the two tiers
of the clerestory above. The sturdy detached buttresses thus
form part of the s wall of the cloister walk. The terse resilience
of these tiers upon tiers of flyers, which come out together some
50 ft (15.2 metres) from the clerestory wall plane, must have been
appreciated as a positive value when they were built.

The West Front

2 The W FRONT was the slowest-growing part of Westminster Abbey, with original work of the C12, C14–C16, and early C18 (by *Hawksmoor*). A close look soon dispels any drive-by impressions of a coherent Perp design. The Norman cores within the lower w towers suggest their presence in the broad, flat-faced buttresses and in the odd blocking of one light of the lower w windows (the s one partly hidden by the Jerusalem Chamber, *see* p. 198). These windows must date from the refacing of *c.* 1338–43, but they respect C13 conventions, with unenclosed non-matching quatrefoils at the top. So here the pattern was set for the aisle windows of the later C14. Similar windows to N and S. Also of *c.* 1338–43 but already in the newest Perp style is the PORCH, slightly projecting between slimmer buttresses that align with the aisle arcades. It is of the splayed or 'welcoming' type, pioneered at the choir screen at St Paul's not long before. Pretty, thin-ribbed vault, canted sides decorated by blank arcading with mullions running bolt upright into the tracery. To its l. and r. are two niches each, and another row of niches runs above. The designer is unknown, but *William Ramsey III*, then engaged on no less innovative work at St Stephen's Chapel at the Palace of Westminster and at St Paul's Cathedral cloister, is the likeliest candidate. The C12 cores give out a little way above the lower windows, and the gallery stage on the towers belongs to the early C15. Its windows have three circles like those of the nave, but with quatrefoils rather than cinquefoils (now blocked) and a quatrefoil frieze below. The spandrels had mouchette decoration like those of the porch, but the s side was changed by *Hawksmoor* to Perp-style panelling. Also Perp are the three-light windows of the next stage, initiated by Abbot Islip in 1513. Only the N one was complete when work stopped in 1534. Its s counterpart is due to *Hawksmoor*'s resumption after 1732, hence the detailed differences in the spandrels. Other Hawksmoor fingerprints include the rebuilt W WINDOW, keeping the seven-light and four-tier arrangement of *c.* 1491–5 but simplifying the tracery, e.g. with a quatrefoil band below the arch; the heraldic frieze below, carved by *John Boson* or *Henry Cheere*; the renewed niche canopies just below that; the bulky recasing of the lower buttresses, decorated with shallow trefoil-headed panelling; and (above the w window) the big, entirely un-Gothic cornice with its inscription to George II and the date 1735.

Hawksmoor's TOWERS draw back a little from the lower stages. Begun in 1735, they were finished in 1745, after his death. They too have strong cornices, as well as such solecisms as curly Baroque open pediments over the clock in the N tower and the corresponding openings on the s. But their general outline is nonetheless plausibly medieval. Hawksmoor may have had in mind the late C14 w towers of Beverley Minster, where he supervised repairs in 1717–31. The buttresses carry on with squared-up panelling of Gothic elements, and the large three-light bell openings are also in a squared-up Perp manner. Their ogee hoods end in a crocket against the top cornice. The open-work parapet between the polygonal pinnacles is based on that

formerly on Henry VII's Chapel. *Henry Cheere* did much of the carving.

The RESTORATION of 1989–93 saw the parapet and pinnacles renewed, along with much else, and a gable cross set up. The heraldic carving was painted, and STATUES put in the niches: six saints on the central buttresses, joined in 1996–8 by four Virtues beside the porch and ten C20 martyrs above, chosen from every continent. Chief designer *Tim Crawley*; other carvers *Neil Simmons, John Roberts, Andrew Tanser*. RAILINGS in front reordered by *D. Buttress*, 1994, with new Hawksmoorean-Gothic piers. In the pavement a MONUMENT to victims of oppression, violence and war, 1996, by *Kenneth Thompson*. A flat inscribed boss.

Henry VII's Chapel

Finally, back to HENRY VII'S CHAPEL. This was begun by Henry VII as a new Lady Chapel in 1503, when the hope was that Henry VI might be canonized and his body translated from Windsor. Henry VIII completed it as his father's chantry chapel, *c.* 1510. The result is Late Perp at its best, both bold and sumptuous, with a delightfully broken plan. It has nave and aisles, and five radiating E chapels, like the Abbey itself; but externally the chapel owes as much to secular as to sacred traditions. This shows in the astonishing treatment of the lower storey, 'welded into one striated crystalline mass by the application of the densest possible grid of Perpendicular panelling' (Christopher Wilson). In the aisles each window is a bow flanked by two half-bows, in the chapels it has canted sides and a central V-projection. Much display of heraldry, especially the portcullis. The panelling carries on around the buttresses, which continue up as complete octagonal turrets nearly as high as the clerestory. Above the high pierced parapet they have statue niches with carved name-tags – three over the aisles, four over the chapels, all now empty. The tops are crocketed ogee domes, originally of lead, like the late C15 examples at St George's Chapel, Windsor (which Henry VII must have wanted his chapel to outshine). The other dominant structural motif is the flying buttresses which span to the clerestory. These again succeed in looking massive, although of openwork design. They rise from the turrets as two bars with foiled tracery between. The bottom bar is a straight diagonal, that above curves to meet the wall. Clerestory windows of five lights, more conventionally ecclesiastical-looking. At the far W two tall fat stair-turrets. Broad, panelled, solid parapet.

The authorship of the design has to be guessed at, the building accounts having been lost. Until recently it was assumed that one man amongst the circle of royal masons must have been responsible. However, close examination of the structure has indicated a decided break in work at aisle roof level, raising the possibility that the vaults and upper parts were by a different hand. Such a handover would also account for the change to more conventional, church-like windows in the clerestory. The best candidate for the lower parts is *Robert Janyns Jun.* (†1506), who introduced similar fenestration at Henry VII's Tower at

Windsor, begun in the 1490s. For the rest, datable after *c.* 1506–7, *William Vertue* has the strongest claim.*

RESTORATIONS of the chapel have been generally respectful. In 1809–22 the mason *Thomas Gayfere Jun.* faithfully refaced it in Bath and Portland stone at the behest of Parliament, under *James Wyatt* and *B.D. Wyatt*. The pierced top zone and pinnacles are designs of this time. Much of the C19 facing was replaced in the restoration of 1992–5 under *Donald Buttress*. The work included a new population of the squat creeping beasts that take the place of crockets on top of the flying buttresses (carvers *Rattee & Kett*). A brown limewash was applied to most parts above the paler Kentish ragstone of the plinth. Metal WEATHERVANES added in 1981 and 1994 re-create a C16 allurement.

INTERIOR

6 What first distinguishes the interior of Westminster Abbey is its extreme height in relation to width. The actual proportion is 3:1. No comparable English church is so similar in this respect to the C13 cathedrals of France. It is true that the Abbey is neither as high as Reims or Amiens nor provided with an elevation designed so single-mindedly to emphasize height. But compared with Lincoln or Wells the difference is indeed startling. Equally startling by such home comparisons are the height of the arcade storey, which comprises fully half the internal elevation, and the steepness of its pointed arches. The clerestory is also higher than in any earlier English church (though still modest by the standards of Amiens), and its lack of a wall-passage also follows French custom. A further distinctive feature is the piers all of Purbeck marble. They were never painted, and their dark grey, greenish, or purplish accents combine with the unprecedentedly full carved ornament to rich effect. But to conjure up a complete picture of the Abbey in the C13, one must think of it in a glow of colour: red and gilt on the diapering over aisle and gallery arches, gilt arch mouldings with red, green or blue hollows, painting around the vault bosses, plain surfaces lined out in red to imitate ashlar, and deep strong colours from stained glass. In addition, to distil out the original appearance one must blot out all the monuments save a very few in the eastern arm. The Abbey is architecturally so much of a piece that it ought to be visualized pure and not as a mixture of styles and scales.

The Eastern Arm

6 We must now examine the interior in detail, and it is best to start at the E END, leaving the Chapel of Henry VII again to the end. The chancel or central E vessel contains the sanctuary and the feretory, or place of the shrine, but not the choir. It ends in five sides of an octagon and is, just as at Reims, surrounded by an ambulatory with radiating chapels. The HIGH VAULT introduces

* The suggestion is made by Tim Tatton-Brown. Vertue and Janyns were amongst three masons who submitted estimates for Henry VII's tomb in 1506.

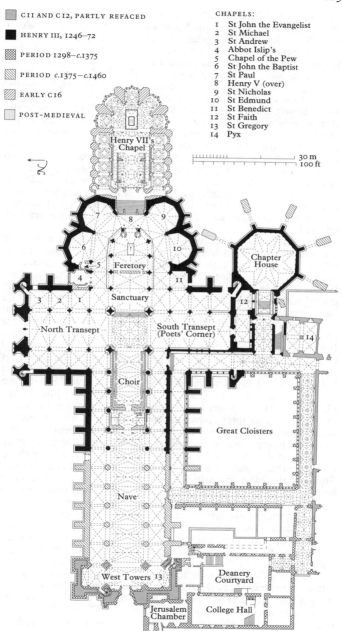

CII AND CI2, PARTLY REFACED

HENRY III, 1246–72

PERIOD 1298–c.1375

PERIOD c.1375–c.1460

EARLY C16

POST-MEDIEVAL

CHAPELS:
1 St John the Evangelist
2 St Michael
3 St Andrew
4 Abbot Islip's
5 Chapel of the Pew
6 St John the Baptist
7 St Paul
8 Henry V (over)
9 St Nicholas
10 St Edmund
11 St Benedict
12 St Faith
13 St Gregory
14 Pyx

30 m
100 ft

Henry VII's Chapel

7 8 9

6 10

Feretory

5

4 11

3 2 1 Sanctuary

Chapter House

North Transept

South Transept (Poets' Corner)

12

14

Choir

Great Cloisters

Nave

West Towers 13

Deanery Courtyard

Jerusalem Chamber

College Hall

Westminster Abbey. Plan
(after RCHME, 1924)

the mixture of English and French accents immediately. It consists of oblong bays with quadripartite ribbing, to which however is added a longitudinal ridge rib, broader than the others and given special prominence by stiff-leaf decoration and giant leaf bosses. The ridge rib is an English device, introduced partly for technical, partly for aesthetic reasons. The English way of filling vaulting cells, as illustrated here and in the aisles and chapels, leads at the crown to an untidy edge. The bands of grey Reigate stone across the cells of chalk show that clearly. In France the stones were shaped so that, where the two halves met at the crown, they lay snugly parallel. The ridge rib in England hid the jagged edge. But at the same time it also established a connection from bay to bay which was the outcome of an English desire to break the logically impeccable isolation of the French bay with its quadripartite vault. The French in the C13 (and even later) insisted on the finality of these divisions, the English wished to blur them and achieve spatial unity. More French in character are the vault springings, which by English standards are very tall and narrow.

The CLERESTORY has two-light windows with bar tracery of the kind derived from Reims, that is with two uncusped lancets under a cusped circle (here a cinquefoil). They are framed by areas of plain wall, except in the narrower bays around the apse. Window shafts of Purbeck marble. The bay design is not integrated with the GALLERY below, unlike in C13 France, where the shafts tended to be carried on downwards (and also in English C14 cathedrals, e.g. York, Gloucester, Canterbury). Galleries were characteristic of English Norman churches and those of much of France in the C11 and C12. But in France they had been replaced by triforia, that is shallower passages or arcades contained within the wall thickness, when the High Gothic style was created just before 1200. In England galleries were kept, e.g. at Lincoln and in the Ely retrochoir, to mention only two major C13 precedents. One might have thought that a building so French as the Abbey in other respects might have dispensed with one. That Henry of Reynes perpetuated it may have been due to the precedent of the C11 church, especially if the galleries there had some specialized use during the coronation ceremony. The gallery is as wide as the ambulatory and extends through all four radiating chapels. Towards the interior each bay has openings with twin cusped lancets on Purbeck marble shafts, and bar tracery above with a cinquefoiled circle: two in each aisle bay, one in each apse bay. All the openings are lavishly duplicated in depth, one complete range facing outwards and the other, independent of it, into the gallery. The result is perhaps less effective than the double tracery in the clerestory of the Angel Choir at Lincoln, where more direct light comes in and the changing relation of the layers tells as one moves along. The voussoirs of the main gallery arches are given stiff-leaf decoration, or sharply cut leaves in square panels, or left unenriched. Their spandrels and those of the arcades below are filled with diapering, in the form of squares filled with roses – a motif derived probably from the w front of Amiens, but applied with a thoroughness here which reflects the Anglo-Norman liking for all-over surface patterning. Its ultimate source and likeliest

point of reference was the metalwork of reliquary shrines – in other words, the whole interior was to be understood as a kind of shrine, on the model of the Sainte Chapelle. For the significance of the different sizes of diapering and of other small changes between the parts, *see* The Progress of the C13 Work, pp. 132–3 below.

The ARCADES have arches of extremely complex section, on strong circular piers provided with four slim detached shafts (with two shaft-rings) in the four main directions. This shape is again that of Reims (and before Reims of Chartres and after Reims of Amiens). But the piers at Westminster are of Purbeck marble, the favourite native material, which Anglicizes their character effectively. On their shallow moulded capitals stand single vaulting-shafts also of Purbeck. Tie-rods were built in between these capitals to strengthen the structure, as at Reims and also at Canterbury, the last previous occasion when French innovations in structure were imported wholesale into England. One shaft-ring at the sill height of the gallery.

The AISLES have quadripartite vaults with big central bosses, ribs with complex mouldings including fillets, and no ridge rib. The strangely squashed plan of the third bay is due to the planning of the chapels, which extend w of the start of the ambulatory – the only means by which Henry of Reynes could make their openings wide enough to match that of the Lady Chapel vestibule across the E end. On the outer wall here a blind lancet. The AMBULATORY also has trapezium-shaped vaults, but of the more usual form with the widest side outwards. The shape of the CHAPELS is of six sides of a nonagon, with the rest open to the ambulatory. The vaults have seven ribs carried up to one boss. The w chapels have three sides filled with windows, the E chapels four, with the other sides solid. They are set out so that each aisle vista is closed by a window, as at Reims. These are now darkened externally by Henry VII's Chapel, but would originally have been more telling against the narrower Lady Chapel that preceded it. The Reims-type bar tracery has been described with the exterior (*see* p. 117). Other features derived from there are the continuous wall-passage in front of the windows – something that remained exceptional in England – and the blind tracery on the windowless bays. The lower stage of blank arcading has pointed-trefoiled cusping, much of it mutilated. SCULPTURE. In the spandrels remains of foliage, both stiff-leaf and naturalistic. Naturalistic leaves were a recent French innovation, of *c.* 1240–5. They occur at the Sainte Chapelle in Paris and at Reims, and represent in visual terms the turn towards an interest in nature also noticeable in C13 philosophy, science and poetry. In the w chapel, N side, some foliage with birds and beasts in it, and fragmentary figures and demi-figures in addition (also in the E chapel, with figures in two sizes, some oddly twisted). In the w chapel on the S side a figure within snaky foliage, holding up two crowns. The E chapel on this side and w chapel on the N retain simple AUMBRIES with straight-headed double openings. For sculpture in the gallery *see* p. 135.

Of the C13 LADY CHAPEL all that can now be discerned is that it had an oblong vestibule, for the beginnings of the

continuation of the wall-passages into it can still be traced at the E end. Fragments of its walls have also been identified under Henry VII's Chapel.

The Transepts

The N TRANSEPT, the usual point of entry, will be described first. It extends four bays from the crossing and has E and W aisles. The E and W sides continue the system of the E arm. The N WALL is treated in five levels, as follows. At ground level are four Purbeck marble arches on shafts, adjusted to take account of the portals. The double doorway in the middle has the depressed pointed arches raised above the capitals by inserted vertical pieces: a favourite device of Henry III's masons, seen in several places at the Abbey.* Some capitals with leaf carvings. The voussoirs are given fleuron-like studding with rosettes, the spandrels damaged foliage carving with some figure groups (Samson and the lion, centre; seated figures, E). Wall-passage above with six pointed-cusped arches, decorated cusp spandrels, and diapered main spandrels. The third level is a tier of six lancet windows with deep embrasures. In their soffits is a beautiful chorus of angels, busts in medallions of two shapes, altogether twenty-four, making music, censing, holding a sundial, and so on. They are outstanding examples of the soft, full, rounded style of sculpture which runs parallel at Westminster with the sharper, more dramatic style of the S transept figures (see below, p. 131). In the E and W walls also two standing figures of kings in relief. Above the lancets are three double unglazed openings which continue the level and design of the gallery. They have blank outer arches, perhaps for painted inscriptions, and sculptures of censing angels in the spandrels to l. and r., inferior to those of the S transept but fine to see nonetheless. The middle spandrels have thick stiff-leaf scrolls, and corbels for lost figures. The W corbel has an extremely telling bearded head. The rose at the summit is *Pearson*'s lamented work of *c.* 1890; the original design is discussed above (see Exterior, p. 119). All four spandrels were originally glazed, which explains why the wall rises up above vault level.

AISLES. The E aisle of the N transept was used for chapels, the W aisle as the usual visitors' entrance. Both have N windows of a tall single light, between blind openings made lower to fit the arch: a common English motif from the later C11, but here treated with three little rib vaults and diapered central reveals. The N doorway in the W aisle has another arch of the Westminster type (cf. S transept, Exterior, p. 119), framed by very narrow blind lancets. Excellent blank arcading, with capitals and foliage-carved spandrels of both stiff-leaf and naturalistic types, as in the E arm, as well as the earlier French form of the crocket capital (E aisle, N wall). At the N end of the E aisle is a small E doorway with another Westminster arch. The S chapel on this side extended one bay into the E arm until the early C16, when Abbot Islip's Chapel was inserted. SCULPTURE. Some spandrels have

*Also used a little earlier in the so-called Prince's Chamber at old Westminster Palace, of 1237–8.

figure scenes (E aisle, N wall, St Margaret and dragon, Christ in Judgement; W aisle, W wall, dragons, a censing angel, and a group of three seated figures and two heads). In the W aisle are bosses with figures, e.g. King David with the harp, N, and an exquisite Annunciation.

The S TRANSEPT is likewise four bays deep and has E and W aisles. Its chief glory is its sculpture (see below); its chief oddity is that the W aisle swallows up the E walk of the cloister, so that a solid wall up to the height of the cloister roof, which is considerably lower than aisle height, blocks off this side from the central space. The explanation is the limited leeway that was available to Henry of Reynes in planning his new church between two fixed points: the first Lady Chapel, to the E, and the CII cloister and its buildings, to the S.

The S WALL in the centre is treated for the most part like that of the N transept. The differences are as follows. The ground floor had no large entrance to fit in, and so has a more graceful design of five arches, with diapering rather than foliage carving in the spandrels. The middle arch is the modest entrance to St Faith's Chapel (see below). The outer four are blank; three on shafts, the fourth, at the far r. and higher up, a plain blocked opening to the former night stair (demolished c. 1745 for the Argyll monument). Above the wall-passage is a tier of cusped lancets, instead of the plain lancets with sculpted soffits in the N transept. They have tall steep sills to get above the cloister buildings. The gallery openings are glazed, and again have diapering instead of foliage carving above (for the sculpture again see below). The rose window above can best be seen from within. It is probably a close version of the C13 design, renewed in 1451–62, and (faithfully) again in 1814 and 1901–2. Here the spandrels remain glazed at both top and bottom. p. 130

The E AISLE has or had a different arrangement of chapels from that in the N transept. A square chapel (Chapel of St Benedict) opens off the angle with the E arm, and the S bay is marked off by a screen wall (rebuilt c. 1723) which originally had a chapel altar against its W side. Thus the way was kept clear to the E doorway in the S bay, corresponding to that in the N transept, but of special importance as the private royal entrance from Westminster Palace. It too has an arch of Westminster type. The simple staircase doorway hard by it in the S wall leads up to the wall-passages and galleries, and also to steps down to the Chapter House undercroft to the SE. The S wall above it has two peculiarities: the arches of the wall-passage arcade are uncusped and stand in front of blind trefoiled arcading, and the window above is of two lancet heads with a very early instance of Y-tracery, enclosing a distorted central quatrefoil.

In the W AISLE, the screen wall between the W piers is given two tiers of blank arcading with stiff-leaf capitals and some diapering in the spandrels. On the N wall, i.e. facing the first bay W of the crossing, the treatment is different. The doorway into the cloister is framed exceedingly finely with another of those stilted Westminster arches, with an almost straight-sided depressed head on exceptionally high side pieces. Voussoirs with leaf scrolls forming medallions. To l. and r. a blind stilted lancet arch; above,

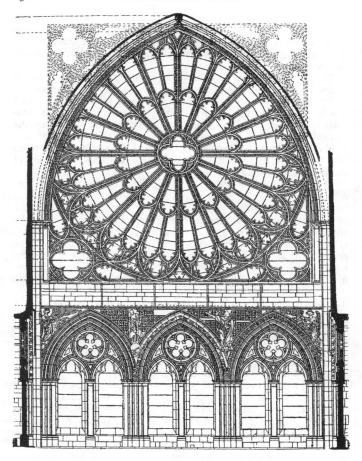

Westminster Abbey. South transept. Elevation, upper levels
(W.R. Lethaby, *Westminster Abbey and the Kings' Craftsmen*, 1906)

three large blank quatrefoils, in the same somewhat coarse style
as the cloister N walk tracery. The original use of the area on top,
i.e. beneath the vault, has been much debated. A platform for a
hidden choir is one suggestion; another, more commonly made,
is that it functioned as a royal pew or 'box'. Arguments in favour
include the special care lavished on interior details invisible from
the floor, especially in the triple S window, with its diapering in
every reveal and carvings of secular or military character (*see*
Sculpture, below). Against this must be set the restricted view of
the high altar and the very unkingly access routes, via small plain
doorways in the transept E aisle (and onward along the precari-

ous wall-walk), or in the SW buttress facing the cloister E walk. Perhaps the idea simply took hold that the space was too good to waste, and so it was embellished for the king's use when the masons reached this upper stage. Any such initiative would also have coincided with the advent in 1253 of the new master mason, *John of Gloucester*, who certainly made other changes to Henry of Reynes's design (*see* The Progress of the C13 Work, pp. 132–3 below). Or it may be that Henry III himself intervened when he saw the potential of the space. Whatever the first use, it must have ceased by the late C14, when the space was adapted for a MUNIMENT ROOM (for fittings *see* p. 193).

The SCULPTURE of the S transept is outstanding. The large figures in the gallery spandrels have survived (St Edward, l., and St John, r., with arm extended), as well as the censing angels in the outer corners. These angels are the best large C13 figures in the Abbey, in their facial type obviously derived from Reims, and more exactly from the style of the master of the Joseph, the Anna, and the smiling angels of the W front, of *c.* 1245. The English carver has given their limbs and folded mantels an almost alabaster-like sharpness and an emphasis on line typical of his country. Nothing could be more characteristic than the rendering of the bones in the foot of the l. angel. The colouring is partly original. Of comparable quality are the BOSSES in the W aisle, properly visible only from within the Muniment Room. All have figures and scenes instead of the foliage prevailing in the E arm. The best are in the rib vaults of the three stepped windows in the S wall, which double as a kind of entrance screen. They represent combats of man and centaur, man and dragon, and dragon and centaur. The carving is precise and angular, the faces and draperies sharply lined, and the actions conducted with great energy; all have largely original colouring. The other bosses measure some 30 in. (76 cm.) across, e.g. that in the E bay of the nave aisle, just N of the Muniment Room (Coronation of the Virgin). All these bosses, as well as the censing angels on the S wall, the heads in St Faith's Chapel and the gallery and the sculpture in the E chapels, may be the products of one workshop.

St Faith's Chapel

ST FAITH'S CHAPEL (not always open) was built *c.* 1250, integrally with the S transept and the N wall of the Chapter House vestibule, which provides the only light. Considered as a single space it is awkwardly long and narrow, consisting of a W part of two bays and an E part of one. The two are separated by a two-centred arch. The W part served as the main vestry. It has quadripartite rib-vaulting, and on the N wall three ill-proportioned bays of large blank arcading with Westminster arches. Plainer recesses in the S wall. Across the W end runs a gallery on a tunnel vault, which connected the Dormitory with the night stairs in the S transept. The E part has a sexpartite vault, the only one in the Abbey. It is cut across on the N by a diagonal wall enclosing the SE transept staircase. Mouldings like those of the adjacent Chapter House vestibule. The ribs spring from well-preserved corbel heads of remarkable eloquence, among the best (and best

preserved) in the Abbey: smiling lady, 'dreaming youth', African, and leering grotesques. For the furnishings *see* p. 170.

The Crossing

6 The spacious CROSSING is kept clear by placing the choir out of the way in the E bays of the nave. The space was thus visible from the transepts during coronation services. It has four big soaring Purbeck piers, enriched by shafts. Each of the four arches stands on one strong round shaft. Between them in the diagonals are groups of three thin shafts. On these high up rise round shafts connected with the projected design of the lantern. Henry III may have wanted this feature in order to let the light stream down to the crossing, where the throne would stand. The piers have only one tier of shaft-rings, at the level of the main arcade. The present LANTERN consists of bald walls with lancets, from *Hawksmoor*'s uncompleted tower of 1725–6. The timber ceiling brightly painted with a giant Puginian pattern is of 1958, designed by *S.E. Dykes Bower*.*

The Progress of the Thirteenth-Century Work

The building accounts of the Abbey in the C13, though incomplete, are still very informative as to what was done from year to year. It seems that the transepts, the E walls of the cloister, and the Chapter House were all begun concurrently when the E end was set out in 1246. The beginning of the internal sculpture, around the chapels and transepts, can therefore be placed *c*. 1250. More precisely, small differences in the fabric suggest that work in the first six or seven years went on with the N piers and arches of the E arm first, a little earlier than those on the S, and then the S spandrels and galleries and the S transept, in advance of the N transept (which was less important for the monks' use of the church). Chief amongst these small differences are the following. Pier bases in the apse and the first three N bays are more deeply hollowed out (i.e. again more like Reims) than those in other parts, suggesting that *Henry of Reynes* was still developing his ideas after work started. Another change concerns the pattern of tie-rods. Wooden ones were used in the areas with hollow bases, and also between the ambulatory and the two chapels on the S side. But in the corresponding bays of the main S arcade, i.e. between central vessel and ambulatory, iron bars begin to appear, running into the capitals. Another, more easily noticed alteration concerns the size of the diapering in the arcade spandrels. The smaller and earlier type appears in the E end, the S side of the E arm, and the E side of the S transept (and also within the Chapter House and cloister), the larger and later in the rest of the S transept, the N transept and all round the gallery. On the N side of the E arm, in the two bays nearest the crossing, the 'masons' muddle' where the sizes meet is unconcealed. The S transept

* Replacing *Wyatt*'s plaster tierceron vault of 1803–4, added after a fire and itself burnt in 1941.

gallery also starts off with the voussoir enrichment as in the E arm, that is with a sequence of diapering, foliage and mouldings, but on its w side big undercut dogtooth begins to appear too. What is known of the progress of the work points to the year 1253, when *John of Gloucester* took charge, for the changeover in both diapering and voussoir types. Another revision, in the N transept, also suggests his hand: it is the abandonment of monolithic attached shafts for the gallery piers, as in the E arm and S transept, in favour of integral construction of coursed stones. The implication must be that John's changes aimed to reduce costs or delays, probably at a time when Henry III was impatient with progress. John had carried forward enough work on the E parts by 1259 for demolition to begin on the Confessor's nave, which means that John must also have completed the crossing. The detailed changes that followed after that are described with the nave, below.

The Nave

The NAVE dates entirely from 1259–72 in its E parts and from the C14–C16 at the w, apart from the areas where refaced C11–C12 fabric can be shown to have survived. The joint between the two later periods can easily be detected if one looks for it, but it remains remarkable that the C13 design was so reverentially carried on. We have every reason to be grateful. A radical change from one style to another may be historically very instructive, as in the E parts of Ely or the w parts of St Alban's, but it subverts the aesthetic value of the interior in which it happens. At Westminster we can maintain the illusion of a work all of one design – indeed an English Reims or Chartres.

The first job of a detailed survey of the nave must be to compare the C13 parts with the transepts and E end. Such a comparison will show how French forms were progressively Englished. The first bay of the nave, i.e. that in line with the transept w aisles, had of course for safety's sake to be erected at the same time as the crossing. So it still has features in common with the earlier parts, some of which were then at once modified or dropped. *John of Gloucester* made the first changes, and more followed when *Robert of Beverley* took over after 1260. The most telling concerns the high vault. It has, in addition to the longitudinal ridge ribs of the E arm and transepts, transverse ridge ribs and one tierceron rib in each cell. That is almost the system of the nave of Lincoln and of Ely presbytery, both of a decade or so before, except that their transverse ribs stop short of the clerestory wall. The E vault responds are built integrally with the crossing, so the new design must have been due to *John of Gloucester*, even if the vault itself came after his time. The most important change to the piers, from four to eight shafts (four detached and four attached), is also his. But other alterations to the piers must have been *Robert of Beverley's*, since they take effect only from the second pair. Here the shaft-rings change from marble to bronze, and from a continuous encircling ring to individual rings on each shaft. The vaulting-shafts also lose their full capitals for a simpler shaft-ring-like moulding at the level of the

main capital. Robert's hand appears on the gallery too, where the leaf enrichments around the arches are given up in favour of mouldings after the second bay.

In the AISLES, the wall-passage in front of the windows continues, but the arcade spandrels below have SHIELDS instead of foliage and figures. This is the earliest surviving architectural heraldry in England, and the first known in an ecclesiastical interior.* The shields are carved as if suspended by straps from little animated heads, in order of rank from E to W. The source is Continental, though such chivalric displays were avidly taken up in English architecture. So the N side starts with the Empire and France (eagle, fleur-de-lys), the S side with St Edward and England (cross with five martlets, three lions). Much original colouring. Whether they were introduced by John of Gloucester or by Robert of Beverley, i.e. before or after 1260, is unclear. The order must have been fixed by 1264, when Roger de Quincy died (seven lozenges, fourth bay, S) and Simon de Montfort was in rebellion (forked-tailed lion, third bay, N). Some intriguing bosses in the vault, e.g. a male head savaged by lions, N side.

The joint between C13 and C14–C16 work runs comes at the fifth bay (fourth windowed bay) from the crossing. The resumption can be dated to 1375–6, when *John Palterton* began to demolish the Norman fabric for Abbot Litlyngton. His task was to link up with the Norman W towers, which had been remodelled some forty years previously; their windows set the precedent of a design in harmony with Henry III's work. The aisle walls must have been built first, and here there is evidence that Palterton reused at least some of the C11 nave walls below sill level. The next landmark was in 1387/8, when Palterton's successor, the famous *Henry Yevele*, ordered Purbeck marble for the first of ten new arcade piers. The gallery dates from the 1410s, the clerestory from 1418 to the 1470s; the vault, by the mason *Robert Stowell*, as late as 1482–90 (the four W bays) and 1504–6 (the next two bays to the E).

Now we can hunt for what further changes this long-drawn-out campaign wrought on the design which Robert of Beverley left unfinished in 1272. The new type of PIERS, beginning at the sixth pair, must be *Yevele*'s design. They have polygonal bases and capitals to the attached shafts, and a different moulding of the shaft-rings. The arch mouldings also differ. But all that matters less in the general impression than the change to the spandrels, where the diapering suddenly ceases (as also on the gallery, above). Another key difference concerns the aisle and clerestory windows. The design of the AISLES must be *Palterton*'s. From the sixth bay (fifth windowed bay) their two lancets each receive cusps, and the cinquefoiled circle is replaced by an unencircled quatrefoil – motifs in no way opposed to C13 custom, and already established externally in the windows of the remodelled W towers. The aisle walls carry on the blank arcading of the C13 parts, but the shields are now painted and not carved, the foliage and

* A little later than the shields known from descriptions of the N transept portals, which were complete by 1253: a feature reinstated in *Scott*'s restoration.

small-scale sculpture are clearly of a later age (see especially the dragons in the spandrels, sixth bay from the E, S side), and the wall-passage is given up. The windows of the CLERESTORY follow those of the new aisles. But the fifth bay is a transitional design, as if to camouflage the change: uncusped lights and an encircled top in the C13 way, but with a quatrefoil instead of a cinquefoil in the circle, and set in a frame of the same shape as those further W. It may be due to *John Redyng* or to his successor *Robert Stowell*, who completed the walls of this bay in 1468. In the GALLERY the openings change a little in their details, and Purbeck stone is given up for all but the free-standing shafts (and also for the vaulting-shafts and the window-shafts of the clerestory). The design of the VAULTS remained the same, but the bosses of the high vault have the big pictorial badges, roses, etc., of the Perp style. The change comes at the fifth bay from the crossing, not the sixth: further evidence that Henry III failed to finish the upper stages of this bay.

The bays under the W TOWERS are set off by a bigger and more elaborate pair of piers. The upper walls continue their system, except that the gallery arches are subdivided by quatrefoil instead of single shafts, and the clerestory windows have Y-tracery of C14–C15 type. The dates probably match those of the nave proper, i.e. 1410s–20s for the galleries, up to the 1460s for the clerestories. The vaults are also different: ridge ribs in the main vault (the only ones used in the aisles), narrower quadripartite vaults on each outer side, to make up the greater width of the towers. The failure of the W windows to align exactly with the aisles may be connected with the retention of the Norman tower cores. In the S wall under the S tower also simple little windows into the abbot's house, which must date from Islip's early C16 home improvements.* The W WALL has Perp blank arcading round the doorway, and above it the seven-light window with four transoms, of c. 1491–5 but renewed with some alterations by *Hawksmoor* after 1732. The whole is framed by canted panelling.

The Gallery

What appears of the arches and flying buttresses within the C13 gallery space is double-chamfered and frankly utilitarian. But in contradiction to this, the roof beams towards the E end rest on the inner side on beautifully carved figures, demi-figures of men, a demi-figure of a woman wearing a wimple, a ram, a monster, and so on. In style they go with the sharp, harder-lined figures of the S transept and St Faith's Chapel rather than the more rounded and lyrical manner of the angel busts in the N transept. Their presence again begs the question of what use might have been intended for this remote space. Extra chapels? Viewing galleries for the coronation ceremony? More room for choirs or musicians?

*In the upper part of the SW tower a C17 brick fireplace was identified in the C19. It dates from the occupancy of the house during the Commonwealth by the regicide John Bradshaw, who converted the space as a study for himself.

The Roofs

The steep medieval ROOFS remained until the 1960s, when all but that over the E arm were destroyed. It is a shocking fact that no proper record of the nave and S transept timberwork was made. The RCHM was however permitted to survey the N transept roof in 1964. The C13 roofs have or had upper and lower collars with scissor-braces crossing the lower collars. Scissor-braced roofs were already being constructed c. 1200, and the Westminster design has contemporary parallels at e.g. the nave of Ely. Tie-beams and additional trusses introduced under *Wren* after 1699 were removed from the E arm roof in 1965–6, along with parts of the C13 structure. In the N transept there were additional longitudinal diagonal braces of the early C18. The C15 part of the nave roof is known to have had collar purlins carried by crown-posts, and straight braces.

Henry VII's Chapel

The greatest change to the C13 design for Westminster Abbey is HENRY VII'S CHAPEL (properly, the LADY CHAPEL), of 1503–c.1510, which replaced the Lady Chapel of 1220–45. It was begun with a view to being the shrine of Henry VI (†1471), who Henry VII hoped might be canonized, and at the same time a chantry chapel for the Tudors.* Its main vessel takes its shape and size from the C13 E end (and likewise has five radiating chapels), just as its floor level matches that of the Confessor's chapel: a scrupulous solution to the anticipated problem of housing two royal saints and their cults in one church. The size and splendour of the new chapel also trumpeted the arrival of the Tudor dynasty; Henry VII's will stipulated that 10,000 masses for his soul should be said inside it.

The chapel is attached by a large VESTIBULE, reached by a triple-arched opening made around the adapted E piers of the bridge supporting Henry V's Chapel. The width was determined by that of the C13 Lady Chapel vestibule, of which short stretches of refaced walling remain. A broad staircase of twelve steps rises from just within the entrance to a level only a little below that of the main pavement. The covering is a transverse four-centred tunnel vault, highly enriched with panelling. On the side walls are three tiers of panelling or tracery, of which only the furthest E of the four window-patterns of the top tier are glazed. Below these windows small side entries lead into the chapel aisles, which are wholly cut off from the nave by the extended stalls. The nave is entered by another triple doorway, ahead.

The CHAPEL itself consists of a nave with aisles of four bays and a polygonal chancel with five radiating chapels. Nave and chancel have a FAN VAULT of the most glorious richness and size, of the kind known as a pendant fan vault. It is the most advanced elaboration of this uniquely English school of vaulting, and it strikes the viewer as a proper climax to the complex and tri-

18

*Thus the S aisle became the chantry chapel of Henry's mother, Lady Margaret Beaufort, whose tomb is there.

umphant symphony of the chapel. Even so, it seems to represent a change of plan from first intentions, attributed by Tim Tatton-Brown to the replacement of *Robert Janyns* (†1506) by *William Vertue* for the parts above the aisle arcades.

The division into bays is by strong transverse arches with a fringe of cusping. These are given a form similar to (and influenced by) the arched braces of timber roofs. Thence also comes the openwork tracery in their spandrels, here combined with a diagonal bracing rib. Even the cusped fringe has a wooden precedent, at the great-chamber vault of Crosby Hall, formerly in the City (1466–75). Then however, at a certain height, these transverse arches disappear into the solid vault and only their cusping remains visible. The points are marked by huge pendants, from which the greater area of the fans themselves radiate. The pendants are structurally in fact part of the wedge-stones of the arches or braces, but appear suspended in the air. The whole vault can thus be read as a design for nave and aisles with the arcade piers removed. The rest is made up of part-circles radiating from above the arch springings (sides), and elongated convex-sided diamonds along the middle, each with a small central pendant. A different system is needed to fit into the five-eighths of an octagon over the chancel. The fans springing up from the main pendants are smaller, leaving a central area that is proportionately larger. Its filling is a concave-sided octagon, enclosing a pendant within an eight-pointed star decorated with heraldic badges. One point of the octagon is cut off by the broad panelled chancel arch: a minor botch, meant to remedy structural weaknesses that followed from the change in design for the upper parts. The arch is cusped on both edges and overlaps one of the main cross-arches on the w, where pendants break into it.

Technically the vault is also a spectacular *tour de force*. Its stones are laid not in a mixture of ribs and infill but as continuous courses of cut blocks, the only large-scale fan vault to use this exacting method. Their thickness is pared down to a mere 4 in. (10 cm). The source of the interpenetrating cross-arches with tracery above is undoubtedly Oxford, partly in the Divinity School vault of the 1480s but more in its subtler successor of *c.* 1500 at Christ Church. Also seemingly unique is the deep recession of the thousands of vaulting cells, giving the whole its pierced filigree look, and the lacy openwork frills around the tops of the fans.

Now for the rest of the chapel. The arcades have depressed four-centred arches that are shallow in front and deeply moulded behind, one of several features recalling St George's Chapel at Windsor. That building was begun in 1475 by Henry Janyns, and it is likely that Robert, his son, had also worked on it. Five-light clerestory windows, with similarly depressed arches over the aisles, but with steeper heads over the five E chapel openings. The W window, i.e. over the entrance, is a broad and very rich traceried design of fifteen lights, with small roses inserted between the main upper arch and side arches. These upper parts can be attributed to the later master, but the wealth of sculpture – in quantities unparalleled within any surviving English church – must be due to the first designer. Statues line up above the

arcade, against the E walls of the aisles and the side walls of the
E chapels, and in two tiers on the panelling below the chancel
arch. There were more than a hundred originally, and nearly all
survive within their niches. The chapel was also intended to
sparkle with colour and gilding. Stained glass was installed, but
there is no sign of the King's instructions to paint the figures ever
having been carried out. The interior was lightened in 1934, and
again limewashed and gilded in restoration by *Donald Buttress* in
1992–5.

The panelled bay windows of the AISLES AND CHAPELS have
been described above (*see* Exterior, p. 123). From inside their
fanciful and broken outlines are even more attractive than from
outside. Another surprise is that they continue up above the
vaults to end under their own little stone ceilings. The disjunc-
tion with the vaults suggests a revision by *Vertue* of *Janyns*'s inten-
tions, and parts of the roof had to be cut away to achieve it. The
vaults look strangely insubstantial as a result – an effect echoed
down the centuries by Soane, e.g. at No. 11 Downing Street
(*see* p. 264). In the aisles they are again of pendant type, but of
more conventional square plan. Smaller fan vaults over the aisle
lobbies, W; the N aisle has a sacristy enclosure here. The E chapels
have rectangular fan vaults with pendants omitted. Those nearest
the chancel arch have low stone SCREENS of three pretty bows
curving forward, an echo of the window shapes of the aisles. Until
the C18 such screens also stood in the aisle E bays.

The INTERIOR SCULPTURE of the chapel, the largest remain-
ing assembly from late medieval England, deserves a closer look.
A few of the figures of saints have been lost, but not enough to
reduce their effect within the whole architectural composition.
In the E chapels and against the E walls of the aisles stand large
figures, and below them run friezes with demi-figures of angels,
of a much lower order of carving. Above the arcade runs another
such frieze and then a tier of smaller figures, five for each bay,
with a double tier on the chancel arch (Doctors of the Church,
N, and Evangelists, S). The W wall also has a frieze of demi-angels,
and heraldic sentinel beasts on half-octagonal shafts against the
entrance piers (and also in the vestibule; other beasts over the
lower statue canopies).

It is clear that more than one master or workshop was active
on the STATUES. Some figures are long, erect and nobly placid,
others nimbly moving with angular, broken drapery folds.
Specially good examples of the first type are at the E end of the
N aisle, of the second the five small figures above the opening
of the NE chapel. We do not know the names of the carvers
individually, or whether they were English or Netherlandish.
Laurence Ymber has been suggested as sculptor in charge, and
Prior Bolton, called 'master of the works' for the chapel in Henry
VII's will, as deviser of the programme. The most proficient
master seems also to have worked at Eton College Chapel.

It is worth a bit of neck-craning to take in the wonderfully
varied costumes and attitudes of the figures. The giant hats of
the ten philosophers or prophets with their books or scrolls by
the W end would justify a study on its own. Some saints appear
more than once, e.g. St Sebastian with his executioners (NE

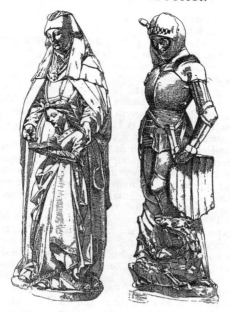

Westminster Abbey. Henry VII's Chapel.
Statues of St Anne and St George. Drawings
(W.R. Lethaby, *Westminster Abbey and the Kings' Craftsmen*, 1906)

chapel l. wall, and s aisle w bay). The figures of the extreme E
chapel suggests that Henry VI's shrine was to have stood here:
St Peter and two royal English saints, Edward and Edmund, s, a
niche initialled H.R., N.* In the central niche above its entrance
is a presiding figure of Christ.

FURNISHINGS AND MONUMENTS

Introduction

Westminster Abbey has the greatest assemblage in the country of
monuments from the Middle Ages to the C18, besides a marvel-
lous collection from later centuries. The tally is now over 450,
grave-slabs excluded. Most of the styles, types and fashions from
the C13 to the mid C20 have left their mark, although from the
later C18 the supply of larger monuments dwindles in favour of
statues and busts. Nor are the monuments the whole story: the
medieval chapels, stalls, screens and paintings would be out-
standing anywhere, not to mention the post-medieval stained
glass and other furnishings. Nowhere else in Europe can the

*With a replacement statue of 1998; modelled by *Tim Metcalfe*, carver *Matthew
Hyde*.

sacred and continuing rites of kingship be so well comprehended from a physical setting.

To understand and enjoy this treasure house presents the visitor with two challenges. The first is due to the press of the crowd, who are shepherded round a mostly fixed route, since 1998 beginning at the N transept paybooth. In addition, access to the feretory is now limited to guided parties, to reduce the erosion caused by stroking hands and shuffling feet. The descriptions therefore follow the present circuit, to keep page-turning to a minimum. The exception is Henry VII's Chapel, which as in the architectural descriptions is placed at the end.

The second challenge is to fit the contents into some sort of historical narrative, and to make sense of their grouping by type and date. For this it is first worth recalling the topography. The crossing and transepts, originally separated by screens, are now visually continuous. The sanctuary starts immediately E of the E crossing piers, and extends into the far W bay of the E arm, where it is closed by the reredos and high altar. It rises higher than the aisles, which means that the monuments and screens around the sanctuary come down to the ground on their outer sides. The raised floor continues E of the high altar to form the feretory, i.e. the Chapel of St Edward the Confessor, at the heart of the apse. Enclosing it on the N, S and E is the ambulatory, with chapels radiating from it: a small chapel next to each transept, two larger and polygonal ones on each side, then on the E axis Henry V's Chapel on its oversailing bridge. Beyond this point is Henry VII's Chapel, with its own vestibule. The choir occupies the three bays W of the crossing, i.e. the two E bays of the nave, with the organ loft and choir screen in the bay immediately W of that. The aisles of these nave bays thus have the character of passages (as also does the bay SW of the crossing, where the cloister squeezes in). The nave proper extends for seven more bays to the W, plus one bay between the W towers.

10, 11, 14, p. 148 The most sacred place in the Abbey was the feretory, where a garland of royal tombs appeared in the C13–C14, as close as possible to the saint's beneficent power. Then tombs were put up in the chapels, mostly on the ambulatory sides. They included royal cousins, abbots and former abbots, joined after the 1390s by some bishops and other courtiers. Henry V and Henry VII had new chapels of their own, as has been mentioned, while other chapels were formed within the C13 fabric on the N side (Abbot Islip's Chapel, Chapel of the Pew). Otherwise, the tombs were of modest size in relation to the height of the arcades and the whole building, though amazingly varied in form and materials. The Reformation abolished the chapel altars (releasing a great deal of space), made proximity to the shrine a matter of mere prestige, and further eroded any religious scruples about self-important display. The first megalomaniac monuments are therefore those to Late Elizabethan courtiers. Some are more sumptuous, more massive and higher than the tomb of Elizabeth herself (Lord Hunsdon, 36 ft or 11 metres high); a surprising number commemorate women. The types are basically few, 24 whether built against walls in several tiers or (less commonly) free-standing with or without canopies, and such motifs as

coffered arches, flanking columns, obelisks and strapwork cartouches repeat time and again. Sculptural quality is uneven, though by the time of the tombs of Mary Stuart and Elizabeth in the 1600s it matches the best of the Netherlands, the homeland of most of the leading sculptors then working in England. By then the advanced fashion was for black and white marble, rather than the alabaster and coloured stones of the later C16.

The 1600s–10s began a great liberation of iconography, with the Elizabeth Russell and Vere monuments (†1601, 1609) and the works of *Nicholas Stone* (nine examples or so) whose inventiveness on both small and large scales is astounding. By that time monuments were spilling over into the transepts, including small hanging ones alongside the older standing types, and with effigies standing or seated as well as in repose. Stone was trained abroad, and from the Continent came also the hardly less innovative *Hubert Le Sueur* (four works, 1620s on), who revived the use of bronze. After the Commonwealth a move towards simplicity of monuments is noticeable at the Abbey (though not elsewhere in England), and quite a number dispense with effigies and figures in favour of a large urn. Where effigies do appear, the usual pose is reclining, a formula that persisted into the grander, more eloquent and more varied tombs of the early C18. Their final outcome was the spectacular allegorical machines of *L.-F. Roubiliac* and his Continental fellows: heavy in weight, ingenious in conceit, and brilliant in execution. The Abbey and its cloister have at least eight Roubiliacs, and at least fifteen and seventeen monuments wholly or partly by *Peter Scheemakers* and *J.M. Rysbrack* respectively, though many are minor pieces. Several were designed by such architects as *James Gibbs* and *William Kent*. They were fitted in wherever there was space, which by then usually meant the transepts or the nave, and latterly on window ledges after the walls filled up. Monuments of this period commemorate the expected clerics, aristocrats and warriors, but also poets (gathered in the S transept from the mid C16), and some very obscure people too, for after the later C17 an Abbey burial was open to any who could afford the fees.* But the feeling also grew that public figures alone deserved conspicuous commemoration. Shakespeare got his by public subscription in 1740–1, the naval hero Captain Cornewall by Parliamentary grant in 1744. The next in a growing stream of official commissions was for General Wolfe in 1760, one of seven works in the Abbey by *Joseph Wilton*. Other Neoclassical sculptors here in force are *Joseph Nollekens* (eight), *Thomas Banks* and *John Flaxman* (five each), and *John Bacon Sen.* and *Jun.* (at least nineteen). The standard ingredients are sarcophagus bases, obelisk backs (which replaced the architectural 'reredos' type from the early C18), trophies and drapery or flags, portrait busts

25

29

30

31

43,
46,
47

44

45

64

65,
66

*Conversely, it is astonishing how many monarchs were buried here without any monument, before Windsor again became the preferred royal mausoleum after the late C18: Edward VI, Mary I, James I, Charles II, Mary II, William III, Anne, George II; also a host of consorts, princes and princesses. Oliver Cromwell (†1658), interred at the E end of Henry VII's Chapel, was ejected in 1660, with other Parliamentarians.

or medallions, and allegorical mourners or attendants, all used with varying degrees of relief and on small as well as large scales. In the mid C18, yellow, brown and other coloured marbles came into fashion, but by *c.* 1780 white, black and grey were again the norm. Pyramidal or free-standing groups as large as *Nollekens*'s Three Captains (1784–93) went up well into the C19 – the last, to Lord Holland, as late as *c.* 1847 – but big official projects were increasingly steered towards the roomier spaces of St Paul's (beginning with the commission in 1790 for four statues of worthies to stand under its dome). Instead, the Victorians favoured busts or space-saving portrait statues on tall plinths, amongst which most of their leading sculptors are represented. Another type was the Neo-Medieval monumental brass, of which the nave has some very original examples. There are also several monuments of the revived recumbent-effigy type.

All this was not done without cost to the medieval Abbey. Most vulnerable was the wall arcading, so easily masked or destroyed by new monuments. Many of the chapel screens also became casualties. The feeling that terrible damage was being done by this crowding took increasingly firm hold from the early C19, especially as the Gothic Revival approached its most devout and exclusive phase. Pugin speaks of 'vile masses of marble' (1841), the *Ecclesiologist* of 'a Pantheon, or house of demons' (1843), Ruskin of the 'ignoble incoherent fillings of the aisles', William Morris of 'Cockney nightmares' (why Cockney?) and 'the most hideous specimens of false art that can be found in the whole world'. Yet Morris did not recommend that the monuments should be removed, for he knew that this would mean making good with yet more imitation Gothic. Fortunately nothing came also of the grand C19 fuss over moving the monuments to some new Panthéon or Campo Santo. This was proposed, e.g., by the *Ecclesiologist* in 1843, and culminated in a Royal Commission in 1890–1 to consider proposals by *J.L. Pearson*, *J.P. Seddon* and others for new cloisters, chapels, or great towers dwarfing the Abbey (*Sir Herbert Baker* even designed a memorial cloister for the E end in the C20).

The changes actually made were more modest in effect. In the 1820s–40s new, appropriately Gothic stalls, reredos and w screen were provided. *George Gilbert Scott* prepared a report on restoring the royal tombs in 1854, for which Government money was eventually voted, the first grant of its kind. Scattered parts were recovered and refixed, and crumbling surfaces 'indurated' with shellac. Otherwise Scott's hand fell lightly on them. From 1864 he was aided by the great Dean Stanley, whose vision of the Abbey as a kind of national house of memory led to its annotation with inscriptions recording previously unmarked tombs. Scott also refaced the reredos, and pressed on with the installation of stained glass (much of which was lost or damaged in the Second World War). The oft-proposed purge of later monuments never happened, though many had their backings trimmed in 1873–8. Only in the 1920s–60s were an unlucky few banished to the gallery or off the cloister. In some cases this was to make room for war-memorial chapels (commissions put in the safe hands variously of *J.N. Comper*, his son *Sebastian*, and *Sir Albert*

Richardson); in others, the aim was to expose more of the medieval fabric. Burials since the C20 have mostly been of cremated remains, and monuments limited to lettered slabs or tablets, carefully placed portrait medallions, or commemorative stained glass. A more obvious change was the wholesale cleaning and recolouring carried out under *S.E. Dykes Bower* after 1953. The Elizabethan and Jacobean monuments responded best to this treatment, which often extended to making good missing features; on the other hand, some of the later C17 now look much too spick-and-span.

It is sheer perversity to deny that the monuments lessen the impact of the architecture, with its uncommon unity of style. In turn, many monuments are themselves too hemmed in to see properly, such as in the N transept aisles or N tower bay. The nave aisles on the other hand are frankly an exhibition of monuments, which can be walked along as if in a museum or gallery. All this is the outcome of accident, of actions unconcerned with aesthetic value (made worse by the tendency in the C18 to design the backdrop without knowing where a monument would be sited). The orderly minded or the avid medievalist may still find the results as disgusting as the Victorians did; others will relish the collision of styles and personalities, historical and artistic.

The description follows the usual visiting circuit, i.e. N transept; clockwise round the E end, taking the chapels in order of occurrence (except that Henry VII's Chapel is kept to the end); sanctuary, crossing and choir enclosure; S transept, with St Faith's Chapel; nave, including choir aisles. A final reminder: the decorative sculpture of the medieval fabric, both in the main church and in Henry VII's Chapel, is treated with the architecture (*see* Interior, above). p. 125

North Transept

The usual entry for visitors is through the N door. The N transept has far more large monuments than its S counterpart, especially C17 aristocratic tombs, C18 naval or military heroes, and statues of C19 statesmen.

Central space

N WALL. STAINED GLASS. Rose window by *Joshua Price*, his last work (1721–2), to designs by *Sir James Thornhill*. Radially arranged Apostles and Evangelists in the pictorial technique of the C18, cut down *c.* 1890 to fit Pearson's new tracery. In the lancets below six Acts of Mercy, 1958 by *Brian Thomas*, in a sympathetic and colourful style. – PAINTING of the high vault (transepts, E end and nave E end). Big acanthus leaves around the bosses, spiral bands alongside the ribs. Introduced under *Wren*; renewed under *Dykes Bower* after 1953 (executed by *Campbell Smith*). – PORCH, by *Donald Buttress*, 1997. Postmodern Perp, of steel, with small areas of exact Tudor ornament. – MONUMENTS. Admiral Wager, l. of the N door. By *Peter Scheemakers*, 1743–7. Seated Fame holding portrait medallion supported by

the infant Hercules. Grey obelisk back; base with relief of sea battle after *Samuel Scott*. – Admiral Vernon, r. of the N door. 1763, the final work in the Abbey by *J.M. Rysbrack*. Victory crowning a bust with laurels, with sail, flags and trophy against an obelisk.

E SIDE, from N to S. John, 1st (Holles) Duke of Newcastle, designed by *James Gibbs*, carved by *Francis Bird*. Final designs 1721, erected 1723. A vast tripartite composition, more Baroque than any of Gibbs's buildings. The source is Carlo Rainaldi's altar for the church of Gesù e Maria (*c.* 1675) in Rome, where Gibbs and Bird both trained. In the centre the Duke, white marble, on a black marble sarcophagus framed by columns. He is in armour and looks to heaven. To l. and r. stand Wisdom and Sincerity. Pediment above, with angels, breaking boldly back in the middle. Upper storey over this middle part, with armorial under another pediment and putti above it. – Then mostly statues of statesmen, 77 a ghostly assembly beginning with three Cannings: George, the Prime Minister, by *Sir Francis Chantrey*, 1829–34; his son the 1st Earl Canning, 1871 by *J.H. Foley*; 1st Viscount Stratford de Redcliffe, by *Sir Joseph Edgar Boehm*, 1884. Canning Sen. inaugurated the type of cylindrical plinth used for most of the C19 statues. – William, 1st (Cavendish) Duke of Newcastle †1676, and Margaret, his literary Duchess. Inscribed base with trophies in relief. Sarcophagus with recumbent effigies, resting in an old-fashioned way on a half-rolled-up mat. Black and white reredos back with columns, big looped draperies and big segmental pediment. Attributed to *Joshua Marshall* (GF). – Statues of Sir John Malcolm by *Chantrey*, 1838, and Disraeli, 1881–4, by *Boehm*. – Then a *Roubiliac*: Vice-Admiral Warren, 1753. Excellent and not big. Double-curved pedestal. Seated figure of Navigation on the r.; Hercules standing on the l. and bending tenderly over the bust. Originally there was a big falling flag behind. – Statues of Gladstone, 1903 by *Thomas Brock*, and Peel, by *John Gibson*, 1853.

W SIDE, from N to S. William Pitt, 1st Earl of Chatham, 1779–83 by *John Bacon Sen.* He got over £6,000 for it; and it is huge enough, of the standing pyramidal type for which the Abbey soon had little room. An obelisk 30 ft (9.1 metres) high. In its niche a statue of Pitt, haranguing. Below, a big balanced arrangement of five allegories: Prudence and Fortitude above, Britannia between 65 Ocean and Earth below. – Statue of Palmerston, 1870 by *Robert Jackson*.* – Three Captains monument, 1784–93, the largest work by *Joseph Nollekens*, after some consultation with *Sir Joshua Reynolds*. It was an official commission to three naval captains (Bayne, Blair and Lord Robert Manners) killed in 1782, and is similar to the Chatham monument in size and arrangement. Huge black obelisk. At the top Fame on a *columna rostrata* (i.e. a triumphal column ornamented with projecting ships' prows), with three portrait medallions suspended and a little flying allegory. Below, standing Britannia with lion, and reclining Neptune with seahorse. The column is Greek Doric of the Delian order, i.e. fluted at top and bottom only. – Viscount Castlereagh (2nd Marquess of Londonderry), statue by *J.E. Thomas*, 1844–50.

* Whose tomb-slab, to the SW, is markedly medieval: *Scott*'s revenge on Palmerston for spiking his first Foreign Office design (*see* p. 265)?

North transept, west aisle

Described anticlockwise, i.e. starting with the E SIDE from S to N. MONUMENTS. 4th Earl of Aberdeen, Prime Minister, bust by *Matthew Noble*, 1874, on a Gothic bracket. – Elizabeth Warren, 1822–4 by *Sir Richard Westmacott*, copied from a statue made for Lord Lansdowne not long before (called The Houseless Traveller). A seated beggar girl holding her baby, one breast bare: a moving work, and a landmark in return to pathos in sculpture after Neoclassical restraint. – Sir G. Cornewall Lewis, 1864, bust by *Henry Weekes*. – General Sir Eyre Coote, the first big work by *Thomas Banks*, 1784–9. Erected by the East India Company. Obelisk almost as huge as that of the Three Captains at its back. Victory hangs a portrait on a palm tree which supports a trophy. Weeping Mahratta captive and cornucopia, r. Classical detail and draperies. – Charles Buller †1848. Bust by *Weekes*. – Francis Horner. Statue by *Chantrey*, 1823. – In the centre of the aisle: 1st Earl Mansfield, Lord Chief Justice, 1793–1801 by *John Flaxman* 66 at a cost of £2,500. Unusual amongst the Georgian monuments in being wholly free-standing. Mansfield sits in robes with wig on a tall circular pedestal. Wisdom and Justice standing to l. and r. At the back Death as a naked youth leaning on an extinguished torch, a very pagan treatment. Moved one bay N in 1933. – E side, continued. Smaller standing monuments below. Brig.-Gen. Hope by *Bacon Sen.*, 1793, with a mourning Québecoise and beaver; in the carving Bacon's usual finesse. – Jonas Hanway †1786 by *J.F.* and *John Moore*. Relief on sarcophagus with seated woman clothing boys. Portrait medallion at the foot. – Sir Clifton Wintringham †1794, by *Banks*. Mourning wife with hair hanging down, and reliefs of Sir Clifton as a Roman physician visiting the sick. – Above, Maj.-Gen. Edwardes, by *William Theed*, 1871. Bust on pedestal with two seated angels – an C18 composition interpreted with Victorian sentiment. – Busts to r. and l.: Warren Hastings †1818 by *Bacon Jun.*, Richard Cobden by *Thomas Woolner*, 1865 (installed 1867). Above the latter, Sir H.S. Maine, medallion by *Boehm*, 1889.

N WALL. MONUMENTS. 2nd Earl of Halifax by *Bacon Sen.*, 1782. Lively and pretty; with eloquent Rococo bust and two putti at different levels. – In the triforium, three figures by *Scheemakers* from Rear-Admiral Watson's monument of 1760–3, designed by *James Stuart*. In the middle the Admiral in a Roman toga (until 1957 framed by a classical arcade with palm-tree columns). On the r. a kneeling figure symbolic of the Black Hole of Calcutta. On the l. a seated Indian prisoner, symbolic of those Watson captured at Ghereah in 1756. – Sir William Sanderson †1676, with a telling bust on curly pediment. Attributed to the *Burman* workshop (GF).

W WALL. STAINED GLASS. Bunyan Window, 1911, by *J.N. Comper*. – To its S, HMS *Captain* memorial window, 1873 by *Clayton & Bell*. A 'direct imitation of old glass', with some scenes deliberately aged. – MONUMENTS. All contained in the C13 arcading. From N to S: Lt.-Gen. Guest, 1752, designed and made by *Sir Robert Taylor*. Lively Rococo ornament and lifeless bust. – Admiral Balchen, by *Scheemakers*, 1744–6, with trophies and a

relief of a foundering ship. – Bishop Warren †1800, diagonally across from his wife's monument and like it by *Sir R. Westmacott*. No portrait. Standing figures of Religion and an angel; somewhat dull. – Two by *Scheemakers*, with busts: Lord Aubrey Beauclerk, 1743–5, with trophies; General Kirke, 1741–3, with putti. – Brig.- Gen. Kane †1736, by *Rysbrack*. Simple pedestal with volutes; excellent bust. – Bishop Bradford †1731. By *Sir Henry Cheere*; no figures. – Archbishop Boulter †1742, also *Cheere*, with sarcophagus and oak garland, trophies and bust.

North transept, east aisle

This aisle was once three chapels, of St John Evangelist (S bay, formerly extending E into the space of Abbot Islip's Chapel), St Michael (middle) and St Andrew (N). Between the S bay and the main transept a late C15 stone SCREEN with superimposed cinquefoiled openings. The space is now very full of monuments, which are described anticlockwise, i.e. beginning with the E SIDE behind Wolfe's monument (for which *see* North Ambulatory, p. 151 below). Against its back a late C13 COFFIN LID with foliated cross. – The first MONUMENT is Sir Francis Vere †1609. Free-standing, already of black marble and alabaster rather than polychromy and paint. Four kneeling knights support a slab on which is placed Sir Francis's armour, carefully carved piece by piece. Below, recumbent effigy on half-rolled-up mat. This novel conceit for England derives from the Nassau monument at Breda in Holland, of as long before as *c*. 1535; it was followed by Maximilian Colt for the 1st Earl of Salisbury at Hatfield (†1612). The carving here is inferior to Colt's, however, and Vere's tomb is now attributed to *Isaac James*. – Behind, against the Wolfe monument, Capt. Edward Cooke, 1806 by *Bacon Jun.* Tall and white. The captain, with a sail behind him, is attended by a brawny sailor and descending Victory. Relief of a sea battle below.

E WALL. Admiral Storr †1783, bust, unsigned. – Sir George Holles, *c*. 1632, by *Nicholas Stone*. Base with fine relief of horse-man in battle. A split pediment above, with volute ends and a fat garland, on which are Bellona and Minerva, rather huddled and pinched. The model (as for the other Holles monument, p. 163) is Michelangelo's Medici tombs. In the middle a pedestal with proud standing portrait statue, thought to be the earliest on an English monument. – To the l., Admiral Pocock, 1796 by *Bacon Sen.* Large seated Britannia, holding out a thunderbolt. Her elbow rests on a portrait medallion. – Above, Grace Scot †1645/6, a little thing, but important in the development of the cartouche type; attributed to the *Stone* workshop. – In front, Lady St John †1614, stiffly reclining effigy; not *in situ*. – J.G. Nightingale †1752 and his wife Lady Elizabeth †1731. One of *Roubiliac*'s most famous, masterly and immediate works; made in 1761. While out walking a flash of lightning gave Mrs Nightingale such a shock that she miscarried and died. Against a channelled archway with canted sides stands the husband, holding his wife and vainly trying to ward off Death in the form of a gruesome skeleton pointing a lance at her. Death stands with us on the ground, having just slipped out of the heavy

door of a vault below. The skeleton, carved by Roubiliac's chief apprentice *Nicholas Read*, is of hideous realism yet carries the same fantastic conviction as late medieval demons and monsters. Roubiliac must have known the skeleton on Bernini's tomb to Alexander VII at St Peter's in Rome (1671–8), but his is a crueller representation of grave's victory and death's sting. – To the l. three beautiful but fragmentary C15 NICHES from the chapel reredos, richly canopied; found buried in the floor and reinstated in 1876. – In place of the altar the MONUMENT to the charitable Sarah, Duchess of Somerset †1692, by *Grinling Gibbons*. Reclining on a sarcophagus, as if it were a couch. Eyes turned to heaven, pleading gesture. To l. and r. two kneeling boys. The back has gone. – Lord Norris †1601, made *c*. 1611, it seems, by *Isaac James*. A giant free-standing eight-poster, with two recumbent effigies on a sarcophagus, but also with more fully realized kneeling figures – six sons, three per side – than the Elizabethans usually managed. At the short ends an arch on piers between the columns. Solid central upper storey, with military reliefs to N and S, the début in the Abbey of this format of narrative sculpture. Cruder painted trophy to the w. The figure on top is Mercury.

N WALL. Mid-C13 DOOR, E. – MONUMENTS. Sir James Simpson, bust by *W. Brodie*, 1875. – Statue of Mrs Siddons by *Thomas Campbell*, 1843–5. – Unusual bellied tablet above to Susannah Davidson †1767, by *R. Hayward.* * – Bust of Dr Baillie on a Grecian pedestal, by *Chantrey*, 1827. – Above, 3rd Lord Rayleigh, 1921 by *Derwent Wood*, with portrait relief.

W SIDE, from N to S. Statues of John Kemble, the actor, completed by 1830 by *J.E. Hinchliffe* to designs by his late master *Flaxman*; and Thomas Telford, the engineer, 1839 by *E.H. Baily*. – Above, minor tablets: Charles Stuart †1801 by *Nollekens*, the brothers Forbes, 1803, and Rear-Admiral Totty †1802, both by *Bacon Jun.* – 6th Earl of Mountrath, 1766–71, the last echo in the Abbey of Roubiliac's dramatic manner. By *Joseph Wilton*, to designs by *Sir William Chambers*. Sarcophagus; the Countess kneels on it in a thin dress, revealing the form of the body. Large angel on clouds from the l. Upper part, with the Earl awaiting her on high, removed in the 1870s. – Against its r. side Admiral Kempenfelt †1782, by *Bacon Jun.*, 1808. Small; a rounded obelisk with reliefs of the sinking Royal George and an absurd apotheosis of the three-quarter-naked admiral. – Sir W.W. Follett †1845, statue by *William Behnes*. – Sir John Franklin, the explorer, †1847. By *Noble*, 1875. Nice relief of a ship being buffeted about in ice and wind.

For the crossing and sanctuary *see* below, pp. 164–5.

North Ambulatory

On the inner, S side here, the royal monuments lining the sanctuary and feretory appear, with a few later ones in front or below. The outer, N side mostly opens off into chapels. Since the royal monuments are best considered together, the two sides are

* Missing its horrendous relief showing Death stabbing her (now in the Lapidarium).

described separately; those in the sanctuary will be met again later in the circuit. Described bay by bay from W to E. At the entrance, IRON GATES of 1733, classical, designed by *John James*. – Some of the C13 PAVEMENT remains, of squared stones laid diagonally between straight E–W courses (more in the S ambulatory).

South (inner) side

First bay, i.e. N of the N transept E aisle. – MONUMENTS. On the S side, the first two of the great medieval procession around sanctuary and feretory. To the W, and visible – frustratingly – from the sanctuary only, is Aveline, Countess of Lancaster †1272. A reduced version of the central bay of her husband's tomb,

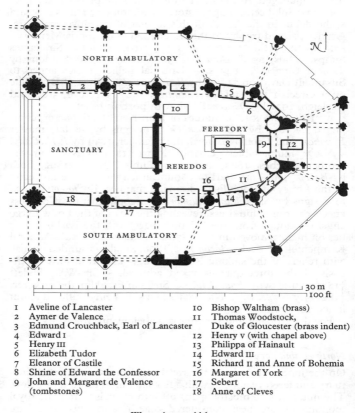

1	Aveline of Lancaster	10	Bishop Waltham (brass)
2	Aymer de Valence	11	Thomas Woodstock,
3	Edmund Crouchback, Earl of Lancaster		Duke of Gloucester (brass indent)
4	Edward I	12	Henry V (with chapel above)
5	Henry III	13	Philippa of Hainault
6	Elizabeth Tudor	14	Edward III
7	Eleanor of Castile	15	Richard II and Anne of Bohemia
8	Shrine of Edward the Confessor	16	Margaret of York
9	John and Margaret de Valence	17	Sebert
	(tombstones)	18	Anne of Cleves

Westminster Abbey.
Plan of the east end, showing tombs in sanctuary and feretory
(after RCHME, 1924)

in the bay to the E. The date is probably *c.* 1295, the designer probably *Richard of Crundale*, mason. Gable with cusped arch and crockets, tomb-chest with weepers. Excellent quality of sculpture, though badly preserved. The Countess wears a wimple and long robes, the Y-shape of the curves across and the main diagonals from one hip to the opposite foot typical of *c.* 1300. Two pillows, the upper set diagonally and upheld by angels. Two dogs support the feet. Shafts painted in red, black and gold patterns, gable with heraldry and rosettes, vault with vine-scroll. Early drawings record the gable trefoil painted to show Aveline's soul being carried to heaven. – Against the back and facing the ambulatory, 1st Earl Ligonier, 1773 by *J.F. Moore*. Dull, symmetrical composition. Fame in the middle; below, l., urn with portrait medallion; trophies behind; more portraits below.

To the E, Aymer de Valence †1324, cousin of Edward I. Of *c.* 1325–30, designed by or under *Michael of Canterbury*. Another of the gabled type, also closely derived from that to Crouchback just beyond (*see* below) but taller than Aveline's, and characteristically adapted also to the fashions of the advanced Dec style. The arch is five-foiled, cusped and sub-cusped, and the main cusps have ogee forms. Rich, lush carving, in full relief. Foliage sprouts on the cusps, and licks up the gable in the form of crockets. In the gable a trefoil with a mounted knight. High relief also for the recesses for weepers on the tomb-chest. Split-cusped circles between their gables. The weepers are more agile and supple than those of Crouchback's tomb, of a generation before. They turn easily into profile and demi-profile, and there is a certain irresponsibility and sensuality in the way they let their weight rest on one hip. The effigy is cross-legged. At his head two angels hold a small figure representing his soul. Much original colouring. – On the floor two BRASSES in raised Purbeck marble slabs, from tombs on the S side dismantled in 1772: below the tomb of Aymer, Sir John Harpeden †1457, knight in full plate-armour 4 ft 6 in. (1.4 metres) long; to the N, Abbot Esteney †1498, figure 4 ft (1.2 metres) long, vested for mass, one hand blessing. Wiry gable above his head, 3 ft (91 cm.) high.

Second bay. MONUMENT to Edmund Crouchback, Earl of Lancaster, brother of Edward I, †1296. The prototype of a group of architecturally ambitious and influential monuments made by the court workshops under *Michael of Canterbury* (cf. the two immediately W). Tomb-chest like recent French examples, with small weepers in recesses under crocketed gables, ten per side. On it a large tripartite canopy with a small quadripartite vault. The centre has a cusped arch with leaf decoration in the cusps, a steep crocketed gable, and in the space below it diapering and a trefoil with a figure of Crouchback in life, as a knight on horseback. The side parts are of similar design but extremely narrow, so that their gables tail off almost to the width of the pinnacles. There is an English precedent for the triple-gabled canopy at Hereford (Bishop Acquablanca †1268), but the combination of different gable widths is another recent French innovation. It may have been meant here to allow a clear view through the middle up to the rood over the altar. On the curiously clumsy brackets of this middle gable stood angels holding candles.

Sumptuous big top finial. Another novelty is the ogee arches, the earliest at the Abbey, in a quite inconspicuous position under the gables towards the ambulatory. The form first appeared in England on the Eleanor Crosses a few years before (*see* Charing Cross Station, p. 300). The weepers are in style so close to figures on the crosses (especially the Waltham Cross) that the same carver may well be responsible for these. The Waltham carver was *Alexander of Abingdon*, Imagour or Imaginator, a man traceable till 1312. Crouchback is represented cross-legged, turning towards where the rood would have been; two angels hold his pillow. The effigy, weepers and architecture were all painted and gilded, partly over gesso (cleaned and restored 1921, 1971–6). Base towards the ambulatory with a frieze of painted knights, including Crouchback's relations, standing on a brown ground with small flowers. Dark green background as if to represent the dense leafage of a wood. – COFFIN LID in front with foliated cross, later C13 type, *ex situ*.

Third bay. The first bay alongside the feretory, with a good view of its tombs and glimpses of the shrine and reredos behind (*see* pp. 155–60, below). The first MONUMENT is to Edward I, †1307. Large, completely undecorated dark Purbeck tomb-chest, with no effigy: a soldierly rebuke to vain display, or merely unfinished? Mid-C16 inscription. The wooden canopy and iron grille have been lost. – The timber STEPS in front, later C19, perpetuate the post-Reformation access route.

Fourth bay. MONUMENTS. Henry III, †1272. Erected in or by 1280, in the most honorific position just N of the shrine. The base and tomb-chest are amongst the inlaid works of the Cosmati of Rome, who also decorated the shrine of the Confessor himself (*see* Feretory, pp. 155–6 below). The panels of porphyry, overlapping circles, etc., best preserved towards the ambulatory, are characteristic. Both stages have or had twisted columns inset at the angles, now reduced to two at each lower corner (originally three), and a solitary column above. On the S, towards the feretory, two trefoiled niches l. and r., flanked by pilasters, and in the middle a pediment on smaller pilasters, more 'Renaissance' than anything in England before Henry VIII. There are parallels with the later Cosmati altar at S. Maria Maggiore in Rome, and also with the later C13 papal tomb-chests at Viterbo. The EFFIGY was made by *William Torel*, the first English royal example in bronze gilt. It was commissioned in 1291, a year after Henry's body was placed within. The figure is slim and frail with long limp hands and long feet with pointed shoes. Drapery with long parallel folds to l. and r. and a few quiet loops across. Sensitive, far from vigorous face. The figure originally held the sceptre and rod of virtue, and had a head canopy and lions at the feet. Henry's crown was enriched with jewels. Thin TESTER of timber, with quatrefoil angle brackets. – To the E, invisible from the ambulatory, Elizabeth Tudor, infant daughter of Henry VII, †1492. Small. Tomb-chest of Purbeck marble, lid of dark Lydian marble. The effigy is lost.

Fifth bay. MONUMENT to Queen Eleanor of Castile, first wife of Edward I, †1290. Tomb-chest of 1291–2 by the mason *Richard of Crundale*, a reversion to Northern Gothic models. Purbeck

marble, with blank trefoiled arcading under crocketed gables.*
Shields are carved under the arches, as if suspended from
branches of oak, maple, thorn, etc. (now much eroded). The
EFFIGY is again of gilded bronze and was made by *Torel* at the
same time as Henry III's. The queen lies on a gilded bronze top
plate nicely powdered with lions and castles, with a marginal
inscription in Norman French. Her robe and mantle flow down
in the same long, fine parallel folds as Henry's. The face also has
the same tender and vulnerable character. One raised hand, orig-
inally holding a sceptre, the other holding her cloak-string. Above
the head a trefoil-arched gabled canopy. The small leaf crockets
on it already have the knobbly, non-naturalistic shapes usual by
the early C14. Lions at the feet. The view from the ambulatory is
obstructed by an outward-curving IRON GRATE, made by *Thomas
of Leighton*, 1293-4 (found in pieces and restored by *Scott*, 1849).
The composition is in tiers of paired stamped scrolls, still resem-
bling the stiff-leaf foliage conventions of the earlier C13. Trident
spikes along the top, beast heads at the bottom. The wooden
TESTER is C15. Also towards the ambulatory, the plinth on which
the tomb-chest rests has faded PAINTING of *c.* 1300. It repre-
sents Sir Otto de Grandison, a fellow crusader with Edward I,
kneeling to the Virgin, r., and on the l. four courtiers or clerks
also in prayer.

The description continues with the N ambulatory N side. For
Henry V's Chapel *see* pp. 157-8; for Henry VII's Chapel *see* pp.
180-5.

North (outer) side

First bay. MONUMENTS. Blocking the N transept E aisle, General
Wolfe †1759. The second Abbey monument paid for by Parlia-
ment, after a competition in 1760 won by *Wilton*. Finished 1772.
Wilton's first public work shows the influence of his Flemish
training, and also the mid-C18 turn to emotive tableaux and con-
temporary dress. Huge tent canopy behind, against trees. The
General reclines dying and semi-nude, tended by two strong-
featured soldiers. One indicates Victory flying in from on high,
l. Two scrawny lions at the angles. On the plinth, relief of the
Battle of Quebec in fisheye perspective, cast unusually in lead.
By 'Capitsoldi', probably *G.B. Capezzuoli* of Florence. – Tablets
against the E wall. Brian Duppa, Bishop of Winchester †1662,
convex. Signed by *Balthasar Burman*. – Below, J. Beresford
†1812, with trophies, by *Henry Westmacott*. – Sir J. Oughton
†1780, delicate, by *R. Hayward*. – Pretty coloured Gothic tablet
commemorating the Countess of Pembroke, widow of Aymer de
Valence. 1991, designer *Donald Buttress*.

Second bay. ABBOT ISLIP'S CHAPEL (Jesus Chapel). Made
in the 1520s, i.e. during Islip's lifetime (†1532), probably by the
Abbey mason *Henry Redman*; decorated up to 1530. Very rich,
with the exceptional feature of two storeys each with an altar.
Henry V's Chapel also has two levels (*see* p. 157), but the late C15
chantry chapel of Edward IV at Windsor is a closer precedent

*A near-identical tomb for her entrails at Lincoln Cathedral was destroyed in 1641.

in that each of its levels was provided with an altar. Islip's is arranged differently, like an early double-decker bus with 'inside' and open top, rather than an enclosed upper chamber with oriels. Three-bay panelled wall towards the ambulatory with shaped and pierced transoms. The entrance fills the narrower W bay. Some mid-C20 renewal of the E bay. Cornice with the carved letters ISLIP and the Abbot's two rebus, a hand holding an eye within a slip of foliage, and a man falling ('I slip') from a tree. Upper level with panelling and small figure niches, continued on the W wall, inserted facing the N transept. Inner walls panelled with blank tracery, and a lierne vault on quarter-fans after that over Henry V's tomb, recoloured 1938–9. It has a defaced boss surrounded by stiff, straight ribs. To the N and S shallow bays with depressed tunnel vaults, of different designs both deriving from Henry VII's Chapel. Mutilated carving of Christ with angels on the E window respond. The staircase climbs within the thickness of the W wall, with a squint into the lower chapel. The upper one became a NURSES' MEMORIAL CHAPEL in 1950, when *Sebastian Comper* restored the whole. – STAINED GLASS by *Hugh Easton*, 1949–50. His characteristic big pictures of earnest idealized figures in clear glazing. The lower window commemorates Islip (a piece of C16 glass with the Abbot's rebus is reset over his head) and also the Abbey's safe deliverance from war. – Upstairs, ALTAR, made up in 1950 from parts of Abbot Islip's monument, originally in the lower enclosure: marble slab, paired bronze columns of Renaissance character. The original form was a four-poster, with an effigy (lost) below. – CRUCIFIX over, after that by *Giambologna* (1529–1608) in SS Annunziata, Florence. – (C16 WALL PAINTINGS of two kings, faded monochrome, E wall.) – STALLS, 1950.

Third bay. MONUMENTS. Two tablets flank the Chapel of the Pew doorway. Juliana Crewe †1621, l., alabaster, of advanced Mannerist forms. – Lady Jane Crewe †1639, r. Small relief of her expiring in bed; disconsolate husband, and four children. The atmosphere Italianate, the feeling genuine. Skull-and-crossbone capitals to the aedicule frame.

CHAPEL OF THE PEW. Hollowed out of the wall in the later C14, W of the Chapel of St John (*see* below), but not originally opening into it. Doorway with two-centred cusped and sub-cusped arch. Square hoodmould on angel busts. Original painted wooden HALF-GATES with iron guards on top. – Broad richly canopied RECESS above, late Perp style and exquisitely carved. Thought to come from the altarpiece of the Chapel of St Erasmus, built c. 1485–6 by Queen Elizabeth (Woodville) s of the C13 Lady Chapel, and demolished for Henry VII's Chapel c.1502. Islip reset it with a surround of his own badges and a painted inscription. The INTERIOR is only 9 by 6ft (2.7 by 1.8 metres) in size. Its form is puzzling, with two staggered bays with tierceron vaults. The first has panelled walls – an early appearance of this staple later Perp motif – and a good boss of the Assumption. The bays are of different dates, probably due to enlargement after 1376, when a bequest was made to a chapel here that was already being used for masses for Aymer de

Valence. The added inner bay must date from Richard II's reign (1377–99), as the PAINTING inside both parts includes traces of Richard's badge of a hart; also brocade patterns, etc. The niche in the N wall matches the entrance details. It looks reset. The doorway through to the Chapel of St John, r., was cut after 1524. – SQUINTS into Islip's chapel, W, and the Chapel of St John, E; 1520s. – SCULPTURE in the N niche, a Virgin and Child in alabaster (like aspic), hieratic in style. By *Sister Concordia Scott*, installed 1971.

Fourth bay. MONUMENT. Rear-Admiral Holmes †1761, another by *Wilton*. Roman dress; elegant pose with one hand on hip, the other on a big gun, draped with a huge banner. Grey obelisk behind.

CHAPEL OF ST JOHN THE BAPTIST (reached through the previous chapel). The first in order of the polygonal C13 ambulatory chapels, and indicative of the way MONUMENTS colonized them, especially after the Reformation. By far the largest and, at 36 ft (11 metres), the tallest in the Abbey, is that of the 1st Lord Hunsdon †1596 and wife, at the E end. Oversized sarcophagus under deep coffered arch, with a chequered false-perspective top and obelisks l. and r. To l. and r. of these big coupled red columns, and in front of them taller obelisks. Then a complete upper tier, again with columns and obelisks. The obelisks stand on six-poster bases. Third tier with an octagonal domed structure in the middle. Much ribbonwork; very unorthodox in many details.

Other furnishings, proceeding clockwise. In the corner, r., MONUMENT to the Countess of Mexborough †1821, tablet with weeping female and urn. It might be in any village church. – On the S side, three late medieval clerical monuments in a line, all with tomb-chests with the customary shields in square foliated panels. First, Abbot William of Colchester †1420, the effigy with two angels by the pillow, a dog at the feet. Traces of colouring remain. The canopy is lost. – Above, tablet to Lt.-Col. C. MacLeod. Sub-standard *Bacon Jun.*, 1813, with angel. – Thomas Ruthall, Bishop of Durham, †1523. Formulaic effigy, in poor condition. It blocks the original chapel entrance. – Abbot Fascet †1500. No effigy. Big canopy, the E support of which is panelled outside and serves as a back behind the head of Bishop Ruthall, where it is dated 1520. It has a depressed arch with panel vaulting and plain straight top. – Mary Kendall †1710. Kneeling in a Baroque attitude between two columns. – Sir Thomas Vaughan †1483. Plain chantry tomb, the chest with damaged 3 ft (91 cm.) brass of knight in armour under a big ugly four-centred arch. – Col. Edward Popham †1651 and wife, the only Cromwellian monument suffered to remain after the Restoration. Black and white. Their clumsy figures lean on a pedestal with a helmet. Pilasters l. and r., baldacchino above. Attributed to *William Wright.* – Tomb-chest with blank trefoiled arcading on the upper stage. Probably designed *c.* 1270–90 for a younger member of the court circle; moved from the Chapel of St Nicholas in the C16. – In the middle of the chapel, Thomas Cecil, 1st Earl of Exeter (†1623) and wife. Also black and white. Big square tomb-chest

with large recumbent effigies. Space left for the Earl's second
wife. The tomb-chest has compartments with wreathed shields
separated by pilasters. Finely lettered top slab.

Fifth bay. MONUMENT, l. William Pulteney, 1st Earl of Bath,
by *Wilton*, 1767. Reredos back with pilasters and pediment.
Against the entablature a portrait medallion with thin garlands.
Strongly diagonal composition, but calm figures: Wisdom, seated,
and Poetry, standing, l. and r. of a big urn.

CHAPEL OF ST PAUL, behind. SCREEN of stone, from the time
of Abbot William of Colchester, i.e. 1386–1420. Three tiers of
panelling, the lowest partly solid, the others pierced. Embattled
top. The l. part missing, the r. part cut into by the MONUMENT
to Lord Bourchier (Henry V's standard bearer, †1430) and wife.
This has the usual quatrefoiled tomb-chest, here with shields
within garters and large eagles and lions bearing standards at
the angles. Four-centred arch, an early and squashed-looking
example, with starved lierne-vault panelling inside. No effigy; the
carving big and coarse. With the screen, brightly repainted and
gilded 1967–8. – OTHER MONUMENTS. In the middle, 1st Lord
Daubeney †1508 and wife, with alabaster effigies, two tiny bedes-
men at his feet. Railings reconstructed 1889. – Clockwise from
the entrance: Sir Rowland Hill, bust signed *W.D. Keyworth Jun.*,
1881. – Sir Henry Belasyse (†1717), 1735–7 by *Scheemakers*. Black
obelisk with urn on sarcophagus, against the back of the monu-
ment to Lord Bath. – The rest late C16 to mid C17, each filling
one bay. Sir John Puckering †1596 and wife. The accepted type.
Tomb-chest with children kneeling against it. Two recumbent
effigies, he behind and a little higher. Coffered arch with elabo-
rate strapwork around the inscription, columns l. and r. Big
upper storey with figures of a Purse Bearer and a Mace Bearer,
and obelisks. – Sir James Fullerton †1632 and wife. Another
with recumbent effigies, husband again behind wife and higher
up, but by now without strapwork or a canopy to the back arch.
Attributed to *William Wright* (GF). – Sir Thomas Bromley †1587.
Also typically Elizabethan. The effigy is propped up on a partly
rolled-up mat, and lies on a sarcophagus with eight children
against it. Shallow arch with Fame and Immortality in the span-
drels, putti in the tympanum holding a purse of office. – Dudley
Carleton, 1st Viscount Dorchester, 1640 by *Nicholas Stone*. In a
much more classical taste. Tomb-chest with reclining effigy, com-
fortable and at ease. Probably the earliest English example of this
new courtly and elegant version of a familiar attitude. Tall fluted
columns l. and r., broad open segmental pediment. – Where
the altar stood, Countess of Sussex †1589. Recumbent effigy,
columns, strapwork, under an achievement between obelisks. –
1st Lord Cottington †1652 and wife †1633. An amalgamation of
two C17 monuments. Black marble structure of 1634–5 by *Hubert
Le Sueur*. Top aedicule with Lady Cottington's frontal bust in gilt
metal, surrounded by a gilt metal wreath. Below, an inscription
plate and a sarcophagus standing on a very high base. On it
an effigy of her husband (reburied here 1679), until 1867 placed
on its own slab in front. He reclines in the costume of
c. 1630–40, twisting upwards to look at her. Attributed to *Cibber*
(GF).

Feretory (Chapel of St Edward the Confessor)

The FERETORY (from *feretrum* or bier) is used to describe the elevated area around the shrine of Edward the Confessor, who was canonized in 1161. It was the most spiritually potent area of the medieval Abbey, and the burials around it are almost exclusively royal.

SHRINE and PAVEMENT. Abbot Richard Ware (1258–83), in 1268, obtained from Rome antique porphyry and other coloured marbles for a pavement, and also Italian masters to lay it down and do other work (payments of 1267/8 and 1271/2 refer specifically to paving). The results may be seen on the Confessor's shrine and surrounding pavement, on Henry III's tomb and that of the royal children (*see* North Ambulatory, p. 150 and South Ambulatory, p. 163), and in the pavement in front of the high altar (*see* Sanctuary, p. 164 below). These share decoration of the entirely Roman type known as Cosmati work, current in Italy between the C12 and C14. It is distinguished in materials by a mixture of red and green porphyry slabs and glass mosaic (here set into Purbeck marble), in design by circles surrounded by ribbons intertwined or plaited and by repeated diamonds and diagonal squares. Though the medium is common enough in Rome it is clear that as an export it carried the highest prestige. The only surviving English precedent is the late C11 work around Becket's shrine at Canterbury.

SHRINE OF EDWARD THE CONFESSOR, †1066. Strictly what remains is the C13 shrine base with a C16 cover. The base is of Cosmati work inlaid in Purbeck marble. It has the usual Cosmati motifs seen in the pavement, and twisted pillars or colonnettes in addition: at the corners, and flanking the recesses for kneeling in below. Twisted pillars at a shrine may refer to the 'salomonic' columns – said to have come from Solomon's temple – at the shrine in Old St Peter's, Rome. There are three recesses on the N and S sides, one on the E. They have trefoil-pointed heads, a Northern Gothic motif, though one that appeared in Italy soon after 1270. As there are no Italian parallels for a shrine of this type, it seems that the overall design owes much to England. Work on the ensemble appears to have gone on for some time after the saint's body was translated here in 1269. The base, dismantled at the Dissolution, was reassembled less than perfectly in 1557, during Mary I's revival of Catholic practice. Of this time the cornice (partly of reused tracery) and the wooden shrine COVER. This has two diminishing orders of Renaissance arches separated by pilasters, heavily restored and prettified by *Dykes Bower* in the 1960s. A black marble ALTAR, W, was added in 1902. The shrine itself was commissioned by Henry III in 1241, i.e. before the rebuilding. Illuminated manuscripts show that it was of the customary C12–C13 coffer type with a steep 'roof'; written accounts dwell on its pure gold enriched with precious stones. It would have been visible from the W before the present, higher reredos was erected in the mid C15.

A difficulty arises over the identity of the Roman workman or workmen who came to distant England for the C13 campaign.

The sanctuary pavement was signed by *Odericus* and dated 1268, the base of the shrine by *Petrus Romanus*, 1269. These may have been the same man, or Petrus may have been the son of Odericus; a Petrus Oderisi was the master of the tomb of Clement IV at Viterbo, completed 1274, which has strong affinities with the Westminster work.

In the pavement to the E, remains of two brass and glass-mosaic TOMBSTONES, John de Valence and Margaret de Valence, †1277 and 1276 respectively, also part of the work of the Cosmati. – BRASSES. To the NW, Bishop Waltham of Salisbury †1395, with canopied surround (damaged): the first non-royal burial from outside the Abbey community. To the SE, Thomas Woodstock, Duke of Gloucester †1397 (indent only), an unusual design with tiers of small figures.

REREDOS, at the W. The back of the high altar reredos remains as completed in 1440 by the mason *John Thirsk*. The lower part is panelled, with doorways to r. and l. framed by big statuary niches, with smaller niches in their frames. Between them a long run of damaged canopies with miniature pendant vaults. The chief interest is the undercut FRIEZE with stories from the Life of Edward the Confessor. The subjects, from l. to r., are: (1) the swearing of allegiance to the unborn king; (2) his birth at Islip; (3) his coronation; (4) the Devil (destroyed) appears before him on the Dane-Geld casks; (5) he warns a thief to escape; (6) Christ appears to the king; (7) his vision of the Danish king ship-wrecked; (8) Harold and Tostig quarrel before the king; (9) his vision of the Seven Sleepers of Ephesus; (10) he gives a ring to St John, disguised as a beggar; (11) water used by the king cures the blind; (12) St John gives the ring to two pilgrims; (13) the pilgrims return the ring; (14) the dedication of the Abbey (damaged). Trefoils between the scenes, in the form of a ribbon linking up below.

RETABLE. The Westminster Retable is to be placed in the feretory when conservation work is complete. In spite of its fragmentary state, it is the finest late C13 panel painting remaining from Northern Europe. Originally it is thought to have been placed above the high altar, the C15 reredos of which has a recess fitting its large size (11 ft by 3 ft, 3.4 by 0.9 metres). The likeliest date is the 1270s–80s. The Northern medium of linseed oil is used, but whether the artist was English or French will perhaps never be possible to say. The closest parallels are with manuscript illumination, and specifically with the Douce Apocalypse, which was produced for the English court circle. But even if made in England, foreign workmanship is not impossible; the iconography has roots in both countries, and the glass for the inlays came from Northern France.

The retable consists of five parts, all with frames covered in gesso and enriched with painted or gilded glass in imitation of mosaic (and originally also with quasi-antique cameos). Parts one and five have St Peter, l., and St Paul, r. (missing), under cusped arches and gables. Parts two and four are exotically panelled with four eight-pointed stars of Islamic derivation, arranged as two tiers of two. Part three, i.e. the centre, is a tripartite frame of micro-architecture like the canopy of the Crouchback tomb

(*see* pp. 149–50), with cusped arches and gables. Under the middle one stands Christ, blessing with his r. hand and in his l. holding the world (with a minute landscape with animals, birds and fishes). To the l. and r. are the Virgin and St John. The proportions of the figures are elongated, the heads very small. One must go close to appreciate the delicacy of transitions, especially in the modelling of the faces. They are quite different from the contemporary Italian innovations of Giotto and Pietro Cavallini, with their directed shadows, and yet share in their quest for more three-dimensional effects. In the star-shaped panels are stories of the miracles of Christ. Three scenes are still recognizable, l.: the raising of Jairus's daughter, the healing of the blind man, and the feeding of the five thousand. What can be recognized of action is of great tenderness.

CHANTRY CHAPEL OF HENRY V. By the early C15 there was no space for further major tombs around the feretory. Henry V's chantry chapel was therefore built as a double-decked and high-walled stone bridge, projecting E over the ambulatory. The idea is most ingenious and succeeds in fitting a complete and quite roomy chantry chapel into the congested space. The tomb-chest is placed at the E end of the feretory platform, which was extended slightly E to receive it. This was done in 1422, several years after Henry made his will, in which the basic outlines of the whole were determined. The tomb-chest was completed *c*. 1430. Above it, and carried as a bridge across the ambulatory to above the entrance of the former Lady Chapel, is the loft or stage with the altar. This was started in or after 1438, when materials began to be amassed for it, and not finished until the 1450s. Two spiral staircases lead up to it, placed in front of the two E piers of the apse. The little vaults at their tops are fans. The idea came from the relic tribune at the E end of the Sainte Chapelle, though the general effect is close to the usual C15 English gatehouse. The TOMB-CHEST, of Purbeck marble, has recesses with rather French depressed segmental heads, and an effigy of oak formerly sheathed with gilt silver. A head and hands of polyester resin, by *Louisa Bolt*, were added in 1971, replacing silver parts stolen in 1546.

The structure of the CHAPEL, now badly decayed, was by *John Thirsk*. The staircase turrets are all of Perp openwork, with a frieze of canopied niches between them. The loft is solid, with a frieze of undercut heraldic beasts and a tall upper tier of figures in niches, doubled at the E where the parapet rises to make relic enclosures facing the altar. These double tiers continue along the E wall on either side. Ornament and statuary encrust the wall above. The loft vault has elaborate lierne enrichments. At the E end is an open arch, originally for access to the C13 Lady Chapel, later replaced by the vestibule to Henry VII's Chapel (*see* pp. 127–8 and 136). The style and scale of the SCULPTURE are far from uniform. Life-size figures stand against the stair-turrets. The largest groups among the rest show Henry V, twice on horseback (against the E returns), and twice crowned and with attendants (on the bridge sides). Some show the broken jagged angular draperies introduced in the Netherlands *c*. 1430 (e.g. Annunciation above the altar). The small figures with the broken folds are

on the whole of better quality than the long, stiff and lifeless, more traditional figures against the turrets. Hardly any can compare with the best in France and Germany. – Iron GATE to the tomb platform, at the w. Close diapering below, Perp tracery above, of angular patterns paralleled by some of those of the monument itself.* Reassembled and restored *c.* 1853. (– Above, simple TOMB-CHEST of 1878, when Katherine of France, Henry's queen, was reinterred here. The cornice over it has trefoils in it just like those of the reredos, Thirsk's other major work here.)

CORONATION CHAIR. Displayed since 1998 E of Henry V's tomb. Made in 1299–1301 by *Master Walter of Durham*, the King's Painter, to contain the Stone of Scone seized by Edward I in Scotland in 1297. It is of oak with arms curving up to the back. In the middle of the back rises a steep gable. The chair is decorated with blank arcading with circles, quatrefoils and trefoils. The forms may echo those of a metal chair commissioned for the same purpose in 1297 but never finished. They show an advanced knowledge of architectural forms, e.g. in the trefoil-headed arcading along the back. It was once also entirely covered with decoration of *c.* 1330–50 in glass mosaic and gilding. Naturalistic leaf patterns visible on the l. arm outside. The lion supporters are of 1727. In 1996 the Stone was returned to Scotland.

Henry VII's Chapel see pp. 180–5

South Ambulatory

The royal monuments continue along the inner, N side. On the outer, S side are just two chapels (the Chapel of St Benedict, W, is included with the S transept, p. 166). The description is from E to W.

North (inner) side

First bay. MONUMENTS. Queen Philippa of Hainault, wife of Edward III, †1369. Made in 1367–9 by *Jean de Liège*, a sculptor from Brabant then working for the French court. Dark grey marble tomb-chest with very damaged, originally daintily pierced white alabaster niche-work. The difference from the treatment of the English-designed tomb-chests forty and thirty years before is remarkable. Equally remarkable is the difference in sculptural style. The elegant stylizing of the early C14 is here replaced by a new veracity in portraiture and costume. This is specially notice-able in the face of the middle-aged Queen and in the two solemn weepers at the NE end, recovered with their niches and replaced by *Scott*'s detective work in 1857. The figures, of marble, were originally painted and decorated with gold, glass and beads. There were also bronze angel attendants. To the l. and r. of the Queen buttress strips with four tiers of niches for figures.

*And very unlike the mid-C15 iron screen formerly to the E, much of which has been reassembled in the Lapidarium. Previously the E end of the feretory was occupied by an altar where the more precious relics procured by Henry III were kept. There was also a W altar, and two pillars with golden statues by the chief shrine.

Pretty filigree canopy. The very modest wooden TESTER may be original. – Below, Sir Robert Aiton †1638. Hanging monument of black and white marble, with a bronze bust in an oval niche attributed to *Francesco Fanelli*. Much livelier than Le Sueur's portraits. To its l. and r. standing figures of Apollo and Minerva, very classical and sedate. Two mourning putti on the pediment. These parts perhaps by *I. Besnier*.

Second bay. Edward III †1377. Begun *c.* 1386, when Purbeck marble was shipped for the tomb-chest. On it six flat recesses, separated by slender buttresses and two-tier panelling. The design was probably by *Henry Yevele*, who was certainly responsible for Richard II's very similar tomb-chest in the bay to the w (*see* below). In the recesses exquisite, rather toy-like, yet very realistic figures of Edward's children, rendered in bronze (or, properly, latten). From l. to r., they are the Black Prince, Joan de la Tour, Lionel, Duke of Clarence, Edmund, Duke of York, Mary, Duchess of Brittany, and William of Hatfield. The identities of four are corroborated where the small enamelled shields survive below. Another six, facing the feretory, are lost. The effigy is also of bronze gilt, by an unknown maker. It is impressive in the new calm way of which Chaucer's age was capable, with none of the alluring mannerisms of the earlier c14. Placid face with hair and beard in long even flow. The features are close enough to Edward's funeral effigy to suggest some attempt at a portrait. His hands held two sceptres. The effigy is flanked by flat strips instead of buttresses, and on these are four tiers of small bronze angels. Straightforward three-sided canopy above the head of the effigy with concave-sided steep gables; vaulting inside. Exceptional oak TESTER, probably by *Hugh Herland*. The form is a row of ogee-sided decorated gables and rich openwork cusping, parapet and cresting. Below the tomb-chest and towards the ambulatory a lower stage of square panels with shields.

Third bay. MONUMENTS. Richard II and Queen Anne of Bohemia (†1399 and 1394), the first at the Abbey to be shown side by side. Made in 1395–7. Tomb-chest of Purbeck marble, very like that of Edward III to the E, but a little longer, more damaged and without attendant figures. The stone was supplied by *Henry Yevele* and *Stephen Lote*, who must also have designed it. Gilt-bronze effigies made by *Nicholas Broker* and *Godfrey Prest*, coppersmiths, after a design from an unrecorded source. They have exquisite engraved decoration with fleurs-de-lys, lions, the white hart of Richard II, eagles, leopards, ostriches, broompods, etc., extending on to the pillows and top plate. The effigies, which have lost their arms, have gentle long parallel folds in the draperies, like those of Edward III. Excellently characterized faces. Two separate plain canopies above their heads. Simple wooden TESTER of 1396, with faded PAINTING by *John Hardy*: the Coronation of the Virgin, Christ in Majesty, and two pairs of angels holding shields. – Margaret of York, infant daughter of Edward IV, †1472. Small dark marble tomb-chest, between Edward III and Richard II. The brass effigy is missing.

Fourth bay. MONUMENT. King Sebert. A niche with a broad segmental arch, forming part of the substructure of the sedilia of *c.* 1308 (*see* Sanctuary, p. 164 below). It replaced an earlier

but certainly spurious tomb to this early C7 East Saxon king and legendary founder of the Abbey. Blocked in the C15 with blind panelled tracery, including some straight-sided lozenge shapes. The early C14 PAINTINGS on the sedilia backs are easily inspected, though less well preserved than those on the other side. They may be by *Thomas of Durham*. They show the Confessor, l., and fragments of an Annunciation, r., with figures 8 ft (2.4 metres) tall. In the characteristic style of the earliest C14, more familiar from illuminated manuscripts than from monumental painting. At Westminster this style appears as a somewhat more vigorously stylized development of that of the retable and the wall paintings of the S transept S wall (*see* pp. 156–7 and 168). Strong, dark colours. – GATES of 1733 at the exit, designed by *John James*, a pair to those in the N ambulatory but set one bay further E.

South (outer) side

First bay. MONUMENTS. Sir Thomas Ingram †1671, l., with cherubs in coils of drapery. Coarse. – Sir Richard Tufton †1631, with white marble bust in oval niche; curved open pediment with Michelangelesque mourners. Attributed to *William Wright*.

CHAPEL OF ST NICHOLAS. SCREEN of stone, the more intact counterpart to that in the Chapel of St Paul. Period 1386–1420. – In the middle, MONUMENT to Sir George Villiers and his second wife, parents of the 1st Duke of Buckingham. Made for £560 in 1631–2 by *Nicholas Stone*. White marble effigies, he in armour, on a big black and white marble sarcophagus with inscription and armorials. Stone subcontracted the E armorial (hers) to *Harry Akers*, the W one (his) and the corner pieces to *Anthony Goor*.

Other fittings are described clockwise from the entrance. MONUMENTS. Lady Cecil †1591, wife of Sir Robert, later 1st Earl of Salisbury. Small alabaster tomb-chest with angle pilasters, the top obviously not belonging. – BRASS in front of Sir Humphrey Stanley †1505. 3 ft (91 cm.) figure. – Lady Jane Clifford †1679. Big square urn of black and white marble, on feet to which cherubs' heads are attached. The inscription as if it were written on two nailed-on pieces of parchment. Attributed to *John Bushnell*. – Countess of Beverley †1812 by *Nollekens*. Large, stark Grecian tablet. – Anne, Duchess of Somerset †1587, widow of 'Protector' Somerset, who built the first Somerset House (*see* p. 318). Large standing wall monument. Recumbent effigy, the mantle from one side draped around her legs. Shallow coffered arch with strapwork cartouche, coupled columns on each side. Superstructure with obelisks, and achievement between coupled columns. – Nicholas Bagenall, a baby, †1688. Free-standing, small, steep black pyramid with urn. – Behind, hanging monument to Lady Fane †1618 (restored 1764). Frontally kneeling figures under baldacchino of drapery, looped to columns on the l. and r. Outside the columns small standing angels. – Below, r., a plain Purbeck marble tomb-chest, said to be to Lord and Lady Carew †1470. – Lady Burghley †1589 and daughter. Like the Duchess of Somerset's, but with two effigies, and with red

24

columns used to give greater depth. These frame three daughters and one son (Sir Robert Cecil), kneeling and facing E. On the flat upper storey another kneeling figure, representing Lord Burghley. – William Dudley, Bishop of Durham †1483. The Purbeck tomb-chest and lierne-vaulted canopy with suspended arches and pierced parapet derive closely from the Brocas tomb (†1396) in the Chapel of St Paul. Finely decorated cornice; indent only of the brass. – Anne Harlay †1605, daughter of a French ambassador. White obelisk on square pedestal (cf. Margaret Hoby's monument, also †1605, at Bisham, Berks). – Marchioness of Winchester †1586. The familiar later C16 formula, except that one child is given its own poignant mini-monument with sarcophagus, bottom l. Attributed to *Garat Johnson Sen.* – On top, Elizabeth, Countess of Exeter †1591. Reclining figure from a larger tomb, dismantled for the following. She wears an unusually large hood. – Elizabeth, Duchess of Northumberland. Designer *Robert Adam*, 1778, maker *Nicholas Read*. Large, flat, standing wall monument of an unusual tripartite composition. Arch in the middle with black inscription plate and a toy-sized lion and unicorn outside it. Above this a larger inscription, 'Esperance en Dieu', and a fluted straight-sided sarcophagus with a delightful relief of Charity. To the l. and r. above stand Faith and Hope, against tall pedestals with urns. The summit an urn and putti against an obelisk. – Philippa, Duchess of York †1431. Undistinguished effigy on a decorated tomb-chest, formerly with a timber canopy.

CHAPEL OF ST EDMUND. SCREEN. C15, of wood, straight-topped. MONUMENTS. An exceptionally rich and strange collection, especially of the Middle Ages and C17. In the middle, three medieval BRASSES, the first two the finest in the Abbey. Eleanor Duchess of Gloucester †1399, wife of Edward III's youngest son. 5 ft (1.5 metre) figure in widow's dress; architectural surround with tripartite canopy and the swan badge of her family, the Bohuns. – To its N, Robert Waldeby, Archbishop of York †1397. 5 ft (1.5 metre) figure and single canopy. – Sir Humphrey Bourchier †1471, on a quatrefoiled tomb-chest, the figure largely gone. Little brass badges of elbow-cops by its side.

OTHER MONUMENTS, mostly clockwise from the entrance. John of Eltham †1336, brother of Edward III, i.e. a royal monument. Datable after 1339. Tomb-chest and effigy of alabaster, amongst the earliest in that material. He is in armour, turning slightly towards the shrine, with crossed legs resting on a lion; two angels at the pillow. Niches on the sides for weepers, grouped in threes. These little royal figures are best preserved towards the ambulatory. They are very outré in the sway of their hips, and step out as if dancing. On the lower stage, panels with unusual deep-sunk double-curved frames. They are close enough to details of contemporary work inside St Stephen's Chapel to identify its chief mason *William Ramsey III*, who had a sideline as a tomb-maker, as the designer. A canopy, with three tall slim arches of equal width, was destroyed in 1776. – Blanche of the Tower and William of Windsor, infant children of Edward III (†1342 and 1348). Tiny tomb-chest with two alabaster figures of youths on top. By *John Orchard*, 1376. – 4th Earl of Stafford

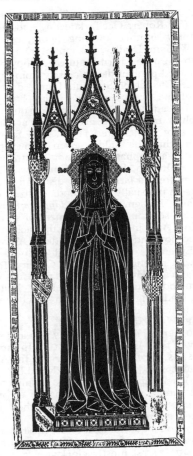

Westminster Abbey. Chapel of St Edmund.
Brass of Eleanor, Duchess of Gloucester †1399.
Rubbing (H.F. Westlake, *Westminster Abbey*, 1923)

†1762. Large tablet with inscription and arms stained rather
than carved in the marble, an experimental technique by
the eccentric mason *Robert Chambers*. – Frances, Duchess of
Suffolk, †1563. An important memento of what monuments of
ambition were like by the mid c16. Still the free-standing tomb-
chest with a recumbent effigy in repose, with no activity in the
draperies. All alabaster. The sides however have panels with a
little strapwork, separated by pilasters. Roman colonnettes at
the angles. The figure lies on a mat with a rolled-up top as her
pillow, after the new Netherlandish fashion. – Behind her feet to

the l. Bishop Monck †1661, by *William Woodman Sen.*, 1723. Sarcophagus, plinth, obelisk.

Francis Holles †1622, aged eighteen, but already a soldier. Of 1623/4–7 by *Nicholas Stone* and with all the originality of that great innovator. Seated figure in Roman dress, like a young Mars, on a drum-shaped pedestal. His pose derives from Michelangelo's Medici effigies at S. Lorenzo in Florence, the pedestal probably from a Roman altar shown in J.-J. Boissard's *Rome* (1602). It has thick garlands hanging from female heads. – Lady Seymour †1560 and Lady Knollys †1568, small hanging monuments, the earliest such in the Abbey. – In the next corner, Elizabeth Russell (†1601), godchild of Queen Elizabeth and Leicester. Attributed to the *Cure* workshop, 1602-3. As the earliest seated effigy in the Abbey it was highly influential, though unlike Stone's her closed eyes and the skull beneath the foot show that she is represented as if dead. The circular pedestal with bucrania, eagle and garland may derive from the same source-book as Stone's. – John, Lord Russell †1584, father of the above. Standing wall monument attributed to the *Cure* workshop. He reclines stiffly on his side, hand against cheek, on a bulgy sarcophagus. A baby below his feet. Shallow arch between columns, in the spandrels Victories. Against the back, shield held by two bedeswomen. – Sir Bernard Brocas †1396. The effigy is characteristically stiff and solid and no longer aspiring to earlier C14 elegance. But the straight-topped recess still has the diagonal shafts of that time, combined with Perp motifs such as transoms on the top panels. Ogee-gabled niches to l. and r., and three arches also with ogee gables. Inaccurate C18 antiquarian inscription. – Sir Richard Pecksall †1571, another large wall monument. Tripartite, with four Corinthian columns. Three kneeling profile figures in niches, he higher up than his two wives. – Edward Talbot, 8th Earl of Shrewsbury, †1618, and wife. By *William Wright*, c. 1619. The largest and showiest in the chapel, with a strange belt-and-braces deployment of architectural elements. Figures on a bulgy sarcophagus, the slab with extra support from six black Ionic columns. Two recumbent effigies, his behind and a little above. Over them, a coffered arch with both columns and smaller side arches as supports. In one of these a kneeling child, facing sideways. Big top achievement. – William de Valence †1296, half-brother of Henry III. On a tomb-chest of Reigate stone with shields in quatrefoils. On this an oak chest with scanty remains of architectural decoration, some with its original stamped metal sheathing. The effigy is of gilt copper plates on an oaken core, partly engraved and partly with *champlevé* enamel: a unique use on an English monument (cf. Bishop Mauricio †1238 at Burgos Cathedral, Spain). The work must have been done at Limoges, the centre of this medieval art. – STAINED GLASS. Three reset royal shields of arms, C13.

Third bay. MONUMENT. Late C13 tomb-chest of Purbeck marble with Cosmati decoration, based on C12 Roman examples. Thought to have been moved c. 1396 from the feretory, where it marked the burial place of several children of Henry III and Edward I.

Sanctuary, Crossing and Choir Enclosure

The sanctuary comprises the two bays E of the crossing, which is open. The choir and its screen fill the four bays W of the crossing.

6 SANCTUARY. REREDOS. The Abbey's chief High Victorian show-piece, designed by *Scott* and executed in stages 1866–73. It is a kind of re-imagination of the C15 original, based on the surviving E face (*see* p. 156), and on traces discovered when the previous, less archaeologically exact installation of 1823–4 was dismantled.* Sumptuous materials: alabaster, marbles, Lebanese cedar, porphyry and jewels. In the centre the Last Supper made in mosaic by *Salviati & Co.* to designs by *J.R. Clayton* (*Clayton & Bell*), 1866. It occupies the likely position of the C13 retable. Heads of women below by the same designer, but executed by *Rust* of Lambeth. To the sides four big statues carved by *H.H. Armstead*, 1870; also by him the top frieze of the Life of Christ. Lesser carving by *Poole & Sons*, the Abbey masons (stone) and *Farmer & Brindley* (timber). Gilt and enamel plaques by Messrs *Skidmore*. The C15 reredos was taller than the C13 one, which probably allowed a view of the shrine from the W. The tiers of sculpted figures above at the eve of the Reformation are shown in a contemporary drawing of Abbot Islip's funeral.

12 PAVEMENT, in front. At 25 ft (7.6 metres) square, the largest of Abbot Ware's Cosmati works, signed originally by *Odericus Romanus* and dated 1268. The patterns resemble those in the feretory (*see* pp. 155–6 above, where the attribution is discussed), but the whole is much more lavish – more so than any Italian example. The technique is also different, with much larger areas of pure mosaic. A special significance attached to the design, as an inscription of brass letters formerly explained. It referred to the pavement as a model of the universe (*macrocosmum*), and to the appointed duration of the world. The oblongs in the N and s borders are thought to mark the graves of Abbots Ware and Wenlock (†1284, 1307). – Above, three brass CHANDELIERS, C17.

SEDILIA, S side. Made *c.* 1308, in conjunction with the monument to the legendary Sebert below it (*see* above, pp. 159–60), but of oak instead of the usual stone. The reason may have been to allow easy removal during the Coronation service. To the ambulatory four tall cusped pointed arches with steep gables and encircled quatrefoils below them. To the presbytery the gables form crocketed canopies, with openwork trefoils instead of quatrefoils. Finely carved small headstops at the bottom. The structure still has much original colour and gilded gesso, formerly with glass inlay. The PAINTINGS here show two kings, with blanks where two saints must have been.

* Designed by *B.D. Wyatt*, executed in plaster by *F. Bernasconi*. It replaced an altarpiece of 1706 designed by *Wren*, who reused parts of his marble altar of 1686 for Mary of Modena's new chapel at Whitehall Palace, dismantled after 1689. Two better-preserved reliefs survive in the Museum, and two figures of angels at Burnham-on-Sea church, Somerset; *see* also p. 199 for the four ruined statues in the Abbey Garden.

MONUMENT, S side, to the W. Anne of Cleves †1557. Only the base remains, low and long, with four short broad pilasters with busy decoration still in the Early Renaissance style. But in the middle panels also more up-to-date motifs such as tapering pilasters and skull-and-crossbones. – PAINTING. Large triptych by *Bicci di Lorenzo* (†1452), given in 1948. In the centre a Madonna and Child with angels; saints to l. and r. – SCREEN behind, five bays of oak, in style like the sedilia. 1857, designer *Scott*.

On the N side, MONUMENTS to Aveline of Lancaster, Aymer de Valence and Edmund Crouchback, C13 and C14 (*see* North Ambulatory pp. 148–50).

By the crossing, N side, PULPIT. Early C17, with tester. Tapering pilasters and bits of strapwork, but also garlands.* Pedestal and back-board by *Sir W. Tapper*, 1935, iron steps by *Bainbridge Reynolds*. – LECTERN, S side. Inventive Neo-Baroque, 1949 by *Sir Albert Richardson*.

CHOIR STALLS, to the W. Of 1843–8 by *Edward Blore*, ornate Dec style, somehow more repetitive and pedantic than his choir-screen front of ten years before (*see* p. 175). Canopies brightly coloured under *Dykes Bower*, before 1964. The mid-C13 ones were destroyed in 1775 and replaced by *Henry Keene*.

STAINED GLASS. At the far E end, i.e. over the ambulatory (but barely visible from there). The three clerestory windows have mostly C14–C15 glass of many periods, skilfully reassembled in the C17 and again repaired *c.* 1702–6. E window, St Edward the Confessor and St John, *c.* 1490, SE window, two more C15 figures, NE window, two large figures made up of fragments. – Below, in the triforium, E window by *Comper*, 1951, showing Eleanor of Castile and Margaret Beaufort. – Below, immediately above Henry V's Chapel, a post-war window by *Edward Woore* incorporating four figures from a war-damaged *Burlison & Grylls* window of 1903 in the S transept.

South Transept

From the early C17 a cluster of poets' memorials began to form in the E aisle here around the tomb to Chaucer, who was buried in the Abbey as a courtier rather than a poet. Many date from long after the deaths of their subjects. The name POETS' CORNER seems to have developed in the C18, and is sometimes now applied to the whole S transept. Many scholars and writers of other kinds are honoured on the W side, as are architects.

East aisle, including Chapel of St Benedict

N WALL, that is on the back of the sanctuary S side. MONUMENTS. Dr Busby, Head Master of Westminster School, l.

*Displaced PULPITS: by *Henry Keene*, 1775, with palm tree support for the tester, now at Trottiscliffe church, Kent; by *Edward Blore*, 1827, now at Shoreham church, also Kent; by *Scott*, 1862 (nave); now at St Anne's Cathedral, Belfast.

1702–3, commissioned from *Edward Chapman* and executed with his son-in-law *Francis Bird* (who signed it). White marble, with reredos background and reclining figure with scholar's cap. A very telling portrait. – Archdeacon South †1716, r. The same composition, but black and white, and with a fuller, bigger figure. Above the inscription panel behind it three cherubs' heads and rays. By *Bird*. – Between them a section of Anne of Cleves' monument (†1557, *see* above, p. 165).

CHAPEL OF ST BENEDICT, off the E aisle at the N. MONU-MENTS. On the l. pier just outside, bust of Archbishop Tait by *H.H. Armstead*, 1884. – Partly blocking the entrance, John Dryden (†1700), 1720–1 to a *Gibbs* design; the excellent bust by *Scheemakers* a substitute of 1731; deprived *c.* 1850 of its big aedicule back. – STAINED GLASS. S window, 1948 by *Hugh Easton*, a war memorial for the citizens of Westminster. Figures of St George and St Michael. – MONUMENTS. In the middle, Lionel Cranfield, 1st Earl of Middlesex †1645 and wife. By *Nicholas Stone, c.* 1638–*c.* 1647. Black and white marble. Big plain free-standing tomb-chest with recumbent effigies, still with (mythological) animals at their feet, but no longer shown praying. Excellent achievements to E and W. – To the l. a low tomb-chest brass to Dean Bill †1561, i.e. at the end of the medieval tradi-tion. 2 ft (61 cm.) figure. – Anticlockwise around the sides: Cardinal Langham, Abbot of Westminster 1349–62; buried here 1379 (N). Tomb by *Henry Yevele* and *Stephen Lote, c.* 1394. Chest with shields in quatrefoils framed within squares. Recumbent alabaster effigy with two angels by the pillow, two dogs at the feet. Original iron railings to the ambulatory, with some architectural decoration. Original canopy destroyed *c.* 1715. – Countess of Hertford †1598. High and colourful wall monument (28 ft, 8.5 metres), where the altar once stood. Recumbent effigy; groups of three columns around a square pier to l. and r. Back wall with two arches and strapwork. Second tier above the centre, with coupled columns and achievement. Five obelisks on top. – In front, TILES probably of the C13, with foliage or heraldic decoration. – S wall. MONUMENTS. George Sprat, an infant, †1683, with three cherubs' heads. – Dean Goodman †1601, kneeling figure in a niche, with 1950s-60s painted decoration. – St Benedict, a small carved bust, 1968 by *Albert Siegenthaler*. – The DOORWAY below probably served the anchorite's cell made in the C14, in the angle with the S transept; an associated recess with piscina and squints was found behind Dean Goodman's tomb in 1936.

E WALL, from N to S. MONUMENTS. H.W. Longfellow, bust by *Brock*, 1884. – Above it, Martha Birch †1703, tablet with superior carving. – Abraham Cowley †1667, by *J. Bushnell*. With a big urn and no effigy. It breaks ruthlessly through the C13 arcading. – Geoffrey Chaucer †1400. Erected by an admirer as late as 1556. Canopy of four ogee arches; circular pillars l. and r. with lattice decoration. Purbeck marble chest of chantry tomb type, i.e. with space to say mass at one end. There is a parallel for such a conservative tomb at Chelsea Old Church (Duchess of Northumberland †1556, a nearly identical design), but the suspicious absence of a top stage to the canopy suggests that

Chaucer's may be an older work salvaged from elsewhere. – Above, John Roberts, †1776 by *R. Hayward*, Adamesque and of great finesse. – John Philips †1708, ugly portrait medallion in trees and branches. – STAINED GLASS over, 1994 by *Graham Jones*, in memory of the architectural historian Edward (Ted) Hubbard †1988. Cobalt colouring; numerous panels intended for future inscriptions. – On the floor in front, an evocative cluster of inscribed SLABS to C19 and C20 writers. The first, side by side, mark the tombs of Tennyson (†1889) and Browning (†1892; of Italian marbles). The rest are post-war and commemorative, with some excellent lettering. – Continuing S, Barton Booth, the actor and property developer (†1733; *see* Barton Street, p. 699). 1772 by *William Tyler*. Bulgy pedestal and portrait medallion with two putti. – Michael Drayton. Hanging monument with bust pushed down into a segmental pediment. Inscription below. By *Edward Marshall*, *c.* 1632. – Above, bust of Matthew Arnold by *A. Bruce Joy*, 1891.

S WALL. The DOOR into the Chapter House crypt, l., is a fragment of the original doors to the N transept. – STAINED GLASS. Two-light window, 1869 by *Clayton & Bell*. – MONUMENTS, E to W. Ben Jonson (†1637), designed by *Gibbs* and carved by *Rysbrack c.* 1723. Pedimented tablet with fine portrait relief and a swag of masks. – Samuel Butler †1680. Frontal bust against black obelisk, erected 1721 (altered). – Below, Edmund Spenser (†1599), 1620(?), by *Nicholas Stone*. First erected by that great memorializer Lady Anne Clifford; renewed 1778. Quite big, but very simple. – John Milton (†1674), erected 1737 by *William Benson*, Wren's successor at the Office of Works, incorporating an earlier bust by *Rysbrack*, whose name forms part of the lengthy inscription. – Thomas Gray †1771 by *Bacon Sen.*, placed as if it were the base of Milton's monument. Seated figure holding a portrait medallion.

W WALL. MONUMENTS. Centre: Matthew Prior, poet and ambassador, 1721–3. Designed by *Gibbs* and carved by *Rysbrack*. But the portrait bust is by *Antoine Coysevox*, 1714, said to have been commissioned by Louis XIV. Recessed on a black sarcophagus, with standing figures of Thalia and Clio. Top pediment with reclining putti. – To the l. William Mason, 1799. A better *Bacon Sen.* than Gray's, to its l. Poetry mourning over a portrait medallion. – Above it, Thomas Shadwell (†1692) by *Bird*, after 1700. Bust in front of obelisk, perhaps the first English use of this formula. – To the r. of Prior, Granville Sharp, the abolitionist, 1813 by *Chantrey*. Relief portrait with freakish profile. – Above, Charles de St Denis †1703, with small bust. – At the N corner eloquent bust of Tennyson by *Woolner*, 1857 (installed 1895).

PIERS. The MONUMENTS on the piers to the N are: middle pier. Christopher Anstey, the poet, †1805. Big tablet by *C. Horwell*. – N pier. William Blake (†1827), unearthly bronze bust by *Epstein*, 1957. – On the far (E) side, Sir John Betjeman (†1984), installed 1996. A blank early C18 cartouche found in the triforium, modified with Gothick bellcote, prayerbook and bible (designer *Donald Buttress*) and inscription (designer *David Peace*).

Main transept

s WALL. Here, screened off, was the Chapel of St Blaise, dis-
mantled in the C18. The two medieval WALL PAINTINGS framed
within the wall arcade are of St Christopher and the Incredulity
of St Thomas, discovered and restored (by *E. W. Tristram*) in
1936–8. Dating probably from *c.* 1300, they are the most monu-
mental in England of their time, nearly 9 ft (2.7 metres) tall.
Extremely elongated figures, much in the style of certain con-
temporary English illuminators, such as the Madonna Master of
the Lisle Psalter. Perhaps because of the different scale and tech-
nique, the forms here are broader and flatter and the outlines
stronger. Each also shows a strong interrelationship between the
figures. St Christopher is captioned in Lombardic lettering. –
STAINED GLASS. 1901–2, by *Burlison & Grylls* to *G. F. Bodley*'s
designs, giving a more appropriate light than some later Abbey
windows.* In the rose window a ring of prophets, sibyls and
philosophers surround Virtues and angels, who surround Christ.
In the spandrels the Annunciation below, Adam and the Baptist
above. Two tiers of lancets below with saints and teachers. The
antiquary M.R. James drew up the scheme.

 MONUMENTS. E SIDE, S pier. Adam Lindsay Gordon
(†1870), impressionistic bust by *Kathleen Scott*, 1934. – Thomas
Campbell, statue, 1848 by *W. Calder Marshall* (installed 1855). –
William Wordsworth, seated statue by *Frederick Thrupp*, 1851–4;
at first under the SW tower. – S.T. Coleridge (†1834), bust by
Hamo Thornycroft, 1884. – Screen wall, centre: Shakespeare,
1740–1, designed by *William Kent*, statue by *Scheemakers*. Paid
for by public subscription, under a committee including Lord
Burlington and Pope. The background is a richly detailed blank
doorway with pediment. Shakespeare stands, with his legs ele-
gantly crossed, leaning on a pile of books placed on a tall pedestal.
On this the heads of Henry V, Richard III and Queen Elizabeth,
and some props. His l. hand points to a scroll with lines slightly
misquoting Prospero's in *The Tempest*. The costume resembles
the Van Dyck manner popular in the C18. – Above, Keats and
Shelley, oval tablets linked by a thick flower garland. 1954, by
Frank Dobson. – To the l., Dr Johnson, fine bust by *Nollekens*,
1777, in a setting of 1939. – Above it, Robert Southey, aedicule
with good bust by *Weekes*, 1846. – To the r., James Thomson, 1762
by *M. H. Spang*, to a design by *Robert Adam*. Seated figure in a
toga, with book and cap of Liberty, resting on a circular pedestal.
On it a relief of the Seasons, which as so often is better than the
main figure. A putto on the r. – Above, Robert Burns, bust by *Sir
John Steell*, 1885.

 S WALL. MONUMENTS, from E to w. Oliver Goldsmith †1774,
above the door to the St Faith's Chapel (*see* p. 170). Inscription
and oval portrait medallion, with attributes. By *Nollekens*. – Sir
Walter Scott. Copy of *Chantrey*'s bust of 1820, made by *John
Hutchinson*; installed 1897. – Above, John Ruskin, bronze medal-
lion of 1900–2 by *Onslow Ford*. – John, 2nd Duke of Argyll

* Replacing work by *Ward & Nixon*, 1841–7, the first instalment of Victorian
reglazing.

and 1st of Greenwich, the first London monument by *Roubiliac*, 46
1745–9. Nowhere in the Abbey does he appear greater as a
sculptor. In spirited portraiture and delicacy of draperies the
Argyll monument is supreme, and indeed need not fear com-
parison with any contemporary monument in France or Italy. Big
black base with relief of Liberty and Magna Carta and putti
against a background of lightly indicated architecture. To the l.
stands Eloquence, gesticulating towards us; to the r. Minerva
seated and looking up to the main group. The figures establish
at once the diagonal movement so essential for Baroque compo-
sition. Above, on the sarcophagus, reclining, the Duke, his head
to the r., carrying on the movement from below. His elbow rests
on the thigh of History, who stands writing his name and titles
on an obelisk that forms the back of the composition. She stops
short at the 'Gr' of Greenwich to indicate that that title died with
him. The idea of an obelisk with a figure writing on it was taken
by Roubiliac from the Mitrovitz Monument in Prague, 1714, by
Fischer von Erlach, but the group also owes much to the papal
tombs in Rome. – CLOCK, 1808.

W WALL, that is cloister wall, below the Muniment Room.
Mostly smaller, often hanging, MONUMENTS. They profit from
being contained in the C13 wall arcading. From S to N: first bay.
J.S. Mackenzie †1800, son-in-law of the Duke of Argyll. By
Nollekens, with portrait. – Above, Mary Hope †1767, tablet
designed by *Robert Adam*. – Sir Edward Atkyns †1750 and others,
by *Sir Henry Cheere*. No effigies, but pretty ornament; brown,
white and pink marble. Sarcophagus below, inscription above,
crowned by a shield in a rocaille cartouche. – Above, Maj.-Gen.
Sir Archibald Campbell, by *Wilton*, 1795. Large, with Fame,
portrait medallion, and putto. – Sir Thomas Robinson and wife,
c. 1778 by *John Walsh*, nothing special except for the two well-
characterized busts in Roman dress. His has recently been attri-
buted to *Filippo della Valle*, hers to *Edmé Bouchardon*. – Replacing
its top, Jenny Lind, the singer, 1894, of cemetery quality. – Above,
Handel, by *Roubiliac*, 1761. Another instance of Roubiliac's psy-
chological insight. Handel appears here the type of the ageing
theatrical manager. Yet closer inspection reveals in his face the
signs of inspiration. Above, an angel in clouds is playing the harp.
An organ also in the background, all this very lightly carved so
as to convey distance. Before Handel lies a piece of music: 'I
know that my Redeemer liveth', from *The Messiah*. The frame is
a grey marble Gothick replacement for the arcading. – Against
the first pier: W.M. Thackeray, bust by *Marochetti*, 1865; Joseph
Addison (†1719), statue on a circular base with Muses, by *Sir R.
Westmacott*, 1803–9; Lord Macaulay, bust by *N. Burnard*, installed
1867. – Second bay. William Outram †1679. Urn but no figures,
a fashion of those years (cf. e.g. Cowley, p. 166). – Above, Dr
Stephen Hales, 1762 by *Wilton*. Figures of Religion and Botany,
showing the influence of Wilton's training in Flanders with
Laurent Delvaux. Botany has a portrait medallion; at her feet the
winds on a globe (Hales invented the ventilator, a blessing for
prisons, ships, etc.). – Dr Isaac Barrow †1677, with bust. Attrib-
uted to *Jasper Latham* (GF). – Above, Dr Wetenhall †1733, big
tablet. – Sir John Pringle †1782, by *Nollekens*. Portrait and draped

obelisk. – Against the second pier, John Keble, bust by *Woolner*, 1872. – Third bay, bottom row. Sir Richard Coxe †1623, by *Nicholas Stone*, pedimented. – Below it, James Wyatt, the architect, †1813, simple. – Dr Casaubon, 1634 also by *Stone*, perhaps to a design by *Inigo Jones*. Also black and white; strongly architectural. – William Camden, the antiquary, †1623. Frontal bust or upper body on tall pedestal. – Top row. Sir Robert Taylor, the architect, †1788. No figures; various marbles; urn and inscription. – Dr Grabe †1711. Seated in his Geneva robes on his sarcophagus. Excellent figure, remarkably informal. By *Bird*. – David Garrick (†1779), by *Henry Webber*, 1797. Two louche allegories representing Tragedy and Comedy. He stands, a resilient figure, with a cynical face, and opens a curtain. It is a brilliant piece of characterization and shows what surprises the works of the lesser-known English C18 sculptors may hold in store. – Busts on the third pier, N: Bishop Thirlwall, 1878 by *E. Davis*, and George Grote by *C. Bacon*, 1872. – In the floor nearby, SLABS to other writers and architects, the latter including Adam and Chambers.

St Faith's Chapel, off the S transept. WALL PAINTING. In a recess in the E wall a large figure of St Faith, crowned, holding a book and gridiron; commanding, if not of attractive features. The very elongated proportions and small head point to a date *c.* 1290–1310, as do such details as the fleurs-de-lys on the ground. Below, a 'predella' of eight-pointed stars, and in the centre a small defaced Crucifixion with the Virgin and St John. On the l., a kneeling monk with inscription, suggesting monastic rather than royal patronage for the work. Chevron decoration in the reveals. – AUMBRY in the S wall. Trefoil-headed. – PAVEMENT. Many late C13 TILES in the E part. The rest paved with marble, 1971.

Nave, including Choir Aisles

The present circuit makes it difficult to visit every part, so there can again be no ideal treatment. The description is in the following order: choir S aisle, E to W; nave S aisle, E to W; nave centre, W to E; nave N aisle, W to E; choir N aisle, W to E.

Choir south aisle

There are four bays, enclosed on the N side by the choir S wall. First bay, S side. MONUMENTS. Three tablets to Scots, two designed by C18 architects: *Gibbs* for the Marchioness of Annandale, 1723, architectural, *Adam* for William Dalrymple †1782, coloured marble. – N side. William Thynne †1584. Tomb-chest with recumbent effigy in armour on a half-rolled-up mat. Attributed to *Garat Johnson Sen.* – Above, Dr A. Bell †1832 by *Behnes*. Nice relief of schoolteaching. The inscription praises Bell's so-called Madras scheme of monitorial education. – Sir Thomas Richardson, 1635 by *Le Sueur* and exceptionally sombre. Black marble monument with bronze bust on pedestal, in a bronze-trimmed oval recess. Bulgy base and pediment.

Second bay, s side. In the centre Sir Cloudesley Shovell †1707. By *Gibbons*, price £387 10s.; a variant of his Duke of Beaufort tomb at Great Badminton (†1700). Base with trophies and relief of shipwreck. Above it a sarcophagus on which lounges the admiral, in Roman dress with wig (promptly ridiculed by Addison in *The Spectator*, 1711). On each side coupled black Corinthian columns with putti over them and inscription under a baldacchino of curtains between. – Above, Sir Godfrey Kneller by *Rysbrack*, 1722/3–30. Originally intended for Twickenham church, near Kneller's house in Middlesex. The principal feature is a bust *en negligé* between two putti, one holding a portrait of Lady Kneller. At first a standing monument under the N W tower; moved and modified *c.* 1847. – William Wragg, 1779. Nice relief of shipwreck, with mourning figure, l. Signed R.H., i.e. probably *Richard Hayward*. – Above: Clive of India, oval portrait, 1919 by *John Tweed*. – N side. Elizabeth Freke and Judith Austin †1714 and 1716. Hanging monument with two oval portrait medallions. – Grace Gethin †1697. She kneels tightly between two angels clasping two black columns. Broken scrolly pediment with two small allegories. – Below, Richard Dimbleby (†1965), with bronze portrait by *Nicholas Dimbleby*, 1989.

Third bay, s side. Thomas Knipe †1711. Typical large tablet with Doric pilasters. – John and Charles Wesley, 1875 by *J. Adams Acton*. Circular medallion with double portrait, and relief of preaching below. – George Stepney †1707. Attributed to *Gibbons*. Bust under baldacchino of curtains. Two weeping putti; obelisks l. and r. – Isaac Watts (†1748), 1779 by *Banks*. Charming hanging monument. Square base with fine tondo of Dr Watts, pen in hand, listening to an angel. Fine foliage in the spandrels. Bust and small putti on top. – Above: John and Sir Paul Methuen, by *Rysbrack* (contract 1758). Large, but no figures except two putti. – To the l., Charles Burney, bust on Grecian pedestal, high up. By *Sebastian Gahagan*, 1819, after *Nollekens*. – N side. Against the pier, r., James Kendall †1708, cartouche, typical of *c.* 1700; excellently carved. – General Paoli, the Corsican patriot, †1807. Bust by *Flaxman*, exhibited 1798. – Thomas Owen †1598. Stiff on his side, an early example of the pose, under a flat arch. Strapwork cartouche, columns l. and r. – Tablet to General Trigge †1814, by *Bacon Jun.*

Fourth bay, s side. Admiral George Churchill, brother of the 1st Duke of Marlborough. By *Gibbons*, 1710. White architecture. Urn on pedestal with seraphim, in niche. – High up, Martin Folkes P.R.S. (†1754), designed by *W. Tyler* and executed in 1788 by his assistant *Robert Ashton*. Seated statue on the l., two putti on the r. busy with a microscope and compasses, a third by an urn on a pedestal, higher up in the middle. – Other minor monuments, e.g. (r.) William Julius †1698, cartouche with cherubs' heads and death's head, and General Strode †1776 by *R. Hayward*, very chaste, with small mourning figure. – N side. Thomas Thynn †1682, by *Arnold Quellin*. Reclining figure with pleading gesture and looking to heaven, on a sarcophagus decorated by a relief with the scene of Thynn's murder by hired highwaymen in Pall Mall. Back architecture with draped pediment. – S.A. Barnett, 1916 by *Sir George Frampton*, mini-tablet with figure of a sower.

31

CANDELABRA, currently stored in this aisle. By *Benno Elkan*, 1939 and 1942, standing pieces with little figures from Old and New Testaments. A major work by this German-Jewish exile, in a kind of Neo-Romanesque Expressionist style. – Iron GATES at the W end. 1764 by *Wood*. Gothick.

Nave south aisle

MONUMENTS, from E to W. First bay. Major André, hanged as a spy by the Americans in 1780. Designed by *Robert Adam*, carved by *P.M. van Gelder*. Straight-sided sarcophagus with relief of Washington receiving André's petition, and Britannia mourning on top. – Sir Palmes Fairborne, Governor of Tangier, †1680, with urn; formerly with reliefs of Moorish towns. By *J. Bushnell*. – Lt.-Col. Townshend. Another *Adam* design, of 1760, an early work. A fluted sarcophagus with a fine floridly carved relief of Townshend's death by *John Eckstein*, assisted by *L.-F. Breton*. Two native American atlantes, the work of *Thomas (Sen.) & Benjamin Carter*, support it. Trophy above and obelisk. – Above, Sir John Chardin (†1713), by his cousin *Cheere*, 1746. An unusual design with very large bronze lettering. Large obelisk reaching high into the window space. At its foot, a globe, geographical instruments, and books: he was a travel writer, merchant and diplomat.

Second bay. 1st Earl of Godolphin †1712, the statesman. By *Bird*. Draped bracket and well-characterized portrait. – Sir Charles Harbord and Clement Cottrell †1672. Double inscription panel and relief of sea battle. Broken segmental pediment. – Above, Lt.-Gen. Hargrave, by *Roubiliac*, signed and dated 1756/7. One of his most famous and sensational works. Crashing-down pyramid of massive stone blocks in false perspective. The General climbing open-mouthed out of his tomb. On the r. Time breaks across his knee the scythe held by Death, a skeleton, who collapses at his feet.

Third bay. Almost identical standing memorials by *William Stanton* to Ann *née* Fielding, †1680, l., and Carola *née* Harsnett, †1674, r., second and first wives of the polymath Sir Samuel Morland. He demonstrates his learning in Hebrew, Greek, Ethiopic and English inscriptions. Shields on top. – Between them, John Smith †1718. Designed by *Gibbs*, carved by *Rysbrack*. Sarcophagus and obelisk, for which the C14 wall arcading had to be raised. On the sarcophagus a rather saucily placed female weeping over a portrait medallion. – Above, Maj.-Gen. Fleming, 1751/2–4 by *Roubiliac*. Obelisk with bulgy double-curved sides and portrait medallion. Trees grow l. and r. of it. Below, Hercules and Minerva tying together emblems of wisdom, prudence and valour.

Fourth bay, around the W cloister door. Col. Herries †1819, Hellenizing relief designed by *Sir Robert Smirke*; bust above by *Chantrey*. – Lt.-Gen. Sir James Outram, by *Noble*, 1866. Bust, on a pedestal showing the relief of Lucknow. Seated mourning Scind and Bhil chiefs to l. and r. – Above the door, Field-Marshal Wade, 1747/8–50, another *Roubiliac*. Portrait in relief in an oval medallion. Below and over the sarcophagus loosely hanging garlands. Higher up a big composition of Fame pushing away

Time who is trying to pull down a pillar decorated with a trophy. – To the r., Ann Whytell by *Bacon Sen.*, 1791. Pedestal and urn; charmingly carved figures of Innocence and Peace. – Below, 1st Lord Lawrence, bust by *Woolner*, 1871 (installed 1881).

Fifth bay. STAINED GLASS. YMCA window, by *Dudley Forsyth*, 1921. – MONUMENTS. High up, bust monuments of Dean Ireland †1842 by *J. Ternouth* and Dean Buckland by *Weekes*, 1859. – Dean Thomas †1793, Bishop of Rochester, bust on pedestal, by *Bacon Jun.* – Katharine Bovey, 1727–8. Designed by *Gibbs*, sculpted by *Rysbrack*. Sarcophagus with balancing seated allegories (Faith and Wisdom) attending a portrait medallion. The back reaches into the window zone with a broken scrolly pediment. – Dean Pearce, Bishop of Rochester, *c.* 1777 by *Tyler*. The composition similar to Dean Thomas's. Decorative elements as in the Rococo monuments, but no longer Rococo in spirit.

Sixth bay. STAINED GLASS. Brunel memorial window, 1868. Clearly influenced by Morris and Burne-Jones, it is easily the finest C19 window in the Abbey. Figures designed by *Henry Holiday*, arched setting by *Norman Shaw*, early for both; made by *Heaton, Butler & Bayne*. It shows Virtues and episodes related to the Temple. Moved from the N aisle *c.* 1950. – MONUMENTS. Dean Wilcocks †1756. By *Cheere*. Rococo base with relief showing the abbey completed by the two W towers built under Wilcocks. Above, pretty, free group of putti and loose garlands and cartouche within the wall arcading. – Dean Sprat, Bishop of Rochester, †1713. By *Bird*. Tablet in plain architectural setting. – Above, Admiral Tyrrell †1766. By Roubiliac's pupil *Nicholas Read*, whose reach here proved greater than his grasp. A vast rocky expanse with figures of History, Navigation and Hibernia, a globe, a very Rococo anchor, and the wonderfully carved stern of HMS *Buckingham*, r. An upper stage, removed from the C19 onwards, showed the nude Admiral zooming up into clouds; this figure survives in the Lapidarium.

Seventh Bay. STAINED GLASS. British Flying Corps window, 1922 by *Harry Grylls* (*Burlison & Grylls*). – Below it, the ABBOT'S PEW, created for Abbot Islip, i.e. period 1500–33. An oak gallery with simple Perp blank arcading, flat top and remains of side screens. A shallow arched opening in the back wall gave entry from the abbot's house (*see* pp. 196–7). – MONUMENTS. Within the wall arcade, Dr John Freind, 1730–1, *Gibbs* and *Rysbrack* in collaboration again. Fairly simple; bust on pedestal, black and white reredos back. – William Congreve †1729. By *Bird*. Sarcophagus with books, masks, etc., and an oval above with an extremely vivid demi-figure in relief, after Kneller's Kit-Kat study. – BRASSES. Dean Bradley, 1904, designed by *J.R. Clayton* (*Clayton & Bell*), after that to Dean Bill (*see* p. 166). Makers *Barkentin & Krall*. – Further w, 1st Lord Baden-Powell †1941 and Olive Baden Powell †1977, with portrait medallions. By *Willi Soukop*, 1981.

ST GEORGE'S CHAPEL (eighth bay, i.e. under the SW tower). To the E, SCREEN of stone erected by Abbot Islip, i.e. also early C16, with two-light openings and embattled top. The chapel behind was originally used as the baptistery, and also by the Consistory Court. In 1925–32 *Sir Ninian Comper* converted it into a First World War memorial chapel. He designed the heavy

SCREEN of wrought and cast iron and gilt ALTAR in the style of
c. 1530 (modelled by *Bertram Pegram*, made by *Frank Knight*).
– Inscription stone, w wall, 1926, designed by *H.P. Cart de
Lafontaine*, carved by *Reginald Hallward*. – Engraved GLASS
SCREEN within the iron one, 1978 by *David Peace*. – Jacobean
PANELLING on the s wall, with a blind arch pattern. – STAINED
GLASS. w window. Large, not well-preserved figure of St George,
C15, and more bits of old glass. – s window, poets, 1876 by *Clayton
& Bell*.

 MONUMENTS. s wall. Henry Fawcett, the blind Postmaster-
General. A characteristic but small-scale work by *Alfred Gilbert*,
of 1885–6. Portrait medallion above seven fantastic figurines of
silvered bronze. They represent, from l. to r.: Brotherhood (an
old man seated), Zeal, Justice, Fortitude, Sympathy (a nude girl
entwined with brambles); Industry, and again Brotherhood (a
young rural labourer, also seated). Brackets with tiny, morbid
reliefs below. Wreathed roundels to his wife Millicent Fawcett
added 1932, designed by *Sir H. Baker*. – Above, James Craggs,
Secretary of State. Designed by *Gibbs*; made 1724–7 by *G.B.
Guelfi*. The most conspicuous work in England by this Italian
protégé of Lord Burlington. Cross-legged figure leaning on an
urn, hand on head: an attitude which became very popular for
mid-C18 monuments. Originally in the s aisle, and with an archi-
tectural surround (partly reconstructed in the Lapidarium). To
the l., General Booth, founder of the Salvation Army, †1912.
Small bust by *A. Siegenthaler*, 1965, after a model of 1905 by *Mary
Booth*. – w wall. Two busts by *Woolner*: F.D. Maurice, 1872 after
one of 1858, and Charles Kingsley, 1876.

Nave central space

STAINED GLASS. w window, 1735 by *William Price*, the figures
possibly to a design by *Sir James Thornhill*. These make three tiers
of patriarchs and prophets, above a row of heraldry. – PORCH
below it, a big glass box with engraved angels by *David Peace* and
Sally Scott, 1990. – PAINTING. Against the NE pier of the s tower,
a large portrait of Richard II, thought to have been made for
display in the choir to represent the King's person during his
absence. Datable to the mid 1390s (payment recorded 1396).
Richard appears seated in full regalia on a Gothic throne painted
without much sense of structure and volume. But the head is
clearly lifelike, and in the softly graded modelling volume is con-
vincingly expressed. The style is related to that of Bohemia and
North Germany, and it may be significant that Richard's queen
was from Bohemia and that a mid-C14 cycle of royal images
appears in the castle at Karlstejn there. It is the earliest known
contemporary portrait painting of a sovereign. Extensive resto-
rations 1733, 1866 (by *George Richmond* and *Henry Merritt*).
Most of the decorated background has been obliterated. Frame
designed by *Scott*, made by *Clayton & Bell*, 1872. – CHANDE-
LIERS, like crystal bombs. Designed by *Dykes Bower* and *A.B.
Read*, made by *Pilkingtons*, 1965. An aim was to conceal the light
bulbs. – PULPIT, N side. With linenfold panelling; probably early
C16. Formerly in Henry VII's Chapel and possibly made for it.

Canopy restored by *Dykes Bower*, and steps by him. – Two ALMS-BOXES with scrolly side volutes. Originally part of the late C17 choir screen, where they supported tall pyramids by the entrance (now in the Lapidarium).

MONUMENTS. All on or by the w wall. s of the w door, F.D. Roosevelt, tablet with carved eagle by *H.W. Palliser*, 1948. – Admiral Hardy, 1734 by *Cheere*. Reclining against an obelisk, a fine figure in a telling attitude. – Over the w door, William Pitt the younger, 1807–15 by *Sir R. Westmacott*. Rather a dull performance and difficult to see. Pitt stands and addresses an invisible crowd. To the l. Anarchy subdued and chained, a muscular male body turned towards us. To the r. History, a female figure, with her back towards us. – N of the w door. John Conduitt and wife, †1737 and 1739. By *Cheere*. Sarcophagus and obelisk. The portrait medallion and the putti below and above are of bronze. Interpolated tablet of 1874. Conduitt commissioned the Newton monument (*see* below), which his monument faces down the nave. – 7th Earl of Shaftesbury, the philanthropist. Statue in Garter robes by *Boehm*, 1888. For monuments to the N *see* Nave N aisle, p. 176; for those on the choir screen *see* below.

FLOOR SLABS. Near the w door, the Unknown Warrior, 1920, of black Belgian marble with indifferent lettering. Also Sir Winston Churchill, 1965, lettered by *Reynolds Stone*. – To the s, by the painting of Richard II, 1st Earl Mountbatten and Countess, 1985. By *Christopher Ironside*, in bi-coloured metal. – Further E, around the sixth bay, more BRASSES, of architects and engineers. From w to E: Robert Stephenson, with large figure in modern dress, *c.* 1861 by *Sir G.G. Scott*. – Sir Charles Barry, 1864, with cross flanked by depictions of the Houses of Parliament. Both made by *Hardman*. – Sir George Gilbert Scott, 'architectus peritissimus', 1880–1. Designer *Street*, makers *Barkentin & Krall*. With a cross attended by a knight and an architect and a vignette of Scott himself at work. – To its N, J.L. Pearson †1897, by *W.D. Caröe*, with a crucifixion in mid-C14 manner. – G.E. Street by *Bodley*, 1884. Another *Barkentin & Krall* product.

CHOIR SCREEN or PULPITUM. The choir is closed to the w by a choir screen one bay deep. The original was rebuilt in or after the late C17, and again in 1728 by *Hawksmoor* in his austere Gothic taste. *Edward Blore* in 1834 put a richer and archaeologically correct façade on it, with openings evocative of the great Dec tomb canopies further E. Six little sculpted kings and queens. Inner ceiling improved with fan-vaulting, probably by *Henry Keene* in 1775. Bright polychromatic decoration by *Dykes Bower*, extending also to *Pearson*'s ORGAN CASES of 1895–c. 1899, which were redecorated in 1959 and restored to their original positions within the arcades.* – Iron GATES of *c.* 1725, designed by *Hawksmoor* but embellished and given a new overthrow by *Sir W. Tapper c.* 1930.

*Instrument by *Harrison & Harrison*, 1937, incorporating some pipework from the C19 *Hill* organ (1848, rebuilt 1883), which in turn incorporated pipes of the early C18 or late C17. The organ case of 1730 is now at Shoreham church, Kent.

On the screen to l. and r. of the doorway two large MONU-
MENTS by *J.M. Rysbrack*, designed with some contribution
from *William Kent*. To the l. Sir Isaac Newton, 1731, seemingly
after a drawing by *John Conduitt* (*see* Nave w wall monuments,
above). The composition is entirely Baroque, yet there is nothing
operatic about it. Newton appears reclining on a black sarcoph-
agus with fat scrolly feet, a noble figure with intelligent, vigorous
features. His elbow rests on four books: Divinity, Chronology,
Optics and Phil. Princ. Math. Two putti, r., showing a proof
in astronomy. Obelisk back with a large globe showing the con-
stellations and the course of the comet of 1680. Astronomy
reclining on the globe. On the sarcophagus a relief with more
putti, referring to optics, the law of gravitation, and the new stan-
dards of coinage. – To the r., 1st Earl Stanhope, Secretary of
State, 1733. A similar composition, obviously meant as a coun-
terpart. The figure (in Roman armour) also reclining, one putto
with shield on the l., a tent behind, and Minerva on top. Both
monuments now disappear up inside Blore's Gothic frames.

Nave north aisle

Described from w to E. First bay, under the NW tower. STAINED
GLASS. W window. Impressive large figure assembled from
fragments of *c.* 1400. – N window, Trevithick memorial, 1883 by
Burlison & Grylls. – MONUMENTS. Under the aisle arch, 3rd
Marquess of Salisbury, the Prime Minister. Designed by *Bodley*,
made in 1909 by *Sir W. Goscombe John*. Recumbent bronze effigy
on a freely detailed black marble sarcophagus, with bronze
figures of his forebears in niches. – Behind it, free-standing, Capt.
James Montagu by *Flaxman*, 1798–1804. Standing figure in
modern dress, crowned by Victory. Circular base with lions l.
and r., and a relief of battle, unusually naturalistic for Flaxman.
Seated mourners in relief behind. – Then clockwise around the
bay, starting on the w wall. Above the doorway to the tower stairs,
General Gordon, bust with shield and scrolls below, bronze. 1892
by *Onslow Ford*. – Zachary Macaulay by *Weekes*, 1842. Bust and
relief referring to his work for the liberation of the slaves. – Joseph
Chamberlain. Bust by *Tweed*, pedestal designed by *Edward
Maufe*, 1916. – On the wall-passage: Dr Arnold of Rugby †1842,
demi-figure with hands, by *Alfred Gilbert*, 1896; Capt. Horneck,
1746–7 by *Scheemakers*, portrait medallion with standing allegory
and putto; Major Rennell †1830, bust by *T. Hagbolt*. – Col. Sir
R. Fletcher †1813. By *Baily*, *c.* 1830. Good, with two standing
soldiers. – Over it, Admiral Hope, *c.* 1820 by *P. Turnerelli*, with a
naval still life. – North wall. 3rd Lord Holland, *c.* 1847 by *Baily*.
Called 'The Prisonhouse of Death'. The inspiration must be
Canova's great tableaux of mortality. Big doorway with tapering
sides. Three large seated allegories below. Bust on top. No
inscription. – To l. and r. two busts, 1st Earl Russell, 1880, and
3rd Marquess of Lansdowne, 1873, both by *Boehm*. – E side.
George Tierney, 1832 by *R. Westmacott Jun.*, with allegories on
pedestal and bust on top. – Above this Lt.-Col. Lake †1808, by
James Smith, sarcophagus with draped banner against dark
marble. – Sir James Mackintosh, 1855 by *Theed*. Base with alle-

gorical figures; pedestal with bust on top. – 3rd Viscount Howe, 1759–62, designed by *James Stuart* and carved by *Scheemakers*. Large, noble inscription plate on lions. A mourning figure representing Massachusetts Bay seated on top, perhaps a little too small. Originally over the w door and with an obelisk back.

Second bay, i.e. the first of the aisle proper. STAINED GLASS. Sir Henry Royce window, 1962 by *Comper* (installed by *John Bucknall*), the last of a pictorial series conceived by Dean Robinson in 1907, which confusingly incorporate small figures of kings and abbots. The others, many of which are also memorials to engineers, were installed in the seven windows to the E up to 1927, apart from the Parsons window in the fourth bay, 1950. – MONUMENTS. Across the w end, Charles James Fox, 1809–15 by *Sir R. Westmacott*. A brilliant piece. Fox expiring Roman-fashion on a couch, Liberty holding him, Peace mourning at his feet, an African praying for him. Installed *c.* 1822; until the 1830s set against a screen wall between N transept and crossing. – N wall. Sir Henry Campbell-Bannerman, 1911, designed in colourful marbles by *Maurice Webb*, with a bronze bust by *Paul Montford*. – General Stringer Lawrence †1775. By *Tyler*. Erected by the East India Company. Tall pedestal with relief of the Relief of Trichinopoli. Seated and standing allegories of the Company and of Fame; bust on top.

Third bay. From now on the MONUMENTS are the chief interest. Dowager Countess of Clanrickard †1732. Reclining effigy on sarcophagus. – Lady Martha Price †1678. A big cartouche; no figures. – Dr Woodward, 1731–2, by *Scheemakers*. Seated female (Nature, or else Philosophy), holding a portrait.

Fourth bay. Robert Killigrew †1707. By *Bird*. With a large trophy of arms arranged fan-wise, cut out of one stone. – Low down, a simple tablet to the sculptor Thomas Banks, †1805. – Below it, the famous 'O Rare Ben Johnson' (i.e. Jonson), inscribed on a floor slab reset upright in 1821. – On the wall-passage captains Harvey and Hutt, a design by *Bacon Sen.*, executed by *Bacon Jun.* 1804. Seated figures of Britannia and Fame, l. and r. of an urn with double portrait in medallion; originally larger, and set on the floor.* – High up, l., bust of Sir Charles Lyell by *Theed*, 1877. – In the floor, medievalizing BRASSES by *Hardman* to Dr John Hunter (†1793), *c.* 1860, and Sir Robert Wilson †1849.

Fifth bay. Mary Beaufoy †1705, by *Gibbons*, signed; not at all good. She kneels between pilasters and is crowned by cherubs. Putti seated l. and r. lament her. – Jane Hill †1631, a kneeling figure. Against the back wall small figure of a shrouded skeleton and a Tree of Life, with Latin mottoes. Attributed to *William Wright* (GF). – William Morgan †1683 and Thomas Mansell †1684. Twin oval inscriptions, flanked and separated by twisted columns; scrolly pediment with urn and tucked-in armorials. Attributed to *James Hardy* (GF). – On the wall-passage, Governor Loten by *Banks*, 1792–3. Large standing allegory of Generosity, very Grecian. One hand holds a lion, the other rests on a portrait medallion. Formerly with a stepped pyramid back.

* A relief from it now forms part of a monument to Harvey in Eastry church, Kent.

Sixth bay. Edward Mansell †1681, by *W. Woodman Sen.*, pedestal with cartouche. – Robert and Richard Cholmondeley †1678 and 1680; no figures. Attributed to *William Stanton* (GF). – Dr Mead, the celebrated physician, 1754–5. By *Scheemakers*. Bust on a pedestal with (broken) caduceus and books. – On the wall-passage above, Spencer Perceval, Prime Minister, assassinated in 1812. By *Sir R. Westmacott*, 1814–16. A disjointed composition. Recumbent effigy, on a half-rolled-up mat: a remarkable archaism. Seated Power (with fasces) at his head; Truth and Temperance at his feet. Relief of the murder above.

Seventh bay. Vice-Admiral Baker †1716, by *Bird*. With *columna rostrata* on sarcophagus. – Admiral Priestman †1712, also by *Bird*. Dull, but noteworthy as the earliest English monument of the type with a portrait medallion against an obelisk. Its clustering naval trophies derive from Holland.

Eighth bay. Philip Carteret †1710, aged nineteen. Signed by *Claude David*. An odd composition with a bust against the back wall, but free of it and below a lumpy Baroque figure of Father Time. – E. Carteret †1677, hanging monument, attributed to *Abraham Storey* (GF). – 1st Viscount Teviot †1710. Big stately standing monument.

Choir north aisle

Four bays, that at the far E joining on to the N transept W aisle. Sometimes called the MUSICIANS' AISLE, after the Abbey's organist-composers commemorated here. Described from W to E. First bay. Iron GATES at the W end. 1764 by *Wood*, a pair to those in the choir S aisle. – STAINED GLASS. Prisoners of War memorial, 1926 by *Comper*, the easternmost of his row of eight (*see* p. 177). – MONUMENTS. N side. 1st Earl of Normanton, Archbishop of Dublin. By *Bacon Jun.*, 1815. The Archbishop stands above in high relief. To the l. charity folk, to the r. clergymen. On the plinth a relief of Cashel cathedral, Co. Tipperary, as rebuilt under his charge. – S side. Lord John Thynne, Sub-Dean, 1885. Designed by *Pearson*. A pink alabaster recess with recumbent effigy by *Armstead*. – Above and to one side seven portrait memorials to men of science. Clockwise from bottom l.: William Ramsay, bronze by *C.L. Hartwell*, 1922; J.D. Hooker, 1915 by *Frank Bowcher*; Sir G.G. Stokes by *Hamo Thornycroft*, 1909; J.C. Adams by *A. Bruce Joy*, 1895; 1st Lord Lister †1912, by *Brock*; A.R. Wallace †1913, also *Bruce Joy*; Charles Darwin †1882, bronze, by *Boehm* (the best).

Second bay. STAINED GLASS. Turle memorial window, 1882 by *Clayton & Bell*. – MONUMENTS. N side. Sir Edmund Prideaux †1728 and wife †1741. By *Cheere*, after 1745. Fine Rococo detail; two putti; double portrait medallion above. – Richard Le Neve †1673; no figure. Attributed to *Abraham Storey* (GF). – Admiral Temple West, 1758–61 by *Wilton*, obelisk back and very convincing bust. – Above, on the wall-passage, two Neo-Greek sarcophagi with reliefs, both by *Chantrey*. To the l., E.L. Sutton, *c.* 1840, with mourning woman lying over books; to the r. Sir G.L. Staunton, *c.* 1824, showing him seated expounding law to an Indian. – S side. William Wilberforce, by *Samuel Joseph*, 1835–40.

Seated statue, the face so violently characterized that it is almost a caricature. – Behind, tablet with relief to Dr Plenderleath †1811, by *Bacon Jun.* – Almeric de Courcy, 23rd Lord Kinsale †1719. Black sarcophagus bearing down on two putti. On it reclining figure in Roman dress wearing a periwig. Looped canopy on the reredos back, with fluted Corinthian pilasters. Attributed to *Richard Crutcher* (GF). – Sir T. Stamford Raffles by *Chantrey*, *c.* 1832; seated statue. – Above, nice little monument to Capt. Bryan †1809, another by *Bacon Jun.* – To the l., cartouche to Purcell †1695, attributed to *W. Woodman Sen.* (GF).

Third bay. STAINED GLASS. Robert Stephenson memorial, 1862 by *W. Wailes*, but 'pickled' *c.* 1948 by resetting the scenes in clear glass. They show architectural and engineering wonders ancient and modern (the Ark, Nineveh, Menai Bridge, Newcastle High Level Bridge) and portraits of engineers. – MONUMENTS. N side, within the medieval wall arcading. Dr Croft, †1727. Organ on the base; bust at the top. Attributed to *W. Woodman Sen.* (GF). – John Blow, Croft's predecessor as Abbey organist, †1708. Cartouche with two cherubs' heads. Open music book at the foot showing a canon composed by Blow. Attributed to *James Hardy* (GF). – Philip de Sausmarez, by *Cheere*, erected *c.* 1757. Excellent Rococo pedestal with sea battle in relief. Oval medallion, two putti, shell garlands; very lively and elegant. – S side. Dr Chamberlen, 1729–31. By *Scheemakers*. A cultured scholarly face; reclining figure on black sarcophagus; Physic and Longevity stand l. and r. One of these, probably Longevity, is by *L. Delvaux*. Reredos back. – To the r., Orlando Gibbons (†1625), black marble bust by *A. G. Walker*, 1907, after that by Nicholas Stone at Canterbury Cathedral. – S. Arnold †1812. Tablet by *Nollekens*. – To the l., Michael Balfe, tablet by *L. A. Malempré*, dated 1881. – BRASS in the floor to Bishop Monk, whose daughters founded St James-the-Less (*see* p. 766). 1859 by *Hardman*.

Fourth bay, i.e. the far W section of the back of the choir enclosure. Mary James †1677, by *J. Latham*. Urn on a pedestal. – Sir T. Hesketh †1605. Reclining stiffly on his side. Columns l. and r. and big heavy strapwork behind. By the same workshop as Thomas Owen's monument in the choir S aisle (*see* p. 171). – Sir T. Fowell Buxton †1845, seated statue by *Thrupp* on a Gothic pedestal. – W. E. Forster, medallion, 1888 by *Henry Pinker*.

Gallery, including Lapidarium

Some MONUMENTS were transferred to the gallery in the later C19 and C20. In the S transept E gallery two large obelisk-backed compositions by *Rysbrack*, moved in 1936 to expose the medieval paintings in the S transept. John Gay, 1736, designed after a tomb of 1683 by F. Girardon in Tournai Cathedral. Standing putto on pedestal holding a portrait medallion. – Nicholas Rowe and his daughter Charlotte, after 1740. High pedestal with bust of Rowe. Seated female mourner. Portrait of his daughter in profile behind. – N transept E gallery, Sir Christopher Hatton Jun. and wife, †1619 and 1623, transferred from Abbot Islip's Chapel in 1950. An innovative composition. Rather stodgy figures reclining on the sloping sides of a pediment. Back with putti and arms

against knotted drapery. – E arm, S side. G.L. Johnstone, a minor *Flaxman*, 1815, with prostrate mourner.

On the N side a LAPIDARIUM or museum was created after 1995, for items from the Abbey not included in the public museum in the cloister. An intriguing chronological display: Norman ARCHITECTURAL FRAGMENTS, part of an E chapel WINDOW (grisaille and non-figurative patterns; probably *c.* 1255), architectural MODELS including *Wren*'s proposal for a crossing tower and spire of *c.* 1720 (restored 1981), and much else, including sections of MONUMENTS large and small. Major pieces of part-dismantled works are mentioned above; others, entirely banished, include Lady Eland †1694, a rare work by the Huguenot *Nadauld*, 1704, with a nobly austere and very un-English relief of mourning.

Henry VII's Chapel

Central space

The monument of Henry VII and Elizabeth of York (†1509, 1503) takes precedence. It is the greatest monument of the Early Renaissance in England, and stands within an earlier screen that is itself the grandest piece of English Late Gothic metalwork – though neither was made by an Englishman. The position is determined by the diagonal square on which the chapel E end was set out.

The MONUMENT itself was made by *Pietro Torrigiano*, who had been a pupil of Ghirlandaio in Florence, almost certainly to his own designs. Torrigiano is remembered as the rowdy youth who knocked in the nose of a fellow pupil, Michelangelo (who was no doubt a trying boy). He had none of Michelangelo's overawing genius, but for delicate, sensitive work in the Late Quattrocento tradition the choice could not have been better.

Work began in 1512, and was to cost £1,500. It was completed, it seems, just before 1518. The images were cast by *Nicholas Ewen*. The monument is a tomb-chest with the customary recumbent praying effigies, perhaps a deliberate reference to royal tradition by the new dynasty. But in every other respect it breaks with English monumental conventions, and it must be remembered that in 1512 there was nothing else in England to represent in three dimensions the new taste which Torrigiano brought with him (except perhaps the monument of Lady Margaret in the S aisle here, *see* below, p. 184). Even the combination of materials, black marble with a white top slab, was unfamiliar. It is treated as a sarcophagus, with pilasters instead of buttresses, decorated with pretty candelabra shapes. Between them, instead of cano-pied niches, wreathed figure medallions; at the ends, instead of angels, winged putti; on top, instead of gaunt figures in angular draperies, living likenesses in mantles with amply rounded contours. Their gentleness, tenderness and unison of lifelikeness with sheer beauty of modelling were unprecedented in England. On the corners four seated fully dressed angels, their faces child-like yet of supreme dignity. Also outstanding are the Trajanic classical lettering of the tomb-slab and the six medallions on

the sides, each with two standing figures. The subjects are: N side, E to W: St Barbara and St Mary Magdalen; St Anne and St Christopher; St Vincent and St Edward the Confessor. S side, E to W: St Anthony and St George (a Roman soldier à la Donatello); St John Baptist and St John Evangelist; St Michael Archangel and the Madonna and Child. Modest restoration by Scott, 1869. 21

The SCREEN, 'a little building of brass' (Lethaby), was begun in 1505, probably to enclose the tomb begun at Windsor c. 1501 and transferred here incomplete in 1503, and completed c. 1512.* It was supplied by a 'Dutch' smith called *Thomas*, that is a man from the Netherlands or Germany, but the style is entirely English and Perp. Elaborate openwork tracery in two tiers. Pierced, ribbed coving to the outside as well as the inside. Pierced parapet with, in the middle of each side, a big candle bracket coming forward, carrying a giant crowned rose. At the angles of the screen are heavy hexagonal turrets, also of openwork. Doors under depressed segmental arches to the N and S. Statuettes in two tiers stood in niches flanking the turrets and the doorways. Six of them survive. Amongst them are some in a style which might be called a truly English Renaissance, that is a new calm and evenness of fall in the draperies achieved without borrowing from Italy (e.g. Edward the Confessor, St John the Baptist). Restored 1869.

ALTAR at the W end. Of 1935 by *Sir Walter Tapper*, on the pattern of *Torrigiano*'s canopied Renaissance altar of 1519–20, and incorporating parts from it: two pillars (of four) with close early Renaissance decoration, and part of the marble frieze. – ALTAR-PIECE of the Virgin and Child by *Bartolommeo Vivarini*, c. 1480. – STALLS. Mostly of c. 1512. Two rows, the back with tall intricate canopies in the English way. But some details, e.g. of the wirily looping foliage, are decidedly Flemish Flamboyant in character, and foreign workmanship is likely here. Also exceptional is the alternation of half-hexagonal and half-octagonal shapes. Pretty lierne vaulting under them, and under the book-rests of the upper row. The stalls of the E bay are matching mid-C18 additions, under reused C16 canopies; also the lower stalls in the next bay to the W. They accommodated extra Knights of the Bath, who were assigned the chapel on their Order's revival in 1725. Plenty of entertaining MISERICORDS, some of which derive from contemporary prints by Dürer and Israel van Meckenen (mermaid and merman, monsters, monkeys, wife beating husband and vice versa, David and Goliath, Judgement of Solomon). The return stalls in the W corners, meant for royalty, have scenes of the grape harvest. That on the S shows the new Renaissance interest in the nude body. Another misericord is C13, reset. It has stiff-leaf foliage (S side, first to the l. of the second stair from the W; from Henry III's choir stalls?). Also heraldic 22

*This project was abandoned in turn by 1506, when a new design was commissioned from *Guido Mazzoni* of Modena. He proposed kneeling figures above cadaver effigies, with four more at the corners, a composition close to his lost tomb for Charles VIII of France. But Henry's will in 1509 specified a traditional, recumbent treatment after all.

STALL PLATES of Knights of the Bath and their esquires, of brass or copper, enamelled or painted, and BANNERS above. – W DOORS or gates. Three openwork doors of oak, entirely plated with bronze openwork panels with such emblems as the portcullis, crown and roses, fleurs-de-lys, falcon and fetterlock, and three leopards. The work is similar enough to Henry VII's monument screen to allow an attribution to *Thomas Ducheman*. – FONT. Purbeck marble. The fine big bowl with its quatrefoils is C15 or early C16. Moved here in 1871 and restored by *Scott*. He designed the ogee COVER, made by *Farmer & Brindley*, 1872. – PAVEMENT of 1699 and later. Diagonal black-and-white squares.* – STAINED GLASS. E window by *Alan Younger*, 2000, close and somewhat bitty scenes. – W window by *John Lawson* of *Goddard & Gibbs*, 1995, to mark the end of the chapel's restoration. A major work in the mid-C20 heraldic tradition. For windows in the E chapels *see* below. The C16 windows showed Old and New Testament scenes in the clerestory and W window, heraldic badges in the chapels. The former were destroyed in 1643; a few of the latter lasted until 1940.

Chapels at the east end

Five radiating chapels of identical plan fill the E apse. Clockwise, from the NE:

FIRST CHAPEL. MONUMENT, attached to the W wall. George Villiers, 1st Duke of Buckingham, assassinated 1628, and his Duchess. Of *c.* 1631–4 by *Le Sueur*, with marble parts by *Isaac Besnier*. The first non-royal tomb in Henry VII's Chapel, a sign of Buckingham's high favour with Charles I. Tomb-chest with recumbent effigies, and seated mourners facing outwards: Neptune and Mars, E, Benevolentia and Pallas, W. Also a small bronze statue of Fame, at the effigies' feet. Her bronze trumpet is lost, as are the ornaments formerly on the four big corner obelisks. These rest on bronze skulls. Back wall (W) with three kneeling children, and one child behind, reclining. Three variously shaped pediments above, with allegorical figures high up.

SECOND CHAPEL. MONUMENT. John Sheffield, 1st Duke of Buckingham (of Buckingham House), †1721. Designed by *Denis Plumier* and completed after his death by *Scheemakers* and *Laurent Delvaux*, 1721–2, under *Gibbs*'s supervision. Large, lively composition, anticipating the inventiveness of Roubiliac. The Duke reclining on a sarcophagus and trophies, in the field armour of a Roman general. At his feet the Duchess, a natural daughter of James II. Higher up, on a pedestal, Father Time (by *Delvaux*), with medallion of the Duke's children. Putti alongside. – Portable ORGAN by *John Snetzler*, mid-C18, in an architectural case. Given 1965. – STAINED GLASS in all four side chapels by *Alfred Fisher* and *Peter Archer*, 1995 onwards, with emblematic scenes commemorating donors to the restoration.

THIRD, E CHAPEL (RAF CHAPEL). STAINED GLASS. Battle of Britain Window, 1946–7 by *Hugh Easton*. Denser and more

43

*Much of it replaced after 1737, when *Henry Flitcroft* made a big family vault for George II.

colourful than usual for him, which suits the windows' forty-eight small lights. Heraldry, Crucifixion scenes, and a kind of nude male seraphim. ALTAR designed by *Sir Albert Richardson*, ALTAR RAILS by *J. Seymour Lindsay*.

FOURTH CHAPEL. MONUMENTS. Duc de Montpensier †1807, brother of King Louis-Philippe of France, who set it up in 1830. Tomb-chest with robed effigy by *Sir R. Westmacott*, rather in the troubadour style. – A.P. Stanley, the great Victorian Dean. Designed by *Pearson* and carved by *Boehm*, 1882–4. Tomb-chest with recumbent effigy.

FIFTH CHAPEL. Original DOOR to the low stone screen. – MONUMENTS. 1st Duke of Richmond and 2nd of Lennox, cousin of James I, †1624 and his wife †1639. A giant black and gilt installation by *Le Sueur*, almost filling the chapel. Recorded as existing 1628. The composition derives from Netherlandish and French precedent. Sarcophagus with recumbent effigies. At the angles four life-size bronze caryatids, weeping under Ionic capitals. They represent Faith, Hope, Charity and Prudence. On them a big entablature and a big openwork gilt dome like that of an arbour. On the top, figure of Fame with two trumpets, balancing on one foot, much like such French work as the younger Pierre Biard's Fame of 1597 (in the Louvre). Large caryatids were an accepted motif in France too, though free-standing; for tombs they were rather a Flemish tradition (cf. Cornelis Floris's tomb of Frederick I of Denmark at Schleswig, c. 1550). – To the E, Esmé, 2nd Duke of Richmond and 5th of Lennox, †1660. An obelisk supporting an urn, which holds his heart.

North aisle

Both aisles can now be entered only at the extreme W. MONU-MENTS. Queen Elizabeth I †1603. By *Maximilian Colt*, 1605–7. Free-standing, and nothing like as flaunting as the monuments erected by her courtiers. Four bays by three, making a total of ten black columns. They carry two straight-topped side pieces and a coffered middle arch rising much higher. White marble effigy, brilliantly characterized. Replica crown, collar and RAIL-INGS, added 1976–87. – To the E the 'Innocents' Corner' with the monuments to two infant daughters of James I: the first of the new Stuart dynasty. Princess Sophia †1606, three days old. By *Colt*, 1607. The questionable conceit of an alabaster cradle, accurately portrayed with its embroidered cover. The baby faces E, so one has to go round the hood of the cradle to peep in. – Princess Mary †1607, two years old. Of 1608. Tomb-chest with seated putti at the angles. On the top reclining girl. – Set in the E wall above: Edward V and Richard, Duke of York, the Princes said to have been murdered at Richard III's request after 1482. The bones were found in 1678 at the Tower of London. The monument is by *Joshua Marshall*, a pedestal with broad low urn. No effigies. – Further W on the S wall: Sir George Savile †1695. Plain sarcophagus with medallion and two putti. Restrained white reredos back. – 1st Earl of Halifax †1715. Big obelisk on bronze gryphons.

South aisle

The ALTAR is by *Detmar Blow*, 1924. – TAPESTRY above, looking
C16. – MONUMENTS. First those free-standing in the centre, from
E to W. Lady Margaret Beaufort, Countess of Richmond and
Derby, Henry VII's mother, †1509. Made in 1511–13, in collabo-
ration between *MaynardVewyck*, a Flemish painter, and the sculp-
tor *Pietro Torrigiano*. 'Counsel in devising' was given by the Prior
of St Bartholomew-the-Great, William Bolton (*see* also
p. 138). What matters most in the monument must be due to Tor-
rigiano, who here created the earliest known Italian Renaissance
work in England. Tomb-chest already of black marble, not the
usual English Purbeck, with classical pilasters and shields in
wreaths. Inscription in Roman lettering. Recumbent effigy, again
– as in the tomb of Henry VII – with a wonderful understanding
of character, life-like and yet spiritualized. The effigy has buttress
strips still in the Gothic taste on each side, and over its head a
Gothic canopy with pierced tracery. At her feet a Yale, a heraldic
beast. These upper parts, and the traditional pose, presumably
follow Vewyck's designs. – The RAILINGS of Spanish iron
(put back in the C20) were made by *Cornelius Symondson*, 1526–7,
and originally carried much decoration. They were paid for
by St John's College, Cambridge, founded by the Lady Margaret.
– Free-standing further W Mary Stuart, Queen of Scots,
†1587. Begun in 1607 by *Cornelius Cure*, who died that year;
finished by *William Cure II, c.* 1613. Two groups of four columns
carrying straight canopies, connected by a coffered arch: a super-
structure similar to that of Queen Elizabeth's tomb, but bigger
and heavier. Thistles decorate the coffering. White marble effigy
of superb craftsmanship high up on a sarcophagus. The iron
RAILINGS were removed in 1820 but refixed in the 1950s. –
Yet further W Countess of Lennox †1578. Free-standing tomb-
chest with decorated pilasters and no canopy. Corner obelisks.
Kneeling children against the tomb-chest. Recumbent effigy,
her mantle draped across her legs. Restored and recoloured
1957–8.

Other monuments from E to W: To the l. of the altar General
Monk, 1st Duke of Albemarle, †1670. Of 1742–6, designed by
Kent and made by *Scheemakers*, after the funeral effigy. Black
obelisk and *columna rostrata*. The Duke stands to the r. in armour.
To the l. seated female figure leaning on a portrait medallion
of Monk's son. – Catherine, Lady Walpole †1737, wife of Sir
Robert; ordered by her son Horace. By *Filippo della Valle*,
1740–1. A commemorative monument, not a tomb. Its pure
classical taste is very original by comparison with conventions
then current in England. The pose and draperies follow a
Roman statue identified both as Modesty and as Faustina,
wife of Marcus Aurelius. Simple square pedestal by *Rysbrack*,
1754, with inscription plate framed by leaf scrolls. – At the W end,
three portrait tablets to Imperialists: 1st Earl of Cromer, by
Sir W. Goscombe John, 1920; 1st Marquess Curzon †1925, by
Sir Bertram Mackennal; 1st Viscount Milner †1925, by *Gilbert
Ledward*.

Vestibule

Bookmark-like PLAQUES to donors were fitted into the panelling in 1999. Designer *Donald Buttress*. PAINTING of the vault in gentle dusty colours, a late C19 scheme restored in the 1990s.

THE ABBEY PRECINCTS

The Abbey's precincts are crammed with interest, but can be hard to comprehend in their entirety. They are described here under three heads, organized with a view to ease of visiting. p. 186

The first section begins with the Great Cloister, which is C13–C14 within enclosing walls or structures partly of the late C11. These occupy the orthodox positions: the cloister to the s of the nave and s transept; on its E side, the former Dormitory, with the mid-C13 Chapter House projecting further E still; on its s side, the ruins of the Refectory. Also included is the Deanery (formerly the abbot's house), largely of the late C14, which is laid out around its own courtyard w of the Great Cloister, and the much-rebuilt Little or Farmery (Infirmary) Cloister, SE of the Great Cloister, now a mixture of the C12, C14, C17 and C20. Dean's Yard, the second section, is a big semi-public space of mixed architecture, lying to the sw. Also very mixed in its build- ing stock is Little Dean's Yard (now the central focus of West- minster School), which forms the third section and which lies E of Dean's Yard and s of the cloisters. School properties in the Deanery and Great Cloister are treated in the first section, those in Dean's Yard in the second. 2

The CLOSE TO THE N OF THE ABBEY extended some way N of the present Parliament Square and The Sanctuary (qq.v.). For completeness' sake and to visualize the close as it was, it is worth mentioning the NORTH GATE which stood some 300ft (91.5 metres) N of the N transept, the WEST GATE at the E end of Tothill Street, rebuilt in the later C14 and demolished in 1777 (and with the ALMONRY and HENRY VII's ALMSHOUSES just outside it, to the sw), and the BELL-TOWER, a plain detached structure on the site of the present Middlesex Crown Court. This was built in 1249–53 and taken down in 1750. It was 75ft (22.8 metres) square and 60ft (18.3 metres) high, plus a leaded spire. Salisbury had such a campanile, and later examples still exist at Chichester and Evesham.

Cloisters, Deanery and Abbey Garden

Great Cloister

The GREAT CLOISTER occupies very nearly the space of its C11 predecessor. Still of this time are the outer s wall, and parts of the outer E wall and (probably) the N wall; the line of the w arcade wall was traced in 1909, slightly E of the present one. Many carved fragments have also been recovered. Rebuilding began in the C13 with the N side and the N part of the E side. The latter is peculiar for the inclusion of its N part within the volume of the p. 188

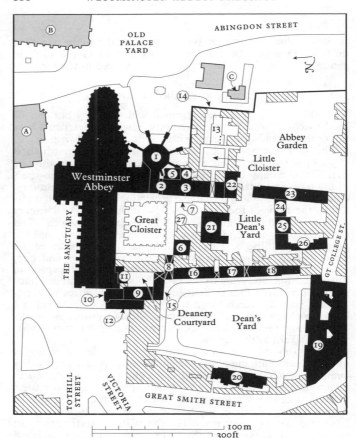

Westminster Abbey. Plan of the precincts

I	Chapter House and vestibule	17	Guest House
2	Day stair (to Library)	18	Hospice of Treasurer
3	Chapel of the Pyx and Museum,		and Monk Bailiff
	with Dormitory over	19	Church House (part)
4	St Dunstan's Chapel	20	Choir School
5	Gymnasium	21	Ashburnham House
6	Song School	22	School Buildings on part
7	Dark Cloister		of Reredorter site
8	Parlour	23	Dormitory ('College')
9	Hall	24	House of the Master of
10	Jerusalem Chamber		the Queen's Scholars
11	Jericho Parlour	25	Grant's House
12	Abbey Shop	26	Rigaud's House
13	Infirmary Chapel (ruins)	27	Site of Refectory
14	Precinct wall	A	St Margaret
15	Abbot's house (part of)	B	Palace of Westminster
16	Cellarer's Building	C	Jewel Tower

s transept, as has been noted. Big buttresses come down over it into the cloister garth, as do the giant flying buttresses embracing the N walk. The rest is C14, of two advanced but very different styles; the earlier is due to repairs that followed a fire in 1298.

The rebuilding work started at the NE corner at the very beginning of Henry III's church, in 1246, under *Henry of Reynes*. By 1249, when the mason *Master Alberic* or *Aubrey* was working on capitals for it, the cloister must have been well advanced. Its earliest parts are the N bays of the E walk, and then the E bays of the N walk not long afterwards. Quadripartite vaults here, with the same bands of grey stone as in the church itself. Those on the E side are the earliest of the new Abbey. The DOORWAY from the nave here is exquisitely decorated with two orders of Purbeck marble shafts, rosettes up the hollow moulding between them, diapering closer to the opening, foliage roundels in the voussoirs, and a hoodmould on crowned heads. The l. side has crocket capitals. In the cloister proper, the inconsistent tracery motifs seem to reflect the succession of masons after Henry of Reynes's departure in 1253/4. The three N bays of the E WALK take the place of the W aisle of the S transept, as has been explained. The three bays of blank tracery of the wall arcade and the first two openings towards the cloister garth are of three lights with pointed-trefoiled heads, and above three unencircled trefoils, a motif invented, it seems, only a few years before at the Sainte Chapelle in Paris. The S bay of the three is broader, so the trefoils do not touch the arch. The N bay wall arcade lacks shafts, to make space for the book chests that would have stood here. But in the N WALK the wall arcade tracery has unencircled quatrefoils instead of trefoils, a change probably due to *John of Gloucester*, i.e. after 1253. The first, blind bay on the S side matches. But the openings to the garth revert to the circle-based tracery of other parts of the Abbey. The cinquefoil cusps in these are *Sir G. G. Scott*'s well-meaning embellishments of what were originally just three plain circles, a motif traceable to *Robert of Beverley* after 1260. The W end runs on for two bays W of the part of the nave rebuilt by Henry III, and omits the wall arcade tracery. Here the lower S wall of the C11 nave seems to have been left *in situ*. The glazing of the tracery and that of the heads below reflects the original throughout.

Back to the E walk, where the system of the N part soon breaks up. On the outer wall this is due in part to the various rooms off to the E. The fourth bay (the W wall of St Faith's Chapel) has three plain blank arches and no tracery. In the fifth bay is the Chapter House entrance (*see* p. 189). The narrow sixth bay has the doorway to the Library (formerly the day stairs to the Dormitory). It has one order of columns and a tympanum with two blank arch heads and a quatrefoil filled by a stiff-leaf arrangement of symmetrical cross-shape. The seventh bay (with the entrance to the Chapel of the Pyx in it, *see* p. 193) and eighth bay mark the start of the C11 walling, on a different alignment. The cloister walk proper is different again, due to rebuilding in a rich Dec style after an extensive fire of 1298. The date may therefore be as early as *c.* 1300–10, as Christopher Wilson has suggested,

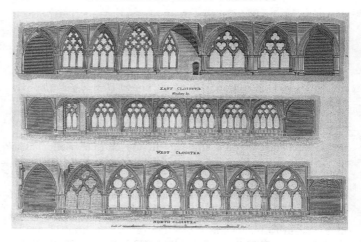

Westminster Abbey. Great Cloister. East, west and north sides.
Engravings (J.P. Neale, *The History and Antiquities of the Abbey
Church of St Peter, Westminster*, 1818–23)

rather than the traditional date in the 1340s. The change is
announced by openings towards the garth with elaborate reticu-
lated tracery, much restored *c.* 1835 by *E. Blore*. The first is in
the fourth bay, a two-light opening squeezed in just s of the
blank wall where the great SW buttress of the transept projects
externally. The fifth bay, with the Chapter House entrance, has
a four-light opening and a more sumptuous display of tracery. It
consists of alternating types of ogee-framed quatrefoil, each with
spikes projecting from the junctions of the four lobes. These
motifs, bristling with sharp points, are repeated seven and four
times apart from the fragmentary forms where the system fits
into the main arch. The details are close enough to *Michael of
Canterbury*'s work of the 1290s–1300s, especially at Canterbury
and St Stephen's Chapel (*see* p. 228), to allow an attribution to
him. Another advanced feature is the lierne vault over the
Chapter House bay. The three bays to the s have quadripartite
vaults enriched by ridge ribs and transverse ridge ribs, with a pro-
nounced downward slope from N to S.

The s WALK, begun in 1344 and vaulted in 1349, adopts the
new Perpendicular style introduced to the Abbey in the W porch.
The difference appears in the tracery, of two straight-sided
panels. It is a very close match for that of the upper cloister at
Old St Paul's Cathedral, begun in 1332 by *William Ramsey III*
(†1349). So Ramsey may well have been the designer here too;
certainly a former subordinate of his, *John Palterton*, was in
charge at the Westminster cloister by 1352. The cusping pattern
in the panels, which differs from St Paul's, is due to *Scott*'s
renewals of almost all the s-side openings. Tierceron vaults, with
ridge ribs and transverse ridge ribs. (For the openings in the

outer S wall *see* the Refectory, below, pp. 193–4.) The W WALK is a little later, completed in 1365 under Abbot Litlyngton, so may be *Palterton*'s own design. It has four-light openings and there-fore five panels, arranged three above two. The far N opening on the W side is narrower, to fit into a nave buttress, and has two openings and three panels. Just ahead here is the beautiful late C14 DOORWAY into the S aisle, with two-centred arch and four circles with tracery above. Two of them have mouchette wheels. The vault on this side is a lower version of that of the S walk. Where these vaults meet those of the N and E walks, blank tracery between the bays overcomes the difference in height.

Rooms off the Great Cloister, east side: Chapter House, Library, Chapel of the Pyx and Museum

The Chapter House was built by *Henry of Reynes*, concurrently with the E arm of Henry III's new Abbey. Its exterior is described above (*see* p. 120). Its crypt must have been begun at once, i.e. in 1246, and the superstructure continued without a break. Already in 1250 Matthew Paris called it 'incomparable'. A lectern was ordered for it in 1249, and in 1253 temporary canvases were bought for the windows. A royal council was held here in 1257, so the tile pavement must have been laid by then. But from the late C16 it was adapted as a store for official records, and in 1751–2 its vault was declared dangerous and taken down. When this use ended *Sir G. G. Scott* restored the Chapter House at Gov-ernment expense, in 1866–73. He found it an injured carcase full of bookcases, staircases and galleries, but rich in clues and frag-ments of what had once been. If we have an idea today of its noble original beauty, Scott's work has given it to us.

The ENTRANCE BAY in the cloister makes an exceptionally rich ruin. The way in is by a low double doorway framed within a blank arch of full height. The arch has three orders of Purbeck shafts with traces of foliage between. The outer order carries the arches and ribs of the cloister vault, the inner two carry archi-volts with small-scale carved decoration, one with fragmentary seated figures representing the Tree of Jesse, the other and inmost with foliage circles. The doorways themselves have no capitals or any other hiatus between jambs and arches. They have a hollow chamfer decorated with more sprays of stiff-leaf foliage. The large tympanum above them is given the unusual and typically Westminster all-over enrichment of large foliage scrolls. In the spandrel between the doorways rises a large stiff-leaf bracket for a (missing) figure of the Virgin and Child. Smaller brackets above the apexes of the doorways support two angels. Enough is preserved of the r. one for the Westminster features of slender proportions and long, sharply cut, parallel vertical folds to be recognizable.

The doorway leads into a low, dark OUTER VESTIBULE, two bays wide and three deep. The height could not be increased because of the need to respect the Dormitory floor level above. The vault has ribs of an elegant complex section and stiff-leaf bosses, the N side partly renewed by *Scott* (where the old library staircase was). It rests on circular Purbeck shafts with moulded

capitals. Along the walls blank arcading with pointed arches of so shallow a curve that they are almost triangular. In the E end bay of the S side is a DOOR, perhaps as early as the late C11. Traces of original ironwork and fragments of skin on it.

The INNER VESTIBULE is as wide as the outer one but has no subdivision into aisles. Here the vaults, which also rest on Purbeck shafts, run across in a single span, in one near-square and one narrow bay. The room consequently seems wider, and it is also considerably higher, with space for the staircase ascending to the Chapter House proper at the far end. And before *Scott* closed up the open tympanum of the entrance arch ahead, the room was also even more full of light. So there can be no doubt that the designer was conscious of the crescendo he was here achieving. The wall towards the outer vestibule again has two doorways with no hiatus between jambs and arches, but with stiff-leaf sprays all up both. Above them is blank arcading just like that of the cloister N walk: three lancets and three unencircled quatrefoils. In the lancets are brackets for statues. The whole composition is, like the entrance from the cloister, enclosed by an arch of three orders on tall Purbeck shafts. Stiff-leaf sprays up the jambs between the shafts, and in the arch one order of voussoirs with stiff-leaf foliage too. In the S wall is one three-light window, restored by *Scott*, and one slim lancet. The three-light window is so typical of *c.* 1300 that it must be part of the repairs done after the fire of 1298. Two two-light windows opposite, to St Faith's Chapel.

7 The CHAPTER HOUSE is of an exceptional architectural purity. It is octagonal, like the slightly earlier one at Beverley, now lost (Lincoln's, also earlier, is ten-sided). But whereas their walls had had no larger openings than lancets, Henry of Reynes filled the whole wall space of six of his eight sides with four broad four-light windows nearly 40 ft (12.2 metres) tall and 20 ft (6.1 metres) wide. The seventh window is truncated by the entrance below; the eighth, hard against the S transept, has blank tracery, which gave Scott an accurate model for re-creating the six lost windows. These made full use of recent French inventions in the E chapels of Notre Dame (*c.* 1240) and the Sainte Chapelle (begun *c.* 1241–3) – more so than the windows of the Abbey itself, with their dependence on the earlier C13 model of Reims. One large foiled circle crowns and dominates each window. Below it are two arches, each containing an unencircled quatrefoil, and below these are the four even pointed cusped lights: a perfectly logical design. The dado zone below the windows also deserves special study. The arcading above the stepped stone bench has trefoiled arches which are not pointed, an early C13 French motif also used in the blind porch of the N transept. Their centres align with the mullions, making five arches in each bay. On the E side the back wall is recessed so that the arcading stands free. The capitals of the Purbeck shafts include stiff-leaf types from the simplest upright leaves to the later 'wind-blown' variety. Most are reliable restorations, by *Poole & Sons*. The spandrels mainly have six-inch-square diapering like that of the C13 church proper, but occasionally more natural motifs are introduced (E bay, r. of Christ in Majesty, SE bay, SW bay), especially a rose motif with leaves

growing on a trellis. At the eight angles the Purbeck shafting gets very rich, for the central vaulting-shaft comes down into the dado zone, and in the window zone three nook-shafts for the windows are fitted in on either side. In addition the vault is carried on a tall slim central pier of eight shafts tied together by two shaft-rings. *Scott* rebuilt the vault following evidence from recovered rib fragments, some of which he reused. Its design is evolved on the pattern of the Lincoln chapter house, with three ribs and a boss in each of the eight triangular cells, but omitting ridge ribs and liernes. Originally it was braced with horizontal iron ties spanning from the pier (cf. Salisbury). Scott and his engineer *R.M. Ordish* used concealed iron framing instead, under a new steep-pointed roof.

The ENTRANCE WALL sadly has been tampered with. It has a large, tall arch on two orders of Purbeck shafts. There are two doorways, and the inner order carries these. Between the two orders on the l. side a chain of nine well-preserved seated figures, a reminder of how exquisite the carving even of minor details must originally have been. The capitals are largely Scott's. The arch has one order of voussoirs with seated figures of a Tree of Jesse connected by foliage scrolls. The trumeau of the double doorway is also Scott's, as is alas the large double-sided group of Christ in Majesty which blocks the quatrefoiled circle (sculptor *James Redfern*). The narrow blank pointed-trefoiled arches to the l. and r. of the doorway are original. Above them in two rounded-trefoiled recesses stand the two figures of the Annunciation, which will be discussed in a moment. The spandrels between these recesses and the main arch are filled somewhat awkwardly by trefoils each with two figures of angels of different sizes, according to the spaces available. The remaining wall space again has diapering. It is curious that such cacophony as the meeting of the pointed main arch with the trefoils and trefoiled heads of the recesses and altogether the bitty disposition of forms on this entrance should have been devised by the same artist who conceived the tall, airy, spacious whole of this Chapter House, the pattern for Salisbury (*c.* 1260) and others to come.

SCULPTURE. Annunciation, w wall. Two figures by *William Yxewerth*, paid for in 1253. They are slender figures, rather stiffly erect, with the sharp ridges in the drapery like those of the angels in the transept, but with less elegance of action. The arm of the angel, l., is unfortunate; it seems withered. The attitude and drapery of the Virgin are derived from Reims, but from the stage preceding that of the Joseph and Anna, that is, from the Queen of Sheba, etc. The elongation is English (cf. Wells). Some original colouring on her head. She is of Reigate stone, he of Caen.

TILES. The pavement of tiles of *c.* 1255 was relaid by *Scott* but is otherwise little restored. Mostly of foliage, but also shields, an archer, a horseman, St Edward and St John, a king, a queen, a bishop, a smiling fish (the salmon of St Peter, from an Abbey legend) and an oft-repeated rose window. This last is of special interest architecturally as it represents fairly accurately what the N transept rose was like – an eminently up-to-date design, not only from an English point of view. In the pavement Henry III

placed the proud inscription: 'Ut rosa flos florum sic est domus ista domorum' (As the rose is the flower of flowers, so is this house that of houses). Work by the same tilers has been identified at Chertsey Abbey, Surrey, and Hailes Abbey, Gloucs.

PAINTINGS. After the mid C14 the backs of the seats of the Chapter, that is the blank arches of the dado zone, were painted with pictorial scenes. A connection has been suggested with the use of the room by the House of Commons between *c.* 1352 and 1395, but some initiative by the Abbey seems more likely. A C15 source identifies the monk John of Northampton (†1404) as their instigator, but he may not have been the only patron, especially as several styles and campaigns appear. What remains is damaged or badly restored, and in any case does not seem to have been of very high quality. The E wall, where the abbot and prior sat, was a Last Judgement. Seated Christ in the centre. Angels and Instruments of the Passion l. and r. In the NW bay scenes from Revelation. The first arch deals with the legend of St John, the second, third and fourth with the events of the Apocalypse. Below these a Bestiary was added in the late C15. Such animals as the reindeer and roe, the wild ass and tame ass, the dromedary and the camel still appear. The upper inscriptions are in black letter, written on vellum and pasted on. Minor traces in the SE bay, S bay and S W bay. The source of the composition of the Apocalypse is illuminated manuscripts, the source of the style probably Hanseatic (Master Bertram of Hamburg).

STAINED GLASS. With historical scenes from war-damaged windows by *Clayton & Bell*, installed from 1882 as a memorial to Dean Stanley. Reset stamp-album fashion and added to by *Joan Howson*, 1950–1, with enjoyable emblematic miniatures peppered across them. The C19 window over the entrance remains. – In the inner vestibule S wall, J.R. Lowell memorial, 1893, two windows by *Clayton & Bell*. Below and part of the memorial a MONUMENT by *Sir G. Frampton*, with portrait relief.

CRYPT. The Chapter House has an octagonal crypt, accessible from a passage and steps off the S transept E aisle. It has a low vault, springing from a thick circular pier to eight slim wall-shafts. The ribs are simply chamfered. Windows are square and heavily barred, walls extraordinarily thick (up to 17 ft, 5.2 metres; built for some reason in two phases). The central pier is hollowed out, as if for a locker for valuables. The E side was equipped for an altar (with a plain PISCINA and AUMBRY).

LIBRARY (first floor). Formed *c.* 1450 by walling off the N part of the Dormitory. Access is by the monastic DAY STAIR formed in the mid C13 in the bay S of the Chapter House entrance, rediscovered in the 1850s and restored by *Scott* (but remade as a dog-leg in *Sir Walter Tapper*'s alterations, 1932). The library has a heavy, strictly utilitarian mid-C15 hammerbeam roof, pierced with big dormers; windows of C15–C16 type below, E. Refurnished in 1623 by Dean Williams with projecting shelves or BOOK-PRESSES at right angles to the side walls, like a contemporary college library at Oxford or Cambridge. A little strapwork decoration on top of the ends. Blind pointed mid-C15 recesses in the N wall, added to support recasing of the S transept front above and exposed when Tapper removed Williams's gallery here. Also

a doorway leading to the W gallery of St Faith's Chapel, and so on originally to the former night stair into the S transept. Next to it is *Tapper*'s beautifully crafted spiral staircase up to his toplit library extension under the E cloister walk roof.

The MUNIMENT ROOM opens off the N end of this gallery. It occupies the space over the N part of the walk housed within the volume of the S transept. Its original function and embellishments are discussed above, pp. 130–1. The present use dates from the later C14, the likely period of the inserted partition with its huge and much-restored late C14 PAINTING of Richard II's white hart. – TILES. Late C13. Some excellently preserved. – FURNITURE. Superb CUPBOARD with punched and painted decoration, dated by dendrochronology *c.* 1400. Other sound utilitarian pieces, including big CHESTS from between the C12 and C15. – STAINED GLASS. Detached mid-C13 roundel with the Resurrection, in style like the panels now in the Abbey Museum (*see* below).

CHAPEL OF THE PYX AND MUSEUM. These were originally one, and formed the undercroft of the Dormitory of *c.* 1066–75. The chapel fills the two N bays, the museum five bays to the S. The C11 room continued a little further N, but was cut off in the mid C13 when the day stair was constructed. The remaining C11 features are the circular piers, those capitals which are undecorated, the groin vaults and some of the plain transverse arches. Several capitals have carved enrichments of the late C12, partly of plain upright leaves, partly of stiff-leaf and some more richly lobed leaf shapes.

The CHAPEL was formed in the late C12 by inserting the cross wall to the S. The original surfaces survive better here. Its mighty double DOOR has been dated to after 1303, when the treasure kept within was robbed. – Simple medieval ALTAR, with a sunken recess in the slab. – TILES in front, probably laid 1291. – Two big CHESTS, late C13 and C15, built *in situ.*

The MUSEUM was created in 1908 by removing inserted walls of various dates. One blocked original E window, and on one E arch some early painted zigzag decoration in red. The present display, of 1987, includes much of unique value in understanding the history and furnishing of the Abbey: ARCHITECTURAL FRAGMENTS, including a capital with the Judgement of Solomon on one face, comparable with historiated C12 capitals known from Reading Abbey and perhaps due to work on the monks' quarters funded by Henry II (1154–89); six panels of outstandingly good STAINED GLASS of *c.* 1250–70; remains of the EFFIGIES carried at state funerals in the C14–C17; and WAX FIGURES made after that time to stand by the tombs, adding a Madame Tussaud attraction to the Abbey. Also a late Roman SARCOPHAGUS with inscription to Valerius Amandinus, found reused in the churchyard in 1869.

Rooms off the Great Cloister, south side: Refectory

In the S RANGE of the Great Cloister was the REFECTORY, a roofless ruin since 1544, but still visible above the cloister walk as a wall with tall blocked early C14 windows inserted in it. They have been dated to repairs of 1305–6, by *Robert the Mason,*

following the fire of 1298. The later C11 wall within the walk was ruthlessly refaced in Clipsham stone in 1973, replicating two early C14 RECESSES near the W end. The larger, of four lancet niches under large reticulated tracery, served as the monks' towel cupboard. In the next bay, W, a DOORWAY to the Refectory (now into the Song School), also of 1304–5, with handsome cusping and sub-cusping. Another associated feature is the restored LAVATORIUM or washing-place recess, in the enclosing wall of the W walk to the S. Segment-headed; one original figure corbel in secular dress, r.

The fullest view of the Refectory is from the garden of Ashburnham House to the S, in Westminster School (*see* p. 202). Here the E wall may also be seen, with the stub of the S wall projecting from it. On this side the N wall is of the later C11 up to very near the top. Its lower part has blank arcading with plain block capitals, much restored *c.* 1920–30 when C14 infill was removed (continued inside the SONG SCHOOL of *c.* 1912, to the W). In the upper windows transoms and cusped Y-tracery appear. Angel corbels above, for a timber roof. These seem later than the early C14, perhaps from major work recorded in 1408–9. The E wall is also C11, but with full early C14 refacing below: blind arcading, with clustered shafts and trefoiled heads. The different treatment reflects the creation of a two-storey arrangement at this end, probably in the 1340s. The stone-built upper chamber here stands over the Dark Cloister, immediately to the E. It was reconstructed to a mid-C13 appearance by *Scott* in 1863, and again for Westminster School in 1960, with an external S staircase. Attached at the SW was the MISERICORD, a mid-C13 structure where a quota of monks could eat meat, a thing forbidden by the rule of St Benedict in the Refectory proper. It was vaulted below, to allow access through from the kitchens to the S (traces under and within the present buildings). At 130 ft (40 metres) long the C14 Refectory was unusually large, and the medieval House of Commons sometimes met in it.

From the Great Cloister, the choice of routes lies W, past the Deanery and into Dean's Yard, or S to the Dark Cloister and then E to the Little Cloister and Abbey Garden. The upper parts of the Deanery can be glimpsed at the SW (*see* p. 198). At the SE, the unfortunate stone-faced 1950s flytower of the reconstructed Dormitory (*see* p. 205).

Monuments and fittings in and around the Great Cloister

The MONUMENTS are mostly modest tablets; many show the ravages of pollution. The description is clockwise from the NE.

E WALK, from the N. Second bay. The most touching inscription in the Abbey is here: 'Jane Lister, dear childe, died Oct. 7th 1688'. – Third bay. S. and A. Duroure †1745 and 1765. Designed by *George Dance the Younger*, with advanced, if rather dry architectural detail. – Fourth bay. Edward Godfrey, †1640 aged twelve, a strange cartouche with tabulated genealogies. – Arcade wall. Lt.-Gen. William Barrell †1749 (restored 1855), with trophy, attributed to *Roubiliac*. – Eighth bay. Daniel Pulteney †1731.

Designed by *Leoni*, sculpture by *Rysbrack*. Big sarcophagus and pyramid. Reclining figure on it, reading. – STAINED GLASS. C19 fragments reset in the 1950s in the tracery of the N bays. – Two sets of good iron GATES of 1721–2 (s end, also in the w walk), with reticulated heads. Maker *Thomas Knight*, designer probably *W. Dickinson*. – Down the Dark Cloister, two damaged COFFIN LIDS (C13?), fixed upright: one with a sunk quatrefoil, the other with a defaced cross.

S WALK, from E to W. In recesses below the wall bench, three defaced EFFIGIES of early abbots, survivors of eight relocated *c*. 1246, probably from the old chapter house. The traditional identifications are: Laurence †1173, the figure now utterly unrecognizable; Gilbert Crispin †1117/8, of black Tournai marble and with staff, in sunk relief; William de Humez †1222, also in high relief, with a false name and date 1082.* – Later MONUMENTS. First bay. Edward Tufnell †1719, master mason to the Abbey under Wren. Quite elaborate, with bust, and inscription referring to his refacing of much of the fabric. – Third bay. John Hay, urn-topped architecture signed by *Rysbrack*, 1754. – Edmond Halley, slate, shaped like a flaring comet. 1986, by *Richard Kindersley*. – Fourth bay. Magdalen Walsh, with urn, 1751. Signed *P. Scheemakers*. – Fifth bay. Col. Ligonier, tablet by *Roubiliac*, 1748. – Tablet in coloured marbles, 1979, to the circumnavigators Drake, Cook and Sir Francis Chichester. Designer *Eric Fraser*. – Sixth bay. Colonial Civil Service, 1966, one of several large tablets designed by *S.E. Dykes Bower*. – Then down the Parlour passage. Here on the N wall Capt. Cornewall, erected 1744, the first monument to a naval hero voted by Parliament. By the young sculptor *Robert Taylor* (later the knighted architect). Removed 1925 from just inside the W door of the nave, where it stood 36 ft (11 metres) high, to this ignominious, cut-down position. Medallion between Fame and Minerva-Britannia, these two allegorical figures carved by *B. Cheney*. All architectural features are replaced by rockwork. Relief of a naval battle below. – s wall. SCULPTURE by *Michael Clark*, 1966 (installed 2002). Cast figures of Christ and two saints.

W WALK, MONUMENTS from S to N. At the S end several lettered slabs to Surveyors and Clerks of Works, including W.R. Lethaby †1931. – Second bay. Memorial to Submarine, Commando and Special Forces, by *Gilbert Ledward*, 1948: three bronze figures. – Third bay. Lord Fraser of Lonsdale. Tablet by *David McFall*, 1976, including braille lettering. – Fourth bay. Sir Richard Jebb †1787. Defaced obelisk with portrait medallion and roundel with mourner. – Fifth bay. William Woollett, the engraver, by *Banks*, 1791–2. Relief of artist with muses and genii; bust on top. – Sixth bay. Arthur O'Keeffe and wife, †1756 and 1762. By *Benjamin Palmer*, with bust. – Tablets to organists or choristers, several with carved scrolls of music (e.g. Benjamin Cooke †1793). – Seventh bay. Charles Godolphin †1720 and wife †1726. Reredos back, with vortex of cherubs' heads. – Eighth bay. George Vertue †1756, the antiquary; architectural. – Edward

* For a different interpretation *see* the late Freda Anderson in *Church Monuments* 4, 1989.

Wortley Montagu. Tablet of *Coade* stone with sarcophagus and mourner. Formerly dated 1787. – In the N WALK nothing of note.

The Deanery

The DEANERY complex was the abbot's house until the Reformation. It forms a self-contained group around a courtyard W of the Great Cloister and S of the nave. Its chief parts are later C14 and early C16. In 1925 Lethaby called it the most complete medieval house remaining in London. The medieval character is even stronger now, due to the destruction in the Blitz of tall C17 chambers that extended over the SW end of the Great Cloister. The courtyard can be looked into from the Parlour passage at its S end. Outer faces to Dean's Yard, SE, and The Sanctuary, W, where the house was built across part of the W front of the Abbey church.

The approach is by the PARLOUR, the passage W from the S side of the Great Cloister, built 1363–5 by *John Palterton*. It is in two parts each of two bays, of which the W part passes under the Gatehouse into Dean's Yard. Tierceron vaults, matching those of the cloister W and S walks. Two-light windows in the N wall of the E part. The W part is reached though an archway in a cross wall with an ogee hoodmould on its W side.* The GATEHOUSE has a broad sturdy external face, heavily restored 1863–8 by *Scott*, with a tall window to the Abbot's Chamber over the gateway. It has two lights and flowing tracery, with flanking statuary niches.

The DEANERY COURTYARD is reached by another tierceron-vaulted PASSAGE, leading N off the W end of the Parlour. In its E wall a Gothick doorcase added in rebuilding of the bomb-damaged SE section by *Seely & Paget*, 1946–53, one of many such rehabilitation jobs in London by them. The hall fills the W side of the courtyard, the Jericho Parlour block the N, with a much-altered range on the E. The S range, also much modified, is C14 in its masonry on this side.

The abbot's HALL is now COLLEGE HALL of Westminster School, built *c.* 1372–5 also by *Palterton*; the tall transomed windows were glazed 1375–6. There are four of these on each side, each of two lights with a hexagonal tracery opening filled with four dagger shapes – a similar motif to those of the Great Cloister S and W walks. Access is by an external stair and C18 brick porch at the S end. Roof of low pitch, on corbels with angels holding shields, some with Litlyngton's arms. Partly original tie-beams on arched braces with small kingposts, the end ones with traceried spandrels. In the roof a small louvre, originally for a central fireplace. At the S end a plain late C16 SCREEN, with a gallery with round-arched panelling. But the panelling between the doorways, with sophisticated straight-sided blank tracery of lozenge or diamond shapes, must be a fragment of the late C14 joinery. PANELLING at the dais end of 1733. Armorial PAINTINGS over it, mostly pre-Victorian. S of the hall and fronting Dean's Yard is the KITCHEN, still in use.

* For the monument to Capt. Cornewall in the W part *see* above, p. 195.

The JERUSALEM CHAMBER, not visible from the courtyard, lies directly N of the hall. The two were linked in the C16 by a VESTIBULE, built as part of the Jericho Parlour range to the W (*see* below), with access from the dais end of the hall. It has a small ornamented C16 lamp niche. The chamber itself has two restored W windows matching those of the hall, and an early C16 N window of four plain lights. The low-pitched roof rests on tie-beams on small arched braces, re-exposed in *Scott*'s restoration for Dean Stanley (1868–81). It was recoloured *c.* 1955 by *Dykes Bower*. A Victorian historical frieze seems to have been destroyed at the same time. The name Jerusalem perhaps recalls wall paintings or tapestries originally to be seen here. The present TAPES-TRIES include parts of two woven at Brussels by *W. Pannemaeker*, *c.* 1540–50, to *Bernard van Orley*'s design. FIREPLACE with coupled Doric columns flanking a restored opening and two more orders of columns in the overmantel. Set up by Dean Williams (1620–44); said to commemorate the betrothal of Charles I to Henrietta Maria in 1624. Dean Stanley's introductions include linenfold PANELLING of cedarwood, and BUSTS of Henry IV (who died in the chamber in 1413) and Henry V. (BASEMENT divided by a row of oaken posts.)

The JERICHO PARLOUR lies within the main storey of a three-storey N range of the early C16, built by Abbot Islip hard up against the SW tower of the church. The difference in date is at once visible: the stone is buff as against the grey of the late C14 hall, the work cuts against the N end window of College Hall, l., and the windows are typically plain, mullioned and segment-headed. They have two, three, four or eight lights, the last being that of the Jericho Parlour itself. Fine linenfold PANELLING inside it. Access from the courtyard is by steps up at the r. to an E ANTEROOM, which also connects via a larger inner room, N, with the nave S aisle below the abbot's pew: all part of Islip's work. In the lowest storey a late C14 W–E wall remains. (Also a small room with an early C16 brick vault. The top storey has three rooms, two with early C16 moulded ceiling ribs. C16 and C17 panelling.)

The E RANGE, now painted white, is the present DEANERY. The middle and S parts were reconstructed by *Seely & Paget*, but the N part remains C16–C18. It was raised to three storeys by Dean Neile in 1606. On its W and S sides pretty timber-framed oriels of the kind now rare in London. They may date from later in the C17. The E side overlooks a small garden towards the W walk of the Great Cloister. In Seely & Paget's rebuilt part, S, an open-well staircase of C17 pattern, with waisted balusters. The C14 E range took the form of a narrower N–S corridor or gallery.

The S RANGE has on the first floor a room with windows of C14 type, looking S into Dean's Yard (renewed) and N into the courtyard. Access can be had from a post-war staircase inserted N of the Parlour at the E. Minor STAINED GLASS here by *Hugh Easton*. The staircase leads also to the ABBOT'S CHAMBER within the gatehouse, S. The Perp-style ceiling is post-war. To the N, high up, restored C14 cinquefoiled windows with segment-headed reveals. The SE corner is filled by the original, outer NW corner of the late C11 REFECTORY, faced with *opus reticulatum*, that is

square stones and red tiles set diamond-wise (cf. the Reredorter remains in the Little Cloister, *see* p. 199). Two two-centred arches in the s wall connected originally with the Cellarer's Building (*see* No. 20 Dean's Yard, p. 200). Above are corbels indicating a former inserted floor and an early C14 frieze of foliate panels. Windows on the w side, overlooking Dean's Yard, have medieval TILES reset on their sills, from the former floor. To the e a narrower room (the Abbot's Chapel?), heavily restored, with a traceried two-light e window. It can be seen from the Great Cloister.

An external view of the w RANGE, from The Sanctuary, shows the Jerusalem Chamber and College Hall as one low rubble-built block, partly concealing the s tower of the w front. In its n wall is the N window of the Jerusalem Chamber. On the w, a windowless half-octagonal stair-turret, n, two windows, a shallow buttress, then the four matching windows of College Hall. *Sir G.G. Scott* put on the crenellations, renewed *c.* 1990. The low front attachment began *c.* 1847 as part of *Blore*'s No. 21 Dean's Yard (*see* p. 201 below), but was largely rebuilt for the ABBEY SHOP in 1954–6 by *Dykes Bower*, with Georgian-Gothick fenestration.

Dark Cloister

Continuing the e cloister walk to the s is the DARK CLOISTER, which opens into Little Dean's Yard (*see* p. 202). The first, tunnel-vaulted part is later C11, and runs between the Refectory, w (punctured by two oval windows, C17 or C18), and Dormitory undercroft, e. After the vault ends the w side has a long strip of wooden-framed window of uncertain date, then a stretch of C14 walling. On the e side a completely plain tunnel-vaulted PASSAGE, also later C11, leads e into the Little Cloister (*see* below). The windowless bay running parallel to its s may have been a strong-room or prison. Further s, the Dark Cloister originally turned w to skirt the Reredorter or latrine range (*see* p. 205).

Little Cloister and Infirmary Chapel

The LITTLE CLOISTER is to the eye still essentially late C17, though much had to be rebuilt after the Second World War. But the masonry of the outer wall is mostly from *John Palterton*'s rebuilding of the Abbey INFIRMARY in 1364/5–c. 1390 (hence the alternative name FARMERY CLOISTER). The C12 infirmary took the usual monastic form of an aisled hall. It was damaged by the fire of 1298, but its C12 chapel remains as a ruin (*see* below), extending to the e, just as at Canterbury, Ely and other monastic establishments. The C14 rebuilding took the characteristic late medieval form of individual chambers, here arranged around a cloister. Traces of the C14 arcade walls were excavated in 1922.

The present cloister ARCADE is probably of 1680–1, five bays by five, with segmental arches on oblong piers. Good iron GATE into the garth, w. The N side is overbuilt by the surrounding CANONS' LODGINGS, which continue on the w and s. The

bombed-out N and S sides were rebuilt *c.* 1947–1956 by *Seely & Paget.* Late C17 style, cross-windowed and dormered. Differences from the pre-war arrangement include the dinky single-storey office in the middle of the S side, and the way the N range runs straight on E of the cloister. In this part a niche with a STATUE of St Katherine, commemorating the Hon. John Seely (Lord Mottistone), 1966. In addition the top storey of the stone-built, late C19 W side was taken down, and a dormer storey made to match. Of the C14 work, the two arches of the W approach remain, and the pattern of openings to the chambers round the walls (partly restored): straight-headed windows of mostly two ogee lights, alternating irregularly with pointed-arched doorways. Exceptions include the S end of the W side, a precious fragment of the E wall of the late C11 REREDORTER. In it a small round-headed window, above which is a pattern of square facing-stones and tiles set diamond-wise. In the middle of the E side a fine but eroded DOORWAY to the chapel, made in 1371–2 by *Palterton.* Two-centred arch with two orders of clustered shafts, and the reveal between them decorated with a chain of quatrefoils running up into the arch without a break.

The INFIRMARY CHAPEL OF ST KATHERINE is visible in outline, at a much lower level than the cloister. It had a nave with aisles of five bays and an oblong chancel, just under 70 ft (21.3 metres) long overall. Only stumps or stubs on the N and E sides, but on the S, partly built into the wall, are the tall aisle piers, alternately circular and octagonal. The octagonal ones have an edge, not a side, towards nave and aisle. Restored multi-scalloped capitals and arches with traces of zigzag and crenellation motifs. The infirmary arcades at Ely, *c.* 1170–80, are similar (though with only the alternate octagonal piers rotated). The date here cannot be much earlier, perhaps *c.* 1160; the chapel is mentioned as in use in 1163. In the remaining S wall of the S aisle a round-headed window with roll moulding. Built on at the S here is the boxy little INFIRMARER'S HALL, C14, but possibly earlier than the cloister. Much altered, and partly rebuilt in brick. Two Y-traceried windows in the N wall.

The rest of the S range can be seen from the ABBEY GARDEN, reached by a passage running S from the cloister E side, just W of the Infirmarer's Hall. No. 5, W, is bleak brick Gothic of *c.* 1860. No. 4, E, is C17, five bays, with an C18-looking top storey and Victorian cornice and chimneys. L-plan. (Staircase with an open well and slanting square balusters, probably mid- rather than late C17. Variously panelled rooms.) Its E side rests on part of the PRECINCT WALL of the Abbey. This part is datable to *c.* 1374–6, when the Jewel Tower encroached on Abbey land. The rest, of the C13–C14, bounds the garden to the S and E. On the W side are buildings of Westminster School, notably *Lord Burlington*'s dormitory (*see* pp. 205–6). At the S end two brick CANONS' HOUSES by *J.L. Pearson,* 1882. – STATUES in the garden. Four sadly weathered figures by *Grinling Gibbons* with *Arnold Quellin,* from *Wren*'s great altar of 1686 for Mary of Modena's new chapel at Whitehall Palace (*see* p. 234). – Crucifixion by *Enzo Plazzotta* (†1981), given 1993. Overheated.

Dean's Yard

Dean's Yard is a large enclosure like a cathedral close. The s part was originally filled by the Abbey's service buildings, including a great C15 granary (running N–S within the E side), bakehouse and brewhouse. The granary, used as the Westminster School dormitory *c.* 1560–*c.* 1730, was demolished in 1756. More clearances followed in 1815. Now it has a lawn and trees completely surrounded by buildings. These make no coherent picture, chiefly because they differ so much in character without taking advantage of the fact. In particular, *Baker*'s Church House across the s side (*see* below) fails to dominate the space, and is yet too emphatic to merge with it.

The E SIDE is the best place to start. In the NE corner is the former abbot's house (*see* pp. 196–8), including the entrance to the Great Cloister. Buildings to the s now chiefly belong to Westminster School. Most are later C14, but with much subsequent heightening and alteration.

Nos. 20 and 19 were the CELLARER'S BUILDING and GUEST HOUSE of the Abbey, built *c.* 1388–91, though much renewed and altered. No. 20 (now the CHAPTER OFFICE) is of rubble stone below, the upper floor or floors mostly C18 brick. In the stone part small Gothic windows irregularly grouped, and, r., an C18 Gothick doorway with fanlight and side lights. Within is a tierceron-vaulted ground floor, subdivided but originally of four bays. Wall-shafts without capitals, ribs with elongated hollow-chamfered profiles, bosses carved with foliage. In the E wall remains of some original windows, now blocked by an added range. Two first-floor rooms have ostentatious mid-C16 grisaille decoration, the only remaining instance in Westminster. In the N room, candelabra shapes between paired vertical scrolls, and a coat of arms in a very rustic aedicule, all light on dark. The s room has dark-on-light work, including an inscription to Queen Elizabeth, on one wall only. (In another room, part of a late C14 roof, flat-pitched with tie-beams.) The GUEST HOUSE (No. 19) was adapted for the school first in 1461. At its N end is the BLACKSTOLE TOWER, no longer any taller than the rest. Over the archway a fragmentary carved C16 panel, and one two-light mullioned window. The passage has a much-renewed tierceron vault, square on plan, so that the Cellarer's Building projects behind. It joins on to a brick back range added in the later C17, of five bays, with flush sash boxes. The Abbey's kitchen yard originally lay E of here. The s end bay of No. 19 has quadripartite vaulting on the ground floor.

Also later C14 in origin is No. 18, originally the hospice of the Treasurer and Monk Bailiff. Heightened, rubble-faced and drastically re-Gothicized for the school, 1886. The l. bay is in the form of another, broader tower, this time with a longer passage under a two-bay tierceron vault, to Little Dean's Yard. On the N side here a small brick-built addition, with an inserted Venetian window and open-well staircase, perhaps from alterations of 1765. No. 17 is yellow brick of 1807–9, built as a canon's house. Stone open-well staircase; distinctive details, e.g. the insistent joinery motif of a rectangle with indented corners. To its s some

C14 stonework appears, incorporated into the return of Church House.

S SIDE. CHURCH HOUSE, 1936–40 by *Sir Herbert Baker & Scott*, was built as a national headquarters for the Church of England. Baker, who had been making designs since 1929, had time to develop his weakness for site-specific reference and symbolism. A long, even front to Dean's Yard, of three or four storeys, brick above a flint-faced ground floor intended to suggest ancient underlying continuities. The centre has a triple entrance porch below a niche with the statue of a prophet (by *Wheeler*) and then a curiously depressed pediment, lower than the façade to l. and r. This pediment, and the raising up of the whole on a terrace, are evocative of the 1750s houses formerly here. The far l. part houses the chapel, with big round-arched windows above a passage on the ancient gateway site into Great College Street. The E part facing this street is a dormitory for Westminster School, built 1935–6. Church House runs on S along the E side of Tufton Street, with a Tudorish oriel lighting the House of Convocation, along Little Smith Street, r., and back N up Great Smith Street, with a mullioned window. (The CHAPEL is panelled and apsed at both ends. In the centre, not externally expressed, is a large circular ASSEMBLY HALL used for the Church Assembly (now General Synod). Renewed by *A.T. Scott* after bomb damage, 1949–50.) The first Church House, built in two Gothic phases 1890–1901 by *Sir A.W. Blomfield*, occupied a smaller site at the S end.

W SIDE. A mixed C19–C20 assortment. Nos. 5 and 6 (dated 1897), Free Jacobean, were built as office chambers by *G.A. Hall*. Nos. 4a and 4b, trifling Neo-Georgian infill by *Sir W. Tapper*, c. 1935. WESTMINSTER ABBEY CHOIR SCHOOL at Nos. 3b–4, tall red brick with stone, is nice stripped Neo-Tudor by *A.G. Wallace*, 1913–15. Minor STAINED GLASS on the ground floor by *A.K. Nicholson*, 1925. No. 3 is the former Queen Anne's Bounty offices by *Edward Blore*, 1847–8, dull Neo-Early Tudor. Duller extension, r., c. 1937. This replaced all but two bays of *Sir G.G. Scott*'s Neo-Gothic No. 1, built as a school boarding house in 1862. A larger extension, of 1899–1900 by *H. & P. Currey*, shows up on Great Smith Street behind (*see* p. 702).

On the N SIDE the back of *Scott*'s building facing The Sanctuary (q.v.). The wildly detailed iron RAILINGS are by *W.D. Caröe*, and (probably) also the pretty Ketton-stone-faced Gothic annexe, 1911. No. 21, Neo-Tudor of c. 1847, was formerly the Chapter Clerk's House. By *Blore*, with help from his young assistant, *William Burges*. Burges signed drawings for the porch, with its very Burgesian angel corbels. The S range of the Deanery courtyard (*see* p. 196) concludes the circuit.

Little Dean's Yard (Westminster School)

Westminster School grew up in connection with the Abbey. It can be traced to a school mentioned in the C14 within the Almonry, which lay a little SW of the Abbey close. In 1461 premises were taken on the E side of Dean's Yard (the present No. 19; *see* above). When the Abbey became a cathedral in 1540

the school was refounded by Henry VIII, with forty Scholars, and again by Elizabeth I in 1560–1. It became self-governing under the Public Schools Act in 1868. Its buildings have remained comparatively modest, at least by the standards of Eton or Winchester. Several were built for the Abbey and taken over later. The Abbey church itself does duty for a chapel. Other school properties lie off the site, to the s (*see* Great College Street, Marsham Street, Vincent Square, pp. 700, 705, 724).

LITTLE DEAN'S YARD has been the heart of the school since the C17. It is a large irregular area, opened up *c.* 1785–90 from what was a cobbled lane between garden walls. The buildings are of brick, a nicely haphazard, uncompetitive mixture. The interesting ones are described clockwise from the N side.

ASHBURNHAM HOUSE originated as the PRIOR'S LODGING, the late C14 shell of which remains within the red brick of the C17 rebuilding. This is generally dated to work of *c.* 1662 for William Ashburnham, the King's Cofferer. Externally the house appears a modest version of the progressive mid-C17 type, with shallow projecting wings, a broader centre (here of five bays), and plain rusticated doorcase. But the symmetry dates only from 1930–1, when *A.L.N. Russell* added a balancing two-bay wing, l., to what was an asymmetrical L-plan. Low ground floor, tall first floor, second floor added probably *c.* 1848. Medieval masonry is exposed on the W side; the hipped-roofed, two-storey appearance survives in part behind.

INTERIORS. The authorship of the very sophisticated C17 rooms has been much debated. *John Webb* (1611–72), deputy and successor to Inigo Jones, has a strong claim, attested by a descendent of Ashburnham in the early C18. That the arrangement is not as symmetrical as, according to Jonesian rules, it ought to be, must be due to the retention of so much older walling. Thus the ENTRANCE HALL is not set centrally. It represents the house in its original depth, evidenced by blocked C14 window openings exposed in the back wall. This became the spine wall when the house was enlarged to make the usual C17 double pile. Fireplace with console brackets, with little herm-like supporters attached. It may be earlier than the 1660s, but looks rather late for the building work proposed here in 1596. Of that time perhaps the four-centred-arched fireplace openings in the former KITCHEN, W.

The STAIRCASE, the superb solution of a difficult problem, opens off to the W of the room behind the entrance hall. It is of the type with a square open well, but to reach the *piano nobile* a very precise arrangement of steps was necessary within the limited space available (23 ft by 14 ft 6 in., 7 by 4.4 metres). The spatial effect, especially the dramatic moment of finding oneself below the dome, must be experienced. The climb starts between the E walls, for eight steps up to a landing within the well. Then a turn N for just three steps, another landing, nine steps S, a third landing, and the last eight steps rise E to yet another, first-floor landing. The upper walls are articulated by Ionic pilasters and attached columns, with one column free-standing on the newel of the final landing. The ceiling, richly stuccoed with scrolls, has a thick garland round a large opening into an oval lantern. Its

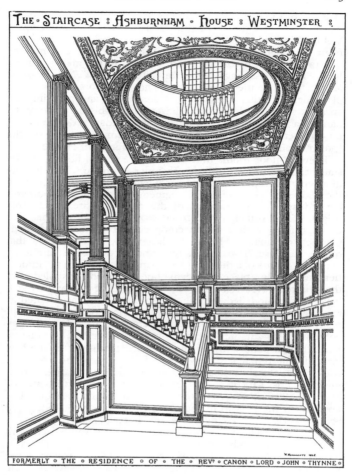

THE · STAIRCASE ⦂ ASHBURNHAM · HOUSE ⦂ WESTMINSTER ⦂

FORMERLY ○ THE ○ RESIDENCE ○ OF ○ THE ○ REVᴰ ○ CANON ○ LORD ○ JOHN ○ THYNNE ○

Ashburnham House, Little Dean's Yard. Staircase.
Drawing by William Wonnacott
(Francis Bond, *Westminster Abbey*, 1909)

windows are separated by four triplets of columns, carrying a
cornice with another thick garland and a shallow dome. Bellied
balusters between the columns, echoed more substantially in
the main balustrade. Doorcases with blind lunettes and lush
acanthus drops. Two cross-windows in the N wall.

There is nothing else in C17 English architecture quite like this
staircase, which makes the game of attribution especially com-
plicated. On *Webb*'s side, the ceiling design recalls a drawing of
1649 from the Jones–Webb circle for one at Wilton House, Wilts.,
and the lantern has affinities with that over Mansart's staircase

at Blois, of the later 1630s: a sophisticated and recherché source which only an élite of English designers could have known. Webb's biographer John Bold finds the spatial effects different from documented staircases by the architect, but this may be due to the need for compression to fit on to the medieval part. John Harris has suggested as an alternative *William Samwell* (1628–76), a gentleman architect known for his sophisticated planning. A further puzzle is that the joinery and panelling are an awkward fit, at least in the lower parts. This may betray the hand of an amateur, or even an attempt to adapt a design meant for another building: a straw to clutch at for those who see the (posthumous) hand of *Inigo Jones* at Ashburnham House.

The first-floor rooms now serve as the school library. At the stair head, a VESTIBULE, with an inner doorcase with a lunette of deeply carved foliage, between half-columns like those on the staircase. The over-large segmental-pedimented doorcases beyond appear on drawings of the 1810s, so are presumably original. The principal READING ROOM, l., has another fine coved ceiling, with a round compartment (originally domed) between rectangles. The thick plasterwork style matches that of the staircase. Two larger, two smaller doorcases, modestly enriched. Doors of a distinctive six-panelled type with the middle tier smallest. Fireplace with cyma hood, probably installed after the originals were removed after 1707–8. The rooms to the N have been remodelled, perhaps when the house was adapted as canons' residences in 1739. GREENE, to the W, is entered pompously through a segmental-arched opening on paired Corinthian columns. This cuts into the cross-vaulted inner bay, so must be later, though plainly C18. From the garden to the N is the best view of what remains of the Abbey's Refectory (*see* pp. 194–5).*

To the E of Ashburnham House (and communicating with it internally) is TURLE'S, dull Neo-Tudor brick formrooms by *Pearson*, 1883–4. Post-war top storey, replacing a gable. The opening to the r. is from the Dark Cloister (*see* p. 198). Hard against Turle's and facing E is a copybook Palladian GATEWAY of 1734. Its rusticated blocks were diligently vandalized with the names of C19 schoolboys by moonlighting Abbey masons. It leads to an external staircase of the period 1664–9, and an upper VESTIBULE of *c.* 1680–1. Ionic columns to its doorway, and a big oculus in the S wall. The INNER VESTIBULE has a fine big mid-C17 Mannerist doorcase of timber, with ornamented pilasters and tympanum. It may be of a date with the BUSBY LIBRARY to the E, built probably in 1657–9 by the great Head Master Dr Richard Busby, but with a ceiling datable *c.* 1680–1. Burnt out 1940; rebuilt by *Sir Hubert Worthington*, 1951. The ceiling was copied. Its rich style is similar to those in Ashburnham House, but with more foliage motifs and fewer architectural ones: the sign of an artisan's design, rather than an architect's?** S wall

*Facing the house from here was a classical temple front of the mid–late C17, destroyed in 1882.
**Or else by Busby's protégé and pupil *Robert Hooke*, the polymathic architectural amateur (who designed a church for him at Willen, Bucks.). There is a good chance also that the 1650s–60s work was by Hooke.

rebuilt 1804. Its round-arched window with mullions making an inner arch may perpetuate the mid-C17 form. The bookcases copy the C17 ones.

These buildings all stand on part of the site of the late CII REREDORTER or latrine range of the Abbey, which was built T-wise at the S end of the Dormitory. Fragments still existing include a section of wall in the Little Cloister (*see* p. 199) and the great E–W barrel vault, with an arch with alternating voussoirs; (also two arches incorporated into the first floor of Turle's to the W, exposed by bombing in 1940).

The monks' DORMITORY itself, to the N, became 'SCHOOL', i.e. the single room in which all teaching was originally conducted, in 1599. Externally it appears above and behind the vestibule as an uninteresting plain brick range, the result of drastic reconstruction by *Carden & Godfrey* in 1957–9 of the bombed and burnt-out shell, and before that by *B.D. Wyatt* in 1814. Also in 1957–9 the S gable was made shallower and an ugly square FLYTOWER raised at the N, prominent in views from the Great Cloister. On it a lantern surmounted by a gnat-like phoenix by *Michael Murray*. INTERIOR with a panelled dado and pitched roof, relying for effect on armorial carving and painting evocative of its predecessor. Large round-headed openings, mostly after the work of 1814. But near the S end of the W wall a late CII doorway survives, its arch again of stones in two colours. Above and opposite in the E wall remains of Norman windows. Also, the two doorways and trio of windows in the renewed S wall may perpetuate the CII arrangement. In these windows armorial STAINED GLASS by *Carl Edwards*. Below them a late C17 ORGAN CASE from the Abbey. Until 1868 there was a big C17 niche called the shell at the N end, and until 1941 a tall hammerbeam roof of *c.* 1450.) The two painted BACK DROPS for the school's Classical plays are by *Frederick Fenton* to designs by *C.R. Cockerell*, 1858.

To the E, an early C16 chamber faced in later brick, with straight-headed Perp openings and an C18 Venetian E window. In its W wall a nook-shaft of a Dormitory window, i.e. of the CII. Below this chamber and contemporary with it is the former CHAPEL OF ST DUNSTAN. In its E wall a blocked straight-headed window, in its S wall a pretty piscina with uncusped rib vault. Its N wall is open to the school GYMNASIUM, formed in 1861–4. Its W wall is the outer E wall of the medieval Dormitory. It shows blocked medieval windows of several shapes, to the C15 library and monks' chambers.

To the S of this dense conglomeration is a screen wall by *A.L.N. Russell* dated to Jubilee year, 1935, with an ARCHWAY into the Abbey Garden. Associated work included embellishment of the inner, brick face of the DORMITORY or 'COLLEGE' immediately to the S, which has its main façade on the garden side, E. This is an early work by *Lord Burlington*, 1722–30; burnt out in 1941, and reconstructed by *Worthington*, 1947–50. It accommodated the King's (or Queen's) Scholars, i.e. those of the C16 foundation as opposed to boys lodged in separate, semi-private houses. Burlington manoeuvred avidly to design it, and its extreme restraint reads as a manifesto for his austerely

rational taste.* The cornice is of Palladio's Ionic type, but the fifteen-bay elevation below it is wholly astylar, i.e. without columns or pilasters. Three storeys, with very small-scale enrichment of the mouldings. The lack of central emphasis reflects the plan, which is entered at the ends and which had little differentiation of interiors. Round-arched ground floor, enclosed by *Blore* in 1846 for extra accommodation. First-floor windows with alternately triangular and segmental pediments. Top windows small and square. This storey gave the only light to what was originally one vast upper chamber, until *T.G. Jackson* opened up every second window below in 1895. In the post-war re-Georgianizing the rest were also glazed, and the chamber floored across and subdivided. Hipped copper roof. The facing is Bath stone, an innovation for London, but with brick-built end attachments. These look C18, but relate uncertainly to the rest. Their original use is unclear; by the C19 both housed staircases. s attachment extended for a sanatorium in 1846, also by *Blore* (heightened 1906).

The S SIDE of Little Dean's Yard looks like one large plain late C18 building partly Jacobeanized. Its history is actually more complicated. The HOUSE OF THE MASTER OF THE QUEEN'S SCHOLARS was remodelled, and GRANT'S, its r.-side neighbour, newly built by *R.W.F. Brettingham* in 1789–90. They originally made two-thirds of a nine-bay façade with a pedimented centre. RIGAUD'S, the r. part, was then rebuilt in Queen Anne style by *Jackson*, 1896–7. The C18 parts each have tripartite windows to l. and r. of the door bays. The l. house retains its perron stair. Narrow staircases run up strangely from both sides within the entrance. Further evidence that fabric of before 1789 may survive is a four-centred-arched fireplace in the basement.

FURTHER READING

Visitors who want more biographical and historical details should consult the excellent *Official Guide* (latest edition 2002). The best general book is the *New Bell's Cathedral Guide* by C. Wilson, R. Gem, P. Tudor-Craig and J. Physick, 1986. The cultural world of the Abbey builders is explored in P. Binski, *Westminster Abbey and the Plantagenets*, 1995, the lives of the monks in B. Harvey, *Living and Dying in England 1100–1540*, 1993, the later history of the fabric in T. Cocke and D. Buttress, *900 Years, the Restorations of Westminster Abbey*, 1995. A general history appeared in 1966: *A House of Kings*, ed. E. Carpenter. P. Lindley, *Gothic to Renaissance, essays on Sculpture in England*, 1995, has many insights into the architectural sculpture and monuments. The best earlier books include (listed chronologically): accounts by H. Keepe, 1683, J. Dart, 1723, and R. Widmore, 1751; E.W. Brayley & J.P. Neale, *The History and Antiquities of the Abbey Church of St Peter, Westminster*, 1818–23 (lavishly engraved), and G.G. Scott et al., *Gleanings from Westminster Abbey*, 2nd ed. 1863, on the fabric;

*By contrast, the Baroque design prepared in 1713–14 by *William Dickinson* at the behest of Wren, which Burlington followed in outline, looks like a leftover wing from Hampton Court Palace.

A.P. Stanley, *Historical Memorials of Westminster Abbey*, 5th ed. 1882, on the personalities; important architectural volumes by W.R. Lethaby, *Westminster Abbey and the Kings' Craftsmen*, 1906, and *Westminster Abbey Re-Examined*, 1925; general surveys by F. Bond, 1909, and the RCHM, 1924; detailed histories by H.F. Westlake, 2 vols., 1923, and J. Perkins (Alcuin Club), 3 vols., 1938–52; L. Tanner and R.P. Howgrave-Graham, *Unknown Westminster Abbey* (King Penguin), 1948; and important chapters in the *History of the King's Works*, 4 vols., 1963–82. H.M. Colvin, author of the last, has also edited *The Building Accounts of Henry III*, 1971. Well-illustrated accounts include books of 1972 (Annenberg School Press) and 1995 (J. Field, *Kingdom, Power and Glory*), and beautiful photographs of the monuments by J.W. Blundell, 1989 (text by J. Physick). The Chapter House has its own guide book (English Heritage, 2002); one for Henry VII's Chapel will appear in 2003 (T. Tatton-Brown and R. Mortimer, eds.). For Westminster School *see* books by L. Tanner, 1923 and 1934, J.D. Carleton, 1965, and J. Field, 1987.

CHURCHES

ST MARGARET WESTMINSTER
Parliament Square

Of *c.* 1482–1523, the only pre-Reformation parish church remaining in Westminster. Founded perhaps in the late C11; first recorded under Abbot Herbert, 1121–*c.* 1136, in association with the neighbouring Abbey; rebuilt under Edward I (1277–1307). Its final rebuilding went as follows: nave from *c.* 1482; s aisle 1489–90, paid for by Lady Billing; N aisle by 1504; chancel *c.* 1518, for Abbot Islip; tower, at the NW, 1515–23. The masons were the Abbey's, of whom *Robert Stowell* (†1505) designed the nave, his successor *Henry Redman* (†1528) the tower. The carpenters were *Richard* and *Thomas Russell* and others of their family. The House of Commons adopted the church in 1614, and voted large sums to modernize it in the C18 and C19. This meant refacing in Portland stone, not without alteration.

The TOWER, called in 1734 'sadly maim'd and deform'd', was in 1735–7 heightened and partly rebuilt by *John James*. It remains an important example of Gothicism of the days of Kent. A backward glance at the Abbey w towers will show the difference from Hawksmoor's more personal approach. James perpetuated the polygonal buttresses, as seen at Canterbury Cathedral, Bath Abbey and some southern parish churches. An oddly detailed quatrefoil frieze and panelling in the battlements. The large Perp bell-openings are framed rectangularly, with naïve Baroque putti heads in the spandrels. Crenellated top and slim timber lantern. SUNDIALS of 1982.

The NAVE was one of *Sir George Gilbert Scott*'s last restoration jobs, in 1877–8 (earlier repairs by *W.R. Gritten*, 1845). Scott made

the ogee-headed tracery, plausible but essentially speculative, as was proved when one original window arch with a more acute point was exposed during the work (S aisle, far E). No buttresses. The rainwater heads suggest some refacing dates: 1726, N, 1782, S. Crenellated E parapets. In 1905–6 the chancel was extended E by some 6 ft (1.8 metres) by *Walter Tower*, and the E clerestory windows made. On the N aisle E wall, a little C19 lead BUST of Charles I, in a niche made in 1956. Other additions are the shapeless SE vestry, 1778, and *J.L. Pearson*'s lacy Late Gothic porches, 1891 (W) and 1894 (SE). The triple W porch, with its pretty parapet and vault, contrasts oddly with the plain nave behind. Gothick pinnacles on the W end added 1998.

16 INTERIOR. The church is eight bays long without any structural division between nave and chancel. Slender piers with four shafts and four wave mouldings in the diagonals, four-centred arches with tracery decoration in the spandrels, and a clerestory. E and W windows of five lights, non-matching. All this is familiar Late Perp, finely proportioned, and without the more usual depressed arches of the early C16. In the S aisle wall lower and upper doorways to a ROOD STAIR, made 1532. The N aisle preserves part of a blocked doorway to the tower staircase. Abbot Islip is commemorated by two fragments of stone FRIEZE with his rebus, reset in the chancel E wall above the panelling. The limewashing dates from 1991–2. Roof by *Scott*, panelled and with carved and gilt decoration at the chancel end; the angel stops are also his. Until 1877 there were N and S galleries, originally of the C17 (the S one designed by *Wren*, 1681–2), and a large enclosed W lobby above triple galleries. In 1758 a polygonal apse in the Gothic style was made within the E end by *Kenton Couse*, to accommodate the new E window (*see* below); *S.P. Cockerell* made the E end straight again in 1799–1802.

FURNISHINGS. REREDOS. In the centre an extremely unusual relief copy of a Titian painting of Christ at Emmaus, by *Sefferin Alkin*, c. 1758. The vogue such carved pictures had enjoyed under the late Stuarts was long over then. Hinged wings and outer figures of saints by *Kempe*, 1905–6; contemporary PANELLING in the sanctuary. – ALTAR designed by *Peter Foster*, 1986 (made for the Abbey). With Baroque scrolled legs in the Dykes Bower idiom. – Much by *Scott*, or of his time: STALLS, except for three original bench ends with renewed poppyheads, side SCREENS, good TILES, eagle LECTERN, PEWS. – PULPIT. 1883, designed by *Sydney Vacher*, carved by *T. Earp*. Of painted stone with openwork sides, like the C15 example at Cirencester. Iron handrail made by *Barkentin & Krall*.* – SCULPTURE. Small wooden figure of St Margaret, early C15 French. In the rood loft door a headless composite of two large stone figures, C15–C16. – FONT. Square baluster and circular marble bowl, by *Nicholas Stone*, 1641. Made for the Broadway Chapel (*see* footnote p. 723). – In the S aisle two good big *opus sectile* PICTURES by *J.C. Powell*, 1893–4. – ROYAL ARMS, W gallery. Later C17. Small. – Fine wrought-iron GATES (W porch), given 1893.

* A pulpit of 1682 is now at Meopham church, Kent.

STAINED GLASS. Perhaps the most interesting of any London parish church, though not the most coherent. E WINDOW of c. 1515–27, of Dutch manufacture, from the circle of *Cornelis Engebrechts* of Leiden.* It came in 1758 from Copt Hall, Essex. Before that it was at New Hall, Wilts., until c. 1740, having come there – according to one C18 tradition – from the dissolved Waltham Abbey, Essex. It shows the Crucifixion against a blue sky with a large crowd and green landscape below. In the flanking lights Henry VIII below St George, l., and Katharine of Aragon below St Catherine, r. The niches of these figures display the transition from Gothic to Renaissance detail. Close scrutiny has shown that the central three lights originally formed one window, which was pieced out c. 1540 to suit a three-light arrangement. The tracery matches that recorded in 1737, but the glass was changed here and there by *William Price*, who installed it at Copt Hall. His are, e.g., the two central angels in the tracery and also it seems the dark shadows around many figures. Head of St Catherine by *Kempe*, of 1905–6 when the window was reset higher. – N and W WINDOWS from an important sequence of 1881–94 to notable people. N aisle, from E: E.A. Morris (after Botticelli) and Admiral Blake, 1891 and 1888, by *Edward Frampton*. – W. Caxton, 1882, by *Henry Holiday*, makers *Powells*. Fragments only. – W.H. Smith (Light of the World), 1893. Bright and lucid. Multiple credits: designer *J.P. Seddon*, after sketches by *Maud Seddon*; cartoons by *H.G. Murray*; painting by *L. Jacques* for *Belham & Co.* – N aisle W window, Milton, by *Clayton & Bell*, 1888 (restored 1949). Scenes from his life and from *Paradise Lost*. – W window, Raleigh (who is buried here) by *Clayton & Bell*, 1883. – S aisle W window, Lord Frederick Cavendish, murdered in 1882 in Phoenix Park, Dublin. Of 1883, another by *Henry Holiday*, made by *Powells*. Brooding colours – myrtle, crimson, dark green – and big bold figures. – S AISLE. Excellent abstract glass by *John Piper* called Spring in London, made by *Patrick Reyntiens*, 1967–8. Mainly diagonal lines. The colours subdued, but not anaemic. Mainly grey, echoing the surrounding stone, enlivened by patches of stippling and by strips of green, orange and yellow. – S aisle E window, armorial, in memory of Speaker Fitzroy. Designed by *Sir Herbert Baker*, made by *Hubert Hendrie*, 1946.

MONUMENTS. Remarkably many, but nearly all small, and often set too high for easy viewing. Most post-Reformation styles are represented; the C16–C17 examples are often to lesser courtiers who did not warrant an Abbey burial. Clockwise from the NE: N AISLE. Robert English et al., early C17 (obscured by the organ). One of several with the usual kneeling figures in profile. – Tomb recess, late medieval, plain, with indent of a small brass; said to be that of Lady Billing †1499. – Sir Francis Egoike †1622. He kneels frontally in a curtained recess. – Jane Musgrave †1763, one of a sequence of coloured marble monuments attributed to *Sir Henry Cheere*. – Cornelius Vandun †1577, stiff bust in circular strapwork niche. – James

*See Hilary Wayment in *Antiquaries Journal* 61/ii, 1981.

Palmer †1659/60, also a bust, in an oval curtained niche (badly damaged). Attributed to *Joshua Marshall*. – Above and also damaged, Robert Stewart †1714. Obelisk above sarcophagus, cherubs and cherubs' heads. Designed by *James Gibbs*; attributed to *Andrew Carpenter* (GF). – Canon Conway, with bust by *R.C. Belt*, 1878. – Elizabeth Corbett †1724, architectural, with epitaph by Pope. – Sir Thomas Crosse †1738, big and high up. Attributed to *Cheere*. – W WALL. Dr Colquhoun †1820, Neoclassical relief by *C.H. Smith*. – Sir Peter Parker †1814, an allegory and relief showing his death in battle. Signed by *C. Prosperi*. – Peregrine Bertie †1721, with good cherubs' heads. – Samuel Langford, above. Pedimented, and signed (*William*) *Stanton*, 1691. – Dorothy Stafford †1604, and Blanche Parrye, 1595–6, with solitary kneelers. – W AISLE PIERS: N, cartouches to Emery Hill †1677 and Sarah English †1729, attributed to *Jasper Latham* and *Robert Hartshorne* (GF); S, John Churchill †1715, especially fine, with cherubs holding back drapery, and Bishop Womack †1685/6, cruder, with palm fronds, attributed to *Grinling Gibbons* (GF). – S AISLE. Owen Jones †1634, with sophisticated alabaster border and black and gilt tablet, one of several clearly from one workshop (*see* also E. Reynoldes †1623, second bay, with sphinx heads, and R. Willis †1640, fifth bay, with consoles in profile). – Mary Brocas †1654, bust in an oval curtained niche, attributed to *Joshua Marshall*. – William Arnold, 1735 by *Thomas Carter Sen.*, a blunt dark obelisk with portrait. – Sir John Crosse, MP for Westminster, †1762. Coloured marble, also with obelisk. Attributed to *Cheere*. – Hugh Haughton †1616, a little family in a box. – William Wilson †1708, Samuel Peirson †1768 and (above) Peter Newton †1660, cartouches; the last attributed to *Joshua Marshall*. – Alfred Lyttelton †1913, with relief portrait and seated Virtues. By *W. Goscombe John*. – H.O. Arnold-Forster †1909 by *J. Havard Thomas*, and J.C. Rogers †1874 by *Robert Jackson*, Gothic, also with portraits. – Lady Dudley †1600. The only standing monument. Recumbent effigy in front of arched back architecture. Attributed to the *Cure* workshop (GF). At her feet a large kneeling male effigy, contemporary, but in a different style. – Margaret Graham, erected 1762. Good portrait bust. – John Lekeux †1754, high up. Attributed to *Cheere*. Coloured marbles, also with a bust. – John Makcullo, physician to James I, †1622 (damaged). – Nicholas Dering †1688/9, cartouche with skull. Attributed to *James Hardy* (GF). – Brass plate with Thomas Cole †1597 and family kneeling in a room, and diverting inscriptions. – Fragment of a tomb-chest of *c.* 1500 (Lady Billing's?), of Purbeck marble, with square cusped panels and shields. – S AISLE E WALL. William Caxton, 1820, by *Henry Westmacott*. Plain and dutiful. – John Leng, Bishop of Norwich, †1727, signed by *Andrew Carpenter*. A big multicoloured marble tablet. – W PORCH. Dean Farrar, 1904 by *W.D. Caroë*, with bronze portrait by *N. Hitch*. Farrar was the rector who had restored and embellished the church. – SE PORCH. 1st Viscount Sherbrooke, inset bust by *Moses Ezekiel*, 1894.

CHURCHYARD to the W with some early C18 RAILINGS, obelisk PIERS and octagonal stone BOLLARDS. Railed TOMB SLAB to Alexander Davies †1665, owner of what became the

Grosvenor lands, and family (renewed). Other tombstones removed or turfed over 1881–2.

METHODIST CENTRAL HALL
Storey's Gate

1905–11 by *Lanchester & Rickards*, in a surprisingly worldly Viennese style. It might almost be a very substantially built kursaal. To have deferred to the Gothic of Abbey and Parliament nearby would not have suited the proud independence of Edwardian Nonconformity. It is the most impressive of the multi-purpose central halls the Methodists built in major cities around 1900. A fund opened in 1898, which raised 'one million guineas from one million Methodists', covered the costs.*

The hall forms a broad mass, near-square in plan, the N and S sides with central recessions. Channelled stone, with on the entrance front, W, and S front a Composite order treated mostly as half-columns. Above the entrance this is carried around a broad bow housing the staircase. Above, the four main faces continue up as square attics with Ionic columns. Big square leaded dome with chamfered angles, sitting on the walls without an intervening drum. The attic over the entrance, finished as late as 1934, was originally to have been flanked by twin towers. In the detail some squaring off (the capitals), but also much fluent carving by *Henry Poole*, notably the hieratic angels over the entrance. Lead trophies on the dome modelled by *Poole*, frieze and leafwork by *H.C. Fehr*. Structurally the building is hybrid: framed in concrete (based on the *Kahn* system) and steel, with some brick arches too. The dome for example is made by eight steel lattice stanchions, joined by concrete girders at the springing.

The major INTERIORS are barely altered. Access is by an unabashedly theatrical staircase, rising gently to an oval half-landing serving lesser meeting rooms, then returning in a broad surging flight to an upper landing by the central window. From here twin arms climb to a columned lobby called the Crush Hall. Bronze handrail and other metalwork by *Singer & Co.* of Frome. STATUE of John Wesley in the Crush Hall by *Samuel Manning Jun.*, c. 1848, after a model by *Manning Sen.* exhibited in 1825; brought in 1972 from a Wesleyan college in Richmond, Surrey. After the exterior and ascent the large MAIN HALL is disappointingly subdued, with deep cantilevered galleries and a flattened coffered dome that sits well below the exterior profile. Broad corridors encircle it at both levels. Offices etc. in the outer ranges; in the NE part a chapel enclosure formed in 1994, with STAINED-GLASS figures by *Florence Camm*, c. 1939, from a former chapel on the third floor. Also a big ground-floor hall. Interior alterations are proposed by *Richard Griffiths Architects* (2003).

*Here and to the W stood that freak the ROYAL AQUARIUM (1875–6 by *Alfred Bedborough*), a giant palace of entertainment along the lines of Alexandra Palace (*see London 4: North*), with tanks of fish as the special draw. Reconstruction of its theatre by *F.T. Verity* in 1901 failed to rejuvenate it.

ROYAL AND GOVERNMENT BUILDINGS

THE PALACE OF WESTMINSTER*
(HOUSES OF PARLIAMENT)

3, One of the most familiar buildings in the country, the Palace of
pp. Westminster is known particularly for its site beside the Thames
220 and its three contrasting towers, the massive square Victoria
–1 Tower at the s end, the octagonal spire of the Central Tower
and, above all, the slim Clock Tower with its steep and ornate
roof above its bell chamber, the sound of whose great bell, Big
Ben, is closely connected with Parliament in the public imagi-
nation. Designed by *Charles Barry*, who was helped by *A. W. N.
Pugin*, and slowly built between 1840 and the 1860s following a
major fire in 1834, the palace is a confident building in Tudor
Perpendicular style, chosen to harmonize with the adjacent
Henry VII's Chapel (*see* Westminster Abbey). The building also
marks a turning point in the Gothic Revival because it combines
both the earlier phase of the Picturesque and the classical sym-
metry of the planning with a new interest in authentic Gothic
detail. Its C19 character and present use, however, mask its
origin as a royal palace, still containing magnificent medieval
survivals, and its connection with the law courts in and around
Westminster Hall until 1882.

The Palace until 1834

Edward the Confessor started building his palace *c.* 1050, at the
same time as he began rebuilding the Abbey of St Peter. There-
p.6 after the precinct on Thorney Island was to consist of church,
monastery and palace, of which the Abbey buildings had the
better land. This explains the low-lying position of the palace.
This remained the primary residence of the Norman kings,
witness of which is the spectacular size of Westminster Hall, as
first built by William II in 1097–9. It is by far the largest Norman
hall in England and may well be the largest of its date in Europe
(Goslar, Germany, *c.* 155 ft (48 metres); Westminster Hall *c.* 240
ft (74 metres)). The place was not a fortress, though Fitzstephen
speaks *c.* 1174 of a wall and bulwarks ('cum antemuralis et prop-
ugnaculis'). No evidence has ever been produced for the existence
of a keep. Adding and rebuilding continued through the C13 and
C14 and to the time of Henry VIII. The principal medieval parts
p.8 were, apart from Westminster Hall and the surviving two-storey
cloister of 1526–9 to its E: St Stephen's Chapel, begun 1292 E
of the s end of the hall and one of the most magnificent eccle-
siastical buildings in the country when finally completed in
1363 (marked for us by its remaining undercroft); the Court of
Requests (or White Hall, C12), a second, smaller hall to the s;
the Painted Chamber with its famous wall paintings of the late

* This entry was revised by Alexandra Wedgwood.

C13, which was situated E of the S end of the Court of Requests
and projected to the E as far as the E end of the chapel; and more
apartments S of the Painted Chamber, including the Prince's
Chamber (1237–8). The Painted Chamber owed its specially rich
treatment to its joint function as Henry III's bedroom and audi-
ence chamber; it had its own small chapel attached at the NE. Of
these apartments and the Court of Requests nothing is pre-
served, but fragments from the Painted Chamber and the upper
chapel of St Stephen may be seen at the British Museum. The
only other medieval building surviving is the C14 Jewel Tower
(q.v.), which stood at the SW corner of the palace precinct.
Other work of the C14 included the sensational roof added when 17
Westminster Hall was reconstructed in 1394–1401.

A fire in 1512 gutted the Privy Palace, which lay at the S end
of the site, and from 1529 Whitehall became Henry VIII's prin-
cipal palace in London. Westminster retained the status of a
palace, but became more than ever the seat of divers public insti-
tutions. Parliament met here and law was administered. Soon
after the suppression in 1547 of the religious collegiate founda-
tions, which included the college of St Stephen, Parliament began
regularly to use the substantial empty buildings on the site, the
House of Commons sitting in the upper chapel of St Stephen,
and the House of Lords using a large room in the Privy Palace,
known as the Queen's Chamber. Law courts continued to sit in
Westminster Hall, as before, and a new Court of Exchequer was
built on to its NW side in 1569–70.

Proceeding now to the C17 and C18 we must remember that
the buildings of and around the palace were by no means in a p.8
monumental style. The informality with which the area was
treated is indeed astonishing. Of Westminster Hall nothing was
visible at ground level except its N entrance. Even the flanking
turrets were hidden behind later accretions containing amongst
other things two pubs. There were plenty more ale-houses and
coffee-houses nestling against the walls of other parts of the
palace. The area between Westminster Hall and St Margaret's
church was all built over except for the winding St Margaret's
Lane (later St Margaret Street). Houses also extended to the E
and N of Henry VII's Chapel to within a few yards of its walls.
Old Palace Yard was more or less of the same extent as now, but
New Palace Yard, N of Westminster Hall, was irregular. Later on,
gardens were provided on the raised shore, but the present, C19
embankment lies yet further E.*

The medieval chapel was transformed in 1692 by *Wren*,
who removed the upper walls and blocked the Gothic windows,
making three rounded-headed E windows and rectangular side
ones. The interior was wainscotted and galleries provided which
were widened in 1707 (after the Union with Scotland), but
the inconvenience of the House of Commons led to a proposal
for a new parliament house in 1733. Between then and 1739
William Kent made designs for a grand domed Palladian build-
ing standing immediately S of Westminster Hall, within which

*The previous water line was to the E of the corridor leading to the E from the
present Central Lobby.

he was then making a screen to the law courts in his familiar Gothick. It remained on paper, however, and only minor additions were made in the later C18. In 1755–60 the central block of a new building, known as the Stone Building, was constructed on the w side of Westminster Hall. It was designed by *John Vardy Sen.* and was of standard Palladian composition, with a pedimented central block flanked by lower wings terminating in pavilions. The s wing was added in 1766–9. The building was continued E across Old Palace Yard in 1768–70, to form the new main entrance to the House of Commons.

Meanwhile the inadequate facilities of the Houses of Parliament worsened, and in the 1790s *John Soane* made several schemes for imposing Neoclassical buildings. These were defeated by a mixture of Government parsimony and the influence of *James Wyatt*. The influx of Irish members following the Act of Union (1800) made action imperative, and up to 1812 *Wyatt* was responsible for substantial piecemeal additions and alterations: the House of Commons was enlarged, the House of Lords moved into the Court of Requests, and the Speaker's House was rebuilt beside the river. Following Wyatt's death in 1813, *Soane* was given responsibility for the Palace of Westminster. His work began in 1818–20 with the rebuilding of the N front of Westminster Hall. Then followed the construction of the new Law Courts in a characteristically personal Neoclassical manner (1822–5), ingeniously fitted in against the w wall of Westminster Hall. This style, however, on the façade abutting Westminster Hall, which was increasingly revered as one of England's greatest architectural achievements, drew forth ferocious criticism, and Soane was forced to Gothicize it. Simultaneously on the s side of the palace *Soane* provided a new royal entrance and staircase (Scala Regia) also in a grand Neoclassical style, a royal gallery, committee rooms and libraries. Also in the 1810s the Painted Chamber – by then used as the Court of Requests – was restored, and the surviving parts of its important C13 painting cycles discovered and recorded.

On 16 October 1834 the palace was consumed by a fire which burnt out the centre of the site, including both chambers. Westminster Hall and the Law Courts survived, as did the cloister and the undercroft of St Stephen's Chapel, both sadly damaged, and all the new Soane buildings to the s. It was quickly decided to build large new Houses of Parliament on the site, and a competition was announced in June 1835.

The Nineteenth-Century Palace: Competition and Design

The terms of the competition asked for the new building to be in the Gothic or the Elizabethan style. That in itself was a remarkable move. It established Gothic as the national style even for secular architecture and even on the largest scale, and it introduced to official recognition the Elizabethan style as a *débutante*. Ninety-seven designs were submitted; only six of them were Elizabethan. A good many survive, but not alas those of the winner, *Charles Barry*. Barry was already the architect of the

Travellers' Club and other buildings in the classical or Italian styles, and also of a number of economical Neo-Gothic churches. His son, Bishop Barry, in his biography says that here Barry 'would have preferred the Italian style'. If, for a small committee of intelligent and competent laymen, he was so successful with Gothic, that was partly due to the clarity of his plan and partly – the larger part, it seems – to a set of exquisite and 'minute drawings'. After a good deal of controversy in the 1860s, and C20 research especially by Phoebe Stanton, it is now clear that these drawings were by *Augustus W.N. Pugin*, the most fertile and passionate of the Gothicists. Barry was forty in 1835, Pugin twenty-three. He had not yet written any of his fighting pamphlets; not even *Contrasts* had come out. But he had already won recognition as a man of immense enthusiasm for and knowledge of Gothic architecture, and as a brilliant draughtsman. Pugin's diaries prove that Barry approached him for help early in August, that Pugin worked for short periods at Barry's office and that Barry visited Pugin in Salisbury, and that at the time the Barry drawings were delivered he had paid Pugin considerable sums. Part of that may have been for work on other jobs, but there can be no question that most of it referred to the Houses of Parliament. Nor was that all. In 1836–7 Pugin made drawings from which an estimate of the cost of the building was made. After this he went his separate way, but then in September 1844 Barry invited him back to help with the interiors, and he went on assisting Barry until his death in 1852. In 1844 his position was made official. He was awarded a salary of £200 a year as superintendent of woodcarving. In fact he did much more. He designed, it can safely be said, all the details in metal, stained glass, tiles, wallpaper, textiles etc., down to door furniture, ink stands, coat-hangers, and so on.

However, that does not mean that Barry was idle or incompetent. The plan of the building and its elevations, modified over and over again to meet changing views or demands, and all the work on its execution, were Barry's. For, though Barry's son and Pugin's son quarrelled in public, Barry and Pugin themselves worked together amicably and with mutual respect, it seems. Pugin admitted that he could not have planned such a building, Barry that he did not have the knowledge of the innumerable medieval details. For both believed in all-over ornamentation, inside and out, what Bishop Barry calls 'a kind of diapering of the whole'. In addition, Pugin would not have survived the battles which Barry had over years with committees, Barry would not have had the brio to go on from sheet to sheet of original, spirited, ever-new detail. Barry's working technique was staid and reliable, Pugin drew amidst a continuous rattle of marvellous stories, slashing criticism and shouts of laughter. Barry called him his comet. And in the end Barry was knighted and died at the age of sixty-five, Pugin died insane at the age of forty.

Barry and Pugin disagreed on the basic conception of architecture, but they went on collaborating. The secret of the undoubted architectural success of the Houses of Parliament lies in this collaboration of two utterly different men and in the union

of two utterly different views. Barry 'held regularity and sym-
metry as main principles of design', Pugin believed in functional
asymmetry and was, we know, impatient of what to him was the
Palladian skeleton of the design. His biographer Ferrey reports
him as saying: 'All Grecian, Sir; Tudor details on a classic body.'
But Barry was in fact not a rigid formalist either. For one thing
his plan from the first incorporated the two principal asymmet-
rical elements: the Victoria Tower and the Clock Tower. Other
elements which must have pleased Pugin came in only later.
Barry had intended at first to have flat roofs and battlements
throughout, but then saw that on such long frontages, visible
roofs were necessary. He studied Flemish town halls and
similar buildings to see how secular Gothic could be reconciled
with pitched roofs. And as for the central flèche and the pretty
turrets visible above the roof-line, they are, curiously enough,
afterthoughts, made necessary by the devices of the appointed
expert on heating and ventilation, Dr Reid. He insisted on large
vertical ducts in various places, and their outlet was disguised
by Barry. So the building, as we see it now, has more of the
picturesque, more to please Pugin, than the lost designs of 1835
can have possessed.

In now examining the building as it stands, the main point to
be made at once is that in spite of this seeming picturesqueness
it is planned with brilliance as well as clarity and good sense.
Barry integrated the surviving medieval buildings into his plan,
opening up the s wall of Westminster Hall, and making it and
the rebuilding above the undercroft chapel into his public route
into the centre of the new building. The plan consists essentially
of a N–S spine which contains on the principal floor all the main
rooms: from s to N Robing Room – Royal Gallery – Prince's
Chamber – House of Lords – Peers' Lobby – Central Lobby –
Commons Lobby – House of Commons. To the E as well as the
W this spine is accompanied by inner courtyards of varying size.
The archways through the E series of courtyards are all in line.
The circulation is excellently planned for the various users; the
monarch's entrance is under the Victoria Tower, the members of
both Houses have their own, and the public entrance is through
St Stephen's Porch. The river front is again rationally planned,
the main residences in the end pavilions: Speaker's House to the
N, Lords' officials, where now the Lord Chancellor has his flat,
to the s, and along the long recessed centre the libraries, com-
mittee rooms and refreshment rooms.

THE EXTERIOR

Building started from the river front, following the construction
of a coffer dam and the embankment. The main dates are as
follows: foundation stone 1840, House of Lords occupied 1847,
main parts of the building ready and Royal Entrance first used
by Queen Victoria 1852, Clock Tower complete 1858, Victoria
Tower complete 1860. Barry died in that year, and his son *E.M.
Barry* finished off the NW part and remaining interiors, until his
dismissal in 1870.

One should study all the façades of the Houses of Parliament from the point of view of how symmetry and asymmetry are combined; there is enough of the one to give a feeling of order, and enough of the other never to let curiosity flag. The RIVER FRONT 3 especially has been blamed for being a Palladian composition in Gothic disguise. But that is not a fair criticism. It is almost always seen obliquely and quite apart from the various flèches and turrets which break its regularity (and which were, as has been said, not Barry's original plan) all regularity is decisively broken by the two principal vertical accents of the whole building which are always in the picture, the Victoria Tower and the Clock Tower. Barry endlessly revised this elevation to balance the vertical and horizontal on the long façade, before he found a satisfactory solution. The two end pavilions project, and between them lies a terrace which was raised for flood protection in 1971–2.

On the S FRONT, facing Victoria Tower Gardens, one can begin to appreciate the details. Here each bay is marked by panelled octagonal buttresses with crocketed ogee caps and tall pinnacles, and divided by a central line of four niches containing statues of Saxon kings and queens designed by *John Thomas*. Barry's disposition of elements on a large scale is masterly. Also by Barry is the fundamental Perp motif of close panelling with tracery and blank tracery, with ever-repeated bay windows and oriels, and with an infinite number of carved details, foliage, figure sculpture, crockets and finials. Led by *John Thomas*, the craftsmen produced excellent work. The source was the exterior panelling of Henry VII's Chapel; also certain motifs come from St Stephen's Cloister within the very building, and in addition such examples of Perp architecture as the porch of Cirencester church, Gloucs., and the George Inn at Glastonbury, Somerset. In Black Rod's garden, the PEERS' FIRST WORLD WAR MEMORIAL, two bronze figures executed by *John Tweed* 1928–32, after a long and troubled history, and intended for the oriel in the Royal Gallery. It was placed in its present site in 1999.

As we walk along the W SIDE facing Old Palace Yard, the Victoria Tower with its majestic mass and its big pinnacles on the top is the beginning. It is 323 ft (98.4 metres) high. The trumpet blast of the Victoria Tower is immediately followed by a long stretch of completely even, quiet façade. The Peers' Entrance is exactly in the middle of that part. Here one finds a splendid equestrian STATUE of Richard I by *Marochetti*, erected 75 in 1860, after a clay model shown at the Great Exhibition in 1851; the reliefs on the plinth are later still, 1866–7. Then the front comes forward, with the grand nine-light window which copies the former S window of Westminster Hall. Barry removed this when he introduced his gatehouse motif of St Stephen's Porch as the main public entrance to the building and opened up the S end of Westminster Hall, so joining it to his new design. Much figure sculpture around and above the window, and, below, a DRINKING FOUNTAIN and TROUGH designed by *S.E. Dykes Bower*, 1955, to commemorate the Coronation. More figure sculpture above St Stephen's Porch. Then follow the refaced walls of Westminster Hall with their broadly set flying buttresses

away from the main structure. The offices between these were built only in 1888 (by *J.L. Pearson*). In front of them on Cromwell's Green, a STATUE of Oliver Cromwell by *Hamo Thornycroft*, 1895–9. Then into New Palace Yard, along the front of Westminster Hall with its fine show façade by *Henry Yevele* (*see* pp. 229–30). Taking up the N–S direction again one sees another even stretch with statues by *J. Thomas* of kings and queens from William I to Queen Victoria. In front of this an arcade with four-centred arches in Portland stone with six kings by *H.H. Armstead*, added by *E.M. Barry* in 1864–7. It provided covered access to the new underground station, and now to Portcullis House as well (*see* p. 247). Charles Barry always wanted to enclose New Palace Yard with two more office ranges, but those who wished to preserve the open views across to Westminster Hall finally prevailed, and the present splendid PIERS and RAILINGS were designed by *E.M. Barry* in the 1860s, with metalwork made by *Hardman*. New Palace Yard now contains an underground car park, 1972–4. FOUNTAIN in the centre, recalling earlier ones of the C12 and C16, by *Walenty Pytel*, commissioned in 1977 for the Queen's Silver Jubilee.

So the northernmost corner is reached, and the CLOCK TOWER (316 ft, 96.3 metres) with its completely unorthodox top: a fairy tower of no archaeological precedent, but based on Pugin's earlier design for Scarisbrick Hall, Lancs. It also recalls a medieval predecessor of 1365–7. The clock face projects and, above, the roof rises in a truncated pyramid, turns square again, and then ends in another pyramid. The sides of both pyramids are concave. The original polychromy has been much altered. The N FRONT has the same details as the S front.

The STONE used was the magnesian limestone of Anston in Yorkshire. It was badly quarried and has therefore given much trouble. A major restoration, which involved much replacement and recarving, was undertaken from the late 1920s and was incomplete at the outbreak of the Second World War. The palace was hit by bombs several times, the most serious being in May 1941, when the House of Commons was completely destroyed. The rebuilding and restorations started immediately at the end of the war. Work on the Victoria Tower was finally finished in the 1950s. From 1981 another extensive restoration and cleaning of the stonework took place. The exterior was completed by 1993, and work on the internal courtyards is following. All of this is by *Weatherall, Green & Smith*. Many of these courtyards were infilled in the 1960s–70s to provide more accommodation, e.g. *Eric Bedford*'s ugly building in Star Chamber Court, 1967, along with various additions on roofs, before the necessity for a new parliament building was at last recognized (*see* Portcullis House, Whitehall, p. 247). The CONSTRUCTION on which Barry insisted, with the warning of the fire of 1834 in his mind, has masonry walls, ceilings of cast-iron beams and shallow brick arches, and galvanized cast-iron plates as the roofing material (the main contractor *H. Grissell*). The basic structure of his building has not been substantially altered, but the fireproof roof plates have been restored.

THE INTERIOR

Interior Decoration

The palace was built at a period when there was a clear distinction between the fine arts of painting and sculpture and the decorative arts of wallpaper, metalwork, woodcarving, ceramics and so on. Barry planned totally designed interiors where every detail was under his control, and this he achieved with the decorative arts, carefully vetting Pugin's designs. Barry also made it possible for Pugin to work with his close group of colleagues who understood his style: *John Hardman* for metalwork and stained glass, *Herbert Minton* for tiles and *J.G. Crace* for decorative painting, wallpapers and some furniture.

The fine arts, however, were considered too important to be left to the architect and in 1841 a Select Committee was appointed 'to take into consideration the promotion of the Fine Arts of this country in connection with the rebuilding of the New Houses of Parliament'. The Committee was chaired by Prince Albert, who had married Queen Victoria in 1840. He was earnestly interested in the elevating capabilities of art, and had learnt to appreciate the work of the German Romantic Movement, particularly that of the Nazarene school of painting. The Prince wished to see the new Houses of Parliament generously enriched by painting and sculpture, and he felt that mural painting in fresco, as recently revived in Munich, would give the desired results. The positions for paintings and statues were chosen and the subjects determined; Cornelius, the most distinguished of the German painters (except for Overbeck, who lived in Rome), was asked to come to London to advise in person, and then competitions were held and their results, cartoons for monumental history paintings, exhibited in 1843, 1844 and 1847. From there artists were selected, including *Daniel Maclise, C.W. Cope, J.C. Horsley, Edward Armitage* and *William Dyce*. This programme got under way very slowly and with many difficulties, largely because the techniques and requirements of fresco painting were little understood. Before long Cope and Maclise, the artists for two of the major schemes, abandoned fresco for a technique known as waterglass. Following Albert's death (in 1861) the Fine Arts Commission was wound up in 1863 with only a fraction of the projected work completed. Mosaic was used for some decoration in the 1860s, but enthusiasm had declined. It revived in the C20 with major schemes, first in the East Corridor 1908–10, and then St Stephen's Hall 1912–27.* From the 1980s there has been considerable interest and effort put into buying and commissioning works of art, both painting and sculpture, for the Palace of Westminster Collection. Much internal refurbishment has taken place during the same period, wherever possible returning rooms to their original C19 decoration.

* Clare Willsdon in *Mural Painting in Britain 1840–1940*, 2000, explains the complex propaganda behind much of this work.

The Interior

We shall first follow the usual 'Line of Route' on the principal floor for the public through the building, then add what needs architectural comment in those parts which are not open to the public, and finally comment on the surviving parts of the medieval Palace of Westminster. The prevailing colours will be noted: red for the Lords' rooms, green for the Commons'.

The entrance for visitors is the same as that for the monarch, though she arrives in a coach, under the arch of the VICTORIA TOWER. The quality of the stone carving is immediately obvious from the crockets on the pinnacles to the lions flanking the entrance arch and the statue of the young Queen Victoria. The metalwork was designed by *A. W. N. Pugin* and made by his colleague *Hardman* in Birmingham. The Royal Staircase leads steeply to the vaulted NORMAN PORCH. Both of these areas and the Queen's Robing Room were parts of the palace completed by *E. M. Barry* after his father's death in 1860, and are in a typically High Victorian style, both bolder and more colourful than his father's work of the 1840s. In this way, in the Norman Porch, there are mosaics in the vault and coloured marbles on the floor. The stained glass, which shows Edward the Confessor, the monarch who built the first palace, and Queen Victoria, the monarch of the new palace, was designed by *Pugin c.* 1850 and manufactured in full colour by *Hardman*, but was found too dark, and in the mid 1860s it was returned to Hardman, who substituted the present beautiful grisaille glass. The name Norman Porch derives from the original plan that it should house statues of Norman kings. In fact there are portrait busts of sixteen prime ministers who have sat in the House of Lords.

The QUEEN'S ROBING ROOM is used at the State Opening of Parliament, where the monarch assumes the Royal Parliamentary robes and the Imperial State Crown. The fireplace is a splendid design by *E. M. Barry*, with brass figures of St George and St Michael manufactured by *Hardman*, and the stained glass was designed by *J. H. Powell*, Pugin's son-in-law. The Fine Arts Commission chose the Arthurian legend for the decorative theme, and the frescoes by *William Dyce*, painted between 1850

1	Victoria Tower	15	St Stephen's Porch
2	Royal Staircase	16	East Corridor
3	Norman Porch	17	Lower Waiting Hall
4	Queen's Robing Room	18	Commons' Libraries
5	Royal Gallery	19	Lords' Libraries
6	Prince's Chamber	20	Members' Reading Room & Tea Room
7	House of Lords	21	Lords' Refreshment Rooms
8	Peers' Lobby	22	Members' Dining Room
9	Peers' Corridor	23	Speaker's House
10	Central Lobby	24	Peers' Robing Room
11	Commons' Corridor	25	St Stephen's Cloister
12	Commons' Lobby	26	Westminster Hall
13	House of Commons	27	Clock Tower
14	St Stephen's Hall (Chapel under)	28	Visitor Centre

Palace of Westminster. Plan of principal floor as in 1902

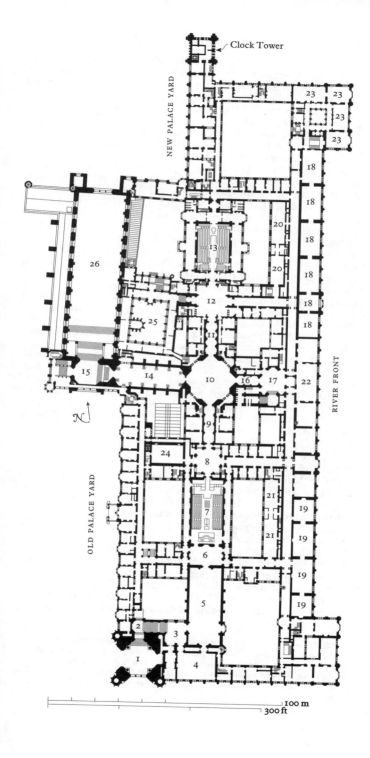

Clock Tower

NEW PALACE YARD

RIVER FRONT

OLD PALACE YARD

N

23 23
23
23
18
18
18
20 18
13 18
20 18
12 18
26
25 11
15 14 10 16 17 22
9
24 8
21
7 19
6 21 19
5 19
19
2 3
1
4

100 m
300 ft

and his death in 1864, illustrate Hospitality, Generosity, Religion, Mercy and Courtesy with stories from it. Dyce had studied the technique of fresco painting at first hand with the Nazarenes and as a result he was successful with it. Stylistically his work is close to that of the Pre-Raphaelites, but also shows the influence of Raphael himself and his Roman *Stanze*, particularly in the Religion fresco. Beneath the frescoes is an excellent series of oak relief panels, 1866–70 by *H.H. Armstead*, which tells the story of King Arthur and Sir Galahad.

Next the ROYAL GALLERY, a processional room also used at the State Opening of Parliament. The floor is covered with *Minton*'s encaustic tiles, designed by *Pugin c.* 1851 in strong patterns of buff, red, blue and (originally) white, now rubbed away. In the niches of the doorways and oriel window are gilded stone statues of kings and queens by *J. Birnie Philip*, 1867–9. The ceiling has decorative panels originally painted by *Crace*, and overpainted in the 1970s. The stained glass was replaced after the Second World War, repeating Pugin's design but omitting the background diaper panels (*Hardman Studios*). The Fine Arts theme is British History. Only two of the planned pictures were ever painted, but these two large and impressive works by *Daniel Maclise*, The Death of Nelson, 1863–5, and The Meeting of Wellington and Blücher after Waterloo, 1860–1, dominate the room. They were painted using the waterglass technique, which allowed for more detail than fresco.*

The PRINCE'S CHAMBER is a lobby for the House of Lords, also forming a passageway between the Peers' staircase and their library. The masterly woodcarving and the clocks, fireplaces and furniture were all designed by *Pugin* and made by 1847. The stained glass is post-war by *Carl Edwards*. Tudor and Stuart History is the artistic theme. The bronze panels are by *W. Theed*, 1853–6. Above are portraits of C16 royal figures, executed by *Richard Burchett* with the assistance of his pupils at the Royal College of Art, South Kensington, 1854–60. They are based on actual C16 paintings, but not always correct ones. Above that again are blank panels where it was intended to place replicas of the late C16 Flemish tapestries depicting the defeat of the Armada, which were burnt in the fire of 1834. The over-life-size marble statue of Queen Victoria, flanked by figures of Justice and Clemency, of 1856–7 by *John Gibson* in a Neoclassical style, looks somewhat out of place.

HOUSE OF LORDS. The 'Parliament Chamber' was built for the ceremonial of the State Opening of Parliament, rather than the daily sittings of the Upper House, and is therefore richly ornamented. It forms indeed the joint *chef d'œuvre* and *tour de force* of *Barry* and *Pugin*. 'Nothing could be more magnificent and gravely gorgeous', wrote Nathaniel Hawthorne of it. The

* A scheme suggested in 1925 by the 1st Earl of Iveagh to donate mural decorations for the empty spaces as a War Memorial, with *Frank Brangwyn* as the artist, was eventually rejected in 1930 after many canvases had been produced. The bronze figures commissioned instead are now in Black Rod's garden (*see* p. 217). Their place in the oriel window has now been taken by cases for Books of Remembrance for both World Wars.

throne especially with its big canopy (restored and regilded in the late 1980s) and its brass candelabra is of an inexhaustible wealth of invention. Much Early Victorian work could be dead and mechanical. It is to these pieces designed by Pugin and vetted by Barry that one ought to look to appreciate what craftsmen in the 1840s were capable of, if spurred by a master of design. The carved wood is everywhere superb. The ceiling, painted by *Crace*, is panelled. Each large panel is subdivided with a magnificent gilded wooden device in the central lozenge, and is surrounded by a pierced inscription with the repeated words 'Dieu et mon Droit', which formed part of the original ventilation system. The whole was the subject of an excellent restoration by *Donald W. Insall & Associates*, 1980–4. The floor of the chamber is supported on a grid of cast-iron beams and also played a part in the ventilation system. The brass railing to the gallery was made by *Hardman*. The fine arts elements are the frescoes at the N and S ends and the statues of the Magna Carta barons in niches between the windows on the E and W walls. The frescoes date from 1846–9. Their subjects read in pairs across the chamber: The Spirit of Justice, N end, by *Daniel Maclise*, is illustrated at the S end by Prince Henry Acknowledging the Authority of Chief Justice Gascoyne by *C. W. Cope*; in the centre at the N end The Spirit of Religion by *J.C. Horsley* is illustrated by The Baptism of King Ethelbert by *Dyce*; and The Spirit of Chivalry at the N end by *Maclise* is illustrated at the S end by Edward III Conferring the Order of the Garter on the Black Prince by *Cope*. The statues, made by *Elkingtons* and others, are of zinc, electroplated in copper. They were modelled 1848–58 by *John Thomas*, *P. MacDowell*, *W.F. Woodington*, *H. Timbrell*, *J.S. Westmacott*, *T. Thornycroft*, *F. Thrupp* and *A.H. Ritchie*. The chamber has been very little altered since it was opened, though it was used by the House of Commons during the Second World War with the Speaker's Chair placed at the N end. The stained glass was originally kings and queens designed by *Pugin* and made by *Ballantine & Allan* of Edinburgh, the only original stained glass not made by Hardman. It was replaced after bomb damage by armorial designs by *Carl Edwards*, 1956. The lighting has also been frequently altered.

The PEERS' LOBBY is the main entrance to the House of Lords and also to the corridors which run along the E and W walls of the chamber and double as division lobbies. The splendid brass doors to the chamber, designed by *Pugin* and made by *Hardman*, are based on the early C16 bronze gates to Henry VII's Chapel. The *Minton* encaustic tiles here are very fine examples, again designed by *Pugin*. The ceiling (recently well restored) is panelled and painted, and there is a good brass chandelier and engraved clock faces. The stained glass has been much altered.

The PEERS' CORRIDOR has encaustic tiles of the 1970s, copies of the original *Minton* ones. The stained glass, though designed by *Pugin* in full colour, was here also altered to grisaille in the 1860s to let in more light. The subject of the paintings is that of English history of the first half of the C17, all by *C. W. Cope*, 1856–66, realistically treated, neither pompous nor

self-consciously stylized. Some are painted in fresco, some in
waterglass. In the tradition of British fair-mindedness, the E side
is intended to illustrate aspects of the virtues and heroism of
Parliamentarians and the W side those of Royalists. The subjects
are paired across the corridor.

90 The CENTRAL LOBBY is a vaulted octagon, with four
great archways and four big windows. It lies underneath the
octagonal Central Tower which in turn is surmounted by a spire
300 ft (91.4 metres) high. This spire is constructed with an inner
brick cone, and it and the tower were added at the insistence of
Dr Reid, who wanted the tower to act as a chimney for his count-
less flues. Barry was glad to adopt this feature, which gives a
strong external accent to the centre of the palace, but Dr Reid's
requirements, his lack of practical understanding of architecture,
his difficult temper and his unwillingness to communicate with
Barry caused many problems before he was made to leave in
1852. Ventilation was a major concern in the early days of the
new palace, and several very different schemes were tried. The
tiled floor, now sadly worn, is the most ambitious scheme by
Pugin and *Minton*.* In the deep jambs to the four entrance arches
stand kings and queens in niches. *John Thomas* was the sculptor
in charge of all the architectural stone carving. Above the
archways are four mosaics of the patron saints of the United
Kingdom: St George and St David to the N and S, by *Sir E.J.
Poynter*, 1869 and 1898, both executed by *Salviati & Co.*, who
also decorated the vault in 1870; St Andrew and St Patrick to the
E and W, by *R. Anning Bell*, 1923 and 1924. Beneath the windows
are placed four marble statues of statesmen: Lord John Russell,
by *J.E. Boehm*, 1880, Lord Iddesleigh also by *Boehm*, 1888,
the 2nd Earl Granville by *H. Thornycroft*, 1895, and Gladstone
by *F.W. Pomeroy*, 1900. The great brass corona was made by
Hardman in 1856, and is a good example of what could be done
after Pugin's death.

The COMMONS CORRIDOR continues the treatment of the
Peers' Corridor with renewed encaustic tiles, altered stained glass
and mural paintings with subjects from the second half of the
C17 by *E.M. Ward* in fresco and waterglass. They were commis-
sioned in 1849 and painted in 1853–68. Those on the E side relate
to 1650–60, those on the w to 1685–9, with again an attempt to
do justice to both Royalists and Parliamentarians.

In the COMMONS LOBBY another world is reached. It is a
world which is both lighter and plainer. Barry's and Pugin's work
here and in the Commons' chamber was destroyed by a bomb
in 1941. The rebuilding was entrusted to *Sir Giles Gilbert Scott*
and *Adrian Scott*, with *Oscar Faber* as engineer. The former
entrance to the House of Commons (now called the Churchill
Arch) was left partly unrestored as a reminder of what the
building had suffered. The bronze statues of Churchill by *Oscar
Nemon*, 1969, and David Lloyd George by *Uli Nimptsch*, 1963,
are on either side of the arch. A scheme to include statues or
busts of all the C20 prime ministers is in progress in 2003. The
statues are of Clement Attlee by *Ivor Roberts-Jones*, 1979, Herbert

* *Pugin*'s stained glass was removed after the Second World War.

Asquith by *Leonard Merrifield* and *Gilbert Bayes*, 1948, and Arthur Balfour by *David McFall*, 1962; also Benjamin Disraeli by *Count Gleichen*, 1883. The statue of Margaret Thatcher by *Neil Simmons*, 2001, is expected to be installed in 2004, and that of Disraeli will probably be moved. The most remarkable bust is that of Ramsay Macdonald by *Epstein*, 1926.

HOUSE OF COMMONS. Planning for the rebuilding began during the war and work started immediately after. It was reopened in 1950. The proportions and layout of the chamber remained the same as before. The Select Committee also chose to keep to the Gothic style, but Sir Giles Gilbert Scott's personal responsibility is fully established by his report, in which he writes that although the general form and arrangement conform with the instructions of the Select Committee 'no attempt has been made to follow the design of the old woodwork and stonework'. For Pevsner in 1957 'Nothing could show up more poignantly the inferiority of the C20 in comparison with the early C19 Gothicists. To Pugin the Gothic style was a style, a unity of structure and ornamental enrichment. Scott thought he could keep the one without the other. Had he been fully alive to the implications of a split between principles and forms, he would have built in the C20 style, a style in its principles of skeletal construction closer in spirit to the Gothic style than any since the C15. But he thought he could keep the Gothic form without Gothic ornament. The result could only be, aesthetically speaking, a neuter. Pugin knew better. People call his Gothic second-hand. But he has succeeded to a unique degree in re-creating the sense of infinite detail and infinite pain which such a style as the Perpendicular needs. Once that faith in detail goes, life leaves the design. That is what has happened in the House of Commons and the Lobby. It is even more evident in their exteriors than inside. The bare walls are C20, the Gothic details of the windows are a concession to certain evocative qualities which refuse to evoke anything if introduced so parsimoniously. Of such things as the light fittings – neon-Gothic is the term coined within the walls of the House for some of them – the less said the better.' Almost fifty years later, away from the 'style wars' of the 1950s, it is possible to be more dispassionate and to admire the quieter, paler, angular features of Scott's Gothic style, and to think that his adaptation of the neon tube for Gothic chandeliers is ingenious. Like Pugin, he also designed all the furniture and fittings, most of which were donated by the countries of the Commonwealth. For some of these, as for example the Speaker's Chair, the table and the despatch boxes, the donor countries provided material from native trees.

The Line of Route takes visitors through the division lobbies, past the desks where votes are recorded and into the chamber. The Government benches are on the W side with the Opposition opposite, the press gallery is above and behind the Speaker's Chair and the public gallery opposite. Access to the private areas of the building lies behind the Speaker's Chair. Visitors then retrace their steps to the Central Lobby and leave via St Stephen's Hall and St Stephen's Porch, or via Westminster Hall (*see* below, pp. 229–30).

St Stephen's Hall replaced St Stephen's Chapel of the old palace, the place where the Commons sat from the mid C16 until the fire of 1834. (Beneath it the Chapel of St Mary Undercroft survives, *see* p. 228 below.) It was rebuilt by *Barry*, keeping its original shape, but forming part of his main entrance for the public into the heart of the building. Again there are *Minton* tiles, and some of *Pugin*'s best stained glass, with the arms of various boroughs. It is the wall paintings and sculpture, however, which are important here. The project for these history paintings was the second big one of the C20, with the theme of The Building of Britain, and the Speaker, W.H. Whitley, was in control of the scheme, with Sir David Cameron as artistic director. The programme was intended to be non-controversial and educational. It was carried out in 1926–7, in a light-coloured simplified academic style reminiscent of the work of Puvis de Chavannes and Early Renaissance models. The paintings from the w end on the s wall are by *Sir Thomas Monnington, Sir William Rothenstein, A.K. Lawrence* and *Vivian Forbes*. Those on the N wall, now from the E, are by *Sir George Clausen, Charles Sims, Glyn Philpot* and *Colin Gill*. King John assents to Magna Carta, by *Sims*, was the only painting to break the stylistic code and attempt to be 'modern', and was much criticized for it. In between the paintings are set marble statues of C17 and C18 statesmen, executed between 1845 and 1858. They are, from the E end on the s wall: Hampden (*J.H. Foley*), Selden (*Foley*), Walpole (*J. Bell*), Chatham (*P. MacDowell*), Pitt (*MacDowell*) and Grattan (*J.E. Carew*); on the N wall Clarendon (*W.C. Marshall*), Falkland (*J. Bell*), Somers (*Marshall*), Mansfield (*E.H. Baily*), Fox (*Baily*) and Burke (*W. Theed*). Henry-Russell Hitchcock felt they looked 'like petrified lobbyists', but they give some indication of the great oratory which had been delivered in this space. At either end of the hall are mosaics by *R. Anning Bell*, 1925–6, recalling the history of St Stephen's Chapel.

In St Stephen's Porch, First World War memorial, 1919–22 by *Sir Bertram Mackennal*, its top destroyed in the Second World War when the window above was blown out. The stained glass by *Sir Ninian Comper* now in that window is a Second World War memorial containing coats of arms or monograms of Members and staff of both Houses who died, and badges of their regiment, squadron or ship. On the w wall a large painting by *Benjamin West*, Moses Receiving the Tablets of the Law, painted in 1784 for the Chapel Royal at Windsor Castle, and, either side of the entrance, two painted wall panels by *Macdonald Gill*, 1932.

Other Parts of the Palace, not on the Line of Route

Original fireplaces, wood panelling and brass fittings and much furniture survive throughout the building, e.g. in the committee rooms on the first and second floors of the river front. Rooms of particular note are the following. The East Corridor has rich and colourful wall paintings in oil on canvas of 1908–10, in bright realistic styles with history subjects from the late C15 to the mid C16, intended to illustrate the story of the Reformation, with

clear but now forgotten references to contemporary politics. The artists were *H.A. Payne, Denis Eden, F. Cadogan Cowper, Frank Salisbury, Ernest Board* and *John Byam Shaw*. The project was overseen by *Edwin Abbey*, who imposed common adherence to a red, gold and black colour scheme and certain compositional devices, thus achieving remarkable homogeneity. – LOWER WAITING HALL, E of the East Corridor out of the Central Lobby, which gives access to the river front and the upper floors. The *Minton* tiles, fireplace, woodwork and stained glass all belong to the early 1850s and are to *Pugin*'s designs. Bust of Cromwell, probably C18 Italian. Also life-size statues of John Bright by *A. Bruce-Joy*, 1902, and Sir William Harcourt by *Waldo Story*, 1906. – COMMITTEE STAIRS. At the foot is a large seated statue of Barry by *Foley*, 1861–5. At the turn of the stairs The Commons Petitioning Queen Elizabeth to Marry, a painting by *Solomon J. Solomon*, 1911, once intended as part of the East Corridor scheme. The stained glass here is among the best surviving examples of the original work. – The UPPER WAITING HALL was once called the Poets' Hall on account of the wall paintings illustrating stories from the work of the country's greatest poets, the second series for the Fine Arts Commission. They were executed in 1848–54, but deteriorated badly and were covered for some ninety years. They were successfully restored in the late 1980s and early 1990s by *Krystyna Barakan*. Placed clockwise from the stairs in chronological order of the authors, they comprise *C.W. Cope* illustrating Chaucer, *G.F. Watts* Spenser, *J.R. Herbert* Shakespeare, *J.C. Horsley* Milton, *John Tenniel* Dryden, *Edward Armitage* Pope and Sir Walter Scott and *Cope* Byron. STATUE of J.H. Chamberlain by *John Tweed*, 1927. The remaining eight statues come from the exterior. – On the principal floor of the river front are situated the COMMONS' and LORDS' LIBRARIES and some of the REFRESHMENT ROOMS. The libraries have particularly fine carved woodwork and much original furniture, though some of it has been displaced by information technology. The MEMBERS' DINING ROOM was given realistic carved panels of fruits and hunting trophies by *T.H. Kendall* of Warwick, 1874–6. They form an interesting contrast to the stylized medieval carvings designed by Pugin in the late 1840s. The room was subsequently enlarged. The first-floor COMMITTEE ROOMS of the river front retain most of their original fittings.

At either end of the river front is a projecting twin-towered pavilion built around an inner courtyard. That at the N end comprises the SPEAKER'S HOUSE. This was fitted up in 1858, that is to say after *Pugin*'s death, and it is instructive to see the adaptation of his style in the State Rooms on the principal floor; the brass railing to the staircase, still manufactured by *Hardman*, is thinner and less flowing, the furniture and decoration in general more glamorous and heavier, the stained glass, also made by *Hardman*, and the *Minton* tiles still much the same. A room originally in the Sergeant-at-Arms's house has been added to the State Rooms and now houses the State Bed, restored in the 1980s. At the S end is a matching pavilion originally occupied by House of Lords officials. An apartment, recently made on the first floor, now comprises the LORD CHANCELLOR'S

RESIDENCE, with one fine room, the River Room. It was thoroughly redecorated 1997–8 with reworked Pugin wallpapers and textiles, and a mixture of C19 original and 1990s Pugin-style furniture. In 2003 it contains a loan collection of sculpture and paintings.

The PEERS' CLOAKROOM contains many original fittings, including stained glass and hat, coat and umbrella stands, all designed by *Pagin* and made by *Hardman*. The toplit PEERS' ROBING ROOM (Moses Room) on the principal floor, finished 1856, was at some time planned to be a C19 'Painted Chamber' on the theme of Justice, but this was never completed. The paintings are by *J.R. Herbert*: Moses on Mount Sinai, waterglass on plaster, 1864, and the Judgement of Daniel, on canvas, finally hung 1880.

THE MEDIEVAL PARTS

15

p.8

There are two surprising survivals, even apart from the wonders of Westminster Hall. The CHAPEL OF ST MARY UNDERCROFT, often misleadingly called the Crypt Chapel, is the lower chapel to St Stephen's, which was a double royal chapel. It was begun in 1292 for Edward I, replacing an earlier chapel with the same dedication whose site is unknown, and was conceived in rivalry to the Sainte Chapelle in Paris. The undercroft was completed by 1297. The upper chapel followed slowly: a first phase in 1320–5/6 under Edward II, a second and much more extensive campaign for Edward III, from 1331 to 1348, when the King founded the College of St Stephen; the lavish decoration of both chapels was completed in 1363. The interior of the upper chapel then contained elaborately moulded engaged shafts encrusted with thousands of paterae made of stamped and gilded gesso. Indeed every available surface was painted, gilded, diapered or stencilled, and there was a full scheme of stained glass. There were paintings below the side windows, and at the E end an Adoration of the Magi with figures of St George, Edward III and Queen Philippa with their sons and daughters, probably with a great altarpiece above. The canons sat in stalls along the side walls and there was a pulpitum. A splendid W porch was built in 1345–8 and survived until 1834. St Stephen's Chapel, both as it once stood and as it now survives in the shape of the undercroft, is of considerable significance, for in it can be traced many of the roots of later Decorated Gothic. The first two of its master masons, *Michael of Canterbury* and his son *Thomas*, were prominent members of a school of Kentish masons.* Their distinctive contribution lay in a particular enthusiasm for complex geometrical forms, notably the ogee. The wall-shafts are Purbeck marble and the vault of the chapel is possibly the first lierne vault in England, with the ornamental liernes forming star-like patterns to each bay. The large central bosses show the martyrdoms of saints, with that of St Stephen himself over the altar. They were however much restored following the fire of 1834. The exterior

* After 1337 the chief mason was *William Ramsey III*.

was renewed by *Charles Barry* from 1845, and he added the octagonal turret as part of his symmetrical façade to the S window of St Stephen's Porch. The lowest level of this was subsequently used as a baptistery after the decision was made to reinstate the chapel, of which the internal restoration was the work of *E.M. Barry*, 1860–70. He made a new W entrance down stairs from Old Palace Yard, and renewed another from the SE corner of Westminster Hall to the NW corner of the chapel. He also added a vestry to the NE bay, which was renewed in the 1950s.

The younger Barry's interior work was typically High Victorian, both bolder and more colourful than the rest of the Palace of Westminster. The elaborate alabaster DADO to the E, N and S walls, the marble and tile FLOOR and Purbeck columns were provided by *William Field*, who was the chief contractor used at Westminster by E.M. Barry. The PAINTING of the E wall, baptistery and altar-bay vault is by *Clayton & Bell*, probably executed by *John Spreckley Cuthbert*, the remainder by *J.G. Crace & Sons*, to designs by the architect.

FITTINGS. ORGAN, following a design by *Pugin*, by *William Drake*, 1999. – STAINED GLASS illustrating the story of St Stephen, by *J.H. Powell*. – GATES and RAILINGS at the W end by *E.M. Barry*, possibly made by *Skidmore*, inspired by the grille made in 1294 for the tomb of Eleanor of Castile in Westminster Abbey (*see* p. 151). Brass panels and figures to the PULPIT and LECTERN by *Hardman*. – Splendid decorated alabaster FONT and COVER by *E.M. Barry*.

ST STEPHEN'S CLOISTER was built in 1526–9 N of the chapel and E of Westminster Hall, replacing an earlier cloister. It shows that the College of St Stephen continued to prosper after the fire of 1512 and the abandonment of the palace as a major royal residence. It is two-storeyed, like the C14 cloister at Old St Paul's, is longer by one bay from N to S than from E to W, and has a two-storey oratory projecting E from the W side. As with the chapel it is now a fascinating mixture of original and C19. On the ground floor ornate *Pugin* fireplaces under the original fan vault. The upper, vaulted N walk forms part of the MEMBERS' ENTRANCE and is wholly *Barry*, but the upper oratory with its vault, richly panelled walls and pretty detail exactly follows John Carter's pre-fire drawings. *Barry* reinstated the external pinnacles and after the bombs of 1941 the S, E and W sides were almost completely rebuilt.

Westminster Hall

WESTMINSTER HALL in the lower parts of its walls is Norman, built for William II in 1097–9. This early hall already had its present length (240 by 68 ft, 73.2 by 20.7 metres), and probably its main entrance at the N, so that the dais end could be close to the royal apartments. The walls were plain below and above had twelve round-headed windows with a wall-passage in front, connected by two lower arches between each two windows, the system of the slightly earlier clerestory of Winchester cathedral transept. Some of the capitals from this work, exposed in *Sir Robert Smirke*'s restoration of 1834–7, may be seen at the Jewel

Tower (*see* p. 232). Richard II began the remodelling in 1394.
It was completed in 1401. The masons were *Henry Yevele* (*see*
p.8, Westminster Abbey, p. 114) and his deputy *Walter Walton*, the
17 carpenter *Hugh Herland*. The remodelled hall has the largest
surviving hammerbeam roof, and owing to this roof cons-
truction could dispense with internal supports (though there is
evidence that its predecessor may also have had a single span).
The RCHM, always very reserved in its judgements, called
Westminster Hall 'probably the finest timber-framed building in
Europe'. The timbers are very massive, the hammerposts, the
largest members, being in section 39 by 25 in. (100 by 64 cm.),
and nearly 21 ft (6.5 metres) long. The whole roof, with its thir-
teen trusses, weighs 660 tons. Hence, one might think, the six
big outer stone flying buttresses visible on the W side; but they
were probably intended to prop up the walls. There were only
ever three buttresses on the E side, and Barry removed these. The
latest theories suggest that the weight of the roof is in fact carried
on the walls and the corbels.* Steelwork was introduced by *Sir
Frank Baines* in the 1920s in the timber roof, to secure it. He also
added a new louvre, repeating the design by *Soane* of 1821. A
peculiarity of Westminster Hall is that there is an arched brace
to each bay, intersecting the hammerbeam construction, giving
fascinating complex visual effects. In addition there are small
transverse arched braces from the hammerposts to the main
purlins. Tracery is used to fill in the spandrels everywhere, and
angels holding shields and emerging from small clouds are carved
against the hammerbeams. The main arched braces and the
brackets for the hammerbeams rest on stone corbels which form
part of the frieze running all along the E and W walls below the
windows. It is decorated with the chained white hart and other
motifs from Richard II's coat of arms.

The windows in the E and W walls are of two lights with ele-
mentary Perp tracery, and have hoodmoulds with defaced carved
stops. Much more important are the N and S windows. The S
window was set back and renewed by *Barry* to gain space for his
dramatic dais, up a wide staircase, and to incorporate this great
building into his new design. These two windows are of nine
lights, with two-centred heads and three side lights on each side
gathered under a subordinate two-centred head – a familiar Perp
pattern. The other two staircases in the hall are part of *J.L.
Pearson*'s work following the demolition of *Soane*'s Law Courts
in the 1880s. There was much discussion on what should take
their place; William Morris and the SPAB wanted the site to be
left untouched. Pearson's work, for which no brief was given, was
a compromise. He made low enclosures housing offices against
the outer W wall, thereby preserving the medieval masons' marks
exposed during demolition. His two-storey projecting annexe at
the N end originally housed an upper Grand Committee Room,
now used as a second debating chamber, and a lower open area
for waiting horses, subsequently a cafeteria (converted into a
VISITOR CENTRE in 2001).

* *See* Gene Waddell in *Architectural History* 42, 1999.

The N FAÇADE of Westminster Hall is unique because *Yevele* used twin towers, a huge window and a screen of niches interrupted by a vaulted 'welcoming' porch, all forms more familiar on great ecclesiastical buildings (cf. Westminster Abbey). The towers, which are crenellated, stop short of the gable summit and have more statue niches flanking the two-light transomed windows of the middle storey. The façade was restored in 1807–8 by *Wyatt*, more archaeologically in 1818–20 by *Soane*, who removed statues of kings added in 1398, and was again brutally renewed following the Second World War. The STATUES were again initiated in rivalry with the French kings, this time those within the analogous hall in the Palais de la Cité in Paris. Five of them, in a damaged state, are now inside, on the sills of the E windows.* The N wall of *Barry*'s dais, that is the inner wall facing the hall, has six earlier royal statues, commissioned in 1385–8 for the hall from *Thomas Canon* and painted by *Nicholas Tryer* (conserved 1995): outstanding for their date, though inferior to French work of the period. They stand in niches by *Barry* which are closely based on the originals of the 1380s, by *Walton*.

FURTHER READING

A well-illustrated all-round treatment is C. and J. Riding (eds.), *The Houses of Parliament, History, Art, Architecture*, 2000, which also has a full bibliography; also M.H. Port (ed.), *The Houses of Parliament*, 1976. *The History of the King's Works*, 6 vols., 1963–82, covers both old and new palaces. On Westminster Hall and the medieval palace *see* also E.W. Brayley and J. Britton, *The History of the Ancient Palace and late Houses of Parliament at Westminster*, 1836; P. Binski, *The Painted Chamber at Westminster* (Society of Antiquaries Occasional Papers 9), 1986; J. Cherry and N. Stratford, *Westminster Kings and the Palace of Westminster* (British Museum Occasional Papers 115), 1995; and articles by Christopher Wilson and Philip Lindley in D. Gordon, L. Monnas and C. Elam (eds), *The Regal Image of Richard II and the Wilton Diptych*, 1998.

JEWEL TOWER
Abingdon Street

An isolated survival of the medieval Palace of Westminster (*see* above). Built in 1365–6 by Edward III, as a repository for the King's personal treasure. It stood at the SW corner of the palace precinct, which was more private and secure than the area around Westminster Hall. The accounts show that *Henry Yevele* was the architect. The site encroached on the lands of Westminster Abbey, beyond the earlier palace wall, which ran beneath the

*A sixth stands in Trinity Church Square, Southwark; Soane's own house in Lincoln's Inn Fields displays two C14 brackets from Westminster Hall on the front, and other oddments within (*see London 2: South* and *London 4: North*).

tower.* It is L-shaped and three-storeyed, of squared ragstone, with some ashlaring lower down. Staircase in a polygonal turret on the NE side. That the effect is not medieval is due to changes by the Office of Works, 1718–19 (mason *Benjamin Jackson*): enlarged round-arched windows dressed with Portland stone, and a plain parapet and stair-head of brick. The inner angles bear scars of perimeter walls running N and E, beyond which the tower was lapped by a moat that communicated with the Thames. For security the walls facing this moat had fewer and smaller windows. Others were made after 1621, when the tower was adapted as a record repository for the Parliament Office; Nos. 6–7 Old Palace Yard, alongside, served the same body (q.v., Streets). From 1869 to 1938 the tower housed the Weights and Measures Office. Attached structures were removed in restoration of 1948–59. Excavations of 1963–4 re-created part of the MOAT, and revealed a medieval ashlar-faced QUAY to the E. These have been incorporated in the small garden around the tower.

INTERIOR. Each floor has one larger room, with a blocked fireplace, and one smaller inner room. The keeper's quarters were on the ground floor, where the main room has a two-bay tierceron vault, patterned and profiled like that at Litlyngton's Cellarer's Building in Dean's Yard (p. 200). Three good big bosses with grimacing faces and intertwined birds. In the smaller room a cross-vault and a blocked garderobe. The lower stage of the staircase is restoration of 1952, but the first-floor doorway off it retains the C14 shouldered head and rere-arch. Also C14 the window embrasure opposite. A brick wall divides off the lesser room, converted to a brick-vaulted strongroom for records in 1621. Iron DOOR with original lock. The larger room was vaulted probably in 1753. On the second floor the main doorway is double-rebated (C14 DOOR and ironwork), the window embrasures also rebated: evidence that this was the most secure level. Wall to the lesser room of 1726, its doorcase with suggestively medievalizing mouldings. Displayed on the ground floor eight exceptionally early historiated CAPITALS from William II's Westminster Hall of 1097–9 (*see* p. 229), discovered in 1835. They have animal as well as military subjects, a soldier attacking a tower, etc., comparable to scenes on the Bayeux Tapestry.

WHITEHALL
(streets and public buildings)

History and Introduction

Whitehall is at once a route and a precinct. Its spine is the road that runs for half a mile between Westminster Palace and Charing Cross, following the river. As a precinct it is shorthand for the institutions of Government. Their buildings are a remarkable mixture of the resplendent and the makeshift, a testimony both of the continuity and the recurrent parsimony of the British

*The exit of the C12 drain from the Abbey, which passes beneath its garden, was found in the precinct wall in the 1960s.

state. But Government took centuries to dominate the area, and purpose-built official architecture falls far short of monopolizing it even today. Some ministries are based in surviving aristocratic houses, terraces or adapted commercial premises, and some new-built offices even preserve fragments of the old Whitehall Palace. This, the greatest English royal palace of the Tudors and Stuarts, dominated the route until 1698, when most of it was destroyed by fire. *Inigo Jones*'s Banqueting House is its chief relic. The story of the rest is told in more detail below. p. 235

That leaves the land to the N and S of the Whitehall Palace site. Most of this originally belonged with the ordinary fabric of Westminster, a network of small streets and yards and domesti-cally scaled buildings. The N end and parts of the E side at the S end, which are still of mixed street architecture, reflect this ancestry. Greater houses had to be squeezed in on unpromising sites, such as Harrington House, whose façade of *c.* 1695 survives in Craig's Court. Also on the E side, there have been two distinct phases of clearance and rebuilding, unconnected with the steady growth of the various ministries. The first came about when the S end was replanned in the 1740s–50s, in connection with Westminster Bridge. For this a new N–S street called Parliament Street was created, supplementing the ancient road further W (called King Street). The clearance during the C19 of everything between these routes accounts for the present exceptionally wide roadway at this end. The second phase, decreed in the 1790s but not finished until the 1820s, created new side streets of superior terraced houses, of which the only survivor is Richmond Terrace, also towards the S end. But the most famous terrace is of course in Downing Street on the W side, laid out in the 1680s. This origi-nally marked the border between the royal or Governmental buildings to the N and the streets of old Westminster to the S. Wholesale clearance in this SW area has made it the only survivor of these N of Parliament Square.

WHITEHALL PALACE, thanks to excavations in 1939 and 1950 and much recent scholarship, is much less of an architectural puzzle than it used to be. The landholding at its core is first recorded in 1158, and by the 1220s already had a residential cluster with a chapel. This was bought in 1240–1 by Walter de Grey, Archbishop of York, and in future was called York Place. By the 1290s the improved complex was grand enough for Edward I to borrow it. In the next great expansion, begun in the later C15 under Archbishop Neville, a new great hall was added, and a gatehouse facing Whitehall, N of the present Banqueting House. When in 1514 Wolsey became Archbishop of York he began at once to reconstruct and expand the palace further, including a replacement great hall and a new long gallery built on land reclaimed from the foreshore. The new name Whitehall was adopted around this time, and may reflect an obsolete usage referring to any festively decorated great building. The wine cellar preserved at the Ministry of Defence (*see* p. 243) is testimony to the size and ambition of these works, which were however seized by Henry VIII after Wolsey's fall from favour in 1529.

Henry had lacked suitable quarters in the capital since the fire at Westminster Palace in 1512. He also required apartments for

his successive queens, which meant much new building near the river. But his greatest plans affected the area to the w. In 1531 he bought over 180 acres (73 hectares) s and w of Charing Cross, including hundreds of houses for clearance, the premises of the Hospital of St James, and the land which became St James's Park. On its w edge, that is w of the roadway, Henry built a kind of leisure complex that was the most novel feature of the expanded palace. As finished in 1534, it had a tiltyard for jousting, four tennis courts (of which fragments remain within the so-called Old Treasury complex, *see* pp. 259–60) and a fancifully ornamented octagonal cockpit. To reach it, a Privy Gallery was built across from the e side, crossing the road through the upper storey of a new gateway later dubbed the Holbein Gate. This was of typical Tudor-Gothic form, but the Renaissance was represented on it by portrait roundels like those at Hampton Court (some of which may be salvage from here). Other buildings begun by Wolsey, at Esher and Ipswich, were quarried for materials to drive all this work forward, as was the partly abandoned Westminster Palace. Further s, another gateway called the King Street Gate was built in the 1540s, with domed turrets and other French Renaissance devices. The public street was quarantined within high walls between these gates, which were the chief external showpieces of the Tudor palace. At 23 acres (9 hectares) it was the largest in Europe, but the external effect was of a rambling assemblage of buildings, large and small, high and low, on no account the equal of Henry's Hampton Court or Nonsuch.

A new start, which was also something of a false start, was signalled by *Inigo Jones*'s Banqueting House of 1619–22. This may have been meant as the first part of a greater scheme along regular, Renaissance lines. Certainly gigantic plans to rebuild in this style were made in the late 1630s for Charles I, taken up at so unpropitious a moment as 1647–8, and again by Charles II after 1660. The earlier ones are by *Jones*, partly in collaboration with *John Webb*; the later ones are by *Webb*, succeeded by *Wren*. The first and larger Jones-Webb designs were influenced by the Escorial in Spain and even more by Delorme's plans for the Tuileries Palace in Paris. The area covered was meant to be everything from Charing Cross to the Palace of Westminster and from the river into St James's Park. One very distinctive feature was a large circular court towards the river end. *Wren* made new plans in 1665 – his trip to Paris in that year may have been made in connection – and in 1670, but Charles II lost interest in favour of new works at Greenwich, Windsor and Winchester. In the end *Wren* did piece in some more modest improvements for Charles, followed from 1685 by works for James II's queen: new apartments along the axis of the Privy Gallery (at right angles to the Banqueting House), a spectacularly Baroque Chapel Royal that was instantly dismantled by her Protestant successors, and the Queen's Privy Lodgings on the river side, which it fell to Queen Mary to occupy in 1691.* The last has left traces in the form of the river stair e of the Ministry of Defence (*see* p. 244). Once

26,
27

*Four statues from the chapel altar survive in Westminster Abbey Garden (*see* p. 199).

more, none of these exteriors could match the greatest new royal works, at Greenwich or Hampton Court.

The same year 1691 saw part of the palace at the s burn down, and after the much larger fire in 1698 no attempt at rebuilding was made (though *Wren* and his office produced some dramatically Baroque designs). St James's Palace became the usual residence of the monarch, supplemented by the recent accommodation at Kensington Palace and Hampton Court, until Buckingham House was bought in 1762. The Banqueting House found a use as a Chapel Royal; the King Street Gate was pulled down in 1723, the Holbein Gate in 1759. The part of the palace w of the road, already much partitioned and altered for courtiers' lodgings, was further adapted for official apartments and departments. Other sites were leased to individuals who built houses for themselves, including *Vanbrugh*'s 'Goose-Pie House' of 1700, in Scotland Yard. Dover House and Gwydyr House are the most intact survivors, and also the greater part of No. 10 Downing Street, for which Walpole secured Treasury funds. In addition to these, buildings gradually began to appear which must be called truly public buildings. The earliest were the first Horse Guards of 1663–4 (on part of the site of Henry VIII's tiltyard, just N of the tennis courts and cockpit) and the first Admiralty Office of 1693–4, N of the palace boundary. There followed the new Admiralty of 1723–6, the Paymaster General's Office of 1732–3, *William Kent*'s Treasury of 1733–7 on the cockpit site, and the new Horse Guards of 1750–9, to name the chief survivors.

50,
p.
256,
54

p.
259
48

However impressive some of these buildings were individually, those who cared for the general effect found the piecemeal approach frustrating. Defoe lamented in 1725 that the 'offices and

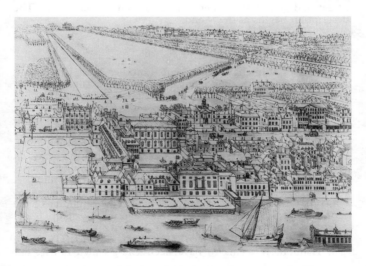

Whitehall Palace and St James's Park, view from across the Thames.
Drawing by Leonard Knyff, *c.* 1695–7

places for business are scattered about', instead of a single build-
ing 'suiting the majesty and magnificence of the British princes,
and the riches of the British nation.' *Sir John Soane* was just one of
the architects who later dreamed of drawing the whole district
together under one single plan, though his own chief contribution,
the Board of Trade and Privy Council offices (1824–7), was
dismantled within twenty years.* Major schemes and minor
proliferated to a bewildering degree in Victorian times, with
their architectural competitions and administrative comings and
goings. The sequence of major new blocks actually built from
then onwards is: Board of Trade, Home Office and Privy Council
92, (*Sir Charles Barry*, 1844–7); Foreign, Colonial, India and Home
p. Offices (*Sir G.G. Scott* and *M.D. Wyatt*, 1862–75); Admiralty
268 Extension (*Leeming & Leeming*, 1888–1905); Old War Office
(*William Young*, 1899–1906); New Government Offices (*J.M.
Brydon*, 1899–1915); Office of Woods and Forests (*J.W. Murray*,
1906–9, extended 1951–2); Board of Agriculture (*H.N. Hawkes*,
1912–14); then a gap until the Ministry of Defence (*Vincent Harris*,
1939–59). A near-complete clearance of Whitehall was anticipated
in the megalomaniac masterplan by *Leslie Martin*, adopted in
1965, but this joined Soane's plans in the dustbin of architectural
history in 1970 (for more detail on the unexecuted C20 schemes
see footnote p. 247). New work since then has been more adaptive
and incremental, with the exception of Portcullis House, parlia-
mentary offices by *Michael Hopkins & Partners*, 1998–2001. Its
p. neighbour on the Victoria Embankment side, *Norman Shaw*'s
249 New Scotland Yard (1888–1906), is also described below.

The distinct areas of the route were formerly marked by dif-
ferent street names: from N to S, Charing Cross, then Whitehall,
then The Street (between the two gates), then at the S end King
Street and (later) Parliament Street, which is still in use. The
description begins at the N end.

The North Part, by Charing Cross

The start of Whitehall is like many another West End street,
except for the preponderance of BANK BUILDINGS. For
Drummond's, W side, *see* Trafalgar Square (p. 375). On the E side
Nos. 3–5, formerly a National Bank, 1864–6 by *Nelson & Innes*,
but horribly cut up in the C20. Superimposed columns, French
pavilion roof. At Nos. 7–13 the old Canada Emigration office
by *Alfred H. Hart*, 1902, mishandled late-Shaw classical. No. 15,
of 1884, housed Messrs Cox & Co., bankers to the army, an
atypically unchurchy commission for *Ewan Christian*. Of stone,
three big gables, with much mullioning and transoming. A
smaller gable, r., marks an extension of 1900 by *J.H. Christian*.
CRAIG'S COURT opens off to the E here. This reminder of the
domestic past was laid out *c.* 1693–5 by Joseph Craig or Cragg.
Of this time or just after the front of HARRINGTON HOUSE
across the end, a little-known survival of a late Stuart mansion
in London. It seems to have been Craig's own house, but

* Hardly longer lived was his State Paper Office of 1830–4, one of the earliest build-
ings in the new Italianate manner, pulled down in 1864 for the new Foreign Office.

was renamed after the Earls of Harrington inherited in 1809. Three storeys, with a heavy modillion cornice and three-bay quoined centre. The wings are casually non-matching, with a third, narrower bay on the l. side only. And yet the frontispiece is sophisticated, with Ionic columns framing the entrance, matching pilasters framing a balcony above, and cherubs' heads in the top entablature. Who could have designed it? Overdoor carving in the style of *c.* 1770–90 (but perhaps dating from repairs of 1906). Also later the excellent front-hall staircase, with ramped balustrades in the manner of *c.* 1730–40, climbing in three flights with three dainty twisted balusters to each step. Other interiors and the back parts were destroyed in 1927–30, when *Sir R.J. Allison* incorporated the house in a unique TELEPHONE EXCHANGE. He added the big mansard, which sweeps round to join a much larger new block on the N side, l. This has a charming doll's-house front, five bays of thin russet brick with subtly linked window aprons. It looks across to the back of the recruiting depot of 1911, on the s side (*see* p. 238, below).

After that on the E side of Whitehall busier, narrower properties less worth examining (Nos. 25–35). On the W SIDE is the WHITEHALL THEATRE by *E.A. Stone & Partners*, 1929–30. Its smartness and relative smallness are typical of 1920s London theatres, and the front of plain white stone cubes proved influential elsewhere. Rather French-looking interior by *Marc-Henri & Laverdet*, with sparing geometrical and Art Deco motifs (restored 1985). Next Nos. 16–18, another former bank (Cocks & Biddulph's), 1873–4 by *Richard Coad*. Now a pub. Red Suffolk brick, red Mansfield stone, red terracotta: all classical, but gabled Northern Renaissance rather than bankers' Italian. Extended 1902 to Spring Gardens behind, minor Neo-Wren by *J. Oldrid Scott*, who had his office here. Then KIRKLAND HOUSE, Neo-Georgian of 1929–30 by *Wimperis, Simpson & Guthrie*, built as Glyn, Mills & Co.'s bank, with Government offices above. In 2000–2 converted by *HOK* as the entrance block for the remodelled Old Admiralty complex, with a new glass-walled staircase at the back (*see* below, p. 250).

Back to the E SIDE for Nos. 37–39, *Treadwell & Martin*'s Neo-Gothic OLD SHADES pub, 1898, all swooping curves and prongs. Their Nos. 41–43, 1904, is an early example of repeated uniform storeys on an office building, breaking out in little turrets and a steep wooden-lanterned roof. At Nos. 49–53 Italianate chambers of *c.* 1862, with a granite pub front of 1896 on the corner. The s flank was refaced *c.* 1908, when the old archway across Great Scotland Yard was pulled down.

GREAT SCOTLAND YARD is probably named from a property here that was owned by the Scottish royal house. A C16 tradition traces its beginning to Kenneth II's visits in the 970s. In 1519 its s part was merged with Whitehall Palace, but the rest remained a distinct, rather workmanlike entity. One major presence from the mid C16 was the Office of Works and its store-yards. The space was then much wider, and had to its s two lesser enclosures called Middle Scotland Yard and Inner Scotland Yard, subsumed by C19–C20 rebuilding into the

present Whitehall Place and the Old War Office (*see* below).
The Metropolitan Police had its first headquarters in an
adapted house on the s side (1829–90). The greater pre-C20
width appears from No. 1, the relic of a small early C19 terrace,
set back on the N side. Next to it the former Central London
Recruiting Office by the *Office of Works*, 1911 (later the
Ministry of Defence Library). Crowded grey- and red-brick
elevations in a kind of Neo-1700, around a toplit drill hall. The
lower wing to the r., dated 1910, is used for police stables.
At Nos. 13–15 a fire station of 1883 by *Alfred Mott* (since 1953
the CIVIL SERVICE CLUB), betrayed by its slim lookout
tower. Quite festive, with red Mansfield stone pilasters.

After Great Scotland Yard the departments of state take over.
Those on the E side stretch back towards the river, those on
the w have St James's Park as their hinterland. The sides are
best explored separately, and from here on the description is
therefore split between the two. Monuments in the roadway
are grouped with the E side.

East Side, from Great Scotland Yard south to Richmond Terrace

DEPARTMENT FOR THE ENVIRONMENT, FOOD AND RURAL
AFFAIRS. Set end-on, facing the Admiralty Screen. It occupies
three interlinked blocks. That on Whitehall was built as the
Office of Woods and Forests by *J. W. Murray*, 1906–9, five bays
wide and five deep. It continues the becolumned style of the
Old War Office next door, with which its cornice aligns, though
with a square-headed top storey to balance the Banqueting
House beyond (both *see* below). *C. H. Mabey* did the carving.
A larger attachment at the back was made by the *Ministry
of Works* (architect *C. E. Mee*) in 1951–2, when the Ministry
of Agriculture took over. This is in a well-handled classical
style, though in the half-concealed pilasters on the mezzanine
falling for a Lutyens mannerism (alterations in progress 2003).
Above the entrance, s, a large coat of arms, and to its l. and r.
two large allegories and several keystones all carved by *James
Woodford*. A bridge across Scotland Place joins the former
BOARD OF AGRICULTURE BUILDING, built in 1912–14;
designed by *H. N. Hawkes* (†1911), executed by *H. A. Collins*.
Uneasily tall by comparison with Murray's palazzo, with
columns set high up at each end. Much plainer side and back.
The frame is concrete (*Hennebique* system), as the Office of
Works had by then come to prefer.

OLD WAR OFFICE (Ministry of Defence). It stands immediately
to the s. Designed in 1898 by *William Young* of Glasgow
(†1900), begun 1899, and completed in 1906 by his son *Clyde
Young*. Young's is certainly a forceful design, even if it nowhere
transcends the Baroque transformations of the Grand Manner
of the day. It has the two lowest storeys plain with banded
rustication, but Gibbs surrounds above and in the centre ten
recessed giant Ionic columns. The four angles are marked by
circular turrets with attached columns and stone domes, a
reminiscence of Wren's designs for Whitehall Palace of 1698.
Much SCULPTURE by *Alfred Drury* high up. On Whitehall

the figures represent Peace, N (Sorrow of Peace, Winged Messenger of Peace), and War, S (Horrors of War, Dignity of War). To Whitehall Place, N, Truth and Justice; to Horse Guards Avenue, S, Victory and Fame. Versions of the same behind. Architectural carving by *C.H. Mabey*. Restored from 1987 by *Cecil Denny Highton*; further restoration is proposed (2003).

Within are two courts, a large rectangle to the W, treated quite elaborately, and a triangular well to the E. The main entrance from Whitehall is given four pairs of alternately blocked columns. (It leads into a relatively low entrance hall, with a marble column-screen opening on to a staircase of the grandest club type, starting in one arm, and continuing in two at an angle of 90 degrees and back by another 90 degrees. Gallery around all four sides, glazed dome on top. *Farmer & Brindley* did the marble linings. Inside are thirteen C18 marble chimneypieces acquired in 1904. They came from houses in Pall Mall formerly occupied by the War Office: seven from *Matthew Brettingham Sen.*'s Cumberland House (1761–3), five from *Soane*'s Buckingham House (1792–5), one from Schomberg House. That in Room 203, by *John Bacon Jun.*, may have originated from Wimpole Hall, Cambridgeshire.)

The MONUMENTS of Whitehall proper begin around the Old War Office. In the roadway in front, an equestrian STATUE of the 2nd Duke of Cambridge by *Adrian Jones*, 1906–7. The younger *John Belcher* designed the plinth. Further S, at the head of Horse Guards Avenue, the 8th Duke of Devonshire, bronze statue by *Herbert Hampton*, 1909–11, plinth by *Howard Ince*. Further down the avenue a statue of a Gurkha was set up in 1997, a copy of *Richard Goulden*'s figure at Kunraghat, India, 1924. Down Whitehall Place, to the N of the Old War Office, the ROYAL TANK REGIMENT MEMORIAL, by *Vivien Mallock* after a design by *G.H. Paulin*, 2000. Five bronze figures on a plinth, as if alert to what might trundle round the corner. In style close to post-war Socialist Realism.

BANQUETING HOUSE. By *Inigo Jones*, 1619–22, his first great work in London proper, begun three years after the Queen's House at Greenwich. It is organized definitively by the use of the orders, so that no measurement could be altered without disruption. To appreciate fully how new such an approach to design then was, one should remember that the fantastic and overcrowded four-storey frontispiece of old Northumberland House, not far to the E, had been built only about ten years before (*see* p. 356). The sobriety, the gravity, the learning of Inigo Jones must have been overwhelming by comparison.

Jones's design is the outcome of close study of Palladio's work at Vicenza. It is by no means a copy, but elements from such palazzi as the Porto-Barbaran are evident. The building is seven bays wide and two main storeys high. But the windows are generously spaced, the floor heights are considerable, and the whole is raised up on a tall square-windowed basement. The orders are superimposed against smooth, even rustication, Ionic below Composite – the latter a personal variant with one tier of acanthus foliage instead of the usual two. The three

middle bays project slightly and have attached columns, the
outer two bays on both sides have pilasters instead, which are
coupled on the angles for emphasis. The first-floor window
pediments are alternatingly triangular and segmental, and
the capitals of the upper order are linked by garlands (here
suspended in pairs from carved masks): devices both with a
good Palladian pedigree. By way of contrast, the first-floor
window surrounds have outer side strips that come down
below the sills, which seem to derive from Michelangelo's
courtyard façade of the Palazzo Farnese in Rome. The finish
is a balustrade, rather than the central pediment shown on a
drawing by Jones, which would have stressed the centre more.
The rear façade, which overlooked the Privy Garden of the
palace, is the same. Originally there was a polychromatic
mixture of stone facings: Oxfordshire below, Northampton-
shire above, and dressings of Portland stone, a pioneering mate-
rial for London (chief mason *Nicholas Stone*). Later renewals
left it all Portland, starting with *Sir William Chambers* in 1774
and ending with *Soane* in 1829–33 (mason *Thomas Grundy*).
Sash windows were installed by 1713, replacing Jones's arrange-
ment of mullioned-and-transomed ones (with some of the
lower tier treated as 'bastard' or blocked windows).

How did this dazzling building function as part of the
palace? The first house or room for banquets on the site was
Queen Elizabeth's timber-framed structure of 1581, meant to
be temporary. Its ceiling was painted to look like holly and ivy
and hung with feigned grapes, 'cowcumbers', pomegranates,
and so on. It was replaced *c*. 1606–9 by a brick and stone struc-
ture, probably by *Robert Stickells*, of similar size and arrange-
ment to Jones's. Building accounts show that its elevations
were two-storeyed and classical, also like Jones's, but with flat
projecting bays, four in front and three behind. It had three-
sided internal galleries and aisles, and until it burnt down in
1619 the masques, banquets and other ceremonies of the court
were held there.* Jones's commission therefore fulfilled estab-
lished needs, for 'festive occasions, for formal spectacles, and
for the ceremonials of the British Court' (as a contemporary
inscription put it), and he worked closely with a commission
of courtiers to these ends. The N and S ends reflect arrange-
ments already in force in 1619: the S end could be reached
from the Privy Gallery, for access by the Court, and the N end
provided a public entry, at first by a crude timber-framed
staircase enclosure. This unsatisfactory set-up also suggests
that Jones hoped to carry the rebuilding further. Certainly his
successors *John Webb* and *Wren* made designs in which the
Banqueting House fitted into larger classical compositions.
But nothing came of these, and instead the Banqueting House
became a Chapel Royal in 1698. *James Wyatt* added the present
N staircase bay in 1808–9, set back and rendered and with
details matching Jones's. Over its door is a C19 BUST of Charles
I, installed after 1950: a twin to that on St Margaret (q.v.). The
distinctive RAILINGS seem to be *Soane's* work.

p.
235

* Foundations of these predecessors were exposed within the basement in 1963–4.

INTERIOR. Wyatt's staircase is self-consciously Jonesian, with the closed string and waisted balusters he might have used. It leads up in a dog-leg, past the entrance of the undercroft, to the magnificent SALOON with its *Rubens* ceiling. The room is an exact double cube, 55 by 55 by 110 ft (16.8 by 16.8 by 33.6 metres) – a homage to Vitruvius's proportions for an ideal basilica – but with a gallery cantilevered round three sides, a feature without precedent in Continental Renaissance architecture. It has stone balusters, the upper halves of which are the mirror image of the lower, and its half-height position makes it a logical internal expression of the exterior. The walls are likewise divided into bays by orders, Ionic demi-columns below, Corinthian pilasters above. Between their capitals is a painted frieze of garlands, also echoing the outside. The N end has three doors on to the landing.* The four detached columns in the centre were introduced to support an organ when *Sir Robert Smirke* renewed the gallery in 1835–8. The throne wall opposite was restored to the C17 appearance by removing the gallery in 1972–3. At first Jones provided a huge niche here, as if in a Roman basilica, but in 1625–6 this was filled in and the lower entablature carried across.

Jones's CEILING was as innovative as his façades. Its wide flat span was made possible by a roof type new to England, hipped at the ends, with kingpost trusses each with a secondary post on each side (replaced in 1830). The ceiling has no more than nine large panels, kept separate by a grid of timber carved with guilloche, instead of the usual interlocked Jacobean patterns of squares, lozenges and stars. Four panels remain rectangular; in the other five, arranged as a quincunx, ovals are inscribed.

What however bursts this rational classicism are the PAINTINGS by *Rubens*, with their Baroque exuberance and rich flow of composition and technique. The convention of canvases organized within enriched ceiling compartments, though new for England, can be traced back to C16 Venice. Rubens was already busy with one such scheme, at the Jesuit church in Antwerp, when first approached for the Whitehall job in 1621. Documentary references show that much of the programme dates from around that time, but Rubens was not successfully 'booked' until his diplomatic mission to London in 1629–30. The canvases, painted at his Antwerp studio in 1630–4, were in position in 1635 (after which masques, which required smoky torchlights, could no longer be held here). Rubens received £3,000 for them, with various other presents from Charles I (who in 1649 was to step from the Banqueting House to his execution). The style is Rubens's softer, more free late manner, the subjects the glorification of the happier reign of Charles's father James I, shown in a central apotheosis with Justice, Zeal, Religion, Honour and Victory. Long narrow border canvases show triumphs of putti. In the large s picture the King points to Peace and Plenty embracing under his rule. In the oval to the E Reason holds a bridle above Discord, in

* Over the middle one a BUST of James I by *H. Le Sueur*, 1639.

that to the w Abundance triumphs over Avarice. The N picture alludes to the Union of the English and Scottish crowns, with Minerva holding two crowns over a symbolic infant under James's gaze. In the E oval Minerva is driving Rebellion to Hell, in the w oval Hercules beats down Envy. Restorations are recorded in 1686, 1732 (by *William Kent*), 1776–7 (by *G.B. Cipriani*), 1830–1, 1906–7 and 1947–50. The present arrangement, of 1972–3, is based on Rubens's original sketch, with a dual focus on the throne end and the public entrance. During the ceremonies, when tapestries were hung below the balconies, the effect must have been breathtaking.

The groin-vaulted UNDERCROFT was originally used for drinking parties, and was equipped with a grotto and fountain. It now appears entirely C20 (restorations 1964, 1992).

Attached to the s end of the Banqueting House is a quiet stone-faced three-bay building of 1893–5, by *Aston Webb & Ingress Bell*. Built for the ROYAL UNITED SERVICES INSTITUTE, which took over the Banqueting House as its museum after use as a chapel ceased in 1890. At the s end an asymmetrically placed polygonal turret. Figured cornice richly carved by *W.S. Frith*. Low-key interiors: oblong staircase with Tuscan colonnette balustrade; lecture theatre within a projecting semicircle behind, overlooked by a neat little balcony above the entrance; pilastered first-floor saloon.

GWYDYR HOUSE (WALES OFFICE). It joins directly on to the above. Built *c.* 1772 probably by *John Marquand*, for Peter Burrell, whose son was 1st Lord Gwydyr. Burrell was Surveyor General of Crown Lands and stored official records here, but his was not a true official residence, and it became Government offices only in 1842. It is handsome but in no way specially remarkable. Five broad bays of brick, three original storeys. Tripartite doorway with applied columns with foliage necking and a Venetian window above, preceded by a fine lampholder with extinguishers. Cornice rebuilt larger and attic storey added 1884–5, by *John Taylor* for the Charity Commissioners. Rear elevation of 1938, an echo of the front, after C19 additions were taken down. Front hall with triglyph cornice, the customary later C18 treatment. The rather Soanean doorcases must be C19, perhaps of more than one period. Behind, an open-well cantilevered staircase of stone, the lower part still with the C18 wrought-iron balustrade of entwined lyre pattern. The curved corners of the flights are an unusual, rather French device. (First-floor rooms with pilastered doorcases and C18 plasterwork.)

In front, another equestrian STATUE: 1st Earl Haig, by *Alfred Hardiman*, erected 1937 after models of 1929 and later were rejected. Stylized horse and naturalistic rider were much criticized in combination. Base designed by *S. Rowland Pierce*.

MINISTRY OF DEFENCE. By *Vincent Harris* with the *Ministry of Works* architects, built in phases 1939–59 for the Board of Trade and Air Ministry. This giant runs for 550 ft (168 metres) behind the Banqueting House and its satellites, with entrances on Horse Guards Avenue, N, and Richmond Terrace, s, and a frontage towards the Thames behind. The present, unified ministry has been the sole occupant since foundation in 1964.

The plan is a great quadrilateral wedge, narrowing from N to S and with four gently curved and copper-roofed cross wings. These have higher angle-blocks with pedimented ends, and (at the N and S) giant untapered Tuscan columns embracing the top two floors, similar to those on Harris's Manchester Central Library of 1930–4. These colonnades and the plain utilitarian windows on the seven lower storeys were carried over from his competition-winning designs of 1913–15, which signalled the eclipse of Whitehall Baroque by something more reticent and rigid, and also more suitable to the hundred-foot elevations then newly allowed. This first plan was for a smaller site, earmarked for the Board of Trade. Harris's enlarged design with its taller cross wings dates from 1934–6, but had not yet risen above ground when war stopped work in 1941. Further revisions made in 1945–6 eliminated columns proposed for the short ends of the cross wings, but this was hardly enough to prevent the complex seeming out of its time on completion (Pevsner called it 'a monument of tiredness'). Today its power as a composition can be better appreciated, at least in long oblique views, as can its appropriateness for one of the more traditional ministries. But the effect closer to is chilling, barely tempered by the traditional motif of alternating Gibbs surrounds below (nodding approval to the Edwardian across the road). Main entrances with huge aluminium doors flanked by pylons, those on the N finished with massive sculptures by *Sir Charles Wheeler* representing Earth and Water. Each was carved in 1949–52 from 40 tons of Portland stone. Figures of Fire and Air intended for the S side were vetoed by the Treasury. Remodelling by *HOK*, begun in 2001, will make open-plan offices and create the inevitable glazed-over interior courtyards.

(INTERIORS. Harris's building has as its spine a long ground-floor concourse, with a central double-height Pillared Hall. The real interest, however, is the sequence of RETAINED INTERIORS from older buildings on the site. The earliest is a considerable fragment of the WINE CELLAR of Whitehall Palace, in 1949 lowered by prodigious engineering skill to a position in the NW basement. It dates from 1514–16, i.e. the first phase of Cardinal Wolsey's work, and is very like the one Henry VIII later added to Wolsey's Hampton Court Palace (*see London 3: North West*). Five bays, with four octagonal central piers with simple moulded capitals. The vaults, all of brick, are cross-ribbed with ridge ribs in a very elongated single-chamfer section. Platforms for barrels restored. The E wall, which was also the W wall of the palace cloister, is C15 and must belong to Archbishop Neville's work, i.e. of 1465–76. In the N wall a four-centred-arched doorway with Wolsey's (defaced) arms. A recess in the W wall at the S underlay the bay window of Wolsey's Great Chamber directly above, just SW of the C15 Great Hall, which stood on the site of Horse Guards Avenue. Exterior of stone-dressed brick, remodelled after the cellar was incorporated in a new house for the 1st Viscount Torrington, c. 1722. It has low, broad segment-headed windows. The other five rooms, reassembled from parts stored in 1936, are within

the courtyard spaces on the third and fourth floors. Four are
from PEMBROKE HOUSE, one of the first Palladian villas, built
in 1724 by *Henry Herbert*, later *9th Earl of Pembroke*, with *Colen
Campbell*. Its story is complicated by later work: enlargements
by *Pembroke* and *Roger Morris*, *c.* 1730 and *c.* 1744, and recon-
struction for the 10th Earl by the builder *Charles Evans* in
1756–8 and by *Sir William Chambers* from 1760.* ROOM 27 was
the gallery, a long room with a square recess facing a canted
bay. It mixes 1720s and 1750s work, with a fine *Chambers*
ceiling (plasterer *William Perritt*), and a pedimented doorcase
on Corinthian columns, of uncertain date, relocated to one
end. ROOM 25, which originally opened out of the gallery,
has another *Chambers* ceiling made by *Perritt*, with a mixture
of flat and overlapping motifs, figures, tripods and trophies.
ROOM 24, one of two bedrooms saved from the former N
wing, is probably by *Roger Morris*, i.e. *c.* 1730 or 1744. It has
a deep alcove flanked by attached columns, and a plaster
ceiling of entwined arbour pattern, another essay by *Chambers*
and *Perritt*. ROOM 13 directly below has a similar alcove, but
the ceiling is simpler, probably of 1744 or 1756–8, and more
Rococo. ROOM 79 is of *c.* 1722 and from Torrington House,
or more exactly from the part renamed Cromwell House after
the house was subdivided *c.* 1770. Panelled, with a pilastered
arcade along one wall.)

QUEEN MARY'S STEPS. NE of the Ministry of Defence, just
off Horse Guards Avenue in the gardens by Victoria
Embankment. Here in 1938–9 a corner of the base wall of
Henry VIII's Whitehall Palace was found and rebuilt, and in
front of it, also largely reconstructed, the NE corner of a RIVER
TERRACE built out in 1691–3, complete with steps curving
down to the water. This was designed in *Wren*'s office, and
drawn out by *Hawksmoor*. The whole terrace was 280 ft (85
metres) long. Fragmentary column-bases at the top of the
steps, from a watergate which *Sir W. Chambers* made in 1773–4
to serve Pembroke House (*see* above).

p.
235

The STATUES in front of the Ministry of Defence building,
s of Gwydyr House, are all Field Marshals and Viscounts of
the Second World War: from l. to r., Slim, in bush hat, by *Ivor
Roberts-Jones*, 1990; Alanbrooke, 1991–3, also *Roberts-Jones*,
and Montgomery by *Oscar Nemon*, 1980, roughly finished,
hands characteristically behind his back. Setting of stone kerbs
made 1992–3.**

*East Side, from Richmond Terrace south to Bridge Street and
Victoria Embankment*

The rest of the E side of Whitehall was proposed for complete
replacement in the late 1960s, beginning with designs for a new

*For a full account *see* Steven Brindle in *Georgian Group Journal* 8, 1998. The
balustrade was salvaged for the Queen's House, Greenwich (*see London 2: South*).
** *W. McMillan*'s little statue of Sir Walter Raleigh, 1959, was removed to
Greenwich in 2001. A monument to Women of the Second World War was pro-
posed for the roadway in 2002.

riverside Home Office at the s end. Conservationist opposition combined with official parsimony soon brought a gentler, more incremental approach, and in the end only the SE sector was cleared for a wholly new building (Portcullis House), built as late as 1998–2001. The other buildings form three main groups, reconditioned to varying degrees for ministries or parliamentary offices: Richmond House and its satellites in Whitehall, Nos. 34–47 Parliament Street to their s, and the former New Scotland Yard on Victoria Embankment.

RICHMOND HOUSE (DEPARTMENT OF HEALTH and DEPARTMENT FOR WORK AND PENSIONS). A composite of old and new. Running back from Whitehall is RICHMOND TERRACE, a long terrace of 1822–5 (or, rather, its retained façades). Designed by *Henry Harrison*, built as a speculation by his brother, *George*. It is the chief survivor of early C19 improvements on the Crown lands E of Whitehall.* Grecian Ionic, with pedimented six-column centre, and four-column angle pavilions. It is less fanciful and eventful than the kind of thing Nash did at the same time in Regent's Park, but solidly designed and solidly built in amber brick and Bath stone. Harshly restored in 1983–6 by *BDP*, reversing C19 alterations, as an adjunct to *Whitfield Partners'* RICHMOND HOUSE, completed in 1987. This appears as a recessed entrance range where the mews once stood, facing Whitehall. A building of some pomp, in a kind of Neo-Tudor immediately evoking the Palace of Westminster and Henry VII's Chapel. Stone-faced oriels, two-storeyed and of profuse sizes and rhythms, come forward between tall fluted uprights. The upper parts of these change from all stone to broad irregular stripes of stock brick, a reference to Shaw's New Scotland Yard behind (*see* pp. 248–50, below); some have slots for ventilation. Between them the floors die back to finish in leaded hoods. The front is asymmetrical, coming back to the street on the r. Behind, the new part steps down irregularly and changes from red brick to stone, with canted leaded sills and angled window hoods (best seen from Derby Gate, s, past refurbished older properties also linked with Richmond House: *see* below). ENTRANCE HALL with close, rather Mackintosh woodwork, used in disorientating combination with large mirrors in the 1980s fashion. An imperial staircase climbs to the r. (Several later C19 interiors are reassembled in Richmond Terrace, first floor.)

CENOTAPH, in the roadway in front of Richmond House. The chief national war memorial, by *Lutyens*, 1919–20. A tall oblong pier, finishing with a stylized stone coffin ('cenotaph' means empty tomb). It is an original conception, subtly proportioned, with neither effigy nor religious reference. First created in timber in a great rush in 1919, for a visit by the French and American commanders, when its reticence was

*Two predecessors called Richmond House stood here, or near here: one of *c.* 1660, dem. *c.* 1740; the other, built to its N *c.* 1711 for the 1st Duke of Richmond, several times altered, and burnt 1791. To the N on part of the MoD site was Montagu House (dem. *c.* 1950), an urban chateau of 1859–62 for the 5th Duke of Buccleuch by *William Burn*.

widely acclaimed; so it was perpetuated in Portland stone. At least fifty-five versions or derivations have been identified elsewhere in Britain. Not all share its special finesses, which were clearly inspired by those of the Parthenon. For the Cenotaph has no vertical or horizontal lines. The apparent horizontals are convex to a common centre *c.* 900 ft (274 metres) below ground, the verticals converge towards a point *c.* 1,000 ft (305 metres) in the air. The flags, replaced annually, are integral to the conception, though Lutyens at first wanted them and the carved wreaths to be of coloured stone. In 1938 he designed demountable RAILINGS, set up every November.

PARLIAMENT STREET runs S from the entry to Richmond House. It was enacted in 1738 and made in 1741–50 in connection with Westminster Bridge (q.v.), replacing smaller streets and courts that had colonized the Bowling Green of old Whitehall Palace. The first house, altered mid–late C18, properly marks the end of Whitehall (No. 85 there). Next to it No. 54, formerly Grindlay's Bank, 1898–9 by *Alfred Williams*. Red brick with two deliberately unequal stone-faced angle motifs, a gable of New Scotland Yard type and a turret. Much use of Gibbs surrounds in the centre. Banking hall panelled and pilastered. No. 53 is of a familiar West End type, red brick and brown terracotta with Loire-style motifs and an Arts-and-Crafts frieze: 1893–5 by *H. Huntly Gordon*. After that every C19 front is of Portland stone. Nos. 49–50, bitty eclectic-Italianate by *E.T. Hall* and *H.A. Hunt*, 1877–9, was offices for the printers Messrs Waterlow, whose boss Sir Sidney Waterlow started the Improved Industrial Dwellings Co. No. 48, the RED LION pub, free Flemish of 1898–9 by *Gardiner & Theobald*, has a granite ground floor; interior quite well preserved.

Then DERBY GATE, which leads into the back of New Scotland Yard (*see* pp. 248–50, below). The following block was amalgamated and restored for parliamentary offices by the *Casson Conder Partnership* and *Ramsay Tugwell Associates* in 1985–91, after long neglect while more drastic plans came and went (*see* footnote, below). They rebuilt behind some fronts, with new stone-striped brick elevations to Cannon Row behind and an underground link to the Palace of Westminster. First No. 47, the old WHITEHALL CLUB, of 1864–6 by *C.O. Parnell* (now the House of Commons Library). A palazzo in what at the time was described as 'Florid Italian'. Big cornice, coupled columns in two storeys, and Venetian and other tripartite windows to the flank. A fine abundance of foliage carving above the entrance here, and in other places as well; the doorcase with its putti was executed by *James Tolmie*. Nos. 45 and 46, of stone, are exceptionally chaste for their date: 1870–1. Nos. 44 and 43 were built after 1753 for the speculator James Mallors, probably to designs by *Sir Robert Taylor*. They incorporated older, smaller houses of *c.* 1710 as back premises, facing Cannon Row. No. 44, with a refined stucco coat of the 1830s, has a fluent Rococo ceiling inside. No. 43 is a perfect exemplar of a mid-C18 London house front. Three storeys, with band courses and bracket-cornice of stone; Doric doorcase of wood, with open pediment. (Small D-shaped staircase with a Chinese-

Chippendale fretwork balustrade). At Nos. 38–42 two more late Italianate office chambers, *c.* 1871–2. No. 37 was Lucas's Restaurant, 1874 by *Henry Cotton*. Tall and narrow, in style like early Waterhouse, with a new round-arched entrance to the offices. On the corner with Bridge Street is a big block busy with oriels, of 1888, designed by the *London & North Western Railway Estate Office* as the railway's own London office. A domed corner turret removed in 1938 was restored in replica, and the ground-floor arcade put in. Round the corner in BRIDGE STREET the former St Stephen's Tavern, 1875, slim French Renaissance.

PORTCULLIS HOUSE, the first free-standing new building in the Whitehall precinct for half a century, fills the rest of Bridge Street with its indestructible stone and bronze mass. By *Michael Hopkins & Partners*, design published 1993, built with revisions 1998–2001; engineers *Ove Arup & Partners*. It houses offices and facilities for 210 MPs, connected umbilically by subway to the Mother of Parliaments across the way.* The project required something bold enough to stand up to Parliament, but also needed to acknowledge Shaw's New Scotland Yard on the other side. So Shaw's great sloping roof and stacks give the cue for the top hamper, while the vertical rhythms of Barry's palace are echoed by the insistent Derbyshire gritstone piers of the five storeys below (nineteen bays, with thirteen towards the river). The piers are structural, and diminish as they rise – a device used earlier in Hopkins's Inland Revenue complex at Nottingham. But things go visually awry where the massive bronze-faced roof storeys begin above. Here the piers look too slender for what they must support, finishing weakly below the broad flat vent-shafts which spread like embedded crane-grabs across the roof slope. These shafts meet up below fourteen fat stubby flues also of bronze, giving a skyline reminiscent at once of factory and Tudor palace. The core is an oblong courtyard or atrium, entered on the river side. It is roofed fairly low down, with an arched diagonal grid made rather unexpectedly of laminated oak, braced with the thinnest steel lattice. This settles on six segmental concrete arches, which open on to an inner circulation passage.

Much ingenuity went into the SERVICES, which aim to operate at 25 per cent of the normal cost. Within the roof space

*The post-war history here makes the Victorian haverings in Whitehall look positively tedious. Redevelopment of a much larger site was decreed in 1959, but an outline scheme commissioned in 1962 from *Sir William Holford* was overtaken by *Sir Leslie Martin*'s utopian masterplan for Whitehall of 1964–5 (*see* Introduction, p. 236). A consortium of designers called the *Whitehall Development Group* drew up a scheme for Government offices along these lines, presented in 1969, but this was killed off by public enquiry in 1970. Richmond Terrace and the N block of New Scotland Yard (*see* below) were then reprieved, and a competition for new parliamentary offices held, won in 1973 by *Robin Spence & Robin Webster*. This was dropped in 1975 to save money. A less destructive and more tactfully picturesque successor by *Casson Conder*, 1978, foundered for the same reason a year later. A plan formulated in 1982 led instead to the restoration of all the buildings w of Cannon Row (*see* above), and – eventually – to the present new block. The chief casualty of its construction was *John Whichcord Jun.*'s ST STEPHEN'S CLUB, a François I pile at the angle with Bridge Street, of 1873–5 (dem. 1994).

is machinery allowing waste heat to warm incoming air in winter. In summer the air is cooled by water drawn from aquifers, which then flushes the lavatories. Other ruses include little window hoods on the bronze panelling between the piers, which bounce natural light into the rooms. These have cast waveform roofs, creating service voids.

Hopkins's most exciting interior sits beneath: the new WEST-MINSTER UNDERGROUND STATION, opened 1999, one of the great and varied sequence along the Jubilee Line extension (begun 1992, commissioning architect *Roland Paoletti*). What might have been just another burrowing exercise was raised to sublimity through the new construction technique by which a huge open concrete box is sunk down to platform level. Its raw grey-brown walls, braced by titanic horizontal cylinders spanning between the foundation piers, form the sombre cage through which angled escalators and landings lead down to the underworld. Anyone who has ever pored over Piranesi's prison engravings will shiver with recognition in this vast space, which reads as a kind of dark unconscious to the tightly controlled architecture above. The combination of superhuman machinery, exhilarating internal vistas and bafflement as to the shape and sense of the whole is just the same.

Excavations here in 1992–7 found Neolithic and early Bronze Age remains comprising a ditch, postholes and flint scatters. The site was subsequently flooded by rising river levels, and in *c.* 1180 a dock was built within the royal palace along the S edge of the station site, with the majority lying under the present Bridge Street. By the mid C15 most of the site had been reclaimed and the area was used for houses for the canons of St Stephen's Chapel.

NEW SCOTLAND YARD stands on Victoria Embankment next to Portcullis House, into which it is plugged by a lightweight covered bridge. It comprises two similar buildings, *Norman Shaw*'s only major public commission, for the Metropolitan Police headquarters; in 1973–9 converted for parliamentary offices (now called Norman Shaw Building, North and South).

The NORTH BUILDING, an epoch-making design erected in 1888–90, shows *Shaw* in transition from his domestic style to the grand manner of such country houses as Bryanston, Chesters, and – in our area – of the Piccadilly Hotel (*see* p. 560). A powerful free-standing composition of four storeys. Convict-quarried grey Dartmoor granite below, orange-red brick with thin Portland bands above. Cylindrical angle tourelles. Behind these at either end of the side façades, and especially characteristic of the later Shaw, two lively stone and brick gables with aedicules, each ending in a broken pediment from which rises an obelisk. Imitations of these, the tourelles and the banded stone may be seen all over England. Between the gables a great grey sloping roof with two rows of tiny dormers and two great oblong stacks. Strongly modelled entrances, especially that towards the S. Its doorcase shows the influence of Belcher's Baroque novelties, but the whole is unclassifiable stylistically (Shaw wrote in 1890 that he had aimed less for 'style' than for 'character'). Under an upper balcony a MEMORIAL to Shaw,

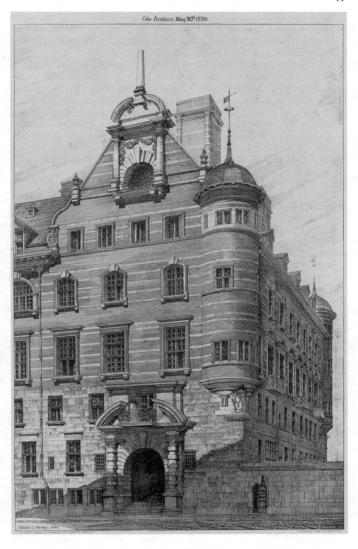

The Architect. May 30ᵗʰ 1890.

North Building, New Scotland Yard, Victoria Embankment
(Whitehall). Drawing by Gerald Horsley
(*The Building News* 58, 1890)

1914 by *W.R. Lethaby*, with a portrait relief by *Sir Hamo Thornycroft*. The plan – a rectangle with central courtyard – is Shaw's modification of preliminary designs of 1886 by the Police Surveyor *John Butler Sen.**
A wide gateway and yard separate this block from the SOUTH ANNEXE, designed from 1896 and built in 1902–6, with assistance from *J. Dixon Butler*. This is smaller, with a gable instead of a tourelle at the S end, and it destroys Shaw's intended effect of a single citadel. The iron GATES are *Reginald Blomfield*'s, a design of 1896 that had caught Shaw's eye (maker *Thomas Elsley*), but the piers and lead urns are *Shaw*'s own. A smaller gate at the back (Derby Gate) is reached under a bridge between the blocks. A separate section here houses the former Cannon Row Police Station (1900–2).
From the S side another bridge spans to a larger POLICE STATION, smooth stone-faced stripped classical, by *W. Curtis Green*. Built 1937–40 as the first part of an intended larger block, which would have extended across the site of Richmond Terrace, behind. The fragment lacks the character of Green's 1920s work, or of the Ministry of Defence to the N. Before 1890 the police headquarters was in Great Scotland Yard (*see* p. 237, above); in 1967 it moved to Victoria Street (*see* p. 722).

West Side, from the Admiralty south to Downing Street

From here onward the buildings fall into two classes. The first are of consistent design all round: chiefly the Horse Guards, Foreign Office and New Government Offices. The others are of several phases, often very different in scale and style, and need to be looked at from the park side for a fuller understanding. Now that Downing Street has been closed there are just two cross-routes by which to do this: through the centre of Horse Guards, or along King Charles Street further S, i.e. between the Foreign Office and New Government Offices.

The ADMIRALTY was initially the houses and office of the Lords of the Admiralty. It was separate from the Navy Office, which was sited near the Tower of London from the C17 until 1788, when it moved to Somerset House (*see* pp. 318–25). *HOK*'s office conversion of 2000–2 allotted the oldest, E part to the Cabinet Office, with Kirkland House on Whitehall, N (*see* above). The big rear extension is used chiefly by the Foreign and Commonwealth Office.
The Admiralty complex presents an entirely C18 face to Whitehall. The main block sits back behind *Robert Adam*'s ADMIRALTY SCREEN, made in 1760–1 in connection with street widening. His first London work, it has a gravity and simplicity which he was to lose later. Ten Tuscan columns against a blank wall, end pavilions with blank niches. A colonnaded screen set directly on the ground was a new motif for public architecture in London. Restored in 1923, infilling side

* Some foundations were reused from *F.H. Fowler*'s unfinished Grand National Opera House, begun in 1875 in imitation of the Paris Opéra.

openings made in 1827–8. Straight top, with two sea horses rising above. These are by *M.H. Spang*, as are the ships' prows in the end pediments (modern l., ancient r.). Adapted in 2002 by *HOK*, with wheelchair ramps to the doorways in the back wall, and steel and glass shelters behind.

Visible behind is the OLD ADMIRALTY (now RIPLEY BUILD-ING), of 1723–6 by *Thomas Ripley*, the undistinguished successor to Vanbrugh as Comptroller to the Office of Works. This oldest of all the Government offices is three-storeyed, of brick with a deep forecourt – the wings project nine bays – and a rather tight portico of four giant Ionic columns with a pediment. The wings are plainer, with quoin pilasters dividing each into three. All told it is a dull design, with little of the new Palladian rigour and nothing of Baroque licence. The U-plan and central pediment, but not the portico, were repeated from the previous Admiralty of 1693–4 (by *John Evans*, carpenter). Ripley's building was planned mostly as separate apartments for the Lords of the Admiralty, with a shared Board Room, but was converted to offices in 1868 when the Navy Board moved here. An extra apartment, invisible externally and now truncated, was added N of the N wing by *Edward Holl*, 1810.

p. 235

ADMIRALTY HOUSE, immediately adjoining on the S side, was built as an enlarged residence for the First Lord in 1786–8. By *S.P. Cockerell*, an early work. He took over the job – and perhaps some features of the design – from *Sir Robert Taylor*, who certainly provided the incumbent, the 1st Earl Howe, with a town house in Grafton Street (*see* p. 526). Admiralty House has no main entrance of its own, being attached to the S wing of Ripley's Admiralty. Its Whitehall front is two and a half storeys high, of yellow brick with three widely spaced bays, with a recessed centre in which the principal motif is a first-floor Venetian window under a relieving arch. To the S an extra, very narrow bay. It stands back behind a plain wall which hides a low kitchen block. The rear has five plain utilitarian brick bays, rebuilt 1954. It looks on to Horse Guards Parade, which is gained through the centre of the Horse Guards (*see* below).

INTERIORS. The ENTRANCE HALL behind the portico of *Ripley's* 1720s block has plain coupled Doric pilasters. Little swags over them, and an enriched cornice: probably of 1786–8. Ahead, a niche with the near-life-sized model for the statue on top of Nelson's Column, 1844 by *E.H. Baily*. To the l. a plain fireplace with a war-memorial overmantel designed by *F.G. West*, 1921. Behind this hall a barrel-vaulted CORRIDOR (repeated on the first floor) runs N–S. It has simple, rather bleak plaster panels more in the Vanbrugh than the William Kent style, and simple groin-vaulted rooms off it. Open-well STAIRCASE at its N end with slanted wrought-iron balusters up to the first floor, made in part by the noted smith *John Montigny*, but no great showpiece. The upper, steeper flights are later. The corresponding S STAIRCASE has a plainer balustrade, but was otherwise enriched in 1786–8 by *S.P. Cockerell*. He designed the glazed oval dome (*see* also Admiralty House, below) and plasterwork (executed by *John Papworth*) with nautical motifs. The little tritons supporting a second-floor

gallery on the w side are by *James Hoskins*. A first-floor landing
running E, inserted 2002 by *HOK*, carries on the C18 balus-
trade design. S doorway inserted *c.* 1957, with a bust of Nelson
above.

Off on the w side the BOARD ROOM, abutting the Admi-
ralty Extension, for which the SW corner of Ripley's block was
sacrificed. Oak panelling with high Corinthian pilasters, prob-
ably taken over from the building of 1693–4. Also reset are the
fabulous garlands and trophies hanging down above the fire-
place, attributed to *Grinling Gibbons* and dated 1695. The pear-
wood carvings show a good knowledge of nautical instruments,
amongst which scholars have recognized Oughtred's Ring Dial
and Gunther's Quadrant. They now frame a wind compass of
c. 1710 (probably by *Robert Norden*). Ceiling of 1786–8 by *S.P.
Cockerell* (renewed 1947 and later), with slanting octagonal-
coffered coving and a centre with overlapping circles, a motif
from Palmyra. Elsewhere, some very early mahogany doors, of
Jamaican origin.

The rooms of *S.P. Cockerell*'s own ADMIRALTY HOUSE
are reached via a plain outer hall within the S courtyard range
of Ripley's building. Beyond is a STAIRCASE HALL with seg-
mental plaster vault and Roman Doric pilasters, ending at
the r. in an arch on paired columns framing the staircase. In
a niche a cast-iron stove with terracotta flue in the form of a
columna rostrata. The niche surround is prettily ornamented:
drops of game and flowers suspended from animal heads (*J.
Papworth* plasterer). The staircase, of cantilevered type, is set
in a transverse oval well and splits at the half-landing into two
arms which gracefully curve back. This is repeated from first
to second floor, and there the first, single arm appears as a
bridge rising across the stairwell (cf. the contemporary Navy
Stair at Somerset House, p. 324). Cast-iron balusters alter-
nately solid and open, with acanthus ornament: original, or
early–mid C19? They turn plain above the first floor. Glazed
transverse oval dome.

With a few exceptions the other rooms are treated more
simply, with modillion cornices and plain ceilings with acan-
thus centrepieces. A further economy was the use of second-
hand fittings. Of the fine marble FIREPLACES, three came
from 'York House', which can only mean the present Dover
House to the S, of 1754–8 (designer *James Paine*, carver *Thomas
Carter Jun.*, *see* p. 256), which was then being altered. Another
was from Egremont House in Piccadilly, also 1750s (*see* p. 564),
and four were demolition spoils from the great Wricklemarsh
House at Blackheath, of *c.* 1724–7 (by *John James*, for Sir
Gregory Page). They are a puzzle to identify; at least one must
have been altered in installation (done by *R. Westmacott Sen.*).
Wricklemarsh also supplied much joinery for reuse.

The GROUND FLOOR has four principal rooms, two facing
w and two E. The LARGE DRAWING ROOM, facing w, has a
big doorcase with console brackets, possibly that between the
hall and saloon at Wricklemarsh, *sans* pediment. Fireplace
also surely from Wricklemarsh, perhaps adapted from an over-
mantel: swagged consoles, rich frieze, small open pediment.

To its s the MUSIC ROOM, with another magnificent fireplace flanked by busts on pedestals decorated with rams' heads. It looks 1750s, i.e. from Dover House; but the busts and delicate central relief of allegorical females, all much later in style, must be *Westmacott*'s insertions. Of the two E-facing rooms, the SMALL DRAWING ROOM has a shallow plaster vault decorated with plain squares. Pink and white marble fireplace from Egremont House, with a dolphin frieze (of *c.* 1759 by *Benjamin* or *Thomas Carter Jun.*). The LOWER DINING ROOM, centre, has a pedimented doorcase with Ionic half-columns. Fireplace with a relief after Paolo Mattei's once-famous painting of the Choice of Hercules, probably from Dover House.

The FIRST FLOOR has four main rooms, plus a VESTIBULE over the staircase hall with a coved ceiling with big intersections and scrolly bands. The LIBRARY, facing W, has a pedimented doorcase with Corinthian half-columns and a fireplace with youthful herms, both surely from Wricklemarsh. To its s the BEDROOM with another Wricklemarsh fireplace. The STUDY, facing E, has a flattened elliptical vault. The inner end, marked out by Corinthian pilasters, doubles as a kind of vestibule to a back stair, s. Lastly, the UPPER DINING ROOM, in the centre and facing E. Ceiling with a deep cove decorated with slanting octagonal coffering. Deep penetrations in it for the Venetian window with its Ionic columns, and to the sides. Fireplace with Ionic columns of Siena marble, frieze and relief, recorded as coming from Dover House, but looking slightly later than the 1750s.

The giant ADMIRALTY EXTENSION, now used by the Foreign and Commonwealth Office, closes the N side of the Horse Guards Parade. By *Leeming & Leeming* of Halifax, built 1888–1905 in an involved and costly three-stage process that did nothing to enhance the qualities of the design. Red brick mixed with stone, the style early Neo-Wren with French touches. Three-quarter columns on the centre and on applied porticoes towards each end, above which square sculpted pavilion towers are set up. These copper-topped towers and the whole central section were afterthoughts, for the design approved in 1887 had smaller pavilions and a low column-screen between them, exposing the N cross range with its domed centre. But the naval arms race made more rooms necessary, and so in 1901–5 a new seventeen-bay s range with somewhat petty detail took the place of the intended screen, and the towers and dome were made higher to set it off. The r. tower masks the rear of the C18 part. Their domes support radio masts and wires like giant washing lines, successors to the late C18 rooftop signal from which a chain of lookouts carried messages all the way to Portsmouth. The Leemings' design was a tamer recension of that which won the competition for a combined Admiralty and War Office of 1883–4, which would have swept away the C18 buildings. (For Admiralty Arch to the N, linked by bridge to the C19 part, *see* Trafalgar Square, pp. 375–6.)

Attached to the extension on the park side is the CITADEL (*W.A. Forsyth*, consultant), a fortress or ministerial air-raid shelter

of 1939. The creeper-grown exterior, of blocks of compressed pebble and flint, is curiously impressive in its seemingly accidental grouping. The highest peak served as a watch tower. It is the most visible sign of the vast underground citadel that extended as far as the former Department of the Environment in Marsham Street (*see* p. 705). Tunnelling went on fastest *c.* 1949–56, before the USSR acquired the H-bomb.*

PAYMASTER GENERAL'S OFFICE (now OFFICE OF THE PARLIAMENTARY COUNSEL). The next in sequence on both Whitehall and Horse Guards Parade. Of 1732–3 by the joiner *John Lane*, replacing late C17 premises. Lane was an associate of Colen Campbell and Roger Morris, two arch-Palladians, and his design is appropriately villa-like. It stands immediately by the road, of five brick bays, with a three-bay pedimented centre. The harshly detailed Gibbs surrounds on the ground floor date from alterations some time before 1849. Diocletian window in the pediment. Bombed 1940, destroying the l. part; reconstructed 1964–5. The extra N bay, with tripartite windows, was added in 1806. It stands on a vaulted basement from the previous house here, of 1734–5. The back, on Horse Guards Parade, is surprisingly ambitious: stone-faced, of five bays, the ends distinguished by Venetian windows on all three floors and by pediments. The explanation is that the façade was salvaged in 1910–11 from the park side of the old No. 37 Great George Street (q.v.), probably of *c.* 1760–70. The C18 plan was irregular, and incorporated extra stabling for the Horse Guards on the ground floor, S. (One room was preserved, at the rear on the ground floor, furnished after 1806 with pilastered panelling from the house of 1734–5. Pedimented chimneypiece with bearded profiles.)

HORSE GUARDS. This most appealing and most accessible of the C18 buildings in Whitehall was built in 1750–9, combining barracks with offices for the Secretary at War and other placeholders. The author of the drawings, as Richard Hewlings has discovered, was *Stephen Wright*, but he seems likely to have elaborated or modified designs by his former master *William Kent* (†1748). The final form was not settled until *c.* 1752, and the Board of Works continued to make detailed decisions after that; the executants were *William Robinson* and *John Vardy Sen.*** In composition it takes forward the restless style of such late Kent essays as the lodge at Badminton in Gloucestershire. The central part was finished in 1753, followed by the N wing and S wing in that order. *Andrews* and *William Jelfe* were the masons. Latest restoration 1991–4.

The full stone-faced extent of the complex can be seen from Horse Guards Parade. What distinguishes it at once from Inigo Jones's designs or indeed from Wren's Greenwich is the drama of its recessions and projections: seven-bay centre block,

* *Lutyens*'s memorial FOUNTAIN of 1924–5 to the Royal Naval Division, removed when the Citadel was built and later set up at Greenwich, is to be re-installed on Horse Guards Parade.

** A drawing by *Kent* survives, datable after 1745, showing a more spreading and less richly rusticated composition. Vardy nonetheless published an engraving of the finished building inscribed 'Wm. Kent Invt.'

five-bay wings lying back, three-bay angle pavilions coming forward again. The centre moreover repeats the same trick: three-bay centre, one-bay recessions, one-bay angle blocks projecting again. In addition, these angle blocks have square eminences on top, the angle blocks of the whole composition have pediments, and the centre of the centre has nothing but a balustrade and the clock tower appearing above and behind. This is as much in the Wren-Gibbs tradition as it is Palladian, with some details – especially the open lantern – reminiscent of Vanbrugh. The ground floor has pitted rustication, and flatter rustication spreads over the upper storeys except for the turrets and pediments and the set-back parts of the linking wings (heightened by one storey by *Thomas Rice c.* 1804). Principal windows are Venetian, one in the middle of each pavilion and three on the projections of the central part. An arched carriageway and flanking foot passages go through the central bays towards the E front and forecourt.

From Whitehall there is the same lively grouping, though the surfaces are unrusticated and generally plainer. First two outer buildings bordering on the street, each of seven bays and two storeys with three-bay pediments. The wings receding from here housed the Foot Guards, l., and Horse Guards, r., with much vaulting for their stables. Between them the famous sentry boxes, as plain as two pikestaffs below their pediments. The main front behind is also of seven bays with centre and angles projecting, with an extra storey over the angles (with pyramid roofs), and a pediment over the centre with a carved armorial by *James Richards*. The motifs of clock tower, courtyard towards Whitehall and central passage come incidentally p. from the predecessor of 1663–4, England's first true barracks 235 in the sense of purpose-built quarters for a standing army.

INTERIORS. The central part of the ground floor is filled by vaulted archways. To the N and S are the main staircases, modest in size and plainly decorated. The rooms of distinction are in the centre, i.e. the General's Office facing Horse Guards Parade, Octagonal Hall to its E, and Conference Room facing Whitehall. The OCTAGONAL HALL goes right up into the lantern, in three storeys, with niches in the upper walls. It is dated 1759. The GENERAL'S OFFICE has a compartmented ceiling simply decorated with a big central oval of the Inigo Jones kind, doorcases with pulvinated friezes, and of course the central Venetian window, with Ionic pilasters to match the exterior. Walls originally panelled. The CONFERENCE ROOM, originally meant for a chapel, is plainer still, with a guilloche band at two-thirds height. In the other offices some timber fireplaces to pretty Palladian designs.

The MONUMENTS around Horse Guards Parade almost vanish into the great gravelled space, which seems even larger since car parking was banished in 1997. By Horse Guards two EQUESTRIAN STATUES: Earl Roberts, 1924, a version of *Harry Bates*'s figure in Glasgow, and Viscount Wolseley by *Sir W. Goscombe John*, 1917–20. Near them two great GUNS. The Cadiz Memorial, S, incorporates a French mortar taken 62 at the siege there in 1812. Splendid cast-iron mounting with a

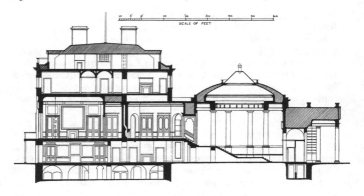

Dover House, Whitehall.
Section, showing (right) the extension of after 1787
(*The Survey of London*)

monster markedly like a Chinese dragon, made in 1814 by the
Carriage Department at Woolwich to designs by *Robert Ship-*
ster, and erected 1816. To the N a cannon of 1583/4, captured
at Alexandria in 1801. Its carriage, moulded in 1803 by one
Ponsonby, shows a lion, crocodile, and Britannia pointing to the
Pyramids. Facing them from the park edge is the GUARDS'
MONUMENT of 1925–6, by *H.C. Bradshaw*. A blunt obelisk
37 ft (11.3 metres) high, with five dummy-like guardsmen
by *Gilbert Ledward* in front. On the S side two STATUES:
Kitchener by *John Tweed*, 1921–6, against a screen wall by
Sir R. Blomfield, and Mountbatten by *Franta Belsky*, 1983, on
an impressive stepped plinth. Behind Mountbatten an orna-
mented LAMP STANDARD by *S. Nicholson Babb*, given 1907
by the Royal Academy. On this side, from r. to l., Downing
Street's walled garden with Nos. 12, 11 and 10 overlooking, the
Old Treasury (Kent's block, then Dorset House around the
inner angle), and the back of Dover House.

50 DOVER HOUSE (after 1885 the Scottish Office, now SCOTLAND
OFFICE) was built by *James Paine* in 1754–8 for Sir Matthew
Featherstonehaugh, 1st Bart., and remodelled after 1787 for
the young Duke of York by *Henry Holland*.★ It has two faces,
one to Whitehall, the other – the house proper – to Horse
Guards Parade. The latter, which looks at first like Paine's mid-
C18 Palladianism, turns out to be mostly *Holland*'s. Three
simple and dignified storeys, five bays plus two small recessed
outer bays, and rusticated all over. First-floor windows pedi-
mented or (in the centre) Venetian with a blind arch and a
bigger blind relieving arch over it. This window, at least in its
lower parts, must be a remnant of *Paine*'s front, which had
three such bays but was of brick above the rusticated ground
floor – a stripped-down version of the becolumned design

★ York swapped the house in 1792 for Melbourne House, later also remodelled by
Holland: *see* Albany, pp. 494–5.

published in his book of 1767. Cornice and dormers probably also *Paine*'s; continuous first-floor balcony, looking *c.* 1830; recessed S bay heightened by two storeys 1899–1900. Paine's Whitehall façade is of five bays, stone, with low projecting service wings with pediments facing N and S. *Holland* refaced their ends and built within the forecourt, which can no longer be appreciated from outside, but in recompense he contributed the most elegant piece of architecture to the whole of Whitehall. It has often been said that Holland understood the progressive Parisian trends of his day better than any of his contemporaries. Dover House bears that out. The smooth minimal rustication of the bare wall, the Ionic portico with its slim columns set straight on the pavement, and the relationship between portico and shallow-domed hall behind, are entirely in the spirit of Peyre or early Ledoux. Stuart and Revett's depictions of the monuments of Athens were also influential, e.g. for the novel enrichment of two detached columns carrying projecting entablatures on either side of the portico. The outer parts, set slightly forward, represent Paine's wings refaced.

Holland's ENTRANCE HALL is an ingenious and spatially very exciting solution to the problem of making an enclosed approach to the first floor. A rotunda 40 ft (12 metres) in diameter, with a central ring of eight elongated Doric columns in pink and buff scagliola. Five steps rise around and between the circular pedestals of five of the columns to an intermediate landing under the dome, then diminishing segmental steps continue to an upper gallery or landing, formed behind the other three columns, in the ends of which are hidden doorways to the ground-floor rooms. Over the main entrance a martial sculpted frieze. A short straight flight climbs onward to the UPPER HALL, with which Holland replaced the central room of Paine's courtyard front. It has rounded ends and arched openings in the far wall. Between them an unusual fireplace with angled uprights, and an overmantel relief after Michelangelo. Ceiling with swagged borders. On the park front, the former drawing room, N, has a *Paine* ceiling with angular guilloche bands and enriched compartments. Plasterer *Joseph Rose Sen.* Fireplace with female herms, perhaps *Holland*'s. The two rooms to the S have ceilings with decorated covings, from the 1st Lord Dover's occupation, *c.* 1831. Below is the Duke of York's private suite, three rooms remodelled by *Holland.* The central one is prettily painted with Etruscan or Raphaelesque decoration against pale green framing (restored 1955, 1990). Rooms to either side with entrance screens of two Ionic columns at the back. (Other rooms of various dates; work is recorded by *J. Yenn*, 1805, and *J.P. Gandy Deering*, before 1828; restoration by the *Ministry of Works*, 1953–5. The SE room replaces Paine's staircase.)

The so-called OLD TREASURY (now mostly the CABINET OFFICE) has the most complex fabric of all, belied by its even façade to Whitehall. This is *Sir Charles Barry*'s work of 1844–7, incorporating parts of *Soane*'s elevation of 1824–6. Behind is an agglomeration of structures and periods: the early

C18 Dorset House at the NE, *William Kent*'s Treasury block of 1733–7 directly behind it, *Soane*'s SW wing for the Privy Council, and – unexpectedly – substantial chunks of Henry VIII's Whitehall Palace. Some of the last are now preserved within the premises which the *Ministry of Works* made for the Cabinet Office in 1960–4, after severe wartime damage behind the Whitehall front. Exteriors visible to the public are described first, then interiors and inward-facing elevations.

Barry's work of 1844–7 housed the Board of Trade, Home Office and Privy Council.* His Whitehall FAÇADE is Early Victorian in its ornamental richness and relatively low relief, with a Corinthian giant order over twenty-three bays of rustication. Windows vertically linked, with no pediments to introduce other than vertical and horizontal lines. The accents lie on the five-bay angles, which have raised attics and project a little, with pilasters rather than engaged columns. Balustraded and urn-topped parapet. *Soane*'s front was not dissimilar but had one storey fewer, so that the columns rose from just above ground level. These also projected much further at the ends – or rather at the S end only, for the intended N part was never built. This N pavilion would have jutted inconveniently far into the street, and the completed part anyway proved too small; so after less than twenty years Soane's building was dismantled. Barry reused its columns and entablature, with a new and richer frieze.

The S end, facing Downing Street, has five bays of Barry, then four plainer bays. These, seldom remarked, are survivors of *Soane*'s Privy Council Office, which was built integrally with his Board of Trade block. They have simple rectilinear mouldings, of a more personal character than the rather commonplace pomp of Soane's lost Whitehall elevation. Soane hoped that this might serve as part of a triumphal E–W route through London, all designed by him.

To see the C18 Treasury and Dorset House, a walk back to HORSE GUARDS PARADE is necessary.

William Kent's TREASURY BLOCK of 1733–7 stands forward and to the r., facing N. Kent came up with many great schemes as an official architect, including a new royal palace and Houses of Parliament, but had much less success in getting them built. Even here, the seven bays were originally meant to run on for another four on each side, to end in Kent's favourite square angle turrets with low pyramid roofs. With the round-arched basement below the two main storeys, the effect as executed is of a building on stilts. It has even, decisive rustication and as its most prominent embellishment a four-column Ionic portico on the second floor (mason *Andrews Jelfe*, carver *James Richards*). The first floor lacks an order, but has a full Doric cornice with regal motifs in the metopes. On both these floors are square-headed windows, locked into the round-

*The location of Government departments shifts endlessly. Soane built for the Board of Trade and Privy Council; Barry added additional space for the Home Office, which from *c.* 1809 had been using Dorset House. This moved not long after into Scott's new complex to the S. And so on.

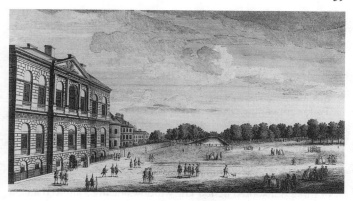

Treasury Block, Horse Guards Parade (Whitehall),
with St James's Park.
Engraving from J. & J. Boydell, *Views in England and Wales*, 1755

arched openings by architraves linked to the impost blocks.
Blank tympana above, except in the centre bay which has an
aedicule below, a Venetian window above. Royal arms in the
pediment. Round the r. corner these graduated textures are
dropped, apart from the rusticated basement, and broad blank
arcades appear. Eight bays here, the furthest five set back, with
intermittent mezzanine windows above both main storeys. The
brick-faced rear elevation, to Treasury Green, could formerly
be seen via the groin-vaulted passage which runs back from
the basement entrance.

DORSET HOUSE, to the l., appears as shapeless Georgian brick
fronts cramped into the SE angle, facing a small garden. Typical
of the *ad hoc* conversions and extensions of the E part of old
Whitehall Palace from the later C17. Four storeys, with a
canted bow facing W. The lower storeys must belong to work
for the 1st Earl Stanhope 1716–*c*. 1719, but have been altered.
The canted bow appears in a plan of 1754; altered to its present
form by 1827. Top storey later still.

INTERIORS. Ugly, mean office spaces of 1960–4 now lie
immediately behind the Whitehall front, enclosed behind by
perfunctory Neo-Georgian brick towards Treasury Green,
w. A little way in from the N entrance, standing remains of
the GREAT CLOSE TENNIS COURT of 1532–3 appear as pre-
served features, rising from well below the present ground-
floor level. They represent 30 ft (9 metres) of the w wall, with
a three-light mullioned window with plain arched heads
(restored), nearly 16 ft (4.9 metres) high, together with 45 ft
(13.7 metres) of the NW turret. The turret top is decorated
with flint and stone chequerwork, as at so many parts of the
old palace. The tennis court measured 83 by 26 ft internally
(25.3 by 7.9 metres). It had identical turrets at the corners, five
uniform windows, buttresses between, and a crenellated top: a

match for the better-surviving 'tennis play' at Henry VIII's Hampton Court. The E wall facing Whitehall remained in a mutilated state into the 1840s. N of the surviving turret is a stretch of plain wall from the GREAT OPEN TENNIS COURT, of matching area, which lay open to the sky.

Henry's other two tennis courts lay to the SW, reached by a two-storey GALLERY on the axis of the present main entrance. This survives, the upper level and S wall having been restored to a Tudor appearance in the 1960s work (the lower level has cross-vaulting of C18 type). It ran just S of the Great Close court to finish at the cockpit on the site of Kent's Treasury, with an external face towards Treasury Green, S. On the upper level here five restored straight-headed windows of three lights, and on the inner (N) wall a fireplace, a two-light window, and a larger window (now blocked, and visible only from outside), of three transomed lights. The windows facing S allowed a view of the tennis, in one open and one enclosed ('close') court set parallel and to the S. The scars of the N–S walls of the SMALL CLOSE TENNIS COURT remain at the W, as well as the gable end of its N wall, rising above. In it a four-centred-arched opening. The rest of the N–S walls are now just low footings on the grass of Treasury Green.*

The next interiors chronologically are in DORSET HOUSE, just W of the engulfed fragments of the Great Close Tennis Court. They belong to more than one campaign, starting apparently with the extensions for the Duke of Monmouth in 1673–5. This seems the likeliest date for the STAIRCASE, two and a half flights around a square open well, with heavy square newels and twisted balusters without the little bulb-like footings that became standard by c. 1700. But the Vitruvian scroll frieze at half-height and Greek-key-framed ceiling lantern appear Early Georgian. On the S landing a screen of three plain arches, plausibly of 1808–9, when *James Wyatt* adapted Dorset House for the Home Office. The chief rooms lie W, in an L-shape over-looking the little garden. The structure must belong with additions built 1716–c. 1719 for the 1st Earl Stanhope, one of George I's chief ministers. However, some internal features are of a Palladianizing kind suggestive of at least ten years later, i.e. during the occupancy of the 1st Duke of Dorset after 1725. In the angle, the SKYLIGHT ROOM, toplit and panelled, approached from the W through an ante-room with an Ionic column-screen plausibly of the 1710s, and with ceiling mould-ings like those over the staircase. The finest room lies N, behind the canted bow. The chimneypiece is lavish, with as the crown-ing motif an eagle set within a swan-necked pediment on the

*Buried remains include kitchen fireplaces in the centre of the W wall, inserted 1604–5, when the Small Close court was made into lodgings for Princess Elizabeth. The same unsporting fate overtook the Great Close court in 1663–5, for the Duke of Monmouth, but in this instance a new kitchen was built, on the W side. Part of it remains in the basement, with a restored segment-headed fireplace. The Tudor wall of the palace precinct was identified further S, under the present structures in Downing Street. Also during the 1960s excavations, two successive C9 buildings were recorded under Treasury Green, the later a timber-framed hall 26 ft (8 metres) wide with 18 ft (5.5 metre) bays.

half-columns of the overmantel. Noble, not over-ornate stucco ceiling, with the typical scrolls and trails of *c.* 1730. The work within the bow is later, given away by the urn of later C18, Neoclassical type. To the N, a long narrow dressing room, with a Doric cornice. w of the Skylight Room lobby, two largish rooms facing N. They have good enriched cornices and door-cases, and also overmantels with delicately carved foliage in a style akin to that in the room with the bow. A plan of 1754 shows them in use as a drawing room (E) and the Duchess's dressing room (w). Access to the storey above was originally via back stairs s of this room.

Kent's TREASURY BLOCK is reached at the end of the Tudor tennis court gallery. Its unusual planning was clearly meant to suit specialized uses: major rooms on two different floors, not adjacent and enfiladed as in a private house; lesser rooms including two mezzanine storeys, interrupted here and there to accommodate taller-ceilinged rooms on the floors below. The style is Kent's customary rich Palladian, and extremely well preserved.

The biggest alteration is the big first-floor STAIRCASE HALL on the E side, inserted to improve circulation by *Soane*, 1818.* Designed on a shoestring, but characteristic of him none-theless. The best thing is the artful way the twin L-shaped flights are whisked up through the upper corner walls, only to re-emerge on to a linking, U-shaped balcony across the entrance wall. *Kent*'s MAIN STAIRCASE lies to the SE, a roomy oblong of full height, bleak in feel despite its enriched S-scroll balusters. Of the three greatest Kent rooms, two face N, the third and finest, the first-floor BOARD ROOM, w. This has a deeply coved ceiling, nearly square, with guilloche bands (plas-terwork throughout by *George Worrall*). Abundant frieze, of flowers, swags, cartouches and shells. Four good doorcases; walls green-damask-hung, as originally. Elaborate chimney-piece, with an overmantel, flanked by coupled stone brackets linked at the top by a garland in the mouth of a lion mask. They frame a round niche for a bust, at present *Nollekens*'s Spencer Perceval, *c.* 1812. Small swan-necked pediments on top. A drawing for it suggests the collaboration of *Kent* and the elder *Vardy*, who designed the lower part. This has coupled columns with basketwork-like capitals, evoking the legendary inspiration for the Corinthian order, a basket penetrated by acanthus shoots. Excellent contemporary furniture, including an exceptional Chair of State. ROOM 103, in the centre of the N front, has oak panelling with giant Corinthian pilasters. This does not immediately line the walls but makes the front of book or document cupboards. These seem to be later C18 or even C19 installations, as the pilasters are now pushed forward of the cornice, neither aligning with it nor meeting neatly in the corners. Ceiling remarkably restrained, just a big cove with a broad enriched frame round the oblong centre. The third great room is immediately above, on the second floor behind the Venetian window. Here the ceiling is richer, of nine

*One of Richard Hewlings's many Whitehall discoveries.

compartments, made by frames of remarkable depth with the unusual motif of enriched guilloche along their sides. Also richer by comparison is the fireplace, of marble, with foliage and big brackets. Several other rooms on the major floors with elaborated cornices, panelling, and a nice variety of fireplaces; also a toplit BACK STAIRCASE of flattened D-shape.

The PRIVY COUNCIL block at the far SW of the complex preserves some little-known *Soane* interiors of 1824–6. Their survival is some consolation for the loss of his later rooms at the Bank of England, which shared their fusion of delicate detail, economical starkness and spatial fluency (*see London 1: The City*). The ENTRANCE has a shallow, fluted dome with a round flat centre, resting on no less shallow segmental arches, themselves mirrored by four segmental steps up to each side doorway. That to the l. leads to a LOBBY with unfluted Primitivist Doric columns in pairs, of which those on the r. (N) serve as a screen to a staircase swerving down to the basement. Its balustrade is thin, with minimal diamond-shaped ornaments. Very strange ceiling, with little shadowed gaps above the top mouldings of the cornices. Small rooms beyond with characteristic flush panelling, a fireplace with black marble insets, etc.

The PRIVY COUNCIL CHAMBER on the first floor remains, tamed and neutered by *Barry* in 1844–5. Double-height space, three bays long. The simple grooved panelling topped with a thin Grecian frieze and the minimal fireplaces are Soane's, originally set off by three grandiose door and window aedicules. Above them a blank zone, then simplified rectangular panels at window level, and a flat ceiling with a broad, drily detailed cornice: Barry's replacement for *Soane*'s starfish vault and skylit borders. The approach from the E is still Soane's, by twin corridors which open on to an inner, side-lit room with a stern little black marble fireplace. The thick fleshy cornice must be *Barry*'s, however, since it matches his work in lost parts of the building.

DOWNING STREET. The street was built in 1682–3 by the Puritan turncoat Sir George Downing. It was originally a cul-de-sac and finished at the W in a slight widening called Downing Square. Of all that there remain Nos. 10 and 11 on the N side, now interconnected and very much altered. No. 10 became famous from 1732–5, when it was remodelled at Treasury expense as a house and office for Sir Robert Walpole. Since then over thirty Prime Ministers (who are also First Lords of the Treasury) have followed suit. The other houses were mostly replaced by the Foreign Office (S side; *see* below) and Treasury (N side, E end), leaving a passage towards the park, inaccessible to the public since the 1980s.

The modest house fronts of Downing Street are deceptive in two key ways. The first is the true size of No. 10, which is really two late C17 houses combined in 1732–5, the rear and larger one with a much grander front towards Horse Guards Parade (*see* below). The second is how much is owed to *Raymond Erith*'s drastic reconstruction of 1960–4. He stabilized the shifting fabric with new concrete floors, inserted modern ser-

vices, and rebuilt many parts in facsimile or in unassertive Neo-Georgian. So No. 10 has five blackened brick bays from *Kenton Couse*'s refacing, ordered in 1766 but probably not done until 1774–5, but its two r. bays and low bow-ended addition are of 1960–4. Their details harmonize with Couse's, who gave a minimum of decoration to his doorcases (two, not one, because the house was then subdivided; the r. one has the famous fanlight and wrought-iron overthrow). The E flank, facing the courtyard known as Treasury Green, is by *Sir Robert Taylor*, 1781–3, replacing a service wing of 1732–5. The nearer part is two-storeyed with two large windows below, their mullions carried up into concentric inner arches; upper storey by *Soane*, 1825–6. The set-back part beyond was heightened *c.* 1914. Next to No. 10, l., is the four-bay front of No. 11, since 1806 the usual home of the Chancellor of the Exchequer: apparently of 1682–3, but with a pilastered C18 doorcase. No. 12 beyond is a big tall house by *Erith* in contrasting red brick, replacing two storeys kept after old No. 12 caught fire in 1879. The fronts now have to be viewed aslant through Greek Revival SECURITY GATES, designed by *English Heritage*, 1989.

Now for the N PART of No. 10, which overlooks a delicious walled garden to the r. of Kent's Treasury block on Horse Guards Parade. This larger and more formal house was built *c.* 1676–7 for the 1st Earl of Litchfield and his Countess, a natural daughter of Charles II, but took its present form in 1732–5. No designer is known for it, but some or all of the official architects *William Kent*, *Henry Flitcroft* and *Isaac Ware* were probably involved. Seven by five bays, with the central three broken forward; basement, two storeys, and a hipped roof to a new design by *Erith*.* Former basement entrance with a rusticated surround. The W front, of five bays, has a terrace in front. Next to it a white-painted bay which was added during *Erith*'s reconstruction of No. 11: a segment-headed window to the new Dining Room lobby, and a pretty trellis veranda with the Venetian motif above it. It makes a right angle with the plain four-storey N wall of No. 11, refaced 1847. Finally the six non-symmetrical bays of *Erith*'s No. 12. Its big boxy W front is also of six bays and four storeys, but regularly treated.

INTERIORS. No. 10. The rooms face outwards to the N, E and S and inwards on to a shapeless courtyard. The most memorable are of 1732–5, especially those glamorized by *Quinlan Terry* for Mrs Thatcher in 1988–9, or of 1825–6 and by *Soane* for Frederick Robinson (a Chancellor and future Prime Minister, as Viscount Goderich). The plain ENTRANCE HALL and inner hall lie within the C17 house, separated by a broad arched doorway in the style of *Taylor* and doubtless of 1781–3. Taylor's CORRIDOR ahead, linking the front and back parts, has a broad shallow niche, l., and windows to the courtyard, r. The outer wall below these is treated as a broad plain cornice resting

* He removed a three-bay pediment, added in 1937 to match that introduced in 1732–5 and taken down probably in 1781–3.

on two truncated Composite columns, like an antiquarian vignette of a buried Hellenistic temple: a prank by *Erith*, who reconstructed this part. The corridor opens into an ANTE-ROOM, with one of several angle fireplaces at No. 10, i.e. in the usual position for later C17 rooms. The famous CABINET ROOM beyond was enlarged to the E in 1796, with a screen of two pairs of sumptuous Corinthian columns. Cornice, fire-place and panelling date from 1732–5, as does the STAIRCASE off the ante-room to the r. This is of stone, with an oblong open well and a rather heavy railing of alternating S-patterns, now enlivened by Neo-Regency lanterns. It starts in the base-ment and rises to the first floor. The main upper rooms are the STUDY (beyond an ante-room W of the landing), plain but for its Kentian cornice and fireplace with black marble columns, and WHITE ROOM, TERRACOTTA ROOM and PILLARED ROOM along the N front. These have doorcases, cornices and refined white marble fireplaces of the 1730s, but were made more palatial by *Quinlan Terry* in 1988–9, with becolumned overmantels and (in the first two rooms) new Anglo-Palladian ceilings. Of these the Terracotta Room's is the more convinc-ingly Kentian, of white and gold with a quatrefoil centre. Also new the big E doorcase, with an arch little joke in its frieze: a tiny figure of a busy thatcher. It leads to the Pillared Room in the NE corner, enlarged after 1781 with an Ionic column-screen at the S end. Through here lies *Soane*'s portion. The simple SMALL DINING ROOM first, wood-grained, with sunk or inlaid mouldings and a fireplace set under a window. Its low ceiling increases the surprise of the broad double-height STATE DINING ROOM beyond. This also has typically Soanean panelling, and one of his shallow starfish vaults, with thickly ornamented cutaway groins widening from a point at the springing to meet in a diamond crossing and boss-like rosette. A corridor behind the inner wall joins on to the service stair, one of two rebuilt by *Erith*, which completes the circuit. Below the State Dining Room is the former KITCHEN with three oblong groin vaults, and other offices belonging to *Taylor*'s work.

54

79

No. 11 has much more of *Erith* inside, including the renewal or reworking of several older interiors. The FRONT HALL retains an angle fireplace, likely to be a C17 feature. But the STAIR-CASE, entered to the l., is of *c*. 1730, not large, with gracefully carved tread-ends and triplets of slim turned balusters for each step. At the back of the ground floor is the DINING ROOM added by *Soane* in 1824–5. To get light into its depths he used the same fascinating trick as in his breakfast room at No. 13 Lincoln's Inn Fields (*see London 4: North*). The ceiling has a large central oblong and two narrow side strips. The oblong has a shallow fluted dome like an awning stretched across and gently inflated. The side strips go up higher and have skylights. *Erith* remade the room by blocking the entrance in its E wall and adding a new lobby for access at the W, below the veranda. Matching detail. The main first-floor interior is the STATE DRAWING ROOM, five bays wide. Some fireplaces and other details belong with work attributable to *Taylor*, of

c. 1772.* (The first floor connects with No. 12, where a spacious stairhall gives access to the Chancellor's private apartments; the ground floor houses the CHIEF WHIP'S OFFICE.)

West Side, from the Foreign Office south to Parliament Square

FOREIGN OFFICE (since 1968 properly the FOREIGN AND COMMONWEALTH OFFICE). By *Sir George Gilbert Scott*, 1862–75, the key building in the so-called Battle of the Styles; some interiors by *Matthew Digby Wyatt*. Originally it housed the Home Office (until 1977–8), Foreign Office, Colonial Office and India Office together.

92, p. 268

The HISTORY of the project is tortuous. The Foreign Office, formally constituted in 1782, at first operated from houses in Cleveland Row. From 1795 it was on the s side of Downing Street, where the Colonial Office later joined it. *Soane* adapted the premises in 1825, but complete rebuilding was soon projected. *Decimus Burton*'s schemes of 1836–9 remained on paper, as did *Pennethorne*'s persuasive Italianate designs of 1854–5 (which included a new War Office). Then in 1856–7 an international competition was held – a break with the tradition of employing official architects – with separate prizes for a block plan and for new Foreign Office and War Office buildings. *Scott*'s Foreign Office entry, in Italo-French Gothic, was only placed third; first place went to *H.E. Coe* (Scott's former pupil) and *Henry Hofland*, for a Second Empire proposal in the manner of Visconti's New Louvre in Paris (begun 1851). Scott got the job in 1858, when a change of Government brought a new rebuilding committee chaired by the medievalist MP A.J. Beresford Hope. In the same year the brief was extended to include a new India Office (successor to the old East India Company), on the w part of the site where the War Office was to have been. Scott generously agreed that the company's former Surveyor *Matthew Digby Wyatt* should design the interiors of this part. A revised Gothic design was exhibited in 1859, and it is worth trying to visualize how a vast Scott-Gothic building in this place would throw Whitehall out of balance visually. But meanwhile the ministry had changed again, so that Scott now reported to Lord Palmerston. He wanted none of that, and insisted on Italy. Scott then tried to get away with an Italo-Byzantine design, which Palmerston called 'a regular mongrel affair'. So Scott 'bought some costly works on Italian architecture and set vigorously to work to rub up' what had grown rusty, and duly produced Neo-Renaissance designs for an enlarged site in 1861. All these struggles were publicized and ardently debated in Parliament and outside. In 1865–6 the E sector was allotted to build a new Home Office and Colonial Office.

* *See* Richard Garnier, *Georgian Group Journal* 9, 1999. *Soane*'s earlier, minor work here for the Hon. John Eliot, 1797–1805, is no longer apparent; *see* Richard Hewlings, *Transactions of the Ancient Monuments Society* 39, 1995.

Scott's BUILDING certainly is a most competent piece of High Victorian design, in which he seems to have suppressed his usual leaning towards picturesque variety. But it is true that the façade towards the park, where the India Office was, is eminently picturesque, and also eminently attractive. Here there is an asymmetrically placed tower with large granite columns below the square top, rising behind a rounded corner. Scott admitted candidly in his *Recollections* that 'the idea as to grouping and outline' here was suggested by a sketch by *M.D. Wyatt*, and a similar tower occurred in *Pennethorne*'s design. The N side, towards Downing Street, is irregular too and even has the un-Italian motif of a polygonal bay. At the park end, unmistakable traces remain of the unbuilt screen with which Scott meant to close Downing Street.

Otherwise the building is symmetrical: the very long s side towards King Charles Street is, and the E part shared by the Home and Colonial offices towards Whitehall, which was completed last (1870–5). This is tellingly bolder in relief than Barry's Treasury to the N, where the Home Office was previously accommodated, and tellingly taller too – and would have been more so had the Exchequer not vetoed the tall domed towers Scott intended on each corner. Only in the early 1990s were their plain footings topped with parapets and balustrades. The ground floor has an applied arcade with figures spreading out in the spandrels, the upper floors have two orders of coupled columns (pilasters instead at the angles) and a balustrade, with figures on it standing out against the sky. The upper windows are tripartite with granite colonnettes. On the first floor portrait medallions appear above the windows, and above the first- and second-floor centre windows more spandrel figures. The origin is Genoa and Venice, the character is opulent without being showy, and the principle of enrichment is that of overall coverage. A closer view reveals deviations into quasi-medieval detail – foliage pier-capitals on the E front, thin strings of red and grey granite inset with glass bosses – so Palmerston did not have his way entirely.

Many SCULPTORS were employed, some of whom had worked for Scott on the Albert Memorial. *H.H. Armstead* and *J. Birnie Philip* shared the spandrels on the Whitehall front, and Britannia and her four standing companions above – the only executed parapet figures, fewer than originally proposed. Others included *Hugues Protat, C.R. Smith* and *Farmer & Brindley*. On the N front a memorial RELIEF to Viscount Grey of Fallodon by *Sir W. Reid Dick*, 1937, designed by *Lutyens*.

The complex has at its centre a large oblong QUADRANGLE aligned E–W, reached by broad openings in the long N and s sides (through wrought-iron GATES made by Messrs *Skidmore*). This quadrangle continues the cavalcade of columns and sculpture. The subjects hint at the subdivisions within: the Continents for the Colonial Office, NE angle, figures with city emblems for the Home Office, SE angle, females personifying nations for the Foreign Office, NW, and different racial types for the India Office, SW. Here and there gaps appear, where the intended figures were not provided

or where stonework (the discs over the windows) was left uncarved. Incongruous 1920s mansard.

INTERIORS. The four zones are all different in plan around their internal courtyards. The chief rooms were rejuvenated by a six-phase restoration in 1984–97, after stagnant decades in which consecutive proposals to rebuild or remodel were shot down (*see* footnote p. 247). The *Property Services Agency*, joined later by *Cecil Denny Highton* (subsequently merged into *HOK*), achieved 25 per cent extra usable accommodation without sacrificing any major C19 rooms.

The old INDIA OFFICE is the largest division and also the most intriguing, both because Wyatt's style is more inventive than Scott's swotted-up Cinquecento, and for the spoils brought from the old East India House in Leadenhall Street in the City. Entrance is made from the Quadrangle into a square STAIR-CASE HALL or lobby, with one flight climbing between groups of four Doric columns. Weighty, omnivorous detailing: door-cases with jointed pipe-like mouldings of red stone, corridor vaults with peculiar pendants amidst classical coffering. East India House supplied the early C17 fireplace with herms, a sophisticated piece, and three Romanizing statues of 1760–4 by *P. Scheemakers*, from the old Court Room: Stringer Lawrence (a homunculus), Clive, and Admiral Pocock. The first floor is reached by the GURKHA STAIR, off the corridor to the r. It has a long open well within a cage of grouped red granite columns, and a dome with a ring of concave-sided hexagonal piercings: a bizarre form surely intended to evoke India. The half-landing rests on caryatid piers. Statues in niches over, from l. to r.: Sir Eyre Coote by *Thomas Banks*, 1784–8, Cornwallis by *J. Bacon Sen.*, 1793–8, Wellesley by *H. Weekes*, 1845, Wellington by *M. Noble*, 1853. Above them a bad PAINTING by *Spiridone Roma* of Corfu, 1778, The East Offers its Riches to Britannia (from the Revenue Committee Room, East India House). Also a statue of a Gurkha by *R. Goulden*, 1929–30, and (on the upper landing) a wall painting by *Frank Salisbury*, 1924, India's Homage to the Unknown Warrior.

Just beyond is the DURBAR COURTYARD, at seven bays by five the largest of the four lesser courtyards, and the only one treated as a showpiece. It was originally open – hence the top balustrade – but was glazed over in 1868, a year after comple-tion, and the patterned marble floor made. The walls are arcaded, with superimposed galleries on ground and first floor at the short ends, and the indispensable orders of polished granite columns. Decoration in what might be called the South Kensington manner by *Minton, Hollins & Co.*: friezes, of della Robbia-type majolica below, tile above, and also majolica ceil-ings to the galleries. In the corners statues by *Hugues Protat*, *W.G. Nicholl* and *T. Phyffers*, and reliefs of Indian history by *Phyffers*. Busts above the second-floor windows again by *Protat*; the brackets have letters that spell out THIS COURT WAS BUILT AD 1866 M.D. WYATT ARCHITECT. Other carving by *T. Earp*. Glazed roof of utilitarian design, much renewed in 1903 and 1984–7. The chief offices are on the first floor, includ-ing the former COUNCIL CHAMBER behind the gallery at

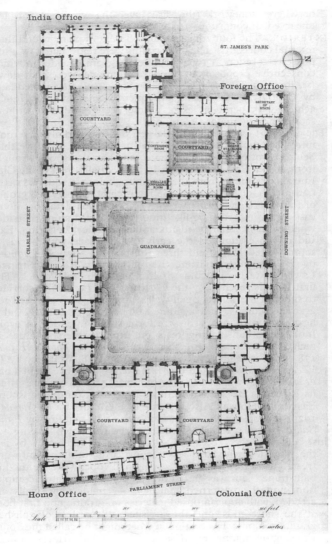

Foreign and Commonwealth Office (formerly Public Offices),
Whitehall. Plan as completed in 1875
(adapted from Ian Toplis, *The Foreign Office, an Architectural
History*, 1987)

the W end. Three bays by three, very tall, the ceiling with side
groinings. The towering chimneypiece of 1729, *Rysbrack* at his
most Baroque, is from East India House. The central relief
shows a seated Britannia receiving riches from the Indies.
Asia and Africa, behind, lead a camel and a lion. To the r. the
River Thames, with ships putting to sea behind. Two huge
pensive herms below. Also doors and doorcases, probably also
from *Theodore Jacobsen*'s original interiors of 1726–9, and
some transferred furniture. Redecorated 1986 by *Ian Bristow*,
after Wyatt's scheme: white, gilt, apple green, bronze. To its N
the MUSES' STAIR, perhaps the most marvellously weird of
Wyatt's designs, with roots in North Italian Mannerism of the
mid C16. The top is a flattened octagonal lantern with stucco
goddesses supported by pairs of cherubs, resting on beams
and columns rising from a square upper gallery. Paired grey
marble columns further down, the stair-rail inset with a creepy
polished ridge. Where the upper flight crosses the lower
half-landing is a solid panel pierced through with an oculus.
Just off here in the quadrant overlooking the park is the little
OVAL ROOM, which was the office for the Secretary of State
for India. A very pretty *studiolo*, in plan a quatrefoil with one
missing lobe. Timber cladding to the apses carved by *Phyffers*,
with diamond coffering above. The twin doorways are said to
have been for simultaneous entrances by princes of equal rank.
The original FOREIGN OFFICE lies N and E. Its three chief
rooms make up the LOCARNO SUITE, an L-shape around the
inner courtyard, meant for conferences and receptions (there
was in the end no official residence in the building). Scott's
decoration, executed by *Clayton & Bell*, was scoured off in
1926 under *Sir R. Blomfield*, but was magnificently restored
in 1988–92, even down to replica lamp fittings. The largest
space is the GRAND RECEPTION ROOM, which also faces the
Quadrangle and so is windowed on both sides. It is vaulted, of
double height, with a painted zodiac. The restorers introduced
matching doorways to the DINING ROOM in the angle, giving
access to the India Office corridor. The CONFERENCE ROOM
to its N, all pink and gold, has a coffered ceiling divided by big
cross-beams on pierced iron spandrels with majolica plaques
in them. In the opposite side of the courtyard is the STATE
STAIR (1863–8), *Pax Britannica* at its proudest, glowing with
marbles, mosaic, granites and gilding. The plan is the familiar
club type, one flight splitting into two right-angled arms,
but it fits into a space that is unusually broad in relation to
its depth. Galleries with columns around three sides, round-
arched windows along the fourth, with a flattish central dome
and vaulted octagonal-coffered sides. The architectural details
are mostly Roman Renaissance of *c.* 1500. In the dome are
Clayton & Bell paintings (partly renewed) with figures sym-
bolizing twenty countries then represented at the Court of St
James's. Two glorious bronze gasoliers by Messrs *Skidmore*,
after Scott's designs; mosaic pavement by *Minton & Hollins*.
At the stair foot, statues of the 4th Earl of Clarendon by *J. Bell*,
1872–4 (on a plinth by *Scott*), and of Lord Salisbury by *Herbert
Hampton*, 1909. The gallery is lined with unintentionally camp

MURALS allegorizing Britannia by *Sigismund Goetze*, painted
from 1912 and installed in 1921. The Colonial and Home
offices are without rooms of state, but some interiors stand out:
the galleried LIBRARY of the old Colonial Office (extended
by the restorers), bisected by pole-like cast-iron columns, and
the big plain octagonal Home Office STAIRCASE in the inner
SE angle. Some rooms have fireplaces from No. 14 Downing
Street (dem. 1861–2), possibly of *c.* 1772 and to designs by
Sir Robert Taylor. These E parts have more corridors with
natural light than at the W, and use *Dennett*'s patent fireproof
construction, more advanced (because timber-free) than the
Barrett system employed for the rest.

NEW GOVERNMENT OFFICES (TREASURY). By *J.M. Brydon*,
an archetypal early monument of the Neo-Baroque. Designed
1898, and built in two phases 1899–1915; first occupied by the
Home Office, Health Department, and the boards of Educa-
tion and Local Government. Brydon died in 1901 and *Sir
Henry Tanner* (*Office of Works*) carried on the building with a few
variations. It is linked to the Foreign Office by an enclosed
triple-arched BRIDGE across King Charles Street, added by
1908. Even here, the difference in styles appears at once. The
architectural motifs are more forceful, the relief is yet bolder,
and the sculptures (by *W.S. Frith* below and behind, *Paul
Montford* on the top) proportionately bigger. At the main block
the overall rhythm is the same as at Young's Old War Office (*see*
p. 238), designed in the very same year. Its climax is the S front,
with a centre flanked by super-Wren towers with stone domes.
On their main storeys they have diagonally set coupled columns
intermittently blocked. As for the rest of the façades, fewer and
grander motifs have taken the place of Scott's all-over pattern.
The two lowest floors are plainly rusticated, the storeys above
have giant attached or detached columns and pilasters, with
square corner towers at the E and a pediment between sculpted
by *Sir B. Mackennal*. This part was completed in 1908, the W
phase with its curved corners in 1911–15. The principal motif
within is a large circular court, introduced in memory of the
boldest of the mid-C17 plans for Whitehall Palace (*see* p. 234),
and more Palladian in character than the outside. It has blind
rusticated arcading to the two lower storeys and giant engaged
Ionic columns above, paired and with pediments over the main
exits. Brydon's intended balcony was omitted. A glimpse can
be had through the triple openings on the N and S sides, in line
with those of the Foreign Office. These are barrel-vaulted, with
Doric columns to the piers, and seem to owe something to
Chambers's Somerset House vestibule (*see* pp. 320–1). Imper-
ishable bronze GATES, designed by the *Office of Works* with
Bainbridge Reynolds. Remodelled within by *Foster & Partners*
from 2000, creating open-plan offices and making lesser court-
yards and light wells into glass-roofed communal spaces. The
Treasury is to occupy only the W part of the renovated building.
The chief INTERIORS are in the earlier, E part. The STAIRCASE,
of yellowy Mazzano marble executed by *Farmer & Brindley*,
suffers from complications around the half-landing for access
to the mezzanine. At the top, facing Whitehall, a barrel-

vaulted CONFERENCE ROOM, originally the Audience Room
of the Local Government Board. A grand display of orders,
Corinthian columns of streaky-shafted marble interspersed
with a timber Ionic order of equal height. Neo-Wren fireplaces
and plasterwork. (The CHANCELLOR'S ROOM, formerly
Deputation Room, Board of Education, is in the centre of the
N side: apse-ended, with carving and plasterwork in late C17
style.)
The basement, reinforced after 1938, was used as the CABINET
WAR ROOMS in 1939–45. The Imperial War Museum opened
part of this claustrophobic two-level warren to the public in
1984. Entry is on the park side, by the steps at the end of King
Charles Street. Here a fine STATUE of Clive of India by *Tweed*,
1912, moved from near Gwydyr House 1916. Good reliefs on
the plinth.

Further Reading

One well-illustrated general history stands out: S. Foreman, *From
Palace to Power*, 1995. S. Thurley, *Whitehall Palace*, 1999, covers
the royal apartments on the E side, S. Thurley and H.J.M. Green,
in *Transactions of the London and Middlesex Archaeological Society*
38 (1987) the excavations of 1960–2 on the W side. E. Sheppard,
The Old Royal Palace of Whitehall, 1902, covers a larger area,
more anecdotally. The important Whitehall Palace plan of 1670
was published in 1998 (London Topographical Society, ed. S.
Thurley). The *Survey of London*, vols. 10, 13, 14 and 16, 1926–35,
deal together with the E and much of the W side of Whitehall.
The History of the King's Works, 6 vols., 1963–82, and M.H. Port,
Imperial London, 1995, have much essential information on the
royal and Governmental buildings. Leslie Martin's terrifying
Whitehall plan appeared in 1965 (HMSO); the wider post-war
story is summarized by S. Games in *RIBA Journal* 87, April 1980.
Works on individual buildings include: Banqueting House:
P. Palme, *The Triumph of Peace*, 1956; Foreign Office: books by
I. Toplis, 1987, and A. Seldon, 2000; No. 10 Downing Street,
books by R.J. Minney, 1963, and A. Seldon, 2000.

OTHER PUBLIC BUILDINGS

MIDDLESEX CROWN COURT
Parliament Square

Built as the Middlesex Guildhall in 1912–13, by *J.G.S. Gibson
& Partners* (detailed by *F.P. Skipwith*). Since 1971 used as a
Crown Court, for which the *Property Services Agency* restored
and adapted it in 1985–8. Of Portland stone. Its nearness to
the Abbey determined the choice of Gothic, then a long-faded
fashion for civic buildings. It uses what might be called an Art
Nouveau version of the style, essentially original even if playing

with Gothic motifs. Typical are the big encircled segmental arches of the doorway and the main window above, the statues under canopies, and nearly every detail of the central tower on the main front, w. Decoration in concentrated bursts, notably *H.C. Fehr*'s historical figure frieze and statuary around the portal below (carver *Carlo Magnoni*).

In the entrance hall a BUST of King Edward VII by *P. Bryant Baker*, 1912, and the Middlesex Regiment WAR MEMORIAL by *Richard Goulden*, a bronze soldier against a cross, illustrated 1925. The semicircular main staircase, l., rises in an open cage with a Flamboyant vaulted top. Two well-preserved original court-rooms, No. 1 with false fan-vaulting on corbels carved with figures of Justice intent on proceedings. Court No. 3 on the upper floor, larger and with a hammerbeam roof, was the former Council Chamber for Middlesex.

Reset against the back wall is a GATEWAY of pitted rusticated blocks, dated 1655, from the old Bridewell Prison in Greencoat Row off Francis Street (*see* Westminster Cathedral, p. 673). Chillingly inscribed 'for such as will beg and live idle'. It was removed *c.* 1884 to the former Westminster Sessions House here, by *S.P. Cockerell*, 1804–8. In 1892–3 this was almost entirely rebuilt by *F.H. Pownall* for the new Middlesex County Council, which had decided to keep a presence within the new County of London.

QUEEN ELIZABETH II CONFERENCE CENTRE
Broad Sanctuary

By *Powell Moya & Partners*, 1981–6 (feasibility study 1975), the one big new Government building of that decade. It is quietly pragmatic rather than monumental, and lacks the forthrightness of the firm's early work. Nonetheless it holds its own on this sensitive site, diagonally opposite the Abbey and next to Methodist Central Hall. The brief was for secure conference facilities, for which several large volumes were needed. The great mass enclosing them stands free on three sides. These are treated not as façades but as infillings of a thin planar frame of smooth concrete – a material then commonly shunned. This cantilevers out for a concourse on the third floor, then steps back above. At concourse level, full-height glazing and slatted aluminium screens bind the whole together visually. Further horizontal stress comes from the breaking of the concrete uprights here in favour of thin stainless-steel hangers. Below the overhang, lead facing covers much of the uprights and all of the rectangular rooms that outcrop with tentative asymmetry. More leading on two top storeys, and some disfiguring plant enclosures above. By the road in front is a triangular GARDEN with unfriendly high granite kerbs. The raised feature in it is a ventilation tunnel for the underground Government citadel (*see* pp. 253–4).

The previous buildings here went in 1950. On the garden site stood the old Westminster Hospital, collegiate Gothic of 1831–4 by *W. & H.W. Inwood*, heightened later in the C19 and facelifted by *Percy Adams* (*Adams, Holden & Pearson*) in 1924. To

the N was the Stationery Office, converted in 1853–5 from the old Parliamentary Mews, of 1825 by *Decimus Burton*. A new Colonial Office on the combined site, a rigid old-school design of 1949 by *Thomas Tait* (*Burnet, Tait & Lorne*), was abandoned at foundation stage in 1952. In 1958 an open space was decreed for the S part. A competition followed in 1961 for a block housing a conference hall and Government offices on the remainder, won by *William Whitfield*, but Leslie Martin's Whitehall plan of 1965 called this in question.

WESTMINSTER BRIDGE

Of 1854–62, by *Thomas Page*, with *Sir Charles Barry* as architectural consultant. Seven arches of unambitious span, the shape 'drawn parallel to an ellipse' for greater navigation clearance. Structural ribs with cast-iron haunches and wrought-iron crowns, a transitional design (ironwork by *Cochrane Bros & Co.*). Parapets Gothicized with quatrefoils, and Tudor Gothic lamp standards on the piers, all to harmonize with the Palace of Westminster. Penrhyn and Cheeswring supplied the granite. The 84 ft (25.6 metre) width between parapets was exceptional for the period. The sage green colour follows the C19 scheme.

Old Westminster Bridge was of 1738–50, by the Swiss *Charles Labelye*, after plans submitted in 1734. Before then the only crossing was at London Bridge. Labelye introduced scientific expertise to British bridge design, for instance in confirming mathematically the equilibrium of the arches. He was required to design piers that might serve equally for stone or timber arches, and only after work began was it decided to use stone throughout. There were fifteen semicircular spans, 76 ft (23.2 metres) clear at the centre and diminishing evenly towards the sides. The foundations were prefabricated in timber caissons, sunk into dredged excavations and pre-loaded. A notable settlement failure of one pier was overcome by making the affected spandrels hollow for lightness. Scour of the shallow foundations subsequently dogged this, as it did other Thames bridges, and it closed in 1846.

STREETS

GREAT GEORGE STREET

Cut through in 1752–7 on the initiative of one James Mallors, joining the Westminster Bridge approach with St James's Park. The gate by the park went in 1854. The New Government Offices of 1899–1915 now fill the N side (*see* pp. 270–1). Much of the S SIDE was pulled down to make Parliament Square. What remains is a redoubt of professional headquarters buildings. Just one

house survives from the C18 terraces, which were early instances of symmetrical grouping, designed by *Sir Robert Taylor*.*

The ROYAL INSTITUTION OF CHARTERED SURVEYORS marks the E corner with Parliament Square. A late work by *Alfred Waterhouse*, 1896–8, Franco-Flemish style in red Ruabon brick dressed with Ancaster stone. The chief rooms show up by their big windows: library across the N front, first floor; staircase some way down the E side; meeting room (now Lecture Room) beyond, altered in the early C20 to have three round-headed windows. The curving corner, S flank and lower bow-fronted S extension are by *Paul Waterhouse*, 1911–12. Set back beyond them is a hard, insistently vertical section of 1977–8 by *Rolfe Judd Group Practice*, with uprights sloping back in a mansard profile. This 1970s work accompanied much heightening, and unattractive remodelling inside (*Denys Lasdun*'s bold scheme for complete rebuilding, of 1962, was still-born). Waterhouse's open-well STAIRCASE remains, of marble, with a pierced balustrade and triple landing screen. Ground-floor interiors with hesitant classical ornament, setting off C18 chimneypieces salvaged from the old houses here, leased by the Institution from 1868. That in the NE room stands out: pedimented, of timber, with coarse foliage carving and an inserted overmantel painting of Westminster Bridge. It must date from *c*. 1760. (A panelled interior from old No. 5, preserved by the Victoria & Albert Museum, includes an identical fitting.) The LECTURE ROOM was handsomely redone in English oak by *Tatchell & Wilson*, 1928–9 (carver *George Alexander*). Giant columns at the stage end. To its W the COUNCIL CHAMBER, of 1910–11, reworked in 1976 and 1998. On the roof an upper viewing terrace made 1977–8.

Next door is the front part of No. 11 (1756), now incorporated in the Surveyors'. Three bays wide, with a bracket-cornice and Ionic porch. Pediment against its top storey, formerly echoed on the house opposite. Handsome S-curved wrought-iron stair-rail inside, amidst 1970s butchery. Nos. 8–10, tall offices for Middlesex County Council in artificial stone, 1930 by *A.C. Blomfield & A.J. Driver*(?), stripped Beaux Arts style.

The INSTITUTION OF CIVIL ENGINEERS, next, is by *James Miller* of Glasgow, 1910–13 (NW pavilion 1936–7). Two big storeys, with large recessed Ionic columns on the upper floor: all rather in the Reginald Blomfield style. Armorial over the porch carved by *Albert Hodge*. A modest SE extension was made during refurbishment by *BDP*, 1988–91. The fine, self-assured INTERIORS have panelling, metalwork and fibrous plasterwork to the highest Edwardian standards. The axial ENTRANCE HALL interpenetrates majestically with an Imperial STAIR-CASE, l., through superimposed tripartite screens. Glazed domes above each, that to the entrance visible through a large circular well in the landing floor. On the newels busts of engineers by *H.C. Fehr*, 1897. Galleries and lobbies open off

* *See* Richard Garnier, *Georgian Group Journal* 12, 2002. The pretentious façade of old No. 37 survives, re-erected at the Paymaster General's Office, Whitehall (p. 254).

on every side: a Baroque effect, made easy by steel framing. The chief first-floor room is the huge GREAT HALL, with giant pilasters in Louis XVI taste, and a war memorial ceiling painted in 1920 by *Charles Sims*. Its bright, posterish (or perhaps Post-Impressionist) colours are more up-to-date than its chief subject, a giant symbolic female figure. The LIBRARY along the E side reuses panelling and pilasters from the short-lived headquarters by *Charles Barry Jun.*, 1895–6, demolished for the Government buildings opposite. On the W side of the ground floor a good suite panelled in late C17 style. Armorial STAINED GLASS in the entrance hall by *Hugh Easton*, 1956; in the entrance passage ENGRAVED GLASS by *Majella Taylor*, 1996; reset in the basement, PAINTED GLASS by *A. W. Moore & Sons* from the 1890s building, with charming vignettes of bridges, etc.

Third of the professional headquarters buildings is the INSTITUTION OF MECHANICAL ENGINEERS, W of Storey's Gate (properly in Birdcage Walk). By *Basil Slade*, 1896–9, haphazardly composed Northern Renaissance, the r. part built for separate occupation. On the Institution an Ionic four-column porch and an applied Corinthian portico over it, set off-centre. Angles with attic towers and non-matching pavilion roofs. Adding to the muddle is the E extension of 1910–12, l., a becolumned Portland block by *James Miller*, a near-match for his Civil Engineers opposite. INTERIORS in contrasting styles: library with an Elizabethan interlace ceiling, Renaissance-style former tearoom lined with marble (basement), large lecture hall to the rear, remodelled by *Miller* 1933.

STOREY'S GATE is a short street built up in the later C17 by the mason *Abraham Storey*, along the course of the old Thorney Island ditch. On the E side is the Queen Elizabeth II Conference Centre (q.v.). The W side is minor C19–C20, e.g. No. 8 (ABBEY BUILDINGS), gabled Flemish Renaissance by *W. Gilbee Scott*, 1882. To its S is MATTHEW PARKER STREET, an L-shape laid out in 1909 behind Methodist Central Hall (q.v.). It soon filled with bulky red brick offices, mostly converted to flats 2000–2. The blocks at each end of the N side are by *H. Chatfeild Clarke*, 1911–13, No. 4 (w side) is by *Lanchester & Rickards*, 1914, with a big shaped gable.

OLD PALACE YARD

Named from the palace founded by Edward the Confessor. One medieval part remains: the C14 Jewel Tower and its quay, to the S. Chaucer had a house at the NE, pulled down in 1503 for Henry VII's Chapel. Older houses to the S here and in Poets' Corner were levelled mostly in 1895, to give a view of the Abbey Chapter House. The garden thus created is dominated by the GEORGE V MONUMENT, a stone statue in naval robes, by *Sir W. Reid Dick*, 1947 (designs made 1939; the high pedestal by *Sir Giles Gilbert Scott*).

One stone-faced house remains on the S side, or rather two houses (Nos. 6–7) in one severely Palladian villa-like

composition that closes the view from halfway up Whitehall.
Built 1754–6, for the Clerk of Parliaments and for his assistant.
The designer was probably *Kenton Couse*, the Clerk of Works
responsible for the site, or perhaps his patron *Henry Flitcroft*,
who reported on the proposal in 1753. It has a pedimented
centre and round-arched lower windows. A two-storey cor-
ridor communicating with the Jewel Tower behind (q.v.) was
demolished after the Second World War. Adapted *c.* 1992
as offices for the House of Lords. They have stone stair-
cases with plain iron balustrades. (Groin-vaulted entrance
probably by *Soane*, 1792–3, with other late C18–early C19
work.)

ABINGDON STREET, to the S, is an ancient lane widened and
renamed after 1750, in connection with the new Westminster
Bridge (q.v.). Those C18 houses which survived the war were
sacrificed for a garden set over an underground car park, made
in 1963–6. On the long plain turf area an abstract bronze
SCULPTURE by *Henry Moore*, Knife Edge Two Piece, 1967 (a
second cast from that of 1962).

PARLIAMENT SQUARE

The present layout is of 1950, by *Grey Wornum*. It is essentially
a square traffic island with a lawn and formal paved walks,
seats and trees on the N and W sides. The statues of statesmen
were repositioned in connection. In the previous arrangement,
of 1868 by *E.M. Barry*, the central enclosure was smaller, the
green strip to the W somewhat larger. The land was cleared
long before, notably under an Act of 1806, to make a setting
for Abbey and Parliament.

Of the STATUES two face S, the rest all E – i.e. towards the Houses
of Parliament. From E to W, N side: Churchill, by *Ivor Roberts-
Jones*, 1973, a massive greatcoated figure with a stick; Field-
Marshal Smuts, 1956 by *Epstein*, seeming rather unfortunately
to be striding off his pedestal; Palmerston, 1871–6 by *Thomas
Woolner*, whose first attempt was rejected (1869), on a plinth
by *E.M. Barry*. W side: Lord Derby, 1874 by *Matthew Noble*,
with reliefs on the base by *Horace Montford*, one showing the
interior of the House of Commons before 1834; Disraeli,
1883 by *Mario Raggi*, likewise robed; Peel, 1877 by *Noble*,
using metal from another rejected essay, by *Marochetti* (1868).
In the gardens to the W two more: Canning by *Sir Richard
Westmacott*, 1827–32, in antique robes (moved from New
Palace Yard in 1867), and Abraham Lincoln, 1920, standing in
front of his Grecian chair, a copy of *Augustus Saint-Gaudens*'s
famous figure at Chicago.

London's first traffic signals (1868) and gyratory system (1926)
were in Parliament Square. The traffic now makes the central
space almost inaccessible. Recent proposals to remedy this have
culminated in *Foster & Partners*' World Squares For All scheme
(1996, revised 2000); *see* also Trafalgar Square, p. 373.

THE SANCTUARY

The name is a relic of the right of sanctuary within the Abbey precinct. Now largely clear of buildings. It should be a thrilling public space, except that a busy diagonal road cuts across from Parliament Square. Even so, there is no better orientation point in this part of Westminster: ahead to the E, the W front of the Abbey, St Margaret to its l., and Parliament Square with the Palace of Westminster rising beyond; on the N side, the Middlesex Crown Court and Queen Elizabeth II Conference Centre; on the W side Methodist Central Hall, then blunt-ended C20 buildings where Victoria Street streams away to the SW (*see* pp. 721–2).

The only domestic buildings are the extraordinary group on the s side by *Sir George Gilbert Scott*, 1852–4, which incorporate the entrance into Dean's Yard (*see* p. 201).* They are Gothic – a mixture of English motifs of *c.* 1250–1350 – faced in Bath stone, with a central, formal gatehouse, vaulted inside. But the two sides are carefully asymmetrical, and especially varied in their skyline: the first truly dramatized roofscape in Victorian London. Scott recommended an accidental-looking arrangement for such long terraces in his *Remarks on Secular and Domestic Architecture* (1858): 'a few of one scale and a few of another, some higher than others – a group of gabled fronts, and another with parapets and dormers . . . chiefly arranged with a view to varied wants'. Long used as offices; carefully restored by *Haslemere Estates*, 1985.

In front is *Sir George Gilbert Scott*'s MONUMENT of 1859–61 to those of Westminster School fallen in the Crimean War. 'A pleasing innovation upon the stereotyped style of other columnar monuments', wrote *The Illustrated London News*. A red granite column, with a shaft-ring from which hang shields, a big Gothic capital, a lantern-cross on top, and a statue of St George and dragon yet higher up – a typical High Victorian overdoing of effect. St George is by *J.R. Clayton* (of *Clayton & Bell*), the four monarchs in niches below by *J. Birnie Philip*.

VICTORIA EMBANKMENT
East of Whitehall

The creation of *Sir Joseph Bazalgette*, 1864–70. For the full story *see* the central section, pp. 376–7. This s part, on the Whitehall riverfront up to Westminster Bridge, is more rigid in layout, and has the most consistently grand architecture overlooking it. Most are described under the main Whitehall entry (q.v.).

At the s END – an exclamation mark for Westminster Bridge – *Thomas Thornycroft*'s BOADICEA, a bronze group with the queen and daughters on a chariot and prancing horses. Begun

**Edward Blore* made more conventional designs for the site in 1847–8, but retired before they could be built.

1856, cast in plaster 1871. A site was envisaged first at Hyde
Park Corner, then at Kensington Gardens. The artist died in
1885, and his son *Sir Hamo Thornycroft* oversaw casting in 1897.
Only in 1902 was the group unveiled, on a plinth designed by
Sir T. G. Jackson. Steps down beyond to WESTMINSTER PIER,
recessed in the Embankment wall. Of the buildings, *see* p. 247
for Portcullis House, pp. 248–50 for New Scotland Yard, pp.
242–3 for the Ministry of Defence. The GARDENS are those of
the old private houses, remodelled and thrown together in the
mid c20. Here a defile of MONUMENTS. The Chindit Monu-
ment, 1989–90, is by *David Price*, sculptor *Frank Forster*. On
top the mythical chindit or chinthe, a Burmese temple
guardian. STATUES: Viscount Trenchard by *W. McMillan*, 1961
(plinth by *Sir A. Richardson*), and Viscount Portal, 1975 by
Oscar Nemon, roughly modelled and looking skyward. The
Fleet Air Arm Memorial, 2000, shows a figure of Daedalus
by *James Butler*. He has wings, but also an airman's helmet
and underwear. *Trehearne & Norman* designed his tall seg-
ment-sided pedestal. Further N General Gordon, by *Sir H.
Thornycroft*, 1885–8. A meditative figure, one foot on a broken
cannon. Tall plinth designed by *Waterhouse*, and carved by
Farmer & Brindley. On it two reliefs of enigmatic females,
the mood of the New Sculpture already manifest. Originally
in Trafalgar Square; set up here 1953. Queen Mary's Steps,
exposed in a sunken well beyond (*see* p. 244), show how
much further W the Thames extended in the late c17.

On the river wall *Sir Reginald Blomfield*'s RAF MEMORIAL of
1921–3. A big tapered pylon, twice incurved above, with a
gilt-bronze eagle by *Sir W. Reid Dick* taking off from the top.
Opportunely placed at the head of Whitehall Stairs, one of the
grace-notes of the c19 Embankment, which has twin flights
climbing to a landing over a giant rusticated arch.

Next after the Ministry of Defence is a long block made up of
Whitehall Court, S, 1886–92, and the National Liberal Club,
N, 1884–7. WHITEHALL COURT is by *Archer & Green*. Eight
storeys of superior flats, Portland stone, with slated pyramid
roofs, balconies, loggias – enough to make Chambord pale
with envy. Seen from St James's Park, the skyline is beyond
belief. The flats were of fireproof construction, planned with
unusual care to keep separate the day rooms, night rooms and
service rooms. Lifts were provided as well as staircases, set
around internal light wells. The undertaking ruined Jonathan
Carr, the developer of Bedford Park, and Jabez Balfour's
Liberator Co. took over and finished it (cf. the same architects'
Hyde Park Hotel, p. 757).

The NATIONAL LIBERAL CLUB is by *Alfred Waterhouse*, planned
jointly with Whitehall Court, but more eclectic in its detail.
One fully realizes the differences only when the upright and
more tightly composed corner tower is reached. The main
rooms fill two tall storeys and a deep half-basement. Above
were a hundred bedrooms, an unusually high number, reflect-
ing the provincial roots of the membership. The club rooms
are hallmarked by all-embracing use of patterned faience
(makers *Wilcock & Co.*). The imperishable substance even

faces the columns which make shallow aisles along the biggest rooms of all. The style is Waterhouse's own rather bitty mixed Renaissance, detailed with help from his son *Paul*. Floors and framing mostly steel, probably its first consistent use in a London building (*W.H. Lindsay*'s patent). The club now uses only the first-floor suite; the ROYAL HORSEGUARDS HOTEL next door took over the bedrooms *c.* 1986, and in 1995–7 restored the rest for function rooms. These main rooms wrap tightly around an oval grand staircase, remade (after war damage) by *Clyde Young & Bernard Engle*, 1950–1, as a cantilevered marble spiral embracing three storeys. In the corner tower a staircase of full height, in the low terrace towards the river originally billiard rooms. Much atmosphere of the Liberal golden age: within the entrance stained-glass portraits of Harcourt, Rosebery, Gladstone, Morley; in the dining room a STATUE of Gladstone by *Onslow Ford*. The hotel introduced spectacular candelabra, after *Waterhouse*'s designs for other buildings, and lined the former library with dummy book spines.

The GARDENS in front were laid out in 1875 to designs by *G. Vulliamy*, more formal than those off the Strand. Three statues, each on a green island: from s to N, Tyndale by *Boehm*, 1883–4, with books and press; Sir Bartle Frere by *Brock*, 1887–8, with relief on the plinth; Sir James Outram by *Matthew Noble*, 1862–71, with four bronze trophies. Railings of 1997, after *Bazalgette*'s design of 1873. In front of them the PLIMSOLL MONUMENT by *F.V. Blundstone*, 1929, with bronze supporters. On the Embankment wall, at the bottom of Northumberland Avenue, MONUMENT to Bazalgette himself, 1899–1901 by *G.B. Simonds*. A Quattrocento aedicule with portrait bust. He faces towards Whitehall Place, l., and Northumberland Avenue, r. (*see* pp. 355–6), both created in the 1870s to give access to the Embankment. For Hungerford Bridge *see* pp. 301–2; for the continuation of Victoria Embankment *see* pp. 376–81.

THE STRAND, COVENT GARDEN
AND TRAFALGAR SQUARE

Map: 282–3

INTRODUCTION

The key to understanding this extremely diverse area, which includes so many famous names and sights, lies in the sequence of town planning schemes which have sprouted off the trunk of the Strand since the C17. These vary hugely in size and scope, and much of the interest of the area, its rifts and frontiers and pockets, derives from them.

The STRAND itself follows a natural curve of elevated land, close to the river but secure from high tides. It was therefore the natural Roman route between the City and Westminster. The discrete Anglo-Saxon settlement of *Lundenwic* grew up here, of which a large area was uncovered s of the Royal Opera House in 1995–6: a major street and alleys, with domestic and industrial buildings of the C7–C9. Long before the Norman Conquest this was abandoned in favour of the revived Roman settlement (*see* pp. 4–5). From the C12, but especially the C13, the Strand doubled as a kind of exclusive linear suburb, with great houses on the s side, accessible from the river. At the E end there was also a cluster of Inns of Chancery, commemorated in the present Clement's Inn, which belonged with the legal quarter around Chancery Lane (*see* especially *London 1: The City*). The parish churches of St Clement Danes and St Mary-le-Strand stood in

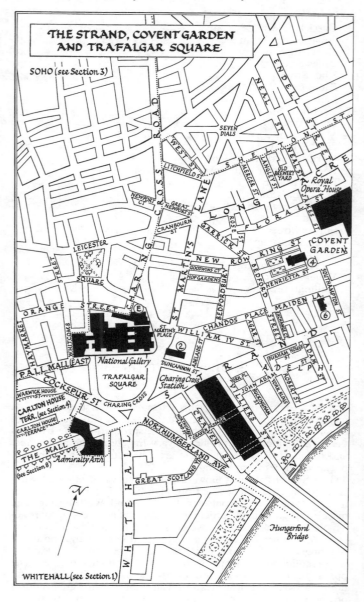

THE STRAND, COVENT GARDEN
AND TRAFALGAR SQUARE

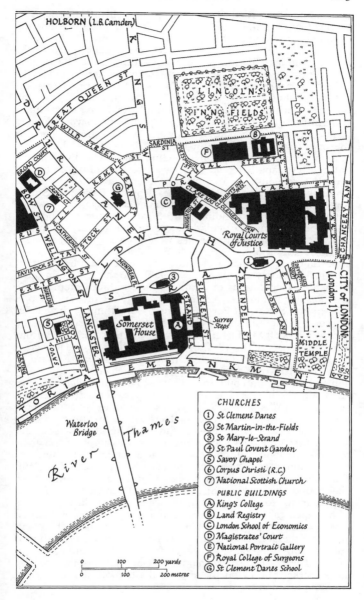

HOLBORN (L.B. Camden)

LINCOLN'S INN FIELDS

Royal Courts of Justice

Somerset House

Surrey Steps

MIDDLE TEMPLE

Waterloo Bridge

River Thames

EMBANKMENT

CHURCHES
① St Clement Danes
② St Martin-in-the-Fields
③ St Mary-le-Strand
④ St Paul Covent Garden
⑤ Savoy Chapel
⑥ Corpus Christi (R.C.)
⑦ National Scottish Church

PUBLIC BUILDINGS
Ⓐ King's College
Ⓑ Land Registry
Ⓒ London School of Economics
Ⓓ Magistrates' Court
Ⓔ National Portrait Gallery
Ⓕ Royal College of Surgeons
Ⓖ St Clement Danes School

0 100 200 yards
0 100 200 metres

the middle of the road, St Martin-in-the-Fields to the N and W, by St Martin's Lane. After 1290 Edward I marked the junction of routes at this end by the last of the crosses erected to his queen Eleanor, and the name Charing Cross was later applied to the area around it ('Charing' is older, derived from the Old English *cerr*, a turning or bend in a river). Religious houses along the Strand were surprisingly few. On the S side by Charing Cross was the Hospital of St Mary Rouncevall, an Augustinian foundation of 1222, of which the chapel lasted until 1608, the monks' quarters until 1705. Further E was the Hospital of the Savoy, founded as late as 1505 on the site of a royal palace; its simple chapel is the only standing building in the area from before the Reformation. From that time on the churchmen who lived in the palaces were rapidly replaced by lay aristocrats, of whose houses

p. 378 even less remains: the York Water Gate of 1626–7 on Victoria Embankment, and (probably) the 'Roman Bath' off Surrey Street, thought to be a relic of old Arundel House.

Of less exclusive buildings, the Strand by the C17 boasted numerous taverns, particularly around Charing Cross. By the early C17 also smaller properties were growing up fast along a tangle of lanes N of the Strand, despite official disapproval. Their appearance is familiar from drawings and old photographs, mostly four-storeyed or more, with gables to the street and often jetties too. Generations of clearance have reduced them to one untypically humble survivor, the so-called Old Curiosity Shop in Portsmouth Street, off Portugal Street. Something of the baleful

60 closeness of the suburb in its latter days can still be sensed in the narrow alleys off St Martin's Lane. Some of these, e.g. New Row,

p. 341 were enterprises of the 4th Earl of Bedford. The same earl owned the land of COVENT GARDEN itself, the great leap forward in early Stuart town planning (1629–37), which the King allowed him to build up on condition that the plan and designs of *Inigo Jones* were followed. The open land here, formerly a garden belonging to Westminster Abbey, was enough to lay out a whole new parish complete with church. Here for the first time a regular open square was created as an amenity for the houses, and for the first time also a uniform design was imposed on their builders. Of Jones's design one C19 near-replica of the terraces remains, along with his much-reconstructed church of St Paul. The rectilinear discipline was carried through into the street plan round about (King Street, Henrietta Street, James Street, etc.), but not to the houses there, which appear in early views with shaped gables and other individualisms. Another influential novelty was the provision of mews streets for the stables and offices of the greater households (Maiden Lane, Floral Street).

p. 342 Subsequently the Piazza was taken for a market, culminating in *Charles Fowler*'s large new market hall of 1828–30, followed by more market houses on the sites of the demolished terraces: a fate unique amongst the West End squares.

Covent Garden was the last big open area left, but later in

p. 335 the C17 the domains S of the Strand began to give way to new RESIDENTIAL STREETS. Buckingham Street and *Nicholas Barbon*'s Essex Street are of this time, and still show runs of the 1670s–80s. Later and more intact is Craven Street, 1730 and

later, though this was never an aristocratic house site. Nothing is left of *James Paine*'s Salisbury Street, 1765–73, with its mirrored terraces composed with grandeur on the slope to the river. It was far surpassed by the *Adams'* ADELPHI (1768–74), an entire miniature estate built on a much larger site, and set on a great embanked podium of brick vaults. Its plan remains, with several of the outlying terraces. Both schemes were made possible by the survival of large aristocratic freeholds. Largest landholder of all was the Crown, for whom SOMERSET HOUSE, the chief work of Robert Adam's rival *Sir William Chambers*, was begun just to the E in 1776. The site was that of the house Lord Protector Somerset built in 1547–52 and later adapted as a royal palace. The new occupants were government offices, the Learned Societies, and, at *Sir Robert Smirke*'s E wing of 1829–35, the new King's College. The Victoria Embankment has diminished the impact of the long lower terrace, which originally rose straight from the river. Inside the complex, however, the Georgian atmosphere is barely sullied, an atmosphere as much of an ideal classical city as of a single building.

59

pp. 319, 321

p. 15

The early C19 was especially concerned to improve and embellish the capital, by entire new routes and precincts as well as isolated monuments. In 1811–17 the first Waterloo Bridge, the third crossing in central London, was built just W of Somerset House. A little later much thought was given to the junction with the new Regent Street axis, which reached Pall Mall just W of the congested junction at old Charing Cross. On the N side of this junction stood the Royal Mews, a useful sacrificial victim for the new TRAFALGAR SQUARE, a brainchild of *John Nash*. Its completion dragged on – the lions on Nelson's Column were not finished until 1867 – but the remaining original buildings are all of the 1820s–30s, by leading classical architects of the day. Canada House is by *Smirke*, severely Grecian, the National Gallery, weaker but also more picturesque, is by *William Wilkins*, and the West Strand Improvements, a no less picturesque series of buildings in the Strand and around the new Adelaide Street, are by *Nash* and *Decimus Burton*.

p. 307

After the 1830s the Government lost interest in such great enterprises, however; Wellington Street, intended as a major new N–S route for traffic from Waterloo Bridge, dwindled in execution to a jerky series of widenings and incisions. The picture of VICTORIAN IMPROVEMENTS is therefore mixed. *James Pennethorne*'s plan of 1839 for through roads issued only in diminished fragments, at Endell Street (*see* Wellington Street) and Cranbourn Street. Garrick Street, begun in 1859 through a pocket of slums, was architecturally more ambitious, though short; it got under way only after the formation of the Metropolitan Board of Works in 1855. The Board's greatest effort was the VICTORIA EMBANKMENT, begun 1864: a heroic fulfilment of the dreams of generations of town planners, prompted by the urgent need to save London from choking in its own sewage. The great new drain ran alongside a new underground railway and carried a new highway on top, a parallel route to the Strand that continued down the Whitehall shore unhindered by the turbulence around Trafalgar Square. Most of the land thus reclaimed

4

was devoted to gardens – the largest green expanse in the area by far – while the old foreshore land to the N was freed for new users. The Savoy Hotel, begun 1889, is the most impressive survivor of these. A few wharfside buildings still stand as land-locked fossils: domestic C18 in Craven Street and Buckingham Street, a remodelled C18 warehouse in Villiers Street, and the rebuilt C17 archway in Essex Street. An almost unbroken run of hotels and chambers of the 1870s–80s remains along Northum-berland Avenue, a boulevard made by the MBW to link the Embankment with Trafalgar Square. Two other big C19 projects deserve mention, at opposite ends of the Strand. Charing Cross Station was built in 1860–5 for the South Eastern Railway, pushing across from the S bank on the axis of the short-lived Hungerford Bridge and Market, but has been much altered since. At the E end is *G.E. Street*'s Royal Courts of Justice of 1871–82, his greatest single work, almost unaltered outside and in.

More than seven acres of slums N of the Strand were levelled for the Royal Courts of Justice; four times as much land was cleared by the newly formed London County Council for the KINGSWAY and ALDWYCH scheme, London's most ambitious new roadways since Nash's time. The clearance stretched N from just W of the courts, and NW along Drury Lane. Under the plan settled in 1899, a broad N–S avenue ran S from Holborn to touch at the Strand end a crescent no less broad, with its W arm placed to take traffic from the top of Waterloo Bridge. Keen to avoid the timid architecture and shallow plans of earlier new streets, the LCC planned deep sites for the buildings, in such quantity that the last was not filled until 1935. Their fronts are of Portland stone, with the best in the Aldwych section. The new axis fixed for ever the division between the legal world around Lincoln's Inn Fields and the theatres and market trades around Covent Garden, areas which had previously shaded into one another.

That nothing so bold remains from the C20 was not for want of trying. In particular, a joint team working for the GLC, Westminster and Camden councils drew up drastic plans for the COVENT GARDEN area, in anticipation of the market's closure in 1974. Their defeat marked a turning point in the history of London, as important in its way as the first development of the 1630s. Unflagging community opposition, local government poli-ticking and shifts in general attitudes to historic townscapes all played a part. The First Draft Plan of 1968 already assumed that Fowler's market house would be restored, together with a 'char-acter route' from E to W. This would have entered the area from Bow Street, and continued W of the Piazza along King Street, Garrick Street and New Row. On this line ordinary buildings were to remain alongside the jewels, an idea reflecting the new concept of conservation areas. Outside this strip, much more radical replanning was proposed. A public open space was to be created to the N, along Long Acre. New buildings were to have included (in the Piazza) a conference centre, interconnected by elevated pedestrian decks of the kind then being enforced in the City. The decks were to have crossed two new E–W roads, one N of our area through Seven Dials, the other just N of the Strand, itself supplemented by a sunken four-lane carriageway. A revised

scheme of 1971, by the *GLC Covent Garden Development Team*, reduced the emphasis on traffic. Meanwhile the boroughs had fallen out of love with the plan, which had been met locally with a horror quickly translated into dauntless resistance. A Public Inquiry rejected the proposals in 1973 and, though it accepted redevelopment in principle, 245 buildings were listed in one go in the same year, killing the prospect stone dead. Small-scale restoration and infill were the norm thereafter, formally endorsed as planning policy in 1978, with the aim of protecting established trades and activities. Nor did the community groups rest content there: in the early 1980s a struggle with the GLC saved the Jubilee Hall of 1904, the one part of the market still scheduled for demolition. Already by 1980 Fowler's market had been converted by the *GLC Historic Buildings Division* to house restaurants and shops, the Flower Market had become the London Transport Museum, and a start had been made on rehabilitating the older houses, for example with 'period' shopfronts (Russell Street, Long Acre). The presumption in favour of keeping older buildings grew stronger as the unlikeliest industrial structures proved adaptable for e.g. dance studios, or (increasingly, by the early C21) luxury apartments. Almost the only parts of the 1971 plan to be realized in the end were two island blocks of offices and of *GLC* flats on the N side of Long Acre, completed 1981–2.

Nothing so sweeping was ever proposed for central London again; planning shrunk to something more regulatory and incremental, the commercial potential and historic interest of standing buildings and quarters were more carefully weighed, and new roads and traffic discouraged in favour of pedestrians, the true lifeblood of the city.* Though the old community has dwindled under commercial pressures, the runaway success of Covent Garden undoubtedly encouraged further attempts to tame road traffic and to make the city fabric more permeable generally. The Strand now benefits from *Westminster City Council*'s improvements of *c.* 1993–7, including a linear central refuge; public access was granted through Somerset House in 2000; and new walkways over Hungerford Bridge were completed in 2002. Pedestrianization of the N part of Trafalgar Square is also under way.

Finally, out of chronological order, BUILDING TYPES not otherwise mentioned above. The older PARISH CHURCHES were rebuilt after the Restoration: St Clement mostly by *Wren*, St Mary-le-Strand and St Martin-in-the-Fields by *Gibbs*, with the greater resources of the early C18. St Paul Covent Garden was also rebuilt after a fire in 1795, but on Jones's plan and with some of his materials. None of the C19 Anglican foundations around Covent Garden survives, though *Butterfield*'s rectory of St Michael Burleigh Street still stands, off Tavistock Street. From before the First World War there are also the Roman Catholic church of Corpus Christi, Maiden Lane, and the National Scottish Church off Russell Street, both on constricted urban sites, and a defunct early C19 chapel in West Street. Of PUBLIC BUILDINGS *Sir John Taylor*'s Magistrates' Court in Bow Street,

33
38,
p.
293

*The last wholesale erasure of urban fabric was for *Frederick Gibberd & Partners*' Arundel Great Court (1971–6), an office precinct on the S side of the Strand.

1879–80, is several degrees above the London average, but *Ewan Christian* and *J.K. Colling*'s National Portrait Gallery of 1890–5 suffers from a cramped site at the back of the National Gallery. The recent extensions to these galleries are diametrically different: extrovert and historically engaged at the National (*Venturi, Rauch & Scott Brown*, 1987–91), more introverted at the Portrait Gallery (*Jeremy Dixon/Edward Jones*, 1996–2000). The latter firm's Royal Opera House extension of 1997–9 is closer to the Venturi model, but less exhibitionist in its reinterpretation of the arcaded piazzas on Covent Garden proper. The same campaign restored *E.M. Barry*'s theatre of 1857–8 and incorporated part of his Floral Hall of 1858–60. The Opera House is treated here as a public building, other THEATRES under street entries. The area is of course especially rich in these, including the great Theatre Royal, in *B.D. Wyatt*'s incarnation of 1810–12, in Russell Street, *Samuel Beazley*'s Lyceum of 1834 in Wellington Street (both rebuilt in part), *Frank Matcham*'s Coliseum of 1902–4 in
112 St Martin's Lane, and the smaller houses of the Strand and Aldwych (though cinemas are entirely absent).

The Strand and Aldwych also feature several grand HOTELS of the latest C19 and early C20, the Savoy paramount. Examples from the less cosseting generation immediately before include *E.M. Barry*'s Charing Cross Hotel of 1863–5, and several in Northumberland Avenue and the Covent Garden Piazza, now in other uses. Victorian PUBS make a strong showing (Long Acre,
97 Catherine Street, St Martin's Lane). Individual HOUSES rarely stand out, apart from two in King Street, a high Baroque design of 1716–17 attributed to *Thomas Archer* and a smaller house by
59 *Paine*, besides the fragments of the Adelphi already mentioned. The chief reason is that the area was less appealing to the élite by the C18. The next century saw further declines in status, and later Victorian slum clearance schemes produced a representative parade of SOCIAL HOUSING along Drury Lane.

OFFICE BUILDINGS include examples of the fashion of *c.* 1860 for classicism diversified by Gothic-derived trim (Bedford Street, Garrick Street, Tavistock Street). In other Covent Garden streets the Bedford Estate sometimes compelled adjoining lease-holders to adopt matching designs (King Street, Henrietta Street, Tavistock Street). C20 highlights include the splendid shipping and travel headquarters in Cockspur Street, *Holden*'s former British Medical Association on the Strand (1907–8), and
4 from between the wars Shell-Mex House and the New Adelphi, a stone-faced Gog and Magog s of the Strand, overlooking the
p. Victoria Embankment. The last are now joined by *Terry Farrell*'s
301 Embankment Place (1986–91), an air-rights block over Charing Cross Station, one of the best London office schemes from the high Postmodern years. There is also the semi-public category of IMPERIAL HIGH COMMISSION BUILDINGS, grand stone affairs of the 1910s–30s: the former New Zealand House on
101, the Strand, Australia House and India House at the Aldwych,
109 and South Africa House in Trafalgar Square. The last two are under-rated works by *Sir Herbert Baker*, of special interest for their interiors in native styles and decorative ensembles by non-European artists. For INDUSTRIAL BUILDINGS one must

explore N of Covent Garden. Those in the utilitarian tradition include the charming Carriage Hall in Floral Street and the 1830s buildings for Combe & Co.'s brewery N of Long Acre. *A. W. Blomfield*'s premises in Garrick Street for Heaton & Butler, 1864, and Newnes's stone-faced building of 1934–6 in Southampton Street stand out amongst the more self-advertising buildings; the latter is the largest survivor of the many publishing and printing houses formerly in Covent Garden. For lovers of MONUMENTS the area offers all the riches of Trafalgar Square and the fullest 32 part of the Victoria Embankment.

FURTHER READING. The *Survey of London* vol. 35 covers the Theatre Royal and Royal Opera House, vol. 36 the rest of the parish of St Paul Covent Garden (both 1970). Dianne Duggan in *Architectural History* 43, 2000, adjusts the picture of the C17 development. Vols. 16, 18 and 20 of the *Survey*, 1935–40, deal with St Martin-in-the-Fields and its parish. J. Diprose, *Some Account of the Parish of St Clement Danes*, 1868–76 (2 vols.) covers this, much smaller area. Of a rich crop of books on Covent Garden, R. Thorne, *Covent Garden Market*, 1980, and J. Richardson, *Covent Garden Past* (1995) stand out, while the politics and planning are explained by J. Hillman, *The Rebirth of Covent Garden*, 1986, and R. Home and S. Loew, *Covent Garden*, 1987; C. Anderson, *Save the Jubilee Hall*, 1992, reports from the community side. Other monographs include C. Amery, *A Celebration of Art and Architecture*, 1991 (National Gallery), G. Hulme, B. Buchanan and K. Powell, *The National Portrait Gallery*, 2000, D.B. Brownlee, *The Law Courts*, 1984, A. Saint et al., *A History of the Royal Opera House*, 1982, D.G.C. Allan, *The Houses of the Royal Society of Arts*, 1982 (2nd ed.), and *The Adelphi Past and Present*, 2001, R. Somerville, *The Savoy*, 1960, and R. Mace, *Trafalgar Square*, 1976.

CHURCHES

ST CLEMENT DANES
Strand

Said to have been founded by Danish settlers in the C9–C10, but first recorded only in 1135. Clement's Well, mentioned in Fitzstephen's account of late C12 London, lay to the N. The present church is of 1668–70 (tower), 1680–2 by *Wren* (church) and 1719–20 by *James Gibbs* (upper tower and spire), all in good Portland ashlar. Burnt out in 1941; restored by *Antony Lloyd*, 1955–8, as the Royal Air Force church.

Wren's unusual plan requires explanation. The old church had a projecting chancel, single N and double S aisle, and W tower, all at a slight angle to the Strand. Wren kept the tower, which meant accepting the old alignment and curtailing his new church at the SE. His solution was to finish both E corners in convex curves, between which bulges an apse with a flattened end: a

markedly Baroque and immensely satisfying treatment, without parallel in the contemporary City churches. The side elevations recall St James Piccadilly (p. 584), Wren's ideal basilican galleried church: five bays, segment-headed windows below, taller round-headed windows in lugged frames above. The S side, more ornate, has garlanded cherub's-head keystones and cornice enrichments above the windows. The disparity is because the Strand originally ran along the S side only, the N side facing ordinary houses across the churchyard. The NW doorcase is rusticated and pedimented, its counterpart on the S plainer, but originally screened by a domed SW porch like a tempietto (removed 1813). In the early C19 also the parapet was stripped of Wren's urns. At the W END Wren added low domed lobbies flanking the tower, with shallow Baroque doorcases below big oculi. The latter are repeated in the W wall proper. The carver and chief mason was *Edward Pierce*.

The TOWER is typical London artisans' work of the 1660s, more profuse and less assured in its motifs than Wren. Its masons were *Joshua Marshall* and *Stephen Switzer*, either of whom may have provided the 'plottforme' mentioned in the contract. Curious obelisk-buttresses, seemingly a Gothic reminiscence and not an encasement of older masonry. Round-headed apertures with Y-tracery, another Gothic echo. Awkward main doorcase with Tuscan pilasters set against channelled stone. Odd bulging frieze; odd top feature with squashed-looking scrolls and tablet. The fluted urn is C18. Above were stubby pinnacles and an octagonal lantern, removed by *Gibbs* in 1719–20. His work begins with the clock stage, above which are bell-stage windows with typical Gibbs surrounds. Though the heightened tower is some-what too tall, its graceful spire is faultlessly proportioned. Three diminishing octagonal stages, the middle one with a concave architrave à la Baalbek. Urns on the lower two stages; urns on the corners of the tower, where the plinth comes diagonally forward. The mason was *John Townesend*. Some Wren churches in the City were also given spires in the 1710s–20s.

33 The reconstructed INTERIOR has plasterwork, galleries and some fittings redone from drawings and photographs of the C17 work (omitting embellishments of 1897–8). One of the most successful post-war Wren church restorations, atmospheric and wholly convincing. The remarkable feature is the E end, where Wren's barrel-vaulted nave curves down towards the apse. The ceiling here has thick plasterwork, with the royal arms on an even bed of leaves (Wren's plasterers *Robert Powell* and *Edward Goudge*). A narrower barrel-vaulted bay follows, then the apse proper, with rich diagonal coffering intersected by the E window. The nave is more straightforward, with Corinthian columns rising from gallery level to groin-vaulted aisles. Innovations of the 1950s include some 750 floor-set RAF BADGES of slate (carver *Adam Bienkowski*), and the broad spiral staircase in the SW lobby. It leads up to the gallery and down to the CRYPT, restored as a chapel. This lies N–S, of four aisled bays, with a pointed groin vault on cylindrical piers.

FITTINGS. The new woodwork is dark-stained. REREDOS, a near-copy of *Pierce*'s of the C17. Paired columns set diagonally. – ALTARPIECE by *Ruskin Spear*, a diptych of the Annunciation.

Gentle figures in the Neo-Romantic manner, the colours bistre and umber.★ – In the E windows STAINED GLASS by *Carl Edwards*, 1958, stiff and formal by comparison. – The THRONES in the chancel incorporate C15 Florentine embroideries. – Wrought-iron COMMUNION RAILS and LECTERN by *Lloyd*, in a traditional style. – PULPIT. The chief C17 survival. Hexagonal, with profuse garlands and drops (carver *Pierce*) framing inlaid circular panels. – SHRINES in the aisles for Books of Remembrance, glass-fronted, with miniature domes like those on the W lobbies. – ORGAN (W gallery). By *Ralph Downes*, the case after that for the 1690s instrument by *Father Smith*. – FONT (crypt). A big drum of black Norwegian granite. – MONUMENT here to the European Resistance, a bronze relief by *Elizabeth Lucas Harrison*, 1981.

MEMORIALS. W of the church STATUES of the RAF's wartime leaders, by *Faith Winter*: 1st Lord Dowding, 1988, S, 'Bomber' Harris, 1992, N. Further W the GLADSTONE MEMORIAL, 1899–1905 by *Sir Hamo Thornycroft*, on a base designed by *John Lee*. A fine robed figure, with allegorical groups on four lower, diagonal pedestals (Courage, Aspiration, Brotherhood, Education). Until *c.* 1994 the roadway encircled it. E of the church the JOHNSON STATUE, given by the sculptor *Percy Fitzgerald* in 1910. Affectionate caricature reliefs on the plinth. Further E a superior cast-iron LAMP STANDARD of *c.* 1890.

ST MARTIN-IN-THE-FIELDS
St Martin's Place and Trafalgar Square

First recorded in the later C12. Rebuilt by *James Gibbs* in 1721–6, at a cost of £33,661. It is as grand an C18 church as any in London. Even those built under the New Churches Act of 1711 do not surpass it. Its magnificent temple front, a portico of six giant Corinthian columns with a pediment, was something new in English churches, though Hawksmoor's St George Bloomsbury (*see London 4: North*), started in 1716, and John James's St George Hanover Square, started in 1721 (*see* p. 479), must have been known to Gibbs.★★ What he contributes and what turned out to be a doubtful blessing, as it became very widely imitated (also in Ireland and America), was the way he combined portico and steeple. He placed the latter over the middle of the W end with staircase lobbies l. and r., and then pushed the portico in front of the W front. Integration this can hardly be called. The idea was already suggested by Gibbs in designs for London churches made 1713–14, and again in his alternative schemes for St Martin submitted 1720, which featured a dramatic circular nave. The steeple is an excellent design, the bell-stage with coupled pilasters, the lantern recessed, octagonal and with attached columns, then a concave-sided entablature and concave-sided obelisk spire with

★ *William Kent*'s altarpiece of 1721, of which his enemy Hogarth engraved a hilarious travesty, was burnt in the war.

★★ *John James* proffered designs for St Martin too, as did *Nicholas Dubois*, *George Sampson* and *James Thornhill*.

three tiers of circular openings. The height is 192 ft (58.5 metres).
Upper part rebuilt exactly 1842.

The treatment of the sides and back is monumental too – as
Gibbs liked it (cf. his All Saints, Derby, and St Nicholas,
Aberdeen). The sides begin with special stress on the steeple bay
by means of a pair of recessed giant columns between giant
pilasters. Then the five bays expressing the body of the church:
giant pilasters again and windows in two tiers, both with the char-
acteristic blocked surrounds. The E bays repeat the W bay treat-
ment, and there are indeed inside here another pair of staircases.
On the E façade is a very large Venetian window between two
bays treated like the N and S sides, but with two outer half-bays
to make up the width. Balustrade on top, coming out on to the
portico. Gibbs's presentation drawing shows urns along this
balustrade, as does the impressive model for the church now at
the Victoria and Albert Museum (which also shows an alterna-
tive treatment of the spire), but these may well not have been
carried out. Royal arms in the W pediment carved by *Christopher
Cass Sen.*, the chief mason. Other craftsmen included *Thomas
Bridgwater*, also paid for carving, and the carpenters *Benjamin
Timbrell* and *Thomas Phillips*.

The spectacular position of the church is a C19 contribution.
Before Trafalgar Square was made it simply faced the lower end
of St Martin's Lane. The portico steps narrowly escaped removal
when Charing Cross Road was made in the 1870s; in 1900 they
were slightly cut back. Fine cast-iron RAILINGS close in the
portico (maker *William Nind*, 1737). They were extended around
the churchyard in 1829–31, to a matching design (makers *Cottam
& Hallen*). MARKET STALLS to the E by *John Prizeman*, 1988–9,
with cast-iron Doric columns. Under the portico a SCULPTURE
called In The Beginning, a stone block with a roughened top
revealing a new-born baby. 1999 by *Mike Chapman*.

The INTERIOR looks back to Wren's St James Piccadilly (*see*
p. 584); that is, it has a wide not very tall nave without a clerestory,
covered by an elliptical barrel vault (Gibbs considered an ellip-
tical profile gave a better acoustic than a segmental one). But the
columns are giant, as formerly at Wren's St Augustine, City, with
balconies fitted in above the level of their bases on three sides.
Another difference from St James is the use of square blocks of
entablature between column and vault. This more classically
correct treatment, in line with C18 preferences, can also be read
as the consquence of Gibbs's use of shallow saucer-domes over
the aisles (rather than the transverse barrel vaults on full entab-
latures at Wren's St James). The special feature of the E end is
that the chancel is narrower than the nave. Two boxes look into
it from the N and S, and also open diagonally towards the nave.
The N side was the royal box, facing the Royal Household. These
sweeping sides as a transition from nave to chancel, and the
way the ceiling also curves down, derive from another Wren
church, St Clement Danes (q.v.), with whose spire Gibbs was
then busy. The unique effect here is the interpenetration created
by the boxes. Plasterwork shared between *Giovanni Bagutti* and
Chrysostom Wilkins, very rich, but neither as dense nor as indi-
vidual as Wilkins's work at St Mary-le-Strand (q.v.). The W

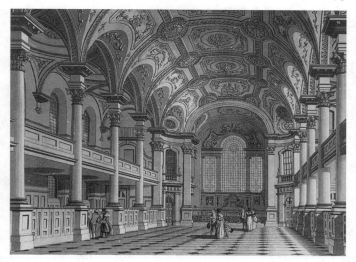

St Martin-in-the-Fields. Interior. Engraving
(Thomas Malton, *A Picturesque Tour through the Cities of London
and Westminster*, 1792)

lobbies have solid close-string staircases of timber, in the N one
continuing with a more slender upper flight.

FURNISHINGS. COMMUNION RAILS, 1720s, reordered in
T.H. Lewis's alterations of 1858. Partly cast-iron, said to be the
earliest communion rails in this material. They formerly curved
outwards. – Neo-Georgian REREDOS or hanging-frame by *E.
Maufe*, 1924. – MOSAICS in the chancel, after 1882. – PULPIT.
Hexagonal. Presumably that designed by *Gibbs*. Exceedingly
dainty staircase, seemingly remodelled, with three thin twisted
balusters to each step. – BOX PEWS of 1799, lowered in 1858 and
again altered in *Sir Arthur Blomfield & Son*'s restoration, 1887. –
STALLS of 1858. – ORGAN by *J. W. Walker & Sons*, 1990, with case
in early C18 style. The C18 organ is now at Wotton-under-Edge
church, Gloucs. – FONT of veined marble, oval, of 1689 (from
the previous church). – FONT RAILS, very pretty, with repoussé
panels; from St Matthew Spring Gardens (1731, dem.). – CHEST
of 1597, within the rails. – Six replica CANDELABRA of *c.* 1978.
– SCULPTURE. St Martin and the Beggar by *James Butler*, 1951
(S aisle). Bronze group by *Chaim Stephenson*, 1994 (W end). –
Patterned post-war GLASS; originally the E window had painted
glass by *James & William Price*, 1726. (Not on display in 2003:
FONT COVER, and WHIPPING POST dated 1752.)

The CRYPT below has brick groin vaults on three rows of
massive, short pillars. Subdivided in 1987 by *John & Mark
Prizeman*, for a café and shops; further reordering by *Eric Parry
Architects* is proposed (2003). At the W end some minor MONU-
MENTS. Sir Theodore de Mayerne †1655, the famous physician

painted by Rubens. Half-effigy on a tall plinth. – Elizabeth Macdowall †1670, tablet with frontal bust held by two putti. Attributed to *Jasper Latham* (GF).

OLD ST MARTIN'S was large, aisled, and externally messy: the result of work particularly of 1606–9, when the chancel was rebuilt and the nave enlarged. The tower, at the NW, was reconstructed in stone in 1662–8 by *Richard Ryder*, with a cupola of 1672 by *Wren*. Stukeley described a 'Roman brick arch' found in the excavations in 1722.

For auxiliary buildings to the N *see* Adelaide Street.

ST MARY-LE-STRAND
Strand

1714–17 by *James Gibbs*, his first work, under the 1711 Act for the Fifty New Churches; consecrated 1724 (masons *John Townesend* and his brother *William*). Gibbs took over the job from *Thomas Archer*, whose church got no further than foundations. It resurrected a church first mentioned as a chapelry in 1150 but demolished by 1548 for the first Somerset House (q.v.); the parishioners used the Savoy Chapel in the interval.[*]

The church is admirably placed on an island site in the Strand, and visible from all sides, as if it were a casket one can handle with one's hands. Indeed all sides are treated with loving care. The E end, in its composition and such details as the long fine festoons l. and r. of the apse windows, is taken from St Paul's, but the slender proportions give it quite a different mood. The N and S sides are of seven bays, in two orders (Corinthian over Ionic), also as at St Paul's. But the orders here are columns, and the way in which bays two, four and six project and are crowned by pediments of alternating shape set against the balustrade adds a livelier, much more diversified rhythm. Surmounting urns, in a different rhythm again. The lower stage has channelled stone with playful little niches in each bay, while in the five central bays the upper stage features Venetian windows with pilasters, appearing as if behind the front layer of columns. The end bays are narrower and have pedimented windows instead. All this movement and layering points back to Gibbs's Roman training with Carlo Fontana – something which leached out of his later designs – though the whole is nothing like a Roman church. The W front repeats these motifs, but adds the eminently successful semicircular entrance porch with its concentric steps, taken from the transept fronts of St Paul's. Above are paired columns carrying a pediment, and immediately behind this the tower goes up. On top of the clock stage is an oblong stage with detached columns carrying a slight entablature to N and S only. Then follow some pretty bits of decoration, and then a similar motif, but smaller and less high, with a square core and overlapping angle pilasters, and on top of this a slim concave-sided top stage on which the little lantern is perched. Reading from bottom to top, there are

[*]Not to be confused with Holy Innocents to the N of the Strand, recorded in 1085 and suppressed in the mid C13 (though still standing as a ruin in 1324).

five diminishing round-headed openings, those of the tower separated by circular openings that themselves diminish as they rise. These subtleties are all the more remarkable in that a tower was not at first intended: Gibbs's plan had been for a huge column topped by a statue of Queen Anne in front of the w end.

Now the INTERIOR. It is surprisingly simple in its omission of aisles, but otherwise both thoughtful and elaborate. The super-imposed orders are repeated, but in a richer dress, Composite over Corinthian. By the apse they give way to superimposed coupled columns which support a cramped-looking pediment, echoing the motif of the w front. At the w end the lower order steps forward with coupled columns, supporting a balustraded gallery. Light comes from three round-headed windows in the apse, and from nave windows set high up to exclude noise. Their heads intersect the elliptical-vaulted ceiling, which is 38 richly coffered in an odd pattern of squares and lozenges in bands (plasterers *John* and *Chrysostom Wilkins*). It is inspired by Fontana's SS Apostoli and Cortona's SS Luca e Martina, both in Rome. Roman too the thick carved stonework of the apse, with no fewer than thirty-three cherubs' heads variously arrayed in an architectural framework. Little circular vestries fill the E angles.

FURNISHINGS. Chiefly original. PULPIT of 1720–3 (joiner *John Simmons*). Generous bellied outline, finely decorated with openwork carving round the base. Cut-down foot, very short and thick. – PANELLING, carried round the apse in place of a full reredos, and into the vestries and the muniment room (on the w gallery). – COMMUNION RAIL. Also by *Simmons*. Fluted balusters fashioned as Doric columns, on bulbous turned bases. Moved forward in *R.J. Withers*'s restoration, 1869–70 (other major repairs 1887–9 by *Macvicar Anderson*, 1933–4, 1981–6 by *Purcell Miller Tritton*, who rebuilt the steeple, etc.). – ROYAL ARMS over the apse. – Set into the chancel walls, two PAINTINGS by the American-born *Mather Brown*, 1785: Agony in the Garden, s side; Annunciation, N side. – Plain FONT of veined marble, on baluster stem. Small flattened domed COVER. – PEWS and STALLS, reworked in 1869–70. – STAINED GLASS. Apse, of rich deep blues, *c.* 1947 by *Sidney Toy*. The rest, patterned glass made by *W.M. Pepper*, begun 1871. – At the w end six framed PORTRAITS of parish worthies, C18–C19. – GATEPIERS to the little churchyard at the w, with Gibbsian carving. Not *in situ*.* – GATES of *c.* 1840. – RAILINGS: w end, *c.* 1890; E end, of traditional but free design, 1990.

ST PAUL COVENT GARDEN

By *Inigo Jones*, built 1631–5 in connection with the 4th Earl p. of Bedford's new Covent Garden (q.v.). The earliest mention 341 dates from 1629, the consecration from 1638. The first new

*A little watchhouse by *Sir William Chambers*, added between them in 1780, was removed *c.* 1840.

parish church in London since before Elizabeth's time, it broke completely with native architectural traditions: a new way of building, intended to suit the Protestant Church of England.

The legend that Jones promised Bedford the 'handsomest barn in England' is familiar, and the church is in fact a perfectly plain oblong with no subdivision inside.* Widely overhanging eaves, deep portico with two square angle piers and two sturdy Tuscan columns between. The conceit of square piers derives from the Etruscan temple as illustrated by Scamozzi, the rest from Palladio's Tuscan order, though with rather different proportions. Originally there were six or seven steps up from the Piazza, so that the temple origin was more explicit. The Burlingtonians venerated this essay after an Antique type, and *Lord Burlington* himself was said in 1727 to have spent over £300 restoring the portico. The church also points forward – more so than any other work by Jones – to the simplicities of late C18 Neoclassicism. The Piazza lies at the E end, and since the church is properly oriented the big E doorway is thus a sham. Contemporary evidence shows however that the altar was originally meant for the W end, with the entrance under the portico. The plan changed during construction, probably due to Bishop Laud's intervention. Rusticated GATEWAYS to either side, reinstatements by *Donald W. Insall & Associates* of C17 ones removed in 1877. Jones's source for them was the Roman amphitheatre at Verona. The dates are 1991–2 (N) and 1995 (S, with a pretty fountain behind).

Though Jones's conception can be savoured undiluted, the church has had an unlucky history, and the visible fabric is mostly C18 or later C19. The red brick facing is as late as 1887–8 (by *A.J. Pilkington*). Jones's walls, of rendered brick, were stone-faced in 1788–9 by *Thomas Hardwick*, but badly damaged by fire in 1795. Hardwick restored the shell up to 1798, renewing the portico (which has a plaque inside commemorating the work). The present big side arches were made during *Henry Clutton*'s restoration of 1878–82 to ease the passage of market traffic. Originally they were narrower and lower, smaller even than Jones's simple arched windows on the N and S sides. These have frames running round uninterruptedly. Before Clutton each side had a fourth window at the extreme E, the blocked outlines of which may be seen inside. Clutton also took down Hardwick's bellcote (larger than the one by Jones) from the ridge of the roof.

Entrance is gained by passages through the churchyard from the streets to the N, S and W. The W FRONT has two more round-arched windows and a central doorcase with oculus over, i.e. the same arrangement as within the portico (if only because *Butterfield*'s restoration erased lesser doorways beneath the windows there, 1871–2). Low wings to each side: an original feature, made lower by *Clutton*. Also by him the semicircular steps and the holes cut to house the bells. The interior has a spare quality that may not be far from what Jones intended, though nothing remains from his time. His ceiling is known to have been painted in false

* The theory that this represents a 'Puritan' style now looks untenable: *see* Dianne Duggan in *Architectural History* 43, 2000.

perspective. The present ceiling is compartmented plaster of 1887–8, to a more Jonesian design than Hardwick's; it may well be Clutton's brainchild, carried out by Pilkington.

FITTINGS. REREDOS designed by *Hardwick* in the shape of a four-pilastered Corinthian portico. Reset higher by *Butterfield* in 1871–2, and stripped of its seated angels. The PAINTING is a tondo after Botticelli. – COMMUNION RAIL designed by *Hardwick*. Wrought iron, with narrow S-scrolls. – Polychrome PAVEMENT by *Butterfield*. Inappropriate. – SCREENS of Roman Doric columns projecting on the l. and r. The columns and urns come from the former N and S galleries, removed in 1871–2. The raking W GALLERY remains, remade probably by Butterfield, using more of Hardwick's columns. (Jones did without galleries, but the parish installed four between 1643 and 1675, one side at a time.) – PULPIT. Designed by *Hardwick*. Hexagonal. The lower parts seem to incorporate older carvings. – FONT. Cast stone, late C17 style, with baluster stem. – WOOD CARVING on the W screen. Wreath of flowers from St Paul's Cathedral by *Grinling Gibbons*, who is buried here (†1721). Presented in 1965 as his memorial. – STAINED GLASS. E windows by *Brian Thomas*, 1968–9. Golden C17 motifs against clear glazing. – MONUMENTS. John Bellamy, of the Whig Club, by *J. Flaxman*, 1795. – Edward Hall, 1799, also by *Flaxman*, very Athenian. – Ellen Terry. Silver cinerary casket and surround in Art Nouveau taste, 1929, by *Paul Cooper*. – Many C20 tablets to other theatre folk, famous or forgotten. – CHURCHYARD laid out by *Clutton* with dwarf walls, 1878–82; nice GAS LAMPS. C18 GATES of wrought iron to W, S, and N.

SAVOY CHAPEL
Savoy Hill, off Savoy Street, Strand

Built in 1510–16 as part of the Hospital of St John (*see* below). Restored 1864–5 by *Sydney Smirke* after a fire, and adapted by *Malcolm Matts* for the Royal Victorian Order in 1939–40. The chapel is aisleless and very simple, of five unbuttressed bays. Tall late C19–C21 back elevations corral it gloomily about. Transomed three-light windows in hollow-chamfered reveals, cusped on the upper lights. The C19 renewals are seemingly reliable, apart from the S wall and thin bell-turret, of squared rubble. This was *Sir Robert Smirke*'s doing, of 1820–1. It replaced a SE tower and an ante-chapel that once joined the rest of the hospital. Low offices and robing room to the W, of brick, added 1957–8 by *A.B. Knapp-Fisher*. At the N they engulf a vestry of 1877 by *J.T. Perry*. Churchyard to the E. The flat timber ceiling, a close but not exact approximation to the burnt C16 one, has an applied mesh of quatrefoils in two sizes. Painted shields stand in for the Tudor carved ones. The treatment owes something to *T. Willement*'s restoration of the old ceiling after a lesser fire in 1843. At the E end remains of a painted FRIEZE, probably from *Clayton & Bell*'s work of 1886, and a damaged square-headed PISCINA.

FURNISHINGS. REREDOS, an elaborate panelled Dec affair by *Sydney Smirke*, 1864. On it a small PAINTING of the Virgin and

angels, from a C14 Italian polyptych. – WAR MEMORIAL with bronze figurine by *Gilbert Bayes*, 1920. – Also by *Bayes* the bronze Art Nouveau LECTERN, 1915 (vestibule). – STALLS. Ritual E, *c.* 1865, ritual W, 1939–40, for the Order. – ORGAN of 1965 over the W stalls. Dramatically outswept case, designed by *A.B. Knapp-Fisher*. – FONT and COVER by *Edward Blore*, 1864. Very fancy late Dec. – STAINED GLASS. Ritual E window and five windows nearest, 1952–6 by *Joan Howson*, with lettered pictures and lots of bald patches. – Ritual N. George V window by *Reginald Bell*, 1935. Rev. Henry White memorial by *Clayton & Bell*, 1891. – Ritual S. D'Oyly Carte memorial, 1902 (altered). By *E.J. Prest*, after designs by *J.E. Carr*. Ugly angels singing. – In the internal vestry window C13–C16 pieces, given 1954.

The chapel is a reminder of the HOSPITAL OF ST JOHN OF THE SAVOY, successor to the great palace of that name. Henry III granted its land to his kinsman Peter, future Count of Savoy, in 1245. His palace was acquired in 1284 by Edmund of Lancaster, brother of Edward I, and extended and grandly rebuilt from 1351 by Henry of Lancaster, but was sacked during the Peasants' Revolt of 1381, when it belonged to John of Gaunt. It stood derelict until 1505, when Henry VII ordered its replacement by the new hospital, finished *c.* 1517. The main structure, E of the chapel, was cruciform: the usual plan for Italian hospitals after the mid C14, and one which also found favour in Spain (cf. the Hospital de la Santa Cruz, Toledo, 1504–14). The S transept joined on to a domestic riverside range, at the W end of which a N–S wing housing the master's lodgings extended back up to the chapel. Suppressed in 1553, the hospital was revived in 1556 by Queen Mary, but in 1702 again suppressed. Defoe in 1725 called the Savoy 'not a house, but a little town, being parted into innumerable tenements and apartments'. Some were used by foreign Protestants, other parts for barracks, which burnt down in 1776. Ambitious plans by *Chambers* to replace them came to nothing. Not until 1816–20 was the site cleared, and the Waterloo Bridge approach, a W addition to Somerset House (q.v.) and the street called Savoy Hill laid out.

CORPUS CHRISTI (R.C.)
Maiden Lane

1873–4 by *F.H. Pownall*, his last church. Yellow brick with stone dressings, early French Gothic style. Heavy N (ritual W) tower with pyramid spire, without entrance. Presbytery to the l., gabled, banded with white and black brick. The interior is aisled, tightly planned, and not on axis with the street front. Of red brick, now overpainted. Ritual N aisle carried on as a chancel chapel. *Thomas Earp* carved the capitals and also the HIGH ALTAR of Caen stone with its figure group, likewise partly overpainted. – ALTAR in front, later C19 Continental work, with a marble relief of angels. – STAINED GLASS. E window, four quatrefoils of saints, 1876, designed by *Percy Fitzgerald*. – N chapel, Coronation of the Virgin, unusually good, probably of similar date. – Ritual S aisle by *Mayer*

of Munich, blocked externally. – FONT. Unearthed on site during construction. Octagonal, with figured quatrefoils on each face. It looks like English C15 work, but is said to have come from a C19 mason's yard. – STATUE. Gentle standing bronze of St Tarsicius, a boy martyr, by *Karin Jonzen* (†1998).

NATIONAL SCOTTISH CHURCH
Crown Court, north of Russell Street

1909 by *Eustace Balfour* (of *Balfour & Turner*). Externally undemonstrative, red brick and stone, leavened with a few C16–C17 reminiscences. At the s end a square open turret. The rectangular interior, rising from the first floor, is an imaginative evocation of early C17 Scotland, with much timber sheathing of the steel frame. Galleries on lean square piers diagonally braced, simplified rib-vaulting over the aisles, tie-beams with queenposts to the clerestory. Over the ritual E end rich strapwork, and the arms of George I (plasterer *J.M. Turner*). These commemorate the first church on the site, of 1719. – Of *c.* 1909 the plain FONT of Iona marble and the ORGAN, given by Andrew Carnegie. – STAINED GLASS. Small post-war panels by *Reginald Bell* (1947–55), *M.C. Farrar Bell* (1974, etc.), and others.

FRIENDS' MEETING HOUSE *see* ST MARTIN'S LANE

PUBLIC BUILDINGS

CHARING CROSS STATION
Strand and Victoria Embankment

A medium-sized terminus, built in 1863–5 for the South Eastern Railway (Act 1859). The engineer was *John Hawkshaw*, the contractors *Lucas Bros*; the old Hungerford Market provided the site (q.v. Hungerford Bridge). The HOTEL facing the Strand is by *E.M. Barry*, his proudest effort, richly adorned with aedicules and such-like Mixed Renaissance motifs. It was probably the first English building on which terracotta was used so extensively. Here it is *Blanchard*'s, of a pale stone-like colour masked by painting. Around 1953 *F.J. Wills & Son* rebuilt with straight horizontals the two pavilioned top storeys, suppressing the French accent that Barry no doubt thought proper for a Channel Ports station. More attractive are the little non-matching conservatories over the end porches: the l. one added before 1897, the other not long after. There were 214 bedrooms originally. From the long E wing a cast-iron bridge, itself suggesting a

mid-Victorian railway carriage, crosses Villiers Street to a tall brick EXTENSION by *J.L. Fish*, of 1879–83 and more conventionally ornamented. In the main part quite a grand open-well staircase. The best interior is the former COFFEE ROOM in the E wing, first floor, a large tall square with splayed corners and red marbled columns. Winged female figures in the splays. A big tearoom with a coffered ceiling faces the Strand.

In front of the hotel the substitute ELEANOR CROSS, designed by *E.M. Barry*, and carved by *Thomas Earp*, 1864–5. *Arthur Ashpitel* 'assisted *con amore* in the search for precedents' (*The Architect*), though the admixture of red Mansfield stone makes it more unmistakably Victorian than, say, Scott's Martyr's Memorial at Oxford. The cross of *c.* 1293 stood further W, where the Charles I statue now is (*see* Trafalgar Square), and marked the last resting place of the funeral cortège of Edward I's queen on its journey from Harby in Notts. to the Abbey in 1290. Piers in front, reinstatements of 1989 after *E.M. Barry*.

The STATION itself, opened in 1864, was redeveloped in 1986–91 by *Terry Farrell & Co.* on the 'air rights' principle (engineers *Ove Arup & Partners*), raising over the platforms a huge office block called EMBANKMENT PLACE. Nothing this fearless had been done on the N embankment since the 1930s, and as a piece of scenography Embankment Place is the equal of Whitehall Court or Shell-Mex House. It forms a great mass with a curved roof, stepping down at the river end by two storeys, also with a curved roof. On each side are three stone-faced towers, topped by bow-fronted meeting rooms. Their inner sides slope back to meet the roof. The sources owe much to American Postmodernism, and even where Farrell's high-tech roots show, as in the steel chevrons crossing the curtain-walling at this end, the effect is of decorative patterning. The curve of the roof is made by seven giant arched trusses, rising from piles driven through the C19 substructure. The form also recalls the 1860s station roof, which had unbuttressed segmental trusses. This collapsed in 1905, to be replaced by a visually less interesting horizontal structure, part of which remains over the concourse. Closer to, the new block brings to life the station side of Villiers Street, with a sheer-sided forebuilding faced in red brick between polished black stone ends. In the outer parts vast circular openings, showing where a new pedestrian passage is threaded through from the concourse to Hungerford Bridge. Behind the l. part is a great recess for the office entrance (PRICEWATERHOUSE-COOPERS), converted from one of the C19 vaults. Mysteriously lit, with a fountain issuing as if from a giant pipe, this space suggests the sanctum of some strange earth-cult. Upper interiors with two plain atria, fitted up by *Swanke Hayden Connell*, 1992, rather less spectacularly. The tunnel-vaulted CRAVEN PASSAGE, r., has been restored as a shopping arcade. In the vaults here is the PLAYERS' THEATRE, relocated from the old Gatti's music-hall premises in the vaults facing Villiers Street, which it had used since 1946. Mostly scavenged fittings. Farrell also refaced the landward spans of Hungerford Bridge, beyond, and made another shopping arcade below one of them. The details here are nowhere near as good.

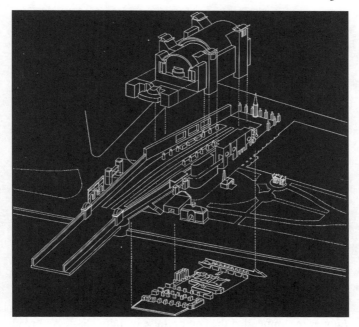

Embankment Place (Charing Cross Station).
Exploded drawing

CHARING CROSS UNDERGROUND STATION. On the
Northern Line platforms appealing MURALS of 1979 after wood-
cuts by *David Gentleman*, showing the Eleanor Cross being made.

COVENT GARDEN MARKET *see*
COVENT GARDEN

HUNGERFORD BRIDGE

A glum utilitarian railway bridge by *John Hawkshaw*, 1860–4, to
the South Eastern Railway's Charing Cross station (*see* above).
Transformed with new walkways by *Lifschutz Davidson* and the
engineers *WSP Consulting* in 1999–2002, following the lead
set by the many spectacular and celebratory footbridges in the
regenerated Docklands. Several big changes were made to the
competition-winning design of 1995–6. This was meant as a
Millennium project, but suffered several delays, partly due to fear
of unexploded wartime bombs in the river bed. The final cost
was £30 million.

The broad WALKWAYS hang well clear of the railway bridge from angled spear-headed pylons, which rest on new caissons linked underwater and back to back. The upstream walkway allows superb views, lost to pedestrians since a previous walkway was sacrificed for *Brady*'s bridge widening of 1882–8. The disappointment comes at the ends, where structural poetry gives way to mere prose: lightweight staircases with brittle-looking glass balustrades, set end-on or at right angles. The previous design featured a more dramatic South Bank approach, via circular bastions and gangways leading diagonally to shore.

The C19 BRIDGE has nine spans, the six river spans of 154 ft (46.9 metres). Pin-jointed trusses, a fine example of the techniques of the period; the cross-girders renewed in 1979. The two red brick piers were reused from *I.K. Brunel*'s HUNGERFORD FOOTBRIDGE of 1841–5, a suspension bridge which at 676 ft (206 metres) had a larger span than any in Britain. Architectural detail was by *J.B. Bunning*. Its chains were used in 1861–4 to complete Brunel's Clifton Suspension Bridge at Bristol. The footbridge was meant to encourage trade at Hungerford Market, a late Neoclassical masterpiece by *Charles Fowler* of 1831–3, pulled down to build the station. It had a fish market by the river, with steps up to a general market in an austere basilican hall by the Strand.*

The new walkways conclude the saga of attempts to replace this ugly railway bridge. From the late C19 a new road crossing was favoured, and in 1927 a Royal Commission advised by *Lutyens* recommended the compromise of a double-decked road and rail structure, but Waterloo Bridge was rebuilt and widened instead. No more successful was the *Richard Rogers Partnership*'s poetic high-tech fantasy, exhibited 1986, for a cable-stayed monorail shuttle with a walkway on top.

KING'S COLLEGE (UNIVERSITY OF LONDON)
Strand

Founded in 1828 as an Anglican riposte to the 'Godless' University College in Bloomsbury. It was granted the E part of the Somerset House site (q.v.), previously used as the building yard of the Office of Works. The Old Building is of 1829–31 by *Sir Robert Smirke* (*see* below). It stands on the E side of a long narrow court, and shows itself externally only towards the Thames, where Chambers's splendid motif of the arch with the open colonnade above was repeated (completed 1835). Beneath lie massive concrete foundations, a Smirke speciality. The college had little money for land to the N, so Smirke's original Strand entrance was an exceedingly modest archway. Pugin had an easy job making this appear mean by showing it in *Contrasts* (1836) side by side with the gateway of Christ Church, Oxford.

The college is now entered through the NEW BUILDING of 1966–71 by *Troup & Steele*, consultant *E.D. Jefferiss Mathews*. A long front to the Strand, with a driveway into the courtyard.

* *See* Gavin Stamp in *A.A. Files* 11, 1986. The market itself was founded in 1681.

Two recessed and four oversailing storeys, as restless as possible, then three top storeys which are completely different: flush, with long, even window bands, as if they were a later addition made to gain space. The lower parts have chamfered and stop-chamfered precast members and verticals and horizontals connected by diagonals. Entrance remodelled 1997 by *Shepheard Epstein Hunter.* By the courtyard entrance a wall-mounted SCULPTURE by *Fred Kormis* called The Marchers, given 1975.

The view from here has on the W nothing but the brick back of the Somerset House quadrangle. On the E Smirke's OLD BUILDING appears in sharp foreshortening. The design is some-what stereotyped, with none of Smirke's usual Grecian purity – partly, no doubt, because its N end is visible from the Somerset House courtyard and so had to be harmonized with it. Twenty-five bays long and two and a half storeys high, stone-faced, with a centre of five bays and angle pavilions of three. The latter have giant Corinthian pilasters, the centre attached giant columns. Balustrade on top, round-arched windows below; balustraded area and double basement, Somerset House-style. Carved armorial on the centre. A mansard was added in 1886–8 by *Banister Fletcher*, who raised the centre by a storey; raised again 1931–2. The S and NW parts were also heightened, 1899–1900 and 1925.

INTERIORS. Classical ENTRANCE HALL with staircases to l. and r., arranged with originality so that they climb back towards the entrance. They now slide up the sides of an inserted floor with Grecian coffering, of 1928 by *S.J.B. Stanton* and *F.W. Troup.* The chief spaces are the colonnaded great hall, in line with the entrance, and the chapel above it on the first floor. The rest housed teaching rooms, a library, an anatomical museum, and (in the basement) a school, which moved to Wimbledon in 1897. Apartments for professors were on the second floor, with the principal's house facing the river.

The CHAPEL was reconstructed in 1861–4 by *Sir G.G. Scott* on the model of 'an ancient basilica', and embellished further up to *c.* 1890. In 2000 *Inskip & Jenkins* restored it to a glowing, harmoniously Victorian appearance, reversing *S.E. Dykes Bower*'s half-hearted simplifications of 1948–9. Arcades and windows in a heavy Italo-Romanesque style, turning Quattrocento at the apse. The arcades are of five bays, of cast iron, with columns changing from fused octagons to twin round shafts. Iron-framed walls above – a weight-saving device – with original parquetry cladding. Beamed ceiling of 1931–2, inserted when the chapel was overbuilt. Scott's apse is daringly supported on two thin cast-iron columns and an arcaded brick substructure facing Strand Lane (*see* Surrey Street). – REREDOS and fine WALL PAINTINGS by *Powells*, after 1864, from cartoons by *Clayton & Bell* or *Salviati* (in the apse). Patterned ceiling and stencilled walls of 2000. Figures of prophets in the W aisle arcades, *opus sectile* of after 1889–90. – STAINED GLASS by *Joseph A. Nuttgens*, 2000. Decid-edly pictorial figures, rich heavy colours. – Gothic STALLS at the W; PEWS in similar style. – LIGHT FITTINGS like inverted parachutes, 2000. – Silvered CRUCIFIX with crown of thorns, 1960s, by *Louis Osman.* From the college hostel chapel in Vincent

Square (*see* p. 724). – BRASS over the NW door to Prof. T.R. Jones
†1880, signed *Gawthorp*. Wonderful border with, e.g., fishes, a
newt, and mammals at the top of the tree.

Later EXTENSIONS are of all shapes and sizes. Facing the
Embankment, partly visible from the Somerset House terrace to
the S, is a tall nondescript brick wing. At its foot the former chem-
istry block, two-storeyed and stone-faced, by *Stanton* and *Troup*,
1931–3. Overshadowing them to the E is the tall MACADAM
BUILDING of 1972–5 by *Troup, Steele & Scott*, linked by a glazed
bridge across Strand Lane. A similar treatment to the Strand
block, which was supposed to extend down Surrey Street to
join it. The differences are that there is no top section and that
a two-and-a-half-storey podium, glazed between its blue brick-
faced piers, takes up the fall in land levels. The effect is more
successful, particularly seen from across the river.

LAND REGISTRY
Lincoln's Inn Fields

By the *Office of Works* under *Sir Henry Tanner*, 1903–5 (centre and
W wing) and 1912–13 (E wing). Big, symmetrical Neo-Jacobean,
red brick and Darley Dale stone, with four towers on the four
corners. The style and outlines follow sketches after Blickling
Hall in Norfolk, made by the Chief Registrar *Sir Charles
Fortescue-Brickdale*.

LONDON SCHOOL OF ECONOMICS
Houghton Street, north-east of Aldwych

A cramped mini-precinct, hobbled by the narrow and incon-
venient street plan. Bridges link the blocks high up. The earliest,
on the W side of Houghton Street, is of 1920–33, built in stages
from S to N. By *Trehearne & Norman*, an unenterprising choice.
The big round-arched portal goes with the first phase, of 1920–1.
Its detail is up-to-date but neither challenging nor refined. By the
same the stone-faced block opposite, 1931–8. Its continuation N
is the CLARE MARKET BUILDING, 1966–9 by *Cusdin, Burden &
Howitt*, with a canted curtain-walled tower on a brick podium,
and another canted tower N of Clement's Inn Passage. This N
part joins on to the white-rendered ST CLEMENTS BUILDING,
stretching back along Clare Market: adapted by *White-Cooper &
Turner*, 1959–61, from the former St Clement's Press works. At
the splayed N corner a mosaic by *H. Warren Wilson* showing the
course of the Thames. Facing it is the latest part of the main
block, the former library of 1932–3, decorated by relief figures
by *E.S. Frith*. This replaced the LSE's first building here, of
1899–1902 by *Maurice B. Adams*.

For other buildings colonized by the LSE *see* Portugal Street
and Aldwych.

MAGISTRATES' COURT
Bow Street

By *Sir John Taylor*, 1879–80. Gravely Palladian, in direct descent from Pennethorne and the official architecture of the mid C19. Eleven bays, the fourth and seventh broken forward and with even channelled quoins, echoed on the end piers. Recessed centre with Corinthian columns. The court is in the N part, with an angled entrance; interiors updated 1937. The S part was formerly a police station, with low cell ranges around a rear courtyard. Conversion to a police museum is proposed. The previous court, where the novelist Henry Fielding presided, was set up on the E side in 1740.

NATIONAL GALLERY
Trafalgar Square

Erected in 1833–8 by *William Wilkins*, and designed as the crowning visual effect for the newly made Trafalgar Square. In this it fails, as Summerson's *Georgian London* pointed out in 1948: 'The façade is divided into no fewer than thirteen sections, six on either side of the central portico. Unfortunately, all the subsidiary sections have approximately equal value and the two sorts of pavilions are so similar in weight that one is inclined to evaluate them as alternative suggestions rather than complementary parts of a single design. To make his design still more "interesting", Wilkins set a dome over the portico and turrets over the terminal pavilions, like the clock and vases on a mantelpiece, only less useful.' To be fair to Wilkins, he wanted a site fifty feet further S, but the vista of St Martin-in-the-Fields had to be protected. In oblique views his composition works better, especially the portico with its eight Corinthian columns.

The gallery was built to house John Julius Angerstein's collection, bought in 1824 and at first shown at his house in Pall Mall with other publicly owned paintings. In 1826 *Nash* suggested a National Gallery for the present site, where the Royal Mews had stood (*see* Trafalgar Square), and in 1832 he and *C.R. Cockerell* competed unsuccessfully for it; but Nash's star was then fading. For economy Wilkins put the gallery in the W wing, the Royal Academy in the E. Toplit galleries filled the upper storey, storage, offices and cast galleries the basement. The wings were necessarily just one room deep, because the back land was taken by St George's Barracks (W) and St Martin's Workhouse (E). Passages towards both had to be incorporated, hence the doorways within the lesser porticoes. Their column bases and capitals came from the portico of *Henry Holland*'s Carlton House (dem. 1829; *see* p. 439), one of several discreet recyclings. The statuary was originally made for Marble Arch or Buckingham Palace from 1828: relief over the main entrance by *D.J. Rossi*, lesser figures by *E.H. Baily*, frontal seated Minerva on the E façade by *Flaxman* (made as a Britannia). Some stone came from *William Kent*'s

Crown Stables of 1732, the most imposing part of the old Royal Mews – so much so that at one point it was proposed to adapt it for the gallery. Leaded mansard of 1977.

On the turfed front strip two STATUES, of bronze, have found asylum. James II, W, of the Roman victor type, was made in 1686 for Whitehall by *Grinling Gibbons*'s workshop, almost certainly by two Flemings, *Laurens van der Meulen* and *Dievot* of Brussels. George Washington, E, given 1921, is a cast after *J.-A. Houdon*'s marble figure of 1788 at Richmond, Virginia.

ADDITIONS to Wilkins's building were made as the collection grew, though more than once in the C19 the gallery was almost replaced or relocated. The first big change, now no longer apparent, was *Pennethorne*'s reconstruction of the central vestibule in 1860–1. A competition followed in 1866 for complete rebuilding, won by *E.M. Barry* with a rich domed Neo-Wren design. In the event he built only a NE extension, on the former workhouse land, in 1872–6 (signalled externally by a stone belvedere). Next came an addition to its W by *Sir John Taylor*, 1885–7, on part of the barracks site. For this Pennethorne's work was all but destroyed. Externally the Wilkins design was continued further E in 1890–5 when the National Portrait Gallery was built, wrapping round Barry's extension. Here a bow with engaged Corinthian columns is the centrepiece. The removal of British pictures to the new Tate Gallery eased matters, and the rest of the barrack land was built up more slowly: N of the W wing in 1907–11, including the plain centre of the E front (*H.N. Hawkes*, concrete-framed on the *Kahn* system); further N in 1927–9, not externally visible (Room 29 by *Sir R.J. Allison*, with *Romaine-Walker & Jenkins*, and Room 31). The N pavilion of the W front is as late as 1970–5, built in connection with the much larger extension to the N and W by the *Department of the Environment* (*James Ellis*). A new main road was then projected along Orange Street, which encouraged a forbidding, defensive treatment: stone-faced, mostly blank walls, with a few slit windows besides the glazed public entrance. The overhanging top storey houses offices and workshops. An E continuation which would have replaced the National Portrait Gallery remained unbuilt. The SAINSBURY WING of 1987–91 is a separate building, standing to the W and differently angled towards Trafalgar Square (*see* below).

The INTERIORS of the main block are planned on a single axial system, and their skirtings and bolection-moulded doorcases of dark marble give the different phases a family resemblance. From 1986 most of the grander rooms have been restored close to their original state, replacing the makeshift neutral settings favoured from the mid C20. The most assertive are later Victorian, in rich Cinquecento style. Behind the entrance vestibule is *Taylor*'s work of 1885–7 (decoration by *J.D. Crace*): dome-lit staircase with branches to l. and r., large central gallery, and another large gallery, Room 30, set lengthways beyond. Much coloured marble, e.g. the Numidian red columns, contrasted with green fabric-hung walls. On the staircase and landing floors MOSAICS by *Boris Anrep*, 1928–52, including portraits of Bernard Shaw, T.S. Eliot and other C20 notables. E of the central gallery *E.M. Barry*'s

WILLIAM WILKINS, 1833–8, WITH INTERNAL ALTERATIONS

E. M. BARRY, 1872–6

SIR JOHN TAYLOR, 1885–7

EWAN CHRISTIAN, 1890–5 (ORIGINALLY NATIONAL PORTRAIT GALLERY)

OFFICE OF WORKS (H. N. HAWKES), 1907–11

SIR R. J. ALLISON WITH ROMAINE-WALKER & JENKINS, 1927–8

National Gallery. Plan

extravagant sequence of 1872–6 begins, centred on an impracti-
cally huge octagon with four short arms. Opulent decoration,
also by *Crace*: paired columns of green Genoa marble, a coloured
marble floor, and busts and reliefs of artists high up by *E.W.
Wyon*. Barry's Room 34, as restored in 1993–4, has a flat etched-
glass ceiling and restored lettering in the lunettes. Wilkins's gal-
leries have been remodelled, though their plan can be traced, e.g.
the little Rooms 7 and 42 tucked within the side porticoes. The
most ambitious C20 spaces are Room 9 in the 1911 wing, with
pitched glazing above segmental arches, and the barrel-vaulted
Duveen Gallery of 1929 (Room 29, altered), towards the w end
of the N range. In a former light well between these ranges is the
Sunley Room for temporary exhibitions, made 1983–4. Rooms
19–28, in the wing of 1970–5, were remodelled by *Purcell Miller
Tritton* in 1996–9, in simplified early C19 style; Rooms 15–17 are
also their work, of 1989–91. The GROUND FLOOR has in Wilkins's
range some unexpectedly tall round-arched openings. Plans by
Jeremy Dixon/Edward Jones are being drawn up in 2003 for greater
public use of this level.

The SAINSBURY WING is by *Venturi, Rauch & Scott Brown*,
built in 1987–91. The labour pangs of this w extension were long
and painful. The site was Hampton's furniture store, a Nash era
building burnt out in 1940, and bought by the Government in
1958. In 1959 a competition to extend the gallery was organized
by *The Sunday Times*, won by *Barrie Dewhurst*'s highly expressive
design of overlapping blocks in a squared spiral. But the next
extension was built to the N instead, and the site was kept vacant
for a proposed new National Portrait Gallery. Only in 1981 was
an official competition held, for a self-financing block incor-
porating offices for rent. Public voting on a shortlist of seven
schemes failed to produce a clear winner (a scheme by *Richard
Rogers & Partners* in their Lloyd's idiom got the most votes both
in favour and against). The shortlist was then cut to three, of
which the trustees preferred a design by *Skidmore, Owings &
Merrill*, the Government that by *Ahrends, Burton & Koralek*. The
latter was then reworked to suit curatorial needs, introducing
a glazed access tower towards the square. Its fate was famously
sealed by the Prince of Wales, who in 1984 compared it to 'a
monstrous carbuncle on the face of a much loved and elegant
friend'. Then in 1985 John, Simon and Timothy Sainsbury
promised funding for a building wholly devoted to gallery uses,
and a new shortlist of six firms was drawn up. They shared a more
or less Postmodern classical idiom, but only the two American
entrants took Wilkins's Corinthian order as the departure point:
Harry Cobb of *I.M. Pei Partnership*, and *Robert Venturi*'s firm,
declared the winners in 1986.*

The Sainsbury Wing is effectively a separate building, neatly
bridged from the old gallery by a stone drum that opens for a
walkway below. In plan it is relatively simple: toplit galleries on
the first floor, reached by a grand staircase on the inner side; a
restaurant and conference rooms in the mezzanine; shop and

*The others were *Colquhoun & Miller*, *Jeremy Dixon/BDP*, *Piers Gough* (*CZWG*),
and *James Stirling, Michael Wilford & Partners*.

foyer on the ground floor; lecture theatre and exhibition galleries in the basement. Few of these close-packed functions can be inferred from outside, being wrapped within finely executed façades mostly of stone or brick. It is with their detailing that the adventures start. Venturi's fame began with his *Complexity and Contradiction in Architecture* (1966), and, true to form, the design revels in the quiddities of site and context. Most obviously, Wilkins's Corinthian order is carried on around the shallow angles of the Trafalgar Square front, but in a rushing, Baroque movement instead of Grecian staccato: first a cluster of over-lapping pilasters, then two smaller clusters where the wall comes forward, then further on a final half-column with a pilaster peeping out behind. The entablature sheds balustrade and dentils as it goes, stopping altogether before the SW corner. A similar diminuendo appears in the upper walls, with their two blind windows and the phantom of a third. But the entrance is just a run of big dark voids chopped out wide enough to demonstrate that the walls above cannot possibly be load-bearing. Different contextual references come into play as the front bends back along the street. Here a single giant transomed window appears, intended as a reference to the clubhouses of Pall Mall, though largely blocked behind. The plinth runs on to the W front, of plain brick to mirror the simple early C19 warehouses on Whitcomb Street, and scored with thin plain grooves. Similar scorings mark the N front, which is taller, near-flush, and also brick-faced. Almost no windows, but to the l. a giant panel with a classically lettered inscription. Returning past the linking drum, brick and stone give way to unabashedly C20 smoked glazing by the grand staircase; similar glazing defines the entrance, recessed behind the stone front. The pilasters there state firmly that the wing is part of the main gallery, a connection not at all obvious in some other competition entries – or indeed at Stirling's Clore Gallery at the Tate (*see* p. 689), which started the high game of architec-tural chameleonism. No-one could accuse the design of cliché or pastiche; even the railings at the entrance are of a wholly original cut-out form. But all the teasing references are ultimately too cerebral and passionless, an architectural cryptic crossword rather than a poem to art. And those who do enjoy a good crossword may yet feel the lack of a strong underlying form, particularly on the Trafalgar Square front with its many little breaks on plan: a fault that shows up increasingly with repeated viewing.

The INTERIOR, free from the pull of context, plays more relaxedly with architectural precedent. The foyer with its piers and columns is too diffuse to come off, but the grand side-lit staircase that rises to the r. makes fine scenography, widening as it climbs, like Bernini's Scala Regia in the Vatican in reverse (though it is strange that the focus at the top is a mere lift lobby). Its ceiling is decorated with paired arched trusses, recalling with Venturi's typical double-coding both late Soane and Victorian engineering. The inner wall breaks at the mezzanine landing. Above this is a frieze carved by *Michael Harvey* with artists' names, then four tall windows with glazing bars – a Georgian 'quote' – allowing views out from the galleries through the

exterior glazing. The cross-axis at the top is that of the main gallery, a magnificent enfilade running from across the bridge to cut obliquely through the new gallery grid. The openings on this axis have arches and nice fat Tuscan columns of *pietra serena*, a dark grey Italian stone used also for the skirtings and the openings between the other galleries (round-arched in the central range, square in the sides). Natural light comes through skylights into boxy lanterns, derived like the simple flat covings from Soane's gallery at Dulwich (*see London 2: South*). Characterful without obtrusiveness, they complement the Italian Renaissance paintings in most of the rooms. Only the irregularly shaped outer galleries do not come off, and here again the lack of decisive form is the culprit.

NATIONAL PORTRAIT GALLERY

St Martin's Place, north of Trafalgar Square

The main block is a Florentine Quattrocento palazzo of 1890–5, by *Ewan Christian* with *J.K. Colling*. Built with £80,000 given by W.H. Alexander, on condition that the Government found the site; he also chose Christian as architect. Two storeys, large round-headed windows, but the colonnettes in the jambs oddly enough decidedly Early English. *Frederick Thomas* carved the busts of portraitists. Stepped E corner with rather inconspicuous main entrance, a lower pedimented block with a row of short pilasters derived from S. Spirito in Bologna. S of the entrance a shallow E wing treated as a continuation of the elevation of the National Gallery (q.v.), which in 2000 took over its ownership. To the W, along Orange Street, is the rather Transatlantic DUVEEN WING of 1931–3, four big plain bays wide (of an intended seven). By *Sir R.J. Allison* and *Sir J.G. West* of the *Office of Works*. The long access ramp of *c.* 1996 is from *Jeremy Dixon/Edward Jones*'s work, of which more below.

The C19 INTERIOR comprises three storeys, of which the lower two were originally side-lit. They are reached off the r. of the staircase, which is of Imperial plan, less claustrophobic since the restoration of the double-height landing in 1999 (sacrificing *Roderick Gradidge*'s flamboyant Neo-Victorian decoration of 1990). Much of the ground floor was converted from office to gallery space in 1993, by *John Miller & Partners*. The ONDAATJE WING, *Dixon/Jones*'s main addition, lies behind the staircase, slotted with great resourcefulness into a back yard N of the National Gallery. It dates from 1998–2000 (competition 1994; engineers *Ove Arup & Partners*). Its chief function is the reform of the gallery's intractable circulation, by means of a giant escalator up to the second-floor galleries, previously the least visited. It is housed in a long calm white hall on axis with the entrance. Light comes from a clerestory on the escalator side; on the r. an open mezzanine with information terminals, then a new first-floor gallery, screened by staggered slanting walls. Inscriptions carved by *Incisive Letterwork*. Foster's Sackler Galleries at Burlington House are an obvious precedent (*see* pp. 491–2), but its forms are more self-effacing, recalling the anonymous Inter-

national Modernism of the 1930s. On top is a new third floor, housing a restaurant with thrilling views across the roofs and s down Whitehall. More quirky is the early C20 gallery, in the first floor of the Duveen Wing, remodelled in 1996 by *CZWG* with aquamarine glass screens under a low, undulating slotted ceiling. For the ancillary block *see* Orange Street, p. 423.

ROYAL COLLEGE OF SURGEONS
Lincoln's Inn Fields

1835–7 by *Sir Charles Barry*. But the principal motif, the noble giant Ionic portico with straight entablature, comes from the predecessor of 1806–13, designed by *George Dance the Younger* with *James Lewis*. Barry reused it, though to keep it centred he moved a column from the w end to the e, and added fluting to Dance's plain shafts. Barry's front was of two more bays to l. and r., and was higher by one half-storey. Then in 1887–8 *Stephen Salter* added two more bays l. and two r., the giant pilasters, and alas the two top storeys, one with wreathed circular windows. Barry's façade thus lost most of its sense. The higher and yet heavier angle erections are of 1937, by *Lanchester & Lodge*.

Barry's INTERIORS are in the severe Hellenic spirit of his earliest works. The vestibule has Greek Doric columns, making a double screen to the great sober staircase, l. This has flat, summary coffering (restored after bomb damage) and a Parthenon-derived figure frieze, one of several in London by *John Henning Sen. & Jun*. Three flights climb to Barry's delightfully reposeful library, facing the street, with bookcases only against the wall and not projecting into the room. Cases divided by antae, gallery cast-iron railing and another tier of bookcases above. The attractive light green colour is said to be original. The e part belongs with the extension of 1887–8.

The back parts, heavily bombed in 1941, were rebuilt in 1952–62 by *Alner W. Hall*. His work includes the HUNTERIAN MUSEUM, off the landing to the w. The hallway joins the rebuilt parts with a Doric rotunda with a statue of John Hunter by *H. Weekes*, 1864. Also in the hallway 'Mors Ianua Vitae', a hallucinatory sculpted cinerary urn to Dr and Mrs Macloghlin by *Alfred Gilbert*, 1905–9. Behind the rotunda the College's portraits are displayed in oak-panelled meeting rooms in traditional styles, some with reset Neoclassical fireplaces. They culminate at the e in a huge pilastered hall, set behind the NUFFIELD COLLEGE OF SURGICAL SCIENCES of 1956–8, also by *A. W. Hall* (consultant *Sir E. Maufe*), tamely Neo-Georgian in red brick and stone.

ROYAL COURTS OF JUSTICE
Strand

1871–82 by *G.E. Street*, the greatest secular monument of the 91 Gothic Revival in London after the Houses of Parliament. In 1866–7 a competition was held for new law courts here, on a

seven-acre site of specially disreputable slums. Soane's Law
Courts S of Westminster Hall (see p. 214) had been rapidly out-
grown, and the long-sought unification of Common Law and
Chancery departments made a replacement still more urgent.
Eleven architects sent in designs, all Gothic, though in other
respects dissimilar. *E.M. Barry*'s design would have given
London something busier (with a dome), *Waterhouse*'s, something
harder and thinner, *Sir G.G. Scott*'s, something as competent but
in its rigid symmetry much duller, *Burges*'s something more spec-
tacular and aggressive. The fumbling that followed was typical of
Victorian official projects. Joint victors were declared, *Barry* for
plan, *Street* for elevations, followed at once by bitter argument
and paralysis. In 1868 the new Tory administration plumped
for Street alone, subject to thorough revision. Further delays
ensued while he made designs for an alternative site, on the new
Embankment. Revision also meant the disappearance of much
in the competition brief: a great record tower at the W, and
covered bridges to the Temple, S, and Lincoln's Inn, N. The
plan with a hall aligned N–S was settled in 1870, the found-
ation stone laid in 1874. Street died in 1881, having exhausted
himself drawing almost every detail, and completion was over-
seen by his son *A.E. Street*, with *Sir A.W. Blomfield*. The whole
cost £1,973,221, and ruined the contractors, *Bull & Sons* of
Southampton.

The Royal Courts of Justice is not a popular building now and
perhaps never will be. Even when new it appeared somewhat out
of its time, a High Victorian hangover in the heyday of Queen
Anne. Yet it is serious and competent in its use and adaptation
of the French and English mid-C13 styles. Moreover, as a com-
position it is not without sensitivity, attuned as it is to the unfold-
ing oblique views along the Strand. The façade here is an object
lesson in free design, with none of the symmetry of the classics,
yet not undisciplined where symmetry is abandoned. We start
from the E tower, a heavy tower with a big hipped roof, placed
just a little W of the actual E end. One of several big archways
leads through it. To the W it is followed by three almost identical
bays, the unit of the façade, as it were. Then follows one bay
flanked by tourelles; a triple archway to a deep quadrangle
between the court-room wing, W, and office wing, E; then a
similar tourelle bay, and the repetition of the unit bays. However,
there are now only two and then, instead of the big tower, a
polygonal end. But the polygonal end is at the same time the r.
end of the centrepiece of the W block, a symmetrical centrepiece
with the gable of the Central Hall appearing above the portal. In
fact this symmetry carries on and takes in two units and one more
tourelle bay. So there are two symmetrical groups, one wholly
and one freely symmetrical, and they boldly overlap in the
middle.

It is not necessary to go on analysing in such detail. But one
should appreciate how much judgement and visual discrimina-
tion have gone into Street's elevations. The tripartite gateway to
the quadrangle is specially interesting, its N side in particular with
the arches upon arches on the upper floor. Best Portland stone
from the Whitbed is the chief facing, with some columns of

granite and red sandstone (the latter partly replaced). Though less dramatic, the sides are equally rewarding, especially the E wing with its beautifully proportioned tower and turret at the N end. On this side red brick appears with generous stone facing, and stone ornaments in bands and chequer. Much brick too on all four quadrangle fronts. The skyline also ought to be taken in: the two E towers, various gables, and the tall flèche of the Central Hall, introduced as late as 1879–80. Such carving that there is – much less than might be expected – was by T. Earp and firm: mostly foliage, but with figures of lawgivers on four gable summits. The fine projecting CLOCK on the SE tower was put up in 1883 as a memorial to Street, and to his designs.

Street was especially interested in the crafts, and the METAL-WORK along the outer screen walls deserves notice. These big screen walls, open in arches with or without gables, are used to emphasize the main frontages even where the building recedes more or less. The makers were *Thomas Potter & Sons*, the designer partly Street himself, partly *A.E. Street* (the W enclosure and its stone screen, *c.* 1884).

INTERIORS. The CENTRAL HALL is the principal apartment. It is 230 ft (70.1 metres) long and 82 ft (25 metres) high, rib-vaulted, with three plain lancets to the N, the rest grouped lancets with geometrical tracery. Stiff-leaf foliage throughout. In the lower zone blank arcading, and richly foliated double doorways with diapering. Magnificent polychromatic mosaic floor, made by *Burke & Co*. Street intended the plain upper walls for mosaics. The (very modest) heraldic STAINED GLASS follows his designs. Original balconies on the short ends. The little ones in the middle of each long side date however from 1909 (*Sir H. Tanner*), as do the staircases below them. These modified Street's circulatory system, which used the favourite C19 principle of symmetrical concentric routes to keep apart judges, counsel, jury and public. From the ground floor eight original spiral stairs lead up into gloom, four from off the hall, two each to its S and N. To the N also an impressive aisled and vaulted cross-axis. A corridor around the first floor leads to the court rooms, numbering nineteen originally. Mostly of one size, they differ in the many types of roof used, including, e.g., full timber rib vaults (court rooms 10 and 11, S). Behind run superimposed narrower corridors and offices, and jury rooms at ground level beneath the court rooms. N of the Central Hall is an upper-level entrance from Carey Street, originally reserved for barristers. Over the S quadrangle gateway the BAR ROOM, with two-bay arcades. (Bright stencilled decoration after Street's designs, restored 2001.) Fireproof construction throughout, of iron girders and concrete jack-arches (*Dennett & Co*.'s system), in the public spaces mostly hidden.

SCULPTURE in the Central Hall. On the E wall the MONU-MENT to Street, 1883–6, designed by *Blomfield* with sculpture by *H.H. Armstead*. He is shown seated in a big niche, holding metal dividers. Frieze of artists and craftsmen below. STATUES of Lord Russell of Killowen by *Thomas Brock*, 1904, and Sir W. Blackstone by *P.W. Bartlett*, 1925. Upstairs, Edwin Field by *T. Woolner*, 1877.

EXTENSIONS. The main N–S alignment left unused much cleared land to the W. The part by the Strand became a garden, with on its N side the WEST GREEN BUILDING of 1909–12 by *Sir Henry Tanner*. Four court rooms inside. Street proposed an auxiliary block here in 1874, but even so it is astonishing that Tanner impersonated him so late and so exactly inside and out (Leonard Stokes called it 'a sort of *rechauffé* of Street'). Towards the Strand a crocketed gable, the finial a figure of Justice. At each end a tourelle, and behind a tower and a flèche. A covered bridge and triple archway join the main block. Heraldic W window by *Rupert Moore* (*Whitefriars*), 1968. Additions to the N by the *Ministry of Public Building and Works* (chief architect *Eric Bedford*). QUEEN'S BUILDING, 1966–8, is a five-storey office slab, stone-faced with projecting bay windows to Carey Street. Sinister SCULPTURE of a judge by *S. Charoux* in the entrance. At its W end a twelve-storey office block of 1970–3 (THOMAS MORE BUILDING). The *Property Services Agency* wrapped a stack of court rooms around its NW corner *c.* 1988. Postmodern, with turret, but so simplified that the references to Street barely signify.

ROYAL OPERA HOUSE
Bow Street and Covent Garden

By *E.M. Barry*, 1857–8, the oldest intact theatre in London; extended in 1980–2, and again in 1997–9 by *Jeremy Dixon/Edward Jones* with *Charles Broughton* of *BDP*, incorporating part of *Barry*'s Floral Hall of 1858–60. Barry's theatre was never a match for such C19 opera houses as those of Paris or Dresden, and the latest extension will look to some like a compromise no less English: inconsistent in elevation, and less coherent for having recycled a section of the Floral Hall. But Covent Garden is not a *tabula rasa* like the South Bank, and the way in which the extension mediates between the C17 context of the Piazza and the C19 theatre architecture is in the spirit of the regeneration around, which since the 1970s has drawn strength from the old urban grain and the accidents of history.

History

The first Theatre Royal here was built in 1731–2 by *Edward Shepherd*, operating under one of the royal patents of 1662–3. A smallish oblong box without any street elevation, like its counterpart in Drury Lane (*see* Russell Street), it was reached by a passage from the Piazza to the S. In 1792 *Henry Holland* remade the auditorium horseshoe-fashion and built a grand entrance portico on Bow Street, W. It burnt down in 1808, and was rebuilt in 1808–9 by the young *Robert Smirke*, on an enlarged site extending N to Floral Street. This third theatre was detached, masculine and severe, with a stocky Greek Doric portico – the first in London of that order. There were four seating tiers, again horseshoe-shaped, and the grandest foyer and staircase yet seen in a London theatre. The capacity was 2,800. In 1846–7 *Benedict*

Albano rebuilt Smirke's interior as the Italian Opera House, but in 1856 this too burnt down. Its manager Frederick Gye at once organized a replacement, built 1857–8. *Barry*'s theatre was intended as a general purpose house, though the Opera House name stuck. Its axis ran E–W, not N–S as before, to accommodate the Floral Hall on its S side. Thus it was smaller than Smirke's, though with a larger stage and auditorium.

In 1946 the theatre became the national opera house, and also the home of Sadler's Wells Ballet (now Royal Ballet). The back-stage facilities were hardly adequate for this. Space to expand at last became available after the market left, in 1974. Early plans, by *Gollins, Melvin, Ward & Partners*, allowed for a phased scheme including a second auditorium for 1,200. Of their proposals only one section was built, a block of rehearsal rooms extending W to James Street (1980–2). In 1983–4 a competition was held for the larger area stretching S to Russell Street and the Piazza. The backstage was to be rebuilt, but to bring in revenue space for offices, shops and parking was also specified. The victors, *Jeremy Dixon* with *William Jack* of *BDP*, published their designs in 1986. They proposed to restore the angle of the Piazza in a classical idiom, changing to something plainer on the side streets and on an auxiliary block N of Floral Street. Delays ensued through lack of funds and disagreements over how much (including the Floral Hall) might be demolished to clear the way. A less destructive plan followed in 1989, for which Dixon formed a partnership with *Edward Jones*. This foundered when office rents collapsed. Then in 1994 a penultimate design was presented, on which *Charles Broughton* of *BDP* took the place of William Jack. It was purged of offices for rent, though the Piazza shops were kept. The space thus released allowed all major facilities for opera and ballet to be grouped within. The same facilities feature, some-what reordered, in the final design of 1996, built in 1997–9 with the help of the National Lottery and private donations. The cost all told was £214 million. Theatres came quicker and cheaper in the C19: Smirke's went up in ten months (£187,888), Barry's in eight (£70,000).

Exterior

The VICTORIAN THEATRE. *E.M. Barry* is best known for his Gothic and Louis XIV designs, but greater London theatres were by tradition classical, stuccoed and porticoed, and his building of 1856–7 follows suit. The portico is six-columned, Corinthian, on a rusticated ground floor open for a carriageway until 1950–1. Paired angle pilasters, their capitals treated as smooth, unsightly blocks. In niches by the portico figures of Melpomene, S, by *D.J. Rossi*, and Thalia, N, by *Flaxman*; above them and behind the portico a long (and altered) frieze of Ancient and Modern Drama, modelled by *Flaxman* and made by *Rossi*: all salvaged from Smirke's theatre of 1808–9. Sculpture intended for the pediment was never executed. Within the portico an extension to the crush room made *c.* 1900, glazed and round-topped like a hothouse. To Floral Street, N, a run of nine plain sunk through-storey panels, and a simplified cornice. Above bays five to nine

rises the mighty flytower of 1997–9. Its mouldings and urns follow Barry's, but are fashioned in coated expanded polystyrene. The five bays beyond belong with the *GMW Partnership*'s EXTENSION of 1980–2, which has taller, round-headed windows towards James Street, w.* Here the deference to Barry's treatment shows up less since 1991, when *Dixon/Jones* inserted big shopfronts.

Barry's FLORAL HALL was placed with wondrous disregard of decorum right next to the Opera House on the s. It was also built for Frederick Gye, who was particularly interested in glass and iron structures. Here, in 1859, we have the spirit of the Great Exhibition, tempered by intricate cast-iron decoration on the main members, and by the use of brick for the side walls. Only the E part remains, four aisled bays deep, re-erected and raised up on a stone-faced basement of 1997–9.** At the same time the semicircular glass roof, dismantled after a fire in 1956, was re-created over the centre. Originally there were four more bays and then a glass dome, also lost in 1956, and a short s transept on to the Piazza. The white colour matches the first paintwork. Gye meant to use the hall as both a flower market and a select winter garden, for which use he provided stairs up to the Opera House landing; but the Duke of Bedford spoiled things by opening a rival flower market in the Piazza. In 1887 the Bedford Estate itself bought Gye's white elephant, for trading in foreign fruit.

The EXTENSIONS by *Dixon/Jones* and *BDP* begin here. Their problem was how to build on a giant scale but with more than an eye to context. Further replication of the Barry idiom was out of the question, while facsimile Inigo Jones would have been too low and also quite unsuitable for the outer sides. Instead, a new classical elevation was devised for the Piazza, with a less traditional handling for the rest. These parts begin l. of the Floral Hall with a glazed strip, rather understated for its function as an additional entrance. Then a projecting wing of offices, wrapped around scenery workshops. These have smooth, solid elevations of finely jointed stone. Tiny balconies to some top windows. On Russell Street, s, are shops and a top row of plain oculi, with an opening to the r. part-filled with an angled signboard like a giant light switch. Both fronts are stronger and less cluttered than the earlier, more commercial proposals. The Piazza elevations on the other hand are in essence the same essays in stripped classicism presented in 1986. Their walkways and shops relate comfortably to the Piazza, which has thus recovered something of the urbanity intended by Inigo Jones. Portland stone is used, in deference to London tradition. Tuscan colonnades below, with a false mezzanine of narrow slots piercing the barrel vault behind. Two storeys above with plain windows with glazing bars, grouped in big sunk panels like Barry's on Floral Street. On top a generous public viewing terrace, sheltered by a free-standing loggia with a pitched copper-clad roof, the whole supplying something of the proportions of a cornice. Roofscape of big busy shapes: rendered upper walls, hipped leaded roofs of the rehearsal studios,

*It replaced a whole street called Mart Street, made in 1933 for market access.
**Other parts are being re-erected at Borough Market, Southwark (2003).

etc. From the inner angle an unobtrusive passage runs back to Bow Street. Over the colonnade ends carved armorials by *Dick Reid*.

The chopping and changing between parts works least well on James Street, w, where three elevations jostle: the end of the colonnade, a four-bay version of the Bow Street treatment, then the extension of 1980–2. But the success of the Piazza as townscape more than justifies the outside-in design, besides the proper connotations for a theatre of its unabashed scene-setting and masquerade. So it is troubling that the sixth bay of the N colonnade has paired instead of single columns: a disruption of classical logic, and an affront to the convention that masquerade is, in the theatre, a serious business.

Interiors

Barry's circulation spaces to the THEATRE are not large, though treated with grace. Pilastered ENTRANCE HALL, with a statue of Frederick Gye by *Count Gleichen*, 1880. To the S the GRAND STAIRCASE, two flights beneath a coved ceiling. Steps lead down from its landing into the restored Floral Hall, as Gye first intended, except of course that the levels are now different. Busts of Melba by *B. Mackennal*, 1899, of Patti by *L. Durand*, 1869. The CRUSH ROOM over the entrance hall has Ionic pilasters, and a column-screen at the far end, reinstated (short of the original alignment) in 1997–9. Paintings by *A. Terwesten* (1645–1711) and others, perhaps introduced in *E.O. Sachs*'s modernization of 1899–1901. The gilded AUDITORIUM has three even horseshoe tiers, Continental in derivation, but with deeper seating according to English tradition. Serpentine fronts with female herms, modelled by *Rafaelle Monti*. Also by him the tympanum relief: Music, l., Poetry, r., Queen Victoria's head between. The lid on this nobly proportioned box is a big square saucer-dome on flattened elliptical arches, painted pale blue. Hinged sections were made in it in 1997–9 to conceal the stage lights. It hangs from wide iron lattice girders, between which workshops were originally fitted (ironwork designed and made by *H. Grissell & Co.*, general contractors *Lucas Bros*). The tiers, also iron-framed, are structurally independent of the auditorium walls. The seating, made still steeper in 1997–9, was originally level, and had far more boxes. In 1999 the capacity was 2,268. The computer-controlled stage machinery, paralleled only at Carlos Ott's Opéra Bastille in Paris (1983–9), can change between productions in forty-five minutes. (ROYAL SUITE, on several levels on the N side. Foyer with Neo-Adam decoration, probably early C20; anteroom with a big coved ceiling.)

The Floral Hall (now VILAR FLORAL HALL) has been altered much more, with sturdy timber-decked galleries inserted within the aisles. It now serves as a bar, café and occasional performance space, accessible throughout the day, and shared by the whole audience in intervals: all aimed at making performances less hierarchical and exclusive. A huge mirrored end wall supplies the effect of the lost bays, broken high up by a window into the restaurant. The pierced arcade capitals served originally to

ventilate the basements. On the line of the former s wall is a glazed screen with glass fins, with views through it to an escalator climbing from within the entrance to the restaurant and viewing gallery. (Earlier proposals featured a new grand staircase on this side.) In the basement of the s wing is a STUDIO THEATRE seating 420.

ST CLEMENT DANES SCHOOL
Drury Lane

1907–8 by *C. W. Reeves*. The familiar multi-storey Board School product. Rather old-fashioned elevations, with segment-headed windows. Projecting extension of 1927–8, in keeping.

SOMERSET HOUSE*
Strand, Lancaster Place and Victoria Embankment

Built on the site of a royal palace in 1776–1801 for public offices, principally the Navy Office – an innovation in England, though the Uffizi in Florence (1560) was a celebrated demonstration how an administrative building could be made architecturally imposing. The use of Portland stone, however, and extensive rustication links Somerset House to recent public buildings in Whitehall, Kent's Treasury (1733–7) and the Horse Guards (1750–9). The architect was *Sir William Chambers*, by that time effectively head of the Office of Works as its Comptroller, and Treasurer of the newly founded Royal Academy. Premises in the block facing the Strand were allocated to the Royal Academy, and two other learned societies under royal patronage, the Royal Society and the Society of Antiquaries. Their presence helped to justify the splendour of the building, and that of the Academy in particular the academic nature of its architecture.

p. 15 The palace had been begun in 1547–52 by Edward Seymour, 1st Duke of Somerset ('Protector' Somerset). His front towards the Strand marked the coming of a truer understanding of the Franco-Italian Renaissance than had previously existed in England. There were also architecturally important C17 contributions, the chapel fitted up by *Inigo Jones* in 1630–5 and a gallery facing the river in a very pure classical style, which had been erected in 1662–3, after the Restoration, probably by *John Webb*.

Chambers believed that the river gallery was to a design by Inigo, and used it as the source for his own Strand façade, reproducing the main motifs almost exactly. This Palladianism, on which the design of the whole building is founded, gains variety and animation from Chambers's memories of much more recent public architecture on the Continent, in particular the Trevi Fountain in Rome, under construction when he was a student there in the early 1750s, and the grand Mint building in Paris, newly completed when he visited in 1774. The design of the

* This entry was revised by John Newman.

Somerset House. Block plan, with the nineteenth-century
completion lightly shaded

building develops logically from the fairly narrow Strand front,
through a columned vestibule into an expansive courtyard and
finally, through the columned Seamen's Hall, to a far-extended
frontage towards the Thames and river terrace. Everywhere
sculpture is important, the work of sculptor Academicians, and
something else which gives a French flavour. (For the sculptors
see below.) As throughout the building Chambers insisted on the
highest standards of craftsmanship, the names of the principal
master craftsmen must be listed: *John Devall* and *John Gilliam*,
masons; *Edward Gray* and *John Groves* and *Richard* and *Henry
Holland Sen.*, bricklayers; *James Filewood* and *Samuel Wyatt*,
carpenters; *Richard Lawrence* and *Sefferin Alken*, carvers; *Thomas
Collins* and *Thomas Clark*, plasterers; *William Palmer*, smith.
Besides these Chambers relied on his two co-ordinating clerks of
works, *John Yenn* and *Robert Browne*.

The STRAND BLOCK was built first, in 1776–80; since 1989
the COURTAULD INSTITUTE OF ART. Its N façade is relatively
narrow (only a matter of nine bays) and takes its place in a street
frontage, so depends much on sculpture and sculptural relief for
its effect. The ground floor is treated as a tall rusticated arcade,
open in the centre three bays, but to l. and r. occupied by
windows in pedimented Doric aedicules. The keystones of the
arcade are carved with bearded heads symbolizing Ocean and
eight great English rivers. *Joseph Wilton* carved all but the three
E-most, which are by *Agostino Carlini*. The windows of the *piano
nobile* are set within pedimented Ionic aedicules, the centre
three bearing tablets with profile medallion portraits by *Wilton*

of George III, his Queen and the Prince of Wales. This storey
and the half-storey above are taken together by giant Corinthian
half-columns, which carry an unbroken entablature and top
balustrade. The centre three bays are crowned by an attic with
standing figures as on a Roman triumphal arch (or the Trevi
Fountain) and garlanded oval windows *à la française*. The figures
(carved by *Carlini* and *Giuseppe Ceracchi*) are in Roman garb
and carry fasces, to represent Prudence, Justice, Moderation
and Valour, the qualities (according to Baretti's *Guide* of 1781)
'by which Dominion can alone be maintained'. Above, the arms
of the British Empire supported by Fame and the Genius of
England. The original group by *John Bacon Sen.* was renewed by
Farmer & Brindley in 1896. Behind all this a glimpse of the timber
clerestory of the great exhibition room (*see* below). At street level
handsome ironwork, now painted blue, railings protecting the
area, and tall openwork lamp standards, made in 2000 from a
drawing by *Chambers*.

The three open arches provide access to a splendid Doric
VESTIBULE. Four bays in depth of coupled columns carry an
enriched plaster vault. The frieze is Chambers's first departure
from orthodoxy. No triglyphs, just bucrania and guttae. In the
stone-faced side walls trios of doorways, the central one on each
side bearing a bust by *Wilton*, to the E Newton, for the Royal
Society, to the W Michelangelo, for the Royal Academy.

Towards the S the Strand Block, facing the courtyard, spreads
out prodigiously, the centre, now of seven bays, framed by three-
bay wings which come forward by three bays. Rusticated ground
storey, and a giant Corinthian order above, as on the Strand
front, with again a central attic against which stand emblematic
figures, by *Wilton*, of the Four Continents, and a display of the
British arms above supported by tritons, this by *Bacon* (restored
1965). On this side the Great Room clerestory is more easily
seen. But Chambers introduces numerous variations, and con-
trasts pilasters in the centre with half-columns on the fronts of
the wings. He allows rustication to rise behind the order on the
wings, and there are several new window forms. Keystones of
the central arches carved with female heads, those over the rather
fantastic doorways in the wings carved with male ones, all by
Joseph Nollekens. (These doorways gave access to two minor Gov-
ernment offices.) Crowning the centres of the wings decorative
stone chimneystacks flanked by lead sphinxes, by *John Cheere*.
The sunken light wells in the angles of the wings, where the rus-
tication of the walls is especially rough, originally housed great
open water tanks, for use in case of fire. The W tank survives,
roofed over.

The focal feature of the entire courtyard is the bronze MONU-
MENT of George III by *John Bacon Sen.*, completed in 1789, with
below it a reclining figure of Father Thames. The semicircular
balustrade here marks a light well two storeys deep which illu-
minates the subterranean vaults intended (but never used) for
the storage of the National Records. These vaults extend below
the cross-passage which runs to E and W past five-bay extensions
of the Strand Block, that to the W added by *Smirke* in 1817–22.
At each end of the passage a noble rusticated Doric gateway, pro-

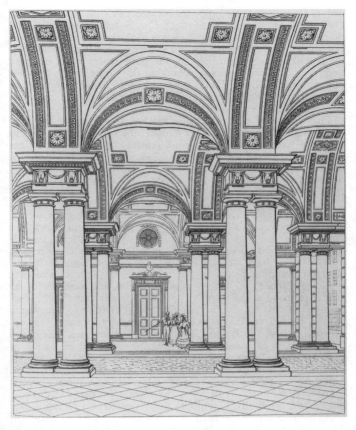

Somerset House. Vestibule in Strand Block. Engraving
(John Britton & A.C. Pugin, *Illustrations of the Public Buildings of
London*, 1825–8)

viding access to the side streets which formed part of Chambers's
general scheme.

The COURTYARD is closed by three continuous ranges, of
twenty-three bays to E and W and a central South Range of nine-
teen bays. Here the majority of the Government offices were
sited, the Navy Office accessible from the Seamen's Hall in the
centre of the South Range, and its ancillaries (Sick and Hurt,
Navy Pay and Victualling) in the entire W half. E of the Seamen's
Hall was the Stamp Office, and in the E range the Salt, Duchy
of Cornwall and Exchequer offices. The façade of each range is
treated as a unified three-storey palazzo composition, the walls
part rusticated, part smooth ashlar, crowned by continuous
entablatures and balustrades. Three-bay centrepieces, where the

order, Composite now, appears *in antis* but fully in the round. Over these, to E and W, rows of *Coade*-stone vases and little domed timber lanterns. Similar vases in the centre of the S front, but the climax of the composition here is a rather weak pediment and dome (of timber). In the pediment a relief of a sea nymph by *Richard Rathbone*. Flanking the dome, stone trophies of armour, by *Thomas Banks*. – SCULPTURE flanking the central doorways by *Wilton*. Tribute-bearing tritons and oval reliefs of appropriate deities, Neptune, Ceres, etc.

The courtyard was artificially made up well above the level of the unembanked river. This allowed the offices, of six storeys in all, to have two below ground, reached by dramatic bridges and walkways from the broad, double-depth area. (Top storey in the roof space.) FOUNTAINS, a rectangle of eleven by five jets, designed by *Dixon/Jones*, 1999–2000, and PAVING in setts, by *Donald W. Insall Associates* of the same date.

The sense of lively drama reaches its most impressive pitch on the THAMES FRONT, to which the Seamen's Hall gives access. This was designed no doubt to outdo the Adam brothers' Adelphi begun eight years before. It is *c.* 520 ft (158 metres) long, including the eastward completion by *Smirke* for King's College, but not the four W bays, which Chambers did not envisage (*see* Inland Revenue Building below, p. 324). Down at river level a mighty rusticated arcade all along, which for the first century of its existence stood at the water's edge. Broad central arch with rusticating blocks, to give access for boats to the storage vaults within. Its full semicircular form, inspired by Piranesi, was re-exposed *c.* 1998. To l. and r. monumental watergates. They have flanking pairs of giant Tuscan columns sheathed in bands of rustication, in a conscious echo of another supposed Inigo Jones building, the York Water Gate, a few hundred yards upstream. Lions lie on top. These are at the level of the terrace which extends end-to-end in front of the façade proper. Here, most boldly and originally, Chambers has repeated in two main side accents the motif of the mighty arch without jambs to stand on. These sheer semicircles look doubly dramatic because of the elegant transparent porticoes above them, though this idea came from Palladio and not Piranesi. The central feature is less successful, a mirror image of that in the courtyard, and here the recessed pediment and yet further recessed small dome are not a strong enough focus for such a long and spectacular façade. Matching sculpture too, of tritons and deities, flanking the central doorway.

Under the W transparent portico two handsome doorways, the l. one to the house of the Navy Treasurer. Behind this, facing the side street, the yellow brick TERRACE of houses for the Navy Commissioners. The street itself was excavated *c.* 1870 down almost to river level, making the doorways of the houses inaccessible. High-level cast-iron BRIDGE of 1896; low-level pink brick BLOCK, also late C19, for the Civil Service Volunteer Rifles (reconstructed in the 1950s after war damage?). The WAR MEMORIAL erected for them by *Lutyens c.* 1923 has now been repositioned on the river terrace in front of the Navy Treasurer's doorway. It has solid, painted flags attached to the stone pier, like

those Lutyens proposed for the Cenotaph (*see* pp. 245–6). At the far w end of the terrace a simple ramp BRIDGE, 1999–2000 by *Dixon/Jones*, providing direct access to Waterloo Bridge.

INTERIORS. The premises of the Learned Societies in the Strand Block (since 1989 occupied by the Courtauld Institute and Gallery) contain a number of excellent rooms. Many have uncommonly good plaster ceilings, by *T. Collins* and *T. Clark*, in a style quite different from contemporary Adam work, though no less antique-inspired. Identical ENTRANCE HALLS l. and r. of the columned vestibule, and nearly identical semicircular STAIR-CASES rising out of them beyond screens of Doric columns. The wrought-iron railings differ (the Royal Academy – w – gets the more elaborate design), but both staircases are embellished with pilasters, rising in sequence from Doric to Corinthian, at each of the four levels. At the third, *piano nobile*, level the landing is covered with a shallow coffered tunnel vault, to mark the entrance to the Societies' public rooms. On the Academy's (w) stair there were originally, at second and fourth levels, painted allegorical panels by *G.B. Cipriani*, of which only the frames have survived. The plaster casts in both entrance halls belong to the Royal Academy's collection; the Furietti Centaurs in the w hall even occupy their original positions.

Now that the PUBLIC ROOMS are interlinked as the exhibition rooms of the Courtauld Gallery, they can all be reached from the w (Royal Academy) staircase. At basement level here, like a miniature stage-set and reached by a typically ingenious twisting staircase, the semicircular rusticated front of the ACADEMY KEEPER'S HOUSE (now restaurant). The *piano-nobile* landing opens into the square ROYAL ACADEMY ANTE-ROOM (Gallery 6). Restrained plaster decoration, rather French in character, on walls and ceiling. Paintings in the cove by *Cipriani*, ceiling paint-ing, the 'Theory of Painting', a copy of *Sir Joshua Reynolds*'s origi-nal now in Burlington House. To the N of this, the ANTIQUE ACADEMY (Gallery 1), with a big niche for a stove. The central N room, the ROYAL ACADEMY MEETING ROOM (Gallery 2), was the main showpiece. The ceiling plasterwork incorporating noble female figures originally framed paintings by *Benjamin West* and *Angelica Kauffmann* which too can now be seen at Burlington House (*see* p. 489). Twin marble chimneypieces by *Wilton*. Gallery 3, for the Society of Antiquaries, is the most restrained of the three Meeting Rooms. The joint ANTE-ROOM for the Royal and Antiquarian Societies (Gallery 4) closely matches the Royal Academy ante-room, but here *Cipriani*'s paintings are mono-chrome. The central s room (Gallery 5) was the ROYAL SOCIETY MEETING ROOM. Its ceiling has enriched coffering. The colour schemes here and in Gallery 2 reflect the originals, which used pink, pea green and lilac.

The steep top flight of stairs leads to the Royal Academy's exhi-bition rooms, the square ANTE-ROOM, and the GREAT ROOM, lit from high up by four tripartite thermal windows. The ceiling here was painted by *Charles Catton*, with a central sky and groups of putti in the spandrels, all now lost. At this level, in the ante-room, now virtually a fixture, is a brought-in piece by *Chambers*, the CHARLEMONT CABINET, designed for the 1st Earl of

Charlemont's coin collection and originally forming one side of a room in his town house in Dublin. Exquisite carved decoration by *Sefferin Alken*.

The E ENTRANCE HALL is now the entrance to the Courtauld Institute. In 1987–8 *Green Lloyd* extended the stair down to open up access to Chambers's great double-height brick VAULTS. At the top of the stair, LECTURE ROOM, remodelled from *Chambers*'s Royal Academy Museum. Reticent plasterwork.

In the SOUTH RANGE the Navy Office had two impressive rooms. The central entrance hall, the SEAMEN'S HALL, is divided by screens of Doric columns. Much more exciting is the NAVY STAIR in the SW angle. Spacious oval well, toplit. The stair starts in two curved flights, which meet to form a stone fly-over to the first floor (where the Navy Board Room was situated). From the first to the second floor one curved flight. This part of the building was reconstructed in 1950–2 by *Richardson & Houfe* after serious bomb damage during the Second World War.

In 1998–2000 the lower two levels of the South Range and the vaults below the river terrace were fitted up by *Inskip & Jenkins* as exhibition spaces for the GILBERT COLLECTION of *objets d'art*. Polished steel, glass, mahogany, and no concession to Chambers in what had been utilitarian areas.

The INLAND REVENUE BUILDING, Lancaster Place, 1851–6 by *Sir James Pennethorne*, faces W on to the approach to Waterloo Bridge, and to the E is incorporated into the back of the Navy Office Commissioners' terrace. Elaborate W front fifteen bays wide with wings projecting by four bays. Three full storeys plus an attic. The style studiedly imitates Chambers with just enough variation to avoid pastiche. Much high-level sculpture by *W. Theed*. Royal arms in the central pediment and seated Britannia above. Otherwise standing female figures representing cities of the United Kingdom.

It has become apparent during the course of the above description that the original functions of Somerset House are now much changed. In conclusion a brief survey can be given of what has been a struggle between the two original uses, administrative and cultural.

First the cultural use expanded when from 1829 the E part of the complex was built for King's College, partly to Chambers's design, partly departing from it. But soon the Learned Societies began leaving the Strand Block, the Royal Academy in 1837, the others in the mid 1870s. The Registrar-General's department took over the Strand Block, and stored its records in the vast vaults under the river terrace. Those who came to consult birth certificates or wills examined them in the Seamen's Hall. The Navy Office departed in 1868, and the South Range came to be the main registry of the Family Division of the High Court. Meanwhile, as successor to the various tax offices among the original occupants, the Inland Revenue expanded from Pennethorne's building to the W, to occupy more and more of Chambers's building, not only the Commissioners' terrace, but the W and E ranges of the courtyard itself.

From the late 1980s this process was put in reverse once more. In 1989–90 the Courtauld Institute of Art and its Gallery were

installed in the Strand Block. In the mid 1990s the South Range was cleared of civil servants and the river terrace vaults cleared of the Registrar-General's records, so that it too could be devoted to cultural uses. Besides Sir Arthur Gilbert's collection in the vaults, mentioned above, an outpost of the Hermitage museum, St Petersburg, has been installed in part of the E side of this range.

WATERLOO BRIDGE

By *Rendel, Palmer & Tritton*, 1937–44 (opened 1942), with *Sir Giles Gilbert Scott* as collaborating architect. Of high architectural merit, resilient and elegant in the shallow twin arcs of its five spans, each of nearly 240 ft (73 metres). They are reinforced concrete box girders, cantilevering, not arching. Spandrels faced with Portland stone, with exposed aggregate concrete around the rim of the arches. The cutwaters are concrete shells encasing the relatively flexible structural piers. Plain railings. Staircases down to the Embankments are neatly tucked away within the abutments. At these four points are small plinths, meant for sculpture that was never installed. The NE stair was adapted in 2000 for access to the Somerset House river terrace.

The forerunner was by *John Rennie*, 1811–17, a design of great strength and directness, with similarities to his earlier Lune Aqueduct, Lancs., and Kelso Bridge in Roxburghshire. There were nine elliptical arches of 120 ft (36.6 metre) span, entirely uniform, giving a level parapet. Coupled Greek Doric columns attached to the piers. The granite masonry was meticulously cut, with voussoirs 9 ft (2.7 metres) deep at the haunches. Inverted arches internally carried the thrust across the piers. The shallow spread-footings on piled foundations were less substantial, however, and severe settlement of two piers in 1923 led to the bridge's controversial demolition in 1934–6.

STREETS

ADELAIDE STREET

Here, immediately behind St Martin-in-the-Fields, the West Strand Improvements can be seen at their most complete. They were planned and largely designed by *Nash*, and finished in 1832. On the W SIDE, facing St Martin, are ST MARTIN'S PAROCHIAL BUILDINGS, 1827–30. First the fine stucco façade of the former St Martin's Schools: seven bays, rusticated ground floor, upper floor with giant Ionic pilasters and round-headed windows. Designed with one large schoolroom per floor, each for 350 children. Next to it the Vestry Hall, a pedimented front with a circular relief in the tympanum of St Martin and the beggar, by *W. Pitts*. The main room has

gilt-lettered panelling; also a big carved royal arms, looking
c. 1660 and presumably from the church. Then the Vicarage,
with a mid-C19 top storey and a canted bay facing w. This
originally formed one end of a symmetrical composition
along St Martin's Place (*see* St Martin's Lane).
The E SIDE of Adelaide Street is made by *Nash*'s triangular block
along the Strand (q.v.), reconstructed in 1973–8. It starts there
with the original lettering, at the corner with the twin pepper-
pots. In front here is the unlikely OSCAR WILDE MONUMENT
by *Maggi Hambling*, 1998: a head and hand of bronze open-
work, self-resurrecting from a green marble sarcophagus. In
Adelaide Street Nos. 1–4 are complete, Nos. 5–7 1970s fac-
simile reinstatement, and then the composition continues up
to another pepper-pot at the corner of WILLIAM IV STREET.
Here is another centrepiece with a giant order.
The N SIDE is the longest side of another triangular block (now
CENTRAL POLICE STATION), in the same modest yet digni-
fied stucco style. In Nash's time it had a hospital at either end.
The w corner was the Ophthalmic Hospital, 1831–2, with a
Greek Doric entrance. The likeliest designer is *Decimus Burton*.
Originally of three storeys; heightened rather well in 1875–6 by
John James Thomson, and again in 1910. In 1987–8 it was recon-
structed behind the façades by *Metropolitan Police Property
Services Dept*, with a bridge to a new central section in a Nash
style. Also reconstructed was the E range, the former Charing
Cross Hospital of 1831–4, certainly to *Burton*'s design. It has
a rounded s corner towards the Strand, stressed by giant half-
columns. The order is Corinthian, after the Lysicrates monu-
ment in Athens. Fourth storey by *Thomson*, 1877; also the
four-column Doric portico on Burton's long Agar Street front,
E. Between the hospitals were ordinary 1830s houses, taken
over by the Charing Cross Hospital and rebuilt 1881 and again
1902–4. In 1973 the hospital decamped to Fulham.

ADELPHI

The three brothers *Adam*, the *adelphoi*, leased the site of Durham
House in 1768, obtained the necessary licences by Act of Parlia-
ment, and began building that year. It is hard to visualize now
what their Adelphi looked like. As for what it meant, it was the
first great Georgian riverside composition in London, a row of
first-class residences forty-one bays long, built to one consistent
pattern, with two detached side accents to l. and r. They rested
on an arched substructure of warehouses with a quay in front:
a pioneering exemplar of the splendours of embanking. A likely
source is the arcaded shoreline of Diocletian's Palace at Spalatro
(Split in modern Croatia), as published by *Robert Adam* in 1764.
The central block was called Adelphi Terrace or Royal Terrace,
seemingly the earliest usage known of that word for a uniform
row of houses. Between it and the side ranges were streets
running N–S, joined by a third street along the back. Financially
this huge enclave was not a success, partly because the Govern-

ment refused to lease the warehouse space as the brothers hoped. So in 1774 a lottery had to dispose of the houses. This brush with bankruptcy embittered Robert Adam, whose gifts never found fulfilment in any other great London building.

At first sight the individual HOUSES were just the same four-storey brick houses as were going up in Marylebone or Bloomsbury, but it was the principal accents where *Robert Adam*'s finesse of design appeared at its most striking: attenuated pilasters rather than columns or demi-columns, decorated with the prettiest anthemion ornament; doorcases in keeping; and plasterwork and chimneypieces also in keeping. Compared with contemporary architects in France, Germany or Italy, Adam remained a Palladian throughout his life; but compared with the style of the English Palladians before and around him, his was all the same a revolution. The 'light mouldings, gracefully formed [and] delicately enriched' praised in his own published *Works in Architecture* were appearing in various forms from the hands of rival architects, it is true, but for interiors only, and there was nothing in London to compete with the elegance of the external motifs of the Adelphi. In these Adam elaborated a new Neoclassical domestic idiom, set apart from the orders of the Renaissance and all their public or religious connotations.

This legacy was treated with Victorian disregard in 1872, when the central block was smothered in Italianate stucco (perhaps by *Scurry & Wright*, who were then attending to failing timbers in the vaults). But then in 1936 the entire central block was destroyed. Let what stands in its stead speak for itself. Houses survive only in the two side streets – Adam Street and Robert Street – and in John Adam Street, along the back.*

In ADAM STREET Nos. 6–10 remain. No. 10 with its quadrant corner is the introduction. Nos. 8 and 9 have pretty timber doorcases of different design, one taken from another Adelphi house. No. 7 faces down John Adam Street, making one of the major accents of the whole composition. It is distinguished by giant pilasters of *Liardet*'s cement, with anthemion decoration, and a pediment raised on short pilasters or dies, with the Adams' arms in it. The cast-iron balconettes – some of the earliest in London – were made by the *Carron Company* of Falkirk, in which John Adam had a share; their heart-and-anthemion motifs were to have a long run. No. 7 and No. 6 have C19 stucco additions. The rest went in 1937, for offensively bland offices by *Andrew Mather*.

Replacing the whole centre is the NEW ADELPHI, a big office block by *Stanley Hamp* (*Collcutt & Hamp*), 1936–8, savagely ungraceful, with reiterated uprights and set-backs in a transatlantic commercial idiom. The Embankment front has two projecting wings reaching over a little-visited promenade. They are here pierced by big square openings with square pillars. Above, giant relief figures at the corners: from E to W, by *B. Copnall*, *A.J.J. Ayres*, *G. Ledward*, *D. Gilbert*. On the sides and back stone

4

*Also a ceiling from Garrick's house, No. 5 Adelphi Terrace, at the Victoria and Albert Museum.

gives way to brick, with cast-iron bay windows in the nooks and recesses. At the N entrance carved panels by *Newbury Trent*. Two storeys added 1993.

The N side of JOHN ADAM STREET is more intact. To the E the buildings of the ROYAL SOCIETY OF ARTS are all the Adams', and of uncommon interest. The farther ones, taken over in 1957, are the former Adelphi Tavern of 1771, on the E corner, and Nos. 2 and 4. Its E return has an original pediment above the central three bays, but C19 vermiculated rustication below and on John Adam Street. Nos. 4 and 6 have matching door-cases. The latter, which has taller windows, was built as the secretary's house, No. 8 as the society's house proper (1772–4). *Robert* and *James Adam* both signed the drawings. The façade of No. 8 has three wide bays with an attached temple front of fluted Ionic columns (the capitals of Erechtheum type). Of stone, to distinguish it as a public building. The doorcase is tripartite, with Tower-of-the-Winds capitals. Above it is the characteristic Adam version of the Venetian window, with a fluted relieving arch. Triglyph and patera frieze, interrupted by the inscription 'Arts and Commerce Promoted' (the society was founded in 1754 as the Society for the Encouragement of Arts, Manufactures and Commerce). Sculpture has been introduced to match the first Adam design: plaques 1980, statues on the parapet 1994. For the 1920s frontispiece on the N wall *see* Strand, p. 367.

INTERIORS. Four properties are merged here, so the story is complex even before later interventions are considered. The historic rooms are impeccably presented, despite their various present uses. The ENTRANCE HALL is mostly good Adamesque of 1922 by *A. T. Bolton*, who replaced the side walls with column-screens. C18 survivals include parts of the staircase, l. (which originally continued to the second floor); also one fire-place, from elsewhere in the house. On the landing big inset paintings of 1864 of Victoria (by *J. C. Horsley*) and Albert (by *C. W. Cope*). Also the President's Chair, designed by *Sir W. Chambers* in 1759 for the society's first premises, which he con-verted from a house off the Strand just to the E. Ahead on the ground floor is the BENJAMIN FRANKLIN ROOM, a restora-tion by *Bolton* of the Adam design (changed in 1863–5), putting back the four slim quasi-Doric columns. Here the Society's collection of prize-winning designs was displayed. Two fire-places, of marble rather than the normal Adelphi wood, moved from the Great Room above. *L. Manasseh & Partners* made good the walls in 1971, removing Bolton's bookcases. Plain flat ceiling.

The GREAT ROOM directly above was designed for the members' debates, originally with semicircular seating facing N; now arranged as a lecture hall, with raked seating facing E. *James Barry*'s remarkable history paintings remain. They date from 1777–83, with revisions up to 1801, and for all his huge ambitions were the only such cycle Barry completed. He described their object thus: 'to illustrate one great maxim or moral truth, that the obtaining of happiness . . . depends on cultivating the human faculties'. The first canvas, l., shows

mankind in a state of nature, learning the beginnings of civilization from Orpheus. Second, 'A Grecian Harvest-Home, or Thanksgiving to the Rural Deities.' Third, crowning the victors at Olympia; Pericles is a likeness of the elder Pitt. Fourth, 'Commerce, or The Triumph of the Thames'. The triumphal river car is drawn by Drake, Raleigh, Cabot and Captain Cook. Fifth, the distribution of prizes by the Society, with Dr Johnson and Burke recognizable. The picture in the picture is Barry's 'Fall of Satan'. Sixth, along the whole s wall, 'Elysium, or the State of Final Retribution'. Two portraits interrupt the sequence: *Gainsborough*'s Lord Folkestone, 1776, and *Reynolds*'s Lord Romney, 1770. The pilastered dado is *Bolton*'s of 1922, the frieze and coving are original, the circular lantern was made in 1996 by *Troughton McAslan*.

The first-floor rooms continue with an apse-ended ante-room and then the former Committee Room in No. 6 (now DRAWING ROOM), deliberately plain. Behind it a passage leads into No. 4, where the front room ceiling is a delicate design of four lobes and diagonal medallions. Doorcases and window surrounds installed 1957, salvaged from *Adam*'s demolished rooms at Bowood, Wilts. These were of 1761–5, so are heavier than Adelphi work. Also from Bowood the chimneypiece in the room next door, in No. 2. This is long, with a rounded inner end and a ceiling with husk garlands trailed around an oval. Converted to a library 1971; to be restored after part of the basement is adapted for a new library, planned for 2003. Carved doorcase of *c*. 1750 from Fineshade Abbey, Northants, with another such in the FELLOWS' READING ROOM beyond. This was the chief interior of the Adelphi Tavern, the best survivor of the grand taverns of later C18 London. The ceiling has three ovals and two half-ovals, with Bacchanal paintings of the school of *A. Zucchi*. Chimneypiece from Bowood, as are the doorcases in the smaller room to the N.

The ground-floor rooms in the houses to the E are altered and less interesting, apart from the large TAVERN ROOM in the SE angle. Its Adam ceiling of diamonds and circles was restored and continued a little W in 1990; fireplaces and doorcases again from Bowood. *Green Lloyd* glazed over the back yard in 1989–90, and some rooms were modified in conjunction. As a way of exploiting back land the solution is familiar enough, but it stands out for the drama and ruggedness of the open steel-framed staircase that climbs within the space. It continues down to the vaults, which were converted for meetings and functions. A sloping access road beneath No. 8 was exploited to make a second lecture theatre, part of the granite roadway being left exposed. The wine vaults directly beneath it were joined up with the impressively lofty spaces to the E, a remainder of the great groin-vaulted catacombs that underlay the whole Adelphi.

ROBERT STREET has the 1930s block along its E side. On the W side the survivals are Nos. 1–3, amongst the last parts to be built. Each is unusually broad, with a continuous dormered upper storey of 1908. No. 1 is thought to be the oldest

surviving London house outside the Inns of Court to have been arranged from the start as flats or chambers. On it an early C19 doorcase, on No. 2 an original one. No. 3 has attenuated pilasters, coupled at the angles on the Thames front, and with a pediment. Inside, the houses have staircases with rounded ends and stick balusters (that at No. 3 a reinstatement, 1984), and a few ornamented ceilings. The low structure in front of No. 3 is No. 11 Lower Robert Street, Adamesque of 1906 above (by *A.B. Hayward*), but resting on the carcase of one of the 'cottages' or small mezzanine houses in the Adam substructure. A fragment of the VAULTS beneath the houses may be seen off York Buildings to the w.

p.
31

ALDWYCH

Aldwych, with Kingsway to its N (q.v.), is the greatest episode of C20 town planning in Westminster. Clearance for it began in 1900. The plan is a crescent doubling back on the Strand. Its w end is aligned with Waterloo Bridge, and its E end was intended to join up with a new Thames bridge. Kingsway runs N from the apex. The LCC was determined that the petty architecture of Charing Cross Road etc. should not be repeated, and in 1900 a limited competition was held. The eight entrants all designed buildings in an Imperial classical style, though no-one then knew what would occupy them. But in the end the street was not built to one design, and of the eight only *Ernest Runtz* did anything here. Aldwych consists entirely of buildings of monumental scale, mostly with steel frames. It took until 1935 to fill so much empty land, so their styles range nicely from early Edwardian embroidery to interwar stripped classical. New housing for those displaced necessarily went up earlier, much of it along Drury Lane (q.v.), where many smaller streets were also widened and rebuilt.

Coming from the w, the first building on the N side is No. 1, built for the Morning Post in 1906–7 by *Mewès & Davis*. Two top storeys and a dome of different pattern were added by *G. & T.S. Vickery*, 1927–8, when it became general offices. They diminish the Parisian elegance of the design, which was a surprising choice for a newspaper. As at the Ritz (*see* p. 559) – likewise erected by the *Waring-White Building Co.* – a steel frame was used, and Norwegian granite facing, superbly carved with masks and trophies by *A. & F. Manuelle*. The chairman's office was over the s vestibule, the printers in the basement, the compositors below the roof. In 1997–8 converted to a hotel by *Jestico & Whiles*; restaurant in the s corner by *Golding Design Associates*.

The dome of No. 1 was originally balanced on the opposite corner by the Gaiety Theatre, a landmark in early Edwardian taste. It was of 1902–3 by *Runtz & Ford*, with energetic Baroque elevations by *Norman Shaw*. The present dull, lifeless building is of 1957–60, stone-faced and with nothing to recommend it (future uncertain). It was built for English Electric, after a competition won by *Gordon Tait* (*Burnet, Tait*

& *Partners*) in 1955. Tait's design had two slabs at right angles, but the company wanted more traditional façades, and when Tait refused to alter his design the job went instead to *Adams, Holden & Pearson*.* In 1983 *Heery Ltd*. infilled its light well for CITIBANK. Of *Shaw*'s work MARCONI HOUSE survives, incorporated behind. This, originally the Gaiety Restaurant, has façades to Aldwych and the Strand with an arched ground floor, alternating pediments to the first-floor windows (on the Aldwych side with columns), three more storeys with completely undecorated windows, and then a storey with a frieze of standing personifications by *H.C. Binney*. Above, one plain 1950s storey replacing the lower dormer storey in Shaw's steep roof.

Next on the N side a wonderful piece of symmetry: a block with the tall Waldorf Hotel flanked at the corners by twin theatres, the STRAND, w, and the ALDWYCH, e, twin designs by *W.G.R. Sprague*, 1905. Each has a rounded entrance with columns and a row of fat urns on the parapet. Dixhuitième interiors with superior stucco work, differently arranged, e.g. the Aldwych has a round balcony over the foyer, and in the auditorium two balconies to the Strand's three. At the Strand *H. van Hooydonk* assisted with the decoration, which features marble pilasters and a relief of Apollo in his chariot over the proscenium. The WALDORF HOTEL between, much taller, is of 1906–8 by *A.M. & A.G.R. Mackenzie*. This has French pavilion roofs over the three bays at each end, giant Ionic columns in the middle, and a frieze of putti by *Emil Fuchs* between the fifth-floor windows. Interiors also French (the younger Mackenzie had studied under René Sargent in Paris): e.g. the rather understated palm court in the central enclosure.

Opposite (s side), INDIA HOUSE, 1928–30 by *Sir Herbert Baker & Scott*. The Indian High Commission was founded in 1919 as a first step towards self-government, so the usual classicism would not have been appropriate here. The exterior shows off Baker's weakness rather than his strength, attempts at elegance on the wrong scale, and small Indian motifs – sculpture, balustrades and railings – which appeal more to the mind than the eye. Black granite entrance with Asoka columns above, a symbol of empire (carver *Sir Charles Wheeler*).

The INTERIORS are more decidedly Indian, dressed with red sandstone, with balustrades treated as openwork *jali*-type screens, some of which were carved in India. Several rooms are lined with Indian or Burmese woods. Baker shows his hand most in the smooth flattened dome and pendentives of the entrance hall, in a few simple ceilings of C17 English deriva- 109 tion, and in the tight and ingenious plan, by which, e.g., the white marble lantern over the entrance hall doubles as a dome-like *chattri* within the High Commissioner's Room above. The MURALS, of 1930–2, are collaborations by Indian artists sent for special training to London and Rome: *R. Ukil, S. Choudhury, D.K. Deb Barma* and *L.M. Sen*. Themes are again entirely Indian, as are most of the styles, though some

* *Sir Charles Wheeler*'s two allegorical bronze figures were removed in 1971–2.

approach a kind of Art Nouveau. The boldest are in the central space: Seasons below, historical vignettes above. Smaller scenes in two big rooms to its l.: the Reading Room, with its centre open to overlook a basement hall, and the Gandhi Room above, an arcaded library with a gallery squeezed in high up. Down MONTREAL PLACE, W, a BUST of Nehru by *Lati Kalcatt*, 1990, the pedestal by *Peter Leach Associates*. For the corner buildings towards Kingsway, N, q.v.

The Kingsway axis is closed and the section between Strand and Aldwych finds its climax in BUSH HOUSE, by *Harvey W. Corbett* of the New York firm *Helmle & Corbett*. The central block, of 1920–3, represents a big-business classicism which the Americans handled more successfully than the English. The exedra or entrance niche is especially impressive, with two huge Corinthian columns and an entablature acting – in the way of the Roman baths – as a screen in front of a giant coffered niche. On the entablature symbolical figures of England and America by *Malvina Hoffman*. These refer to the building's original use as a trading centre (cf. the relief of Atlantic commerce on the S pediment), and are nothing to do with the BBC whose motto runs below. Also emblematic of 1920s America is the Hellenistic or Quattrocento detail, simplified but not squared off in the familiar, European way. The plain broad wings are later, of 1927–8. Low colonnades link them to the centre. The Strand side in its quieter forms is an acceptable background to the finesse of Gibbs's St Mary-le-Strand. The S wings are later still: E, 1930–2, W, 1934–5; a central tower proposed *c.* 1921 was not executed. E of the main S entrance a MONUMENT to Andrew Young, valuer to the LCC, portrayed in relief by *Eric Bradbury*, 1924.

In the E part of the crescent several blocks by *Trehearne & Norman*, later than their Kingsway work, and with ground-floor columns instead of a giant order: MELBOURNE HOUSE, 1928–9, balancing India House on the central block; COLUMBIA HOUSE opposite, N side (No. 69, of 1928); also No. 95 (1921–2, by the firm's chief assistant *E. Frazer Tomlins*). Between the last two the big ALDWYCH HOUSE, 1920–2, by *Gunton & Gunton* for Agricultural & General Engineers. Symmetrical, with giant Doric columns of the part-fluted Delian type. Spectacular staircase by *Hunter & Partners*, 1991. Less showy but more interesting *J.J. Burnet*'s No. 99, further E. Built for the General Accident Insurance in 1909–11, and still close to his more quizzical Scottish manner. Non-repeating storeys, with such original motifs as the dark frame around the main ground-floor windows and the triangular arrangement of *Alfred Hodges*'s cast and carved figures. Ionic columns at the entrance. Burnet's interiors, ingeniously planned and beautifully detailed, were restored and converted for the LSE by *Shepheard Epstein Hunter*, 1995–6. At the back a double-height galleried banking hall, reached by a vestibule also with a gallery, shaped to disguise differences of axis. Panelled board room in the front mezzanine. Other new parts, e.g. staircases, clearly differentiated.

AUSTRALIA HOUSE, on the E triangle of the crescent, is by *A.M. & A.G.R. Mackenzie*, 1913–18, the first of the really big Dominion headquarters. By comparison with Burnet's the design seems commonplace, in spite of its parade of paired columns and *Harold Parker*'s two huge figure groups guarding the corner entrance. Above, a great bronze group of Phoebus and the horses of the sun, by *Sir B. Mackennal*, Parker's fellow Australian (1915, installed 1924). The architects were constrained by having to incorporate the former Victoria House at the SW corner, 1907–9 by *Alfred Burr*, though its shaped gable – suggested by the LCC's consultant *Norman Shaw* – was taken down. The ground-floor rooms form one great marble-lined 101
axis in the Beaux-Arts manner, with a controlling Doric order. It passes between twin D-shaped staircases to end in an aisled exhibition hall. Australian stones and woods were used, but the mood is mostly French C18, implemented by top-flight British firms: the *Bromsgrove Guild* (entrance gates), *W. Turner Lord & Co.* (stucco), *Wylie & Lochhead* (wood carving), *Starkie Gardner* (balustrades). Works of art were commissioned later, e.g. murals in the upper vestibule by *Tom Thompson*, a kind of Australian Piero della Francesca, 1958–60. To its E the High Commissioner's Room, in the prow over the entrance.

BEDFORD STREET

It runs N–S, at the W end of the 4th Earl of Bedford's Covent Garden estate. Built up from 1631; now mostly commercial Victorian. Coming from the S, Nos. 4–9, W side, are the former Civil Service Supply Association, an early department store: by *Lockwood & Mawson* of Bradford, 1876–7. Red Suffolk brick and red terracotta, in a dainty North Italian Renaissance. *Chapman Taylor Partners* rebuilt behind its façades in 1984, adding the mansard and sturdy ground-floor pilasters. On the E side, S corner with Maiden Lane, Nos. 41–42, 1912–13 by *Crickmay & Sons*, red brick with quoins and Art Nouveau shopfronts. In a similar idiom ALDINE HOUSE diagonally opposite, 1911 by *E.K. Purchase*, for the publishers Dent & Sons. It has a corner turret, super-Georgian shopfronts, and a lesser front to Chandos Place, l. (separated by Nos. 67–68 there, stucco of 1866–8). Facing Aldine House, Nos. 37–40, rough and ready Italianate; Nos. 38–40, a tea warehouse of 1861 by one *Griffiths*, has been home since 1881 to THE LADY magazine. Nos. 14–16, W side, 1863–5, are by *S.S. Teulon*: a surprise, as their commercial Italian is nothing like his usual Gothic. The former POST OFFICE at Nos. 17–19, in a remarkably serious Roman High Renaissance, is by *James Williams*, 1883–4. No. 34, the N corner with Henrietta Street, by *Charles Gray*, 1857–8. The Early Victorian palazzo formula, but with a strong contrast between channelling below and round arches above, the detail going loose and incorrect. Gray, a co-founder of the Architectural Association, aimed to develop a new style

from such mixtures (cf. Tavistock Street). At the N end, W side, Nos. 22–25, a big but gently handled block by *Fitzroy Robinson & Partners*, 1988–91. Brick-faced, with an open tempietto of columns on the corner.

BELL YARD

The easternmost N turning off the Strand. The Royal Courts of Justice lie to its W (q.v.). The E SIDE has some modest Victorian offices. No. 5, loose Renaissance, is dated 1854. By *Isaacs & Florence* No. 7, 1879, simple brick, and No. 8, 1881, stone, with a giant bell, which was Messrs Maxwells', law publishers. The narrow Gothic No. 13 is by *William Low*, 1870, the golden stone Italianate offices next door probably by *William Elsdon*, c. 1878.

BOW STREET

First rated 1633; cut through to Long Acre, N, 1792–3. Dominated by the Royal Opera House, W side (q.v.). On the E side, the DESIGN COUNCIL, masked in 2002 by *Dixon/Jones* and *Baily Garner* with wire-mesh screens cantilevered out from the upper storeys. Blushing behind this metal yashmak is a former telephone exchange by *G.R. Yeats* (*Ministry of Public Building and Works*), 1964–7, an extension of the 1920s building in Russell Street, s (q.v.). Upper windows with concrete panels projecting boldly between vertical supports. Office conversion by *Ben Kelly*, 1998, with coloured partitions defining flexible, free-flowing spaces. After the Magistrates' Court (q.v.), a former bank, 1897 by *R.S. Wornum*, of one build with his flats in Broad Court to the E (*see* Drury Lane, p. 346). STATUE of a ballerina in front by *Enzo Plazzotta*, 1988.

BUCKINGHAM STREET

The most rewarding of the streets built after 1673 on the site of the Duke of Buckingham's house (*see* Victoria Embankment). Their names commemorated him: George Street, Villiers Street, Duke Street, Of Alley, and Buckingham Street.* Various builders and speculators took a hand, *Barbon* included. Their houses make up the best such group left in Westminster, varied in plan, and mostly still with some bolection panelling and box cornices inside. The fine heavy RAILINGS also remain, and a wonderful variety of (mostly C18) doorcases.

The description runs down the W side and back up the E. Nos. 8–12 are all of *c.* 1675–80, now stuccoed. No. 8 already has the

* Of Alley is now York Place, George Street now York Buildings, Duke Street now the E part of John Adam Street.

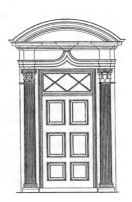

Buckingham Street, Nos. 13, 10, 9, 18 and 17.
Seventeenth- and eighteenth-century doorcases. Elevations
(*The Survey of London*)

space-efficient plan usual from the C18, with the staircase
alongside a smaller rear room. No. 9, of three bays and one
blind half-bay, has a nice door-hood on carved brackets. At
No. 10, first occupied 1676, a naïve doorcase with rusticated
pilasters. Upper front altered late in the C18 to a canted bay
window. Staircase between front and back rooms, as usual in
the 1660s–70s, with a narrow light well. Gracefully twisted thin
balusters, four of which together make the newels. Their pro-
portions and details suggest the early C18. Original closet wing,
a rare early example. No. 11, of six large-windowed bays, has
thin quoins and grotesque keystone heads. Timber staircase
of mid-C18 type; two rich Adamesque first-floor ceilings and

p.
31

friezes. Also of six bays No. 12, with a clumsy Grecian door-
case framing an older one carved with acanthus. Staircase with
newel pendants and heavily twisted balusters on bulb bases:
the same which Samuel Pepys, resident 1679–88, must have
climbed to his bed. No. 13 is a late C18 reconstruction, hence
the Chambers-style doorway. No. 14 was residential chambers,
a rare London type; built *c.* 1792 by *Peter Bogue.* Doorcase with
Doric columns, river front ten bays long.
The E SIDE meets the gardens with Nos. 15–16, BURDETT
HOUSE, offices by *Trehearne & Norman, Preston & Partners,*
1962–4. Stone-faced, with triangular-headed ground-floor
windows.* No. 17, looking *c.* 1720–30 externally, has an extra
half-bay, l., and a doorcase frieze curving up in the middle.
(Bolection panelling in some rooms, suggesting a late C17
date.) At No. 18 a facsimile front of 1960–6 with giant end
pilasters. Original Corinthian doorcase, i.e. early C18, with
carved brackets. More chambers by *Bogue* at No. 19, *c.* 1797.
Departures from the domestic norm are the even storeys,
awkward eight-bay front and very large doorway. The gener-
ous stone staircase has rounded ends and a simple iron
balustrade. On the landings fan-lit doorways to the chambers,
each originally of two rooms. No. 20, with a handsome banded
brick front, is of 1676. Staircase between front and back rooms,
rebuilt larger *c.* 1800. No. 21 also *c.* 1675, refronted.
The E corner with John Adam Street is No. 22, an early example
of Italian medieval, *c.* 1857 by *R.P. Pullan.* Coloured tile frieze,
rounded windows of bright red brick, and a gabled porch on
lush foliage capitals. William Burges (Pullan's brother-in-law),
E.W. Mountford and Guy Dawber all had offices here. The
part up to the Strand was reduced to a pedestrian alley in the
1950s. More refronted houses of *c.* 1675 in John Adam Street,
to the E (Nos. 21 and 27, S side; *see* also Adelphi), and in YORK
BUILDINGS, parallel to Buckingham Street on the E (Nos. 6
and 7, W side). The gabled Nos. 13–15 (WATERGATE HOUSE),
1906–7 by *Thompson & Walford,* overlooks Embankment
Gardens.

CAREY STREET

It runs E–W behind the Royal Courts of Justice. At the W end
NEW COURT, offices by *Seifert & Partners,* 1964–8. Like its
predecessor, of 1872–9 by *Waterhouse,* it fills a whole block and
has a central courtyard. Seven storeys, plain grey mosaic bands
between windows, typical Seifert piers. E of Serle Street Nos.
51–52, a pretty brick house of 1888 by *George Sherrin.* Two-
storeyed, like most of the little houses built in the shelter of
the New Square of Lincoln's Inn, N (*see London 4: North*). On
it a statue of Thomas More by *Robert Smith.* Within is an
entrance to Lincoln's Inn, via an ingenious circular lobby with
half-flights up the sides. The little SEVEN STARS pub (No. 53)

* An oval ceiling from old No. 15, painted with an allegory of Summer, is displayed
at the Museum of London.

features a timber-fronted bay. Dated 1602 on the front, but plainly not older than New Square behind, i.e. of the 1680s. The simple stone Nos. 58–59 was a branch of the Clerical, Medical & General Assurance, by *Dunn & Watson*, 1920.

At No. 60 a fine house of 1731–2, built for Richard Foley MP, with rubbed brick dressings and a Doric doorway of *c.* 1800; restored 1929–32 as the Law Society's President's House. Six windows wide, irregularly spaced as if meant as a pair, but planned as one house within, with a fine (if narrow) mahogany staircase, r., and open-well back stair, l. The former has two column-balusters per tread and carved tread ends. In the ceiling a panel painted with architecture in foreshortening, ascribed to the Thornhill circle (cf. No. 8 Clifford Street, pp. 514–15). The papier-mâché ornament around it and within the wall panels is closer in style to the London Rococo of *c.* 1740, and must be later. In 1929–32 *Lander, Bedells & Crompton* added a back chamber for the Solictors' Disciplinary Tribunal, with corner columns and a shallow Grecian lantern. Round the corner in STAR YARD, No. 3, a warehouse of 1883, delicate brick Gothic reminiscent of C15 Bruges. By *W.F. Unsworth*, a pupil of Street and of Burges. Also a cast-iron Victorian URINAL.

CATHERINE STREET

Laid out *c.* 1631, at an angle to the main Covent Garden grid. Just N of Aldwych, W side, is the little DUCHESS THEATRE, 1928–9 by *Ewen Barr*. Odd, modernistic Tudor, with three square bays with linenfold panels. Tightly planned, intimate interior in a stripped classical style, by *Marc-Henri & Laverdet*. Reliefs by *Maurice Lambert* flank the proscenium. At the NE corner with Tavistock Street Nos. 2–6, 1902–5 by *H. Heathcote Statham*, editor of *The Builder*. Three self-consciously original red brick façades. Each has a flat canted bay and ribbed cornice, with banded or chequerwork patterning. *The Builder* itself was at No. 4, where Statham merely refronted its premises of 1874 (by *Habershon & Brock*). On the W side No. 23, the OPERA TAVERN, by *George Treacher*, 1879, excruciating eclectic-Renaissance. For the Theatre Royal, NE, *see* Russell Street.

CHANDOS PLACE

An early C17 formation on the Bedford Estate. Under the West Strand Improvements, *c.* 1830, the S side was rebuilt (*see* Adelaide Street). The N side is commercially miscellaneous. For its E end *see* Bedford Street. *Rock Townshend*'s Nos. 62–65 has one of London's earliest Postmodern elevations, of 1982–4, before stereotyping set in. Polychromatic brick, with odd Y-shaped windows and a flared cornice. Slightly altered 2001–2. Also by *Rock Townshend* Nos. 53–59, 1989–90. More subdued,

but very handsome in its damson sandstone, orange brick and black marble doorcase. It replaced part of a PEABODY ESTATE of 1880–1, as did the flats in BEDFORDBURY behind: DUVAL COURT, polychrome yellow brick of 1992–3 (*Rock Townshend* again), and the plainer DAVEY'S COURT, 1979–82 by *Chapman Taylor Partners*, set over an arcaded terrace with shops. Nos. 20–22 Bedfordbury, opposite, are offices of 1988–90 by *Rolfe Judd*, with a strong cornice and an air of Trecento Tuscany. Minor buildings after the SW corner with Bedfordbury include the MARQUESS OF GRANBY, *c.* 1850, with Nash and Gothick motifs gullibly combined. Nos. 40–42, 1874 by the surveyors *Chadwick & Sons*, was the workshop of Benham & Froud, metalworkers. Tall piers, with half-piers tucked in at each storey.

CLEMENT'S INN

A gated lane between Aldwych, W, and the Royal Courts of Justice, E. The buildings of the former Inn of Chancery, founded by 1442, were demolished 1868–91 for residential and commercial chambers, replaced in turn in the later C20.[*] To the Strand stone-faced offices by *GMW Partnership*, 1983 (Nos. 263–265), evocative of a traditional elevation, with double-height tripartite windows and vents arrayed like dormers and chimneys in the mansard. Behind, *F. Boreham, Son & Wallace*'s offices of 1971, less congenial, faced in polished granite or aggregate. Much setting back and forward, following the footprint of the massive towering 1880s mansions they replaced.

COCKSPUR STREET
with the east part of Pall Mall

The funnel-like connection between Trafalgar Square and Haymarket and Pall Mall to the W. *John Nash* widened and straightened it *c.* 1820. Notable for late C19–early C20 premises for shipping and travel agencies, with tall, disparately ornate fronts of a kind more familiar in the City.

Coming from Trafalgar Square, Nos. 29–34 were begun for Cunard in 1906, a subdued design by *Mewès & Davis* (the three r. bays). In 1914 extended by three bays, l.; in 1925 taken to the corner by *Grace & Farmer* and given a square clock turret, for the Royal Mail Steam Packet Co. The façades were incorporated in a hotel in 1998–2001 by *Whinney Mackay-Lewis*, who made the swollen mansard, two matching bays on the flank, and the narrow elevation at No. 28. The scheme extends behind Nos. 25–27, of which Nos. 26–27, 1887–8 by *T. Barnes-*

[*] Three other Inns of Chancery lay further W. Lyons Inn and New Inn went in the C19. Strand Inn, S of the Strand, was demolished in 1549 to build Somerset House.

Williams, was the map publishers Stanfords, as hinted by its *Doulton* terracotta motifs of globes and Atlases.* Nos. 21–24 was built speculatively in 1914–15 by *Metcalfe & Grieg*, with noncommittal sculpture by *L.F. Roslyn*, then in 1920–1 customized as Norway House by *J.T. Westbye* of Stavanger, with *F.T.W. Goldsmith*. By them the Norwegian grey granite facing below, with figure of St Olaf by *Gustav Laerum*, and armorials modelled by *Sirnes*.

Buildings facing (N side) are much larger. Nos. 2–4, 1926–8 by *Septimus Warwick* with *A.J.C. Paine* of Montreal, was the Sun Life Assurance of Canada. It stands next to Canada House (*see* Trafalgar Square) and repeats its giant Greek Ionic order. A ponderous oval-windowed mass heaves up above. N front to Pall Mall East with pilasters rather than columns. Rebuilt internally in 1987–9 by *D.Y. Davies Associates*: flashy, cursorily detailed spaces; awkwardly placed atrium with fountain – an embarrassing preamble to the DEPARTMENT OF CULTURE, MEDIA AND SPORT offices upstairs. More successful in its treatment of top storeys is the former Oceanic House (No. 1), shipping offices of 1903–6 by *Henry Tanner Jun.*, which erupts into an Edwardian Baroque adventure with much use of applied open pediments. Antae and engaged Ionic columns below. The main front, W, faces a triangular island with the equestrian STATUE of George III in contemporary dress, by James Wyatt's youngest son *Matthew Cotes Wyatt*. Commissioned 1822, the first royal statue financed by public subscription; erected 1836.

Back on the S side, WARWICK HOUSE STREET turns off to the SW after Nos. 21–24. It is a fragment of the old route from Charing Cross to St James's Palace, superseded by Pall Mall. On its S side the TWO CHAIRMEN pub, 1755–6, with a later canted bay. No. 20 Cockspur Street, r., 1901 by *W. Woodward*, built for the Wagons-Lits company. Pretty Franco-Flemish late Gothic, a little like early Aston Webb. Some offices with stained glass and Neo-Jacobean panelling. Then the higher Nos. 17–19, built for the Grand Trunk Railway of Canada by *Aston Webb*, 1907–9. Top floor with windows recessed between concave-sided uprights, a favourite Webb device; carving by *W.S. Frith*. Ground-floor design reinstated 1999.

Nos. 14–16 (now BANK OF SCOTLAND), 1906–8, is the major London work of *A.T. Bolton*, Soane's biographer, who took over from *H.W. Stock*. A blithe, inventive design. Three bows recessed between paired Ionic columns. Narrower entrance bay, r., carried up as an attic with sculpture. Originally there was a stone lantern on top. Built for the Hamburg-Amerika Line, but bestowed as war reparations on the Peninsular & Oriental. They remodelled the ground floor with caryatids representing Britannia and Asia by *E.G. Gillick* (1918). Large, well-kept HALL, panelled in Cuban mahogany by *Waring & Gillow*, with yellow scagliola columns. The P&O introduced watery paintings on walls and ceiling, designed by *Geoffrey*

*On the site of *Robert Adam*'s British Coffee House of *c.* 1770, the finest such building of C18 London.

Allfree, executed after his death by *Frederick Beaumont*, 1920–1. Polygonal domed office behind.

The offices continue without a break along the s side of PALL MALL. No. 125, of 1912–13 by *Smee & Houchin*, has Grecian Ionic columns of bronze below. Big recessed metal bow over, then a rampaging Viennese Baroque dome of copper, finished with an openwork globe. Much tamer is the becolumned Nos. 121–124, 1880–2 by *Alexander Peebles*, for the Life Association of Scotland. No. 120 (BANCO SABADELL) is by *Lutyens*, 1929–31, for Crane Bennetts, heating and sanitary engineers. One of his most successful commercial elevations, though surprisingly little known. Doorcase and big arched showroom window, mezzanine, then two-storey columns of his Delhi order (see the little bells on the capitals). Above the balustraded attic a set-back storey with full-width pediment. Plain, deep openings. Interesting vaulted interiors.

For New Zealand House, facing, *see* Haymarket, p. 415, for the clubs to the w *see* Waterloo Place, p. 445.

COVENT GARDEN

The area received its name (Garden of the Convent) from being a produce garden of Westminster Abbey. The Crown granted the site to Sir John Russell in 1553. In 1629–37 it became the first square to be laid out in London, complete with the new church of St Paul (q.v.) at the w end. The development was promoted by the 4th Earl of Bedford, but the plan and the choice of architect – *Inigo Jones* all round – were enforced by the Crown.

Though the ultimate archetype is a Roman forum, the PLAN derived from more recent models. The Piazza d'Arme at Livorno is said to have provided the pattern – John Evelyn noted as much in 1644 – but Jones no doubt owed something to recent work in Paris too, especially the Place des Vosges of *c.* 1605. Streets entered in the centre of the N side (James Street) and E side (Russell Street), with two streets continuing the line of the square to the w (King Street, Henrietta Street). In addition, mews streets – the first in London – ran to the N (Floral Street), and s of Henrietta Street (Maiden Lane). The houses on the N and E sides had rusticated tall arcades and stuccoed fronts with giant pilaster strips, derived from Serlio. The space, which was paved, was called the PIAZZA, and the cockney soon called the arcades the piazzas. By way of contrast were two free-standing hipped-roofed houses by the church, in Jones's astylar manner. The s side faced the gardens of Bedford House, built *c.* 1586 for the 3rd Earl, which stood nearer the Strand. Bedford himself undertook only three houses, plus the vaults beneath the rest. The rest were the work of different building lessees, including *Edward Carter* from the Office of Works and *Isaac de Caus*, who also helped with the drainage. Thus Jones harnessed the leasehold system to achieve a single highly realized design: a device not generally exploited until after the Restoration, but of the greatest possible importance in the creation of Georgian London.

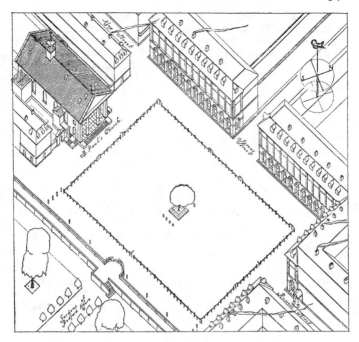

Covent Garden. Axonometric drawing,
showing the original design (John Summerson,
Georgian London, 1945)

Not one of these houses stands today, for the Piazza enjoyed
only a few decades as the premier square of London. Its decline
is linked with the rise of the famous fruit and vegetable MARKET.
Trading is first mentioned in 1649, but only in 1670 did the 5th
Earl obtain a charter to levy tolls. In 1704–6 Bedford House came
down, new houses with plain fronts were built along the S side,
and market booths were set up for the first time in the central
enclosure (replaced on a grander scale in 1748 and 1828–30). As
the élite withdrew to the smarter new squares to the W and N,
the houses of the Piazza became coffee houses and lodgings, and
also 'bagnios' and brothels. Of Jones's buildings the house just N
of the church lasted only to 1689, the far NW house in the Piazza
to 1716 (*see* No. 43 King Street). The other terraces, variously
altered, went mostly in 1858 and 1876–90, years of rapid expan-
sion for the market. The spur was the extension of tolls from
c. 1860 to cover trading outside the chartered area, which the
Bedford Estate accommodated in new market halls on the E and
S sides. Other sections were left vacant for carts and stalls, or
rebuilt with new hotels, banks and chambers. Several of these
echo Jones's design to some degree, for the Bedford Estate
retained a genuine concern for architectural effect. But in 1918

the market was sold to a private company, from whom it was bought by the Government in 1962. Two years later the decision was taken to move it, and trading transferred to Vauxhall in 1974. The various plans and counter-plans for redevelopment of the area are described above, pp. 286–7. With the reconstruction in 1997–9 of the Royal Opera House, to the NE, the process was complete.

The Market House

The Piazza is half-filled by *Charles Fowler*'s MARKET HOUSE, built by *W. Cubitt* for the 6th Duke in 1828–30, roofed over later in the C19, and restored and converted for shops and restaurants by the *GLC Historic Buildings Division*, 1977–80. There were no British precedents for such an ambitious conversion – the Faneuil Hall Marketplace in Boston, remodelled in 1972–8, is often cited as an overseas parallel – and its immediate success inspired a host of imitations. Twenty years on, the market remains immensely popular, though the small independent shops of early years are less in evidence.

Fowler's structure remains almost intact, the best-preserved Late Georgian market house in England. It has three parallel E–W ranges, with external Tuscan colonnades of Aberdeen granite. The outer ranges are two-storeyed (the upper parts intended for dormitories), and have at the outer angles low pyramid-roofed lodges. In the centre of each long side is a tall pedimented pavilion, curiously placed just E of the entrance passage proper. At the W end the central range stands free, a little set back. Above its columns a balustraded terrace and then the upper storey, pilastered and with a big central pediment broken by a lunette. Through the middle of this range runs a glass- and timber-roofed passage, with shops where herbs and flowers were sold. Their shopfronts were modified with plate glass in 1871–2. Segmental relieving arches above them, then a clerestory of rectangular openings with colonnettes. Delicate produce was traded at the E end, which is dif-

Covent Garden Market House. Engraving
(*The Architectural Magazine* 5, 1839)

ferent again: columns stand four deep across the whole width, making a continuous upper terrace. On the central pediment allegorical figures by *R.W. Sievier*, of *Coade* stone. The upper terrace has a glazed restaurant shelter added *c.* 1985. Its wings evoke Fowler's twin hothouses for the sale of potted plants, but with an obtrusive round-topped link between.

The shelter first provided was modest, limited to a small area in the N court. Municipal markets of the 1820s elsewhere were already much more spacious (Liverpool, Leeds). To remedy this defect twin ROOFS were raised over the outer courts, giving the market its bulky external presence. The dates are 1874–5, S, and 1888–9, N, the builder and designer *W. Cubitt & Co.* Iron columns set just clear of the walls support airy iron skeleton arches and a glazed and slated roof with an open clerestory. After much debate the restorers retained these enclosures, and major changes were limited to the upper E terrace, from which offices added 1901–23 were removed, and to the S court. Here two large oblong areas were sunk into the floor, to allow public access to the vaults running beneath most of the site. Some fifty shops were created in all, some with restored or replicated fronts to Fowler's design.

Other Buildings

The buildings are taken anticlockwise from the NW. Many are by *Henry Clutton*, whose robust orange-red brick and stone façades have a strong family likeness; some interiors by other hands. Clutton's BEDFORD CHAMBERS, 1877–9, is with its open arcade closest to the Jones design, though to a larger scale. Other differences are the horizontally rusticated pilasters and the attic storey where Jones had a hipped roof. Within the arcade a Mannerist doorcase to No. 43 King Street (q.v.), added *c.* 1879. Behind, reached from James Street, E, is a large warehouse courtyard, arcaded below and glazed over at first-floor level. Continuing E, around the angle down to Russell Street, S, a less literal version of the Piazza has been re-created by the Royal Opera House extension (q.v.). On Bow Street this incorporates part of the Floral Hall of 1858–60 – a separate enterprise from the Bedfords' market – which originally broke into the N side of the Piazza here.[*] The S corner with Russell Street is RUSSELL CHAMBERS (once the Hummums Hotel), 1886–7, with elevations after *Clutton*. The first 'Hummums' or Turkish bath here opened in 1683.

Then the former FLOWER MARKET, 1871–87 by *W.R. Rogers* of *W. Cubitt & Co.*, restored and converted in 1978–80 for the LONDON TRANSPORT MUSEUM (*London Transport Architect's Department*). With its extensions this complex building also has fronts in all three surrounding streets. Of 1884–7 the round-arched Piazza elevation, with a taller open-pedimented

[*] *Terry Farrell*'s shop for Clifton Nurseries, an early and flagrant piece of British Postmodernism, stood by Russell Street 1981–*c.* 1993. It made teasing play with the form of a Doric temple, realized in glass, lightweight steel and Teflon.

section with a big lunette at the N end. The return wing, S, was made in 1978–80 by enclosing an iron-framed market shelter, perhaps of 1904–5. Also of 1884–7 the Tavistock Street front, S, which best expresses the interior arrangement. Two 'naves', each with a giant lunette and pediment above paired round-arched windows, alternate with a single window marking each of the three aisles. A bracket-cornice runs across the whole. Inside, the E 'nave' returns at right angles across the N end, which explains the lunette facing the Piazza. The cast-iron structure, of 1871–2, replaced a smaller, temporary structure of 1860–3. It has slim colonnettes with elliptical-arched spandrels, a glazed clerestory, slated roofs and then an upper clerestory, also glazed. Display mezzanine inserted 1993–4. Towards Wellington Street, E, was the only architectural frontispiece of the 1870s market: narrower, with three big handsome arches, of white brick, Portland stone and salmon terracotta. To the NE, at the corner with Russell Street, an extension of 1904–5 by *Lander, Bedells & Crompton*, with the upper offices reached by a festive Baroque stair-tower. Adapted for the THEATRE MUSEUM in 1984–7.

Last of the market buildings is the JUBILEE HALL of 1904 on the S side, where foreign flowers were sold: also Anglo-Baroque, also by *Lander, Bedells & Crompton*. A sturdy four-square block, red brick and stone, with corner turrets and Tuscan-columned piers between the windows of the upper hall. From 1978 this housed a sports centre, the lower level a flea market: both typical of the regenerative uses Covent Garden was beginning to attract. Proposals by the GLC for commercial offices here were therefore fought off by community groups. Instead, a mixed-use block was built on vacant land at the W (1984–7, by *Covent Garden Housing Project Architects*), including extra market and sporting facilities: a victory for 'community architecture' but an architectural disappointment. Unconvincing massing, routine Postmodern detailing. Red brick offices to the Piazza, arcaded for market stalls below. Twenty-eight flats behind, of yellow brick and differently treated. On the W wall a SCULPTURE by *Penny Glydewell*, bronze and slate with an inset bell.

The W corner of Henrietta Street is the former Covent Garden Hotel, now LLOYDS BANK, another by *Clutton*, 1876–8. This lacks arcading, unlike the slimmer, near-matching blocks on the W side: by *Alfred Williams*, 1889–90 (now NATWEST BANK), S, and *Clutton*, 1883–5, N. The first houses here rose no higher than the columns of St Paul's church, between them.

CRANBOURN STREET

A modest new street made and built up 1843–5 (Act 1841). Its planner *James Pennethorne* hoped it would continue E, to rival Holborn or the Strand. The S side E of Charing Cross Road is still all Early Victorian. *William Dent* built the central range to his own designs, Italianate tipping over into eclectic. E section heightened to match, 1851. Of buildings in the W part the

Hippodrome belongs with Charing Cross Road, the Warner cinema with Leicester Square (pp. 402, 418–19).

CRAVEN STREET

The creation of the Hon. William Craven, 1730; *Henry Flitcroft* laid it out, working with the carpenter *Thomas Phillips*. On the NE side is the longest stretch of C18 houses off the Strand. They were bought up in the 1880s in case Charing Cross Station needed extending, and fell into neglect. *Jestico & Whiles* restored them from *c.* 1989, with some rebuilding of back parts.

The terrace begins off the Strand with No. 42, rebuilt with a facsimile C18 front *c.* 1989. Nos. 31–41 are of 1730–1, with red brick dressings. Rounded door voids, top storeys and other changes of *c.* 1792, after the first leases expired. No. 39, four bays wide, has a pretty front-hall staircase with delicate turned balusters. No. 36, the home of Benjamin Franklin in 1757–75, permits a detailed look at one of the smaller houses. In the major rooms fielded panelling and box cornices, that of the first-floor saloon with dentils. Dog-leg stair, with three turned balusters per tread, carved ends, and Doric column-newels. Internal partitions are of timber. In the closet wing some angle fireplaces; C19 back addition. Restoration of the structure in 1997–8 as an intended museum to Franklin, by *D. W. Insall & Associates*, respected the 1790s additions. In CRAVEN PASSAGE between Nos. 34 and 35, No. 1 is also of *c.* 1731–2. *Flitcroft* undertook No. 33 for himself, but it is just like the rest. No. 32, still three-storeyed, and No. 31 were reconstructed after a fire in 1762. Plainer brickwork and wider doorways with side-lights mark Nos. 25–30, all of 1791–2; No. 25 has two stuccoed bows on the flank, originally with a river view. On the opposite side, Nos. 14 and 15 replicate houses that tumbled down under restoration (1986), but Nos. 11–13 belong to 1730–1.

DRURY LANE

An ancient route running NW from Aldwych (called 'old' in 1199). Named from the house built or remodelled by Sir Robert Drury in the early C16, on a site beyond the present S end.* By the C18 the address was disreputable, by the C19 a slum, and in 1877 the MBW scheduled it for rebuilding. The model housing that resulted is the chief interest (for the Theatre Royal *see* Russell Street). The walk is from S to N; the N extremity belongs to Camden (*see London 4: North*).

The NE side begins with KEAN STREET, made *c.* 1900 as part of the clearances for Kingsway. On its W side, some contemporary commercial buildings. The corner warehouse (Nos. 3–7) has steep twin pedimental gables. Nos. 9–13, more

* *See* Patricia Croot in *London Topographical Record* 28, 2001.

utilitarian, was converted to flats in 2000–1 by *Child Graddon Lewis*, with a new glass-block rear wall. Next in Drury Lane the St Clement Danes School, q.v. It faces the E end of Tavistock Street, which has two blocks of flats of 1902–3 by *W.E. Riley* of the *LCC*, red and stock brick. More impressive is BRUCE HOUSE, further up on the NE side, with its main front to Kemble Street. Built in 1904–6 by *J.R. Stark (LCC)* as lodgings for 699 men, and reconstructed by *Levitt Bernstein Associates* as Peabody flats, 1992–4. Its C18 details and mansard gables – unusual in England but typical of the LCC – give it none of the uncharitable look of the charitable architecture of *c.* 1860–90. This appears in all too familiar form NW of Bruce House, at the WILD STREET PEABODY ESTATE of 1880–1. The architect responsible for this gaunt, ever-repeated design was *H.A. Darbishire*. The six storeys made the estate exceptionally dense (1,080 persons per acre were allowed for), since reduced by demolishing blocks in the courtyard. Across Drury Lane DRURY HOUSE, lurid Postmodern of 1986–9 by *Fitzroy Robinson Partnership*, with green and pink patches. It overlooks DRURY LANE GARDENS, created in 1877 from St Martin-in-the-Fields' burial-ground, the first such transformation in Westminster. Little red brick Gothic mortuary, r., and lodge, l.: probably by *Elijah Hoole*, whose patroness Octavia Hill was the moving spirit. On the N edge of the gardens quieter brick and stone offices by *EPR Partnership*, 1986–9, then another group of *LCC* flats, 1902: three parallel balcony blocks, with pitched roofs and other modifications of 1985–6.

The next W turning is BROAD COURT. Along its N side are artisans' flats by *R.S. Wornum*, 1897, a nice and human-looking job, with exaggerated shell-head doorcases. On the NE side at Nos. 141–147 Drury Lane a showy warehouse by *C.F. Hayward* and *B. Woollard*, 1896, with some grey and brown stone and a small Ionic order. The back part facing Wild Street, 1907–15 by *Spalding & Spalding* and *G.C. Lambert*, was Lambert & Butler's tobacco factory. Plainer and more logical, with Doric giant pilasters as mullions. All converted to flats 1998–2000. The S corner with Great Queen Street is the PRINCE OF WALES pub, 1931 by *Alfred W. Blomfield*, faced in Portland stone as a dignified neighbour to the Freemasons' Hall, NE (*see London 4: North*).

ESSEX STREET

A substantial close built up from 1675 by *Nicholas Barbon*, across the site of Essex House. This began as the Bishop of Exeter's house in the early C14, on part of the Outer or 'New' Temple. Latterly it consisted of a great mid-C15 hall, C16–C17 additions by various aristocratic owners, and large gardens. The Middle Temple and the City tried to stop Barbon, but he bribed the lawyers by building them the chamber block called New Court, just to the E (*see London 1: The City*). The C17 houses are of red brick, three-storeyed, with straight-headed windows, stone bands and keystones touching them.

At the s end is *Barbon*'s renewed ARCHWAY towards the river, incorporated in offices of 1953 by *Stone, Toms & Partners* and *G.F. Lang* after severe air-raid damage. It served to screen residents from the commercial tumult of the wharves. The arch, flanked by giant Corinthian pilasters, has a solid tympanum and two oculi above. Only the steps and some footings on the outer side remain from the C17. Also of that time No. 19 (on the w SIDE), *c.* 1675–82, with a restored front and doorcase with carved consoles. Nos. 15–17, 1988–90 by *Dunthorne Parker*, much taller, is treated as if to suggest three house fronts. On the E SIDE, Nos. 32 and 34 survive from four by *Thomas Alderman*, bricklayer, after 1675. No. 32, renovated in the C18 and with a timber Doric doorcase, keeps part of its C17 staircase. At No. 34 the C17 front was partly renewed in 1930. Specially elegant open-well staircase with slender turned balusters and a swept handrail. It occupies the C17 position between front and back rooms, but the details suggest a date after 1736, when the first leases fell in. Between, No. 33, 1880 by *J.P. St Aubyn*, a good approximation to a house of *c.* 1720. No. 35 is mid-C18. Also later C17 are Nos. 11 and 14, 1676, w SIDE. No. 14 is refronted, but retains flush sash boxes. Enriched Doric doorcase of *c.* 1750. *Hesketh & Stokes* at the terracotta Nos. 36–39, 1892 (E SIDE), must have loathed the tradition of such subdued architecture. Here is a surfeit of arabesque decoration, and in addition more light for offices. No. 42 is by *Michael Newberry*, 1972, three flat bays with rounded angles. The triple-bowed Nos. 46–48 were premises for *The Portfolio*, 1884 by *H. Cowell Boyes*. Red brick and stone, strangely patterned to echo half-timbering. Carving by *E.R. Mullins*.

Barbon's undertaking continued into DEVEREUX COURT, which runs E from Essex Street towards the Middle Temple. By him the remodelled Nos. 22, 23 and the DEVEREUX pub (earlier the Grecian Coffee House), with gimmicky stucco of 1844. On it a bust of Robert Devereux, 1st Earl of Essex, with a date 1676. In the dog-legged return to the Strand, Neo-Georgian chambers of 1951–3 by *Walker, Harwood & Cranswick*.

FLORAL STREET

Made *c.* 1632 just N of the Covent Garden Piazza, as a pioneering example of a mews street (cf. Maiden Lane). Extended w into Garrick Street 1861–5. For the Royal Ballet School in the E part, N of the Royal Opera House, *see* Nos. 53–54 Long Acre. To its w, BERTORELLI's restaurant (No. 44a), a warehouse of *c.* 1901, converted by *Bowerbank, Brett & Lacey*, 1982. They added flats on top, with a bowed balcony neatly bisected by a solid pier.

w of James Street, Nos. 9–10 (s side) is a slab-sided warehouse probably of *c.* 1860, when much of London's seed trade moved here from Hungerford Market (*see* Hungerford Bridge). At No. 12 the former PARISH SCHOOLS, 1838 by *E.H. Browne*, but restyled externally in 1860 by *C.G. Searle* following suggestions by *Charles Parker*, then surveyor to the Bedford Estate.

Parker is best known for his pattern book *Villa Rustica*, and this is typical of its Italianate style, with a slim campanile for the entrance and staircase. Beyond it some 1980s buildings in Victorian warehouse styles. They face Nos. 28–29, the former CARRIAGE HALL of Messrs Turrill, dated 1833 (builder *Samuel Grimsdell*). The materials are mixed timber- and iron-framing, facing Floral Street as a two-storey range with twin upper loading doors. Continuous sashes here and in the oblong central courtyard, which is three-storeyed with a slim iron colonnade below. Other iron uprights of square section. Restored for use as offices and shops as part of *Gibberd, Coombes & Partners'* Nos. 18–26 Long Acre, 1982–6 (q.v.).

GARRICK STREET

Made in 1859–61, joining Cranbourn Street with Covent Garden across what were slums. The plan, by *Frederick Marrable* for the Metropolitan Board of Works, derived from a scheme by *James Pennethorne* first mooted in 1838. The buildings were finished by 1868, mostly in the eclectic Renaissance favoured by 1860s London commerce. Typical is the SE corner with King Street, the former premises of Storr & Son, auctioneers, 1859–60 by *Arthur Allom* (consultant *M. Digby Wyatt*). It preserves the palazzo air, but the discipline has slackened: windows are straight with lugged frames, segment-headed, arched, or straight with rounded corners. Inside, the staircase rises from a delightful hexagonal domed vestibule, with an oculus through to the upper landing. Down ROSE STREET just beyond, the LAMB & FLAG, a pub probably of *c.* 1688, refaced in 1958, keeping the closed-string staircase and other early features. On the w side of Garrick Street, Nos. 9–21, a symmetrical group by *Marrable* of which the centre is the GARRICK CLUB, 1864. Its palazzo air is more marked, but small-scale decoration invades the window surrounds. The facing is Portland render, magnificently blackened. Staircase not of the stereotypical club plan but a dog-leg, with twisted timber balusters. To the l., Nos. 9–11 have tall arcaded shopfronts of dark marble, very characteristic of the 1860s. Facing the club on the N corner with Floral Street is No. 14, the one Gothic building. Built as premises for the glassmakers Heaton & Butler by the young *A.W. Blomfield*, 1864. Oddly broken frontage; red and yellow brick.

GREAT NEWPORT STREET

Built up early, from 1613. No. 5, N side (PHOTOGRAPHERS' GALLERY), all shiny black 1930s tiling externally, is the only C17 survivor. Its staircase is an open well with unusual waisted balusters and plain newels: forms suggestive of the 1650s, when *Richard Ryder* undertook to rebuild this side. Nos. 6–7 (ARTS THEATRE), nondescript early C20, was converted to a small

subscription theatre in 1927 by *Morley Horder*, redecorated by *Basil Ionides*, 1933, and reinstated after a fire in 1951.

HENRIETTA STREET

Laid out 1631 as one of the two streets running w from Covent Garden Piazza. Largely rebuilt by 1730. Nos. 3–10, towards the E on the s side, are c18 under stucco of the 1850s–70s. Nos. 3 and 4, which face the Piazza, are of 1780–1, Nos. 5–8 of 1730–1 (Nos. 5–6 refaced by *W.G. Bartleet*, 1873). Nos. 7 and 8 retain good doorcases with Ionic columns, and staircases with finely twisted balusters; original staircases also at Nos. 9 and 10, 1726–7. Nos. 11–19 are Victorian through and through. The big retained façade at Nos. 12–13 was Ashley's Hotel, 1876–9 by *Pennington & Bridges* in mixed Parisian style. Nos. 15–16 and 17–18 show the shift to red brick and Northern Renaissance; respectively of 1887–8 by *H.E. Pollard*, and 1891–2 by *J.T. Woodard* for the publisher C. Arthur Pearson. More inventive are the brick-pilastered Nos. 23–24 (N side), 1885–6 by *Spencer Chadwick*, and Nos. 25–29, the former ST PETER'S HOSPITAL for urology. This is of 1881–2, the first major work of *J.M. Brydon*, in early Norman Shaw style rather than the Neo-Baroque which made his name.

JAMES STREET

The N entrance to the Covent Garden Piazza, built up 1635–8. On the E side at the s the Royal Opera House extensions, q.v. They face Nos. 27–31, a nice up-and-down run of late c17–c18 houses. On No. 29 a Late Georgian double-bowed shopfront, restored in 1980–1 by *Ray Luker* and *Ian MacCaig* (*GLC Historic Buildings Division*), who added a plausible pilastered companion at No. 28. The N corners with Floral Street are both pubs: the WHITE LION, w, 1888 by *Alexander & Gibson*, muddled eclectic; the Jacobethan NAG'S HEAD, w, 1900 by *P.E. Pilditch*.

KING STREET

Laid out in 1633–7. The most rewarding street in Covent Garden, entirely pre-c20, with some exceptional Georgian houses and a strong mid-Victorian showing.

First on the N SIDE is No. 43, very probably by *Thomas Archer*, 1716–17. One of the best Baroque house fronts in the West End, though stuccoed and sadly altered. Built for Admiral Russell, 1st Earl of Orford, whose family ties may explain why he was allowed to break the uniformity of the c17 Piazza. Seven bays. Four giant Composite pilasters on rusticated piers, the entablature coming forward above. Tall, slim windows

with segmental or elliptical heads, the middle three originally divided by sunk strips. Attic storey and urns probably of 1871, replacing a parapet which ramped up to a central window. Recessed porch, its two small columns reintroduced in the *Fitzroy Robinson Partnership* restoration of 1977 (but cut away to fit against a 1930s joist). Behind was a double-height stairhall, of which the upstairs part survives as a separate room.* It has both panelling and finely moulded plasterwork in an uncommon style suggesting North Italian work or influence: ceiling with a big oval panel, segment-headed wall compartments with classical figure roundels garlanded with oak. Good carved wooden chimneypiece in the room to the E, in style *c.* 1740. Back stair with an open well and closed string.

Nos. 41–42, 1877, has a tall red brick and stone elevation by *Henry Clutton*, very like that of his hotel on the S side of the Piazza. Rear shop extension of 2001 by *TP Bennett*, under big curved glazing. Then a mostly C18 run. No. 38 (AFRICA CENTRE), 1773–4, has at the back an oblong hall with a continuous cast-iron balcony on slim colonnettes, looking *c.* 1860; built probably for Messrs Stevens, auctioneers. No. 37, also of 1773–4, was built for the lawyer John Lane, and is soundly attributed to *James Paine*. Top-floor window framed by a wide brick arch below an open pediment, a favourite Paine motif. First-floor windows in round-arched reveals; ground floor altered with a big elliptical-headed window, its Gothick tracery added 1973–4 by *A.G. Macdonald* for the ROYAL SCOTTISH CORPORATION. Interesting interior: entrance hall with three pendentive domes, deep semi-elliptical stairwell with niches, a third-floor gallery and plain outcurved balusters. In the rear hall, also of 1973–4, relics of the previous premises in the City: foundation stone of 1673 from Black Friars Lane, Baronial fireplace from *T.L. Donaldson*'s building of 1879–80 in Crane Court. At No. 35 a four-storey palazzo of 1866 in Roman High Renaissance style, restored by *Crouch Butler Savage Ltd.* 1988, with a new design on the ground floor. At the E end three paired frontages, typical of the controlling hand of the mid-C19 Bedford Estate. Nos. 31 and 32, early C18, have Italianate stucco of *c.* 1860 by *Nelson & Innes*, with *Charles Parker. C.G. Searle* probably designed Nos. 29–30, of 1859–61. Nos. 27–28 are more complex: No. 27, l., is of *c.* 1760, twice remodelled in the C19 for the Westminster Fire Insurance; No. 28 was built to match in 1856–8, by *T. Little*. At No. 27, now MOSS BROS, the dignified ground floor with Roman Doric columns dates from 1808–10 (by *J.G. Mayhew*), the grooved stucco, bracket-cornice and giant armorial from the period 1853–7 (probably by *Charles Mayhew*). Interior altered 1938, keeping at the back a toplit former board room (1856–7), with a handsome Corinthian order and foliage frieze. NW extension of 1875–6 by *F.W. Porter*, round-arched brick, facing Rose Street.

The S SIDE is less rich. No. 15, 1773, narrow, has a Venetian window and three-light window above, framed by an elliptical

*The staircase, removed *c.* 1932, has been re-erected at South Walsham Hall, Norfolk.

arch. The next group shows the mid-Victorian linking of first-
and second-floor window-frames, e.g. No. 14, 1704–5, refaced
probably in 1862, and Nos. 12–13, 1873 by *Spalding & Cross*
for Barr & Sugden, seedsmen (heightened 1883).

KINGSWAY

The need for a street to connect the Strand with Holborn to
the N was discussed frequently during the C19. In 1898 the LCC
published plans for the new road, which also allowed further
reductions of the slums around the S end of Drury Lane (q.v.).
The formal opening of Kingsway took place in 1905. It was the
most prestigious of the LCC's Edwardian street improvements:
a broad tree-lined avenue 100 ft (30.5 metres) wide, with a tunnel
beneath for electric trams (the S part used for cars from 1961),
laid out on a scale to rival the boulevards of Continental capi-
tals. The buildings came slowly, from 1903 to 1922. Architectural
attention focused on the new Aldwych crescent (q.v.), linking
Kingsway to the Strand. Most of the other tall stone-faced build-
ings are not individually outstanding, though impressive in the
aggregate; the lion's share went to *Trehearne & Norman*. The best
of the exceptions belong in the N part (*see London 4: North*).

The Westminster part begins on the E side with Sardinia Street,
made to join Kingsway with the SW corner of Lincoln's Inn
Fields. Along Kingsway the aesthetically indifferent No. 22,
1959–60 by *L. Solomon, Kaye & Partners*, with curtain walling
between solid, stone-faced end bays. In its S end the ROYALTY
THEATRE, by *Burnet, Tait, Wilson & Partners*, a modest replace-
ment for *Bertie Crewe*'s failed London Opera House of 1911.
The W SIDE starts with No. 41, 1909–10 by *Gibson, Skipwith
& Gordon*, with merfolk carved by *Gilbert Seale* over the door,
and an open cupola. Then a long run by *Trehearne & Norman*,
all with a giant order high up: PRINCES HOUSE (1920–1),
ALEXANDRA HOUSE (1915–16), YORK HOUSE (1913–14),
IMPERIAL HOUSE (1912–13). No. 11 (W.H. SMITH), with
twin bows, was the first building in the S part: by *Cubitt
Nicholls, Sons, & Chuter*, 1906. Also early Edwardian in style
the balconied former bank at No. 20 (E side), 1908 by *R.C.
Harrison & Son*. *Trehearne & Norman* return at the big near-
matching blocks on the S corners with Aldwych, designed by
Thomas Tait when he was their chief assistant, and more orig-
inal in detail. The dates are: E block 1913–14 (rebuilt behind
by *Rolfe Judd*, 1998–2000, with atrium), extended to Houghton
Street, E, 1921–2; W block 1919–22. In the latter a former bank,
converted to a restaurant by *Julyan Wickham*, 1996: brightly
coloured, with greenish glass slats on the ceiling.

LANCASTER PLACE

The Waterloo Bridge approach from the N. On the W side, facing
the dignity of Somerset House, is BRETTENHAM HOUSE, by

W. & E. Hunt, 1931–2. A long solid stone front, with simplified foliage decoration to the arched entrances and central first-floor balcony. The style a bit like Holden's of the 1920s, stripped classical with Neo-Georgian window shapes, and a fondness for stepping up and down (fully eight times at the river end). On the site were *Smirke*'s Duchy of Lancaster Offices of *c.* 1817–23, rather a plain affair.

LITCHFIELD STREET

One of the streets *Nicholas Barbon* made on the Newport House property after 1682 (cf. Newport Court, Soho, p. 421). Of Barbon's time Nos. 25 and 26 (N side), with key blocks and bands touching them, and No. 27.

LONG ACRE
and streets to the north

Now one of the primary shopping streets of Covent Garden. The name refers to part of the Westminster Abbey lands acquired by the 1st Earl of Bedford in 1552. The 3rd Earl made the street in 1615 along its N boundary; built up mostly after 1631. The N side belonged to the Mercers' Company, whose badge of a maid's head appears on many buildings. In the C18 home to numerous cabinet makers; by the mid C19 a centre of carriage building, with eight workshops in 1873. Many were succeeded from the later C19 by printing houses. The description runs from W to E.

Coming from St Martin's Lane, the S side at first belongs with Garrick Street, q.v. STANFORD'S the map sellers at Nos. 12–14 is by *Read & Macdonald*, 1900. Free Flemish with a large gable and thin window. Nos. 15–17, 1998–2001 by *Hamilton Associates*, uses crowded motifs and materials. Down the alley, l., an artwork is incorporated: a carved frieze of plaited stalks, by *Paula Haughney*. More offices over shops at Nos. 18–26, by *Gibberd, Coombes & Partners*, 1982–6. Red brick infill, stone framing carried round as arches high up. For the restored carriage hall behind *see* Floral Street. On the N side, Nos. 132–137, 1906 by *W. Woodward*, logical and bald, with a giant applied shop arcade. Nos. 127–130, 1906 by *W. Burch* for Morgan & Co., carriage builders, is a more congested design. In MERCER STREET a little beyond, Nos. 3–5 (E side), *c.* 1905, and Nos. 6–8 (W side), 1909, built for the Mercers' Company and out of the ordinary run of artisans' houses. Brown tiles, red brick and flush stone dressings. The staircases, less open than many, have elaborate iron railings; exuberant Baroque arches on the skyline. The E corner with Mercer Street is Nos. 120–123, *c.* 1904 by *W. Flockhart*, sparely detailed. It faces Nos. 27–29, a four-storey fruit warehouse with an up-to-date stone front of 1935 (*J.M. Sheppard & Partners*), with window bands and streamlined touches. Adapted for St Martin's School of Art

by the *GLC*, 1978–80, but vacated 1999. Nos. 30–31, *c.* 1878, was Strong's carriage works, remorselessly ornate brick with a Venetian motif screened over with cast-iron window framing. Gothick shopfront by *John Prizeman* for the bookseller Bertram Rota, 1975, a harbinger of regeneration after the market shut. More banded brick and cast-iron windows at Nos. 32–33, dated 1862.

Back on the N SIDE, No. 116, of 1895 and unusually ornate. It marks the W corner with LANGLEY STREET, a canyon of brick mid-C19 warehouses. The E side has Nos. 6 and 7–8, a graceful design with arched windows in through-storey recesses, built in the 1830s for Combe & Co.'s brewery. The 1830s sequence continues round the N corner into SHELTON STREET: Nos. 24–26, with tall openings (adaptations for a scenery workshop?), and No. 34, with big orthodox windows and a bracket-cornice. A C20 section between gives entry to OLD BREWERY YARD, with a doorway with cast-iron Doric columns on its W side.* In NEAL STREET, parallel with Langley Street to the E, Nos. 17–19 and 3–7 also belonged to the C19 brewery, the latter particularly attractive with its concentric relieving arches. The brewery sits behind Nos. 107–115 Long Acre, another fruit warehouse (Messrs Poupart), pilastered and self-important: 1936–7 by *E.A. Shaw & Partners*. At the corner with James Street COVENT GARDEN UNDERGROUND STATION, a *Leslie W. Green* job of 1906. Crude offices on top, added as late as *c.* 1964.

ODHAMS WALK diagonally opposite (N side), a quadrangle of housing of 1974–81 by *Donald Ball* for the *GLC*, develops the dense, introverted low-rise planning ushered in by Lillington Gardens (p. ••). The public face is not friendly: shops below, a brown brick citadel cantilevered out above, with a public walkway crossing N–S which few seem to notice or use. All makes better sense within. Its three-dimensional labyrinth of interlocking units was influenced by the vernacular housing of Italian hill villages and the like, which Modernist architects rediscovered in the 1960s. The basic unit is an L-plan flat with an inner corner providing a private outdoor enclave. They are planned symmetrically across a diagonal axis, but the forms are so broken up that the repetitions nowhere appear. The landscaping, by *Hillary Harris* and *David Comben*, includes public areas on multiple levels. On the fourth floor a continuous wall-walk, suggestive of patrols and look-outs, gives access to the uppermost flats. Nothing could be less like the dogmatism of the tower block era than these beguiling terraces. The name recalls Odham's Press, which had huge premises here and to the E (*see* below).

The S SIDE continues with smaller properties. Nos. 48–52 are altered Georgian houses. At Nos. 53–54 the handsome new ROYAL BALLET SCHOOL, 2000–3 by *ECD Architects*, brick-faced with giant windows on the flank, but set above shops: a strange thing for a school. Behind, in Floral Street, it

*The wedge-shaped warehouse of 1882 on the N side of Shelton Street also belonged to the brewery, which closed in 1905.

incorporates two houses of *c.* 1830 (Nos. 46–47 there). An enclosed bridge by *Wilkinson Eyre* links the school to the Royal Opera House, to the s. A strong, sharp-edged form, which nonetheless takes a while to puzzle out. The square close-set framing gradually rotates through ninety degrees, a bit like a twisted concertina bellows, with part-solid, part-glazed infill.

Nos. 60–61 Long Acre, the KEMBLE'S HEAD, is a wonderfully pretentious stuccoed pub of 1836 by *James Collis*, with a frieze of ox masks. Another good show at No. 66, the SUN TAVERN, 1856–7 by *R. W. Armstrong*: eclectic Italianate, with a Venetian motif to the entrance. *Seifert & Partners'* large office block on the n side, a rather sore thumb for the revived Covent Garden, originated in a planning consent of 1965 for the whole Odham's site. The present, smaller block is a compromise, permitted in 1975 and built *c.* 1979–81. A jumpily modelled mass sunk in its own well (and thus shop-free), and covered in yellow-pink artificial stone. Repeated square oriels; upright windows cut into the angles. Entrance refashioned by *Michael Squire Associates*, 1998. Beyond it a tall gabled late C19 run, e.g. Nos. 81–82, the FREEMASONS' ARMS, 1896 by *Treacher & Fisher*, carved with masonic arcana. It faces Nos. 69–76, 1887 by *W. S. Witherington*, formerly Woodfall & Kinder's printing works. Queen Anne detail eked out over a long brick front. Iron-framed interior, using *Dennett & Ingle*'s fireproof system. On the n corner with Drury Lane, Nos. 78–79, gault brick with stucco arches linked at the imposts. They date from street widening of 1835.

MAIDEN LANE

Thought to follow an ancient track through the Abbey garden; laid out in 1631 as a mews for Henrietta Street (q.v.). The Bedford Street end, w, preserves the original narrowness. At the w end, s side, Nos. 23 and 24, 1882 and 1887 respectively, strangely narrow and tall. Nos. 21–22, set back, are flats of 1995–8 by the *Goddard Manton Partnership*, brick and stone, with a glass-roofed restaurant behind No. 23. In front a quaint architectural SCULPTURE by *Eamon Hughes*, 1998. Nos. 18–20 form the back of the ADELPHI THEATRE on the Strand (*see* p. 365). Probably 1880s, but the very modest royal entrance, r., is likely to date from work of 1868–9 by *Joseph Lavender*. Nos. 16–17 are structurally of *c.* 1635, behind simple refacing of 1806–7. Glazed workshop attics. The n side is mostly backs of later C19 buildings in Henrietta Street (q.v.). No. 35, RULES, is a very early restaurant building: 1873 by *Alfred Cross*. Pinched brick Italianate. Interesting inside, with panelling and toplit back area. More ornate Nos. 36–39, SUSSEX MANSIONS, 1886–8 by *Walter Stair*. They face Nos. 9–10, the back block of the VAUDEVILLE THEATRE, 1925–6 by *Robert Atkinson*, with a big overarched Venetian window in the Adam way and a pretty Neo-Adam board room for Messrs Gatti within (cf. Nos. 409–410 Strand, p. 365). E of Corpus Christi church,

No. 42, N side: the works and showcase of *Cox & Sons*, church furnishers, 1873 by *S.J. Nicholl*. Red brick, with thin Flamboyant Gothic detail, but framing practical-looking sashes.

NEW ROW

Made by the 4th Earl of Bedford after 1635, continuing the line of King Street to St Martin's Lane. Simple houses, none outstanding, but with the gas lamps making quite a characterful ensemble. The oldest are refronted late C17 (e.g. Nos. 3–5 and 13, S side), the rest mostly C18–early C19. Disrupting this scale No. 12, 1882–3 by *J.W. Brooker*, built on the E corner of Bedfordbury after its widening for slum clearance.

NORTHUMBERLAND AVENUE

A short, wide avenue, planned from 1873 by the Metropolitan Board of Works, opened 1876, and built up by 1887. Stone elevations were compulsory, and the council of the RIBA was consulted on the designs.* These were remarkably similar: big, high and ornate, with a preference for small and superimposed motifs, and with underpowered pavilion or mansard roofs. For the *British Almanac* in 1884 this 'new Charing Cross style' represented 'money without culture'. Many were hotels, all but one built for Messrs Gordon & Frederick, and all converted to office use in the C20.

The keynote was set by the corner buildings towards Trafalgar Square, both undertaken for Gordon & Frederick. The SW one, prettily particoloured, is by the brothers *Francis*, 1882–3. Of alterations by *Sir Edwin Cooper*, 1913, one urbanely designed doorway remains. Grand Buildings, the larger NE block, was originally the Grand Hotel, of 1878–81 by the brothers *Francis* and *J.E. Saunders*. Jakob Burckhardt wrote home to a friend at Basel of this 'seven-storeyed, nicely be-sculptured oval stone belly'. Rebuilt in near-facsimile by the *Sidell Gibson Partnership*, 1986–90, a safety-first solution deplored both by advocates of an unabashedly new building and by those who wanted the old one restored. The decoration was re-created, but the windows have a strange deadness that fails to convince. Other differences are the recessed shopping arcade, with roughly carved heads by *Barry Baldwin*, and a big atrium within the Strand corner. It also takes in the site of a 1960s block that supplanted *Edis*'s prodigious Constitutional Club of 1883–6, further down on the NE side. Here it finishes with an octagonal pavilion, where Northumberland Street comes in. The little SHERLOCK HOLMES pub there is by *J.W. Brooker*, 1891; its etched-glass windows are early Neo-Victoriana, 1957.

* *George Vulliamy* of the MBW made unexecuted designs for the whole length.

Nos. 22–25, 1883 by *R. Walker*, goes Ottoman on the flank, where a Turkish bath was incorporated.

On the SW SIDE a very large block with a certain French elegance, originally the Victoria Hotel: by *Isaacs & Florence*, 1883–7. Nine floors, twenty-one bays, giant pilasters on ends and centre. Carving by *Daymond & Sons*, at the entrance by *J. Boekbinder*. The public rooms were lavish, as is clear from the huge entrance hall with its handsome marble-banded walls. As a hotel it was however soon outranked, due to its stingy provision of bathrooms. Next to it, stretching down Great Scotland Yard, is the former Society for Promoting Christian Knowledge (now NIGERIA HOUSE), 1876–9, mixed Cinquecento by *John Gibson*, heightened and given a French roof-line in 1891–2 by *Waterhouse*. Then the big wedge of the METRO-POLE BUILDINGS, the former Hotel Métropole of 1883–5, Messrs *Francis* and *J.E. Saunders* again. An ill-assorted collection of motifs over a long and high façade. Up to four superimposed pilasters, mostly embracing two storeys. Spandrels of the main entrance carved by *H.H. Armstead* with personifications of London. Government offices since 1936. On the opposite side *Sir Herbert Baker's* ROYAL COMMONWEALTH SOCIETY of 1934–6, rather anaemic. Rustic basement, four upper storeys, one with round-headed windows. Sculpture by *Sir Charles Wheeler*, as usual with Baker. The interiors and back elevation went in rebuilding of 1996–8 by *RHWL Partnership*. Most of the inside is now a hotel; a new clubroom for the society by *Morey Smith*, a light, free-flowing space on three levels. Then No. 16, offices by *Martin & Purchase*, 1885. Across Craven Street the PLAYHOUSE, 1881–2 by *F.H. Fowler*, with Corinthian pilasters, a curved end, and a top storey added by *Graham Berry*, 1987, in keeping. Reconstructed inside in 1906–7 by *F. Billerey* of *Blow & Billerey*, in an unusually chaste white and gold Louis XV style, after damage from falling fabric from Charing Cross Station behind. Kidney-shaped foyer; auditorium with two undulating balcony fronts, triumphant caryatids by the boxes, and big Watteau-esque paintings of pierrots etc. by *Brémond & Tastemain*. (Exceptionally complete sub-stage machinery.)

To make the street, NORTHUMBERLAND HOUSE, the grandest Jacobean house in London, was demolished in 1874. Built *c.* 1605–12 for Henry Howard, 1st Earl of Northampton, it was attributed by Vertue to *Bernard Janssen*. It made early use of a street front of full height, with a fabulously ornate frontispiece opening to a central courtyard. Eight or more major updatings followed after 1642, when it passed to the 10th Earl of Northumberland. *Edward Carter* altered the street front (1642–9) and *John Webb* designed new state rooms when the S front was rebuilt *c.* 1655–9. In 1748–53 *Daniel Garrett* remodelled the street front further, and added S wings with more state rooms, finished by *James Paine* (1757); in 1770–5 *Robert Adam* recast the C17 state rooms. In 1780 the street range was reconstructed after a fire, shortening the turrets. *T. Cundy I* reworked the S range and made a new staircase in 1818–24, and *Salvin* made a new ballroom as late as 1869, after another

fire. Various spoils may be seen around London: the C18 Percy lion from the parapet at Syon Park (*see London 3: North West*), Cundy's balustrade at No. 49 Prince's Gate, Kensington, part of Adam's Glass Drawing Room in the Victoria and Albert Museum, an C18 gateway at Bromley by Bow Health Centre (*see London 5: East and Docklands*).

PORTUGAL STREET
with PORTSMOUTH STREET

Portugal Street runs behind the s side of Lincoln's Inn Fields. Largely rebuilt *c.* 1900, when Kingsway was made. At the w, the London School of Economics (q.v.) occupies the s side. To the N the little ST CLEMENT DANES PARISH HOUSE, niggardly red brick Gothic by *H. & P. Currey*, 1897–8. Then Nos. 29–31, KING'S CHAMBERS, 1904 by *Ridge & Waymouth*, Free Style in peacock mood. Next to it the tall GEORGE IV pub, 1898 by *Perry & Reed*, less confidently loose. Facing are the former BELL'S and CHURCH TIMES (Nos. 6–7), 1903 by *Horace Field*, in a restrained Neo-Hampton Court, very early for the style.

PORTSMOUTH STREET leads off N here. LINCOLN CHAMBERS on its w side, 1907, is plainly *Ridge & Waymouth* again. Opposite is the IMPERIAL CANCER RESEARCH FUND extension of *c.* 1972, matching the main premises which face Lincoln's Inn Fields to the N. These are by *Young & Hall*, consultant *John Musgrove*, 1959–62: six storeys with a tall, originally windowless attic, neatly detailed, with dark metal window-frames and brick spandrel panels. Next on the E side the OLD CURIOSITY SHOP (Nos. 13–14), curious indeed, and claimed spuriously to be Dickens's original. The one-bay, two-storey corner shop is traditionally dated 1567, but more likely early–mid-C17. Windows a century or more later again. Over-hanging upper storey; tiled roof, cemented and painted. On the w side, the flank of the former ST PHILIP'S HOSPITAL, a cramped red brick Norman Shaw design by *A.A. Kekwich*, 1904–5 (future uncertain). Built as casual and receiving wards for the Strand Union workhouse.

Back in PORTUGAL STREET, s side, a giant block built as the headquarters of W.H. Smith, 1920. Beaux-Arts detail overlaid on red brick. It dispatched a million newspapers a day in its prime. In 1976–8 converted for the LIBRARY of the LSE; remodelled more drastically by *Foster & Partners*, 1999–2001, with harsh new windows. A great void was made within, 123 extending to basement level and dominated by an impressive helical staircase ramp, recalling the one at Foster's Reichstag in Berlin. Six slim columns adjoin the ramp, which is formed as a shaped steel box-section and which orbits two wallclimber lifts. Some exciting cross-views result. At the top is a timber-framed dome bisected to favour light from the N, which doubles as a vent for exhausted air. No concessions to the recent revival of colour and texture in Modernist interiors; the grey and

white palette will be found restful or antiseptic, according to taste. A bow-sided enclosed bridge spans back to the main LSE complex, SW. King's College Hospital occupied the site 1839–1913; to the W lay Clare Market, established 1657. For the Royal College of Surgeons and Land Registry on the N side, *see* Public Buildings.

RUSSELL STREET

The E entrance to the Covent Garden Piazza, made *c.* 1631. Notable for its coffee houses in the late C17–C18. The narrower E part is older, *c.* 1610.

On the S side here is the great THEATRE ROYAL, DRURY LANE, with the entrance front in Catherine Street, W. The first, short-lived theatre dated from 1635/6. A permanent theatre followed in 1662–3, for which Sir Thomas Killigrew was granted a royal patent. It burnt down in 1672, and *Wren* is thought to have designed its successor. Both were externally retiring, reached by passages from the street. In 1775 David Garrick employed *Robert Adam* to remodel and extend Wren's theatre, with a portico on Catherine Street. *Henry Holland*'s replacement for R.B. Sheridan, 1791–4 (burnt 1809), was larger still, with a long pedimented front to Russell Street.

The PRESENT THEATRE was built in 1810–12 by *Benjamin Dean Wyatt*, and is still London's finest theatre on the traditional model. It was also the first large London building erected under a single contract, by *Henry Rowles*, a nephew of Henry Holland. Two-storey elevations, of stucco to the W, brick to the N. Lower windows round-arched. At the W end simple antae define broad outer bays, with pedimented upper windows to the three bays between. This up-to-date Grecian style, doubtless chosen with a nod to Smirke's new Covent Garden theatre (*see* Royal Opera House), was also more economical than Wyatt's first proposal, which had porticoes to N and W. Covered approaches were eventually provided: the raw W porch on coupled square Doric piers, 1820–1 by *James Spiller* under the direction of *Soane* and *Samuel Beazley*, the handsome Ionic colonnade, N, of 1831 by *Beazley* alone. This has twenty columns, spaced with pairs at each end; of cast iron, originally painted and dusted with stone, with iron lampholders between. Further E a handsome plain scenery store added in 1814, five more bays, with arched windows below. Round the corner in Drury Lane more back-of-house additions, 1899–1900 by *P.E. Pilditch*, red brick. The upper wall of Wyatt's auditorium was visible above the skyline until 1921–2, when *Emblin Walker & F.E. Jones* and *Robert Cromie* rebuilt it.

The INTERIOR is delightful. Wyatt's foyer suite remains almost intact, a sequence unmatched in London, and closer indeed to the great public spaces of Continental theatres. Most altered is the foyer itself, where box offices of 1921–2 now stand

between the Greek Doric columns at each end. In the wall
ahead are three openings, the centre leading to a rotunda, the
sides to symmetrical staircases. The double-height ROTUNDA
has a circular balcony and a noble dome, coffered Pantheon-
wise. Upper entrances through four screens of Corinthian
columns *in antis*, another Pantheon reminiscence. The light
and airy STAIRCASES, of Imperial type, are reached from
the rotunda through Ionic column-screens. Iron balustrades,
the uprights linked by simple rings. A further flight returns
through space to an upper landing against the outer wall. Inset
tapestry paintings of 1921–2 at this level. Above the foyer is
the SALOON, worthy of a great town mansion. It has paired
pilasters, and apsed ends screened by columns in the Adam
way. Beyond the N apse is a former coffee room, domed, with
barrel-vaulted sides; its s counterpart has been destroyed.
Further along the N side is the ROYAL RETIRING ROOM,
square and pendentive-domed, with a column in each corner.
Louis XVI plasterwork, added later. A small D-shaped staircase
allows external access. After all this the big AUDITORIUM of
1921–2 is, inevitably, disappointing, though notable as the last
fanfare in a London theatre of the grand Edwardian manner.
Mixed Empire style, broad proportions, with three tiers above
the stalls and three bays of boxes by the proscenium. (Previous
remodellings, 1822 and 1901, perpetuated Wyatt's four-tier
arrangement and near-semicircular plan.) Some *Asphaleria*
stage machinery, from 1908; also fragmentary foundations from
one of the older theatres.
 SCULPTURE. Statues in the foyer: Shakespeare, of lead, C18,
by *John Cheere*; Noël Coward, of bronze and seated, by *Angela
Conner*, 1998. In the lower rotunda statues in niches of Shake-
speare (of plaster, after *Roubiliac*), Garrick, Balfe (1872 by
L.A. Malempré) and Kean (by *J.E. Carew*, 1835). In the upper
rotunda *Nollekens*'s bust of Sir Samuel Whitbread, chief entre-
preneur of Wyatt's theatre, 1814. Outside, l. of the porch, a de
luxe commemorative DRINKING FOUNTAIN by *Sidney R.J.
Smith*, 1897, of fiery red sandstone. By *Brock* the bust of Sir
Augustus Harris, the theatre's manager; putti by *M. Laylor*.
On the N side is the FORTUNE THEATRE, by *E. Schaufelberg*,
1922–4. A radical break with Edwardian theatrical traditions,
both in its small size (440 seats) and architecturally. The frame
of bush-hammered concrete, originally unpainted, allowed
an efficient internal arrangement. Steel-framed windows set
flush. A little decoration in cast lead. Above the centre a statu-
ette of Fortune by *M.H. Crichton*. Lilliputian marble-lined
foyer; auditorium with simple ornament, a few zigzags and
discs. To its W a TELEPHONE EXCHANGE, by a Lutyens pupil,
J.H. Markham of the *Office of Works*, 1925–7. Stone and red
brick. At third-floor level four very queer aedicules with free-
standing columns supporting heavy pediments, projecting
without visible support. For the N extension *see* Bow Street.
The rest of the s side has the Theatre Museum, in part of
the Flower Market extension (*see* Covent Garden), and some
later C18 houses. At No. 8, of 1759–60, Boswell first met

Dr Johnson. Restored shopfront of 1979. Houses opposite went in 1996 for the Royal Opera House extension.

ST MARTIN'S LANE

The old N–S lane between the church of St Martin and that of St Giles-in-the-Fields (*see London 4: North*). Built up from the C16 to the earlier C17. Characteristic of this time are the long narrow courts off on each side. Theatres came in the 1890s.

The S end was widened when Trafalgar Square was made, *c.* 1830, and renamed ST MARTIN'S PLACE. Islanded in its roadway is the ambitious MONUMENT to Edith Cavell, 1916–20 by *Sir George Frampton*. She stands in front of a tall pylon of Bodmin Moor granite, finished with a figure of a protecting mother above a cross. On the E side the former London Press Exchange (also a POST OFFICE), by *Fitzroy Robinson & Partners* (*Sir Howard Robertson* consultant), 1958–62, stone-faced, and rather Continental in flavour. Abstract spandrel reliefs of bronze. First in the lane proper is No. 29, THE CHANDOS pub, reconstructed by *Hunt Thompson Associates* 1985. Neo-Victorian interior; tepid exterior, with simplified aedicules and an automaton of a cooper on top. No. 31 is probably late C17 in origin, behind self-important mid-C18 refronting. Arched central window, keystone heads to the flanking windows, panels and garlands above. The main room has a compartmented ceiling.

In contrast to this domestic past, the COLISEUM represents the theatrical present. Of 1902–4 by *Frank Matcham*; after 1968 the Sadler's Wells Opera Co., now ENGLISH NATIONAL OPERA. Oswald Stoll built it as a variety house on the largest scale (capacity 2,358), in rivalry with his former partner Edward Moss's Hippodrome (*see* Charing Cross Road, p. 402). The result is just what a palace of entertainment should be, Baroque, with a St Paul's-type tower placed asymmetrically and carrying a large globe. On the front versions of the big projecting aedicules with columns that came in with Belcher's Colchester Town Hall (1897). Terracotta façade by *Hathern*'s of Leicestershire (who carried out a trial assembly there before transhipment); restored by *RHWL* from 2001. Re-creation of its lost sculpture is planned. Also part of *Matcham*'s composition the offices at No. 36, with a recessed columned bow. Marble-lined foyer with mosaic dome (signed *Diespekers*' patent); marble open-well staircase, with a BUST of Stoll's mother Adelaide by *Sir W. Reid Dick*, 1925, at the foot. The site is irregular, so the AUDITORIUM is set askew. It is tremendous, devil-may-care Neo-Rococo, with a ribbed dome, canopied boxes, and in the angles by the stage sculptures of chariots drawn by lions. The large bars were originally tearooms equipped with telegram offices, intended as places of resort between and during the four performances scheduled each day. The restoration aims to reorder circulation and re-create a glass roof on the upper terrace, removed 1950–1.

On the W SIDE is a mixture of smaller theatres, late C19 blocks of chambers from the Charing Cross Road stable, and late C20 offices. No. 114, with a bow filched from Mackintosh's Glasgow School of Art, is of 1997–9 by the *T.P. Bennett Partnership* (with retained façades to Charing Cross Road, *see* p. 401); No. 110, round-arched red brick, is by *Rolfe Judd*, 1981. The DUKE OF YORK'S THEATRE, 1891–2 by *Walter Emden*, has a three-bay loggia externally and an attractive Louis XV auditorium with three serpentine gallery fronts. Columns supporting these were removed by *Renton Howard Wood Levin*, 1979, who restored the C19 colours. Further up, Nos. 94–99, a great double-gabled pile of chambers of 1893–4.

Opposite is the ST MARTIN'S LANE HOTEL, remodelled in 1997–9 by *Harper Mackay* from a free-standing office block of 1964–6 by *Seifert & Partners*. Seifert's typical zigzag rhythm of projections between the windows, which have had thin metal frames jammed in. The interiors temper white-box minimalism with large areas of colour or coloured light, and doggedly provocative mixed furnishings, Neo-Rococo, gnomes, etc. The model is the Royalton Hotel, New York, an earlier and more flamboyant project for the owner Ian Schrager, with the same consultant, *Philippe Starck*. At Nos. 52–53, late C18, a Neo-Georgian entrance leads to the FRIENDS' MEETING HOUSE of 1956, by *Hubert Lidbetter*; the meeting house itself occupies the bombed shell of its predecessor of 1882–3 (by *W.W. Lee & J.A. Tregelles*). A plain auxiliary block of 1882–3 remains, facing Hop Gardens, S (No. 8 there). Further up the lane, steps up into GOODWIN'S COURT, a surprisingly complete survival, 60 paved and murky. On its S side Nos. 1–8, late C18, all with original bowed shop-windows.

Back to the lane. On the W SIDE, in another showy mansion block of 1892, is THE SALISBURY (No. 90), with a well-preserved, exceptionally ornate pub interior of 1898. Plenty of cut, frosted 97 and stained glass, and a row of shallow niches with curved leather-covered seats. On them several lamps fashioned as figurines of alluring Belle Époque maidens with flower-stalks and flowers. Next the ALBERY THEATRE, 1902–3 by *W.G.R. Sprague*. Portland stone, free classical with giant pilasters, the central five of nine bays advanced. Built for Charles Wyndham, like Wyndham's Theatre immediately behind, also by Sprague (*see* Charing Cross Road, p. 402). Restrained French Neo-classical interior (decorators *Waring & Co.*, consultant *Claude Ponsonby*), with coupled half-columns and pilasters. Three cantilevered bombé-fronted tiers. Nos. 82–84, the former WESTMINSTER COUNTY COURT, 1908–9 by *H.N. Hawkes* of the *Office of Works*, stone-fronted too, with columns recessed between the windows and a festive English Baroque flavour. Carving by *Gilbert Seale*. Converted to restaurants 1996.

Further N the topography becomes labyrinthine. St Martin's Lane reaches a six-ways and broadens. The first corners on the W side belong with Cranbourn Street, on the E with Garrick Street, both mid-C19 creations (qq.v.). Ahead on the W side, l., a big stripy former pub of 1898 by *R.A. Lewcock*. Then mostly post-war buildings, notably ORION HOUSE, built (as

Thorn House) in 1957–9 by *Andrew Renton* of *Basil Spence & Partners*. It was admired when new as one of the first British office buildings to take after Gordon Bunshaft's influential Lever House, New York, i.e. a tower juxtaposed with a low horizontal range and aesthetically almost on a podium. This derivation alas no longer appears, due to reconstruction in 1988–90 by *RHWL Partnership*. A stodgy block of flats to the S, with simplified aedicules on top, replaces the lower range, which served as a showroom and which ran under and just touched the twelve-storey slab. The space below this has been enclosed, and the slab clad in shiny grey panelling bulked out with convex-ended attachments. Its open framing remains on top. Reset on the N side, a tall abstract gunmetal SCULPTURE by *Geoffrey Clarke*, called The Spirit of Electricity, 1958. An upright spindle with an attached segment pierced by spikes, designed to cast thorny shadows. A more usual 1950s office type opposite, WELLINGTON HOUSE, 1959–60 by *N. Green*. Ahead lies Seven Dials, for which *see London 4: North*.

SOUTHAMPTON STREET

Laid out in 1706 on the site of Bedford House, connecting Covent Garden market with the Strand. Nos. 26–27, W side, date from 1707–8, fine four-storey houses of brown brick dressed with red. No. 27 has quoin piers and key blocks; bronze plaque to David Garrick, resident 1749–72, by *H.C. Fehr* after a design by *Fitzroy Doll*. Some interior features are plausibly of Garrick's time: a fine column-newel staircase, cyma reversa doorcase, etc. Then red brick chambers of *c.* 1893–6; Nos. 28–29 (*J.R. Vining*) and 30–31 (*J.T. Woodard*) have tourelles on the corners with Maiden Lane. Distinctive shopfronts of blue and green faience on the rest. They confront the big TOWER HOUSE, the former printing house of George Newnes, 1934–6 by *A.A.H. Scott*. Stone, with headache-inducing channelling, and an octagonal corner turret. Reconditioned by *Lifschutz Davidson*, 2001–2, with rebuilding behind Nos. 3–7, late C19 chambers to its S. On No. 3 a rich timber CLOCK, designed by *Lutyens* for Newnes's firm, 1904.

STRAND

First recorded as *Strondway*, in 1002. The name refers to the fact that, before the Thames was embanked in the C19, this was the street nearest the river bank. The Romans used it to travel between the City and a ford somewhere near the site of Westminster Bridge. Scattered remains found e.g. near St Martin-in-the-Fields suggest the presence of Roman villas, but extensive settlement came only in the C7, when the Strand became the backbone of *Lundenwic* (*see* pp. 4–5). After Alfred resettled the walled City in 886 the settlement seems to have been abandoned.

Its revival in the C11 must be connected with the new importance of Westminster, and by the late C12 the Strand was, according to Fitzstephen, a *suburbium* with houses and spacious gardens. The churches of St Clement Danes and St Mary-le-Strand were already then in the middle of the roadway. Along the river there grew up a string of large mansions in their own grounds. The Savoy, built *c.* 1370 by Henry, Duke of Lancaster, was the greatest of them. Others belonged to churchmen: of bishops' palaces, Llandaff, Chester and Worcester stood on the site of Somerset House, Carlisle on the site of Shell-Mex House, Durham on the site of the Adelphi. To recover their boundaries one must explore the shelving lanes s of the Strand (Strand Lane, Carting Lane, Milford Lane, etc.), which ran between what were at first private walled enclosures. Since the usual access was by water, the river fronts and watergates of these houses came to be treated with more pomp than their Strand sides, which were mostly hidden by tenements. The deep, narrow medieval plots can still be picked out by their narrow fronts on both sides of the Strand.

All the churchmen's houses passed into lay hands after the Reformation, and the reigns of Elizabeth and the early Stuarts were the heyday of the Strand as an aristocratic quarter. By the mid C16, as can be seen on maps and views, houses lined both p. its sides, and a village had begun to grow N of St Clement Danes. 15 After the Restoration and the shift of court life further w, the great enclaves s of the road were also turned over to ordinary houses. In the C18 the Strand settled down as a street of conviviality, retail and business, consolidated in the 1770s by the demolition of the royal palace at Somerset House in favour of Government offices. The greatest private housing scheme of C18 London, the *Adam Brothers*' Adelphi (q.v.), was begun to its E a little earlier, in 1772. Waterloo Bridge was thrown across in the 1810s from just w of Somerset House, King's College founded in the 1820s on the further, E, side, and the West Strand Improvements made in the 1830s as a formal approach to Trafalgar Square (*see* also Adelaide Street). Views of this time show repeated four-storey houses with shopfronts along most of the rest. The Victorians broke up this uniformity: Charing Cross Station was built at the w end, and the Royal Courts of Justice rose at the extreme E, close to the Inns of Court. In the 1860s also the Victoria Embankment was made, severing the Strand from the old water-borne trades. Then in 1900 clearance began w of the Courts for the great Aldwych and Kingsway scheme

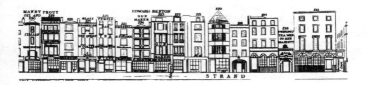

Nos. 215–230 Strand. Engraving
(John Tallis, *London Street Views*, 1838–47)

(qq.v.). Beginning in 1899, most of the s side was widened, and grand hotels and offices built. Many theatres opened in the C19, now reduced to four. Post-war buildings are disappointing; the best, *Denys Lasdun*'s store for Peter Robinson (Nos. 65–72, 1957–9), was demolished in 1996.

Of other DEMOLISHED BUILDINGS four in particular should be described here, since they are often confused. In 1608–9 the NEW EXCHANGE, 'Britain's Burse', was built by the 1st Earl of Salisbury where Nos. 54–64 now stand (s side; dem. 1737). Luxury shops were its chief feature, arranged in two double galleries. *Simon Basil* supervised the design, taking features from drawings by *Inigo Jones*. Further E, where the Strand Palace Hotel stands, was EXETER 'CHANGE or EXCHANGE, built *c.* 1676 by *Nicholas Barbon*, also with a two-storey arcade of shops (and latterly a famous menagerie). This went in 1829, and *J.P. Gandy Deering*'s EXETER HALL was built at the back of its site (opened 1831, dem. 1907), an imposing Greek Ionic building intended for public and religious meetings. The names went back to Exeter (or Burghley, or Cecil) House, a great mansion of the 1570s with a double-courtyard plan. The short-lived NEW EXETER CHANGE was a covered shopping passage to the E, of 1842–3 by *Sydney Smirke* (dem. 1863).

Today the best things in the Strand are undoubtedly its churches and public buildings, together with the Aldwych crescent. But in the connective tissue are many interesting buildings, and a few outstanding ones. *Westminster City Council* has recently raised the tone by improving shopfronts and street furniture, including a continuous central pedestrian refuge (completed 1997). The STREET LAMPS are older, made by *Singer & Co.* of Frome from 1899.

North Side, from west to east

For South Africa House *see* Trafalgar Square. Then at once the largest block of the WEST STRAND IMPROVEMENTS, stucco of 1830–2, planned and designed by *Nash* (builder *William Herbert*). Two round pepper-pot towers diagonally placed, and then nicely composed stucco fronts accented by giant pilasters, the other two corners with single towers. The centrepieces are pilastered except on the Strand, where a great glazed void appears in the middle, giving entry to COUTTS' BANK: a conversion done by *Sir Frederick Gibberd & Partners*, 1973–8 (engineers *Scott Wilson Kirkpatrick & Partners*). This created what is claimed to be the first modern atrium building in Britain, though not of course a completely new design. The effect is unsettling, but could have been worse: the *GLC* planned to cut a road through the block here, as part of the Covent Garden rebuilding (*see* pp. 286–7), but Coutts successfully appealed against in 1972. The glazing replaced Coutts' rather pompous premises of 1903–4 by *J. Macvicar Anderson*, which in turn supplanted Nash's pretty, pendentive-domed Lowther Arcade. A secondary front on Adelaide Street, E, also lost 1903–4, was replaced in the 1970s with a facsimile Nash design (as was the damaged N frontispiece on William IV Street).

Behind the glass, escalators climb to Coutts' large atrium, shaped like a triangle with truncated corners. Forceful steel beams span to the centre. The lining is cream Botticino marble. Below the glazing, fountains and greenery and a marble figure of Thomas Coutts seated on a Greek chair, by *Chantrey*, 1827. A large carpet designed by *C.F.A. Voysey*, 1890s, is displayed by the entrance. Coutts' first premises were at No. 59, a house of 1738, much remodelled: in 1770–1 and 1780–3 by *James Paine*, 1838–9 by *Thomas Hopper*. (Salvaged, two c18 fireplaces, and in the board room Chinese wallpaper brought back from Lord Macartney's Peking embassy in 1794.)

At the next junction, set back, the corner appears of the former Charing Cross Hospital (*see* Adelaide Street). On the E corner with Agar Street ZIMBABWE HOUSE (No. 429), 1907–8, by *Charles Holden* for the British Medical Association.* A building of more virile character than almost anything of that date in London. Ground floor and first two storeys of grey Cornish granite, the rest of Portland. The uncompromisingly cylindrical columns and the many short sharp horizontals are easily remembered motifs. The second-floor windows are framed by *Epstein*'s famous sculptures, carved *in situ*, and since 1937 mutilated and headless. They were his first major work in England. Erosion, not puritanism, lay behind the decision to hack parts off, but what remains is very eloquent. Next to it in AGAR STREET a stone elevation by *Chapman Taylor Partners*, 1984–5, interfusing Holden motifs with the firm's vertically stressed style. It replaced a fire-damaged section of the former Civil Service Stores; part remains at Nos. 423–427: by *Ellis & Clarke*, *c.* 1931, round-arched and simplified. Nos. 418–422, by *G.R. Crickmay & Sons*, 1906–7, big stone-faced Free Baroque. Then up the gas-lit EXCHANGE COURT for No. 419a, sober early c19 brick. Graceful pilasters and columns on the ground floor, looking *c.* 1910: added for the Corps of Commissionaires, founded 1859, which found ex-servicemen jobs guarding buildings.

Mostly narrower, busier, and sometimes naïve fronts follow. At No. 417 a squeezed Neo-Elizabethan pub by *H. George Leslie*, 1907. *Crickmay & Sons* return at Nos. 413–416, built 1913–16 as the first New Zealand House. Astylar, urbane, with a tall mansard and carved Maori masks, etc. The ADELPHI THEATRE at Nos. 411–412 has a front of 1930 by *E. Schaufelberg*, in the jagged style (restored 1993). The shell includes older fabric – eleven building campaigns are recorded between 1806 and 1901 – as appears behind, Maiden Lane (q.v.). Powerful crystalline forms of 1930 inside: big light fittings, balcony fronts, etc. (restored 1993). The former Adelphi Theatre Restaurant next door (Nos. 409–410) is of 1886–7, by *Spencer Chadwick* for Gatti Bros. Polished granite below, substantial Corinthian columns above. Pilastered, marble-lined interior, now an amusement arcade. The front of the VAUDEVILLE THEATRE is of 1890–1 by *C.J. Phipps*, who reused the shell

* It replaced another of the West Strand Improvements, the Westminster Life & British Fire Office, a brilliant design by *C.R. Cockerell*, 1831–2.

of his theatre of 1869–70. Diminishing storeys, originally with
a pedimented gable. Auditorium remodelled for Messrs Gatti
1925–6 by *Robert Atkinson* in simplified late C18 style, keeping
Phipps's rounded ceiling of 1890–1 (cf. Nos. 9–10 Maiden
Lane). At No. 396 the narrow eclectic front of *The Observer*,
probably *c.* 1877, which would make it the oldest remaining
national newspaper office. No. 395, 1895, was a vintner's.
Elaborate pilastered interior. The strange Nos. 388–389 is by
Farrow & Turner, 1930–1, with a huge Venetian motif on its
flank. Built for Horne Bros, tailors, founded here 1886. Then
MANFIELD HOUSE, 1930 by *Trehearne & Norman*, lofty and
plain.

The big STRAND PALACE HOTEL next, by *F.J. Wills*, 1928–30.
The facing is artificial stone (here soapy-looking *Doulton*'s
Carraraware): the favourite material of the J. Lyons empire.
The older back part, built for the same in 1907–9 by *W.J. Ancell*
and *Henry Tanner Jun.*, was originally reached by a narrow
front on the Strand. The flanks show the two phases. To the
NE, a detached extension by *Wills*, *c.* 1930, linked by bridge
across Exeter Street. There were 980 bedrooms in 1930.
Entrance remodelled by *Dennis Lennon & Partners*, 1967–8,
replacing fabulous jazz-modern decor of 1929–30 by *Oliver
Bernard* (assisted by *J.M. Richards*, later editor of the *Architec-
tural Review*). Some was salvaged by the Victoria and Albert
Museum; more remains in the basement, including a staircase
with a stepped frosted-glass handrail lit from within.

On the E corner of Burleigh Street Nos. 356–359, a pilastered
composition of houses of 1829–32. Built under the same Act
that decreed the West Strand Improvements, probably also by
William Herbert under *Nash*. Rebuilt behind in 1984–5, with
restoration of lost stucco detailing; No. 355, an Italian Gothic
refacing of *c.* 1870, was also incorporated. Cruder Gothic trim
on the LYCEUM TAVERN, No. 354, probably as late as 1906.
Collcutt's Nos. 352–353, a restaurant of 1902, is rusticated all
over. Also of 1902, but still gabled and Late Victorian, the
WELLINGTON pub next door (*Bird & Walters*).

The N side goes on with the Aldwych scheme, the end of
Clement's Inn, and then the Royal Courts of Justice (qq.v.).
For the Gladstone monument *see* St Clement Danes.

South Side, from west to east

The rebuilt Grand Buildings belong with Northumberland
Avenue (q.v.). Then two large office blocks standing clear on
three sides, each showing the fashion for tall narrow windows
and mansarded skylines. First No. 5 (LAND SECURITIES) by
Abbott Howard, finished 1982, white marble-faced with glossy
glazed stair-towers. More refined is *Casson, Conder & Partners*'
No. 11, 1981–5. Flush windows, but strongly modelled other-
wise, with set-backs and clustering oriels high up where stone
facing gives way to lead. Its counterpart across Charing Cross
Station forecourt is the former Villiers House (Nos. 32–50):
a reconstruction by *Hurley Robertson & Associates*, 1995–6,
using the frame of offices by *Trehearne & Norman, Preston &*

Partners, 1957–9. Tame plain stone replaced the fifties chequerboard elevations. The HALIFAX BUILDING SOCIETY (Nos. 51–55) is by *G. Val Myer & Watson Hart*, 1932–4, tall and symmetrical, but without conventional classical motifs. Not so Nos. 56–64 of 1924–6, the former Saxone by *Yates, Cook & Darbyshire*, Neo-Adam with some squared-off detail. In the same vein but more accomplished the delicate applied portico on the back of the ROYAL SOCIETY OF ARTS (*see* also Adelphi), visible down Durham House Street: by *Maurice Webb*, 1926–7. Plaques by *E.J. & A.T. Bradford*, pediment sculpture by *Walter Gilbert*. The big arch below, formerly a public roadway, was glazed for a secondary entrance in 1989–90 by *Green Lloyd*. At Nos. 65–72, offices by the *Fitzroy Robinson Partnership* 1992–7, stone-faced and bulky, with a polygonal corner to Adam Street, l. Nos. 77–86 are CECIL CHAMBERS, 1899–1900 by *Joseph Sawyer*, the street range of the former Hotel Cecil. Red brick and stone, with red Peterhead granite below, an underpowered giant order above. In 1997–8 double-height shopfronts were reinstated to the first design and the upper part converted for flats. In the middle a tall archway with colonnades, originally to the hotel forecourt. The hotel, opened in 1885, was the largest in Europe. It had 800 rooms in suites of three to eight, each with a bathroom. The architects were *Perry & Reed*, the developer Jabez Balfour, who also undertook Whitehall Court and other great works but ended in prison for fraud. Its distinguishing feature was the enormous pavilion domes on the river front. The replacement, Messrs *Joseph*'s Shell-Mex House (No. 80 Strand, 1931–3), is described under Victoria Embankment.* 4

The next block is the SAVOY HOTEL, founded by Richard D'Oyly Carte of Savoy Operas fame (for the medieval Savoy *see* the Savoy Chapel). Having built the Savoy Theatre here in 1881, he decided three years later to add a hotel to compete with the best in America. It opened in 1889, overlooking the Embankment, and at once became the chief rival to the architecturally more imposing Hotel Cecil. What gave the Savoy its enduring lead were no fewer than four updatings before 1930. In 1896–7 part of its courtyard was built over, then in 1903–4 the founder's son Rupert D'Oyly Carte added two large blocks and a forecourt towards the Strand. This made the Savoy the largest hotel in London. In 1910 the Embankment block was refronted and upgraded, in 1929–30 the Strand entrance given its present smart appearance. To follow this story the site must be walked around first; its architects and designers are introduced as we come to them.

First down CARTING LANE. The back of the Savoy Theatre of 1881, by *C.J. Phipps*, appears on the l., of painted brick with broad grooved piers. It was advanced both technically and aesthetically: electrically lit, and decorated by *Collinson & Lock*,

*The site was once bisected by Salisbury Street, made up of symmetrical terraces by *James Paine*, 1765–73, on Cecil family land. SALISBURY HOUSE itself was built 1599–1603 for Sir Robert Cecil, later 1st Earl of Salisbury, by *Simon Basil*. It broke away from the quadrangular plan, facing the Strand with two open courtyards.

a firm linked with the Aesthetic Movement. Altered in 1929, when dormers were removed, and in restoration of 1990–3 (*see* also below), when the C19 treatment was extended round the S corner. At the bottom of Carting Lane a rare STREET LAMP with fat fluted shaft, designed to burn sewer gas (*J.E. Webb*'s patent, 1895). Here the FIRST BLOCK rears up, of 1884–9 (heightened in matching style at the NW, 2001–2). The little-known architect *Collins B. Young* is credited with its design, but the basic outlines owed much to *Richard D'Oyly Carte* himself and to the builder *G.H. Holloway*. The muddled, rather Transatlantic result still appears on the flanks, with balconies mechanically superimposed above weak-looking paired granite columns. Their special interest is the cast-iron balcony fronts, with swirl-and-blob motifs looking forward to Art Nouveau. Payments for unspecified ironwork were made to *A.H. Mackmurdo*, a relative of the owner, and other works by him are so similar that he must have been their designer (he later muddied the water by claiming to have designed the whole hotel). Contemporary accounts dwelt more on the facilities, including electric light throughout. Most remarkable for London were the seventy bathrooms, whereas the Victoria Hotel in Northumberland Avenue, opened two years before and sleeping 500, had just four. It is said that the builder asked D'Oyly Carte whether he was catering for amphibian guests. Once more, *Collinson & Lock* did the decoration, and *Maples* the interiors, which featured *Morris* wallpapers: another calculated break with the mid-Victorian hotel tradition.

The RIVER FRONT is quite different, having been reworked in 1910 by *Collcutt & Hamp*. This meant filling in the C19 balconies to provide more space and more bathrooms. The result is remarkably unassuming, and incidentally also remarkably functional. Artificial stone, large horizontal bedroom windows alternating with small ones for the bathrooms, and ornament only near the top. Wavy concrete *porte-cochère* by *Eric Janes*, 1957. On the E flank, facing SAVOY HILL, the C19 entrance appears as red granite archways. Originally this led to a fore-court with a fountain, partly infilled in 1896–7 by *T.E. Collcutt* and *G.H. Holloway* – work described in *The Builder* as entirely steel-framed. *Collcutt* had earlier worked on the interiors, but the bedrooms of 1910 towards the river were furnished by *René Sergent* of Paris. Continuing uphill, the great mass ahead belongs with the Strand extensions of 1903–4 (called SAVOY COURT), for which *Collcutt* was also responsible. They too are steel-framed, with facing of *Doulton*'s Carraraware, a creamy, matt-glazed terracotta. On the Strand side are two blocks with round turrets, and with repeated canted bays on the E block. Between them is a new entrance, reached via a deep forecourt. Closing it on the S is a third added wing, an excellent design: tiled hipped roof, an applied arcade with giant spandrel figures, then lower storeys of plain windows. The lower parts were altered in 1929–30, when *Easton & Robertson* waved a magic Deco wand over them. The canopy front was remade in smart chromium, keeping *F. Lynn Jenkins*'s statuette of Count Peter of Savoy, 1904. On the E side a double-height restaurant

façade. It faces the SAVOY THEATRE, W. This was given a mirrored stainless-steel front (replacing a refronting of 1904), in which a new entrance was made. The men in charge inside were *Bertie Crewe* and *Frank A. Tugwell*, with *Basil Ionides* as chief designer. Burnt out in 1990, their interiors were re-created by *Whitfield Partners* (completed 1993), true to the dizzying originals. The framework belongs at the classicizing 112 end of the Deco spectrum, especially the great tunnel-like proscenium surround of aluminium-leafed coffering. Smaller motifs of Chinese, jazz or Aztec flavour. Two clear-span balconies. A new top storey of 1990–3 houses a health club.

The other INTERIORS begin with a broad entrance hall, panelled by Messrs *Gillow* and with a frieze modelled by *Bertram Pegram*, 1904, and carry on in a great procession down to the river front. Other interiors altered 1929 and in mid-1970s refurbishment. (BALLROOM below the foyer, restored to the 1910 scheme.)

In the EAST STRAND BLOCK is the COAL HOLE pub (No. 89), with a partly pastiche Arts-and-Crafts interior, and the SAVOY TAILORS' GUILD (Nos. 93–95), with an elaborate 1900s shopfront perhaps by Collcutt's assistant *A.N. Prentice*. In the W block is SIMPSON'S restaurant (No. 100), stronghold of English cooking, founded in 1848. Downstairs room with Hungarian oak panelling. Two large upper rooms, prettified Neo-Adam, one with painted mythologies. Alterations by *Oswald Milne*, 1929, of uncertain scope.

Next some typical medium stone-faced offices, of 1924 (Nos. 105–109, *Trehearne & Norman*), and 2001–2 (Nos. 110–116, *Michael Squire & Partners*). The latter is built unusually of load-bearing panelling. Its r. end is carved with a tall RELIEF designed by *Langlands & Bell*, artists whose work often draws on architectural themes, representing the surrounding streets in block plan. WELLINGTON HOUSE (Nos. 125–130), 1924–6, shows *Trehearne & Norman* Egyptianizing.

After Lancaster Place and Waterloo Bridge, Nos. 133–137, a curved gabled quadrant in buff terracotta. By *A.N. Bromley*, 1897. Built as offices for the National Telephone Company, commemorated by a relief over the r. entrance. *Elsworth Sykes Partnership*'s Nos. 138–142, 1986–8, is like a po-faced Postmodern *mairie*, with pavilion roof and clock. At Nos. 143–144 the smallish STRAND CONTINENTAL HOTEL, 1911 by *Withers & Meredith*, with canted bays and thick carved garlands at the top. Then some unassuming four-storey fronts, mostly C18, on both sides of SOMERSET HOUSE (q.v.), the wings of which run behind. A blocking cornice links Nos. 146–149. On the far side, E, Nos. 152 and 153 are of *c.* 1700, refronted; No. 156 has curious pitted stucco detail, looking *c.* 1840. After King's College (q.v.), some smaller properties of *c.* 1900. At No. 169 a single arch to Aldwych underground station (*Leslie Green*, 1906, closed 1994), topped by *F.W. Troup*'s stone-faced classrooms for King's, of 1927. No. 171, 1905 by *Thomson & Pomeroy*, gabled miniature Norman Shaw Baroque.

Next ARUNDEL GREAT COURT, 1971–6 by *Sir Frederick Gibberd & Partners* (outline approval 1968). The concept was that of

a giant quadrangle enclosing a semi-public garden at Strand level, made on the roof of the service basements. To achieve this uninteresting goal two complete streets first laid out for the C17 Norfolk Estate were erased (*see* Surrey Street), along with a mass of C19 buildings. The great symmetrical office quadrangle replacing them communicates merely a drab efficiency. Strong stone bands with chamfered lower edges, smoked glazing between, and narrow stair-towers that show up higher in distant views. Nine storeys to the Strand, seven down the sides. Here are additional entrances and also steps up to what was the central garden, largely infilled in 2000–1 by *HLM*'s brittle-looking glass-clad extension. The s range facing Temple Place houses the HOWARD HOTEL (heightened 2001–2).

On the far side of Arundel Street, E, is the no less disastrous ABBEY LIFE HOUSE, by *A. Swift & Partners*, 1963–5. A medley of variously sized blocks linked by a raised terrace, all with the same coarse large-scale details. Two ARTWORKS by *G.E. Wickham*: at the N end a ceramic relief, on the E facing Milford Lane a semi-abstract sculpture called Winged Form. On the upper W terrace also three prone sculpted females by *H. Poole* from old Ingram House, Edwardian Baroque of 1907 by *H.T. Hare*, which stood at the Strand end. Unlike its usurper, Ingram House followed the concave street line formed here *c.* 1789–96 by Alderman Pickett, as a setting for St Clement Danes. The curve still appears at Nos. 199–203, brick and stone Neo-Georgian of 1957–9 by *W. Braxton Sinclair*, built for the Huddersfield Building Society. After Essex Street, No. 216, the little portal of TWINING'S, with two chinamen and a golden lion of *Coade* stone. Columns with acanthus capitals, probably from an entrance of 1787, moved from further W in 1835; reconstructed in 1953 with a different top part. The firm sold tea from 1706 in Devereux Court, behind; a lion is recorded as Thomas Twining's shop sign in 1717.* Nos. 217–221 was a London & Westminster Bank branch, by *F.W. Hunt*, 1897. Five bays, with pilasters turning to columns where the centre sets back. The less conventional LLOYDS BANK (Nos. 222–225), 1882–3 by *Goymour Cuthbert* and *W. Wimble*, was built as the Royal Courts of Justice Restaurant: hence the festive coloured stones, atlantes, etc. Glistening majolica-lined vestibule with Palissy-like fishes, made by *Doulton*. Further in, painted tile friezes by the same firm, and tile pictures: larger ones after Ben Jonson (by *J.H. McLennan*), smaller ones showing varieties of chrysanthemum. At No. 226 a narrow early C19 house. Nos. 229–230 (WIG & PEN CLUB), stuccoed, are especially interesting for their use of timber. No. 230 is late C17 or early C18, with a timber-framed bay on shaped brackets. It groups with No. 229, early C17, which may well be the oldest ordinary house in Westminster. Frame entirely of timber; jettied first floor, second floor on a further overhang. Nos. 231–232, THANET HOUSE, is by *Joseph, Son & Smithem*, 1903, with lots of blocking and low stocky turrets. The little

p. 363

* Its banking house of 1835–7 by *Henry Mawley*, on the r., was destroyed in 1941.

gabled No. 233 is by *T. Batterbury*, 1901. Temple Bar, in the roadway beyond, belongs with the City.

SURREY STREET

Made in 1676–8, with other streets now vanished beneath the 1970s Arundel Great Court on the E side (*see* Strand). The site was previously Arundel House, home of the Dukes of Norfolk. *William Winde* and *Jonathan Wilcox* were involved in the street layout; Winde may have provided designs for a house for the 6th Duke, begun in 1677 but never finished. The streets remained with the Norfolks, and were mostly rebuilt from *c.* 1887 by their estate surveyor *John Dunn*. Chief survivors are Nos. 24–32, two former hotels of 1893–4, in an ornate Flemish style of buff terracotta and orange brick.* To the N Nos. 33 and 34, yellow brick mid-C18 houses.

Between Dunn's two buildings, Surrey Steps lead to STRAND LANE, formerly a public route down to the river, but now blocked at both ends. At the N end ST CLEMENT DANES' WATCH HOUSE, early C19, built partly over the lane and with a pretty iron veranda. In the basement next to it, r., is the so-called ROMAN BATH, one of the odder properties of the National Trust. It is a spring-fed oblong with a semicircle at one end, formerly lined with C19 marble slabs. David Copperfield took a cold plunge in it before setting off to walk to Hampstead. The dimensions of the bricks are not Roman, and the high ground level also rules out a Roman origin. More likely is that the bath belonged with ARUNDEL HOUSE, which would suggest a C16 or early C17 date. Arundel House owes its place in the history of English art to the marbles assembled there by Thomas Howard, Earl of Arundel and Surrey, the first such group of antiquities in Britain.

TAVISTOCK STREET

Laid out in stages: between Wellington Street and Catherine Street *c.* 1631; to the W 1706–14, across the old Bedford House precinct (*see* Covent Garden); to the E 1899–1900, through to Drury Lane. In the W part, S side, is *Lutyens*'s COUNTRY LIFE building of 1904–5, an early example of Hampton Court Wrenaissance. Its proprietor Edward Hudson was one of Lutyens's most steadfast patrons and publicists. Seven bays, the centre emphasized by wider spacing and over the doorway a big segmental pediment reaching up to enclose a mezzanine window. On other mezzanine windows segmental tops and bottoms, linked to the tall windows of the *piano nobile* above. Attic windows added in 1956–7 by *Robert Lutyens &*

* And also Nos. 13–15 Arundel Street, *see* Victoria Embankment, p. 380. A previous estate surveyor was *H.R. Abraham*, whose buildings have all been demolished.

Greenwood, lessening the impact of the chimneys. Carving by
A. Broadbent. Cross-vaulted entrance hall.

Then a mid-Victorian cluster at the top of BURLEIGH STREET,
E, which was cut through into Tavistock Street in 1856. The W
corner is of 1859–60 by *Charles Gray*, eclectic Italianate with
polychrome-tiled metopes; the E corner, built in 1857–8 as the
Strand District Board of Works office by its surveyor *G.F. Fry*,
has masks, festoons and triple windows. By way of contrast its
neighbour, S, is by *William Butterfield*, the former St Michael's
Vicarage, 1859–60. Narrow and tall, and L-shaped towards the
street. Red brick, with stone dressings and yellow diapering,
and a carved roundel of the saint. In 1993 converted for
the Community of the Resurrection. St Michael's church, of
1831–3 by *James Savage*, stood diagonally opposite until 1906.

E of Wellington Street a run of houses mostly of *c.* 1730, a few
still with panelled interiors: Nos. 11–19, N side, and Nos.
34–38, S. Nos. 40–42 are by *John Blyth*, 1858, just like ordinary
builders' houses. For the E extension *see* Drury Lane.

TRAFALGAR SQUARE

The odd man out of the West End squares: a paved space with
hard landscaping, made as much by demolitions as by enclosing
open land, and publicly accessible from the outset. Before its
creation from the 1820s, this crucial joint in the pattern of old
London, between the E–W axis of the Strand and the N–S axis of
Whitehall, was emphasized by no more than a modest widening,
from which a third axis, Cockspur Street, ran W towards the
bottom of Haymarket. N of the crossing was the church of
St Martin-in-the-Fields, standing some way up the narrow St
Martin's Lane, surrounded by mean houses. The area of the
square proper was filled by the ROYAL MEWS, first mentioned
in 1273 as a place of confinement for the royal hawks in moult
('mew'). In the C15 it doubled as a pleasure garden. Rebuilt as
stables under Elizabeth I, it latterly had an inner and an outer
courtyard, divided by *William Kent*'s Crown Stables of 1732.

The moving spirit of the new square was *John Nash*. He sug-
gested a 'square or crescent' at Charing Cross as early as 1812,
and such a square was provided for in the Act for Regent Street
of 1813. The decision after 1820 to transfer the mews to Buck-
ingham Palace at last unlocked the site, but the plan took a while
to fix. From the start Nash wanted a short straight street (Pall
Mall East) to run E from Regent Street, to align at the E with St
Martin's portico. In 1822 the site of what is now Canada House
was leased, S of this alignment on the W side, still without
an exact idea of what its setting might be. In 1825 the New
Streets Commission recommended an enlarged square, includ-
ing replanning of the area SE of St Martin (*see* Adelaide Street
and Strand), for which a scheme by *Nash* was published in 1826.
This showed a National Gallery on the N side, with Parthenon-
like premises for the Royal Academy in the middle of the square.
Only the gallery was built (q.v.), voted in 1832, to designs by
William Wilkins. As the main accent of the composition it has

insufficient power in bulk and height. The land itself lies on a slope, a disadvantage put right as late as 1840–5 by *Sir Charles Barry*, drawing on suggestions of 1837 by *Wilkins*. Barry designed the terrace on the N side with steps down at each end to the square proper, and low walls running down the side slopes. So the design of Nelson's Column predates its setting, and the design of the buildings predated both. The National Gallery of course remains, and Canada House on the W side, but its counterpart on the E went in the 1930s to build South Africa House. The S side has changed even more. At first there was just one exit, into the neck of Whitehall. In 1876 Northumberland Avenue was made to its SE, balanced after 1901 by the widened entrance to The Mall through Admiralty Arch, SW. At the NE corner, from which Nash projected a grand straight road towards the British Museum, a new connection was made in the 1880s in the more meagre shape of Charing Cross Road (*see* p. 401).

Trafalgar Square is changing considerably in 2003, under plans commissioned in 1996 from *Foster & Partners* and approved in 2000 (*see* also Parliament Square). These will close the N side to traffic, and cut a grand staircase through the N terrace on axis with the National Gallery portico.

Monuments

In the square stands first of all the STATUE of Charles I, facing 32 down Whitehall. It is of 1629–33 by *Hubert Le Sueur*, the first equestrian bronze in England. Like most of his work, it is stilted by comparison with the best Continental productions, of which the equestrian statues to the Medici Grand Dukes in Florence and to Henri IV on the Pont Neuf in Paris were then quite recent. Unlike these monuments of state, Le Sueur's was most remarkably a private commission, for Lord Weston, later 1st Earl of Portland. Buried for safekeeping during the Commonwealth, it was set up here only in 1675, on the exact site of the C13 Charing Cross (dem. 1647; for its C19 avatar *see* Charing Cross Station). His sword is of *c.* 1948, replacing one lost in 1810. The tall pedestal with its badly weathered trophies was carved by *Joshua Marshall* in 1675, perhaps to designs by *Robert Streater*.

The background is NELSON'S COLUMN of 1839–43, which makes Charles I seem small and delicate. Its total height is 170 ft (52 metres), plus the 17-ft (5.2-metre) high statue of Nelson. The column was designed by *William Railton*, and the statue – made in two pieces of Craigleith stone – is by *E.H. Baily*. Railton, whose other buildings were mostly churches and parsonages, was the surprising victor of a competition of 1838–9; Baily's design was runner-up. As first proposed the column was over 200 ft (61 metres) tall, and even the reduced version needed a brick pyramid on a concrete raft for foundations. The stone is Devon granite from Foggin Tor. Rich Corinthian capital of bronze, modelled by *C.H. Smith & Co.* after the Temple of Mars Ultor in Rome. The lower sculpture was commissioned officially after voluntary subscriptions ran out, but Government retrenchment substituted the tall plain

base for the steps Railton intended. The reliefs against the base, of 1849–54, are remarkably convincing, dignified as well as dramatic. Especially good are *J. Ternouth*'s, E (Battle of Copenhagen), and *W. F. Woodington*'s, N (Battle of the Nile). The others are by *M. L. Watson*, finished by *W. F. Woodington*, W (Battle of Cape St Vincent), and *J. E. Carew*, S (Death of Nelson). The lions on the outer diagonals, of 1858–67, are *Sir Edwin Landseer*'s designs. They are 20 ft (6.1 metres) long and 11 ft (3.4 metres) high and were cast by *Marochetti*. An earlier set, by *Thomas Milnes*, was rejected (now at Saltaire, Yorks.).

Other MONUMENTS in the square are as follows. In line with the column two generals from the wars in India: Havelock, E (*W. Behnes*, 1858–61), and Napier, W (*G. G. Adams*, 1855). Flanking the N terrace on the pedestal to the E the equestrian statue of George IV by *Chantrey*, commissioned in 1829 for Marble Arch in its first position in front of Buckingham Palace, cast in 1836, and set up here in 1843 (finished by *T. Earle*). All sorts of proposals have been made for the W pedestal, vacant since the 1840s; from 1999 it has been used for temporary displays of commissioned sculptures. The FOUNTAINS N of Nelson have quatrefoil granite basins by *Barry*, intended both for ornament and to hinder too large a crowd from gathering. Their centrepieces are by *Lutyens*, 1939. The refreshingly unpompous bronzes in the Swedish Milles taste, by *Sir Charles Wheeler* (mermen) and *W. McMillan* (mermaids), were fixed after the war. They commemorate two admirals, whose BUSTS can be seen against the E part of the N terrace: Jellicoe by *Wheeler*, Beatty by *McMillan*, both 1948. The third, of Admiral Cunningham, is by *Franta Belsky*, 1967. The main surface, originally macadamized, was stone-paved as late as 1925–6 (renewed 1987). On the ends of the side walls four polyhedral bronze LANTERNS (*Bude Light Co.* makers). Of later lamps two very good ones with griffins and putti stand near the Charles I monument, dated 1878.

Buildings

The buildings are a disparate group. CANADA HOUSE, on the W side, was erected by *Sir Robert Smirke* in 1824–7 for two bodies, the Union Club, S, and Royal College of Physicians, N. It is unified by a Grecian Ionic order, with a free-standing six-column portico to the N and another *in antis* to the square. The division between the parts, just N of this portico, showed up originally by the change from Bath stone to stucco on the club end. Stone replaced stucco here in 1924–5, when *Septimus Warwick* remodelled the club for the Canadian High Commission. His is the four-column S portico, replacing Smirke's shallow bow, and also the big Portland stone offices towering up behind (*see* Cockspur Street). In Smirke's time the entrance was from the square, into the tripartite third bay. The central section was twice heightened for the club, interfering lamentably with Smirke's proportions: first in 1841–50 by *Decimus Burton*, again in 1903 by *J. Macvicar Anderson*. Warwick

extended this superstructure by one bay to the S. The Physicians' part was annexed for Canada and remodelled in 1965–7.

Of INTERIORS the best belong to the club part, modified by *Warwick* in 1924–5, and in 1997–8 considerably restored by *Cecil Denny Highton/HOK*. The S entrance hall was re-created to Warwick's design, with scagliola columns. Ahead, l., Smirke's big open-well STAIRCASE climbs to full height, toplit from an oblong lantern in a rectilinear coffered ceiling. Paired open cast-iron balusters. The room facing it was the entrance lobby in club days. Behind the E portico is the GREEN ROOM, three bays wide with a compartmented ceiling, reduced from four bays by Warwick. The GOLD ROOM beyond, chief survivor from the College of Physicians, has overlapping antae and a beamed ceiling, in what Pugin called Smirke's 'new square style'. To its W an art gallery was made in 1997–8, where the Physicians' grand staircase lay. The HIGH COMMISSIONER'S ROOM is above the Green Room, i.e. in the club part. It is a very early instance of the Dixhuitième revival, with a coved and gilded ceiling with foliage knots and arabesques.

Carrying on anticlockwise, the S side begins with the former Union Bank of London (No. 66), 1870–2 by *F.W. Porter*, with superimposed pink granite columns and French pavilion roof ('exceedingly expensive and commonplace', said *The Architect*). Nos. 62–65, tall and with a clock tower, housed the Canadian Pacific Railway: an outlier of the big stone travel offices in Cockspur Street to the W. 1902–4 by *G.R. Julian*. Nos. 57–59, curving round to the approach to Admiralty Arch, is an insurance office of 1914–15 by *Sir Reginald Blomfield*. Its form and details take after DRUMMOND'S BANK on the facing corner, undistinguished Italianate by *P.C. Hardwick*, 1879–81. Drummond's roomy interiors have Adamesque column-screens and friezes, reflecting the bank's C18 origins. (In the board room a fireplace from *Robert Adam*'s alterations, 1777–8, to the previous premises.) Trapezoidal canopy on the r. flank, 1961, formerly for drive-in banking.

ADMIRALTY ARCH goes functionally with the Government buildings of Whitehall (*see* p. 253), but as a design belongs with Trafalgar Square and The Mall. It was designed in 1905–7 by *Sir Aston Webb* and built in 1908–11, as part of the national monument to Queen Victoria. Its counterparts are the sculptural group in front of Buckingham Palace, and the refacing of the palace itself (*see* pp. 645 and 655–6). Three archways of equal height, office wings of several storeys curving forward and with normal fenestration, and a square attic with inscription on top. The tapering plan cunningly hides the unavoidable change of axis. Webb's eclecticism comes out most in details, e.g. the capitals with their little masks (carver *W.S. Frith*). In the N wing a house for the First Sea Lord was provided (oval toplit staircase with columned landings). Pomp was further tempered with utility by the concealment of three office storeys within the top block. The great GATES were the largest in the country when new. Facing The Mall, stone figures of Navigation and Gunnery by *Sir Thomas Brock*, 1911. In 2001–2 Admiralty Arch

was converted for the Cabinet Office by *Gilmore Hankey Kirke* and *HOK*, along with the C18 Admiralty and Kirkland House in Whitehall (*see* pp. 251 and 237).

After Whitehall come the two curved blocks at the top of Northumberland Avenue (q.v.), the smaller genuine Late Victorian, the larger a 1980s simulacrum.

Finally on the E SIDE *Sir Herbert Baker*'s SOUTH AFRICA HOUSE of 1930–3. Baker linked his building to the grand and simple portico of St Martin by porticoes to the W and at the rounded SW corner, which lie more or less level with Gibbs's. The rusticated ground floor takes care of the slope by developing from one to one and a half storeys. The chief weakness is the way the upper portico sets back above the entrance; Baker wanted a tall tiled mansard here, but a stone-faced attic was forced on him. Numerous small Baker motifs, in window shapes and ornament. Of the sculpture, *Coert Steynberg* did the stone figure of Dias in the niche, r. (1934), *Sir C. Wheeler* the gilt winged springbok on the S corner, *Laurence Turner* the timber overdoor, *Joseph Armitage* the other carving. Less confident elevations behind, on the rest of the triangular site, where Messrs *Joseph* designed commercial offices behind Baker's fronts.

INTERIORS. Baker, the dominant architect in South Africa in the 1890s–1900s, was entirely at ease with Cape Dutch traditions. His nostalgia comes out best in the version of a Cape VOORHUIS or parlour, with its blue-and-white tiles and beamed ceiling and panelling of stinkwood. It lies S of the ENTRANCE, which has steps up between colonnades to a modest double-domed HALL and main staircase, crossed by the main N–S axial corridor. Here are a tapestry map by *Macdonald Gill*, and a bronze head of Baker by *Wheeler*, 1933. The Cape Dutch fanlights were carved by *L. Turner*. Plenty of decorative motifs from South African flora and fauna; also paintings mostly by South African artists (1933–8): *Gwelo Goodman*, in the ANTE-ROOM to the S, *J.H. Amschewitz*, on the first floor, and *Jan Juta* and *J.H. Pierneef*, in the double-height EXHIBITION BASEMENT. At the S end is the READING ROOM, with an alabaster overmantel carved by *Wheeler*. Its ceiling, of different heights, originally allowed a view through a gallery into the LIBRARY above (with a plaster ceiling depicting South African plants). Previously on the site were the Golden Cross Inn of 1832, behind (by *Sir W. Tite*), and towards the square a block with a giant order by *G. Ledwell Taylor*, 1830, later Morley's Hotel.

VICTORIA EMBANKMENT
South of the Strand

Made in 1864–70 by *Sir Joseph Bazalgette*. The idea of an embankment was far from new. *Wren*'s proposed quay for the City after the Great Fire was never completed, but in the C18 the Adelphi and Somerset House pointed the way. In the early C19 interest quickened, partly to relieve congestion on the Strand, partly because narrowing the river would augment the cleansing

effect of the tide. Only a few isolated sections were built, however, e.g. at the Millbank Penitentiary from 1812, and at the Palace of Westminster after 1839 (*see* pp. 709, 216). *James Walker*, engineer to the latter embankment, defined a feasible course for its extension in 1840, and in 1844 a Royal Commission recommended an embankment all the way from Blackfriars to Chelsea; but no empowered authority existed to do this. Meanwhile it was clear that the sewage problem could only be solved by new intercepting pipes discharging downstream. The Metropolitan Board of Works, founded in 1855, was charged with sorting things out, a task more urgent after the 'Great Stink' in the hot summer of 1858. In 1860 the project was endorsed, and an Act passed in 1862.

Bazalgette's scheme was presented the following year. It was for a brick structure on concrete foundations, with a battered river wall of granite. Below the roadway were a huge sewer, secured with the relatively new material of Portland cement, and gas and water pipes. (Two more E–W sewers ran N of our area, another two on the S bank.) Work proceeded in sections of one to two hundred feet, which were enclosed with concrete-filled iron caissons, drained and infilled. According to *The Builder* in 1906, the architectural detailing of river wall and steps was by *C.H. Driver*. A large part had to be dug up again when it was decided to include a tunnel for the Metropolitan District Railway. The whole cost £1,156,981, raised by dues on coal and wine. Apart from the new tree-lined roadway, much of the 37¼ acres (15 hectares) won from the river was given over to public gardens. The S part, behind Whitehall, is described on pp. 277–9, the NE part in *London 1: The City*. They have in common the rich LAMP STANDARDS with dolphins twined round the foot, modelled by *C.H. Mabey*, the great bronze lion-mask MOORING RINGS, and the BENCHES with cast-iron sphinxes or camels, reproductions of 1870s designs made in 1977. Statues were set up in the gardens from early on, joined in the early C20 by memorials along the river wall, their subjects more pacific than in the Whitehall section.

The description starts just N of Hungerford Bridge (q.v. Public Buildings). On the land side of the road is EMBANKMENT UNDERGROUND STATION, 1914 by *H.W. Ford*, single-storeyed with Doric columns. Utilitarian addition to the r., 1957. On the platforms excellent MURALS by *Robyn Denny*, completed 1988: ribbons of colour against white, arranged to echo the curve of the river. Close by the station a little free classical building of 1900–1 by the *LCC*, built as a generating station for street lighting. Against the river wall here the W.S. GILBERT MEMORIAL by *Sir George Frampton*, 1915, with figures of Tragedy and Comedy.

Further on CLEOPATRA'S NEEDLE, made of pink granite or Syenite for Thothmes III, *c.* 1468 B.C. It was one of two originally erected at Heliopolis, but moved to Alexandria by Augustus in 10 B.C. to stand in front of the palace there. Hieroglyphs were added by Ramses II, *c.* 1300 B.C., and *c.* 1000 B.C. by Siamun. Presented to the nation by the Egyptian

Viceroy in 1819, it came to London only in 1877, after a float-
ing iron cylinder was made to transport it. Its twin, given to
the United States in 1869, is now in Central Park, New York.
The huge bronze sphinxes at the base were set up in 1882.
They were modelled by *Mabey* after *George Vulliamy*'s designs,
based on a small antique figure owned by the Duke of
Northumberland. Steps down to the river beyond, of 1864–70.
The view from here is particularly good, across the river to the
Festival Hall and London Eye, and along it to the City and St
Bride, St Martin Ludgate and St Paul's.

Facing the obelisk across the road, the BELGIAN WAR
MEMORIAL of 1917–20, designed by *Sir Reginald Blomfield*,
with a concave wall and a bronze group by *Victor Rousseau* of
people rushing to one side and carrying garlands.

Now into the EMBANKMENT GARDENS, which in this central
section were laid out by *Alexander McKenzie*, assisted by *Joseph
Meston*. The outlines of their markedly informal plan remain
around the edges. Of the structures the most substantial is the
YORK WATER GATE at the S end, erected in 1626–7. It origi-
nally gave access to the gardens of York House, the 1st Duke
of Buckingham's mansion (dem. 1676 for Buckingham Street).
The gate was erected by *Nicholas Stone*, it is not sure if to his
design; his grand-nephew said so, but Summerson suggested
the cosmopolitan *Sir Balthazar Gerbier*, surveyor to the 1st
Duke, who was working on York House at that time. There are
certainly parallels in Gerbier's work elsewhere. On the other
hand, *Inigo Jones* cannot be ruled out, while a contemporary
drawing at the Soane Museum is in the hand of neither archi-

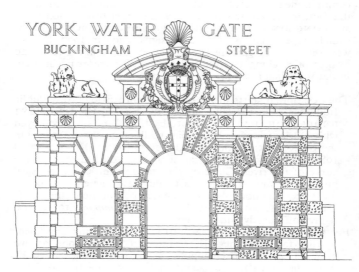

York Water Gate, Victoria Embankment Gardens. Elevation
(*The Survey of London*)

tect. The gate is tripartite and has round openings. To the s it has Tuscan demi-columns with bands of pitted rustication, a big open segmental pediment over the raised centre, and eroded lions couchant on the sides. Villiers arms in the pediment. The ends also have half-columns, but the N side is simpler, with rather fat pilasters and spiked ball-finials. Inside, the central steps are marked off by little two-bay arcades with timber balustrades. The gate should of course be visualized standing immediately by the river. The present sunk surround and plinth date from 1988–9 (earlier restorations 1823, 1893). The York House property had until 1539 been the Bishops' of Norwich. Bought back in 1557 by the Archbishops of York, it was however occupied generally by the Keepers of the Great Seal instead. To the l., by Villiers Street, a BANDSTAND by the *Terry Farrell Partnership*, 1988–90, pantiled like an Italian rural building. The FOUNTAIN stuck in its back wall has an open timber frame recalling the spire of St Martin-in-the-Fields.

Of BUILDINGS OVERLOOKING THE GARDENS the first belong with Villiers Street or Buckingham Street (qq.v.). The very large ones begin with the grim New Adelphi of 1936–8 (*see* 4 Adelphi). The former SHELL-MEX HOUSE at No. 80 Strand, by Messrs *Joseph*, 1931–3 (principal designer *F. Milton Cashmore*), is less showy and more startling in its big heavy elevations. Thirteen storeys, with set-back profiles that owe a lot to Lutyens's 1920s designs, but finished with a big square erection with a clock (nicknamed 'Big Benzene') that is even larger than that of Big Ben. It is thoroughly unsubtle, but succeeds in holding its own on London's river front. The steel frame made a 25 ft (7.6 metre) grid around two courtyards, allowing modular offices of 12 ft by 24 ft (3.7 by 7.3 metres). Impressive stone-lined circulation spaces. Adapted for PEARSON by *Marshall Cummings Marsh* and *IA*, 2000–1, with a glazed scoop-like entrance on the Strand side.

Now for the MONUMENTS. Going N, the first encountered is the STATUE of Robert Burns by *Sir John Steell*, 1882–4, a version of that in New York. In front the IMPERIAL CAMEL CORPS MONUMENT, by *Cecil Brown*, 1920, a little square plinth with a camel and rider in bronze. Then the STATUE of Sir Wilfrid Lawson by *David McGill*, 1909, from which allegorical figures round the base were stolen in 1979. It faces a SCREEN WALL with outcurved seats and pond: a memorial by *Lutyens* to the 1st Lord Cheylesmore, 1926–30. On the same side the HENRY FAWCETT MEMORIAL, an aedicule designed by *Basil Champneys*, 1886. Ornamental details by *Frampton*; sculpted relief by *Mary Grant*, apparently a replacement, since dated 1896. Next the STATUE of Robert Raikes by *Thomas Brock*, 1880, in C18 dress, and the D'OYLY CARTE MEMORIAL, 1989, a little garden with an astrolabe in front of his own Savoy Hotel (*see* Strand, pp. 367–9). The ARTHUR SULLIVAN MEMORIAL is by *Sir W. Goscombe John*, 1903. The nude, modelled in Paris in 1890–9, was an afterthought. She leans disconsolately against the pedestal in the Père Lachaise manner.

Beyond the gardens the low INSTITUTION OF ELECTRICAL ENGINEERS, built in 1886–90 as a joint examination hall for

the Royal Colleges of Physicians and Surgeons. By *Stephen Salter*, latterly joined by *Percy Adams*. Red brick and stone. *Adams, Holden & Pearson* neutered it in 1958–61, stripping off much ornament, squaring off the top storey, and adding the shallow entrance range. In front, a bronze STATUE of Faraday, 1988, after *Foley*'s marble original at the Royal Institution (*see* p. 497). The N part is Savoy Hill House (1880), annexed only in 1984 and thus with C19 ornament intact. Some interesting INTERIORS by *Adams & Holden*, 1908–10, when the Institution moved in. The Pentelic-marble-lined entrance hall shows an advanced stripped classical taste. Main lecture hall behind, with mahogany panelling carved by *W.S. Frith*.

Near here on the river wall, *Frampton*'s MONUMENT to Sir Walter Besant, 1904, a version of that at St Paul's. Then the tense, elegant, shallow curve of the first arch of Waterloo Bridge, and after that the great substructure of Somerset House, and King's College (qq.v., Public Buildings). Here the road divides. At the junction a STATUE of Brunel by *Marochetti*, commissioned 1861 for Parliament Square and installed here with a proto-Baroque stone surround by *Norman Shaw*, 1872–4. Further on is TEMPLE UNDERGROUND STATION, 1914–15 by *H.W. Ford*, a low structure built over the tracks. On its landward side Nos. 13–15 Arundel Street, 1884: one of the few buildings by *John Dunn* on the Norfolk Estate not levelled for the 1970s Arundel Great Court to the l. Red brick, collegiate in flavour; reconstructed and heightened 1998–2000. After that the big Portland stone GLOBE HOUSE (BRITISH AMERICAN TOBACCO), 1996–8 by the *GMW Partnership*, a cousin to the rebuilt Adelphi or Shell-Mex House. The skyline feature is a big glazed volume under a shallow curved imitation-copper roof. On columns by the entrance two sinewy bronze figures by *Sir Charles Wheeler*, 1933, from *Sir H. Baker*'s Electra House, previously on the site; before that *Bodley & Garner*'s School Board Offices, a Queen Anne landmark of 1872–6, were here.

The gardens continue beyond, with STATUES of W.E. Forster by *Henry Pinker*, 1889–90, and a seated John Stuart Mill, the 'body stunted by brains' (Fitzjames Stephen) captured by *Thomas Woolner*, 1875–8. The Lady Somerset Memorial is by *G.E. Wade*, 1897, the little girl holding out a bowl of water a replacement of 1991 for that stolen in 1971.

Outside the gates the former ASTOR ESTATE OFFICE (with the 1st Viscount Astor's flat above; now used by the Bulldog Trust, a charity). By *J.L. Pearson*, 1893–5, his last domestic work and a perfect gem of its kind. His son *Frank L. Pearson* designed much of the interior, working with *J.D. Crace*. Two storeys only. Symmetrical front of Portland stone in an early Elizabethan style, treated with great finesse, and nowhere with slavishly copied elements. The cornice is Doric, but the mullioned and transomed windows have flattened four-centred lights. Round-ended staircase bay at the rear, NE. W side reconstructed after war damage, 1949–51. Excellent wrought-iron RAILINGS and still better GATES, by *Starkie Gardner*. At the entrance bronze LAMP STANDARDS by *W.S. Frith*, with naked infants playing with a telephone and electric lights.

The INTERIORS are just as lavishly equipped. The GREAT HALL, the principal first-floor room, faces the Thames. It is treated as an Elizabethan great hall, except for the lack of a dais and the use of mahogany for the hammerbeam roof. Three windows and two outer bay windows; also a bay window each to E and w, both with stained-glass scenes of Swiss landscapes by *Clayton & Bell*. Much sculpture, including a gilded frieze of famous heads by *Nathaniel Hitch*, and on the middle door nine silver-gilt panels by *Frampton* of seated female figures, e.g. Genevieve, Enid, Elaine. The LIBRARY, facing E, has sculpture by *Frith*. (STAIRCASE HALL in the middle with a gallery of ebony columns around the upper floor. Newel figures and frieze carved by *Thomas Nicholl*, after Dumas and Shakespeare.)

Back on the river wall, another bas-relief by *Frampton*, to W.T. Stead, 1913–20. And so to the big square-headed ARCH at Temple Stairs (1868), impressive in its simplicity. Within the arch a little block designed by *Sir Edwin Cooper* records the naming of this section 'King's Reach' in 1934. On it bronzes of boys riding ships or dolphins, by *C.L.J. Doman*.

VILLIERS STREET

Built after 1675 on part of the Duke of Buckingham's former property (cf. Buckingham Street). On the w side was the York Buildings Waterworks, which in 1712 pioneered the use of steam power. Transformed when Charing Cross Station was built on the w side in 1863–5 (q.v.), and again after 1986, when the station was reconstructed and the street pedestrianized. The E SIDE is mostly modest later C19 commercial. Nos. 33–37 was built as a coffee saloon by *A.J. Bolton*, 1869, for the ice-cream magnate Carlo Gatti. Pilastered, of sandstone; one storey with colonnettes. To its r., white-painted and easily over-looked, the former warehouse of Messrs Minier, seed merchants: built in 1792 by *Peter Bogue*, with No. 14 Buckingham Street, behind. After the river was embanked it was heightened and converted to offices (1880–1). Further down, against the flank of the station, CARRARA HOUSE, of 1958–60 by *J. Seymour Harris & Partners* for themselves (refurbished 2000). A clean curve of curtain walling with a display of white marble.

WELLINGTON STREET

Created in 1833–5 as part of a new artery N from Waterloo Bridge. As projected in 1830 it was to have reached N to Bloomsbury, but economies were made in length, width and straightness. The route continues along a widened Bow Street (q.v.), via an awkward dog-leg crossing of Long Acre, to the new Endell Street of 1843 (*see London 4: North*).

The LYCEUM THEATRE stands on the w side just N of the Strand. Originally of 1834 by *Samuel Beazley*, replacing his

theatre of 1816 that burnt in 1830.* The façade and grand Corinthian portico of 1834 remain, with coupled outer columns, powerfully placed on rising ground. The attic storey and the inside are of 1904 by *Bertie Crewe*, whose front echoes the angle pilasters of Beazley's design. In 1996 *G.A.R. Holohan & Associates* restored the theatre, after a long stint as a dance hall. Symmetrical new brick elevations were made to Exeter Street, N, and Burleigh Street, E, the latter pilastered, with summary mouldings and a big new flytower. Crewe's theatre was built for music hall, with an extravagantly large and ornate Louis XV auditorium. A grand staircase links the foyer with an upper hall. In the auditorium an undulating lower gallery, and ornate box-fronts in two tiers between Corinthian columns. Coving and dome freighted with painted allegories.

At the SW corner with Exeter Street is No. 21, of 1860 by *R.J. Withers*, once offices and galleries for the auctioneers Sotheby's & Wilkinson. Polychrome brick, with close-set round-arched windows and a bracket-cornice. Diagonally opposite is the former Victoria Sporting Club (now a restaurant), built in 1863–4 for London's bookies by *C.O. Parnell*. Rounded corner in a very lush Victorian Baroque. The entrance hall, with a ribbed dome, flows into a round-ended stairhall with cast-iron balustrade. First-floor room with enriched compartmented ceiling. Survivors of 1833–5 the pub on the NW corner with Exeter Street, and on the E side Nos. 20–26, probably also *Beazley*'s, brick with a pretty continuous balustrade. Also on the W side hulking offices for G. Monro & Co., fruit brokers, 1936 by *Epps & Ponder*: an extension to earlier, more ornate premises in Tavistock Street (1912 by *Lewen Sharp*).

To the N of Tavistock Street on the E side, Nos. 28, 30 and 42, typical mid-C18 houses, show where an older street was absorbed. Facing them a good sturdy warehouse of 1872–3, by *Vincent Grove* for Findlater & Co., wine merchants, on the NW corner with Tavistock Street. Then two parts of the former Flower Market (*see* Covent Garden).

WEST STREET

On the boundary between Camden and Westminster. It dates from 1684 and *Nicholas Barbon*'s development of the Newport House site (cf. Newport Court, Soho, p. 421). On the N side the former WEST STREET EPISCOPAL CHAPEL, founded 1700 and first used by Huguenots, but rebuilt or remodelled, probably in 1840. Plain, symmetrical front of yellow brick. Two straight-headed doorways, four round-headed windows. Completely altered inside. To the l. stark Gothic offices by *C.W. Reeves*, 1905, built when the chapel served as a mission house for St Giles's parish. Next to it CAMBRIDGE COURT, completed 1984, infill housing from the last days of the *GLC* (by

*Succeeding in turn a theatre converted in 1794 from the Incorporated Society of Artists' exhibition hall, of 1771 by *James Paine*.

David Fordham and *David Junkison*). Seventeen flats around a first-floor internal courtyard.

E of the chapel two theatres by *W.G.R. Sprague*, planned as a non-matching pair. The little AMBASSADORS', 1913, has a pilastered front and a charming, compact interior ornamented with ambassadors' crests. The ST MARTIN'S, 1914–16, has by contrast fat engaged columns. Plain two-tier auditorium, with giant Neo-Georgian colonnades of walnut: the arrival of Quiet Good Taste in Theatreland. In the foyer a MEMORIAL by *Eric Gill* to Meggie Albanesi, 1924. On the S side at Nos. 1–5 THE IVY restaurant, undistinguished early C20, but with a well-crafted interior by *M.J. Long* (*Long & Kentish*), 1990. Thickly moulded ceilings; much specially commissioned art: entrance screens by *Eduardo Paolozzi* and *Tom Phillips*, respectively jazzy and elegantly frail; stained glass designed by *Patrick Caulfield*.

SOHO

INTRODUCTION

Really fine buildings are not common in Soho, and yet its layered history and teeming life make its labyrinthine streets specially intriguing. They fill an irregular quadrilateral bounded by Oxford Street on the N, Charing Cross Road on the E, Regent Street on the W, and Pall Mall and Trafalgar Square on the S. Of these Oxford Street is ancient as both route and boundary, whereas Regent Street merely underscored an established gulf in wealth and fashion between Soho and Mayfair. At Charing Cross Road, cut through after 1882 mostly along the periphery of the parishes of St Giles and St Martin-in-the-Fields, no such frontier can be felt, while at the S end Soho blends into the entertainment-cum-general-purpose area around Leicester Square and Haymarket.

The DEVELOPMENT of Soho dates largely from the later C17 building boom. Before the Reformation most of the land belonged to Abingdon Abbey and (through the old St Giles's Hospital) to the Lazar House at Burton Lazars, Leics. Henry VIII took these and other lands in 1536 for a park for Whitehall Palace – the very name Soho comes from a hunting cry – but Elizabeth I began granting away parts for farming in 1560. The openness of the area before 1660 is shown by Faithorne and Newcourt's map, surveyed in 1643–7: a few houses straggle up the lane that became Great Windmill Street and creep in from St Martin's Lane to the E, between which stand two recent mansions, Leicester House and Newport House. By the time of Blome's parish maps of *c.* 1689–90, streets and houses fill the whole of the new St Anne's parish E of Wardour Street and Whitcomb Street, and to the W Golden Square and Berwick Street are in place on land assigned to St James's, another new parish. Filling in the NW part took longer: Great Marlborough Street dates from 1704, Argyll Street from as late as 1735. All this work entailed a huge number of grants, leases and sub-leases; the major dates and developers are identified in the street entries.

The new faubourg was varied in character. Its STREET PLAN reflected the prevailing N–S alignment of the old fields, several of which were separately developed (e.g. Poland Street), so that it is much easier to cross Soho this way than from E to W. The

MAYFAIR
(see Section 6)

SOHO

CHURCHES

1. St Anne
2. Notre Dame de France (R.C.)
3. Our Lady of the Assumption (R.C.)
4. St Patrick (R.C.)
5. French Protestant Church
6. Welsh Presbyterian Church (former)
7. Orange Street Chapel

PUBLIC BUILDINGS

A. St Martin's School of Art
B. St Peter's School
C. Swimming Baths
D. Westminster Reference Library

builders and developers included Col. Thomas Panton (around Great Windmill Street and E of Haymarket), *James Axtell* and *Isaac Symball* (Golden Square), the bricklayer *Richard Frith* (Soho Square, at the NE, and streets to the S), and *Dr Barbon* (Gerrard Street and the Newport Court area). Confronted with such determination to build, the Crown vacillated at first between opposition and the desire to control, the latter issuing in the supervision by *Wren* of the layout of Golden Square and Panton Street. A good few houses of this first phase remain, mostly altered and of middling size. On the whole Soho saw less coherent planning than aristocratic St James's and Mayfair, and somewhat less also of private gardens and mews. Even Leicester Square was an irregularly planned afterthought, forty years later than the grand house on its N side, while the Duke of Monmouth's great house in Soho Square was undertaken for him by the developers rather than by one of the architects then in favour at court. New markets were provided off Carnaby Street and near Newport Court, though neither was planned jointly with a square or larger estate in the way of that for St James's Square (*see* Haymarket).

None of the economies mattered when a Soho address still had a fashionable lustre, but this faded in the C18, as Mayfair expanded to the W and Marylebone to the NW. The wave of rebuilding after 1730, when C17 leases expired, gives a mixed picture. Many NEW HOUSES were as grand or grander than their
41, predecessors, but their artisans' Baroque style generally ignored
p. the rising Palladian fashions (Dean Street, Meard Street). It is
28, striking how conservative externally is Soho's finest Georgian
p. house, the present House of St Barnabas in Soho Square
429 (1744–6). In Noel Street (off Berwick Street) and D'Arblay Street, both made on freehold land that reverted to the Duchy of Portland in 1735, the houses are very modest, befitting an area that was increasingly middling in character.

The mixed social and cultural history of Soho shows in its
p. SACRED BUILDINGS. In the 1680s many Huguenots came here.
427 Their present church in Soho Square moved from the City only in the C19, but it had several precursor chapels. One of these took over a short-lived Greek church founded in 1677 (commemorated by Greek Street): evidence that the area was then already favoured by foreigners. This chapel became in turn the Anglican church of St Mary in 1850, one of several Victorian churches demolished in the mid C20 after the population dwindled. St Thomas Kingly Street, remodelled from a chapel of ease of 1702, followed in 1973. St Anne, founded in 1677 and much recon-
70 structed, is therefore the sole Anglican presence in Soho, the 1860s chapel at the House of St Barnabas excepted. Of Roman Catholic churches there are three, however: a French one (Notre
113 Dame), established just N of Leicester Square in 1865, St Patrick, founded in 1791 in Soho Square to minister to the Irish, and Our Lady in Warwick Street, which began in the C18 as the Portuguese embassy chapel. Home-grown Nonconformity is represented by the Orange Street Chapel and the former Welsh Presbyterian Church in Charing Cross Road, besides the early C19 hulk of the Craven Chapel in Marshall Street. The first

synagogue arrived as late as the early C20, but its ambitious post-war premises in Dean Street have already closed. Not all incomers were religious: Karl Marx lived in Frith Street, and lectured at a pub in Great Windmill Street.

As its social standing subsided, many TRADES AND MANUFACTURES found a home in Soho. There is now nothing to show for some, such as the C18 tapestry industry, but substantial premises survive for printing and for film (Wardour Street), for preserved foods (Soho Square and Charing Cross Road), motor vehicles (Brewer Street and Poland Street) and textiles (Golden Square). The retail trades have left plenty of older SHOPFRONTS, p. including London's oldest (Haymarket), and its best Gothick and 407 Rococo survivors (Frith Street, Dean Street). HOSPITALS also favoured Soho from the mid C19 to the early C20, though all have now closed; Dean Street alone had three. General-purpose C20 OFFICES are less interesting, though the area has some memorable taller examples: *Raymond Hood*'s Ideal House in Great Marlborough Street, 1920s, the 1960s New Zealand House, p. Haymarket, by *Robert Matthew, Johnson-Marshall & Partners*, 416 and *Quinlan Terry*'s 1980s (and Neo-Georgian) Dufour's Place, 119 Broadwick Street. Also worth seeking out is the *Richard Rogers Partnership*'s vigorous new medium-rise block of 1998–2000, likewise in Broadwick Street. PUBLIC BUILDINGS are modest and of no special note.

More conspicuous than any of these are BUILDINGS FOR ENTERTAINMENT. Of PUBS Soho has few big examples but a crowd of smaller ones, two with excellent Late Victorian interiors (Argyll Street, Frith Street). More particular to Soho are RESTAURANTS, several of which, established within foreign communities, began to attract English custom from the mid C19. They divide into three categories. The small and select always tend to adapt older buildings. The enormous eating houses of the late C19 and early–mid C20 are represented by the group in Coventry Street, Rupert Street and Shaftesbury Avenue, mostly now reduced to retained façades. A more recent trend is for spectacular internal conversions, often on multiple levels; a few of the best are mentioned here (Wardour Street, Lexington Street). THEATRES included two rebuildings by *Nash* of C18 venues in Haymarket, done in connection with the Regent Street scheme; of these the Theatre Royal remains, while the Royal Opera Arcade survives from the other. Smaller Late Victorian and early 96, C20 venues went up in force in the new Shaftesbury Avenue p. and Charing Cross Road. CINEMAS begin with the Rialto in 71 Coventry Street (1912–13, disused), and cluster thickly around Leicester Square to the E, where they mostly supplanted C19 theatres and variety houses. Some of these had been adapted in turn from EXHIBITION BUILDINGS, a category now almost forgotten; the most spectacular were a panorama on the site of the church of Notre Dame (1793) and a huge hollow globe built on Leicester Square's gardens (1851). The chief survival is the London Palladium theatre in Argyll Street, an Edwardian remod- 95 elling of a bazaar and exhibition rooms built in 1867–8.

HOUSING continued into the mid C19 on the traditional pattern, including the pretty little streets that replaced Carnaby

p. Market in 1820–5 (*see* Carnaby Street). Also in our area, but most
431 untypical of it, is Suffolk Street, rebuilt in the 1820s as part of
the Regent Street scheme. A turning point comes in the 1850s,
for Soho the peak decade for population, when the first attempts
were made to address the miseries of overcrowding. A small
block of model housing of *c.* 1850 remains in Ingestre Place off
Broadwick Street, and much more from the 1880s–1890s
(Charing Cross Road, Brewer Street, Rupert Street). Private
housing was swelled by mansion blocks along Charing Cross
Road and Shaftesbury Avenue. From the C20 the most con-
spicuous buildings are three tower blocks built for Westminster
City Council between 1959 and 1975 (Berwick Street, Broadwick
Street, Ingestre Place).

Over the same post-war period many good older houses were
levelled, mostly for medium-sized offices of no merit, and the fear
took hold that the character of Soho was under threat. Demoli-
tions for the last large-scale council housing, at Nos. 51–85
Charing Cross Road (1979–83), were therefore fiercely opposed
locally. The rise of CONSERVATION saw the formation of the
Soho Society, in 1972, and Conservation Areas covering most of
the district were designated not long after. Wholesale clearance
has since given way to gentle rehabilitation and like-for-like
replacement, policies influenced by the GLC's successes in
Covent Garden. Legal changes in the early 1980s allowed a cull
of the sex shops and clip-joints that had multiplied since the mid
1960s. The residential population has since risen steadily, at first
largely thanks to the Soho Housing Association, through which
the Soho Society and the City Council work in partnership.
Besides refurbishing much C19 model housing, it has commis-
sioned several compact new schemes (Brewer Street, Dean
Street, etc.). Ten years later even the least promising buildings
could be converted to private flats (Wardour Street).

Post-war immigration and mass tourism mean that Soho no
longer feels uniquely cosmopolitan, and of foreign communities
only the Chinese in and around Gerrard Street still endure in
strength. What remains of the old industries is shrinking fast,
superseded often by offices for media companies, many of them
in resourcefully converted older buildings (Beak Street, Greek
Street). At the same time the ordinary small shops are giving way
to bars and cafés. Yet most of Soho seems able to absorb such
changes without losing its demotic, unpredictable edge. For one
thing, the first developers left the street pattern too muddled ever
to be tidied up completely (Soho would feel very different had
it been built on a uniform grid). Also, the mass of humdrum
C19–C20 buildings – the same that stop almost any Soho street
photographing well – still shelter a vast range of trades and
activities; it is hard to see how somewhere as rackety as, say,
Berwick Street could ever be gentrified from top to bottom.
Meanwhile the street life and night life of Soho pullulate as never
before.

FURTHER READING. The *Survey of London* covers St Anne's
parish in vols. 33–4, 1966, and the relevant parts of St James's
parish in vols. 30, 1960, and 31–2, 1963, and St Martin's parish

in vol. 20, 1940. F. Sheppard, *Robert Baker of Piccadilly Hall and his Heirs* (London Topographical Society), 1982, has additional information on the earlier period. J.H. Cardwell et al., *Two Centuries of Soho: its institutions, firms and amusements*, 1898, is self-explanatory. Good general accounts include S. Dewes, *Soho*, 1952, J. Summers, *Soho*, 1989, and R. Tames, *Soho Past*, 1994, the last particularly well illustrated. D. Farson, *Soho in the Fifties*, 1987, puts the case that Soho isn't what it used to be.

CHURCHES

ST ANNE SOHO
Between Wardour Street and Greek Street

The landmark is the remarkable tower by *S.P. Cockerell* of 1801–3, 70 now incorporated in a mixed-use scheme of 1989–91 on the site of the bombed-out church of 1677–86. The tower is of yellow brick with stone areas in surprising places, and has the oddest of spires. The bell-stage is all stone with a strong batter and Tuscan columns squeezed into the angles of the openings. Above this four very small pediments and a circular triple-stepped plinth. The top, round and lead-covered, receives its bulbous form from the way in which, almost at the very apex, circular clock faces bulge out in all four directions. Below, all is flatter and more summary: a round relieving arch to the door, battered brick end piers joined by a shallow-arched stone band, then a grooved brick stage with a plain oculus. On the w face a plain TABLET of 1757 to Theodore, King of Corsica, with a philosophical epitaph by Horace Walpole. The CHURCHYARD became a garden in 1891–2.

The complex of 1989–91, attached behind, is by the *Westwood Partnership* (*Jan Piet* and *Julian Luckett*). It houses a small parochial chapel, a rectory, premises for the Soho Society, and twenty flats for the Soho Housing Association. The new parts are tactfully deployed in relation to Cockerell's tower. Seen from the w they spread out nave-wise, with one thin upright window on each side. Steps lead down to flanking courtyards. Facing Dean Street, E, are commercial offices with a plain sashed Neo-1800 front, with to the l. a rendered section in a late C17 style above the entrance lobby. In the entrance passages the DEDICATION STONE of the C17 church, FOUNDATION STONE from *Cockerell's* former Watch House to the s, 1801 (dem. *c.* 1910), and a new DEDICATION STONE by *Lida Lopes Cardozo*, 1991. The CHAPEL, subdivisible for flexibility, is characterless apart from the FITTINGS: abstract STAINED GLASS by *Julia St Clair Forde*, CRUCIFIX by *Thomas Duttenhoefer* of Darmstadt, and FONT and COMMUNION TABLE designed by *Julian Luckett*.

To the l. of the Dean Street front, a slice of the quoined end wall of the C17 CHURCH survives. *Wren* provided designs for it, and served on a commission appointed in 1685 to press on with

the work. That the building differed from his office's drawings was due probably to *William Talman*, whom the commission suggested to finish it. A steeple was added in 1718. The nave was remodelled 1830–1 by *Robert Abraham*, and bombed 1940–1.

It was a struggle to keep the church alive. *Jacques Groag* laid out the ruined nave in 1942, and in 1945 sketched plans to consolidate it as a war memorial, but in 1953 most of it was demolished. Bold new multiple-use proposals of 1965 (by *Ahrends, Burton & Koralek*) were superseded by a joint scheme of 1976 for the church and the Soho Society, in turn succeeded in 1980 by a version of the executed design.

NOTRE DAME DE FRANCE (R.C.)
Leicester Place, off Leicester Square

113 By *H.O. Corfiato*, 1951–5. Façade of two-inch-thin Stamford bricks, with the upper storeys developed simply with the normal fenestration of flats. Below, the concave front of the church, with relief of the Virgin by *Georges Saupique* above the portal. The jambs also carved, by Saupique's pupils at the École des Beaux-Arts in Paris. Steps up to the interior, which is much more Neoclassical in spirit, though in plan anticipating the intimacies of the Liturgical Movement. It is a rotunda with an ambulatory arcade of twelve giant unfluted, almost untapered round piers, a glass and concrete lantern, and a flat glass ceiling. The plan derives from the previous French Catholic Church here, converted in 1865–8 by *L.A. Boileau* from *Robert Mitchell*'s Panorama of 1793–4. Boileau's church was of great interest in that it had unconcealed iron piers, iron arches and iron ribs, in a rectilinear arrangement visually at odds with the brick circumference. It was repaired after bomb damage in 1940, but in 1948 Fr Deguerry took over, determined on a new church. (A few iron stanchions were reused, in the basement meeting-room.)

The ambitious FITTINGS embody the intense interest in *art sacré* in post-war France. TAPESTRY above the altar woven at Aubusson to the design of *Dom Robert de Chaumac* of Buckfast, Devon. – MOSAICS of the side altar by *Boris Anrep*. – FONT of Vosges sandstone, designed by *E. Stoll* of Alsace. – PULPITS of polished stone, carved with incised symbols by Beaux-Arts pupils. – WALL PAINTINGS in a side chapel by *Jean Cocteau*, 1960. They represent the Crucifixion in the middle with the Virgin as the principal figure and of Christ only the legs visible, the Annunciation on the l. wall in demi-figures, the Assumption on the r. wall. All in outline, in various colours, and only a little tinting otherwise. The draughtsmanship precise and elegant, similar to Picasso's in his most classicist mood, the mood however of a somewhat mannered sentimentality reminiscent of German, Austrian and Swedish work of the 1920s. – STATUE of Notre-Dame des Victoires (gallery). A stirring story. Made by *Henri Vallette* in Paris, *c.* 1942–4, incorporating the head of a bomb-damaged version of 1865 from this church. The head was parachuted into occupied France. The original, at the church of

Notre-Dame des Victoires in Paris, is a C19 version of a figure attributed to Puget, 1663.

OUR LADY OF THE ASSUMPTION (R.C.)
Warwick Street

Built 1789–90, by *Joseph Bonomi*. The unique survivor of the C18 Roman Catholic chapels of London, from just before the relaxation of the Penal Laws. Before that worship in the capital mostly went on under the protection of diplomatic missions. The present chapel indeed began in 1730 at the Portuguese Embassy at Nos. 23–24 Golden Square, behind (q.v.). In 1747 the Bavarian Embassy took over. The first chapel, on back land, was sacked in the Gordon Riots (1780), and later rebuilt with an unassuming brick front to the street. The three middle bays are stressed by a pediment, with blank round-headed windows below. One glazed window either side. On the ground floor three round-arched doorways, with stone doorcases and two square windows of early C19 date. The red staining of the brick dates from 1952, the gilded cross, stars and angels from 1952–7.

The INTERIOR falls into two parts, of which the W has preserved the C18 character. Three galleries on thin iron columns, painted to resemble wood and with gilt Adamish capitals. Round-arched windows. Coved ceiling of 1853, with big compartments and rosettes, by *John Erlam*. Cast-iron balustrade of the gallery probably also of 1853, but modified when *J. F. Bentley* shortened the galleries in 1874–5. Bentley made the E end Veneto-Byzantine, part of an uncompleted scheme for complete reconstruction within the C18 walls. His apse is faced with grey marble panels and mosaics. In 1900 Bentley revised the apse decoration, executed with variations after his death in 1902 by *J. A. Marshall*. Of 1910 the MOSAIC of the Coronation of the Virgin, by *George Bridge* after cartoons by *George Daniels*, based on Bentley's sketches. The saints below are later. – HIGH ALTAR of 1914. – ALTAR RAILS 1908, with metal columns. By *Marshall*. – In the Lady Chapel, S, a pretty late C18-style mahogany REREDOS designed by *Douglas Purnell*, 1960, incorporating *ex voto* offerings. The mosaic ALTAR FRONTAL was designed by *Bentley*. – SCULPTURE. Over the NE door a large relief of the Assumption by *J. E. Carew*, 1853, from the previous high altar. The style like late Italian Baroque. – PEWS with Baroque ends, 1912. – SIDE ALTAR. Of coloured marble, Italian, Neoclassical, early C19. Brought 1958 from Foxcote House, Ilmington, Warwicks. REREDOS of 1965 by *Purnell*, in keeping. – FONT. Simple bowl and baluster. Probably *c.* 1790. – PAINTING across the W wall, Annunciation, by *Adrian Maretti*, 1959. – ORGAN CASE (W gallery). 1790s, restored 1960 by *Purnell*.

ST PATRICK SOHO SQUARE (R.C.)

1891–3 by *John Kelly* (*Kelly & Birchall*) of Leeds. It replaced an Irish mission chapel, converted in 1791–2 from assembly rooms established in 1761. Red brick, in a kind of simplified
p. 427

Renaissance. Campanile with doorway to the square. The church lies back to the E, reached by a long ante-room. Its N side is simply arched, with swept buttresses joining nave and aisle. Impressive interior, very Italian, with shallow side chapels instead of true aisles, a clerestory, broad barrel vault and broad apse. Big domed side chapel, S. – FITTINGS. Much was kept from the preceding chapel, including scarce survivals from the era of re-established Roman Catholic worship. – Oval FONT with fluted bowl. – STOUPS by *Mayer* of Munich, 1875, in the form of marble angels holding shells. From old St Mary Moorfields (*see London 1: The City*). – Numerous side ALTARS, including the late C18 former reredos, Ionic (S side, second from W). – Many PAINTINGS, some quite good; ante-chapel, by *G. Pownall*, early C20; main reredos, Crucifixion after Van Dyck. – MONUMENT. Rev. Arthur O'Leary, founder of the first chapel, †1802. With portrait, draped female and Irish harp. – SCULPTURE. In the entrance, a Pietà said to be by *T. Phyffers*, 1860.

FRENCH PROTESTANT CHURCH
Soho Square

p.
427
By *Aston Webb*, 1891–3, his favourite work. Free Franco-Flemish Gothic, round-arched, in plum brick and brown and black terracotta. Living accommodation towards the square, almost like an office building: four-storeyed, with lanterned gable flanked by steep slated hipped roofs above side oriels. Carved stone tympanum of 1950 by *J. Prangnelli*. The interior has aisles and an apse, mostly faced in buff terracotta. Curious aisle vaults with ribbed saucer-domes, big bosses, and a glass eye in the centre of each bay. Clerestory with graduated tripartite openings, and the narrowest balcony all round, projecting above the arcade piers. Great relish in the details, e.g. the radiator recesses detailed like château fireplaces. Wooden wagon vault in the nave. Also of terracotta the broad PULPIT and stalky FONT. Simple WAR MEMORIAL by *Adrien Montagu*, 1920, from *Webb*'s French Protestant School in Great Marlborough Street (1897–8, dem.). The congregation began in 1550, in St Anthony's Hospital, Threadneedle Street (*see London 1: The City*).

ORANGE STREET CHAPEL

By *Kieffer, Fleming & Keesey*, 1927–9, the heir to a Huguenot chapel established on part of the site *c.* 1693. A simple stucco front, the broad pediment broken by the round-arched entrance.

WELSH PRESBYTERIAN CHURCH (former)
Charing Cross Road

By *James Cubitt*, 1886–7. An original design. Of white stone, cut small; in the Norman style, but on a central plan with a dome externally octagonal (cf. Cubitt's earlier Union Chapel,

Islington, *London 4: North*). Compact interior (now a bar), with rubbed brick squinches supporting the dome, Byzantine-fashion. Galleries on elliptical-headed arcades on three of the four sides. Joined on to the N the former MANSE, with a gabled red brick front at No. 136 Shaftesbury Avenue.

PUBLIC BUILDINGS

ST MARTIN'S SCHOOL OF ART
Charing Cross Road

1937–9 by *E.P. Wheeler*, for the LCC. Quite a modern brick façade, if of no very special merit. The entrances have Lethabyish decoration, the jambs studentish figure reliefs (by *Adolphine Rylands*). Big studio windows at the top. On the site was the first Greek church in England (1677); in 1682 it became Huguenot, in 1850 Anglican, as St Mary (rebuilt 1872–3 and 1900–1).

ST PETER'S SCHOOL
Great Windmill Street

1870–1 by *J. T. Wimperis*. A narrow gabled frontage, stern Franco-Italian Gothic in yellow brick and stone. Built as a memorial to the 14th Earl of Derby, whose bust is on the front. To Archer Street, S, an extension of 1877. The CHURCH of St Peter (dem. 1954) stood S of Shaftesbury Avenue. It was by *Raphael Brandon*, 1860–1, in a richer Gothic.

SWIMMING BATHS
Marshall Street

By the baths specialists *A. W. S. & K. M.B. Cross*, 1928–31. Disused since 1997. A consequential front for such a narrow street, arcaded below, with a pedimented entrance bay carved with bathing belles by *H. Tyson-Smith*. The two baths have ferro-concrete barrel vaults and marble-lined walls. A maternity centre and laundry were included.

WESTMINSTER REFERENCE LIBRARY
Orange Street and St Martin's Street

A stone-faced corner building by *A.N. Prentice*, 1926–8. Palladian, but with unusually tall windows.

STREETS

ARGYLL STREET

Built up as late as 1735–45, on land belonging to the Dukes of Argyll. Argyll House (dem. 1864), muddled in plan and aspect, was built in 1737–42 for Lord Ilay, later 3rd Duke of Argyll, where the London Palladium now stands on the E side (*see* also Great Marlborough Street).

On the W SIDE mostly the backs of Regent Street blocks, except for No. 18, the ARGYLL pub of 1868. This has the best remaining interior of the late C19 type with separate bars divided by internal screens (installed *c.* 1895 by *R. Sawyer*): a maze of mahogany and engraved mirrors under a Lincrusta ceiling. On the E SIDE, two of the once-fine houses of *c.* 1740 remain (No. 8, and the cruelly Victorianized No. 10), alternating with interwar commerce: the jazzy No. 11, tall stone, by *W.A. Lewis & Partners*, 1933, and – still taller – No. 9, by *Waite & Waite*, 1934, in Nailsworth stone from Gloucestershire.

Then the LONDON PALLADIUM, a big theatre with a strange history. Its site was excavated for cellars for G. Haig & Co., wine merchant (1865–6), with provision for building on top. This was duly done by *Owen Lewis* in 1867–8, for the Corinthian Bazaar and Exhibition Rooms. Though altered, the great pedimented front is of this date. It has giant columns on pedestals, between which the entrances are squeezed in. The business soon failed, and in 1871 was adapted as premises for Hengler's Circus (modified 1884–5). Then in 1909–10 *Frank Matcham & Co.* reworked it as a huge music hall, at a cost of £250,000. Externally two columns were removed to make the rather raw central entrance, and statuary put on. A new audi-
torium was made, in the familiar theatrical-French manner, but of exceptional volume and breadth. It faces S, i.e. at right angles to the entrance, and has extremely deep and steep balconies and a segmental-vaulted ceiling with an elongated lantern. Matcham also provided a remodelled concert room on the first floor, a palm court (converted from the C19 wine cellars to the N), box-to-box telephones, and changing rooms so that evening dress could be donned 'on site'. Interior restoration by *RHWL*, 1996–8.

95

BEAK STREET

A characteristic Soho street. The E section up to Kingly Street was developed *c.* 1689 by Thomas Beak, the rest in two stages from *c.* 1668. From the W, Nos. 10–14, S side, are overspill from the Regent Street rebuilding, 1925. On the N SIDE some C18 and early C19 houses (Nos. 15–23), with good shopfronts at Nos. 19 and 23. No. 21 spans KINGLY COURT, lined with later C19 former warehouses. Further on Nos. 41–43, of *c.* 1687

(altered), Canaletto's home in his London years. On the w corner with Marshall Street the OLD COFFEE HOUSE pub (No. 49), its ground floor embellished in 1894 by *M.T. Saunders* as a teetotal 'temperance tavern' for Reid's brewery. w of Marshall Street larger commercial buildings, e.g. Nos. 57–63, *c.* 1897 by *D. Cubitt Nicholls, Sons, & Chuter,* stone-banded red brick of a kind seen all over Soho. No. 40 (S SIDE) was a Metropolitan Police Section House, 1909–10 by *J. Dixon Butler.* Closer to the free-wheeling LCC manner of *c.* 1900 than to his more formal police station and court house idiom. Nos. 42–44, a giant-pilastered later C19 warehouse, refurbished in 1991 by *Hawkins/Brown* for themselves, with a curved steel-clad mansard and a glazed rear wall. Further on is *Henry Cotton*'s SUN & 13 CANTONS pub, 1882, Gothic and Queen Anne piratically mixed. On the E corner with Great Pulteney Street Nos. 50–54, a handsome warehouse of 1904–5 in apple-green glazed brick. The N SIDE has refronted houses of *c.* 1719 (Nos. 65–73, 77–79), with some more nice C19 shopfronts; No. 75 by contrast is a nastily fussy Neo-Jacobean ex-pub of 1847, formerly with a shaped gable. No. 79 (JOHN WILKES), with a shopfront of *c.* 1850 with cast-iron arched lights, is the last of the Soho gunmakers.

BERWICK STREET

Soho at its roughest: battered C18 houses and plainish later buildings, housing mostly old-fashioned trades. Its dates are 1687–1703 for the S part, up to Broadwick Street, undertaken by James Pollett (cf. Poland Street); after 1707 for the N part, to Oxford Street. The first houses were rebuilt 1734–41.

Starting at the S end, KEMP HOUSE (w side) is a block of fifty-seven flats by *L.C. Holbrook* of *Riches & Blythin* for Westminster City Council, 1959–62. The tower, not symmetrically placed, rises to seventeen rewindowed storeys from a long three-storey podium, which overhangs to shelter the street market. The lower part is penetrated by the glazing of a staircase, continued as a cleft straight up the tower between projections joined in front by the steel framing.* The older houses lie mostly N of Broadwick Street. No. 24 (E side) is a former pub of 1826, the upper windows with round-arched settings. At Nos. 27–29 a big pilastered terracotta-clad warehouse of *c.* 1890. Opposite, Nos. 79–81, maltreated Early Georgian, with on the flank of No. 81 a stone tablet dated 1736. Contemporary with them No. 77, and Nos. 31 and 32 (E side).

No. 67, late C18, makes the S W corner with NOEL STREET, named after the Duchess of Portland (*née* Lady Elizabeth Noel), for whom its w part was built up in the 1740s. On the S side of Noel Street Nos. 19–20, 1987–9 by *Graham Moss Associates*, modelled and stridently coloured to suggest three

* *Blore*'s St Luke's church, 1838–9 (dem. 1935), Gothic, stood on part of the site.

upright bays. N of Noel Street, Nos. 46–48 and No. 52, E side, and Nos. 57 and 58, W, of *c.* 1740, some refronted in the C19; No. 52 has a Venetian window, No. 57 (the GREEN MAN pub) segment-headed window reveals.

BREWER STREET

Laid out in 1664–70 by Sir William Pulteney. Never a smart street; it had originally two breweries and a saltpetre works. Beginning by Regent Street, W, the E corner with Warwick Street (N side) is of 1910–11 by *Metcalfe & Grieg*, tall, stone-faced, with blocked columns and something of Belcher & Joass's adventurism. For the Regent Palace Hotel, S side, *see* Glasshouse Street. Nos. 80–84, N side, are late C17 houses. On the E corner with Lower James Street, a house of 1780 with a blind Venetian window and Diocletian window on its flank. The Portland-faced Nos. 72–74, unusually refined for Soho, were built in 1922 as offices for Burberry's, by *W.R. Howell* of Reading. Up BRIDLE LANE, JOHN BROADWOOD HOUSE was the first undertaking by the Soho Housing Association: by *Simon Crosse* of *Feilden & Mawson*, 1976–80. Twelve family flats on an introverted site, with gardens behind. Uncommunicative public face, of red brick with a few historicist touches.

Further along Brewer Street on the S SIDE, older properties at Nos. 45–57, gently rehabilitated by the *Goddard Manton Partnership* in 1988–94. No. 57, looking *c.* 1800, was pierced with a passage into SMITH'S COURT, whose typical jumble of C19 mews and warehouses was adapted for offices. At No. 55 the GLASSHOUSE STORES pub, polychrome brick, probably 1876. Nos. 49 and 51, refronted *c.* 1860, are early C18. No. 45a, visible down a gated passage, is a late C19 horse-age relic with a ramp and gallery to upper-level stabling.

Diagonally opposite, the LEX GARAGE, one of the first super-garages: 1928–9 by *J.J. Joass* and *Robert Sharp* (future uncertain). Simplified forms in yellowish faience, with a vaguely Byzantine corner turret. It made early use of ramps rather than lifts, and incorporated a chauffeurs' clubroom and dressing rooms for their employers. Back on the S SIDE a long crimson brick run of shops below flats for the 'respectable poor', of 1883–5. Designed for the Crown Estate to specifications by *Arthur Cates*. Most ornate is the DUKE OF ARGYLL pub on the E corner, by *J.T. Wimperis*; the rest by *Robert Sawyer* (Nos. 9–35, partly rebuilt after bombing in 1940, and Nos. 3–7, E of Rupert Street). The block behind was rebuilt in 1979–80 by *Westwood, Piet, Poole & Smart*, for the Soho Housing Association. On the N side facing, the pedestrian alleys of GREEN'S COURT and WALKER'S COURT show the unambitious scale of the late C17 development. Architecture and uses at this end are pretty basic, e.g. Nos. 6–10, the RAYMOND REVUEBAR, converted from older buildings in 1972.

BROADWICK STREET

Until 1936 called Broad Street. Broad only in part, the conse-
quence of development in different stages. The first, traversing
Berwick Street (E), was made in 1686–9, the rest in four bursts
between *c.* 1693 and 1734. The extension into Carnaby Street,
w, is as recent as *c.* 1979. Some good C18 houses; later C20 blocks
big enough not to worry about contextualism.

Soho's newest landmark is on the SW corner with Berwick
 Street, just after the narrow E part of the street finishes: offices
 by the *Richard Rogers Partnership*, 1998–2000 (INGENIA).
 They have repeated silver-grey storeys with bands of hori-
 zontal screens, carefully detailed and visually strong. Glazed
 lift tower, r., a favourite Rogers device, with orange internal
 framing; balancing it on the l. a big glazed upper room under
 a tilted segmental roof, in outline similar to *Munckenbeck &
 Marshall's* earlier competition-winning design for the site.
 Facing, Nos. 20–24 (WARNER BROS), 1988–90 by *Thompson
 Wintergill Faulkner*, symmetrical, with a shallow bow and
 attention-seeking chequerwork panels, violet and grey. Then
 on the N side two tall blocks of flats over shops by *John Gill
 Associates*, *c.* 1983. Red-brown brick, the w part with windows
 alternately narrow and wide. The s side has TRENCHARD
 HOUSE, a very large police section house, orderly Neo-
 Georgian. By *S.G. Livock*, 1938–40.
INGESTRE PLACE, behind, has for its centrepiece INGESTRE
 COURT, by *Westminster City Council Architect's Department*,
 1970–5. Fifty-two flats in a robust twelve-storey tower with
 recessed corner windows, set on a three-storey office podium.
 Khaki tile facing. It replaced early artisans' dwellings by
 Charles Lee, 1853–5, built for the General Society for
 Improving the Dwellings of the Working Classes, a brainchild
 of Lord Ingestre (later 19th Earl of Shrewsbury). Smaller
 artisan lodgings of the 1850s remain at No. 7 on the E side. To
 their N the former ST JAMES'S DWELLINGS by *H.H. Collins*,
 1886–7. Red brick, by this date humanized with pilaster-piers
 and window-box guards. Built by St James's Vestry for single
 women, mostly in one-room tenements with gallery access.
Back in Broadwick Street, continuing w on the s side, Nos. 32–37
 (MCA), 1989–92 by *Cecil Denny Highton*, the most invasive
 of Soho's Postmodern offices. Banded stone façade, chopped
 back so that a glossy blue curtain-walled bow emerges. w of
 Lexington Street is the JOHN SNOW, a pub of *c.* 1870, solid
 yellow brick. Named after the doctor who demonstrated the
 water-borne infectivity of cholera, after a local outbreak in
 1854; replica of the infected PUMP, 1992, in the roadway to
 the E.
Older houses on the N side. No. 46 is of *c.* 1705, refaced. Nos.
 48–58 are a very nice terrace of 1722–3. *John Mist*, a leading
 London pavior, was the contractor. Each has three bays and
 four storeys, with segment-headed windows and door-hoods
 on carved brackets. These may be by the carpenter *John Meard*

Jun., lessee of No. 56, since those on his Meard Street houses match (q.v.). Fully panelled interiors, to consistent and orthodox plans, i.e. two rooms with a dog-leg staircase alongside the rear one, with a small third room in a back closet. *Quinlan Terry*'s restoration of 1981–4 removed accretions and made good lost woodwork. The work was funded by an extraordinary block of offices and flats behind, also by *Terry*, 1983–4 (reached from DUFOUR'S PLACE, l.) An implicit critique of Modernist tower blocks, but too personal and peculiar to have had much influence. Tight T-shaped plan, of true load-bearing brick, but tall enough to confound polite Georgian proportions. Instead it has six plain storeys in three repeating pairs. Ornament is kept to the centre: cast stone frontispiece in false perspective, broad Dutch gable with obelisks, and thin cupola housing service ducts. Other details trip over the prevailing symmetry, e.g. the divergent fenestration of the l. wing.

In antipathetic contrast is WILLIAM BLAKE HOUSE to the E, by *Stillman & Eastwick-Field* for Westminster City Council, 1964–6. Tower of offices and seventy-two flats on top. Rough brown-granite facing panels, with wooden window-frames and balconies, also brown. It stands on a large podium with canted corners, containing warehouses and shops, which was meant to be compatible with any future system of upper-level pedestrian decks. The flats are approached from Dufour's Place, the offices up steps from Marshall Street, W. In the office entrance SCULPTURE by *J. W. Mills*, an impressive triptych in aluminium and bronze of William Blake, whose birthplace was demolished to build the block. On the S side of Broadwick Street, offices by *Douglas Marriott, Worby & Robinson*, 1967–70. Lower block with a fussy motif of projecting beam ends, upper part with pretentiously irregular fluted uprights.

CARNABY STREET
and streets to the east

Laid out *c.* 1685–6 and rebuilt in the 1720s. Named from Karnaby House, built on the E side in 1683. On this side most houses are as late as 1820–5, when the former Carnaby Market site was built over with small new streets. In 1957 the first of the boutiques opened that plucked the street from obscurity. Lettered arches at each end, of 1983, ram the point home.

Coming from the N, Nos. 24–29 and No. 21 are of 1820–5, modest, with distinctive rounded corners with splayed shop entrances. Some were built by *Thomas Finden*, surveyor to the landowner the 1st Earl of Craven; since Finden began styling himself architect soon after, the design is probably his. Nos. 22 and 23 are 1720s, refaced. To the E are more 1820s houses, in two little passages and in the pretty NEWBURGH STREET at their end, which runs parallel with Carnaby Street. Here more original shopfronts, with flat bows and twin doorways (Nos. 5 and 6); others are 1980s restorations. The W side, less complete, includes Nos. 13–15, a facsimile of 1985 of

houses too decayed to save. In GANTON STREET across the s
end, Nos. 2–8 are also of 1820–5, No. 4 with a Chinese Chip-
pendale fanlight; w of Newburgh Street some refronted early
C18 houses. More of the 1820s on the w side of MARSHALL
STREET, E (for the rest of the street q.v.).

The w SIDE of Carnaby Street is less appealing. No. 32 is by
Finch Hill & Paraire, 1856, humble coloured brick. No. 36,
1970s brick with five glass-box oriels, filled in the space of
a narrow alley. No. 40 is refronted 1720s, the conservative
Nos. 43 (an ex-pub), 45 and 46 of 1858, Nos. 44 and 47 of the
C18. The building facing (E side) is by *Douglas Marriott, Worby
& Robinson*, 1978–80. Red-brown brick with a leaded crust,
trying hard to break up its bulk. On the flank of No. 9, to its s,
a gaudy mural on Soho themes by the *Freeform Arts Trust*, 1991.

CHARING CROSS ROAD

An enterprise of the Metropolitan Board of Works, opened 1887
in conjunction with Shaftesbury Avenue (Act 1877, amended
1883; cost £778,238). It runs s–N, from Trafalgar Square to
Tottenham Court Road. To save money older streets were
incorporated and widened, hence the sinuous course at the s.
Laissez-faire prevailed where new architecture was concerned.
The results are generally dull, mainly red brick with small gables
and turrets, and nothing to draw the eye in distant views.

The s end has on the w side the National Portrait Gallery (*see*
p. 310), on the E side the former WESTMINSTER CITY HALL,
an underpowered curving stone front. Central pilastered part
of 1890–1 by *Robert Walker*, built as St Martin's Parish Vestry
Hall. The newly incorporated city added a fourth storey and
a five-bay wing, l., by *John Murray*, 1901–2. Then in 1923
Murray incorporated on the r. *David Brandon*'s Provident
Savings Institution of 1871–3, refacing its upper floors to
match. Rebuilt behind the façades 1997–9, with a new section
on St Martin's Lane (*see* p. 361). Next the GARRICK THEATRE,
of 1889 by *W. Emden* with *C. J. Phipps*, for W.S. Gilbert. Front
with eight-column loggia by the entrance, to the l. of a win-
dowless wall. Unusually spacious foyer; very fine auditorium,
partly sunk, with three U-shaped tiers under a dome and no
proscenium arch. Seated females in relief, figure friezes and
caryatids animate the plasterwork.

The Garrick Theatre faces an informal triangle with the
STATUE of Sir Henry Irving, 1908–10 by *Brock*. N of it a sump-
tuous three-armed lamp standard, *c.* 1890. The far (w) side of
the triangle was part of the former Castle Street, from which
No. 1 remains, plain early C19. Gabled 1890s buildings follow,
of which the nice Gothic-derived No. 13 is the BEEFSTEAK
CLUB, 1896 by *Frank Verity*. The main clubroom is panelled,
with an open kingpost roof. No. 15 belongs with Nos. 29–30
Leicester Square (q.v.); No. 17, gabled glazed brick, is by
E. Wimperis, 1902. ALHAMBRA HOUSE (Nos. 23–33), is by
Mather & Weedon, 1938, in connection with their Odeon, also

in Leicester Square. Plain horizontal windows and opaque glass facing, renewed to a different pattern. On the E side, facing, a run of tall commercial buildings bearing dates of the early 1890s. No. 4, quite handsome, was a woollen warehouse; the rest less ambitious, e.g. *E.B. I'Anson*'s No. 18, 1893, and Nos. 24–28, 1892, by the normally extrovert *F.T. Pilkington*. This makes the N corner with the narrow CECIL COURT, famous for second-hand bookshops; it was rebuilt for the Salisbury Estate in 1888–90, in neutral plain glazed brick. WYNDHAM'S THEATRE is of 1898–9, by *W.G.R. Sprague* for the actor-manager Charles Wyndham. Stone front, a pediment between taller attics, with more and better carving than theatres of a decade before. Horseshoe-plan interior, with two balconies and three tiers of boxes. The superior Louis XVI decoration includes figure sculpture over the proscenium and Boucheresque paintings by *J. Boekbinder*. Then on the w side the LONDON HIPPODROME, 1898–1900 by *Frank Matcham* for (Sir) Edward Moss. A large block in blowsy Loire style, faced with red Mansfield stone. Square angle tower, with open metal crown and chariot. Shops and residential chambers wrap around the auditorium. Built not for plays but for an indoor circus, complete with floodable stage for water shows. Largely rebuilt inside 1958; now a night-club.

LEICESTER SQUARE UNDERGROUND STATION faces the Hippodrome (E side). Main building to the familiar *Leslie Green* design, 1906. On Cranbourn Street (s), at No. 21, the sign of J. Wisden & Son, with wicket. Pilastered Anglo-French offices on top, rather crude; by *Homer & Lucas*, 1911, for the Playgoers' Club. s of Cranbourn Street an auxiliary station building of 1932–5 by *Adams, Holden & Pearson*, a disappointing little stone wedge.

From the N corner of Great Newport Street, a long, high, drab range of artisans' dwellings over shops, 1883–4 by *George Borer* (Nos. 48–80). The *Improved Industrial Dwellings Co.* was co-opted to put it up, to rehouse people displaced by the new street. Gingered up with penthouse flats by *Hunt Thompson Associates*, 1996. Its counterpart, w side (Nos. 51–85), was replaced by *Diamond Redfern & Partners*, 1979–83. Long colonnade with shops below, small windows for flats above. The facing is red brick of a merciless shade and texture, broken up by big flat projections coming down to different levels. A car park and cleansing depot are incorporated behind. To its N are the former Welsh Presbyterian Church (q.v.) and Cambridge Circus (*see* Shaftesbury Avenue).

N of Cambridge Circus, the E SIDE (London Borough of Camden) continues with Nos. 86–94, mansions by *J. Hartnell*, typical 1891. Then a dominating block by *Ian Fraser & John Roberts Partners*, 1982. Six storeys stepping up to eleven behind, girdled by a band of flat oriels round the fifth floor. The corrugated verticals recall Hoeger and Hamburg *c.* 1930. An unappealing inlet marks where a side street was closed off. On the w SIDE the s corner of Old Compton Street is No. 99a, remarkable Neo-English Baroque, with the usual blocked columns but of green glazed bricks banded with stone. By *C.H.*

Worley, 1907 (designed 1904). Then some humble survivors of the old Crown Street, e.g. No. 101 (N corner), of the first build, *c.* 1683. At No. 105 the disguised carcase of an early cinema (1911). Then St Martin's School of Art (q.v.). Nos. 104–110 (E SIDE), budget streamlined brick, by *Mitchell & Bridgwater*, 1936. The PHOENIX THEATRE, 1930, is by *Giles Gilbert Scott*, who did the main elevation, and *Bertie Crewe* with *Cyril Masey*. Italianate exterior, circular entrance lobby with tiles, leading to a Renaissance interior by *T. Komisarjevsky*, with painted panels by *V. Polunin*. Nos. 114–116, with heads in roundels, by *Roumieu & Aitchison*, 1888, for Crosse & Blackwell. Much richer Nos. 126–136, mansion flats of 1889, late Germanic Gothic with a stepped gable. Further up on the W SIDE two recycled warehouses, also built for Crosse & Blackwell. Nos. 147–155, 1877–85, designed by *R.L. Roumieu*, has a whimsical angle turret and round-headed windows; converted to showrooms 1925–6. Also turreted, but disguised by Empire ornament, the ASTORIA: a drastic remodelling by *E.A. Stone*, 1926–7, of *Roumieu & Aitchison*'s warehouse shell of 1893. At first a cinema; gutted 1968, and now a rock venue. For Centre Point, NE, *see London 4: North.*

COVENTRY STREET

The link between Piccadilly Circus and Leicester Square, given over to big offices and places of entertainment. Largest of these is the TROCADERO complex, N side (begun 1982 by *Fitzroy Robinson Partnership*, reworked 1987–91 by *Module 2*; engineers *Ove Arup & Partners*). Financial troubles and a change of ownership spun out the work. *Module 2*'s new parts appear externally as a small frontage and a larger mansard, their perfunctory classical detailing badly shown up by the retained restaurant façades to each side. The l. one, of 1892–4 by *Treadwell & Martin*, was Scott's seafood restaurant. Painted Bath stone, a little bony, but cornering nicely with an octagonal turret. To the r. a giant Lyons' restaurant, in shiny white artificial stone. This begins with a powerful square-rigged section of 1921–3 (*F.J. Wills*), which alone seated over 3,000. At the corner, lower, earlier premises – the very first Lyons' Corner House – by *W.J. Ancell*, 1907–9. Big broken pediments, round corner turret. Towards Rupert Street a repetitive long new section, almost windowless, with an entrance to the OTHER CINEMA, 1983–5, a shoestring basement conversion by *Burrell Foley Associates*. The Trocadero INTERIOR is a vast windowless void leading to shops and cafés, cinema, etc. The criss-crossing escalators and bridges were redone by *Proun Architects*, 1999, raising the level of sensory overload. Inside the CINEMA, l., panels of *F. Lynn Jenkins* and *Gerald Moira*'s Arthurian figure frieze of 1896, boldly mixing paint and metal leaf, reset along the escalators. From the original Trocadero Restaurant, of which the façade survives along Great Windmill Street (*see* Shaftesbury Avenue).

On the S SIDE No. 22, by *H.H. Collins*, offices of the Northumberland Avenue type: of 1882, when the street was widened. After the back of Nos. 28–29 Haymarket, the PRINCE OF WALES THEATRE, 1937, by *Robert Cromie*. Understated Art Deco, with an underpowered corner turret; artificial stone. Broad interior with twee Deco ornament. It replaced a theatre of 1883–4, part of a larger block all by *C.J. Phipps*, of which the former Prince's Hotel survives as Nos. 32–39. Tall, stone, choked with ornament. The block facing it comprises Nos. 5–6, l., by *Ford & Walton*, 1908, with tricksy decorated pilasters, Nos. 3–4, the former RIALTO CINEMA, 1912–13, externally by *Hippolyte & F.E.B. Blanc*, one tall simple stone arch, and Nos. 1–2, also of 1912–13 but more intricate, by *Emden, Egan & Co.* (The Rialto has the finest early cinema interior in London, worthy of a full-scale theatre: by *Horace Gilbert* of *Gilbert & Constanduros*. Marble Imperial staircase; Rococo oval auditorium with a sweeping gallery. Disused in 2003.)

D'ARBLAY STREET

A shortish street on the Duchy of Portland's lands, built up 1735–44. Renamed in 1909 for Fanny Burney, Mme D'Arblay, who lived nearby. Original Nos. 2–4 and 32, E of Berwick Street, and Nos. 13, 24 and 25, to the W. A passage by No. 21, S side, leads to PORTLAND MEWS. Plain C19 warehouses and stables, e.g. No. 8 (E side), 1884 by *Spalding & Auld*.

DEAN STREET

Begun *c.* 1678, along with Soho Square to the E; finished by 1697. *Nicholas Barbon* and *Richard Frith* were amongst the builders. It has the best remaining houses from the great Soho rebuildings of the 1730s; also several smallish hospital premises of *c.* 1900, most now in other uses. The description is from N to S.

Just S of Oxford Street, No. 102 (W side), by *Belcher & Joass*, 1910: spartan, but illustrating their influential simplified detailing. No. 1 on the E side, red brick and ornate terracotta, was part of the Tudor Hotel, 1898–9 by *P.E. Pilditch*, formerly extending to Oxford Street. Reconstructed 1986–7. At No. 96 (W side) the BATH HOUSE pub, 1899 by *W.J. Farthing*, with a pretty recessed ground floor. No. 94 is early C18, refronted. Then on the E SIDE the back of Soho Square begins. No. 6 is the back of Trotter's warehouse (Nos. 4–6 there), i.e. probably also of 1801–4. A forthright brick front of three broad bays. Segment-headed arches below, the middle one open as a big carriageway. Tripartite windows above. No. 7 goes with *C.H. Worley*'s No. 3 Soho Square, 1903. The round-arched Italianate Gothic No. 8, 1877–8 by *C. & F.E. Eales*, was the private hospital of Dr David Jones; ground floor restored 1976.
Facing (W SIDE), No. 91, latterly the West End Hospital for Nervous Diseases, built 1911–13 to treat venereal troubles,

by *A. Saxon Snell*. A tightly controlled seven-bay classical front, with an open-pedimented Doric porch seemingly imitated from No. 90, a house of *c.* 1756–67. This has instead of a fan-light a tiny window with cobweb glazing bars. Turned-baluster staircase.

No. 90 makes the corner with CARLISLE STREET, a short blind street of 1685–7. The *point-de-vue* from Soho Square was the pedimented Carlisle House, 1686, unfortunately bombed in 1941. On the s side Nos. 4 (with later c18 doorcase), 5 and 6 are late c17. Three-bay c18 houses opposite: No. 16, 1773; No. 17, with another pedimented doorcase, 1765; No. 19, E of Dean Street, 1737, part of *John Sanger's* rebuildings in Soho Square proper. No. 88, 1791, is the greatest joy in Dean Street: a Rococo shopfront with vivacious Rocaille decoration, now unique in London. Of 1735–6 No. 86 and two houses in ST ANNE'S COURT behind it. On the s side there is one of the Soho Housing Association's intricately planned blocks, by *Peter Mishcon & Associates*, 1985–7. Shops below, houses above and behind, stepping back down to a first-floor garden facing RICHMOND BUILDINGS, the next w turning off Dean Street. The lofty red brick wall at its far end belongs to a large early GARAGE, *c.* 1907.
Then on the E SIDE of Dean Street the SOHO THEATRE, converted by *Paxton Locher Architects*, 1999–2000, from the former West End Great Synagogue, by *Joseph Fiszpan*, 1961–3, a large bland brick-faced building that included several auxiliary spaces. Its upper storeys were converted to flats, with a smallish theatre below, marked externally by a large lettered panel screened by rough-and-ready metal. Also included are a lesser theatre space, writers' centre, and a restaurant fitted under the raking theatre seating. To the s of Richmond Buildings on the w SIDE some quite ambitious early Georgian houses on the former Pitt Estate, which was rebuilt unusually thoroughly in the 1730s. On No. 80 a tablet with the dates 1732 and 1916, when it was again rebuilt. Nos. 76–79 remain, also of 1732. Nos. 78 and 79 are smallish, the former with a squat Doric doorcase. Much grander are Nos. 77 (altered) and 76, four bays each, with segment-headed windows, end pilasters and a fourth storey (original at No. 76). First-floor window surrounds probably c19, though those at No. 76 have Vanbrughian rustication acceptable for 1732. The same house has one larger window with an elliptical arch, disruptive externally, but symmetrical to the three-bay saloon behind. Good Ionic-pilastered doorcase. Behind it a narrow stairhall, the staircase with turned fluted balusters and an open well. On its walls a *trompe l'œil* Corinthian order framing views of ruins and seascapes, attributed to the theatre painter *John Devoto* (cf. No. 20 Cavendish Square, *London 3: North West*).*
Christopher Hussey suggested a connection with the Hon. James Hamilton, naval officer and son of the 7th Earl of

*And also No. 75 Dean Street (dem. 1923), which had a staircase marvellously painted with *trompe-l'œil* architecture and contemporary figures. In 1914 it was the subject of the first, unsuccessful Preservation Order made under the Ancient Monuments Act of 1913. The stairhall and ground-floor rooms were reconstructed at the Art Institute of Chicago, but the paintings were lost.

Abercorn, the first occupant. Other interiors with superior panelling, cornices and Kentian chimneypieces. *Thomas Richmond* was the builder.

Nos. 69–70 (PITCHER & PIANO) were built by *John Meard Jun.*, 1732–3, but stuccoed over in the C19, and uglified by two extra floors as the printing house of Messrs Novello, *c.* 1864–75. To Meard Street, l. (q.v.), a low stuccoed extension perhaps of *c.* 1834, when the Novellos began living at No. 69. Some panelling and a good dog-leg staircase remain inside No. 70. Nos. 67 and 68, a mirrored pair each of three bays, are also *Meard*'s, of 1733–4. Enriched Doric doorcase of stone at No. 68, which was Meard's own house. The interior is almost intact: fully panelled rooms, some with simple stone fireplaces, closet wing, dog-leg staircase with slim turned balusters to full height. Less-common survivals include two cesspits still with drains, discovered during restoration for David Bieda in 1994–7 (*John Dickinson* architect). No. 67 (BLACK'S CLUB) has a similar doorcase, but much inside is facsimile replacement after illegal stripping-out in 1989.

On the E SIDE C18 houses are fewer, less ambitious, and less well preserved. Nos. 26–28, *c.* 1734, and No. 29, *c.* 1692, share a delicate glazed frontage redolent of Mackintosh, for QUO VADIS restaurant (1997 by *Long & Kentish*). Also of the early 1730s, but with segment-headed windows, Nos. 33–33a and Nos. 39–41, the latter on part of the Pitt Estate (for Nos. 34–35 between *see* Nos. 51–54 Frith Street). Stucco hoodmoulds on No. 41, home to the COLONY ROOM CLUB, a Soho landmark since 1948. Nos. 42–43, not large and with a gentle bow, was the Royal Ear Hospital, 1903–4 by *Rogers Field* and *A.O. Collard*. Another Soho institution, the GROUCHO CLUB for media people, was converted from the nondescript Nos. 44–45 by *Tchaik Chassay*, 1984–5 and later.

Less interest s of Old Compton Street. The FRENCH HOUSE pub (No. 49), dull only architecturally, is by *Alfred W. Blomfield*, 1937; contrast *J.S. Quilter & Son*'s costly olde-worlde GOLDEN LION (No. 51), 1929. On the w side a Neo-Georgian block replacing St Anne's church (q.v.), and No. 54, the former parish rooms, baggy Neo-Wren by *W.C. le Maître*, 1910.

FRITH STREET

Begun *c.* 1678 as part of the Soho Square development. Named from *Richard Frith*, the chief developer (with *William Pym*). Unusually rich in older houses. Coming from the square, Nos. 64 and 63 (W SIDE) have fronts of *c.* 1734, perhaps on C17 shells. Nos. 60–62 are of *c.* 1680–8; No. 61 refaced 1950, No. 60 with a pretty Ionic doorcase of *c.* 1780. Of *c.* 1800 No. 59, with an imitation C18 lampholder, and No. 58. On the E SIDE, No. 5, *c.* 1731 with a neat stone doorcase. Nos. 6 and 7, bricklayer's Baroque of 1718 (refronted 1909). Giant end piers and vertical window recesses, showing deviations from the C18 elevation drawing. Mirrored plans; one double Doric doorcase. Built for Sir James Bateman on part of his

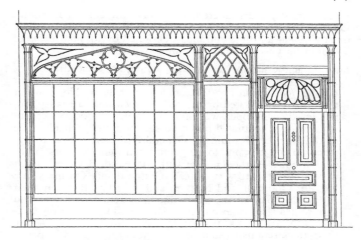

No. 15 Frith Street, shopfront. Elevation
(*The Survey of London*)

Monmouth House property (*see* Soho Square), with the similar
Nos. 8–10 (dem.). Inside Nos. 5–7 (now HAZLITT'S HOTEL)
some good simple panelled interiors and staircases. The NW
corner with BATEMAN STREET is the DOG & DUCK pub, 1897
by *Francis Chambers*: commonplace outside, but inside with
mirrors and coloured tile linings intact.

Continuing S, the W side has bulky warehouses for Osborne,
Garrett & Co., perfumers, by *G. Gordon Stanham*. Brick above
stone. Built in stages: Nos. 53–54 *c.* 1905, extended to Dean
Street (Nos. 34–35) 1923, to Bateman Street, N, after 1926, to
Nos. 51–52 (matching) in 1934. Facing (E side), Nos. 15–18,
c. 1734, altered. At No. 15 a fantastic Gothick shopfront,
perhaps as late as 1816, but still of mid-C18 Batty Langley type.
The tracery is cast iron. Then on the E side Nos. 44–49,
1804–7, mostly with the familiar round-headed relieving arches
along the first floor. At No. 22, (E side), built 1914, John Logie
Baird first demonstrated television in 1926. Houses S of Old
Compton Street are less well preserved: Nos. 26, 29 and 30, E
side, and Nos. 39–41, W, of various earlier C18 dates. Nos. 37
and 38 are of 1781, with Nos. 23 and 24 in ROMILLY STREET.
No. 22 and perhaps No. 21 there are late C17, refaced; No. 19,
1763–4, has one of the few canted bays on Soho houses, prob-
ably added 1790. For the E part *see* Greek Street.

GERRARD STREET

Laid out by *Barbon* from 1677 on the land of Lord Gerard of
Brandon, later 1st Earl of Macclesfield. Gerard's own house, on
the S side, burnt down in 1887. Other late C17 and C18 houses

remain, mostly much altered. They form the core of London's Chinatown, handsomely acknowledged in 1985 by CHINESE GATEWAYS at all three entrances, designed by *Richard Swain* of Westminster City Council's planning department.

Starting at the E, Nos. 47 and 41, S side, are refaced late C17. Nos. 3–6 on the N side, 1733–4, have a plaque naming their builder *John Whetten* or *Wheeten*, on the r. flank. No. 9, wider than the rest, is dated by the *Survey of London* to 1758–9, but its closed-string open-well staircase looks *c.* 1700. Stuccoed, with a heavy, mutilated porch on square piers, probably done in 1825 for the Westminster General Dispensary. Nos. 10–12, stuccoed late C17; on No. 12 giant fluted Ionic pilasters, probably original. At the E corner with Macclesfield Street a brick warehouse of *c.* 1875 with scaly Gothic detail. On the S side No. 40, 1799, tall, and Nos. 39 and 36, 1737. Between front and back rooms of the last a fine swept-ended staircase and light well: a late instance of this plan type. Then a terribly cliff-like TELEPHONE EXCHANGE by *F.A. Llewellyn*, 1935–7. No. 31, *c.* 1683, retains its staircase; No. 30, 1778, a good Neoclassical doorcase. No. 16, N side, of 1730, Nos. 17–19 altered late C17, No. 20 apparently also early C18, with brick pilaster-piers. MACCLESFIELD STREET, halfway along, also dates from 1677. Nos. 2 and 3, W side, may be late C17. No. 11 (DE HEM'S), E side, is a typically ornate *Saville & Martin* pub, 1890. In HORSE AND DOLPHIN YARD behind lurk funny little glazed-brick offices of 1900 by *A. Ventris*, for the health board of Strand District Board of Works.

GLASSHOUSE STREET

Once part of the ancient lane running NW from Piccadilly; in 1391 recorded as Suggen Lane. Now like a string across the bow of the Regent Street Quadrant, the back of which forms the S side. The huge REGENT PALACE HOTEL dominates, modelled with giant pilaster strips and filling an entire, irregular block. Of 1912–15 by *Sir Henry Tanner* and *W.J. Ancell*, for Salmon & Gluckstein, the men behind J. Lyons & Co. The white faience (here *Burmantofts'* 'Marmo') was favoured for Lyons' houses. In 1915 the corridor length was estimated at two miles. 1940s top additions; NE extension 1934 by *F.J. Wills*, linked by bridge across Sherwood Street. The cavernous basement restaurant retains much of *Oliver Bernard's* smart decoration of 1934–5, with exotic banded capitals, etc. Restored by *David Connor*, 1994, for the ATLANTIC BAR AND GRILL. To the E, N side, the Neo-Baroque Nos. 4–6, *Sir Reginald Blomfield* forgetting his French manners; built for the London, County & Westminster Bank, 1910. W of the hotel, a contrast in pubs: No. 42 (THE GLASSBLOWER), a converted wine warehouse of *c.* 1871; No. 44 (LEICESTER ARMS), W, by *R. Sawyer*, 1892, from the era of competitive dressing.

GOLDEN SQUARE

Begun in 1675, under Sir William Pulteney's lease from the Crown (1668). The plan, with two short approach roads a little way in from the corners on both N and S sides, was probably drawn up by *Wren*. Building was organized by *James Axtell*, *John Emlyn* and (later) *Isaac Symball*. The thirty-nine houses, which had unusually inconsistent elevations, took until *c*. 1706 to complete. The social decline of Soho saw woollen clothmakers setting up shop in several of them by early Victorian times. The present buildings are predominantly early C20 or latest C20.

In the middle is a STATUE of George II in Roman costume set up in 1753, attributed to *John Nost* and said to have been made in the 1720s for Canons, the 1st Duke of Chandos's palace in Middlesex. The pedestal is so low that the king fails to dominate as he should. This might not be so noticeable in a picturesque layout, but in 1952 Golden Square was formalized with raised terraces, alas of Cotswold-type wallings. Urns on pedestals were introduced *c*. 1987.

The most memorable front is in the middle of the N SIDE: Nos. 34–36, *Leonard Stokes*'s only office building, 1913–15 for Messrs Gagnière. A fine façade in a markedly progressive spirit. Entrances l. and r. with open pediments, the staircases above them clearly expressed. The centre has Stokes's typical low, deep arches, and large tripartite windows above with hardly any period motifs. *A. Broadbent* did the lacy carving. Reconstructed by *Harper Mackay*, 1996–7, for M. & C. SAATCHI. Spare, all-white entrance, with a decidedly monumental single-flight staircase to the circulation gallery.

From here the description runs clockwise and selectively. On the E SIDE, Nos. 2–3 are offices of 1913–14 with Wren trim by *R.H. Kerr*, Nos. 5–7 a triple-gabled block of 1995–6 by the *Elsworth Sykes Partnership*, broken up into parts of stone or brick. At No. 10 one of *E.K. Purchase*'s ornate narrow fronts, dated 1908. No. 11, of 1778, was coarsely refronted in 1954. Pretty Adamesque doorcase, probably of *Coade* stone. Graceful interiors: a plaster overmantel showing a vestal (ground floor), first-floor ceiling with oval figure reliefs, staircase with S-scroll balustrade. No. 12, in the SE angle, has populist pseudo-Celtic detailing. By the *Fitzroy Robinson Partnership*, 1995–7. p. 33

The S SIDE is mostly tall gabled Edwardian offices, none of them specially good, but as a group instantly evocative of old Antwerp or Amsterdam. Their particulars are (E to W): No. 13, *W. Woodward*, 1906, extended 1912–13 to No. 14; Nos. 15–16, 1907–8, *Woodward* for Burberry's; No. 17, *Melville S. Ward*, 1902, for the same; No. 18, of stone, 1905; No. 19, *c*. 1923. On the flank of the last in LOWER JOHN STREET, a reset plaque for 'Johns Street' with the date 1685. The adjacent No. 4 appears to be timber-fronted, probably done to reinforce a late C17 brick façade. (Just one room per floor, with the staircase behind the narrower l. bay; small closet in the space behind it.) No. 9, facing (W side), is superior infill by *Trehearne & Norman*, 1988–90. A shallow bow between piers with dark p. 31

channelling, echoing narrow Edwardian fronts, but without pastiche. To the r. of this BERNARD QUARITCH, built 1886 for Holland & Sherry, drapers, by the contractors *Holland & Hannen*. They may have designed the remarkably grand and consistent façade. Fourteen bays, gaunt giant pilasters, tall thin windows.

The W SIDE of the square continues with some older houses. No. 21, *c.* 1684–5, was refaced in the late C18, hence the segment-headed doorcase. No. 22, rocketing above the C18 roof-line, is of 1915 by *Naylor & Sale* of Derby, for a Huddersfield wool firm. No. 23, of 1684, still shows the C17 floorbands and large windows. Added storey and doorcase of *c.* 1820. No. 24, of 1675, was refronted *c.* 1730 and rebuilt behind in 1959. A plaque records the Portuguese Embassy, in residence 1724–47 (*see* also the chapel of Our Lady of the Assumption). Nos. 25–29 are by *Mewès & Davis* for Dormeuil Frères, 1924, big, Portland-faced, and decorous to a fault. Rebuilt inside by the *Halpern Partnership*, 1994, with a skeletal glass-walled atrium with lifts. Nos. 30–31, stretching along Upper John Street, is by *W. Nimmo & Partners*, 1995–2000, grooved stone with upright windows. Little bronze reliefs of film-making below, by *Giles Penny*. Its plan re-creates the short return in the corner, erased in 1929. Finally, back on the N SIDE, Nos. 32–33, also *Nimmo & Partners*, 1987–9. Red brick and stone, contextual, with mostly small-scale Postmodern motifs.

GREAT MARLBOROUGH STREET

A broad commercial street, the N side much rebuilt recently. Developed in 1704, at first between Poland Street, E, and Carnaby Street, W. Extended W in 1736, to the line of Argyll Street, and in 1820, into the new Regent Street. On the S side here the half-timbered building for Liberty's (*see* pp. 456–7).

Facing Liberty's, and hardly more typical of 1920s London, the former IDEAL HOUSE, by the celebrated American architect *Raymond Hood* in collaboration with *Gordon Jeeves*, 1927–9. The client was the National Radiator Co., for whom Hood did a much larger building in New York. Pevsner deplored its showmanship, 'an architectural parallel to the Wurlitzer in music'; but in logic and finish it outshines the mass-market Deco of the 1930s. Black sheer granite facing. For ornament the showroom windows and coved top cornices have the lush floral motifs of the Paris Exhibition of 1925, done in bright champlevé enamels. This decoration of top and bottom, with repeated storeys between, suggests a baby Sullivan-era sky-scraper. Matching N extension of seven bays, 1935–6.

To its E is the flank of the London Palladium, a jumble of low stucco buildings. The l. one is the ravaged lower part of a house of 1750, built for the 3rd Duke of Argyll (cf. Argyll Street) and taken by his mistress. Further on at Nos. 19–21, a former Magistrates' Court and Police Station, 1913–16 by *J. Dixon Butler*. Delicate, free Neo-Georgian in stone, with one

of Butler's characteristic big doorcases. Closed 1998; under conversion to a hotel in 2003. (Three Neoclassical fireplaces inside, kept from the pre-1913 premises, of which two may date from alterations by *Benjamin Latrobe*, 1793.) The triangle of land facing (S SIDE) is confusingly also part of Great Marlborough Street, laid out to join the top of Carnaby Street. Smaller buildings here. On the W side No. 29, the SHAKESPEARE'S HEAD pub, 1928, by *G.G. Macfarlane* for Watney's. Tudorish, with the Bard appearing to look out of a corner window. Facing (E side), Nos. 30–31, altered early C18 houses. Nos. 32–33, 1930, has budget Liberty-style half-timbering. Nos. 34–43 are a representative late C19 mixture running back to the main part of the street, e.g. Nos. 39–43, 1876, Franco-Italianate. At Nos. 44–45 a new building by *Michael Squire & Partners* is under way (2003). Minor *Dunn & Watson* at No. 46, with a crowstepped gable, of 1902. No. 47, *c*. 1710, has a stucco front of *c*. 1830 with bitty classical enrichments. Two Neo-Rococo interiors, perhaps of 1905 by *W.L. Dowton*, when the Royal College of Music was here. No. 48, 1774, plain, was built as 'the Casino', a short-lived assembly room. The modernistic Nos. 49–50 is of 1939, by *Waite & Waite*.*

The late C20 buildings on the N SIDE can be taken in from here at a sweep. Nos. 14–18, two solid buildings by *Hamilton Associates*, were built as one job in 1997–9. One stone-faced, one brick-faced, both finished with a kind of belvedere storey. No. 13, 1988–90 by *Ardin & Brookes & Partners*, has white panelling and green glazing with a corner tourelle. Nos. 10–12, 1990–1 (SONY), is by *Seifert Ltd*. Red brick, posing as symmetrical, but not quite managing it. Nos. 5–9, the back of MARKS & SPENCER'S in Oxford Street (*see* p. 461), is by *Lewis & Hickey*, 1970–2. Abruptly patterned upper storeys, slate in sunk areas, black brick in raised ones, with no legible logic.

GREAT PULTENEY STREET

Laid out *c*. 1718–20 on Sir William Pulteney's estate, replacing narrower, inferior streets of *c*. 1668. At the S end, W side, Nos. 35–40, early C18 three-bay houses. On Nos. 36 and 37 straight-headed doorcases, on No. 38 a late C18 Doric doorcase. The rest is mostly big late C19 warehouses for the wool trade. On the E SIDE Nos. 2–7, built in stages *c*. 1888–91 and united in 1923. Nos. 8–13 (MICROSOFT), offices of *c*. 1963, were refaced by *Harper Mackay* in 1999. Hard and sharp, the windows flush, the unglazed terracotta tiles without visible jointing. Facing it, Nos. 32–34 by *A.E. Hughes*, terracotta-faced, 1904–6, and Nos. 28–31 by *A.E. Hughes & Son*, 1911–12, with a showy centrepiece. No. 23, of 1722, was built by the plasterer *Isaac Mansfield* for himself; refaced *c*. 1780, with a doorway with Gibbs surround. Ionic-pilastered stair-arch, narrow open-well

* Replacing the church of St John the Baptist, 1885, by *A.W. Blomfield*.

stair. It faces Nos. 17–18, a superior warehouse of *c.* 1900. Giant pilasters; small pilasters for window imposts.

GREAT WINDMILL STREET

In 1585 a windmill was recorded N of the line of Coventry Street. The track up to it was built up by Col. Panton after 1671. The S end belongs with Piccadilly Circus, E, and Shaftesbury Avenue, W. N of Shaftesbury Avenue are typical modest Soho houses and their commercial replacements. The process is frozen at Nos. 41–43 (W side), two buildings designed in 1904 by *W. Whiddington* for Fuller & Richard, stationers, sandwiching an older house. Facing (E side), the front of Dr William Hunter's house, built in 1767 by his kinsman *Robert Mylne*. It had five bays, as the surviving cornice shows, and three storeys. At the back were Hunter's celebrated museum and anatomy school. Messily refenestrated in 1888, to make dressing rooms for the Lyric Theatre behind (*see* Shaftesbury Avenue). The WINDMILL THEATRE, N, was built in 1897 and converted to a cinema *c.* 1909, a plausible date for the playful white-faience frontispiece. Squat turrets high up, added in 1931 by *F. Edward Jones*, when it became a theatre famous for nude revues. The RED LION (No. 20), where Marx lectured in 1850–1, was reconstructed in 1866, the likely date of its Italianate front. A detour into ARCHER STREET, r. Nos. 13–14 on its N side are by *Adams & Holden*, 1912, early for this kind of stripped brick Neo-Georgian. Built as clubrooms for the Orchestral Association. Carved figure of Euterpe by *Charles Pibworth*. Nos. 24–25 Great Windmill Street are flats by *R. Sawyer*, 1883–6, outliers of those along Brewer Street (q.v.).

GREEK STREET

Mentioned 1679; named from the Greek church formerly to the E (q.v. St Martin's School of Art). The best houses are from rebuilding in the 1730s–40s.

The greatest house, No. 1 (E side), belongs with Soho Square (q.v.). Its builder *Joseph Pearce* also put up No. 3, *c.* 1744. No. 59 facing, brick with grudging domestic touches, was the SOHO CLUB AND HOME FOR WORKING GIRLS: by *Robert Walker*, 1883–4. Besides lodgings it provided entertainment and evening classes. Of the early 1730s No. 58, and (E side) Nos. 6 and 8. Between these the PILLARS OF HERCULES, 1935 by *J.S. Quilter & Son*, a half-timbered pub with a carriageway into MANETTE STREET. On the N side there, after the surprise of No. 1's chapel, the former St Anne's parish workhouse, 1770–1 by *James Paine*. Five bays, top storey of 1804, probably also the porch and stucco. Nos. 12–13 Greek Street began *c.* 1684 as one seven-bay house, subdivided in the C19, and stuccoed after 1914. Remodelled in 1982–4 by *APT*, who converted to offices a tight close of warehouses of 1873 behind

(by *Lee Bros & Pain*). Its name, WEDGWOOD MEWS, recalls Josiah Wedgwood, whose showroom occupied the houses 1774–95. No. 14, also late C17, has pilasters and pediments of *c.* 1919, when the St James and Soho Club moved in; one of the earliest London working men's clubs (1864).

Opposite (w side), No. 51, 1734, and the more individual No. 50, 1736 (builder *William Frith*), with an arched centre window, cornice and pilastered Roman Doric doorcase. No. 48, over-painted and easily overlooked, is of 1741–2. Since *c.* 1900 L'ESCARGOT: a relief shows the first restaurateur, M. Gaudin, riding a snail. Compact open-well staircase, with pilastered entrance arch and turned balusters. First-floor saloon with a good emergent-Rococo stucco ceiling. Facing (E side), four diverting SHOPFRONTS. No. 17, rebuilt 1971, retains an early C19 double-width example, perhaps of 1824 and for Michael Tijou, carver and gilder. On No. 18, early C19, a naïve round-arched Gothic front, probably of 1862–3 by *A.H. Morant*. At No. 20, built for the colourmen Hopkins & Purvis in 1842, the iron hoist survives in front. No. 21, also early C19, has a shopfront with elongated Ionic columns.

At the SE corner with Old Compton Street, the THREE GREYHOUNDS, another Shakespeare's-England pub (1924 by *W.F. Foster*). No. 29 is the COACH AND HORSES, apparently *c.* 1840, with odd columns of 1889 on the pub front. On the w side, altered houses of *c.* 1735 flank ROMILLY STREET. On the N corner, Nos. 37–39a, part of KETTNER'S: Soho's longest established restaurant (1868), which expanded from No. 29 Romilly Street. In its Greek Street rooms Louis XV decoration, probably of *c.* 1895. Romilly Street was laid out (as Church Street) *c.* 1678. For the part w of Frith Street *see* that entry.

HAYMARKET

An ancient lane that became the parish boundary between St James's, w, and St Martin-in-the-Fields, E. The hay market itself came about in the mid C17 to serve the Royal Mews on the site of Trafalgar Square (*see* p. 372). It moved to a site just E of Regent's Park in 1830. From 1663 to 1688 there was also a live-stock market, which removed to what later became Curzon Street (*see* p. 517). It was during this period of the C17 that the street was first built up. Important changes were made by *Nash* after 1813, to tie in with Regent Street, w, and Suffolk Street, E. Now a pocket compendium of West End types: Georgian houses, Nash stucco, theatres, cinemas, a department store and C19–C20 offices. The sides are treated separately and from N to S.

W SIDE. The N end belongs with Piccadilly Circus, p. 451. S of Jermyn Street an autonomous stone-faced block built as the Capitol, an early *Andrew Mather* cinema, 1922–4. It originally had a strange urn-topped corner tower. Reconstructed 1936–7, 1962, and again 1998–9, when the cinema closed.

Now down ST JAMES'S MARKET for No. 1 (S side), of 1907 for the builders Styles & Son. By *Treadwell & Martin*, but very

subfusc for them. The street commemorates the market built in 1663–6 to serve St James's Square and hinterland (*see* p. 582), rebuilt under *Nash* in 1817–18, and levelled in 1916.

Back to the Haymarket. Nos. 52–54 are by *T.S. Darbyshire*, in the rebuilt Regent Street manner. Designed 1922, built 1926. FINLAND HOUSE (No. 56), 1958 by *Pekka Saarema* with *K. Wakeford, Jarram & Harris*, and the bigger ST ALBAN'S HOUSE (Nos. 57–61), by *Lewis Solomon, Kaye & Partners*, 1962–7, are nothing special. The UGC HAYMARKET is by *Frank Verity* and *Sam Beverley*, built as the Carlton Theatre in 1926–7. A flat, even façade, disfigured by signage. Designed as a ciné-theatre; in 1977–9 reconstructed as a triple-screen cinema, with an office block in place of the former back stage. The long Adamesque foyer survives, and the heavy ceiling in Screen 1. Nos. 66–71 next door is again of the Regent Street kind, of 1914–15 by Messrs *Tanner* for the Crown Estate, with squared-off pilaster capitals.

HER MAJESTY'S THEATRE, of 1896–7, forms the S corner with Charles II Street. Designed by *C.J. Phipps* – his last work, largely delegated to *W.H. Romaine-Walker* – for the spectacular productions of Sir Herbert Beerbohm Tree. Internally and externally it is several cuts above the typical Late Victorian London theatre. A big broad French Renaissance front with lots of small windows and busy motifs. In the middle a square pavilion roof. Tree himself lived and entertained within the floors beneath its dome; a plaque to him is on the N front, 1919 by *Romaine-Walker*. Until 1957 and the demolition of the Carlton Hotel, the elevation continued as one huge symmetrical front down to Pall Mall.* Pretty Neo-Jacobean foyer. Two-galleried auditorium, an enlarged version of that at Phipps's Lyric, Shaftesbury Avenue. Louis XVI style, modified 1914 by *Romaine-Walker & Jenkins*. Some details after Gabriel's Opera at Versailles, e.g. Corinthian columns framing the boxes. Coffered proscenium arch; on the side walls pilasters and blind arcading. Pie-slice-shaped ceiling paintings by *Charles Harker*, 1914. (Exceptionally complete wooden stage machinery.) Basement bar panelled in polished wood, possibly from alterations of 1930–1 by *E. Schaufelberg*.

Behind the theatre runs the ROYAL OPERA ARCADE, with an inconspicuous stucco front to Charles II Street, N. It is of 1816–18, the first true shopping arcade in Britain, designed in the Parisian mode by *Nash* and *G.S. Repton*. Doric pilasters define the bays, which have small groin vaults with glazed circular piercings for light and ventilation. Big lamps on wrought-iron cross-throws, for shopping after sundown. The shops have flat fronts and convex sides, and lunettes to little upper offices. The stone portals must represent a rebuilding to the Nash design in 1896–8. Shops were made on the E side only in 1963, as part of New Zealand House (*see* below).

Before 1896, this side had an entrance to the PREVIOUS THEATRES on the site, which is holy ground for the English

* The hotel opened in 1899. *Isaacs & Florence* worked out the design, with advice from César Ritz. Some interiors by *Mewès & Davis*, their first London commission.

stage. The playwright-impresario-architect *Sir John Vanbrugh* designed and promoted the first, in 1704–5. Its modest Haymarket front belied an architecturally impressive (but at first acoustically disastrous) interior. It featured operas and also masquerades, for which a special 'long room' was provided. There followed alterations in 1778 and (by *M. Novosielski*) in 1782, fire in 1789, and reconstruction in 1790–4 again by *Novosielski*. He introduced the horseshoe-shaped auditorium to Britain, keeping the feature of a separate assembly room. In this incarnation it was the second biggest theatre in Europe, albeit unfinished externally (*Thomas Leverton*'s façade, designed 1796, was never completed). A satisfactory treatment came only with *Nash* and *Repton*'s magnificent encasement of 1816–18. Besides the shopping arcade it had open colonnades or arcades on all three outer sides. Finally *Lee, Sons & Pain* reconstructed the theatre in 1868–9, after another fire.

Then at the W corner of Haymarket and Pall Mall NEW ZEALAND HOUSE, by *Robert Matthew, Johnson-Marshall & Partners*, 1957–63 (engineers *Scott Wilson Kirkpatrick & Partners*). A good example of the post-war formula for office buildings with a tower riding above a stretched-out podium, which here tempers the impact on this sensitive site but falls short of making a satisfactory street-level environment. The structure is of reinforced concrete. Lower range of four floors, tower another fifteen (total height 255 ft, 68.6 metres). This has distinctive thin projecting floor strings and a solid top. Glazing from floor to ceiling, of unusual size for the date. Ground floor and mezzanine are recessed, with stainless-steel-clad pilotis to the oversailing floors. Black Belgian marble facing to the lower walls, Portland above. At the entrance towards the Haymarket a far-projecting cantilevered canopy. A charming feature is the planted court at third-floor level, visible through the building on the Pall Mall side. By the main entrance are glass panels engraved on New Zealand themes by *John Hutton*, 1963. The ENTRANCE HALL is a free-flowing space, adventurous but not quite exhilarating. The tower comes down as a grey marble-faced core, around which the lower floors are wrapped. Slatted wood ceiling; stairs to a mezzanine gallery. Also a timber Maori Pillar called Poihi, carved by *Inia Te Wiata*, 1972.

p. 416

E SIDE. First Nos. 33–34, houses of *c.* 1741, with at No. 34 the oldest shopfront known to survive in London. Until the 1970s it was Messrs Fribourg & Treyer, tobacconists, and still bears their insignia. The date may be 1751, when Fribourg moved in. Twin bows, of a depth proscribed by the 1774 Building Act. Radial fanlights and bracketed hoods to shop door and house door. Inside, some C18 shelving and a delicate Adamish screen. HAYMARKET HOUSE (Nos. 28–29), by *Stone, Toms & Partners*, begun in 1939 but finished in 1954–5, looks like a pre-war design. SCULPTURE on the front by *Jane Ackroyd*, 1992, Moonlight Ramble, a spiralling chromed assemblage. Nos. 26–27, pompous but well-detailed offices of 1913 with square angle towers, by *Leonard Martin*. After Panton Street, Nos. 22–24, typically diverse fronts of 1877–8, show the smaller scale of Victorian commerce (No. 22, r., by *William Wimble*).

New Zealand House, Haymarket. Axonometric drawing
(D. Stephen, K. Frampton & M. Carapetian,
British Buildings 1960–1964, 1965)

At Nos. 18–22 is BURBERRY'S, by *Walter Cave*, 1911–13. An
unhackneyed design. Ground floor with Tuscan columns and
straight entablature; above, giant Ionic columns and arches.
All between is recessed steel framing, showing the influence
of the new Selfridge's. One stone dormer per bay. Until
1998, when an all-white scheme was imposed, the INTERIOR
retained much of Cave's limed-oak finishes. The staircase
wraps octagonally around the lift shaft. Used for offices since
2000. Nos. 11–12, 1907–8 by *F.M. Elgood*, was built as offices
for the whisky distillers Dewars, hence the Scotch-baronial

tourelle and Aberdeen granite facing. Marble-lined office like a banking hall, with a bronze frieze and barley-ear motifs in the decoration. Further on, the THEATRE ROYAL has a stucco front by *Nash*, 1820–1, facing down the extended Charles II Street, towards St James's Square. A composition at once imposing and slapdash. Portico of six Corinthian columns and pediment. Tall attic with a long panel of nine circular windows, treated as little cast-iron wheels. Two more such lights further down on either side, one above the other, and another in the pediment. The back faces Suffolk Street (No. 19 there). Its five large round-headed windows give on to the back stage: a feature which theatre experts call unique. Extremely tall rusticated doorway, for scenery. Oval-windowed attic. The auditorium was reconstructed by *S.D. Adshead* for *Stanley Peach*, 1904–5 (replacing an interior by *C.J. Phipps*, 1879–80, with the first 'picture frame' stage). The result is gorgeous, in a superior Louis XV style, well proportioned and with much gold and dark wood. Ceiling paintings by *Harker*. Restored by *John Rowe-Parr*, 1994. The theatre was founded in 1720 just to the N, and enlarged 1767. Next door No. 7, a little Nash-era front of *c.* 1823, survivor of three. Nos. 5–6 is a blowsy pilastered job by *Archer & Green*, 1883–4, for Arthur Tooth & Sons, art dealers. Heads on the front of Reynolds, Turner, Flaxman and Landseer. For buildings further S *see* Suffolk Street.

IRVING STREET

The SE exit from Leicester Square; made in connection with it, 1670. Widened on the N side in 1895–7, the date of Nos. 1–8, routine red brick by *G.D. Martin*. More variety opposite: No. 21, 1856, a Parisian effort in crimson brick; No. 20, flat-topped North Italian Gothic of 1875 (*A. Wilson, Son & Aldwinckle*); Nos. 11–13, differently gabled, by *Saville & Martin*, 1891–2.

KINGLY STREET

In origin a footpath between Piccadilly and Marylebone, built up from 1686. The W side is all backs of buildings on Regent Street. The first houses were replaced in the 1720s. Of this time Nos. 1, 2, 7–11 and 19 on the E side, most with C19 stucco embellishments. At Nos. 9–11 these form a single composition of *c.* 1830, with giant Grecian pilasters linked by segmental arches. Nos. 12–13, 1887 by *Lansdown & Harriss*, is like a stray from Marylebone, with shaped gables and carved red brick and sandstone. It was the vicarage of St Thomas, which stood opposite until 1973.* The coloured brick offices on its site

*This was a plain affair of 1702, remodelled *c.* 1822 by *Thomas Hardwick* (inside) and *C.R. Cockerell* (W end). The latter, demolished *c.* 1903, fronted Regent Street.

are by *Chapman Taylor Partners*, 1991–4 (BARTLE BOGLE HEGARTY). SCULPTURE of a black sheep on the front by *Martin Cooper*. Further up on the S corner with Ganton Street, a warehouse and tailor's shop by *Banister Fletcher & Sons*, 1912. Cast lead-panelled spandrels mask its concrete floors. The N corner is the BLUE POSTS, 1892, an amateurish pub by *Cox Dear*. Another pub at No. 33, THE CLACHAN, vulgar and prosperous, dated 1898. For Liberty's buildings, *see* pp. 456–7.

LEICESTER SQUARE

Leicester Square, beloved by tourists, was originally Leicester Fields. It was laid out in 1670 by Robert Sidney, 2nd Earl of Leicester, in front of Leicester House, a double-pile hipped-roofed mansion built by the 1st Earl in 1631–5. This stood some way back and off-centre, at the NE. Thus it failed to command the whole, which is of markedly irregular shape. The ordinary houses were also more modest than in, say, St James's Square. Leicester House was pulled down *c.* 1791, and Leicester Place made across its site. Socially the square went steeply downhill after 1844–5, when traffic began streaming through from the widened Cranbourn Street, E (*see* p. 344), and the extended Coventry Street, W (q.v.). Hotels and entertainment venues began taking over, of which *Robert Abraham*'s GREAT GLOBE occupied the gardens in 1851–62, a Pantheon-like exterior enclosing a giant sphere modelled with a relief map of the world. A covered market (by *Hawkshaw & Barry*) was mooted for the derelict site in 1871, but the garden was rehabilitated instead. The great variety theatres gave way between the wars to the giant cinemas which now dominate the square.

The GARDEN, first enclosed *c.* 1720–5, was replanned in 1989–92 by *P.T. Nicholls* (*Design Research Unit*) on a diagonal cross plan with LAMP-POSTS of Victorian pattern. The C19 layout was by *James Knowles Jun.*, 1874, done after the fake Baron Grant bought the land for the public. Knowles designed the centrepiece, the SHAKESPEARE MONUMENT, the most unpretentious that a capital has ever put up to the greatest national poet. *G. Fontana* carved the statue, a copy of *Scheemakers*'s in Westminster Abbey (*see* p. 168). Also of 1874 four bedraggled BUSTS in the corners: Hunter by *T. Woolner*, SE, Newton by *W. Calder Marshall*, SW, Reynolds by *H. Weekes*, NW, Hogarth by *J. Durham*, NE. The little STATUE of Charlie Chaplin is by *John Doubleday*, 1981. In 1989–92 also a paved area for street theatre was made to the N, a big stone KIOSK for theatre tickets to the S (by *APT*), set above a huge underground electricity substation.

The buildings around are a discrepant, uneasy lot, vacillating between English, Continental and American. Starting on the E SIDE, S end, CAPITAL RADIO (Nos. 29–30), a refronting in Neo-International Modern by *Rolfe Judd Planning*, 1996–7, of offices of 1953–4. No. 28, tall and gabled, is by *J.P. Crosby*, 1901. Then the ODEON, 1937 by *Mather & Weedon*, black

granite, showily austere with a big square tower on one side. The outlines of the Odeon house style show up despite the lack of the usual yellow tile facing; *Thomas Braddock*, of Mather's office, has been credited with making the difference. Matching s extension 1989–90, by *Glyn Miller*. Entrance remodelled 1998–9 by *Stephen Limbrick Associates*, who also re-created some of the magnificent Art Deco reliefs in the auditorium (by *Raymond Britton Riviere*), destroyed in 1967. On the site was the once-celebrated Alhambra Theatre; its minareted final incarnation, 1883 by *Perry & Reed*, replaced a no less Moorish adaptation of *T.H. Lewis*'s failed 'Panopticon of Science and Art' (1851–4). Nos. 17–18, with a convex glazed front (altered), was the Samuel Whitbread, one of the very few post-war pubs in the West End. By *T.P. Bennett & Son*, 1956–8, something of a showpiece for Whitbread & Co.

N SIDE. Just E of the square, in Cranbourn Street, the WARNER WEST END, 1938 by *E.A. Stone* and *T.R. Somerford*, wildly modernistic, with an angular middle pylon set back against a concave façade. Much fluting; Expressionistic reliefs (Sight and Sound) by *Bainbridge Copnall*. Rebuilt behind 1991–3 by *HGP Greenchurch Allchurch Evans*, who cut a cylindrical glazed stair-tower into the angle. Banal new interior. Nos. 10–15, VICTORY HOUSE, terracotta in the busy and familiar Collcutt style, built as the Hôtel de l'Europe by *Walter Emden*, 1898–9. QUEEN'S HOUSE, of a rich commercial Late Victorian Baroque by *Saville & Martin*, 1897–9, was also formerly a hotel. Rebuilt behind by *MAP Architects*, 1985, with a maladroit Postmodern flank to Leicester Place. The EMPIRE cinema was built for MGM in 1927–8, by *Thomas W. Lamb* of New York, with *F.G.M. Chancellor* of *Frank Matcham & Co*. The Cinquecento front with its giant Venetian motif was repeated from Lamb's Albee Theatre, Cincinnati, 1927. Lamb's huge and luxurious interior (3,226 seats) was rebuilt in 1962 and further subdivided in 1989. The previous Empire, a famous variety theatre, was upgraded from an unsuccessful panorama house of 1880, and reconstructed in 1904 by *Frank Verity*. Verity's w flank wall remains in Leicester Street, just N of Nos. 1–6. This is of the anonymous streamlined idiom, band upon band round a round corner: by *Wimperis, Simpson & Guthrie*, 1937. Remodelled by *Rolfe Judd*, 1998–9, with a giant video screen.

Across Leicester Street, just outside the square proper, the SWISS CENTRE, by *David du R. Aberdeen & Partners*, 1961–6 (future uncertain), a stocky office tower on a two-storey podium with rounded corners. Above one of these a circular pavilion with conical roof, adapted for cinema use in 1973. On the front a CARILLON with animated Helvetic figures carved by *Fritz Fuchs*, 1968 (altered 1985). In the pedestrianized street in front an 'antique Swiss inn sign', presented 1977.

The w SIDE is FANUM HOUSE, built for the Automobile Association to one design by *Andrew Mather*: N part 1923–6, centre 1936–7, s part 1956–9. Giant order, big attic, big mansard, all somewhat overstretched. On the s SIDE the ODEON WEST END, also by *Mather*, 1929–30 (built as the Leicester Square Theatre, a dual-purpose house). Heavy white faience, without

the conviction of its rivals here. Interior reconstructed 1968
and 1991. The HAMPSHIRE HOTEL, Nos. 31–36, opened in
1990 in the brick and yellow stone shell of the Royal Dental
Hospital, 1899–1901 by *Young & Hall*.

LEXINGTON STREET

Narrow, atmospheric, but architecturally basic. Victorian and
C20 warehouses in the long s part, houses mostly of 1718–19
at the N end, replacing the first generation of the 1670s–80s.
On the w side here, Nos. 43–53, with a good run of modest
C19 shopfronts, some with early C18 segment-headed windows
above. The similar Nos. 44–46 (E side) are a study in pleasing
decay, carefully kept up by ANDREW EDWARDS, printseller.
In the s part No. 10 (E side), 1876–8, grim polychrome brick.
LEXINGTON HOUSE next door, *c.* 1960 commercial, was
adapted by *David Chipperfield* in 1995–6 for WAGAMAMA's
restaurant. A frosted bottle-glass screen conceals queueing
customers, who overlook the kitchens through an internal
window. The dining basement uses mixed materials, polished
red marble piers, wood linings, and blocks of painted colour.

LISLE STREET

The w part was formed in 1682–3 on part of the gardens of
Leicester House (*see* Leicester Square); in the early 1790s
extended E, across the rest. Of this date Nos. 14–27, a whole
uniform terrace on the N side. No. 18, with a pediment and a
date plaque 1791, faces into Leicester Square down Leicester
Place. Its Roman-cement dressings are mostly lost, as are the
top balustrade and stretches of the shared cornice. Several
Neo-Georgian shopfronts from restoration by the *GLC Archi-
tect's Department, c.* 1984. At Nos. 34–35, s side, also *c.* 1791,
the gently bowed shopfronts are original. Next to them the
PRINCE CHARLES CINEMA, converted in 1968 from an
integral theatre and office block by *Carl Fisher & Associates*,
1961–2. Stone frame, mosaic stone infill. Further w on the N
side No. 5, 1897 by *Frank Verity*. A rare brand of Northern
Renaissance, with a big stepped gable after the Meat Hall at
Haarlem.

MARSHALL STREET

Laid out in 1733 for the 3rd Lord Craven, on land used to bury
victims of the Great Plague. At the N end is a small municipal
cluster, part of a group once including the workhouse (*see*
Poland Street). For the swimming baths q.v., Public Buildings.
No. 19, dated 1894, like a big gabled gatehouse, was the office
of the workhouse guardians. Probably designed by *J. Waldram
& Son*, surveyors. Upper parts prettily reconstructed behind

for the Soho Housing Association by *CGHP Architects*, 1990. To its N are City of Westminster employees' flats of 1906 by *Joseph & Smithem*. Art Nouveau window-box grilles.

The small houses on the w side belong with the group of 1820–5 E of Carnaby Street (q.v.). To their N the former CRAVEN CHAPEL (Congregational), of 1821–2 by *Robert Abraham*, with a pattern of superimposed windows. Much altered for commerce in 1930, etc. It makes the corner with FOUBERT'S PLACE, a cross-street named from Henry Foubert's riding school, operative here *c.* 1710–78. On its N side is the chapel's former school (Nos. 41–43), by *R.H. Burden*, 1873. Polychrome Gothic, with quatrefoil balconies and much cogged brick. Infants', girls' and boys' storeys were superimposed (the girls' school doubling as a hall), above vaults for rent. To its l. a warehouse of *c.* 1890 (Nos. 33–39), with big foliage pilaster capitals. No. 28 (s side), lean grey brick Gothic, is another former school, probably of 1871.

Further s in Marshall Street, Nos. 1–2 (E side), later C19 warehouses remodelled by *Hawkins/Brown*, 1991, with a glazed bow in the old party wall.

MEARD STREET

Created by the carpenter *John Meard Jun.*, 1722–33, replacing two C17 courts. His houses survive remarkably intact, making this one of the most rewarding of all Soho streets. Meard began at the Wardour Street end, w, in 1722. His Nos. 13–21 here, s side, are of three bays and storeys, with simple Tuscan doorcases. Their counterparts opposite went for the tall and harsh ROYALTY MANSIONS, tailors' flats and workshops of 1908 by *H.A. Woodington*. In 1732–3 Meard tackled the Dean Street end, E (*see* also his Nos. 67–70 there). Here Nos. 2–6, N side, and Nos. 1–7, s, have a full four storeys. Doorcases with fine carved console brackets, twinned at Nos. 3 and 5. Pulling down the property between the courts made room for four more houses, of which Nos. 9 and 11 remain, stepped out on the s side. They have three storeys and (at No. 11) a bracketed rather than pilastered doorcase. All the houses have or had straight window heads and good rubbed brick dressings. Some ground floors have been stuccoed or given shopfronts. Those on Nos. 4 and 6 are replacements of the 1980s. Panelled INTERIORS, with closet wings and pilastered openings to timber dog-leg staircases with open strings: nothing unusual, but exceptionally numerous and consistent.

NEWPORT COURT

Part of *Barbon*'s development of the site of Newport House (1627), which he bought in 1682. Its focus, a large market square, was erased *c.* 1882 to make Charing Cross Road. Some modest houses above shops remain. Nos. 21–24a, s side,

41

p. 28

c. 1688, have segment-headed flush-framed windows tied by key blocks into brick bands. No. 19, l., is also late C17. Of the 1770s–80s Nos. 18, 20, and 25–27, Nos. 2–8 in NEWPORT PLACE, round the r. corner, and the less well-preserved houses on the N side of LITTLE NEWPORT STREET, S.

OLD COMPTON STREET

Built up 1677–83, chiefly by *Richard Frith* and *William Pym* (cf. Frith Street). In the C18 and C19 a French enclave, and the chief Soho shopping street; by the late C20 a byword for the 'pink pound'. Architecturally it is the usual Soho muddle. From E to w: No. 63, S side, and No. 68, N, are refaced 1730s houses. Opposite No. 68, the former Swiss Hotel (Nos. 51–53), 1890 by *W.A. Williams & Hopton*, ornate, but mutilated above. On the w corner with Dean Street, N side, stuccoed Italianate offices by *A.H. Morant*, 1862. Further E on the S side, Nos. 37 and 27–33, three-bay 1720s houses, rather mauled. They face Nos. 38–42, handsomely classicized probably by *David Mocatta*, 1846. Nos. 19 and 21 on the S side are of *c.* 1785, Nos. 13–17 probably refaced late C17, with one blind half-bay.

The PRINCE EDWARD THEATRE on the N side here is by *E.A. Stone*, 1929–30 (interiors by *Marc-Henri & Laverdet*). Seven bays, the middle recessed, with square Doric piers. Round arches below. Plum-coloured brick, with tile courses instead of stone dressings. Spanish-colonial attic shutters were added in refurbishment for Cameron Mackintosh by *RHWL Partnership*, 1992–3. Circular entrance, with oval foyer above. (Large Art Deco auditorium, built as a ciné-theatre; sympathetically remodelled 1992–3.) The acute corner with Moor Street, S side, is by *C.H. Worley*, *c.* 1904, like his explosively Baroque No. 99a Charing Cross Road beyond. MOOR STREET, not long, has houses mostly of 1734–8. Back in Old Compton Street, some late C17 survivors: Nos. 4 and 6, N side, and No. 5, S, with the conservative feature of a central chimneystack.

ORANGE STREET

A wavering composite of three older streets. The w part probably belonged with Col. Panton's development of 1671 (*see* Panton Street). It used to be called James Street, see the refixed cartouche dated 1673 on Nos. 2–6, S side. Nos. 10–12, with Postmodern canted oriels, and Nos. 14–18, with half-cylindrical ones, offices respectively by *Lyons & Sleeman & Hoare*, 1991–2, and *Scott, Brownrigg & Turner*, 1988–90. The latter incorporates the shell of No. 20, plain early C19, on the corner with Whitcomb Street. The route E of here was laid out in two stages *c.* 1692–6. On the NE corner the HAND AND RACQUET, a nice solid pub dated 1865. On the S side No. 30, an islanded period piece by *Charles Pike & Partners*, 1967–70. Not aligned with the street, the upper block (now a hotel) not aligned with the

office podium, and much splaying and chamfering of details. Then mostly public buildings: on the N side the Reference Library and Orange Street Chapel (qq.v.), on the S side the National Gallery and National Portrait Gallery (pp. 305–11). The ARCHIVE BUILDING for the latter on the N side, 1990–2, is by *Grimley J.R. Eve* (*Stanton Williams*'s plan for new galleries here was abandoned as too expensive). Its W part, ending in big channelled aedicules, is a reused façade by *H. Goslett*, 1914–15, for Ciro's dining club. M. Ciro's once-celebrated restaurants began in Monte Carlo; an English syndicate built this club using his name. The new part has a central entrance, scooped in and glazed. Ciro's replaced public baths of 1847–9, thought to have been the first erected under the 1846–7 Acts.

PANTON STREET

Laid out by the disreputable Col. Panton after 1671, with Oxendon Street (cf. Orange Street). *Wren* oversaw the plan, paving and drainage. On the S side, Nos. 5 and 6 are of *c.* 1673, heightened and with C19 embellishments. The COMEDY THEATRE next door is by *T. Verity*, of 1881, i.e. before the theatre boom from *c.* 1890. Provincial-looking front, with an applied portico. Verity's progressive plan, avoiding corridors, was lost in reconstructions of 1911 and 1933. The auditorium retains Verity's circular dome and three horseshoe tiers on slender iron columns, the lower two (altered 1955) continued as boxes. Loosely late C18 style. Then a large drab development by *Oscar Garry & Partners*, 1962–4, with a slab of flats and a garage at the back. Panton Street offices converted for a cinema 1969. It faces the rebuilt STONE'S CHOP HOUSE, N, one of *Richardson & Houfe*'s Neo-Georgian rearguard actions, 1961–3 (design 1955). The canted ends, spindly first-floor balusters, windowed cornice and set-back copper attic are their hallmarks. Mr Stone established his hotel *c.* 1778.
In OXENDON STREET to the N, No. 8 is structurally late C17 but the mid-C18-style front is *N.J. Aslan*'s, done for himself 1958.

POLAND STREET

In origin a long narrow field called Little Gelding's Close, developed after 1689 by James Pollett, with land to the E and SE. Named from the King of Poland inn, formerly at the N end. Houses were built mostly in 1705–7, e.g. No. 62, the STAR & GARTER, externally appearing early C19 (S end, W side). Nos. 58–59, 1996–8 by *Goddard Manton Partnership*, has a slim glazed bow on a tilted stone prop. Opposite (E side), Nos. 1–5, a nicely logical range by *Bartlett & Ross*, 1902–3. Built for L'Acre, who made motorized delivery tricycles. Six divisions, each with a segment-headed showroom window and triple windows over. Delicately carved cornices and uprights. Of 1705–6 No. 54, W side, with a blind half-bay, and No. 7

diagonally opposite, refronted, with a Late Georgian fanlight. On the w side at Nos. 49–51 the entrance to the POLAND STREET CAR PARK of *c.* 1934. Its N wall, on which blocked windows appear internally, is a relic of St James's Workhouse: specifically, of *Charles Lee*'s female infirmary wing, 1858–9.

RUPERT STREET

Built shortly after 1676, in part by *Barbon*. Bisected by Shaftesbury Avenue in the 1880s. The s part has the Trocadero block on its w side (*see* Coventry Street), with mostly C18–C19 buildings facing it. The finest is Nos. 14–16, the former Gambarinus restaurant, by *Shoebridge & Rising*, 1898, less conspicuous but better preserved than the big dining houses on Coventry Street. Late Low Countries Gothic, gabled and elaborately carved, the lowest stages of polished black stone. Nos. 22–28 belong with Nos. 27–31 Wardour Street behind (q.v.), of 1728, but have been refronted and generally much altered. CAFÉ FISH (Nos. 34–40), later C19, has an intrepid interior by *Mackenzie Wheeler*, 1998: double-height space, partition like a great rusted ship's wall. N of Shaftesbury Avenue mostly gritty C19 flats. ARCHER STREET CHAMBERS, w side, 1881–3, like a Peabody block – except that Peabody's never included a pub.

SHAFTESBURY AVENUE

Cut through 1884–6 between Piccadilly Circus, sw, and New Oxford Street, NE. The Act to make it passed in 1877, but the need to rehouse those displaced delayed work. The same weak picturesque brick architecture prevails as in its counterpart, Charing Cross Road (q.v.), with which it intersects at Cambridge Circus. From there the road runs on into the Borough of Camden (*see London 4: North*). The Westminster section has extra interest for its sequence of five theatres on the N side.

Coming from Piccadilly Circus, facing the London Pavilion, the NW side has PICCADILLY MANSIONS, 1888–9 by *Martin & Purchase*, 'elaborate but totally uninspired' (*Survey of London*). Its close rhythms are taken up by *Powell Moya & Partners*' NATWEST, 1979–82, with curved glazed bows looking unhappy in the pick-hammered concrete frame. On the SE side the back of the TROCADERO complex (*see* Coventry Street), here also with both new and retained façades. The sandstone Northern Mannerist front to Great Windmill Street, r., is the original Trocadero restaurant, successor to the famous music hall: by *J. Hatchard-Smith* and *W. J. Ancell* for J. Lyons & Co., 1895–6, too early for their white-glazed 'house style'. Then the front of Avenue Mansions, 1888–9, turret-and-gable stuff by *Wylson & Long*, and a section by *Proun Architects*, 1999, replacing a disastrously heavy range by the *Fitzroy Robinson Partnership*, 1982–4, of the first phase of the conversion. Brick end

stops, studded metal piers and much glazing between, and an
aerofoil canopy. More mansion flats of 1889 at the corner with
Rupert Street (by *H. W. Rising*).

Opposite (NW SIDE), set back at an angle, the ST JAMES'S
TAVERN, 1896 by *W.M. Brutton*. Quite grand, with a tourelle,
and *Doulton*'s tile pictures of Falstaff inside. The Cityish
Nos. 25–27 are by *Joseph & Smithem*, 1888. Then the LYRIC p.
THEATRE, 1888 by *C.J. Phipps*, hardly different from the 71
ordinary street frontages. Good Art Deco mirrored foyer,
bars, etc., by *Michael Rosenauer*, 1932. Phipps's auditorium has
his usual circular ceiling, and three balconies with boxes in
the returns, prettily decorated in late C18 Anglo-French style.
Much stronger is the APOLLO THEATRE of 1900–1, the only p.
theatre by *Lewen Sharp*. Of stone, Neo-Baroque in a Central 71
European way, with corner erections with over-life-size angels
by *T. Simpson*. (Exceptionally rich Rococo interior, designed 96
with *H. van Hooydonk*, with three cantilever balconies.) Of the
same date the former restaurant, r., also *Sharp*'s.

Across Rupert Street a complete block all by *W.G.R. Sprague*,
1905–7, including the Gielgud Theatre, l., and Queen's
Theatre, r. (refronted). The developer was Jack Jacobus, whose
shoe-selling business was housed at Nos. 39–45, the grand
pilastered block between. The GIELGUD THEATRE (the Globe
until 1994) has a buttressed Baroque angle dome and circular
windows high up. Louis XVI interior: foyer with delightful oval
gallery. (Part-circular auditorium, with giant pilasters by the
stage.) At the QUEEN'S THEATRE *Westwood, Sons & Partners*
redid the war-damaged exterior in 1957–9. Rounded corner;
glass, mosaic and black brick. *Sir Hugh Casson* collaborated on
the new foyer. Sprague's Cinquecento auditorium is largely
intact, with an oval dome set side-on.

In the facing block (SE side) a long stretch of 1888–9. Nos. 58
and 60, minor works by *Thomas Harris*, Free Style. Of what
follows *Martin & Purchase*'s Nos. 66–86 and Nos. 90–98 are
the nadir, *J. Hartnell*'s Nos. 100–112, of carved brick, the
highlight. Opposite (NW side), Nos. 55–63, a plain pilastered
furniture warehouse of *c.* 1873, from the former King Street,
which was subsumed into the new route. Nos. 75–77, 1905 by
E.K. Purchase, has square bays and an arched mezzanine.
These set a rather obvious rhythm for Nos. 79–91, *GMW
Partnership*'s offices of 1984–5. No such contextualism at
WINGATE HOUSE, a long office block and cinema by *H.G.
Hammond* of *Burnet, Tait & Partners*, 1957–9. Stone frame with
brick infilling. The first floor treated differently, as so often.
Glazed top canopy. In the basement a cinema (CURZON
SOHO), in 1998 remodelled by *Robin Moore Ede* with *Panter
Hudspith*, with unusually generous circulation spaces. The
graceless brick mass facing (S side) is by *Seifert & Partners*,
1981–4. Palliative oriels; a visually unsupported tourelle, r.,
marks a FIRE STATION. Next to it the manse of the former
Welsh Presbyterian Church (q.v.).

CAMBRIDGE CIRCUS is split by roads into seven unequal slices.
The finest by far is the concave-fronted PALACE THEATRE,
on the N corner with Shaftesbury Avenue. Built for Richard

D'Oyly Carte, 1888–91, to designs by the builder *G.H. Holloway* and the architect *T.E. Collcutt* – the same team as at D'Oyly Carte's Savoy – with *J.G. Buckle* as consultant on the theatre workings. Externally it is typical of Collcutt's middle period. Loire style, with octagonal turrets in two sizes, but otherwise in fairly low relief. The materials are red Ellistown brick and *Doulton*'s pink terracotta, intricately modelled by *Walter Smith* (exterior restored by *Jaques Muir* for Andrew Lloyd Webber, 1988–9). Built as a full-scale opera house, so the interior too is exceptionally fine. Rich marble open-well staircase. Thrillingly atmospheric interior, thickly crusted with Northern Renaissance decoration in sombre brown hues. Three cantilevered tiers, the greatest display of the technique in a British theatre to that date. The uppermost was given a serpentine front by *Emblin Walker*, 1908. At the back of the stalls a tunnel-vaulted lobby with strapwork. (Some stage machinery from the unique system devised for D'Oyly Carte by *Walter Dando*, of mixed wood and iron.) Going on clockwise, the SPICE OF LIFE pub is by *H.M. Wakley*, 1899, also turreted, the former Cambridge pub, 1887, is by *Wylson & Long*, as is the MARQUESS OF GRANBY of 1886, after the NE quadrant across Charing Cross Road. The two tall S corners with Charing Cross Road are by *Martin & Purchase*, 1889.

SHERWOOD STREET

A short street formed in the 1670s. On the E side, No. 3, built as Snow's Chop House, 1906 by *J. Hatchard-Smith*. White faience, set off by a green balcony. Further up, the PIC-CADILLY THEATRE, 1927–8 by *Bertie Crewe* and *E.A. Stone*. A long curved front with Doric pilasters and arcaded ground floor, reminiscent – at several removes – of Nash.

SOHO SQUARE

Built up from 1677 on Soho Fields by *Richard Frith*, bricklayer and citizen, with *Cadogan Thomas*, timber merchant. Finished by 1691. John Evelyn and family went in 1689 'to winter at Soho, in the great square'. Its forty-one houses were socially a little higher than Golden Square or Leicester Square. Larger ones had a balustraded 'flat' on the roof. The genealogist *Gregory King* claimed credit for the plan, which has a street entering centrally from N, E and W and two more on the S (Greek Street and Frith Street), like St James's Square (*see* p. 624). Between the S streets lay MONMOUTH HOUSE (hence the early usage Monmouth Square). This was begun for the bastard Duke of Monmouth in 1682 by *Frith* and *Thomas*, and bought unfinished in 1717 by Sir James Bateman, Lord Mayor of London. He added a wild Baroque façade with a giant split pediment, attributed to his kinsman *Thomas Archer*. Ordinary houses replaced it in 1773, by

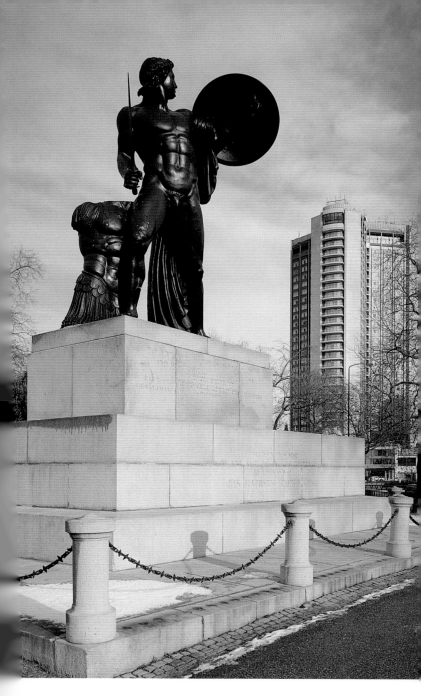

Hyde Park, with the Achilles statue by Sir Richard Westmacott, 1814–22.
Background, London Hilton, Park Lane (Mayfair), by Lewis Solomon,
Kaye & Partners, 1961–3 (pp. 555, 663)

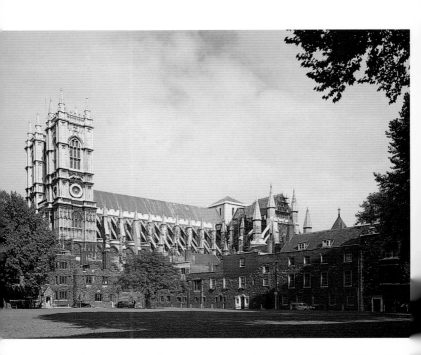

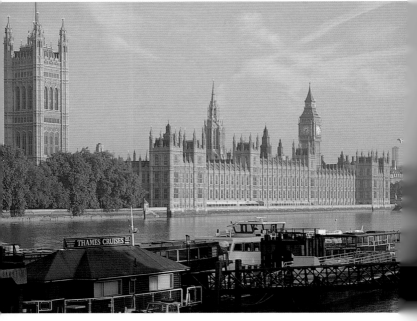

2. Westminster Abbey, thirteenth to eighteenth century, from Dean's Yard to the south (p. 108)

3. The Palace of Westminster, by Sir Charles Barry with A.W.N. Pugin, 1840–mid 1860s, from Lambeth Bridge (p. 212)

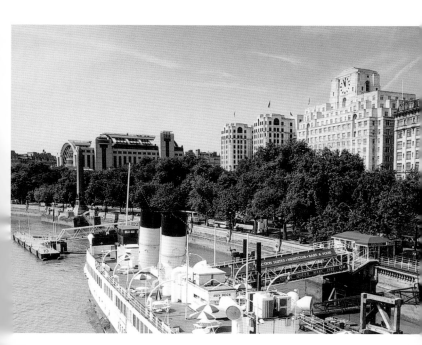

Victoria Embankment (Strand), by Sir Joseph Bazalgette, 1864–70, from Waterloo Bridge, with buildings south of the Strand overlooking (pp. 366, 376)
Churchill Gardens, Grosvenor Road (Pimlico), by Powell & Moya, Phase One, 1947–52, from the south-east (p. 778)

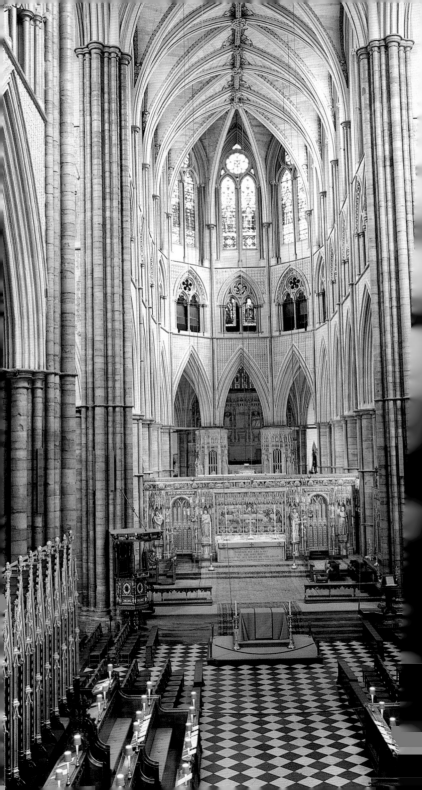

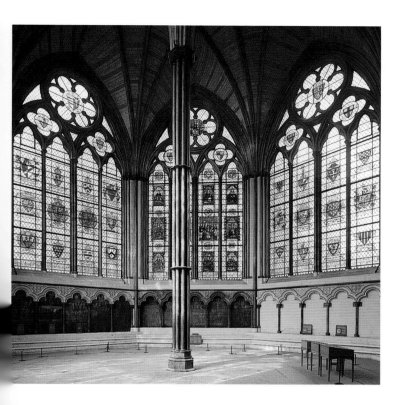

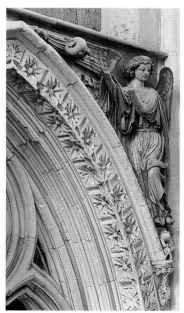

Westminster Abbey:
Interior, begun 1246, looking east
(p. 124)
Chapter House, 1246–c.1253,
interior (p. 190)
Boss from the west aisle of the
south transept, early 1250s (p. 131)
Angel from the south transept,
early 1250s (p. 131)

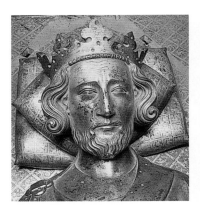

Westminster Abbey:
10. Head of effigy of Henry III, by
 William Torel, north ambulatory,
 commissioned 1291 (p. 150)
11. Monument of Edward III, south
 ambulatory, mourning figure,
 (William of Hatfield), c. 1386
 (p. 159)
12. Cosmati pavement of sanctuary,
 dated 1268, signed by Odericus
 Romanus (p. 164)

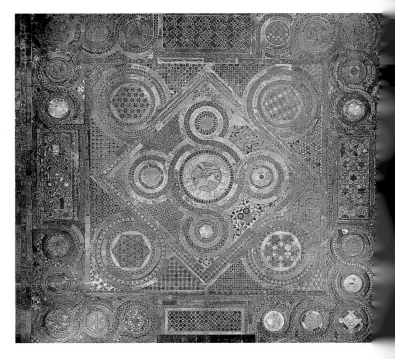

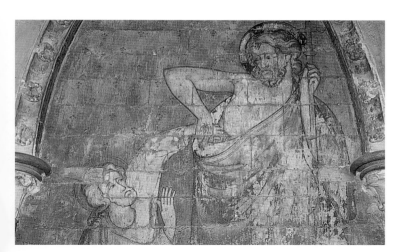

Westminster Abbey:

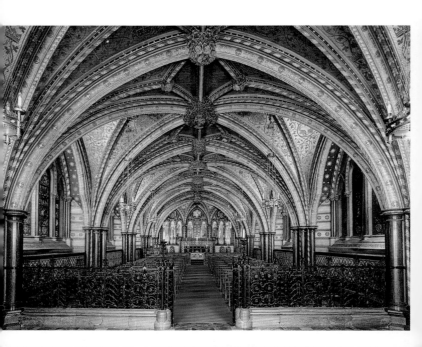

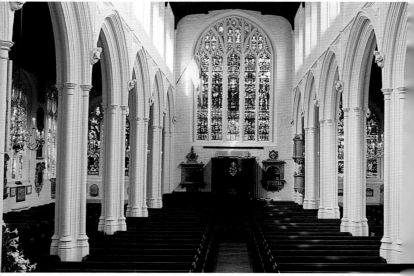

15. Palace of Westminster, St Mary Undercroft chapel, begun 1292 by Michael of Canterbury, restored 1860–70 by E.M. Barry (p. 228)
16. St Margaret, Westminster, *c.*1482–1523, interior looking west (p. 208)
17. Palace of Westminster, Westminster Hall, remodelled 1394–1401 by Henry Yevele with Walter Walton (carpenter Hugh Herland), interior looking south (p. 228)

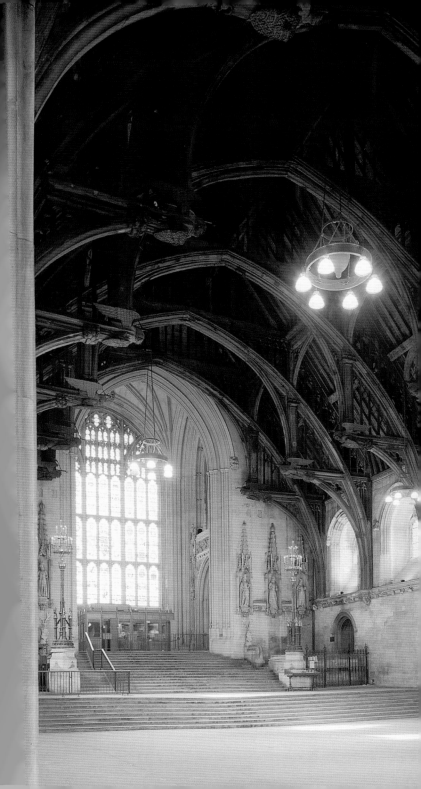

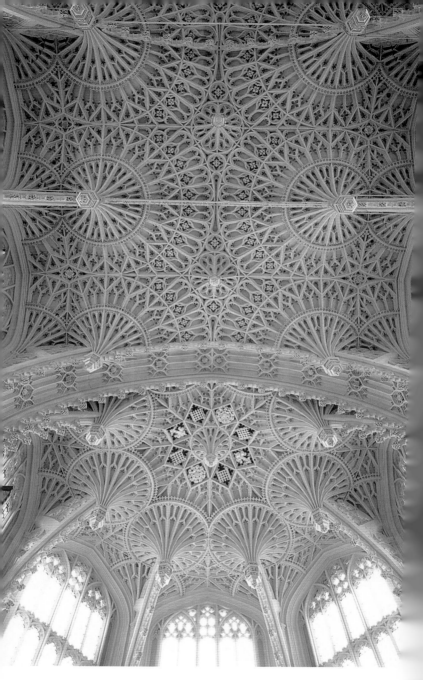

18. Westminster Abbey, Chapel of Henry VII, *c.* 1503–*c.* 1512, vault, attribute
to William Vertue (p. 136)
19. St James's Palace, Chapel Royal, detail of ceiling, dated 1540 (p. 600)
20. St James's Palace, 1531–*c.* 1540, gatehouse, from St James's Street (p. 59

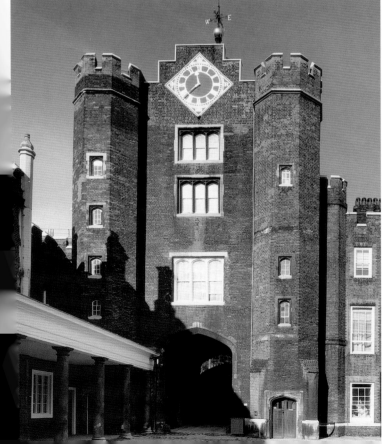

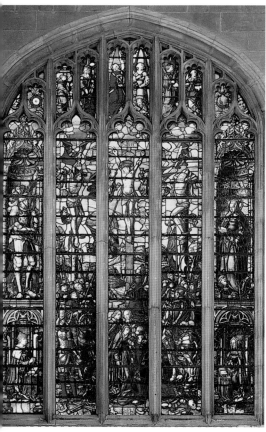

21. Westminster Abbey, monument of Henry VII, 1512–c.1518 by Pietro Torrigiano, roundel of Virgin and St Michael (p. 181)

22. Westminster Abbey, Chapel of Henry VII, misericord, c.1512 (p. 181)

23. St Margaret, Westminster, east window, c.1515–27, circle of Cornelis Engebrechts (p. 209)

24. Westminster Abbey, Chapel of St Nicholas, monument of Anne, Duchess of Somerset †1587 (p. 160)

25. Westminster Abbey, north transept east aisle, monument of Sir Francis Vere †1609, attributed to Isaac James (p. 146)

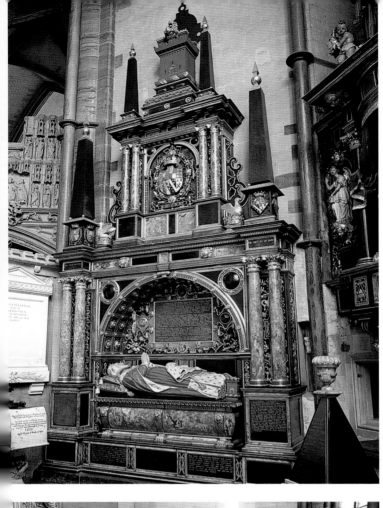

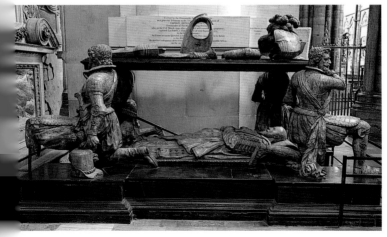

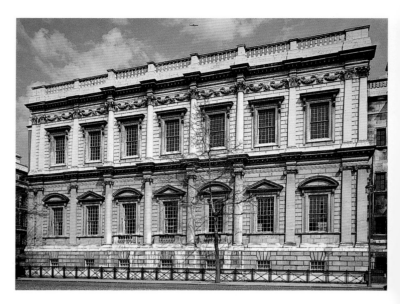

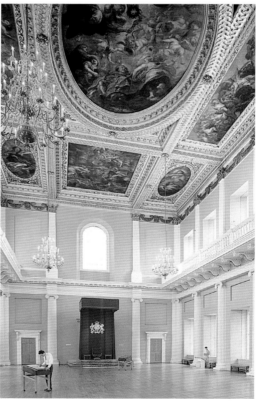

26. Banqueting House, Whitehall, by Inigo Jones, 1619–22 (p. 239)
27. Banqueting House, Whitehall, interior, showing ceiling paintings by Sir Peter Paul Rubens, 1630–4 (p. 241)
28. The Queen's Chapel (St James's), 1623–5 by Inigo Jones, interior (p. 587)

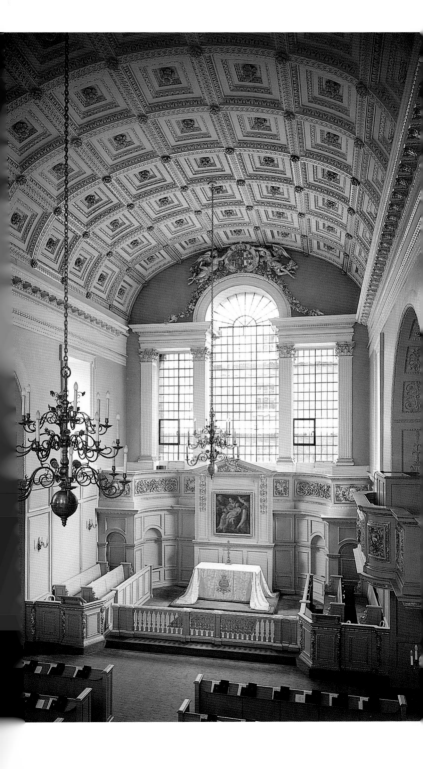

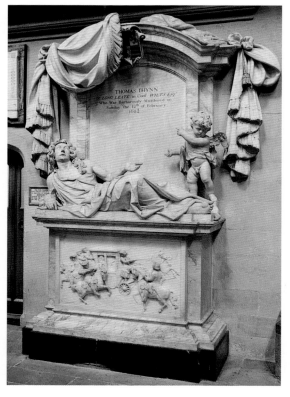

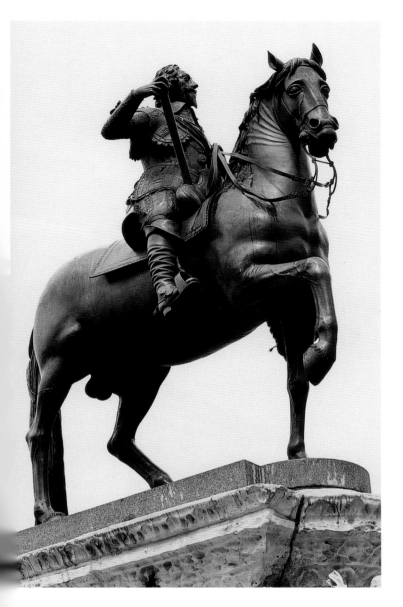

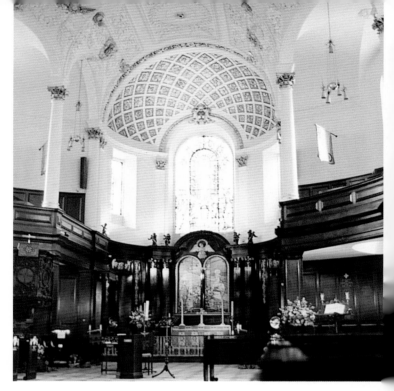

33. St Clement Danes (Strand), 1680–2 by Sir Christopher Wren, restored 1955–8, interior (p. 290)
34. Schomberg House, Nos. 80–82 Pall Mall (St James's), façade of 1698, restored 1956–8 (p. 616)
35. Queen Anne's Gate (South Westminster), houses on the north side, c.1704–5 (p. 713)
36. Bluecoat School, Caxton Street (South Westminster), 1709, from the south (p. 699)

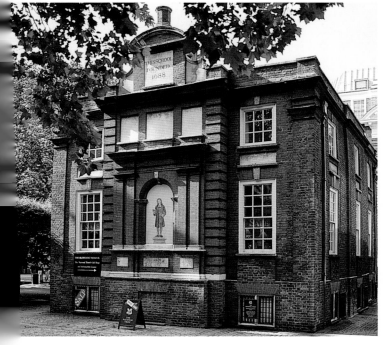

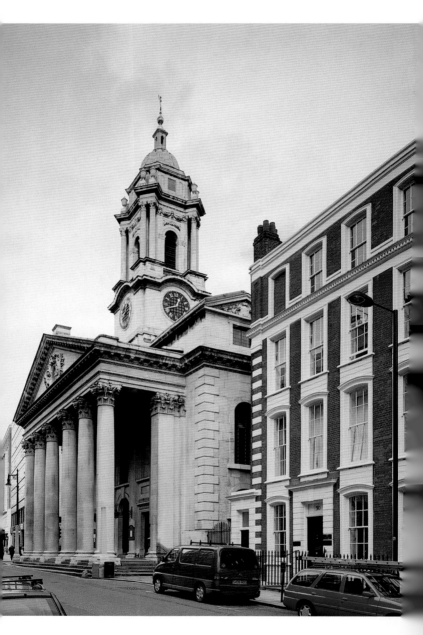

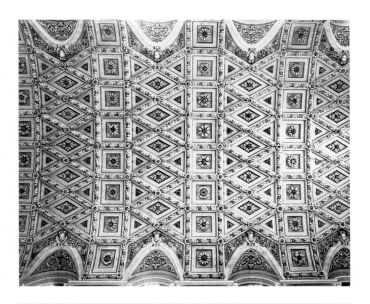

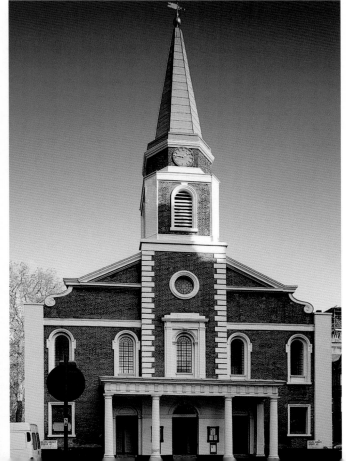

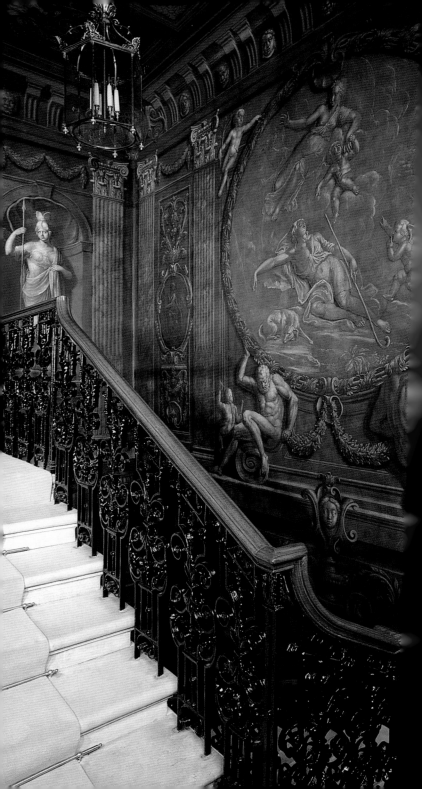

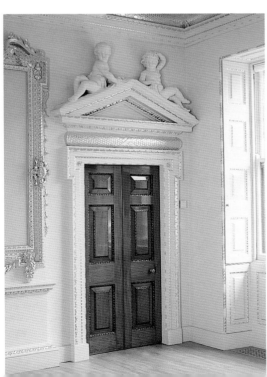

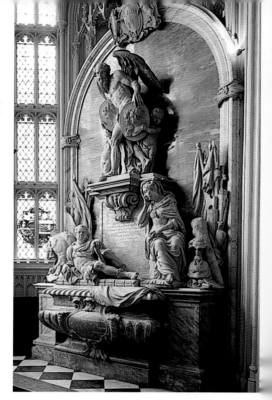

43
44 45

46
47

Westminster Abbey:

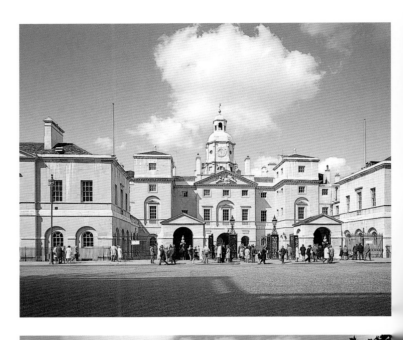

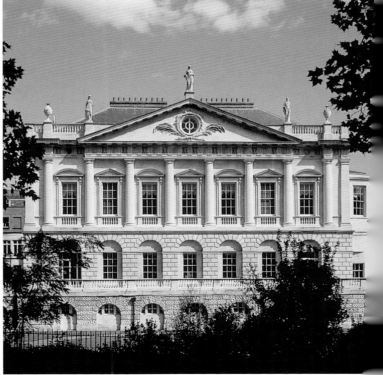

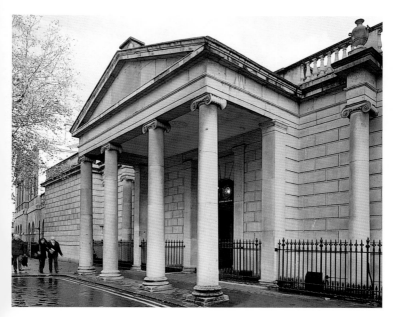

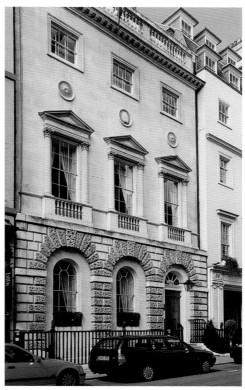

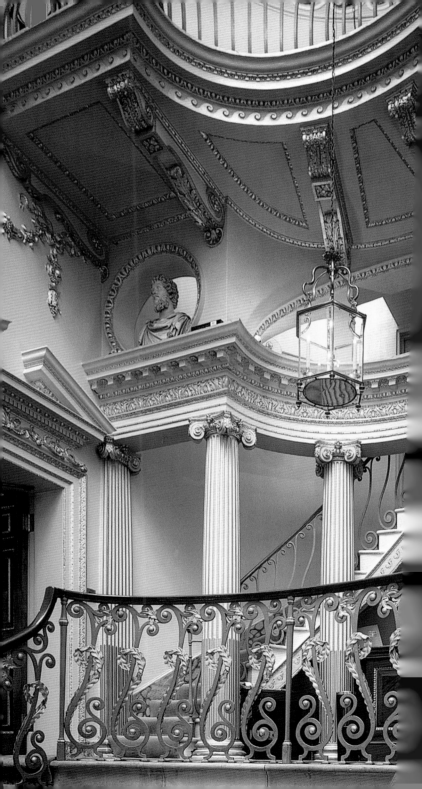

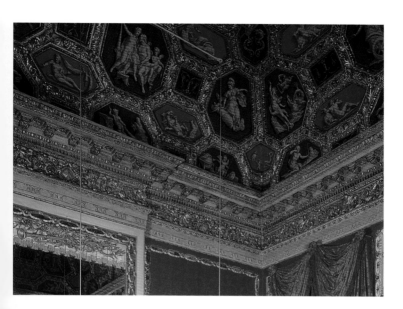

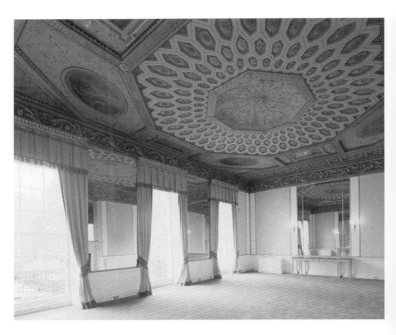

55. Lichfield House,
No. 15 St James's
Square (St
James's), 1764–6
by James Stuart,
Saloon (p. 630)
56. No. 20 Hanover
Square (Mayfair)
detail of staircase
c. 1785 by
Samuel Wyatt
(p. 535)
57. Spencer House,
No. 27 St James'
Place (St
James's), Palm
Room, by James
Stuart, period
1758–66 (p. 623)
58. Brooks's Club,
St James's Stree
(St James's),
1776–8 by Henr
Holland, Great
Subscription
Room (photo
1968) (p. 639)

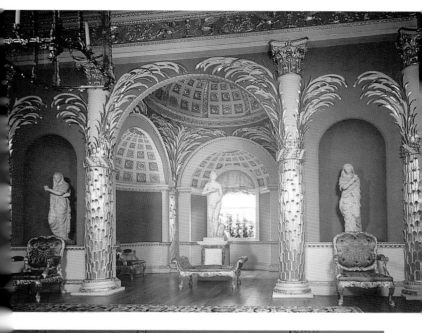

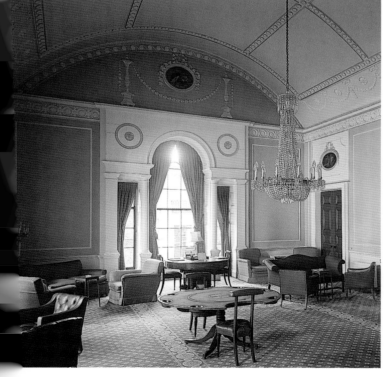

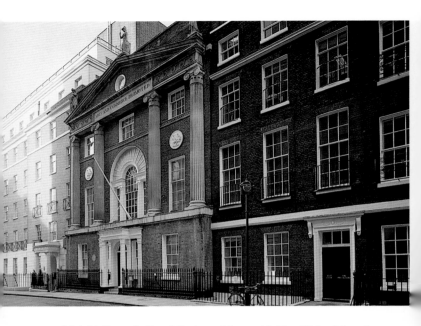

59. Adelphi (Strand), Royal Society of Arts, with No. 6 John Adam Street (right), 1772–4 by Robert and James Adam (p. 327)
60. Goodwin's Court, St Martin's Lane (Strand), shopfronts, late eighteenth century, looking east (p. 361)

61. No. 34 Grosvenor Street (Mayfair), lampholder, eighteenth century (p. 533)
62. Cadiz Memorial, Horse Guards Parade (Whitehall), erected 1816, designed by Robert Shipster (p. 255)

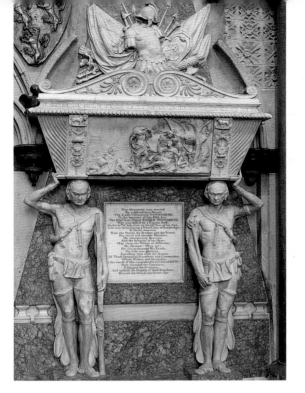

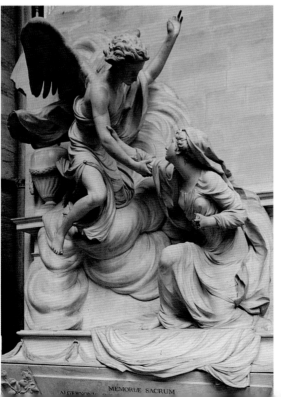

Westminster Abbey:

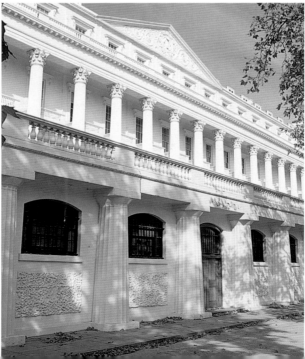

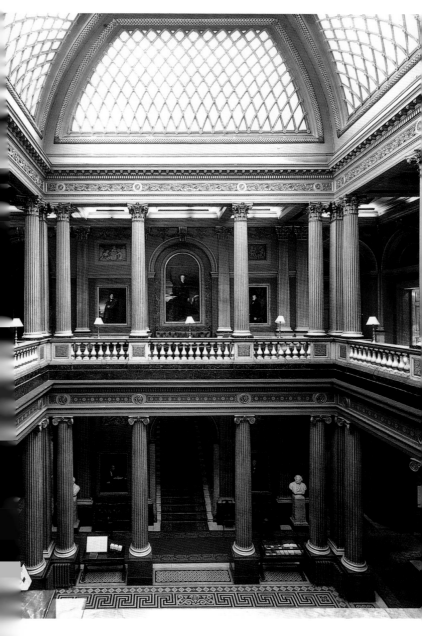

70. St Anne Soho, steeple, 1801–3 by S.P. Cockerell (p. 391)
71. St Barnabas (Pimlico), 1847–50 by Thomas Cundy II, from the south-west, showing the clergy house, right (p. 764)

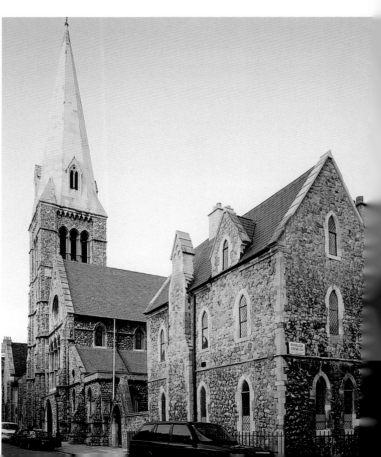

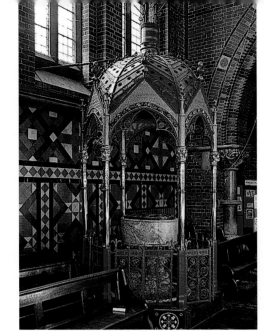

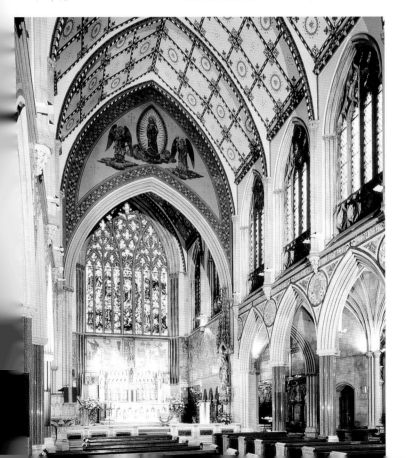

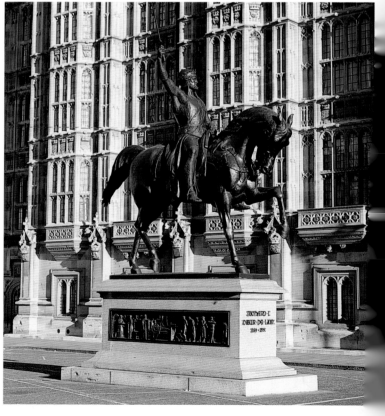

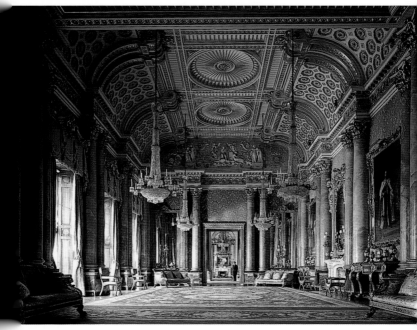

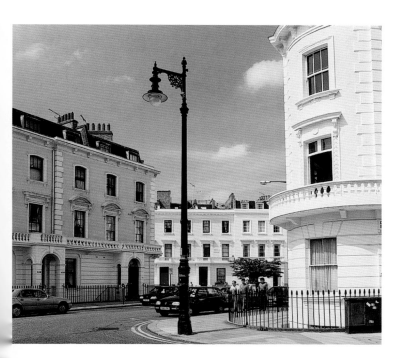

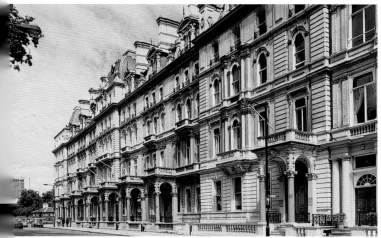

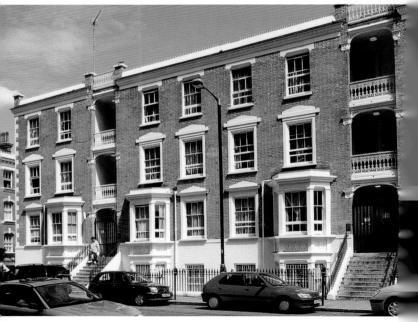

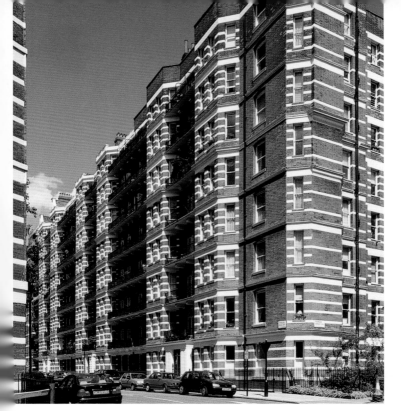

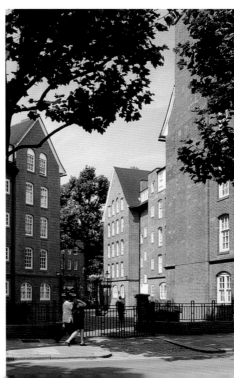

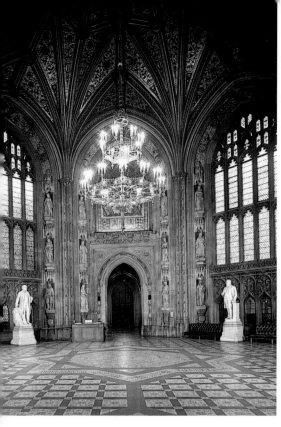

90. Palace of Westminster, 1840–mid 1860s by Charles Barry with A.W.N. Pugin, Central Lobby, with later decoration (p. 224)

91. Royal Courts of Justice (Strand), 1871–82 by G.E. Street, from the south-east (p. 311)

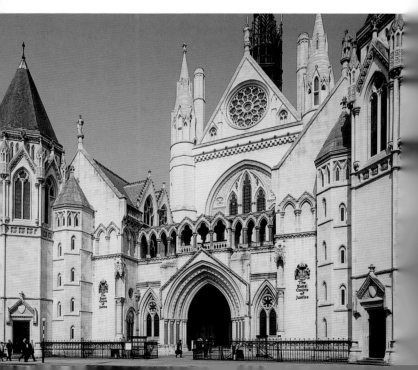

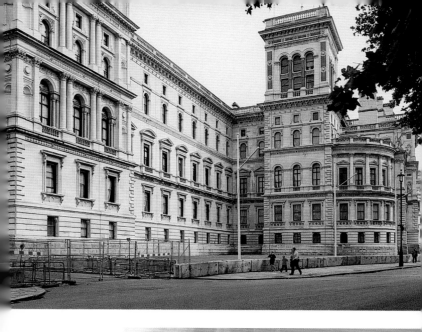

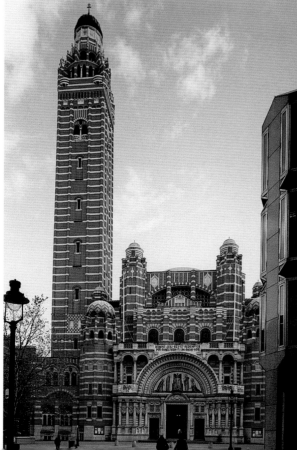

| 90 | 92 |
| 91 | 93 |

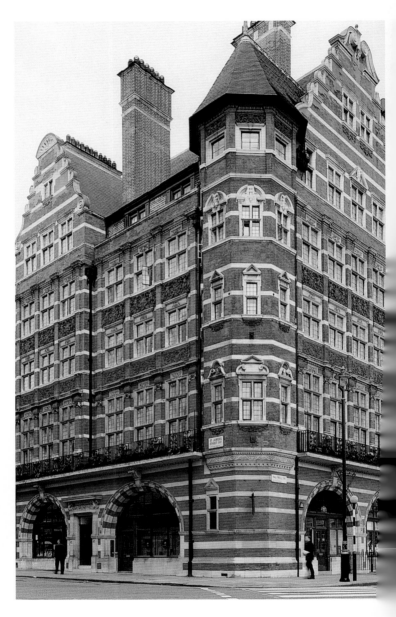

94. Alliance Insurance (former), Nos. 1–2 St James's Street (St James's), 1882–3 by Norman Shaw, from the south-west (p. 638)
95. London Palladium, Argyll Street (Soho), detail of interior of 1909–10, b Frank Matcham (p. 396)
96. Apollo Theatre, Shaftesbury Avenue (Soho), 1900–1 by Lewen Sharp, detail of interior (p. 425)
97. The Salisbury, St Martin's Lane (Strand), interior of 1898 (p. 361)

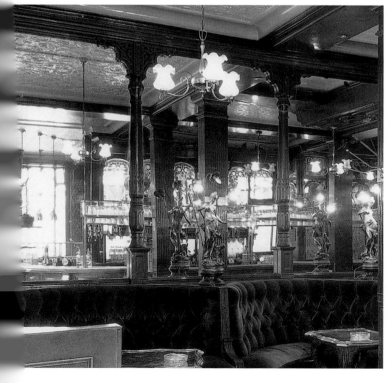

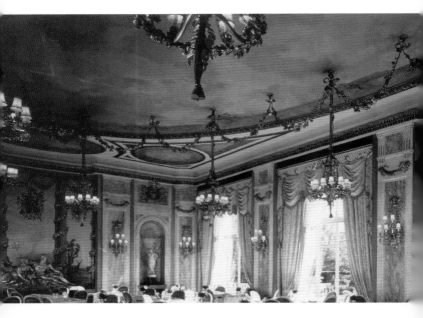

98. The Ritz, Piccadilly, 1903–6 by Mewès & Davis (decorators Waring & Gillow), restaurant (p. 560)
99. Burberry's, Nos. 18–22 Haymarket (Soho), 1911–13 by Walter Cave, from the south-west (p. 416)

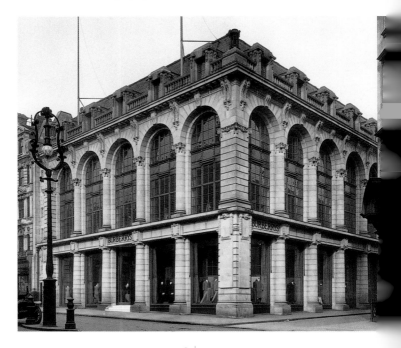

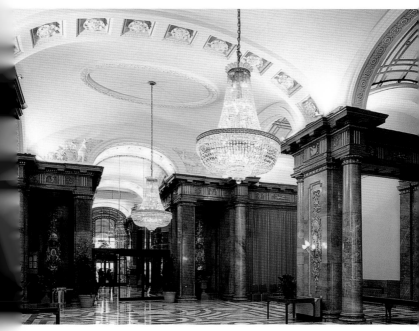

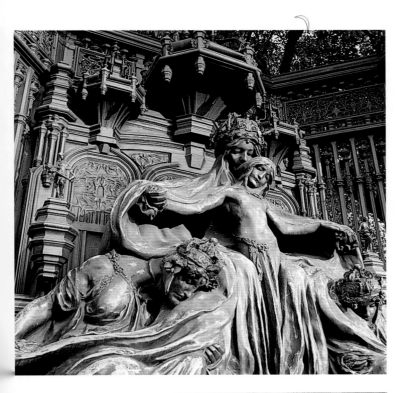

102. Wellington Arch,
 Hyde Park Corner
 (Royal Parks), Peace
 descending on the
 Quadriga of War,
 1907–12 by Adrian
 Jones, detail (p. 658)

103. Queen Victoria
 Memorial, The Mall
 (Royal Parks), 1904–22
 by Sir Thomas Brock
 and Sir Aston Webb
 (p. 655)

04. Queen Alexandra
 Memorial, Marlborough
 House (St James's),
 1927–32 by Sir Alfred
 Gilbert, detail (p. 594)

05. Royal Artillery
 Monument, Hyde Park
 Corner (Royal Parks),
 1921–5 by Charles
 Sergeant Jagger and
 Lionel Pearson, detail
 (p. 659)

106. Liberty's, Regent Street (Nash Route) Great Marlborough Street wing, 1922–3 by E.T. & E.S. Hall, showing the entrance section (p. 456)
107. Piccadilly Circus (Nash Route), from the east, showing the Quadrant, 1923–7 by Sir Reginald Blomfield, and the Piccadilly Hotel, 1905–8 by Norman Shaw (left side, centre) (p. 454)

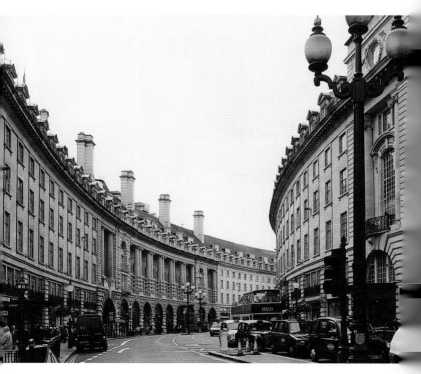

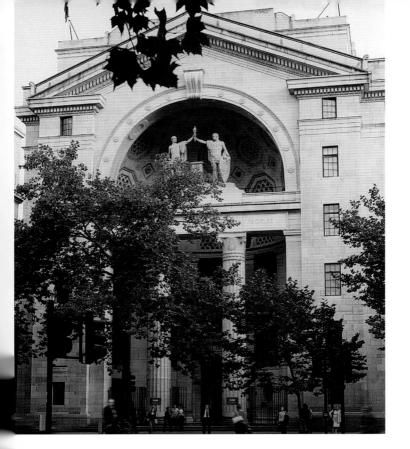

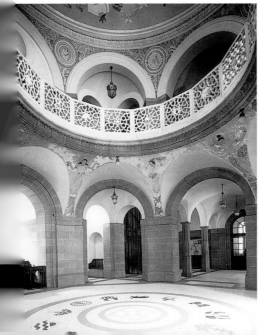

108. Bush House, Aldwych (Strand), by Harvey W. Corbett (Helmle & Corbett), central block, 1920–3, from the north (p. 332)

109. India House, Aldwych (Strand), 1928–30 by Sir Herbert Baker & Scott, interior, showing paintings by R. Ukil and S. Choudhury, 1930–2 (photo *c.*1934) (p. 331)

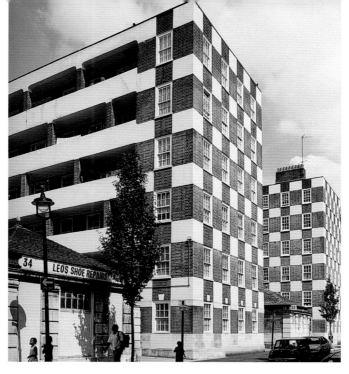

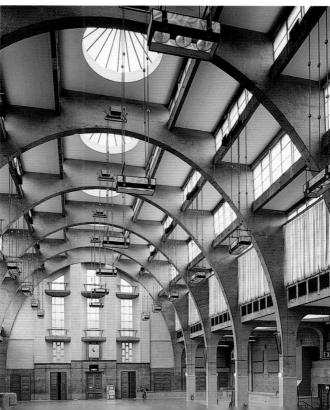

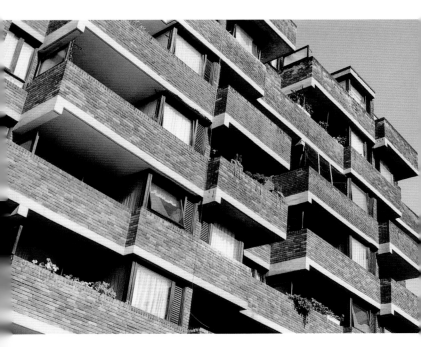

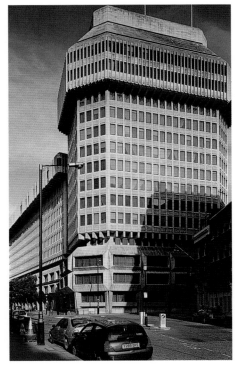

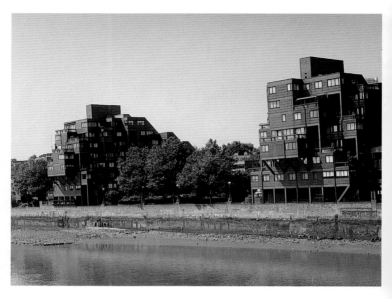

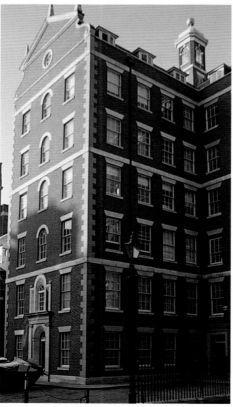

118. Crown Reach, Grosvenor Road (Pimlico), completed 1983 by Nicholas Lacey and Maguire & Murray, from Vauxhall Bridge (p. 782)

119. Dufour's Place, off Broadwick Street (Soho), offices, 1983–4 by Quinlan Terry, from the south-west (p. 400)

120. Channel 4, Horseferry Road (South Westminster), 1991–4 by the Richard Rogers Partnership, from the north-west (p. 704)

121. Clore Gallery, Tate Gallery (South Westminster), 1982–6 by James Stirling, Michael Wilford & Associates, from the south-west (p. 689)

122. Fountain Square, Buckingham Palace Road (Belgravia), 1988–91 by Arup Associates (Peter Foggo), showing Chalice, 1991 by William Pye (p. 749)

123. Library, London School of Economics, Portugal Street (Strand), interior, 1999–2001 by Foster & Partners (p. 357)

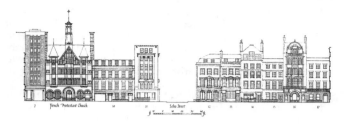

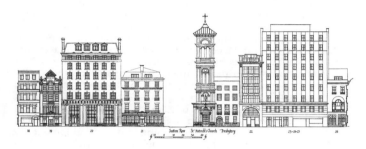

Soho Square, north and east sides. Elevations as in 1964
(*The Survey of London*)

which time the square was no longer so aristocratic. In the C19 commerce and institutions took over, but only in the 1890s did the churches of St Patrick and of the French Protestants disrupt the Georgian skyline. Taller and also broader offices followed.

The first GARDEN may have been the earliest in any London town square. The C17 plan of two right-angled paths remains, but with great trees in addition. To the N a stone STATUE of Charles II in armour, by *C.G. Cibber*, before 1683. It formed part of a monument with four figures of English rivers larger than life against the pedestal. Without them he looks rather too pedestrian. Removed in 1876; the monarch restored 1938, the rivers since lost. On his original position, centre, a silly half-timbered ARBOUR of 1925–6, reusing some older beams. It hides an electricity substation.

The BUILDINGS are described clockwise, beginning on the W SIDE N of Carlisle Street. First No. 38, 1735 by *John Sanger*, carpenter. Fine mid-C19 shopfront, with Corinthian columns and unstinted cornice. On the l. return a house door and canted bay, possibly original. Flanking plain pilasters and top storey of after 1812. No. 1 is by *E.K. Purchase*, 1904–5, unworthy red brick. No. 2 by *Sanger*, also 1735, the Doric door-case perhaps *c.* 1760. Staircase between front and back rooms, remodelled in 1987 to dog-leg plan. No. 3, 1903 by *C.H. Worley*, an excited convex and concave front with Art Nouveau details.

Nos. 4–6, seven plain brick bays of 1801–4, was the warehouse of John Trotter, 'Storekeeper-General' in the French wars (lesser front at No. 6 Dean Street, q.v.). In 1816 he converted it to the very successful Soho Bazaar, a quasi-charitable enclosed market selling products of 'Female and Domestic Industry'. Stone display front of 1890, by *Arthur Lett* for the publishers A. & C. Black.

N SIDE. No. 7, lofty and tawdry, by *North, Robin & Wilsdon*, 1930.

p. 427

Nos. 8–9 are the French Protestant Church (q.v.). No. 10 embraces two houses of *c.* 1681, united 1696. Still the original three-storey height. The end piers and ground-floor channelling are later. The upper part of the r. house staircase remains, of dog-leg plan with a small light well; lower part restored 1986, not to the original plan. The tall No. 11, Portland stone with squared-off classical ornament, is by *W.A. Lewis*, 1929. On the E corner with Soho Street, the Travertine-faced No. 12, offices by *APT*, designed 1970: an early stab at a domestic but non-period image for a sensitive site. No. 13 is of 1768–9, with mid-C19 stucco and bowed shopfront. No. 14 is of *c.* 1980, replicating an altered front probably of 1796. No. 15, heightened, is of *c.* 1680. Interior panelled, with

p. 33

timber partitions; very solid staircase with moulded strings. Then around the NE corner a mixed-use development by *Hanna & Manwaring*, 1971–3. Rough brown brick. Its different heights reflect those of the old Nos. 16–19 – a meaningless sop to context thirty years on.

E SIDE. No. 20, 1924–5 by Messrs *Joseph*, a big stone palazzo

p. 427

built as headquarters for Crosse & Blackwell, after its pickle factory here moved away in 1921. Doric columns below, like a Georgian bank on a giant scale. The founders lived over the shop at the plain No. 21, rebuilt or renovated for them 1838–40 (display front *c.* 1910). Rear extension along Sutton Row, followed by part of the factory, all probably mid-C19. For their other premises *see* Charing Cross Road.

After St Patrick, No. 21a, 1791–3, built as the presbytery for its predecessor. Pretty bowed first-floor balconies. Then a building of 1999–2000, a replica of the boring front of old No. 22 (1913–14). Nos. 23–25, 1938–9 by *G. Jeeves & Partners*, was tempered in 1997 by *Allies & Morrison*'s refronting in pale brick and subtly incised stone. No. 26, 1758–9, was designed for himself by *Sir William Robinson* of Newby (now Baldersby) Hall, Yorks., helped by the carpenter *Thomas Dade*. Its narrow front, once mirrored by the old No. 25, has a large Venetian window on the first floor, with blind balustrade and relieving arch. Segmental arched doorway below, a restoration of 1985. In the inner angle, behind an Ionic colonnade, a fine toplit stone staircase rises to a first-floor gallery. Wrought-iron balustrade with unusual little curlicues attached (*Robert Johnson* smith). Good doorcases (carver *Thomas Speer*; some doors veneered in mahogany by *Chippendale*).

S SIDE. At the E corner with Greek Street (No. 1 there) is one of the best and best-preserved mid-C18 houses in London; since 1862 the HOUSE OF ST BARNABAS. The shell of 1744–6, a speculation by the bricklayer *Joseph Pearce*, was fitted up

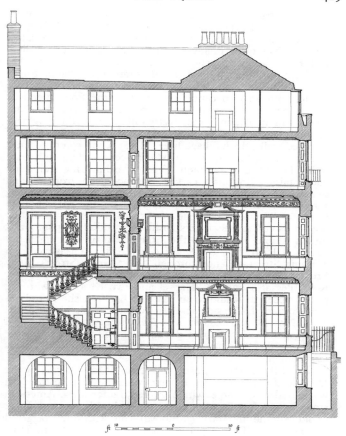

No. 1 Greek Street (House of St Barnabas), 1744–*c*. 1757.
Section, east to west (*The Survey of London*)

c. 1755–7 for Richard Beckford, younger brother of Alderman
(later Lord Mayor) Beckford. Quiet exterior, its un-Palladian
elevations explained by the *Survey of London* as an attempt
to harmonize with its C17 neighbours. Widely spaced, well-
proportioned windows; no enrichment except a bracketed
stone doorcase to Greek Street with obelisks l. and r.

The INTERIOR is easily the finest in Soho. Its Kentian door-
cases and panelling combine with vigorous Rococo carving
and plasterwork, a little old-fashioned for mid-1750s London.
Comparisons have been made with the Mansion House of a
few years before (*see London 1: The City*), but no connection
can be proven beyond Beckford's City background; affinities

with the Bristol school have recently been pointed out by Tim Mowl and Brian Earnshaw. ENTRANCE HALL with open-well staircase to the first floor only, with wrought-iron balus-trade of lyre type. Richly stuccoed wall panels and ceiling, with masks and cartouches. The main ground-floor room has similar but more restrained wall decoration. On the first floor are three major rooms. The SALOON, in the outer angle, has a ceiling with an oval centre representing the Four Elements in the persons of gawky putti. In the diagonals the Four Seasons in medallion busts. Overmantel with overlapping half-columns, above a good reproduction fireplace of 1960. Carved panelled walls, thick foliage frieze. The second room, to the E and facing N, has another playful Rococo ceiling; silk-hung walls. The third, a bedroom, faces E, behind the stairs and back stairs. Gloriously carved fireplace with trophies and swan-necked pediment. Especially elaborate door and window surrounds. This room was subdivided for the Metropolitan Board of Works, in occupation 1855–61; its predecessor, the Westminster Commissioners for Sewers, added the plain brick offices behind c. 1847. To the S these join on to a small but substantial CHAPEL by *Joseph Clarke*, 1862–4 (visible from Manette Street, reached through No. 7 Greek Street). Early French Gothic, of banded stone, rising from a battered plinth. Roof tiles also banded. E apse, and two bays also with big paired apses to N and S, so that the flat wall shows only at clerestory level. The side apses are linked by aisle-like passages within. STAINED GLASS by *John Hayward*, 1957–8. To the N of the chapel Clarke planned dormitories and a cloister for the charity, which provides temporary accommodation for home-less women.

The rest of the S side is mostly C20. Nos. 27–28, 1983–5 by the *Rolfe Judd Group Practice*, belongs with the first Postmodern wave. Red brick, large, with a layered, rather Meso-American stone frontispiece. Tall slotted pedimental gable above – a ghost of old Monmouth House (*see* above) – but with sides staggered by one storey. The shapeless Nos. 29–30, formerly the Hos-pital for Women, were refaced by *Percy Adams* of *Adams & Holden*, 1909–10. His inexpensive but sophisticated white faience detail masks premises by *E.L. Bracebridge*, 1867–9, l., and a much-recycled house shell, r. (rebuilt or remodelled c. 1730, and for the hospital c. 1865). Down the alley called Bateman's Buildings, l., a red brick extension of 1894; another of 1906–9 to Frith Street, W, by *Adams*, with three canted faience bays. The hospital, founded in 1843 in Red Lion Square, was the first in the world open to women of every social class. Remodelling in 1996–8 by *Rolfe Judd Planning* made a health centre in the rear part, and added ochre rendering. In the SE corner Nos. 31–32, 1936–7 by *G. Jeeves* for Twentieth Century Fox, anonymous.

Finally the S part of the W SIDE. Nos. 33–34, by *Leslie Norton*, as late as 1950, but still looking back to Hampton Court; extended 1955–6, r. No. 36, of c. 1680 in origin, has a late C18 front. At No. 37, of 1766, a handsome stone shopfront with an early use of Greek Doric columns: done for Dulau & Co.,

booksellers, before 1812. On the return a canted bay and a reset C18 doorcase; good first-floor ceiling with thin Rococo foliage. Staircase with S-scrolls, relocated in 1922 when *Richardson & Gill* added a warehouse extension on Carlisle Street.

SUFFOLK STREET

A supporting player in *Nash*'s Regent Street scheme. The street was made in 1663 by the 3rd Earl of Suffolk. Nash renewed it in 1820–4, cutting off its S part to make Pall Mall East, the approach to what became Trafalgar Square. This end has since been rebuilt. Its E corner is the former United Universities Club of 1906–7, *Sir Reginald Blomfield*'s earliest essay in London in his Champs-Elysées style. Interiors are by contrast late C17 English. Carving by *W. Aumonier Jun.*, that over the Suffolk Street entrance to designs by *Henry Pegram*. Matching extensions of 1923–4, N, and 1939–40, E, the latter after the club absorbed the New University Club (*see* footnote p. 639). The predecessor was Grecian, by *William Wilkins* and *J.P. Gandy Deering*, 1822–6, heightened 1850–1; the club merged in 1971 with the Oxford and Cambridge Club, Pall Mall (*see* p. 617). On the W corner the no less French KINNAIRD HOUSE, 1915–22. By *A.C. Blomfield*, cousin of Sir Reginald, for Barclay's Bank. Four square corner pavilions, and over the entrance a thin open turret. Rebuilt internally 2000–1.

The small-scale stucco architecture of *Nash*'s time begins further up. On the W side, No. 23 forms with the whole N side of SUFFOLK PLACE one symmetrical entirety to the corner with

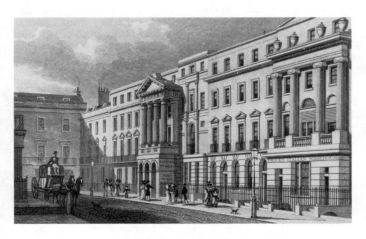

Suffolk Street. Engraving,
showing east side and part of north end
(James Elmes & T.H. Shepherd, *Metropolitan Improvements*, 1829)

Haymarket. In front of the ground floor an attached screen of Doric columns, then a fine cast-iron balcony railing, and a pediment over the middle (partly rebuilt after war damage). Next to it on Haymarket the little No. 4, also of *c.* 1822–3, with Soanesque incisions. Originally both designs were mirrored along the s front of Suffolk Place. Back in Suffolk Street, Nos. 20–22 are again of one design; No. 19 is the back of the Theatre Royal, Haymarket (q.v.); No. 18, now incorporated with the theatre, has the favourite late Nash tympanum with shell and fluting. Across the top Nos. 15–17, Neo-Regency of 1956 on the site of a *Lewis Wyatt* building bombed in 1941, too mild to provide the *point-de-vue* once afforded by its Greek Doric porch. Coming down the e side, Nos. 12–14 are also by *L. Wyatt*, Nos. 8–11 by *Nash*, with fine Greek detail in the iron balconies. Modest interiors, with e.g. ceilings with rosette borders. Next the former entrance to the Society of British Artists, by *Nash*, with a portico of four Roman Doric columns on an enlarged ground floor, much grander than the others. Ground floor remodelled by *Casson, Conder & Partners*, for access to their new Hobhouse Court behind, 1974–9 (*see* Whitcomb Street for the former gallery proper). No. 6, by *Edward Cresy* for himself, 1824, has upper storeys modelled on the Casa Cogollo in Vicenza, then believed to have been Palladio's own house. On the first floor a big arched central window flanked by Ionic columns, and a smaller window above flanked by Corinthian pilasters. No. 5, of two bays, by Cresy's friend *G. Ledwell Taylor*, *c.* 1826.

WARDOUR STREET

Longest of the older Soho streets. It began as Colmanhedge Lane, recorded in 1585 as the n part of the way from Charing Cross to Oxford Street.* Built up haphazardly from *c.* 1676, by Edward Wardour and others. Much rebuilding *c.* 1720–40. In the c19 known for antiques and music shops, in the c20 for film-company offices. It is described from s to n.

Facing the Swiss Centre on the w SIDE, No. 3 is superior infill by *Proun Architects*, 1991–4. Front of load-bearing glazed ultramarine brick, only just asymmetrical, with the attic wall swerving back. It incorporates the rather feminine white-glazed front of No. 5, a restaurant of *c.* 1909. Nos. 7–11, of 1727, retain their mansard storeys. On No. 9 a plaque lettered 'Exchange and Bullion Office', and the date 1798. The turreted pub on the corner with Lisle Street (e side) is by *W. G. Shoebridge*, 1896. Back on the w side, Nos. 27–31, of 1728, with an unusual two-storey archway into RUPERT COURT. This has been rebuilt, but the answering houses remain in Rupert Street (Nos. 22–28 there). No. 30, the s corner with Gerrard Street (e side), is by *E. J. W. Hider*, a restaurant of 1909, latterly Maxim's. Quaint later mansard. Nos. 41–43 (w side), of

* The continuation s of Coventry Street is the present Whitcomb Street, q.v.

1904–5 by *H.M. Wakley*, was Willy Clarkson's, theatrical cos-
tumier. A finer show in its small compass than some London
theatre fronts, with recessed bows and a Voyseyish clock.

After Shaftesbury Avenue and St Anne's churchyard is
BOURCHIER STREET, r., an alley on a pre-C17 alignment.
Here are seventeen white-rendered flats by *Koski, Solomon &
Ruthven*, 1995–8, strongly articulated, with elements of De Stijl
and 1920s Corbusier. In Wardour Street mostly large C20
commercial blocks, e.g. Nos. 60–66 (E side), pilastered Egypto-
Greek offices by *W.A. Lewis & Partners*, 1930. Nos. 68–70,
plain industrial, 1885 by *A.F. Wells*. Opposite, Nos. 93–95, 1915
by *Joseph & Smithem*, an early cinema showroom, and the
contemporary INTREPID FOX pub, likewise in white artificial
stone (*W. Bradford & Sons*). A plaque shows which Fox
is meant; the name dates from the Westminster election of
1784.

A diversion w into PETER STREET, l., one of the few Soho culs-
de-sac left, built *c.* 1675–1693. On its N side, Nos. 2–4, early
C19 (No. 4 dated 1828), and a plain former Board School
(now part of WESTMINSTER KINGSWAY COLLEGE), 1880 by
E.R. Robson. This faces brick-clad flats for the Soho Housing
Association by *CGHP Architects*, 1996–8, with skeletal oxblood
balconies. Tightly planned around a first-floor courtyard,
above a barrow store for Berwick Street market.

Back in Wardour Street, E side, Nos. 76–88, 1906–8 by *W.
Woodward*, unusually big, of Mansfield stone over red granite.
Twelve giant arches unite the upper floors. On the w side a
run of Portland-faced earlier C20 offices, starting with *Blow &
Billerey*'s Nos. 103–109, 1912. Bold broad giant arch, a pedi-
ment, and a large expanse of glass below. Back on the E SIDE,
No. 90, SOHO LOFTS, one of the largest residential conver-
sions in Soho, of 1995 by *CZWG*. They kept the street front of
c. 1908, and the much rougher big warehouse block behind,
which was heightened and topped with curved-roofed pent-
houses. On the ground floor is Sir Terence Conran's MEZZO
restaurant, designed by the *CD Partnership*. At 700 covers it
was then London's largest post-war restaurant. Low entrance
block, with a picture-windowed bar sandwiched between a
curving grey granite plinth and a riveted girder. Nos. 102–114,
flats above shops, are by *Henry Tanner Jun.*, dated 1904.
Nos. 135–141 opposite, 1931–2 by *James J.S. Naylor*, were built
as offices and a film store for WARNER BROS, with as much
glazing as the building acts allowed. Stone borders, with
triplets of canted metal bows with fluted panels between: a
quietly ghastly effect. Early C18 survivors: Nos. 130 and 132,
E side, Nos. 157–165 and 171, W; the latter from wholesale
rebuilding on the Portland estate, 1735–43.

The E SIDE continues with more interwar offices, e.g. FILM
HOUSE (Nos. 142–150), post-classical by *Gunton & Gunton*,
1928 (demolition proposed). Then offices for the former
NOVELLO's, the music publishers, 1906–10. By the younger
(*Frank L.*) *Pearson*, who had married the chairman's daughter;
converted for shops and offices 2000–1. Pearson's adaptation
of period elements is scholarly and remarkably original. The

source is the Hanseatic town hall, the materials orange brick and stone. Ground floor with depressed arches on short Ionic columns. Above that five very tall transomed three-light windows with alternating pediments. No gables. The entrance on the l. is busier, with a balcony and oriel. Statues, never executed, were intended between the main windows. Extremely ambitious INTERIOR, in a mid- to late C17 English style. The grand staircase, a stately climb under a cupola, is derived with variations from that at Ashburnham House (*see* pp. 202–4). It leads via column-screen and ante-room to an oak-panelled and pilastered recital room across the front, where busts of Handel and Bach preside. On the inner wall an outswept musicians' gallery. The former PRINTING HOUSE at the back is earlier, of 1898, also by *Pearson*. Quiet elevations to Sheraton Street, S, and Hollen Street, N, the latter with reliefs of putti printing and making music. Sheraton Street leads into GREAT CHAPEL STREET. On the NW corner the former St Patrick's Schools, 1888, as harsh as a warehouse. It faces No. 7, offices of 1964 by *N.J. Aslan*. A pretty front with upright curtain walling and a bow, framed by blue polished stone.

Back in Wardour Street, Nos. 175–179 (W side), built in three stages 1907–12, with a frisky roof-line. No. 199, the goldsmiths BLUNDELL & SONS, 1899, has what may be an original shopfront. Opposite (E side), a big office block with rounded uprights by *Gibberd, Coombes & Partners*, 1982–5, with retained façades to Oxford Street (Nos. 111–125 there, *see* p. 461).

WARWICK STREET

Built up from the mid 1670s. The back of Regent Street dominates the W side. Typical mixed Soho commercial opposite. No. 20 is a gem of 1906–7 by *J.N.R. Vining*, then fresh from the LCC's Architect's Department. Gabled stone Arts and Crafts, the looping stone balustrade set on corbels. The client was Liberty's, which may explain the Art Nouveau flavour. Further S, the church of Our Lady (q.v.).

WHITCOMB STREET

The lower part of the ancient lane from Charing Cross to Oxford Street (cf. Wardour Street). The interest is in the S part, facing the National Gallery extension, E. First some sturdy plain 1820s brick buildings, of the vintage of Nash's Suffolk Street behind. Gently remodelled for shops and offices by *Ronald Green* of *Casson, Conder & Partners*, 1974–9, after spot-listing foiled the Crown Estate's plans to rebuild completely. Most powerful is Nos. 5–9, with a carriage arch and tall upper storey with blind arcading. Less formal but no less solid Nos. 11–13. Wine vaults below; the upper part housed the Society of British Artists, important in the history of the London art world. *James Elmes* designed its first gallery (1823), which was peri-

odically redone (1857, 1926, 1979); access was through No. 7
Suffolk Street, q.v. No. 17 goes with HOBHOUSE COURT,
reached through a smaller courtyard behind No. 19. Its infor-
mality, small scale and traditional materials are characteristic
of 1970s conservation architecture. New work includes the
leaded stair-tower, s, and the back of No. 15.

Whitcomb Street continues N with small pre-C20 houses. At
No. 25 a pretty gate with wrought-iron foliage and blackbirds,
c. 1990 by *Jo MacDonald*. Behind, the tiny wedge-shaped
EXCEL COURT, with stuccoed C18 or early C19 houses one
room deep.

THE REGENT STREET SCHEME
(NASH ROUTE)

INTRODUCTION

John Nash's splendid *Via Triumphalis* is quite simply the greatest piece of town planning London has ever seen. Its origin was the need to connect the Prince Regent's palace, Carlton House, with Marylebone Park, that is Regent's Park. This area of fields and woods reverted to the Crown in 1811, so plans were made by Nash for converting it into a park in the modern, ornamental sense, with a 'guingette' or pleasure palace for the Regent, a serpentine pond, and circuses and terraces of houses for people of quality. In the complete plan Regent Street is, as it were, the trunk of the tree. Its root was Carlton House, the top the verdure, the villas, and the terraces of the park. A N–S street in the neighbourhood of Regent Street had anyway been felt necessary for a long time. Plans had been put forward by *John Gwynn* (1766), *Thomas Leverton & Thomas Chawner*, architects to the Land Revenue Office (1808), by *James Wyatt*, apparently in association with *John White Sen.*, a little later, and by Nash himself, whose plan was enacted in 1813. He was a personal friend of the Regent and his circle, and rumours went round that his wife, twenty-one years younger than he, had had an affair with the Regent before Nash married her. But whatever the reason for his employment, his revised plan was certainly a work of genius.

A straight avenue in the Parisian sense was out of the question. Land had to be bought, and that eliminated certain courses. The line in the end adopted was a straight run N from Carlton House, through Waterloo Place, to a circus at the crossing of Piccadilly. Then a curve to the NW had to be negotiated before a straight run towards Oxford Street could be reached, a run that had as its backbone the former Swallow Street (for its remaining fragments *see* pp. 468 and 576). Nash made this Quadrant his chief display piece, with sweeps of colonnades leading you round. It was a way of making the most ingenious use of the principle of Picturesque planning: surprise. (His memorandum referred

p. 448

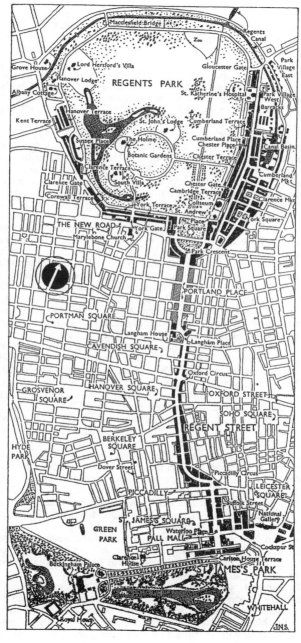

Regent Street, Regent's Park, St James's Park, etc.
Map showing the extent of Nash's works of 1811–35
(John Summerson, *Georgian London*, 1945)

explicitly to the High Street at Oxford, a paramount example of picturesque growth.) At the junction with Oxford Street was another circus, and then, to join up with the Adam brothers' Portland Place, another change of direction became necessary. This again Nash managed with utmost resourcefulness. He placed in the *point-de-vue* a church with a circular portico and tower, a shape which looks right from any direction, and thus masked the awkward turn. That church (All Souls Langham Place), the beautifully embracing widening of Park Crescent, and the park itself are treated in *London 3: North West*; Park Village, the enclave of villas N of the park, in *London 4: North*.

At 90 ft (27.4 metres) the new street was wide, with gas and sewerage laid on, and it mixed commercial and residential premises together. Close to Carlton House, in Waterloo Place and most of the lower part of Regent Street, were large town houses. From Piccadilly Circus to Oxford Circus commerce predominated. The façades were not uniform. Nash did not believe in too much uniformity, and besides could not enforce it where leases had been taken for individual plots. He was content to try to arrange at least one long symmetrical front within each block. So there was in the end an attractive variety of Palladian palace façades, smaller façades of different design, and Anglican parochial chapels. Master-strokes included such informalities as the domed Harmonic Institution on the N corner with Little Argyll Street, and opposite it the projecting portico of *C.R. Cockerell*'s Hanover Chapel. Other architects were enlisted: for instance, *Soane* did a block, *Robert Abraham* collaborated on the County Fire Office N of Piccadilly Circus, and *G.S. Repton* designed another chapel, in the lower part of Regent Street.

The oligarchical implications of the plan did not stop with the Regent's stout person. The new route fixed for ever the boundary between wealthy Mayfair on the W and humble Soho on the E. The swerve of the Quadrant meant that St James's Square and its mansions were preserved. All the same, Nash's presumptions were different from those of the Victorians. He was not clearing slums for clearance's sake, but working carefully so that the Crown's books would balance. By hugging the edge of the smart West End, his street minimized the cost of demolition, while remaining attractive to the fashionable trades which could afford the highest rents. In all this he had to be, in Summerson's words, at once 'architect, surveyor, valuer, estate agent, engineer and financial adviser'. Though *James Burton* and *Samuel Baxter* took on much of the work, Nash had to act as builder for parts that promised less profit, notably the Quadrant and Park Crescent. What threw his calculations in the end was not the cost of acquisition but the big disbursements to compensate disrupted businesses. Return on outlay was as a result not the 7.3 per cent he had proposed, but only 2 per cent. But no one on that account would say that the street was a failure.

The Regent when King, however, lost interest in Carlton House, and it was pulled down in 1827, just fourteen years after the plan had first taken shape. The root of the whole scheme was thus cut. Nash tried to make up for this by planning Carlton House Terrace with its broad fronts to the park, the Athenaeum

and United Service Clubs to the N, and the Duke of York's Column, on the main axis of Carlton House. Nor did his efforts stop there, for Nash was careful where possible to tie in the streets to the E. The 1813 plan required the widening of the E end of Pall Mall, and its continuation up to the portico of St Martin-in-the-Fields. Nash had already proposed an open space at Charing Cross, S of this road, in 1812, and in the 1820s this took shape as Trafalgar Square (*see* pp. 372–3). In 1821–4 the Theatre Royal in the Haymarket was rebuilt, to close the newly extended view E along Charles II Street from St James's Square, and the little Suffolk Street N of Pall Mall rebuilt in connection (pp. 417, 431). The last parts to be planned were in 1830, at the S end: the so-called West Strand Improvements, in Adelaide Street and at the junction of the Strand and Trafalgar Square (pp. 439–40, 372–3).

Nash's plan remains almost inviolate, but little architecture of his time is left in our area. On the main route there is only Carlton House Terrace with its column, much of Carlton Gardens to the W, the two clubs in Waterloo Place, and one somewhat later stucco building in lower Regent Street. To the E are the Theatre Royal and Royal Opera Arcade (*see* Haymarket, pp. 414–15), most of Suffolk Street, and the group around Trafalgar Square, including the West Strand Improvements. p. 441 p. 431

Nash contrived the route to appear at its best travelling from S to N, and that is the route followed here, up to Oxford Circus and the limits of our area.

CARLTON HOUSE TERRACE and
CARLTON GARDENS

Carlton House Terrace commemorates CARLTON HOUSE, built in 1709 for the future 1st Lord Carleton. It was bought in 1732 for Frederick, Prince of Wales, for whom *William Kent* laid out the gardens. In 1763–9 *Sir William Chambers* remodelled it for the widowed Princess Augusta, incorporating an older house on Pall Mall. More grandiose work began in 1783 for the then Prince of Wales, who employed *Henry Holland* and the Frenchman *Guillaume Gaubert* to turn Carlton House into his very own Golden House of Nero. A new portico and a column-screen of Parisian hôtel type were made towards Pall Mall, and French decorators introduced heady novelties within, colour-coded rooms, ceilings painted with trellis and billowing cloud, etc. £20,000 was granted to complete it in 1787, but 'Prinny' could not stop spending and by 1795 he was £640,000 in debt. And yet work went on, in a more eclectic manner: *James Wyatt* was engaged, and also *Thomas Hopper*, who added in 1807 a Gothic conservatory with cast-iron fan vaults, balanced in 1813 by *John Nash*'s Gothic dining room at the E end. But the Regent had no use for Carlton House after he became king in 1820, and in 1827 it was pulled down, saving a few fittings for (e.g.) Buckingham Palace (*see* pp. 644–51).

CARLTON HOUSE TERRACE was built in 1827–33 on the land released by Carlton House. It was designed by *Nash* as the new

s termination of his triumphal way, and young *James Pen-nethorne* helped on the designs. The composition must be seen from St James's Park. It consists of twin stucco blocks separated by the splendid stone stairs up to the Duke of York's Column, which went up as the finishing touch in 1831–4. Like Nash's earlier Regent's Park terraces, the group is conceived on a remarkably large scale, and the ranges may rank as the greatest terrace houses ever built in Britain. But Nash liked to think in bulk; he was less interested in detail and in workmanship. The blocks are of two and a half storeys except for the end pavilions which have three and a half. Each is thirty-one bays long and stands on a deep terrace, which is raised above The Mall on short squat Greek Doric three-quarter-columns of cast iron. The ranges themselves have giant Corinthian columns above the ground floor, detached in the long centre, attached in the two projecting pavilions. Capitals are fashioned after the Pantheon in Rome. The twenty-one middle bays, recessed behind their columns and yet oddly enriched by balconies to the main-floor windows, have a five-bay centre marked by a pediment. Their scrolly acanthus decoration is by *F. Bernasconi*. The E terrace was completed only in 1863–9.*

The DUKE OF YORK'S COLUMN dates from 1831–4 and was designed by *B.D. Wyatt* (competition 1829–30). It is of the Tuscan order after Trajan's Column in Rome, and carries above its capital a square balcony and then a drum and dome (on the pattern of Wren's Monument in the City). The stones are grey Aberdeenshire and red Peterhead granite, the foundation a concealed concrete pyramid. On top a bronze statue of the Duke in Garter robes by *Sir R. Westmacott*, making an overall height of just over 137 ft (41.8 metres).

The individual HOUSES, nine in each range, are approached from the garden side, N. The houses differ more than the fronts suggest: Nash was happy for other architects to chip in, sometimes for interiors only, sometimes for the back elevations. Then inevitably the rich owners began to redecorate, followed in many cases by changes for institutional use. Since *c.* 1961, the enlightened policy of the Crown Estate, itself housed in the E terrace, has been to grant leases to professional, cultural and scientific organizations.

The EAST TERRACE begins with No. 10 (BRITISH ACADEMY), one of the larger houses in the ends. It has interiors of 1905–7 by *Blow & Billerey* in grandiloquent Parisian style, for the 2nd Viscount Ridley; the upper stage of the porch is also theirs. The stone-lined entrance hall has a vaulted bridge supporting the landing, which frames the approach to a black marble staircase, climbing in three flights. Bronze balustrade by *Bainbridge Reynolds*. At first-floor level the short ends have column-screens, behind one of which a lesser staircase spirals upwards, and the ceiling opens in an oval gallery, with glazed lantern above. Three main first-floor rooms, white and gilt, with weighty cornices.

*Nash intended a third terrace to the W, replacing Marlborough House, and others SW of St James's Park, on land later taken for Wellington Barracks (*see* p. 690).

The Duke of York's Column, Carlton House Terrace.
Engraving, showing scaffolding for erection of the statue
(*Architectural Magazine* 1, 1834–5)

The largest has an unfinished ceiling painted by *Brémond &
Tastemain*, the style like late Delacroix. Ground-floor interiors
restored to a convincing early C19 appearance by *Feilden &
Mawson*, 1997–8; the first interiors were by *Ignatius Bonomi*,
for Sir Matthew White Ridley (1827). In the porch a bronze
TONDO of the Fall of Phaeton by *J. G. Lough*, the Ridleys'
protégé, *c.* 1850. At No. 11 (FOREIGN PRESS ASSOCIATION)
Pennethorne did the interiors, for the 5th Lord Monson. Stair-
case with one straight flight and twin semicircular returns,
cleverly complicated by *Lutyens* for Benjamin Guinness, 1922: a
bridge was added from the landing to the gallery across the far
wall (made *c.* 1876), and a column-screen made below. Pretty
round-arched lobbies separate the first-floor rooms.
Nos. 12–17 are set back, their mouldings making a carelessly raw
join with the pavilion blocks. *Nash* built Nos. 12–15 as his own
speculation, with symmetrical porches of six Ionic columns,
and mirrored plans with apsed-ended staircases against the
party wall. Nos. 16–17, undertaken in 1863–6 by the builder-
contractor Sir Samuel Peto, have a wider porch. At Nos. 13–14
the porch shelters a marble STATUE of Queen Victoria by
Brock, 1897–1902, from the former Constitutional Club in
Northumberland Avenue.

No. 12 is the INSTITUTE OF CONTEMPORARY ARTS, entered through the lower terrace facing the park. The ingenious conversion to provide exhibition gallery, theatre and café within this space was by *Fry, Drew & Partners*, 1966–9 (since altered). The upper galleries, taken over in 1987, preserve Nash's (or else *Pennethorne*'s) prodigally built-up cornices and coved ceilings. Nos. 13–16 have been amalgamated for the CROWN ESTATE OFFICE. The chief interest inside is No. 16, recast in 1866–70 by *Owen Jones* and now the chief surviving example of his unique Graeco-Moorish style. The patron was Alfred Morrison, a great collector of Chinese porcelain; the decorators were *Jackson & Graham*, Jones's usual collaborators. Scrupulously restored by *Hunter & Partners* for the Crown Estate, 1989, with matching work to disguise where rooms have been thrown together. Ceilings have tessellated sunk coffering after the Alhambra, painted in strongly contrasted dark colours, with some big central motifs, e.g. the sunk umbrella-dome in the ground-floor Waiting Room. Doorcases and cornices are flattish and have distinctive light-on-dark Grecian patterns. The staircase has an apsed end, and a solid balustrade said to be by *Aston Webb*, 1890. In the Conference Room, first floor, a brightly enamelled alabaster fireplace by *M. Le Pec*. Parts of *G.F. Watts*'s allegorical murals from No. 7, done in the mid 1850s for the 3rd Earl Somers, are shown here. On the second floor *Webb* returned to design bedrooms for the 1st Viscount Cowdray, 1919. From the first floor a passage leads into Nos. 13–15, reconstructed inside for the Crown Estate in 1970–1 by *Michael Inchbald*. He kept a later C19 tripartite screen in No. 13, and extended the Nash vestibule beyond in a similar style to make a broad spine-corridor between the three houses. A fantastic double staircase of 1872 at Nos. 14–15 was removed. In 1989–90 the houses were again reordered, and pairs of scagliola columns and other C19 features concentrated on the ground floor of No. 15. No. 17 mirrors the plan of No. 16. Big, chilly D-shaped staircase. The house is linked with the MALL GALLERIES, made in 1971 within the lower terrace by *Kenneth Peacock* of the *Louis de Soissons Partnership*.

The far E pavilion is the very large No. 18, built in 1863–9 by *William Burn* for the 5th Duke of Newcastle, and still a private house. The main external difference is the balustrade type. In 1873 *George Devey* extended the porch for the 2nd Earl Granville. The most important changes however were due to the fabulous wealth of the Astors. *J.L. Pearson* designed new interiors for William Waldorf, later 1st Viscount Astor, in 1895 (working with his son *F.L. Pearson*; executed by *J.D. Crace*). Later decoration by *Paul Phipps*, 1904, for the Hon. J.J. Astor. The big dome-lit STAIRCASE is the chief survivor of *Burn*'s work. It breaks into two flights, each returning in two stages. A shallow arcaded gallery runs from the landing around two sides, the third being treated in relief. Ground–floor rooms of the 1890s: Drawing Room, N, French Renaissance with a deep compartmented ceiling and tall inlaid marble chimneypiece; two parkside rooms in a more English style, with Adamesque ceilings. First-floor rooms facing the park Early Georgian, with

painted panelling. The climax is the pair of gilded rooms to the N, amongst the most extravagant essays in London in the Louis XV style. Superbly carved trophies; painted doors; delicate plaster reliefs. The smaller room is a looking-glass box with the merest skeleton of gilt architecture. Do they belong to 1895 or 1904?

The N side and E end here are made by large stone-faced blocks of 1970–5 by *Howard V. Lobb & Partners*, consultant *Sir Frederick Gibberd*. They house flats and offices, including the BRITISH COUNCIL. The general massing respects that of Nash. Solid elevations, with strong square uprights and deeply recessed windows, owing much to 1960s works by Powell & Moya at Oxford and Cambridge. Linking bridge in the NE corner, sheltering steps down towards Cockspur Street. In 1997–9 the W office block was remodelled and extended N by the *Halpern Partnership*. Small external SCULPTURES were introduced, by *John S. Carter* (entrance) and *David John Kent* (E wall). In the newly made atrium a FOUNTAIN called Nautilus, by *William Pye*, working with *Terry Pawson Architects*, for ANGLO-AMERICAN. A tall stepped steel upright, in section like a nautilus shell, with water rushing down it into a pool. Seascape MURAL high up by *Adrian Bartlett*. Steps alongside No. 18 lead down to a paved square facing the park, made as part of the 1970s work. The balustrade along The Mall, of *c.* 1910, formerly marked off County Hall in Spring Gardens, cleared to make the 1970s buildings.*

WEST TERRACE. The houses here also have individual porches, but of varying design, Doric as well as Ionic. Nos. 6–9, embracing the end pavilion and the two houses adjacent, were converted by *William Holford & Partners* for the ROYAL SOCIETY, 1965–7. Three of them were individual commissions, from *Nash* (No. 9, for James Alexander, and No. 7), and *B.D. Wyatt* (No. 6, for the Marquess of Tavistock). Finest inside is No. 6, which in 1889–90 was transfigured inside for C.H. Sanford, by *Sir Ernest George* (decorators *Collinson & Lock*). The style is Italian Renaissance, of contrasted periods and moods. What remains is as follows. Cinquecento entrance hall, marble-lined and with blue and gilt coffered ceiling. To the r. the stairhall, Quattrocento, with richly and prettily decorated pilasters and grand three-flight staircase of white marble, with slender balustrade; the ceiling coffered, with singular mother-of-pearl rosettes. The former dining room, facing the park, has exquisite inlaid panelling. First floor. Smaller library room with similarly inlaid doors and a tessellated ceiling. The better-preserved main library, towards the park, is more Cinquecento, timber-pilastered, with carved doors, panels above the windows, and opulent part-gilt cornice. Only the insipid ceiling paintings disappoint. *Holford*'s bookcases are

* This, the old LCC headquarters, joined on to the park front of Carlton House Terrace. By *Frederick Marrable* for the Metropolitan Board of Works, 1859–60, in Italianate style; heightened by *G. Vulliamy*, 1878; enlarged 1889–90 by *T. Blashill*. To its N was a terrace of 1866 in harmony with Nash, and N of that *Nash*'s own CARLTON MEWS, built to serve the houses.

passable, but his other interventions, e.g. removing doorcases and pilasters, are utterly insensitive. Nos. 7–9 were the German Embassy until the Second World War. They were remodelled by the National Socialists in 1937 (architect *Albert Speer*, working under him *Piepenburg*). Enough survives to chill the blood. Doors each with four square inlaid panels, thin cornices of distinctive stepped form, and in one room a large recessed bookcase. Fireplaces, Travertine linings etc. noted by Pevsner in 1957 have gone. *Holford* also changed the staircase in No. 8 to have flights down as well as up, and made the ugly ceiling over it. Backlit armorial STAINED GLASS by *Whitefriars*, 1960. No. 9 also has an exquisite Grecian fireplace of *c.* 1830 with Homeric frieze. Rather cramped staircase at No. 7, Neo-Rococo of *c.* 1870. Internal renovation by *Burrell Foley Fischer* began in 2001. A gravestone to the German ambassador's dog (†1934) remains in the garden, far l.; beyond, a ramp into the lower terrace, converted by *Holford* for parking.

Continuing w, No. 5 (TURF CLUB) was by *Nash*, for the 2nd Earl of Caledon. Some interiors from then, e.g. first floor, park side, with deep decorated coving. Other rooms apparently remodelled *c.* 1860. The exterior, with the typical late Nash triple window, was copied when *Decimus Burton* built Nos. 3 and 4. These were converted for the INDUSTRIAL SOCIETY in 1972 (*Peter Barefoot & Partners*), keeping little more than the C19 staircases and some cast-iron reinforcement. Nos. 1 and 2, forming the end pavilion, have orthodox Grecian porches. No. 2 was reconstructed in 1991–2 for the ROYAL COLLEGE OF PATHOLOGISTS, by *Bennetts Associates*. Spacious, free-flowing interiors, with a neat if somewhat bland vocabulary of maple panelling and aluminium and glass cornices. The Edwardian-looking staircase must date from *F.W. Foster*'s alterations of 1908–9, for Mrs Maldwin Drummond. No. 1 (INSTITUTE OF MATERIALS), by *J.P. Gandy Deering*, has the most space-hungry of the remaining C19 staircases, climbing slowly beyond screens of paired piers below Ionic columns. Masculine Grecian detailing; early C20 balustrade. Opposite No. 2 a STATUE of the 1st Marquess Curzon, who lived at No. 1, of 1931 by *Sir B. Mackennal*.

CARLTON GARDENS continues Carlton House Terrace to the w. Built at the same time by *Nash*, but with fewer formalities, and not surviving nearly so well. Pairs of houses face each other across a little square open to the park on the S. In addition there was a third block of houses, in line with the E block and N of the roadway. No. 4, just w of Carlton House Terrace, was rebuilt in stone in 1932–3 by *Sir Reginald Blomfield*, as the headquarters of a paint company. Pevsner thought its height made nonsense of Nash's classical principles. But Blomfield wanted to carry on all along the terrace in the same manner, which would certainly have been properly classical, though intolerably lugubrious. In 1934 Nash already had enough admirers to stop the plan.* Its use by the Free French after

*And yet as late as 1947 a plot was hatched to add storeys designed by *Louis de Soissons & Partners* to the terraces, to serve as a new Foreign Office.

1940 is recalled, across the road, by a STATUE of General de Gaulle by *Angela Conner*, 1993.

No. 3, S, overlooks The Mall across a continuation of the low terrace from the E. Paired Ionic columns to the doorcase, with an added porch; staircase with a fancy balustrade, perhaps from *J.L. Williams*'s work for the Hon. Philip Stanhope, *c*. 1892. Facing, No. 1, with a bow to the square, and No. 2, with a bow to the park. On No. 1 also a N porch with a conservatory of 1857 on top. Built for Sir Alexander Cray Grant MP; since 1947 the Foreign Secretary's residence. (Open-well stair with scrolling cast-iron balustrade, perhaps early C20. One first-floor room with a pendentive ceiling.) The 9th Duke of Devonshire took No. 2 in 1921 and had Neo-Palladian interiors made to recall his demolished Devonshire House in Piccadilly (p. 562), using salvaged fittings by *William Kent*. These were removed in the 1940s but replicated in 1963, for the Royal Fine Art Commission. One fine reset fireplace remains, mid-C18, with a trophy frieze. Between the groups the terrace was breached in 1955 with a double staircase to the park (designed by *Louis de Soissons*), framing the MONUMENT to George VI, a slender bronze statue by *W. McMillan*.

On the N rises STIRLING HOUSE, a big Postmodern-classical design of 1989 by *James Stirling, Michael Wilford & Associates*, executed with revisions after Stirling's death by *Michael Wilford & Partners*, 1998–9. The blunt glazed prow and shallow curved balcony over the entrances, on the short sides, are familiar Stirling devices of the 1980s. Inset corners; long sides setting back high up, with flats on the top floors. Both axes symmetrical. Changes to the design of 1989 include the use of limestone instead of sandstone and (regrettably) the abandonment of the toplit lobby, the kernel of Stirling's plan.

WATERLOO PLACE

One of the more dramatic pieces of town planning in London. It began as the S end of *Nash*'s *Via Triumphalis*, at the time when Carlton House stood as its termination S of Pall Mall. After its demolition in 1827 the two Carlton House Terraces were built (q.v.), with the Duke of York's Column and the stairs down into St James's Park. The N part of the site was used for two clubs, with gardens to the S. The main axis gives a clear view N up the hill of Regent Street, closed by the pale hovering façade of the County Fire Office in Piccadilly Circus (q.v.). p. 448

The CLUBS are the first in the great sequence that continues along the S side of Pall Mall. The United Service Club, E, is by *Nash*, the Athenaeum, W, by *Decimus Burton*. Both are stuccoed, originally treated to resemble Bath stone. The elevations would have matched too, had the Commissioners of Woods and Forests had their way.

The UNITED SERVICE CLUB (since 1978 the INSTITUTE OF DIRECTORS) began at No. 2 Regent Street, a Grecian building of 1817–19 by *Robert Smirke* which, as Summerson wrote,

'struck the key-note for the new club architecture of London'. For their new home of 1826–8 *Nash* gave them something more Roman. His building is simple in outline, seven bays wide on each of its three fronts. The principal windows are all pedimented. To Pall Mall a broad two-storey portico of coupled Roman Doric columns below Corinthian ones. The entablatures run on from it right round the building. Much of the effect derives however from *Decimus Burton*'s alterations in 1858–9. His ground-floor window surrounds and the lush Italianate frieze *John Thomas* carved below the cornice show clearly their Victorian origin. The pediment sculpture is of 1858–9 too, as is the fluting of the upper columns. Burton also removed Nash's porch from the w front, and thereby accentuated the contrast with the Athenaeum (a Roman Doric porch to the s remains). By Burton too the first bay of the substantial extension on Pall Mall, immediately l. of Nash's part; the rest is of 1912–13 by *Thompson & Walford*, in a matching style. The same firm added the mansard in 1929–30.

The INTERIOR is composed round an extremely generous central staircase. It climbs from the w, which entails an awkwardly angled approach from the entrance hall on the n. A stillborn proposal to incorporate the staircase from Carlton House, which could only have fitted in sideways, seems to explain the arrangement. The entrance (reorganized 1986) has Ionic column-screens and a fine caryatid fireplace, reset. The staircase starts in one arm, and goes on in two breaking at 90 degrees. There is a gallery all round on the first floor and a lantern with side light (rebuilt after war damage) over the centre. Cornice and coving both altered. Tall waisted balusters of cast iron, closely set. On the half-landing, STATUE of Frederick, Duke of York, by *Thomas Campbell*, 1829. The whole s front has the former smoking room on the ground floor, Library on the first, with a division into three parts by yellow Ionic columns below, grey Corinthian columns above. These are the most splendid apartments. The tripartite room was to become a hallmark of club architecture. Wilkins had used it in his University Club in Suffolk Street in 1826. It is of course derived from c18 country houses. Other rooms similarly masculine and intimidatingly large. Especially vast the former dining room of 1858–9, merged 1886 by means of a second column-screen with a room in Nash's building.

The ATHENAEUM was conceived by the Tory politician and critic J.W. Croker as a club for artists and literary men and built in 1827–30. Therefore *Decimus Burton*'s architecture, a square two-storey block with unpedimented first-floor windows, strikes a note of erudition and Grecian beauty. Entrance is by a porch of paired Roman Doric columns to Waterloo Place. On it a large gilt copy by *E.H. Baily* of the Pallas Athene of Velletri, and above the main windows a Panathenaic frieze carved by *John Henning Jun*. Its background was painted blue, Wedgwood-fashion, in 1856. The Doric frieze of the porch extends round all three sides, with alternate triglyphs curving nicely outwards to support a fine cast-iron balcony. A dentilled cornice and balustrade are the crowning motif. The

unfortunate set-back attic was added in 1899–1900 by *T.E. Collcutt*. The area wall is of 1894, of Purbeck stone and green Irish marble, designed by two artistic members, *Ambrose Poynter Jun.* and *Sir Lawrence Alma-Tadema*.

The INTERIOR equals the distinction of the exterior, and retains in several rooms Burton's fine hanging lights and furniture (made by *Taprell & Holland*) from 1830. Deep, aisled ENTRANCE HALL with Tower-of-the-Winds columns, and over the centre a segmental tunnel vault. The STAIRCASE starts just within the end columns. It is of the type then usual for clubs and private palaces, splitting at right angles from one flight into two, and back again at right angles to reach the landing, which rests on the tunnel vault below. Glazed octagonal dome; chastely plain walls; handsome cast-iron balustrade with thick leafy uprights. A cast of the Apollo Belvedere faces the landing, between engaged Corinthian columns; more casts in niches in the aisles, above handsome round-arched fireplaces. All this is Burton's, but the decoration is later: partly of 1891, designed by a committee including *Alma-Tadema* and *Poynter* (the rich coloured marble dadoes and hanging lantern), partly of 1994–5 by *Caröe & Partners*, based on records of Burton's scheme (marble floor in false perspective, white scagliola on the columns). Also later the circular reliefs on the aisle walls, after *Thorwaldsen*. Staying on the ground floor, the COFFEE ROOM s of the hall has restrained wall-panelling, a compartmented ceiling, a fine black marble fireplace, and decoration follow-ing a scheme of 1956 by *Sir Albert Richardson*. To the N the smaller MORNING ROOM, which shows the rich 'Pompeian' decorations introduced by the 1890s committee. Wall coverings of Lincrusta, like stamped leather. Statue of Psyche by *Thorwaldsen*, given 1912.

On the first floor the DRAWING ROOM occupies the whole E front, tripartite as usual, but with divisions restrainedly marked only by paired brown scagliola columns, in form matching those by the staircase. The central space had a shallow oval dome, replaced by a flat ceiling in 1927. Handsome white marble fireplaces. Colour scheme of 1990, after Burton's drawings, with green walls. LIBRARIES fill the three other rooms, entirely book-lined. *Collcutt*'s attic houses bedrooms and a SMOKING ROOM, with a weighty Adamesque ceiling. Pressure for space was relieved previously in 1868–9 by *T.H. Wyatt*, who made rooms below ground in the garden, reached down a staircase from the SW corner of the hall; *Victor Heal & Partners* remodelled these *c.* 1961, in stripped Neo-Grecian style.

From the later C19 an unusually rich crop of bronze STATUES grew up against the garden railings S of the clubhouses. All are generals or explorers. To the W, Field Marshal Burgoyne by *Boehm*, 1874–7, and Sir John Franklin by *Matthew Noble*, 1861–6, with a good relief on the plinth of Franklin's funeral in the ice. To the E, Lord Lawrence by *Boehm*, 1882 (replacing a much-criticized first version), Lord Clyde by *Marochetti*, 1867 (on a high circular giant pedestal; below Britannia seated on a lion), and Scott of the Antarctic, 1915, by his widow *Kathleen* 76

Scott. In the centre of the roadway, trotting away from the park, an equestrian statue of Edward VII by *Sir Bertram Mackennal*, 1912–21. Well-designed plinth by *Lutyens*. By the kerb just s of each club, an inscribed MOUNTING BLOCK of granite, 'erected by desire of the Duke of Wellington 1830'. The column and the statues further w are described under Carlton House Terrace, q.v.

More sculpture just N of Pall Mall: the GUARDS' CRIMEAN MONUMENT, by *John Bell*, 1858–61. It was much criticized at the time, not least for being unheroic; its stoicism may be more appreciated today. Honour holds out wreaths high up above three Guardsmen, one for each regiment. In 1861 the wreathed lamp standards were added. In front and subsidiary to it, STATUES of two figures associated with the war: Sydney, 1st Lord Herbert of Lea by *J.H. Foley*, 1866–7, r., and Florence Nightingale by *A.G. Walker*, 1914–15, l., with a plinth to match. A relief on Herbert's plinth shows Florence, his ally in reform, visiting the Herbert Hospital at Woolwich. Herbert's statue was originally outside the former War Office in Pall Mall; the Guards were moved N to accommodate the newcomers. In front an elaborate LAMP STANDARD of the 1830s.

The BUILDINGS of this N part are amongst the most attractive in the rebuilt Regent Street scheme. The plan continues the exceptionally broad *place* s of Pall Mall, then narrows by straight returns at the N end. *Nash* built it up in 1815–16 with symmetrically arranged houses, later taken by banks and insurance companies. These were rebuilt larger in 1902–26, to designs by *Sir William Emerson*. The style is similar to Chambers's Somerset House, except for the tall attics with superimposed columns. Porticoes on the centre of each long

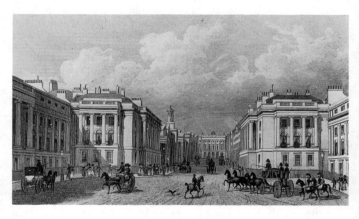

Waterloo Place, looking north,
showing the original architecture. Engraving
(James Elmes & T.H. Shepherd, *Metropolitan Improvements*, 1829)

side and on the returns, as on the Nash houses they replaced, but with pediments in addition. Sculpted portals, varying slightly in design. The W corner with Pall Mall was finished first, for the bankers Henry King & Co., 1902–3. Good double-colonnaded banking hall. The E corner was another bank, Messrs Cox, 1909; since 2002 a hotel. Different architects did the interiors: e.g. in the narrower N part, *Thompson & Walford* on the E (Nos. 7–9, 1908–10, for North British & Mercantile Insurance, with plasterwork by the *Bromsgrove Guild*), *Claude Ferrier* on the W (No. 11, 1911–12, for Trafalgar House). Inside No. 12, parts remain of *Terry Farrell & Partners'* Crafts Council gallery of 1981, a very early deployment of the fat caricature columns that became such a cliché of Postmodernism.

REGENT STREET
South of Piccadilly Circus

The steepest part of *Nash*'s great scheme, linking the formal episodes of his Waterloo Place and Piccadilly Circus. Its architecture, built 1817–20, was relaxed by comparison, and few façades corresponded across the street. They included *Nash*'s own house (No. 14), and at No. 11 *G.S. Repton*'s St Philip's Chapel, a Grecian curiosity with a tower after the Choragic Monument of Lysicrates. Their replacements are much more divergent than in the main part of Regent Street further N.

The junction with Waterloo Place is marked by Charles II Street, which *Nash* extended E to Haymarket in 1813–18, later building a theatre there to close the view (*see* p. 417). No. 2, on the NE corner, is the former UK Atomic Energy Authority, 1955–8 by *Trehearne & Norman, Preston & Partners* and *Leslie C. Norton*. Its sills have a pattern of small raised squares. The top two storeys recede and have the skeletal canopy favoured by the firm at this time. Much use of yellow cladding: a departure from the Portland stone norm, presumably to imply technological excitement.* Opposite (W SIDE), Nos. 1–3, BRITISH COLUMBIA HOUSE, signed by *Alfred Burr* and dated 1914 and 1915. A big enriched palazzo with a through-storey porch. Sculpture by *F.W. Pomeroy*, not at his best. Nos. 5–9 by *Wimperis, Simpson & Guthrie*, 1950 (planned from 1938), pares the traditional detail to the minimum, as does REX HOUSE facing (Nos. 4–12), of 1937–9 by *Robert Cromie*.

Back on the W SIDE, Nos. 11–13, conventional Edwardian with twin domes: No. 11 by *F.E. Williams*, 1905–6, No. 13 a matching extension of 1922. No. 15 (formerly Club Chambers) is of special interest as the only survivor in Regent Street of the age of stucco. It went up in 1838–9 to designs by *Decimus Burton*, replacing a short-lived private mansion. Inside were small residential suites for rent, with shared reading and dining rooms. The façade of Burton's palazzo remains from the first

* It replaced the Junior United Services Club of 1855–7, by *Nelson & Innes*, successor in turn to the first United Service Club (*see* Waterloo Place).

floor to just above the third; two more storeys heaped on in 1879, for the Army & Navy Stores. In 1989 the ground floor was partly restored, and the rear parts rebuilt.

The PLAZA CINEMA next door is a forceful classical building by *Frank Verity*, 1925–6, with a rounded entrance corner finished with a generous drum and dome. One of the earliest grand West End cinemas, built as its first London venture by the American distribution company Paramount. Bets were hedged by providing also for live stage shows. The board room occupied the base of the dome, which is covered in zigzag blue and gold tiles. Rebuilt internally 1967–8 and again 2002–3.

On the E SIDE, Nos. 14–20 is a large symmetrical block of 1924–9, built in stages to a single design by *Joass*. Columns to the shop parts rather than high up, and detailing a cut above the usual in the new Regent Street. The little No. 22 was an early rebuilding: 1871, for the silversmiths Elkington & Co., by *Frederick Peck* in a heavy version of C17 French. Ground floor of 1986 by the *Rolfe Judd Group Practice*, a stab at the C19 design, with a non-matching extension along Jermyn Street, l. Everything N of here belongs with Piccadilly Circus (q.v.).

PICCADILLY CIRCUS

Piccadilly Circus is not a circus at all. It is vaguely triangular, and the architecture which surrounds it tends to stress that. It was different in *Nash*'s day, when quadrants just as regular as those at Oxford Circus closed the corners. The triumphal way from Carlton House negotiated Piccadilly through this space and up the short distance N to the County Fire Office. From there it swept W between the Doric colonnades of the old Regent Street Quadrant. What knocked the space out of kilter was the making of Shaftesbury Avenue in 1884–5, for which the NE quadrant was demolished. Then in the early C20 the Regent Street rebuilding made the remaining curves into angles. The architecture now falls into halves, with the urbane Portland stone along Regent Street confronted from the E by Late Victorian buildings for commerce and entertainment, competing for attention in turn with the blinking advertisements to the NE.

A tour of the buildings can run anticlockwise, starting with the rebuilt former COUNTY FIRE OFFICE on the N side. Of 1924–7 by *Ernest Newton*, with a rounded dome, and a sculpted Britannia and Lion on top by *Hermon Cawthra*. Scupture and columns recall its predecessor, a collaboration between *Nash* and *Robert Abraham*, based on the Queen's Gallery at Old Somerset House (*see* p. 318). Newton was also required to emulate the arcade, French channelled piers and swagged attic of *Sir Reginald Blomfield*'s QUADRANT of 1923–7 on the W side. This has by way of contrast twin concave-sided domes, and along Piccadilly a balustraded lower parapet with urns and children dodging round them. This part, formerly the premises of Swan & Edgar, was internally rebuilt in 1985. The rest of the Quadrant is described under Regent Street, q.v. Where

Regent Street comes in on the s, the blocks are L-shaped in plan. Façades designed in 1918 by *Blomfield*, with similar tall arched windows but lacking the grace-notes of arcades, domes and urns (w block completed 1929, e 1924).

Next, dominating the s side of the Circus, is the CRITERION, bigVictorian of 1871–4, the premier surviving work by *Thomas Verity*, and the first West End venture of the railway caterers Spiers & Pond. It was essentially a monster restaurant with a theatre in the basement.Verity's design signals to the customer with big twin pavilion roofs, and beneath each a pedimented feature with Venetian window, and then small twin aedicules with sculpture by *E.W. Wyon*. Access was from a round-arched central entrance, restored in outline in 1989–92 when the *Renton Howard Wood Levin Partnership* reconstructed and extended the complex (*see* also below). The INTERIORS now have three separate entrances. The central one serves LILLYWHITE'S, who have extended their shop on the w into the upper rooms, including the Great Hall, marked externally by big round-arched windows. This is later C17 in flavour, with pilasters and a glazed dome. The CRITERIONTHEATRE through the r. entrance is original, upgraded by *Verity* in 1883–4 and refurbished in 1992.The street entrance preserves the carefree 1870s appearance, with a painted ceiling, mirrors and tiles, the last made by *W.B. Simpson & Son* after fairgroundish cartoons by *A.S. Coke*. Similar linings in the staircase to the small subterranean auditorium, which is largely still as modified in 1883–4, with two iron-fronted balconies. An openable prompt-side box allowed scenery to be moved via the auditorium. The l. entrance is to the former Long Bar (now CRITERION RESTAURANT), a *fin-de-siècle* Byzantine remodelling of 1899 by *Frank Verity* (restored 1984). Glistering gilded mosaic ceiling by *Burke & Co.*; walls sheathed in Tennessee and Vermont marble (their first English use).

To the e, replacing *inter alia* a matching extension of 1878–9, stands a big new block by *Peter Howard* of *Renton Howard Wood Levin Partnership* 1989–91.* A heavy slab of stone, carrying on in simplified form the Blomfield elevations. The Haymarket corner is leavened by a frothing FOUNTAIN with four frenzied bronze Horses of Helios, by *Rudy Weller*, 1992. Over them a glazed cylindrical oriel, three springing gilt figures also by *Weller* (meant for the Three Graces), and a bubble-like dome. The offices (McKINSEY & Co.) are reached via a new pedestrian passage along Jermyn Street, s. Escalators rise under a coffered chromium barrel vault to an atrium lobby, lined on two sides with misted grey glass. Reused on the desk front, a lettered frieze from Verity's demolished rear elevation.

The Criterion faces the LONDON PAVILION, of 1885, with elevations by *R.J. Worley*. It was the first grand West End music hall, occupying most unusually an entire free-standing block. Triangular plan with four-column porticoes on the two main sides, linked by an arcade applied along the first floor. Painted to look like stucco, but originally of particoloured stone.

*They supplanted *Dennis Lennon & Partners*, who made designs in 1972 and 1978.

The owners obtained a cheap site lease by bribery, and rushed it up in four months and three days, working round the clock under electric lights. Reconstructed as a cinema in 1934, and again in 1986–8 by *Chapman Taylor Partners* as an entertainment complex, squeezed under a big new mansard with Victorian details. The parapet was heightened and thirteen big maidens modelled by *Everard Meynell* and *Guy Portelli* set on it.

Across Shaftesbury Avenue the buildings are hidden by the ADVERTISEMENTS which every London visitor feels the need to see. They got out of hand only in the early 1920s, before which there were hardly more than on other commercial streets. Since 1977 they have mostly been confined to this one range, like a noxious but protected species. The first digital sign appeared amongst the neon in 1998.

On the S side of the Circus stands *Alfred Gilbert*'s SHAFTESBURY MONUMENT of 1886–93, with the statue of Eros on a high octagonal pedestal and fountain, so familiar as the mascot of London that one can no longer judge it either as sculpture or monument. It commemorates the 7th Earl of Shaftesbury, the philanthropist (†1885). The conception of a fountain rather than a conventional statue was Gilbert's own, and it set him off on a trail of 'fishes of all kinds, and every class of molluscous and crustacean life'. Eros (properly Anteros, embodying selfless love) is cast in aluminium, its first large-scale use for an English monument. Gladstone composed the inscription. The spreading outer basin was an afterthought, and the setting gave much trouble to all concerned. The first arrangement, a low walled enclosure, was removed in 1894; the present shallow pedestal in two stepped stages is of 1931, by *G. Topham Forrest* of the *LCC*. Distinctive LAMP STANDARDS with elliptical lights, designed in 1932 by *Arthur J. Davis* of *Mewès & Davis*, and multiplied after 1990 throughout Regent Street. Those at the Circus are of bronze. In 1986 Eros was relocated to the S, so that traffic no longer encircles him.

The UNDERGROUND STATION with its near-circular concourse is by *Charles Holden* (*Adams, Holden & Pearson*) with *S.A. Heaps*, 1925–8 (engineer *H. Dalrymple-Hay*). It was the Underground's first reconstruction to abandon street-level buildings in favour of subway entrances. The design, restored in 1989, is clear and spacious. A flat coffered ceiling rests on two concentric rings of columns, clad in faceted red scagliola with bronze trim. Shops are wrapped around the central escalator enclosure and fitted into the Travertine-lined walls.

Piccadilly Circus is the ill-shaped rock on which the hopes of many C20 IMPROVERS have foundered. In 1904–6 *Norman Shaw* proposed a formal square in connection with his Quadrant design. This was rejected, as were more modest designs of 1908–10 by *John Murray* of the Office of Woods and Forests. Interest revived once the W ranges had been rebuilt in such embarrassing contrast to the NE part. *Blomfield* wanted to repeat his façades around a widened E space (designs exhibited 1936). *Sir Charles Bressey*'s Greater London Development Plan (1939) also envisaged widening on the E. After the war,

a stalemate between planners and developers ultimately stopped anything drastic happening. The opening bid was by *Cotton, Ballard & Blow* for Jack Cotton, 1959, for the messy E corner with Shaftesbury Avenue (the former Café Monico site). A public enquiry found its big office tower unacceptable, and *Sir William Holford* was charged with replanning the area to reconcile commerce, pedestrians and traffic. His three successive plans, of 1961, 1962 and 1966, were illuminated by the 1960s' *ignis fatuus* of vertical segregation, with pedestrians forced up on to decks and walkways, and much rebuilding to the E, in Coventry Street and Shaftesbury Avenue. The latest and largest plan allowed for more traffic and for a link with rebuilding in Regent Street, for which elevated walkways were also favoured. But the developers sought yet more office space, projected in 1968 in a scheme with a tower 435 ft (132.5 metres) tall. *Westminster City Council* were behind the next variant, of 1972, which had three lower, octagonal towers by separate developers' architects, linked by pedestrian decks, and far less in the way of theatres and cinemas. Vilification followed. In 1974 the *GLC* announced a policy of 'least change', saving all the chief landmarks, but it took until 1984 to set comprehensive improvements in motion.

REGENT STREET
North of Piccadilly Circus

The rise of Nash's Regent Street is described at the beginning of this section. Its decline and fall set in earlier than is often thought. First in 1848 the colonnades of the Quadrant were demolished, as an obstacle to daylight and a haunt of vice. From the 1870s onward a few individual houses were rebuilt, of which No. 22 is the earliest survivor (*see* p. 450). Victorian photographs also show many buildings raised by one or two storeys, spoiling the Hanoverian lines. Later intruders were increasingly disrespectful to the Regency scale, and the architectural chaos of Shaftesbury Avenue or Charing Cross Road threatened to recur. The Edwardians took the matter in hand with a characteristic feeling for pomp. Waterloo Place was rebuilt to a consistent and chaste design from 1902; Regent Street S of Piccadilly Circus was treated piecemeal, with demolitions up to 1939 (qq.v.). How to treat the Quadrant and the W side of Piccadilly Circus was the greatest conundrum, and after much chopping and changing one of the better episodes of the rebuilt street resulted. The picture further N is more mixed, though not without its highlights. Rebuilding here was officially declared complete in 1927, work carrying on for a year or so after.

The consensus at the time and since was that the new Regent Street route was not a patch on the old; Pevsner called it 'a disappointment throughout'. Formal features survived translation quite effectively, it is true, and the new Waterloo Place, Quadrant and Oxford Circus are visually successful. But Nash's genius for informal composition and picturesque skylines was not passed on, while the new façades are so much taller that the easy

spaciousness seen in C19 views has been lost. Yet a glance at the architectural push and shove of Oxford Street will show the benefits of working consistently and on a large scale, even at the cost of dullness here and there. For the Crown Estate, too, the recipe was successful, as the bronze-fronted shops of Regent Street have stayed at the top of the commercial tree. In 1992 the Estate repaved the street, and introduced street furniture of traditional design. In 2001 a further, ten-year modernization programme was announced. Many buildings will be refurbished, and selected 'feeder' streets closed to traffic.

The Present Buildings: the Quadrant

The destruction of Nash's street got properly under way in the QUADRANT. The man responsible, one is grieved to say, was *Norman Shaw*. His PICCADILLY HOTEL of 1905–8 reached with its back to Regent Street. There Shaw put up the most unashamedly Baroque design, a thickly rusticated ground floor, and above colossal paired columns, their lower parts ringed with heavy square blocks, and circular windows on the second floor with sumptuous garlands around. The height of course was also much greater. The stage was set for the rebuilding of the whole Quadrant in this Imperialist Baroque, but the shopkeepers objected that Shaw's cavernous arcades were quite wrong for display windows, and work was held up while committee after committee considered the problem. In 1916 the triumvirate of *Sir Aston Webb*, *Ernest Newton* and *Reginald Blomfield* was instructed to prepare a fresh design, which in its approved form (1917) was credited to *Blomfield* alone.★ The work dates from 1923–8. Blomfield toned down what his master had done, and did it well and skilfully. His main accents are as grandiose as Shaw's and less noisy. Big rusticated arches reappear, complete semicircles without jambs – a motif taken from Chambers's Somerset House (p. 322). Blomfield used it four times, mostly to screen the entry of streets, and above each placed a recessed pair of Tuscan columns (unblocked, needless to say). But between these accents his façades are quiet over long stretches, and the ends mostly have rather French, rather elegant motifs, with Ionic columns and concave-sided cupolas. Only the keenest-eyed will notice that the results are not quite symmetrical.

Individual businesses found their own architects for the internal arrangements. The CAFÉ ROYAL at No. 68 (N SIDE) chose Messrs *Tanner*, 1923–8, who made a sequence of Parisian banqueting rooms. Its famous Bohemian predecessor here was fitted out by *Archer & Green* in 1865–72; some sumptuous gilt caryatids and mirrors remain, reset in the present Grill Room. A little beyond is the QUADRANT ARCADE (Nos. 80–82), 1925–7, with discreet Neo-Grec detailing by *Gordon Jeeves*. On the S SIDE, AUSTIN REED (No. 103) has in the

★ *The Builder* organized its own competition in 1912, won by the irrepressible *Richardson & Gill*.

basement a large and well-preserved barber's shop by *Brian Westwood*, 1930, lit from a giant Art Deco corona.

Regent Street north of the Quadrant

In the rest of Regent Street the rebuilding aimed to create a symmetrical commercial palace on every street block: an easy matter for a single tenant, but much harder when early piecemeal replacements had to be incorporated. The task was co-ordinated for the Crown by *John Murray*. Oxford Circus and more than half of the rest were designed by Messrs *Tanner*, that is the brothers *Henry Tanner Jun.* and *Ernest J. Tanner*, joined by their father *Sir Henry Tanner* when he retired from the Office of Works in 1913. As Pevsner remarked, however, it is the buildings not designed by the Tanners that one remembers.

The first and best is the NEW GALLERY range (W SIDE), of 1920–5 by *Burnet & Tait*. It has heavy Tuscan columns at the corners and low, squat, somewhat Byzantine domes, echoing the pepper-pots on *Nash's* predecessor building. Figures by *Reid Dick* beneath. Around the top also no pediments or garlands, but only curiously stepped, angular shapes. Good bronze work, modelled by *George Alexander*. Burnet was chosen by the Edinburgh tailor R.W. Forsyth, formerly at the S corner, who had employed him earlier in his home city. The front range in the centre incorporates the New Gallery itself, remodelled by *Nicholas & Dixon-Spain* as a cinema in 1924. It has Britain's oldest surviving Wurlitzer (1925). (Central dome from the first New Gallery, an art gallery converted by *E.R. Robson*, 1888, from a failed meat market put up in 1887.) Robson's work appears at No. 1 Heddon Street round the N corner, of brick and plainly late C19.

The counterpart on the E SIDE is Nos. 106–130, 1911–28, to a design by *Henry Tanner Jun.* A long range, mansarded and pavilioned, with pilasters emphasizing not the main accents but the linking recessions. Next CHESHAM HOUSE (Nos. 132–154), 1923–5 by Messrs *Tanner*, more Beaux-Arts. To be rebuilt behind by *Michael Squire & Partners*. Back on the W SIDE, Nos. 133–167, a longer block with a more confused elevation. The oldest part is the former London Joint Stock Bank on the S corner, of 1907 by *R.C. Harrison*. Its Renaissance aedicules against channelled stone are repeated on the N corner. The rest, of 1921–5, finds Messrs *Tanner* undecided and underpowered. (Under No. 153, CELLARS of the Nash era, joining on to further vaults and cellars from a C17 brewery.) Facing the N part of this range is the former Linen Hall (Nos. 156–170), 1903–15 by *G.R. Crickmay & Sons*. Built for Robinson & Cleaver of Belfast, to a consistent design. Bombastic corner domes, their lower stages of red Norwegian granite. The plan was deeper than most, with a toplit central hall. Next to the Linen Hall is the worst muddle, at Nos. 172–206. Here a big building by *W. Woodward*, of no architectural merit, went up at Nos. 184–186 in 1897–9. This necessarily became the centrepiece when the rest was rebuilt as

weak, unequal ranges in 1905–24 (*Henry Tanner Jun.*), though
Woodward's arcaded balconies were not repeated. Plainer end
blocks, designed by *Joass*; on the s corner a fine marble and
bronze shopfront by him for Mappin & Webb, 1915. (VAULTS
in front of Nos. 172–180, probably from premises by *Robert
Abraham*, 1820–1.) The range opposite (Nos. 169–201, W SIDE)
was a victim of cost-cutting. *Frank Verity* provided a design in
1908 for Nos. 193–197, a confident essay in the Selfridge
manner with giant Greek Ionic columns. After the First World
War this was considered too expensive to continue, though
symmetry required its duplication on the s half, and *T.S.
Darbyshire* designed the neutered Ionic centrepiece and plain
connecting ranges and corners (built 1921–6). On the corner
with Conduit Street, N, a nicely luxurious marble shopfront
by *Mewès & Davis* for Morny, 1924. Next on this side, Nos.
203–221, 1915–24 by Messrs *Tanner*, with Doric columns in
the mezzanine.

LIBERTY'S, facing (E SIDE), 1925–6 by *E.T. & E.S. Hall*
(designed 1914), goes on with the hackneyed screen of giant
columns, but by curving it in above the straight ground
floor and mezzanine achieves at least an individual effect. The
front repays attention for the enormous FRIEZE high up,
sometimes claimed to be the largest sculpture in London.
C.L.J. Doman modelled the centre, *Thomas Clapperton* the
ends, and *G. Hardie & Sons* carved it at their yard in
Shepherd's Bush (1923–4). Above appear carved figures over-
looking the parapet. The theme below is the transfer of
goods to the mother country, and reference was intended to
Arthur Liberty's 1870s beginnings selling oriental silks and
Japonnaiserie. The little Japanese bronzes on the shopfront are
relics from these early days. The s corner, with stubby Doric
columns inside, was formerly a bank.

For the remainder of Liberty's business, round the N corner
and along GREAT MARLBOROUGH STREET, Messrs *Hall*
abandoned Imperial pomp for something unique: a timber-
framed department store, built 1922–3. The style was chosen
for its connotations of Englishness and guild craftsmanship,
with that swelling nostalgia for an older, cosier world that over-
took Britain after the First World War. The timbers are the real
article; they came from genuine men-of-war, the *Hindustan*
and the *Impregnable*; they are pegged and mortised, not just
stuck on. Portland stone (chiselled, not sawn) is used for some
of the gabled bays, for the gabled bridge added to join the
Regent Street range, and round the back. The roofing tiles are
hand-made, the windows are properly leaded, with stained-
glass panels by *Wainwright & Waring*. On the bridge a CLOCK
showing St George and the Dragon, designed by *Hope Jones*.
Laurence Turner carved the bargeboards, shopfronts and the
coats of arms (designed by *Kruger Grey*); *E.P. Roberts* designed
the weathervane, a ship modelled on the *Mayflower* (1924–6).
Pevsner, who knew the Modernist department stores of
Weimar Germany, found all this functionally and intellectually
intolerable: 'the scale is wrong, the symmetry is wrong, the
proximity to a classical façade put up by the same firm at about

106

the same time is wrong, and the goings-on of a store behind such a façade (and below those twisted Tudor chimneys) are wrongest of all'. But he had to admit that, by the Arts-and-Crafts standards upheld by the shop, there was nothing technically amiss. A plainer aesthetic appears round the E corner, with a stone-faced section with staggered staircase windows.

The 1920s INTERIOR is still more extraordinary: a gently creaking cage of seasoned oak, organized around three tall but intimate toplit courts. Their galleries have straightforward uprights and modestly decorated fronts, with more elaboration around the skylights. They are also early examples of the atrium formula, which recurred on a larger scale in the 1930s, e.g. at John Lewis in Oxford Street (*see* p. 462). (Earlier department stores in London sometimes used grand top-lit staircases instead, on the Parisian model, e.g. Whiteley's in Paddington 1908–12; *see London 3: North-West*.) Carving, plasterwork, etc., by the *Liberty* firm.

Liberty's WAREHOUSE stands just to the S, reached from Little Marlborough Street. By *J.N.R. Vining*, 1910–11. Of glazed brick, the mouldings and motifs markedly enlarged.

Back on Regent Street, E side, Nos. 224–244 are DICKINS & JONES, 1919–21 by Messrs *Tanner* (design illustrated 1917). Beaux-Arts classical with a slight Egyptian admixture. Plainer NE extension facing Argyll Street, 1938. Within the central part is a circular atrium, made in 1994. On the W SIDE, Nos. 223–227, between Maddox Street and Hanover Street, is the smallest block on Regent Street, by *T.S. Darbyshire*, 1922–4. N of this, Nos. 229–247, of which Nos. 235–241 (by *G.D. Martin*, on the Hanover Chapel site) is dated 1898. It still exhibits the principle of all-over decoration, and is finished with a French pavilion dome of copper. Built as showrooms for Angelus Player-Pianos. In the spandrels arms of cities in mosaic, by *Salviati & Jesurum* of Venice. Plain, non-matching sides by *Yates, Cook & Darbyshire*, 1922–3.

Then OXFORD CIRCUS is reached. The quadrants have identical fronts with giant pilasters through three storeys. The design was by Messrs *Tanner*, 1911, after a limited competition. The approximate completion dates are: SW 1925, NW 1923, NE 1913, SE 1923. At the NW a matching W extension and pedestrian passage, to a design of 1964 by *A.G. Macdonald*. The NE quadrant was damaged in the Second World War and rebuilt identically. Inside is NIKETOWN, 1999 by *BDP Design*, with a big internal void with bridges to a central drum. The model is the shared semi-public spaces of the more spectacular shopping mall, designed to project an exclusive 'brand image'. (For the rest of this block *see* Oxford Street, p. 460.)

OXFORD STREET

Oxford Street needs no special introduction; nearly every British city has something similar as its main shopping artery. The differences are its length – just over 1¼ m. (2 km.) – and the exceptional size of its department stores. These sit cheek by jowl with smaller buildings of every degree of pretension, a mixture that owes much to the fragmented freehold pattern. Only the very oldest were built without a shop in mind, for shopping floorspace is what really counts here, and the architecture is sometimes hurried and perfunctory. In its bad stretches Oxford Street is indeed like an architectural jumble sale, with decent but wornlooking buildings mixed with mere rubbish. But all in all there is no better place to study retail buildings, the highlights of which match anything in Regent Street or Piccadilly.

Oxford Street began as part of the Roman road from London to the W. Until the mid C18 the names Tyburn, Uxbridge, Worcester and Oxford Road were all used. Public executions were held from 1388 to 1783 at Tyburn, the corner with Park Lane at the W end. Houses began to go up in the 1680s, and Rocque's map of 1747 shows both sides built up as far W as Marylebone Lane. Construction further W was catalysed by the Portman Estate development N of the street, from *c.* 1764 (*see London 3: North West*). Oxford Street was never a fashionable address, and these houses tended to be small and plain; De Quincey's *Confessions* recalls 'never-ending terraces' here in the 1800s. After Regent Street opened in the 1810s these were increasingly turned over to shops. More ambitious architecture came later, notably with the Grosvenor Estate's rebuilding after 1865 of its section along the S side, W of South Molton Lane. But the great strength of the street from the later C19 was the flotilla of famous department stores on the N side, mostly W of Oxford Circus. No new department store has been built since Debenhams in 1971 (Nos. 334–348), though medium-sized mixed shopping malls in new or converted buildings proliferated in the later C20.

The types of Oxford Street architecture will be clear in the first few minutes. First the original domestic buildings, architecturally insignificant except for the enclave of Stratford Place on the N side. Next, narrow, mostly gabled commercial properties still treated individually, then bigger Late Victorian turreted varieties, and finally, large C20-C21 blocks in classical or modern dress. The description is from E to W, in two parts either side of Oxford Circus; the best view is from the top of a bus.

East Part: Tottenham Court Road to Oxford Circus

North side

The first stretch hops up and down between big and very small buildings. The corner with Tottenham Court Road is a large, fiddly block by *Saville & Martin*, 1892, for the Baker Bros, publican-speculators. Towards Oxford Street the TOTTENHAM pub, separately expressed with inset bay and shaped gable. Rare interior: theatrical ceiling paintings of the Seasons by *Felix de Jong & Co.*, painted mirrors by *Jones & Firmin*, and plenty of encaustic tiles. The little No. 8, *c.* 1870, round-arched, is like early Waterhouse. No. 14 (VIRGIN MEGASTORE) was one of Lyons' huge Corner House restaurants, of 1926–8 by *F.J. Wills*. Confident white-faience front, with giant broken-pedimented aedicule. Lesser front to Tottenham Court Road. Reconstructed by *20/20* in 1993–5, and left deliberately raw-looking. In the private areas fragments of Lyons' extravagant marble-lined interiors, designed by *Oliver Bernard*. Nos. 26–32 by *Fitzroy Robinson & Hubert H. Bull*, 1954–5, indifferent curtain-walling. Nos. 34–36, a slim front by *Metcalfe & Grieg*, 1912, still in the artistic style of *c.* 1900. Nos. 40–42, 1923, has a black marble entrance of 1930 with Doric columns, for one of *Palmer & Holden*'s National Provincial Bank branches.

At Rathbone Place the E corner has a reset stone dated 1718, a relic of the first development. The W corner is Nos. 54–62, EVELYN HOUSE, by *Adams & Holden*, 1908–10. Arched mezzanine, and on the upper floors classical details with a tendency to unrelieved right angles, typical of the young Holden. More characteristically commercial is Nos. 64–66, 1906 by *Purchase*. Nos. 70–88 is by *Trehearne & Norman, Preston & Partners*, 1960. Tall floor of shops, then six more floors and open roof canopy. Alternate window-frames project tentatively and are vertically linked. Nos. 90–92, 1900, with a rather Moghul-looking corner turret. No. 100 was the premises of Osler & Faraday, light-fitting manufacturers. By *Constantine & Vernon*, 1926, with the usual pilaster-piers. It replaced Oslers' iron-framed 'London Crystal Palace', of 1858–9 by *Owen Jones*, which had a strange glazed roof of half-quatrefoil section.

After Berners Street is the first department store building, now THE PLAZA, until 1983 the drapers Bourne & Hollingsworth (Nos. 116–132). By *Slater & Moberly*, 1925–7. A successful attempt at monumentality with minimal classical detail, just a Greek-key frieze and a kind of pediment. On the front a SCULPTURE of a girl by *Michael Rizzello*, 1997. The inside (with that of the building immediately N), scooped out in 1985–7 to make a shopping mall, was again remodelled in 1996–7 by the *Colman Partnership*. Their new interior is a giant vesica in plan, with two upper galleries: a strong, memorable space. Nos. 150–154 (HMV) by *Elcock & Sutcliffe*, 1931, in a Wallis Gilbert manner with one large window panel.

The next highlight is at Nos. 156–162: the former MAPPIN & WEBB, 1906–8 by the firm of *Belcher & Joass*, in effect by *J.J. Joass* alone. A wilful design, but done with conviction. The

restless animating spirit is the Michelangelo of S. Lorenzo in
Florence. Tall slender heterodox Doric columns, the height
of ground floor and mezzanine, carry tall square pillars with
angular decoration. On these rest paired columns carrying
arches. Tripartite windows between, vertically linked. In the
mezzanine were the firm's offices, with space for rent above.
The facing is white Pentelic marble, the framing steel, which
allowed the stone to be pared away below. The fourth bay, r.,
is *Joass*'s addition of 1929, betrayed by its different cornice.
Utilitarian rear extension, 1936.

The former WARING & GILLOW fills the next street block
(Nos. 164–182). By *R. Frank Atkinson*, begun 1901, first phase
open 1906; w part and Great Titchfield Street extension 1933
(*Elcock & Sutcliffe* executants). In a riotous Hampton Court
Baroque, less literal than what Reginald Blomfield and others
were then doing. Orange-red brick, grey granite below, and
much Portland stone enrichment above. At the corners ships'
prows with cornucopia, over the centre a tall broken pediment.
Norman Shaw was also involved, at least informally: related
drawings survive in his papers, and a link is traceable through
his Royal Insurance in Liverpool, on which Atkinson worked.
Construction was to the exacting standards of the *Waring-
White Building Co.*, newly set up for the purpose, with steel
framing structurally independent of the load-bearing walls.
Opulent rainwater heads by *C. Wragge*. It accommodated
the furnishing businesses of Gillows, trading from *c.* 1765 in
Oxford Street, and Warings, a mid-C19 Liverpudlian enter-
prise, which merged in 1897. Reconstructed as offices over
shops by *R. Seifert & Partners*, 1977–8, with new elevations of
sober red brick in the NE angle.

Next a stretch of medium-sized buildings. *Guy Morgan &
Partners*' Nos. 184–190 was a 'Bacon-and-Egg' café for J.
Lyons, 1959. Characteristic late-fifties decoration of the
mezzanine. Nos. 192–194, 1887 by *C.F. Hayward*, was the
outfitters Charles Baker & Co. Blunderingly eclectic, of
red brick and seven different stones. Nos. 196–198, 1914, one
of *T.B. Whinney*'s London, City & Midland Banks, with
Egyptianizing trim.

On either side of Great Portland Street stand two buildings by
H. Austen Hall with *T.P. & E.S. Clarkson* for the former PETER
ROBINSON, who set up shop here in 1833. The lesser block,
w (Nos. 200–212), *c.* 1926, has giant pilasters. The main block,
E (now TOPSHOP), 1921–5, is the usual commercial giant-
column stuff of the time, but with a remarkably powerful treat-
ment of the two lower floors: the first-floor windows large,
horizontal and entirely unmoulded, the entrances with giant
coffered arches rising up in three places between. Hall copied
this arrangement from Starrett & Van Vleck's store of 1914
for Lord & Taylor in Fifth Avenue, New York. The block forms
the NE quadrant of Oxford Circus (*see* Regent Street, p. 457),
towards which *Henry Tanner*'s elevations are followed. The
fourth floor here, remodelled by *HOK* for themselves 1997–8,
features a long barrel-vaulted former tearoom painted with
operatic scenes by *George Murray*.

South side

Up to Soho Street all is still pre-war, modest in scale, and in 2003 very unloved-looking.* The curved E corner belongs with the Charing Cross Road scheme: 1887–9, by *T.M. Houghton*. Nos. 9–15 is TOTTENHAM COURT ROAD UNDERGROUND STATION, one of *Harry Measures*'s jobs for the Central London Railway (Central Line), 1899–1900. Terracotta offices on top by *Delissa Joseph*. The forceful, brilliantly coloured tile decoration in the underground areas by *Eduardo Paolozzi* is the most ambitious example of the cosmetic refurbishments planned from 1979 (completed 1985). No. 17, gabled, is by *Batterbury & Huxley*, 1886. Nos. 19–23, routine commercial of 1909–10 by *Gilbert & Constanduros*, was the Cinematograph, the first purpose-built West End cinema. Nos. 37–39, 1913 by *D. Joseph*: the Selfridge pattern of giant columns, but for only three bays. Nos. 45–49 is yellow brick quasi-Gothic of *c.* 1875, No. 53, dated 1900, still at that date narrow and gabled.

After Soho Street, the miserly Nos. 63–65, 1878, built for Bonham's the auctioneers. Then Nos. 73–89, the seven E bays 1929–30 by *Gordon Jeeves & H.A. Welch* for Drage's the furnishers, enlarged in 1952 by another twelve bays, r. All black or grey polished granite with uprights rising up unbroken, windows with metal panels between, and decoration with the wavy and zigzag motifs of the 1925 Paris Exhibition. Next Nos. 91–101 by *Sir John Brown, Henson & Partners*, 1957, curtain-walled, but still with a top cornice. No. 103, on the W corner with Great Chapel Street, quite delicately done: 1908 by *P.E. Pilditch*. Nos. 105–109 was built for Henry Heath's, the hatters, in 1887–8 by *Christopher & White*. On the gables terracotta beavers modelled by *Benjamin Creswick*, a protégé of Ruskin. His delightful figure frieze illustrating the hat trade has been destroyed. Nos. 111–125, busy retained façades by *Banister Fletcher* and *H.H. Collins* dated 1887, show the assembly of properties into one composition. Large arches gather shop and first-floor windows together.

Best of the next block are *Simpson & Ayrton*'s Nos. 133–135, cast stone with an inset bronze bow, 1911, and the turreted Nos. 141–143, *c.* 1885, on the W corner. No. 145, early C19, is the only older house still with brickwork exposed. At No. 147 a Jacobean phantasmagoria of *c.* 1897. No. 151 was refronted for Bata shoes by *Bronek Katz*, 1956. Glass and fading panelling, originally all apple green.

Then the PANTHEON (MARKS & SPENCER, Nos. 169–173), all black granite, 1937–8. Elevations by *Robert Lutyens*, stripped classical, the proportions inelegant. The rest by *W.A. Lewis & Partners*. For the rear extension *see* Great Marlborough Street, p. 411. The original Pantheon of 1769–72, called by Gibbon 'the wonder of the XVIII Century and the British Empire', at once made *James Wyatt*'s reputation. It was a huge assembly room, treated inside with a Pantheon-like dome and superimposed column-screens after S. Sophia at Constantinople. Its career

* The Crossrail scheme, first proposed in 1991, would see Nos. 1–23 rebuilt.

was erratic: converted to an opera house 1789, but in 1792 burnt out and rebuilt again as assembly rooms; in 1812 made into a theatre by *N. W. Cundy*; in 1833–4 rebuilt as a bazaar by *Sydney Smirke*; after 1867 merely a wine warehouse. Further typical late C19 fronts at Nos. 181–185, of which No. 181, 1886, is *T.E. Collcutt* in his familiar pretty, busy and gabled style; it went with Nos. 175–179, E, altered beyond recognition. Then two partly curtain-walled shop blocks: Nos. 187–195, 1957 by *C. Edmund Wilford & Son*, and the former Littlewoods (Nos. 197–213), by *Littlewood's Dept of Architecture and Planning*, 1959–62. No. 219, by *Ronald Ward & Partners*, is in the anonymous idiom of window bands with a rounded corner. Reliefs of the Festival of Britain on the front, with the date: 1951. At Nos. 225–235, 1997–2000 by the *T.P. Bennett Partnership*, the details are 1910-style paraphrases, asymmetrically deployed.

The corners with Argyll Street house OXFORD CIRCUS UNDER-GROUND STATION, a chance to compare two early tube companies' styles. The E corner is by *Measures*, 1899–1900 (compare Nos. 9–15). Its superstructure was the Central London Railway's offices, spartan red brick and terracotta. On the w corner the Bakerloo Line station (1905–6), with *Leslie W. Green*'s familiar *sang-de-bœuf* arcading. Offices on top by *D. Joseph*, 1922, Parisian-looking grooved stone.

West Part: Oxford Circus to Marble Arch

North side from Oxford Circus to Stratford Place

From here on the N side is mostly big full-width blocks. To the w of Oxford Circus first Nos. 242–274, shops by *T.P. Bennett & Son*, 1957–62. Above these, behind a big parapet, is a recessed superstructure, nearly symmetrical and five storeys high. This is the LONDON COLLEGE OF FASHION by *Douglas Stark* of the *LCC Architect's Department*, 1962–3. At the back a complicated composition culminating in an office tower of twenty-two storeys.

Then JOHN LEWIS, by *Slater & Uren*, 1958–60. Like its neighbour it is large, rather restlessly subdivided in its façade, and more interesting as a result. Four storeys above the shopfronts, then a glazed recessed storey and a deep flat canopy. Upper windows framed in one great stone panel with yellow-tiled reveals. Mullion grids of grey tile infilled in green. The grid is broken by full-height glazing for the staircase. On the E wall a SCULPTURE by *Barbara Hepworth*, 1961–3, a stringed aluminium piece, called Winged Figure. Enlarged from a work of 1957, losing the power of her smaller-scale creations in the process. The rear part facing Cavendish Square is mostly of 1939 by *Slater, Moberly & Uren* with *Franz Singer*: part of a complete rebuilding planned in 1936 and interrupted by the Second World War. Stone-fronted with vertical accents, not as uncompromisingly modern as Peter Jones, its 1930s sister store in Sloane Square, where the architects also worked (*see London 3: North West*; a curtain-walled proposal by *William Crabtree*, chief designer of Peter Jones, was thought insufficiently tradi-

tional for Cavendish Square). The kinship between the two is closer in the simple unornamented atrium within the 1930s part, intended to display fabric by natural light. John Lewis began in Oxford Street in 1864.

Nos. 308–318 (HOUSE OF FRASER) is the former D.H. Evans by *Louis Blanc*, 1935–7. Of a German type, with very closely set uprights as the one and only motif. The stronger ones form the chief division and turn at the top in a curve backwards into the roof, like ship's ladders: a typical motif of the streamliners. Subordinate uprights divide the windows into three narrow lights. The first London store with escalators throughout, it also boasted a fifth-floor restaurant for 1,000. It replaced short-lived Neo-Baroque premises by *John Murray*, 1909; D.H. Evans's firm began here in 1879.

At Chapel Place the big C20 blocks give way to Nos. 324–326, twin commercial fronts dated 1879. By *A.E. Hughes*, who was much employed in Oxford Street. Nos. 328–332, the former Sun Insurance Office by *Macvicar Anderson*, 1902. Pilastered like a bank, and with a near-matching extension of 1913 behind. Then the big and dispiriting DEBENHAMS (Nos. 334–348), 1968–71 by *Adrian V. Montagu & Partners*. This has narrow windows between wide chamfered verticals faced with aggregate. Better inside, due to *Fitch*'s dramatic circulation space with free-standing escalators, made 1987. Debenhams here are the heirs of Marshall & Snelgrove, who had Second Empire premises of 1870 by *Horace Jones* and *Octavius Hansard*. The next block (Nos. 350–352) is by *Gunton & Gunton*, safety-first Neo-Georgian flats of 1935, now a hotel. Nos. 354–358 was a National Westminster Bank branch of 1969–70, a good instance of *Seifert & Partners'* pattern-making. Six storeys, the upper four with dark grey polished granite forming elongated octagonal windowframes.

Stratford Place

Stratford Place, the only C18 episode of note left along Oxford Street, opens off here. It was the chief work of the short-lived *Richard Edwin*, a pupil of the younger Brettingham, and was built in 1771–c. 1780. The owner was the *Hon. Edward Stratford* (later 2nd Earl of Aldborough), who may have contributed to the design; certainly he is thought to have played a part in designing his own Aldborough House, Dublin, of 1792–8. The land was part of the City's Conduit Mead Estate (*see* New Bond Street, p. 543), including the site of a C16 banqueting house where the City Corporation feasted once a year. The PLAN is a close of terraced houses, widening at the end into a small square with more houses on each side and Stratford's own mansion across the end. On Oxford Street were gates between twin lodges. The terraces were formally composed, with emphases on ends and centre. Though the terraces are depleted and the mansion enlarged, the C18 conception can still be appreciated.

First the mansion (STRATFORD HOUSE, since 1962 the ORIENTAL CLUB). The nine-bay front is deceptive: the C18

house comprised only the five central bays, appearing as a villa of the familiar type, though in its proportions rather tall and narrow and in many of its details deriving from Robert Adam's rather larger Lansdowne House (*see* pp. 498–9). Finely rusticated basement, vermiculated around the openings. Above it in the middle four engaged Ionic columns carry a pediment with a frieze of festooned bucrania. Delicate skyline of urns and balustrade. Sculpture in the pediment, Fame and Mars (the Stratford supporters) with full armorial. The three-storey wings, in matching style, are no older than 1908–9, for the 17th Earl of Derby (whence the later name, Derby House): by *Romaine-Walker & Jenkins*, who also renewed most of the stonework. The additions replaced C18 single-storey service wings masked by Doric colonnades, over which an upper storey had been raised in 1890. The new E wing is much the larger. Rear elevation of plain stock brick.

INTERIORS. The C18 work follows the Adam style, but without Adam's refined detail or supple planning. Other rooms in various elevated Edwardian styles, some of 1902 (for Sir Edward Colebrooke, later 1st Baron), others of 1908–9. In the latter years also some *Robert Adam* fireplaces of the 1770s were introduced from The Oaks, Lord Derby's house in Surrey. The ENTRANCE HALL, set off-centre, has shallow niches; fireplace (*Adam?*) with veiled terms. To the r. the BAR, formerly the dining room. Ceiling with circular motifs and paintings by *A. Zucchi*. Good original fireplace of coloured marble, with relief of a pagan procession. Shortened in 1908–9, when a column-screen at one end gave way to a corridor into the E extension. Beyond the entrance hall the toplit STAIRCASE, of 1908–9, replacing the C18 one. Louis XVI, with mirrored false openings, oval skylight, and *Starkie Gardner* balustrade. Beyond, the beautiful LIBRARY, remodelled in 1902. It has mahogany panelling, pilasters trimmed with ormolu, and a ceiling in the thickened version of the Adam style then in favour. Fireplace probably *Adam*. Other major rooms occupy the E extension of 1908–9. The big DINING ROOM, reached down steps, is a loose version of Adam's Pavilion at The Oaks, spoiled by alterations for club use. Set in the ceiling are mythological tondi by *Giovanni Romanelli* (1610–62). (The former BALLROOM above, designed by *Sir Charles Allom*, was partitioned for bedrooms.) BACK STAIRS behind lined with reset capricci of ruins by *Antonio Jolli* (1700–71). The room beyond, with a garden view, was Lord Derby's private dining room. FIRST FLOOR. The two best C18 rooms face Stratford Place. The SMALL DRAWING ROOM (W) is segmentally barrel-vaulted with a pattern of circles and paintings in them by *Biagio Rebecca*. The DRAWING ROOM (E) also has roundels and half-roundels by *Rebecca*, of Cupid and Psyche. Original fireplace, an excellent piece attributed to *Banks*: standing Fame and Mars, and a relief of the Muses. Doors heightened 1908–9. SMOKING ROOM behind with panelling in Central European Rococo style, possibly imported. Reset in it seven canvases of *fêtes champêtres*, also Central European-looking.

The SQUARE by Derby House is complete on the E (Nos. 8–10): stuccoed, of eleven bays, with arched ground-floor and pedimented first-floor windows.* On the W side Nos. 12 and 13 are original, but the stone-faced Nos. 14–15 is of 1954 by *Ronald Ward & Partners*, Neo-Georgian but not matching. Of the long TERRACES to the S that on the E side is also nearly complete (Nos. 2–7). Of brick, originally twenty-three bays long, with round-arched ground-floor openings. As accents the centre has giant pilasters and a pedimented attic, the original end houses giant pilasters and attics without pediments. The ground floor of these accents is rusticated; the pattern and also the type of pilaster derive from Derby House. No. 1, by Oxford Street, went in 1890, but its little square LODGE remains, like a sentry box. *Coade*-stone lion on top. Of the corresponding W terrace only No. 16 is left. Nos. 17–19, a big fluted stone mass of 1931 for Lilley & Skinner by *Gordon Jeeves*, doesn't even try to fit in; and yet their earlier premises immediately S, of c. 1920 by *Arthur Sykes* (now HMV), deliberately echoed the Edwin elevations.

The INTERIORS of these houses vary in depth and plan. Nos. 2 and 3 have elaborate Neoclassical ceilings; at No. 2 also a front-hall staircase, at No. 3 (remodelled 1927 by *H.P. Cart de Lafontaine*) an open-well staircase with fanciful balustrade and an Ionic column-screen in the main ground-floor room. In No. 4 a markedly spacious staircase with second-floor column-screen. In No. 9 a showy French Rococo saloon, late C19. No. 10 (ROYAL SOCIETY OF MUSICIANS) has superior Adamesque ceilings and fireplaces in two first-floor rooms, now combined. In Nos. 12 and 13 some less refined ceilings, and narrow open-well staircases.

North side from Stratford Place to Marble Arch

Now back to the shopping. AVON HOUSE (Nos. 362–366) is a former Maison Lyons, 1915–16 by *Lewis Solomon & Son*. White faience with windows vertically linked, more French than F.J. Wills's work for the firm. After James Street, Nos. 376–384 of 1957–9 (formerly C&A), transformed with an impressive triple-height glass front by *Gensler Associates* for GAP, 2000. Of similar type Nos. 388–396, 1959–60 by *W.S. Hattrell*, dull.

SELFRIDGE'S (Nos. 398–454) was begun in 1908. Here was a department store the likes of which London had not seen before. Gordon Selfridge, who had made a mint in Chicago retail, lighted on London for his next enterprise in 1906. He considered that 'it was the duty of the great business house to unite beauty with its effort', and so he built a whole block to one mighty reiterated motif. Ground floor with large shop windows and short pillars between, and on them colossal Ionic columns richly decorated on shaft and capital. Square columns at the angles. The columns frame all-glass expanses, broken

* The lease drawings of 1772 show a grander treatment with pilasters and pediment, and a different handling of the Oxford Street elevations.

by cast-iron panels that conceal the steel framing between the three upper floors. The motif made history in England. Enriched attic and top balustrade. Further enrichment at the central entrance, where the façade is a little recessed so that the columns stand free, and between them there is space for a gigantic polychrome figure and a clock. The figure, by *Gilbert Bayes*, is 11 ft (3.4 metres) high and is called the Queen of Time (sculpture elsewhere by *Sir W. Reid Dick*). The clock dates from 1931, for the building was not put up all at once. The nine bays from the E opened in 1909, the rest in 1920–4 (w and rear) and 1926–8 (centre). The length is 525 ft (160 metres). It remains the largest department store in the West End.

Who was the architect? There is no simple answer. Gordon Selfridge's own connections are the key. The initial drawings were done in 1906, by *Albert D. Millar* of *Daniel Burnham*'s Chicago practice, and Burnham's big booming voice is still recognizable throughout. Burnham had worked for Selfridge before, at the main store of his erstwhile Chicago partnership Messrs Marshall Field. The elevation designs however were modified in 1907 by *Francis S. Swales*, a Canadian-born American trained at the École des Beaux Arts in Paris, whose sketch had caught Selfridge's eye. The column decoration is indeed Parisian, deriving from Philibert de l'Orme's work at the Tuileries. Selfridge was also on good terms with Waring & Gillow, and he retained their architect *R. Frank Atkinson* (*see* Nos. 164–182 above), who successfully challenged the LCC's prohibitions on broad metal-framed windows and open interiors. A no less significant debt to American practice was the importance of the engineer. The steel frame was designed by *Sven Bylander*, a Swede who lived in New York, who had made his London début at the Ritz (*see* p. 559). Regulations demanded that it be structurally independent of the stonework, i.e. the store is not a fully framed building in the Chicago sense, but the exposure of so much framing between the piers was something new. The carver was *W.B. Fagan*, the founder of the cast-iron panels *Walter Macfarlane* of Glasgow. For the later phases some names change, though the song remains the same: *Millar* remained, as a representative of Burnham's successor practice *Graham, Anderson, Probst & White*; *Sir John Burnet & Thomas Tait* took over as London consultants, and the details of the entrance and its great flat canopy fell to them. Selfridge also dreamed of putting something jaw-dropping on top of his store. The megalomaniacal square tower designed in 1918 by *Philip Tilden* cannot have been meant seriously. Later plans for a giant dome got no further than the steel substructure. New display windows by *Eva Jiricna* are proposed (2003).

The INTERIOR was meant for maximum uninterrupted floor space, though fire regulations compromised this at first. Browsing was encouraged, a departure from Victorian practice, nor were there any of the grand staircases then in European favour. Refurbishment since 1995 has reinvigorated the building, with full horizontal vistas, spacious escalator wells, and a mixture of specialist departments (by a range of designers) and

the now-usual boutiques for individual brands. The distinctive dwarf columns on the ground floor have been kept or reinstated. SCULPTURE of Josephine Baker by *Eduardo Paolozzi*, inside the main entrance. In the first-floor café a bronze MEMORIAL to Selfridge by *Bayes*, 1940.

EXTENSIONS. Selfridge wanted to expand N as far as Wigmore Street, but the actual limit is Edwards Mews, to its S. The first extension was along Duke Street, E side, 1933, by *Millar*, linked by bridges. Upper floors, plainer, of 1955–76. The centre of the mews front is a multistorey GARAGE for a thousand cars, by *Duke & Simpson* with *Sydney Clough, Son & Partners*, 1957–9. Blue curtain walling, purple mosaic, yellow tile. At the NW corner SELFRIDGE'S HOTEL, 1971–3 by *David Brookbank & Associates*, joining the main block to allow continuous shopping space below. Stone elevations, wisely subordinate to the older part. Garage and hotel are proposed for replacement by *Foster & Partners* (2003).

Back to Oxford Street. The pilastered MARKS & SPENCER, 1929–32 by *Trehearne & Norman* with *W.A. Lewis*, shows clearly what a convinced single-minded design Selfridge's was. One of *A.T. Bradford*'s carved heads of Lewis Carroll characters remains. 1970s N extension. Nos. 468–478, hard red brick of 1983–6 by the *Seymour Harris Partnership*, modelled to suggest separate upright fronts. A hybrid at Nos. 480–504: offices by *Sheppard Robson*, 1999–2001, a dull front with glazing within a broad stone frame, set above shops retained from the previous block of 1959. Trading went on without a break during rebuilding.

After Portman Street the MOUNT ROYAL, 1933–4 by *Francis Lorne* of *Burnet, Tait & Lorne*. Important as an early Modernist essay on a London thoroughfare, entirely without classical rhetoric. Now a hotel, but built with some 700 small flats, originally with a shared top-floor gallery like a promenade deck. Red brick in two shades makes long broad bands, in which their windows are placed. Stair-bays of the vertically glazed kind – then already common on the Continent – appear in a kind of oriel guise, finished on top with some Dudok motifs. They start high up because of the separation of shopping and residential sections. The CUMBERLAND HOTEL and the smaller building following are by *F.J. Wills*, 1930–3, both with giant columns; the hotel was for Messrs Lyons, but stone was used rather than their usual faience. The pair was built with the excellent intention of setting off Marble Arch by two identical façades behind it to the l. and r., but the W block was thrown off balance when the former Regal Cinema on the corner (1928) was demolished in 1964. MARBLE ARCH UNDERGROUND STATION, beneath the hotel, has on the platforms pretty panels of arches by *Annabel Grey*, 1985.

Next the ODEON CINEMA by *T.P. Bennett & Son*, 1963–6. The upper part, curtain-walled above a large blank area, is cantilevered out above the entrance. Until subdivision *c.* 1994 it had the largest screen in Britain. On Edgware Road, behind, a twenty-four-storey office tower.

South side from Oxford Circus to Marble Arch

Except at the far W end the buildings on the S side are more modest than those opposite. After Oxford Circus the first turning is SWALLOW PASSAGE, a fragment of old Swallow Street (*see* also p. 576). Nos. 263–267 is a Postmodern horror of *c.* 1985. Nos. 275–279, banal mid-C20, conceals a hall built in 1875 for the ice-rink craze; in 1881 made into the first SALVATION ARMY HALL in central London (refitted 1959–60 and later). Nos. 291a–b, Northern Renaissance by *R.J. Worley*, 1894, makes the E corner with Harewood Place. For Nos. 293–295 *see* Hanover Square, No. 14 (p. 535). The tall No. 299, 1916–19 by *D. Joseph*, has channelled piers like those over Oxford Circus station. No. 311 (TESCO) was the shop and chief southern office of Woolworths, 1924. By their architect *William Priddle*, in their squared-off white-faience house style. No rival to the big boys on the N side. No. 313 is the former Noah's Ark pub, by *J.T. Alexander*, 1890, in a lovable kind of fairground Rococo. What has the operatic statuary to do with Noah?

So to New Bond Street. On the E corner, No. 329, 1972, polished grey granite with first-floor picture windows. Opposite, ZARA, 2000–2 by *Allies & Morrison* (Nos. 333–337). A strongly expressed frame, with pale stone cladding giving way to all metal before the top. No. 353, dated 1905, is by *E.K. Purchase*, characteristically loose. At Nos. 355–361 a new shopping block by *Fletcher Priest* is under way in 2003, replacing the twin ranges of Sedley Place. This was built in 1872–3 for Angelo Sedley, furniture-maker, to designs by *Richard Bell*. Shops faced the street, warehouses and workshops the alley behind. Nos. 363–367 is by *Joseph Emberton*, 1938–9, the old His Master's Voice building. One of the first Modernist West End shop façades, more assertive and less pure than his Simpson's in Piccadilly (*see* p. 557). Black granite facing. The diminishing bands of glass bricks have small windows inset, designed to reduce sound penetration without obstructing light. Hideous fascia of 2000. Nos. 369–373, *c.* 1897, is *Purchase* again, big and tired.

WEST ONE SHOPPING CENTRE (Nos. 375–383) faces the broad entry made by South Molton Street and Davies Street. One of the few wholly new shopping centres or malls built in the West End since the Second World War. *Chapman Taylor Partners'* building is of 1977–81, for MEPC and the Grosvenor Estate, revised from proposals of 1971. Anodized aluminium elevations with taut shallow bays set close, let down by the weak roof-line, where some bays finish as gables and others stop short. Brick behind, in deference to the *genius loci*. Shopping atrium inside, cramped and charmless, with access down to BOND STREET UNDERGROUND STATION. *T. Chatfeild Clarke*'s Nos. 385–397, 1887–9, Loire style, introduces the later Victorian architecture of the Grosvenor Estate section. Of good gauged Bracknell brick, with badges, crests and bosses. Nos. 399–407 is LLOYDS BANK, by *Burnet, Tait & Partners*, 1967–70. A bold design with storeys of different heights,

divided by stone bands and narrower mullions. Enormous first-floor windows to the former banking hall. Nos. 407–413 are all that remains of *Thomas Cundy III*'s scheme to rebuild the whole Grosvenor section in Second Empire style. Designed 1864, built 1870–2. Variations arose from different executants working up the designs. Nos. 415–419 (formerly Horne Bros), built in stages 1923–35, is by *G. Thrale Jell*, derivative of Richardson & Gill's City work of the 1910s. On the site was *A. W. Blomfield*'s church for the deaf and dumb, 1870–3.

KEYSIGN HOUSE (Nos. 421–429), between Lumley Street and Balderton Street, is a stripped-down block by *Trehearne & Norman*, 1937–9. Nos. 431–433, weak gabled Jacobean, is by *F. Boreham*, 1875–6, extended w 1890. By *Balfour & Turner* Nos. 439–441, 1907–8. Portland, with black granite columns teasingly used: paired below, single and on corbels above. The westernmost C19 building is Nos. 443–449, 1876–8 by *J. T. Wimperis*, another Grosvenor favourite, more in a Queen Anne style. Then between North Audley Street and Park Street a very large development by *Fitzroy Robinson & Partners*, built in phases 1961–9. A long podium with shops, above at the E end a hostel for University College (GOLDSMID HOUSE), at the w end a fourteen-storey office slab on stilts. For all its size the result is bland, not helped by the subfusc mid-sixties palette.

ALLDERS (Nos. 499–521) was built in 1928–30 for Gamage's, the department store, but proved unsuccessful. The familiar brick and stone with occasional big columns in the higher regions. Elevations by *Lutyens*, one of his bread-and-butter consultancy jobs; tamer still since 1938, when C&A put plain stone facing on the centre. Messrs *Joseph* handled the internal arrangements. Flats in the end blocks.

For the w corner *see* Park Lane, p. 552, for Marble Arch *see* p. 662.

MAYFAIR AND PICCADILLY

INTRODUCTION

Mayfair is the epitome of London wealth, sometimes rivalled in fashion, but never entirely surpassed. Max Beerbohm's description of its Georgian heart still holds true for large expanses: 'grim and sombre, with its air of selfish privacy and *hauteur* and leisure, its plain bricked façades, so disdainful of show'. These houses are often more varied and more diversely enriched inside than in the later C18 expanses of Marylebone to the N, and their interplay with the later residential and commercial buildings, not least along Piccadilly, gives Mayfair a special fascination.

The name comes from the old May Fair, transferred in 1686–8 from Haymarket to a site near the present Curzon Street, and suppressed in the mid C18. At first it traded in open fields, through which straggled the stream called Tyburn or Tybourne.

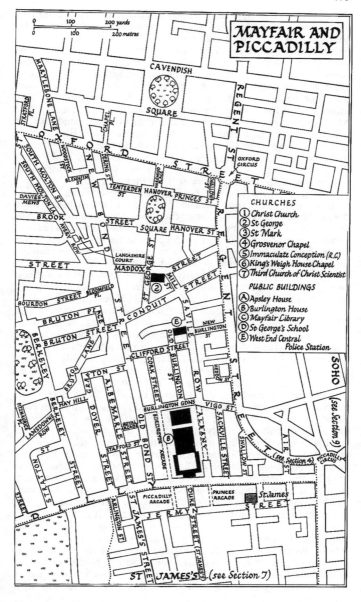

MAYFAIR AND PICCADILLY

0 100 200 yards
0 100 200 metres

CAVENDISH SQUARE

OXFORD CIRCUS

CHURCHES
① Christ Church
② St George
③ St Mark
④ Grosvenor Chapel
⑤ Immaculate Conception (R.C.)
⑥ King's Weigh House Chapel
⑦ Third Church of Christ Scientist

PUBLIC BUILDINGS
Ⓐ Apsley House
Ⓑ Burlington House
Ⓒ Mayfair Library
Ⓓ St George's School
Ⓔ West End Central
 Police Station

SOHO (see Section 9)

PICCADILLY CIRCUS

ST JAMES'S (see Section 7)

The land had mostly been part of the manor of Ebury, originally Eia or Eye, which extended s to the Thames through what is now Victoria and Pimlico. It was bequeathed to Westminster Abbey before 1087, but Henry VIII's strong arm took it in 1536. One part was merged into Hyde Park, the rest being sold and re-sold until its ownership became complex. Then after the Restoration great houses began to be built along Piccadilly (q.v.). Lesser tributary streets were fitted in between them, or built on land initially used for gardens (Stratton Street, Berkeley Street). The heyday of planned development came in the early–mid C18, by which time the new suburbs of St James's, South Bloomsbury and Soho were largely complete. Only then were the broad acres to the N built over, progressing roughly from E to W and S to N. By c. 1775 the process was complete, more than a century after streets began feeling their way N from Piccadilly.

The map shows the chief landholdings, the outlines of which help explain some anomalies in the street plan, with the main dates of building. The old line of the Tyburn was the most important internal boundary. From Piccadilly the holdings extend various distances to the N. The deepest, at the E end, went with Burlington House, the only great C17 mansion to survive, though no longer recognizable as such. Not until 1718 did the architect *Lord Burlington* begin the orderly layout of streets to its N. Next comes a block between Old Bond Street and Dover Street, late C17 creations on the site of Clarendon House, the nine days' wonder of the Restoration. These and the straight streets that follow were largely created by London builders, and though aristocratic in character were unambitious in plan. On the Curzon lands immediately to their N, built up after 1715, a market was provided (named Shepherd Market after its builder *Edward Shepherd*), but the elongated shape of the estate likewise precluded any great formal focus. The same is true of Nathan Carrington's freehold to its SW, on which Hertford Street was formed c. 1764, and of the Conduit Mead Estate centred on New Bond Street, an irregular T-shape owned by the Corporation of London, built up mostly after 1716.

This leaves three big blocks centred on the three Mayfair SQUARES: Hanover Square, Grosvenor Square and Berkeley Square. Hanover Square, at the extreme NE, was created after 1713 by the 1st Earl of Scarborough. Streets run off it symmetrically, including the funnel-shaped St George Street to the s with 37 its oblique view of the portico of St George Hanover Square, the parish church for most of Mayfair from 1725.* It may have been planned by *Thomas Barlow*, who was certainly responsible for Sir Richard Grosvenor's development, the greatest of these three estates. As agreed in 1720, it took the form of a forthright street grid prolonged from the new Grosvenor Square to the very edges of the available land on all four sides. The house types and uses were carefully graduated, and the new streets joined up with their neighbours wherever possible. This was harder to achieve to the s, where the land of the Lords Berkeley of Stratton was not laid out for building until after 1736. The chief feature here

* Burlington House and its hinterland belong to St James Piccadilly.

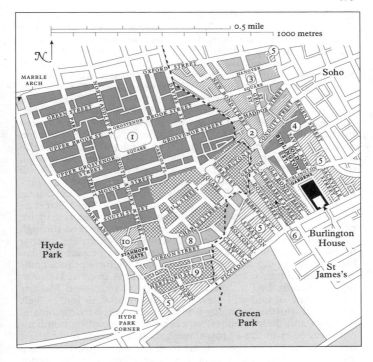

1 Grosvenor Estate, 1720—1760s
2 Conduit Mead Estate (Corporation of London), mostly after1716
3 Lord Scarborough's estate, 1713 onwards
4 Lord Burlington's estate, 1718—c. 1739
5 Various late C17 and early C18 developers
6 Sir Thomas Bond and others, 1683 onwards (Clarendon House site)
7 Lord Berkeley of Stratton's estate, 1736—c. 1759
8 Sir Nathaniel Curzon and heirs, c. 1715—1765
9 Nathan Carrington, c. 1764—71
10 Westminster Abbey lessees, c. 1740—60

- - - -· *Course of Tyburn brook*

Mayfair.
Map showing seventeenth- and
eighteenth-century estate development

was Berkeley Square. Two major streets run to its w, another to
its E, with a generous provision of mews streets – something
Grosvenor was also careful to supply. In terms of town planning,
the story of Mayfair effectively ends there. The C20 cut
through a few culs-de-sac left by the C18 (Curzon Street,
Savile Row), besides turning Park Lane into an urban freeway
(1958–63).
 The E boundary of Mayfair, and its character as a residential
quarter for the élite, was reinforced after 1813 by the line of

Nash's Regent Street (Heddon Street and Swallow Street, imme-
diately to its w, are effectively bits of Soho stranded on the wrong
side of the border). But in truth Mayfair had long embraced more
uses and building types than might be thought. Some of the c18
functions – barracks by Park Lane, the workhouse in Mount
Street – have entirely disappeared, as have most of the Grosvenor
Estate's pubs (the 1st Duke of Westminster, born 1825, was very
down on drinking). Other features of the c18 support systems
remain – the precinct of Shepherd's Market, scattered taverns
and shops, and enclaves of more modest housing, perpetuated
83 by the Grosvenors in the form of Victorian artisan flats (Bourdon
Street, North Row, Duke Street). The E part of Piccadilly also
attracted shops and inns, as did Oxford Street along the N edge,
though Park Lane along the w remained fully residential until
the c20. Elsewhere, residential uses inexorably gave way to com-
merce. Of the streets off Piccadilly to the N, Old Bond Street
soon filled with luxury shops, followed by New Bond Street to
its N. Streets further w were well known by the early c19 for
private hotels, many of which still operate from knocked-through
Georgian houses (Dover Street, Half Moon Street, etc.); other
hotels clustered in Brook Street. Regent Street proved a Trojan
horse for shopping and trade, and by Mid-Victorian times com-
mercial buildings or tenants were spreading w from it. Hanover
Square already had no private residents by 1920, and Mayfair
E of the line of Old and New Bond Street now no longer feels
residential. Further w, many houses are occupied by diplomatic
premises and their satellites; others were colonized by bombed-
out businesses in the 1940s, though in recent years quite a few
have become homes again. Apart from St George, the remaining
RELIGIOUS BUILDINGS lie in this western zone: the Grosvenor
39 Chapel, sole survivor of the chapels of ease that served the
c18 population, two c19 former parish churches, St Mark and
Christ Church, and three spectacular non-Anglican places of
73 worship: the Immaculate Conception (R.C.) and King's Weigh
House Chapel (formerly Congregational), both Victorian, and
the drastically altered Third Church of Christ Scientist, which is
Edwardian Baroque.

p. As for DOMESTIC ARCHITECTURE, too many fine GEORGIAN
28 HOUSES remain to mention individually. The brick Baroque of
the early c18 shows up well in Albemarle Street, Clifford Street
40, (with a painted hallway at No. 8), St George Street, Bruton
37 Street, Brook and Upper Brook Street, etc. The Palladianism
42 that gradually supplanted it appears e.g. at Burlington House,
in Burlington Gardens and the vicinity, and more pervasively
in Berkeley Square and the streets w of it (Hill Street, Charles
Street, Chesterfield Street), where well-proportioned mid-c18
house fronts survive in force. Berkeley Square also contains
52, one supremely fine house by *Kent* and a good pair attributed
53 to *Flitcroft*. The more Neoclassical 1760s–70s are best represented
by *Sir Robert Taylor*'s magnificent terrace in Grafton Street and
51 Ely House in Dover Street. Interior work by *Robert Adam* remains
in Curzon Street, Piccadilly, Sackville Street, Hill Street and
Hertford Street, and at two mansions, both heavily altered:
Lansdowne House in Berkeley Square, and Apsley House. His

rival *Sir William Chambers*'s Melbourne House shows much less change externally, but inside and behind belongs to *Henry Holland*, who transformed it into bachelor flats thirty years later (*see* Albany). The other C18 house with a forecourt to Piccadilly, *Matthew Brettingham Sen.*'s No. 94, has also been much altered within. Just one great early C19 house remains, *William Atkinson*'s No. 100 Park Lane, 1827–8; the grandest elevation of this period, *Lewis Vulliamy*'s Royal Institution in Albemarle Street (1837–8), is a mask for older fabric. Many more C18 houses survive under refacings or with interiors of the C19–C20, which may now constitute their chief interest.

The best place to follow the domestic story from Victorian times onwards is the GROSVENOR ESTATE, always the most coherently managed of the great Mayfair landholdings. Up to the 1870s its usual policy was to rebuild or refront houses in a solid but commonplace Italianate manner, to designs supplied or influenced by its surveyor *Thomas Cundy II.** The shift to a more picturesque gabled architecture reflected the personal tastes of the 2nd Duke, who succeeded in 1869 and who was quick to take up the new Queen Anne fashion. He also directed commissions to a portfolio of 'approved' private architects, who initially included *Ernest George, Col. Edis, J. T. Wimperis* and *Thomas Verity.* p. 541 Mount Street, rebuilt in 1880–97 as a mixture of houses and of chambers with or without shops below, is the epitome of this red brick and terracotta epoch. By the 1890s–1900s the leading partnership was that of the Estate Surveyor *Eustace Balfour* and *H. Thackeray Turner*, who developed an innovative Arts-and-Crafts style, best seen at the park end of Mount Street and in Brook Street. After that time Francophile smartness or Neo-Georgian rectitude became the norm, as the later phases of Green Street or Park Street bear witness. The most consistent Neo-Georgian enterprise was the rebuilding of most of Grosvenor Square in the 1920s–60s, much of it for flats (the last true mansion built in Mayfair is No. 38 South Street, begun 1919). More attractive are the interwar mews-scale developments in Lees Place, Mount Row (Davies Street) and other backwaters.

Other Mayfair streets show a similar progress through the fashions. Without the Grosvenors' economics of scale the results tend to be smaller and more scattered, with a few exceptions such as *J. T. Wimperis*'s Chesterfield Gardens (Curzon Street), of the 1870s. Commercial areas became architecturally more varied still, as a walk along Old and New Bond Street shows. Here are several purpose-built C19 art galleries, excellent shopfronts and interiors old and new, and one of the several SHOPPING ARCADES that cluster around Piccadilly, of which *Samuel Ware*'s Burlington Arcade of 1818–19 stands at the head. Piccadilly 67 also has some of the finest commercial buildings in London,

*The Surveyors to the Grosvenor Estate were *Thomas Barlow*, 1720–30, then a hiatus until *William Porden c.* 1784–1821, the three *Thomas Cundys*, I (1821–5), II (1825–67) and III (1867–90), *Eustace Balfour* 1890–1910, *Edmund Wimperis* 1910–28, *Detmar Blow* 1928–33 (but already appointed architect to the 2nd Duke in 1916), and *George Codd* 1933–c. 1946. In addition *Fernand Billerey* and *Lutyens* acted as consultants, 1923–33.

98 especially of the early C20, when *Norman Shaw, Mewès & Davis, Belcher & Joass* and *W. Curtis Green* all were busy here. Before that time the part of Piccadilly facing Green Park was extensively rebuilt with mansion flats, generally without the panache of the Grosvenors', or with clubhouses junior in quality and (usually) in status to St James's. The rise of commerce in Piccadilly was demonstrated most powerfully by the loss of Devonshire House in the 1920s for *Carrère & Hastings'* block of flats of the same name. By a similar process Park Lane acquired a new, commercial Grosvenor House and a Dorchester Hotel (in lieu of the C19 Dorchester House). The hotel was iconoclastic in its way, but the Modern Movement truly arrived in the area only in 1935–6, with *Joseph Emberton's* department store for Simpson's in Piccadilly. Few other mid-C20 blocks were so well designed, and the POST-WAR ARCHITECTURE of Mayfair is often at its best when set off against older buildings, as are *Ernö Goldfinger's* and *Peter Moro's* blocks in Albemarle Street. The richest building internally is *Michael Rosenauer's* Time & Life headquarters in New Bond Street, 1951–3, the most monumental *Eero Saarinen's* US Embassy in Grosvenor Square of 1957–60, the tallest, the smug London Hilton on Park Lane, 1961–3. Since the 1970s some architects have taken the Postmodern road, most conspicuously *Chapman Taylor* on the S side of Berkeley Square (1987–8), but a reversion to traditional materials and a contextual approach has been more common. The results can be attractively subtle or merely dull; the standard of details and materials is generally better than on the buildings being replaced.

FURTHER READING. The *Survey of London* covers a good proportion of Mayfair: vols. 31 and 32, 1963, the SE corner within the parish of St James Piccadilly, including Burlington House; vols. 39 and 40, 1977–80, the Grosvenor Estate at the NE. Vol. 39 also gives the best overview of the domestic fashions of the London élite. For the early period *see* also F. Sheppard, *Robert Baker of Piccadilly Hall and his heirs*, 1982, and, for the Grosvenor Estate, C.T. Gatty, *Mary Davies and the Manor of Ebury*, 1921 (2 vols.). Nothing so detailed exists for the rest, though B.H. Johnson, *Berkeley Square to Bond Street*, 1952, deals with the development of the central section. Books concerned with C17 and Georgian London as a whole are listed on p. 101. One good general book is R. Colby, *Mayfair, a town within London* (1966). Plenty of gossipy books touch on the social side of Mayfair life. More detailed accounts include A. Callender (ed.), *Godly Mayfair*, 1980 (Grosvenor Chapel), F. James (ed.), *The Common Purpose of Life* (Royal Institution), 2002, Q. Crewe, *Crewe House*, 1995, A.I. Dasent, *Piccadilly in Three Centuries*, 1920, and *A History of Grosvenor Square*, 1935, J. Desebrock, *The Book of Bond Street*, 1978, C. Hussey, *The Story of Ely House*, 1953, S.C. Hutchinson, *The History of the Royal Academy 1768–1986*, 1986 (2nd edn), and H. Montgomery Hyde, *Londonderry House*, 1937. Apsley House has its own guide book. Business histories are plentiful, but often skimped when it comes to buildings; exceptions include B. Hillier, *Asprey of Bond Street*, 1981, and the Ritz, covered by H. Montgomery-Massingberd and D. Watkin, 1980,

and M. Binney, 1999. Several houses are fully described in *Country Life*, to which the magazine's index is the best guide. The standard pre-C17 history is by W.L. Rutton, *Archaeologia* 52, 1910.

CHURCHES

CHRIST CHURCH DOWN STREET

1865 by *F. & H. Francis*, enlarged to the w 1871–2. Now in non-parochial use. Ragstone, entirely urban in type, rising sheer from the pavement and with windows set high. The style is early Dec. Two-bay NE transept, with porch in the base of what was to have been a tower. Partly rebuilt by *R.L. Hesketh* after a fire in 1906, e.g. the flowing E window tracery, and the straight S parapet instead of individual gables. Interior painted 1955, concealing the multicoloured C19 banded brick. Very naturalistic leaf capitals, carved by *F.G. Anstey*. Timber barrel-vaulted roof of 1906. – Nice W GALLERY with repoussé panels in the Arts-and-Crafts taste; 1906 by *Hesketh*. – STAINED GLASS. E window, a remake of 1906 of that by *Clayton & Bell*, 1865, in memory of H.T. Hope, brother of Beresford Hope, the Gothic Revivalist. – W window by *Clayton & Bell*, c. 1880. – Transept. E wall, N, memorial to the architect J.T. Wimperis, 1905 by *James Beckham* (*Bell & Beckham*), very attractive; S, 1878 by *Clayton & Bell*. N wall. Roundel by *Powell & Sons*, 1865, painted by *Emma Cons*. – REREDOS of Caen stone, also in memory of Hope, with carved panels by *Anstey*. – FONT also by *Anstey*, round-arched. – WAR MEMORIAL by the altar, a ceramic panel of Christ by *W. Glasby*, c. 1920. – LIGHT FITTINGS. Arts-and-Crafts coronae of c. 1906.

ST GEORGE HANOVER SQUARE
St George Street

Built under the New Churches Act of 1711, as part of the Hanover Square scheme (q.v.). Designed in 1720 by *John James*, and built 1721–5 (*Joshua Fletcher* chief mason, *John Meard Jun.* carpenter; *Hawksmoor* also made designs). A big six-column Corinthian temple portico, on which a statue of George I was to stand, projects into the pavement area. In the tympanum an oculus framed by a cartouche and martyr's palms. A lantern or short tower rises on the W end of the actual church, behind it. Other London churches of the period share the six-column portico motif, notably Gibbs's St Martin-in-the-Fields, also designed 1720 (*see* p. 291), and Hawksmoor's St George Bloomsbury, started 1716 (*see London 4: North*). But the idea had already been put forward in a design by Gibbs of 1713, and earlier still in a design by Hawksmoor for Queen's College

Chapel, Oxford. The lantern derives from the Wren School: its coupled columns projecting in the diagonals and surmounted by urns from St James Garlickhithe, its profile from Chelsea Hospital. Urns reinstated 1972. Clock stage below. The N elevation, to Maddox Street, is as cyclopean as if it were Hawksmoor's, with two tiers of windows, linked into one pedimented composition by heavy rusticated aedicules. James had no strong personal style, mixing his sources without fully digesting them, hence the awkward juxtaposition of massive rustication and delicate cornice. The W bay, housing the gallery staircases, is different: it has transverse pedimented attics, another Hawksmoorean feature (compare St Anne Limehouse, *see London 5: East and Docklands*). The S wall, facing an alley, is plainer. At the E end appears a shallow chancel with broad Venetian window, its columns doubled and paired in depth. Against the lower wall a rough brick VESTRY of 1725, with extensions. Two obelisk LAMP STANDARDS by the W front, late C18 (renewed 1994).

The aisled INTERIOR feels comfortable and not over-large. Galleries rest on square pillars, which support Corinthian columns. The nave has an elliptical coffered barrel vault, the aisles diagonally coffered transverse barrel vaults (plasterer *Isaac Mansfield*). In the E bay these turn to groin vaults to clear the window heads. Restorations in 1871 (*Benjamin Ferrey*) and 1894 (*Sir Arthur Blomfield*, forming the present chancel). The E chapels with their Doric column-screens date from 1926, the baptistery enclosure, NW, from 1935, both by *Sir Reginald Blomfield*.

FITTINGS are mostly of the 1720s. REREDOS with sides canted forward and coupled columns against them. It frames a PAINTING by *William Kent*, a large Last Supper (1724). Hot colours; Baroque composition diagonally into depth, but the figures of French type ultimately derived from Poussin. – COMMUNION RAILS with carved and pierced foliage panels. Not necessarily original. The former gates are incorporated in STALLS of 1894, with new carving to match. – PEWS also with C18 work incorporated. – PULPIT, richly carved, with excellent wrought-iron stair-rail. It rests on six Corinthian columns of 1894. – Two big CANDELABRA, twenty-four branches each. – W GALLERY on two Ionic columns, with modest but splendidly carved ROYAL ARMS. – On the gallery an ORGAN CASE of 1725 by *Gerard Smith*, enlarged in 1894 by *A. Blomfield* (the outer towers) – Marble FONT in early C18 style, designed by *R. Blomfield*, 1930.*

STAINED GLASS. The E window is filled with glorious glass of *c.* 1525, attributed to *Arnold van Nijmegen*, from the Carmelite church in Antwerp. Installed by *T. Willement*, 1841, with some new work. The subject is the Tree of Jesse. He is enthroned centrally, shown sleeping. Roundels on the throne of Isabella of Portugal and St George, the latter Willement's substitution for Charles V, Isabella's husband. Above the throne the Virgin and Child. Six ancestors of Christ appear to either side, with four more in the outer lights. Another four in the aisle E windows, with frames by Willement of the Apostles' heads. Background of vine scroll with

*SCULPTURE. A pair of cast-iron dogs formerly within the portico, of *c.* 1908 by *Adrian Jones*, are now at the Royal Veterinary College, North Mimms, Herts.

plump grapes. The figure of God the Father, originally above the Virgin, is at St Mary and St Nicholas, Wilton, Wilts. – N chapel, by *F.C. Eden*; designed 1919, remade after 1945.

ST MARK NORTH AUDLEY STREET

By *J.P. Gandy Deering*, 1824–8, his only church. The Commissioners contributed £5,556. Reconstructed within by *Sir Arthur Blomfield*, 1878, along the lines of his work at St Peter Eaton Square, now destroyed (*see* pp. 734–5). Closed 1974, and long neglected; again vacant 2003, after a spell in congregational use.

The handsome, strikingly original Neo-Greek front is of barely one house-width. Two tall Ionic columns (Erechtheion type) *in antis*, much-eroded straight entablature without pediment. Octagonal bellcote behind, somewhat after the Tower of the Winds, with pierced stone screens (originally of iron) instead of louvres. The church proper is wider. It lies some way back, reached through an impressive square lobby with tall square piers making three bays by three. At its E end the twin gallery staircases rise in open compartments. Within, only the round-arched-windowed N and S walls preserve the 1820s appearance, so thorough was *Blomfield*'s work of 1878. His are the slim Auvergnat Romanesque arcades with clustered Mansfield stone piers. Polychrome brick above, the clerestory windows to a faster rhythm. The three-gallery scheme was kept, but with Neo-Jacobean fronts. Open timber roof, with the 1820s members exposed, raised and embellished to match. The little lanterns in it were made *c.* 1899 by *J.F. Bentley*. Space for the choir was in the former E nave bay.

FURNISHINGS. A good ensemble, with much of 1878–9. – Coloured marble PULPIT carved by *T. Earp*. – Mosaic REREDOS designed by *N.H.J. Westlake*, executed by *Powells*, 1881–3 (marble panelling to the sides *c.* 1899, designed by *Bentley*). Above and forming as it were one continuous picture the E WINDOW, by *Lavers, Barraud & Westlake*, *c.* 1878. – More STAINED GLASS by the firm in the N aisle (first two from E, both †1872, but altered by Messrs *Powell*, 1884); also the N aisle gallery (first from E, Annunciation, 1871, especially good). Next to this a window by *Henry Holiday* (makers *Powells*), 1883, darker and more brooding, and one designed by *Harry Burrow*, 1872. Other windows by *Powells*: N aisle (two, W, 1884 and †1925), S aisle (three, 1883, 1884, 1889), and W (1923, a hieratic figure group). – Square FONT with incised pictures, 1902. – Twin ORGAN CASES, C17 style, probably of *c.* 1930 by *E. Maufe*. – Ambitious mosaic MONUMENT to Rev. Joseph Ayre †1898, who oversaw the restoration (N aisle, surely by *Powells*); several of the windows commemorate his family. – Very domestic WAR-MEMORIAL CHAPEL (NE), made 1919 perhaps by *C.J. Blomfield*; STAINED GLASS by *H.R. Foulger* with *Karl Parsons*, W (1921), and *Leonard Pownall*, E, the latter incorporating fragments from Ypres Cathedral; REREDOS carved by *Mewburn Crook*, with paintings of wartime scenes by *Fred Appleyard*.

For the former auxiliary buildings behind *see* Duke Street.

GROSVENOR CHAPEL
South Audley Street

39 The only survivor of Mayfair's proprietary chapels, simple and
homely and somewhat Colonial-looking in its present surround-
ings. Planned from 1723, built 1730–1, as part of the Grosvenor
Estate layout; since 1831 a chapel of ease to St George Hanover
Square (q.v.). Sir Richard Grosvenor induced four builders to
put it up in return for low ground-rents. Of the four, *Benjamin
Timbrell* almost certainly supplied the design, which owes much
to Gibbs's St Peter Vere Street on which he had worked (*see
London 3: North West*). The resemblance was closer before a
pediment was removed from the spreading Doric w porch, and
the main pediment above reduced by making volutes at the ends,
probably during *William Skeat*'s repairs of 1829–30. w front of
five bays, sides of six. Yellow brick, windows round-headed above
segment-headed, their stucco trim probably of 1829–30 (simpli-
fied 1951–2). The tower, edged with quoins some time after 1890,
projects a little. The sides reach up to it above the volutes by the
remaining fragments of pediment. Bell-stage with canted corners,
then a rather bare octagonal spire.

INTERIOR. In the vestibule are twin gallery staircases of stone,
with turned balusters. The nave ceiling is an elliptical barrel
vault, the aisles groin vaults, with simple guilloche-banded com-
partments. Galleries on three sides, with square pillars below and
Ionic columns above. The effect was much altered by *Comper*,
who in 1912–13 placed between nave and chancel an open screen
flanked by giant Ionic columns, thus making a Lady Chapel of
the former chancel. His intention was to continue the columns
and heavy entablature up to the w end. The giant executed frag-
ment sits tensely within the milder C18 work. Comper wanted a
baldacchino too, of which two Corinthian columns against the
screen are the beginning. Coloured decoration is confined to the
SCULPTURE on screen and rood beam (painter *H.A.B. Bernard-
Smith*, 1927). The chancel retains its original tripartite REREDOS,
divided by Corinthian pilasters, and fine plaster ceiling, typical
proto-Rococo of *c.* 1730 with the Holy Spirit represented as a
dove. By *Comper* the LADY ALTAR and PYX above (1921).

OTHER FITTINGS. Wrought-iron COMMUNION RAIL, plainly
Comper's in part, but incorporating what must be work of *c.* 1730.
– PULPIT with stair, prettily carved, of *c.* 1730; in 1877 cut down
and moved off-centre. – PEWS. Also cut down in 1877. – FONT
in the central aisle. White marble bowl on fluted pillar. 1841. –
ORGAN CASE by *Abraham Jordan*, 1732, a Grosvenor gift. –
STAINED GLASS. Three unobtrusive windows by *Comper*, s aisle,
two dated 1927 and 1949. – MONUMENTS. Many tablets. N aisle.
Mary Rich †1755. A cartouche in late C17 style, except for the
slightest Rococo details. – N gallery. John Wilkes, the radical MP,
simple tablet by *Flaxman*, 1798; matching tablet to his daughter
Mary †1802. – Sir Richard Hunter †1848. Large relief of the Rest
on the Flight to Egypt. – Lady Chapel. Col. F. Robertson †1791,
by *Bacon Sen.* The inevitable mourner in relief, but accompanied
by an elephant.

Two HOUSES lie to the E, of which that attached to the N side was a parish school, built 1841. Much altered and enlarged.

IMMACULATE CONCEPTION (R.C.)
Farm Street

The English headquarters of the Jesuit order. By *J.J. Scoles*, 1844–9, in a sumptuous Neo-Dec-cum-Flamboyant style. Ragstone, with Bath stone dressings. Gable, rose window and porch at the ritual W (actually S) end, to Farm Street. The derivation is the S transept of Beauvais, an adventurous choice for the Anglocentric 1840s. *Adrian Gilbert Scott* rebuilt the war-damaged gable and pinnacles differently in 1951, making the resemblance closer still. The church grew a great deal after 1849. The outer aisles, with non-matching windows to the street, are by *Henry Clutton*, r., 1876–8, and *W.H. Romaine-Walker*, l., 1898–1903. The INTERIOR depends for its effect on the contrast between Scoles's 73 tall high nave and the vaulted aisles and elaborated side chapels. Nave of eight bays, with a pointed panelled roof. Four-light clerestory windows, and a nine-light N (ritual E) window inspired by Carlisle Cathedral (reset higher 1864). The red granite piers are 1870s replacements. Clutton's aisle, r., is divided by altars into chapels. Romaine-Walker's, l., consists of polygonal chapels with sumptuous Flamboyant arcading. The internal buttresses divide these chapels from each other and cunningly enclose the confessionals. At each end strange glazed skeleton vaults. Also bigger chapels r. and l. of the chancel. The r. chapel (Sacred Heart) was rebuilt after a fire, by *Clutton* 1858–60, i.e. earlier than the aisle; the larger l. chapel (St Ignatius) is part of Romaine-Walker's work. He contrived an additional entrance between it and the chancel, opening N into St George's Gardens (*see* Mount Street); TYMPANUM here of 1914.

The FURNISHINGS are outstandingly rich and fine for an English Catholic church. HIGH ALTAR designed by *A.W.N. Pugin*, 1848. Its tall reredos is a departure from his beloved medieval models, though impeccably medieval in detail. The type is known as a Benediction Altar. Tall centre pinnacle and two less tall side pinnacles, and twelve small pinnacles between. The figures are the twenty-four Elders of the Apocalypse. Attached CANDELABRA by *Pugin*, made by *Hardman*. The two Venetian MOSAICS were inserted in 1875. – Free-standing ALTAR in front, a fibreglass cast of 1992 of the bottom stage of the high altar (what would Pugin have said?). – Marble PANELLING of 1864, when the chancel was raised; designed by *G. Goldie*. – ALTAR RAIL with lapis panels, 1901, designed by *Romaine-Walker*. – Painted STATUE of the Virgin, over life-size, by *Mayer* of Munich. Canopy designed by *Fr Ignatius Scoles*, son of the architect, who gave up the profession for the priesthood. – Gothic PULPIT of stone. – STAINED GLASS. Disappointing E window by *Hardman*, Tree of Jesse, 1912. W windows by *Evie Hone*, 1953. Non-naturalistic; typically strong colours. Clerestory. Tracery lights by *Wailes*, c. 1849, from windows otherwise destroyed. –

Ceiling PAINTING by *Austin Winkley*, 1987. – Lettered MOSAICS over the arcades by *F. Monteiro* and *Fr Michael Beattie*, 1996; *Romaine-Walker* decorated the spandrels, *c.* 1898.

R. AISLE. The Sacred Heart Chapel was furnished 1859–63. Much alabaster in the High Victorian way. In the frieze slim ANGELS, carved by *T. Phyffers*; said to be designed by *J.F. Bentley*, then Clutton's assistant. – ALTAR FRONTAL with three powerful brass reliefs by *Phyffers*. – Inlaid ALTAR by *T. Earp*. – Above, a MURAL by the Rhineland painter *Peter Molitor*, in a late Nazarene style. – Other chapels are notable for the rich Dec REREDOSES: first chapel (St Aloysius), 1883, designed by *A.E. Purdie* and carved by *Farmer & Brindley*; second chapel (St Joseph) and third chapel (St Francis Xavier) designed by *Clutton*. – PAINTINGS in the chapels mostly by *Charles Goldie*. – By *Purdie* the former Agony Chapel of 1905 (converted from a porch), down steps at the far end, and the Lourdes Altar nearer the main entrance, 1887 (main statue by *Thomas Paty*, other sculpture by *Anstey*).

L. AISLE. Chapel of St Ignatius, by the chancel. REREDOS designed by *Purdie*, 1888, from the previous chapel. – Big STATUARY of *c.* 1903, designed by *Romaine-Walker*: Carved by *A. de Wisepelaere* of Bruges (Calvary group) and *Charles Whiffen* (St Francis Xavier). – Between the side chapels gleam more polychrome marble STATUES of the 1900s, designed by *Romaine-Walker* and carved by *Whiffen*, apart from St Francis of Rome (by *J. Swynnerton*, 1908); particularly heady *Whiffen*'s St Margaret of 1909. – In the third chapel a copy of Pierre Legros' statue of St Stanislaus at S. Andrea al Quirinale, Rome. – In the fourth chapel a *della Robbia* RELIEF of the Virgin, on a bracket lettered by *Eric Gill*, probably in 1925.

THE KING'S WEIGH HOUSE CHAPEL
(THE UKRAINIAN CATHOLIC CATHEDRAL
OF THE HOLY FAMILY IN EXILE)
Duke Street

1889–91 by *Alfred Waterhouse*. His hard style and hard materials are unmistakable. Red brick and much buff *Burmantofts*' terracotta. Round-arched throughout. Corner site with SW tower, with pinnacles and spire after S. Etienne at Caen in Normandy. Lesser NW tower; gable between, with triple-arched entrance below. Oval auditorium, appearing externally above the squared-off ground floor. Attached buildings in Binney Street, behind, less explicitly Romanesque: a former SCHOOL next to the chapel, and MINISTER'S HOUSE to the N (No. 22). The chapel was built for Congregationalists and became the Ukrainian Cathedral in 1965. The name derived from the previous home, on the site of the former King's Weigh House in Eastcheap, City. Inside is a horseshoe gallery, originally continued across the E end by an organ loft. This was removed in 1903 by *J.J. Burnet*, and something more like a chancel made. The original capacity was 900. – STAINED GLASS. W windows by *Anning Bell*, 1903, three figures, harshly coloured. Other windows 1891, subtly tinted foliage. –

SCREEN designed by *W. Borecky, c.* 1980. – CONFESSIONAL, on loan from Westminster Cathedral. Probably 1920s, to a design of *c.* 1910 by *Bentley, Son & Marshall.* – Medievalizing RELIEF said to come from a Roman Catholic chapel in Saffron Hill, Holborn, of *c.* 1855 (dem.), previously home to the Ukrainians.

THIRD CHURCH OF CHRIST SCIENTIST
Curzon Street

By *Lanchester & Rickards*, 1910–12 (tower added 1931–2). Partly demolished 1980, preserving the remarkably secular-looking front, which faces s down Half Moon Street. It might be the entrance to a prosperous insurance company. Giant niche set out with Tuscan columns. Broad frieze and cornice and above a tower of Wren derivation, with miniature porticoes set sideways, but more massive and less articulate. It differs in some respects from the 1910 design. As remodelled, a reading room occupies the r. side, a small church space the l. The niche between now opens to a narrow formal courtyard of brick offices designed by *Grahame Herbert Associates* in 1981. Three-storey sides, six-storey end to balance the tower, with a gate into Clarges Mews. For this the great Edwardian interior was sacrificed.

PUBLIC BUILDINGS

APSLEY HOUSE (WELLINGTON MUSEUM)
Hyde Park Corner

Famous as the house of the great Duke of Wellington, but not built for him. It dates from 1771–8, by *Robert Adam* for Lord Apsley, later 2nd Earl Bathurst. His house was smaller than it is now, of five bays rather than seven, and showed its brick walls. In 1807 the 1st Marquess Wellesley, Wellington's elder brother, bought it, and had *James Wyatt* overhaul it. Wellington acquired Apsley House on his return from the wars, and *B. D. Wyatt*, who before his turn to architecture was secretary to both Wellesleys, remodelled some interiors in 1819. Then in 1826–30 Wyatt returned with his brother *Philip* to remodel more interiors, enlarge the house, and face it with fashionable Bath stone. Two bays were added to the w, housing the Waterloo Gallery, and the giant Corinthian portico applied to the central three bays of the widened front. The treatment is basically Palladian, but betrays the early C19 in, e.g., the broad-shouldered pilastered projections on the w front. On the N front the centre is much further recessed. Much of the blind-windowed E face is cosmetic surgery of 1962, after the houses up to Piccadilly were levelled to widen Park Lane. At the same time the Egyptianizing stone GATEPOSTS and heavy cast-iron RAILINGS were made symmetrical. The railing design follows the Hyde Park Corner Screen to the w (*see* p. 658). Apsley

House opened to the public in 1853; in 1947 it and its contents were presented to the nation, reserving a private family apartment. It is the only great London mansion to retain its full collections, now in the care of the Victoria and Albert Museum. Some Adam colour schemes were brought back *c.* 1950, but were again banished in 1978–80. Restoration of 1992–5 further enhanced the Wyatt work.

INTERIOR. The ground-floor rooms are all plain early C19, some with tile floors of *c.* 1860. The INNER HALL, r. of the entrance, formed the way in to the C18 house. Behind it the fine semicircular STAIRCASE, created after 1826 in an apsed-ended full-height space of Adam's time. Here is *Canova*'s presumptuous 11 ft (3.4 metres) STATUE: Napoleon as a nude hero, holding a gilt statuette of Victory. Made in 1802–6 and set up for a time in the Louvre; bought in 1816 for Wellington by the Government. Around him curves the heavy cast-iron stair-rail, just turning from Empire to Neo-Rococo. Makers *J. Bramah & Sons*, as for the similar one installed some time before at the Wyatts' Lancaster House (*see* p. 590). Ceiling with much bay leaf; its glazed flat roof was made by *Philip Hardwick*, 1853. The first-floor landing rests on elongated console brackets. Adam's drawings show instead an oval staircase, set sideways, with column-screens of diminishing grandeur on the landings.

FIRST FLOOR. The rooms make a circuit around the staircase, with the Waterloo Gallery opening off on the W. There is still enough to remind one of Adam, overlaid with the same ivory-and-gold decoration that prevails in the *Wyatts*' additions. Unity was their end in view, and not the variety which Adam strove for, and the ideal model was C18 France. This French taste appears, e.g., in the paired bracket-cornice of the STRIPED DRAWING ROOM and YELLOW DRAWING ROOM, which have striped hangings, pier glasses and matching ceilings (restored 1992–5). Of Adam's design only the doorcases with urn friezes, all reproductions by Wyatt except for the inner one in the Yellow Drawing Room. The fireplace here also looks Adamish, with eagles and gryphons. S of this the PORTICO DRAWING ROOM, an Adam room redecorated to match. Frieze of scrolls with stags, the Bathursts' armorial supporters. Ceiling of squares and circles, originally coloured green and with painted scenes. Adam fireplace. The great WATERLOO GALLERY is reached from the Yellow and the Portico Drawing Room, which originally faced the park on this side. Banquets were held here on the anniversary of Waterloo, in what is ironically the most French-looking room of all. The heavy gilding and free Dixhuitième decoration (of *G. Jackson & Son*'s 'paste composition') are typical B.D. Wyatt, but Wellington's friend *Harriet Arbuthnot* helped design the door and window ornament, after the Duke stopped talking to his architect for having spent too much. Roof with ornamental gilt sections perforated with flat etched-glass panels round the edge: a technically inventive but visually messy solution to the lighting of Wellington's best pictures. The seven E windows have mirrored shutters which retract into the wall. Red damask hangings, an improvement by the 2nd Duke after 1852.

Continuing anticlockwise, the PICCADILLY DRAWING
ROOM is next. By Adam, but redecorated by Wyatt and deprived
of the column-screen to the end apse. Frieze of anthemion and
satyr masks. Fireplace after Piranesi. A cross-vaulted passage
leads to *B.D. Wyatt*'s DINING ROOM, the chief interior of the
1819 phase. Ponderously Grecian rather than Dixhuitième, with
yellow scagliola pilasters in flattened apses.

BURLINGTON HOUSE
Piccadilly

The home of the Royal Academy and of several of the older p.
490
Learned Societies. At least nine architects have done important
work here, with walk-on parts for half a dozen others. So an intro-
ductory sketch is needed first, starting with the C17 mansion
invisibly entombed within.

Burlington House was begun *c.* 1664 by *Sir John Denham*
for himself. After his wife died mysteriously, Denham sold it
unfinished to the 1st Earl of Burlington, for whom it was com-
pleted in 1668. The house was a grand one: in the 1690s it
paid the highest residential rates in London. In 1717–20 *Colen
Campbell* remodelled and refaced it for the architect 3rd Earl of
Burlington, who it seems was not yet confident enough to take
on the task himself. Campbell supplanted *James Gibbs*, who had
by 1716 designed part of a new forecourt; the ambitious curved
Doric colonnades around its S corners, making a *cour d'honneur*
in the French tradition, may have been by him or by *Burlington*
himself. The fourth name from this period is *William Kent*,
who painted some interiors, and may have designed them too.
Campbell used more Doric columns on his new gateway to
Piccadilly (a version of the York Water Gate, for which *see* pp.
378–9), which was guyed in a scurrilous engraving by Hogarth.
All these forebuildings went in the C19, as did interiors made *c.*
1771–5 by *John Carr* of York, for the 3rd Duke of Portland. In
1815–18 Burlington House was remodelled by *Samuel Ware* for
Lord George Cavendish, who also made the Burlington Arcade
on the W strip of the garden (*see* Piccadilly, p. 561). The N front
was only then changed to harmonize with Campbell's façade.

In 1854 Burlington House was bought by the Government for
'the public service'. Twenty years passed before it was fully put
to use, while administrations and bright ideas came and went.
These included a commission in 1859 from *Banks & Barry* for
premises for the Royal Academy, Learned Societies and Patent
Office, followed by proposals to keep Burlington House and to
build a new National Gallery on the extensive gardens to its
N. Finally in 1866 *Sydney Smirke*'s scheme to adapt and extend
the house for the Royal Academy was accepted, and by 1876
the work was externally complete. The house was heightened
and its S façade altered, a block of exhibition galleries was built
behind it, and a house for the Keeper added on the E side.
Banks & Barry were retained to design tall new premises for the

Learned Societies around the other three sides of the forecourt.*
The N part, a detached block by *Sir James Pennethorne* facing
Burlington Gardens, was for the University of London. Subse-
quent additions to the Academy's premises, by *Norman Shaw*
(1882–5) and *Norman Foster & Partners* (1989–91), exploit the
space between the old house and the exhibition galleries. In 2003
further remodelling is projected by *Michael Hopkins & Partners*,
which will extend to the Burlington Gardens block and trans-
form the dead space between.

Burlington House and its Courtyard

BURLINGTON HOUSE proper closes the courtyard on the N. It
has seven bays, with two broader wings one bay wide and one
bay deep. These wings and the lack of a central emphasis are lega-
cies of *Denham*'s house of c. 1664–8, which had also slighter pro-
jections one bay wide in the inner angles. Denham owed his
Surveyorship of the King's Works to politics, not talent, and
no building designed by him is known. It has therefore been
suggested that *Hugh May*, who oversaw its completion after
1667, was the author. If so, it was amongst his most conservative
designs, for its baggy double-pile plan, hipped roof and astylar
elevations could all be paralleled well before 1660. But it may be
that craftsmen within the Works supplied the design.

Campbell's façade consists of the present ground floor and
first floor. It is pure Palladian, deriving closely from his unused
'New Design for the Earl of Islay' (shown in his *Vitruvius
Britannicus*), based in turn on motifs of Inigo Jones. The ground
floor is rusticated. On the first floor the wings have one Venetian
window between paired Ionic pilasters, carried on between as
engaged columns dividing windows with alternating pediments.
The masons were *Joshua Fletcher* and *Christopher Cass*. *Smirke*'s
conversion, of 1872–3, was of High Victorian cruelty. A second,
Corinthian storey was added to house the Diploma Galleries,
with detail mostly matching, but of overbearing proportions.
Characteristically richer Venetian windows on the wings, using
pink granite for the columns, with statues of artists in niches
along the centre. Further windows were not needed, as the
galleries were toplit. The statues are, from l. to r.: Phidias (by
J. Durham), Leonardo (*E. Stephens*), Flaxman, Raphael (both
H. Weekes), Michelangelo, Titian (both *W. Calder Marshall*),
Reynolds, Wren (both *Stephens*) and William of Wykeham
(*Durham*). On the ground floor a rusticated arcade was put
up in front of the façade from l. wing to r. wing, obscuring the
base of Campbell's *piano nobile*. The carver here was *J. Birnie
Philip*. Within the arcade two simple WAR MEMORIALS: w,
Royal Academy, designer *Trenwith Wills*, 1922, E, Artists' Rifles,
c. 1922, designer *Geoffrey Webb*. The continuation E of the main
building contains the staircase to the Keeper's house, added
by *E.M. Barry*, 1876. The COURTYARD was remodelled in
1999–2001, with a steeper camber. Its focus is a bijou STATUE of

* *Gibbs*'s colonnade was dismantled and moved to Battersea Park, but after 1893 it
was ground up for hardcore because money could not be found to re-erect it.

Sir Joshua Reynolds by *Alfred Drury*, 1929–31, on a plinth designed by *Giles Gilbert Scott*.* In the new paving are fountain spouts, placed according to Reynolds' horoscope.

The Learned Societies are housed in *Banks & Barry*'s big, heavy, palatial ranges of 1868–73. In the Italian Cinquecento style, two and a half storeys high, with a centre one storey higher above a tripartite archway. There are to Piccadilly seven bays on each side of this, then another, lower bay on either side. The central archway, barrel-vaulted and richly coffered, has great rich gates cast by the *Midland Iron Co*. Its alignment is slightly off perpendicular. The side ranges of the courtyard are quieter but of the same character.

Interiors

The way in to BURLINGTON HOUSE is through an oblong ENTRANCE HALL with an excessively low ceiling. It was formed out of three older rooms in 1873, and remodelled in 1899 by *Sir T.G. Jackson* with arched openings in the N wall and flat decorative ceiling compartments. Redecoration in 1962–3 by *Raymond Erith* toned down Jackson's decoration and put in the revolving door housings. The ceiling paintings, of *c.* 1778, come from the Royal Academy's meeting room at Somerset House (*see* p. 323). The centre panels are by *Benjamin West* (The Graces unveiling Nature, centre, with the Four Elements), the others by *Angelica Kauffmann*. The fine Corinthian doorcase in the centre is probably of 1815–18 by *Ware*, who imitated the early Palladians supremely well. He also resited the STAIRCASE to climb directly ahead, giving the house a symmetry lacking in the Palladian Earl's time. It goes up in one flight (widened in 1876) and returns in two to a cross-landing. Thick cast-iron handrail, an advanced taste for the 1810s. Ware's ceiling is more obviously Burlingtonian, as are the doorcases (unless they are of *c.* 1720). To give access to the Exhibition Galleries, the Royal Academy pierced the half-landing wall for an additional flight in line with the first. It also introduced the column-screens of 1876, to designs by *E.M. Barry*, Smirke having retired. The PAINTINGS are reset C18 work. In the ceiling, a roundel of *c.* 1720 by *William Kent*, 'Architecture contemplating the portrait of Inigo Jones'. On the upper walls two large canvases by *Sebastiano Ricci*: The Triumph of Galatea, l., and Diana and her Nymphs, r. They were part of a sequence painted in 1712–15 from the previous staircase, which occupied the right-hand third of the present entrance hall.** The SCULPTURES on the half-landing represent Gainsborough, l., by *Brock* (1939), and Turner, r., by *W. McMillan* (1937).

* Just within the Piccadilly entrance on the W side, the prototype K2 TELEPHONE BOX of 1926, also by *Giles Gilbert Scott*, of timber rather than the standard cast iron.
** This staircase, made in 1715 to designs probably by *Gibbs*, was apparently commissioned by Burlington's mother Juliana during the young earl's absence on the Continent (*see* George Knox in *The Burlington Magazine* 127, 1985). Paintings by *G.A. Pellegrini*, of similar date and thought to come from Burlington House, are now at Narford Hall, Norfolk.

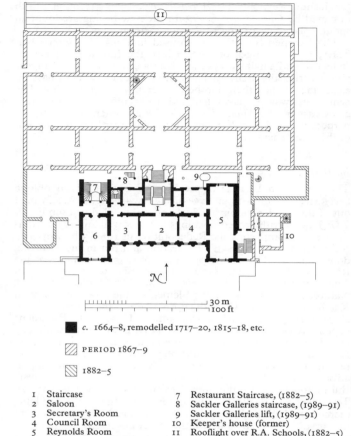

c. 1664–8, remodelled 1717–20, 1815–18, etc.

PERIOD 1867–9

1882–5

1	Staircase	7	Restaurant Staircase, (1882–5)
2	Saloon	8	Sackler Galleries staircase, (1989–91)
3	Secretary's Room	9	Sackler Galleries lift, (1989–91)
4	Council Room	10	Keeper's house (former)
5	Reynolds Room	11	Rooflight over R.A. Schools, (1882–5)
6	General Assembly Room		

Burlington House. First-floor plan,
showing main phases of development

From here the choice is between Smirke's galleries ahead, described in the next paragraph, and the rooms within the original house. The FINE ROOMS on the first floor here are being restored to show off the Permanent Collection (completion due 2004). The central space is the SALOON, which is the least altered interior from Burlington's time. The design may be Campbell's, or wholly or partly by *Kent*. Sumptuous doorcases, one with Corinthian columns and a pediment, the other two with pediments and putti on them. These and the equally sumptuous wall panelling are carved in wood. They have been attributed

to *G.B. Guelfi*, another Burlington protégé. The ceiling, by *Kent*, represents the Wedding Feast of Cupid and Psyche and is nowhere near as good as Ricci's work. The big coving was originally also painted. To the w the SECRETARY'S ROOM, where authorship is again debatable between *Campbell* and *Kent*. Lower and flatter ceiling, with guilloche bands and another *Kent* painting. Chimneypiece with columns, probably one of those by *John Devall* for the *Carr* interiors of *c.* 1771–5. E of the Saloon is the COUNCIL ROOM, formed from the upper part of the former stairhall. *Ricci*'s beautifully light and elegant ceiling is *in situ*. It has some little feigned architecture, and deities appearing in the sky above it. *Ware* reorganized the doorcases when he inserted the floor in 1815–18. The fireplace is *Joseph Wilton*'s diploma work of 1780, from Somerset House. Its reliefs show Perseus and Andromeda and Mars and Venus. The E wing houses the REYNOLDS ROOM (formerly the ballroom), *Ware* in Burlingtonian style, with a big octagon-beamed ceiling; the doorcases of the E wall are replicas of 2001. Fireplace probably 1770s. Behind the Council Room, access is gained to the landing made in 1989–91 (*see* below). The GENERAL ASSEMBLY ROOM in the w wing, designed by *Ware*, has the third *Ricci* wall painting from the old staircase (Bacchus and Ariadne), uncomfortably reset in the ceiling. The doorcase between the engaged columns is by *Norman Shaw*. The main ground-floor interior is the FRIENDS' ROOM at the E end, converted in 1986 by *H.T. Cadbury-Brown* from the former library, itself formed in 1927 from three of *Ware*'s rooms. The doorcase and fireplace may be relics of them.

Smirke's EXHIBITION GALLERIES, built in 1867–9, are planned symmetrically around an octagonal central hall, with a glazed dome and busts of artists for ornament. They have coved, rectangular skylights, some marble doorcases, and details compatible with the Palladian *genius loci*. White and gold decoration. Storage and packing is catered for in the spaces and vaulted corridors below, the Royal Academy Schools in studios along the N side, added in 1882–5 by *Norman Shaw*. Shaw's public galleries, more individual in detail than Smirke's, are reached off the SW corner (two) and SE (the former Architectural Room). The larger SW gallery has pretty *grottesche* decoration in the coving and doorcases after those of the Saloon. To their E is the RESTAURANT STAIRCASE, which extends S into the volume of the old house. Shaw's affectionate understanding of the Early Georgians comes out in its balustrade and Palladianizing doorcases. On the S side a passage with a screen of streaky marble columns. The stairs descend to Shaw's L-shaped RESTAURANT with three ample Venetian windows to the w. The WALL PAINTINGS are Autumn by *Harold Speed*, 1898, Spring driving away Winter by *Fred Appleyard*, 1902, and a big scene of the Academy and its work by *Leonard Rosoman*, 1984–5.

Lastly *Foster & Partners*' SACKLER GALLERIES of 1989–91, which can be reached from the main gallery vestibules on ground and first floor and also from the Restaurant Staircase. The engineers were *YRM Anthony Hunt Associates*, the chief donors Jillian and Arthur M. Sackler. The galleries are less interesting

than their approach spaces, which reconfigured the circulation between the old house and the Victorian galleries, dramatizing a distinction that the C19 was anxious to conceal. The project set a fashion in museums for exploiting odd or underused spaces by means of top-lighting and the use of unapologetically modern materials. How it works becomes clear only gradually. The E side was cleared out to make a long oblong gully, in which is a round-ended glass lift pushed from below. Part of *Ware*'s rendered elevation, restored by *Julian Harrap*, looms surreally close on the S side (best viewed from the first-floor balcony opposite). It is unimpeachably Palladian, rusticated below, with a tripartite first-floor window on the end projection and a top storey with little oblong windows. *Smirke*'s more utilitarian gallery wall faces it, of buff brick. The lift rises to a top landing, where Smirke's cornice now serves as a pedestal for sculpture. Light washes through white opal glass in the squared-off steel-framed roof. Entrance is made from here to three barrel-vaulted galleries lit by louvred rectangular piercings, formed from the C19 Diploma Galleries. The space to their E was converted in 1985–6 for the new LIBRARY, by *Cadbury-Brown*. The landing continues across to the W side, where Foster introduced a staircase cantilevered from two steel columns, balancing the lift. It has rounded ends, frosted glass treads and one of Foster's favourite glass-sided and steel-topped balustrades. Its enclosure is smaller than the E one due to Shaw's infilling of the far end in 1882–5, which destroyed the W end of Ware's façade.

The LEARNED SOCIETIES fit into *Banks & Barry*'s ranges as follows. The part E of the archway, r., houses the Royal Society of Chemistry and the Geological Society, and originally also the Royal Society, now at Carlton House Terrace (pp. 443–4). In the W part, l., are the Linnaean Society, Royal Astronomical Society, and Society of Antiquaries. The INTERIORS, all in one Cinquecento idiom, are like contemporary clubrooms but for the more economical finishes. Most imposing is the Antiquaries' Library, reached by a big staircase lit from the back wall: a splendid toplit space filling both upper storeys, with double galleries with marbled columns, and a fine imperturbable atmosphere. On the Chemists' staircase, opposite, a war-memorial relief by *Ernest Gillick*, 1922. The Chemists adapted the former Royal Society library to the S in 1968, inserting a white groin-vaulted ceiling on thin rods by *Pinckheard & Partners*.

The University of London Headquarters, Burlington Gardens

The former UNIVERSITY OF LONDON HEADQUARTERS faces Burlington Gardens, N of a service yard. By *Pennethorne*, 1867–70. He supplied a plain classical design in 1866, but the new ministry made him change it to Gothic. However, when the walls were nearly twenty feet high the University prevailed upon him to change to a richer and more festive free Cinquecento. Thirteen bays, of Portland stone banded with Hopton Wood and dressed with much red granite. The centre has seven bays and two square angle towers. Between them on the ground floor a five-bay porch, and above this giant engaged columns and large

arched windows. The outer parts have statues in niches rather than windows. On the terrace above the porch there are seated figures, and more celebrities stand on the top balustrade. Those seated are Newton, Bentham, Milton, Harvey (*J. Durham*, 1869); in the niches, Leibniz, Cuvier, Linnaeus (*P. Macdowell*, 1869), Adam Smith, Locke, Bacon (*W. Theed*, 1869); on the balustrade, from l. to r., Galileo, Goethe, Laplace (*E. W. Wyon*, 1869), Galen, Cicero, Aristotle (*J.S. Westmacott*, 1866), Plato, Archimedes, Justinian (*W.F. Woodington*, 1870), Hunter, Hume, Davy (*M. Noble*, 1870). Sides and rear of brick with polychrome bands, a detail carried over from the Gothic false start.

The INTERIOR has a grand clerestory-lit central stairwell. The stairs start as one flight and then divide in two. Hall and landing are each separated from the stairwell by three broad arches. Some elaborate plaster ceilings in front rooms on the first floor, the manner recalling some late works by Pennethorne's master Nash. Originally there were offices in the central part, a lecture hall to the E, examination rooms and a library to the W. The University moved out in 1899; C20 uses ended with the Museum of Mankind (British Museum) in 1970–98. *Hopkins & Partners'* conversion plans include a new home for the Royal Academy Schools.

MAYFAIR LIBRARY
South Audley Street

1893–5 by *A.J. Bolton*, as an extension of his franchise at Nos. 87–102 Mount Street (q.v.) and the adjacent Nos. 26–33 South Audley Street. Slightly plainer François I detail, offset by a capacious pedimented porch.

ST GEORGE'S SCHOOL
South Street

1897–8 by *Philip A. Robson*, son of 'schools' Robson. The usual multi-storey block, but with superior Free Jacobean detail. A lower wing at the E was the teacher's house. At the junction a latrine tower with candlesnuffer roof.

WEST END CENTRAL POLICE STATION
Savile Row

A forceful stone block by *Burnet, Tait & Lorne*, 1938–9 (reconstructed 1996–8). The back displays details of Dutch or Swedish derivation, such as bands of glass bricks in a close stone grid.

STREETS

ALBANY

Albany, improperly but irresistibly 'The Albany', is a close off
 Piccadilly with the house at the N end, and residential cham-
 bers beyond. Close and house were built in 1771–5 by *Sir
 William Chambers*, for the 1st Lord Melbourne, who sold it in
 1792. In 1802–3 *Henry Holland* converted it to apartments on
 behalf of the builder-speculator *Alexander Copland*, with two
 rows of new buildings in the former garden and a secondary
 entrance on Vigo Street, N. The apartments were built for bach-
 elors and were sold freehold. In popular opinion they had a
 flavour which was slightly disreputable and wholly enviable.
 The flavour is sustained into Pinero's *Second Mrs Tanqueray* and
 Compton Mackenzie's *Sinister Street*.
Chambers's FRONT is not at all eventful. Seven bays, brown brick,
 with Doric porch and three-bay pediment. Cornice also Doric.
 On the first floor the central three windows are gently empha-
 sized: little rams' skulls, blocks in the cornice, and on the
 middle window a pediment. Second-floor windows perhaps
 made taller in 1802–3. Ground-floor windows round-arched,
 the outer ones masked by low cramping side wings in the same
 style, also by *Chambers*. These are nine bays long, only one and
 a half storeys high, and again with a three-bay pediment. They
 housed the kitchen, E, and stables, W, also converted to apart-
 ments (now offices). The main house has twin bows behind.
What is so delightful about Albany is the back parts by *Holland*,
 another long courtyard or close, with a covered way (called the
 Ropewalk) all along its middle, and branching off from it the
 entrances to the chambers. These have three storeys and simple
 stuccoed fronts, with slightly segment-headed windows. They
 are planned in paired sets, like the Inns of Court and the
 Oxford and Cambridge colleges, except that basements and
 attics were originally service quarters. Stone staircases. The
 Ropewalk rests on timber columns. Its odd brackets and
 upswept inner roof give it a Chinese flavour, reminiscent of
 Holland's dairy at Woburn, Beds. (1789). To VIGO STREET
 nice square two-storey lodges, flanked by tall brick houses
 also by *Holland*, with two-storey bows. No. 8, r., has a radial
 fanlight; at No. 7, l., the bow was converted to an entrance in
 1894, by *J. T. Wimperis* for the publisher John Lane. PLAQUE
 by *Will Carter*, 1985, for the 50th anniversary of Penguin Books,
 which were published from here. Holland added a new
 entrance with shops in Piccadilly (demolished); two *Coade*-
 stone eagles from these stand behind the main house.
INTERIORS. Holland did away with most of Chambers's ele-
 gantly shaped rooms. In the spartan entrance hall are what
 may be some Chambers doorcases, reset. Stone staircase with
 plain railings, the upper flight (by one *Grieg*) and mosaic floor
 installed 1894–5. Chambers's staircase, also of the flying type,
 was more lavish. The establishment was intended to have a

common dining room like a club, but this failed to catch on. (One *Chambers* ceiling survives: the former State Dressing Room, first floor to the NW.)

ALBEMARLE STREET

Laid out after 1683, across part of the site of Clarendon House (q.v., Piccadilly). In 1708 Hatton described 'excellent new building' here, but Strype in 1720 found the district 'like the ruins of Troy', full of abandoned house-beginnings. A little square proposed for the N end was never built.

From the S, the W SIDE begins with Nos. 49 and 50, of *c.* 1717–19 by *Benjamin Jackson*, who was also Master Mason to the Crown. Three bays and four storeys each, segment-headed windows with key blocks, modillion cornice. No. 50 (JOHN MURRAY) was home from 1812 to the publisher John Murray I, as his brass plate still tells visitors, and remained the Murrays' residence until *c.* 1928. Good timber staircase. Of other fittings, some were present when Murray bought No. 50 from William Miller, bookseller: the ground-floor column-screen, and some fitted bookcases in the main first-floor room. This has a substantial Jonesian ceiling – surely post-1719 – and a gruesome mid-C19 marble chimneypiece. Ground-floor closet with shallow fluted dome, looking *c.* 1800. No. 49 has rusticated giant pilasters with recut Baroque capitals. Plainer pilasters on No. 47, also early C18.

On the E SIDE, No. 3, an extension of Agnew's in Old Bond Street, by *C.H. Townsend* and *C.H.B. Quennell*, 1914. Well made but (for Townsend) surprisingly conventional, with outswept flat oriels. No. 5 is a superior stone-faced house of *c.* 1760, in the style of (say) Brettingham or Ware. Rusticated ground floor, pedimented central window above. No. 6 was built for Sir Richard Neave by *George Gibson* (†1800), but the aedicules etc. look mid-C19. The finer No. 7, built for Sir John Norris, 1721, was used as Grillon's Hotel in the early C19. Of five bays, brown and red brick, with segment-headed windows and restored sashes. Off-centre doorcase with big Baroque triglyph brackets and a nice lamphood. Refined but masculine interiors in a style of *c.* 1780–90, when the Lords Monson were in residence.* Front room with swagged bucrania frieze; one first-floor room with a frieze of musicians; good marble'fireplaces. In the angle with the closet wing (still with its 1720s doorcases and cornices) is a splendid oval stairhall, with steps rising along one side, a balcony returning along the other. Unusual balustrade, of iron, with small paired leaves and oval flower-heads. On the S corner with Stafford Street No. 8, 1869, in a debased style with incised decoration. Built as a pub-cum-hotel for Frederick Shelley, by *Henry Cotton*.

Back on the W SIDE, Nos. 45–46, by *Ernö Goldfinger*, 1955–7, an early speculative Modernist office block for Mayfair. Six

*The Cooper-Hewitt Museum in New York has a drawing attributed to *Michelangelo Pergolesi* for a ceiling here, now destroyed.

storeys, four wide bays (proportioned on the Golden Section), with broad two-bay oriels on the third and fifth floors, and a definite cornice. Steel frames to the oriels, the rest concrete, but stone-clad in deference to context. It served as a model for Goldfinger's giant Alexander Fleming House, Southwark (1962–7; *see London 2: South*). Nos. 43–44, 1921 by *Delissa Joseph*, has a big bronze Grecian surround, designed by *W. J. Fryer* for Fiat's showroom. On the s corner with Stafford Street No. 41, an excellent work by *Peter Moro* for the furniture makers Hille, 1961–3. A narrow frontage of sober curtain walling, above first and ground floor treated as one. Main staircase behind, its glazed rounded end evoking Gropius's Werkbund pavilion at Cologne (1914).

North of Stafford Street, a less eventful stretch. The E SIDE shows the return of contextualism: Nos. 9–10, 1971–4 by *Gollins, Melvin, Ward & Partners*, brick crammed with upright windows, and No. 11, 1983, early C18 pastiche. At No. 12 the Royal Arcade, *see* Old Bond Street. On the W SIDE altered, mostly C18 houses, including Nos. 30–34, BROWN'S HOTEL (founded 1837), unified under stucco. In No. 29, built 1794, is a curious room with shallow Gothic arcades, mentioned as existing in 1820. Later the stucco foliage was bizarrely altered with little figures of Hindu gods.

Opposite Brown's Hotel (E SIDE), No. 13, powerful Joass-like commercial of 1922, then Nos. 14–20, mostly early C18: see e.g. the timber staircase in No. 17. No. 16, rebuilt or refurbished probably in the period 1777–86, has an entrance hall with plaster vaulting and medallions, attributable to *Sir Robert Taylor*. In No. 18 a lavish showroom staircase, probably done for Mme Caley, Court Dressmaker, *c.* 1903.

Nos. 20–21 are the ROYAL INSTITUTION, founded at No. 21 in 1799 by Benjamin Thompson (Count Rumford), Thomas Banks and others, for the advancement of scientific knowledge. The gown of classical learning was thrown over No. 21 only in 1837–8, when *Lewis Vulliamy* added his stucco screen of giant Corinthian half-columns (restored 1995), and regularized the window openings to number thirteen. Vulliamy's columns take after the Temple of Mars Ultor at Rome. The story of the premises is much more involved than the fronts suggest. The oldest part is No. 20, r., 1703–5 (refaced), which preserves a plain C18 appearance. The much larger No. 21 began as its extension, built for the 1st Earl of Grantham probably between 1709 and 1723. It was at first rather oddly one room deep and eight bays long (the first seven bays of Vulliamy's front). Vulliamy's six N bays embrace two further extensions, one of after 1755 (when Nos. 20 and 21 were separated), the other of 1799, when the Institution took over. The adaptation was by the Orcadian *Thomas Webster*, executed and perhaps modified by *George Saunders*.

INTERIORS. The present entrance lies N of the C18 ENTRANCE HALL, which has an exceptionally spacious staircase up to the first floor. Its date is probably *c.* 1775, when No. 21 passed to William Mellish, its architect very likely Mellish's friend *John Carr* of York, then busy also at his

Blyth Hall, Notts. It splits into two right-angled flights at the half-landing, with a gallery returning along the outer wall. Balustrade of wrought iron with double lyre pattern, as often used by Carr. STATUE of Michael Faraday, begun by *J.H. Foley* (†1874), finished by *Brock*. Adamesque plasterwork of 1928–9, from *L. Rome Guthrie*'s modernizing of the premises. The lecture theatre and ante-room lie N of the staircase gallery, the library to the S. The LECTURE THEATRE, reconstructed in 1928–9, respects the appearance and arrangement of its predecessor of 1800–2 except for the omission of iron columns from the gallery. The plan is a semicircle with a little extra space in front. The ceiling has a central lantern, which was lowered to procure darkness during daylit demonstrations. Steep tiers of seats, cut by two entrance gangways; some reset panelling. Also of 1928–9 a large laboratory extension behind the staircase, replacing a wing of 1872–3, and the rear spine corridor through to No. 20. The LIBRARY is *Guthrie*'s, 1935, in the Holland style, not at all technocratic. No. 20 beyond was converted in 1896 by *W. Flockhart* to house the Davy-Faraday Laboratory. The LONG LIBRARY here has a chimneypiece with a *Wedgwood* plaque, brought in 1937 from No. 32 Soho Square (Sir Joseph Banks's house), where the Institution first met. A phased refurbishment by *Terry Farrell & Partners* was begun in 2002.

N of the Royal Institution, No. 22, a much-altered house by *Sir Robert Taylor*. It went with his work of the early 1770s in Grafton Street and New Bond Street (qq.v.). Otherwise, some nice contrasts of *c.* 1900. *R.J. Worley*'s No. 23, 1896–7, is of the cheerful type with red brick, pink terracotta, and arabesque ornament. On the W side the big Frenchified No. 26 by *Gale, Durlacher & Emmett*, 1905, and GARRARD'S (No. 24) by *Sir Ernest George & Yeates*, 1911, chaste and classical stone.

AVERY ROW

The boundary between the Conduit Mead Estate, E, and Grosvenor Estate, W, defined originally by the Tyburn. In the 1720s the bricklayer *Henry Avery* covered over the brook, and built unambitious houses. Nos. 11–20, E side, are early C19, Nos. 4–10 of various C18 dates. Of the houses of *c.* 1725, No. 6 has a timber frame, No. 5 a bowed early C19 shopfront and a plan with just one room per floor. Nos. 1–3, built in 1911 by *W.C. le Maître* as a factory for Garrards the jewellers, stands just S of the entry to LANCASHIRE COURT. More C18 houses here, including No. 9 in the narrow N extension, amidst mostly Victorian small houses and workshops. This part leads back into Avery Row via further yards to the N and W, through passages made by *John Taylor Architects*, 1998–9. Their mixed-use scheme seeks to rejuvenate what were isolated spaces as a quarter of shops, flats and restaurants, with the minimum of new building. This gentle approach looks back to a scheme commissioned in 1984 from *Anthony Richardson & Partners* by

Westminster Council, as a counter to voracious plans for new offices and shops by *Gibberd, Coombes & Partners*.

BERKELEY SQUARE

Berkeley Square was such a fashionable address in its heyday that it is a surprise that this long, leafy rectangular space should have come about almost by accident. Yet a glance at the plan, with its skewed N side and streets entering haphazardly, shows the difference from such planned developments as Grosvenor Square. Its origin may be traced to 1696, when the 3rd Lord Berkeley of Stratton sold his house on Piccadilly to the Duke of Devonshire, undertaking to keep the view to its N unobstructed by building. The promise was honoured by the 4th Lord, who began *c.* 1738 to extend the houses of Berkeley Street (q.v.) along what is now the square's E side, and by the 5th Lord, who granted leases for the W side 1741–5. The principal developers were the carpenters *Edward Cock* and *Francis Hillyard*. The Berkeleys must also have appreciated that a square would be an asset to their burgeoning estate, which included Bruton Street on the E side, Hill Street and Charles Street on the W (qq.v.). The S side became gardens for Lansdowne House, built in the 1760s in line with the main W side. The N side, which belonged to the Grosvenors, had already been built up in the 1720s, along with Davies Street (q.v.); not until 1820–1 were its houses rebuilt to face the square. The 1930s liquidated much of the Georgian legacy, and built over the gardens of Lansdowne House. Part of that house survives, however, as do most of the discreetly grand Early Georgian houses on the W side.

The GARDEN was first enclosed in 1747 and taken properly in hand in 1766–7, when the present rounded ends were made. Its beautiful plane trees are said to have been planted in 1789. In the middle a funny little PUMP HOUSE with Chinese roof, of *c.* 1827 but much restored (replacing an equestrian statue of George III, 1772). At the S end a pathetic little FOUNTAIN with a marble figure of the Woman of Samaria, given by the 3rd Lord Lansdowne, 1865. By *Alexander Munro*.

The older houses can be taken first. Off the SW corner, in FITZMAURICE PLACE, the LANSDOWNE CLUB is a fragment of *Robert Adam*'s Shelburne, later Lansdowne House. Begun *c.* 1762 for the 3rd Earl of Bute, it was sold incomplete in 1765 to Lord Shelburne, later 1st Marquess of Lansdowne, and occupied 1768 (main decoration finished 1777). Shelburne chose it rather than pursue Adam's design for a house at Hyde Park Corner, commissioned 1761. Lansdowne House was in character somewhere between a country and a town house, to an L-plan, with the front facing the garden to the W and a single-storey library wing tucked behind the houses of Charles Street to the N. The present façade is due to reconstruction as a residential club by *Charles W. Fox* in 1933–5. It followed the making of Fitzmaurice Place, between the square and the E

end of Curzon Street. This required that the front lie 40 ft
(12.2 metres) further back, so that the splendid front rooms
were lost, with other disturbance inside.* The façade was
reassembled with tighter and narrower proportions. The lower
side-pavilions were demolished (s) or rebuilt larger (N), the
upper floors heightened, the four-column attached portico
remade without windows in the outer bays and with a new
ground floor, etc. The Ionic order and frieze Adam derived
from the Temple of Concord in Rome.

The principal INTERIORS were on the ground floor, an
unusual arrangement for mid-c18 London. An ENTRANCE
HALL of 1933–5 occupies the space of the stairhall at the centre
of the c18 house, and incorporates part of the old balustrade.
To the l., the shell of the c18 drawing room houses the ADAM
BAR, a 1930s reprise of Adam's large ante-room, which for-
merly lay to its E. Replica ceiling, a circle with eight reset paint-
ings by *G.B. Cipriani*, inscribed within an octagon. Columns
mark the outline of the former apse. Original fireplace (mason
Thomas Carter Jun.). To the r. of the hall, another drawing
room, altered but still with some Adam plasterwork. Between
the two, where Adam's first plan shows a room with a canted
end, is the ROUND ROOM, of uncertain date. It may follow a
design provided by *Gavin Hamilton* in 1771. The grisaille clas-
sical figure frieze is later, perhaps from the younger *George
Dance*'s alterations of 1788–91. The room faces a tall bedroom
range across a courtyard made over a large basement swim-
ming pool, all of 1933–5. The former library or sculpture
gallery, now the BALLROOM, is reached via a roomy arcaded
loggia along the courtyard N side (added *c.* 1870 by *T.H. Wyatt*;
refronted 1933–5). The present interior, of 1816–19 by *Sir
Robert Smirke* for the 3rd Marquess (altered and overbuilt
1933–5), strikes one as very masculine after Adam. It has a
shallow tunnel vault with plain coffering, and antae marking
off part-circular ends (of the 1930s their half-height galleries,
and flat roofs in lieu of Smirke's natural side-lighting; panels
over the wall recesses replaced Lansdowne's antique reliefs).
The pre-history of this room is as follows. Adam's scheme, for
a central oblong screened by columns from octagonal toplit
ends, lapsed after he fell from Shelburne's favour in 1771. The
owner then toyed with a string of proposals, by (in order)
Gavin Hamilton and *Francesco Pannini*, then *C.L. Clérisseau*,
F.J. Belanger and *Joseph Bonomi*: names evoking the cos-
mopolitan Neoclassicism from which Adam's own style sprang.
Only *c.* 1788–93 was the library fitted up, to striking Pompeian
designs by the younger *Dance*; its rounded ends and central
vault were retained in outline by Smirke. 1930s interiors by
White Allom (restaurant, etc.), smooth Art Deco.

The W SIDE proper begins N of Charles Street, with a long range
of 1740s houses. Most have good railings, with some superla-
tive lampholders, amongst the best in London. Several con-
temporary mews, reached from Hay's Mews, w, and numbered

* The principal drawing room was reconstructed at the Museum of Arts at Philadel-
phia, the dining room at the Metropolitan Museum in New York.

correspondingly there. No. 52, amongst the smaller houses, has a doorcase with Ionic columns. Entrance with dado supporting Ionic pilasters, carried as a column-screen across the stair foot: perhaps by *Mervyn Macartney*, who lived here 1888–90. One panelled first-floor room, L-shaped and with pilasters at the junction. Facing Charles Street behind is the former No. 52a, *Macartney*'s own house, built on back land 1889–90 (heightened 1901). Nicely deferential to the *genius loci*, with two canted bays and what looks like a reused mid-C18 doorcase of stone. Nos. 51–49 all have big stone doorcases on console brackets; No. 51 is stuccoed. No. 50 (MAGGS BROS) was leased by *Edward Cock* in 1744. Weird first-floor ceilings, said to be of 1864, done as if from moulds of mixed periods. Three good assorted fireplaces in the main rooms, brought in *c.* 1938, the largest made up from Adamesque C18 pieces. Simple C18 MEWS, accessible by a vaulted tunnel under the garden. Its front is a sham, with the true wall set back behind unglazed window openings. Some late C19 stable fittings. No. 48, an ugly seven-storey gatecrasher faced in inferior cast stone, is of 1937 by *Keith Braden*. No. 47, of 1744, has a stone front in remarkably pure imitation Quattrocento by *Ernest George & Peto*, who in 1891–3 marvellously transformed the house for the mineral-water millionaire Edward Steinkopff. Of the C18 house they kept only the plan form and the treads of the staircase, which was given a magnificent S-scroll balustrade made by *Starkie Gardner*. The new interiors, memorable for superb joinery, take their various cues from France. The main ground-floor rooms are Henri II, including the intimate rear study with radiant rosewood ceiling and stamped leather walls. First-floor rooms Louis XV, with boiseries, painted panelling and a more feminine air. Restored impeccably in 1997 for an American bank, by *Garnham Wright Associates* with *David Mlinaric*. 1890s MEWS, Quattrocento to match.

Nos. 46 and 45 are an outstanding pair, attributable to *Henry Flitcroft*, to whom No. 45 was mortgaged by its lessee, the mason *John Devall* (1744–5). Mirrored stone-faced fronts, each of four bays with chamfered-rusticated ground floor and door surround, and all first-floor windows with pediments and balcony balustrades. No. 45 has an added storey, probably 1838–9 by *Sir Robert Smirke*. In plan each has a two-bay front hall with grand open-well staircase behind, two large rooms to the side, and a smaller room behind the staircase coming out as a two-storey canted bay with simple Venetian motif.

INTERIORS. No. 46, built probably by the carpenter *John Phillips*, was the home of the Earls of Darnley 1745–1835. Their arms appear on the staircase, with other, rather feathery plasterwork (by *Heafford*) from alterations for the 3rd Earl by *George Shakespear, c.* 1771–4. Earlier in style and doubtless of 1744–5 the fine wrought-iron balusters, with a lyre shape over a double C-scroll, the scrolly plasterwork by the lantern, solid Palladian panelling, and modillion cornices. Also original the mighty fireplace in the grandest room (first floor), with male and female Bacchant terms and tall overmantel with Bacchic attributes in plaster. Ceiling of *c.* 1771–4, with three others on

this floor (maker *Joseph Rose Jun.*), more Adamesque than the staircase plasterwork. White-painted, the motifs circles and part-circles, with sphinxes and gryphons. Compartmented ground-floor front ceiling, perhaps from *Norman Shaw*'s alterations for H.B. Mildmay, 1889–90.

In No. 45, the wall between hall and staircase has matching Ionic half-columns on both sides: an infilled column-screen? On the second floor a stone-balustraded gallery overlooks the staircase, which has lyre-shaped balusters, not quite identical to No. 46. Lantern light, with a further gallery above and around it, seemingly from the early C19 heightening. Next to the entrance hall a room with a rich fireplace with herm-consoles and Ionic overmantel: probably done for the 4th Earl of Powis by *C. G. Hare*, *c.* 1908. He also remodelled the dining room behind, since altered. First-floor rooms redecorated by *Chambers* 1763–7, for the 1st Lord Clive ('of India'). Doors in rich mahogany-like wood, part of Clive's Indian booty. But the style of the ceiling in the crimson-hung ballroom, front, with its small playful arabesques, suggests the C19 or even early C20, and the fireplace with its festooned brackets must be of *c.* 1745. Back stair inserted 1938 by *A.R. Fox*, a graceful concrete spiral. MEWS also of *c.* 1745, with a double-height kitchen. A pilastered range of *c.* 1980 joins it to the house.

Then follows No. 44 (CLERMONT CLUB), which might well be called the finest terrace house in London. *William Kent* built it in 1742–5 for Lady Isabella Finch. As a spinster, she was free to give over most of the space to entertaining and display. The front does not tell much of this splendour. It is of only three bays, has the brick exposed, and as its distinguishing features no more than pediments to the first-floor windows and a lavishly proportioned rusticated central door arch. The entrance hall is hardly more assertive, with modest arched openings with Vitruvian scroll imposts; the r. opening has steps up to a tiny former porter's lodge. The excitement starts with the STAIR-CASE, a self-confident conception of great spatial ingenuity. There is no other English C18 staircase which can so convincingly be compared with those of the great German and Austrian Baroque architects. It fits into a volume with a square core and two semicircular apses. The staircase starts in the middle, runs up to a half-landing in one apse, and returns in two arms to the first floor. Here the other apse is hidden by a brilliantly Baroque screen of cabled Ionic columns, curving back in the centre. Behind it is the staircase from the first to the second floor. The second-floor landing echoes the Baroque shape of the screen, but oversails it on four big brackets, making a bridge between the front and back rooms. It sits over a screen wall pierced with big circles and a central Diocletian window. The well is glazed above one apse, the rest being coffered. Its tight planning within a rounded space was hugely influential on the next generation of town houses. *Robert Dawson* made the thick plaster niches and linking swags on the upper walls, *Benjamin Holmes* the balustrade with S-scrolls twisting like seahorses, a near-match to that at Kent's Holkham Hall, Norfolk.

52

53 The majestic drawing room or SALOON on the first floor is
deeply coved, filling the space behind the blind second-floor
windows. Coving and ceiling are richly and heavily coffered
and gilded in a manner derived from Cinquecento imitations
of the Antique (cf. Kent's No. 22 Arlington Street, pp. 602–4,
where many of the same craftsmen worked). The octagons,
squares, lozenges and left-over pieces have inset paintings of
the Loves of the Gods, in grisaille on blue or red grounds. *Kent*
may have painted them himself, although when he died, in
1748, the room may not have been finished. The central rec-
tangle has a thick border band, and the coving springs from a
deep-shelving Corinthian cornice with copious foliage frieze.
Enriched doorcases, paired fireplaces (by *Joseph Pickford*) with
yellow marble columns. Pier glasses with gilt trophies over: late
C18, or of *c.* 1840? The damask hangings are from *John Fowler*'s
restoration for John Aspinall's Clermont Club, 1962 (consul-
tant *Philip Jebb*).

 The BEDROOM and BOUDOIR behind the saloon completed
Lady Isabella's apartment. They were redecorated *c.* 1790 by
Henry Holland, for the 1st Lord Clermont. He added wall
panelling with diagonal and circular motifs, leaving intact
Kent's cornices and ceilings. Behind the staircase on the
ground floor, the DINING ROOM, the ceiling with simpler,
typically late Kentian plaster decoration. Similar ceiling to the
small room next to the entrance hall. In the garden stands a
sumptuous octagonal Gothick PAVILION, of 1963–4 by *Fowler*
and *Jebb*; formerly with a side corridor to the house, replaced
in 1989–90 by a larger linking conservatory, also Gothick, by
George:Trew:Dunn. Behind, the 1740s MEWS, with an unusu-
ally consequential five-bay front, the centre three pedimented
and projecting.

 Then some less individual and more altered 1740s houses.
No. 43, also with pedimented first-floor windows, has a spa-
cious but plain toplit staircase, reached by a side corridor.
No. 42 and No. 41, both stuccoed, have non-matching canted
bays facing the end of Hill Street. Within No. 42 an elegant
D-shaped staircase of *c.* 1790; No. 41 is a facsimile rebuild of
1984. At Nos. 39–40 new offices by *Hamilton Associates* are
planned. They will be stone-faced, like Nos. 36–38, of 1951–2
by *Howard, Souster & Partners*. A vestigial giant order here.
No. 35, 1742, not large, has what looks like an infilled Ionic
column-screen just within the entrance. At No. 34 an outlier
of the Grosvenor Estate rebuilding of Mount Street (q.v.), red
brick and terracotta of 1880–2 by *J. T. Wimperis*. The C18 houses
of the square turned E here, so that the space did not drain
away from its NW corner, as now.

N SIDE. At the corner with Davies Street is Nos. 29–30, an atrium
block of 1994–7 by the *Whinney Mackay-Lewis Partnership*.
Stone-faced, vertical proportions, bronzed oriels. Wavy steel-
mesh canopy by the sculptor *Rob Olins*. Nos. 27 and 28 date
from the Grosvenor Estate rebuilding of 1821–3. *Thomas
Cundy I* may have supplied the elevations. No. 28 was the
first house *Thomas Cubitt* completed in the West End. The

staircase, of stone, has a Grecian cast-iron balustrade. In No. 27 French-style interiors of *c.* 1900. Nos. 25–26 (CADBURY SCHWEPPES), 1906–7, one of *F.T. Verity*'s stone-faced Parisian *immeubles*, was an early violation of the Georgian scale. Detail by *Albert Richardson*, notably the Empirish entrance hall. Heightened 1988–91, and rebuilt behind.

The E SIDE begins with No. 24, *c.* 1747, stuccoed, and No. 23, 1890 by *Wimperis & Arber*, a mansion in stone. The N corner with Bruton Street is Nos. 20–22, bland Neo-Georgian of 1938 by *Howard & Souster*. Then BERKELEY SQUARE HOUSE, one of the largest interwar office blocks in Westminster: 1937–8 by *G. Jeeves* and *H.O. Hamilton*. Its determinedly mid-C20 idiom comes off better than Neo-Georgian might have done. Stone below brick, and no decoration to speak of. Three deep recessions above, so all rooms could be naturally lit without facing light wells. Nos. 1–3 form a small picturesque appendix. No. 3 is *Huntly Gordon*'s own house, 1895–6, rather Lethabyish in Bath stone; No. 2, refronted 1899 by *E.C. Macpherson* of Messrs *Maple*, more Gothic in detail; No. 1, dated 1901, by *R.G. Hammond*, with polygonal angle turret.

On the S SIDE is LANSDOWNE HOUSE, 1987–8 by *Chapman Taylor Partners*, replacing an unlovely 1930s block built over the former mansion gardens. Grandiose Postmodern, of good Portland and polished granite, the profiles eventfully layered and staggered above and below. The centre relates awkwardly to the taller, mansarded wings. Large atrium within, the walls similarly treated, with corners sunk to light the basement; wallclimber lifts. The boundary between the former gardens of Lansdowne and Devonshire houses is marked by LANSDOWNE ROW, a pedestrian promenade behind and to the S. Simple one-storey shops along its S side by *Oscar Carey*, 1958.

BERKELEY STREET

Laid out after 1684 on part of the gardens of Berkeley House, Piccadilly. Two big deep 1920s blocks on the W side replaced the gardens of its successor, Devonshire House. The S one was the headquarters of Thomas Cook, a late *Arnold Mitchell* work, 1924–6. A powerful four-square design, stone-faced, with sunk slots giving the effect of quoins. Windows grouped in threes over each shopfront. Heightened 1957–8, and again in 1999–2001 by *EPR Partnership*, who reconstructed it as an atrium block. The MAY FAIR INTERCONTINENTAL HOTEL, N, is of 1924–7, by *W.H. White*. Conceived as service flats, which is just what it looks like.

The E SIDE has nothing earlier than the latest C19. Nos. 1–7 belong with Piccadilly (q.v.). At No. 10, 1914–16, *Richardson & Gill* appear still in debt to Richardson's former master Verity. No. 12 is a well-crafted Palladian exercise of 1913. Several of the following run through to Dover Street, with the main façade there. No. 13, 1909, was added behind No. 37 Dover Street for the Albemarle Club, by *Smith & Brewer*. The

concentration of a few motifs is characteristic of them. Bowed brick front, Tuscan columns below, balcony on stone brackets fashioned as cherubim. At No. 16 a building by *Trehearne Architects* is under construction (2003). No. 18, before 1905, is by *Hoffmann*, No. 19 by *Richardson & Gill*, built as a residential hotel 1909–10. The style looks back to Cockerell-era Grecian. HAY HILL beyond, which slopes up to Dover Street, is named from Hay Hill Farm, as the lands around Berkeley Square were once known. On its N side No. 12 (EFG PRIVATE BANK), 1989–92 by the *Sidell Gibson Partnership*. White stone, with a rounded corner. Small-scale Postmodern detail, a kind of paraphrased late C19.

BOLTON STREET

Bolton Street, in 1708, was the end of London to the W. No more houses then were to be met until Knightsbridge was reached. On the E SIDE Nos. 11–20 are mid–late C18, some with stucco fronts. That at No. 11 (Fanny Burney's house) is by *C.H. Flack*, 1896, in bathetic mimicry of early Norman Shaw. Nos. 5–10, red brick chambers of *c.* 1900; Nos. 8–10 by *W. Wonnacott*, 1903. The railings here, with an Art Nouveau tree motif, were designed by *A. Harold Smith*.

BOURDON STREET

A roomy backwater on the Grosvenor Estate, laid out by *Thomas Barlow* from 1720–1. The plan with islands of building on the N side is largely his. Victorian improvers considered it a suitable place for artisans' dwellings, two blocks of which remain on the N side. ST GEORGE'S BUILDINGS of 1852–3, by the specialist *Henry Roberts*, the first such housing on the Grosvenors' London lands, was built for the St George's Parochial Association (founded 1849). Open access galleries with minimal iron framing, served by a central staircase. Basic classical trim. Top storey added 1876. GROSVENOR BUILDINGS further E, of 1868–9 by *R.H. Burden* for the same association, are of banded streaky-bacon brick. The flats have internal access. W extension 1891–2, also *Burden*. Both blocks modernized *c.* 1987.* They confront gabled red brick stables and coach houses which parade prettily down the slope on the S side. Built by *Jonathan Andrews*, 1889–1900, perhaps to a design by *H.J. Helsdon*, except for No. 30 (centre), 1890–2 by *T.H. Watson*. To the W, GROSVENOR HILL COURT, a dark brick-faced slab of flats on a free-standing podium. By *B. & N. Westwood, Piet & Partners*, 1962–8. At the E end, BLOOM-FIELD COURT, 1987–9 by *Hunter & Partners*. Tall Postmodern

* Demolished, artisan flats of 1854–6 further E, a commercial venture by the builder *John Newson*. Also sundry philanthropic buildings, including public baths of 1853–4, a mission church (St Mary) by *Sir A. W. Blomfield*, 1880–1, and a shelter for 'fallen' women, 1889–90.

patterned brick, compacted around a minuscule courtyard. (For the building to its N *see* New Bond Street, Nos. 135–137).

BROOK STREET

Brook Street runs W–E, from Grosvenor Square to Hanover Square. Mostly built up from 1720 as part of the Grosvenor Estate. The E end however crosses the Conduit Mead Estate (around New Bond Street), and ends in Lord Scarborough's development of the 1710s around Hanover Square.

Coming E from Grosvenor Square, on the N SIDE, No. 88 is a solid five-bay house of 1725, remodelled for Henry Trail by *C.R. Cockerell* in 1822–4. The square Ionic porch is probably his. Top storey by *Mewès & Davis*, who in 1909–10 recast the house for the Hon. Henry Coventry. (A bold axial plan, with a central gallery leading to a double-apsed dining room, and a staircase opening off the gallery, r. The styles are a fashionable mix, mostly Louis XVI, but scholarly Neo-Adam or Neo-Wyatt in the front apartments. Garden and garden buildings also of 1909–10, in a formal French style.) No. 86, dated 1725, was reconstructed in 1922 by *C.H. Biddulph-Pinchard* for doctors' consulting rooms, with a pretentious Wren-style rear wing. At Nos. 80–84 the style is a kind of red brick *entente cordiale*, with late C17 devices and steep pediments. 1910–13 by *Maurice Hulbert*.

The S SIDE is at first less interesting, two Neo-Regency stucco houses of 1925–6 (Nos. 75 and 77), and a red-granite-faced interloper of *c.* 1975 at No. 73. Then Nos. 69–71, the former mansion of Walter Hayes Burns of New York, brother-in-law to Pierpont Morgan; since 1927 the SAVILE CLUB. Not an arresting front: an C18 carcase at No. 69, conventionally stuccoed and heightened, and in 1891 extended for the Burnses by *G.H. Trollope* to No. 71. This has a square projection with French-style wavy glazing bars. The inside was redecorated very expensively by *W.O. Bouwens* of Paris, using French craftsmen, with an anthology of Louis XV devices. Entrance hall in No. 69 and staircase with iron stair-rail. In the extension is a billiard room, with an open staircase sweeping up theatrically by its S end, and splitting to return into a first-floor ballroom. Its balustrade is of carved wood. Dining rooms next to the ballroom, with gilt and marble in a very dainty Dixhuitième. (Many opulent fireplaces, that in the lounge an Italian piece brought in 1927 from the previous club premises at No. 107 Piccadilly. On the second floor a library with boiseries and monkey paintings.) No. 67, also 1720s, was stuccoed and balconied in the 1790s. Porch 1852. The timber front-hall staircase remains, restored. No. 65 is of 1811–12 by *Charles Elliott*, with an original porch; other dressings of 1866. No. 63, chaste stone, is by *G.T. Hine*, 1907–9.

Back on the N SIDE, No. 78 is an overfed Gothico-Baronial concoction by *C.F. Hayward*, 1873–5, for J.H. Baxendale (reconstructed 1999). Not a common style on the Grosvenor Estate.

p.
28 It replaced one of two houses of 1726 by *Colen Campbell*, the other being his own residence at No. 76, the first of a good mid-1720s run.* Just two bays wide, limiting the options for Palladian display, but with explicitly post-Baroque dressings and proportions. Engaged Ionic porch; top storeys of 1871–2. Central staircase, rebuilt, keeping Campbell's pendentive dome. (Also the back parlour, a simplified version of Campbell's published design of 1729, with sunk panelling and festooned doorcases. The great Mayfair builder *Edward Shepherd* built and lived at No. 72, 1726. Much more Baroque than Campbell's front, of red brick, with quoins and emphatic ground-floor rustication. Heightened 1909–10. Very fine interior, spatially more inventive than Campbell's. A cross-vaulted passage leads to a dog-leg timber staircase with Tuscan column-balusters and other architecturally derived enrichment, extending E behind the front room of No. 70. At the top a column-screen to the front room, now enclosed. From here up the staircase is set against the front wall, leaving the volume above the lower flights free. The ground-floor front room still has panelling with timber architectural features, and a ceiling with a thick scrolling surround. One can imagine Shepherd receiving clients and patrons here. No. 70, of 1725 by the carpenter *Lawrence Neale*, has a late C18 porch and a peculiar stunted C19 top storey.

At No. 66 some of the very best Early Georgian work in Mayfair is to be found. Its front makes a sober pair with No. 68, l., with even quoins and a stuccoed ground floor, possibly original. *Edward Shepherd* undertook No. 66 in *c.* 1723–5, and though he sub-leased No. 68 to the mason *Thomas Fayram* it is likely that the men worked in concert. Shepherd then fitted up No. 66 to *c.* 1729, apparently for Sir Nathaniel Curzon, working with his plasterer brother *John*. Its mixture of Baroque and Palladian features is consistent with Shepherd's work elsewhere, though some features may be due to *Detmar Blow*'s redecoration for the Grosvenor Estate Office in 1926. Through the bracketed doorcase is a HALL with a splendid dog-leg staircase, richly carved frames and swagged scallops on the walls, and a rich plaster ceiling arranged in two groin-vaulted bays. Wrought-iron balustrade with lyre motifs. It leads up to a spectacularly decorated, but by no means large, SALOON. The walls have fluted Corinthian demi-columns with garlands strung between the capitals, and two walls also have hanging chains of fruit and flowers of the highest quality of carving. The w wall has a chimneypiece with tapering pilasters flanking the opening and an overmantel on which putti play seated on exceedingly curly volutes. To its l. and r. niches with shell tops, also very Baroque. On the N wall an eared doorcase of more Palladian pattern, its pediment cutting across the panelling (is it *Blow*'s introduction?). Simple ceiling, probably of *c.* 1900. The room behind has a pretty Rococo ceiling, lightly treated in the manner of *c.* 1750. The ground-floor front room must also be *Shepherd*'s: Ionic pilasters instead of half-columns, flower

*A lead cistern dated 1726 and initialled CC survives in the area.

No. 66 Brook Street. West wall of saloon. Elevation
(*The Survey of London*)

baskets and trophies on the walls, Baroque doorcase with taper-
ing uprights. Plain back stair. No. 53 DAVIES STREET began
as the rear wing of No. 66, divided off in 1823. Its Grecian
stucco façade, attributed to *T. Cundy II*, probably dates from
the later 1830s when the Estate Office moved in. It is articu-
lated at each end by paired giant pilasters, with balancing
entrances and attics with the Grosvenor crest. The range was
originally just one room deep. A fine Early Rococo ceiling on
the first floor testifies to its c18 origins. The chief room below
has stripped panelling, partly 1920s, of simple c18 form. Its
fireplace is set unusually in the outer wall. No. 68 is of less
interest inside, mostly well-observed Neo-Early Georgian of
1934–5, by *Joseph Emberton* for Philip Hill.
After Davies Street comes CLARIDGE'S, a large red many-
dormered block by *C. W. Stephens*, 1895–8. *Caröe* made more
picturesque plans in 1889–93, but lost the job when a new
consortium took over, headed by César Ritz and Richard
D'Oyly Carte. The business began in the 1810s as Mivart's
private hotel, which merged in 1854 with adjacent premises
run by William Claridge. Crowned heads resorted to it, and
so Stephens's new hotel had a royal suite along the first floor
(some remaining rooms, French or Adam style). *Oswald Milne*
made the new entrance with its granite flowerpots in 1929, and
in 1930–1 added the not particularly appealing E wing, in
brown brick. For the chief c19 PUBLIC ROOMS *Ernest George
& Yeates* were employed, of which the spacious staircase

remains, and the former ballroom in line with it in the s range. The French Salon to its E is a remodelling of 1909–10 by *René Sergent* of Paris, with Watteauesque paintings by *Felz*. But the presiding spirit is *Milne*'s seductive Art Deco of 1929–31, the best sequence of the period in any West End hotel. Those in the C19 part are remodellings, those in the E extension were of course new, with a separate street entrance and circular lobby. Motifs are abstract or architectural rather than figurative, with repeated ziggurat profiles and a near-monochrome palette. Plenty of mirrors throughout. In the inner foyer an unearthly glass chandelier by *Dale Chihuly* of Seattle, 2000, added in refurbishment by *Thierry Despont*.

Nos. 41 and 43 are 1720s, No. 41 Italianized by *Barry* in 1852, No. 43 altered to match apart from the big bow, probably done *c.* 1920 for the Guards Club (*Wimperis & Simpson*). The remaining older interiors are early C20 Neo-Georgian. Later the Bath Club. Back parts rebuilt 1985–8.

No. 39 (COLEFAX & FOWLER) was transformed for himself by *Sir Jeffry Wyatville* in 1821, when still plain Mr Wyatt. A stucco miniature in the Wyatt family tradition, with a rounded and domed inset corner. The work included a rear wing, partly visible from Avery Row. Shopfronts 1926–7. The C18 builder was *Thomas Phillips*, master carpenter, who lived here 1723–36. By him the open-well staircase with its triplets of balusters. Wyatt gave its compartment a frieze in deliberately old-fashioned style, more C17 than C18. Other rooms with very shallow segmental ceilings and spare ornament, notably the upper gallery in the wing. Its yellow decoration and mirrored door surrounds are *John Fowler*'s work of 1958–9, done with and for *Nancy Lancaster*. Wyatt's drawing office was below.

The N SIDE after Davies Street has less of individual interest. Nos. 56 and 58, of 1852–3, and 48 and 50, 1862–3, are standard *T. Cundy II*. Nos. 52 and 54 between are early *Morley Horder* houses, 1895, minimal Neo-Tudor. *Balfour & Turner* were more inventive at Nos. 40–46 in 1898–9, a defiantly strange composition of red brick and stone. Five striped gables, and a long stone projection below in which porches, bays and balconies are asymmetrically arranged. Only the polygonal ending, r., strikes a wrong note.

The Grosvenor Estate ends at the oblique line of South Molton Lane and Avery Row, where things turn steadily more commercial. No. 34 (N side) was Symonds' Hotel, *c.* 1902–5 by *Giles, Gough & Trollope*, handsome, with triple pediments; long return with shops to South Molton Street (q.v.). No. 32, on the E corner, and No. 37 (s side), have early C19 stucco. Nos. 31–35 are stone-faced early C20 showrooms of Bond Street type. *Leonard Martin*'s No. 33 of 1928, courteously old-fashioned, contrasts nicely with *Sir John Burnet & Partners*' go-ahead Art Deco diagonally opposite, at No. 28. This is of 1929, built as Bechstein's showrooms. No. 31, 1914 by *Lovegrove & Papworth*, replaced one house of a group of 1721–2, built by *George Barnes*. Nos. 23–29 remain, with typical segment-headed windows. Nos. 27–29 was originally one four-bay

house. The glazed shop extension behind No. 27 is by *McDowell & Benedetti*, 1998. No. 25 was home in 1723–59 to Handel; a plaque on No. 23 records the briefer stay of Jimi Hendrix. No. 25 has giant pilasters, a first floor restored in 1953–4 to the C18 form, an early C19 attic storey, and a rear wing rebuilt *c.* 1790 with a sideways-facing bow. No. 23, also heightened, has lined-out C19 stucco. In 2000–1 the upper floors of both houses were converted by *MRDA* for the HANDEL HOUSE MUSEUM. The staircase at No. 25, now entered from Lancashire Court (behind), has strange but not unprecedented upward-tapering balusters. Other rooms are re-creations for the museum, with new panelling of early C18 type and plain fireplaces from houses in Russell Street, demolished for the Royal Opera House extension in 1996 (*see* p. 315). In No. 23 some original panelling and a plainer staircase. No. 20, with mid-C19 stucco, still shows the early C18 three-storey height.

Across New Bond Street, towards Hanover Square. The gardens and yards that served the big houses there were built over in the C19. For those incorporated with Fenwicks (s side) *see* New Bond Street. Nos. 14–16 opposite, in undercooked-looking ter-racotta, is offices by *Joseph & Smithem*, 1887. Nos. 8–12, stone-faced and flat, is by *Katz & Vaughan*, 1950–2, No. 6 by *Joseph Dunning*, 1858, sole survivor of an Italianate terrace. Nos. 2–4 are by *C. O. Parnell*, 1860, originally the shop and residence of Harry Emanuel, jeweller. Red brick, amply decorated with Jacobean motifs. Big bulgy bow at one end. Plainer upper storeys replaced a Frenchified roof in 1914.

BRUTON STREET

Developed from 1736 on the land of the Lords Berkeley of Stratton, like Berkeley Square to its w; named from Bruton, a Berkeley estate in Somerset. Rocque's map, 1746, shows it wholly built up. Commerce largely took over from the 1920s.

On the N SIDE a good run of mostly late 1730s houses, many with C20 plate-glass shopfronts, plus the usual outbreaks of stucco, added aedicules, raised attics, etc. From the w, No. 21 (CULPEPER), altered early C19, has a Neo-Georgian shopfront by *Basil Ionides*, 1931. Nos. 22–33 are to the more generous C18 scale. No. 22, builder *Edward Cock*, has a stone staircase with scroll balusters, altered at the foot. The fronts of Nos. 23–25 were probably designed by *Isaac Ware*, who took a joint lease at No. 23 in 1739. They share a bracket-cornice. First-floor ceilings at No. 23 in the Jonesian manner: Ware's work, or *c.* 1900? In No. 24 a pretty open-well staircase with altered S-scroll balusters. Its vestibule has fluted Ionic pilasters, and *trompe-l'œil* paintings by *Richard Shirley Smith*, 1984. The front of No. 25 was remodelled in the 1910s by *Simpson & Ayrton*, with two large tripartite windows with Adam-style detail. At No. 26 remodelling came in 1934, for the couturier Norman Hartnell, by *Gerald Lacoste*. By him the smart display window

framed in polished granite and marble obelisks. (Intact in 1999, chrome interior fittings, with much mirror-glazing and one moulded glass chimneypiece; the C18 staircase and one Rococo ceiling remain.) Nos. 27 and 28, of 1737 by the carpenter *John Neale*, have segment-headed windows of pre-Palladian type. Staircases with carved treads and turned balusters. That at No. 28 is especially good: the extra three-quarter bay, r., allows an open-well arrangement up to the first floor, with pilastered dado and lavish Rococo ceiling with masks, shells and scrolls. Ground-floor panelling with alternating broad and narrow divisions. No. 30, refaced, has a later C18 staircase with lyre-scroll balustrade; No. 32 early C19 stucco and Greek Doric porch.

More than half the S SIDE is now Berkeley Square House, W end, and the Time & Life Building, E end (*see* Berkeley Square and New Bond Street). In between, Nos. 12–13, facsimiles of stuccoed mid-C18 houses that collapsed during alteration in 1984.[*] Further W, the COACH AND HORSES at No. 5, an unusually painstaking essay in the half-timbered jolly-good-ale manner. 1933 by *Cecil M. Quilter*.

BRUTON LANE, by No. 5, follows the line of the Tyburn Brook, between the Berkeley lands, W, and the Conduit Mead Estate, E.

BRUTON PLACE is the mews behind the N side, running back into Berkeley Square. A few Georgian buildings, e.g. Nos. 1–7 at the E end. On the N side, No. 42 was erected as their office by *Mitchell & Bridgwater*, 1936–7, progressive for the date, with characteristic concrete lintels and sills.

BURLINGTON GARDENS

Formed in the mid C17, as an extension to Glasshouse Street (*see* p. 408). It divided off the old garden of Burlington House from the BURLINGTON ESTATE to its N, which the architect *Lord Burlington* laid out for building under Acts of 1718 (Old Burlington Street, Clifford Street, Cork Street, qq.v.) and 1734 (Savile Row, q.v., and New Burlington Street). The result was the most architecturally ambitious and imaginative part of old Mayfair, and it is a pity that so little remains of it. *Burlington* designed a few larger houses himself, notably in Old Burlington Street, and closed the main vistas with imposing symmetrical buildings, of which the much-altered No. 1 Savile Row (q.v.) remains at the E end. Other large houses were by his protégés and architectural fellow-travellers: *Leoni* (*see* below), *Colen Campbell* in Old Burlington Street, *Kent* probably in Savile Row. Clifford Street has runs of houses of the usual pre-Palladian London type instead.

N SIDE. Between Savile Row and Old Burlington Street is the former UXBRIDGE HOUSE, the first English work by *Leoni*, 1721–3, altered and extended 1785–9 by *John Vardy Jun.*,

[*]The greatest C18 house was No. 17 (demolished 1937), the birthplace of Queen Elizabeth II. It was of 1736–42, probably by *Edward Shepherd*, and had an applied portico on a round-arched rustic base.

assisted by *Joseph Bonomi*. Begun for John Bligh, later 1st Earl of Darnley, but completed for the 3rd Duke of Queensberry, and at first called Queensberry House; the 1780s work was for the 1st Earl of Uxbridge. The Victorians then adapted and extended it as a bank. The story is therefore more complicated than the stately front suggests.

What one sees is ten bays wide, with the uncanonical number of nine giant Composite pilasters, a top balustrade, and rusticated ground floor with round-headed openings. The seven W bays represent Leoni's house, which was a double-pile building of stone-dressed brick, with a different treatment of parapet and ground floor. Vardy refaced the brick in Portland stone, retaining Leoni's pilasters, and added the three E bays, perpetuating the typically Palladian omission of pilasters at the ends. He also cut down the first-floor windows and added the iron balcony (like the excellent RAILINGS probably made by *James Messenger*). Vardy made a second, N extension, now No. 1 Old Burlington Street. This had a new main entrance, in a different position from the present Doric porch. The wide S porch is by *P.C. Hardwick*, who in 1855 adapted the house for the West End branch of the Bank of England. He returned in 1875–8, when the W part was converted into an airy columned banking hall, for which a stone-faced N extension was made along Savile Row. Used by the Royal Bank of Scotland 1930–98; converted in 2001–2 for JIL SANDER.

Of the C18 rooms the open-well STAIRCASE remains, opening off from the banking hall on the l. Its three stone flights are Leoni's, the balustrade with wrought-iron enrichments apparently of 1785–9, the date of Vardy's dignified oval coffered dome, skylight and wall panelling (plasterer *Joseph Rose Jun.*). Fireplace with relief of putti by *Westmacott Sen.*, c. 1790. Three medium-sized rooms off the landing preserve an C18 appearance: to the S, the W part of the former great drawing room, its ceiling probably 1720s but altered; the other two, SW and W, each with a fine ceiling by *Rose* and a large acanthus-embellished fireplace, probably 1720s.

Further W on the N side is Nos. 3–5, by *Fitzroy Robinson & Partners*, 1971–2. An early instance of their chunky style, much multiplied in the 1970s. Grey stone bands, white mullions, rebated corner windows. On the S SIDE, from W to E, the Burlington Arcade belongs with Piccadilly, the former University of London with Burlington House, the lodges facing up Savile Row with Albany (qq. v.).

CHARLES STREET

Built on the Berkeley lands *c.* 1749–59; mostly contracted for by the carpenter *John Phillips*, assisted by the builder-architect *George Shakespear*. The houses favour stone doorcases of Palladian type, straight-hooded, with consoles on foliate spurs. Plenty of fashionable interventions of *c.* 1900 in addition. The description runs from Berkeley Square to the Alice-in-Wonderland diminuendo at the W.

On the s SIDE, Nos. 51 and 50 are mid-C18 by *Phillips* and *Shakespear*, variously altered (Chinoiserie staircase in No. 51). No. 50 has a central entrance and a front hall; *Wimperis & Arber* added the plain stone oriel in 1899. At No. 49 *Woodrow & Helsdon* put on a new front in 1909. No. 48 represents the Berkeley Square type, of five bays, with a moulded cornice and obelisks in front of the doorway. Later C18 segmental doorway arch. Opposite (N SIDE), No. 1, dated 1901, small and gabled with foliage carving, typical *R. G. Hammond*, who was much employed in the street. No. 2, mid-C18, has been given a full-width canted bay on iron columns. Then on the E corner with Hay's Mews the RUNNING FOOTMAN, 1936–7, one of the best of *Alfred W. Blomfield's* pubs for Watney Combe Reid. Simple brick Neo-Georgian, except that each front has a two-storey attic, its upper window pushing through the eaves. The w corner is No. 6, towering Italianate stucco of Kensington type by *Thompson & Morgan*, 1848. No. 7 is of 1900 by *F.M. Elgood*, best known for his work in Marylebone. Portland-faced; free, Gibbsian style. Back on the s SIDE, No. 44, *c.* 1911 in yellow stone and an unusual purple brick, is *Hammond* in plainer mood, No. 43 a remodelling by the same, 1905, the date also of the Wrenaissance No. 42.

Then the mid C18 returns. The N SIDE as far as Chesterfield Hill was undertaken by *Benjamin Timbrell* and *John Spencer*, e.g. Nos. 8 and 10. At the latter some good thick plasterwork, and a Doric porch perhaps by *Henry Harrison*, who worked here *c.* 1830–40. No. 11, four bays wide, was refronted in stone in 1892 by *Wimperis & Arber*, for Charles Fish. Mid-C18 motifs, densely deployed. Much Late Victorian intervention inside, though the front-hall staircase with fine lyre-shaped balusters looks mid-C18 still. On the s SIDE, Nos. 39–41, *c.* 1750–3 by *Phillips* and *Shakespear*, all unusually well preserved inside and out. No. 41 is of five bays with a moulded cornice. (Stairhall with Rococo decoration and timber balustraded staircase; Rococo plasterwork.) No. 39, also of five bays, has a late C18 Ionic doorcase, probably contemporary with the fine first-floor interiors. The likeliest date is *c.* 1792, when the ownership changed. Two rooms have discreet but advanced Neoclassical decoration, with inset strips of painted grotesque ornament and refined doorcases and cornices. In a third room enchanting Chinese wallpaper painted with flowering trees, birds and butterflies. Generous front hall with mid-C18 two-flight staircase and wrought-iron balustrade.

Next door, No. 37, converted from two C18 shells by *W. Allwright* of *Turner Lord* in 1890, for the 1st Lord Revelstoke. It houses the ENGLISH SPEAKING UNION, established 1926 by Sir Evelyn Wrench to promote Anglo-American friendship. Allwright's stone front has, apart from its Rococo display of iron, two crazy pediments l. and r. of the main window, halfway up the façade and carrying on their apexes one round window each. Ornate interiors, a notable instance of late C19 Francophilia, intended to show off Revelstoke's French furniture. They also demonstrate the taste for dramatic contrasts between rooms. In the entrance hall and room to l. Louis XIV

boiseries of oak. The Wedgwood Room, r., is blue and white Louis XVI, with Boucheresque overmantels by *P.V. Galland*. At the back an overpowering Louis XV marble staircase, its balustrade of bronze and cast iron, overlooked by a shallow second-floor gallery and lit by a Venetian window. Ceiling painted by *Galland* in chocolate-box Tiepolo manner. First-floor front room with a loosely Cinquecento ceiling dated 1900, for a later owner, the 6th Earl of Dartmouth. French C18 painted doors. Behind, a walnut-lined ballroom again shows Revelstoke's French taste. Fireplaces include one from *Robert Adam*'s Derby House, Grosvenor Square, and two inlaid stone Italian pieces. A pavilioned MEWS of 1890, stone-fronted to the courtyard, houses the Union's library.

Facing the Union (N SIDE), No. 12, flats by *Paul Hoffmann*, 1924, with twin Regency bows, and another *Hammond* house at No. 14, 1902, with a canted bay. No. 16, of 1753, unusually large, has obelisks in front of the free Ionic doorway. This dates from *Mewès & Davis*'s remodelling of 1913–14 for the Hon. Mrs Greville, who moved here from No. 11. Interiors designed with assistance from *Lenygon & Co.* and other decorators, in a mixture of C18 French and Anglo-Palladian. Of the 1750s also Nos. 17, 18 and 18a. No. 17, five-storeyed, has two vigorous Rococo ceilings. The architectural amateur *John Chute* lived here 1766–76, and the ceilings at The Vyne, his Hampshire house, are comparable, though none are necessarily to his own design. The stuccoed No. 18a faces Chesterfield Hill with a canted bay, added 1922 by *Wimperis & Simpson*. On the w corner, *Hammond*'s Nos. 18b, 19a and 19, bulky Bath stone houses of 1905–6 in an eventful free Neo-Georgian.

Facing No. 18b are Nos. 30–32 (S SIDE), indifferent Neo-C18 refrontings of 1988–90 for the Saudi Embassy behind (q.v. Crewe House, Curzon Street). No. 29, *c.* 1750, has a Doric doorcase. On the N SIDE Nos. 20–23 and 25–27a are again mid-C18. No. 20, stuccoed, has remarkably ornate mid-C19 ironwork, No. 21 an iron balcony of the same period which frames the C18 doorcase like a baldacchino. After No. 22 the street dwindles to an alley, with on the S side the looming houses of Chesterfield Gardens (q.v. Curzon Street). By *Hammond* No. 24, 1907. Good Rococo ceiling in No. 27. No. 27a has on its flank that unique survival, a jettied and weatherboarded wall in Mayfair. The house is said to have been built as his own workshop by *Phillips* in 1754. Closing the view, the little RED LION pub, stuccoed and altered mid C18.

CHESTERFIELD STREET

Remarkable in that it preserves the appearance of complete Georgian brick terraces. Laid out and built up in 1755 by *John Phillips*, on Curzon land. His Nos. 1 and 15, on the S corners with Curzon Street, have a touch of formal planning: a projecting entrance bay, with simple Venetian window over. On the W SIDE, No. 13 has a central entrance, one of several in the street, and a staircase with good lyre-pattern balusters. Thick

cast Art Nouveau area railings at No. 12. No. 10, 1795, has a most individual features: four bays, inset Tuscan doorcase (resited after 1879), round-arched ground-floor windows. (First-floor room with painted panels of the Continents, style of *J.F. Rigaud*.) (In No. 9 excellent Chinoiserie ceilings.) On the E SIDE No. 1a is early C19 infill; No. 6, in Venetian-red brick, a passable replacement for three bombed-out houses: 1956 by *Hening & Chitty*.

CLARGES STREET

A street N of Piccadilly, where it runs along Green Park. Laid out by Sir Thomas Clarges (†1691), and built up from the early C18. The W SIDE retains medium-sized C18 houses. Nos. 33 and 34 at the N end, *c.* 1780, have *Coade*-stone doorways of Bedford Square type. In No. 33 a good ceiling with circular motif. Nos. 35 and 36 are of *c.* 1730, as their segment-headed windows suggest, under stucco. FLEMING'S HOTEL occupies Nos. 39–42, cream-painted houses again of *c.* 1730, of which No. 40 has giant end pilasters. Also of this period Nos. 43–46, No. 46 (Charles James Fox's house) with stucco trim of *c.* 1830. The E SIDE is dominated by CLARGES HOUSE and No. 17, long neutral ranges by *Chapman Taylor Partners*, 1964.

CLIFFORD STREET

Built 1719–23 as part of Lord Burlington's estate (*see* Burlington Gardens). The houses have fewer Palladian refinements than e.g. in Old Burlington Street.

On the N SIDE, No. 9 was built 1719–21 by *Benjamin Timbrell*. Refaced five-bay front, with pilaster strips and straight-headed windows. Central doorcase with pediment on Ionic demi-columns and pilasters, and projecting scrolly lampholders. The inside was mostly burnt out in 1988, but the entrance hall was reconstructed (by *Damond Lock, Grabowski & Partners*), incorporating what woodwork remained. Paired Ionic columns separate the vestibule, with compartmented ceiling, from the staircase, l. This is of wood, of the type with one arm splitting into two and turning back. Closed strings, fashioned as enriched entablatures. The swagged mask frieze and other rich Kentian details look later than 1721: perhaps of 1737, when the 1st Lord Falkland took the house.

No. 8, of *c.* 1719, faces down Cork Street. Three and a half bays, with segment-headed windows and rusticated quoins topped with urns. Reinstated ground floor of 1981. Perpendicular to the front, a narrow but remarkable double-height stairhall, painted for the connoisseur Thomas Walker MP, the first occupant. It has been attributed to *Sir James Thornhill*, a fellow-member with Walker of the Society of Virtuosi of St Luke, but Croft-Murray thought it the work of unidentified painters in

40

Thornhill's circle. The frame is of coloured feigned architecture, with unorthodox cornice with bracket and mask frieze and a *trompe-l'œil* pierced dome. Grisaille pictures between: on the largest wall, E, Diana and Endymion, shouldered by atlantes; on the stair side, W, Alphaeus, Arethusa and Diana; on the N wall Minerva. Subsidiary putti, etc. The staircase, of stone with a slim open well, continues as a gallery along the upper landing. Wrought-iron balustrade in the manner of Tijou, of slanted openwork balusters. Open-well back stair immediately behind. Panelled first-floor front room with a finely carved cornice; one second-floor ceiling with putti and blue sky, probably painted after 1914 by and for *Andrew Russell*'s decorating firm. Nos. 6–7, of 1997 by *Trehearne & Norman*, replicate C18 fronts destroyed in 1962, but No. 5 is authentic, of 1722 (altered). Inside a groin-vaulted passage leads to an unusually good timber open-well stair, with the familiar twisted balusters, etc. No. 4 has a giant Doric pilaster, l., but is otherwise more modest.

Facing (S SIDE), Nos. 16–18 are of 1723; No. 18, since 1919 BUCK'S CLUB, has the false date 1717 on a rainwater-head. No. 18 is the most domestic-looking; five bays, segment-headed windows, brown brick with red trim. Inside another pretty staircase, to the first floor only, with three thin twisted balusters per tread. p. 33

The rest of Clifford Street is later C19. The corners with Old Burlington Street are *W.G. Bartleet*'s No. 3 (NE), 1890, Queen Anne, and No. 19 (SE), 1888, a bullish display of square-headed windows. Continuing W, on the W corner with Cork Street, Nos. 15–15d are of 1900 by *S.F. Bartleet*. Further W on the N side, No. 10, *c.* 1899, Flemish and flat, by *Hudson & Booth*. Rebuilt behind by *MR Partnership* with *Jon Bannenberg*, 1993, for the ESKENAZI GALLERY. A miniature atrium allows natural light to reach the showrooms.

CONDUIT STREET

Part of the Conduit Mead Estate, built up from *c.* 1715. Increasingly a street of fashionable shops. The description runs W from Regent Street.

First on the S SIDE Nos. 61–65, the retained façade of Lewis & Allenby's silk warehouse, 1866. By *James Murray*, an attentive pupil of Barry. Stately Cinquecento, of five diminishing stone storeys, with Doric pilasters to the shopfront. Post-war buildings opposite, notably No. 4, 1986–9 by *John Taylor & Associates*. Coloured brick, unequal bows: echoes of Colquhoun, Miller & Partners' Whitechapel Gallery extension (1985).

Greatest of the C18 houses is No. 9 (N SIDE), remodelled by *James Wyatt* for Robert Vyner MP, 1778–9, from two houses of 1718. Wyatt's front is of three broad bays with arched ground floor and giant Ionic pilasters above. Frieze with characteristic thin garlands and oval paterae, doorway with recessed Doric

columns. First-floor windows pedimented. The Victorian top storey may have replaced a full-width pediment. Original stucco front (*Higgins*'s patent, an early use). Between 1859 and 1934 No. 9 housed the RIBA, sharing at first with the Architectural Association and Architectural Exhibition Society, for whom three toplit galleries were added behind. Of Wyatt's interiors the barrel-vaulted entrance, some ground-floor plasterwork, and two first-floor ceilings remain. The rear first-floor room is a toplit creation by *Macvicar Anderson*, 1879, used first as a meeting room, latterly as the library. The Adamesque plasterwork may be later. Of the three rear galleries of 1859, by *Charles Gray* and *J. Edmeston Jun.*, the E one remains, with a ribbed glazed barrel vault. Centre gallery by *Arthur Keen*, 1924 (the Meeting Room), a big square with fine Soanic dome and four small corner domes on a concrete frame devised by *Oscar Faber*. W gallery by *H. T. Hare*, 1910. In 2001–2 converted to a restaurant.

The ROYAL BANK OF SCOTLAND opposite (S SIDE) is by the *Tooley & Foster Partnership*, 1995–8. Postmodern, with the well-worn device of a through-storey concave entrance placed off-centre. Then on both sides a stretch mostly of the 1900s or 1950s. No. 55, S side, and No. 17, N, are both of 1906 by *E.K. Purchase*, the latter in a French Flamboyant Gothic style unusual for him. *Treadwell & Martin*'s No. 20, also 1906 and with a big gable, is more original in its handsome Arts-and-Crafts motifs. Houses of *c.* 1720 opposite, Nos. 48, 47, 43 and 42; No. 47, with segment-headed windows and floor strings, shows the Early Georgian character best. Nos. 39–41 is by *Romaine-Walker & Jenkins*, 1915, quietly Gallic with a fine black marble shopfront.

Finally the N side up to New Bond Street. The E corner with St George Street is of 1975–8 by *Seifert & Partners*, rough brick with a rounded corner. On the W corner the former Limmer's Hotel, 1886 by *C. J. Shoppee*, red brick and stone, Louis XIII style. Nos. 26–27 is by *A. H. Kersey*, 1896–7, crowded red brick and pink terracotta, with an elaborate gable. Plain refacing of 1925–6 below, for the Ambassador Club.

CORK STREET

Built up from 1718 as part of the Burlington Estate (*see* Burlington Gardens). Now best known for its galleries of contemporary art. The E SIDE was until *c.* 1820 just gardens and yards behind the houses of Old Burlington Street. At the S end Nos. 19–20, 1818 (heightened probably in 1861), thought to have been built as stables for No. 32 there. At No. 21 showrooms for Lenygon & Co., decorators, *c.* 1911, with three giant pilasters on the central bays. Nos. 28–30 are of 1959–62 by *Gollins, Melvin, Ward & Partners*, a cut above the usual office product. Five storeys with flush window bands. Grey granite between, applied 1984; towards Old Burlington Street still the original yellow stone facing. At Nos. 31–32 typical mansion flats of 1886–8, probably by *George Wyatt*.

Back down the W SIDE. Nos. 2–4, 1996–7, are by *Rolfe Judd*, neighbourly brick and stone. Nos. 5–6, Neo-Early Georgian flats by *Gervase Bailey*, 1926, in the red-trimmed grey brick he liked. *Chapman Taylor Partners'* No. 7, designed 1963, is in elevation similar to Nos. 28–30. No. 9, Queen Anne of 1891 by *W.G. Bartleet*, has good carved brick. POLLEN HOUSE (Nos. 10–12) is by *Belcher & Joass*, 1924–5, with big diamond bosses etc. characteristic of Joass. Nos. 13–14, a former hotel of 1881 by *R.E. Tyler*, underpowered Queen Anne.

CULROSS STREET

A subsidiary E–W street on the Grosvenor Estate. In the shorter, E part some smallish houses of *c.* 1730–3, refurbished as smart retreats *c.* 1924–32. Nos. 4–12, N side, preserve the C18 appearance best. Behind No. 2 are reset early C18 GATES to a shared garden of 1928–9, designed by *E. Wimperis*. In the W part mostly mews houses. (No. 24, *c.* 1820 by *Philip Wyatt*, has a formal Neoclassical elevation behind.)

CURZON STREET

The site of the May Fair, moved from Haymarket in 1686–8 and suppressed in the mid C18. The fields used for it passed to Sir Nathaniel Curzon *c.* 1715. Small-scale building soon began at the E end, and in 1721 the *London Journal* reported that all the Curzon land would be built up. Last to be finished was Curzon Place by Park Lane, in 1760–5, on the site of a former barracks. In the 1930s new roads were made to join the E end to Berkeley Square, the W end to Park Lane. The best Georgian houses lie nearer the park; the description begins at the E.

The start is unpromising. On the S SIDE two big red brick blocks by Bolton Street, both built as flats: E, 1939; W, uglier, 1934. On the N SIDE No. 1, huge stone-faced offices of 1995–8 by *T.P. Bennett Partnership*, its long convex front too big to take in all at once. Traditional proportions, loosely 1930s details. By the entrance a twisting stainless-steel SCULPTURE by *Eilis O'Connell*, called Helix. The first Georgian survivor is the little No. 55 (S SIDE), *c.* 1800, with a pretty French Rococo interior of a century later. After Clarges Street, Nos. 50–52, brick offices and flats of 1965 with an effective concave front. On the N side, the WASHINGTON HOTEL, of two parts: the older, l., by *P. Hoffmann*, 1911, tall, jolly, asymmetrical Neo-Baroque, the newer, r., *Iain Pattie Associates'* bitty Postmodern refacing of 1986–8 of a crisp 1958 extension by *Katz & Vaughan*.

The N SIDE continues after the Church of Christ Scientist (q.v.) with two celebrated Mayfair firms: the barber G.F. TRUMPER at No. 9, *c.* 1912 with a splendid interior to match, and the bookseller HEYWOOD HILL at No. 10, altered mid-C18. No. 12, the E corner with Queen Street, was the last building

designed by *Arthur J. Davis*, *c.* 1948, the style round-arched
Neo-Regency stucco. Facing (s SIDE) are Nos. 48–49, C18,
stuccoed *c.* 1840, at which time probably also the handsome
shopfront was made and the pretty ornamental bits stuck on.
No. 47, *c.* 1740, spans the first of two entrances to Shepherd
Market behind (q.v.), and partakes of its modest scale. No. 46,
tall red Queen Anne, is by *J.S. Moye*, 1880.
The big oblong block next on the s side is LOMBARD HOUSE,
a mansion of 1899–1901 by *Romaine-Walker & Besant* with
Achille Duchêne. Built as a wedding present from William K.
Vanderbilt to his daughter Consuelo, wife of the 9th Duke of
Marlborough. It cost £350,000. The Portland stone façades
with their elevated giant Ionic order are less memorable than
the uneasy situation, without mews or garden and bounded on
every side by public streets. To walk so close to its big mask
keystones and triglyph balcony brackets still feels a little
improper. Gutted in the Second World War, it was recon-
structed as offices, and then in 1998–2000 restored with new
'period' interiors. It replaced the Mayfair Chapel, notorious in
the mid C18 for clandestine marriages.
CREWE HOUSE (the SAUDI EMBASSY), n side opposite, is a
happily preserved detached mansion in its own grounds, a type
formerly more frequent in the West End. It lies back, screened
by railings and stuccoed gate lodges introduced by *Michael
Lyell Associates*, who converted the house for the Saudis in
1988–90. Its history is complex. *Edward Shepherd* built the two-
and-a-half-storeyed central block in 1746–7, the generous bow-
fronted wings following probably in 1753–4, after his death. It
seems always to have been stuccoed (called the 'white house'
in the ratebook). But almost everything one sees derives from
later updating. The portico above the ground floor was remod-
elled *c.* 1818 for the Hon. James Stuart Wortley, making the
pediment shallower, and changing the four applied Ionic
columns from Roman to Greek. Tuscan *porte-cochère* below of
1988–90. The ill-proportioned two-bay sections to each side
date from 1937, when *H.J. Starkey* remodelled Crewe House
as offices for Messrs Tilling; in the C18 each side had just one
window. The big Venetian windows on the ground floor below
them lost their Gibbsian rustication in the mid C19, when the
wing elevations were also altered. Rising up behind is a flat-
topped office extension of 1960.
 OF INTERIORS the oldest survivor is the double-height front
hall, gracefully Neoclassical, done 1911 by *Elms & Jupp* for the
1st Marquess of Crewe. The rest are of 1988–90. Traditional
styles towards the front; in the w saloon a good late C18 fire-
place with Bacchic relief, not original to the house. Behind,
the 1960 block was remodelled to make large galleried recep-
tion spaces in an Arabian style. White plasterwork carved in
the *muquarnas* manner; close-mesh wooden *mashrabiya* screens
to the Ambassador's enclosure (*diwan*); cornice fashioned
from part of the cloth from the sacred *Quaaba* at Mecca. Giant
tented chandelier roof. Closing the Embassy forecourt on the
r. are palazzo-like offices by *Rolfe Judd*, 1996–9; on the l., mid-
C18 houses at the bottom of Chesterfield Street.

The next landmark is the CURZON CINEMA, the best post-war cinema in London. Of 1963–6 by *H.G. Hammond* of *Burnet, Tait & Partners*, replacing the Modern Dutch cinema of 1934 by the same firm. Shops to the street, tallish offices and flats above with neat bands and top canopy of stone. Balconies are being added behind, as shown in an original variant design, in refurbishment by the *Halpern Partnership*, 2002–3. The cinema appears externally as a windowless stone panel to Curzon Street and windowless brick sections by the entrance in Hertford Street, l. Medium-sized interior (542 seats), but feeling larger now that so many auditoria are subdivided. Coffered ceiling designed by *Victor Vasarely*, contrasted with rough abstract fibreglass murals by *W. Mitchell & Associates*. Then post-war offices on the N side, e.g. No. 17a, neat stone-framed infill of 1962–4 by *Chapman Taylor Partners*.

Next on the S SIDE Nos. 28–32, grand mid-C18 houses facing the former gardens of Chesterfield House. Nos. 31 and 32 are of 1799–1801. No. 32, of three bays, has round-headed first-floor windows, and C19 glass bearing the Earls Howe arms in the fanlight. Disjointed early C20 interiors. The real interest is in the garden: a great Ionic PORTICO, grandest survivor of the Georgian architectural shams put up to improve West End back views. It is shallow, six columns wide, with a frieze of swags and bulls' heads. In it a STATUE of a seated maiden by *Rudolph Schadow*, 1818. No. 31, of two bays, has a central stair-case with simple guilloche bands.

No. 30 (since 1983 CROCKFORD'S) was originally two houses of *c.* 1750–5, made into one by *Robert Adam* in 1771–2, for the Hon. H.F. Thynne. Six-bay stuccoed front without firm char-acter, the first-floor windows with alternating pediments, the attic plainly later. Of Adam's work two grand interiors remain, plus a few fireplaces. His plasterer was *Joseph Rose Jun.* The circular former DINING ROOM, on the ground floor at the rear, has a deep cove and flat centre, not quite a dome. Entrance through a beautiful shell-headed apse. On the first floor at the front, the DRAWING ROOM has a barrel-vaulted ceiling with painted medallions and a pattern of rectangles and quatrefoils. Original green and pink colours; the matching fourth, end bay is however of *c.* 1900, replacing Adam's apse. Other rooms by *H.T. Hare* for Mrs Adair, *c.* 1900, notably the chocolate-brown BALLROOM added at the back of the first floor. His lusher version of Adam enlarges the motifs, which threaten to mesh together.

Nos. 28 and 29 are of the more usual three bays. No. 29, broader, has an Ionic doorcase and bracket-cornice. Oblong toplit stone staircase, the balusters with paired scrolls. Pretty plasterwork of *c.* 1800, e.g. delicate concentric garlands in the first-floor saloon; a second-floor room has Corinthian pilasters. No. 28 has round-arched windows with impost blocks.

Opposite (N SIDE) is the close of mansions called CHESTER-FIELD GARDENS, built in 1876–8 over the garden of Chester-field House to the W by its then owner, Charles Magniac MP. *J.T. Wimperis* designed four houses on its E side, following on from the SE corner house of 1870–1 (three more to its E

have been demolished). Eclectic French Renaissance style, with plenty of loggias, canted bays and so on. The corner house, the only one in brick rather than Portland stone, has the largest front. Intimidating open-well staircase, like a hotel. The others have distinctive arched porches. Nos. 5–7 (rear parts rebuilt 1985) make a near-symmetrical group, with an octagonal pavilion-turret on No. 6. (Grand ballroom in No. 8.) An ornamented screen wall closes the view. For the replacement of Chesterfield House, w side, *see* Stanhope Gate. From here on, the N side of Curzon Street is all C20, notably LECONFIELD HOUSE, a big slab of 1938, stretching w to South Audley Street. Named from the mansion it replaced, of 1878–9 for the 1st Lord Leconfield, the last design of *Anthony Salvin*.

On the S SIDE the Georgian story resumes at DERBY STREET, which has on the E side Nos. 2–5, humble mid-C18. Back in Curzon Street, Nos. 18–23 are substantial houses originally of *c.* 1763–5, with good railings and torch extinguishers. Nos. 21–23 (CURZON HOUSE) is a remarkably self-effacing remodelling of 1883–4 by *David Brandon*, for the 3rd Earl Howe. He followed the three-bay front of old No. 21, r., with a new entrance bay projecting slightly in the middle. This has a large and a small Venetian window, a pediment and an arched doorway. Arcaded reveals along the ground floor. Twin-pedimented former COACH HOUSE behind, perhaps also of 1883–4, visible from Derby Street. In 2001 No. 21 had a good Neo-Georgian entrance lobby, with a pilastered timber screen to the l. apparently by *Philip Jebb, c.* 1982, from the days of John Aspinall's casino here. Very large open-well staircase beyond, in the style of *c.* 1720. No. 19 has an Ionic doorcase and the special interest of *Soane*'s rear addition of *c.* 1807, for Sir John Seabright, Bart. It has a sideways-facing bow. The front of No. 18 is disrupted by a flat mid-C19 oriel. Entrance passage with pretty flat-domed ceiling, *c.* 1800. No. 18e has an Ionic doorcase and stuccoed canted oriel on the corner with CURZON PLACE. In 2003 Nos. 18–23 were under renovation, in connection with new building in the mews, in Curzon Place and in Park Lane (q.v.), by *Michael Hopkins & Partners* with *Rolfe Judd Planning*.

On the N SIDE, Nos. 18a–18b (NAT WEST), by *Michael Lyell & Partners*, 1969–71. Recessed porch and hall fitted in the angle of a taller L-shaped block. Bronzed cladding; wide windows with chamfered corners. The façades of Nos. 5–6 Stanhope Gate are incorporated behind (q.v.).

DAVIES STREET

A long straight street on Grosvenor land, between Berkeley Square and Oxford Street. Mostly big C20 blocks, with relatively few C18–C19 survivals. Most intriguing of these is BOURDON HOUSE of 1723–4, N of Berkeley Square on the w side (now MALLETT'S, the antique dealers), one of the rare surviving town houses built on their own. Originally it was no bigger than a medium terrace house, two storeys plus a

mansard, of brick with brick quoins, with two bays to the street and a five-bay s façade with a three-bay pedimented centre-piece. This s front is screened by a wall with a sturdy blocked stone doorway, enclosing a big tree in a fragment of garden. After 1737 a three-storey, two-bay N addition was made on Davies Street, with a new main entrance there. Alterations of 1864 and 1872 gave this part quoins and a cornice to match the rest, which was raised by a storey and a mansard. The openwork tiled parapet and (probably) the Tuscan w doorcase date from these C19 works. In 1909–10 *Eustace Balfour* added a big wing to the SE, in matching style. On its N side an addition of 1974–5, heightened since. The C18 INTERIORS are not lavish. The staircase has carved tread-ends and slim turned balusters, reordered after 1737 to face the pilastered entrance archway. Other rooms panelled, that in the SW corner with Ionic pilasters and arched or broken-pedimented doorcases. In the Edwardian wing a very pretty octagonal shell-lined lobby like an C18 grotto, done for Mallett's by *Gordon Davies*, 1975. The 2nd Duke of Westminster lived at Bourdon House 1917–53, after Grosvenor House was given up.

Of the office blocks, Nos. 1–7 opposite (w SIDE) is by *Construction & Design Services*, 1963–7, stone-faced with upright windows, Nos. 13–27 by *Kohn Pederson Fox*, in progress 2003.

MOUNT ROW runs w between these blocks, a broad service street with some inventive buildings of *c.* 1930 on the N side. Nos. 6–10 is by *Frederick Etchells*, 1929–31, exactly contemporary with his Modernist No. 233 High Holborn, but treated wholeheartedly like an Elizabethan manor house, with twin half-hipped gables and hoodmoulded casements. Central passage to No. 8 behind, an older structure which he remodelled with crenellated walls. Folkish carving by *T. Downer*, who also executed the fine brick swags on *T.P. Bennett & Son*'s Nos. 12–14, a pretty five-bay Neo-Wren front of 1926–7. By the same firm the more conventional No. 16 (with *Joseph Emberton*) and No. 18, 1929–30. On the s side, mews of 1892–3, from the rebuilding of Mount Street (q.v.).

Davies Street continues on the E SIDE with Nos. 4–26, shops, flats and houses by *Wimperis & Best*, 1910–12. Brick-faced with a shared cornice, the s part calmer, the N part (including Nos. 55–57 Grosvenor Street) breaking out in canted bays, a porch with piggybacking columns, etc. Blander 1920s blocks follow. Then THREE KINGS YARD on the w, a T-shaped mews crossed at its neck by a wing with a little clock turret (by *Joseph Sawyer*, 1908–9). Beyond it is the CHANCERY of the Italian Embassy, at No. 4 Grosvenor Square behind (q.v.), 1931–2 by *Brown & Barrow*. Solid Neo-Georgian, with a becolumned portal. Nos. 39–49 Davies Street, a long gabled range of 1883–6 by *Edis*, and the flank of Claridge's on the E side (*see* Brook Street), represent the red brick Northern Renaissance taste of the 1st Duke of Westminster.

To the N of Brook Street a cluster of older houses. For No. 53, w side, *see* Nos. 66 and 68 Brook Street. Nos. 55–61 are straightforward houses of 1824–7. On the E side, No. 50 (the RUNNING HORSE pub) and Nos. 52–54, built 1839–40 by

Joshua Higgs, show the advent of Italianate dressings. Behind them in DAVIES MEWS, stables by *R. Blomfield*, 1902–3, solid stone-dressed red brick. Hyperbolic swan-necked pediments below, added for an antiques market by *Hugh Richards & Associates*, 1979. No. 56 is the Drill Hall of the former Queen Victoria's Rifles, by *Trenwith Wills*, civilized latter-day Neoclassical of 1950–2. Openings in rhythms of three, five and seven. Next to it the wedge-shaped former factory and showroom of Messrs Boldings, sanitary suppliers, 1889–91 by *J. T. Wimperis*. Sturdier than domestic Grosvenor Estate architecture of the day, but with the familiar contrasting terracotta, with shell and rosette motifs. The basement displayed lavatories, plumbed in to allow 'practical illustration of the merits of each'. On the site was the Grosvenor Market, a triangular enclosure of 1785–6. Opposite is No. 65, dull Neo-Georgian offices of 1948–50 by *Howard, Souster & Partners*, one of the Lessor Scheme blocks. On the site until 1939 was *Balfour & Turner*'s church of St Anselm, of 1894–6.* Along its s side in ST ANSELM'S PLACE, No. 23, surely the smallest ducal residence ever built in London: 1966–7 by *Claud Phillimore*, for the 4th Duke of Westminster. Three neat Neo-Georgian bays.

DERING STREET and TENTERDEN STREET

Dering Street is two streets, given one name in 1886: the old Shepherd Street, SE of Oxford Street, and Union Street, turning SW into New Bond Street. Mixed commercial architecture in the former. Best is No. 4 (W SIDE), *c.* 1904, *Treadwell & Martin* at full throttle: white-banded stone, elliptical-arched showroom window, twin rounded bays. Turning into New Bond Street, No. 9, *c.* 1730, shows the modest C18 scale.

TENTERDEN STREET joins the s end of Dering Street with Hanover Square. *Covell Matthews Wheatley*'s EMI GROUP (1985–7), N side, is a lively bit of pop architecture: above, double-curved dark glass; below, two skewed storeys recessed behind non-matching piers. Pompidou-type ducts in front.

DOVER STREET

Laid out *c.* 1683, the s part across the grounds of Clarendon House, the N part across the Conduit Mead Estate. Named after Henry Jermyn, Lord Dover, one of the speculators. The greater houses lay on the W, with mews in Berkeley Street. Many were adapted for the hotels that, by the 1880s, already outnumbered private houses here.

The s end starts with contrasting contemporaries: *Seifert & Partners*' Nos. 44–48 (W side), granite-faced offices and shops

* Fittings and much fabric reused in the new St Anselm in Wealdstone: *see London 3: North West.*

of 1970–1, and Nos. 5–7 (E side), flats by *Paul Manousso & Associates*, 1973, more mindful of the Georgian context. Dark purple-brown brick, slim triangular bays, with a low proportion of void to solid. Nos. 8–10 are plain C18, No. 11 Italianate of *c.* 1880 by *Octavius Hansard*. Back on the W side, Nos. 41–42 are C18, stuccoed, with a central Greek Doric porch probably added *c.* 1831 for Batt's Hotel. No. 40 (since 1896 the ARTS CLUB) was of 1699, reconstructed *c.* 1800 and largely rebuilt, after wartime damage, by *Braddock & Martin-Smith*, 1956–7. Six broad bays, four storeys, first-floor aedicules. The likeliest date for this design is 1792–3, for the 2nd Earl Sudeley, perhaps by the Essex architect *John Johnson*. Matching Doric porches, the r. one added in 1974–5 when *Dennis Lennon* remodelled the club. The C18 staircase remains, with an iron balustrade made for the 1st Lord Stanley of Alderley (†1869). Corinthian column-screen at the top, probably from the same work. Then on the E side Stafford Street, with on the N corner the DUKE OF ALBEMARLE public house, much altered but plausibly late C17. Inside, a crude stone tablet dated 1686. Opposite again, No. 38 is quite a grand house by *John Pilkington*, 1791, for the Hon. W.H. Bouverie. Painted front, channelled below, the first-floor windows irregularly spaced. Three chunky coffered first-floor ceilings look C20.

Next door at No. 37 is the one outstanding C18 design: ELY HOUSE, the West End residence which *Sir Robert Taylor* built for Bishop Keene of Ely in 1772–6, much to Pugin's later horror. Taylor made this three-bay front one of the purest essays in Palladianism. Stone-faced; ground floor with very rocky, restless rustication round the arched windows, first floor with windows in pedimented aedicules. Three paterae above, one with a bishop's mitre; then attic windows and balustrade. At the angles the shallowest returns, establishing autonomy from the neighbouring fronts. Unusual area railings fashioned as thin Doric columns, later embellished with seated lions of iron by *Alfred Stevens*, the most popular of his designs for industrial art (1852). Ely House was heightened and much altered inside in 1907–9 and 1926–7 by *Smith & Brewer*, for the Albemarle Club for ladies. The former dining room by the entrance remains, with plaster medallions, wall panels and marble fireplace, and the cross-vaulted entrance passage itself. (Also the glazed pendentive-dome over the former staircase well, part of the balustrading of S-type wrought iron, and the altered second-floor balcony above (the original staircase went only up to the first floor). In various rooms also such features as a Venetian window with columns inside, an equally richly carved doorcase, etc.) *Smith & Brewer* in 1907–9 continued the entrance passage through to their extension on Berkeley Street (q.v.), via a narrow link building. (This has a deep bow halfway, housing a staircase to the first floor.)

On the E SIDE again, *J. Macvicar Anderson*'s Nos. 17–18, built 1875 as Mackellar's Private Hotel: big red brick, like office chambers. No. 19, also built as a hotel, is in a thoroughly debased style of *c.* 1870, with sunk decoration and much stop-chamfering. Facing (W SIDE), No. 35 was the Empress

Club for ladies, by *Wimperis & Arber*, 1899–1900. Big porch
and two shallow bows, the style Renaissance freely imagined.
Extravagant first-floor drawing room, Louis XIV. No. 34,
1958–61 by *Seifert & Partners*, has scribbly incised decoration
by *Bainbridge Copnall*. MEXBOROUGH HOUSE (No. 33),
1905–6, is composed like No. 35, but with more angular motifs.
Built as service flats, to designs by *J.G.S. Gibson*. No. 32,
Neo-Georgian infill by the *Halpern Partnership*, 1988–92,
with a pedimented Diocletian window. Back on the E SIDE,
Nos. 20–27 are C18: Nos. 21–24 form part of Brown's Hotel
in Albemarle Street (q.v.); in No. 26 some modest Adamesque
plasterwork. The timidly traditional Nos. 28–29, 1955, fills the
site of *John Nash*'s own house of 1797–8, a Neoclassical self-
advertisement demolished after bomb damage. It faced down
HAY HILL, the S side of which is made by *Macvicar Anderson*'s
bulky red brick mansion flats of 1898–9.

DOWN STREET and BRICK STREET

Off the far W end of Piccadilly. Developed in the 1720s by *John
Downes*, a bricklayer, and rebuilt mostly in the 1890s. Coming
from Piccadilly, No. 24 (W side), 1906, was Down Street
Station (closed 1932). The standard oxblood faience arches of
Leslie W. Green's Piccadilly Line buildings. Contemporary
chambers over by *J.P. Crosby*, stone-faced, partly matching
No. 117 Piccadilly, l. (q.v.). Then on both sides uniform red
brick chambers of 1893–4 by *J.G.F. Noyes*, with repetitive bays
lined up to view the park. No. 21, W side, dated 1891–2, was
the vicarage of Christ Church, facing (q.v.). Diagonally oppo-
site, No. 7, a pub front by *Boehmer & Gibbs*, 1892, from an
interesting hybrid development that included residential cham-
bers and commercial stabling. Kept as a fig-leaf for *Rolfe Judd*'s
undistinguished contextual block of 1991–5, which stretches N
to Hertford Street, E along BRICK STREET. In the W arm of
Brick Street, N side, the former stables of old Londonderry
House (No. 11). Queen Anne, built 1882 for the 5th Marquess,
by – unexpectedly – the great church architect *James Brooks*.
Converted to housing 1998–9.

DUKE STREET

Runs N from the E end of Grosvenor Square. The grand show
peters out at once in favour of Late Victorian chambers over
shops, bisecting an unexpected enclave of artisan housing. On
the W SIDE also that queer hiatus, an ELECTRICITY SUB-
STATION hidden under a big raised terrace, with a domed Neo-
Baroque stone gazebo at each end. Made 1903–5, architect
Stanley Peach with *C.H. Reilly*, for the Westminster Electric
Supply Corporation. The terrace was recompense for a public
garden of 1889 on the site. Nos. 54–76, to its N, are a specu-
lation of 1887–8 by *J.T. Wimperis*, red brick and pink terracotta.
On the E SIDE, neighbours for the King's Weigh House Chapel,

are two captivating ranges by *W.D. Caröe*. To the N Nos. 55–73, 1890–2, gabled Franco-Flemish mixed with less precedent-bound forms, e.g. the dainty dormer roofs. Nos. 75–83, S, of 1893–5, simpler and still more free, has a subtly layered all-brick front. At No. 85 stables of 1900–2 by *Balfour & Turner*, with a few brick grace-notes derived from Philip Webb. No. 87, servants' quarters built in 1899 behind No. 9 Grosvenor Square (q.v.), has a Neo-Gothick shopfront of 1924–5 by *O.C. Little*, for the interior designer Syrie Maugham. To both E and W of Duke Street, flats of the *Improved Industrial Dwellings Co.* dominate (now PEABODY TRUST). To the W the dates are 1886–8, to the E 1889–92. The Grosvenor Estate, which commissioned them, insisted on the red brick facing and tile-hung gables. The company's secretary *James Moore* signed the drawings, and may also have contrived the change to rear staircases rather than front access galleries. The latter, older pattern appears at CLARENDON FLATS in Balderton Street, W, an earlier *I.I.D. Co.* scheme (1871–2), also red brick-faced. To its S the former Parochial Institute of St Mark North Audley Street (q.v.), 1872–3 by *R.J. Withers*, chunky bricklayers' Gothic. At No. 16, l., its former gymnasium, begun 1886–7 by *W.J. Bamber*, finished 1900 by *W.B. Pinhey* for the Regent Street Polytechnic. The pinched Gothic front could be of either date. To its S a large GARAGE by *Wimperis & Simpson*, 1925–6, four stripped-classical concrete storeys.

To the E, the I.I.D. Co. blocks extend to GILBERT STREET, including MOORE FLATS, two T-shapes facing a walled garden. Further S No. 27 (W side), a plain house of 1829 (extended 1901), sole remnant of *Seth Smith*'s many rebuildings in this area. Nos. 22–26, 1910–13 by *Maurice Hulbert*, go with his Nos. 80–84 Brook Street, S (q.v.). They face a Voyseyish red brick chalet by *Rolfe Judd*, 1997–9.

FARM STREET

On the N fringe of the Berkeley Estate, frustratingly unconnected with the Grosvenor lands to the N. Laid out by 1740, though houses were leased only from 1749. One survivor, on the N side: the PUNCH BOWL pub, with mid-C19 stucco and lettered frieze. To its E a large Neo-Georgian TELEPHONE EXCHANGE of 1929–32 (*P.K. Hanton* for the *Office of Works*). Then the church of the Immaculate Conception (q.v.), with its rather gaunt red brick former church house by *Goldie, Child & Goldie*, 1886. Otherwise mostly C20 mews and mews-scale offices. Opposite (S side), No. 4, red brick stables of 1893 by *John Aspell*, a survivor from his remodelling of old No. 38 Berkeley Square for the 5th Earl of Rosebery. Further W, No. 22 (FARM HOUSE), a Neo-Tudor remodelling by *T.P. Bennett & Son*, 1928. It seems more, not less, unreal for its well-crafted timber-framing, fretted bargeboards, etc.

GRAFTON STREET

An L-shaped street, continuing the line of Dover Street N of Hay
Hill, then turning E into New Bond Street. It was almost the last
part of Mayfair to be built up, beginning in or just after 1768; an
earlier plan was to put a small square here instead. The land was
part of the City's Conduit Mead Estate (*see* New Bond Street),
the developer the 3rd Duke of Grafton. His architect *Sir Robert
Taylor* designed the houses, which are the chief interest.

We start on the W SIDE with Nos. 1–2, heavy red brick mansion
flats by *Boehmer & Gibbs*, 1898–9. Then Nos. 3–6, broad-
shouldered houses by *Taylor*. They have uncommonly massive
stone doorcases with Doric columns and pediments, stone cor-
nices, and widely spaced windows in utterly plain openings,
like the greater town houses of Dublin. The plans are strikingly
varied, due partly to different depths of site.

At No. 3 the doorcase is a post-war copy and the upper parts have
been rebuilt, probably in 1892–3, when the interiors
were wondrously changed by *Fairfax B. Wade* for Arthur
James. Much remains even so from Taylor's house, built for
Admiral Earl Howe (agreement 1767). The toplit grand STAIR-
CASE is the principal alteration, of Imperial pattern in gilt,
brown and cream, with red marble steps. Onyx-faced lower
wall, Corinthian pilasters above, with trophies of musical
instruments between. What makes it special is the piercing
of the back wall by an extra flight from the half-landing, up to
a first-floor vestibule with a balcony. *Taylor*'s staircase prob-
ably climbed around the walls; the balustrade looks like his,
reused, matched and embellished (its S-pattern, open central
diamond and tendrils recur at No. 4). Probably also by Taylor
the oval dome with eagles in the pendentives. The front
ground-floor room has a Taylor ceiling with quite advanced
antique motifs. In the DINING ROOM, behind, a version of the
famous Palmyra ceiling with repeated octagons with inset
rosettes, and medallions in the interstices, linked by interlace.
Ionic pilasters and column-screen across the end, prob-
ably later. Behind the stairhall, a sequence of smaller rooms
shows Taylor's knack for tight, varied planning: a large square
VESTIBULE, with another good ceiling and at each end char-
acteristic column-screens; behind the far screen a broad apse
and then an octagonal closet, with a stone corkscrew stair off
it. The first-floor rooms have notable paintings, mostly intro-
duced 1892–3. In the front SALOON a large circular Tiepo-
lesque canvas attributed to *Giambattista Crosato* of Venice,
Abundance Crowned by Fame and Justice(?) while Minerva
repels Avarice. In the corners C18 grisailles of the loves of
the gods, probably English. The room behind is apparently
an 1890s remodelling, with Corinthian pilasters. But its tall
becolumned fireplace is mid-C18, as is the ceiling painting of
Minerva protecting Painting (and Sculpture?). Rear rooms in
similar sequence to those below, but complicated by the extra
flight from the staircase into the vestibule. The column-screens
are Corinthian, with a Venetian motif and Taylor's favourite

panelled relieving arch. The house is now part of EFG BANK, joined behind to their No. 12 Hay Hill (*see* Berkeley Street).

No. 4 is the best preserved of the four houses. Built for Lord Villiers, later 3rd Earl of Jersey; first rated 1775. The entrance is a broad vestibule with an elliptical cross-vault, on paired Doric columns carrying sections of full entablature. At the end a two-column screen, also Doric, but taller, as the architrave and frieze are omitted. Giant fanlight over. The staircase beyond has a curved end and rises in one elegant sweep, with a second-floor gallery round three sides, lit from an oval dome. Fine thin wrought-iron balustrade with elaborated S-pattern. (Two main rooms per floor, set back-to-back. Most of the ceilings are original, with unusual details. Against the walls surprisingly short columns or pilasters with Corinthian capitals, carrying straight entablatures from which spring arches over blind niches and other openings. The source may be the courtyard wall of No. 20 St James's Square (*see* p. 633), published in 1773.) PLAQUE to Lord Brougham, *c.* 1900, designed by the City Surveyor *Andrew Murray*.

No. 5, first occupied 1772, has an altered doorcase and a more orthodox plan. Staircase like that of No. 4, but continuing to the second floor. S-scroll balustrade, plainer than at Nos. 3 and 4, but like them with curious attached figure-of-eight arabesques. Circular dome on pendentives. The house has fine fireplaces of various types, not at all uniform in style or materials. One has *Wedgwood* plaques; another, in the ground-floor front room, carving in the manner of Henry Cheere. Some doorcases brought from No. 3. In the first-floor front room the shallowest apse and an interesting stucco ceiling, its rose encircled by outward-pointing segments. In the room behind the motif is a diamond in an oblong.

Lastly No. 6, first rated 1786, but doubtless of the 1770s too. Tunnel-vaulted entrance. The narrow wedge-shaped plan means that the staircase is to one side, at right angles. It has an apsed end and a balustrade of yet another type, with a central open diamond but no S-scroll. Interconnecting first-floor rooms, with two good plaster ceilings: another version of the Palmyra ceiling to the N, the S one more Adamish. Rear parts rebuilt.

The houses on the E SIDE were smaller. Nos. 21–23, two-bay brick houses of *c.* 1775, have each one normal and one Venetian window on the first floor. The latter have unusual relieving arches, typical of *Taylor*. Stone staircases, climbing from the back. No. 22 has ceilings with quadrant and circle motifs. At the corner, Nos. 18–20, FITZROY HOUSE, five storeys by *Maurice Pickering*, 1964–6, faced with narrow white unbonded tiles in the YRM manner.

The E arm of the street has fewer *Taylor* houses left. Some of the casualties had canted front bays. Nos. 7 and 7a, N side, were cruelly altered in 1910 and later. Traces of Taylor's work inside, amidst some Louis XV redecoration. Canted back bay, lit by a Venetian window. Then some 1960s–70s offices, notably *Seifert & Partners'* Nos. 11–14, 1971–3. One of their better buildings, though devastating to the former rhythm of the street. Grey

granite, the distinguishing feature stacks of boxed-out windows near the ends. WARTSKI's shopfront at No. 14, 1974 by *John Bruckland*, makes handsome use of patinated bronze panels. On the S SIDE No. 16, of *c*. 1775, with an ambitious stucco front of 1856. Staircase with apsed end, barrel vault, oval lantern and s-scroll balustrade: enough to show *Taylor*'s hand.

GREEN STREET

A late developer of the Grosvenors, built up from *c*. 1730 to the mid 1760s. It now shows the Late Victorian delight of the Estate in many-gabled blocks. Nos. 60–61 are the Georgian exception, on the S side at the E end. Plain Victorian sashes give a severe appearance. The l. part (No. 61) was built in 1730 by the staunch Palladian *Roger Morris* for himself, an unusual villa-like house with a three-bay centre and set-back two-bay wings. The plan was formal too, with the middle taken up by two big rooms set back to back. Originally this centre was of two storeys rather than three, but a storey was added probably in 1908. The back has also been reshaped, notably by *Henry Harrison*, who was employed by both the 2nd Viscount Hampden (†1824) and the 11th Earl of Kinnoul, resident 1833–57. Here the central part is slightly recessed. A low front range and a back range of full height join it to No. 60, a smaller C18 house. Of these, the back range is of *c*. 1773–89 in its lower storeys, of 1869–70 above: probably by *Macvicar Anderson*, nephew and assistant to *William Burn*, who united the houses for the 1st Duke of Abercorn. Porch of the same date. The front range, also of *c*. 1773–89, enclosed what was originally a private courtyard. (The INTERIORS of No. 61 are enlivened by Neoclassical sculpture installed by the Duke. In the room W of the hall, which faces the entrance with a broad apse, a version of *J. Gibson*'s relief of Venus and Cupid, *c*. 1839. Plaques of the 1840s by *Pietro Tenerani* (of the Duke's daughters), *Thorwaldsen* and others decorate the staircase, of stone with an open well, which occupies the central compartment on the W side. This may well be *Harrison*'s work, replacing Morris's staircase, which opened off the entrance hall. The two chief first-floor rooms were knocked through for one giant ballroom after 1919. Adamish interiors in the rear wing of No. 60, which if of 1869–70 would qualify as some of the earliest of the revived taste. No. 60 proper was undertaken in 1730 for James Richards, the King's carver, but is plain inside.)

Facing are Nos. 2–11, 1891–5 by *Maurice Hulbert*, interrupted by *Balfour & Turner*'s tellingly restrained No. 10, 1893–5. This has a recessed entrance excellently carved with a Tree of Life (probably by *Laurence Turner*). Nos. 55–59 are by *H. O. Cresswell*, 1897–9, Nos. 51–54 by *J. T. Wimperis*, 1882–3, more thoroughly red and with a square angle turret. Nos. 25–31 are by *Edis*, 1891–4, his own speculation, with Nos. 105–115 Park Street. Nos. 37–47, facing (s side), have fronts mostly of equal value, in C18 styles. Dates 1912 to *c*. 1930. The finest is

No. 46, 1913–15 by *Wimperis & Simpson* for Lady Strathcona and Mount Royal, red brick with quoins. Also of 1913–15 No. 45, by *F.W. Foster*, and No. 40, by *Yetts, Sturdy & Usher*, both stone-fronted. Nos. 41–44 are imitation Queen Anne's Gate of 1915–16 with some reused C18 doorcases (*Wimperis & Simpson*), Nos. 38 and 39 again of stone, 1912–14 (*E. Wimperis*). They face No. 32, a very pure Neo-Early Georgian mansion by *Sidney R.J. Smith*, 1897–9, for the 4th Lord Ribblesdale. Red Fareham brick with alternating quoins, and a bow towards Dunraven Street, l. Smith's more usual manner appears at Nos. 16–19 there, of 1897–8, with gables and carving and other little events. Nos. 2–6 Dunraven Street, the corresponding houses to the s, are by *F.W. Foster*, variously Neo-Georgian. Dates between 1907 and 1916. No. 1, another gabled house (1883–4 by *J.T. Smith*), makes the corner with WOOD'S MEWS. On the N side here No. 5, a courtyard mews block of 1886–7 by *J.T. Wimperis*. It has a small clock turret.

GROSVENOR SQUARE

Grosvenor Square, at 6 acres (2.4 hectares), is the largest square in Mayfair. It was projected by 1720 by Sir Richard Grosvenor, and built up *c.* 1725–31 with the adjoining streets. These enter in pairs at each corner. There were fifty-one houses in all, and for the first time in a London square their fronts were organized in places into greater compositions. The E side was built by *John Simmons* with a pedimented centre and taller ends, which was cheaper and more practical than *Colen Campbell*'s becolumned palazzo façade proposed in 1725. Campbell may have had a hand in *Edward Shepherd*'s group on the N side, which combined three houses in one pedimented Palladian composition, set uncomfortably off-centre. Some single houses also sported a giant order, and several had illusionistic painted stairhalls, of which that at No. 44 (dem. 1967) survives in part at the Victoria and Albert Museum. Later the *Adam Bros* embellished five houses, including *Robert Adam*'s magnificent Derby House (No. 26, 1773–5, dem. 1862). A new wave of rebuilding began in 1814, and from the 1850s the Grosvenor Estate insisted on solid Italianate elevations by *Thomas Cundy II* and his son for these. After *c.* 1870 came gables and red brick, followed by near-complete rebuilding for flats and hotels in the 1920s–60s. Only three houses – Nos. 4, 9 and 38 – remain from before the C20.

The GARDEN was replanned in 1947–8 by the *Ministry of Works* in memory of F.D. Roosevelt (designer *B.W.L. Gallanaugh*). Paths and planting were made looser, offset by a straight paved axis aligned on *Sir W. Reid Dick*'s STATUE of Roosevelt on a lofty plinth at the N end. Big symmetrical fountain basins on each side. He now confronts the EAGLE SQUADRONS MEMORIAL of 1984–6, a lettered obelisk designed by *Trehearne & Norman, Preston & Partners*, topped by *Elizabeth Frink*'s cadet-sized bronze eagle. Commemorative GATES to its s, 1984. Part of the garden is to be redesigned in memory of the British

victims of the terrorist attacks of 11 September 2001. The United States connection began in earnest when its former Embassy opened at No. 1 in 1938, though the future president John Adams had lived as ambassador at No. 9 in 1785–8. The garden of *c*. 1725 was smaller, an oval parterre designed by *John Alston* – the first such planting in a London square – centred on an equestrian figure of George I.

The UNITED STATES EMBASSY on the W side is now the dominant presence. Of 1957–60, by the Finnish-born American *Eero Saarinen*, best known for his curving, shell-like designs, with *Yorke, Rosenberg & Mardall* (engineer *Frank Newby* of *Felix Samuely*). The limited competition held in 1956 was the first big opening in post-war London for overseas architects, and great things were expected. Reception was mixed, however: Pevsner thought it 'impressive but decidedly embarrassing', Ian Nairn 'pompous and tragic'. Chief bone of contention was the façade, a stone screen or grille with windows of Georgian proportions in deference to the London tradition, but given an unexpected twist by its chequerboard rhythm and by making the frames of gilded aluminium. Nowadays fewer will be troubled by such pattern-making, which was then common enough on both sides of the Atlantic, though rarely made so explicitly screen-like. This explicitness is due to the way the very tall ground floor sets back, to show that the floor plate above is a giant grid of diagonally arranged concrete beams with ends exposed. There is a certain logic to the change at this level, since the lower part was mostly cast *in situ*, with precast work above. The final effect of forced monumentality is due more to its pervasive symmetry, its isolation by a sunk well and ashlar-faced glacis, and to the EAGLE by *Theodore Roszak* at the top, rising up against the sky and having a 35-ft (10.7-metre) wingspan. At the back two wings, framing a centre of one high storey only. The inside finishes are extremely impressive. STATUE of Eisenhower in front, r., by *Robert Dean*, given by the people of Kansas City in 1989.

OTHER BUILDINGS. Flats or hotels of the 1920s–60s fill most of the square, large blocks of brick with stone dressings and Neo-Georgian detail, with mansards, some pediments, some balconies, and occasional giant columns. The guiding hand was *Fernand Billerey*'s, whose partner *Detmar Blow* was also the Grosvenor Estate's surveyor. Billerey's coherent scheme for rebuilding the whole square was approved in 1932. By 1969 the N side had been done, though with deviations on the upper storeys, and much of the S side as well. The description runs clockwise from the US Embassy.

In the NW angle is Nos. 22–23 by *Read & Macdonald*, a palatial stone-faced mansion of 1906–7, put up not for some confident nobleman but as a builders' speculation. The N SIDE proper follows *Billerey*'s grandiose composition, pilastered at the ends, the centrepiece with giant Corinthian columns. From the W, the dates are 1933–5 (Nos. 18–21), 1959–61 (Nos. 16–17), 1936–8 (Nos. 14–15) and 1961–4 (the MARRIOTT HOTEL, with an entrance forecourt in Duke Street). No. 9 in the NE corner, *c*. 1725, is three-storeyed and simple, with a deep porch

of the early C19 set against the flank of No. 88 Brook Street (q.v.). Plain mid-Victorian rear addition (No. 9a).

The E SIDE is C20 but for No. 4 in the centre, of 1865–8 by the builder *C.J. Freake*, with a five-bay façade by *T. Cundy III*. Weighty Italianate style, in stone-dressed white brick, conforming to Grosvenor Estate policy of the day. The CANADIAN HIGH COMMISSION, r. (Nos. 1–3) is the former American Embassy, of 1936–8. Its architects *Charles Peczenik* and *T.H.F. Burditt* worked with an American guest star, *J. Russell Pope*, but the Neo-Georgian slab might be by anyone. Its formula recurs at No. 5 (1961–4) and Nos. 6–7 (1955–8), omitting the giant pilasters. No. 4 was remodelled inside as the ITALIAN EMBASSY in 1931–4 by *Lord Gerald Wellesley*, in a simplified style designed to complement fine furniture and works of art. Of the 1860s probably the marble grand staircase, with a free Rococo balustrade of *c.* 1970. For the rear block in Three Kings Yard *see* Davies Street.

The S SIDE begins in the corner with Nos. 49–50, maisonettes of 1926–7 by *Wimperis, Simpson & Guthrie*, a slightly less self-certain design than Billerey's. No. 48 is contemporary. Behind it, No. 13 CARLOS PLACE, a little brick enigma by *Vincent Harris*, 1924. Built as a squash court for Stephen Courtauld, then at No. 47 in the square. A niche framed by simple end piers; open attic with lion's-head blocks. Doorway and two tiny windows inserted *c.* 1953, when it became an art gallery. *Wimperis & Simpson*'s Nos. 14–15 adjoining are comely Neo-Georgian flats of 1920–1, with a broad top pediment. Nos. 45–47 in the square date from 1938–9, the MILLENNIUM BRITANNIA HOTEL at Nos. 39–44, by *Seifert & Partners*, as late as 1967–9. This has a columned centrepiece to match Billerey's opposite, and a main entrance at the back in Adam's Row. Here it appears without its Georgian dress, in dark brick and broad concrete bands. One of its two back courtyards was infilled in 1998–9 for a ballroom. No. 38 is the best of the older houses. Four-bay stucco front of 1854–5, the usual *Cundy II* product, for the 4th Lord Calthorpe. It masks a house of *c.* 1727, transformed by *John Johnson c.* 1776 for the 3rd Duke of Dorset. Of this time probably the back bow and bow-sided wing; mews block rebuilt 1986–7 for the INDONESIAN EMBASSY. (Interiors in Johnson's usual Adamitic mode: staircase with S-scrolled balustrade and oval dome, ground-floor rooms with a stucco Bacchic relief (front) and a ceiling with classical monochromes (back). First-floor ceilings with paintings in the style of *Biagio Rebecca*.) Finally Nos. 35–37, 1935–6 by *Michael Rosenauer*, and the taller Nos. 32–34 in the SW corner, by *G. Jeeves*, 1958–60, stone-faced.

GROSVENOR STREET

It runs W from the SE corner of Grosvenor Square. Built up from 1720 with superior houses, up to five bays wide. The Grosvenor Estate Surveyor *Thomas Barlow* agreed for most of the S side, then subcontracted most of it. The results were externally consistent, with segment-headed windows, and angle pilasters on the

larger houses. Some have stucco dressings of the mid C19, when
T. Cundy II ruled the roost as the Grosvenor Estate surveyor;
others were wholly rebuilt then. A second surge of rebuilding
followed from the 1890s. From the 1920s some houses became
dressmakers' shops, and big Neo-Georgian blocks replaced
others. The sides are described separately, W to E.

The S SIDE begins with No. 43, of 1726, built for Bishop Hoadly
 of Salisbury probably by the bricklayer *Robert Phillips*. Brick
 cornice; pretty late C18 Ionic porch. Four original storeys,
 the top heightened 1909. Its front-hall staircase was destroyed
 in 1949, but some robust 1720s plasterwork remains on the
 first floor. Chief upper rooms knocked through by *F.T. Verity*
 in 1894, and given luxuriant Rococo decoration.
No. 46 next door, remodelled from 1899 for the plutocrat Sir
 Edgar Speyer, is the latest and greatest mansion in the street.
 Its front and most of the inside are of 1910–11, by *Blow &*
 Billerey. Three broad bays, sober Palladian, tempered below by
 heavy rustication of Florentine type with brooding Parisian
 keystone masks. Speyer's INTERIORS set out to stupefy. The
 ENTRANCE HALL is a tenebrous space, with a dark wood-
 panelled ceiling and walls. It has not one but two main stair-
 cases, one at each end, with twin arcades between them. The
 explanation is that Speyer's work merged two older houses,
 which the Grosvenor Estate insisted be redivisible. The l. one
 is intricately carved late Continental Gothic, incorporating
 some original work. It may date from earlier work for Speyer,
 by *Sir A.W. Blomfield*. At the r. an oaken version of the Scala
 dei Giganti in the Doge's Palace, set in a double-apsed well.
 Probably made by *L. Buscaylet* of Paris. On the first floor,
 between the staircases, the ITALIAN ROOM was fitted up with
 inlaid panelling, a stone Renaissance fireplace, and a painted
 and gilded ceiling, also *ex situ*. (On the ground floor behind,
 a large L-shaped DINING ROOM, with panelling designed by
 Billerey and a large stone medieval fireplace, and a smaller oval
 room panelled in late C17 style. A vast MUSIC ROOM fills
 the first-floor back, an oval with square side spaces and carved
 and gilded Louis XV decorations, designed by *Billerey*. Painted
 ceiling, a sky with allegorical figures, probably by *Maurice*
 Tastemain.) Nos. 47–48, dressmakers' premises of 1938–9 by
 Gerald Lacoste, has a Neo-English Baroque frontispiece and a
 swanky spiral staircase. The l. part incorporates a 1720s house
 shell. No. 49, of 1725, was heightened in 1870 by *Waterhouse*.
 (Rear addition by *Weeks & Hughes*, 1882, with arabesque paint-
 ings.) On No. 50, of 1724, a typical compendium of alterations:
 balcony 1869, top storey 1905, bow-sided porch 1907 (by *W.*
 Woodward). Typically Edwardian French inside, for William
 Spencer Morgan Burns, a nephew of Pierpont Morgan.
 No. 51, also of 1724, keeps the three-storey height. (Interior
 features from at least three early C19 phases, 1824–36.) No. 52
 was built by *Benjamin Timbrell* in 1724–6 and refronted by *T.*
 Cundy II, 1854–5, in red brick rather than his usual grey. In
 1902–4 *Hooydonk* made a first-floor suite of reception rooms
 in a relaxed Continental Rococo.

Nos. 55–57 belong with Davies Street (q.v.); then Nos. 58–60, houses of 1723–5, variously altered. At No. 58 the top storey was added in 1907–8, the Adamish shopfront in 1936 (*Anns & Haigh*). Edwardian interiors of two phases: 1907–8, by *J.D. Coleridge* – probably including the English Rococo first-floor saloons – and 1909, by *Mellier & Co.*, including the quasi-Georgian staircase. No. 59 has quoins, aedicules and other sympathetic Anglo-Baroque embellishments of 1910, done for Ralph Lambton by *Robert Oglesby* of the *White Allom* firm. They kept the splendid front-hall staircase, with twisted timber balusters and a rich ceiling (plasterer *David Audsley*). At No. 60 the C18 front alone remains. Then three gabled houses of 1904–6, typical of *R.G. Hammond*'s slightly underpowered eclecticism. The next 1720s group is Nos. 66–69. At No. 66 the giant pilasters are C18, the top storeys of 1912. Neat D-shaped staircase of 1793–4 by *Charles Elliott*, with one Adamesque ground-floor ceiling. First-floor rooms of 1913–14, by *W.H. Romaine-Walker* for Robert Emmet, a rich American expatriate, working with *Carlhian & Baumetz*. They have boiseries from the Convent of the Maurist Sisters in Paris (a few in the main, L-shaped room, now white-painted) and an hôtel of the Carambacères family (boudoir, behind). On No. 67 a mutilated pilastered doorcase, on No. 68 a porch of 1867 with ridiculous half-height Corinthian columns. *David Mocatta* Italicized the front of No. 69 in 1851. Garbled interiors. The full-height stairwell has flights to the first floor only, and a second-floor gallery.

The GROSVENOR ESTATE OFFICE building at Nos. 70–72 is by *Sheppard Robson*, 1998–9. Patinated metal window guards (by *Giuseppe Lund*) and a few thin scorings help its buff brick front stand out. Nos. 73 and 74 are C18 under stucco, No. 75 good Neo-1720s by *Wimperis & Simpson*, 1912–14, with a porch from the original house by *Thomas Barlow*. It masks offices by *Tooley & Foster*, 1998, with a small atrium. Nos. 79–80, 1852–3, are by *Sydney Smirke*, who lived at No. 80: a dull bolt-hole for such a professional. The smallest C18 house is No. 81, c. 1736.

The N SIDE has kept fewer houses. Nos. 36 and 35, good facsimiles of 1976–7 (*Rolfe Judd Group Practice*), replaced altered C18 houses. No. 34, built in 1725–8 by *Richard Lissiman*, stands out for its giant quoin pilasters and broad five-bay front (restored 1976–7). Later stucco; nice iron railings with 61 lampholders and snuffers. At the front another first-class open-well staircase, of stone, with a close wrought-iron lyre-pattern balustrade and first-floor gallery. The plasterwork and big doorcases are contemporary. At No. 33 a chaste stone front of 1912 by *Turner Lord & Co.*, masking a house of one build with No. 34. The NE corner with Davies Street is No. 28, by *C.W. Stephens* for Lord Edward Spencer-Churchill, rather *démodé* for 1907. No. 27, of 1725 behind early C19 stucco, has an unusual palmette frieze. *Wimperis & Simpson*'s No. 26, 1913–16, is clumsily Neo-Georgian. Nos. 23–25 and *T. Cundy II*'s Nos. 17 and 14 further on (dates 1852–7) typify the grey brick Italianate fronts favoured on the mid-C19 Grosvenor Estate. At Nos. 21 and 22, *Balfour & Turner* were at their most

inventive: twin gabled houses of 1898–9 with banded fronts and quasi-Byzantine blind arcading. No. 16, five bays with rusticated angle quoins, was built *c.* 1724 by *Thomas Ripley*, the future architect of the Admiralty. In 1837–59 it housed the RIBA. The off-centre porch with four Corinthian pilasters was done for a dressmakers' firm in 1935–6, by *Wimperis, Simpson & Guthrie*; also theirs the convincing mimic C18 front at No. 15, 1937. Inside No. 16 one big interior of 1935–6 with a column-screen. The grand earlier C20 staircase behind was probably remodelled from that made *c.* 1910 by *F. W. Foster* for Mrs Keppel, Edward VII's mistress. The main first-floor room has lavish plasterwork and pilasters of later C18 pattern. Then commerce takes over: Nos. 9–13, offices by *Rolfe Judd Planning*, under construction 2003; Nos. 4–8, designed in 1989 by the *Rolfe Judd Group Practice*, contextually minded Postmodern with a giant pedimental top contraption; and Nos. 3 and 2 (the little GROSVENOR ARMS pub, by *W. S. Payne*), both of 1881–2, just outside the Grosvenor Estate.

HALF MOON STREET

One of three streets between Piccadilly and Curzon Street. The *point-de-vue* there is the Third Church of Christ Scientist (q.v.). Building began *c.* 1730 and many C18 houses remain, some denatured by amalgamation for hotels. On the E SIDE, Nos. 4 and 5, *c.* 1883, overspill from Victorian Piccadilly. Nos. 6–15, C18 houses, mostly two bays wide. No. 13 has an early C19 gault brick front, and armorial stained glass dated 1878 in the doorway, put in by Henry Wagner of the Brighton church-building dynasty. On the W SIDE, No. 42, austere chambers of 1885–7 by *Macvicar Anderson*. Nos. 39–40 are big heavy houses of *c.* 1870. Nos. 25–28 are C18, the middle two with bludgeoning late C19 alterations.

HANOVER SQUARE

Laid out from 1713 for the 1st Earl of Scarborough (first leases 1717), with the streets adjoining. The plan may have been by *Thomas Barlow*, who acted for Scarborough in settling the site of St George in St George Street (q.v.). This opens funnel-wise from the S, exhibiting to advantage the church portico. Balanced pairs of streets enter on the longer, N–S sides. The present GARDEN layout, a St Andrew's cross, dates from 1949. To its S a large bronze STATUE of the younger Pitt, 1825–31 by *Chantrey*. Contemporary dress; tall granite plinth. In the garden a small FOUNTAIN, with a sculpture of flying ducks by *David Norris*, 1988 (moved from New Bond Street). On the N side a CABMEN'S SHELTER of 1897.

Only four original houses remain, all in the W half. No one design was imposed on the builders. No. 24, in the SW angle facing N, is unusually demonstrative (largely rebuilt in facsimile *c.* 1983). Three bays, four storeys, of brown and red brick,

with aprons to connect the windows vertically, framed by flat terminal piers. The windows are all segment-headed and have fluted keystones. Corinthian doorcase with cabled pilasters. To the l., No. 25, vauntingly tall Northern Renaissance of 1902, begun by *Percy W. Meredith* and finished by *H.M. Wakley*; to the r., Nos. 22–23, stone-faced, big, by *G. Jeeves*, 1926–8.

Continuing clockwise along the W SIDE, Nos. 21 and 20 are remodelled survivors of a group by the Huguenot engineer *Nicholas Dubois*, c. 1717–20. At No. 21 the Venetian-windowed projection to Brook Street is probably late C18, and the Gibbsian ground floor is *Alfred Williams*'s alteration of 1893 for the London, County and Westminster Bank. Balustrade 1914, red staining of the brick 1856. No. 20 (KNIGHT FRANK), of five bays and four tall storeys, was heightened and internally reconstructed by *Samuel Wyatt*, probably done c. 1785 for Elizabeth Coke. Porch of 1890 by *W. Flockhart*. By Wyatt the lofty staircase, with diagonal grid balustrade and eagles in the skylight pendentives (cf. No. 15 St James's Square, p. 630). 56 Restrained ceilings, mostly with concentric ovals; in the dining room on the ground floor an Ionic column-screen. Fireplaces of grey or coloured marble, one on the first floor with big standing maidens and a sleeping cupid. The main first-floor rear room is apsed; the room beneath was altered when *Vincent Harris* attached a two-storey wing for the present firm in 1910. Access. to the new rooms is carefully contrived: from the landing, a passage with timber oriels leads to a glazed-domed Doric-pilastered saleroom; the ground-floor offices open off a long tunnel-vaulted corridor. The rest of the W side is 1960s–70s. No. 19, of stone with serried upright windows, 1970–3 by *Burnet, Tait & Partners*; No. 18 by *Ronald Fielding*, 1962–4, with angular pointed arches on the ground floor (replacing *B.D. Wyatt*'s Oriental Club of 1827–8). On the N corner with Tenterden Street, *Hanna & Manwaring*'s No. 17, 1973–8, typical brown-brick stuff of that time.

On the N SIDE, No. 16, c. 1720, with a Doric porch added; grace-lessly heightened by *John Belcher Jun.*, 1909. Two buildings by *Paul Hoffmann* next: the tall No. 15, 1904, of the type with balconies connecting canted bays, and No. 14 HANOVER HOUSE, 1900–2, a Free Renaissance block extending up to Oxford Street. Its welter of gables and turrets distracts attention from its great size. The E corner with Harewood Place is HARE-WOOD HOUSE: by *Blow & Billerey* with *G.D. Martin*, 1909, in artificial stone. Nos. 11–12, by *D.E. Harrington*, 1964–70, an excited pattern-making façade seemingly in thrall to Saarinen's US Embassy in Grosvenor Square (q.v.). Two-bay windows, staggered by one bay per storey, with stone frames projecting further where they align vertically.

On the E SIDE S of Princes Street, Nos. 7–10, offices and flats by the *Ronald Fielding Partnership*, 1972. Rather elegant stone fronts, with upright windows in alternating chamfered sockets arranged chequerboard-fashion, but far too bulky to suit the character of the square. Nos. 4–6, 1963–6 by *Yates, Cook & Darbyshire*, has the same fault. No. 3 is by *R. Angell & Curtis*, 1937, with squared-off ornament. Then on the S SIDE VOGUE

HOUSE (Nos. 1–2), brown brick, with details reminiscent of the Hoeger fashion of North Germany in the 1920s; 1957–8 by *Yates, Cook & Darbyshire*.

HANOVER STREET

Built up from 1714, a little earlier than Hanover Square to its w. Now mostly a street of shops. No. 15 (S SIDE), probably of *c.* 1715, fashionably dressed *c.* 1830 with Corinthian aedicules and vases. To the l., No. 16, 1964–5 by *Adam Gelister*. Tall, with forthright marble bands and top canopy. *Delissa Joseph*'s Nos. 13–14, r., 1912, has exaggerated segmental-pedimented gables. Nos. 11–12, 1998–2000 by *DEGW*, with the newly fashionable unglazed terracotta cladding; No. 8, 1983–4 by *Alfred Lester Associates*, flush stone with windows neatly stepped 5-3-1. N SIDE, No. 7, 1907, shows *Treadwell & Martin*'s inventiveness withering under the T-square fashion.

HAY'S MEWS

The most spacious Mayfair mews, serving Charles Street, S, Hill Street, N, and Berkeley Square at the E end. The last part belongs with the entry on the square (q.v.). No. 40, N side, and No. 4, S, were respectively the stables and 'motor house' of No. 11 Hill Street (q.v.), of 1904 by *J. Leonard Williams*. No. 40 has an arcade of pilasters, No. 4 has hefty exposed oak framing and a segmental pediment. Further w, THE LODGE, on the NW corner with CHESTERFIELD HILL: 1931–2 by *Philip Tilden* for George Pinckard. Neo-Georgian, conspicuous shutters, rather coarse brick. Diagonally opposite here is No. 6, a stuccoed C18 former pub. Shutters, doorcase etc. of 1924, when *Arthur J. Davis* of *Mewès & Davis* made it his house. Taller mid-C18 houses continue down Chesterfield Hill (first rated 1753), e.g. Nos. 12 and 15, w side.

HEDDON STREET

An H-shaped backwater off the w side of Regent Street, not linked with the other streets around. Laid out in 1722–6 by William Pulteney MP, replacing inferior 1670s development. Buildings are mostly utilitarian C19–C20. At the SW angle No. 15, 1873 by *A. Peebles*, its doorcase aggressively carved with lions' heads. For the New Gallery at Nos. 1–2, S side, *see* Regent Street, p. 455.

HERTFORD STREET

A nice L-shaped backwater, untouched by parkside grandiloquence except at the w end, which runs between the 1960s hotels of Park Lane (q.v.). Otherwise plenty of plain medium-sized

houses of *c.* 1764–71, for the landowner Nathan Carrington. Several are by *Henry Holland*, in partnership with his builder father, also *Henry*, and *John Eldridge* (agreement 1767).

Starting at the top of Down Street on the S SIDE, the W corner is No. 17 (altered), the Hollands' own home. Their No. 18 has a nice Adamish doorcase and an ambitious staircase, D-shaped and toplit, with a second-floor gallery. Also C18 are Nos. 19, 21 (with C19 stucco), 22 (by the *Hollands*) and 23. On the N SIDE the first original house is No. 36. Stuccoed *c.* 1823. (Open-well staircase with S-scroll balustrade and fine plasterwork, perhaps by *Francis Engleheart*.) Nos. 37–39, probably 1760s, altered. No. 40 and No. 41, mid-C19 stucco mansions; No. 41, 1865 by *J. T. Wimperis*, was rebuilt behind the front *c.* 1900–10, an early 'façade job'. Nos. 42–44 are a handsome Parisian trio by *Claude W. Ferrier*, 1915.

The C18 resumes on the S SIDE with the *Hollands*' Nos. 8–13. No. 12 has mid-C19 stucco trim. In No. 11 some particularly good plasterwork, almost certainly a showcase of the work of *Engleheart*, Holland's lessee here (1771). The first-floor saloon shows the transition from illusionistic modelling to the flatter, Neoclassical manner. No. 10, markedly larger, has interiors by *Robert Adam* for General Burgoyne, 1769–71. The canted bows behind are however due to the *Hollands*. (Three enriched and painted ceilings, stone stair with wrought balustrade.) Nos. 8 and 9 are fronts only, restored to an C18 appearance in 1971. Nos. 45 and 46, N SIDE, of 1767, No. 46 with obelisks at the entrance. No. 47 on the corner, 1901 by *Hoare & Wheeler*, has pilasters high up. Another *Holland* house at No. 48. The E side here is CARRINGTON HOUSE, mansion flats of 1936 by *W. & E. Hunt*, a deadly neighbour at close quarters.

HILL STREET

One of the greater streets of the Berkeley Estate, built up mostly in 1745–50. Walking down it in the 1900s, Max Beerbohm felt 'very well-bred . . . and though not clever, very proud'. A high proportion of the C18 houses survives, many with added storeys, porches, cast-iron balconies, etc. The building leases for Nos. 2–30 (N side) were taken by *Edward Cock* and *Francis Hillyard*, for Nos. 5–15 (S side) by *John Phillips* and the mason *John Devall*, for Nos. 17–19 and Nos. 29–39 (S side) by *Benjamin Timbrell*.

Coming from Berkeley Square, the first houses are relatively modest: Nos. 1–5, S side, and Nos. 2–4, N. On No. 5, the COACH AND HORSES, a lettered stucco front of *c.* 1850; on No. 4 a grandstand veranda in cast iron, a replica of 1987 of the mid-C19 design. No. 6 (N side) is an unworthy intruder, of gabled yellow brick: 1893 by *C. W. Stephens*. No. 8, with its six slim bays and long balcony railings, is very handsome mid-C18, internally reworked by *Clough Williams-Ellis*, 1924. It has a cool Neo-Regency staircase. No. 10, also mid-C18, has moderate alterations of *c.* 1900, e.g. the Louis XV balcony (replaced

1987) and toplit rear dining room; original open-well staircase of stone. Rococo saloon ceiling, apparently 'Neo'. Nos. 12–18, mechanical Neo-Georgian flats of 1962–3, will fool nobody. On the S SIDE again, Nos. 7 and 9 are mid-C18, No. 9 with a central entrance. Nos. 11–15, larger, were variously remodelled from the late C19. At No. 11 stone aedicules in late C17 English style, after 1906. To the rear, a first-floor ballroom made *c.* 1892 for the 7th Duke of Newcastle, probably by *Edis*; ostentatious Louis XV, with column-screen and musicians' gallery. No. 13 was reworked in 1907 by *E.B. Hoare*, with cross-windows, Neo-Jacobean interiors, and a compact, tastelessly elaborate staircase. At No. 15 the window surrounds are probably due to *Edis* again, whom the Dowager Duchess of Newcastle employed in 1891; toplit mid-C18 staircase.

No. 17, a four-bay *Timbrell* house of 1748–9 with round-headed lower windows, is specially interesting for the alterations *Robert Adam* made for Sir Abraham Hume, 2nd Bart., in 1777–9. However, the story is complicated by *Hindley & Wilkinson*'s alterations of 1906, for the 'Randlord' Charles Rube. Adamesque porch and first-floor balconies of 1906, as is the elaborate front-hall staircase, though with *Adam*'s ceiling. (Rear wing by *Adam*, with two reception rooms, one above the other. One pilastered first-floor room, of 1906, uses motifs from Adam's drawings for No. 17 at the Soane Museum.) No. 19, with a Doric porch, is of the same build and pattern. Panelled front stairhall, with foliate S-scroll balustrade. (Altered inside 1929 for Barbara, Mrs Euan Wallace, by her brother *Robert Lutyens*, his first work; staircase walls painted by *Rex Whistler*, 1930–1.)

Back on the N SIDE, the mid-Georgian houses resume at No. 20. No. 22 has Victorian vermiculation. Then two orange-red brick houses in mixed Northern Renaissance, breaking the skyline with tall gables: No. 28 of 1892 by *Wimperis & Arber*, with superior stone foliage friezes, No. 30 of 1889 by *R. Fabian Russell*. On the opposite corner with Chesterfield Hill, w, Nos. 32–34 AUDLEY COURT, a six-storey block by *Peter Moro* with *Walter Greaves*, 1960–2. Dove-grey brick, stratified by aggregate-faced concrete floorbands: rough materials for luxury flats. It settles well into the street nonetheless.

The S SIDE continues with No. 25, *c.* 1748, with a deep staircase hall and slender lyre balustrade. No. 27, taller, has mid-Victorian stucco and a canted bay to Chesterfield Hill. Remains of another lyre-balustraded staircase suggest a mid-C18 origin. *Timbrell*'s Nos. 29–35 are all painted or stuccoed with stone bracket-cornices; columned porches of different periods, except at No. 31, which has a console doorcase with obelisks in front. No. 31 also has the best interiors: good front-hall staircase; panelled saloon with a glorious Rococo ceiling, most unusually with grisaille roundels of putti inserted, and with a wide columned opening to a square rear room. This also has a fine ceiling, done for the famous literary hostess Elizabeth Montagu, *c.* 1766. Central painted roundel, with satellites, and painted interlace borders. No. 37, 1889–90, is another red brick gabled affair, by *Edis* for the Hon. H.L. Bourke.

On the N SIDE next to Audley Court, No. 36 has an unalloyed mid-C18 front, five bays wide with a console doorcase set off-centre. Fine front-hall timber staircase with Rococo wall panels and pendants. (Two bedrooms by *Lutyens*, 1935–6, for Baroness Porcelli.) No. 38, with canted bay, was enlarged and pulled about by *W. Flockhart*, 1900, for E.G. Raphael (heightened 1910); ornate Louis XVI interiors, e.g. the curving staircase, perhaps from work before 1891 for Sir Carl Meyer. Since 1947 the RNVR CLUB.

The numbering then jumps to the E side of WAVERTON STREET, which runs across N–S. The broad-fronted No. 40 faces back down Hill Street. Built 1752–3, i.e. a little later than the rest, probably by *John Blagrave*. To the r., Nos. 40a and 40b, 1915–16, quiet Neo-Early Georgian mansions respectively by *W.B. Simpson* and *Wimperis & Simpson*. To the l. one of the last private mansions built in Mayfair (Nos. 42–44), of 1919 for the shipping magnate the 1st Viscount Furness, in a similar red brick idiom. By *W. Ernest Lord* (of *Turner Lord & Co.*) and *Mewès & Davis*. The E door led to Furness's private quarters, the S door to a splendid suite for entertaining, now altered for offices. The Venetian window above this door lights a cavernous grey-marble-lined hall, with a staircase gallery. A rear bow overlooks the generous shared garden (for which *see* No. 38 South Street). Flats on the S SIDE by Waverton Street show the speculative cramming of the 1930s: E, No. 39, perfunctory Neo-Georgian by *L. Solomon & Son*, 1934; W, THE ASCOTT, more modern-looking, 1939–40.

LEES PLACE

A mews-like backwater with a double-kinked plan. Some late Victorian workers' housing, by *F.T. Pilkington* for the Artizans', Labourers' and General Dwellings Co.: Nos. 20 and 22, N side, 1887, with recessed entrances and a leavening of curious detail, and Nos. 10–12, S side, 1890–1, with shops below. To their E some spruce 1930s Neo-Georgian houses: No. 8, 1934 by *Deane & Braddell*, *Frederick Etchells*'s doll's-house-like No. 4, 1930 for the Hon. Evelyn Fitz-Gerald, and No. 3, converted in 1932 for the 1st Viscount Furness by *H.D. Kidd*, from a coach house of 1889.

MADDOX STREET

Built up after 1713–14. Named from Sir Benjamin Maddox, ground landlord of the Hanover Square district. The street is bisected by St George Street. The W PART has the better buildings. On the S SIDE good varied commercial fronts of *c.* 1900, e.g. No. 53, shamelessly impure Gothico-Renaissance by *Melville S. Ward*, 1899. No. 49, the sole early C18 survivor, has typical red brick trim. No. 47, by *Walter Williams* for the tailors Messrs Lawrence, 1892, is thought to have London's first all-faience façade (*Burmantofts*), in an uncommonly glossy

gravy-brown. Exceptionally full Flemish detailing, with putti frieze and dragon-finials. The sumptuous plastered interior (now a restaurant) has at the back former fitting rooms with panelled screens, added 1907–8 by *E.K. Purchase*. Also by *Purchase* No. 45, 1907, with his typical first-floor window and chamfered piers. Nos. 41–43, stone-striped brick, was the premises of Edward Arnold, publisher; 1903–6 by *W. S. Weatherley*. Opposite (N SIDE), Nos. 46–58, a stucco terrace of *c*. 1843. Unusually lengthy for Mayfair, exploiting the back land of streets to each side. The handling differs from the standard 1840s Italianate, e.g. the round-headed windows in flat aedicules and handsome console cornice. Segment-headed shopfronts.

The E PART is less eventful. Nos. 28–32 (N side), 1996–7 by *Rolfe Judd Planning*, has seaweedy metalwork by *Giuseppe Lund*. Nos. 24–26, *Purchase* again, 1910, pilastered and pompous. On the S side, *Gibberd, Coombes & Partners*' Nos. 35–39, 1984, with an arcade of shops. Then No. 31, 1894–5 by *Treadwell & Martin*, Tudorish, *Lawrence Butterfield*'s No. 27 (future uncertain), 1950–1, with porthole staircase windows and pierced top canopy, and Nos. 17–19, signed *Aslan & Freeman*, 1954, with serpentine and Travertine facing. The best building opposite is *Lander, Bedells & Crompton*'s No. 10, 1907, its canted bay balanced by two canted dormers.

MOUNT STREET

As rebuilt in 1880–97, Mount Street is the paradise of pink terracotta and that Franco-Flemish-Renaissance style which the 1st Duke of Westminster fostered on his Mayfair estate. Flats with shops below are the chief type. The name is from 'Oliver's Mount', a remnant of the 1640s Civil War defences, which was still visible when the street was laid out from 1720.

The story begins on the S side at the W end with No. 130, 1880–2 by *J. T. Wimperis*, still in English-derived Queen Anne. Its flank turns to Berkeley Square (No. 34 there), with a copper-capped tower. By 1886–7, the dates of *W. H. Powell*'s Nos. 125–129 and *J. T. Smith*'s Nos. 115–121, the Continental influence was in full spate, in various combinations of red and yellow brick and encrusted terracotta. Inside No. 117, a former poulterer's, some good late C19 TILES. Nos. 4–5 on the N side, survivors of five by *George & Peto*, 1889, are satisfied with red brick and straight gables. The houses to their W and on the curve to CARLOS PLACE (Nos. 1–8 there), stone-dressed and with much variety of elevation, are all by *J. E. Trollope* of *Giles, Gough & Trollope*, 1891–3. The curve leaves a small open space, with a FOUNTAIN given in 1987, incorporating a weighty female nude sculpted in 1973 by *Emilio Greco*. On the S side, No. 114 is the PRESBYTERY of the Immaculate Conception church (q.v.) in Farm Street. 1886–7 by *A. E. Purdie*. Straighter and more sober than its neighbours, with large two-transomed windows. The upstairs chapel has a ceiling with painted foliage, renewed

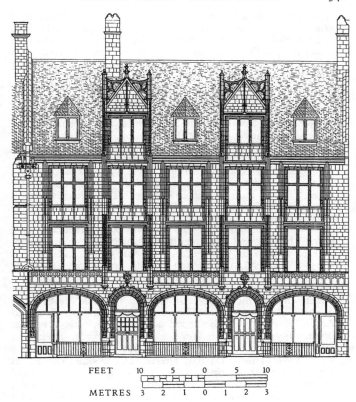

FEET 10 5 0 5 10

METRES 3 2 1 0 1 2 3

Nos. 104–108 Mount Street. Elevation
(*The Survey of London*)

1999, and an elaborate marble altar. Then the gates into St
George's Gardens, that charming, half-hidden green space
in the middle of Mayfair – not a square but like an irregular
fragment of much larger landscaped grounds. Created in
1889–90 from the burial-ground for St George Hanover Square
(q.v.), established in 1723. Small bronze FOUNTAIN with a
prancing horse on top by *Sir Ernest George*, 1892.
Continuing W, the NW corner with Carlos Place is the
Connaught Hotel (once the Coburg), 1894–6 by *Isaacs &
Florence*. Its ninety-two bedrooms put it amongst the smaller of
the great London hotels. More arresting inside than out, with
its open-well staircase of imperishable mahogany and panelled
dining rooms with creamy plaster ceilings. Livelier fronts at
Nos. 104–113 on the S side, all by *George & Peto* and in pink
terracotta, with Flamboyant Gothic details at Nos. 104–108.
Dates between 1886 and 1892. No. 103 is an intruder, Portland

stone offices in a go-anywhere style by *Wimperis, Simpson & Guthrie*, 1937–8, on the site of St George's Parish Workhouse. It faces Nos. 10–12, 1894–6 by *H. Cowell Boyes*, with oriels of Ipswich type. Then on both sides two prolonged terraces with shops below: Nos. 13–26, N, 1896–8 by *Read & Macdonald*, and Nos. 87–102, S, 1889–91 by *A.J. Bolton*. The former has wonderfully spidery shopfronts (a giant round window is a later alteration). The latter is more literal Neo-Renaissance with ample small terracotta decoration. In 1893–5 it was extended to Nos. 26–33 South Audley Street, round the corner. Of the same school the NE block at this crossing, by *T. Verity*, 1888–9. The W corners have shops to South Audley Street but are residential behind: the tall brickish AUDLEY MANSIONS (No. 44) on the N, 1884–6, a speculation by *J.T. Wimperis*, and No. 84 on the S, by *William Lambert* (with Nos. 57–63 South Audley Street), duller, built in stages 1881–92. A Late Victorian mood lingers inside PURDEY'S gun shop within the corner, with its famous Long Room.

In the W part the shops and flats give way to spectacularly large private houses and apartments. On the N side some stone-dressed houses by *J.E. Trollope*, of 1891–3 (Nos. 45–52) and 1895–7 (No. 53), undertaken by his firm *Giles, Gough & Trollope*, with less small-scale detail than the 1880s would have provided. On the S side *Eustace Balfour & H. Thackeray Turner* are in charge, the Grosvenor Estate's favoured partnership in the 1890s (*see* p. 477). They developed a free, understated Anglo-Dutch style with shaped gables and eclectic detailing, impeccably executed in stone-dressed red brick. Their first collaboration on the estate was the E side of BALFOUR PLACE (Nos. 1–6), of 1891–3, partly altered. The W side followed, in 1892–4: two broad triple-gabled fronts with porches formed as double-decked stone loggias, also altered, and the N and S corner houses (No. 79 Mount Street, and No. 5 ALDFORD STREET, S). To the W of each a slightly plainer house (No. 78, and No. 6 Aldford Street), then another complete island block with stables facing Rex Place, E, and houses on Park Street, W, with angled corner bays (Nos. 14–22 there), all of 1896–7. More stabling was provided in BALFOUR MEWS S of Balfour Place, 1898–1900, of which the E side is by *Balfour & Turner*, a plainer but still well-considered design. On the W side, No. 10, a Neo-Georgian pied-à-terre by *Geddes Hyslop*, 1936.

Finally in Mount Street No. 54 (N side), a mighty private mansion of 1896–9, by *Fairfax B. Wade* for the 1st Earl of Plymouth (builders *Trollope & Sons*). Now the Brazilian Ambassador's house. Its elements are English and French Baroque, inventively mixed and distorted: a steep two-storey pediment on each front, stone bands and quoins, and a becolumned two-bay entrance projection. It has a great elliptical-vaulted hall with aisles of marble-veneered piers, a half-flight of stairs within the door and an Imperial staircase at the far end. (This rises to an upper hall, also vaulted, with engaged columns of mixed marbles. The two chief rooms have thick, festive plasterwork. Ground-floor interiors panelled). The rest of Mount Street goes with Park Street (q.v.).

NEW BOND STREET

The N continuation of Old Bond Street (q.v.). It forms the spine of the Conduit Mead Estate, granted by the Crown to the City of London in 1628, in lieu of debts unpaid. The short stretch up to Clifford Street was built up *c.* 1700, the N part under a sub-lessee called Huntley Bigg after 1716. James Ralph in 1734 found nothing worth attention in the 'whole prodigious length', and the C18 survivors are certainly less interesting than their successors, the best parade in Mayfair of the fashionable commercial styles of the C19–C20. In 1986 the S roadway was blocked, and a small pedestrian area made. This marks off the jewellers' stronghold from the rest, where emporia of international brands now mix with longer-established art dealers and luxury shops. Smart, inventive retail interiors are now being created and destroyed faster than ever, often by uniting older properties. The latest C20 favoured plain stone and plate glass without, clinically pale rectilinear spaces within. The trend since is to diversify into areas of plain strong colour. Other installations take their cue from older, more ornate architectural contexts.

South Part, from Old Bond Street to Grosvenor Street and Maddox Street

E SIDE. Coming from the S end, the set-back corner with Burlington Gardens is Nos. 1–5, 1929–30 by *E.A. Stone*, a large stone-faced block of somewhat Veneto-Byzantine detail, with low stone domes. Lower storeys unfeelingly altered for RALPH LAUREN by *Thierry Despont*, 1998–9. Nos. 6–14 are by contrast small-scale properties on shallow plots. Nos. 6–7 (GRAFF), 1893 by *A.M. Ridge*, is ornate Renaissance, with a stone shopfront by *Callum & Nightingale* in keeping, 1993. On No. 8, BENTLEY & SKINNER, looking *c.* 1850, a fine Corinthian shopfront. Nos. 9 and 11, C18 relics, frame No. 10, in a Norman Shaw style by *T.H. Watson & F.H. Collins*, dated 1877 (altered). Nos. 13–14 by *E.K. Purchase*, 1901, is entirely of very red rubbed brick. Nos. 15–16, fussy François I, was Long's Hotel, 1887–8 by *W.G. Bartleet*. Now painted. In front an ingratiating SCULPTURE of Roosevelt and Churchill, bronze figures on a wooden bench. By *Lawrence Holofcener*, 1995.

The N corner with Clifford Street, Nos. 17–18 (LOUIS VUITTON), is by *Joass*, 1931, tall and bulky with angular and fluted details. Built for Finnegan's, leather-goods makers. Nos. 19–20, gault brick premises of 1863–4 by *Thomas Harris*, was Messrs Redmayne's, silk mercers. Spectacular interior for DONNA KARAN, by the American *Peter Marino* with *Househam Henderson Architects*, 1996: black, dull gold and natural stone, with colliding angles reminiscent of the Deconstruction fashion. At the S corner of Conduit Street the WESTBURY HOTEL, a dull, efficient-looking block, stone-faced, with a recessed N forecourt. By *Michael Rosenauer*, 1953–6, for the same freeholder as his Time & Life opposite (*see* below), and intended as its complement. It was the first

English hotel to adopt the American pattern of suites designed for room service, instead of large dining rooms.

Across Conduit Street, Nos. 24–25, 1939 by *Wimperis, Simpson & Guthrie*, also stone-faced, but nicely set off by linenfold-like fluting and slim metal colonnettes. No. 26, formerly Tessier, mid-C18, has a fine becolumned shopfront with round-headed windows, *c.* 1857. No. 27, *c.* 1888 by *R. J. Worley* (altered), typical of his pink terracotta and red brick taste. More older houses at Nos. 31, 32 and 34–36, including SOTHEBY'S at Nos. 34–35. These are demonstratively undemonstrative: stuccoed, early C18, united by a Lombardic display front by *Henry Christian*, 1867. In the gabled porch a sculpture of the lion-headed Egyptian god Sekhmet, of *c.* 1320 B.C., installed when Sotheby's came here in 1917. The 1867 work included wine cellars for Basil Woodd, with a gallery on top as a speculation. Labyrinthine interior, the result of alterations and extensions for Sotheby's in 1916–18 (*J. G. S. Gibson & W. S. A. Gordon*) and since. For the rear parts *see* St George Street. No. 37 is by *C. H. Worley*, 1901, with a nicely detailed Free Style oriel; its attractive shop surround was destroyed in 1999. No. 38, typical *c.* 1870, in Gothic-derived black-banded red brick. Then *Purchase*'s big Edwardian Baroque Nos. 39–42, 1907–8, in white artificial stone. Rebuilt behind its façade 1991, preserving at the back of No. 39 three very superior showrooms by *Raymond Erith* of 1962–6. One is oblong and Anglo-Palladian, another an essay after Soane with pendentive dome and taller apsed ends, the third a grotto-like octagon with shell-work panels. Made for the antique dealers Mallett's; now offices and a museum for SMYTHSON, stationers. Nos. 43–44, 1905–7 by *Ridge*, rather frantically ornate. The s corner with Maddox Street is *Purchase* again, 1900, Flemish.

w SIDE. The buildings carry on from Old Bond Street without a break. No. 180, 1908 by *W. Flockhart*, cast stone with tall pilasters. The sources are French Dixhuitième. On No. 179, *c.* 1800, a bizarre armorial head-dress added *c.* 1897 by *Wimperis & East*, for the court photographers Lafayette. At Nos. 175–176 an extremely ornate Renaissance front of 1883–4 by *Allen & Mackland*, on a slightly earlier building. CARTIER'S panelled showrooms here are by *Mewès & Davis*, 1920s, also Dixhuitième. Nos. 169–174 are a less fancy stucco range of 1874–5, by *C. J. Knight*. The jewellers ASPREY & GARRARD occupy Nos. 165–169. Of these, Nos. 165–167 are big solid early 1770s properties by *Sir Robert Taylor*, built as houses with shops below, on land belonging to the 3rd Duke of Grafton (cf. Grafton Street). What makes them special is the row of five giant shop windows of mid-Victorian pattern, with cast-iron shafts and fancy cresting. They give the best idea in the West End of this now rare type of plate-glass front. The first, at No. 166, is thought to date from *c.* 1865 (Asprey's moved here in 1847). Others followed from 1902, as the firm expanded; No. 169, far l., as late as *c.* 1925. Internal reorganization by *Foster & Partners* is under way (2003).

The N corner with Grafton Street follows (q.v.). Nos. 161–162,

probably built by *Thomas Barlow* in the late 1730s, is much remodelled, e.g. the bank front of 1923 (*Campbell-Jones, Sons & Smithers*). The four-bay No. 160 may also be C18, behind stucco.

On the s corner of Bruton Street, the former TIME & LIFE BUILDING (now MARCONI), 1951–3 by *Michael Rosenauer*. The first post-war company headquarters in the Modernist style in London, conceived as a monument to Anglo-American friendship, and paid for in dollars. This allowed the usual building licences for commercial work to be waived, allowing exceptionally high standards of materials and finishes inside. These interiors were the work of various designers under the co-ordinating supervision of *Sir Hugh Casson* and *Misha Black*, with much input from artists and designers associated with the Festival of Britain. Listing in 1988 reflected the quality and ambition of their work as much as the merits of Rosenauer's architecture. A limited interior restoration was carried out in 1991–3 by the *Elsworth Sykes Partnership*.

Pevsner judged the exterior 'not inspired, but acceptable': stone-faced, with repeated horizontal five-light windows above shops. On the three-storey s part is a terrace, and in its parapet four abstract panels by *Henry Moore*, in upright rectangular openings with rounded corners. The panels nearly but not quite fill them with their massive shapes, intricately stuck into and through each other (Moore originally wanted them to rotate on spindles). The effect, neither wholly solid nor wholly pierced, challenges the conventional relationship between sculpture and architecture. (On the terrace behind is a noble reclining bronze figure by *Moore*, one of several artworks removed *c.* 1990 by Time-Life but reinstated after a test case in 1998 judged it a protected fixture.*) Over the Bruton Street entrance a small sculpture of steel by *Maurice Lambert*.

The chief INTERIORS are configured as a single modulated space that flows on and up from the entrance and out on to the terrace. Its effect is diminished only slightly by the loss of many original furnishings. An abstract stained-glass screen by *Graham Jones*, 1995, faces the entrance. From here the progress is through glass doors on the r. – a later addition – into the large STAIRHALL. This has a broad staircase climbing in two flights, with a black leather rail with decorative brass studding by *R.Y. Goodden*. Walls are clad with timber and various polished stones in subdued colours. Glass doors open from the landing to the double-storey former RECEPTION HALL (now a conference room), with a view through it of the terrace beyond. The hall, also lined with polished stone and wood, is overlooked by a glazed-in balcony at half height. The bronze-panelled r. wall marks where it was shortened in 1991–3. Pevsner appreciated its original ensemble for attempting opulence within a Modernist idiom, though he also thought the variety of elements had been taken to excess. This pleasure in

* The others were a sculpture by *Geoffrey Clarke* called The Complexities of Man, an astrolabe by *R. & C. Ironside* and a *Ben Nicholson* relief.

patterning and playful decoration now appear of their time in seeking a way out of the asceticism of the 1930s; the original curtains, for example, had a pattern of large classical columns. The TERRACE, planned by *Peter Shepheard*, has steps up at the street end. The lower terrace is truncated by an extension of 1991–3, matching Rosenauer's elevations. On the sixth floor were a restaurant and café, respectively by *L. Manasseh* with *Ian Baker* and *Sir Hugh Casson & Neville Conder*; parts of the latter were salvaged by the Museum of London.

After Bruton Street, the FINE ART SOCIETY (No. 148) is the first of three celebrated art gallery buildings in the stretch up to Grosvenor Street. Built as a tall Italianate house-cum-gallery by *H.H. Collins* in 1875–6, its lower parts remodelled by *E.W. Godwin* in 1881. By Godwin the deep entrance with pillars *in antis*, wide first-floor window with an elliptical arch, and piquant, asymmetrically placed name shield held by two putti (*E.R. Mullins* sculptor). Deep interior, toplit behind, with a fireplace remaining from *G.F. Armitage*'s decoration of 1888. The second gallery is Nos. 144–146 (PARTRIDGE'S): the former Colnaghi's, 1911–13, with an elegant façade by *Lanchester & Rickards*. They were called in after work began (original architect *A.M. Ridge*), which may explain why the result is so understated. On the first floor a flouncing Viennese aedicule, with a porcelain Fräulein by *Henry Poole* representing Painting. Fine INTERIORS: main gallery with colonnades, their walnut columns now painted, and lesser galleries off an axial corridor beyond. The ingenious glazed grilles and mirrored skylights which controlled heat and humidity survive intact. The rear rooms, for showing older furniture, have *ex situ* fittings for atmosphere: linenfold panelling, fireplaces of stone or marble. At No. 143 a good iron-crested shopfront of the early C19 (formerly Savory & Moore's pharmacy), preserved in 1957 when the rest was rebuilt.

Last of the three galleries is Nos. 135–137, built as the GROSVENOR GALLERY by *W.T. Sams*, 1876–7, for the amateur artist Sir Coutts Lindsay. Sams's façade is by no means greenery-yallery aesthetic, as one might expect, but busy Late Victorian Neo-Renaissance. In 1903–4 *Walter Cave* converted it for the Aeolian Hall, which displayed player-pianos by the Orchestrelle Co. Of 1925 the Ionic ground-floor front, of coloured marble, with a musical trophy in the pediment.*
The former main gallery lies behind, appearing from down Bloomfield Place, l., as a tall two-storey block faced in red and glazed white brick. Here were shown works by Whistler and other rare spirits who shunned or were shunned by the Royal Academy. In 1903–4 the blind arcading was pierced with windows, to make a concert hall. A little of 1876–7 within, e.g. the D-shaped staircase. Sir Coutts pioneered commercial electricity generation here in 1885–90, from a basement power station designed by the young *Sebastian de Ferranti*.

* The 1870s portal was said to have come from *Palladio*'s demolished S. Lucia, Venice, though drawings of that church do not show it.

North Part, from Grosvenor Street and Maddox Street to Oxford Street

E SIDE. On the N corner with Maddox Street stands a five-storey Franco-Renaissance commercial palace (Nos. 47–48) in *Doulton*'s artificial polychromatic stone, with little grey granite columns. By *W. Flockhart*, 1906 (cf. Nos. 67–68, below). Original shop windows for F. PINET, with bronze Rococo glazing bars and varnished wood. Nos. 49–50, CHAPPELL'S the music publishers, 1965–7 by *Michael Rosenauer*, is still in the stone Time & Life manner (shop façade remodelled by *Kenneth Boyd*, 1971). Chappell's were formerly at Nos. 51–52, utilitarian brick by *Lee Bros & Pain*, c. 1870. Nos. 53–56, 1905–6 by *W.H. White*, quite artful and jolly. FENWICKS (Nos. 57–63) is wrapped in a mixture of retained and replicated facades, unified by buff paint and by *Maurice Broughton*'s nice Ionic colonnaded shopfront of 1988–9. To New Bond Street first a new section, modelled after the Brook Street front, then a coarse later C19 elevation and a rounded corner of 1887, with giant columns framing festive bows. The Brook Street section comprises five two-bay classical house fronts of 1838, survivors of a symmetrical terrace of eight designed by *H.L. Elmes*, for the builder-speculator *John Elger*.

In the group N of Brook Street the plural architectural fashions of *c.* 1895–1915 are on parade. No. 64, 1909 by *J.H. Watson*, has a Louis XVI flavour, with handsome segmental bows. Traces of a bank front by *Sir Edwin Cooper*, 1928. Nos. 65–66 by *A. Keen*, 1896, somewhat Adamesque, shows the easygoing infancy of Neo-Georgian. Nos. 67–68, also 1896, is signed *W.H. Romaine-Walker*. In the same rich Neo-C17 faience as Nos. 47–48, here with a warmer tint. The same patron too, the art dealer (Sir) Joseph Duveen, whose premises these were. No. 69, dated 1900, has much carving and a little finialled turret. Nos. 70–71 by *Palgrave & Co.*, two unequal bays wide, uses the big T-square motifs of 1914–15. Sculpture by *L.F. Roselieb* (two figures) and *T. Rudge* (one, l.). No. 74 is *Treadwell & Martin* in free Jacobean mode, 1906; No. 76 on the N corner with Dering Street, 1910, catches the partnership sobering up after the Edwardian party. Nos. 78–79, stone-faced and sinuous, is a nice coda by *Rolfe Judd*, 1992–6.

W SIDE. On the N corner with Grosvenor Street, HSBC, built for the London, City & Midland Bank in 1909–14 by *T.B. Whinney*. Corner turret, rather teasing detail. Nos. 126 (by *E.K. Purchase*, 1898) and 127 were united by *John Pawson* for JIGSAW, 1996. His interior has subtly irregular white surfaces and an ostentatious lack of rails and handles. No. 124, with a canted bow, is signed *Treadwell & Martin*, 1908; the Palladian No. 123, by *Edmund Marks*, is dated 1879. Of the C18 Nos. 122, 121, 119 and 118, all altered. On the S corner of Brook Street, Nos. 111–112, 1923, rather Nash-like, with a pepper-pot turret. Credited to *Purchase* (†1923) and *Rowland Welch*.

Buildings N of Brook Street are slightly less ambitious. On the N corner, No. 110 by *Morley Horder*, 1905, of stone, with little column-mullions. At Nos. 105–106, *c.* 1907, *Purchase* makes a

grid-like front from large windows. No. 103, mid-C18 with later stucco, was in 1798 home to Nelson. The narrow, boastful No. 101 is by *A.M. Ridge*, 1906. Nos. 100, by *W.J. Green*, dated 1879, and 96, 1878 by *Edis*, are in a simple Norman Shaw style. Between, No. 97 by *J.T. Wimperis*, in the heavier eclecticism of 1867. The s corner with Blenheim Street is No. 95, *Ridge* again, with giant columns; 1879. No. 94, in an undecided style, was one of J. Lyons's restaurants (1904). By *W.J. Ancell*, their usual man, but not yet their usual white faience.

NORTH AUDLEY STREET

Runs N from the W end of Grosvenor Square. The chief interest is on the E side, by St Mark (q.v.). Its former vicarage is at No. 13, r., gabled and Netherlandish, of 1887–8 by *Sir Arthur Blomfield*. Nos. 11–12, survivors of *Edward Shepherd*'s houses of c. 1728–30, have been linked for most of their history. Their muddled stucco front is of 1819, by *Thomas Lee* of Barnstaple for Viscount Ebrington. Six bays, giant Grecian pilasters irregularly spaced above. No. 12 has a seventh bay added in 1888–9, l., and heightening of 1932. (Within are some of the finest Georgian terrace-house interiors in London, made for Col. Edward (later Lord) Ligonier. Their contrasting shapes and grave Kentian style are too sophisticated for Shepherd alone, and Maurice Craig plausibly attributed them to *Sir Edward Lovett Pearce*, who certainly made other designs for Ligonier. The interest increases from front to back. By the entrance lobby a two-bay panelled front room, improved in 1923 by *Philip Tilden* with e.g. a door architrave from Hamilton Palace. Behind it a taller, octagonal LIBRARY, toplit from an ornamented lantern. N of this a miniature oval STAIRCASE up to the first floor. Stone steps, wrought-iron S-scroll balustrade (added by *Tilden*). But the chief room is a single-storey GALLERY along the back of both houses, a smallish tripartite space set out with engaged Ionic columns and a bay-leaf frieze. The taller centre has a shallow coffered dome, big Venetian window and external pediment over it. The sides have groin vaults with decorated groins, and entrances from the staircase hall, N, and from a room once part of No. 11, s (mouldings at this end are replicas of c. 1960). Above the doorways medallions of the C17 popes Clement IX and X, thought to date from the residence of Messrs *Gillow*, 1795–1814. Chimneypiece with curving-forward piers ending in children's heads; overmantel with broken triangular pediment. Third-floor rooms of 1932 for Samuel Courtauld, by *White Allom*: a Chinoiserie bedroom with overmantel by *Rex Whistler* and its own secret staircase, and semicircular marble bathroom by the *Marchese Malacrida*, all reminiscent of Courtauld's previous house at No. 20 Portman Square (*see London 3: North West*).) Nos. 8–10, flats of 1927–9, have Neo-Georgian elevations by *Lutyens*, somewhere between domestic size and his really huge commissions for which new approaches were needed.

To the N of the church No. 14, 1887–8, pretty, slim Northern

Gothic by *T.H. Watson & F.H. Collins*, and No. 15, 1854, with a Gothick shopfront of 1930 by *Richardson & Gill* for Batsfords, the publishers. No. 16–20, lively Baroque by *Paul Hoffmann* of 1908–9, was rebuilt behind in 1989–91 by *Rolfe Judd*, with a decorated Postmodern wing along North Row, N. The W SIDE has chambers over shops, typical of the late C19 Grosvenor Estate: plenty of pink terracotta gables at *T. & F.T. Verity*'s Nos. 24–29, 1891–3, red brick at Nos. 30–42 to its S, built 1896–1909 to designs by *H.S. Legg*. The N corner of the last was altered after war damage.

NORTH ROW

It runs just S of Oxford Street, the commercial architecture of which fills the N side. The S side is a ragbag. Minor late C19 workshops just W of North Audley Street, of which No. 34, 1891–2 by *Balfour & Turner*, was the workshop of Hammond & Co., leather-breeches makers. At Nos. 25–29 a Postmodern brick front by *Hunter & Partners*, 1988, on a 1950s office block. Plain clean horizontal lines at No. 23, offices by *Construction & Design Services*, 1962–9. NORTH ROW BUILDINGS, artisan dwellings for St George's parish (cf. Bourdon Street), low gabled red brick. 1887–9 by *R.H. Burden*. At Nos. 12–14 some tidy hipped-roofed stables by *Sidney R.J. Smith*, 1898; No. 12 went with his No. 32 Green Street (q.v.). Until 1928 they faced mansions of 1866–74 by *T. Cundy III*, of Grosvenor Gardens type, served by a close called Hereford Street.

OLD BOND STREET

The easternmost of the streets laid out on the site of Clarendon House (q.v., Piccadilly). Undertaken from 1684 by a syndicate including Sir Thomas Bond and John Hinde, a goldsmith. New Bond Street, to the N (q.v.), followed after 1700. Bond Street has been a byword for luxuries since the C18, and the present C19–C20 buildings in both parts are as costly and varied a concentration of shops and shopfronts as London can show. The description runs from Piccadilly up the E side and back down the W.

E SIDE. Nos. 6–9 is of *c.* 1911, by *Paul Hoffmann*. Characteristic flouting details, e.g. the little corbelled-out pilasters and undulating balcony; the upper storeys flat. No. 12, ANNA MOLINARI, of discreetly channelled stone with grey slate trim, is by *Ardin & Brookes & Partners*, 1961–5. No. 13, since 1873 BENSON & HEDGES, asymmetrical Italianate stucco of *c.* 1860. No. 14, formerly the art dealer Knoedlers, is by *P.E. Pilditch*, 1910–11, with the familiar recessed bow. More classical and quiet is *Adams & Holden*'s exactly contemporary No. 15; *Oliver Messel* added the Vogue-Regency shopfront and shallow false veranda, 1959. Nos. 16–18, plain stone of 1935–6, were in 1998 united with flush shopfronts by *Roberto Bacciochi*

for PRADA, a two-storey treatment with a minimalist pistachio interior. The former Union Castle offices at Nos. 19–21, chaste Neo-Palladian by *Michael H. Egan*, are as late as 1956–7. No. 22, formerly the silversmiths Crichton Bros, is probably by *W. Flockhart*, c. 1905 (cf. his Nos. 47–48 New Bond Street). An outrageously lush Renaissance façade of *Doulton*'s faience and granite, the clotted top cornice with little eagles moulded in the round. No. 23, early C18, refronted 1843. The corner with Burlington Gardens is No. 24, FERRAGAMO (formerly Atkinson's, parfumiers), by *Vincent Harris*, 1925–6. A successful freak, of Portland stone, but with a Gothic gable and a flèche with a carillon. The design is nice, and one gets used to it. It found amplified echoes at Harris's later Manchester Town Hall extension. Small coloured panels carved by *Nathaniel Hitch*, after designs by *G. Kruger Grey*.

w SIDE. Opposite Ferragamo, TIFFANY & CO. (No. 25) has a fine arcaded classical shopfront of dark serpentine stone from The Lizard, Cornwall. Made in 1865 for J.W. Benson, clock-maker, by *John Drew & Co. The Builder* contrasted it with the 'cavernous insecure aspect' of the large plate-glass shopfronts of the day (cf. Nos. 165–169 New Bond Street). The three r. bays represent a Georgian house, of which the late C18 oval stone staircase survives. No. 26, C18 but burdened with extra storeys dated 1883. At No. 27 a C20 version of the arrangement bewailed by *The Builder*: a becolumned stone building (1922 by *Trehearne & Norman*), floating over a broad reglazed display window.

THE ROYAL ARCADE at No. 28, of 1879–80 by *Archer & Green*, has a tasteless painted stone façade with much female sculpture. Tampered with *c.* 1930, when curving shop windows replaced the lower columns. Nine shops per side with full-height bays and a lesser storey above, nicely paced by arched cross walls (but degraded by the present orange paint).

Further s, No. 31, a slim front of 1898–1900 by *Beresford Pite*, has his characteristic seated or crouching females (by *Farmer & Brindley* after *L.-J. Chavalliaud*, now paint-caked) and discreetly perverse detailing. Next door, a re-creation by *Hawkins/Brown*, 1990–2, of the 1930s premises of Yardley's the parfumier, using part of the old frame. This was by *Wimperis, Simpson & Guthrie* with *Reco Capey*, 1930–1 (extended 1936–9). Its flat bays have been reinstated and the Deco flower frieze copied. On the s corner with Stafford Street, Nos. 34–36 are a former London, City & Midland Bank, 1899 by *W.W. Gwyther*, Portland with Gibbs surrounds and gabled dormers. Ionic half-columned shopfront by *L. Carmellini & R. Magnoli*, 1992, for Versace. The dark riven-slate front of No. 40 is by *Jean-Michel Wilmotte*, 2000, one of several CARTIER shops by him around the world. AGNEW'S (Nos. 42–43), 1876–8 by *E. Salomons & R.S. Wornum*, has the close glazing bars and carved red brick of the first wave of Queen Anne. Pretty rounded oriel on the entrance bay. Ground floor by *Robin Moore Ede & Associates*, 2001. Agnew's at first occupied only the back parts, which give an unrivalled idea of a later Victorian private gallery: a long side-lit ground-floor room with a timber

ceiling grid; staircase with balustrade of gilt repoussé vase panels; top gallery with glazed lantern and alabaster disc frieze. No. 44, by *W. & E. Hunt*, is not quite the ordinary thing of its date: 1906. Lush nude caryatids, applied Ionic colonnade, and C17-style carving. Nos. 45–47, 1990–1 by *YRM*, has canted bays deferring to Nos. 56–60 Piccadilly next door (q.v.). Yellow stone, windows with close-meshed glazing bars à la Mackintosh.

OLD BURLINGTON STREET

The central N–S street on the Burlington Estate (*see* Burlington Gardens). *Lord Burlington* and *Colen Campbell* collaborated on a girls' school that closed the N vista (1719–21, dem. 1937). Another 1930s casualty was No. 29, *Burlington*'s celebrated house for General Wade, 1723. It had an unconventional and very un-English plan, and a rusticated garden front cribbed from a Palladio drawing in Burlington's collection.

Nos. 31 and 32, at the S end on the W side, are the only original houses left. Together with Nos. 3–5 Burlington Gardens (dem. 1971) they were designed by *Campbell*, 1718–23. Their façades, with no articulation of the party walls, seem to have served as a prototype for uniform C18 terraces.[*] Also much emulated were their stone console doorcases, first-floor windows rising from the plinth, and simplified modillion cornices. The second-floor windows originally had square lugged surrounds, the third floor pedimented dormers. No. 32 was altered *c.* 1906 with a shopfront and showrooms in a Neo-Empire taste, but No. 31 is more intact. It is wider by one bay, with an excellent front-hall staircase to the first floor. Pilastered dado; three different types of baluster per tread. Service stair immediately behind, originally side-lit. In the ground-floor rooms compartmented ceilings, elaborated deal panelling, and two grand Kentian overmantels with carved male or female heads linked by taut drapery. Details, e.g. the Greek-fretted dado rail, suggest a date probably *c.* 1730, when Stephen Fox, later 1st Earl of Ilchester, took the lease. (First-floor ceiling painted with Rococo *singeries*, probably done after 1909 for the dealer-decorators *Lenygon & Co.*, later *Lenygon & Morant*.)

pp. 31, 33

Next to No. 31, a sliver of wall with C18 mouldings remains from *Burlington*'s larger and grander No. 30, *c.* 1721 (dem. 1935; interiors preserved at Buxted Park, Sussex, and at Godmersham, Kent). The C20 begins with the messy Nos. 29–30, 1984–6 by *Anthony Smith Baron Partnership*, clad in smoked glass, stone and brown panelling. For the building to the N *see* Nos. 28–30 Cork Street. On the E side facing, Nos. 3–9, a bombastic stone-faced atrium block of 1991–8 by *RHWL Partnership*, replacing a 1960s car park. Tailors'

[*] Cf. James Ralph's *Critical Review*, 1734: 'I would recommend this row as a sample of the most perfect kind for our modern architects to follow.' The best C17 precedent is Inigo Jones's designs for Tokenhouse Yard in the City (*see London 1: The City*).

workshops with offices above at Nos. 10–13, 1928. On the W
side N of Clifford Street, Nos. 22–23, straightforward houses
of 1812, and No. 21, 1882 by *G. Treacher*, a pub of humbler
type; on the E side the back of the Police Station (q.v.).

PARK LANE

Park Lane is the ancient Tyburn Lane, first built up *c*. 1720–60,
and at its fashionable peak from *c*. 1820–30. The *Survey of London*
compares its later progress to that of Fifth Avenue in New York,
from Old Money to New Money to big anonymous C20 blocks.
Pitifully few private mansions remain, of which Dudley House
represents the aristocratic C19, Stanhope House the capitalist
influx of *c*. 1900.* Slightly more common are bow-windowed
C18–C19 terraced houses, some with entrances in streets to the
E (Nos. 93–99, 128–138, etc.). Gordon Cullen likened their
effect from Hyde Park to that of a seafront, with Park Lane as
the promenade. But predominantly there are big and often not
very attractive blocks of flats, hotels and offices of the 1920s and
later. The greatest single C20 change was however the *LCC*'s
street widening of 1958–63, which took away a broad swathe of
parkland to make a dual carriageway. The old perimeter is
marked by the central reservation with its trees. From pavement
level the park now seems hopelessly far away.

North Part, from Marble Arch to the Dorchester Hotel

Because of the ambiguity of its S end, it is better to start looking
at Park Lane by Marble Arch at the N, where it belongs to the
Grosvenor Estate. The corner with Oxford Street is a long
eight-storey block of flats by *F.T. Verity*, 1915–19, in his
usual stone-faced Parisian idiom. Back addition, 2001–2.
Then a stuccoed row of bow-windowed house backs. Their
entrances are in DUNRAVEN STREET behind, developed
c. 1757–8 by *John Spencer*, carpenter, and *Edmund Rush*,
mason. No. 138, of 1832 by the builder *John Kelk*, comes
forward with a specially festive bow and veranda. Doric
shopfront of 1928–9 by *Lutyens*. The next five are structurally
of *c*. 1757–8, with later additions and heightenings. Top storeys

*The C20 casualty list runs, from N to S: Somerset House, 1769–70 by the
carpenter *John Phillips* for the 2nd Viscount Bateman; Camelford House, 1773–4 by
Thomas Pitt, later 1st Lord Camelford, for himself (both at Nos. 139–140); Brook
House, by *T.H. Wyatt*, 1867–9, for the 1st Lord Tweedmouth, altered 1905–7 for Sir
Ernest Cassel; Grosvenor House itself, of 1731–2, improved by *W. Porden* in 1806–8
after the 2nd Earl Grosvenor bought it, and again by *Porden* (1817–19), *T. Cundy
II* (period 1826–48) and *Henry Clutton* (period 1870–82); Dorchester House, *Lewis
Vulliamy*'s Barryesque palace of 1849–53 for R.S. Holford, decorated up to *c*. 1878
(including celebrated work by *Alfred Stevens*); two 'Randlord' houses of the mid
1890s, Aldford House, by *Balfour & Turner* for Alfred Beit, and No. 45, by *Charles
E. Sayer* for the super-flash Barney Barnato, remodelled for Sir Philip Sassoon by
Philip Tilden, 1920s; and Londonderry House (another hotel-trade victim), *c*. 1761–5
by *James Stuart* for the 4th Earl of Holdernesse, reworked *c*. 1824–8 for the 3rd
Marquess of Londonderry by *B.D.* and *Philip Wyatt* in the new Louis XIV style.

on the first date from after 1875, on the second from 1834–5, etc. The three-storey bow on the third house was reconstructed in 1914, keeping the segment-arched top stage built after designs by *Soane*, 1801, for John Hammet MP; also a Soanic porch in Dunraven Street (No. 22 there). In the next block, s of Green Street, the mid C20 obtrudes with the decidedly dull AVENFIELD HOUSE, 1959–61 by *Wills & Kaula*, topped and tailed by older houses. The N one is No. 128, of 1857–8 by *T. Cundy II*, but reworked in 1903–5 for the art dealer H.J. Duveen with projecting bays (by *W. Flockhart*) and French-style interiors (by *W.H. Romaine-Walker*). No. 117, s, is sober Grecian of *c.* 1822, with a top storey of 1903 and much-altered front additions. The new BROOK HOUSE (Nos. 109–116) is of 1993–8 by *Michael Squire Associates*, a creditable updating of the 1930s brick-faced block of flats type. Showrooms below. A MONUMENT to Animals in War is proposed to stand in the roadway here.

DUDLEY HOUSE (No. 100) is something special: a nine-bay, three-storey Grecian house standing on its own, of 1827–8 by *William Atkinson*, for John Ward, 1st Earl of Dudley. Ionic colonnade all along the ground floor. The ornate cast-iron conservatory resting on it dates probably from *S. W. Daukes*'s improvements of 1855 for the 11th Lord Ward, with an extension of 1892 over the four-column porch. Dudley arms on the parapet. Long, asymmetrical return into Culross Street, with a stable block beyond, reached by an iron bridge. No. 100 was damaged in 1940, but restored, re-stuccoed and modernized in 1969–70 for HAMMERSONS by *Sir Basil Spence* and *Anthony Blee*; further refurbishment 1994. Entrance and open-well stairhall behind remodelled in French C18 taste, probably in 1855, though perhaps retaining the balustrade of 1828. Several of Atkinson's large and exceptionally refined interiors remain around them, with gilded compartmented ceilings and friezes in an uncommon Greco-Roman style. Towards the back a new upper stairhall of 1969–70, a creditable attempt to blend into a historical setting, though now looking a bit glossy and uneven.

Nos. 93–99, mostly of 1823–7, are more bow-windowed houses, [78] this time without back entrances. All nonchalantly different, with tented verandas in cavalcade on the middle five. No. 99 and the smaller No. 98 are of 1823–5 by *John Goldicutt*, No. 95, by *John Harrison*, as late as 1842–4, and of brick rather than stucco. Some original features inside, e.g. staircases with Grecian detail; later work in French styles, e.g. by *C. Mellier & Co.*, 1900, at No. 94. No. 93 was Disraeli's house in 1839–72.

Then GROSVENOR HOUSE, a very large enterprise combining hotel and service flats, built in 1926–9 by the speculator A.O. Edwards. It replaced the Grosvenors' C19 mansion (*see* footnote, p. 552), to general dismay at the leap in scale. The plan, by *L. Rome Guthrie* (*Wimperis, Simpson & Guthrie*), has four stepped E–W blocks connected partly by cross wings, partly by the single-storey shops, lobbies, dining room etc. along the pavement. *Lutyens*, the consultant architect to the Grosvenor

Estate, was called in to add finesse to the elevations. They have stone-faced and pilastered footings, helped along by a central quadrant of free-standing columns. Above are bare brick walls and even fenestration, topped by four square pyramid-roofed pavilions for the lift housings ('above the snow-line', as Osbert Lancaster called it). These are treated with a triumphal arch motif on each side, and are placed on the W ends of the wings. Their grouping in views from the park is the best thing about Grosvenor House. American practice informed the bedroom plans, which featured separate bathrooms and entrance lobbies. SE extension, 1956–7; public rooms remodelled 1955–61, and again since. Cliff-like 1930s blocks follow. FOUNTAIN HOUSE and ALDFORD HOUSE are by *G. Val Myer & Watson Hart*, 1935–8 and 1931–2, consultants respectively *Sir Giles Gilbert Scott* and *Lutyens*. Aldford House is less tradition-bound with its long balcony bands of French limestone, though offset by classical aedicules on the ends. Nos. 56–62 and No. 55 (lying back; 1935–8) are two more of these stone and brick blocks.

Then the DORCHESTER HOTEL, built in 1930–1. The plan and bare bones follow the engineer *Owen Williams*'s design of 1929. He resigned before completion when the client tried to make him work with the architect *W. Curtis Green*, whose brief was to soften Williams's extreme functionalism. Even with Curtis Green's trimmings the hotel was hailed as something very modern, perhaps because it had no columns or pilasters except at the very top. The Art Deco influence shows in such small motifs as the friezes with wavy or zigzag lines. The entrance is from the S, projecting convex in front of a concave façade. Upper floors of irregular plan, with spur wings behind. The facing, polished to look like stone, doubled as shuttering for the audacious *in situ* concrete construction. Twelve large hollow piers support a monolithic first-floor slab, which bears the entire load of the upper floors. Sound insulation was by cavities filled with dried seaweed. A more traditional image was projected inside, announced in the Adamesque entrance lobby. Other interiors, in keeping, of 1988–90 (*John R. Harris Partnership* with *Robert Lush Associates*). Originally there were 300 bedrooms. In 1952 the rear central wing was extended and a luxury suite formed by *Oliver Messel*. *W.A.S. Lloyd* added a ninth floor in 1956.

South Part, from Stanhope Gate to Old Park Lane

Next, set back on the N corner with Stanhope Gate, is No. 47, STANHOPE HOUSE. Built for the soap magnate R.W. Hudson by *W.H. Romaine-Walker*, 1898–1901. Elaborate, correctly detailed Perp Gothic, of grey Forest of Dean sandstone, with three symmetrical bay windows and plenty of tracery and blank tracery. The interiors go for diametric contrasts: Late Gothic in the tiny, intricately panelled entrance hall, but Jacobethan in the large room to the S, and Neo-Adam for the oval stairwell and first-floor rooms. Excellently renovated by *Skinner & Bailey*, 1969–70.

No. 45 (formerly the Playboy Club), 1961–3, is a reworking by *Cotton, Ballard & Blow* of a design by *Walter Gropius* and *Benjamin Thompson* of the *Architects' Collaborative*, with *Llewelyn-Davies & Weeks* as consultants. Big names indeed, but were they necessary? Anyway the outcome is a perfectly respectable building but no more. Eight storeys, precast concrete, curved N corner.

After Curzon Street a new scheme by *Michael Hopkins & Partners* is under way in 2003. A very proper Portland-faced mansion remains, sandwiched by bulkier new end blocks, at No. 33: 1878–80 by *E.A. Gruning*. It has a delicate iron veranda, and an enclosed porch and roomy full-height staircase to Curzon Place, behind. For the new parts a motif of canted bays with stone facing is used. To build them a charming run of old houses was demolished, some with bow backs glazed à la Bexhill in 1934. The rebuilding continues along Pitt's Head Mews, S.

Then the street sets back again and gets ready for the forking into Park Lane proper, now styled Old Park Lane, E, and Hamilton Place, W (q.v., Piccadilly). At the widening the LONDON HILTON by *Lewis Solomon, Kaye & Partners*, 1961–3, a low glazed front, and behind it a tall Y-shaped tower coming forward aggressively with a concave front and tapering out to the l. and r. further back. Pevsner thought it inferior to other Hiltons, at Istanbul and Berlin. Nor has the tower won affection since, and it is small consolation that the first proposal in 1957 was for thirty-five storeys, not the thirty that were built. A junkyard of masts has been added to the roof.

On the S corner with Hertford Street is the former Londonderry Hotel (now METROPOLITAN HOTEL). Also by *Lewis Solomon, Kaye & Partners*, 1964–7, extended 1966–9. Only twelve storeys. So much better than the Hilton. Refenestrated and partly remodelled 1995–7, by *Mark Pinney Associates* with *United Designers*. No. 17, adjacent, flats of similar height and treatment to the hotel, with stone-faced bands. Abstract bronze SCULPTURE in front by *Ju Ming*, Taichi Spin Kick, 1991 (installed 1997). From here on the view of the park disappears behind the FOUR SEASONS HOTEL (formerly the Inn on the Park), the third and most idiosyncratic 1960s hotel, a late work by *Michael Rosenauer*, 1967–70. Stone-faced. At the narrower N end a ten-storey tower with chamfered balconies and chamfered corners, along Hamilton Place a zigzagging two-storey entrance range. A panelled Louis-XV-style room from a house on the site is reconstructed inside.

Back to the E SIDE. S of Brick Street is PARK TOWERS, by *Norman Green*, 1964–7. A good, plain, fourteen-storey tower of flats on a neat glazed podium. Stone bands to the tower, carried up in the middle to lessen the window height. Older buildings beyond, more workaday without the park to live up to. At No. 7 big chambers by *Rolfe & Matthews*, 1903, with balconies variously arranged between the bows.

PARK STREET

The longest street on the Grosvenor Estate, running N–S. C18–C19 houses intermixed with big red gabled terraces of *c.* 1890–1910 and Neo-Georgian blocks.

At the N end the gabled type is to the fore: Nos. 106–114, E side, 1887–9 by *J.T. Smith* (the N end rebuilt to the C19 design, 1991), and Nos. 105–115, W side, 1892–4 by *Edis*, with Nos. 25–31 Green Street round the W corner. Nos. 98–104, E side again, are more of the same (1896–8 by *H.O. Cresswell*), but Nos. 91–103 facing is a whole block of imitation Wren, built 1915–25 to designs of 1913 by *Wimperis & Simpson*. Next two Neo-Georgian blocks each with a giant order, more individual than the compositions around Grosvenor Square: UPPER FEILDE, 1922–4 by *Wimperis & Simpson*, with gables on top, and UPPER BROOK FEILDE (Nos. 45–49), by *Wimperis, Simpson & Guthrie*, 1926–7, with giant columns inset in pairs. They face minor Georgian houses, Nos. 84–90, *c.* 1824–5, and Nos. 70–78, 1729, i.e. of the first generation (builder *John Barnes*; well-preserved panelled interiors). No. 72 still has its bracketed doorcase. Of the same build Nos. 66 and 68, under stucco of 1845–6. S of Culross Street is the best early C20 group, 1908–11 by *W.D. Caröe* (Nos. 37–43), wild Anglo-Danish Baroque, with big porches and asymmetrical segmental pediments. They face more small houses, of which No. 64 is by *Wimperis, Simpson & Guthrie* for Stanley Cousins, 1925–6, hipped-roofed in the style of *c.* 1700. No. 62, by *Henry Harrison*, Italianate, is of 1843–4, Nos. 58 and 60 of 1826–7.

After that the W side belongs with Park Lane, the giant buildings of which put the E side in the shade. Nos. 44–50, 1911–12 by *Detmar Blow & F. Billerey*, groups five houses in a Palladian palace front with a three-storey four-column giant portico. The multiple-gabled type returns at Nos. 36–42, 1895–6 by *J.E. Trollope*. No. 34 belongs with them but was remodelled by *Romaine-Walker & Jenkins* for James de Rothschild in 1913–14, just as if it were of *c.* 1780, with a shallow full-width bow. For the S continuation *see* Mount Street, then South Street.

PICCADILLY

With Oxford Street, one of the two main highways into London from the W. Tiswell's map of 1585 shows it as a lane through fields, inscribed 'The Waye from Colebrook [i.e. Colnbrook] to London'. The name comes not from peccadillo or 'pick a dilly' but from the vogue for pickadils or stiff collars. These made the fortune of one Robert Baker, tailor, and when he built himself a grand house *c.* 1612 the wags dubbed it Piccadilly Hall. It stood just E of the site of Piccadilly Circus. Building further W began with the Restoration, especially the royal lease in 1661 to the Earl of St Albans of the S side up to St James's Street. By the 1680s inns, shops and modest houses lined this part, interrupted by St

James (*see* p. 584). The N side, which continues along the edge of Green Park, was much smarter. Here three Restoration grandees built their town palaces, where there was land enough for a deep forecourt and gardens behind. Greatest and shortest-lived was CLARENDON HOUSE, built in 1664–7 for Lord Chancellor Clarendon by *Sir Roger Pratt*. Its winged double-pile plan, astylar façades and hipped roof supplied English architecture with enduring exemplars, despite early demolition in 1683. Immediately E lay Burlington House (q.v.), in its first incarnation of 1664–8; to the w Berkeley House, forerunner of Devonshire House (*see* below, p. 562). Slightly less grand mansions followed in the C18, further w and facing the park. Egremont House (*see* below, p. 562) and Apsley House (q.v.) are the chief survivors. Blocks of flats joined them from the 1880s, and also clubs, of which Piccadilly had fifteen by 1910, some in adapted houses. The most prominent early C20 buildings however are hotels: the Piccadilly at the E end, the Ritz at the park end. The C20 tended to reinforce the division between the E part, almost entirely rebuilt after 1860 with shops and offices, and the more residential w part. Newer hotels have not been allowed to shoot upwards like in Park Lane, nor have C20 road improvements gobbled up too much parkland. So echoes of the old aristocratic *rus in urbe* can still be caught here and there. The description is from E to w.

South Side, from Piccadilly Circus to Hyde Park Corner

First a cliff of mostly narrow-fronted commercial buildings. The transition from Blomfield's Piccadilly Circus is made by No. 215, 1928 by *W.H. White*. Nos. 214 and 213 are tall, vague, eclectic fronts of 1862–3. At No. 214 a café interior of *c.* 1910, in Anglo-Palladian style; No. 213 (by *A.P. Howell*) became in 1894 the first J. Lyons tearoom. No. 212 is *John Gibson's* former National Provincial Bank of 1873, not as good as his earlier banks, with a giant order pushed too high for comfort. Dragons on the cornice (carver *John Daymond*). Nos. 210–211, 1893, with a jumpy skyline. Then at Nos. 207–209 the NATIONAL WESTMINSTER BANK by *Alfred Waterhouse*, 1892–4. Rusticated piers in place of any show of orders, and peculiar pinnacles with little domes. Carved cherubs over the corner entrance by *F.W. Pomeroy*. Neo-Grec interior by *Michael Waterhouse*, 1925, extending s into Nos. 24–27 Jermyn Street (1885–6 by *John Robinson*).

After that the former SIMPSON'S (Nos. 203–206), an excellent, progressive piece of store design of 1935–6 by *Joseph Emberton*. It seems at first as if it consisted of nothing but the familiar bands of windows. However, the proportions and the top canopy add just enough to show that Emberton could handle the new idiom with conviction. The uninterrupted shopfront was achieved by a wide-span steel frame engineered by *Felix Samuely*, of arc-welded steel (a pioneering use in Britain); the curved glazing, by *Pollard*, was to reduce reflections. Calm, understated interiors, unified by an open-well staircase with a hanging chrome light fitting; converted for WATERSTONE'S

bookshop, 1999. Plain w extension on Jermyn Street, 1956–7. On the roof, staff rooms by *Leo de Syllas*, 1962, a lightweight steel-panelled structure in jagged silhouette. Its spiral outside staircase looks like a homage to Emberton's yacht club at Burnham-on-Crouch, Essex. On the site was *Pennethorne*'s Museum of Geology (1846–51), London's first public scientific museum. Nos. 198–202, 1903–4, have paired-windowed elevations by *Robert Sawyer* (future uncertain).

St James's Rectory follows, and then the church itself (q.v.), set back from the street. In the N W corner of the churchyard where the vestry hall once stood, and itself like a little parish watch-house, the former Midland Bank by *Lutyens*, 1922–4. A very successful *hors d'œuvre* of his; Summerson called it impudent, illogical, and enchanting. Of Portland stone and orangey two-inch brick, chosen to harmonize with Wren, but not too high so as not to compete with him. The whole fits into a 42-ft or 20.8-metre cube. Twin entrances, one false, with oval openings and little square windows over. One tall central straight-headed window. *Eric Broadbent* did the carving. In the banking hall a moulded ceiling, w gallery, and much impeccable walnut (bank architects *Whinney, Son & Austen Hall*).

Then comes the former ROYAL INSTITUTE OF PAINTERS IN WATER COLOURS (since 1976 BAFTA), a sound practical design of 1881–3 by *E. R. Robson*, architect of the early London Board Schools. Not far from his habitual Queen Anne, but in Portland rather than brick, and with an artistic admixture of Grecian. Above the shops a large near-windowless wall shows where the galleries were. On it two reclining figures holding a shield and eight busts of watercolour masters by *Onslow Ford*, in circular niches. The original, central entrance was destroyed in 1908. In 1984 the ground floor was restored differently by *Ley, Colbeck & Partners*. They also remodelled the PRINCES ARCADE, made through the w end by *H. Kempton Dyson* in 1930–3. It was the last such arcade to be created in the West End. Partly of double height, but glazed at shop level only. The smooth flattened bows are an improvement of 1984. At No. 189 the former Yorkshire Grey pub, 1898, gabled, tall and narrow. HATCHARD'S at No. 187 is of 1909, by *Cheston & Perkin*. Stone-faced, the centre recessed with giant columns. Neo-Georgian shopfront, modelled on that illustrated by Tallis in 1839 (altered c. 1991). John Hatchard began selling books here in 1801. At Nos. 181–186 another famous name, FORTNUM & MASON. Nos. 185–186, l., an extension of 1996–7, replicates brick Victorian fronts. The rest of 1926–9 by *Wimperis, Simpson & Guthrie*, in their buttoned-up Neo-Early Georgian. Automated Rococo CLOCK on the front by *Eric Aumonier*, 1964. The previous premises, of 1834–5, were exceptionally large for a shop of that date.

After Duke Street comes FRENCH RAILWAYS HOUSE, plain, stone-faced, by *Shaw & Lloyd*, 1960–2. *Ernö Goldfinger* devised its lettering, which reads identically in either direction. Nos. 174–175, 1909–10 by *G. Thrale Jell*, houses the spacious PICCADILLY ARCADE. Twenty-six bow-fronted Neo-Regency shops, and above them glazing bars in a close mesh. Shallow

barrel vault, with artificial light instead of top-glazing. Refurbished by *Michael Haskoll Associates*, 1985. The upper parts to Jermyn Street are inferior reconstruction after war damage. Nos. 166–173, by *William Woodward*, 1905, is a long composition so tepid that its symmetry barely registers. The W part is named EGYPTIAN HOUSE after *P.F. Robinson*'s Egyptian Hall here (1811–12), the first, muddled attempt at an Egyptian elevation in England; its sculpted portal guardians now stand outside the Museum of London (*see London 1: The City*).

The creative temperature rises with the former NORWICH UNION, on the E corner of St James's Street. By *Runtz & Ford*, 1906–8, of white Pentelic marble with pink Welsh jasper below. It suffers not from a scarcity of motifs but from a lack of power to discipline them into one composition. On top stands Justice, robed and with attendants, by *H.C. Binney*. At the former ROYAL INSURANCE opposite, 1906–8 by *Belcher & Joass*, or rather *J.J. Joass*, the indiscipline must be considered a positive quality. The endeavour here was clearly to smash up the classical conventions, but the fragments are left in a restless, disquieting pattern. Michelangelo is one source (cf. Joass's Nos. 156–162 Oxford Street), the Viennese Secession another. Stretched Tuscan columns in pairs below, and Tuscan columns on the attic, but between them instead of any order tall recessed through-storey bays. In their heads putti by *Bertram Mackennal*, in the conceit that they have clambered up from the niches below to hold up the cornice. At the entrance sculpture by *Alfred Drury*. The facing is again Pentelic marble. *W. Curtis Green*'s Nos. 157–160, 1920–1, reduces the number of motifs to more or less one, the set convention of recessed giant columns, turning to pilasters towards Arlington Street, r. Though details and proportions are irreproachable, the palm must go to his more original National Westminster Bank across the way (*see* below, pp. 561–2). Inside, red columns and a strident patterned marble floor, and marvellous black-and-gilt lacquered screens: the last introduced in 1926 by Barclay's Bank, who took over from Wolseley Motors. Converted to a restaurant 2000.

With the RITZ HOTEL the S side of Piccadilly effectively ends, and Green Park follows (*see* pp. 656–7). The Ritz is of 1903–6, frankly Parisian, a clever and influential treatment as evocative as the name of the hotel. *Charles Mewès* had contrived the Paris Ritz in 1897–8 behind the façades of the Place Vendôme; for the London establishment he and his partner *Arthur J. Davis* emulated the taller pavilion roofs of early C17 Paris, e.g. the Place des Vosges. Ground-floor arcading after the Rue de Rivoli, a pragmatic response to enforced street widening. The stone is Norwegian granite below, Portland above (contractors *Waring-White Building Co.*). The weakest part is the Arlington Street front, badly balanced and with the entrance underemphasized. The walls enfold the largest steel frame London had yet seen, industrial structures apart (engineer *Sven Bylander*; cf. Selfridge's, pp. 465–6). This could not yet be expressed externally, because the building regulations still stipulated minimum wall thicknesses. Another innovation

for London was the use of piled foundations, rather than a concrete raft.

Mewès & Davis had a free hand with the INTERIORS, the great César Ritz being too ill. The style is Louis XVI throughout (decorators *Waring & Gillow*). A broad promenade corridor glides from E to W, ending in the restaurant facing the park. On the way one meets first a circular galleried stairwell. Then comes a cross-axis, climbing from a Piccadilly entrance up through a column-screen to a winter garden or tearoom, l. This is toplit and has a nymphaeum and a gilt trellis cornice. Huge mirrors dematerialize the corridor walls. On the restaurant ceiling are bronze-garlanded chandeliers and painted clouds. The bedroom floors were planned so that guests and their servants could share the same storey. (CASINO in the basement by *Robert Lush* of *Richmond Design Group*, 1978. A reversion to Louis XVI, after 1930s remodelling.)

GREEN PARK UNDERGROUND STATION lies just W of the Ritz. Low, blank bunkers of 1969, by the *London Transport Design Panel*. They spoil the NE entrance to the park.

GATES. Further W, opposite Half Moon Street. Of *c.* 1735, made for a villa at Turnham Green. In 1837 bought for Chiswick House, then removed to Devonshire House 1897. They went to their present position, at the top of the Broad Walk, in 1921. Very splendid ironwork with repoussé masks; recently attributed by Edward Saunders to *Jean Montigny*. In 2000 restored and painted blue. Cavendish arms above, looking *c.* 1837. Vermiculated piers, with a band of Greek key. Their design is that by *Lord Burlington* for Chiswick, except that they are taller by two courses. Lead sphinxes on top, thought to be C18 and from Chiswick; the piers either of 1837 or 1897.

PORTER'S REST. Opposite No. 127. A plank on cast-iron columns, for resting heavy loads. Erected 1861 and quite likely unique.

North Side, from Piccadilly Circus to Park Lane

First the long return of *Sir R. Blomfield*'s Piccadilly Circus range (*see* pp. 450–1), with at the E corner understated bronze shopfronts designed by *Joass* (Nos. 14–18, *c.* 1926). AIR STREET provides a magificent view through the arches and column-screens of Regent Street. Then a great block of which *Norman Shaw*'s PICCADILLY HOTEL of 1905–8 forms the best part. Ingenious in the conceit of the screen of giant columns behind which the frontage recedes. But it is also grandiloquent in Shaw's Late Baroque taste – cf. the heavily banded rustication and the heavy curly gable on the l. On the upper terrace a glazed enclosure by *Cobban & Lironi*, 1985–6. The projected r. gable was never built because Nos. 19–20, DENMAN HOUSE, 1903 by *H.A. Woodington*, was in the way. Also Neo-Baroque, but in the small-scale manner that came in *c.* 1890, and not nearly as tall. At first it projected further, but in 1912 Piccadilly was widened and the front reassembled further back. The hotel wanted to complete the Shaw design then, but could not afford it. The hotel INTERIORS were planned by *William*

Woodward and *Walter Emden* (whose joint design for the exterior was set aside in Shaw's favour), and fitted up by Messrs *Goodall* of Manchester. Most notable is the large Dining Room, con-fident Louis XV with boiseries and gilded masks and fronds: a sign that the age of the non-resident diner had arrived. For the N front *see* Regent Street, p. 454.

The buildings following are big, prosperous and unenterprising, with decidedly less body than Shaw's. Dull stone-faced blocks by *H. G. Sumner*, designed 1956, flank Swallow Street. LLOYDS BANK (Nos. 39–40), 1929–30, stone-faced in late C18 English Neoclassical style, and Nos. 4–46, 1937–9, are both by *George J. Skipper*, for the Sutton Estate. They have Ionic porticoes high up facing Sackville Street, where Skipper's designs continue (q.v.). Further W the forecourt of the Albany, q.v. Nos. 47–48, over-tall Neo-Georgian red brick, by *Bomer & Gibbs*, 1926 (formerly Meakers, tailor and hosier). Burlington House, next, is described on pp. 487–92.

The BURLINGTON ARCADE belongs historically with Burlington 67 House, but functionally with Piccadilly. Built by *Samuel Ware* in 1818–19 on the W perimeter of Burlington House, as a speculation by its owner Lord George Cavendish. *Beresford Pite* unfortunately rebuilt the entrance: the upper storey in 1911, a triple arcade ranging with Ware's design; the rest in 1931, a single Baroque arch with two big archaic Greek busts on big brackets (*Benjamin Clemens* sculptor). At the same time coloured mosaics were applied above. On top of the arms of the 4th Lord Chesham, the owner in 1911, and Ware's balustrade, reset. The passage is narrow, not high, without the showiness of later arcades. Shops on both sides, bow-fronted rooms above, and a pitched glazed roof. Ionic pilasters and cross-arches after every four shops. At three points the passage widens, and the roof rises to enclose the third storey. So the whole 585-ft (178-metre) length – longest of any pre-war English arcade – never becomes monotonous. Shopfronts altered with plate glass; the N part rebuilt in 1954, after war damage. Dumpy stone elevation to Burlington Gardens, N, 1937, by *E. Bates* and *W. G. Sinning*.

Back in Piccadilly, COLETTE HOUSE (Nos. 52–55) is by *Ronald Ward & Partners*, 1975. A contextual building, but one that takes strong rather than weak cues from its surroundings. Red brick and herringbone tile, arched windows, unravelling Neo-Art Nouveau ironwork. Its point of departure is the E corner with Old Bond Street (No. 1 there), by *Alfred Waterhouse*, 1880–1. Granite ground floor and red brick and buff terracotta above. Built for Christy's, hatters, but similar to the architect's Prudential branch offices. The W corner is Nos. 56–60, 1904–5 by *Read & Macdonald*, built as Callard, Stewart & Watt's tearooms. Free Style at its prettiest, in Portland stone with metal balconies. Nos. 60–61 is of 1887–8 by *George & Peto*, built as the Albemarle Hotel. The gayest appearance in Piccadilly of terracotta, so popular in late C19 Mayfair. Pink, the style François I, with lots of canted bays and portrait medallions. Plainer extension in Albemarle Street, 1892.

Next *Curtis Green*'s NATIONAL WESTMINSTER BANK, 1926–8,

at the head of St James's Street (Nos. 63–65; cf. Green's
Nos. 157–160, s side). He composes his classical motifs with
much individuality – e.g. in the upper part the aedicular
windows with smaller windows above, gathered together by
giant arches – and shows the nicest sense of proportion and
scale. The top is left open, with a columned loggia. Nos. 66–68,
the former Hatchett's Hotel by *W.S. Weatherley & F.E. Jones*,
is dated 1884. Of the same genre as Nos. 60–61, but much less
amiable. Then between Dover Street and Berkeley Street a
large expanse by *Chapman Taylor Partners*, 1970–4. Offices to
Piccadilly treated as a chamfered stone grid with major and
minor uprights. By Dover Street a SCULPTURE, Horse and
Rider, 1975 by *Elizabeth Frink*. Along Berkeley Street a hotel
wing (Nos. 1–7 there), brown brick with broad flat bays.
The rest of Piccadilly has buildings on the N side only, facing
Green Park. First rises the palatial DEVONSHIRE HOUSE,
1924–6, one of the best 1920s newcomers to the West End.
By *Thomas Hastings* of *Carrère & Hastings*, best known for
the New York Public Library; consultant *Sir Charles Reilly*. Its
builders, *Holland & Hannen & Cubitts*, undertook it as their
own speculation. Eight-storeyed with slightly projecting six-
storey wings, all stone-faced, with sparing but gay Cinquecento
ornament: a fashion then stronger in America than Britain.
The set-backs high up also show American influence. Big
pilaster-framed display windows to Piccadilly, detailed after
those on Carrère & Hastings' Black Starr & Frost building,
New York. Big top cornice. Within were fifty-four self-
contained flats (now offices), reached from a colonnaded
back entrance. The name commemorates the noble though
externally plain house begun for the 3rd Duke of Devonshire
by *William Kent* in 1734, and updated in the 1840s by *Decimus
Burton* and *J.G. Crace*. For the former gates *see* p. 560, above.
Devonshire House in turn supplanted *Hugh May*'s Berkeley
House of 1665, for the 1st Lord Berkeley of Stratton.
Across Stratton Street stands STRATTON HOUSE, also stone-
faced, by *Curtis Green*, 1926–8. An anti-climax after his
National Westminster Bank. Routine 1950s-60s offices a little
beyond it, on the sites of two notable Georgian mansions.* Of
these Nos. 82–84, 1960–2 by *Lewis Solomon, Kaye & Partners*,
has eight flush stone-framed storeys, No. 85, by *Clifford Culpin
& Partners*, c. 1967, plain horizontal bands, and Nos. 86–89,
1955, emblematic reliefs by *Harold J. Dow* towards Half Moon
Street, w. These face across to Nos. 90–93 by *J.G.F. Noyes*,
with bows and gables and the date 1883: the westernmost brick
building in Piccadilly. After that all is stone-faced.
No. 94 is EGREMONT HOUSE, the only aristocratic house in
Piccadilly still set off by a forecourt. Built 1756–8 by *Matthew
Brettingham Sen.* for the 2nd Earl of Egremont, and fitted out
by 1764. Seven bays wide with a central three-bay projection

* Bath House (No. 82) was of 1821 by *Henry Harrison* for Alexander Baring, later
1st Lord Ashburton. Later interiors, including one smart Modernist room by *Serge
Chermayeff*, 1930, for Lady Ludlow. No. 85, built c. 1760 by *Sir Robert Taylor* for the
3rd Duke of Grafton, was adapted for the Turf Club by *John Norton*, 1875.

under a pediment. Venetian window below, Doric without and Ionic within; first-floor windows to each side also pedimented. Main contractors *John Phillips* and *George Shakespear*, then very busy in Mayfair; other craftsmen came from Holkham, Norfolk, where Brettingham was also engaged. The l. half of the front is *Cubitt Nichols*'s reconstruction of *c.* 1958, after war damage. The big Doric porch and single-storey w range date from *J. Macvicar Anderson*'s remodelling for the Naval and Military Club, 1876–8. Balcony probably early C19. Closing the forecourt is a double-gated wall of 1876–8; the lettered piers led to the nickname 'In-Out House'.

The INTERIORS, predominantly C19, preserve the C18 arrangement around a toplit staircase with service stair to the w. On the ground floor *Macvicar Anderson* merged the e and n ranges in 1876–8 for a smoking room, L-shaped, punctuated by pilasters and column-screens. Staircase with cast-iron balustrade and oval dome, also 1876–8. First-floor interiors more subdued and delicate, as appears immediately in the upper stairhall. They probably date from the 1st Marquess of Cholmondeley's occupancy, 1822–9. In the NE room a fine fireplace with maidens on round altars. SW room a reinstatement *c.* 1958. (Of the C18 interiors, designed to show off Egremont's picture collection, the chief remainder is the Octagon Room, set centrally at the rear of the first floor. Shallow-coved, with octagonal coffering; plasterer *Thomas Clark*, perhaps to designs by *Franceso Vassalli*.) In 1876–8 an L-shaped REAR WING was built, with in the n arm a big Coffee Room with Ionic screens on three sides. It overlooks a paved courtyard, with an earlier cast-iron veranda, perhaps 1820s. The club moved in 1998 to No. 4 St James's Square; in 2001 proposals were approved to convert Egremont House and the properties around it to a hotel.

Then a late C19 sequence. The Franco-Flemish house at No. 95, on a narrow site, is by *Alfred Lovejoy*, 1886. (Grand open-well staircase; some reused C18 fireplaces and doors.) After White Horse Street three former club buildings all in a row. Nos. 96–97 was the short-lived New Travellers' Club, by *T. & F.T. Verity*, 1891, with giant pilasters and a fine restraint. Its Ham Hill stone facing was renewed *c.* 1990. Next the former Badminton Club (Nos. 98–100), 1884–5 by *Edis*, Neo-Elizabethan in Portland stone. A special facility was its extensive stabling (dem.). The two are now united; the entrance was nicely remodelled by *Wolff Olins Hamilton* in 1989, with simplified Gibbs openings. Overtowering both is *Edis*'s Nos. 101–104, the former Junior Constitutional Club of 1890–2, the first marble-faced building in London. Tall, free Italian, with three symmetrical gables. The marble is white Norwegian, with Portland trim and Shap granite columns below. Converted for the JAPANESE EMBASSY by *Chamberlin, Powell, Bon & Woods*, 1989. The entrance moved from the r. bay to the centre in the 1960s. Steps up inside the door are needed because the Tyburn valley makes the street dip down steeply here. An impressive column-screened saloon fills the whole front.

At the corners with BRICK STREET two stone-faced houses.

No. 105, E, belongs externally to 1850–1, by the 'design and build' firm of *W. Cubitt, Plucknett & Co.*, for the 4th Marquess of Hertford. Bowed front of three bays plus one either side; paired giant pilasters above a rusticated ground floor. Bow and pilasters echo the previous house, of 1788 by *Michael Novosielski* for the 7th Earl of Barrymore, of which the lower walls were kept. Hertford never moved in, and in 1872 the house was being fitted up for his illegitimate son Sir Richard Wallace (he of the Wallace Collection). It passed to Julian Goldsmid MP, who got *Alfred Waterhouse* to alter it in 1875–9. Mansarded and reworked 1926–7, when *Paul Hoffmann* converted it to a hotel.

At the w corner No. 106 (now INTERNATIONAL HOUSE), a Palladian house built for Sir Henry Hunloke, 4th Bart., 1759–61, perhaps also by *Matthew Brettingham Sen*. Hunloke sold it to the 6th Earl of Coventry, who commissioned *Robert Adam* to remodel the first-floor rooms in 1765–70 (Adam had already transformed the Earl's house at Croome Court, Warwicks.). Façade of five bays, with a rusticated arcaded ground floor and first-floor windows with alternating pediments. Balcony from *Thomas Cundy I*'s alterations for the 7th Earl, of 1810–11; top storey heightened probably at the same time. Towards Brick Street a large Venetian window, outwardly plain but Ionic within. This lights the fine STAIRCASE, starting with one arm and returning in two, with a superior wrought-iron balustrade. It predates the Adam work, as do the doorcases etc. on the ground floor. The landing is managed with superimposed screens of columns, redone in grey scagliola in 1810–11. A second column-screen below opens into the space of the former parlour, w. Here an *Adam* fireplace carved by *John Devall*, from the former dressing room on the first floor. The best room there is the GREAT CHAMBER facing the park, where Adam's ceiling has Apollonian central canvases and a border with grisaille roundels, all by *Antonio Zucchi*. Sage green background, probably not the original colour. Frieze with gryphons, repeated on the doorcases. Ante-room to its E with octagonal ceiling panel (*Cundy*'s?); fireplace plausibly also *c.* 1810. At the back Lady Coventry's former bedroom, with a heavy ceiling seemingly modified by *Adam* with new ornaments, and the former dressing room, a small octagon with mutilated *Adam* decoration on walls and ceiling. Another octagonal room on the ground floor. At the back brick-built extensions for the St James's Club, in occupation 1868–1975, when it merged with Brooks's in St James's Street. The larger, w, including the Neo-C18 CARD ROOM, is by *E.R. Robson*, 1888; E addition of 1912 by *A. Palser* of Messrs *Maple*, with two domed billiard rooms in Louis XVI mode.

The PARK LANE HOTEL at Nos. 107–115 is by Messrs *Tanner*. Of 1925–7 the main block with deeply recessed centre, made asymmetrical by a plainer extension of 1930–1, r. The facing is the white artificial stone called Marmo, with black marble columns at the entrances. Incorporated is an older steel frame ('bird-cage hotel') erected 1913–14 for premises designed by *C.W. Stephens*, but abandoned after its German hotelier was interned. The hotel was the first in London with a bathroom

to each room. INTERIORS aimed at extreme variety: the OAK ROOM in the E range copies the Globe Room of 1637 formerly at the Reindeer Hotel, Banbury; the RESTAURANT on the W has reset boiseries in Louis XV style, done in 1904 by *Carlhian & Beaumetz* of Paris for Pierpont Morgan's house in Princes Gate, Kensington. The delirious BALLROOM, in the extension of 1930–1, is one of London's best Art Deco spaces. Silver, mauve and pink colours; mushroom columns; scrolling and scalloped motifs. Decoration includes paintings by a *Miss Gilbert* of nymphs with wild beasts. The descent is glamorous too: a shallow staircase to a balcony, and then a grand stair down to the dance floor. In Brick Street behind, linked by bridge, a GARAGE of 1928, formerly with chauffeurs' accommodation. ATHENAEUM COURT (No. 116) is by *Adie & Button*, 1935–6, but given Travertine facing and canted bays *c.* 1970. Originally unornamented, with corner windows.

Between Down Street and Old Park Lane is a long Portland-faced stretch, mostly of later Victorian mansions. Nos. 117–118, 1872, are by *C.A. Buckler*, in a grave old-fashioned Italianizing style; No. 119 a near-match. In No. 118 some rich ceilings in Italian Mannerist style. Gaps in the numbering thereafter. Nos. 127 and 128 make one long elevation, to a kind of souped-up Gibbs design by *Adolphus Croft* of *Gillow & Co.*, who built three mansions here in 1888. But at No. 127 (after 1890 the Cavalry Club, from 1976 CAVALRY AND GUARDS CLUB) only the five W bays are of 1888. The corresponding five to the E are of 1908 by *Mewès & Davis*, who also enlarged the porch and added canted bows at the extremities. The 1908 interiors are in mid-Georgian style. C18 elements reused include two Kentian fireplaces in the ground-floor back room, and (it is said) some iron balustrading on the staircase. This is toplit and rather shapeless. The RAF CLUB at No. 128 occupies the other mansions of 1888, hence its double-fronted look, six bays wide with two canted bays. Merged for club premises in 1892, remodelled inside for the RAF by *Aston Webb*, 1919–22. His rooms are clean simplified C18 English, with much use of the Venetian motif. A Tuscan-columned corridor leads to an entrance fronting Old Park Lane (No. 6 there). Next door is *Delissa Joseph*'s No. 1 Old Park Lane, 1914, crowded gabled elevations with tripartite windows. Ground floor refaced for Coutts' Bank in 1923 by *Palmer & Holden*.

The opposite corner is No. 137 (HARD ROCK CAFÉ), a remarkable freak of 1905 by *Collcutt & Hamp*. Seven-storeyed, very tall and faced with artificial stone and with a big pedimented gable using green brick. Originally it housed a car showroom. Nos. 138 and 139, tall and palatial with a shared cornice, are late C19 reworkings by *R.S. Wornum* of houses of 1757–8. *Matthew Brettingham Sen.* built No. 138 for the 3rd Earl of March (later the 4th Duke of Queensberry, 'Old Q'), who used to ogle from its canted bay. It was refaced in 1888 for E.W.B. Denison, with giant Doric pilasters. Ionic pilasters on No. 139, heightened and remodelled in 1890 for Sir Algernon Borthwick of the *Morning Post* (later 1st Lord Glenesk).

No. 140 marks the corner with HAMILTON PLACE, widened in

1869–71, which served until the 1960s as the main route into Park Lane. The land began as part of Hyde Park, granted in 1665 to its Ranger, James Hamilton. No. 140 is a big French-inflected house of 1874–6, designed by one *Marsh*, probably *R.B. Marsh*. Of the same date and type No. 11 Hamilton Place just to the N, and Nos. 4 and 5, W side. Their story begins in 1807–10, when *Thomas Leverton* laid out the street for the Crown Estate as a close of superior houses. On the W side they overlooked Hyde Park, on the SE (via bow windows) Green Park, aspects which attracted some very rich people. Later some were rebuilt, others refaced and heightened. First done was No. 5 (LES AMBASSADEURS CLUB), N, originally by *Leverton* for the 4th Earl of Buckinghamshire, but almost completely rebuilt 1879–81 for Leopold de Rothschild by *W.R. Rogers* of *W. Cubitt & Co*. Lavish superimposed orders on all three sides, the arcaded lower floors originally partly open. The sources are purest mid-C16 French. Stone carving by *Forsyth*; interior decoration by *John Jackson* and by *Mellier* (painting); library woodwork made in Florence by *Rinaldo Barbetti*. No. 4 (since 1938 the ROYAL AERONAUTICAL SOCIETY) is all of 1903–7, by *A.N. Prentice* for Leopold Albu, whose initials appear in the porch ironwork. Similar elevations. The customary financiers' Dixhuitième in the grand open-well staircase and Rococo first-floor library, but the ground-floor dining room is C17 English in style.

The last building before Hyde Park Corner is the big INTER-CONTINENTAL HOTEL, for which the rest of Hamilton Place and four Piccadilly mansions ('Rothschild Row') were demolished.* By *Sir F. Gibberd & Partners*, 1971–5. Stone-faced, the front skipping back and forth in various bays and planes. After the Hilton in Park Lane it appears civilized enough.

PRINCES STREET

A broad street, laid out with Hanover Square and built up 1717–20. Of this time Nos. 5 (refronted 1824), 7 and 8, N side. PORTER'S BUILDING opposite (Nos. 22–25) is a cloth ware-house of 1899–1902 by *S.F. Bartleet*. Red brick and stone Renaissance. Two-storey shops below giant-pilastered offices reached by a turreted staircase bay, l.

QUEEN STREET MAYFAIR

Runs N–S, up the slope from Curzon Street to Charles Street. Built up from *c.* 1750. The N part belonged with the Berkeley lands, the S with the Curzons', but the join does not show. From the C18 the E SIDE retains Nos. 3 and 6–11. No. 9 has the date 1776 on a rainwater head, and early C20 Rococo bal-

*These were mostly C18, refaced. Nos. 147–148 to the E, more spectacular still, went in 1961. It was a palazzo by *Nelson & Innes*, 1861–2, for Lionel de Rothschild.

conies. No. 4, a Queen Anne interloper, by *J. T. Wimperis*, 1883. On the W SIDE only No. 19 remains of the C18. Nos. 20–22, l., 1958 by *A. Swift & Partners*, has windows in slated panels packed close. *Michael Lyell Associates*' Nos. 15–16, 1988–90, brick-faced flats with canted bays, belong with the Saudi Embassy at Crewe House behind (*see* Curzon Street).

SACKVILLE STREET

Formed *c.* 1671; named probably from Capt. Sackville, an early resident. Rebuilt in 1730–2 by William Pulteney MP. Of this time Nos. 29–36 (w side), with three- to five-bay fronts; restored by *Rolfe Judd*, 1987. No. 36 is by *Henry Flitcroft*, for Edmund Turnor. Four bays, with a bracketed stone door-hood and a good stone staircase with wrought-iron balustrade, in a square rear compartment. Ground-floor front room with enriched panelling and a carved overdoor with a mask of Aurora. The rest are more altered, including some stucco fronts, and typical late C18 improvements: at No. 35 a door void with Ionic columns, at No. 34 a good first-floor ceiling, at No. 32 an elaborate doorcase and pilastered entrance with ram's-head frieze. No. 31 has a galumphing porch of *c.* 1870, masking a broad paved hall with an altered timber staircase of *c.* 1730. No. 30 is of broad Palladian proportions, with a mid-C19 pilastered shopfront. No. 29, built for the barrister William East, has an uncommonly tall first floor reached by a broad and p. grand timber stair, arranged in two parallel flights. First-floor 33 ceiling of 1770 by *Robert Adam* for the 1st Lord Boringdon, the paintings lost.

To the N and S and along the E side all is large, heavy Neo-Mid-Georgian, built after a design of 1931 for the Sutton Estate by *George J. Skipper* of Norwich (cf. his Nos. 39–46 Piccadilly, immediately S). Skipper's details were watered down in later phases (NE corner 1961, NW as recent as 1971–2, both by *Cubitt Nichols*). Closing the view to the N are Nos. 5 and 6 VIGO STREET, 1923–4, stone-faced; No. 5, r., by *Guy Dawber*, was the Rembrandt Gallery, hence the bust.

ST GEORGE STREET

Laid out *c.* 1715 by the 1st Earl of Scarborough in connection with his Hanover Square (q.v.), towards which it has a broad funnel-like opening. The plan may have been by *Thomas Barlow*, who also built some houses. The best C18 stretch is on the W SIDE, N of Maddox Street. The fronts are unusual, mostly four bays, with even quoins of stucco and stucco-rusticated 37 aprons linking segment-headed windows. A late C18 tradition has it that the design was Germanic, in allusion to the Hanoverian line. Few houses in the square proper were so treated, however, and France is anyway a likelier source. From the N Nos. 17 and 16 retain C18 doorcases and front stairhalls. At No. 17 the staircase has densely placed balusters, possibly

reset, and the shopfront exposes a late C18 Grecian Ionic column-screen. First-floor ceiling of Adam type, *c.* 1780. At No. 16 the staircase has thin S-scrolled balusters of mid-C18 pattern. The central house is No. 15, of *c.* 1720 by *Nicholas Dubois* for Samuel Hayes, designed to be dominant. Five bays wide with rusticated ground floor, and first-floor windows with aprons and pediments alternating in the Palladian way. In 1774 *Sir W. Chambers* added the Doric doorcase, for the 2nd Earl Fauconberg. The stucco is later. The staircase and much else were lost by fire in 1980, but in 1998–9 the arcaded entrance hall was re-created by *Lees Associates*. One ground-floor room preserves brown imitation marble pilasters and a rich Rococo overmantel: C18, or improvements by *White Allom*, the early C20 occupants? Nos. 13–14 are retained façades, No. 12a a facsimile of 1979. C20 intrusions include No. 18, flats by *Gervase Bailey*, 1934, and (E SIDE) Nos. 25–27, 1960–2 by *Seifert & Partners* in grey and black stone (demolition proposed). For Vogue House, immediately N, *see* Hanover Square.

More of the early C18 S of Maddox Street. Next to St George (E SIDE), Nos. 30 and 32, a different permutation with alternating quoins. Both heightened, No. 32 with a fancy pediment dated 1888. No. 31 between, *Ansell & Bailey*'s well-managed infill of *c.* 1972–6, has paired brick uprights. On the W SIDE Nos. 3–5 and 8–10 are also C18, simpler. Later buildings include Nos. 6–7, 1904–5 by *C.H. Worley* (now SOTHEBY'S), with free classical motifs that tend to crowd each other out. Portal sculpture by *L.F. Roselieb*. No. 11 is more Art Nouveau, with a good bowed shopfront. By *Wimperis & East*, 1897.

SAVILE ROW

Built 1732–5, in the second phase of Lord Burlington's development (*see* Burlington Gardens). Named after Burlington's wife's family. Closing the N vista was a pedimented Palladian house attributed to *Burlington, William Kent*, or both, but in 1936 it was demolished to extend Savile Row N into Conduit Street. At first houses lined the E side only, facing gardens to the houses of Old Burlington Street. From the mid C19 little shops, now all gone, were built up here for the tailors who made the row famous. Area basements on the E side allow glimpses of their remaining workshops. Most of the W side belongs with Old Burlington Street (q.v.).

We begin on the E SIDE at the S end. No. 1 (GIEVES & HAWKES) is of 1732–3, masked by C19 stucco. The design was 'laid down and approved of' by *Burlington*, though *Kent*, the leaseholder of No. 2, may have had a hand. Its conspicuous site warranted a grand elevation with a broad open pediment, but this disappeared under *J. Edmeston Jun.*'s stucco bric-à-brac in 1870, when the Royal Geographical Society moved in. The C18 staircase survives, in a double-apsed well at an angle to the S wall. Its wrought-iron balustrade may be imitation Kent, from

Lord George Cavendish's occupancy in 1784–1818 (*Survey of London*). Of ceilings recorded in 1962, the ground-floor front showroom has the best remains: guilloche banding from the former entrance hall, s, rich dentil cornice to the former morning room, n. The Geographers' former map room behind is by *Edmeston*. Deep glazed coving, half-height gallery of cast iron with typical 1870s eclectic ornament. No. 2 is gentlemanly Neo-Georgian by *Niven & Wigglesworth*, 1914–15. Gieves & Hawkes's enjoyable Neo-Neoclassical shop interior, of 1996 by *Anthony Pierce*, echoes Soane and Thomas Hope. No. 3, a four-bay house of 1733, has in the first-floor saloon an unusual compartmented ceiling: oval relief of a goddess with clouds, sparing ornament of scallops and scrolls. Two fine carved wooden fireplaces of *c.* 1740, *ex situ. Joass*'s Nos. 9–10, 1927–8, is tall and punchy with a central canted bay.

The 1730s return at Nos. 11–14 and 16–17. Though Burlington's control is unproven, their proportions show a general affinity with Palladianism. No. 12 has stone obelisks (renewed) in front and modest panelled interiors. Obelisks again at No. 14 (HARDY AMIES), of four bays, which despite heightening is the best-preserved house. A dog-leg stair and service stair separate front and back rooms. Main staircase with tall octagonal skylight, closed-string balustrade, and an alarmingly large early C19 oriel like an opera box over the half-landing. It communicates with the front saloon, which has a correct cornice and Corinthian pilasters at one end. No. 15, rebuilt or refronted in eclectic-Italianate, perhaps for the Savile Club, in occupation 1871–82. The stuccoed No. 17 has a doorcase with bay-leaf frame, added perhaps by *George Basevi*, resident 1826–45. Opposite (w side), Nos. 30–32, tailors' shops by *R. Angell & Curtis*, typical stone-faced, *c.* 1927.

To the N of Clifford Street the mid C20 takes over. On the E side Nos. 18–19 are by *Bernard Gold*, 1956 (altered), No. 20 by *Stone, Toms & Partners*, of 1951–4, in orange-red brick. On the w side the Police Station (q.v.), then No. 25, straight and utilitarian (by *G. Jeeves*, 1937–8, windows altered). Facing it and in marked contrast is *Curtis Green, Son & Lloyd*'s monumental FORTRESS HOUSE at No. 23, Government offices of 1949–50, built under the Lessor Scheme (now ENGLISH HERITAGE). Stone, three-sided and with a w forecourt, the lower parts with occasional Rococo bits (detailing *J. May*, carving *Laurence Turner*). The forecourt in particular, with its rusticated pylons and pedimented porch like a mausoleum, seems designed to frighten away non-initiates. The frame was considered innovative: the lifting clamps of the precast concrete beams acted as formwork for *in situ* casting of the rest.

The s flank of No. 23 extends along NEW BURLINGTON STREET, the last part of Burlington's estate to be built up, 1735–*c.* 1739. Nos. 1 and 2 remain on the N side, generally much tinkered with. Otherwise mostly earlier C20 commercial; the thoughtfully detailed No. 4, 1912, is by *Niven & Wigglesworth*.

SHEPHERD MARKET

A remarkable backwater, laid out *c.* 1735 and built *c.* 1746. The designer, builder and entrepreneur was *Edward Shepherd* (cf. Curzon Street, immediately N). It is a reminder of how carefully C18 speculators considered the provision of shops. The atmosphere is lazy and gently louche.

The CENTRAL BLOCK, rebuilt 1860, shows how late the Georgian tradition of unadorned brick persisted. Three storeys, stucco ground floors with shops, stucco cornice (mostly lost). A cross-passage is marked by tripartite windows. The W end, a storey lower, was rebuilt piecemeal *c.* 1840. The C18 market house was two-storeyed, the room above doubling as a theatre.

The little streets around are still dominated by *Shepherd*'s simple three-storey houses, many refaced. To the E, Nos. 4–8 are his, as less obviously is No. 10, externally 1860s. The BUNCH OF GRAPES, l., with a nice relief panel, is dated 1882. More C18 houses in the block immediately to the W, with C19 and reproduction shopfronts. The way to Piccadilly is down WHITE HORSE STREET, a curving brick ravine off to the SE. On its r. side Nos. 1–4, modest early C19 houses above shops.

SOUTH AUDLEY STREET

The s exit from the W side of Grosvenor Square, running on beyond the Grosvenor lands as far as Curzon Street. Early C18 houses, and some very good later C19–early C20 buildings.

The N part begins boringly with the 1930s blocks facing Grosvenor Square (q.v.). The shopfront at No. 43, E side, is a Vogue-Regency confection of 1936 by *Howard Robertson*, for Holloways the builders. No. 55, w side, is by *T. Cundy II*, the altered survivor of three white brick palazzi of 1859–60. Ostentatious open-well staircase. Then a long swathe of 1880s–90s red brick and terracotta where Mount Street crosses E–W (q.v.), typical of the late C19 Grosvenor Estate. The same ample small Renaissance decoration continues on the buildings to the s. Nos. 64–70, w side, are by *T. Chatfeild Clarke & Son*, 1891–1900. T. GOODE & CO.'s china shop (Nos. 17–22), on the E side after the Grosvenor Chapel, is worth lingering over. Here in 1875 the 1st Duke of Westminster first intervened to stipulate a 'Queen Anne' design for a tenant. Goode's architect *Ernest George* (*George & Peto*), took to this brief with relish. The oldest part is Nos. 18–19 (1875–6), followed in 1876–7 by No. 17, r., with a lower gable and a zooming chimney on the flank. The Japanesey sunflowers in ironwork and brickwork (carver *Harry Hems*) were already established motifs; less so the twin shaped gables of Flemish type, and the niches with their big blue-and-white urns. Columns of red granite divide the shop windows. Finally in 1890–1 Nos. 20–22 were rebuilt, with a still larger gable and a return wing containing a separate private house. The corresponding return to the s,

i.e. of 1876–7, is a five-bay one-storey gallery with a blind arcade, its pilasters decorated by Japanese tile picture panels. A unique self-opening mechanical door leads to intriguing toplit showrooms, some with friezes and covings painted with birds and cherubs; heady stained glass attributed to *Daniel Cottier*.

After South Street the Georgian past comes forward with opposed ranges of 1736–9. The w side (Nos. 71–75) was by *Edward Shepherd*, the E (Nos. 9–16) by various other craftsmen. Many retain splendid plasterwork of the era. Exceptionally charming is No. 71 on the SW corner, probably meant as one end of a formal Palladian composition. A narrow front, one window wide. This is of Venetian pattern on the ground floor, with Doric columns inside square blocks, and first floor, with Ionic pilasters. Above, a plainer triple window, cornice, and pedimented attic storey with splayed window surround. Entrance in South Street, N, sheltered by a first-floor projection resting on four Doric pillars and two middle columns, perhaps a mid-C18 addition. Blocked doorway, framed by pretty wrought-iron obelisks supporting the lampholder. Pedimented behind, where the *point-de-vue* (glimpsed from South Street) is a tripartite pedimented blind screen with Neoclassical reliefs, facing the house across the leads of the service extension. Its obelisk top disguises the kitchen chimney flues. Entry is made to a stairhall with an open-well stair across the end, with a main room on each side and an extra room in the first-floor projection. Pedimented overmantels, the rear ground-floor room also with a splendid fireplace in the Kent style with carving representing Winter. Matching fireplace in the room above, carved to illustrate Summer. Typical *Shepherd* stucco ceilings with shallow foliage reliefs within thicker compartments. No. 72, much altered, has a doorway with a Gibbs surround.

The pilastered stone fronts of Nos. 73–75 are Edwardian improvements. *Paul Waterhouse* treated No. 73 for Robert Younger, 1909. Teasingly Neo-Neoclassical, with mannered motifs including wreaths and paired half-pilasters. The broad, quietly eccentric front of No. 74 is by *Balfour & Turner*, 1908, for Sir Cuthbert Quilter. Both have fine ceilings, at No. 73 probably by *John Shepherd*, Edward's brother and lessee, of quasi-strapwork form; also some plaster wall decoration. (Ceilings at No. 74, several with deep covings, may date from after the Portuguese Embassy acquired the house in 1740.) Larger still is No. 75, originally two C18 houses, united in 1775–6 for the 3rd Earl of Bute by *Capability Brown* and *Henry Holland*. Stone front of 1907, in a more Palladian taste, by *C.J. Corblet* for the banker-connoisseur H.L. Bischoffsheim; the entrance bay moved N when *F. Billerey* remodelled No. 75 for the EGYPTIAN EMBASSY in 1926–7. The S bay, on Deanery Street, is of 1897–8 by *Balfour & Turner*, the triple rear bows of before 1811 (the S pair perhaps of *c.* 1802 and by *Mylne*, for the 4th Earl of Bute). Colonnaded loggias along the garden, of 1926–7. Inside is a huge stony stairhall in *Billerey*'s accomplished Louis XVI style. (Three main first-

floor rooms. The Ballroom, N, has a ceiling inset with a replica of *G.B. Tiepolo*'s Venus, Eros and Chronos from the Palazzo Contarini in Venice, which Bischoffsheim installed elsewhere in the house (made *c*. 1969; original in the National Gallery). In the corners four allegorical grisailles of unknown provenance. The middle room is painted with naturalistic flowers and arabesques, much restored, but possibly of 1775–6 in part. In the S room a ceiling made of tapestries, probably done for Bischoffsheim before 1880, moved up from the room below.)

The contemporary houses on the E side, mostly stuccoed, are less palatial; Nos. 9, 10, 12 and 14 retain good ceilings. No. 14, the widest, was built by *Roger Blagrave*. Much-altered back additions for the sculptor Sir Richard Westmacott, after 1818. Front-hall staircase. Nos. 12 and 13, by the plasterer *William Singleton*, have rusticated ground-floor surrounds. In No. 12 ceilings with birds, amorini, and plaited or interlaced patterning. Nos. 9 and 10 are a pair, each two bays wide. No. 9 has a wide bow to the E and a C19 entrance in Hill Street, S, below a projection like that at No. 71 but with only three columns, probably added *c*. 1754. (Both have central staircases, small, but going through two storeys around three sides.)

Hill Street marks the end of the Grosvenor Estate. Development S of here, on a mixture of Berkeley, Curzon and Abbey land, took a few years longer. No. 8 on the SE corner is of 1744, but heightened and embellished, probably in 1877 and by *J.T. Wimperis*. Ambitious five-bay front with a shallow central projection. First-floor Venetian window, and the blocked outline of a lunette over it, with a smaller inserted window. Big C18 stone staircase to the l. Its balustrade looks of 1877 or later, as does the column-screen in the hall. Facing (W SIDE), Nos. 76–77, 1970–1 by *Renton Howard Wood Associates*. One of the last Modernist enterprises in residential Mayfair before the conservationist révanche. Massive boxy frame of creamy fine-textured concrete, oversailing upper floors, tinted glazing set flush. No. 78, *Ernest George & Yeates*'s house for Col. E. Whittock, is partly incorporated with Nos. 76–77 inside. Dated 1904, stone, English late C17 style. Nos. 80 and 81 are C18; on No. 81 a mid-C19 stuccoed bay on short Corinthian columns with cabbagey capitals.

Facing this group on the E SIDE is the widening called AUDLEY SQUARE. Its only C18 survivor is No. 3, of 1749–51, unusually with four stone bands. The stark brick AUDLEY SQUARE GARAGE, by *Frank Risdon*, 1959–62, was the first multi-storey car park built by Westminster Council (demolition proposed). Then on the W side the corner with TILNEY STREET, and on its N side Nos. 1–3, originally of 1751–3. No. 1 has pretty Louis XV-tinged interiors, probably early 1830s.

Finally the group on the E SIDE, eclectic Queen Anne as rich and confident as anything on the Grosvenor lands. No. 2 Audley Square, *c*. 1880 by *T.H. Wyatt*, was for Lord Arthur Russell, whose arms appear on the N flank. Hot red brick, dressed with both terracotta and pink sandstone, with one fat Doric column below. Grand first-floor library with column-screens. Nos. 1

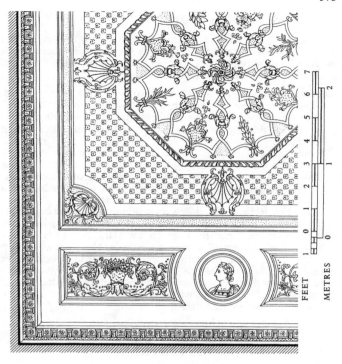

No. 12 South Audley Street. Drawing of ceiling detail
(*The Survey of London*)

and 2, red brick with very gay Renaissance detail, more broken and agitated. No. 2 is by *G.L. Crickmay*, 1883–5, for William Nicholson MP; No. 1 of *c.* 1878–9, designed by *F.P. Cockerell*, completed after his death by *Aitchison Jun.*, for the banker Stewart Hodgson. Rich, well-preserved interiors in both, with crusty plasterwork, ambitious fireplaces, and much dark carved wood. On No. 1 a fine frieze modelled by *Boehm*. The important Aesthetic Movement decoration, executed to *c.* 1893, was restored in 1991. Copies replaced the drawing-room friezes of 1885 by *Lord Leighton*, removed to Leighton House, Kensington, in 1975. Leighton's fellow-artists were *Walter Crane* (mosaics, and a plasterwork zodiac on the staircase vault), *W.E.F. Britten* (painted friezes), and *W. de Morgan* (tiles). For the extreme s part *see* Stanhope Gate.

SOUTH MOLTON STREET

A diagonal accent in the Mayfair grid, marking the line of the Tyburn. Rocque's map (1746) shows the NE side already built up. Much rebuilding c. 1900. Successfully pedestrianized in 1970; since then a redoubt of smart boutiques.

Coming from Oxford Street, the HOG IN THE POUND pub, SW side, with streamlined prow, is by *Musman & Cousens*, 1959–60. Opposite (NE SIDE) begins the characteristic mixture of modest older houses (Nos. 37, 40, 41) and taller Edwardian commercial (Nos. 38–39, *R.M. Roe*, 1902, No. 42, *E.K. Purchase*, 1908). Facing, Nos. 14–26, a near-unbroken C18 run, most with inserted shopfronts. Nos. 21 and 17 (William Blake's house in 1804–20) have timber Doric doorcases. On the NE SIDE again, No. 48, 1911, with Neo-Art Nouveau reliefs of maidens: relics of 1960s psychedelia? Nos. 57–62 are of 1905 by *Ridge & Waymouth*, an original design: red brick patterned with flush stone, brown granite shopfronts, ironwork of uncanonical form. Back on the SW SIDE, No. 13 is of 1902 by *Read & Macdonald*, subdued for them. Nos. 3–9 were built c. 1902 in connection with Symonds' Hotel in Brook Street (q.v.), by *Giles, Gough & Trollope*: a logical elevation with round-arched showroom windows and window triplets above. On the NE SIDE, No. 63, with a late C18 *Coade*-stone doorcase and a surprisingly rich first-floor ceiling.

SOUTH STREET

An E–W street at the S end of the Grosvenor Estate, its character mostly derived from its neighbours. The W end begins on the S side with dull 1930s flats of Park Lane type. They face No. 9, Postmodern offices by *Trehearne & Norman*, 1998–2000. Its close-textured motifs and stone banding take after Nos. 8–12 PARK STREET to the N, survivors of a terrace by *A.H. Kersey*, 1897–1901. In an elusive style of c. 1500, with net-like mullions and transoms. No. 15, N side, and Nos. 24 and 26, S, survive from rebuilding of 1828–36 by *J.P. Gandy Deering*, assisted by *James Gallier*. On No. 24 a squared-off Grecian porch; No. 26, a former coach house, was heightened and remodelled c. 1928. Big back wing for the Egyptian Embassy, 1996–8. The charming William-and-Mary house at No. 28 was *Detmar Blow*'s début on the Grosvenor Estate, 1902–3 (internal details by *F. Billerey*). Built by Sir Cuthbert Quilter for his son, replacing stables linked behind with Quilter's No. 74 South Audley Street (q.v.). For Balfour Mews opposite *see* Mount Street. No. 25, of 1932–3, has a Deco-Chinoiserie porch added in 1936 (*W. Turner Lord*), and a number plaque carved with cavortings by *Sir W. Reid Dick*.

To the E of South Audley Street some small houses of c. 1737 on the S side (Nos. 30, 34, 36; Nos. 32 and 32a are reproductions,

c. 1981). No. 38 was the last private mansion built in Mayfair, begun in 1919 by *Wimperis & Simpson* and *Murray Easton* for the future 2nd Lord Aberconway. Unapologetically nostalgic English Baroque: three storeys, four pilaster strips, porthole mezzanine windows at the ends. Each major floor has just three main rooms, with a near-full-width hall and gallery to the street and non-matching bow-backed rooms behind. Some internal detail by *H.A. Peto*, e.g. the entrance with black marble pilasters dressed with white metal, and cantilevered stair twisting up in the apse. The big GARDEN behind, made 1915–16 by *E. Wimperis*, is shared with the Neo-Georgian houses to the E, and round the corner in Hill Street (q.v.). Nos. 39–47 on the N side are of 1896–8 by *J.J. Stevenson*, Northern Renaissance of a jackdaw kind, with deep recesses to light the staircases. Superbly crafted rubbed brick porches (builder *William Willett*). Beyond the Grosvenor pale, on the S side past St George's School (q.v.), Nos. 56–58: a mews refronted by *Lutyens*, 1935–6, with discreet but distinctive stucco detail, and No. 51, N, a big stack of flats by *E.K. Purchase*, 1901.

STANHOPE GATE

So short that it appears almost like a close off Park Lane. This was more striking before CHESTERFIELD HOUSE was replaced by a hulking big block of flats of commercial design by *P.V. Burnett* and *Cecil Eprile*, 1934–5. It sets forward from the C18 site. The house was a sad and unjustifiable loss: an astylar mansion by *Isaac Ware*, built 1748–9 for the famous 4th Earl, at great expense and with the greatest elegance. It had a *cour d'honneur* with colonnades and balancing side blocks, and interiors in both advanced French Rococo and sober Palladian. In 1869 the property was sold, and houses built on its gardens and the sites of the wings (q.v. Curzon Street and South Audley Street). Sir Michael Bass then bought the house, in 1885, and *Edis* modernized it for him.

There were no houses between here and the park until after 1757, when a lease was granted to *John Phillips*, who sub-let building plots. A view of 1761 shows the new street lined with three-storey, three-bay houses. Post-war losses were cruelly heavy, though the replacements are not too grating. On the N SIDE towards the park Nos. 9–11 remain, No. 10 with an early C20 stone porch and other alterations. *Sheppard Robson*'s No. 13, 1998–2000, has whimsical railings in front. Other preserved façades on the S SIDE: No. 6, with a solid Gibbsian porch probably from alterations by *Decimus Burton*, 1853–4, and No. 5, refaced *c.* 1910 in elegant Louis XVI stone. To the E are offices, including *Gensler Associates*' No. 1 of 1999–2000, Postmodern Neo-Georgian. Metal GATES on its S side by *Freeform*, symmetrically pierced with little leaf shapes.

STRATTON STREET

Laid out after 1684 across the w strip of the gardens of old Berkeley House, predecessor of Devonshire House. A close until 1924, when the Devonshire gardens on its E side were built on, and an extension made into Berkeley Street at the N end.

The former character is shown by No. 6 (w SIDE), C18, in the early C19 given stucco and a pretty shallow bow on an ornamental cast-iron support. No. 8 is an unusual West End house type, quite ambitious Gothic Revival by *Ernest George & Vaughan*, dated 1871. Brick with stone dressings, the composition somewhat undecided, e.g. in the slipped alignments of the floors. At Nos. 10–14 a kind of Postmodern Cotswold front with unequal gables, of 1988–9 by *Michael Twigg Brown & Partners*. Nos. 15 and 16, by *C.J. Harold Cooper*, are a good Arts-and-Crafts pair designed in 1897 for H.A. Johnstone. No. 15, a house of stone, has non-matching gables and a big bay window inset high up. Fantastical details, e.g. the rainwater head by *J. Stirling Lee*, fashioned as a contorted dragon. Its gorgeous interiors are destroyed. No. 16, bachelor chambers of fine variegated brick, has unusual splayed reveals. On the E SIDE, big new offices of 1999–2002 by *EPR Architects*, stone-faced under a giant mansard. Thin steel-framed window guards. Where the street turns E, No. 17 (N side), red brick flats by *R.J. Worley*, 1893. Rebuilt behind, 1987. For the May Fair Hotel to its r. *see* Berkeley Street.

SWALLOW STREET

The s part of what was until the early C19 a major N–S route between Piccadilly and Oxford Street, mapped in its N part as early as 1585. The rest was swallowed by Regent Street, but the westward sweep of Nash's Quadrant reprieved this fragment.*

Coming from the s, No. 12, on an E corner, is the former Swallow Music Hall, 1890 by *R. Sawyer*. More businesslike than recreational, in brown granite and salmon-pink brick and stone. Next to it in Vine Street, r., an early Police Station, 1868–9 by *T.C. Sorby* (disused). Red brick, brutal Gothic-derived detail, minor polychromy. Back extension of 1897–9 by *Dixon Butler*, with a free Gothic front at No. 14 Swallow Street. On the w side Nos. 11–15, *Sawyer* again, 1873, robust polychromatic brick with Italo-Gothic borrowings.

UPPER BROOK STREET

One of the very best Mayfair streets for private houses. It runs w from the NW corner of Grosvenor Square, and was built up in 1728–59. Besides the C18 survivors, the predominant types are

*Another bit lingers on as Swallow Passage, off Oxford Street just w of Oxford Circus.

the mid-C19 Grosvenor-Italianate fostered by *Thomas Cundy II*, and Anglo-French stone-faced mansions of *c.* 1905–15. No postwar buildings at all.

The N SIDE at first faces the flank of the US Embassy. No. 2, 1915 by *Wimperis & Simpson*, is in the Frank Verity style, with an outswept oriel. Nos. 3–5, 7 and 8 are of 1730–2, variously altered; No. 4 in 1858 with the standard *Cundy II* kit of parts, No. 5 less drastically, with quoins. At No. 6 flats by *W.E. Masters*, 1936, Odeonish. Keystone carved by *Newbury Trent*. Nos. 9–10, courteous Neo-Georgian of 1937–8 with balancing bows, are by *Wimperis, Simpson & Guthrie*, with two houses in Shepherd's Place behind. By now the S SIDE has houses too: No. 53, probably 1826–7 for George Farrant, No. 52, 1730 and little altered, and No. 51 by *R.G. Hammond*, 1905–6, with a big gable and oriel. The twin Nos. 49 and 50, 1907–8 by *Maurice Hulbert* with *Rolfe & Matthews*, have giant Ionic pilasters and crammed C17 Anglo-French ornament. Nos. 47 and 48, *c.* 1730–2 under stucco, retain the C18 three-storey height. No. 11 (N side) is Italianate of 1852–3, No. 12 an C18 carcase with a broad Neo-Wyatt front of 1948–9, when *T.E. Scott* converted it for the Canadian High Commissioner's house.

Across Park Street the sides can be taken separately. The N SIDE shows the nice variety achieved in early C20 rebuilding: No. 16, 1912–13 by *E. Wimperis*, No. 17, 1908 by *Wimperis & Best*, also gabled, and No. 18, 1913–16, *Wimperis* again, with interiors by *Ralph Knott & E.S. Collins*. Nos. 19–24, of *c.* 1737–42, are marked by successive updatings inside and out. No. 19 is typical: Cundy-type dressings 1864–5, top storey 1885–6, showy porch 1903–4, by *Romaine-Walker & Besant* for A.W. Davis (also the lavish interiors, with *Mellier & Co.*). No. 21 was stuccoed as late as 1973, No. 22 reconstructed in 1881 by *R.F. Russell*, for the Rev. Sir William Darrell, Bart., in an undecided style. Two Edwardian houses to finish: No. 25, 1907–8 by *Hammond* for Sir Lewis McIver, Bart., and *Arnold Mitchell's* No. 26, 1908–9. This is gabled, externally plainer, but rich within; plasterwork probably by the *Bromsgrove Guild*.

S SIDE. No. 42, with a house-like front, shows that the age of the flat had arrived: 1928–9, by *T.P. Bennett & Son*. At No. 41 a rather Gibbsian stone mansion, 1906–7 by *R.S. Wornum*; of similar type No. 39, 1914–15 by *Wimperis & Simpson*, and No. 37, 1907–8 by *Hulbert*. No. 40 is C18, disguised; No. 38, 1736 with a fine doorway of *c.* 1810, has been stripped back to a Georgian appearance. Best of all are Nos. 35 and 36, a handsome pair of 1737 with doorcases of Gibbs pattern, quoins and vermiculated keystones. Top storey of 1846, a careful match; at No. 35 a lamp overthrow on obelisks, reaching up to the shared early C19 balcony. No. 36 has an unusual plan: a fronthall staircase, with a spacious lesser stair rising from first-floor level behind it, and a full-width back room on the ground floor. This has twin pilastered doorcases, and robustly detailed panelling and ceiling, echoed in other rooms; also some original stone fireplaces. No. 34, 1756, has channelled C20 stucco. No. 33, also of 1756, was remodelled in 1767–8 by *Sir Robert*

p.
28 *Taylor*. John Boyd of Danson, Kent, procured the work, appar-
ently as a speculation. Taylor made three arched openings with
Tuscan columns in the jambs below, with balustraded windows
above. His full-width pediment was replaced by C19 heighten-
ing. Central entrance. In the hall the triple Tuscan columns
recur, forming a vaulted passage with guilloche-banded arches.
Its ends have groin vaults, with a flat dome in the middle where
the staircase opens off. Its S-scroll balustrade may date from
restoration of *c.* 1980. (First-floor front room a perfect cube,
main rear rooms originally large octagons.)

UPPER GROSVENOR STREET

It runs W from the SW corner of Grosvenor Square. The mixture
of private houses is like that of Upper Brook Street, its counter-
part to the N, but with less of the mid C19 and more of the C20.

Of the original houses of 1727–*c.* 1738, No. 48 (S SIDE) is the
best preserved. By *Robert Phillips*, bricklayer, 1727–9, of two
p.
28 bays, with typical lacing of the segment-headed windows
by vertical red brick bands. Timber Doric doorcase with
grotesque mask. (Central staircase plan; interiors of 1920,
by *White Allom* in Early Georgian style, and 1935 by *Syrie
Maugham* for Mr and Mrs George Whigham, the best
surviving example of her work, including a bedroom with
mirrored pilasters and an all-mirrored bathroom.) No. 47 is a
coarse refronting by *R.G. Hammond*, 1905, of an 1820s house.
Ameliorations by *Mewès & Davis*, before 1934, e.g. the cross-
arrow fanlight. At No. 46 dull Neo-Georgian flats by *F. Billerey*,
1937–9, but Nos. 44 and 45 are original, a good pair each of
three bays, with brick cornices. On No. 44 a superior pedi-
mented Ionic doorcase. (No. 45 still has its mews house,
formally composed on the garden front.) *Turner Lord* designed
the fronts of Nos. 41–43, 1912–14, a near-symmetrical group
with a central pediment; Nos. 42 and 43 are structurally
1730s, Neo-Georgian within. Next some stone-faced flats by
Wimperis, Simpson & Guthrie, 1934–6 (Nos. 39–40).
The N SIDE begins past the US Embassy with No. 6, 1825–6
(builder *Samuel Baxter*), with round-arched lower windows.
Nos. 7–9 are of *c.* 1729–30, of which No. 8 was refaced by
Lutyens, 1927–8. One of his fifty-guinea consultancies, and
rather uninspired. Characteristic grooved piers by the ground-
floor windows. On No. 9 a Greek Doric porch. (In its back
courtyard ceramic reliefs by *Gilbert Bayes*, probably 1928.)
The familiar Belgravian Italianate at Nos. 10 and 11, 1843–4
by *Henry Harrison* with *James Ponsford*. The busy carpenter
Benjamin Timbrell built and lived at No. 12, *c.* 1728, but it is
much altered.
After Park Street only the N side has houses, facing the side of
Grosvenor House (*see* Park Lane). Of the 1730s Nos. 15 and
16, No. 15 redressed by *T. Cundy II*, 1863–4, No. 16 stuccoed
p.
33 in 1881. Good interiors, especially in No. 15, of various periods.
Both have stone staircases with enriched wrought-iron balus-

trades, original at No. 16, at No. 15 an early C19 formation in the centre of the house. No. 18 has a central staircase of 1792–3 by *Charles Elliott*, of an elegant D-plan, with a balustrade matching that at No. 66 Grosvenor Street (q.v.). Stucco, porch, balcony etc. probably also 1792–3. The rest are mostly early C20 rebuildings or refrontings, a striking sequence. The most unorthodox is *Balfour & Turner*'s No. 17, 1906–7 for Arthur Hill. Like a C17 Netherlandish town house with its four wide-windowed bays and flat superimposed pilasters, but with thick naturalistic carving, probably by *Laurence Turner*. (Interiors by *White Allom*, with a wrought-iron balustrade after that formerly at their headquarters, No. 15 St George Street, q.v.) *Maurice Hulbert*'s No. 19 is very rich, with a Tuscan Venetian motif on the *piano nobile*. Built 1909–10; entrance modified by *Gerald Lacoste*, 1936, for a couturier. Nos. 20–22 are refrontings of 1908–10. No. 21, done for Gerald Bevan, is a rare work by *Ralph Knott*, the architect of County Hall, who died young, with *E.S. Collins*. Oval top windows, powerful first-floor aedicules. The more conventional No. 20, by *J.E. Trollope* for Isabella, Countess of Wilton, has contemporary Dixhuitième interiors by *Trollope & Sons*.

WOODSTOCK STREET

Built up from 1720, on the land of the 1st Duke of Portland, also Viscount Woodstock. It runs s from Oxford Street with commercial, fairly workmanlike buildings. On the w side the WOODSTOCK ARMS, dated 1876, Queen Anne trim on a harsh High Victorian armature. Next to it the flank of *Fletcher Priest*'s new block at Nos. 335–361 Oxford Street (*see* p. 468). Then on the E side No. 3 by *Treadwell & Martin*, 1907, in an unusual Neo-Baroque mood. No. 22, w side, by *Mitchell & Bridgwater*, 1933, is in a Fritz Hoeger brick idiom. Closing the view from the N, PHILLIPS, Wallis Gilbert style with polychrome faience decoration: 1938 by *Fuller, Hall & Foulsham*. BLENHEIM STREET turns w at the bottom into New Bond Street. No. 11, s side, is by *E.K. Purchase*, prosperous free classical, 1908.

ST JAMES'S

INTRODUCTION

St James's comprises an aristocratic district roughly one third of a mile square, sloping quite steeply down from just s of Piccadilly to Pall Mall and the edge of St James's Park. It falls into three main parts: St James's Palace in the sw corner, the L-shape made by Pall Mall and St James's Street, the outer angle of which touches the palace precinct, and the C17 court suburb planned by Henry Jermyn, Earl of St Albans, filling the inner part of the L and centred on St James's Square. Even the minor streets have plenty to show, while the big three of Pall Mall, St James's Street and St James's Square contain some of the most consistently exciting urban architecture in England. The Crown Estate, freeholder of most of the area, ensures that things are tidily kept up.

20, pp. 594 –5 By far the oldest of the three divisions is the palace of 1531– c. 1540, one of Henry VIII's creations, on the site of a leper hospital founded before 1100. The lands to its s and w were taken to make parks for hunting, which survive as St James's Park and

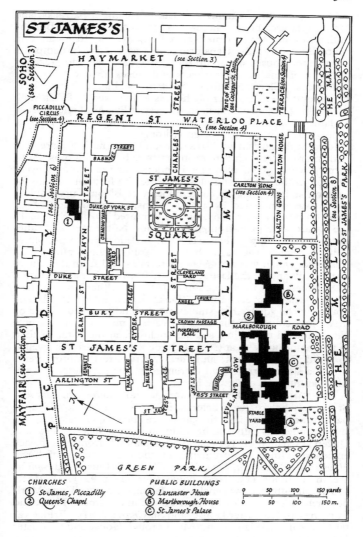

ST JAMES'S

CHURCHES
① St James, Piccadilly
② Queen's Chapel

PUBLIC BUILDINGS
Ⓐ Lancaster House
Ⓑ Marlborough House
Ⓒ St James's Palace

Green Park (*see* pp. 653, 656). By the 1580s the palace had acquired an approach road from the N, now St James's Street, as well as from the E, along a more ancient road a little S of the present line of Pall Mall. Buildings for the Court appeared near the palace from the 1610s–20s, including a 'royal' tennis court. The first enclosure or alley for the game of *palle-maille* also dates from this time, on the alignment of the present Pall Mall.

During the Interregnum the palace became a barracks, and ordinary houses began encroaching from the N and E. But the outlines of modern St James's date from after the Restoration in 1660. By *c.* 1690 the transformation was effectively complete. Aristocratic houses spread up the E edge of Green Park, reached by more or less irregular streets and closes lined with smaller residences (Cleveland Row, St James's Place, Park Place, Arlington Street). Further big houses were raised S of Pall Mall, overlooking St James's Park. In the rest of Pall Mall and most of St James's Street were lesser properties, many used as taverns, shops, and lodgings for foreign visitors.

Lord St Albans's new district, around St James's Square, was both more orderly and more innovative. It was the most complete piece of town planning London had seen since Covent Garden in the 1630s, and closer also to the future template for London squares than its contemporary at Bloomsbury Square, which was dominated by a great mansion on one side. Work went on rapidly after 1665, on land granted by the Crown. In the square were plain-fronted houses for 'Noble men and other Persons of quality'. They were put up mostly by speculative builders, which was usual, but were sold freehold rather than leasehold, which was not. Major streets extend from the square to the E, W and N, the last aligned on *Wren*'s new parish church of St James, built in connection in 1676–84. Other streets run to the N (Jermyn Street) and W (Duke Street, Bury Street). The houses of the square had stables etc. behind, reached *ad hoc* by mews and courts off the lesser streets. A market was also provided, housed wisely in a smaller enclosure at the E, rather than in the main square as at Covent Garden. This E area was levelled to build Regent Street, and further C19 street improvements widened some narrow road entrances on the perimeter, but the C17 plan remains otherwise intact.*

The HOUSES of this select area include some real marvels. St James's Palace itself belongs in the second rank of Tudor palaces, however, though the gatehouse and chapel make impressive episodes. Its outstanding addition is *Inigo Jones*'s crystalline
28 Queen's Chapel of 1623–5, now separated from the palace enclosure. Other improvements, by the starry names of *Wren, Hawksmoor, Vanbrugh, Kent, Nash* (Clarence House) and *Smirke*, are in a minor key. Next come four great PRIVATE MAN-
49, SIONS, all with their own enclosures facing the parks: *Wren*'s Marlborough House, *Vardy*'s Spencer House in St James's Place, and
57 from the C19 Lancaster House, and *Sir Charles Barry*'s Bridgewater House in Cleveland Row. (Marlborough House and Lancaster House are now Government buildings, and have their own entries.) The more numerous second rank includes the late C17
34 Schomberg House in Pall Mall, now just a façade, parkside C18 houses by *Kent, Gibbs* and *Leoni* in Arlington Street and Park Place, and some magnificent terraced houses in St James's Square, where *Robert Adam, 'Athenian' Stuart, Matthew Brettingham Sen.* and *Lutyens* are all represented. The last new mansion was No. 23 St James's Place, a Rothschild house of 1929–30.

*For the site of the market *see* Haymarket, pp. 413–14.

None of the C17 houses of St James's Square survive, and surprisingly few SMALLER HOUSES of the C17–C18. The Crown Estate's policy for many years was to replace such houses with the RESIDENTIAL CHAMBERS that are such a feature of the area. The earliest survivor is No. 18 St James's Square, 1846–7, externally still like a big private house. Those in the streets around tend to be less lavish, and almost always have shops below. Bury Street is full of them, including a recently identified set by *Butterfield*; the best are two 1900s blocks in Jermyn Street, by the unprolific *Reginald Morphew*. Many other COMMERCIAL BUILD-INGS were built likewise with tiers of flats, including *Norman Shaw*'s two for the Alliance Assurance at the s end of St James's Street. Post-war offices are generally less notable, with the exception of *Alison & Peter Smithson*'s famous Economist group of 1962–4 on St James's Street, a master-stroke of urban design. Other post-war highlights are *Denys Lasdun*'s bold flats at No. 26 St James's Place and *Donald McMorran*'s meditative stripped-classical offices at Nos. 100–109 Pall Mall. Post-war offices are now giving way to Postmodern or contextual blocks faced in reconstituted stone (St James's Square, King Street, Pall Mall).

In the end, however, it is for its CLUBHOUSES that St James's is best known. The first clubs emerged in the mid C18 from the ranks of older inns, taverns and coffee houses along Pall Mall and St James's Street. They were centres of conviviality, gambling and politicking, for which an imposing but relatively simple building with a few large interiors was required. White's, Brooks's and Boodle's, all in St James's Street, are of this C18 type. A new category appeared in the early C19, owned by the membership rather than by private proprietors. Reading and study were provided for within most of this second wave, typically in a library subdivided by column-screens at each end, with casts of sculpture to lend an air of classical culture and learning (cf. the Athenaeum, Waterloo Place, pp. 446–7). Since Victorian clubmen could no longer be assumed to have a 'town' address, bedrooms too began to be provided. *Barry*'s Reform Club in Pall Mall (1838–41) was the first to assimilate all these innovations, and the first also to perfect the Italian palazzo style, which Barry initiated at the Travellers' of 1829–32 next door. A prosperous Italianate soon became the norm for major new clubs, though the other chief examples have been demolished. The Palladian or Late Classical type of the 1820s–40s has lasted better: the former Crockford's and Conservative clubs and the present Carlton in St James's Street, and the Oxford and Cambridge in Pall Mall. Lesser Victorian clubhouses could be more mixed in style and function, with offices and flats incorporated (No. 63 St James's Street). *Mewès & Davis*'s huge Royal Automobile Club in Pall Mall, of 1908–11, is the last of the line, exceptionally lavish inside, with a swimming pool and other facilities for sport and leisure.

The clubs and clubmen help keep the heart of old St James's beating. Another traditional speciality that flourishes is luxury shopping, sometimes carried on behind appealing Georgian or Victorian SHOPFRONTS (Jermyn Street, St James's Street). Larger establishments are less common. Two examples are *James Pennethorne*'s much-altered bazaar building at No. 10 St James's

94

114

69, p. 613 p. 612

Street, a white stucco elephant of 1830–2, and Christie's urbane showrooms in King Street, 1893–4. PUBS are scarce, and the only THEATRE, in King Street, was demolished in 1957.

FURTHER READING. The *Survey of London*, vols. 29 and 30, 1960, covers all but the extreme SW and NW parts. General accounts are few. J. Glasheen, *St James's, London*, 1987, is the most recent. St James's Square is the subject of books by A.I. Dasent, 1895, and D. Forrest, 1986. St James's Palace is covered by the *History of the King's Works* and by J.E. Sheppard, *Memorials of St James's Palace*, 1894 (2 vols.), Pall Mall by J.M. Scott, *The Book of Pall Mall*, 1965. For the two chapels *see* D. Baldwin, *The Chapel Royal*, 1990. Books by C. Hussey, 1949, and J. Cornforth, 1996, cover Clarence House. Spencer House and Lancaster House have monographs respectively by J. Friedman, 1993, and J. Yorke, 2001. D. Watkin et al., *A House in Town*, 1984, covers No. 22 Arlington Street. An overview of the clubs is given by A. Lejeune and M. Lewis, *The Gentleman's Clubs of London*, 1979, and articles by S. Ramsey in the *Architectural Review*, 1913. Many also have individual histories, though not all pay attention to architecture; P. Ziegler & D. Seward, *Brooks's*, 1991, and J. Thole, *The Oxford and Cambridge Clubs in London*, 1992, are two that do. For the Economist group *see* Irénée Scalbert in *A.A. Files* 30, 1995.

CHURCHES

ST JAMES PICCADILLY

Of 1676–84 by *Wren*, a large church built in connection with Lord St Albans's great plan for St James's. The bricklayer was one *Hobson*, the masons *John Barratt* and *Abraham Storey*. Heavily damaged in 1940–1, it was restored in 1947–54 by *Sir Albert Richardson*, who reversed some alterations and introduced others.

Wren's materials are red brick with stone quoins and dressings; the copper-covered roof is Richardson's. Plain W tower in front of the W front, with the Jermyn arms carved over the door. The church sides have windows in two tiers, segment-headed below round-headed. On each central window are volutes and a keystone carved as a cherub's head: relics of the transverse axis Wren introduced in deference to the S approach from St James's Square. Doorcases below them have been removed, the N one in *Thomas Hardwick*'s repairs of 1803–4, the more elaborate S one in 1856. Wren's church had a timber cornice; now the N side has a plain parapet by *Richardson*, the S side a modillion cornice by *J. T. Wimperis*, 1884. The OUTSIDE PULPIT to the N churchyard is by *Temple Moore*, 1902. At the E end a broad tripartite window with a Venetian window immediately above, and oval windows to the upper aisles, blocked in 1743. A Wren drawing shows an elegant curved parapet instead of the clumsy gable

executed. The SPIRE, as so often, came later. The present one is
a fibreglass replica, completed 1968, of the lead-covered spire
of 1699–1700. The designer may have been *Edward Wilcox*,
carpenter, or *Wren* or his office. It has a square clock stage sup-
porting an octagonal open arcade and a tall obelisk and weather-
vane. It replaced a simpler design of 1686–7 by the carpenter
Jonathan Wilcox, father of Edward, which was making the tower
walls crack. The top stage of the tower is a harsh facsimile, also
of 1968. Not restored were four little corner obelisks, removed
probably in 1756. The N and S tower lobbies are of 1856 by
Charles Lee, the N one reduced in height by Richardson.

The rebuilt INTERIOR is wide and spacious. Its special
interest is that, according to Wren, it was the most prac-
tically arranged of his large 'auditory' churches. Five bays, with
galleries on square pillars. Corinthian columns on them carry the
barrel vault of the nave. This setting of columns above piers was
a breakthrough for Wren, and he repeated it in the City, e.g. at
St Andrew Holborn. The aisles have transverse barrel vaults pen-
etrating into the main vault. No acknowledgement is made of the
former cross-axis. The restorers reproduced Wren's plasterwork
convincingly, and also some big roses introduced in 1836–7. One
change Richardson made was to run the upper cornice across the
E wall, in line with the lower tier of the window. He also put
timber staircases in the W vestibules, instead of stone ones.

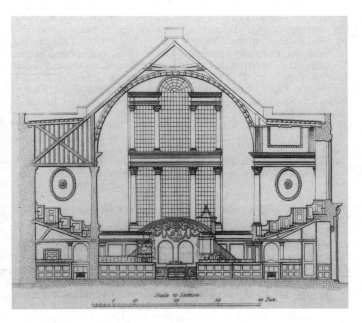

St James Piccadilly. Section, north to south. Engraving
(John Britton & A.C. Pugin, *Illustrations of the
Public Building of London*, 1825–8)

FITTINGS. The key pieces escaped destruction. They are more courtly and luxurious than those of the City churches. REREDOS with carving by *Grinling Gibbons*, given by Sir Robert Gayer in 1684 (restored 1846). John Evelyn, overwhelmed, wrote: 'There was no altar anywhere in England, nor has there been any abroad, more handsomely adorn'd.' Low and broad, under a big segmental arch. The exuberant limewood garlands of flowers and fruit are composed like one of Gibbons's secular overmantels. Central sunburst of cedar to *Richardson*'s design. – COMMUNION RAILS also of 1684, most unusually of white marble. The openwork panels were replaced in bronze in 1821 (maker *Samuel Parker*). Enlarged 1878. – COMMUNION TABLE of oak, with twisted columns, 1684 (altered). – STAINED GLASS. E window by *Christopher Webb*, 1954, traditional. – FONT. By *Gibbons*, 1686; *Arnold Quellin*, his collaborator, may also have worked on it. Of marble. The stem is the Tree of Knowledge, and Adam and Eve stand to its sides. Bowl with reliefs of the Baptism of Christ, the Baptism of the Eunuch, and the Ark on the Waters. The whole of a somewhat Victorian-looking opulence, influenced presumably by pulpits in the Netherlands. The C17 cover, with large flying angel, is lost. – ORGAN. By *Renatus Harris*, from the chapel at Whitehall Palace, 1686; presented 1691 by Queen Mary. Case with three towers and segmental flats. Six angelic figures on top by *Gibbons*. Choir case added 1852 by *J.C. Bishop*. – PULPIT. *c.* 1862. Showy. – PEWS by *Richardson*, of oak, with integral uplighters. – PAINTING (S aisle). Pietà by *Ernest Jackson*, 1923, the setting 1953. – Bronze RELIEF of the Creation and Fall by *Uli Nimptsch*, given 1979 (W end). – Big ROYAL ARMS in the N vestibule. Probably that paid for in 1688, but altered under William III. – MONUMENTS. Many tablets. N aisle: Sir Francis Lumm †1797, by *P.F. Chenu*. The usual mourner. – William Yarrell, zoologist, †1856. With snakes and swans. – 1st Earl of Lifford †1749, with cherubs holding up drapery. – Mary Johnson, lettered tablet by *Eric Gill*, 1930. – W end. J.T. Wimperis, the architect, †1904. – Earlier monuments in the galleries. 1st Earl of Romney †1704 (N gallery, reset). Trophies above and below. Putti on twisted columns to l. and r. Signed by *W. Woodman*. – Similarly composed, 8th Earl of Huntingdon †1704 (S gallery). Its columns have twisted lower parts, with putti sitting outside. According to Vertue by *Francis Bird*. – James Dodsley, 1798 by *Flaxman*, an open book (NW vestibule). – James Hamilton †1814, with Mathematics personified (SW vestibule). (– Under the tower, J.O. Harrison †1833, with bust by *W. Behnes*.)

Plenty to see in the CHURCHYARD, which has been used as a market in recent years. RAILINGS to Piccadilly of 1955, incorporating GATES designed by *Sir R. Blomfield* and made by *Bainbridge Reynolds*, 1937, the piers for which were destroyed by bombing. W of the church a FOUNTAIN of 1947–8, a memorial to the 1st Viscount Southwood, publisher and philanthropist, who paid to have the garden laid out W of the church. Designed by *Richardson*, with figures of infants by *Alfred Hardiman*. Also by *Hardiman* the bronze STATUE of Peace, a Grecian maiden, further W. To the S another statue, of stone: Mary of Nazareth, by *Charles Wheeler*, given 1975. Dated 1920, which would be very

early for something so stylized in England. Just W of the tower the CHURCH ROOM, a well-mannered aside of 1899 by *Wimperis & Arber*. Heightened by *Richardson & Houfe*, 1950; converted to a café in 1983. To Piccadilly, NE, the RECTORY and VESTRY by *Austin Blomfield*, designed 1946, built 1954–6 (future uncertain). Neo-Early Georgian, to balance Lutyens's bank (*see* p. 558).

QUEEN'S CHAPEL
Marlborough Road, off Pall Mall

Being locked except for services, the Queen's Chapel is not as famous as it ought to be. Not only is it one of the best preserved of *Inigo Jones*'s few surviving works, it is also the first church in England built in complete opposition to the habits of the Perp Gothic. In ecclesiastical architecture this had lingered on through the C16 and was to linger on through the C17, until Wren appeared. But the Queen's Chapel is unhesitatingly and uncompromisingly classical, and it is furthermore of a simplicity and beauty rarely matched in the more ingenious and complex designs of Wren. It was begun in 1623, when a Spanish Match was projected for Charles, Prince of Wales, and was described as finished in mid 1625, by which time Charles was king and had instead a French queen. So it was from the beginning a Catholic chapel, and to serve it a community of friars was later installed in St James's Palace. The connecting buildings burnt in 1809, and then in 1856–7 the road was made separating palace from chapel, which now appears misleadingly to belong with Marlborough House. From the 1690s it was much used by Continental Protestant courtiers, then in 1938 it became a Chapel Royal again.

Externally the chapel is brick, from the outset rendered and 'drawne like ashler', with Portland stone quoins and dressings. The plan is a plain rectangle, with a double-cube interior lying E of the Royal Closet, a spacious gallery or pew. Pediments at each end, linked by a blocked cornice of the kind associated with astylar Roman elevations. The W end owes much to the centrepiece of Jones's design for the Prince's Lodging at Newmarket, 1619. It has above the entrance three principal windows, the middle one arched, which come right down to the floor of the Royal Closet. The joinery of the cross-windows appears to be original. S of the W end an auxiliary wing, two bays wide and two storeys high. Its upper windows are plainer, its lugged and triple-key-blocked lower windows richer than those on the chapel. Balancing vestries on the N side were pulled down before 1729. At the E end is a broad Venetian window, the earliest to survive, it seems, in England. It has square Corinthian columns paired in depth. Beyond was a choir for the friars, for which a low domed addition was made in the 1660s (dem. 1709). The side windows have pediments on brackets and more ornate frames than at the W end; the three on the N side are restored, but they match an original window on the S. Gutter spouts fashioned as lion masks punctuate the top member of the cornice. The roof structure is trussed, a system Jones introduced to England.

The beautiful INTERIOR is dominated by the splendid white 28

and gold coffered vault, of elliptical profile and with a richly detailed cornice below it. Palladio's engraving of the Temple of Venus and Rome is the model for the coffering, which is made up of carved timber rather than plaster (which Jones tended to avoid). It need hardly be said how fundamentally different this opulence of classical detail and this reposefulness are from the restless Jacobean ribbed panelled ceilings or open timber roofs. The walls are plain above and panelled below. Midway are coffered-arched recesses, that on the s housing the organ gallery. On the E wall the main cornice stops, and the Venetian window abuts somewhat awkwardly. The olive green colouring and the bright gilding at the E end date from 1938, and are based on original traces; the shade was modified after further tests of 1982.

Quite how the inside looked in Jones's time is not known. The first illustration dates from 1688, that is after three successive refurbishments for Catherine of Braganza, in 1662, 1679–80, and (by *Wren*) in 1682–4. Wren put in the blank s niche with cherub's head and garlands (*John Grove* plasterer). Its N counterpart went after 1819, to make a window in what had been a blind external opening. The date may be 1836, when repairs are recorded. These may also account for oddities in the front of the Royal Closet, which has triple openings and muddled details suggesting a mixture of C17 and later C18 (the garlands and drops). Jones's screen had Corinthian pilasters and must have appeared very different. Simple coved ceiling behind, in the C17 painted blue. Exposed and restored in 1949–51 by *F.L. Rothwell* (*Ministry of Works*), who removed C19–C20 partitioning. The CHIMNEY-PIECE on the closet N wall, of Reigate stone, is an incontrovertible *Jones* survival. The contrast in style to the Wren period is striking. Lower part after Scamozzi, with brackets in profile, upper part with segmental half-pediments and fruit-festooned uprights. Central cartouche added 1682 (partly renewed 1951).

The other C17 FITTINGS are refined in spirit. REREDOS of 1682–4, of unusual form, with quadrant wings pushing forward. Doorways in these gave access to the friars' choir. Busts of Moses and Aaron and other carving by *Gibbons*, who may have provided the whole design. Its pedimented centrepiece dates from 1938, of sympathetic design, made to frame a late C17 ALTARPIECE of the Holy Family from the Royal Collection. It is attributed to *Annibale* or *Agostino Carracci*. – ROYAL ARMS (Portugal and Stuart) also by *Gibbons*, over the E window, with angel supporters trailing festoons. – STALLS of after 1894 in their present form. They incorporate twin angled LECTERNS with drops and cherubs' heads, parts of a pulpit of 1679–80, carved by *William Emmett*. – COMMUNION RAILS with slim balusters, probably those made by *Sir Charles Hopson* and given by Queen Anne c. 1702. – ORGAN GALLERY with carved outcurved front. Almost certainly of 1662, when the organ loft was rebuilt. Central panel with trumpets, answering to that for which *Gibbons* was paid c. 1684. – ORGAN. Made by *J. Snetzler*, c. 1760, for Buckingham House; introduced in the 1830s. Moved from above the reredos 1950. – WAINSCOTING. Doubtless of 1662, since it matches the organ gallery better than the reredos. – CANDELABRA, two, early C18 type, introduced 1938.

PUBLIC BUILDINGS

LANCASTER HOUSE
Stable Yard, off Cleveland Row

The most grandiose private mansion in St James's, and the only one that is entirely free-standing. It was begun in 1825 as a royal residence for the Duke of York, George IV's brother and heir apparent (replacing the late C17 Godolphin House), and was at first called York House.* His architects, *Benjamin Dean Wyatt* and *Philip Wyatt*, had not finished the inside when the Duke died in a morass of debt in 1827. Next year the house was taken by the 2nd Marquess of Stafford, 'the Leviathan of Wealth' (later 1st Duke of Sutherland), and renamed Stafford House. The over-emphatic attic storey was added in 1833–6 by *Sir Robert Smirke* for the 2nd Duke. In 1912 the house was bought by Sir William Lever, the soap baron, who bestowed the present name, for use by the London Museum; in 1952–3 restored by the *Ministry of Works* for conferences and government hospitality.

The EXTERIOR is of Bath stone, like the Wyatts' Apsley House (*see* p. ••), but measures a full nine bays N–S and eleven E–W. Six-column Corinthian porticoes to Stable Yard, N (with columns paired at the ends), Green Park, W, and St James's Park, S. They rest on protrusions of the channelled ground floor, of which the N one acts as a *porte-cochère*. Also pilasters, deployed in pairs on the broad end bays of the S side and along the centre of the E front, and singly just outside the N and S porticoes. The windows of the first-floor end bays have pediments for extra emphasis. The low round-arched SE attachment was for the kitchen, *c.* 1835 by *Smirke*. Against the E garden wall, cast-stone STATUES of Sculpture and Architecture by *E.H. Baily*, 1828, from the E front of Nash's Buckingham Palace.

The INTERIORS had made much progress by 1827, and the retention of the Wyatt brothers ensured continuity of design when the 1st Duke resumed work in 1828–9. In 1833 the 2nd Duke called back *B.D. Wyatt* for the State Rooms, raising the pitch of ornament still further, but he also appointed an architect-in-charge: first *Smirke*, who finished off the lesser rooms, then in 1839–41 *Charles Barry*, who had been consulted informally from *c.* 1833 and who altered or completed several state rooms. The chosen style throughout is undoubtedly French, a very early version of the hybridized late C17 to mid-C18 strain usually termed Louis XIV. The Wyatts also used it at Apsley House and Crockford's in St James's Street (*see* pp. 486, 638–9), and some motifs from Apsley House recur here, e.g. the interlaced borders of laurel and palm. The principal rooms are decorated in white and gold with walls of red or green fabrics. Some craftsmen deserve mention: *F. Bernasconi* and his firm, including *Robert Robson* (plasterwork); *George Jackson & Son* (the more intricate

*Supplanting more modest designs by *Robert Smirke*, which were disliked by the King and the Duke's mistress, the Duchess of Rutland.

relief ornament, in putty composition); *J. Browne & Co.* (fire-places); *W. Croggon* (scagliola).

The PLAN is that laid down for the Duke of York, with only minor revisions: on the first floor, a picture gallery along the whole E side, drawing rooms on the S, sitting rooms and bed-rooms facing the park on the W, and a State Dining Room on the N. The ground floor has additional State Rooms, an excep-tional thing in a town house, along the S side.

The entrance is a low VESTIBULE with apses and columns to l. and r. and a column-screen ahead. Through this is the central volume, an exceedingly spacious STAIRHALL, finished by 1829. Its hugely coved and coffered ceiling carries an oblong lantern itself as big as a large room, with black atlantes (by *Bernasconi*) between the windows. The stair below starts in one arm, breaking by 90 degrees into two and again by 90 degrees, the half-landings on brackets with black figures of herms modelled by *M. Mazzoni.* Columns on the first-floor gallery on the shorter sides only (E and W), with balustrades between, derived from the chapel at Versailles. Scagliola is used not just for these columns but for most of the walls, an exceptionally rich effect. The yellow and brown shades offset big inset paintings by *G.G. Lorenzi,* 1841–8, on the N and S sides. These, mostly copies after Veronese, are used independently of subject purely for their sumptuous design and colouring (though omitting the corpses in the martyrdom scenes). Equally sumptuous and very French cast-iron balustrade, by *J. Bramah & Sons,* and vast lanterns on the newels.

Of the chief first-floor rooms the most concentrated in effect is the MUSIC ROOM or Banqueting Room in the centre of the N side, first used 1838. Strongly architectural elements: concave-sided end recesses with columns; ceiling on a big cove with armo-rials bedded in foliage. The circle-coffered ceiling borders derive from ancient Palmyra. *Barry* designed some details, e.g. the door panels, and enlarged the windows (1839–40). Fireplace with gilt-bronze herms, perhaps by *Antoine Lynen* of Paris. To the E an oval ANTE-ROOM, designed in 1836, with an inset ceiling painting attributed to *G.B. Zelotti* (Cupid and the Three Graces). It leads into the giant GALLERY, now bereft of the great Sutherland col-lection of pictures, which fills the whole of one side (as at Apsley House). It is tripartite with brackets at the divisions, Palmyrene ceilings at the ends, and a coved central lantern with palm-tree uprights designed by *Barry* in 1838. Another inset painting in the lantern: *Guercino's* St Chrisogonus borne by Angels, 1622, from the church of S. Crisogono in Rome. Two recesses on one wall with carved lunettes by *J. Henning Jun.* portraying Murillo. Between them a rich green-black marble chimneypiece with gilt angle caryatids, by *Crozatier* of Paris. *Henning* also supplied the unusual mirrors embossed with foliage, on the S window uprights. The S side centre is the STATE DRAWING ROOM, also white and gold, reached by an ante-room of similar detail from either side. Ceiling coffered in the Palladian way; Dixhuitième wall panels. Separating them, a great enriched traverse of bracket-cornice, coving, rinceau border, etc. Fireplaces also in the manner of *Lynen* of Paris, with more youthful herms than

in the Music Room. The beautiful GREEN ROOM (SW corner), finished c. 1837 in a more Louis XVI idiom, was the boudoir of the 2nd Duchess. Opulent fireplace by *R. Westmacott Jun.*, with children representing Winter and Autumn. Ceiling with inset paintings of a personified solar system by *Henry Howard*. Rooms in the NW corner were destroyed by bombing in 1941.

The chief GROUND-FLOOR ROOMS face the garden. The STATE DINING ROOM behind the Grand Hall dates from 1828–9 and is by the decorators *Morel & Seddon*, best known for their work for George IV at Windsor Castle. Relatively subdued Louis XIV, with little paired cornice brackets and round-topped doorcases carved by *Daniel Horton*. To the E the small GARIBALDI ROOM, with an overdoor portrait commemorating Garibaldi's stay in 1864. The EAGLE ROOM beyond has plain panelling of 1838–9 by *Barry*. The green-damask-hung GOLD ROOM, its counterpart on the W, was formerly a library.

MARLBOROUGH HOUSE
Between Pall Mall and The Mall

By *Wren*, 1709–11, for the 1st Duke of Marlborough and Sarah, his Duchess. His son *Christopher Wren Jun.* helped supervise the work – *Vitruvius Britannicus* even credits the design to him – but his chief role seems to have been to help manage the implacable interfering Duchess. She wrote to Wren *père* that 'I mortally hate all Grandeur and Architecture'. The house is indeed plain, particularly when one thinks of the Marlboroughs' Blenheim Palace in Oxfordshire. It is also the oldest West End mansion whose original form is still appreciable, despite C18–C19 alterations that take a while to disentangle. p. 593

The two lower storeys, of near-equal height, are largely as Wren left them. Of red Dutch brick, with brick aprons, and plinth, cornice and channelled quoins of stone (bricklayer *Richard Stacey*, masons *Edward Strong Jun.* and *Henry Banckes*, joiner *John Hopson*). Straight-headed windows. Decorative carving is limited to the central first-floor window of the garden front, S, towards The Mall. This is of thirteen bays, including wings three bays wide, which project by one cramped bay. Early views show a richer cornice and top balustrade, and sometimes also urns on the skyline and statues in the niches of the wings, not necessarily executed. A third storey was added by *Sir William Chambers* for the 4th Duke, 1771–4, but in 1870 *John Taylor* replaced this with a taller one, detailed to match Wren, and with an additional attic at each end. The Prince of Wales feathers between the S windows tell who these enlargements were for.* The central steps date from *Sir R.J. Allison*'s de-Victorianizing of 1927–8 for Queen Mary, replacing a conservatory of 1860–2. Earlier royal residents included the future George V and another widowed queen, Alexandra. Marlborough House was then given to the Commonwealth Office (1959). In the latest restoration, by *Feilden &*

* The house reverted to the Crown in 1817, but was used in the 1850s by the Government Schools of Design.

Mawson in 1990, chimneystacks after the C19 pattern were reinstated. The first gardens were by *Henry Wise*, 1710–11; just dull lawns now, though Wise's raised S terrace is a significant survival.

The usual entrance is made from Pall Mall, N, past the E end of the Queen's Chapel (formerly part of St James's Palace, qq.v.). The N SIDE, which faces a large *cour d'honneur*, has been altered more than the others. *Pennethorne* added the single-storey entrance range (1860–2), within the shallow recess between Wren's wings. It has a deep Tuscan *porte-cochère*. Above and behind it Wren's two-storey balustraded arrangement remains, out of proportion to the four storeys of the heightened wings. *Taylor* extended these in 1874 by awkward two-storey projections towards the forecourt. This entailed destroying what remained of Wren's colonnades, which stood in front of outer wings (still visible behind). Wren's forecourt continues with plain five-bay office pavilions, set further forward, and likewise heightened from two to four storeys (in two stages, 1878 and 1885). Along the N side it is closed by a handsome screen wall with pedimented segment-arched recesses, the centre twice set back. This is of red brick with channelled dressings, like the house. It must belong to the first Duchess's efforts to make a grand axial entrance from Pall Mall instead of the present sneaking diagonal. Also by *Pennethorne* the great STABLES of 1862 which run towards the E, S of the S side of Pall Mall. These are two-storeyed between three-storey office wings with tripartite windows, the main front detailed with deference to the house.

INTERIORS. Entrance is through *Pennethorne*'s hall and toplit cross-corridor, which gives also on to balancing rooms for Lords and Ladies in Waiting. The principal interior is the double-height SALOON beyond, a near-cube, with a balcony on the inner wall inserted in 1860–2; formerly there was a screen of columns there, probably of after Wren's time. From the balcony a cornice runs all round, above which are paintings of the Battle of Blenheim: by *Louis Laguerre*, 1713–14, remarkably uninspired, and over-cleaned in 1959–61. The S wall shows Marlborough receiving Tallard's surrender at Blenheim, the side walls incidents in the battle. The N wall has trophies on the piers between the windows. On the ceiling, paintings on canvas by *Orazio Gentileschi*, 1635–8, his major English work, done for the Queen's House at Greenwich (*see London 2: South*) and moved here *c.* 1711. In the central circle Peace surrounded by Liberal Arts and Virtues, spoiled by cutting out the connecting passages; Muses in the borders; Music, Sculpture, Architecture and Painting in the corner roundels. Much repainted at the time of installation, perhaps by *Laguerre*. *Pennethorne* removed the centre up into a cupola, but it was reinstated by 1960. On the lower walls framed tapestries. Late C18 fireplace with paired red marble columns and a military relief, perhaps from the decorations by Chambers's pupil *John Yenn*, *c.* 1785. Other architectural elements are as recent as 1903 (though removed 1910 and then reinstated 1927–8): pilasters, frieze, door architraves, overmantels. To the W and E of the Saloon two STAIRCASES with fine original wrought-iron balustrades and further wall paintings by *Laguerre* (partly

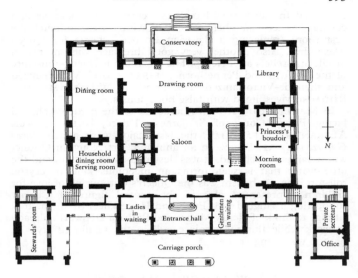

Marlborough House. Plan as in 1862
(Geoffrey Tyack, *Sir James Pennethorne*, 1992)

repainted 1889, by *John Richards*, and again *c*. 1960 by *Tom Keating*). In the larger staircase, W, they represent the battle of Ramillies, in the E staircase Malplaquet. Dully painted architectural surrounds. Also some smaller townscapes, etc.

Other interiors were altered by *Chambers* in 1771–4, with further changes in similar style by *Yenn*, *c*. 1785; *Pennethorne*'s remodellings of 1860–2 included the merging of smaller rooms to make two full-size state chambers. Clockwise from the saloon, the first room is all late C18: frieze with anthemion and urns, doorcases with mask blocks, and a ceiling with concentric circles and corner squares. Doric fireplace with draped bucrania. Immediately S, *Pennethorne*'s STATE DINING ROOM occupies most of the E range, in place of four smaller early C18 spaces. The twiggy leaf frieze and bolection wall mouldings are early C20 embellishments, the ceiling ornament a late C19 one. Fireplaces by *Chambers*, one with female herms and a relief of warriors, another with bearded herms and nautical relief. Gunmetal grates, just as excellent in their way; perhaps from alterations of 1837–9 by *John Phipps*, for Queen Adelaide. Also of 1860–2 the STATE DRAWING ROOM along most of the garden front. Three rooms were thrown together for it, their divisions marked by paired Corinthian columns. The E chimneypiece with garlands and a relief of lions must be *Chambers*'s, its inferior W counterpart must be 1860s. Much of Pennethorne's detail was removed or changed in the early C20, e.g. the replacement of fish-scales on the columns with fluting, and the effect is now standard-issue

Louis XV. In the INDIAN ROOM (SW corner) the doorcases and
ceilings are neo-Chambers of 1927–8, with a frieze to match the
first room (replacing a Bavarian Rococo scheme for Queen
Alexandra). Also another very good fireplace with herms in
profile and reliefs after Aesop. The NW room is chiefly a mixture
of the late C18 and Pennethorne. (FIRST FLOOR. Victorianized
and then de-Victorianized. The Prince of Wales's SMOKING
ROOM survives, lined with false book spines.)

In MARLBOROUGH ROAD, attached to the garden wall and
facing Friary Court of St James's Palace, is the QUEEN
ALEXANDRA MEMORIAL, the last major work of *Sir Alfred
Gilbert*, 1927–32. Bronze in an animated Art Nouveau Gothic,
with a lamp at each end. It was designed as a fountain, and the
little water that is seen forms an ingenious kind of crystal
roll-top. The symbolism was the Queen's outpouring of love for
children, represented also in the central figure of Charity
supporting a languid girl. Faith and Hope kneel by them. It is
strange to think of Henry Moore and Barbara Hepworth already
at work while this masterpiece still in the unalloyed style of
c. 1900 was being created.

104 is the marginal reference beside the QUEEN ALEXANDRA MEMORIAL paragraph.

ST JAMES'S PALACE
Marlborough Road and Cleveland Row

The official residence of the sovereign, but since Queen
Victoria's time no longer the true one. The gatehouse, chapel
and parts of several ranges remain from the palace built for
Henry VIII in 1531–*c.* 1540. Its site was that of the Hospital of

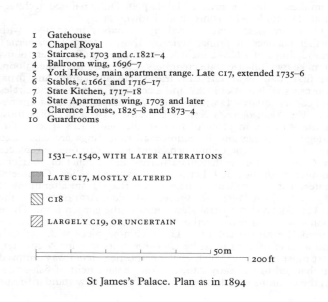

1 Gatehouse
2 Chapel Royal
3 Staircase, 1703 and *c.*1821–4
4 Ballroom wing, 1696–7
5 York House, main apartment range. Late C17, extended 1735–6
6 Stables, *c.*1661 and 1716–17
7 State Kitchen, 1717–18
8 State Apartments wing, 1703 and later
9 Clarence House, 1825–8 and 1873–4
10 Guardrooms

 1531–*c.*1540, WITH LATER ALTERATIONS

 LATE C17, MOSTLY ALTERED

 C18

 LARGELY C19, OR UNCERTAIN

50 m
200 ft

St James's Palace. Plan as in 1894

MARLBOROUGH ROAD

Colour Court

Friary Court

Engine Court

Ambassadors' Court

CLEVELAND ROW

STABLE YARD ROAD

Stable Yard

Lancaster House (*see p.* 589)

St James, founded before 1100 for female lepers, in what must then have been a lonely and desolate spot.* The King was also busy in the 1530s with his new Whitehall Palace, and there is evidence that St James's was meant not for him but for his heir: the illegitimate Henry Fitzroy, Duke of Richmond (†1536) lived and died here, as did the true Prince of Wales, the future Edward VI, born 1537 (and, later, Henry, Prince of Wales (†1612), the first-born son of James I). It would no doubt have surprised those kings that such a moderate palace should house the chief London court of the C18, after the fire at Whitehall in 1698. Even as modernized with new State Apartments in 1703, it remained externally underwhelming; Defoe called it 'really mean' in 1725. George III preferred to enlarge Buckingham House, and when the SE parts of St James's burnt down in 1809 the old Private Apartments there were not replaced. By 1866 most court ceremonial had been transferred to what had by then become Buckingham Palace. The main use since has been for court offices and lesser royal apartments, though the State Apartments are kept up.

The PLAN of Henry's palace remains in part, although its four main courtyards do not correspond exactly to the present ones. The most conspicuous survival is the gatehouse, one of London's emblems, in the N range facing up St James's Street. The rest adopted the two-storey arrangement that was already customary by the 1530s, without a great hall, but including a substantial chapel, something usually provided only in the largest royal residences. Here the chapel fills the N end of the N–S range immediately W of the gatehouse, which thus stands asymmetrically in the courtyard behind: an awkward arrangement, which may well indicate a change of plan in the middle of the work.

The general effect of the palace today is of a medley of plain two- or three-storey brick ranges, sometimes Tudor, more often late C17–early C19, and mostly with battlements and sash windows. It is perhaps how the lesser parts of Whitehall might have looked, had the fire there never happened and piecemeal rebuilding continued into the C19. The largest late C17 block forms the W part of the gatehouse N range, the apartments of 1703 the bulk of the S range. The many lesser sections built or rebuilt in the C18–C19, not all of which can yet be securely dated, are distributed more evenly. The biggest campaign came in the 1820s, under *Nash*: the mess left by the fire of 1809 was sorted out, the State Apartments remodelled, and Clarence House added at the far SW. The buildings now appear much as in the latest C19, apart from the removal of stucco here and there. Public access is limited; description starts with the outside.

Exterior

The N FRONT is now Tudor in appearance only here and there, where stretches remain of red brick with blue brick diapering.

* C14 references mention a stone tower, a hall with chambers at both ends, a cloister and a chapel. Medieval foundations, identified either as of the hall or the chapel, were exposed in Colour Court in 1925.

Other walls here and elsewhere were refaced or rewindowed in 1660 and later (hence the many dated or cyphered rainwater heads around the palace). The GATEHOUSE to Colour Court is 20 of the usual early Tudor type, with half-octagonal turrets to the outside and inside. Four-centred archway, made higher after c. 1750. Windows of several sizes, some with four-centred heads, of which the middle one in the centre and a few on the turrets may be original. At the top a stepped parapet with a CLOCK FACE dated 1832 (the latter largely late C19). Early views show crenel-lated gables instead (and also a big oriel over the archway, and another behind). Ogee-topped cupola, added before c. 1710. At the base of the turrets are Tudor doorways with damaged carving in the spandrels, framed by Portland stone piers of early C18 Gothick form. Main doors perhaps C16, with linenfold carving.

To the r. of the gatehouse is the giant window above the Chapel Royal altar. Only the upper tiers of its central, five-light section are C16. Of 1840 the lowest tier, of 1858 the outer parts; modi-fied in 2001–2, reopening some upper parts while blocking the lowest tier. Crenellation above of 1836–7, by Sir Robert Smirke. Next a big archway made in 1824 into Ambassadors' Court, some C16 walling with windows of Tudor pattern and projecting chimney-breasts, and a lower set-back section with Georgian windows, where another archway was infilled after 1824. Then YORK HOUSE, a long, mostly late C17 apartment range with fifteen very tall first-floor windows. The low top storey, a later addition, was rebuilt with a terracotta cornice in 1890–2. Three matching r. bays of 1735–6, added for Frederick, Prince of Wales, then four-storey offices of before 1793, in different brick. Corner rebuilt 1866 with a curve round into Stable Yard (see below). Tuscan porch on that side.

To the l. of the main gatehouse, additions one room deep conceal the C16 wall. First a plain three-bay house-like front, probably early C18 (recorded 1729), with an oriel on a quasi-Tudor corbel. Crenellated after c. 1858. The rest of 1748 (the two lower storeys, by J. Vardy), with a crenellated upper storey and canted end bow of 1768. The fine cast-iron GATES at the end are dated 1823 and 1923.

The E FRONT starts here with a plain three-storey section facing Marlborough Road, exposed and made good after the fire of 1809. Before then, this was the most congested area of the palace, packed tight around several smaller courtyards and extending E to embrace the Queen's Chapel of 1623–5 (q.v.), the only survivor of several works by Inigo Jones at the palace. Next a half-octagonal C16 turret, pierced through with a pedestrian passage. This continues into a single-storey arcade, part of works begun in 1821 which created FRIARY COURT beyond, a roughly symmetrical forecourt to Marlborough Road. This adopts a plain, grudging Neo-Tudor, mostly of yellow brick, with narrow-notched crenellations. C16 fabric also appears, with part-renewed canted windows to some first-floor apartments: at the inner end of the N side, lighting the Guard Room, and on the E side, N, lighting the Armoury. The bay to its S, to the Tapestry Room, is entirely 1820s, as the contrasting brickwork around it suggests. Other work is later, but in keeping: on the W side, the arcade,

c. 1865, on the S side, offices, period 1848–69, extended E 1879 (and partly reconstructed since 1945); on the N side, the tall set-back range, probably 1865, the plain guard room in front, l., and arcade, r., probably 1861.

The S FRONT is chiefly the State Apartments, seventeen even bays mostly of 1703, overlooking gardens N of The Mall. The design is by *Wren* (or perhaps his office), a plain treatment closer to his late C17 apartments at Whitehall than to the great shows at Hampton Court. Red brick with rubbed orange dressings (brick-layer *Richard Stacey*). Three storeys, the first-floor windows very tall. Windows over them mostly blind. Tall parapet, embattled to suit the Tudor context. Four matching E bays of 1822 (where the hipped roof over the W part dips down), two W bays of the period 1712–29. The taller stucco block joining on to them is Clarence House (*see* below). Just beyond, more good GATES to Stable Yard Road, a private entrance convenient for Buckingham Palace, with a low plain LODGE by *Sir R. Smirke*, r., all of 1838.

There is no W front as such, but the W END can be seen from the edge of Green Park. The view is into Stable Yard (*see* below), with Lancaster House (q.v.) in the r. foreground, the former stables on the l. (N side), the offices at the W end of York House beyond them, and to their S an opening into Ambassadors' Court, in the NW quarter of the palace proper.

The Internal Courtyards

COLOUR COURT is entered from the gatehouse in its NW corner. Immediately to its l. (W SIDE) is the chapel, with simple transomed windows. It sets forward after one bay for the ante-chapel, after the T-shaped Oxford-collegiate plan. Its octagonal buttresses are C19 restoration, done after an added upper storey was removed (probably in 1836–7). Also C16 the stair-turret to the S, then a section of the 1820s, with tall sash windows to the extended staircase. In front, a Doric colonnade of 1703, of stone supporting timber (mason *Benjamin Jackson*). Some columns were reused from an earlier porch in the SW angle. Behind it and looking of similar date a segmental-arched door-way to the ante-chapel, with an eared frame. The colonnade was truncated in 1865, when the S SIDE was rebuilt further N. A new route passing through the N side of Friary Court was made in connection, for easier private access to the Chapel Royal from outside the palace. The E SIDE is of 1821–4 at the S end, then a stair-turret which is true C16 work, then C16 walling, refaced and heightened. N SIDE refaced 1840, likewise simple, sashed and three-storeyed.

AMBASSADORS' COURT lies to the W, reached through a passage just S of the ante-chapel. This passes through two four-centred arches, showing that this N–S range has a C16 core. Elevations are mostly simple, with much less crenellation. The description is clockwise, starting with the S SIDE. The first five bays here belong to a ballroom built in 1696–7 for Princess (later Queen) Anne and her husband. The central bay had an external staircase to the first floor, removed in the early C19. Round-arched and rusticated windows below, until the C19 an open

arcade. Later C19 parapet, replacing a timber cornice. To the w
a plain three-bay section which replaced a cross range dividing
the court in two, demolished *c.* 1824. An enclosed bridge links
this range to the former STATE KITCHEN block, of 1717–18 by
Vanbrugh. To the court a symmetrical, domestic-looking five-bay
front with a later doorway. Visible behind is the tall kitchen
proper, with round-headed windows and circular windows over
on the E elevation. Balancing s range. Further w and in line with
the kitchen, three-storey apartments of later C17 date, but much
rebuilt since; *Soane*'s work of 1806–9 for the Duke of Clarence
probably explains the round-headed staircase window on the w
side. The bow window to its s is mid-C19. Across the w SIDE of
Ambassadors' Court is another range originally of the C17,
heightened and altered. Then on the N SIDE the long rear range
of York House (i.e. the range facing Cleveland Row, mostly late
C17), here partly concealed by a stuccoed two-storey forebuild-
ing probably of the 1830s. This is crudely designed, with super-
imposed pilasters and an open elliptical-headed arcade below.
Further E, set back, the C16 range w of the gatehouse appears,
rebuilt with a later C17 or C18 elevation. The E SIDE begins with
a bay and half-bay, C19 infill of after 1827, which masks the N
part of the chapel. Then the two bays of the ante-chapel, between
slim octagonal buttresses. The plain doorway, r., must date from
the remodelling of 1836–7. The s part is also C16, partly refaced.
The three-bay loggia in front, rusticated and round-arched to
match the ballroom next to it, dates from between 1809 and 1827.

ENGINE COURT lies s of Ambassadors' Court. The back of
the State Apartments forms its s side, that of the ballroom its
N. A low half-octagonal guard-room block of 1877–8 by *John
Taylor,* attached to the N side, fills most of the space. On the E
side a plain front of 1864 for the Picture Gallery, incorporating
windows and other 1820s fabric from the shallower corridor
range formerly here. Four-centred arcading below, partly glazed
in 1894. The simple brick w range is the service wing of Clarence
House, part of the extension of 1873–4 (*see* below).

STABLE YARD lies w of Ambassadors' Court, and is connected
with it by a narrow passage. On its s side are Clarence House
(E, *see* below) and Lancaster House (q.v.). On its N side at the E
the plain four-storey w end of York House (*see* Exterior, above),
C18, apparently of more than one phase. w of the entrance from
Cleveland Row, standing some way further N, the former
STABLES. The long front range of stock brick with red dressings
is by *Hawksmoor,* 1716–17. A small-scale demonstration of his
instinct for mass. Arcaded and open on the ground floor,
windows in deep blank arches above, both with thick impost
blocks. Turrets with concave-sided pyramid roofs over the ends.
Harshly restored 1980. Behind, the stables proper, said to date
from 1661 and converted for offices *c.* 1736. C19 top storey.

Interiors

The CHAPEL ROYAL has the most accessible interior, being
open for services in season. *Smirke* reconstructed the broad
(ritual) w end in 1836–7, with a new entrance passage and

staircase, Royal Closet, and extra side galleries towards the
19 middle. The remarkable ceiling is however original, dated 1540,
and panelled in interlocking octagons, crosses and small
elongated hexagons. The source is Serlio's Fourth Book (1537),
a typically Tudor assimilation of the decorative, rather than the
architectural, potential of the Italian Renaissance. Its pretty
painted decoration is also along lines recommended by Serlio.
Motifs include putti, scrollwork, the arms of Anne of Cleves, and
mottoes of two earlier queens, Katharine of Aragon and Anne
Boleyn. It may be by *Antonio Toto del Nunziata* or *Andrew Wright*,
heraldic painters in the king's service. Mouldings partly of cast
lead. Restored 1988; three missing octagonal panels were sup-
plied in redecoration of 2001–2, when the walls were lined out
in ashlar pattern. Smirke extended the ceiling design into the
ante-chapel, replacing a Tudor ceiling with pendants. At the join
a beam on angel corbels. The side windows of 1858 at the altar
end, blocked *c.* 1971, were reopened in 2001–2. FURNISHINGS.
REREDOS of 2001–2, of oak, designed by *Martin Ashley* in a finely
calculated Late Georgian Tudor style. – STAINED GLASS of the
same date, a tree symbolic of the Commonwealth, commemo-
rating the Golden Jubilee of Queen Elizabeth II. Designer *John
Napper*, maker *Goddard & Gibbs*. – Neo-Tudor PANELLING of
1836–7. – COMMUNION RAILS. Cast-iron Neo-Tudor, 1893.
– ORGAN CASE of 1924–5, designed by *Sir Aston Webb*. – PEWS
of 1876. – Two TAPESTRIES, C16, showing the campaigns of
Hannibal.

STATE APARTMENTS. The key dates appear to be of 1703
under *Wren*, *c.* 1720–30 (attributed to *William Kent*), *c.* 1821–4
by *Nash*, 1866–7 by – surprisingly – the *William Morris* firm,
and 1904 by *White Allom*. The approach is from the LOWER
CORRIDOR, a plain room created in 1865 when the S range of
Colour Court was built. It is broad enough to engulf a Doric
colonnade, built in 1795 as a counterpart to that on the W side
of Colour Court, which now runs down the middle. The
STAIRCASE at the W end is of a very unusual scissor type, two
short arms starting from diagonally opposite sides, meeting at the
intermediate landing and then doubling back in the opposing
diagonals. This wonderful piece of interior scenery is due to
Nash, who pierced the half-landing wall of the dog-leg staircase
of 1703, S, and added another, back-to-back. An arch marks the
division. Wrought-iron balustrades, plausibly of 1703 in the S
part, with a few differences in the N. The big shell-headed niches
on the walls are typical of Nash, but the white-and-gold decora-
tion, most of the Louis XVI plasterwork and the Ionic columns
to the mid-way arch are *White Allom*'s of 1904. Also of 1904 the
balustrades in the four big-arched openings to the first-floor cor-
ridor that runs the full width of the staircase enclosure.

At the top of the S half of the stairs, an ante-room leads W to
the very large BANQUET ROOM, that is the ballroom of 1696–7.
The cornice and most other decoration are of 1821–3, the fire-
place with its festoon frieze clearly of the school of *Kent*. On the
far, W side is the AMBASSADORS' STAIRCASE, first made in
1863 within the 1820s extension. Its panelling and wrought-iron
balustrade of the style of *c.* 1730 are by the *Office of Works*, 1931.

To the E of the landing, the GUARD ROOM, with a painted Tudor fireplace.

The State Apartments lie to the S, accessible from the staircase by the ARMOURY and TAPESTRY ROOM. Both also have Tudor fireplaces with quatrefoil friezes, but their special interest is the redecoration of 1866–7 by *William Morris* and his firm, to designs by *Philip Webb*.* The commission came about through William Cowper, the First Commissioner of the Works and a friend of Rossetti and Ruskin. The colour scheme is sombre, with sprigs and interlaced foliage on a black ground over dado, fireplace, doors, and (in the Armoury) cornice. The Armoury walls have decorative patterns of weaponry, the Tapestry Room, Mortlake tapestries of the Loves of Venus and Vulcan, period 1620–2.

The State Rooms proper lie beyond, along the S side. *White Allom* were busy here too, and white and gold again prevail. The first, QUEEN ANNE'S ROOM (actually of 1822), is entered rather inelegantly in the middle of its N wall. It has *Nash*'s typical coved ceiling with scrolling decoration, but the doorcases are fashioned to match those of *c*. 1720–30 in the next two rooms, the ENTRÉE ROOM and THRONE ROOM (originally the Throne Room and Council Chamber). The triple enfilade through these is Nash's doing – cranking up the effect from the C18 single enfilade – so at least some of their doorcases must be matching work of the 1820s. Both rooms have rich matching fireplaces of 1736–7 from *Kent*'s Library for Queen Caroline, an isolated building on the site of Lancaster House (dem. 1825), and big enriched coved ceilings, culminating in the Throne Room with a pattern of big diamond coffering. Here also two wood-carved drops by *Grinling Gibbons*, their qualities muffled by gilding and (probably) by later extensions. The throne canopy stops the central enfilade, but the outer two continue into the smaller COUNCIL CHAMBER, which has a French-looking fireplace against the wall behind the throne. The SOVEREIGN STAIRCASE beyond, within the section added in the period 1712–29, is pure *Kent* in style, with a fine wrought-iron balustrade. Other decoration is apparently Neo-Early Georgian. The BOUDOIR beyond that is less deep, allowing space to the N for a passage to be made into Clarence House. The PICTURE GALLERY lies off the main sequence, W of the Armoury and Tapestry Room and overlooking Engine Court. Formed in 1864, by widening a N–S corridor; present, subdued decoration 1988. Here a damaged Elizabethan fireplace saved from the old Palace of Westminster, exquisitely carved with a frieze of scrolls, roses and little mermen.

Clarence House

Sited at the W end of the State Apartments, with which it links up. Of 1825–8 by *John Nash* for the Duke of Clarence, who had outgrown his bachelor apartments. Nominally it was a remodelling of his old lodgings, of which C17 walling is believed to survive

*The firm's work of 1881 in the other apartments has been erased, though the C20 red damask hangings reproduce the *Morris* design of that date.

at the S end. The Duke lived here through his subsequent reign
as William IV, Buckingham Palace not yet being ready.

The house is stucco-faced, with even quoins and round-
headed first-floor windows. Main front facing W, of nine bays. At
first this side was three-storeyed, with the main entrance through
a double-decked portico. This was removed in alterations for
the Duke and Duchess of Edinburgh, 1873–4, leaving the house
looking apologetically flat and plain. At the same time the whole
was made four-storeyed, and enlarged to the SE. The builder,
Charles Waller, worked without an architect, Osborne-fashion. He
moved the entrance to the S front, adding five non-balancing bays
to the r. of Nash's original two, which were altered with inserted
windows. The entrance, a Doric *porte-cochère*, may reuse some
columns from Nash's portico. A wall with a low symmetrical
guard-house hides it from view. New service rooms were also
added, extending E into Engine Court, behind.

(The *Nash* INTERIORS were simpler than his work in the palace
proper, many having plain or fluted covings. N–S spine corridor,
with a later C20 staircase in early C18 style at the N end. Much
redecoration, e.g. the DINING ROOM (ground floor, N), Neo-
Adam of 1901–2, for the Duke of Connaught. Some brought-in
fireplaces of coloured marble, including one of *c.* 1765 from No.
77 St Stephen's Green, Dublin, in the LANCASTER ROOM, SE.
The first-floor DRAWING ROOM was formed in the late C19 from
two Nash interiors, with columns at the join; late C19 and early
C20 plasterwork. The shell remains of the domed CHAPEL of
c. 1874–5, created for the Duchess of Edinburgh, who was Greek
Orthodox. Some de-Victorianizing of other rooms in 1947, for
the newly married Princess Elizabeth and Duke of Edinburgh;
other, modest changes for Queen Elizabeth the Queen Mother,
after 1952; further alterations under way, 2003.)

STREETS

ARLINGTON STREET

Built on land carved off from Green Park and granted in 1682
to Henry Bennet, 1st Earl of Arlington (hence also Bennett
Street, to the E). The C17 houses were mostly rebuilt from
the 1730s. On the W side advantage was then taken of the deep
plots to make forecourts, some with forebuildings in the French
manner. There is still some excellent C18 work within these
houses, which accommodated only the élite: Horace Walpole, a
resident, wrote in 1768, 'from my earliest memory Arlington
Street has been the ministerial street'.

Starting from Piccadilly, first the intriguing No. 22, now
WILLIAM KENT HOUSE (since 1947 EAGLE STAR INSUR-
ANCE). Indeed by *William Kent*, built in two phases in 1740–50
for his patron Henry Pelham (completed by *Stephen Wright*).
Restored in 1977–81 by *Stone, Toms & Partners* (*Donald W. Insall*

& Associates consultants), who brought Kent's personality to the fore inside and out, but also swept away the historically interesting forebuildings.* The replacement offices are lugubrious brown brick on an L-plan, left open below for a glimpse of the C18 house, with a taller N wing coming up to the street. Kent arranged the approach for maximum privacy, with a single-storey courtyard range, linked to the house by an arcade which has been re-created in plain brick. The GATES are Neo-C18, with eagles on the piers. The house itself shows straight away the C18 phases. On the r. is Pelham's first house, of 1740–3. It has three bays and three storeys, of brick, with a modest cornice and pedimented first-floor windows set over blind balustrades. Kent's No. 44 Berkeley Square (*see* pp. 501–2) is a close match but for the ground floor, here re-created after 1977 with round-headed windows and an entrance in the r. bay. The lower part to the l., also refaced in the 1970s, was added *c.* 1792 as a dining room for the 1st Lord Eardley, almost certainly by *George Dance Jun.* Its width corresponds to Pelham's s extension of 1747–50, which faces the park behind. Towards the park the house of 1740–3 appears as two tall triple-windowed canted bays to the l., the extension of 1747–50 as the third canted bay and single flanking windows to the r. This casual asymmetry suggests that the addition was an afterthought; Pelham probably needed extra space after he became Prime Minister in 1743, for it was here rather than at No. 10 Downing Street that he based himself.

INTERIORS. Entry is via a lobby into a hall, restored à la Kent. Ahead is *Kent*'s STAIRCASE HALL, quite dramatic, though falling short of the thrills of No. 44 Berkeley Square. Three flights to the stair, approached through Ionic column-screens (the upper screen and apse 1970s re-creations). Beautiful S-scroll balustrade, almost identical to that at Berkeley Square. Plasterwork mostly renewed. The drama begins above the first floor, re-created from photographs of work destroyed in the 1950s: a four-sided balustraded gallery, above it a barrel vault with glazed N side, and thermal windows in the E and W walls. The puzzle is that Pelham's building accounts mention a circular skylight. Yet the details – Greek key, etc. – are compatible with Kent. Was it done when the s extension was built, or did a later designer adopt the Kentian idiom?

Facing the park, the BLUE DRAWING ROOM and, N, the smaller GREEN DRAWING ROOM: the first with a restored Kent cornice and a brought-in fireplace, the second with a new ceiling in Kent's style and a very good chimneypiece, also imported, with brackets fashioned as eagles vomiting fruit. s of these two rooms is the splendid GREAT ROOM, the *raison d'être* of Pelham's extension. It has a ceiling coffered and decorated by red and blue panels with small grisaille mythologies, as at No. 44 Berkeley Square. The match is close enough for an attribution to *Kent*, though he died in 1748 and *Wright*

*The front range had an added *porte-cochère* of 1854–6, by *William Burn* for the 11th Duke of Hamilton, and upper storeys of *c.* 1920. The courtyard behind was filled with a ballroom in the 1880s, for the 1st Lord Wimborne.

oversaw completion. Here the shape is more complex because of the bay window (treated as an apse inside) and indented corners opposite. Also some ornament has been lost, e.g. between the panels on the coving and from the paired brackets dividing them, and some panels repainted. The present cornice partially re-creates *Robert Dawson*'s original; crimson hangings based on a reference of 1754. Of the inner angles that on the r. is thought to have housed a urinoir. Fine fireplace with herms in profile, from *Henry Flitcroft*'s work at Midgham House, Berks., 1738–9 (dem.); overmantel and doorcases are copies after Kent designs for other houses. Continuing the circuit is the OVAL ROOM with niches and half-columns, done in the 1920s for the 1st Viscount Wimborne, probably by *Thornton Smith & Co*. It succeeded a similarly shaped room made before 1838 to link the Great Room with the inner court-yard section. This now houses the MUSIC ROOM, a new cre-ation within the shell of Dance's dining room, replacing a late C19 interior burnt out in 1978. The style is rather like Wyatt's of *c*. 1790; the shallow barrel vault copies the C18 arrangement.

On the FIRST FLOOR the best interior is the SALOON, the chief room of the house of 1740–3, which overlooks the courtyard. The fine ceiling is *Kent*'s, with complex compartments includ-ing small squares set diagonally. Other Anglo-Palladian details by *Thornton Smith & Co.*, 1917, when Wimborne made it his bedroom; frieze and fireplace after casts of the Great Room at Marble Hill (*see London 2: South*). Facing the park, HENRY PELHAM'S ROOM also has a *Kent* ceiling, with a motif of circles; chimneypiece from Mereworth, Kent. The OCTAGONAL ROOM, in fact a long room with canted ends, has another good *Kent* ceiling and what looks like a Kent fireplace, with swagged female herms.

No. 21 (NABIM) has a shallower forecourt, and stands corre-spondingly further back on the park side. Designed in 1738 by *Leoni*, for the 2nd Viscount Shannon. Fine four-square elevation, with Ionic porch off-centre. First-floor windows pedimented with lugged frames. Leoni's drawings omit the arched doorway with satyr-mask key block, which may date from *Chambers*'s alterations of 1769 for the 3rd Viscount Weymouth. Second-floor windows enlarged. Unfortunate man-sard of 1913. The tripartite ground-floor window, l., appears early C19. A triple first-floor window to the park may be contemporary. The bays to its N come forward in a bow on columns, replacing Leoni's deeper rear wing, lopped off in 1913.

The C18 INTERIORS are overlaid with more feminine deco-ration of the later C19, for the van de Weyer family. In the ENTRANCE HALL a big *Leoni* fireplace and simple cornices. Also by Leoni the STAIRCASE behind, of stone with the cus-tomary open well and slanting wrought-iron balusters, but with Victorian plasterwork added, e.g. the trophies below Leoni's swag frieze. Lantern reinstated 1987–8. In the two main rooms, adjacent, the decoration is thoroughly hybridized. First-floor doorcases with Leoni's favourite bay-leaf friezes; also his

the panelling of the ante-room (front), alternately wide and narrow. The ceilings here and in the room to the S are refined Neo-Rococo of the later C19, that in the back room of late C18 type, though closer to Adam than Chambers in style. By *Chambers* surely the doorcase, and also a pretty fireplace in a small rear room. Adapted for offices 1948.

Nos. 17–20 are mansion flats, ARLINGTON HOUSE, by *Michael Rosenauer*, 1934–6. In his version of the contemporary style, with a deeply recessed centre behind, after some Continental apartment blocks of the 1920s. Shallow forecourt. The cladding is Travertine, with white tiles above and Portland stone to the park, a concession to West End tradition. The rear wings step down, with much diagonal angling of balconies. Spacious, well-planned entrance hall. It supplanted four aristocratic houses, of which No. 18, built 1756–60 for the Countess of Pomfret, was the only major C18 London house in Gothic.

Lastly the gateway and stables of No. 16, where the street returns as a close at the bottom. Built 1734–40 by *James Gibbs*, for Maria, Dowager Duchess of Norfolk. A high wall with a big archway rusticated in the Gibbs fashion, and next to it four windows in two storeys. Two further storeys were intended. For the house (now Royal Over-Seas League) and the building next to the gateway, *see* Park Place. The older houses on the E SIDE are less interesting: No. 4, probably 1680s, partly refaced 1786–7, No. 5, narrower and clumsily heightened, 1795–7.

BURY STREET

A N–S street, first rated in 1673. Rebuilt from 1870 with big blocks of chambers or hotels above shops. At No. 16, N end, is QUAGLINO'S, a harbinger of the 1990s craze for giant restaurants. Converted 1993 for Sir Terence Conran by the *CD Partnership*, from a 1950s hotel ballroom basement. Galleried, with luxury conveyed by hard glass and bronze and by columns decorated by different artists. At the entrance a RELIEF by *Dhruva Mistry*. No. 15 next door was the Hotel Meurice, of 1911. Characteristic of *Hoffmann*'s Free Style, stone-faced, with a running hood skipping up between, not over, the windows. Nos. 12–14 were built as the Marlborough Hotel by *G.D. Martin*, 1897–8, the detail mixed but conventional.

The S corners with RYDER STREET are, E, Nos. 6–9, 1909 by *G. Thrale Jell*, W, Nos. 31–35, 1901–2 by *R.J. Worley*. Jell marks his corner firmly with a stone-striped octagonal tower and pagoda roof; Worley's building is softer, with orange terracotta and repeated segmental bows. Next to it Nos. 37–38, 1870, the only known residential chambers by *Butterfield*. The brief seems to have led him back to something like a Georgian terrace front. Reticent flush twin façades, red-banded stock brick trimmed with blue, with small dormers on the parapet. The iron balconettes are detailed like Butterfield's church work.

CLEVELAND ROW

The paragon of distinguished retiredness in the West End – a
close, of sufficiently intricate shape to defeat those unfamiliar
with its topography. Green Park is at the far end, St James's
Palace at the nearer, E end, on the S side. On the N side,
Nos. 3–7, originally private houses and flats, 1905–7 by *Frank
T. Verity*: an outstanding early example of what might be called
the French Embassade type. Down RUSSELL COURT behind
(r.) some simple two-storey stables of *c.* 1790.

Next on the N side is BRIDGEWATER HOUSE, by *Sir Charles
Barry* for the 1st Earl of Ellesmere, a colossal presence in
such a modest street. Final design 1845; carcase finished 1848;
interior completed *c.* 1864. The builders were Messrs *Baker*,
the chief carver *C.H. Smith*, with *John Thomas*. It is externally
a grander and later version of the Reform Club – 144 ft (43.9
metres) long, likewise of nine bays, with the same massive and
masculine palazzo character. But the quoins are of vermicu-
lated rustication, the porch is broad and deep and has Tuscan
columns with similar rustication in bands, the main window
pediments are decorated, and a balustrade, urns and elabo-
rated chimneys sit above the big cornice. So all motifs are in
a higher key and slightly less disciplined. The garden façade,
W, is of seven bays, with the strong horizontals continuing
round below the sills. The end bays here are broad, with
tripartite windows. (Barry's first design, of 1841, had a huge
belvedere tower here, and a giant Corinthian order on the main
block; he also made Neo-Elizabethan designs.) The GARDEN
itself, with raised perimeter walks, is also Barry's design. At the
E the treatment is informal, with a low windowless carriage
house at the front, a courtyard and gateway (its bell-pulls
labelled 'Coachman' and 'Groom'), and a service wing of full
height at the back. This has a belvedere top with columns,
marking the summit of a public staircase to the great picture
gallery formerly along the N side.

The INTERIOR is mostly intact, though the bomb-damaged
gallery wing, N, was filled with offices in *Robert Atkinson &
Partners'* conversion of the house for commercial use, 1948–9.
Further work in 1984–8 by *Technological Research Associates* for
a private company converted some parts into apartments, with
restoration of most of the state rooms. Entry is made by a
club-like LOBBY, barrel-vaulted and coffered, with a column-
screen to a porter's hall, r. The chief interior is the SALOON
ahead, an amazing thing to find in a private house. It is a
scagliola-lined *cortile* of three bays by five, with saucer-domed
arcades on two floors, a tall glazed coving like that at the
Reform Club, and three glazed domes in the ceiling proper.*
The tones change from warm, dark shades below to white
and bright gold above, where the glazing is faceted for extra
lustre. The luxurious Neo-Renaissance decoration, executed
c. 1856–64, is due not to Barry but to *Jakob Götzenberger*,

* As at the Reform Club, this arrangement represents a last-minute change from a
plan with a central, transverse staircase between open light-wells.

an English-domiciled pupil of the German painter Peter Cornelius. Its programme is suggestive of ascent towards high spiritual realms, underscored by aristocratic family references. Twelve big winged female allegories posture in the central coving, modelled in plaster by *Heinrich Bandel* to Götzenberger's designs. Their expressive, fluent style is not quite like anything in British mid-C19 sculpture. Gilded flower-garlands above; ceiling border with roundel busts of divinities. The lower arcade spandrels were reworked in 1910 with standing, dark-grounded figures by *Alexander Jamieson*, replacing family portraits. The painting within the upper and lower ARCADES derives mostly from Raphael's Vatican Logge, unstintingly done. Much heraldry; small figures of knights, pilgrims etc. in the *altdeutsch* style. The outer ground-floor wall has little classical reliefs, including works at the W end by *Sir R. Westmacott* (Venus and Ascanius, 1831) and *R. Westmacott Jun.* (Venus and Cupid, 1838). Also at the W end are four painted lunettes illustrating Milton's masque 'Comus', in which the owner's ancestors featured (a fifth, N, is by *Pauline Plummer*, 1987). The STAIRCASE is off the E corridor, also of the Roman Cinquecento type, that is not large nor spatially spectacular, but running up in three stages between solid walls. The flights have enriched barrel vaults, with enriched domes over the landings.

The other principal rooms, mostly Louis XV in style, can hardly compete with all this. The simplest are on the ground floor facing the garden, a LIBRARY with plain fitted bookcases, and three lesser rooms to its N. The 1980s work formed a further room on the N side, with a Gothick cornice. On the first floor the former DINING ROOM is the grandest, at the W end of the S front. It has a column-screen marking off the bay by the W window. Red marble, gilt-mounted chimneypiece, with consoles with lions' heads; enriched door frames; frieze broken by big scrolled brackets; ceiling with deep coffering and gilded trellis infill. The red and gold embossed wallpaper is probably of *c.* 1900. To its N are an ANTE-ROOM, hardly less rich in its small compass, and STATE DRAWING ROOM, (subdivided 1948–9), both with a frieze with putti holding festoons, and sculpted putti on the overdoors. In one part of the Drawing Room and a lesser drawing room to the N are noble chimneypieces in a mid-C18 style, with standing female supporters holding garlands, perhaps reused from the previous house (*see* below). The picture gallery was originally entered through vestibules with big column-screens, restored in the 1980s work. The W one was made into a CHAPEL, designed by *Michael Giles*. Reredos between the columns, with back-lit stained glass (maker *John Lawson*); Madonna carved by *Michael Madden*; mural painting by *Sara Janson* (also in the E vestibule). Back stairs and service stairs much reordered 1948–9.

Bridgewater House replaced CLEVELAND HOUSE, a much-remodelled mansion built *c.* 1626–7 as Berkshire House, for the 1st Earl of Berkshire. Charles II bought it in 1668 for his mistress Barbara Villiers, later Duchess of Cleveland (whence Cleveland Place), who had wings built to make a forecourt.

Lord Ellesmere's forerunners undertook Neoclassical remod-
ellings by *James Lewis*, 1795–7, and *C.H. Tatham*, 1803–6.
SELWYN HOUSE, detached in the roadway in front, stands
where part of the w forecourt wing used to be. Of uncertain
date, recased 1897 in the style of *c.* 1850–60. To the park a
canted bow and raised private terrace.

On the far, s side of Selwyn House, Nos. 8–12 are narrow-fronted
houses of *c.* 1693–1700, with stucco and other alterations, e.g.
the tiny first-floor bows. At the w end, STORNOWAY HOUSE,
built in 1794–6 by *Samuel Wyatt* for the 1st Lord Grenville, the
future Prime Minister. Altered and stuccoed in the later C19,
e.g. the big decorated pediment on the flank, though the seg-
mental bow towards the park is an original feature. Offices were
made within its bombed-out shell in 1958–9. Attached at the s
is WARWICK HOUSE, by *Sir William Chambers*, 1770–1, for Mr
and Mrs Errington. Externally it is however almost entirely
French Renaissance of the later C19. Top storey of 1853, for the
4th Earl of Warwick, who in 1859–60 had *A. Salvin* add the
bow on the s. (D-plan staircase, with wrought-iron balusters;
one room with a fine chimneypiece by *John Walsh*.) Entrance
on Stable Yard, i.e. within the St James's Palace enclosure.

DUKE STREET, ST JAMES'S

First rated 1673. The E SIDE shows how unassuming the C18
houses were around St James's Square (from the N, Nos. 17,
16 and 11–13). No. 14, with a Diocletian window, is an
apprentice piece by *Leslie W. Green*, 1903. Behind, MASON'S
YARD preserves the spacious late C17 plan, with an electricity
substation as the central island block (proposed for conver-
sion for the WHITE CUBE gallery). On the N side Nos. 7–8,
MATTHIESSEN FINE ART, 1978–81 by *Burnett & Brown*.
Brick with blind arcading, like an early C19 industrial front.
On the w SIDE of Duke Street Nos. 34–36, 1859–60 by *Henry
Faulkner*, typical builders' Italianate, and Nos. 38–42, Flemish-
classical, maltreated 1961–3 with paint and metal windows;
by *Jameson & Wallis*, 1882–3. In RYDER STREET off to the
w a range of 1864–5 by *John Norton*, in an unusual style:
Lombardic, red brick with crude black brick decoration and
very crude, heavy balcony balustrades. It backs on to Christie's
(*see* King Street), who built it speculatively, as chambers; later
the Hotel Dieudonné, for which *W. Woodward* made exten-
sions: 1900–1 by two matching E bays; further E up to Duke
Street, 1902–3, and w 1910–11, in his own manner. Latterly the
Eccentric Club.

On the E SIDE of Duke Street here is No. 10, of 1910–11 by *C. W.
Stephens* for the Supreme Council of Masonry. Straightforward
pomp, like a bank, with giant columns. No. 7 is a pleasing sliver
of infill by *Paul Vonberg* of *Purcell Miller Tritton*, 1993–5, extend-
ing the London Library from No. 14 St James's Square (q.v.).
A canted shop bow pushes out between two Doric columns,
continued unexpectedly upwards as square piers. Then No. 6,
handsome in later C18 taste, 1921–2 by *W. Curtis Green*. Built

for the Clerical, Medical & General Assurance, at No. 15 St James's Square behind (q.v.); rebuilt behind 1991. No. 2 is by the short-lived partnership of *Vincent Harris & T.A. Moodie*, 1910–12. Arcaded ground floor, first floor with over-scaled aedicules, oddly contrasted with unmoulded second-floor openings.

JERMYN STREET

The longest of the streets developed by Henry Jermyn, Earl of St Albans. First leases 1661; complete by 1681–2. It runs s of Piccadilly, with St James Piccadilly as a fulcrum on the N side. Extended W into St James's Street by 1746, E into Haymarket *c*. 1819. By then it was known for private hotels, supplanted in renown by shirtmakers in the C20. Some early shopfronts and runs of older houses remain; otherwise many blocks of residential chambers over shops, of *c*. 1880–1910.

We begin W of Regent Street. Nos. 18–21 (N side), 1895–7 by *E.K. Purchase*, of stone, is on the Piccadilly scale; in No. 21a, BATES the hatters, intact plain fittings of *c*. 1900. In No. 113 opposite, *c*. 1875, good coloured tile linings of *c*. 1900, from Thomas Wall's butcher's shop (now a restaurant). Nos. 111–112 by *Reginald Morphew* is a good example of the licence of 1900, done by a firm hand. Little enrichment: ground floor rock-faced in the Florentine way, strong cornice, almost windowless corner tourelle. Morphew designed very little; the client here was his family's knitwear firm, Standen's. Down BABMAES STREET for *Fletcher Priest*'s No. 4, 1986–8 (E side). Tall and slim. The banded stone, square windows and cut-out attic show James Stirling's magnetic influence.

On the N SIDE thereafter the backs of Nos. 198–209 Piccadilly (*see* pp. 557–8), then St James Piccadilly and churchyard (q.v.). On the S SIDE a run of medium-sized commercial premises. *Treadwell & Martin*'s No. 106, 1906–7, is Art Nouveau Jacobean. At Nos. 101–102 an individual design by *Chapman Taylor Partners*, 1974: white stone-faced with flush dark windows and an all-glazed fourth storey. The W corner of Duke of York Street is No. 97 (HARVIE & HUDSON), inscribed as rebuilt 1910 by *Robert Angell*, who apparently kept the Victorian shop storey with its tiles to a *Pugin* design. Nos. 93, 95 and 96 are unassuming survivors of *c*. 1675, variously stuccoed, No. 93 (PAXTON & WHITFIELD) with a well-lettered Victorian shopfront. A rude interruption by Nos. 91–92, tall flats of 1907, then more late C17 houses at Nos. 88–90. No. 90 has an extra half-bay, l. Panelled interiors, the stair compartment archway naïvely carved. At No. 89, since 1810 FLORIS the parfumier, a good mid-C19 shopfront and a seductive interior with mahogany cabinets modelled on one from the Great Exhibition of 1851.

An early C20 stretch follows. Nos. 85–87 were the Hotel Jules: the tall No. 87 by *F.S. Hammond*, 1915, Nos. 85–86 by *G.D. Martin*, 1905. They merge with a big back-land office devel-

opment by *Gibberd, Coombes & Partners*, 1987–91. On the N
SIDE, the former Prince's Hotel at Nos. 36–38, 1898–9 by
Wimperis & Arber (for the Princes Arcade *see* Piccadilly, p. 558).
Emden, Egan & Co.'s extension to the l., 1911–13, has a flat bow
and etiolated colonnettes. Then the back of Fortnum & Mason
(also *see* Piccadilly), facing on the S side the CAVENDISH
HOTEL by *Maurice Hanna*, 1964–6. Stone-faced, with a
podium and a twelve-storey upper slab with concave front and
heavy top hamper. By the road entrance down Duke Street, a
large semi-abstract RELIEF by *William Mitchell*, in bronzed
fibreglass. The old Cavendish Hotel was the most celebrated
of Jermyn Street's private hotels. Diagonally opposite, No. 50,
DUNHILL'S, by *T.P. Bennett & Son*, 1953–8, also stone-faced.
Windows in bands in a recess lined with yellow tiles. For the
Piccadilly Arcade next door *see* p. 558. In front, a STATUE of
Beau Brummell by *I. Sedlecká*, 2002. Back on the S SIDE, Nos.
70–72, the former Marlborough Chambers of 1902–3, is
Morphew's only other major London building. Also specially
good, seen both from Jermyn and Bury streets. Square corner
tower, big gables, shallow bays crossed or joined by delicate
metal balconies. Excellent sculpture by *G. Seale*, since crassly
painted in parts. The N SIDE finishes with older examples of
the type: Nos. 57–58, 1880, overripe *Archer & Green*; the more
measured Nos. 59–60 by *John Robinson*, 1884–5.

KING STREET

The W entrance to St James's Square, and planned in connec-
tion with it. Now mostly businesslike late C19 and late C20.
For Nos. 1a–1c on the N SIDE *see* No. 18 St James's Square.
Nos. 2–4, unashamed Neo-Georgian of 1954, yet by *Trehearne
& Norman, Preston & Partners*, who were then doing good
Modernist commercial work. After Duke Street, Nos. 5–7,
1897–8 by *Robert Sawyer*, built as a giant pub called The
Feathers. Corner turret, windows aligned and linked by glazed
arches high up. Nos. 8–9 (CHRISTIE'S) is by *J. Macvicar
Anderson*, 1893–4. Typical of his cautious but well-detailed
classicism. Ground floor with Cinquecento rustic bands and
masks, the central bay with triple windows. All inside was
bombed in 1941 and conservatively rebuilt by *R. Atkinson &
Partners* in 1952–3, e.g. the galleried Neo-Early Georgian stair-
case. James Christie II moved here in 1823; the firm began
c. 1766, N of Oxford Street. Also incorporated, l., Nos. 10–12,
chambers by *Arthur Green* (of *Archer & Green*), 1891–2. Red
granite columns below, Portland above, with an octagonal
corner turret.

Facing this range (S SIDE), Nos. 26–28, strident Postmodern
with off-centre circular bows, in style not rooted in place or
period. By *SBT Architects*, 1989–91. Almack's (by *Robert Mylne*,
1764–7), the most aristocratic of all the Georgian assembly
rooms, once stood here. The GOLDEN LION (No. 25) is
another extravagant pub, by *Eedle & Myers*, 1897–9. Tall,
narrow and fanciful, the main ingredients Jacobean. Bowed

ground floor of black marble. Nos. 23–24 (KVAERNER), unlovely big Postmodern again, of 1986–8 by *EPR Architects*. Reset down Angel Court, l., rather French figure reliefs by *Bainbridge Copnall*, 1959, from an earlier office block. One includes portraits of Laurence Olivier and Vivien Leigh. They commemorate *Samuel Beazley*'s St James's Theatre of 1835, reconstructed 1899, but externally barely altered on demolition in 1957. Immediately to the w No. 22, a two-bay house refronted probably *c*. 1770.

CROWN PASSAGE, just beyond, is the only alley running s from King Street to keep the pre-C20 character. Mostly small shops and cafés; about a third Georgian. No. 18 (w side) has a later C18 shopfront with boxed-out bay.

PALL MALL

Named from a ball game called *palle-maille* in French (from Italian *palla* and *maglio*, ball and mallet). It was played on a grassed alley, one of which was established here by 1630. The present street was laid out in 1661, probably along this same alley; The Mall was remade still further s, and the game revived there (*see* p. 654). The new street filled with courtiers (including Defoe's Roxana), rented lodgings, taverns and coffee houses. Some of the last metamorphosed into private clubs after the mid C18, e.g. Almack's at old No. 50 (1762). Insurance offices arrived in the 1790s, and their C19–C20 premises remain in force. The sides are divergent architecturally: mostly commercial on the N, with narrow plots; more imposing on the s, which is owned by the Crown Estate, where C19 and early C20 clubs dominate. Pall Mall was the first British street to be gas-lit, in a trial of 1807. The description is from E to w along the s side, returning along the N.

South Side, from Waterloo Place west to Marlborough Road

The clubs which are the fame of Pall Mall begin with the former United Service Club and the Athenaeum, for which *see* Waterloo Place, pp. 445–7; for Nos. 120–125, on the s side further E, *see* Cockspur Street, p. 340.

The TRAVELLERS' CLUB of 1829–32, immediately next to the Athenaeum, is *Charles Barry*'s first club: the British début of the Italian palace style pioneered in Munich by Klenze ten years before. It is modest in size, stuccoed rather than stone-faced, and only five bays wide and two storeys high. The upper windows have triangular pediments on pilasters, with balustraded aprons coming down to a decorated storey band. Entrance up steps to the r., not the middle; on the l. a plain strip of wall, to stop the cornice chopping into the Athenaeum. The garden façade, s, has windows with arched shell-heads on the Venetian Quattrocento pattern, instead of the Roman manner of the front. Also Venetian in origin is the arrangement of the bays, here 1-3-1, a very influential rhythm for the early Victorians. Above, a bracket-

Travellers' Club. Pall Mall elevation. Engraving
(W.H. Leeds, *Supplement* to J. Britton & A.C. Pugin, *Illustrations
of the Public Buildings of London*, 1838)

cornice and hipped roof, and on this an arched-windowed
belvedere. Barry intended this from the first as a smoking
tower, but shortage of funds delayed it until 1842–3. Later it
was converted into bedrooms. Barry won the competition in
1828 with a no less Italianate design, but for a site further w.

INTERIORS. The rooms fit around an open *cortile* originally
of three bays by three, treated with superimposed cornices and
round-arched openings. The ENTRANCE has columns to the l.,
for a porter's office, and steps up to a barrel-vaulted corridor-
lobby at the end. This was extended along its l. side for a
WAITING ROOM in 1911, by *Macvicar Anderson*, at the expense
of one bay of the *cortile*. The main rooms are the OUTER
MORNING ROOM along Pall Mall, the INNER MORNING
ROOM behind it, and the SMOKING ROOM across the entire
back. They are Grecian rather than Italianate, with antae and
compartmented ceilings. Much furniture designed by *Barry*,
including the fine circular hanging lamps. The STAIRCASE
immediately behind the Smoking Room is a broad dog-leg,
less elaborate in its arrangement than most club staircases.
Mahogany balustrade in English mid-C17 style; over it a
shallow dome with Raphaelesque decoration from a scheme by
F. Sang of 1843. The first floor has two major rooms, of which
the COFFEE ROOM facing Pall Mall was made in 1911 by com-
bining two unequal interiors, keeping the coved ceilings dis-
tinct. The present decoration, a subtle combination of ochre,
grey and sage based on a treatment probably of the 1840s, is

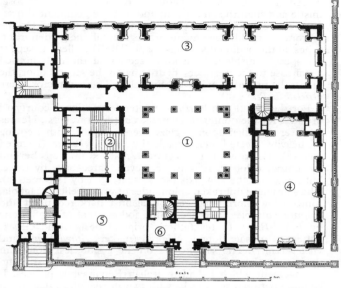

| 1 Saloon | 4 Morning Room | 5 Strangers' Room |
| 2 Staircase | 3 Coffee Room | 6 Porter's Lodge |

Reform Club, Pall Mall. Ground-floor plan, as completed
(*The Civil Engineer and Architect's Journal* 4, 1840)

by *Peregrine Bryant*, 1990. The LIBRARY is tripartite as usual,
the divisions made by lively screens of moderate-sized paired
columns. The effect dates only from *c.* 1838, however, when
the E column-screen replaced a dividing wall. The frieze of the
central space is copied from that of the Temple of Apollo at
Bassae, discovered in 1811 by a future member, *C.R. Cockerell*;
the casts may come from the staircase he made at the club's
first premises, No. 49 Pall Mall, in 1821–2. Redecorated
c. 1970, reinstating oak-graining effects recorded in 1839. The
E side between the main ranges houses service rooms, with two
bedroom storeys added over them by *H.L. Anderson*, 1930–1.
The REFORM CLUB next to the Travellers' was founded in
1836. Its name reveals its political tendency. In 1837 the club
leased the present site, available in connection with a new
road through to Carlton Gardens, and sought designs. *Barry*
was chosen in 1838, and his Reform Club, as completed in
1841, might well be called his masterpiece, of near-perfect
planning and enormous stylistic influence. Compared with the
Travellers' it appears as maturity after lovable youth. The ele-
ments are the same, but everything has more weight and self-
confidence: nine bays instead of five, Portland stone facing
instead of stucco, with an extra upper storey, a big entrance

placed in the centre, and of course a bolder cornice, with rose, thistle and shamrock motifs. In addition the pedimented first-floor windows have demi-columns instead of pilasters. On the w front the middle pediments are segmental; the garden front, s, has all the pediments of this shape. The Travellers' is kept at a respectful distance by a lower section at the E. It housed a staircase to the members' bedrooms on the second floor, the first to be provided in a West End club. The contractors were *Grissell & Peto*.

For the INTERIOR Barry first intended an inner courtyard or *cortile* for the dominant centre, as in the Travellers'. He was however prevailed upon to glaze over the space, with a coving of heavily faceted glass made by *Apsley Pellatt* (restored 1997–8). The result is the SALOON, reached up steps beyond the entrance lobby. It is two-storeyed, three bays by three, but longer on the E–W axis (57 by 52 ft, 17.4 by 15.8 metres). The sides have unbroken colonnades of warm yellow scagliola, Ionic below Corinthian, set off against dark red paint and coloured marbles. The decoration follows that of 1878, done by *E.M. Barry* to his father's original design; the Greek-patterned mosaic floor is original (makers *Alfred Singer* and *Henry Pether*). The STAIRCASE on the E side, less dominant than in the Late Georgian clubs, is confined to the size and arrangement which it had in Italian Renaissance palaces. It runs up between solid walls with two breaks of 90 degrees at domed intermediate landings (one with a BUST of Barry by *Patric Park*, †1855). The COFFEE ROOM all along the s side develops the usual triple clubroom division into a fivefold space, with the three taller main volumes separated by lower bays aligned with the Saloon corridor doorways. These bays have coffered ceilings, and engaged Ionic columns, replacements of 1853 for the original scagliola ones. Columns with strips of coffering between recur on each end wall, and a glazed internal window looks back into the Saloon. The LIBRARY immediately above, converted in 1853 by *Barry* from a drawing room, is similar in plan but richer in treatment: paired Corinthian columns standing free at the dividing bays, enriched coved ceilings in the larger compartments. The other chief rooms are on the w front, MORNING ROOM below (with a half-size copy of the Parthenon frieze), SMOKING ROOM (formerly library) above. Both are lined with bookcases, and have splendid Cinquecento ceilings and columned recesses at the s end. Much of *Barry*'s furniture remains (makers *Taprell, Holland & Son*). Lesser rooms on the N front, the STRANGERS' ROOM below with scarlet decoration of 1993, the CARD ROOM above, equipped with bookcases 1996, both by *Purcell Miller Tritton*; the PORTER'S LODGE has false rustication by *Ian Grant*, 1990–1. Huge, well-planned kitchens in the basement.

In its SERVICING the club prefigured the sophistication of Barry's Palace of Westminster: a small steam engine housed under the pavement pumped and heated water, raised coals, and drove a fan ventilator to extract the air that its own heat had warmed. This was fed into the rooms through ducts hidden in cornices and covings.

Nos. 100–109, offices of 1956–8, are by *Donald McMorran* (elevations) and *D. Armstrong Smith*. A flat, smooth front of classical symmetry and proportion, yet not in period imitation. The shallow segmental arches of some openings are the hallmark. The whole seems to keep a strange ghostly silence.

Next the ROYAL AUTOMOBILE CLUB of 1908–11, last and largest of the clubs of St James's, by *Mewès & Davies* (working with *E. Keynes Purchase*). It shows the type converging with the luxury hotel, with up-to-date steel-framed construction, extensive services skilfully hidden, and three upper bedroom floors. These arrangements are masked by the long *hôtel-de-ville* front, which shows only three major storeys. The design is also a homage to Gabriel's ranges of 1757–75 in the Place de la Concorde, Paris, where the French Automobile Club had found an early home. Giant Ionic columns, the central four set forward in a portico. Pediment sculpture by *Ferdinand Faivre*: a woman, four cherubs, a primitive motor car. To either side and at each end are blank piers with four delicate trophies (The Elements) carved by *Rajon*. Other carving by *C.H. Mabey*. Rear façade to Carlton Gardens in a more C17 manner, with a domed mansard. The lower, Trianon-like block between the shallow-projecting ends here houses the former lounge, with a roof terrace above.

 INTERIORS. Circulation centres on a big oval double-height VESTIBULE, reached up steps from the entrance hall and through square-headed openings in its long side. Its upper level has a fine ornate Doric colonnade. Big group portraits around the walls behind them by *Madwen Biao*, 1997 (the club's centenary year). The familiar flattering club style. Otherwise the walls are lined out in French *stuc*, extending into the axial corridors running off l. and r., and also into the staircase, of narrow open-well type, fitted in at the SW. This discreet placing is another break with the traditions of clubland. Other rooms were collaborations with interior decorators, of whom the Parisian firms understandably inclined to Louis XV or XVI, the Londoners to various phases of Neo-Georgian. In line with the vestibule, S, is the giant RESTAURANT (formerly Lounge) by *Boulanger* of Paris, with paired pilasters, sky-painted ceiling, and a stage and musicians' gallery at opposing ends. To E and W are big rooms each of full depth and with column-screens. To the W, the SMOKING ROOM by *Lenygon & Morant* of Old Burlington Street, with inset C18 paintings of birds and outdoor still lifes, Dutch and Neapolitan schools respectively. The rest is Anglo-Palladian, with a thick over-compartmented ceiling in the central space. This and the frieze of gryphons are reproduced from the drawing room at Cumberland House (old No. 86), one of several buildings on the site taken over in the C19 by the Ordnance Office (later War Office). It was of 1761–3, by *Matthew Brettingham Sen.* for the Duke of York. The corresponding, E room is the RESTAURANT by *Remon* of Paris. Louis XV style, with cut-up C18 landscapes attributed to *Jurriaan Andriessen* on the walls; also racy Futurist-style paintings of cars in the entrance apse, by *Barnaby Gorton*, 2000. Above it on the first floor the MOUNTBATTEN ROOM (formerly Members' Dining Room), *Lenygon*

& *Morant* in a more Anglo-French style à la Chambers.
Restored 1995. Smaller rooms by *G. Jackson & Sons*, includ-
ing the strangely shapeless Billiard Room (now LIBRARY)
across the front, and several little rooms at the W end (COM-
MITTEE ROOM, SEGRAVE ROOM, MALL ROOM). Good
English marble fireplaces in these rooms, mid–late C18.

The sporting facilities thought essential for a major club by
the 1900s are fitted into the basement, approached formally
via a twin-armed staircase under the vestibule. The big draw
is the marble-lined SWIMMING POOL, with triple Roman-
bath-type apses for natural light, but with vaguely Persian
patterns to the mosaics on the simplified Doric colonnades
around all four sides. On the staircase a SCULPTURE of a sea
goddess by *Gilbert Bayes*, 1927. Also Turkish baths.

Nos. 83–85, nine-bay offices of 1911–15 by *Metcalfe & Grieg*, are
as tall as the RAC and continue its cornice and Dixhuitième
air, but fit in five storeys instead of three.

Next SCHOMBERG HOUSE (Nos. 80–82), one of the few remain-
ing houses of C17 London which are more than ordinary ter-
races. It was built or more probably refronted in 1698 for the
3rd Duke of Schomberg, whose father came over with William
III. The four-storey elevation, less sophisticated than those of
Wren and his circle, suggests the hand of a London builder sud-
denly given his big chance; the *Survey of London* records work
in 1698 by the carpenter *Robert Jeffs*, but the design may not
be his. Projecting three-bay centre with a pediment, three-
bay wings each including a single further projecting end bay.
The middle bay also advances very slightly, underscoring the
Baroque sense of movement. Brown brick with red trim, the
middle bay with vertical lacing. Quoins to the centre and wings.
Tall, slender windows, their spacing echoed in the cornice by
brackets formed of acanthus and shells, remade in artificial
stone. Early views suggest there was a cupola above. The pretty
porch with twisting termini atlantes was added only in 1791,
for the Polygraphic Society, which exhibited copies of pictures.
It is of *Coade* stone, as is the tablet on its parapet with an alle-
gory of Painting. It gave entry to one of three units into which
the house was split in 1769. The l. unit, demolished in 1850–1,
was carefully rebuilt to the C17 design in 1956–8, by *C.H.
Elsom*. The trade-off was the demolition of the back parts to
build offices. Their more crowded forms suited an earlier date,
perhaps 1664–7, when two houses were first built here.

At No. 79 the old Eagle Insurance Co. (now P&O), ornate
Lombardo-Venetian of 1866–8, by *David Brandon*. The big
open-pedimented porch dates from *Macvicar Anderson*'s
alterations, 1894–6. 1860s staircase, restored *c.* 1978. No. 78 is
a four-bay brick house probably of *c.* 1720–4, with Victorian
ornament, e.g. windows interlocked by decorated aprons and
bands. The likeliest date is 1862–3, when *T.H. Wyatt* remod-
elled it for the 2nd Marquess of Ailesbury. The cornice and
some sill brackets seem early C18. Porch reinstated *c.* 1982.
Wyatt's work included a ballroom wing at No. 77, visually
distinct, with a broad-shouldered oriel and elaborated pavilion
top. The ballroom is long and quite narrow, with Corinthian

half-columns and rich sunk ceiling panels (first floor); supper room behind, with a sideways-facing bow. Since 1951 the wing has been part of the Oxford and Cambridge University Club, r.

The OXFORD AND CAMBRIDGE UNIVERSITY CLUB is by *Sir Robert Smirke*, 1835–8, assisted by his younger brother *Sydney* (builders *Grissell & Peto*). A strangely incoherent front, uninfluenced yet by Barry's Italian Renaissance, but far distant also from Robert Smirke's usual uncomplicated Neo-Grecian. Seven bays, the ground floor rusticated and with round-headed windows, the first floor with banded rustication and square-headed windows framed by square pillars or half-pillars. The material is stucco, restored to the original stone colour in 2002–3. Above the upper windows are terracotta-coloured panels with reliefs in the antique taste showing 'exalted labours of the mind'. *W. G. Nicholl* modelled them from designs by the artist *Robert Smirke*, father of the architects. Honeysuckle frieze and cornice. Porch with paired Corinthian columns. First-floor balcony of cast iron, as also the area railing of reticulated pattern, into which piers and flambeaux were inserted in 1872. *Sir Reginald Blomfield* added a dormered bedroom storey in 1912. The club merged with the United Universities Club in 1971 (*see* Suffolk Street, p. 431), and the building was overhauled by *Maguire & Murray* in 1972–4, creating labyrinthine sports and function rooms in the basement.

INTERIORS are in the Greek taste, much plainer and more restrained than the exterior. Ceilings are flat or coved with central rosettes, fireplaces large but simply handled, of white or coloured marble, and rooms subdivided mostly by antae rather than columns. Sobriety is tempered by added door cornices, wall mouldings etc., seemingly of different dates; work is recorded in 1857, 1863 (both *Sydney Smirke*), 1907, 1912 (both *Sir R. Blomfield*), 1920, and 1937 (*Blomfield* again). The ENTRANCE has square columns framing a broad flight of stairs up to the main STAIRHALL. This was lined with light brown marble and given a weighty Doric Venetian window over the half-landing by *Blomfield* in 1907. The main staircase is a giant dog-leg, with a fat balustrade in the mid-C17 English Palladian taste. To the r. is the COFFEE ROOM, the largest room (66 by 33 ft, 20.1 by 10 metres), perpendicular to the front. Antae make the familiar tripartite subdivisions. Their capitals look like interwar additions, jammed up against the consoles of the ceiling beams. Present decoration 1993. An opening on the l. of the stairhall leads via a cross-vaulted lobby to the Morning Room, facing the street (now MEMBERS' BAR), and the former Strangers' Dining Room behind, with an oversized Venetian column-screen inserted by *Blomfield*, also 1907. Over the Coffee Room is the LIBRARY, two inter-linked rooms with birchwood bookcases of strong architectural character. The SMOKING ROOM on the other side has the richest ceiling: a pattern of square sunk cofferings, more lavish over the larger, inner part, which corresponds to the Morning Room below. Decorated in yellow tones by *Purcell Miller Tritton*, 2001.

The last buildings are interwar, both tall and stone-faced, with
flats above. Nos. 69–70, built for the Midland Bank in 1922–7
by *T.B. Whinney*, is conservative, with engaged giant columns.
Spacious but shapeless banking hall, with green marble colon-
nades. Nos. 67–68 on the corner to Marlborough Road, of
1930–1, has elevations designed by *Lutyens*. Here he seems fully
in control, and not just pranking up a big utilitarian mass,
as at some of his late commercial projects (cf. Nos. 499–521
Oxford Street, p. 469). Twin pedimented top bays, mannered
mezzanine windows to a different rhythm, and a rusticated
Doric ground floor with pilasters which seem to disintegrate
and recoagulate.

DEMOLISHED BUILDINGS on the S side deserve their own
paragraph. For Carlton House, on the site of Waterloo Place,
see p. 439. At Nos. 100–109 was the original CARLTON CLUB
(for the present one *see* Nos. 69–70 St James's Street): of
1833–6 in *Sir Robert Smirke*'s Grecian style, extended by *Sydney
Smirke* 1846–8, followed 1854–6 by rebuilding of Robert's part
to match. Sydney's was the first club to adopt the luxuriant
Venetian Cinquecento, here based on Sansovino's Library
of St Mark. In 1923–4 *Sir Reginald Blomfield* refaced it to
a smoother design; bombed 1940 and demolished. *Soane*'s
BUCKINGHAM HOUSE (No. 91) was a broad stone-fronted
house of 1792–5, for the 1st Marquess of Buckingham. It
was amongst properties taken over in the C19 by the War
Office and demolished *c*. 1908–12 (*see* also Royal Automobile
Club, above). At Nos. 66–68 was the JUNIOR NAVAL AND
MILITARY CLUB, 1874–5 by *T. Dudley*, a towering French-
Renaissance nightmare.

North Side, from St James's Street east to Waterloo Place

The Alliance Assurance on the corner belongs with St James's
Street (q.v.). The narrow No. 62 has a copy of 1950 of the mid-
C18 shopfront at No. 34 Haymarket (*see* p. 415). Nos. 59–60
(now QUEBEC HOUSE), the former London & Lancashire Fire
Insurance, was refronted by *Guy Dawber, Fox & Robinson* after
wartime blast damage, a reserved Neo-1700 design with lots
of twenty-four-pane sashes. The panelled chimneys remain
from *Dawber*'s more eventful premises of 1905–7. It spans the
entry to Crown Passage (*see* King Street). No. 58, 1910s, and
Nos. 55–57, apartments of 1888 in mixed *ancien-régime* style,
were rebuilt behind in 1972–5, the first instance in West-
minster of façades saved by Conservation Area legislation.
No. 54 is by *Karslake & Mortimer*, 1890–1, for Fosters the auc-
tioneers. Sharply gabled, narrow, with diversified balconies.
Rebuilt behind 1999–2000, including a replica front of the old
No. 53, late C19 with a rounded pedimented gable. *Trehearne
& Norman*'s Nos. 51–52, 1994–5, is in character a sort of
simplified 1915.* Then two blocks of chambers, each with a

*Alderman Boydell's Shakespeare Gallery at No. 52 was of 1782–3, by the younger
George Dance (dem. 1868), with the influential novelty of quasi-Ionic ammonite
capitals on the front.

projecting centre with balconies pushed in: No. 50 by *Metcalfe & Grieg*, 1913, No. 49 by *H.H. & M.E. Collins*, 1897. The latter was adapted for the BRITISH LEGION *c.* 1950, with a bland extension at No. 48. Blandness is not an issue at *Trehearne & Norman*'s Nos. 44–47 (1996–7). It is symmetrical, strongly modelled, with thin stone fins supporting close window screens, and high up also two turquoise-painted balconies of strange kidney-shaped outline. Sills and window heads of steel, inset in the manner of Aldo Rossi. Back to narrow fronts with No. 42, characteristic Franco-Italian of *c.* 1870 (*C.J. Shoppee*); No. 41, also 1870s but more explicitly French, by the Paris-trained *William Harvey*; and No. 40 by *Garland & Christopher*, stuccoed and bowed in Park Lane fashion, 1850.

Then two large nondescript 1960s blocks on either side of the SW entrance to St James's Square, a poor exchange for the great Victorian clubhouses they supplanted. At Nos. 36–39, W, the casualty was *C.O. Parnell* and *Alfred Smith*'s ARMY AND NAVY CLUB of 1848–51, an outstanding example of Venetian High Renaissance. Fourteen of its cast-iron lamp standards are reset around the replacement, of 1962–3 by *T.P. Bennett & Son* (heightened 1970–1). In a glass case on the S front, a war-memorial STATUE of a naked Greek warrior, *c.* 1925, by *Basil Gotto*. Replacement club premises fill the lower floors, with timid, inferior Adam-style detailing. (Some retained fireplaces.) Its counterpart to the E is by *Norman Royce & Partners*, 1966–8, very large, with a weighty leaded mansard and ineffectual boxing-out on some upper storeys. Premises were incorporated for the JUNIOR CARLTON CLUB, but this merged in 1977 with the Carlton Club in St James's Street. Its old home was a Barryesque palazzo of 1866–9 by *David Brandon*, altered and extended symmetrically to the W by 1885–6 by *Macvicar Anderson*. A later annexe survives at No. 29 (*Tatchell & Wilson*, 1929–30), but this took nothing from the style of the club. The more demonstrative Nos. 27–28, pilastered and channelled stone, was built in 1902 by *F.E. Williams* as offices and showrooms for the Wilkinson Sword Co. Nos. 25–26 is a neighbourly job by *Gibberd, Coombes & Partners*, 1987–9. Upright window panels defined by narrow grooves, the central bay carried up as a tall attic. No. 22, by *R.F. Russell* for the Imperial Insurance, 1878, is in the early red brick style of Norman Shaw. An early car showroom at No. 21: by *E. Boehmer* for Renault, 1911, Louis XV, with big display windows.

Broader fronts in the final stretch. Nos. 18–19 is by *H. Tanner Jun.*, 1913, of modern Parisian derivation. Also of 1913 the former Scottish Provident Institution (Nos. 16–17), a homage to the Michelangelo of the Medici chapel, e.g. the second-floor pediments clasping blocks with carved swags. By *Dunn & Watson*, with *W. Curtis Green* and *A.C. Dickie*. Nos. 13–15, flats of 1892–3 by *Joseph & Smithem*, coarser and more profligate. For buildings beyond *see* Waterloo Place, pp. 448–9.

PARK PLACE

A quiet, shapeless close off St James's Street. Built up after 1681.
Of that time Nos. 13 and 14, S side, behind stucco façades of
c. 1830. No. 14 (PRATT'S CLUB) has a timber-framed rear wall,
as do several houses in St James's Place, S, by the same builder,
John Rossington. Otherwise mostly earlier C19 inside, e.g. the
ground-floor column-screen. These arrangements reflect the
select private hotel run by W.N. Pratt, which developed into a
club from c. 1840. At Nos. 7–8 a ghastly Franco-Scottish pile
of chambers by *M.E. Collins*, 1892. On the N side Nos. 4–5,
inventive infill by the *Rolfe Judd Group Practice*, 1986–8. A
white rendered front with three sinuous bows, increasingly
deep from l. to r. Within the r. end a new public staircase up
to Arlington Street, N.

At the W end is the forecourt of the ROYAL OVER-SEAS
LEAGUE, which comprises two big parkside houses and a
1930s extension, NE. Entrance is made through the former
Vernon House, l. Probably late C17 in origin, it was rebuilt
in 1835 and again in 1906–8 for the 2nd Lord Hillingdon
by *Ambrose Poynter Jun.*, after a fire. Poynter's mixed C18 style
appears in the projecting stone porch, stone trim, and first-
floor Venetian window. Along the entrance courtyard on the
N is the League's extension of 1935–7, utilitarian light brick
by Messrs *Joseph*. It entirely fills the former entrance court of
the second house, built in 1734–40 by *James Gibbs* for Maria,
Dowager Duchess of Norfolk. Gibbs's street front was thus
destroyed, but the park elevation survives: perfectly plain four-
bay brick, with an added fifth storey and a continuous second-
floor balcony in the style of c. 1800. Gibbs's stable block also
remains, facing Arlington Street (q.v.).

INTERIORS. Within Vernon House the most notable relic of
c. 1835 is a column-screen in the Buttery (ground floor). Some
Neo-Regency interiors of 1906–8; also the handsome timber
staircase just inside the entrance (carving by *Aumonier & Son*).
From here a continuous space has been made into Gibbs's
house, giving the odd effect of two staircases in one split-level
interior. Gibbs's staircase is big and toplit, of stone, climbing
in three flights behind a screen of Ionic columns. Uncommonly
fine wrought-iron handrail (*Thomas Wragg*, smith): scrolls and
a few leaves, without any indication of baluster or S-motifs.
Each floor has three main rooms, with a back stair W of the
main one. Much detail has been lost, but some pedimented
doorcases and carved marble fireplaces remain, e.g. in the
toplit WRENCH ROOM on the first floor. (Fireplace in the
Rutland Room, adjacent, attributed to *Rysbrack*.) In the 1930s
extension a lecture room lined with Indian woods.

ST JAMES'S PLACE

A close, with unexpected broader openings off it, and great
houses or house sites at the Green Park end. The E part was
made in 1685–6, the W in the 1690s. The first houses were

undertaken mostly by *John Rossington* and family. The E part is still largely lined with their houses of 1685–6, with three-bay fronts and partly timber-framed closet wings (Nos. 2–4 and 6–9, N side, and Nos. 40–45, S). The late C17 proportions show through various later heightenings and refacings. Some retain panelled interiors, with dog-leg staircases reached through pilastered arches. Nos. 4 and 41 have 1970s fronts; No. 5 is a facsimile of *c.* 1987. Past No. 39 is a tiny square formed by mansion flats of the 1890s–1900s and the back of the Carlton Club (*see* St James's Street).

Further W, the houses become more mixed in date. No. 10, 1774–5, has a slanting front with an added balustrade and bow; one big decorated first-floor ceiling. Nos. 11 and 13, 1781, the latter with round-arched windows below and an Adamesque ceiling; No. 14, *c.* 1690–3, behind an early C19 canted bow; No. 15, tall late C18, with a smaller canted bay. The last two overlook a broad yard or small square. Continuing clockwise, No. 31 is late C18, with a wide canted bow, and on the flank a pretty doorway with a glazed arch. Plain open-well staircase, said to be from alterations for Lady Ann Bingham by *Henry Holland*, 1802. No. 29 is 1690s; No. 28, reconstructed in 1794 also by *Holland*, has another handsome doorway.

SPENCER HOUSE (No. 27), one of the large stone mansions turned towards the park, forms the SW part of the square. It is the finest C18 London mansion remaining, built in 1756–8 by the elder *John Vardy* for the young John, later 1st Earl Spencer and his beloved wife Georgiana (chief mason *John Devall*).* Spencer was guided in architectural matters by his friend *Colonel George Gray*, Secretary to the Society of Dilettanti and an advocate of the direct imitation of Antique forms. Gray directed and corrected Vardy's hand, and in 1758 may have been instrumental in replacing him with *James 'Athenian' Stuart*. Stuart's vastly greater archaeological knowledge was deployed in decorating the first-floor rooms, completed in 1766, which are amongst the earliest interiors in Europe to show the Neoclassical turn of the later C18. The special position of Spencer House in the history of taste was recognized in the scholarly and craftsmanlike restoration of 1987–90, undertaken by *Rolfe Judd* on the initiative of Jacob, Lord Rothschild. The main suites are now used for functions, the modernized service wings for offices.

The EXTERIOR shows Vardy's solid grounding in the 49 Palladianism of Burlington and Kent. The more original elevation faces the park: a round-arched rusticated ground floor and a *piano nobile* with engaged Doric columns separating seven windows with alternating pediments. These are organized not in the stereotyped 2-3-2 rhythm but 1-5-1, by means of a broad central five-bay pediment. The single bay to either side has a recessed entablature, then one more column and a setback pilaster to finish. For a Doric façade the treatment is rich: frieze with bucrania and paterae after Palladio, windows

* In 1754 Vardy had designed a house on the site for the 1st Lord Montford, who killed himself before work could begin.

with balustraded aprons, and a skyline of urns and of statues
(Bacchus, Ceres, Flora) carved by *Spang*. To the s a baldly
treated canted bay, over which the entablature skips up in an
open pediment. The sashes are c20 restorations. A rusticated
and balustraded terrace comes out in front. It overlooks a
formal GARDEN, restored after 1994 by *Todd Longstaffe-Gowan*
to the layout of *c.* 1795. The ENTRANCE FRONT on St James's
Place was never finished: the pilaster at the l. marks where a w
wing was intended, which would have repeated the applied
four-pilastered portico framing a Venetian window and niches
at the r. The middle is five bays wide, with windows for an
upper storey instead of a full frieze. Entrance in a projection
with a flattened rusticated doorcase, with a plainer Venetian
window over. The s or service front faces a close opening off
Little St James's Street to the s: plain utilitarian brick, with one
small Venetian window of stone. Two upper office storeys of
1987–9, in keeping, replace bedrooms added after 1926 by the
Ladies' Army and Navy Club. On the old stables site opposite
are Neo-Georgian MEWS by *W. Curtis Green, Son & Lloyd*,
1950.

 INTERIORS. Vardy's plan is a pragmatic arrangement around
an L-shaped court, with the main rooms superimposed on the
park side. These are enfiladed, i.e. not yet in a circuit, as at
Norfolk House in St James's Square (q.v., No. 31 there). On
the second floor were private apartments. Besides Vardy's and
Stuart's work, the Whigs' favourite architect *Henry Holland*
remodelled some ground-floor rooms from 1788 for the 2nd
Earl. The c20 restoration installed impeccable copies by *Dick
Reid* of doors and fireplaces removed in 1941 to Althorp,
Northants and reinstated certain mouldings. Decoration by
David Mlinaric. The c18 plasterers were *Thomas Clark* and
Joseph Rose Jun., the joiner *Thomas Vardy*, brother of John.

 The ENTRANCE HALL is oblong with rounded corners, and
a view into the restored courtyard with its brick elevations.
Tall doorcases and fine Doric entablature, typical of *Vardy*'s
work. The latter derives from two antique Roman sources, a
reminder that a clear line between Palladianism and Neoclas-
sicism cannot be drawn. The ceiling with its reeded circular
compartments looks wrong for the 1750s. It may be by *Philip
Hardwick* and of 1847. Fireplace by *Devall*, of plain stone, with
a central ram's-skin tablet. Cast relief of Antinous over it. To
the l. the simple cove-ceilinged MORNING ROOM, modified
by *Holland*; to the r. the stairhall (*see* below). Off the latter is
the ANTE-ROOM, originally a private dining room, with a com-
partmented ceiling and a great apsed niche coffered after the
Temple of Venus and Rome. *Holland* converted this from a
buffet recess to an entrance, and made another doorway into
the sober LIBRARY beyond, in the N angle of the park front.
Here a simple coved ceiling and the first of the replica fire-
places, with sideways brackets. A still richer one is in the
DINING ROOM beyond, which has Ionic column-screens at
each end. *Holland* gave them Grecian capitals and scagliola
shafts, and removed some pilasters. Their former positions
show from the divisions of *Vardy*'s ceiling, a version of one at

the Horse Guards in Whitehall, where he also worked (*see* p. 254). Frieze of putti holding garlands, after the Temple of Fortuna Virilis in Rome. The extraordinary PALM ROOM to 57 the S has Corinthian half-columns wrapped in palm fronds on one wall, framing an arch to an exquisitely decorated closet, also with palm fronds, formed as three coffered apses opening off a domed central space. The palms derive from a drawing by John Webb for the King's Bedchamber at Greenwich, the main frieze from yet another Roman temple, of Antoninus and Faustina. The green, white and gold colours are original.

A groin-vaulted corridor leads back N to the STAIRHALL. Open-well stair of stone, with a peculiar flat balustrade (smith *John Palmer*). It has restored *trompe-l'œil* foliage painting. Venetian window over the half-landing, framed by Ionic pilasters linked by garlands that carry on round all four walls. These and the barrel vault with coffering in two sizes are by *Stuart*. They show his flatter and sparer style and fondness for using his Greek discoveries (the frieze is after the Temple on the Ilyssus, Athens), though not yet a consciously non-Roman aesthetic. The simple MUSIC ROOM, much restored, lies to the N, with Lady Spencer's closet and bedroom to its E, and her very much richer DRESSING ROOM to its W. Here a ceiling with eight circles around a curved-sided octagon, after a famous example at the Baths of Augustus in Rome, and another Greek frieze. Damask-hung walls. The GREAT ROOM is a match in size for the Dining Room below it, but its gravely glorious coved ceiling and absence of column-screens make it seem larger. The coffering has coving of Roman type, with four giant bronzed medallions (Bacchus, Venus, Apollo, the Three Graces) supported by panthers, griffins or putti, and an urn in relief in each corner. Three flat domes in the centre panel. Greek motifs on the doorcases (added *c.* 1925 by the 7th, 'curator' Earl), and fireplace, a copy of 1992 of *P. Scheemakers*'s original with a figure frieze after the Lysicrates monument. The gorgeous PAINTED ROOM beyond is more innovative still, though to modern eyes its Roman, Herculanean and Italian Renaissance sources tend to pull in different directions. The plan is a pilastered square with a Corinthian column-screen and a triple-windowed semicircle lined with smaller columns to the S. On the walls are painted scenes showing the Triumph of Love, some against the green ground, others on small symmetrically inset canvases. Parts were painted by *Stuart* himself, others probably by *Biagio Rebecca*. Their flattened figures, linking foliage and dark grounds are especially prophetic of later C18 taste. Brightly painted floral scrolls on the pilasters, after Raphael's Vatican logge. Intact fireplace with graceful female herms and a copy of the famous Roman painting known as the Aldobrandini Marriage, with cherub reliefs after *F. Duquesnoy* inset above. The Zodiac presides from the central compartment of the ceiling, which was partly renewed in *Robert Atkinson & Partners*' restoration of 1956. The furniture, designed by *Stuart* for the room, employs appropriate antique motifs.

To the N of Spencer House comes a narrow view out to the park,

then No. 26, by *Denys Lasdun & Partners*, 1959–60, a return
to advanced Modernist forms for luxury flats. Its main impact
is made towards the park. It may be overbearing, it may even
be brutal, and it certainly dwarfs Spencer House. But it has
force and character, in its unexpected rhythm, with a cleft
running up the centre cut by balconies at first- and fourth-
floor levels. To its l. are six upper floors, to the r. four, sub-
divided by two more balconies. The explanation of this strange
3:2 rhythm is that there are split-level flats inside, a device
traceable back via 1930s England to early Soviet architecture.
Polished granite facing, blue bricks in the less important or
emphasized parts, and heavy bronze windowframes. At the top
a penthouse flat and a mighty finishing concrete slab, fore-
shadowing the stratified horizontals of Lasdun's later works.
The engineers were *Ove Arup & Partners*.

Along the branch of the street turning N are more 1950s–60s flats,
likewise replacing wartime losses, but less original: No. 25, with
drawer-like balconies, by *Vigers & Co.*; No. 24, granite-faced;
and *Maurice Bebb*'s Nos. 21–22, 1958–60, with effeminate
Vogue-Regency balconies to the park. The exception is No. 23,
the very last big private house built in the West End: 1929–30
for James A. de Rothschild by *Simpson & Ayrton*. A conser-
vative design, stone-faced, with a broad canted bay that
joined what was once a long parkside sequence.* Interiors
include a library with Chippendale-style fretwork bookcases.
Across the top, No. 20 is a refronted late C18 house, No. 19
perhaps older, with a few Gothick details. On the E side, *J.N.
Horsfield*'s No. 18, 1889, terracotta-dressed Renaissance, and
Nos. 16–17 (STAFFORD HOTEL), originally mansion flats, by
the Wolverhampton builder *Henry Lovatt*, 1899–1901. These
have a grid-like brick front with recessed canted windows
under shallow relieving arches.

ST JAMES'S SQUARE

St James's Square is the first of the true West End squares. The
Earl of St Albans obtained its land by lease in 1661–2, by free-
hold in 1665. So his square is preceded only by Covent Garden
before the Civil War, and that is much further E. The plan
with closed corners and side streets entering centrally is Italian
(Gattinara, Livorno). The building agreement of 1665 shows that
St Albans intended a central entrance on the S side also, instead
of the two side roads executed. Summerson suggested that the
earl, who lived in France in the Civil War, may have brought the
idea for the plan with him, but no French examples can with
any certainty be dated earlier than *c.* 1665 (Versailles). The earl
aimed to provide 'great and good houses' for courtiers, close to
St James's Palace. They were finished in 1677, twenty-two rather
than the thirteen or fourteen first intended. The main plots, on
the N, E and W sides, were much wider and deeper than the
London average. Fronts were strictly uniform: three full storeys,

*Including No. 21, *James Wyatt*'s house for the banker-poet Samuel Rogers, 1802–3.

windows vertically linked, hipped roofs with dormers. The s side had smaller houses, facing Pall Mall. St Albans himself lived from 1667 on the E side, from *c.* 1676 in a larger house on the sites of Nos. 9–11, N side. By 1721 six dukes and seven earls had houses in the square.

No C17 houses survive, and few of their C18 replacements, but St James's Square still has the richest collection of town houses anywhere in London. More individually treated houses or façades came in with the later C18 and C19 (Nos. 5, 11, 12, 15, 20). As private households moved away from *c.* 1840, new building types appeared: residential chambers (No. 17), clubs (No. 16) and institutions (No. 14). All this introduced an attractive variety. Serious damage began in the 1930s, when over-tall speculative offices replaced some greater houses (Nos. 3, 8, 31). But the N half preserves a mostly domestic scale, and the tall trees help conceal the even taller buildings along Pall Mall.

The GARDEN was enlarged in 1817–18 by *Nash*, making a square with rounded corners. The present layout with perimeter planting dates from 2000, the lamps all around from 1910.* On the s side a wooden SHELTER by *Nash*, 1822, with mutilated paired Ionic columns and a pediment. In the centre a bronze STATUE of William III on horseback, erected in 1808. By *John Bacon Jun.*, finishing off the commission of 1794 to his father *Bacon Sen.* In style it looks back to the older Roman Imperial manner (cf. Rysbrack's statue of William at Bristol). To the SW a statue of a stag at bay by *Marcus Cornish*, 2001. Until 1854 the king was surrounded by a circular basin, part of improvements by *Charles Bridgeman* financed through a much-imitated Act of 1726. These featured a smaller, octagonal enclosure with stone obelisks.

The numbering starts at the NE corner with Charles II Street, E SIDE, and carries on anticlockwise.

Nos. 1–2 (BP) are offices by *Sheppard Robson*, 1995–9, replacing a 1950s block. The brown brick and upright windows defer to the square, distracting attention from the big attic. Spacious, calming interiors by *Allies & Morrison*, with a gentle fall of light through the atrium.

No. 3, by *A. & D. Ospalak*, 1933–4, bland Hampton Court style with a top loggia, was the first in the square to reach for the skies. Quality-Street Georgian reliefs by *Newbury Trent*. It supplanted the 3rd Lord Ashburnham's house, probably by *Hawksmoor*, 1712–14.

No. 4 (since 1998 the NAVAL AND MILITARY CLUB) is of 1726–8 by *Edward Shepherd*, for the 1st Duke of Kent. Five bays wide, with an off-centre Ionic porch with bulgy frieze, pedimented first-floor windows, and a square-windowed attic storey above a richly detailed cornice. Above the first-floor windows a strange blank zone, where the tall coved ceiling of the ballroom rises behind. So the proportions are neither Palladian nor Baroque. Early C19 balcony on cast-iron

*Against the railings to the NE, simple stone MEMORIAL to WPC Yvonne Fletcher, shot from inside No. 5 in 1984. The first of several to London police officers killed on duty. Designer *George Cook*, 1985.

brackets. *Ad hoc* plan: front and rear rooms not aligned, stair-
case lying N of the rear rooms, with a long rear wing to its E. In
line with this a plain four-bay extension for family apartments,
of *c.* 1833–4: done by and for the *1st Earl de Grey*, amateur archi-
tect, Francophile and president of the RIBA (executant archi-
tect *W.J. Browne*). Across the end of the garden a three-storey,
quite plain SERVICE BLOCK probably of *c.* 1726 (also reached
from Babmaes Street, NE). Blocking cornice, with pedimented
centre bay. Doorcase with open pediment, of late C17 type
(reset?). Converted for a swimming pool etc. for the club by
John Warren, 1998–9, with other alterations to the main house.
The pretty concentric paving may be by *Lutyens*, 1912.

The INTERIORS are specially interesting for *de Grey*'s inter-
ventions of *c.* 1833–4, an early and unstereotyped instance of
Neo-Louis XIV, comparable to his work at Wrest Park, Beds.
ENTRANCE HALL all 1720s: Doric frieze, heavily Baroque
chimneypiece, with on the far wall three arches and a door to
the inner hall. To the r. a door to the plain back stair, rebuilt
1790. In the INNER HALL a matching frieze, and a big bolec-
tion chimneypiece with satyr-mask brackets and a fine relief of
ancient gods. It may be by *Laurent Delvaux*, *John Nost* or *Sir
Henry Cheere*, all of whom worked at No. 4. The column-screen
opposite is *de Grey*'s work, of Corinthian columns set double,
with unusual incurved volutes. It opens to the STAIRCASE
HALL, a splendid apartment with plastered walls and ceiling.
Staircase of three flights, balusters in the form of fluted
Corinthian columns. Round-headed windows in the N wall, the
niche between them with a plaster version of *J.M. Rysbrack*'s
statue of Inigo Jones at Chiswick. The ceiling is in the Jones
style with a thick central oval, but the window pilasters and
much of the wall decoration are later, done probably to make
good what was removed in 1790. Two ground-floor rooms
mostly 1720s, with nice early C19 fireplaces. On the first floor
the BALLROOM runs all along the front. Coved ceiling with
Palladian stucco decoration, doubtless 1720s. The paired-
bracket-cornice, thin wall swags and big fireplace are *de Grey*'s,
as were putti culled from fireplace and coving in 1950, during
the Arts Council's occupancy. In the overdoors two inset paint-
ings from the earl's collection: The Continence of Scipio, r.,
by *Jacopo Amigoni*, *c.* 1730; Alexander and his Doctor, l., a
photographic copy after *Eustache le Sueur*, *c.* 1650 (original
removed to the National Gallery 1998). The back drawing
room, in French Rococo style, is also *de Grey*'s (plasterer prob-
ably *F. Bernasconi*). Adjacent bedroom with pilastered bed
recess, 1720s. The green and gold decoration was done for
Nancy Astor. In the wing a large panelled saloon in a muddled
version of Louis XVI, perhaps done for the 7th Earl Cowper
in 1881. Made-up fireplace with fine male terms, English C18:
by one of the Duke of Kent's sculptors? Below it a room with
panelling subtly reminiscent of the early C19, done for the 2nd
Viscount Astor by *Oswald Milne* and *Paul Phipps c.* 1922.

No. 5, WENTWORTH HOUSE (N side), is by *Matthew
Brettingham Sen.*, 1748–9. The Palladian character survived
stone-facing by *W. Cubitt & Co.*, 1854–6, for the 1st Earl of

Strafford. Five bays, with Doric porch. Pedimented first-floor windows, possibly retained from Brettingham's work. By Cubitts the enlarged second-floor windows and the top floor. Georgian-pattern sashes were restored in 1988.

The C18 INTERIORS were a collaboration with the owner, another aristocratic amateur, *William, 2nd Earl of Strafford* of an earlier creation. They are restrained but of high quality. Straightforward plan, two rooms deep. ENTRANCE HALL with C18 doorcases, cornice and fireplace, and a loud *Minton* tiled floor of the 1850s. Other ground-floor rooms similar but with finer fireplaces, e.g. that with columns in the former DINING ROOM, rear l.; this and the answering room, r., have Venetian windows. The corridors etc. with carefully matched C20 cornices (most recent work 1988). Toplit STAIRCASE off the hall, r., with three stone flights, to first floor only. Balustrade of brass, the only known example in Georgian London, fashioned as Doric columns. Good plasterwork by *William Perritt*, verging on Rococo. In the central rear room an octagon motif ceiling and generous fireplace with herm supporters. Front rooms overlaid with French Rococo ornament probably in 1854–6, now pale blue and gilt. A ballroom of 1856 and an C18 stable block behind were demolished *c.* 1958.

No. 6. By *Fitzroy Robinson & Partners*, 1958–60. Stone-faced, with Neo-Georgian details at homeopathic levels. Large brick- and mosaic-faced rear wing.

No. 7 is by *Lutyens*, 1911–12, for the three bachelor Farrer brothers. Very subdued Neo-Georgian front, of thin red brick. It may mask a retained wall from the previous house, thought to have been refronted by *Henry Holland* in 1782–3. The top storey, as tall as that below, is Lutyens's addition. Handsome Ionic porch with broken pediment, and *A. Broadbent*'s wonderful botanical carving. Clever plan: front and back ranges are joined by a broad staircase flanked originally by light wells, allowing rooms at staggered levels and heights. The style is early C18, e.g. the LIBRARY behind, with a ballooning barrel vault and strongly architectural cases carved à la Gibbons. Several characteristic Lutyens fireplaces (six C18 fireplaces in upper rooms).

No. 8, by Duke of York Street. Over-tall Neo-Georgian offices by *R. Angell & Curtis*, 1939. Tall light well within, a clean insertion by *Jestico & Whiles*, 1994.

Further up DUKE OF YORK STREET on the w side, a modest C18–C19 group. *W.M. Brutton*'s No. 3, dated 1897, is Jacobean with neurotically tall windows. At No. 2 is the RED LION, 1821, with a pub front by *W.H. Rawlings*, 1871. Uncommonly well-preserved later Victorian INTERIOR: plenty of brilliant-cut and bevelled glass, curving island bar.

Nos. 9–11 St James's Square belong together, as their uniform window heights show. They were built by *Benjamin Timbrell* in 1735–6, replacing the Earl of St Albans's second house. No. 10 was for Sir William Heathcote, who engaged *Henry Flitcroft* for the interiors. No. 11 has been refaced (*see* below), but Nos. 9 and 10 still epitomize the Palladian-influenced Georgian town house. No. 9 was entered from Duke of York

Street, r., between Doric columns that support an early
example of a canted bay. Diocletian window over. No. 10 is
four rather than three bays wide. First-floor balcony, before
1812. Doorcase like that at Flitcroft's No. 36 Sackville Street
(*see* p. 567), with obelisks in front. These and the thick, eye-
leted cast-iron railings are original. Three prime ministers lived
at No. 10: the elder Pitt (Lord Chatham), the 14th Earl of
Derby, and Gladstone. Nos. 9–10 are now CHATHAM HOUSE
(INSTITUTE OF INTERNATIONAL AFFAIRS).

The INTERIORS have suffered much, but some good C18
work remains. In No. 10 a spacious square STAIRCASE with
unusually elegant waisted timber balusters, and a second-floor
gallery. On the upper walls stucco decoration by an unidenti-
fied Italian, copied from that formerly at No. 36 Sackville
Street. Coving above, then a square galleried lantern with
Venetian openings. The flimsy-looking balustrade down to the
basement must date from *Sir Herbert Baker*'s conversion of
No. 10 for the Institute, 1924–5.* Of 1736 the main ground-
floor PARLOUR, with an Ionic column-screen. Doric fireplace
of black marble, perhaps from work by *Philip Wyatt* and
Matthew Cotes Wyatt for the 1st Earl of Blessington, 1821. On
the first floor is *Baker*'s LIBRARY, replacing two bedrooms and
an unusual skylit octagonal lobby. It has a column-screen of
typical Baker form. No. 9, annexed by the Institute in 1943,
was most interesting for the toplit staircase, removed probably
c. 1960. An Ionic column-screen in the former entrance hall
marks where it began, some stucco foliage panels in the room
above its former landing. The ornamented skylight now serves
a second-floor room.

No. 11 was refronted by *Robert Adam* in 1774–6 for Sir Rowland
Winn, 5th Bart., the first known use of *Liardet*'s stucco.
Restored in 1988–91 by the *Thomas Saunders Partnership*, who
removed accretions of 1877 and reinstated features shown on
Adam's drawing. Five bays, the middle three emphasized by
giant pilasters with (restored) leaf capitals. Square-windowed
attic with pilaster strips, and over them four modern statues of
Muses. Ground-floor rustication on the middle bays, with off-
centre Doric porch. Some 1730s cornices and doorcases inside,
but nothing identifiably Adam's. First-floor ceilings probably
from the 1877 work (by *Trollope & Sons*), loosely Adamesque.

No. 12. Built on a giant scale in 1836 for Lord King, later 1st
Earl Lovelace. The designer seems to have been *J.B. Watson*,
working for the builder *Thomas Cubitt*. Refined Italianate
stucco, three bays and three main storeys, with fourth-storey
windows slotted into the bracket-cornice. Grecian interiors,
e.g. the enormous square-well staircase. Other rooms with late
C19 French Rococo decoration. Splendid mid-C18 chimney-
piece in the ground-floor front room, with musical trophies
and a relief of cherubs and birdcage. The rear wing was rebuilt
in 1988–91 as offices for MEPC by the *Thomas Saunders
Partnership*, extending E and W behind Nos. 11 and 13. It has

* Baker's lecture hall behind has been replaced by a Neo-Georgian wing by *Lutyens
& Greenwood*, 1960–2, facing Duke of York Street.

flush bronzed cladding, and new brick-faced mews houses to Ormond Yard, N. The junction with the C19 house is an eight-level atrium, with a complicated lift lobby and balcony stack on the E side. Extravagantly elongated columns round the sides. It has attractive STAINED GLASS by *Graham Jones*, splashy blue and red collaged with architectural motifs.

No. 13 is probably of 1735–7, for Henry Liddell, later 1st Lord Ravensworth. Attributed to *Matthew Brettingham Sen.*, on grounds of style and of a later payment to him for work here. Four bays and three storeys. The brickwork is stained black and has faked vertical joints, giving the peculiar appearance of all headers and no stretchers. The chamfered rustication below was added after 1812, and the entrance moved one bay w. Second-floor windows enlarged in the later C19; chimney on the front wall added after *c.* 1904, both for the Windham Club (here 1836–1941). The INTERIOR has a few 1730s features, amidst Late Georgian work in a Wyattish style, plausibly from work of *c.* 1797 for the bibliophile 3rd Duke of Roxburgh. In the entrance hall a fine fireplace to an Inigo Jones design, and a Doric cornice, both looking 1730s. The stairhall, l., has a good open-well staircase of that period, with slanted wrought-iron balusters, and a Late Georgian fireplace niche and oval-domed skylight. To the l. of the entrance a room with a Greek Ionic column-screen, i.e. also Late Georgian. The principal first-floor room was redecorated for Roxburgh, but its compartmented ceiling may represent old work retained. In 1891 *J. Macvicar Anderson* merged it with the former library behind, making an L-shaped interior. Here another self-consciously Jonesian fireplace. Substantial stone back stair.

No. 14 is the LONDON LIBRARY, 1896 by *J. Osborne Smith*. An uncompromising façade, expressing to a certain extent what it is, and not swayed by the motifs of its C18 neighbours. Entrance and reading room with slim piers, the details vaguely Jacobean. The clangorous steel-framed bookstacks have slatted floors for air and light. Periodic extensions: behind, 1920–2, and 1932–4 by *Mewès & Davis*, including an Adamesque room on the first floor. Here a large chimneypiece with Bacchic putti from *Robert Adam*'s Lansdowne House, *c.* 1768 (*see* pp. 498–9). More recent additions of 1992, N, with a Neo-Victorian elevation to Mason's Yard (by *Neil MacFadyen* of *Carden & Godfrey*), and 1993–5, w, by *Purcell Miller Tritton* (*see* No. 7 Duke Street). The Library was founded as a private body in 1841, moving here in 1845. Within is a BUST by *Boehm* of its instigator, Thomas Carlyle.

No. 15 is LICHFIELD HOUSE, built for Thomas Anson in 1764–6 by *James 'Athenian' Stuart*. Exquisite stone elevation, innovative both in adapting a temple front to a three-bay London house façade and in the Greek derivation of several key motifs. On the ground floor smooth rustication and round-arched openings. First- and second-floor windows are framed by an attached four-column portico, purely Greek, with one pediment right across. Fluted Ionic columns, detailed after Stuart's observations of the Erechtheion in Athens (some capitals carved by *P. Scheemakers*; chief mason *Alexander Rouchead*).

The first-floor windows have pediments. They were cut down and the copper balcony added in 1791–4 by *Samuel Wyatt*, for Anson's great-nephew Thomas, later 1st Viscount Anson. Probably also of this time the inset Doric columns of the doorway. But the side elevation of the rear wing is Stuart's brainchild, with superimposed quasi-Venetian openings after another Athenian building, the Aqueduct of Hadrian.

INTERIORS are a mixture of *Stuart* and *Wyatt*, with alterations after 1856 for the Clerical and Medical Insurance. As on the outside, 'Athenian' innovations are confined to novel motifs, with more Hellenistic richness than Periclean purity (cf. Stuart's work at Spencer House, St James's Place). The ENTRANCE HALL combines a coffered barrel-vaulted approach (*Stuart*) with space amalgamated from two small rooms behind. Fireplace probably *Wyatt*'s, with vine and hop motifs. Ahead is the former STAIRCASE HALL, with *Wyatt*'s lovely glazed dome with diagonal-coffered surround, large eagles in the pendentives, and drapery and figure medallions in the lunettes. The staircase was removed by *W. Curtis Green* in 1928, leaving an altered gallery against the N wall. Its reticulated wrought-iron balustrade is probably *Wyatt*'s, reused. The S wall here was re-created in 1980–2, but the main front and back rooms still lie open to one another. Delicate friezes by *Stuart*; pretty ceilings with thin detached wreaths or garlands, probably his too. The big rear bow with its wreathed ceiling was added by *Wyatt*. In the rear wing first the former back stair (*Wyatt*, much altered), with a bow to the S touching the main bow, then the LIBRARY. *Wyatt* formed this from two smaller rooms, but the far end has since been divided off, immuring an Ionic column-screen of green scagliola (*D. Bartoli* maker). Ceiling and bookcases by Wyatt; two E doorcases and fireplace by *Stuart*, the latter with a frieze of panthers drinking from bowls.

55 FIRST FLOOR. By *Stuart* the great SALOON across the front. Especially fine ceiling (plasterer *Joseph Rose Jun.*), with octagonal flat-domed centre surrounded by Palmyrene coffering. Colours blue, apricot and gold, not original. In the outer panels paintings by *Biagio Rebecca*. Scroll frieze. The design Stuart repeated almost unchanged from his drawing room of *c.* 1765 at Holdernesse House (later Londonderry House; *see* footnote p. 552). Chimneypiece carved probably by *P. Scheemakers* after that at the Great Room, Spencer House, with a figure frieze after the Monument of Lysicrates; door-cases with angled fluted friezes after the Incantada at Salonika. Wall treatment probably *Wyatt*'s: hangings, tall mirrors, thin vertical divisions. In the REAR ROOM a coved ceiling by *Stuart*, with a sympathetic *Wyatt* coda in the bow. Their covings curve differently, with plaster drapery at the join. The antique motifs anticipate the work of Stuart's rival Robert Adam: thin arabesques, little inset paintings by *Rebecca* and others, and a central encircled curved-sided octagon. In the wing one room with coved Palmyrene-coffered ceiling, and an uncommon fireplace with brackets coming out as winged horses. All this looks like *Stuart*. The room beyond has a neat little bowed oriel, probably *Wyatt*'s (shown in a plan of 1804).

Nos. 16–17 are the EAST INDIA CLUB, 1865–6: the façade by *Charles Fish*, the rest by *Charles Lee*. A stucco palazzo of seven bays. Central porch, but to the l. an asymmetrical bay window. Also certain free, that is incorrect, details such as the ground-floor windows with circular panels over the arches. Three closer-set bays to the N may incorporate the front of old No. 16, of *c.* 1805, where the club first met in 1850. Big open-well staircase, big uninspired interiors. Some early C19 marble fireplaces, one with caryatid supporters with arms outstretched, perhaps also from old No. 16. Rear extensions 1939.

No. 18 was built as residential chambers in 1846–7, by *Thomas Johnson*, for the contractor *Sir John Kelk*. Italianate stucco, very rich, but not yet truly eclectic. Balustrades to first- and second-floor windows, pediments to the latter only. Third-floor windows in the frieze. In 1998 made back into flats, with the more modest Nos. 1a–1c King Street behind, also of 1846–7.

No. 19, CLEVELAND HOUSE, is by *Trehearne & Norman*, 1998–2000. Stone-faced with a channelled frontispiece, traditional in general effect, straggling somewhat along King Street. The entry to Cleveland Yard is decorated with sunk striated scoops carved by *Robin Connolly*.

Nos. 20–21 has to the square a seven-bay front, of which the three to the N comprise *Robert Adam*'s No. 20 of 1771–4. It is his most complete town house, built for the young virtuoso and spendthrift Sir Watkin Williams Wynn, 4th Bart. The elements are similar to those of Stuart's No. 15: rusticated and arched ground floor, giant order, pedimented first-floor windows. The chief differences are Corinthian pilasters instead of Ionic columns, balustrade instead of a pediment, and straight-headed ground-floor windows. *John Devall* was chief mason. Of 1936–7 the top storey, mansard and matching S extension, done for the Distillers Company by *Charles H. Gage* of *Mewès & Davis*. The doorway was duplicated to balance, and bowed first-floor balconies close to the Adam design reintroduced.

The well-preserved INTERIORS demonstrate perfectly the movement in Adam's middle years towards flatness, thinness and small cross-vaulted spaces, as well as his gift for compactly planned rooms of contrasting shapes and moods. Work continued on them until 1777 (plasterer *Joseph Rose Jun.*, joiner *Richard Collins*). The present ceilings mostly follow Adam's colours; how he treated the walls is unknown. The plan has two rooms in depth alongside entrance and staircase – the familiar London arrangement – but the rear wing is unusually elaborate, being meant for private apartments.

The oblong ENTRANCE HALL has a ram's-head frieze, plaster roundels with trophies, and a tall console fireplace. Over it a reset lead cistern-front with the building dates. The STAIRCASE HALL ahead has a stair climbing in three flights and a big niche on the wall facing, repeated with decorative variations on the upper landings. Oval skylight. Balustrade of copper (maker *William Kinman*), flat openwork balusters between husk-pattern uprights and a top zone with urns. On the second floor the walls have pilasters with arched recesses, left open for a gallery on the S side. Inset lower down are two

landscapes by *Roberts* of Dublin, and a large copy of Raphael's
Transfiguration (post-war, replacing an original fixture). These
face two nice pastiche roundels portraying Adam and Wynn
(of 1937?). Plasterwork with sphinxes and urns, and figure
medallions modelled more deeply. The back stair, immediately
w, is entirely altered. At the front the EATING ROOM, with a
segmental apse, screened by two columns *in antis* with ram's-
head capitals. Ceiling of Palmyrene octagonal-coffered type.
As usual Adam repeats his frieze on the doorcases (originally
on the fireplace too). Behind, the MUSIC ROOM, with seg-
mental-apsed ends. Rich ceiling, and on the walls more plas-
terwork than in other rooms, featuring musical trophies.
Colours mostly green, purple and white. On the N wall a recess
for an organ, which Adam also designed (now at the National
Museum of Wales, Cardiff). It faces a fireplace with half-
columns and a Parnassian relief, designed by *A. Zucchi*. He
also painted the ceiling roundels, and the apse overdoor of
shepherds and nymphs honouring the ashes of Handel and
Corelli. On the N wall two overdoors by *Nathaniel Dance*. In
the rear wing the LIBRARY, with a columned Venetian window.
Originally it was larger and had column-screens, echoed
by pilasters on the inserted wall at the far end. Excellent
plasterwork, the ceiling with four *Zucchi* roundels of the lives
of the poets. The screened-off part was merged with Sir
Watkin's dressing room, originally octagonal, making a room
with a canted w end; an oval powdering room beyond was
destroyed.

FIRST FLOOR. The ANTE-ROOM over the entrance, with a
fine cross-vault and decorated lunettes, began the C18 circuit.
Fireplace (mason *J. Hinchcliff Sen.*) with details matching the
doorcase. The two drawing rooms correspond in plan with the
rooms below, except that the front has no column-screen.
In the FRONT DRAWING ROOM a ceiling of concentric
ellipses and figure roundels in corners. Doorcases with slim
Corinthian pilasters. Outstanding chimneypiece, designed by
Adam after a plate by Piranesi: uprights with female musicians
in relief, frieze designed by *Zucchi* of Apollo's chariot and the
Hours. Pilastered chimney-glass designed by *Adam*.

The REAR DRAWING ROOM also has fine doorcases, but
its glory is the beautiful segmentally vaulted ceiling. This
is divided across by strips of painted garlands, and along by
Zucchi's paintings on themes of feminine allure. He also
painted the grisaille lunettes showing girls adorning tripods,
and roundels in the apse. Ionic-columned fireplace with relief
of the Triumph of Venus, another *Zucchi* design. Adam's
colours were pale green, pink and white with some gilding; the
present scheme has buff instead of white. In the wing LADY
WYNN'S DRESSING ROOM, effectively a part of the circuit
of public rooms, and so treated very richly: groined in the
centre, barrel-vaulted at the ends, with another Venetian
window. Chimneypiece by *Hinchcliff*, with scagliola swags and
a *Wedgwood* basalt plaque as an added novelty (Venus again).
The plasterwork is a post-war facsimile. BEDROOM beyond,
square and with a low pendentive dome. Two larger but much

plainer bedrooms on the second floor are identifiable by large recesses. No. 21 is commercial Neo-Adam inside, better than average but no more.

The COURTYARD behind No. 20 creditably re-creates the Adam arrangement, done in 1988 after his drawings by *Hamilton Associates*. To one side a stuccoed screen wall, with paired Ionic columns and big arches (left open in the restoration). At the end a copy of the handsome stone façade of the former service block, with a pedimented aedicule and Venetian motif, masking a new office block.

For the S side, much inferior, *see* Pall Mall.

In the SE corner that curiosity No. 31a, probably of 1772, only two bays wide. Top two storeys after 1850; pedimented door-case by *Brian O'Rorke*, 1936.

At No. 31 was the lamented Norfolk House, built by *Matthew Brettingham Sen.* in 1748–52 for the 9th Duke. Its influential plan allowed a complete circuit of public rooms around the staircase. The exquisite Rococo decoration was rivalled in London only by old Chesterfield House (*see* p. 575).* Its replacement is of 1938, routine Neo-Early Georgian by *Gunton & Gunton*, with a rear extension of 1976 (*T.P. Bennett & Son*).

No. 32 (LONDON HOUSE) is by *S.P.* and *C.R. Cockerell*, 1819–21, for Bishop Howley of London. Brick, dressed with Bath and Portland stone. Three broad bays, with three Venetian windows across the first floor. They have unglazed relieving arches, Doric piers, and Doric balustrades in front. Parapet altered and dormers added in 1897–8 by *W.D. Caröe*, for Bishop Creighton. Big Ionic porch of 1931–2, when the Caledonian Club expanded here from No. 33; by *H.L. Anderson*. By the same the ovoid staircase in the rear wing.

No. 33 is another *Robert Adam* house, plainer and more altered than No. 20. It dates from 1770–2, for the Hon. George Hobart, later 3rd Earl of Buckinghamshire. In 1817–23 *Soane* extended it along Charles II Street, for the 2nd Lord Eliot, later 1st Earl of St Germans (the end four bays). Heightened to four storeys perhaps as late as 1878, when one *Leslie* altered No. 33 for the 15th Earl of Derby. The stone balcony on columns and the mansard are of 1911, by *Edmeston & Gabriel*. Three good *Adam* ceilings survive on the first floor, recoloured in 1984, though lacking their inset paintings. The smallest is in a former dressing room, with apsed ends and a relocated Adam fireplace with ram's-head brackets. Ground-floor rooms mostly merged into a banking hall with grey marble columns, doubtless of 1911; some convincing ornament in late C18 style elsewhere. *Soane*'s work is harder to identify. His main interior was Adamized in 1911, for the Caledonian Club. But the ground-floor rooms facing the square have ceilings with odd Doric borders: perhaps from *Soane*'s earlier work for Lord Eliot, documented in 1805–7? Inner angle rebuilt 1984–5.

Finally in CHARLES II STREET, No. 10 (N side), a delicate stucco front by *J.B. Papworth*, 1833, for the haberdasher John Howell. Lower parts altered 1878.

* The Music Room was partly re-created at the Victoria and Albert Museum.

ST JAMES'S STREET

A steep and very broad street, formed in connection with Henry
VIII's new palace at the s end (q.v.). The first firm record is in
1586. Building began in scattered fashion from the early C17. By
1662 the street was thought worth paving, and by 1671 there were
already twenty-eight ratepayers. Favoured courtiers then held
most of the leases, though the Crown remained the chief free-
holder. Great houses were few, lodgings and coffee and choco-
late houses more common. In the C18 some of these developed
into more exclusive gentlemen's clubs, for which the street is still
famous. Their buildings are smaller and their coteries more aris-
tocratic than at the C19 clubs of Pall Mall (q.v.). The celebrated
shops at the s end are comparably smart and discreet.

East Side, from north to south

The first and oldest club is Nos. 37–38, WHITE'S. The first
record is in 1736, in association with a chocolate house started
by Francis White in 1693. In 1755 it moved here from the w
side, to a mansion built by Edward Villiers in 1674, elements
of which may survive within. The earliest visible work belongs
to reconstruction of 1787–8, probably by *James Wyatt*.* His
front remains, entangled by C19 alterations: five bays, two
storeys, an upper blind storey and a balustrade, with a rusti-
cated ground floor and giant Grecian Ionic pilasters. These are
paired in the middle, where they flank a broader round-headed
window on the first floor and a panel of foliage carving above
it. The Louis XVI flavour dates from 1851, when *James Lockyer*
added grooved stone à la Gabriel between the pilasters, and
reliefs of the Four Seasons (by *Sir G. Scharf*) over the side
windows; also the bitty first-floor aedicules, the vermiculation
below, and the front railings. Ground-floor bow of 1811, with
incised Doric pilasters, built out over the old entrance steps
(the door is now to the r.). The ornate balcony with a cast-iron
rinceau front was put on between 1827 and 1839, perhaps by
John Goldicutt. Glazing bars restored *c.* 1970, to the early C19
pattern. Mansarded attic of *c.* 1910.

 (INTERIORS. A visit was not permitted, so the description
is from published sources. The story is again complex. The
low-ceilinged MORNING ROOM, r. of the entrance hall, was
created in 1811 from the previous entrance hall and the room
to the N. A screen of Doric columns marks the former divi-
sion. Bracketed fireplaces and broad doorcase perhaps by *J.B.
Papworth*, who worked here in 1842–3. Behind the hall is the
STAIRHALL, another merged room, enlarged by *T. Milbourne*
in 1882 to take in the room to the N. The stairwell is D-shaped,
with Doric columns interpenetrated by the lower flight, which
splits into two return wings. It may represent a rearrangement
of the late C18 design, which the balustrade type, of iron
uprights with anthemion ornament, appears to respect. Past

* *Robert Adam*'s unexecuted designs of 1787, with a dome and giant columns, would
have outdone this and every other C18 London club.

the back stairs lies the BILLIARD ROOM, inserted *c.* 1890 between two C18 rear wings, with Ionic column-screens at the junctions and a toplit central part. *Wyatt*'s work remains on the first floor, notably in the COFFEE ROOM, which fills the whole street front. Its segmental barrel vault is divided by guilloche bands, the plasterwork, with simple wreaths and large plain areas, already post-Adam in character. Raphaelesque decoration in the end lunettes, probably from *T. Morant*'s work in 1851. The REAR DINING ROOM behind was much altered in the 1880s, filling in a column-screen at the N end and replacing a round bow with a much shallower one, with engaged Corinthian columns. The CARD ROOM in the rear S wing has a flat ceiling with detail similar to the Coffee Room, but with a dentil cornice of mid-C18 pattern, suggesting an earlier interior upgraded in 1787–8.)

Then a stone-faced early C20 commercial run. *William Woodward*'s No. 36, 1904–6, has rounded bows and a curvy turret towards Jermyn Street. Ground-floor columns of grey Kemnay granite. Bows return on Nos. 29–30, 1904–5 by *Leslie W. Green*.

BOODLE'S CLUB follows, very Adamish but not by any of the Adam brothers: 1775–6 by *John Crunden*. Built for the Savoir Vivre, an especially profligate gaming club spun off from Almack's in Pall Mall; taken over in 1783 by Boodle's, which was founded in Pall Mall in the 1760s. Yellow brick. The centre is pedimented, with a giant central Venetian window with Ionic columns and typical Adam fluting in the arched head (cf. Adam's Society of Arts building, Adelphi, p. 328). Side bays carried up in the Palladian way as low square towers, higher than the pediment. They have twin porches with Tower-of-the-Winds columns. The r. one, now disused, served what was originally a separate house. The area railings are Crunden's, but the stuccoed ground-floor bow is of 1821–4 and by *J.B. Papworth*. He may also have enlarged the second-floor windows, changing the relieving arches below them from round to segmental. The plaques are of *Coade* stone. The S flank, exposed for the Economist precinct of 1962–4 (*see* below), was refaced in good yellow brick by its architects the *Smithsons*, broken by a canted metal-faced bay halfway along.

The INTERIOR is unusual in plan. The staircase behind the entrance hall is small and prosaic, with an oblong open well, upright iron balusters and a round top lantern. It seems originally to have stopped at the first floor. The MORNING ROOM in the centre comprises the two principal ground-floor spaces, interlinked one behind the other. They were redecorated by *Papworth* in a distinctive Grecian style, with flat scagliola piers, almost no cornice before the plain low ceiling, and scrolly pedimental overdoors. His fireplaces have been replaced by late C18 ones. From the front part, a segmental arch opens to an annexe, formerly the front hall of the house on the S. Rear parts remodelled 1962–4, adding a CARD ROOM in the new canted bay to the S.

The pride of the club is Crunden's upper SALOON, in the Adam style, though perhaps a little heavier in its forms (with ceiling plasterwork no older than 1919–22, by *Beresford*

Pite). Restored in 1996 by *Ian Bristow* to its C18 colours of pink, white and green. Pilasters with decorated shafts, turning to columns *in antis* on the N wall, both with very Adamish capitals. Intricate frieze, with vases over the pilasters. The excellent white marble chimneypiece with brackets overlapping half-pilasters is attributed to *Thomas Carter Jun.*; splendid columned grate by *Papworth*. Over it a version of the Aldobrandini Marriage (cf. Spencer House, p. 623). Inferior panels showing reclining figures higher up, above a band carried round the walls from the Venetian window's imposts. Of the two small doors on each end wall, those by the window date from 1996, replacing wider openings made when *Papworth* remodelled the small rooms beyond. These have flat-centred pendentive vaults, with elliptical vaultings behind. At the back of the Saloon an extra-large doorway with ram's-head piers leads to the COFFEE ROOM, likewise of double height, made in 1925 by *Hoare & Wheeler*. A stern space in the manner of Smirke, incorporating the bowed end of a smaller C18 room at the N end. In the ceiling a small dome, half-dome and segmental vault. Over it is a SMOKING ROOM added in 1862–3 by *Mayhew & Knight*.

The ECONOMIST group is by *Alison & Peter Smithson*, 1962–4, one of the few 1960s precincts to have stood the test of time, and the only one in central London where the buildings seem to weigh equally with the spaces between them. It came about through Peter Dallas-Smith, a manager at *The Economist* magazine, who hatched the idea of clearing the area around its former office and redistributing the accommodation in new buildings. The three towers that resulted are set on a podium, grouped and proportioned to suit the context – a radical departure at a time when Modernist practice was still dominated by stand-alone monumentalism. The concept of different-sized towers was taken over by the Smithsons from *Maurice Bebb*, consultant architect to the contractors *Sir Robert McAlpine & Sons*. The smallest of them, an irregular four-storey polygon directly on St James's Street, was originally a bank. Behind and a little to the N is *The Economist* itself, a tower of fifteen even storeys, and to its N a smaller eight-storey residential block. They are grouped around a raised, distinctively paved, quite small pedestrian plaza, reached by a gentle ramp as well as by steps. To Ryder Street, S, is an entrance to a car park below plaza level, exploiting the falling ground.

The TOWERS have even concrete frames, with the corners canted to increase the amount of light through the complex (a motif echoed by the bay window added to Boodle's). In deference to the West End, the facing is mostly Portland stone, but of the fossil-rich kind known as roach, relished here for its open-pored texture. It stresses the projecting uprights, rather as Mies van der Rohe used non-structural I-beam mullions on his steel frames. Uprights are also applied to the windowless attics of all three blocks. In their purity and rigour, the elevations look back to the Smithsons' school at Hunstanton in Norfolk of ten years before, and it is ironic that the term Brutalism (or rather New Brutalism), invented by Alison

Smithson around that time, clung to the partnership even after it was extended to the display of over-dimensional concrete chunks in vogue by the later 1960s.

Other differences arise from the functions: on the bank block, the greater window heights of the first-floor banking hall (converted to a restaurant 1998), reached by two escalators set on different diagonals; on the Economist tower, which has uprights set at the same broad intervals, an extra mullion sub-dividing the windows according to a two-person office module; on the flats, a frame of uprights set at half the width, and transomed windows for natural ventilation. An influential novelty for Britain was the planning of the non-residential blocks around a service core, according to recent American practice.

The Economist group was the first 1960s work to be listed, in 1988. Two years later *SOM* remodelled the podium stairs to Bury Street, E, and refurbished *The Economist*'s lobby. Here a STATUE of the founder James Wilson, by *Sir J. Steell*, 1865. To the N, in a little blind yard, an excellent mobile WATER SCULPTURE by *Angela Conner*, 1992, called Eclipse. A wall of falling water with two gently rotating discs, the dark one periodically occluding the light.

After Ryder Street comes an entire block by *Waller & Son* of Gloucester, 1910–12 (N part 1924–7), the largest part of the Crown Estate's abandoned project to convert St James's Street into another Regent Street or Kingsway. High-relief elevations, with rock-faced rustication in bands, giant columns and giant chimneys. Much rebuilt internally 1999–2001; the vast former Lloyds' banking hall, S, is now a bar.

The stuccoed building along the S corner with King Street was built by *James Pennethorne* in 1830–2 as the ST JAMES'S BAZAAR (No. 10), but bears imprints of many later uses. Pennethorne's are the graceful round-arched first-floor windows of changing sizes and rhythms to the N, the broad porch on Tuscan columns below, and cornice, quoins, and pediment on St James's Street. The second-floor windows were inserted in 1847 by *Ambrose Poynter*, who converted No. 10 into chambers. Four extra little oculi in the centre date from *W. Emden*'s alterations for the Junior Army and Navy Club, 1897. The club also made the two-storey bay window to St James's Street, in 1881–2 (by *Wyatt Papworth*; altered for an entrance 1907). Top storey of 1914–15 by *Hoare & Wheeler*, for an insurance company, spoiling the proportions.

Then some older houses. No. 6 is mid-C18 brick in front, late C17 behind, with a gable. LOCK'S the hatters, here since 1765, has a shopfront with simple fluted surrounds and grilles below. The likely date is *c.* 1810–20. No. 5, tall stone of *c.* 1905, has a shopfront probably of the 1950s, copied from one of *c.* 1820 formerly at No. 181 High Holborn. At No. 3, 1731–3, is the early C19 shopfront of BERRY BROS & RUDD, wine merchants, more ambitious in design. Five round arches, with solid shutters below. The three l. arches are impeccable reinstatements of 1931. The firm began here *c.* 1699. (First-floor showroom lined with mahogany and pewter, *c.* 1900, by *C.J.H. Cooper*).

No. 3 goes with PICKERING PLACE, a paved, irregularly shaped

yard reached down a narrow archway, l. (with C18 timber-framed construction on its r. side). The contrast with the grandeur of St James's Street is extremely characteristic of London. The layout perpetuates late C17 development, but Nos. 1–4 were rebuilt along with Berry Bros' house in 1731–3. They have segment-headed windows, some original bracketed doorcases, and one-room plans with separate stair-lobbies.

The S END of the street must be examined on W and E sides together, for *Norman Shaw* built premises for the ALLIANCE ASSURANCE on both. The SE corner (Nos. 1–2) came first, in 1882–3, with façades of equal value but unequal design. Red brick with stone bands, and the scrolly foliage and figure friezes and panels which were to be imitated so much in the West End. The sources are C16 France and Flanders. Big asymmetrically placed stepped gables with volutes, octagonal angle turret, round-arched ground floor. Besides the offices it housed shops and four residential floors. By 1903–5, the dates of the premises across the road at Nos. 87–88, Shaw's style was more classical, treated in a heavily Baroque way. The executant architect was *Ernest Newton*. It is stone-faced and broad, kept low in deference to St James's Palace. Heavy banded rustication and round arches on the ground floor, pedimented upper windows, and a big open top pediment on three of the five bays. Hipped roof, with wide, plain chimneys. Plainer S front; rear front like the main one, omitting the pediment. Insurance hall with beautiful mahogany lining and fireplace with sunburst of voussoirs.

West Side, from north to south

No. 50 began as Crockford's gambling club, *c.* 1826–7 by *B.D. Wyatt* and his brother *Philip*. Theirs is the general disposition of three bays flanked by broader outer bays, but all else dates from *C.J. Phipps*'s refronting of 1874–5 for the Devonshire Club (for secessionist Liberals from the Reform Club). He added a storey, affixed four giant engaged Corinthian columns (replacing pilasters which rose from the ground floor), and made a bay window at each end, with a becolumned triple window over. The new top storey contained a library, billiard room, and other Victorian necessities. After closure in 1976 the club was used as diplomatic premises, followed by conversion in 1997–8 to a casino by *Blee Ettwein Bridges* with *Robert Lush*. They revivified the Wyatts' INTERIORS, which included the first in clubland to abandon Neoclassical discipline for the aristocratic Louis XV craze (cf. the Wyatts' work at Lancaster House, q.v., and Apsley House, p. 486). Low entrance hall, treated simply. Staircase beyond, climbing between black scagliola Ionic columns, of the club type of one flight splitting into two. Simple balusters of metal; oval dome in a richer, mid-C17 French taste. The ground-floor rooms have been restored as *salles privées*, with inserted Doric piers to match the Wyatts' early C19 Grecian mood in the former Morning Room, S; other new fittings Neo-Palladian. The white-and-gilt rooms along the first-floor front are by contrast early C18 French, includ-

ing the former Dining Room in the centre. Its coved ceiling with paired brackets, the twin Rococo fireplaces, and several big depressed elliptical-arched doorcases are original. On the second floor a blindingly glitzy new restaurant in a kind of eclectic Art Deco.

Then mostly commercial C20 for a stretch. Nos. 55–56 is conventional brick of *c.* 1960, with a clumpy front addition by *Chapman Taylor Partners*, 1985–6. *Hamilton Associates'* Nos. 57–59, 1996–9, is contextually minded but rather too big. Stone-faced, with a canted bow.* No. 60, tall squared-off stone by *Leonard Martin* of *Treadwell & Martin*, 1910, housed the offices of the 1st Viscount Furness. Rebuilt behind 1989.

BROOKS'S CLUB, next, was built in 1776–8 by *Henry Holland*. The club began in 1764 as a faction of Almack's in Pall Mall (cf. Boodle's, above), and was notable for gaming and for high Whig politics. It has a fine five-bay façade of stone and white Suffolk brick, with giant Corinthian pilasters, a tall first floor and low second floor. Three-bay pediment above the centre, with an oval Bacchic relief and a handsome frieze of intertwined dolphins and palms. At the ends the pilasters are coupled and slightly advanced, with niches below (a device also used by Adam and James Paine; the N niche since pierced for a window). Off-centre entrance, originally shielded by a rusticated porch removed in 1835. The balustrade dates from alterations of 1889–90, by *J. Macvicar Anderson*. Other C19 embellishments were removed in *Sir Albert Richardson*'s restoration of 1934–6, following reinstatement of glazing bars in 1929. Three bays to Park Place, S, the outer bays wider and with Venetian windows on the first floor. Plainer windows below them, the r. one altered to a shallow bow in 1815. To the l. is Macvicar Anderson's substantial annexe of 1889–90, yellow brick, with two canted bays of different heights.

The INTERIOR has had its share of alterations, but the C18 mood remains, fortified by C20 restoration. The STAIRCASE has two main flights set against the walls, which open in plain round arches to the landing. The stair itself is by *Macvicar Anderson*, 1889–90, the S-scroll balustrade and ceiling with its glass dome given a more C18 appearance by *Richardson* in 1934–6. The MORNING ROOM to the S was enlarged in 1815 at the expense of the entrance space, and given a screen of columns. Two superb *Holland* interiors remain upstairs. The GREAT SUBSCRIPTION ROOM is three bays long, under a 58 broad segmental barrel vault. Its decoration, restored 1966, is far more restrained in distribution and detail than anything by Adam (or than the upper room of Boodle's, opposite). The ceiling has intersecting bands of guilloche and borders of looped chains and husks suspended from bows. In the lunettes are candelabra in plaster relief. Inset paintings attributed to *A. Zucchi*; simple white marble chimneypiece; door handles of ebony, inlaid with mother-of-pearl. The Tuscan half-columns to the Venetian window on the S return are of 1889–90. Next

*At Nos. 57–58 was *Alfred Waterhouse*'s New University Club, assertive Gothic of 1865–9 (closed 1938).

to it, W, with a similarly altered Venetian window, the SPENCER ROOM (originally Eating Room), with the centre of its back wall gently outcurved, and decoration of wreaths and exquisite relief medallions. Further embellishments of 1889–90 were removed in 1935, and two C18 fireplaces brought in. Plainer are the CARD ROOM, N of the Great Subscription Room, and the circular CAVENDISH ROOM, off the landing to the NW (restored to Holland's plan 1975). In the Victorian extension is the LIBRARY, and other rooms in understated mid-C18 English style.

After Park Place, No. 61 (JUSTERINI & BROOKS), a nice tasteful free Neo-Adam effort, 1933. Elevations by the architectural perspectivist *William Walcot*, his only known English building. No. 62 is mid-C18, with a canted bay and later stucco. No. 63 was the MEISTERSINGERS' CLUB, 1886–8 by *Davis & Emmanuel*, typical overdone Late Victorian, with as many different Northern Renaissance motifs as possible spread all over (carver *G. Seale*). The club used only the first and second floors, with offices below and apartments above. Back parts rebuilt 1989–90 by *Michael Squire Associates*, who added the rakish metal-framed bow window in the middle. In BLUE BALL YARD behind are former stables of 1741–2, plain painted brick, with flats above reached from a balcony on wooden brackets. *Dennis Lennon & Partners* reconstructed them as a hotel annexe in 1990, with new stairways and lower doors, all very bijou. No. 66 on the corner, the former Swiss Bank of 1979–82, is by *Rodney Gordon* (*Tripos Architects*). A shock-tactics building that is also an anthology of late 1970s fashions: super-slick finishes, here of dark bronze-anodized aluminium; external framing, rising here from cone-like bases; and contextualism, in the sloped-back upper floors and the slicing off of bays and corner tourelle at matching angles. The result is an instant period piece, a bit too pleased with its own cleverness. No. 68 was Chubb the locksmiths, by *C.H. Mileham*, old-fashioned for 1901. Shopfront with twisted colonnettes.

The CARLTON CLUB at Nos. 69–70 is by *Thomas Hopper*, 1826–7. Built for Arthur's Club, the first to be owned by the members rather than a proprietor, which was founded here in 1811. In the chastest Palladian style. Five bays, stone-faced. Tall ground floor with smooth rustication and round-headed windows, the entrance unemphasized. First floor with six engaged Corinthian columns, windows with alternating pediments, and a top balustrade. The usual added bedroom storey behind, of 1925–6. The Carlton took over in 1940, after its premises in Pall Mall were bombed (q.v.).

The INTERIOR has the main front and back rooms separated by a staircase, with little connecting lobbies to disguise irregularities in the plan. The style is generally Grecian, with coffered ceilings and panelled walls. Elegance is not aimed at, rather a substantial solidity. Amongst the enrichments are robust fireplaces of black marble, and friezes modelled by *F. Bernasconi*. The ground-floor rooms are the MORNING ROOM at the front, originally the Coffee Room, and the present COFFEE ROOM at the back. This has a frieze of vine leaves

and a specially good chimneypiece with rams' heads and lions' feet. Next to the Coffee Room is a smaller room, bow-backed, and similarly decorated. But the STAIRCASE is the dominant space, set in an oblong hall, with a coffered dome over the centre. It starts in two short arms, breaks by 90 degrees and unites into one, then again splits by 90 degrees and once more 90 degrees and so reaches the first floor. Heavy cast-iron handrail, apparently heightened. Light comes from a triple window with an aedicule frame over the half-landing, its form echoed across the upper landing. The first floor has the LIBRARY at the front, with Corinthian pilasters of overpainted scagliola, originally framing big pedimented bookcases. The two rear rooms, the STRANGERS' DINING ROOM and the smaller drawing room, have ceilings of radial pattern.

Nos. 71–73 are more chambers over shops, by *W. Woodward & Sons*, 1908–9. François I, with Art Nouveau ironwork.

No. 74 is the former CONSERVATIVE CLUB, 1843–5 by *George Basevi* and *Sydney Smirke*, who were joint winners of a limited competition held in 1842. In 2003 being converted to offices by *Michael Squire & Partners*, with a big new addition and atrium behind. The front, originally of Caen stone, was substantially replaced with Portland in 1866. It is larger than the Carlton's and a little freer in accordance with its later date. Also with balustrade, also with pedimented windows with engaged columns between them. But the end bays have triple windows flanked by overlapping pilasters, and below them on the ground floor is the entrance with Doric columns, r., matched on the l. by a shallow bow also, somewhat incongruously, flanked by Doric columns. Plain frieze, but with a band carved with scrolls joining up the capitals below it. Double basement, guarded by a stone and cast-iron parapet with fine lamp standards. The club closed in 1959, after which the C19 back parts were demolished. Bedroom storeys added in 1910 are to be replaced by a new double mansard.

The INTERIOR had an irregular plan, with main rooms to the front and (originally) the N side. They are or were lofty spaces with column-screens and coved or compartmented ceilings. On the ground floor the five centre bays and bay window are taken up by the MORNING ROOM. The five-bay centre above comprises the DRAWING ROOM, with a patriotic frieze of roses, thistles and shamrocks, and coving with painted decoration above. The lost wing housed a dining room with a library over it. (A more distinctive 1840s taste is seen in the former STAIRHALL in the angle. It is square, with a circular upper gallery and glazed dome, walls with round arches intersecting big covings, and a mosaic pavement by Messrs *Blashfield*. The style is rich Cinquecento, decorated in the style of Raphael's Vatican logge. This is a renewal of the original painting by *Frederick Sang* and *Naundorff*, done *c*. 1894 by the aged *Sang* (his last work), his son *Henry*, and others. To be restored as the reception hall for the offices. The staircase, destroyed in 1951, opened off the w end in one flight and returned to the landing in two.)

Nos. 85–86, next door to this restrained façade, is High Victorian

at its most lavish: 1862–5 by *J. T. Knowles Jun.* Four bays, a big canted oriel replacing the central pair on first and second floor. Dormered roof-line. The doorway and most of the windows are arched, with the spandrels and the ground-floor wall between them a display of undercut foliage hopping with birds, the species all identifiable (carver *J. Daymond*). Two stones are used, so the effect is mildly polychromatic. Built as office chambers, but soon converted for club premises (long called the Thatched House Club, after a famous tavern once here); since 1978 MARK MASONS HALL. For Nos. 87–88 *see* above.

BUCKINGHAM PALACE AND THE ROYAL PARKS

INTRODUCTION

The Royal Parks run with hardly a break from St James's Park, in the very heart of old Westminster, to Hyde Park and Kensington Gardens, where fields and market gardens surrounded them well into the mid C19. No other great European capital has preserved so much open land near its centre, nor kept so much of it in a quasi-wild state. In addition Buckingham Palace has its own extensive grounds in the angle between St James's Park and Green Park, though this domain began as a private house and gardens, acquired for the Crown only in 1762. All three parks in our area owed their origin to Henry VIII's fondness for the hunt and greed for church lands. St James's Park went with St James's Palace, the successor to the medieval hospital there (*see* pp. 594–6); stocked with deer at first, it was used for wildfowling from the mid C17. Green Park was probably also enclosed in the 1530s. In Hyde Park, the largest by far, deer were still hunted in the late C18.

That the parks survived is due in part to a long process of negotiation and compromise that opened them to other users. Elizabeth I began the practice of military exercises in Hyde Park. In the C17 some public access was granted, and both Hyde Park and St James's Park were used for promenading and refreshment by the fashionable. After the Restoration St James's Park was fully landscaped in the grand style, and its N strip taken to make The Mall, where the game of *palle-maille* was played. The walling-in of Green Park and Hyde Park in the C17 allowed greater control over who was admitted; keys to the walks in Green Park became

p. 235

highly prized. In the C18 also the streams and springs in the parks were exploited by private water companies who made reservoirs, now drained, in Green Park and Hyde Park. The creation of the Serpentine lake there dates from 1727–31, the still more Picturesque remodelling of the St James's Park lake from a century later. Similarly informal are the contemporary lake and landscaping at Buckingham Palace, done for the Regent by *John Nash* and *W.T. Aiton*. Also in the 1820s Hyde Park Corner was remodelled as a formal entrance to London, though the resiting of *Decimus Burton*'s great arch disguises the original logic. It went with *Nash*'s transformation of Buckingham House into 81, Buckingham Palace for George IV, of which the side and garden p. elevations and most of the interiors remain, after later C19 and 646 C20 additions and refacings.

The last big encroachment on the parks was in the 1830s, to build the Wellington Barracks (*see* p. 690). In Mid-Victorian times, however, their seclusion was threatened by road schemes. In the event St James's Park got away with a path and footbridge over the lake, while in Hyde Park an established drive across the Serpentine Bridge was designated a public road (now the boundary with Kensington Gardens). Traffic was again the culprit for the most recent infringement, the Park Lane widening of 1958–63, when Hyde Park Corner was also remodelled.

The three parks now have very different characters. St James's Park is dominated by its long lake, with a gently sloping green surround, bounded on the N by the strong Edwardian accent of The Mall as remodelled by *Sir Aston Webb*. Green Park, partly wooded, is large enough to be briefly disorienting; Hyde Park, huge, variously planted and landscaped, has some still wilder areas, but is also the richest in buildings and monuments. (For Kensington Gardens, to the w, *see London 3: North West*.)

FURTHER READING. The best guide is the official *Buildings and Monuments in the Royal Parks*, 1997 (by L. Trench). Of general books, G. Williams, *The Royal Parks of London*, 1978, and N. Braybrooke, *London Green*, 1959, contain good accounts. For more detailed coverage, the excellent unpublished *Historical Surveys* of 1981 (Green Park) and 1982 (Hyde Park) stand out, compiled by Land Use Consultants for the Royal Parks. *Garden History* and *The London Gardener* have numerous relevant articles. For Buckingham Palace *see* especially the books by H. Clifford Smith, 1931, and J. Harris, G. de Bellaigue & O. Millar, 1968, and articles in *Apollo* 138, August and September 1993.

BUCKINGHAM PALACE
The Mall

p. The principal London residence of the monarch. It did not begin 646 as such, however, nor did the Crown acquire it with that use in mind. The transformation of Buckingham House, as it was originally styled, took place only after 1825 under *John Nash*. Buckingham House was built in 1702–5 by John Sheffield, 1st Duke of Buckingham, as a country house on the doorstep of

Westminster, facing down the Mall.* His architect was *William Winde* (who may have been following designs by *Talman*). Its giant pilasters and four-square attic became common motifs of the English Baroque. In 1762 it was bought as a family retreat for George III's Queen Charlotte, whose chief home it became, suitably adapted over the next two decades by (especially) *Sir William Chambers*. New ranges on the W side, behind the early C18 courtyard wings and quadrants, more than doubled the royal apartments – enough for some Court ceremonies to transfer here after the St James's Palace fire of 1809.

Nash's enlargements were on a much greater scale, but their progress was chequered and the work wrecked his reputation. The new monarch, George IV, asked his architect friend in 1821 to make Buckingham House a kingly residence in succession to his bachelor pad at Carlton House (*see* p. 439). Nash was allowed by Parliament to spend about £250,000. Building began in 1825, keeping the main range of the C18 house, encased and disguised. By 1828 the exterior was complete, save for its patriotic sculpture and the Marble Arch that stood as an entrance to the forecourt (now in Hyde Park, *see* p. 662). But George IV gave orders regardless of available money, and Nash seemed unable to control his own evolving design. He even pulled down part of the new wings and built them up conspicuously higher, all in full public view. So when George IV died in 1830 Nash was promptly sacked from the Office of Works. In 1831 a Select Committee found that over £600,000 had been spent, in a manner to the credit of neither architect nor king. Next year the task of completing the palace for William IV – who was to die in 1837 without ever moving in – went to *Edward Blore*, who had a well-deserved reputation for cheapness and reliability. He altered the design further, giving the upper storeys square-rigged attics instead of Nash's up-and-down silhouette, and taking down his structurally unsound, French-looking dome on the W front. The U-shaped building that resulted was not much like the country houses of the day, nor did the new wing *Blore* built in 1846–50 across the deep forecourt increase the resemblance. *Sir Aston Webb* added the present E façade in Beaux-Arts mode and the big *rond-point* with Queen Victoria's monument and radiating avenues outside (*see* The Mall). From this side, the Palace speaks of the competitive Imperial capital-making of the Belle Époque; behind, the English delight in Romanticized nature takes over.

The Palace Exterior

The Buckingham Palace of the postcards is *Webb*'s E FRONT, 340 ft (103.6 metres) long, a tasteful but insipid performance in the Louis XVI manner added in three summer months in 1913. The work absorbed the surplus of the Queen Victoria Memorial fund. Giant pilasters, attic pavilions with pediments set against them, the central one with royal arms (carved, like the Queen's

* The first major house on the site was Goring House, built or rebuilt after 1633 for the 1st Lord Goring and burnt in 1674; it was replaced by Arlington House, built for the 1st Earl of Arlington, which Buckingham demolished.

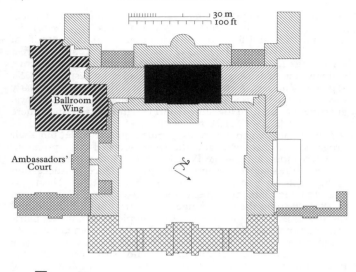

Buckingham Palace. Block plan, showing phases
of construction to 1856
(after H.M. Colvin (ed.), *The History of the King's Works*)

monument, by *Sir Thomas Brock*; other carving by *W.S. Frith*).
All this is no more than a veneer to cover *Blore*'s despised and
crumbling E wing of 1846–50, built to cope with what the Queen
called her 'little family' (builder *Thomas Cubitt*). The GATEPIERS
are mostly by *Decimus Burton* and of 1850–1 (sculpted by
John Thomas), but were repositioned and copied with variations
c. 1904–11 by *Webb*. New ornamental GATES were made to
match, by the *Bromsgrove Guild* (*W. Gilbert* and *L. Weingartner*).
On the locks are Arthur-Rackhamish clambering cherubs (some
now kept in store). Otherwise the palace remains overwhelmingly
a building in the style of *c.* 1830. The transition occurs very
abruptly on the N and S sides, which after four bays step down a
storey and change from Portland to Bath stone. The low wings
here with their Greek Doric columns were one of *Blore*'s improve-
ments, built 1833–4 as counterweights to Nash's four-column

porticoes which were set, too high up, on the wing ends. The S one contains a guard house, the N one (rebuilt *c.* 1948 after bomb damage) is just a screen. Continuing W along Buckingham Gate, the S SIDE shows more of what was added to Nash's palace. First the AMBASSADORS' COURT, which *Blore* closed with a low cross wing fronted with Ionic columns and an Ionic portico, in place of Nash's concave exedra. Then the big square BALLROOM WING of 1852–6, another *Cubitt* contract; his outline proposals were developed by *Pennethorne*, who was then also replanning the layout for Buckingham Gate (*see* p. 694). Together they proved at least as good as Blore at carrying on the idiom of Nash, Pennethorne's stepfather and former master. Pennethorne's own, mid-C19 ideas appear in the great round-arched entrance at each end of the Portland-stone-faced forebuilding added by *Webb*, 1913. Finally, the Queen's Gallery (1999–2002), with its portal by *John Simpson* (*see* below, and also for the Royal Mews beyond).

At the W FRONT, which faces the gardens, Nash's design and style are least disturbed. It is a long façade with five accents. Except for the middle one they are too weak to do their job. They consist of one bay at each end emphasized by coupled detached Corinthian columns; then, after three plain bays, a repeat of the same effect; and then, again after three plain bays, the middle accent, a generous bow window of five bays with attached columns. With *Blore*'s added storey, the whole rises in height from three to four and then to five, the last a blind attic in place of Nash's low dome. Even with the dome, Nash's design lacked grandeur, looking more like one of his bigger Regent's Park terraces than a palace. The bow as the centre motif is also strikingly unpalatial, though understandable here. Original large-paned glass, an early use. In addition there are, equally lacking in coherence, two CONSERVATORIES on the N and S, projecting and framing a terrace. These are in the shape of hexastyle Ionic temples with pediments filled with wreaths, and incorporate some columns from Carlton House. That on the S side was converted in 1842–3 into the palace chapel, bombed in 1940, and adapted for the Queen's Gallery in 1962. Further enlargement in 1999–2002, by *John Simpson*, absorbed *Pennethorne*'s grooved round-arched block to its r. and made the lower block in front. This ends with a Doric temple front with an arch breaking into the pediment, Hellenistic fashion. The great boxy eminence above and behind is the side of *Pennethorne*'s Ballroom Wing. (A third conservatory, at the other end of the N front, was removed in 1836 to Kew Gardens, *see London 2: South*.) The N FRONT is completely off balance, with a bow nearer the garden end and a colonnade further E.

SCULPTURE on the W front. The foliage frieze is by *William Croggon* (Mrs Coade's successor) in his artificial stone. Below it two eroded figure friezes showing King Alfred, designed by *Flaxman* and made by *Sir Richard Westmacott* in the same stone. Frieze above the bow also by *Westmacott*, Fame Displaying Britain's Triumphs, meant originally for the attic of Marble Arch. Balustrades and urns to the terrace in front also of cast stone. On the Pennethorne wing two reset reliefs of 1828–9 from Nash's E front, *D.J. Rossi*'s The Seasons, l., and *E.H. Baily*'s Britannia

Distributing Rewards to Arts and Sciences, on the ballroom part, r.*

The COURTYARD has as Nash's chief motif a big two-storey portico on the W side, which originally faced down The Mall. It has four pairs of columns on each floor, the lower a squat Greek Doric *porte-cochère* of cast iron, the upper Corinthian and of stone, with *Coade*-stone capitals. Sculpture in the pediment, Britannia Acclaimed by Neptune (designer *Flaxman*, executant *Baily*). The friezes to the l. (Waterloo) and r. (Trafalgar) are more works by *Westmacott* intended for Marble Arch, truncated to fit. Crowning figures on the pediment were removed c. 1948. Within the portico a pretty relief of The Progress of Navigation, by *J.E. Carew* after designs by *Westmacott*. An attic storey – another *Blore* improvement – extends on each side for three bays up to projecting bays with two pairs of Corinthian columns each. The cluttering iron and glass veranda is Edwardian. N and S ranges have pilastered central projections and colonnades below, which belonged with the first, lower version of Nash's wings. Originally open, they were infilled by *Blore* to link with his new E range of 1846–50. This is of uninteresting architecture, with second-floor windows linked into the frieze. The stucco effect is due to painting the Caen stone, which proved too fragile for the London air. Pediment sculpture of the Muses, another *Flaxman* design executed by *Baily*, which Blore salvaged from Nash's S wing.

Interiors

The STATE APARTMENTS were created between 1829 and 1836, primarily to *Nash*'s designs, with finishing touches by *Blore*. The commission seems to have refreshed the springs of creativity in Nash. The colours are white with much gold and scagliola, and crimson, blue, green or yellow silks. Heavy classical forms appear – coffered apses, giant columns – and in the details everywhere a tendency to disobey Greco-Roman precedent in favour of C18 France. It might come out in the sudden use of garlands or in small elements such as the succulence of the leaves, the lack of tension in a curve, etc. The rooms carry on from some of Nash's work at Brighton Pavilion, and are also close to B.D. Wyatt's at e.g. Lancaster House (*see* pp. 590–1) and to some interiors at George IV's Windsor. But there is altogether more variety and invention than in the copyist Neo-Dixhuitième of the later C19 and early C20. In the earlier C20 some de-Victorianizing occurred for Edward VII and for George V and Queen Mary, especially of *Pennethorne*'s interiors of the 1850s.

The Apartments were opened to summer visitors in 1993; the route described is that in force in 2001. The guidebook gives details of the furnishings, which include many marvels saved from Carlton House and Brighton Pavilion.

Visitors approach through *Blore*'s AMBASSADORS' ENTR-

* Six cast-stone figures of Virtues by *Rossi*, removed in 1948 from the main W bow, are now kept behind the Royal Mews. Trophies by Rossi over the inner groups of paired columns were removed after 1962. For other sculptures *see* Hyde Park (Marble Arch), Lancaster House, and the National Gallery, pp. 662, 589 and 305.

ANCE, redecorated 1924, which has steps up through an Ionic column-screen. Then into the *Nash* s wing and l. around a dog-legged CORRIDOR, created 1837–9 by *Blore*, to emerge into the courtyard (*see* Palace Exterior, above). The entrance to the w range is the GRAND HALL, of the same uncomfortably low dimensions as the entrance hall of Buckingham House, tempered by a lower floor in the centre. Rounded corners, with niches housing marble nymphs (various sculptors, made 1847–51), set about with Carrara marble columns with gilt bronze capitals by *Samuel Parker*. These continue as a screen across the far end. Lush chimneypiece with a clock flanked by Victories, r., by *Joseph Theakston*, 1829. White and gold decoration of 1902–3 by *C.H. Bessant*, replacing coloured scagliola. Its s end opens into the impressive GRAND STAIRCASE, likewise blanched and gilded 1902–3. The stairs, of Carrara marble, run up in one arm and then return in two, with the added excitement of a third, tunnel-vaulted arm running straight on under an arch on the half-landing to allow the State Rooms to be approached from either end. The opposing flights have a bulgy rounding of the corners, a typical touch of *c.* 1830 (unlike *James Wyatt*'s straight-sided staircase of 1800, formerly within these walls). Balustrade of bronze, a very heavy rinceau pattern made by *Parker* for £3,900. Nash gave the walls scagliola facing, which cracked and was painted over in 1834. Plaster reliefs high up, designed by *Thomas Stothard*: the Seasons (made by his son *A.J. Stothard*), and cupids (by *F. Bernasconi*, in the lunettes). Dome with delicately engraved glass skylights by *Wainwright Bros.*

The State Apartments proper fill the first floor of this w range, which is deep enough to allow for two suites with a long Picture Gallery between. Their mirror doors are an original feature. The courtyard range begins with the GUARD ROOM, token-sized and apsed-ended. Relief panels of 1853 showing Peace and War, by *John Thomas*. The statues include Victoria (by *J. Gibson*, 1847), Albert (by *Emil Wolff*, 1851), and some of the sentimental pieces which their family liked to give each other. The GREEN DRAWING ROOM, in the centre of the e façade and with access to the portico, was created from Queen Charlotte's Saloon. It has a huge coved and bracketed ceiling, a garlanded cornice, and plain lattice-pattern pilasters framing renewed green silk hangings. Stucco work by *George Jackson & Son*; caryatid fireplaces supplied by *Joseph Browne*. In the THRONE ROOM another deeply coved ceiling, with garter stars and shields in the coffering (plasterers *Bullock & Carter*). The throne recess is theatrically divided off by a proscenium with Victories holding garlands, modelled by *Bernasconi* from designs by *William Pitts*. Red silk wall-hangings, reinstating those removed in 1928. The relief friezes, designed in Troubadour style by *Stothard* and modelled by *Baily*, show the Wars of the Roses. On the wall by the thrones four gilt trophies said to come from Carlton House. The facing doorcase, a very uninhibited design of 1833 in *W. Croggon*'s artificial stone, incorporates a bust of William IV.

The PICTURE GALLERY, off to the l., is 155ft (47.2 metres) long and fills the former space of the garden range of Buckingham House. It was remodelled in 1914 by *Frank Baines*,

with a chaste glazed barrel vault and wooden swags carved by *H.H. Martyn* around the doors. Of *Nash*'s room, which had a leaky ceiling with small fiddly glass domes on hanging arches, the chief remains are the four fireplaces with portraits of famous artists. At the s end a column-screen to a LOBBY also of 1914, with *Chantrey*'s maternal statue of Mrs Jordan, mistress of William IV, 1834. From here another lobby leads into the toplit EAST GALLERY, l., the first interior in the Ballroom Wing which *Pennethorne* added in 1852–6. The polychromatic decoration devised for the Prince Consort by *Ludwig Grüner* has gone, mostly in patricidal remodelling for Edward VII, in the white-and-gold Louis XVI taste already encountered in the entrance and Grand Staircase. The East Gallery retains grisaille panels of cherubs by *Nicola Consoni*, high up. Off to the r. is the BALL SUPPER ROOM, with a great shallow-domed ceiling worthy of Nash, giant mirrors, and groups of sculpture (Story of Psyche) above the doorways by *W. Theed* and *Gibson*. Ahead is the BALL-ROOM, 123 by 60 ft and 45 ft high (37.5 by 18.3 by 13.7 metres). The compartmented ceiling and the throne recess with its framing Venetian motif are of Pennethorne's time, as are the weak sculptures by *Theed* over the throne. Pilasters, giant doorcases and *œil-de-bœuf* windows of 1907 by *White Allom*, based on designs of 1904 by *Frank Verity*. The side-lit ANNEXE GALLERY, off on the s, is also by *Verity*. The return is by the WEST GALLERY, which has Neo-Renaissance plaster lunettes by *Theed*, illustrating stories of Venus; the CROSS GALLERY connects back to the East Gallery.

The w RANGE of the State Rooms is entered at the s end at the STATE DINING ROOM, of three bays with saucer-domes, designed by *Blore*. The heavy and restless bracketing of the cove is a motif Nash would not have used. George IV intended a music room here; the fireplaces have musical figures on them, so must antedate Blore's work. The BLUE DRAWING ROOM – the ball-room up to the 1850s – is pure *Nash*, 68 ft (20.7 metres) long and of four bays, subdivided by paired columns and by huge consoles in the coving. The columns, originally of rose-coloured scagliola, were later painted to imitate onyx. Ceiling also saucer-domed. The tympana have gold-ground plaster reliefs by *Pitts*, 1833, including apotheoses of Shakespeare, Milton and Spenser (supplanting unexecuted designs by *Stothard*). The MUSIC ROOM, in the middle of the w front, was finished to Nash's design in 1831, and consists of a wide and deep half-domed bow and a domed square part behind. Dark blue scagliola columns engaged all round, originally set off by yellow hangings; fine-meshed coffering on the domes. The segmental tympana have reliefs of putti by *Pitts*, showing The Progress of Rhetoric. *Thomas Seddon* made the fine parquet floor. The chandeliers are some of the best of those from Carlton House. The WHITE DRAWING ROOM ceiling can boast the remarkable feature of a convex coving, with more fine diagonal coffering. Frieze panels by *Pitts* of the Origin and Progress of Pleasure; pilasters of a one-off Nash design with Garter stars in the capitals, originally with yellow scagliola shafts but redone by 1873 in white and gold. Chimney-pieces after an uncompromising square design by *Flaxman*.

Then via the Picture Gallery to an octagonal ANTE-ROOM and the MINISTERS' STAIRCASE of 1838–9, both by *Blore*. The staircase has an open well and a gilt lead balustrade. In 1902–3 *Bessant* redecorated it and the gallery running s from its foot, which corresponds to the Picture Gallery above (and to the original garden-side rooms of Buckingham House). This MARBLE GALLERY was intended to show the royal sculpture collection. Two fireplaces with columns, probably from Carlton House; carved gilded festoons over them, installed 1902–3, perhaps incorporating early C18 work. The BOW ROOM, off to the r., fills the centre of the W front. Ionic screens each side, a relatively low ceiling, and less ornament than above. The dark marble chimneypieces, of 1810 by *B. Vulliamy*, are C20 introductions.

Other rooms, not normally visitable, are as follows. (On the first floor, the ROYAL CLOSET is reached from the White Drawing Room by a concealed door, N. Here a late C18 fireplace from the Throne Room at Carlton House, later embellished with female bronze fauns of Parisian make.) Three major rooms in the EAST WING (Luncheon Room, Centre Room and Yellow Drawing Room) have Chinoiserie furnishings installed when Brighton Pavilion was stripped and sold after 1845, a very unexpected throwback. The LUNCHEON ROOM at the N includes doors painted with pagodas by *Frederick Crace*, wall paintings by *Robert Jones* of Chinese dignitaries against wallpaper-like backgrounds, and a phenomenal dragon fireplace designed by *Jones* and made by *B. Vulliamy* and *Westmacott*. In the CENTRE ROOM are more lacquer doors, paintings and Chinese fireplaces, this time with figurines, but the matrix of Oriental decoration is due to *Sir Charles Allom*'s 1920s work for Queen Mary. The YELLOW DRAWING ROOM at the s has the most colourful of the Brighton fireplaces, with golden dragons and taller figures (1822, by *S. Parker* and *Robert Jones*), and wallpaper also from the Pavilion. But the ceiling and doors are in Blore's modern French style. The rooms are separated by many bedrooms, with shared access from the long PRINCIPAL CORRIDOR on the courtyard side.

The ground-floor rooms N and S of the Bow Room (E wing), all much smaller than it, are a mixture of *Nash* and later redecoration. To the s, the 1855 ROOM, pilastered and with a fine black marble Regency fireplace installed in the 1920s, and the HOUSEHOLD BREAKFAST ROOM, with a late C18 fireplace; they have matching Nash cornices. To the N, the 1844 ROOM, with paired columns and with additional ceiling decoration dated that year (when the Czar stayed in it), the CARNARVON ROOM, with an advanced, French-influenced fireplace with veiled female terms, and EIGHTEENTH-CENTURY ROOM and ORLEANS ROOM, also with original Nash era fireplaces, carved with pairs of female attendants. The last two rooms have strange ceilings with sternly Grecian compartments resting on a cove of frilly flowers. (The N side has two rooms simplified by *Sir Hugh Casson* as offices for the Duke of Edinburgh, *c.* 1954. The KITCHENS are in the s extension.)

Auxiliary Buildings and Garden

The QUEEN'S GALLERY in Buckingham Gate is a work of resurgent pomp by *John Simpson*, 1999–2002. It can be read in three ways: as a mirror to the early C21 monarchy, as an exercise in latterday classicism, and (inside) as a kind of commentary on the interiors of the palace proper. The first reading is unavoidable after recent years, when the Crown has no longer been taken deferentially for granted. The implied message is that a job worth doing is worth doing well, and that – where the glamour of tradition is concerned – the House of Windsor does the job best of all. In architectural terms, the keynote is struck by the PORTICO, a baby Greek Doric one with fat columns, facing N and standing just beyond the reused C19 wall. It has enough variations from orthodoxy to escape the charge of mere copyism: polychromatic dressings, a pediment with the centre missing to show off the oak roof timbers, a funny wilting acroterion on top, etc. The ENTRANCE HALL behind has other novelties: transenna-like screens to modulate the top-lighting; openings on the long walls with a single Doric column *in antis*, with the more usual paired arrangement confined to the short ends; ornamental bands around the capitals; Soanesque vaults or flattened domes in the spaces opening off, including in the giant SHOP ahead. Also much Neo-Greek SCULPTURE by *Alexander Stoddart*: Homeric friezes and national personifications in relief, and two winged guardians or telamones, r., all for the most part surprisingly convincing. The guardians surmount the entrance to the STAIRCASE, which has parallel flights turned to meet at a high half-landing, all overlooked from behind screens of bright green scagliola columns.

On the upper floor are the four main galleries proper, named after architects of the C18–C19 palace, and with motifs drawn from them. The NASH GALLERY at the far end, with its ceiling derived from that formerly on Nash's Picture Gallery, was where the first and much smaller public gallery was made in 1962, within the shell of one of the Nash conservatories (*see* Palace Exterior, above). The smallest spaces have Soane vaults: two over the landing vestibule, r., two more in the treasure-closets off the PENNETHORNE GALLERY beyond it. As a sympathetic setting for paintings, *objets d'art* and historic furniture in ensemble the galleries work effortlessly well, as indeed do the rooms in traditional styles recently made at the National Gallery (*see* p. 308). Has the wheel of taste come full circle and stopped, or is a revival of the neutral, Modernist display space at hand?

ROYAL MEWS, further SW and facing Buckingham Palace Road. There are two main parts, the main mews and the RIDING HOUSE to its N. This was built in 1765–6 probably to *Chambers*'s design, and ornamented in 1858–60 by *Pennethorne*. By the former the timber cornice of Tuscan type, of the latter time the stucco, rich acanthus frieze (a match for that of the palace) and *Theed*'s big pediment sculpture of Hercules taming the horses of Diomedes. Simple thirteen-bay interior with Tuscan pilasters and a s apse. Roof rebuilt 1913–14.

The MEWS proper, by *Nash*, dates from 1822–5. It is a stucco-

fronted quadrangle, with a big arched stone entrance framed by coupled Roman Doric columns linked by blocks and crowned by a square clock turret with corner columns. The entrance design repeats four times round the tree-planted courtyard, which has lunette windows to the stables below and grooms' accommodation reached by external galleries above. Inside the far range, iron arcades support unexpected pendentive vaults. George III's STATE COACH of 1760–2 is displayed here: the greatest artefact of the English Rococo, though by artists usually thought of as Neoclassical: designer *Chambers*, sculptor *Wilton*, painter *Cipriani*. In front of the mews sober LODGES with Doric porches, the r. one by *Nash*, its twin, l. and the GATEPIERS all of 1857–8. To the w the BACK MEWS, long plain brick ranges also of 1822–5 and by *Nash*, but heightened and extended. Two modest houses for vet and equerry are included (Nos. 16 and 17 Lower Grosvenor Place).

The beautiful GARDENS were landscaped by *W.T. Aiton* and *Nash*, 1825–8, replacing *Henry Wise*'s formal early C18 layout with an irregular lake and artful Picturesque planting. At the w end the WATERLOO VASE, of eroded Carrara marble, begun for Napoleon in 1812–15 and finished with battle reliefs by *Westmacott*, 1819. It is nearly 15 ft (4.6 metres) high. Facing it a pedimented SUMMER HOUSE with four Atlantes, reconstructed after wartime bomb damage. Original parts include the sculpted pediment and inner dome, with Rococo scrollwork typical of the 1740s. It came from the old Admiralty Gardens, Whitehall. Another pavilion, of 1843 and with decorations as a kind of try-out for the Palace of Westminster interiors, was demolished in 1928.

THE ROYAL PARKS

ST JAMES'S PARK

The area was a swamp in the Middle Ages. Henry VIII had it drained for a deer park for St James's Palace to the N, built in the 1530s. James I added a menagerie and an aviary, commemorated in Birdcage Walk along the S side. Faithorne & Newcourt's map, surveyed 1643–7, shows a few plantations and two parterres close to the palace. Charles II began to remodel the park in 1660, and also opened it to the public. The work was supervised by *Adrian May*, brother of the architect Hugh May. It was the earliest of the King's park schemes in the French taste. A straight tree-lined canal was made as the central axis of a *patte d'oie*, aligned on the private stairs of Whitehall Palace to the E. Along the N side The Mall was laid out. To its N were parterres, designed by the French gardener *André Mollet*, later taken to build Marlborough House and Carlton House (*see* pp. 591 and 439).

The Mall remains (q.v.), but the canal has been replaced with the serpentine LAKE which is the main piece of *Nash*'s

pp. 235, 259

remodelling of 1827–8. He may have known *Capability Brown*'s plan of *c.* 1765, which likewise featured an irregular lake with a wooded island at the E end.* The park thus became the finest publicly accessible piece of Picturesque landscaping in London. The Victorians brought it to perfection with the towers of the Foreign Office, rising above the trees to the E, since trumped by the Shell Centre and London Eye on the South Bank. In 1828 also Birdcage Walk became a fully fledged drive, allowing direct communication between Buckingham Palace and Westminster Bridge. Paths and planting have changed a great deal especially at the w end, in the 1850s and when a bite-shaped piece of land was taken in 1903 for the *rond-point* in front of Buckingham Palace (*see* The Mall).

BUILDINGS. On the E island DUCK ISLAND COTTAGE, built for the Ornithological Society by *J.B. Watson*, 1840–1 (restored 1982). A delightful, completely asymmetrical *cottage orné*, with half-hipped gables and bargeboards. On the island was the keeper's house, with a clubroom on land and a bridge with tree-trunk loggia between. The present causeway replaced this as the usual approach in 1857. (A previous 'Duck Island', a system of small canals made as a wildfowl decoy for Charles II, was filled in 1770–1, as was a lake to the w called Rosamond's Pond.) – The FOOTBRIDGE is of 1956–7, by *Eric Bedford* (*Ministry of Works*) and lying low above the water. Prestressed balanced-cantilever concrete arches, faced with Portland stone. It is quite handsome and good to look out from, but the cast-iron suspension footbridge of 1857 remains a great loss (designer *J.M. Rendel*, decoration by *Sir Matthew Digby Wyatt*). This was built in connection with Marlborough Road, the new N–S route from Pall Mall. – REFRESHMENT PAVILION. In 2003 work started on *Sir Michael Hopkins & Partners*' replacement for the 'Cake House' of 1970, demolished in 1999. – FOUNTAIN, s of the lake. A Greek boy with pitcher by *C.H. Mabey*, 1863, the head and hands late c20 replacements. Base designed by *Robert Jackson*. – For the Guards' Monument to the E *see* Whitehall, p. 256; for the Boer War Monument to the N *see* The Mall.

THE MALL

First laid out for Charles II *c.* 1660–2, with four lines of trees, in tandem with the formal landscaping of St James's Park. The land along the Mall indeed remains officially part of the park. It replaced Pall Mall as the venue for the game of *palle-maille* ('No sooner has he touched the flying ball/But 'tis already more than half the Mall', Edmund Waller wrote of the King in 1660: *see* also p. 611). In the C18 it became principally a place of parade for fashionables and disreputables. Its character completely changed in the 1900s, the great age of Imperial image-making, under the hand of *Sir Aston Webb*. He refaced Buckingham Palace at the w

* In 1766 both *John Gwynn* and *Thomas Wright* presented plans for the park, in connection with unsolicited proposals for new palaces; Gwynn's also covered Green Park, Hyde Park and Kensington Gardens.

end (q.v.), made the *rond-point* and Victoria Memorial in front of
it, and designed Admiralty Arch at the E end. In The Mall more
parkland was taken to make a new and wider road, along which
four replacement avenues were planted in 1908. The old road-
way can still be seen to the N. Admiralty Arch joined up with
Trafalgar Square, breaking through the former close of Spring
Gardens, and so The Mall became what it had never been, a
major thoroughfare. Its ceremonial character is indicated by the
superior LAMP STANDARDS, the Edwardian ones ornamented
with little galleons designed by *Sir Thomas Brock*.

The Mall has monuments but no buildings of its own, but the
architectural landmarks are pointed out along the way. The
description starts at Admiralty Arch, with on its S side the Admi-
ralty building of 1888–1905, beyond which is the concrete Citadel
(*see* pp. 375–6 and 253–4). At the entrance to The Mall proper
two MONUMENTS with bronze statues. Captain Cook, S, 1911–14,
is by *Brock*. To the N, Royal Marines killed in South Africa and
China, a battle group of 1902–3 by *Adrian Jones*; *Sir T.G. Jackson*
helped with the plinth. Further along the S side where St James's
Park begins, a National Police Memorial is proposed (2003) to
designs by *Foster & Partners* with the Danish artist *Per Arnoldi*.
Then the ambitious MONUMENT of 1906–10 to members of the
Royal Artillery fallen in the Boer War. Bronze by *W.R. Colton*, a
winged Peace taming a horse. The pedestal and concave screen
wall were designed by *Webb*. Facing are the stucco cliffs of Carlton
House Terrace, and Carlton Gardens beyond (*see* pp. 439–45).
Buildings beyond treat The Mall less formally, as a kind of back
garden. Marlborough House (*see* p. 591) has on its garden wall,
at the corner of Marlborough Road, a beautifully lettered PLAQUE
to Queen Mary with a round profile relief by *Sir W. Reid Dick*,
1967. The GATES to St James's Park here were designed by *Webb*,
with iron gates made by *Bainbridge Reynolds*. Then St James's
Palace (*see* pp. 594–8), the stuccoed Clarence House attached to
its W end (*see* pp. 601–2), and Lancaster House (*see* p. 589).

Then Green Park, and so to the *rond-point* with the
VICTORIA MEMORIAL. The French term for the circus is justi-
fied by its Parisian, Beaux-Arts character. The design is by *Sir
Aston Webb*, 1903, after an idea by (*Sir*) *R.J. Allison* of the Office
of Works; the 2nd Viscount Esher, Secretary to the Works, was
the moving spirit. In the middle stands London's most elaborate
MONUMENT after the Albert Memorial, by *Sir Thomas Brock*, 103
designed in 1904 and assembled 1906–24. It represents symboli-
cally the Queen-Empress presiding over her sea-girt kingdom,
a treatment at once more nationalistic and less personal than
Albert's. The architectural elements are by *Webb*. It is of 2,300
tons of white Carrara marble and is 82 ft (25 metres) high. The
statues on the tall, broad central pillar were unveiled in 1911: gilt
crowning figures of Victory with Courage and Constancy at her
feet, and four auxiliary sculptures of stone: the seated figure of
the Queen to the E, of Charity (a fine group) to the W, and groups
of Truth and Justice to the N and S. Below in the diagonals
bosomy ships' prows. The surround is a wall with a frieze of
tritons and nereids in stone and bronze, then a moat or basin
bisected by two broad staircases. On the surround six bronze

groups, the last installed in 1924 after Brock's death. They represent Progress and Peace (two, E), Manufacture and Agriculture (two, W), Painting with Architecture (N), and Shipbuilding with War (S). The quality of Brock's work has been better appreciated in recent years, though originality and daring must not be expected (Susan Beattie called him 'the great plagiarist of the New Sculpture').

The CIRCUS all around was designed to accommodate sightseers during parades and ceremonies. Much stress on white stone piers with ornate iron gates (made by the *Bromsgrove Guild*). STATUARY on the piers, youths or amorini with shields of Dominions and colonies and appropriate flora and fauna: by the Mall, E, West Africa and South Africa by *Alfred Drury*; to the N, Canada, also by *Drury*, with the finest set of gates to lead into Green Park; by Birdcage Walk, S, Australia, by *Derwent Wood*. The circuit encloses formal gardens, with a view E over the lake of St James's Park, part of which was sacrificed for the memorial. The FLAGPOLES were put up just after the Coronation of 1953.

GREEN PARK

First enclosed probably by Henry VIII, together with St James's Park. The area is 51 acres (20.6 hectares), the plan roughly triangular, with an acute W point. Historically the park boundaries were quite fluid. It was surrounded with walls in 1668, and called Upper St James's Park. Not long after, the NE part was sold and became Arlington Street (see p. 602), while further land was added to the W. Then in 1767 the land S of Constitution Hill was merged with the gardens of Buckingham House.

In the C18 Green Park was much favoured for walking, and in 1730 QUEEN'S WALK was laid out for Queen Caroline along the E side, probably by *Charles Bridgeman*. The alignment shifted W as noble householders in St James's to the E pinched strips of land for their own use, culminating in 1795 with a large intake from the S end. The aristocratic houses and their successors are identified here by their streets, where full descriptions are given. From the N, first Arlington Street: C18 brick at Wimborne House (*Kent*) and, set back, *Leoni*'s No. 21, then *M. Rosenauer*'s 1930s Arlington House. Next the two houses occupied by the Royal Over-Seas League, Park Place, of which that to the N is by *Gibbs* and C18. After that a C20 stretch along the dog-leg of St James's Place. The fifth of these, S of the curious pedestrian tunnel out of the park, is *Denys Lasdun*'s evergreen luxury flats of 1959–60 (No. 26). *Vardy*'s Spencer House, the first great house to address its front to the park (1756–8), also belongs with St James's Place. The next group goes with Cleveland Row: *Sir Charles Barry*'s great Bridgewater House, the smaller Selwyn House, C19, and two later C18 mansions masked by C19 alterations, Stornoway House and Warwick House. Finally, the entrance to Stable Yard at St James's Palace, and *B.D. Wyatt*'s Lancaster House, which as public buildings have their own entries.

The ground to the W lay open well into the C19, but great trees now stand informally through it, with gas-lamps picking out the paths. The strongest formal accent is the BROAD WALK, which crosses from NW to SE. Planted as a gravelled walk in 1905, but returfed in 1912. The Queen Victoria Memorial closes the S view (q.v. The Mall); at the N stand the C18 gates on Piccadilly (q.v.).

CANADA MEMORIAL. On the S side, just inside the Canadian gates of the Queen Victoria Memorial. 1994 by *Pierre Granches*. A break with the figurative tradition for war monuments. A broad tilted plane, rising up as a pointed granite-faced mass, a little too small for a full impact. Water gently and endlessly washes over bronze maple leaves sunk in the surface. A narrow walkway cuts through, aligned on Halifax, Nova Scotia, the servicemen's historic port of embarkation.

FOUNTAIN by *Estcourt J. Clack*, 1954, to the NW. Somewhat in the Swedish Milles tradition. Trefoiled granite basin, supporting a rough-skinned Diana on a spiral cone of vegetation. Given by Sigismund Goetze in memory of his wife Constance.

DEMOLISHED STRUCTURES. 'Snow wells' or ice houses were built for Charles II and his brother in the 1660s. At that time a little pool lay in the central valley, where the Tyburn flowed (filled 1837). A much larger basin to the NE, made in 1703 and enlarged for the Chelsea Water Works in 1729, went in 1855. Of inhabited buildings, the Deputy Ranger's House by *Robert Adam*, 1766–8, was pulled down in 1842.

HYDE PARK CORNER

Hyde Park Corner, of a roughly triangular shape, is the point at which the green open land of the Royal Parks is squeezed between the SW angle of Mayfair and the NE point of Knightsbridge and Belgravia. Apsley House on the N side (p. 485), at the end of Piccadilly, belongs with Mayfair, the former St George's Hospital on the W with Belgravia (p. 755). The corner was for long regarded as the most important entry into London, and a turnpike toll was set up here in 1726. Ideas for something more monumental included triumphal arches by *Thomas Robinson*, later *2nd Lord Grantham* (1761), and a series by *Robert Adam* combined with screens and gateways to the parks to N and S (1778).* *Jeffry Wyatt* in 1794 exhibited another scheme, *Soane* in 1796 yet another. In the 1820s Soane revived the idea as part of the royal route he wanted to make from Windsor to the Houses of Parliament, in conjunction with an enormous royal palace he proposed for the NW corner of Green Park. Nothing came of this, for Nash converted Buckingham House to Buckingham Palace instead. In connection with this palace young *Decimus Burton* was asked in 1824 to design the Hyde Park Corner Screen and a great arch to its S. The composition of screens and gateway did after all materialize, therefore, though as a grand S exit

* For the various C18–C19 schemes *see* Steven Brindle in *Georgian Group Journal* 11, 2001, and Sean Sawyer in *Architectural History* 39, 1996.

towards the palace rather than an overture to the capital from the w.

Burton's SCREEN was built in 1826–9 on the N side. It has three archways, separated by screens of five columns each, on the pattern of Adam's Syon House screen (*see London 3: North West*). The archways also have columns, of the same Ionic order, coupled in the centre. This part moreover rises into an attic with a sculpted frieze, derived with variations from the Parthenon. It is by *John Henning Jun.* together with his father, also *John*, and brother *Samuel*. The untroubled use of the arch motif is by contrast not at all Greek. Gates by *Bramah & Sons*. To the w Burton's LODGE of 1822, with opposed Doric porticoes. Tiny attic storey, with a clock of 1844 and antae for mullions. Apsley House lies to the E, its Bath stone contrasting pleasantly against the colder grey of the screen.

The WELLINGTON ARCH followed in 1826–9. It is Corinthian and strongly Roman, but with the 'modern' variations of a heavy attic stepped back from the ends and a straight entablature over the big coupled columns. Only one archway, with weighty iron gates to *Burton*'s design, also made by *Bramah & Sons*. In 1912 *Adrian Jones*'s bronze group of Peace descending on the Quadriga of War was placed on top. According to Jones's memoirs the Prince of Wales suggested the commission in 1891, and work began in earnest in 1907. It is his best London work, with a fine perilous spirit in the plunging horses. Burton had wanted a smaller quadriga and other sculpture, but the plan lapsed after George IV died in 1830, as did the function of the arch as an entrance to the grounds of Buckingham Palace rather than Green Park. The position of the arch has also changed: originally parallel to the screen, with its flank towards the hospital, it was moved in 1883 to a less satisfactory alignment at the head of Constitution Hill, SE. The name derives from the much-mocked equestrian statue of Wellington by *M. Cotes Wyatt* of 1838–46 that stood on top until 1883. In 1999–2001 restored by *English Heritage*, with access to viewing platforms over the porticoes and to rooms previously used as a police station.

The arch stands on a grassy island reached by numerous subways. The island has low walls and bland lawns, of 1958–62 by the *LCC*, who also widened Park Lane and made an underpass at the w end of Piccadilly. The work swept away *Aston Webb*'s gatepiers of 1907–8 flanking the arch, the N leg of which was adapted for a ventilation shaft. Further improvements to the landscaping, designed by *Kim Wilkie*, are proposed (2003).

Several military MONUMENTS occupy the island. To the N, facing Apsley House, the equestrian WELLINGTON MONUMENT by *Sir J.E. Boehm*, 1884–8. Four fine soldiers at the corners. Pedestal of red Peterhead granite, designed with help from *Howard Ince*. – To its E the MACHINE GUN CORPS MEMORIAL by *Derwent Wood*, 1925, with a painfully inappropriate bronze statue of a naked youth with ceremonial sword. Wreathed machine guns to either side. – To the SW the ROYAL ARTILLERY MONUMENT by *Charles Sergeant Jagger* and *Lionel Pearson*, 1921–5. A moving work, now recognized as a masterpiece of British C20 sculpture. Jagger had served with the regiment, and

his work explores the limits of what public art could then show
of the disasters of war. The culmination is a blunt-nosed 9.2 in.
howitzer, realistically portrayed in stone. Around its pedestal
stand three bronze gunners, with at the N end a fourth lying dead 105
under a greatcoat. The details, e.g. the nails in the dead gunner's
boots, have the directness of documentary photographs. In con-
trast with this realism and stasis are four angular, flattened reliefs
of desperate battle on the sides. *Pearson* designed the beautifully
lettered pedestal and podium, on which no mouldings or archi-
tectural carving appear. Steps at the S end were replaced in 1949
by a flat plinth with bronze tablets, by *Darcy Braddell*. – To the
SE, at the top of Constitution Hill, a MEMORIAL GATEWAY to
the Empire forces of the Second World War, by *Liam O'Connor*,
2001–2. The best part is the two tall pairs of piers topped with
bronze urns, similar in spirit to the First World War battlefield
memorials. To one side a pavilion of weak Moghul character.

HYDE PARK

The park, called after an ancient manor of Hyde, was abbey land
enclosed in 1536 as a deer park by Henry VIII. It was then 620
acres (251 hectares) in size. In the C16 there were 'stands', that is
lookout towers, for watching the hunting, which went on as late
as 1768. Hyde Park was first opened to the public *c.* 1630, but in
1642 its E side was turned over to Civil War defences, and in 1652
the park was sold. Charles II recovered it, and had it walled in
c. 1672. At the Restoration also the custom of fashionable parade
was revived, at first in a central enclosure called The Ring, later
in ROTTEN ROW, laid out in 1690 along the S side by Capt.
Michael Studholme. The name is supposed to derive from *route de
roi*, the King's road through the park to Kensington. As an access
road it was superseded by the Carriage Drive to the S in 1735–6.
Other formal accents have disappeared, notably avenues along the
E side shown in a survey of *c.* 1706 by the royal gardener *Henry
Wise*, which were presumably of his own planting.*

From the early C18 Hyde Park shrank, chiefly to the advantage
of Kensington Gardens. By 1790 it had only 394 acres (159
hectares; the present figure is 340 acres, 137.5 hectares). Land-
scaping in a more natural style began with Queen Caroline, for
whom the SERPENTINE lake was made in 1727–31. The task,
overseen by *Wise* and *Charles Bridgeman*, required the damming
of the Westbourne, merging the ponds along its marshy valley. A
pioneering example of a picturesquely irregular water feature on
a grand scale, it remains the most effective element of the park
visually. Strictly speaking the E part is called the Serpentine,
the W part, in Kensington Gardens, the Long Water. An island
was made in the Serpentine in 1872–3. Still more informal in C18
terms was an outflow lake made at the SE end in 1737; it was
remodelled as a DELL in the 1880s.

* Stillborn C18–C19 proposals included a huge triumphal arch at The Ring by *Leoni*
(1719), *John Gwynn*'s royal palace and radiating avenues (1766), and *Philip* and *B.D.
Wyatt*'s palace N of the Serpentine, promoted by the busybody Colonel Trench
(1824); also numerous embellishments at Hyde Park Corner (q.v.).

A major campaign of improvements in 1824–9 saw new lodges and gates built and a carriage circuit made (architect *Decimus Burton*, road engineer *James McAdam*). Royal interest had a lot to do with this, though the public claim to access was also well established. Further gates were made in the 1840s, to give access from the houses being built all around. Then in 1862 the West Carriage Drive across the Serpentine became a public road. It has since supplanted Bridgeman's lost ha-ha as the boundary with Kensington Gardens. The Victorian enthusiasm for fountains left its mark, and the tally of structures is now considerable. Apart from at the SE corner the landscaping remains informal.

BUILDINGS AND MONUMENTS

The numbers in the following descriptions match those on the map on p. 661.

Buildings in Hyde Park

BRIDGE across the Serpentine (1). By *George & John Rennie*, 1825–8. Five segmental arches and a balustrade, a solid yet elegantly designed piece of masonry. From the bridge one has a distant view to the SE of the Houses of Parliament and Westminster Abbey, and nearer to hand the 1960s Knightsbridge Barracks tower and the high-rise mediocrities of Park Lane.

TEA HOUSE and BATHING PAVILION (2). E of the bridge, on the S side of the Serpentine. A pretty design in the Lutyens style, built for bathers by *J.H. Markham* of the *Office of Works*, 1930. Grey brick with red trimmings, Doric colonnade, hipped roof and lantern. Remodelled in 1995 by the *John R. Harris Partnership*, with new wings in keeping.

BOAT HOUSES (3). On the N shore. The E one of 1902–3, sprucely tiled, timber-framed and brick-nogged. The W one of 1952, with perforated brick walls.

THE DELL RESTAURANT (4). On the brink at the NW corner of the Serpentine. 1964–5, by the ever-inventive *Patrick Gwynne*. Single-storey pavilion with zooming upswept starfish roof of concrete. Glazed below, with sharp angle joints, opening on to a terrace with seats built into the railings. (Demolished in 1989, *Gwynne*'s no less adventurous café of 1963–71 by the bridge, on the S side.)

OUTFLOW BRIDGE (5). 1805–6. Of stone, modest, with balustrade.

RANGER'S LODGE, N of the Serpentine (6). A plain yellow brick villa of 1832, with canted bays. To its S the contemporary RANGER'S COTTAGE (7), single-storeyed.

POLICE STATION (8). A little N of Ranger's Lodge. By *J. Dixon Butler*, 1900–2. From a distance like a medium-sized country house of Charles II's time. Brick quoins. Big hipped roof with tall stacks. Two-bay pavilion wings. Between them a Quattrocento Ionic colonnade. Utilitarian buildings behind, some perhaps from the barracks formerly here (established *c.* 1800).

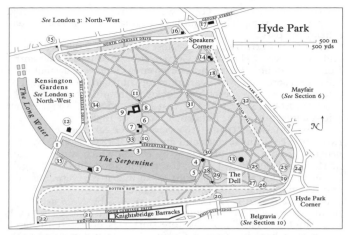

1 Serpentine Bridge
2 Tea house and bathing pavilion
3 Boat houses
4 The Dell Restaurant
5 Outflow Bridge
6 Ranger's Lodge
7 Ranger's Cottage
8 Police Station
9 Magazine Cottage
10 Serpentine Lodge
11 New Lodge
12 Powder magazine
13 Bandstand
14 Kiosk and shelter
15 Victoria Gate
16 Cumberland Gate
17 Marble Arch
18 Grosvenor Lodge (former)
19 Queen Elizabeth Gate
20 Albert Gate
21 Prince of Wales Gate
22 Alexandra Gate
23 Achilles
24 Byron
25 Cavalry Memorial
26 Boy and Dolphin
27 Artemis Fountain
28 Megalith Fountain
29 Holocaust Memorial Garden
30 Mermaid Fountain
31 International Year of the Child Fountain
32 Joy of Life Fountain
33 Norwegian Navy Memorial
34 Rima
35 Princess of Wales Fountain (proposed)

MAGAZINE COTTAGE, just W of the above (9). Neo-Elizabethan, 1861–2. Stable range to its SW.

SERPENTINE LODGE, S of Ranger's Lodge (10). Of *c.* 1830. Single-storeyed, with bracketed eaves.

NEW LODGE, NE of Ranger's Lodge (11). A large brick house with a North Oxford flavour. 1877.

POWDER MAGAZINE (12). At the N end of the Serpentine Bridge, now just inside Kensington Gardens, but originally within Hyde Park. Perhaps by *James Wyatt*, Architect to the Board of Ordnance in 1805, the date on rainwater heads on the N side. A sophisticated design. The building is a square within a square, of yellow brick. The inner square is higher and has to the N and S a pediment and Diocletian window. The outer is a screen wall with a colonnade to the S, of Greek Doric columns between square angle blocks. This must belong to alterations by *Decimus Burton*, before 1823.

BANDSTAND (13). Of 1869, a grand and early example of a typical Victorian amenity. Moved from Kensington Gardens 1886.

KIOSK and SHELTER (14). Two brick rotundas with pointed copper roofs. 1964. They double as ventilators for a vast subterranean car park.

GATES AND LODGES. The greatest are Marble Arch (*see* below) and the screen at Hyde Park Corner, described under that entry. Lodges at Stanhope Gate and Grosvenor Gate were casualties of the early 1960s; other gates are mere openings in the railings. The interesting ones are described clockwise from the NW.

VICTORIA GATE (15). Big cast-iron GATES of 1923, rather mid-Victorian in style. Reticent LODGE of 1838.

CUMBERLAND LODGE (16). Severely Greek, the centre with two Doric columns *in antis* and an attic. Of 1857, cloned by *Pennethorne* from a lodge of 1824–5 by *Burton* which was sacrificed in 1868 to widen Park Lane. Moved W in 1908, further W again under the traffic scheme of 1961–2, so that it is severed visually and functionally from Cumberland Gate.

MARBLE ARCH (17). Designed in 1825–6 by *Nash* as a ceremonial gateway to the forecourt of Buckingham Palace, and built there in 1827–33. When the forecourt was enclosed the arch was rebuilt here by *Thomas Cubitt*, 1851. Islanded since 1908; the present formal and forlorn setting dates from the road widenings of 1961–2.

The arch is clad in white Carrara marble, the first such use for an entire British building. The three archways flanked by monolithic Corinthian columns declare its derivation from the Arch of Constantine, the richest of Roman triumphal arches and the model for Percier's recent Arc du Carrousel in Paris not long before. But the scheme devised by *Flaxman* for SCULPTURE commemorating the Napoleonic wars was implemented only in part, with carved Victories in two sizes in the spandrels, and square panels of standing symbolic figures above the side arches. They are by *Sir Richard Westmacott* (N side; also the laurel wreaths to E and W) and *E.H. Baily* (S side). The plain low attic with its four weak uprights is a penny-pinching revision by *Blore*, sanctioned in 1832. Nash had intended a taller one enriched with sculpture, for which new homes were found: on Buckingham Palace, for much of the figure friezes, on the National Gallery, for some high-relief figures, and in Trafalgar Square, for the equestrian statue of George IV meant for the summit. The cast-iron GATES were begun by *Samuel Parker*, whom they bankrupted in 1832, and finished in 1837 by *Bramah & Prestage*.

In the pedestrians' underworld around the island are mural MOSAICS by *William Mitchell*, 1962.

Former GROSVENOR LODGE (18). Reset on a ventilation housing of *c.* 1964 are bits of Grecian stonework from *Burton*'s lodge of 1824–5.

QUEEN ELIZABETH GATE (19). Gates of 1991–3, by *David Wynne* (centre) and *Giuseppe Lund* (sides). They commemorate the ninetieth birthday of Queen Elizabeth, the Queen Mother. The sides, of silvered spun-sugarish metal, are more acceptable than the centre, with its crude painted heraldry, silhouetted toadstools, etc. The impression is of a fear of formality and a yearning to be liked at any cost.

ALBERT GATE (20). Made 1844–5 by *Cubitt*. Two stone posts, and on them early C19 iron deer attributed to *P. Turnerelli*, after prints by *F. Bartolozzi*. These came from the Deputy Ranger's House at Green Park (q.v.). Facsimile gates of 1984–5. For the two palazzi to the S, and for the sculpture at Edinburgh Gate, W, *see* Knightsbridge, pp. 756–7.

PRINCE OF WALES GATE (21). Made 1847. Twin porticoed LODGES by *Burton*, of 1847, W, and 1851, E (added for the Great Exhibition). Still Grecian, but with unfluted columns.

ALEXANDRA GATE (22). Made 1858. LODGE by *C.J. Richardson*. Doric, but with the columns coupled, showing the end of Grecian purity.

Fountains, Major Monuments, and Sculptures

ACHILLES (23). A bronze adaptation by *Sir R. Westmacott*, 1814–22, of one of the horse-tamers from the Quirinal hill in Rome. Raised in honour of the Duke of Wellington, just N of his Apsley House, using metal from captured French cannon. It stands up, pedestal and statue, 36 ft (11 metres) from the ground. The shield is Westmacott's conception; the sword was added only in 1862. Achilles was the first public nude statue in England, and remains London's greatest monument to a non-royal personage.

BYRON (24). By *R.C. Belt*, 1878–80, assisted by *P. Verhyden*. A costive figure with dog. The plinth, of streaky-bacon marble, was given by the Greek government. Severed from the park by a slip road in 1961–2.

CAVALRY MEMORIAL (25). By *Adrian Jones*, 1920–4. St George triumphant over a Hohenzollern-moustached dragon. Moved here 1961 from Stanhope Gate. Almost nothing was kept of its former setting there, a stone screen designed by *Sir John J. Burnet* to harmonize with Burton's lodges.

BOY AND DOLPHIN FOUNTAIN (26). 1862. By *Alexander Munro*, an early member of the Pre-Raphaelite group, but Berninesque in style. Originally it stood by Park Lane as the centrepiece of a formal sunken garden made on the C18 reservoir site. Removed to Regent's Park 1962; returned here in 1994. Formal setting by *Colvin & Moggridge*, 1994–6.

ARTEMIS FOUNTAIN (27). 1906, by *Lady Feodora Gleichen* (figure cast 1899). She stands on a basin resting on four bronze caryatids.

MEGALITH FOUNTAIN (28). The remains of a fountain set up in 1862. A rough Cornish granite stone, designed to assimilate to a natural landscape.

HOLOCAUST MEMORIAL GARDEN (29). 1983, designed by *Seifert & Partners*, landscape architects *Derek Lovejoy & Partners*. Four boulders on gravel, surrounded by silver birch trees. English and Hebrew inscription from Lamentations: 'For these I weep. . . .'

MERMAID FOUNTAIN (30). Art Nouveau maiden designed by *W.R. Colton*, 1896; replaced in concrete 1974.

INTERNATIONAL YEAR OF THE CHILD FOUNTAIN (31).

By *Theo Crosby* and *Polly Hope*, 1981. Plump Picassoish mother and child of bronze, on a cushion cast from real toys and studded with drinking nozzles.

JOY OF LIFE FOUNTAIN (32). By *T.B. Huxley Jones*, 1963, after a competition in 1958. Star-shaped basin and cantilevered upper basin, on which a male and female nude and little boys disport themselves. Given by Sigismund Goetze in memory of his wife Constance (cf. Green Park).

NORWEGIAN NAVY MEMORIAL (33). On open land N of the Serpentine. 1978. Another boulder composition: a glacier-worn stone upright on three smaller ones.

RIMA (34). By *Epstein*, 1925. A memorial to W.H. Hudson, the naturalist and author; one of Epstein's most important works of his middle decades. Rima is a character in Hudson's novel *Green Mansions*. Relief of a female nude with birds, in a diagonally ascending rhythm, set into a long unmoulded stone wall. Two long pools in front (designer *Lionel Pearson*). Lettering by *Eric Gill*. The whole serves as a bird sanctuary.

DIANA, PRINCESS OF WALES MEMORIAL FOUNTAIN (35). To be designed by *Gustafson Porter* (proposals published 2002).

Demolished Buildings

Of *Inigo Jones*'s LODGE of 1634–5 very little is known. *Sir Joseph Paxton*'s CRYSTAL PALACE of 1851 stood between Rotten Row and Knightsbridge Barracks.

SOUTH WESTMINSTER AND VICTORIA

INTRODUCTION

No district of Westminster is more mixed up than the square mile
or so that lies w of Millbank. Its n part is a smarter but shallow
strip, close to St James's Park. To the sw the boundary is
Vauxhall Bridge Road, over which *Thomas Cubitt*'s self-respecting
stucco terraces spill from Pimlico and along Millbank at the
extreme se. The area between was built up haphazardly into the
mid c19, the last areas finishing some time after clearance and
rebuilding got under way in the older streets. Flats, mansion
blocks and offices are now the dominant types, but so jumbled
up that it is difficult to keep their story within a single narrative.
The following account therefore jumps about in time and space.
 At the Reformation the built-up area was still very small,
centred on the axis running w from the Abbey along Tothill Street
(developed first in the c14) and Petty France. It included some
functions of the Abbey, notably the Almonry s of Tothill Street,
and in the 1470s it witnessed the birth of printing in England,
commemorated in Caxton Street. By Stow's time there were also
ARISTOCRATIC HOUSES, Lord Gray of Wilton's in Tothill Street
and Lord Dacre's in what is now Strutton Ground (Horseferry
Road). Others followed by the mid c17: the Earl of Stafford's
Tart Hall in Buckingham Gate (and Goring House to its n, on
the site of Buckingham Palace), and the future mansion of the
Grosvenors on Millbank, *c.* 1663. Enough ordinary houses had
gone up by the 1630s to warrant building a chapel of ease on the
edge of the open fields to the s (*see* footnote p. 723). Other uses
typical of the London outskirts in the c16–c18 included artillery
exercises and brewing, commemorated in Artillery Row and
Stag Place. From the mid c16 the area was also particularly
strong in SCHOOLS AND ALMSHOUSES, of which the former
Bluecoat School building of 1709 remains in other uses (*see*
Caxton Street); and fragments of the c17 workhouse taken over
by the Grey Coat Hospital school also survive, incorporated in
its post-war rebuilding. The Westminster City School is a late
c19 union of older foundations. Most of the almshouses were
razed in the c19, but several were merged on one site in
Rochester Row, rebuilt 1880–2. Before the early c19 most build-
ing was concentrated NE of here, within the L-shape made by
Horseferry Road. A comparison between Morden & Lea's map

of 1710 and Horwood's of 1799 reveals little new growth beyond this limit.

Why was this district, on the doorstep of Parliament and the Abbey, so marginal to the C18 building boom? One reason must be that neither building was as fashionable a neighbour as the court at St James's. Another is the marshy character of the low-lying Tothill Fields to the s and w. Even the land of Smith Square, to the NE, was soggy enough to give *Thomas Archer* much trouble in establishing his mighty church of St John there (1713–28). This difficult terrain also helps explain why the revival of new building in the early C19 produced such disappointing results. An important date in this process is 1816, when Vauxhall Bridge opened, and with it the new Vauxhall Bridge Road along the sw boundary. Some responsibility also attaches to the Dean and Chapter of the Abbey itself, the freeholder of Tothill Fields, which had a passive or permissive approach to land use and to standards of building and sewerage. Even Vincent Square, the chief open space, was made to safeguard playing fields for Westminster School rather than as a centrepiece for housing. p. 680

The best older TERRACE HOUSES are therefore on land owned and developed by others, notably along the s side of St James's Park after *c.* 1690 – the present Old Queen Street, Queen Anne's Gate and Buckingham Gate. The finest houses here date from the 1700s, 1770s and 1830s. Slightly less imposing houses of the 1720s can be found in good runs in and around Smith Square and Cowley Street. The modest houses of the early C19 survive best in Catherine Place and in Maunsel Street (*see* Vincent Square). Vincent Square also has a few semi-detached houses, a suburban type, of *c.* 1800–30. A handful of terraces can be seen on the former Grosvenor Estate, a pocket of land around Marsham Street and Page Street, which was built up from the 1810s by *John Johnson* (*see* Nos. 44–46 Medway Street, Horse-ferry Road). Nor is there much left of the industrial premises that dotted the area – breweries, building works, the world's first gas works (Marsham Street), and sundry factories. Larger than any of these were two giant early C19 prisons, the vast Millbank Penitentiary (*see* Millbank) and the smaller Middlesex House of Correction, where Westminster Cathedral now stands. 35, p. 714

VICTORIAN IMPROVEMENTS begin with the *Cubitt* houses of 1845–60 on Millbank, already mentioned, and with the great new thoroughfare of Victoria Street, pushed through some of the worst districts after 1845 but not built up completely until the 1890s; a smaller strip of slums to the N was cleared in the 1860s, for the Metropolitan & District Railway. The best-known building of Victoria Street, the Westminster Palace Hotel of 1858–61, has been demolished, but another early super-hotel may be seen in Buckingham Gate, *James Murray*'s former Buckingham Palace Hotel. It belongs to a lesser street-improvement scheme, undertaken after 1853 by *Pennethorne* and still almost intact architecturally. In Victoria Street itself the only big survivors are late C19 MANSION FLATS. It formerly also had London's earliest examples of this building type, of 1853–4 (demolished *c.* 1971). The streets to either side retain the best concentration of later examples in London, instantly

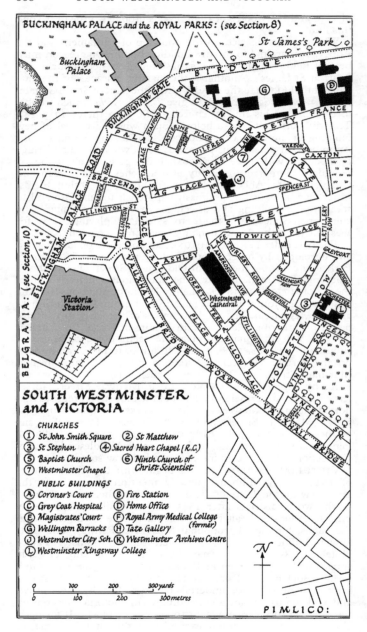

BUCKINGHAM PALACE and the ROYAL PARKS: (see Section 8)

St James's Park

Buckingham Palace

BIRDCAGE

BUCKINGHAM GATE

BUCKINGHAM

PETTY FRANCE

PALACE ROAD

CATHERINE PLACE

STAFFORD

WILFRED ST

CASTLE LANE

VARDON

CAXTON

STAG PLACE

STREET

⑦

BRESSENDEN

WARWICK ROW

AG PLACE

GATE

SPENCER ST.

Ⓙ

ALLINGTON ST

ALLINGTON PLACE

STREET

HOWICK

GREENCOAT PLACE

ARTILLERY ROW

GREYCOAT

VICTORIA

PLACE

TERRY

BELGRAVIA: (see Section 10)

BUCKINGHAM

Victoria Station

CARLISLE

ASHLEY PLACE

AMBROSDEN AVE

GREENCOAT ROW

GREYCOAT

PRIESLEY ROAD

EMERY HILL

③

ROCHESTER

Ⓛ

VAUXHALL

MORPETH TERRAN

Westminster Cathedral

STILLINGTON

EMERY HILL

ROCHESTER

VINCENT

WILLOW PLACE

PLACE

BRIDGE

ROAD

VINCENT SQ

VINCENT

VAUXHALL BRIDGE

SOUTH WESTMINSTER and VICTORIA

CHURCHES
① St John Smith Square ② St Matthew
③ St Stephen ④ Sacred Heart Chapel (R.C.)
⑤ Baptist Church ⑥ Ninth Church of
⑦ Westminster Chapel Christ Scientist

PUBLIC BUILDINGS
Ⓐ Coroner's Court Ⓑ Fire Station
Ⓒ Grey Coat Hospital Ⓓ Home Office
Ⓔ Magistrates' Court Ⓕ Royal Army Medical College
Ⓖ Wellington Barracks (former)
Ⓙ Westminster City Sch. Ⓗ Tate Gallery
 Ⓚ Westminster Archives Centre
Ⓛ Westminster Kingsway College

0 100 200 300 yards
0 100 200 300 metres

N

PIMLICO:

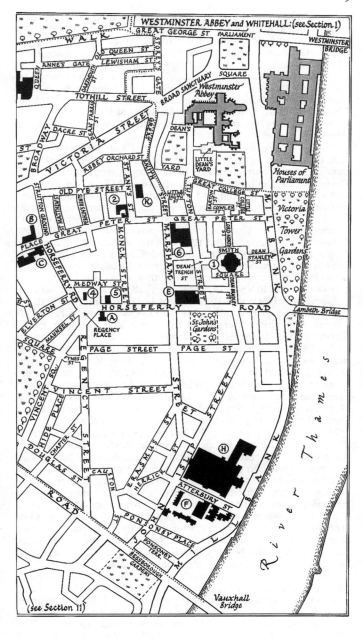

WESTMINSTER ABBEY and WHITEHALL: (see Section 1)

recognizable from the even proportions of their superimposed storeys. Carlisle Place has the oldest remaining, plain buildings of 1861–3, and also some of the most flamboyant, of 1885–98;

88 Ashley Gardens, to the E, are plainer but visually more overwhelming, with up to seven storeys of balconies. Prize examples of c. 1900 are Westminster Palace Gardens in Artillery Row and the giant St James' Court in Buckingham Gate, both by C.J. Chirney Pawley, both more ostentatious in materials and colour. The largest of all, Queen Anne's Mansions of 1873–89 (see Home Office), was by contrast cynically plain, though advanced in terms of services.

All the above were paying concerns, but the area is also rich in PHILANTHROPIC BUILDINGS. In the 1850s–60s three buildings for Guardsmen and their families were built by H.A. Darbishire, of which the former Institute and Orphanage remain, and Henry Clutton's slightly later Roman Catholic convent and orphanage nearby, all of them big and daunting single blocks (see Carlisle Place). Surviving HOSPITALS begin with the grim former Grenadier Guards' Hospital of 1859 in Rochester Row, followed by a cluster of the 1890s–1930s in Vincent Square, and Lionel Pearson's technically advanced Westminster Hospital of 1935–9 in Horseferry Road; all are now in other uses. MODEL HOUSING proper got under way with a range behind the first

p. mansion blocks in Victoria Street, i.e. c. 1853. The oldest survivor
65 is Darbishire's Rochester Buildings of 1862, later merged with the wide expanses of Peabody estates along Great Peter Street. Less
87 intimidating blocks were built by Watney's Brewery in Palace Street in 1882–3, for its own employees. All are eclipsed by the
89 LCC's Millbank Estate of 1897–1902, one of the greatest achieve-
p. ments of public housing in London. Sidney R.J. Smith's Tate
688 Gallery, opened in 1897 as a private benefaction, might also claim to be a philanthropic building. Late C19 CIVIC BUILDINGS proper are economical by comparison: a Coroner's Court in Horseferry Road, a former vestry hall in Caxton Street and a former library and public baths in Great Smith Street.

Earlier than the first model housing as a sign of concern for the poor are the two important Gothic Revival CHURCHES in the area S of Victoria Street, Ferrey's St Stephen Rochester Row (1847–50) and Scott's St Matthew Great Peter Street (1849–51). Both still have schools attached, though St Matthew itself was truncated after a fire in 1977. Also of special interest are the curious former Roman Catholic church-cum-school off Palace Street (1856–8), the Westminster Chapel in Buckingham Gate (1864–5), one of London's monster Nonconformist meeting houses, and Sir Herbert Baker & Scott's complex in Marsham Street, formerly the Ninth Church of Christ Scientist (1926–30).

93, But the true glory of church architecture is of course West-
p. minster Cathedral, J.F. Bentley's Neo-Byzantine masterpiece of
675 1895–1903, as original without as it is rich and moving within.

The EARLY C20 carried on the programme of secular improvement, including the embankment and clearance of the industrial land and wharves along Millbank, in 1880 and after 1900. The office blocks by Lambeth Bridge, which replaced the old horse

ferry in 1862, are as late as 1927–30. Their design fell to *Sir Frank Baines* of the Office of Works, a sign of the movement away from architectural laissez-faire. This was foreshadowed in the failure of a ruthless scheme for the land behind, which would have levelled the streets around Smith Square for big new uniform blocks. It was privately promoted in 1898 (with the glittering names of *Norman Shaw* and *Lutyens* as consultants), and adopted in outline by the same Act of 1900 by which the embankment was extended. But the Dean and Chapter were opposed, as were many persons of influence who were rediscovering the Georgian attractions of the area, and in the end most of the better streets were saved. Large-scale clearance s of Horseferry Road got under way in the late 1920s: much of Marsham Street was rebuilt with private flats and offices by *T.P. Bennett & Son*, much of Page Street with working-class housing, of which *Lutyens*'s chequer- 110 patterned Grosvenor Estate of 1929–35 is well worth a visit.*

The blight having lifted, *Lutyens*, *Oliver Hill*, *Horace Field* and others built a whole sequence of charming PRIVATE HOUSES in and around Smith Square (*see* Cowley Street, Great College Street, Tufton Street), mostly for clients with Parliamentary connections. Anyone who still finds C20 Neo-Georgian dull should study these houses to see how personal and varied the idiom could be in the hands of architects of talent. The neighbourhood of Queen Anne's Gate remained in fashion as an address, though here refurbishment rather than new building was the norm; memorable exceptions are *Troup*'s No. 20 Old Queen Street, 1909–10, and in Buckingham Gate *Reginald Blomfield*'s No. 20, *c*. 1889–92. More modest Neo-Georgian houses of the 1910s–30s appear in strength in and around Catherine Place.

Of other building types the cluster of ECCLESIASTICAL FOUN-DATIONS around Great Peter Street, Tufton Street and Great College Street deserves mention. They had as their lodestone Church House, the first version of which was begun in 1890 in Dean's Yard, just to the N. The dimming of the Gothic lamp can be traced from St Edward's House and the former Society for the Propagation of the Gospel, both of the 1900s, to the Tudor-collegiate Central Africa House in Great Peter Street, of 1928–9. Others are eclectic, e.g. *Caröe*'s No. 1 Millbank (1903–6, for the Church Commissioners), or Neo-Georgian, e.g. *Lutyens*'s St John's Parish Hall in Tufton Street, 1905. The outstanding interwar buildings are both secular: *Holden*'s No. 55 Broadway (London Underground), 1927–9, for its planning and mass and for the external sculpture by *Epstein*, *Henry Moore* and others, and the near-contemporary New Building for the Royal 111 Horticultural Society off Vincent Square, an intelligent variation on an advanced European concrete-framed type.

POST-WAR ARCHITECTURE impinges on the area relatively little, with the great exception of Victoria Street. Its transformation had nothing to do with air raids; Westminster felt the need for modern office blocks, and the C19 buildings were then

* So much progress was made with public housing in the area that only one major post-war scheme was needed: the Hide Tower in Regency Street, 1959–62.

regarded as obsolete. Most of the work took place *c*. 1955–75, including the complete rebuilding of the old Watney's brewery site to the NW, as Stag Place (1959–64). The results, mostly bland at best, have already been replaced in part. Of individual buildings in Victoria Street *Elsom, Pack & Roberts*'s two staggered ranges by Westminster Cathedral, of 1971–5, stand out as memorable in form and generous in planning. Also good is New Scotland Yard, an efficient speculative design of 1962–6 by *Max Gordon* of *Chapman Taylor Partners*; the firm's Caxton House in Tothill Street shows their more sculptural manner of the 1970s. The best office tower is *Ronald Ward & Partners*' Millbank Tower, 1960–3, a shaped tower that responds well to the river.

Of OFFICIAL AND INSTITUTIONAL BUILDINGS, the Department of the Environment complex in Marsham Street of 1963–71, the most egregious example of failed Modernism in Westminster, was demolished in 2002–3 to build new Home Office premises. The existing Home Office complex in Queen Anne's Gate, a ponderous building of 1972–6 by *Sir Basil Spence* and the *Fitzroy Robinson Partnership*, is treated below as a public building, though undertaken by private initiative. Its neighbour is the rebuilt Wellington Barracks of 1979–85, in a good working relationship with the retained ranges of 1833–4, but without the force of *Bruce George*'s chapel of 1961–3. The ingenuity of *James Stirling, Michael Wilford & Associates*' Clore Gallery of 1982–6 (Tate Gallery) continues to shine out even after the Postmodern fashion has faded. The High-Tech school is represented by the *Richard Rogers Partnership*'s Channel 4 building in Horseferry Road, of 1991–4, a more quietly pragmatic tradition by the brick-faced Westminster Archives Centre in St Ann's Street, of 1992–5 by *Tim Drewitt*, a continuing or perhaps revived Modernist tradition by the *Ellis Williams Partnership*'s block for the Grey Coat Hospital school in Regency Street, 1996–8. There is room for more such bold new buildings in this quarter of Westminster, a smaller proportion of which is covered by Conservation Areas than any other division in this book.

FURTHER READING. An excellent introduction is I. Watson, *Westminster and Pimlico Past*, 1993. Few other works address themselves to the whole area. N.G. Brett-James, *The Growth of Stuart London*, 1935, has useful information on the early period, W.H. Mills, *Westminster Old and New*, 1938, on the early C20. The area around Queen Anne's Gate is covered by the *Survey of London*, vol. 10. Other detailed studies include A. Percival, *About Vincent Square*, 1979, and B. Smedley, *Lord North Street 1725–1996*, 1996. For Westminster Cathedral the chief source is W. de l'Hôpital, *Westminster Cathedral and its Architect*, 1919 (2 vols.), and for the later periods J. Browne & T. Dean, *Building of Faith*, and P. Doyle, *Westminster Cathedral 1895–1995*, both 1995. On the Tate there is D. Jenkins, *Clore Gallery and Tate Gallery*, 1992.

CHURCHES

WESTMINSTER CATHEDRAL (R.C.)
Ashley Place, Victoria Street

Of 1895–1903 by *John Francis Bentley*, the leading Roman Catholic architect in late C19 Britain. It is his greatest building by far, and the greatest manifestation in Britain of the late C19 Neo-Byzantine manner. For Norman Shaw it was 'the finest church that has been built for centuries'.

The delay in providing a Roman Catholic cathedral for London owed something to shortage of funds, something to uncertainty over the site. At first it was intended to stand in Carlisle Place, just to the w, where Cardinal Manning bought land in 1867–72. In that period *Henry Clutton* made several designs for a Gothic cathedral, variously inspired by Cologne, Amiens, Notre Dame in Paris, etc. Nothing came of these, nor of a proposal by Sir Tatton Sykes in 1882 to pay for *Baron von Ferstel* to build a version of his Votivkirche in Vienna. In 1883 Manning exchanged this first plot for the present site, part of land released by demolition of the old Westminster Bridewell (Middlesex House of Correction).* It was left to Manning's successor, Cardinal Vaughan, to build the new cathedral. In 1894 he asked for designs from *Bentley*, who, as it happened, had trained in Clutton's office. Against Bentley's preference for Gothic, Vaughan insisted on an Early Christian basilica, partly in order not to compete with Westminster Abbey, partly because it could be built in one rush and ornamented at leisure, and partly for its clear lines of sight inside. But Bentley won him over to something more Byzantine, and went off abroad to look round. He saw Rome, Pisa, S. Ambrogio in Milan, Ravenna, Padua, Venice, Torcello and other places, but was prevented by a cholera outbreak in Constantinople from going there. Yet the roots of his design are more S. Sophia and S. Irene even than S. Mark's at Venice (Bentley said later that Lethaby and Swainson's book on S. Sophia, 1894, and his visit to S. Vitale at Ravenna 'really told me all I wanted').

The final form crystallized very quickly through three variant designs in 1895. Seven years later Bentley died, having lived to walk through his building, but not to see the tower complete. Vaughan died in 1903, the year daily use began; full consecration followed in 1910. The later phases were in the hands of *Bentley, Son & Marshall*, of whom *J.A. Marshall* was the leading light, Bentley's son *Osmond* a less active designer. In most cases they respected Bentley's drawings and intentions, however, so the break was nowhere drastic. In 1927 *L.H. Shattock* took over. Since then the main external change has been *Elsom, Pack & Roberts'* creation in 1975 of the attractive piazza on Victoria

93, p. 675

*Founded 1618, variously altered and enlarged, then rebuilt by *Robert Abraham* in 1830–4; closed 1877. A C17 gateway remains at the Middlesex Crown Court (*see* p. 272).

Street, paved in red brick and white stone, which for the first time allows a direct view of the W front. The site lies NW–SE; directions given are liturgical rather than literal.

93 The EXTERIOR is turreted and strongly articulated, except that the buttressing is contained within the outer walls. The facing is red Bracknell brick with ample bands or stripes of Portland stone, on a plinth of Penryn granite. The brick is load-bearing, but the domes are of mass concrete in the Roman manner, without iron or steel reinforcement; the copper roofing was added in 1948. Of the domes, that over the sanctuary is entirely Byzantine in its peculiar fenestration, and the large tripartite semicircular windows come from the same source. Lattices of *Doulton*'s terracotta fill them. But the clustering half-domes of the great Constantinopolitan churches are absent, while the CAMPANILE is in character more Italian. It is 284 ft tall (86.5 metres) to the top of the cross, almost precisely the height of the most similar Italian campanile, that of Siena Cathedral, and is placed asymmetrically over the first bay of the outer N aisle. Bentley wanted two towers; so this most inspiring element of the design is not due to him. In its slender sheerness it has established itself as one of the beacons of London, and the way in which, at the top, it climbs up by small pinnacles from the square into the octagonal lantern is brilliantly managed. This as well as much of the detail lower down is not at all imitative: see for instance such curious motifs as the brick nogging and the segmental windows with garlands of the outer aisles, which belong with the untrammelled inventions of the English Free Style. The NW porch and the big W portal with its columns and busts are closer to the Italian Renaissance. The W tympanum mosaic, of 1916 by *R. Anning Bell*, was criticized for its white background. At the N porch the lettered tympanum mosaic is of 1981, designer *Nicolete Gray*. The cathedral is externally 360 ft (109.7 metres) long, 156 ft (47.5 metres) wide, and up to the top of the domes 117 ft (35.7 metres) high. The span of the vaults is 60 ft (18.3 metres), the height of the main arches 90 ft (27.4 metres). For the auxiliary buildings beyond the cathedral *see* below, p. 679.

The INTERIOR is without doubt one of the most moving of any church in London. This is – it is true – to some extent due to the fact that it is unfinished. Bentley called the cathedral a 'veneered' building. He wanted to cover the lower walls with marble, the upper walls and vaults with mosaic. The marble was at length completed, but the mosaic has barely been started. As it is, the absolutely bare brick higher up, underlining the straightness of the uprights and the vast curves of the arches and domes, helps to keep Bentley's statement clear and unblurred, while the chapels give some idea of what was meant for the whole.

Westminster Cathedral is a longitudinal domed building, and in this alone Bentley's freedom of adaptation appears. It is really a Byzantine translation of the C16 scheme of the Gesù in Rome, that is a nave with outer chapels, domed crossing, transepts not projecting, and sanctuary. There are other equally original features. The cathedral consists of a narthex, a nave of three domed bays (the third forming the crossing), narrow passage aisles with vastly high galleries above, and low outer chapels a little higher

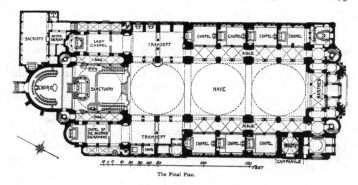

The Final Plan.

Westminster Cathedral.
Plan, 1895

than the aisles. Each aisle bay is subdivided by a square pier, and each of these half-bays is screened from the nave and from the chapels by pairs of smaller arches on columns, which carry the gallery. The vaulting of each aisle bay also is subdivided. Above the gallery there are two high transverse tunnel vaults for each bay. The aisle itself has a tunnel vault running E–W, interpenetrated by the arches which carry the gallery. The crossing is as wide as the nave bays and also domed. The N and S crossing arches are subdivided in the same way as the nave bays, but the two pairs of arches carry a balcony instead of a gallery. Moreover the division of the transepts is continued in a N–S direction by an arched screen, separating a W from an E half. Each of the two has a high tunnel vault running N–S, like those of the aisle bays. This division of the transept Bentley may have seen and liked in Late Victorian churches such as Pearson's St Augustine, Kilburn (*see London 3: North West*). The sanctuary bay is domed too, but here the dome has small windows. Another difference is that marble arcades surmount the galleries. The sanctuary is flanked to the N and S by long apsed chapels – a Romanesque motif – each set between its own narrow passage aisles. The raised sanctuary is followed by a still higher choir in the main apse, sitting over a crypt.

The MARBLES are splendid and their various colours and patterns are an ideal architectural enrichment, because they are smooth and do not introduce anything small, as the mosaics with their figures and stories do. Perhaps that would have been different if mosaicists of Byzantine calibre had been available. But the marbles are wonderful. Over a hundred different stones can be identified. Much of the work in the nave, including the gallery balustrades, dates from 1956–64 and later, done by *Dom Aelred Bartlett* after *Bentley*'s drawings; elsewhere, e.g. in the E apse (1921–2), *Marshall* worked up the designs. Of the twenty-nine monolithic columns, eleven are of a green marble from the same quarries in Thessaly which Justinian had used for S. Sophia.

Their rediscovery and reopening were due to *William Brindley* of *Farmer & Brindley*, who were responsible for much of the marble work. Of other marbles the grey-green is mostly cipollino from Euboea in the Aegean, the yellow Veronese, the red Languedoc, Cork or Swedish (columns of the w gallery), and the white Carrara (the capitals, all different). The grey especially is of superb shades and patterns. Post-war work widened the range, finishing in 1995 with an extraordinary blue marble from Brazil. Bentley wanted the floor to be marble too, but pine parquet was used instead. The MOSAICS, much more varied in treatment, are mostly described with the chapels, below. The only one that need be mentioned here, and the most regrettable, is the crescent-shaped tympanum over the choir: a weak design in jarring turquoise colours by *Gilbert Pownall*, 1934.*

FURNISHINGS. ORGAN in the w gallery by *Henry Willis III*, 1921–32, behind a SCREEN designed in 1927 by *Marshall*, with two trumpeting angels. – STATUE of St Peter, *c.* 1900, after the C13 bronze by Arnolfo di Cambio in Rome (w end). – LIGHT FITTINGS designed by *Bentley, Son & Marshall*, 1909, after sketches by *Bentley*. Iron hoops delicately linked by wrought-iron chains. – CONFESSIONALS. Designed by *Bentley, Son & Marshall, c.* 1910. They too have an Eastern flavour. – PULPIT, made by *Aristide Leonori* in 1899 in Rome, frankly on the pattern of medieval Italian pulpits. Enlarged 1934 by *Shattock*, who replaced a solid base with columns, and added the mosaic of Our Lady of Walsingham (by *John Trinick*). – ROOD, high up. A huge piece, designed by *Bentley* in 1901, painted by *W. Christian Symons*, 1903. Christ faces the nave, the Virgin faces the sanctuary. – BALDACCHINO. No less huge. Designed 1901 by *Bentley*, an elaboration of that at S. Ambrogio in Milan, and made 1905–6. Eight columns of yellow marble. Canopy mosaic designed by *Marshall*. – THRONE, l., of inlaid stone, 1902, copied from that at the Lateran basilica in Rome; inlaid walnut CANOPY, 1906, designed by the Bentley practice (made by *F.A. Fawkes*). – HIGH ALTAR. A Cornish granite monolith weighing 12 tons. – STALLS. Oak and walnut, prettily inlaid. Designed by *Shattock*. – RELIEF of Christ by *P. Lindsey Clark*, 1929, behind the High Altar.

STATIONS OF THE CROSS. The most valuable work of art in the cathedral; by *Eric Gill*, 1913–18. Gill's work in relief always tends to be more graphic than strictly sculptural. In that respect Gill is yet another illustration of that curious English leaning towards line rather than shaped mass. But with these limitations the Stations are memorable as one of the first works of religious art in England to abandon sentimental naturalism and seek for a deeper expression of feeling in intensified line. The material is Hopton Wood stone. Colouring applied by Gill to selected draperies etc. was removed, but the lettering has since been coloured and the haloes gilded. Under the fourteenth panel an epitaph for Gill, 'Lapidarius', cut by his pupil *Laurie Cribb*, 1942.

CHAPELS. These can be taken topographically, from the NW to the E end and back down the S side. The first and the last

* An unfinished mosaic by Pownall in the apse was removed. For the tympanum a replacement design was commissioned from *Boris Anrep* in 1954, but not executed.

(Holy Souls, and St Gregory and St Augustine) are closest to Bentley's own vision. Major work on the others has hung fire since the 1960s. – HOLY SOULS' CHAPEL. Glowingly decorated up to 1908, to a scheme by *Bentley*. He designed the black and white marble work (makers *J. Whitehead & Sons*) and bronze screen. His friend *Symons* did the reredos, of *opus sectile*, and designed the silvery mosaics (makers *George Bridge* and assistants). – CHAPEL OF ST GEORGE AND THE ENGLISH MARTYRS. Incomplete. Most interesting for the reredos relief by *Eric Gill*, commissioned in 1938, finished by *Cribb* after Gill's death, and installed in 1947. It shows a Crucifixion with St John Fisher and St Thomas More, the latter originally with his pet monkey, cruelly chiselled off by order of Cardinal Griffin. Altar 1910; marble work, relief of St George (by *Lindsey Clark*) and bronze screen (by *Shattock*) completed 1931. The last makes a setting for the translated body of St John Southworth. By the entrance a memorial mosaic to the RAMC by *Michael Leigh*, 1952. – CHAPEL OF ST JOSEPH. Mosaics by *Christopher Hobbs* are being installed (2003). Altar 1910, with bronze relief by *H.C. Fehr*. Much work in 1939: marbles and carving, after *Bentley's* designs; mosaic pavement, rougher, designed by *E. W. Tristram*, iron screen by *J. Seymour Lindsay* (installed 1947). – N TRANSEPT. In the passage two alcoves with mosaic half-domes by *Aelred Bartlett*, 1961, in a Roman style. On the outer wall, mosaic of Joan of Arc, 1910, by *Symons* (maker *G. Bridge*). – The little chapel E of the transept porch is the VAUGHAN CHANTRY. Effigy designed by *Marshall* and carved by *Henry McCarthy*, 1907. Chased bronze-gilt screen designed by *Marshall*, made by *Singer & Co.* – BLESSED SACRAMENT CHAPEL. Altar, canopy and communion rail by *Marshall*, 1904–8. Also his the exquisite bronze screen, made by *Singer & Co.* Bentley's proposal for a baldacchino was not carried out. Gaudy mosaics designed by *Boris Anrep* from 1953, fixed 1960–1. The nave depicts the Old Testament, the E end the New, with birds in the W niches. – The N chapel aisle is the tiny SACRED HEART CHAPEL with decoration of 1910–12. Mosaic of Christ designed by *Symons*.

S SIDE. LADY CHAPEL. The gold-ground mosaics are of 1931–2 by *Pownall*, somewhat hard, but more successful than his work in the choir. The four alcove conches and altarpiece are earlier. They are by *Anning Bell*, 1908 (maker *Gertrude Martin*). The marbles are mostly of 1907–8 apart from the floor, done in the 1950s to a *Bentley* design. – The CRYPT can be reached from behind the Lady Chapel. It has an impressive semicircle of monolithic columns of red granite with quasi-Ionic capitals. In it the monuments of Cardinal Wiseman †1865, designed by *E. W. Pugin* and made probably by *R. L. Boulton* of Cheltenham (transferred here from Kensal Green in 1907), and of Cardinal Manning, designed by *Marshall* with bronze effigy by *J. Adams Acton*, 1908. Near Wiseman a mosaic of St Edmund by *Symons*, 1911, near Manning a mosaic by *Anrep*, 1914, unfinished. In the main space a third mosaic, with St Peter, 1933–4 by *Pownall*, and the ledger slab of Count Benckendorff †1917, lettered by *Eric Gill*, 1939. – To the SE of the choir the SACRISTY, large and barrel-vaulted, with becolumned panelling. – S TRANSEPT. Mosaics in the E alcoves

by *Pownall*, 1930. On the piers of the s side a series of plaques. Bronzes of St Benedict and St Vincent de Paul, 1998–9 by *Bryan Kneale*. They flank the Canadian Air Force war memorial, of silvered nails forming a chi-ro monogram, *c*. 1957 by *David Partridge*. On one of the N piers a bronze of St Teresa of Lisieux by *Manzù*, 1958, a slender swaying figure. Further W an early C15 Nottingham alabaster sculpture of the Virgin and Child, acquired 1955.

NAVE CHAPELS, S SIDE. The first is the CHAPEL OF ST PAUL, marble-lined in 1913–17. Mosaics by *Justin Vulliamy*, 1963, assisted by *Boris Anrep*, who however was unhappy with the result. The vault is treated as a billowing velarium. Cosmati pavement by *Edward Hutton*, finished 1940. In the aisle, ledger slab of Cardinal Heenan †1975, lettered in c4 style by *Nicolete Gray*. – CHAPEL OF ST ANDREW. A masterpiece of the Arts-and-Crafts movement, designed by *R. Weir Schultz* and collaborators, and carried out in 1910–16. Given by the 4th Marquess of Bute, and decorated on Scottish themes. The blue-grey marble is Hymettian, the white Pentelic; otherwise much Scottish granite. Fishes and crabs in the inlaid pavement. Decidedly Byzantine the reliefs of saints, by *J. Stirling Lee*, and the mosaics, executed by *Gaetano Meo* and assistants after cartoons by *George Jack*. More Celtic the little reliquary over the altar, by *Harold Stabler*. Screen of gleaming tin by *Bainbridge Reynolds*. The stalls are one of the finest works of *Ernest Gimson*, indeed amongst the best decorative woodwork of its date (*c*. 1912) anywhere in Europe. Slender upright forms and crisp dainty inlay; brown ebony and bone. Kneelers in a matching style by *Sydney Barnsley*, of 1923–6, when *Schultz* returned to design the little confessional in the outer wall. The candelabrum incorporates an ostrich egg. – CHAPEL OF ST PATRICK. The Irish counterpart. The lining and pavement, including Connemara green marble and Cork red marble, were executed under *Shattock*, i.e. after 1927. Altar by *Marshall*, 1910, with entwined snakes and mother-of-pearl shamrocks. Reredos modified in 1961 by *H. S. Goodhart-Rendel*, to fit a statue of the saint by *Arthur Pollen*. Aisle screen of marble, lower than the metal ones. Of mosaics only small panels of St Patrick, E, 1999 by *Trevor Caley*, and St Oliver Plunket, on the wall to the W, by *Anrep*, 1924. – CHAPEL OF ST GREGORY AND ST AUGUSTINE. The theme is the Conversion of England. Marbles chosen by *Bentley*; mosaics of 1902–4. Bright, naturalistic reredos and pictures of *opus sectile*, by *J. R. Clayton* of *Clayton & Bell*: the choice of the patron, the 1st Lord Brampton. Cardinal Hume is buried here (†1999). – The BAPTISTERY to the w has a large marble font made in Rome in 1901 to designs by *Bentley*, and a copy of *Thorwaldsen*'s St John the Baptist. Decoration incomplete.

AUXILIARY BUILDINGS. On to the land beyond the choir *Bentley* squeezed the Archbishop's House and Clergy House, Cathedral Hall and Choir School. The chief buildings date from 1895 to 1906, with later interior decoration by *Marshall*. They too are of red brick with stone dressings, in a very free semi-Byzantine, semi-Italian style with great emphasis on semicircles in plan as well as in window shapes. Two bridges join them to the cathedral, one from the Hall, the other from the cloister or corridor which continues the alignment of the cathedral to the s.

The CATHEDRAL HALL comes first, entered off Ambrosden Avenue on the ritual N side. Its façade is remarkably original, less tied to forms of past styles than any other part of the cathedral group. It has a segmental top between two obelisks. Apsed and tunnel-vaulted interior with the windows forming penetrations. The panelling, of *c.* 1922–32, is a *Marshall* design, the upper decoration a reinstatement of his scheme, done for the cathedral's centenary in 1995.

To the S of the hall is the ARCHBISHOP'S HOUSE, a symmetrical twelve-window façade with a porch on columns carrying a semicircular roof. The mansard is of *c.* 1970. S of this front is a tower, forming the corner of the S range along Francis Street. The S range, commonly called the CLERGY HOUSE, is five-storeyed and has a front boldly stepped in plan. The front has in two places oriel-like apses on buttresses; one is on first-, the other on second-floor level. The latter marks the apse of the Archbishop's Chapel, the former more weakly the S end of the main corridor. The W end of this S range, beyond the chapel, is *Marshall*'s addition, finished in 1906. The inner boundary of the Bentley buildings is the large cloister already mentioned. On its further side the monastic buildings were to have gone up. The CHOIR SCHOOL, a plain oblong brick mass of 1904–5, uses part of the site. Heightened 1971–2; extended to the W, more sympathetically, by *John Phillips* in 1986.

Of INTERIORS the best are in the Archbishop's House. The main staircase lies behind the porch. It climbs gently between columns to an intermediate landing with the charming motif of glazed apses to the l. and r. S of the hall is the diocesan library, also tunnel-vaulted with penetrations, with bookcases designed by Bentley. The fine Venetian aperture on the first floor, now glazed in, opens towards the former private library, reached from the W end of the main landing. The centre of the E range on the first floor is the Throne Room. (*Marshall*'s pale flat decoration of its walls and ceiling was restored in 2001.)

More recent buildings use the land to the W (ritual S) of the cathedral, land intended at first to be leased to build flats. In Francis Street, just l. of the Clergy House, VAUGHAN HOUSE, a detached building by *Roger Carpenter, Kerr & O'Hara*, 1992–4. Brick striped with stone, of staggered massing, with simplified reminiscences of Bentley in windows and railings. It houses flats, classrooms and a conference centre. Behind and beyond by the ritual W end, the ST VINCENT DE PAUL PRIMARY SCHOOL, 1974 by *Burles Newton & Partners*, replacing premises in the Vicentine convent in Carlisle Place (q.v.). A low brick mass with canted bays, their angles weakly expressed.

ST JOHN SMITH SQUARE

By *Thomas Archer*, 1713–28 (masons *Edward Strong Jun.* and *Edward Tufnell*). Burnt out in 1941, and restored as a concert hall by *Marshall Sisson* in 1965–9, a very good job.* Islanded in the

* And more respectful than proposals by *Louis Osman* of 1957 and *Stewart & Shirley Thomson* of 1961.

St John Smith Square. Lithograph
(Rev. M.E.C. Walcott, *The Memorials of Westminster*, 1851)

middle of the square, a suitably conspicuous site for what at
£40,875 proved the costliest of the so-called Fifty Churches. It
is also the boldest manifestation of the English Baroque in inner
London, closer to Continental than to English models, but ulti-
mately distinct from both.

From outside, the church seems of a Greek-cross plan with the
angles concealed by convex quadrants with banded rustication.
The four arms are however treated in pairs somewhat differently.
N and S are the entrances, while E and W are closed. The N and
S entrances have lobbies behind, filling the arms of the Greek
cross, so that the church proper forms an oblong with curved
corners and projecting E and W ends. The entrances giant, indeed
gigantic, Doric columns *in antis* and, above, a wild pediment,
broken wide at the top to allow an aedicule with crowded
columns and pilasters and its own open pediment to stand up in
it. It makes the skyline of the whole pediment singularly jagged
and restless. The E and W ends are provided with one enormous
Venetian window each, instead of the two-storey effect elsewhere.
It is divided by giant pilasters of the same Doric order, its entab-
lature carried round across the channelled masonry of the quad-
rants. Attic over, with thick volutes l. and r., and a pediment –
open again to allow space for a niche in the attic to stick its head
up into the pediment. The four corner towers are circular with
columns set diagonally. The entablature above the columns pro-
jects, not, however, as Wren would have done it, squarely, but
in the form of three-quarter circles, and their bases are rounded
too. The summits have little pineapple-topped ogee lanterns, but
Archer had intended instead a balustrade with two pinnacles
on each tower, consisting of two columns each connected by an

arch. It would have made the skyline of the church even weirder. Even so, the towers have been more violently attacked than anything else of the church; Lord Chesterfield compared them to the legs of an elephant on its back, and later in the C18 a legend began that they were an afterthought, added to stabilize sinking foundations. The steps, too, deviate from Archer's design: he wanted the upper flight to spread out to the edge of the plinth. Garden laid out by *Lanning Roper*, 1972.

The INTERIOR was restored by Sisson according to evidence of its early C18 state, but with seats facing W. The E and W ends are treated similarly, with the projecting part divided off by a broad arch on giant Corinthian columns. In front of this are two more pairs of columns, each pair standing forward from the curved corners to make a square cell. They carry an entablature which supports an elliptical barrel vault. Pilasters continue along the walls of the central part, which is groin-vaulted. The original effect was lost when the columns were removed after a fire in 1742. The plain later interior was by *James Horne*, 1744–5, altered by the *Inwoods* in 1824–5 and restored by *Butterfield* in 1884. Between the giant columns run galleries, supported on timber Ionic columns. These also formed part of the original design. Walls are white, the floor chequered. At the E end a large ORGAN CASE of 1733 by *Jordan, Byfield & Bridges*, from St George Great Yarmouth, Norfolk, installed 1993. CHANDELIER given 1971. The crypt accommodates changing rooms, a restaurant, etc.

ST MATTHEW GREAT PETER STREET

By *Sir George Gilbert Scott*, 1849–51; burnt in 1977 and resourcefully reconstructed on a smaller site by *Donald Buttress*, 1982–4, reversing the usual orientation. Scott's church was early C14 in style, of Kentish rag. His pupil *G.F. Bodley* is supposed to have worked on the design. After 1884 it was extended and embellished under the Rev. W.B. Trevelyan, who inaugurated something of a golden age for the church.

Scott's very convincing, solid and massive tower survives. It stood S of the S aisle, and was intended to be taller and to finish in what would have been one of the greatest Victorian spires. Pyramidal spirelet of 1982–4, too small to show up properly. Scott's nave had two S aisles and one to the N. What remains is one remodelled bay of its central vessel, the chancel, and a later addition and Clergy House to its S, all joined with the tower by a new lobby or link building. Facing St Ann's Street, E, the handsome E window (now ritual W), of five lights, with below it a quirkily detailed new door. The S addition, l., is of 1892 by *Comper*: two-storeyed, of stone-dressed red brick. It houses a Lady Chapel at rood-loft level, a vestry below. The CLERGY HOUSE, of 1891 by *John Oldrid Scott*, occupies the corner to its S. Of red brick, gabled, with sparse lancets and a red sandstone niche over the door. The 1980s additions, quietly subordinate, have steep monopitch roofs. The chancel N aisle was demolished for access to characterless OFFICES built on the nave site (*Biscoe & Stanton*), of which the N part is given over to a boys' club.

Reset in the exposed N wall is a RELIEF showing an angel, from a late C19 mission house by *E.C. Ayton-Lee* formerly nearby.

Entry is made from the tower via its former N arch, reset to the r. in 1982–4. The link to the church is angled, overlooking a court-yard behind the Clergy House. At the end steps up l. to gallery and Lady Chapel, and beyond them a simple ground-floor chapel, screened off from the main church space. This is reached in turn by an inner lobby to the r. As reoriented, the former nave bay serves as the chancel, with the altar against a new end wall. Scott's chancel arch remains, with his (blocked) N chancel arcade and windows. New roof of tongue-and-groove timber and painted steel bracing, pitching steeply down at the altar end. Good strong colours, dark green with some red and gold, contrasted with white-washed walls. The new gallery front is quasi-classical.

The FITTINGS include work by leading High Church artists. MAIN CHURCH. REREDOS carved by *Walter Tower* (of *Kempe & Tower*), 1922, late Gothic style with many figures, and a taber-nacle by *Martin Travers, c.* 1928. – ALTAR with a medieval altar slab. – Other painted DECORATION after *Bodley*. – MOSAIC at the ritual w end and s wall by *Powells*, 1878–80. – Slate TABLET lettered by *John Skelton*, 1984, ritual w end. – PANELLING, N wall, late C19, from the old N chapel. – ORGAN, boxy, with pretty painted decoration. 1984 by *Noel Mander*. – STAINED GLASS. Salvaged figures by *Kempe* and his successor firm, reset in the ritual w window. NE window with tracery lights of *c.* 1850, lower lights †1914 by *Kempe & Co*. One ritual s window (blocked) also *c.* 1850, with floral patterns. – PULPIT of 1698, with panelled sides. From St Mary Lambeth. – CANDELABRUM, brass, style of *c.* 1700. – Iron SCREEN to the ground-floor chapel, *c.* 1988, incorporating part of the former chancel screen. – SCULPTURE. A small (and nude) Madonna and Child by *Guy Reid*, carved timber, 2001. – LADY CHAPEL. By *Comper*, his first important interior. He designed the timber SCREEN and STAINED GLASS, and also what is thought to have been his first 'English' ALTAR, with angel riddel-posts. Stencilling etc. restored and augmented 1982–4, brighter than Comper's colours.

LOBBIES, etc. Glass ENTRANCE SCREEN by *Buttress*, 1990, diagonally braced. – Under the tower, ALTAR and MONUMENT to Bishop Weston of Zanzibar, 1928, by *Travers*. Southern Baroque in inspiration; figures in shallow relief, background like stamped leather. – LECTERN. Spanish, late medieval, of traceried wood. – STAINED GLASS by *Kempe & Co., c.* 1920, reset. – SCULPTURE. Madonna, 1987 by *Sister Concordia Scott*, a fine hieratic bronze. Stations of the Cross, carved stone by *Joseph Cribb*, a pupil of Eric Gill. Painted wooden crucifix, C14 Spanish (gallery).

N of the church a SCHOOL of 1858 by *W.R. Gritten*, minimal stone Gothic. Extension of 1930 on Old Pye Street, N.

ST STEPHEN ROCHESTER ROW

1847–50 by *Benjamin Ferrey*. A large, spreading church, built of coursed Bargate rag and sandstone from near Blyth, Northum-berland. Ferrey was the friend and biographer of Pugin, and his

church is one of the first serious attempts in London at a scholarly Gothic Revival. Dec style – 'Flowing Middle Pointed', the *Ecclesiologist* called it – with a pinnacled NE tower with fine spire (truncated 1968, restored in carbon fibre 1994). The long chancel carries on behind it, its E window starting unusually low down. Caen stone inside, painted white *c.* 1948 under *S.E. Dykes Bower.* Vestry extension of 1890, s, probably by *B. Edmund Ferrey.* Five-bay arcades, tall, with clerestory and open timber roof. The capitals etc. were carved by *G.P.White.* The church in its entirety was a gift of Angela (Baroness) Burdett-Coutts, in memory of her father Sir Francis Burdett MP. A carving over the w door inside represents her, holding a model of it. The intention was to take Christianity into the slums of Westminster, and £100,000 was spent, school and vicarage included. Ventilation was by built-in flues for hot and cold air, very sophisticated for a church.

FITTINGS. Of the original furnishings described in the *Ecclesiologist* in 1850 much remains, of the decoration less so. The chancel retains TILES by *Minton* but the diapered REREDOS is now painted cream, the STALLS stripped of their gilt and blue paint. – BISHOP'S CHAIR of carved wood, 1850. – Original FONT and PULPIT, the latter cleverly projected from the internal tower buttress. – Of the STAINED GLASS by *Wailes*, two windows (of four) remain: one in the Tennant Chapel at the E end of the s aisle, the other, dated 1850, in the s aisle proper. Others with tracery lights by *Powell.* Another s aisle window by *Morris & Co.* (*Sir E. Burne-Jones*), the Good Shepherd, 1890. Bland E window by *Goddard & Gibbs*, 1948, replacing war damage. – In the Tennant Chapel MOSAICS and MARBLES of 1903–4, designed by *A. Reeve.* – Gothic oak SCREENS, mentioned 1890. – ROYAL ARMS, carved wood, ringed with the Garter. Given by the 1st Duke of Wellington, a friend of the Baroness. – MONUMENTS. Dr William Brown †1855 and wife, by *G.G. Adams*, very elaborate with a big relief of the Good Shepherd. – Rev. William Tennant, the first vicar, †1879. Marble bust, 'the work of a former pupil of the school': but who? – Rev. W.A.G. Twining, 1925, with copper-gilt portrait by *Herbert Hampton.*

CHURCHYARD GARDEN redesigned 1986 by *Russell Coates*, with earlier C20 RAILINGS salvaged from Victoria Street. – SCHOOL. In Rochester Street, immediately s. Dated 1876. By *H.H. Bridgman.* Institutional shouldered-arched Gothic, the top storey rebuilt 1953 after bomb damage. s extension 1923–4.

SACRED HEART CHAPEL (R.C.)
Horseferry Road

Of 1962 by *Harry G. Clacy.* Built to replace a chapel of ease to Westminster Cathedral, bombed in 1944. Timid red brick Gothic with a steep tiled roof, set in a pretty garden enclosure, with an attached block to the NE for the Corpus Domini convent.

BAPTIST CHURCH
Horseferry Road

1934 by *Spalding & Myers*. A little pedimented front, rather in the C19 tradition.

NINTH CHURCH OF CHRIST SCIENTIST
(now EMMANUEL EVANGELICAL CHURCH)
Marsham Street

1926–30 by *Sir Herbert Baker & Scott*. Of good red-brown two-inch brick, in the Early Christian style sometimes favoured by this denomination in the 1920s. The entrance treats the round-headed arches and windows rather in a C17 to C18 way. No vertical gestures. Peculiar Gothic touches to Tufton Street behind. The remarkable INTERIORS begin with a spacious lobby, domed and apsed, intended for socializing after the service. Ahead, twin staircases to the main church, a circular hall 100 ft (30.5 metres) across and seating a thousand. Low shallow dome (inscription designed by *Laurence Turner*); applied ring of paired Tuscan columns. N of the lobby, r., is a barrel-vaulted aisled basilica for the Sunday school, in a good smooth Early Christian manner.

WESTMINSTER CHAPEL, CONGREGATIONAL
Buckingham Gate

A huge Nonconformist preaching chapel by *W. F. Poulton* of Reading, 1864–5. In 'an adaptation of the Lombardic style' (*Illustrated London News*). *Rundbogen* throughout, mostly yellow brick, notched and chamfered but not deeply modelled. Broad gabled front made asymmetrical by a slim square tower, r. Its upper part is of *c*. 1935, a jarring cubistic replacement for Poulton's fantastically tall pyramidal spire. The auditorium, a near oval beneath a large roof span, is almost unaltered. Two tiers of galleries, the lower making one unbroken sweep, face the reader's railed platform. The capacity is 3,000. Further lecture halls etc. behind. The first chapel was of 1840–1 by *Tarring*, Greek Ionic, on the site of the Westminster Hospital of 1735–1834.

AUXILIARY BUILDINGS face Castle Lane, NW. First a modest squarish brick and stucco school, with three windows between small paired pilasters. Signed *C. W. Eppy* and *W. C. Bramwell*, and dated 1843. Then the former Institute, 1905–6 by *W. J. Kemp*, red brick and stone in a Bentleyish style, with portcullis corbels.

PUBLIC BUILDINGS

CORONER'S COURT
Horseferry Road

By *G.R.W. Wheeler*, 1893. Incongruously like a small red brick house, set back behind a tiny garden. Central bow window above the entrance. Good Arts-and-Crafts detail. Pyramid roof. Well-preserved COURT ROOM, reached by a staircase with exaggeratedly outcurved balusters. The second-floor accommodation was for families whose houses were being fumigated.

FIRE STATION
Greycoat Place

Of 1905–6 by the *LCC*, in its beguiling brand of free Neo-1700. Rusticated grey granite below, red brick residential quarters above, with untapered Ionic pilasters also of brick.

GREY COAT HOSPITAL
Greycoat Place

Founded in 1698 as a boarding school for seventy children. In 1701 it moved here, to a former workhouse built shortly before 1664, which was wholly or partly rebuilt to suit. It was of half-H plan, like so many C17–C18 English schools, with short wings and a long centre housing a combined hall and chapel. This part, destroyed by bombs in 1941, was rebuilt in 1955 as, in the words of its architect *Laurence King*, 'a twentieth-century version of the Queen Anne style'. His centrepiece is stuccoed, with a version of the former cupola of 1735. Two affixed charity children, of wood, may be of the early C18. Later coat of arms between, of *Coade* stone. King also added a storey, as appears from the wings, which retain older dark brick walls below. E extension probably of 1906, honest sash-windowed brick. The rebuilt back part is a saccharine mixture of pattern-making and semi-period detail.

HOME OFFICE
Petty France and Queen Anne's Gate

By *Sir Basil Spence* with the *Fitzroy Robinson Partnership*, 1972–6. 117 A speculative development, but one conceived for and pre-let to the Government. As a composition it is mulishly proportioned, and seems stranded between the picturesque and the monumental. The clearest view is from St James's Park, above the lower buildings of Queen Anne's Gate. Three thick wings with jutting top storeys project from and rise above a plainer spine range. The E wing, with canted corners, is high enough to read as a tower.

Top-knots faced with thin close-set strips, their rhythms irritat-
ingly out of joint with the brackets underneath, with squat roofs
like truncated pyramids. The nearest parallel is BBPR's Torre
Velasca in Milan, 1957, though its medieval Italian echoes are
irrelevant here. In most directions the first and second floors
also project, in big picture-windowed cells with sloping tops and
bottoms. These rest on pointy canted stilts, visually too weak to
support the whole. Between these and the top-knots up to eight
storeys of plain upright windows. Comfortless central courtyard.
The facing is cast stone. A new Home Office is proposed for
Marsham Street (q.v.).

On the site until 1971–2 stood QUEEN ANNE'S MANSIONS,
'that irredeemable horror' (Pevsner), the behemoth of London
mansion blocks. Built in 1873–89 by and for *Henry Alers Hankey*,
helped latterly by *J. Whichcord Jun.* and then by *E.R. Robson*.
Apart from a few portals it was rudely bare, nothing but uniform
windows and sheer brick walls. These rose unchallenged to four-
teen storeys, statutory height limits not yet being in force.

LAMBETH BRIDGE

Of 1929–32 by the LCC's engineer *Sir George Humphreys*, with
consultant architects *Sir Reginald Blomfield*, and *G. Topham Forrest*
also of the LCC. Five steel arches, made to look solid by steel
plates. The approaches flanked by obelisks. With the twin blocks,
Nobel House and Thames House, on Millbank (q.v.) it makes one
of the last gestures of formal Imperial planning in London.

Slightly downstream lay the previous bridge of 1861–2, one of
four new river crossings recommended by a select committee
in 1854. This was by *P.W. Barlow*, on his principle of the lattice-
stiffened suspension bridge, with three equal spans of 268 ft (81.7
metres). Cheaply built, it suffered severely from corrosion, and
the LCC resolved to rebuild it as long ago as 1892. It revived the
route of the ancient ferry commemorated by Horseferry Road.

MAGISTRATES' COURT
Horseferry Road

By *C.A. Legerton* of *J. Innes Elliott*, 1974, one of three large new
London courthouses of that time. A stocky red brick block, of
minimal personality and minimal expression of function and
purpose.

ROYAL ARMY MEDICAL COLLEGE (FORMER)
Millbank and Atterbury Street

Built for the newly founded Royal Army Medical Corps, in
1898–1907. Two barrack blocks of 1898–*c.* 1901 face the parade
ground on Atterbury Street. The *Royal Engineers* supplied these
designs, of conventionally classical Portland-dressed red brick.

The later college block on the third side, and the mess block facing the river, are by the civilian partnership of *J.H.T. Wood & W. Ainslie*. Their style is a relaxed Neo-Wren with mansard roof, the details not unlike what Aston Webb had recently been doing. The MESS ROOMS have some good detailing, in a mid-C17 English style. In 2003 set for adaptation by *Allies & Morrison*, for Chelsea College of Art and Design.

In the smaller courtyard facing Atterbury Street, a bronze STATUE of Sir James McGrigor, 1865, by *Matthew Noble*; moved from Chelsea Hospital 1909. Behind is a MOORING STONE from the old Millbank Penitentiary (*see* Millbank).

TATE GALLERY (TATE BRITAIN)
Millbank

The gift of Sir Henry Tate, opened in 1897 as a national gallery of British art. Later it expanded to include modern foreign art, and six successive extensions were built. Rededicated to British art in 2000. p. 688

Tate offered a gallery to the nation first in 1889, but it took until 1892 to settle on part of the Millbank Penitentiary site for it (*see* Millbank). His preferred architect was *Sidney R.J. Smith*. A version of Smith's first design, adjusted after official and Royal-Academic criticism, was begun in 1893. Smith's other works were chiefly libraries; here he used the Late Victorian grand manner, somewhere between 1880s littleness and Edwardian swagger. So the composition is symmetrical and stressed on centre and ends; but the ends are underpowered, and within the controlling giant order are – confusingly – two lesser orders, Ionic and quasi-Doric. Sphinxes or gryphons sit above the latter. In the middle a big projecting portico and shallow dome, with steps towards the Thames. The basement is rusticated, bulging out by the portico sides, where two bronze SCULPTURE groups are set: The Rescue of Andromeda by *H.C. Fehr*, r., 1893, and The Death of Dirce by *Sir Charles Lawes-Wittewronge*, l., 1908 (cast from a marble work of 1906). The architectural carving is run-of-the-mill. Later EXTENSIONS line up behind the river front, apart from the Clore Gallery which plays its own game to the r. (*see* below). The shrapnel-pocked flank to Atterbury Street, l., has as its central emphasis part of the addition of 1909–10 (*W.H. Romaine-Walker*), followed by that of 1924–6 (*Romaine-Walker & Jenkins*), with a different treatment of the basement. A new entrance was made at this level by *Allies & Morrison*, 1998–2001, excitingly approached by a ramp from the front, by steps from the back, and guarded by a glass balustrade. The firm remodelled the GARDENS in connection, a severe rectilinear design. The STATUE of Sir John Everett Millais by *Thomas Brock*, 1904, now stands by the corner with John Islip Street, where the NW wing of 1973–9 appears, by *Llewelyn-Davies, Weeks, Forestier-Walker & Bor.** Mostly blank mute walls, with an ugly corrugated top.

* It superseded their radical scheme of 1969 for a glazed attachment along the river front.

top. Taller part-curtain-walled conservation workshops on the central axis, instead of the intended completion of the interwar work.

The C19 INTERIORS were planned for the best display of pictures in natural light, with relatively little architectural show. The front range (E), of 1897, extends r. and l. of a stony two-storey octagonal vestibule. The ground-floor view of the upper octagon is tantalizing, with apses alternating with corridors glimpsed obliquely, like a Baroque Italian stage set. At each extremity is an octagonal gallery, the l. one with a MOSAIC FLOOR by *Boris Anrep*, 1922–3, illustrating Blake. Off the entrance hall, l., STAINED GLASS by *E. Bossanyi*, 1939–41. A range of 1898–9, running parallel and to the w, completed Smith's conception. From here the central, perpendicular axis is formed by the SCULPTURE GALLERIES given in 1935–7 by the 1st Lord Duveen, designed by *J. Russell Pope* of New York, with *Romaine-Walker & Jenkins*. Two spare and severe barrel-vaulted spaces, separated by an octagon based on that at Pope's railway station at Richmond, Virginia. Ionic column-screens (the order of the Theatre of Marcellus), doubled at the junction. Few British architects by the 1930s designed with such conviction in the Neo-Roman manner. At the far end a blank wall shows where the work was to have continued. This monumentality contrasts

1 Sculpture Galleries
2 Gallery 9
3 Extension 1973–9

Tate Gallery. Axonometric plan

with the 1970s extension on the N (r.). It is chiefly one enormous subdivisible space, designed at a time when maximum flexibility had become the thing. The ceiling of three by seven giant concrete cells allows for both natural and artificial lighting. Older galleries lie on the S side (l.), of two phases: 1909–10, given by Sir Joseph Duveen, father of Lord Duveen, to show works by Turner, and 1925–7, given by Lord Duveen mostly to show modern foreign art. The first phase includes the very grand Gallery 9, barrel-vaulted and with *verd'antico* doorcases. Of the 1920s rooms, several were replaced in 1998–2001 by *John Miller & Partners*, or swept away for the spacious toplit staircase up from the basement. It uses carefully textured and toned finishes rather than the usual white-box gallery aesthetic, though the vocabulary is wholly Modernist. At its foot is a lower entrance hall, which also serves new exhibition galleries in the SW basement. This is a confusing place to arrive in from outside, with too many different routes and rooms opening off it. To the r. a corridor leads to the RESTAURANT, painted in 1926–7 by the young *Rex Whistler* with fey, nostalgic mural capricci called The Expedition in Pursuit of Rare Meats.

The CLORE GALLERY is by *James Stirling, Michael Wilford & Associates*, given in memory of Sir Charles Clore. It was commissioned in 1979 to house J.M.W. Turner's bequest of paintings and drawings, and built in 1982–6. Though modest in size, it made a great stir: partly because London was then starved of new public buildings, partly as the first British showing of the architects' enormously influential Postmodernist turn, demonstrated especially at their Neue Staatsgalerie in Stuttgart (designed 1977). That the Clore Gallery has less punch than Stuttgart is due to the absence of Stirling's usual strong plan, though other ruling themes of his later work are all there: the truculent detail, reckless use of colour, and near-obsessive derivation from the facts of the site. The block is L-shaped, physically attached to the old gallery, but with its own entrance in the return wing. This reaches towards a three-story red brick lodge from the old Queen Alexandra Military Hospital of 1903–6 (closed 1977), which occupied part of the penitentiary land. These neighbours are acknowledged by matching their horizontals and materials: standard contextualist devices pushed here to heretical extremes. So the lower cornice mouldings run on from Tate's gallery, shedding much detail after a few feet, while at the opposite end the brick of the lodge invades the square stone grid of the walls, displacing the buff render infill in a much-imitated stepped diagonal. This grid appears at first to control the façades, but a closer look shows how often it is subverted: at the entrance, where it barely registers because the infill is of matching stone; at the outer angle, where it is chopped into by a void to light a reading room and by small windows in the cornice above; and round the r. corner, where it yields abruptly to plain cream brick. Contradiction reigns also where the openings are concerned. The entrance evokes a primal classicism, with a little lunette over a great glazed triangular-headed void, but the cutaway corner to its r., a familiar Modernist device, advertises that the building techniques are fully of the C20. These two big openings are linked

121

visually by glazing in big square apple-green frames. The same colour picks out two canted lookout windows, the smaller poking out informally between the two main voids, the larger placed formally in the answering wall, overlooking a sunk pool, and set above a brick-red timber pergola along the ground floor. All classical ghosts vanish round the r. corner, where the N wall is devoted to utilities. It has the assumed artlessness of Stirling's early Brutalist buildings: angled factoryish glazing, exposed piping, and on the l. part two big louvred windows to the study room, reading irresistibly like a giant robot face.

INTERIORS. The way to the galleries is intriguing and not at all obvious. From the entrance a staircase set sideways climbs to the main floor. Above it a toplit slot of space between sheer walls, one with a square grid, one plain. From the landing the route returns to a lobby just outside the galleries proper, looking back to the staircase through an internal double-height opening. The main colour is a warm apricot, but glazing, handrails and openings are picked out in green, pink, blue or purple: clashes lacking the resonance of those outside. The galleries themselves are calmer. Artificial light mixes with natural light, directed down double-sided ceiling hoppers, a nicely mysterious effect. A few simple mouldings; a few Postmodern-classical touches, e.g. uplighters over doors, reading as giant key blocks. The original oatmeal hues gave way to warmer colours in 1995.

Most of the Edwardian HOSPITAL BUILDINGS survive to the N and NW, in use for the time being as gallery offices. They are a late instance of the pavilion plan in a military hospital, but with day rooms rather than open balconies at the ward ends. The best part is the least formal, a block on John Islip Street, dated 1906. In an internal courtyard a little round-arched former CHAPEL. Plans by *Stirling, Wilford & Associates* for the site were abandoned in 1988. Instead a new modern-art gallery opened in 2000 within the old Bankside Power Station (*see London 2: South*).

WELLINGTON BARRACKS
Birdcage Walk

The main range of 1833–4 and later by the engineer *Col. Sir Frederic Smith*, with elevations by *Philip Hardwick*. Behind it, a long complex of 1979–85 by *George Trew Dunn Beckles Wilson Bowes*, with internal reconstruction of the C19 parts. At the far E end the Guards' Chapel, its W front facing the parade ground. The land formerly belonged with St James's Park, but by 1810 at least part was already occupied by the guards.

The C19 section is stuccoed, almost 500 ft (152 metres) long, like a Nash terrace after some parade-ground discipline (Nash had indeed wanted to put terraces on the site). Central block of twenty-seven bays, linked by Doric column-screens to three-bay end pavilions. The E one was built last, *c.* 1848–54. Accents are provided by giant Doric pilasters· and pediments. The central block is much subdivided into two- and three-bay units, broken slightly back and forth. By the road two replicated LODGES, standing just within good plain RAILINGS dated 1833.

Shadowing the C19 range from behind is the NEW BARRACKS of 1979–85 (design published 1973), which replaced a mass of C19 accommodation. The need to work with what remained no doubt explains why it lacks the exactitude of Chelsea Barracks or the drama of that at Knightsbridge (*see* pp. 768, 736), and the new forms are also disappointingly thick and heavy. A podium interlinks the various blocks, which are of cream-painted concrete with strong horizontal accents and canted corners. Windows mostly alternately wide and narrow, marked by flat discontinuous mullions. W of the C19 barracks is the officers' quarters, set forward by the railings. The barrack blocks, larger and taller, may be seen from Petty France, S, and Buckingham Gate, W.

GUARDS' CHAPEL (Royal Military Chapel). The largest church in the West End in a Modernist manner, replacing the building largely destroyed by a flying bomb in 1944. The main body is of 1961–3, by *Bruce George* (*George: Trew: Dunn*), a more compelling design than the barracks. He incorporated two older features: an apse by *G.E. Street*, 1877–9, from his remodelling of Col. *Smith*'s Greek Doric chapel of 1835–8, and to the N a cloister of 1954–5 by *H.S. Goodhart-Rendel*. The exterior to Birdcage Walk is forbidding. A long, flush wall of white aggregate finish, with slit windows low down. A high slit screen, E, marks where Street's apse is incorporated. To the W a bold high porch, with openings alternately wide and narrow, the shallowest gable on top, and a glass wall behind. The bellcote however sits on the flank, towards Birdcage Walk. Its bell is exposed. Coming forward from the chapel here is the low War Memorial Cloister by *Goodhart-Rendel* (himself a Guards officer), part of a rebuilding scheme abandoned on his death in 1959. It is Neoclassical and surprisingly bland, with little of the inventiveness of his other 1950s work.* Brown brick and stone, with blind niches on the W side.

Inside, the chapel is a plain oblong except for the apse and the short chancel with upper galleries that precedes it. Also separated from the main space is a W narthex, defined by an open three-tier screen reaching up to the ceiling. Each panel of the screen has a shallow segmental arch. The nave has on the N side the low slit windows already referred to, on the S side six shallow chapels, one for each Guards' regiment. Their angled plan and slit windows derive from Coventry Cathedral (1951–62), though the numerous roof-lights give mild rather than dramatic illumination overall. The design is not at all traditional, but has something which makes it suitable for an environment saturated with tradition.

FURNISHINGS. In the apse resplendent MOSAICS, designed by *J.R. Clayton* (of *Clayton & Bell*), and executed by *Salviati, Burke & Co.* and their successors. An acanthus frieze divides the lower scenes (the Passion, 1879–80) from the half-dome (resurrected Christ, excellent Byzantinizing work of 1894). Later mosaics on the vault (1911) and N and S apse walls. Floor mosaics and altar frontal designed by *Sir Nevile Wilkinson*, 1937, more explicitly Early Christian. – Also from the C19 chapel: iron CHANCEL GATE, made by *J. Leaver*; belligerent FONT carved by *T. Earp*,

* Drawings of the complete design are displayed by the SE gallery staircase.

with open wrought-iron cover added 1886; good STAINED GLASS by *Clayton & Bell*, reset in tiers in the W wall and star-shaped porch window. – C20 FITTINGS. Cast aluminium SCREENS by *Geoffrey Clarke*, 1963, on the gallery W walls. Big wriggly shapes against striated bars. They symbolize ceremonial and active duties. – ENGRAVED GLASS in the S chapels. The best is *John Hutton*'s Archangel Gabriel, Grenadiers' chapel (second from E). Other artists include *Gordon Beningfield* and *Laurence Whistler*; also a terracotta RELIEF of cavalrymen by *Rosemary Barnett*, 1964. – On the walls a stirring array of regimental COLOURS.

MONUMENTS in the forecourt. STATUE of Earl Alexander of Tunis, by *James Butler*, 1985. Over-life-size; very naturalistic.

WESTMINSTER ARCHIVES CENTRE
St Ann's Street

By *Tim Drewitt*, 1992–5, replacing the back of the swimming baths on Great Smith Street (q.v.). A tall and ambitious build-ing for the purpose. Orange brick facing, with big cogged panels for ornament on the entrance side. Reading room on top, a smooth curved volume cut by windows to the N and E. Flats by the same architect built in 2000–1 hide this part from the street.

WESTMINSTER CITY SCHOOL
Palace Street

1876–7 by *R.R. Arntz*, who was Surveyor to the Westminster District Board of Works. It united several older endowed schools on the land of another, the former Emanuel Hospital (*see* also Buckingham Gate). Brick Gothic with banded voussoirs, the composition much broken about. In the forecourt a bronze STATUE to Sir Sidney Waterlow by *Frank M. Taubman*, 1901, a version of that in Waterlow Park, Highgate. Behind the main school an attachment for a hall, 1909 (heightened 1957–8).

WESTMINSTER KINGSWAY COLLEGE
Vincent Square

Formerly Westminster Technical Institute. Of several phases, of which the best is on the l. corner, by *H.S. Goodhart-Rendel*, built in stages 1950–7. Decorative, eclectic, and yet entirely free of archness. Yellow brick-faced, with little projecting crosses of five bricks each. Windows with diagonal glazing bars. A curved bow marks the staircase. Over the entrance a sundial by *J. Ledger*, incised with a picture of a dinner table. Next a section of 1930–3, with a strange Gothick timber shopfront, and a more conven-tional wing dated 1907. The college began in 1890 as an initia-tive of Baroness Burdett-Coutts, who collaborated with the LCC to provide its first building (of 1893, by *T. Blashill*).

STREETS

ARTILLERY ROW

Named from the shooting ground established near here in the later C16. On the E side WESTMINSTER PALACE GARDENS, a superior mansion block of 1897–9 by *C.J. Chirney Pawley*. Red brick, with lively figure friezes (cf. his St James' Court, Buckingham Gate), and an internal courtyard. Next to it ARTILLERY HOUSE, offices by *Maurice Webb* with *H.A. Dawson*, 1928–30, modernistic, yet, with the odd batter of the buttresses between the windows, not without individuality. Cream artificial stone facing, modelled by *L.F. Roslyn*.

BROADWAY

First recorded as a street name 1662. Originally just a widening at a T-junction. Today, Broadway architecturally means No. 55, the headquarters of LONDON UNDERGROUND, by *Charles Holden*, 1927–9, a bold building for its date and for London. It also served as visual propaganda for a body then steadily consolidating control over London's various private transport companies. The composition is entirely of the C20: a cruciform group of blocks arranged for optimum natural lighting (after the model of some hospital plans produced by Holden's firm), which step back New York-fashion as they rise. The centre is a tower 175 ft (53.3 metres) high, containing lifts, staircases, lavatories, etc. It has a square, gradually diminishing top. From it extend four spurs, the E one markedly longer. Holden compared the silhouette to a figure astride a horse with panniers. Two-storey ranges between the spurs allow the ST JAMES'S PARK UNDERGROUND STATION to be fitted ingeniously in. What there is of SCULPTURAL DECORATION is of extreme interest. Two large groups by *Epstein*, of Day (S) and Night (N), like a Pre-Columbian pietà). Higher up, eight reliefs of horizontal figures of winds, some more radical than others. These are by *Eric Gill* (E side of N and S wings, also N side W wing, not now visible from the street), *Henry Moore* (N side E wing), *A. Wyon* (S side W wing), *E. Aumonier* (W side N wing, also invisible from the street), *A.H. Gerrard* (W side S wing), and *S. Rabinovitch* (S side E wing). They were considered revolutionary at the time, and Holden had to use all his powers of persuasion to have them accepted. Architectural detail is conservative by comparison. The ground floor has granite columns *in antis*; they are circular piers rather than columns, it is true, and have plain blocks as capitals, but they appear columns all the same. The windows are upright and have glazing bars reminiscent of Georgian sashes, and the wings are connected by diagonal arches high up, close to the tower. Travertine-lined station concourse, reordered in 1988 by *Manser Associates* with a new shopping arcade.

The counterpart in mass to No. 55 is the Home Office (q.v.), to the N in Petty France. Few other buildings stand out. On the E side of Broadway the FEATHERS pub (Nos. 18–20), 1899 by *Shoebridge & Rising*, with first-floor bows and flats above. Next to it QUEEN ANNE'S CHAMBERS, 1903 by *Rolfe & Matthews*, harshly detailed. On the N side, past the prow of London Underground, BROADWAY BUILDINGS, 1924 by *H.J.S. Abrams* (rebuilt internally 1999–2001), still with giant pilasters. The street running W from here is PETTY FRANCE, first recorded in 1494, where French wool merchants used to live. On the S SIDE is ALBANY HOUSE, a long rambling office complex of 1962, with a taller slab set end-on and brick-faced flats behind. Bronze SCULPTURES at the entrance by *Willi Soukop*, Man and Woman, 1963. No. 81, the ADAM & EVE pub, 1881 by *H.I. Newton*, not ambitious; Nos. 79–80, a mare's nest of Neo-Victorian detailing, of *c.* 1989 by *Fookes, Ness & Gooch*. The former PASSPORT OFFICE next door, designed in 1948 by *Ashley & Newman*, typifies the exhausted London office tradition of *c.* 1950. No. 61 is meticulous Neo-1700 of *c.* 1925, but with a pretty shopfront in latest C18 style, modelled on one rescued from the old No. 32 for the Victoria and Albert Museum in 1923. No. 58, early C18, was refaced in 1989–90 by *Moxley & Frankl* and extended to the l. (Unusual late C19 stable building behind, galleried around a roofed-in courtyard. Carriage accommodation below, a ramp to stables and tack room over them, second-floor accommodation for grooms.)

BUCKINGHAM GATE

The name of the new street laid out by *Pennethorne* in 1853–8, which realigned the N part of Buckingham Palace Road to give more space to the palace. Later the name was extended to the older route running SE from the palace to Victoria Street. The amalgamated street, cranked and straggling, changes repeatedly in character.

Starting at the W end, the first block was reconstructed around a triangular atrium in 1983–9 by the *Rolfe Judd Group Practice*. They contributed the section with canted bays in banded stone, facing S on to Palace Street. On the corner next to it a retained façade of mansion flats by *G. Thrale Jell*, 1912, with triglyph balcony brackets in Frank Verity's style. Of Pennethorne's era No. 1, a tall stuccoed house, and No. 2, the former BUCKINGHAM PALACE HOTEL of 1860–1 by *James Murray*, an early instance of a really big London hotel. Seventeen bays wide, Roman Cinquecento, with a far-projecting cornice. Splendid big Corinthian doorcase in English late C17 style, added when *Buckland & Haywood* and *J.N.R. Vining* converted No. 2 for the Nobel organization in 1920–1. Well-detailed entrance of that date, with carving and metalwork by *Farmer & Brindley*. Nos. 4–9 are big stuccoed houses of *c.* 1860, with Doric porches; Nos. 7–9 have a Munich-Italianate flavour, with a central pedimented attic. *Pennethorne*

proposed one grand composition here, but got to design only No. 10, the DUCHY OF CORNWALL OFFICE of 1854–7. This splays around the blunt corner facing the palace forecourt. Three faces each of three bays, with a central Doric doorway with pedimented Venetian window above. Handsome detail, that on the second floor culled in 1951 by *Arthur C. Martin*, who added a storey and made good wartime damage. Within, a curved-ended stair rises behind a column-lined hall, with matching vestibules and major rooms at 45 degrees on each side. The chief office, above the hall, is circular.

Around the corner into the former James Street. This bounded the part of St James's Park taken in the C19 by Wellington Barracks (q.v.). Aristocratic houses were built here from the C17, joined or replaced by terraces in the C18. Nos. 13 and 14, survivors of a run of 1756–7, have oblong fanlights with criss-cross glazing bars. Also of the mid C18 No. 15, with a bracket-cornice and the usual type of timber staircase, and No. 17, with an elaborate late C18 saloon ceiling. No. 16, more individual, has been dated to 1706. Small, of five narrow bays. Quoined, all windows with aprons, with a stone band bending strangely over the arched central first-floor window with its blind balustrade. Niche above, under a broken segmental pediment. Off-centre Doric doorcase. Spoiled inside. No. 20, of *c.* 1889–92, is a free and pretty early house by *Reginald Blomfield*, wholly unlike his later work. Red brick and white stone bands, stepped gable, square copper-roofed oriel; another, miniature oriel over the entrance. Frieze of carved brick modelled by *Henry Pegram*; also an affixed bronze galleon (why?).

Offices and mansion flats now begin to take over. Nos. 25–28 are *Gervase Bailey*'s, 1937, his habitual grey-brick-trimmed Neo-Early Georgian; Nos. 84–85 on the NE side, 1984–6 by the *Halpern Partnership*, with three big wobbly bows cut off below. Next to this the first mansion block of note, Nos. 75–83 of *c.* 1897, with a flaunting curved front and third-floor balconies linked by corbelled arcading. But the greatest show is made by that caravanserai ST JAMES' COURT (Nos. 41–53), on the opposite side past the Westminster Chapel (q.v.). Built as eight contiguous blocks of serviced flats in 1896–1905, by *C.J. Chirney Pawley*, working with *Alexander Graham* and *Henry Bushell*. Its street front is the usual red brick eclectic with white stone bands, except for two huge arched entrances with vast *Starkie Gardner* gates of hammered iron. The l. one has been enclosed, but the r. one still leads to the prodigious internal courtyard. Here the blocks are faced below in jade or primrose faience, with entrances stressed by blue blocked columns and four small female atlantes. Brick above, with cage-like through-storey balconies and long red figure friezes telling Shakespearean stories; gables or onion-domes to finish. Patterned brick paving of 1986; the pretty cast-iron fountain is original. A faceted glass enclosure, l., houses a restaurant of 1999–2000 by *Julyan Wickham*, cheerfully at odds with its surroundings. A street plaque commemorates Emanuel Hospital, an almshouse set up here in 1602 (joined by a school in 1738):

one of a cluster of C16–C17 charitable foundations in this area (*see* also Westminster City School and Rochester Row).

The s part of Buckingham Gate is dominated by 1970s–80s office blocks. Facing St James's Court is WELLINGTON HOUSE, designed 1975 by *Fitzroy Robinson & Partners*, polished-stone-faced. At the *Howard Sant Partnership*'s No. 57, 1972 (sw side), dark bronze curtain walling is used. No. 58 is an older survivor, like an Early Georgian town house apart from the thick-set doorcase. Built in 1886 as offices for the Queen's Westminster Rifles, whose drill hall was behind. No. 59, 1985–8 by *Duncan Cardow* of *T.P. Bennett & Son*, replaced the London Scottish Regiment's headquarters, part of which was re-erected at No. 97 Horseferry Road (q.v.). Postmodern classical, triple-arched below, on cylindrical columns. No. 60, 1980–1 by *Chapman Taylor Partners*, now has shapeless beetroot-coloured cladding of 1995, for the KOREAN EMBASSY.* The best offices are *Elsom, Pack & Roberts*' complex opposite, of *c.* 1975–7. The main part is an eighteen-storey tower (No. 65), square and with rebated corners, dressed in sombre Miesian curtain walling. To the l. a low angled range defines a paved court by the former Bluecoat School (*see* Caxton Street). To the r. a detached three-storey block, a little companion for the tower.

CARLISLE PLACE and FRANCIS STREET

A short perambulation around Westminster Cathedral. Many of the streets here began in clearance and improvement: Carlisle Place and Morpeth Terrace in the 1850s, Ambrosden Avenue to the NW in the 1880s, on the Westminster Bridewell site (*see* also Westminster Cathedral). Architecturally the theme is large-scale housing and hostels of every type, from the 1860s to the 1920s. Densities are high – four to eight storeys – and open spaces few.

Starting from Victoria Street, the w side of CARLISLE PLACE has EVELYN MANSIONS, 1893, tall red brick mansion flats, a plainer variant of those in Ambrosden Avenue (*see* below). Next the ST VINCENT'S CENTRE, built for the Daughters of Charity (Society of St Vincent de Paul) by *Henry Clutton*, and now used as hostels, shelters and community rooms. A long sheer slab of painted brick, with big round-arched windows. The oldest part, N, was built as a girls' orphanage in 1862–3; the centre in 1877–9, mainly for the nuns' own accommodation, with the former chapel corbelled out, l.; the s part is dated 1909. The odd fat hoodmoulds on the last part recur on the top storey of the rest, reconstructed *c.* 1914–20 by *Fr Benedict Williamson & Beart Foss* for a rooftop playground. It faces Nos. 1–3, of 1861–3, which makes them London's oldest remaining mansion blocks.** The builder was *W. Jackson*, the architect

* What became of the important relief sculptures by *Harry Bates*, transferred when the old No. 60 (1886–7 by *T. Verity*) was demolished for street widening?

** Just to the N was St Andrew Ashley Place, of 1851–5 by *G.G. Scott*; bombed 1940, dem. 1953.

possibly *C.O. Parnell*. Four yellow brick storeys with sparse Italianate trim, a small and tame design compared with later developments of the type. Characteristic of these are the mighty CARLISLE MANSIONS next door, 1885–9 by *George Baines*, on land once reserved for Westminster Cathedral. Three variants appear, with gables, balconies and canted bays differently combined. The grandest, on the w side, has decorated porches.

On the SW corner with FRANCIS STREET is MANNING HOUSE, a great stock-brick palazzo built *c.* 1867 as the Guardsmen's Institute by *H.A. Darbishire*, and reconstructed for offices by *Rolfe Judd*, 1989. Nine bays; three tall storeys, the openings round-arched below and above, segmental between; typical 1860s eclectic detail. In 1873–1901 it served as the Archbishop of Westminster's Palace. It faces CARDINAL MANSIONS, *Baines* again, of 1897–8 and externally sumptuous. Then on the s side of Francis Street THE FRIARY (No. 47), a smaller brick block by *Darbishire*, 1865. Built as an orphanage for Guardsmen's children, which surely explains the open arcaded ground floor derived from Brunelleschi's Foundling Hospital in Florence. Upper storeys derived from earlier Quattrocento models: round-arched two-light windows, the top range squeezed into a machicolated cornice. On the end a STATUE by *Arthur Fleischman*, 1961, St Francis haloed by sparrows, set up when No. 47 housed a Franciscan friary. Formerly adjoining, r., were Guards' lodgings of 1853–4 (replaced 1959), also by *Darbishire*: a forerunner of his much-repeated Peabody designs.

From here MORPETH TERRACE runs N, facing Westminster Cathedral and repeating the mansion-block sequence of Carlisle Place: 1897–8, then earlier blocks also by *Baines* (probably 1891), then 1860s. WILLOW PLACE, the turning to the s, is by contrast military or working-class. QUEEN MARY'S BUILDINGS, E side, were built in 1922–4 as army married quarters by the *Office of Works*, plainly in thrall to LCC formulae of plain brick and shaped gables. They have been reconstructed internally, using red brick and white-tiled walkways. Next to it a TELEPHONE EXCHANGE of *c.* 1912 and later, simplified rectilinear brick, and then ADMIRAL HOUSE, 1928–9, typical of *Ashley & Newman*'s flats for Westminster Council, steep-roofed and of two shades of brick. For the Peabody Estate on the w side *see* Vauxhall Bridge Road, p. 783.

s of the Telephone Exchange, GREENCOAT PLACE leads into STILLINGTON STREET. On the r. corner BUCKINGHAM CHAMBERS, glum economical flats dated 1892. Turning l., more of Queen Mary's Buildings line both sides. Back in Francis Street, on the r. corner, No. 29, Neo-Wren of 1912–13 by *R.S. Ayling*, a hostel for the London Diocesan Girls' Friendly Society. Corner entrance with carving by *H.C. Fehr*. Its neighbour is COBURG CLOSE, *Improved Industrial Dwellings Co.* flats of 1875. A veneer of ornament to the street block; long and severe rear range with deep spur wings. Renovated 1986. AMBROSDEN AVENUE opens off to the l., along the flank of Westminster Cathedral. The s corner is a forbidding former Police Section House of *c.* 1890, slightly glazed red brick with

88

a rounded corner. All the rest is mansion flats called ASHLEY GARDENS, built in one campaign 1890–*c*. 1893. Stone-striped red brick with five superimposed balconied storeys, the same design repeated fivefold. It is the same principle as the early Peabody estates, of repeatable units stuck together and stretched or curtailed to fit the edges of the site. Behind, in THIRLEBY ROAD, they rise to eight storeys, of which a full seven have these same repeated balconies – an overpowering spectacle. The designer is unknown. The r. turning off Francis Street is EMERY HILL STREET, lined with lower, friendlier and more varied mansions by *E.J. Stubbs, c.* 1900–2.

Francis Street then curves N back to Victoria Street, and the housing stops. The r. side has giant warehouses from the Late Victorian heyday of the Army & Navy Stores. The nearer part is of 1883–5 by *J. Bull,* handsome red brick with matching terracotta bracket-cornices, and giant columns to the loading bays. Unobtrusively refurbished for offices by *Michael Squire Associates,* from 1996. An earlier warehouse stands to the N in Francis Street, by *James Knowles Jun.,* 1881, red brick with flat rusticated pilasters and tall windows (altered). The opposite side is a big POST OFFICE (South-West District Sorting Office): the main part of 1893–4, big, red and sturdy, the outer angle of 1911, with square stone trim; respectively by *R.H. Boyce* and *Jasper Wager* of the *Office of Works.*

CATHERINE PLACE

An L-shaped street, defining a little enclave laid out *c.* 1810–20. Much rebuilt in the 1910s–30s with smallish unpedantic Neo-Georgian houses, mixing enjoyably with staider C19 survivors. Nos. 2 and 10 (E side) are Neo-1720s, the latter with an C18 doorcase *ex situ* and Regency-type balconettes. No. 15 (W side), 1938–9 by *Robert Lutyens* for the Hon. Algernon Borthwick, evokes a grander Early Georgian type, with an open top pediment. In the outer angle, Nos. 29–37 make a small close of *c.* 1916. Behind No. 33 the neat split-level office of *Mary Thum Associates,* 1999. Around the corner, BUCKINGHAM PLACE runs off SW. No. 10 here was converted from three late C18 houses by *Lutyens* senior in 1914, for his brother-in-law, the 2nd Earl of Lytton (hence the interlaced Ls on the doorcase). Otherwise mostly Neo-Georgian, e.g. No. 8 with another carved Anglo-Baroque doorcase and carved openwork balustrade inside, and at the S end No. 1, a four-square house by *L. Stanley Crosbie,* 1915, with a doorcase of the type of *c.* 1700. Back in Catherine Place, a run of *c.* 1820–30 along the S side is broken by *Claude W. Ferrier*'s No. 46, 1924.

CAXTON STREET

Named from the printer William Caxton, who worked near here in the later C15. A medieval chapel dedicated to St Armel or Ermin is commemorated by ST ERMIN'S HOTEL, at the E end

on the N corner. By *E.T. Hall*, 1887–9, built as mansion flats (the deep forecourt was originally a private garden). Nothing special externally, but enlivened *c.* 1900 by *J.P. Briggs*, who converted it for a hotel and extended it to the E. Probably his are the foyer, with its flamboyantly Baroque staircase, and the barrel-vaulted restaurant, r., both with Neo-Jacobean plasterwork, and the ballroom beyond. This has billowing balconies within an elongated hexagon of giant Ionic columns, and half-understood Art Nouveau plasterwork. Much less tall is CAXTON HALL, 1882–3 by *William Lee & F.J. Smith* (competition 1880). Built for the parishes of St Margaret and St John; used as Westminster City Hall after 1900. François I, symmetrical and not big, with pavilion roofs. Red brick, red Corsehill stone. Sculpture by *Robert Jackson*. Latterly famous for fashionable registry-office weddings, it also had Britain's first municipal air-raid shelters (1938). In 2003 awaiting a new use. BURWOOD HOUSE (Nos. 14–24), by *George Vernon*, illustrated 1929, is a long brick range in quirky Neo-English Baroque.

On the S SIDE, the backs of post-war buildings on Victoria Street and Buckingham Gate (qq.v.). Then a remarkable Westminster relic, the former BLUECOAT SCHOOL of 1709. Established 36 nearby in 1688, it was rebuilt here for William Greene, owner of the Stag brewery to the W (*see* Stag Place). Bought in 1954 by the NATIONAL TRUST, and now used as its shop. Of brown and fine red brick, two storeys externally, three bays by three broader bays, with giant Doric angle pilasters. All four centre bays project slightly. Frontispiece with a rusticated Doric doorcase, a niche above with a charity boy, and an attic with a broken segmental pediment and side consoles. Similar composition to the S, but with a shallow niche instead of an entrance, and an unbroken pediment over. On the W side another pilastered doorcase, with a pretty staircase added by *Philip Jebb*, 1974. Just one big schoolroom inside, panelled, with an entrance screen of four Corinthian columns.

In VANDON STREET just to the N, MURRAY HOUSE (United Women's Homes), 1928 by *Searle & Searle*, red brick with big round-arched entrances. It housed the charity's own offices, with budget flats for single women above.

COWLEY STREET and BARTON STREET

Undertaken from 1722 for Barton Booth, the actor, whose country house was at Cowley, Middlesex. With Lord North Street (*see* Smith Square), they are amongst the most perfect Early Georgian streets in Westminster.

Coming from the S, by the top of Lord North Street, the building ahead is No. 6 (LIBERAL DEMOCRATIC PARTY), Wrenian Revival offices of 1904–5, for the North Eastern Railway. By *Horace Field*, an ardent early Neo-Georgian. With its big doorcase and big pediment, it breaks the reticence of the neighbourhood. Well-observed staircase of the type of *c.* 1730, with slim twisted balusters. To its r. No. 7, a house by *F. Adams*

Smith, 1899–1900, more free in style. It goes with Nos. 10–12
Little College Street, E (*see* Great College Street); the plain
brick early C18 rear wall closing the r. end belongs with No. 9
there. Then on the s side Nos. 13–19, a wonderfully preserved
three-storey range, most with the original bracketed or Doric-
pilastered doorcases. No. 19 was reconstructed in 1920 by
Blow & Billerey for Sir Andrew Agnew, and now looks much
smoother. Nos. 1–3 opposite are also early C18, but largely
refronted, and with two early C19 doorcases.

BARTON STREET, the immediate N continuation of Cowley
Street, is also exceptionally well preserved. No. 6 (E side) bears
a tablet dated 1722. Other original houses are Nos. 1, 3–5,
and Nos. 9–14 on the w side. Windows are segment-headed
or straight-headed. Nos. 9 and 10 have characteristic eared
aprons below them. Doors have shell-hoods (No. 3), pilasters
(No. 4) or pediments on brackets (No. 6); on Nos. 11–14 a
timber architrave links the hoods. No. 8, facing back down
Cowley Street, is good imitation 1720s by *Field*, 1909, his
second house for Walter Runciman MP (cf. No. 15 Great
College Street). No. 2 is an intruder of 1897.

GREAT COLLEGE STREET

A charming street with an atmosphere like a cathedral close. Laid
out *c.* 1720 along the old s boundary of Thorney Island, still
defined on the N side by the stone WALL of *c.* 1374–6 to the
Abbey Garden. The s side mixes early C18 houses and early
C20 houses and offices. FIELDEN HOUSE (No. 10), 1936–7,
Neo-Georgian by *Victor Heal*, makes the corner with LITTLE
COLLEGE STREET. Nos. 10–12 here are houses of 1899–1900
by *F. Adams Smith*, Queen Anne turning Neo-Georgian, the
fronts nicely varied. No. 9, bigger, is of *c.* 1722 behind refac-
ing of *c.* 1900. The sophisticated Palladian doorcase with its
satyr mask must be of *c.* 1730–40 and *ex situ*.

Back to Great College Street. By *Horace Field* Nos. 14–15, houses
in a pretty choice of brick, built in connection with his No. 8
Cowley Street (q.v.). Tie-plates spell out the date – 1905 –
rainwater heads the first residents' initials, the MPs Charles
Trevelyan and Walter Runciman. Nos. 16–19 are of the same
build as Barton Street, *c.* 1722. The grandest is No. 16, with a
projecting centre against which extra little half-width windows
squeeze on the second floor. Dormered top storey by *Lutyens*
for the Hon. Alfred Lyttelton, 1895–6. Panelled interiors,
staircase with ramped rails. No. 19 has the date 1722 on its
flank. No. 20, stripped Tudorish of 1904–5 by *Arthur Blomfield
Jackson* (altered), is an auxiliary block for Westminster School.
Other school properties stand opposite (*see* also pp. 205–6):
the s end of the C18 dormitory, No. 29a, pallid Neo-Georgian
by *E.P. Warren*, 1921–2, and the gabled No. 29 by *T.G. Jackson*,
1896–7, part of his building in Little Dean's Yard. BUSBY'S,
the house next door, is of 1935–6 by *Baker & Scott* and joins
on to their Church House (*see* Dean's Yard, p. 201).

Finally on the s side ST EDWARD'S HOUSE, the house in London of the Society of St John the Evangelist (the 'Cowley Fathers'), of 1903–5 by *Edward Burgess*. Free Gothic of crimson brick, rather noble in its plainness, with an embattled tower. Two storeys were added in 1937 on the Tufton Street side, w. A vaulted lobby there leads to the CHAPEL, simple and calm, with a vaulted narthex and windows mostly on the l.

GREAT PETER STREET

In two parts, of different character. From Millbank w to Marsham Street, early c20 flats, private houses, and offices for Anglican bodies predominate. Further E are hostels and Peabody flats, replacing a warren of slums of which some dated from the first development of *c*. 1621.

Coming from the E, past the blocks on Millbank, the s side has NORTH COURT, flats of 1924–5 by *Matthew Dawson*, with polygonal piers and a big simple cornice à la Lethaby. In the hall a reset compartmented ceiling, said to be late c17, from a house formerly on its back land. Not all its details ring true. More domestic in scale are *Lutyens*'s big boxy houses diagonally opposite (No. 8 Little College Street, and No. 10). Built 1911–12 for the Hon. Francis Maclaren, brother-in-law of the gardener Gertrude Jekyll, and his sister, Lady Norman; restored as private houses *c*. 1997. Here, as at No. 7 St James's Square (*see* p. 627), Lutyens turned to the style of *c*. 1700 at its plainest, with fine thin red bricks, near-flush sashes and a shared hipped roof. (No. 10 has an oval staircase, and some original carved overdoors and fireplaces.) Then on the N side the backs of houses in Cowley Street (q.v.), on the s side the end of Lord North Street (*see* Smith Square).

A stretch follows mostly of earlier c20 offices, many with a Church connection. No. 35, s side (CENTRAL AFRICA HOUSE) was the Universities' Mission to Central Africa, still Neo-Tudor as late as 1928–9. By *H.J.S. Abrams*. The ARTS COUNCIL opposite uses the premises of the SOCIETY FOR THE PROPAGATION OF THE GOSPEL, vacated in 1987 and internally reconstructed. Of 1907–8 by *Sir William Emerson*, in a free Flamboyant Gothic style reminiscent of Caröe. Saint in a corner niche; on Tufton Street a relief of a ship off an unevangelized shore. Entry is made through *A.J. Driver*'s sympathetic extension of 1919–20, E. Inside, a big Gothic fireplace from *William Butterfield*'s offices of 1869–71 for the society in Delahay Street, levelled when the New Government Offices were made (*see* p. 270). Diagonally opposite is MARY SUMNER HOUSE (MOTHERS' UNION), by *Claude W. Ferrier*, 1923–5, orthodox red brick Neo-Georgian. Its CHAPEL, reordered 1985, has modest *Whitefriars* glass, 1946 and 1951.

To the w the character changes, signalled by EDWARD ALSOP COURT on the N side, a brick-faced Salvation Army hostel of *c*. 1996, and the old Department of the Environment site on the s (*see* Marsham Street). Then St Matthew and its

outliers, followed by mostly 1970s–80s offices. On the N side then appears part of the ABBEY ORCHARD ESTATE, the first of an expanse of PEABODY ESTATES stretching N and S. Those on the N side are mostly yellow brick of 1881–4, to *H.A. Darbishire*'s design ('familiar but none the less detestable', Pevsner thought). The HORSEFERRY ROAD ESTATE on the S side, 1922–*c*. 1926 by *Victor Wilkins*, adopts a friendlier red brick style with double-pitched gables, but is likewise arranged round a long narrow court. Retracing our steps a bit, the C19 estates extend N up PERKIN'S RENTS, except for the blocks on the S corner: by *Wilkins* again, r., *c*. 1935, and *Robert O'Hara Architects*, l., 1996–8. The latter has nicely striped brick facing, and steps back to preserve a little late C19 pub. It goes with the OLD PYE STREET ESTATE, accessible from St Matthew Street, parallel to the W. This is standard *Darbishire* Peabody work of 1879–82 in the S part, but its N part, also by Darbishire, is artisan lodgings of as early as 1862, built by the City financier William Gibbs (called Rochester Buildings). The chief differences are shaped gables on their outer N and E ranges, and infilled doorways to what were internal ground-floor access corridors. At the crossing with Old Pye Street yet more Peabodies of the 1880s appear to the r.: the main ABBEY ORCHARD ESTATE, a long unbroken range six storeys high. On its far side further blocks surround an unusually spacious courtyard, with the NW block treated externally as a big curve – a rare sight in Peabody-land. To its W, facing Abbey Orchard Street, a stumpy office tower by *Peter Wood & Partners*, 1965–9, with strong verticals, pebbly finishes, and the canted corners typical of the later 1960s. On the NW corner of Abbey Orchard Street and Old Pye Street a building in prettily diapered brown brick by the *Tooley & Foster Partnership*, *c*. 1989: tall office section, lower rear wing for housing.

p. 65

GREAT SMITH STREET

Laid out in the late C17 along the old winding boundary of Thorney Island, by Sir James Smyth. It turns S from The Sanctuary (*see* p. 277) at the E end of Victoria Street (q.v.). On the E SIDE the tall backs of Dean's Yard. Only two of these make a show here. *H. & P. Currey*'s offices for Queen Anne's Bounty, 1899–1900, is a tall Neo-Tudor oblong of Portland stone with a little bronze relief of the founder. Further S is *Baker*'s Church House, with its flint-faced ground floor (*see* p. 201). A typical mixture of London styles on the W SIDE. No. 14 (ORCHARD HOUSE), dated 1898, has *Doulton*'s terracotta delicately modelled by *W.J. Neatby*, Art Nouveau in flavour, including two gorgeous peacocks. It was gutted to make a big atrium block designed by *Gibberd, Coombes & Partners*, 1988–92, along with Nos. 16–26. New part behind with brick-faced verticals. The other retained fronts are as follows. Nos. 16–18, 1919–20 by *H.J.S. Abrams*, tall and raw, with repeated flat oriels (built for the Labour Board and Office of Works). No. 20 by *Trehearne & Norman*, yellow stone,

typical 1925. *Palgrave & Co.*'s Nos. 22–26 (PARK HOUSE), 1904, red and busy, of pink terracotta, made by *Hathern*. Next a former Public Library by *F.J. Smith*, 1891–3 (designed 1888), in a kind of Germanic Jacobean. In 2001 adapted as a restaurant, preserving some rare original fittings. The l. part joined on to public baths behind (demolished; *see* Westminster Archives Centre). It has reliefs of swimmers by the young *Henry Poole*. Nos. 36–40, *c.* 1725, three-storey houses like those around Smith Square. No. 35 opposite is the former National Library for the Blind, plain Neo-Georgian of 1925–7 by *S. Tatchell*.

HORSEFERRY ROAD

Named truly from a ferry for horses, which operated from at least the C16 until the C19. It crossed over to Lambeth Palace, whose occupant the Archbishop of Canterbury received the tolls. The road is a long architecturally incoherent L-shape.

From Lambeth Bridge and Millbank, the first buildings are big interwar blocks. ERGON HOUSE, N side, was electricity-company offices, of 1927 by *Stanley Peach*. Bronzed infilling between the piers from remodelling of 1987–8 in connection with work on Nobel House, Millbank (q.v.). On the S side the giant-pilastered HORSEFERRY HOUSE, 1933–4 by *E.G.W. Souster*. Next to it, set end-on overlooking St John's Gardens, are the two brick-faced slabs of the old WESTMINSTER HOSPITAL (closed 1993), by *Lionel Pearson* of *Adams, Holden & Pearson*. The E block (1937–9) housed the wards, the W block the medical school and nurses' home (1935–6), linked by tunnel under the gardens. Technically the hospital was interesting for its concern to eliminate noise, for organizing patients in specialist rather than general departments, and for being poison-gas-proof. On the E block the spur wings mark the wards, the big windowless upper projection the chapel. In 2003 being reconstructed for flats. The W block looks less utilitarian since 1996–9, when *Twigg Brown* converted it to flats for rich people, cutting big bronzed bows into the recesses. This was the fifth site for the hospital, now based in Chelsea, since its foundation in 1720. ST JOHN'S GARDENS, established in 1731 and enlarged in 1823, were the burial-ground of St John Smith Square (q.v.). In 1884–5 laid out with radiating avenues. *Twigg Brown*'s lodge and fountain of 2000 are feebly traditional. On the E side the MONUMENT of *Christopher Cass* †1734, Master Mason to the Ordnance. Probably his own design. A niched sarcophagus with a segmental lid, thought to be the earliest granite structure in London.

Back on the N SIDE, DEAN BRADLEY HOUSE is by *Wimperis, Simpson & Guthrie*, 1937–8, satisfyingly plain grey brick, with a loggia of shops and big arches at the office entrance. Next to it the former MR FEGAN'S HOUSE, free Neo-Wren of 1912–13 by *A.E. Hughes*. It sheltered destitute working lads, who were assisted to emigrate to Canada. On the opposite

corner of Tufton Street is the Westminster Magistrates' Court (q.v.), followed by the old Department of the Environment site (*see* Marsham Street). This faces GREAT MINSTER (Government offices, s side), flashy and portentous Postmodern by the *T.P. Bennett Partnership*, 1988–92. Opposite its far end are Nos. 88–94, little 1820s houses probably built by *John Johnson*, and a Baptist Church (q.v.). Back on the s side are the Coroner's Court (q.v.), and then the open triangle called REGENCY PLACE. The high ground here may have been the original 'Toot Hill' or lookout from which Tothill Fields, the area through which the road runs, took its name.

After Regency Place the road bends N. On the inner corner is the Sacred Heart Chapel (q.v.), followed by Nos. 114–122, small houses with shops, *c.* 1830–40. They face the LONDON SCOTTISH REGIMENT HEADQUARTERS (No. 97), symmetrical Postmodern of 1986–8 by *Duncan Cardow* of *T.P. Bennett & Son*, nicely alert to classical barracks traditions. Its red-brown brick facing has an applied portico of giant pilasters, with capitals made of ten cogged courses. Reconstructed inside is the iron-framed DRILL HALL, the most interesting part of the previous premises at No. 59 Buckingham Gate (q.v.), of 1882–6 by *J. Macvicar Anderson*. It has been reduced from five to three bays, but keeps the structural system by which two upper gallery storeys hang from the roof trusses, leaving the floor unobstructed. *Matthew T. Shaw & Co.*, who supplied the ironwork, are likely to have developed its detailed design. Also transferred were a Doric portal and three large WAR MEMORIALS. That for the Boer War, 1904, has a little figure of Queen Victoria probably by her daughter *Princess Louise*. Next door is GRENADIER HOUSE, offices of 1985–7 by *Renton Howard Wood Levin*, brick-faced with leaded oriels.

The CHANNEL 4 HEADQUARTERS, opposite, is the big post-war event in Horseferry Road. By the *Richard Rogers Partnership*, 1991–4 (competition 1990), their first big London job after Lloyd's in the City. The engineers for the structure were *Ove Arup & Partners*, for services *YRM Engineers*. Here are the same excitement in technology, precise and explicit use of materials, and separation of services from spaces served that made Lloyd's a canonical High-Tech monument. The plan is more conventional, however, and the detailing sparer and more delicate. Entrance is made in the angle, through a big glassy concave quadrant which gives away some of the inner workings to passers-by. Two five-storey wings, nearly matching, extend back at right angles; at the joins strip-windowed stairtowers with rounded ends. The cladding is mostly grey steel, but the l. wing has exposed red-ochre-coloured framing, the r. wing a service stack rising asymmetrically and stuck with masts and aerials, of the same red ochre colour – a match for that of the Golden Gate Bridge in San Francisco. The wings are concrete-framed with rounded uprights, and at the far ends more stair- and lift-towers (with external glass-box lifts). As one approaches, the ground by the entrance rises and then opens as a kind of moat lighting a basement lobby, with a bridge across it. Over this hangs a canopy, stayed by thin rods from

120

the parapet. At the back the quadrant shows its convex side, with a canteen below, overlooking a new garden (accessible from Medway Street, s). A plaque here commemorates the Westminster College (Methodist Training College), of 1849–51 by *James Wilson* of Bath (chapel 1872), once on the site.

To the E in MEDWAY STREET, built under the same outline plan as Channel 4, are some perfunctory private flats, and (up Arneway Street, N) the much better NORTON HOUSE, sheltered flats by *Levitt Bernstein Associates*, 1993, with details evoking advanced 1930s work. On the N side otherwise early C20 private housing: the Neo-Georgian No. 12 by *T. Phillips Figgis*, 1929, for the Hon. Paul Methuen, Nos. 13–16, flats in late C17 style with double staircases, probably by *Horace Field & Simmons*, 1912. The s side has tall brick buildings, *A.M. Cawthorne*'s Nos. 26–27 (FRIENDS OF THE CLERGY CORPORATION), 1936, with an odd Modern Dutch frontispiece, and No. 33, a women's hostel by *H.W. Binns*, 1933. Back by Horseferry Road, Nos. 44–46, tiny houses of *c.* 1815–20.

Continuing N, the flank of the Grey Coat Hospital appears on the l. (q.v.), a Peabody estate on the r. (*see* Great Peter Street). The line of Horseferry Road continues N to Victoria Street as STRUTTON GROUND, built up from *c.* 1616. The derivation is from Stourton House, the later name for a house built by the 10th Lord Dacre in the mid C16 to the N. Just two unpretending runs of mostly C19 buildings.

MARSHAM STREET

Called after Sir Robert Marsham, landowner of the N part in the late C17. A plaque lettered 'This is Marsham Stret 1688' survives (currently in store). In the s part mostly big interwar blocks, with none of the comfortable domesticity around Smith Square just to the E. The description is from N to s.

The vast DEPARTMENT OF THE ENVIRONMENT BUILDING, vacant since 1995, filled the NW quarter until demolition in 2002–3. This spectacular failure, the very image of faceless bureaucracy, was of 1963–71 by the *Ministry of Public Building and Works* (architect *Eric Bedford*), supervised by *Robert Atkinson & Partners*.* It had three twenty-storey slabs and five lower wings, with exposed concrete framing, set on stilts above a podium slab. The foundations incorporated remains of two GAS HOLDERS, built after 1875 for the Gas Light & Coke Co., and adapted as Home Office bomb shelters in 1940–1 (the company built the first gas works in the world here, in 1812). The slabs, meant originally for separate ministries, proved inefficient for use by one. Nor did their framing – of a new 'box-shell' system, mixing precast and *in situ* concrete – last very well. By 1990 repairs were costed at £50 million, and in

* *Atkinson* himself made very different designs for the site in 1936 (offices for the Gas Light & Coke Co.), and again in 1949, for ministerial premises, on which work stopped at basement level in 1952.

1992 its abandonment was announced. A competition in 1996 failed to produce a satisfactory outcome, and a low-rise complex planned by *Terry Farrell & Partners* is now intended, including new headquarters for the HOME OFFICE.

On the E SIDE, beyond the former Ninth Church of Christ Scientist on the E side (q.v.), some routine private brick-faced flats of 1998–9. A low passage in them shows where MILLICENT FAWCETT HALL, the chief surviving building connected with the women's suffrage movement, remains within. This is by *Douglas Wood*, 1927–9, an unassuming design with a stone Ionic doorcase, built for the London and National Society for Women's Service. (Barrel-vaulted hall, with library attached; former restaurant below, with freely detailed columns; in 2000–1 modified for a theatre for Westminster School by the *Braithwaite Partnership*.) Then ROMNEY HOUSE, a very large near-islanded office block, mostly red brick, with spare canted bays and a big arched entrance. By *E. Frazer Tomlins* and *Michael Rosenauer*, built in three phases 1931–9. In 2000–2 it served as the first home of the Greater London Authority.

The land to the S of Horseferry Road was bought by Associated London Properties and cleared and rebuilt in the 1930s. Their architects were *T.P. Bennett & Son*, whose blocks are big and brick-faced, mostly with the new horizontal windows, and scarce enrichments, Modern to modernistic. They are: E side, NEVILLE HOUSE, offices of 1937 (replacement proposed), WESTMINSTER GARDENS, ten-storey flats of 1935–6 with double cross wings and a big open semicircular entrance, and MARSHAM COURT opposite, 1934–6, more flats (the faintly Neo-Regency pub N of Marsham Court is by *Sidney C. Clark*, 1937). S of Westminster Gardens, a CHILD WELFARE CENTRE of 1931, characterless stock brick, but with a signboard by *Lutyens*. At the S Marsham Street bends E, through the outskirts of the Millbank Estate (q.v.), into JOHN ISLIP STREET. In its N part were two more 1930s blocks, replaced in 1985. The old names were kept – ABELL HOUSE (W side) and CLELAND HOUSE (E side) – as was the old firm, i.e. *T.P. Bennett & Son*. Big triangular piers, all-over mottled brown stone facing, and a forbidding air. S of Cleland House, a multi-storey hotel was approaching completion in 2003, by *Bennetts Associates* (no relation). N of Abell House, with its long side on Page Street, offices for DEFRA, remodelled in 1998–2000 by the *Fitzroy Robinson Partnership* from a Westminster Hospital slab of 1964–6. Flat glazing, with a few triangular corner stresses.

MILLBANK

It curves SW from near the Palace of Westminster to Vauxhall Bridge. Named from the Abbey Mill, mentioned in the rate-books in 1565. This stood opposite the end of Great College Street until after 1650, when building began to spread S along the bank. The Grosvenor family lived in a riverside mansion

s of Horseferry Road, begun *c.* 1663 for their ancestor Alexander Davies, modernized *c.* 1732 and *c.* 1785, and levelled in 1809 to make a road to the Millbank Penitentiary (*see* below). The embankment made in front of this penitentiary was followed by that for the new Palace of Westminster. Wharves and jetties survived between them until 1880 (N) and the 1900s (s, embanked under the Westminster Improvement Act of 1900, engineer *E.H. Tabor*). The latter work also greatly extended the tree-lined VICTORIA TOWER GARDENS, on the cleared land N of Lambeth Bridge (1912–13). By its N entrance the MONUMENT to Emmeline Pankhurst, 1930 by *A.G.Walker*. Extended by a crescent wall with a medallion by *Peter Hills* of Dame Christabel Pankhurst, 1959. On the lawn *Rodin*'s STATUE of The Burghers of Calais, the last of four versions, cast *c.* 1912 (originally of 1895; erected 1914–15). A turning composition of emaciated figures, inspired by Froissart's story of the besieged city in 1347. Resited in 1959, and placed on a low instead of a high pedestal; Rodin had wanted a site directly in front of Parliament. Further s, *S.S. Teulon*'s weighty FOUNTAIN of 1865–6, an octagonal Gothic house of stone, designed with the amateur architect *Charles Buxton* MP. Roof of bright patterned enamelled iron plates, made by *Skidmore*; carving by *T. Earp* (both restored 1980, the figures recast in replica). It commemorates Buxton's father Sir T.F. Buxton, a slave-trade abolitionist and prison reformer. In Parliament Square until 1949; re-erected here 1957. At the s end a big stone playground SEAT carved with Epsteinish sheep, 1923.

The BUILDINGS of the N part of Millbank are huge early C20 office blocks built on land owned by the CHURCH COMMISSIONERS, themselves accommodated at *W.D. Caröe*'s No. 1. This was the earliest, of 1903–6: stone-dressed brick, with nice scrolly details and wildly asymmetrical façades. Much steel framing was used. The parts were separately let, hence the auxiliary entrances. Stepped windows on the N end light a black marble staircase with typically wilful Caröe details, made claustrophobic by an inserted lift. Modernized *c.* 1989. Next No. 4, the former Crown Agents, by *Simpson & Ayrton*, 1912–16 (NW extension 1920). Of stone, with a massive angle tower of Wren derivation, and a unifying Doric entablature. Reconstructed in 1989–91 by *Omrania* with television studios and an atrium with a restaurant. No. 7, WESTMINSTER HOUSE, is of 1913–15 by *Gunton & Gunton*, for the British-American Tobacco Co. Still Edwardian in its pavilion roofs and all-over decoration, outswept oriels, etc. Its advanced steel frame allowed unobstructed spans of up to forty feet. Extended on to Smith Square 1929.

After Dean Stanley Street come stone-faced office blocks of uniform but not identical design, the biggest London had yet seen, by *Sir Frank Baines* of the Office of Works. The first, Nobel House (1927–9), was for the newly formed ICI; Thames House, s of Horseferry Road (1929–30), was for various users, but is now Government offices. Their allegiance is still to the Imperial Neoclassical tradition of Lutyens and Baker, with

their occasional balconies or aedicules and columniation right at the top, below the large hipped roofs. They are composed with the no less Imperial Lambeth Bridge, between (q.v.), from which they look impossibly solid, like sculpted cliffs. Pevsner deplored their effect, by contrast with the varied and dramatic outline of the Houses of Parliament; but the off-the-peg Modernism on the Albert Embankment opposite (*see London 2: South*) makes them appear almost masterly.

NOBEL HOUSE cost £1,000,000, rises some forty-five feet above the usual London cornice line, and measures twenty-seven bays, plus seven in the splayed s corner. *Alfred Cox* was the associated architect. Creetown granite faces the lower parts. High up, statues of chemists by *C.S. Jagger*. Doors with fine sculpted panels by *W.B. Fagan* illustrating scientific advances, of a silvery nickel-copper alloy developed by ICI. More alloy doors face Smith Square, behind, where a brick-faced part of Nobel House looks in at the SE angle; the vehicle entrance is in Dean Bradley Street, of stone. In 1987–8 the block was subdivided by the *GMW Partnership*, and the Ministry of Agriculture (now DEFRA) took over one part. Here are some interiors in a Wyatt style, e.g. the barrel-vaulted restaurant, now partitioned; others Neo-Wren, with burr walnut panelling. THAMES HOUSE, also with sculpture by *Jagger*, suffers from a nasty cheese-coloured tiled roof. A big archway one-third of the way down was infilled in reconstruction by the *GMW Partnership* for MI5, 1990–2.

Next the MILLBANK TOWER of 1960–3, built for Vickers, by *Ronald Ward & Partners* (first designs 1956; job architect *Douglas Marriott*, engineer *G.W. Kirkland*). One of the few London office towers to have won affection, designed evidently in rivalry with the Shell buildings on the South Bank, but with none of their boxy dead weight. Its thirty-two storeys, 387 ft (118 metres) high, were briefly the tallest in London. Concave-angled sides to E and W, convex-angled sides to N and S, and superior curtain walling to reflect the ever-shifting riverside light. A two-storey podium follows the street, largely open below. At the N end, lying back, an eight-storey T-shaped block with three concave sides, and to the W of this drab eleven-storey flats facing John Islip Street. The structure is of reinforced concrete. Since remodelling by the *GMW Partnership* in 2000–1 the lower levels are friendlier to walk in and less obviously designed for a four-wheeled getaway.

Next come the Tate Gallery and the former Royal Army Medical College (qq.v.). Then Nos. 46–57, a nice symmetrical terrace of *c.* 1845–6, introduces *Thomas Cubitt*'s great enterprises, which extend from here into Pimlico (*see* pp. 762–3). In 1985 a bronze SCULPTURE of a male dancer was affixed, by *Enzo Plazzotta* (1975). Cubitt's terraces continue to the N in PONSONBY PLACE and PONSONBY TERRACE, plainer, of brick above stucco. Refurbished in the later 1980s with some facsimile infill, as part of the Crown Estate redevelopment centred on Bessborough Gardens (*see* Vauxhall Bridge Road, pp. 785–7). On the corner with Ponsonby Place the tall MORPETH ARMS pub, also 1845, with a pretty back addition

by *William Hunt*, 1898. For the C20 offices by the river *see* Vaux-hall Bridge Road.

Over the road an abstract *Henry Moore*, Locking Piece, 1964 (installed 1968), suggested by two pebbles the artist found which fitted together. Bleak, dingy setting, with a fountain surrounded by big sunk hexagons. Near it a big cylindrical MOORING STONE, reset from the river steps of the vast MILL-BANK PENITENTIARY. As completed in 1821, this covered the sites of the Tate Gallery, its military escorts on either side, and the Millbank Estate behind (qq.v.). It was the first national rather than county prison, the largest one in Europe when new. The marshy site brought much trouble to the builders and no health to the inmates. *Thomas Hardwick* began it, to designs by his pupil *John Williams* (†1817), winner of the competition in 1812, but the foundations failed. *Sir Robert Smirke* took over in 1816, beginning again on a concrete base and to a different design. The hub was a hexagonal court centred on a twelve-sided chapel, surrounded by six pentagonal courts within an octagonal wall and moat. Its angle turrets gave it, according to the critic James Elmes, the look of 'a continental fortified château'. The 1,100 cells were planned on the isolation principle, rather than the Panopticon promoted so tirelessly by the philosopher Jeremy Bentham, with its perpetual central surveillance. Closed 1890; demolished 1892–3.

MILLBANK ESTATE
John Islip Street, and to the north-west

Here in 1897–1902 the *LCC* for the first time built working-class 89 flats on the largest scale (4,430 people) which were humane and pleasant to look at. Many of the motifs had already appeared at the Boundary Street Estate in Shoreditch, of 1897–1900 (*see London 5: East and Docklands*), but Millbank pushed the standards of design still higher, with a conscious sense of making a showpiece for London. Facilities were better too, with mostly self-contained flats and no shared lavatories or sculleries.

The PLAN is symmetrical, aligned on the axis of the Tate Gallery and turned towards what passes for its w façade. Blocks radiate symmetrically from a central garden oblong. The angled outer boundaries are those of the old Millbank Penitentiary (*see* Millbank), the site of which was earmarked for public housing by a Royal Commission in 1885; the road plan was settled in 1896. All streets are tree-lined. The blocks vary in shape – straight, cranked or U-plan – and in size. The courtyards between, later relieved by planting and other improvements, were much roomier than what the mansion-block residents of Victoria were being supplied with.

Architecturally the scheme is more consistent than was planned in 1897. In that year the *LCC* (under *W. E. Riley*) was instructed to design blocks for 1,200 people only, and a competition was held for the remainder. But the winning entry, by *Spalding & Cross*, was deemed too expensive, and so the LCC did

the rest too. The results are agreeable, in spirit and materials comparable to the best Arts-and-Crafts designs. Red brick is used, sometimes with white render above, with segment-headed windows on four storeys. Staircase windows are placed with easy logic in ascending rows. Steep roofs, with dormer windows and big gables, within which were lofts for drying clothes. The earliest block, HOGARTH HOUSE in the centre of the NW range (1897–9), stands out for its darker brick bands, polygonal turrets and roof-slates rather than tiles. It was designed by *R. Minton Taylor*, after his Cookham House on the Boundary Street Estate. Taylor designed or oversaw all the other blocks except GAINSBOROUGH HOUSE on the SW edge, for which *C.C. Winmill* signed the drawings. Parts of RUSKIN HOUSE and TURNER HOUSE, facing the gardens, were rebuilt differently after bomb damage of 1941. As at Boundary Street, the scheme included two SCHOOLS by the *London School Board Architects*, dated 1901. They stand on either side of Hogarth House, non-matching, with more ornament than the flats.

OLD QUEEN STREET

Built up *c.* 1700 on land owned by Thomas Sutton, along the line of an older lane S of St James's Park. Interesting for its private houses, which carry on from Queen Anne's Gate, just to the W.

Starting from Queen Anne's Gate, the S corner is early C19 (No. 43), convex, with a shopfront of 1897. Across the way COCKPIT STEPS lead down to Birdcage Walk. They are of 1964, a rebuilding of late C17 steps associated with the 'royal' cockpit (dem. 1810), which was heir to that at Whitehall Palace (*see* p. 234). Nos. 26–34, late C18 with central staircases, have big bows or bays facing Birdcage Walk, where some rise a full seven storeys from the basement.* Several share a curious quasi-Doric cornice of brick. Nos. 30–34 date from *c.* 1774–80. On No. 34 a Doric doorcase (mid-C20?), with columns doubled in depth. Semicircular staircase, with S-pattern balustrade; some good plasterwork. No. 32 has a flat oriel and top storey added in 1912; Nos. 26 and 28 have round-arched first-floor window surrounds. No. 24 is older, *c.* 1690–1700, neutral-looking after late C18 reconstruction. Doorcase of the type of *c.* 1700, probably added 1896. On the S side big over-stretched Neo-Wren offices of 1918–19 (Nos. 25–41) by *C.J. Chirney Pawley*, executed by *H.J.S. Abrams*.

Smaller properties to the E, where the street narrows. No. 20 is by *F.W. Troup*, 1909–10, a funny little two-bay house built for Henry Spicer, of red glazed brick. Characteristic Troup detailing to railings and leadwork. Taller behind, where it joins the parade of bows towards the park. Nos. 9 and 11, S side, are of *c.* 1700, with the transitional feature of gabled rear wings (visible from Lewisham Street, behind).

* Richard Garnier attributes them to *Sir Robert Taylor*.

PAGE STREET

A long straight E–W street of entirely C20 buildings. The highlight
is the GROSVENOR ESTATE, unusually interesting housing 110
of 1929–35 by – of all people – *Lutyens*. It was built jointly
with Westminster City Council, replacing poor housing desig-
nated for clearance after the Thames flooded it in 1928. 616
flats were provided, in seven blocks of five or six storeys, set
parallel and end-on.*They are of U-plan with plain long bands
of balconies around large internal courtyards. On the outer
faces Lutyens relieved the visual austerity by simply linking the
sashes diagonally by white rendered oblongs, making a pretty
chequerboard pattern against the silver-grey brick. This, it
might be thought, is Lutyens at his most modern – and yet the
blocks have classical doorcases, and are punctuated by neat
little stone-dressed lock-up shops, pyramid-roofed or rusti-
cated, and classical gatepiers. The two smallest blocks, com-
pleted in 1930, lie to the S onVincent Street. They face a garden,
made after parts of the two largest blocks were demolished
c. 1970. Lutyens is said to have snatched the estate from under
the noses of *Ashley & Newman*, who did the much more con-
ventional SCHOMBERG HOUSE, 1926–7, between Page Street
and Vincent Street immediately to the W. Further W again
and also in parallel are three blocks linked by arched screens,
1902–4 by *Joseph & Smithem*. Plain big gables, rationed Art
Nouveau trim, red Leicester brick. Built for Westminster
Council, the first multi-storey flats erected by any of the new
Metropolitan Boroughs. For Dalkeith House, on the S side
of Vincent Street, *see* Regency Street. Behind it a large com-
plex by *Assael Architecture* is under construction in 2003: 155
private flats, 39 'affordable' ones, and an ambulance station, in
different-sized blocks with gardens between.

PALACE STREET

A street pieced together from four older streets or alleys after
the mid C19, which seems to change character from corner
to corner. Coming from the S end, first the Westminster City
School (q.v.). Then some artisans' dwellings, built in 1882–3 87
for employees of Watney's Brewery, which filled the site of Stag
Place on the W (q.v.). One four-storey block with open-air
staircases faces Palace Street; another, less plain and with a
lower wing which housed a club, runs down CASTLE LANE,
where it faces a third. Behind the last is a two-storey block of
flats by *CGHP Architects*, 1988–91, thumbing its nose at utili-
tarian preconceptions of social housing. The external staircases
and balconies are sheltered by glazed verandas, a burlesque
of Hector Guimard's famous Metro exits in Paris. The front
is gently cranked, so the whole flounces even more. Further
up, N side, a former school (LCC), 1931 by *E.P. Wheeler*, a

*Yet more blocks were intended at one point, stretching E to the river (*The Builder*
138, 1930, p. 572).

big flush block with jazzy tilework (now WESTMINSTER KINGSWAY COLLEGE). The buildings opposite belong with the Westminster Chapel (q.v.).

Back in Palace Street, No. 43 was built by *J.F. Bentley* in 1880–3 as the presbytery to the former ST PETER AND ST EDWARD CHAPEL (R.C.). Bentley's is a nice free composition on a small site, very handsome in its modesty. Yellow brick with red dressings, segment-headed windows, some laced by vertical red bands. The former CHAPEL faces Wilfred Street behind. Built as a mission chapel in 1856–7, at the instigation of the future Cardinal Manning, but in 1857–8 heightened and floored across so that the lower space could serve as a school. This explains the strange proportions, though not the choice of a round-arched style by its architect, *W.W. Wardell*, usually a Gothicist. It is too plain to be called Italianate, just yellow brick with red trim. Top windows round-headed, set over paired round-headed windows (the clerestory of the first chapel), the windows below originally also of two lights and with blind, not glazed, relieving arches. Closed in 1975; converted to offices in 1990 by *Clarke Renner Architects*.[*]

After Wilfred Street the character changes, and small Late Georgian and Neo-Georgian houses appear. The flank of No. 1 Buckingham Place is Neo (*see* Catherine Place, where the same *soigné* mixture continues). After that a terrace of mostly real Georgian houses (Nos. 23–33). On the far corner of Catherine Place Nos. 17–21, an oddity of 1929 by *Percy C. Boddy*. Red brick-faced in perverse herringbone patterns, with metal Neo-Regency shopfronts. Typical mansion blocks of *c*. 1900 mark the corners with STAFFORD PLACE. This has on its E side, after *G.W.H. Hamilton*'s STAFFORD MANSIONS of 1902, some houses of *c*. 1800 (Nos. 14–20), then simple mews of *c*. 1860 made in connection with Buckingham Gate (q.v.). Finally in Palace Street the WESTMINSTER THEATRE (burnt out 2002; demolition proposed), a small theatre of bizarre ancestry. The forbidding or perhaps rather enigmatic exterior is by *John & Sylvia Reid*, 1965–6. Brick with a rounded corner, faced with thin vertical strips of grey Merioneth slate. Slit windows to the N, and near the top to the N and E. Storeys added 1971–3. Wrapped inside was an eclectic classical auditorium of 1923 by *J. Stanley Beard*, made as a cinema and adapted for theatre in 1931. It was converted from a proprietary chapel built in 1766 for Dr William Dodd, a Royal Chaplain later hanged for fraud; its shell remains, invisible, within. The 1960s work was for Moral Rearmament, who presented didactic religious dramas here.

QUEEN ANNE'S GATE

This street with its outstanding C18 houses began as two closes, Queen Square (w) and Park Street (E), separated until 1873 by a wall and railings. Park Street was laid out first, *c*. 1686, but was largely rebuilt in the C18.

[*] Removed, two early altars by *Bentley*, 1863 and 1867, and a colourful font of *Doulton* porcelain (now in the Victoria and Albert Museum).

The Queen Square part keeps its houses of *c.* 1704–5, which are of uniform design, and the best of their kind in London. They are thought to have been undertaken by or for Charles Shales, a goldsmith, who also provided a small chapel at the SW (demolished). The three groups are Nos. 15–25, S side, Nos. 26–32, N, and Nos. 40–46, at the W end where the street turns S. They are of brown brick, with straight-headed sash windows set flush, and stone bands to mark the storey divisions. Their width varies from three to five bays, and some have an additional half-bay or bays with a very narrow window or blind window. These bays and their even-storeyed proportions mark them as of the pre-Georgian or pre-Palladian era. Their ornament too is of a type soon eclipsed: keystones carved with grotesque heads, and bracketed wooden door-hoods with three pendants connected by shallow segmental arches, with intricate all-over foliage carving. The interiors were panelled, and much of this survives, with some C20 reinstatement. Staircases have twisted balusters.

Of individual houses, the L-shaped No. 15 (S SIDE) marks the SE corner of old Queen Square. Against its N wall stands a creditable STATUE of Queen Anne on a Baroque pedestal, first recorded in 1708 against the wall on the E side of the square. Restored *c.* 1862. Nos. 15 and 17 preserve their three-storey height, eaves cornices and hipped roofs, but No. 15 has a doorway of *c.* 1800. Its inside was remodelled in 1908 by *Lutyens* for Edward Hudson in simplified Neo-1700 style.* Nos. 19 and 23, both heightened after 1850, are near-intact within; No. 21 was reconstructed *c.* 1980, with a facsimile doorcase. On the N SIDE the houses are larger, with staircases of the front-hall open-well type and back stairs behind. No. 26 was restored by *Blow & Billerey* in 1924, though the doorcase and staircase are original. The park elevation has been extended outwards. No. 28 is also restored, by *Aston Webb & Son* for Mr and Mrs Ronald Tree (1929); a copy was provided of the original doorcase in the Victoria and Albert Museum collection. Another facsimile doorcase at No. 32, of 1991. No. 34 is early C19, with three bays of segment-headed windows. Altered *c.* 1901 by *E. W. Sloper* and *Sir Ambrose Poynter*, then extended for Sir Edward Tennant by *Detmar Blow* in 1909, when the big bow facing the park was also refaced. The addition (No. 34a) is lower, of solid flush-mortared Dutch brick.

To the W the scale is rudely broken by Nos. 36–38, *Ernest Runtz*'s premises for the Anglo-American Oil Company, 1908–10 (now NATIONAL TRUST). His big Baroque block, undisciplined in its composition, is in character, material, and design deliberately out of keeping with the rest. It sits in its own gardens, reached by a road just N of Nos. 40–46. These are again of *c.* 1704, as witness e.g. the key blocks on No. 42, but smaller and more marked by C19 stuccoing. The swollen complex to the S is the Home Office (q.v.).

The former Park Street begins just E of the statue of Queen Anne. On the S side here Nos. 5–13, three-bay houses of

*No. 17 was Lutyens's own office in 1910–31.

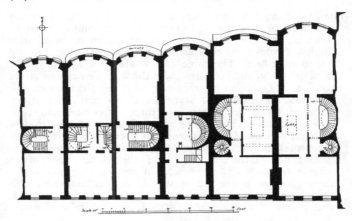

Nos. 14–22 Queen Anne's Gate. First-floor plan
(*The Survey of London*)

1770–1, mostly with matching Doric pilastered doorcases. The designer was *Emanuel Crouch*, Surveyor to Christ's Hospital, which held the freehold. Restored to residential use 1997–8. Old-fashioned interiors for the date, with dog-leg stairs and dentil cornices. The bow-backed row opposite, of 1775–8 (Nos. 14–24, N SIDE), are by contrast amongst the most advanced of their time in Westminster. Their form owes much to *Samuel Wyatt*, who designed at least No. 14 at the far E, and who was plausibly involved with the others.* Each has four nicely graduated storeys, and is slightly larger than its neighbour to the l., like Russian dolls designed to fit inside one another. Cemented ground floors with non-matching arched windows and doorways. On No. 18 an early C19 veranda. The barrel-vaulted entrances lead to fine spacious D-shaped or apse-ended staircases, toplit and set centrally. Nos. 14 and 16 have spiral back stairs in addition, and an extra room between front and back – an early appearance of top-lighting. Several ceilings boast inset paintings within fine twirling plasterwork of rinceau or vine-scroll type. The best documented is No. 14, where *Wyatt*'s client was the connoisseur Charles Townley. The ground-floor room to the park here has engaged Ionic columns of scagliola on three sides (the capitals adorned with little theatrical masks), big niches to display Townley's sculptures, and a swagged frieze with musical trophies. The first-floor parkside rooms at Nos. 20, 22a and 22 also have outstanding ceilings: painted leaf scrolls around the pictures at No. 20,

* *See* D. Cruickshank, *Georgian Group Journal* 2, 1992. On Nos. 5–13 *see* D. Cruickshank & N. Burton, *Life in the Georgian City*, 1990. (In the basement of No. 9, MIRRORS from the Bride of Denmark, a mock-pub built *c.* 1950 for the Architectural Press from salvaged Victorian fittings, with the signatures of *Walter Gropius* and other starry visitors.)

inset Neoclassical grisailles at No. 22a, rich tawny shades at
No. 22. Nos. 6–12, of 1836–8, make a symmetrical composi-
tion with Ionic porches and a continuous balcony. By *James
Elmes*, assisted by his son *Harvey Lonsdale Elmes*, for Charles
Pearson, the City Solicitor, who took No. 8 for himself. The
park fronts are stuccoed all over, with three bows and a small
pediment. Interiors mostly destroyed *c.* 1973, except for a
splendid Grecian sequence at No. 12, which was intended for
the Turkish ambassador. Four Greek Doric column-screens
stand between the entrance and the parkside room, with a
round-ended staircase opening off halfway.

Finally two houses of *c.* 1700, hidden by later remodelling. At
Nos. 1–3, s side, the old part forms the shell of the w end,
reworked by *S. Tatchell* in 1931. The C20 work was by the
builders *Holland & Hannen & Cubitts*, for themselves. Cubitt
arms appear on the big doorcase, good imitation Early
Georgian carved by *George Alexander*. No. 2 on the N side is
externally a stucco mansion of 1833–5, for Sir David Pollock,
but its w part incorporates a house first rated in 1696. To the
park it has a stacked-up central feature, rising from a canted
bay through a bow and a balcony to a little pediment.

REGENCY STREET

A long N–S street formed *c.* 1815, joining Horseferry Road with
Vauxhall Bridge Road (*see* p. 782). Now mostly C20 housing.

HIDE TOWER is the place to start, E of the SE side of Vincent
Square. By *Stillman & Eastwick-Field* for Westminster City
Council, 1959–61. When new it formed one of the sheerest,
most uncompromising towers of London, 160 small flats
212 ft (64.6 metres) high. The structure is largely precast
concrete, an early use (engineers *Charles Weiss & Partners*).
Completely smooth walls of precast units and large white
quartz aggregate panels. Long bands of fenestration. The base
has a recessed core with a Brutalist exposed staircase and
relatively slender pilotis. It gains greatly from standing free
and uncluttered.

To the E of Hide Tower is the little NAPIER HALL, 1904–5 by
Law & Allen, red brick with boxy dormers. Built as a clubroom
for *Blore*'s St Mary Vincent Square, cheap Commissioners'
Gothic of 1836–7 (dem. 1923). The w side has recent private
flats, then BRUNSWICK COURT by *A.F.G. West*, Westminster
City Council Architect, *c.* 1971, with flush brick walls notched
with balconies; DALKEITH HOUSE, to the NE in Vincent
Street, belongs with it. Continuing s, No. 56 on the w side,
like an LCC school, was the Electrical Engineer Volunteer
Corps' drill hall; 1900 by *W.C. Waymouth* (flats since 1999).
Then some unusual three-storey Church Commissioners'
housing of 1901, with triple windows with dumpy Tuscan
frames. In Chapter Street, r., it confronts the much more
spartan CHAPTER CHAMBERS, six-storey housing of 1877. At
Nos. 90–100 an efficient-looking block for the GREY COAT

HOSPITAL school, 1996–8 by the *Ellis Williams Partnership*. Four storeys, bright blue spandrels, external walkways. V-shaped plan, the rear wing near-blind and stone-faced towards Douglas Street, s. In the tall glazed entrance a silvery SCULPTURE of giant wings by *Diane Maclean*. Then bulky, downbeat housing on the E side: GLADSTONE HOUSE and PEEL HOUSE, police accommodation of *c.* 1902–10, the N and S parts apparently by *Dixon Butler*, and MIDDLETON HOUSE S of Causton Street, 1931–3, two Neo-Georgian ranges by *Cluttons* for the Church Commissioners. Down CAUSTON STREET, FAIRLEY HOUSE SCHOOL occupies the former St John the Evangelist of 1956–8 by *Caroë & Robinson*, nominal successor to St John Smith Square. An ungainly crossbreed, with a lean octagonal cupola.

ROCHESTER ROW

In origin a footpath through Tothill Fields, made in 1677 to join up with Willow Walk (now Warwick Way) on the way to Chelsea. Named from the Bishops of Rochester, many of whom were jointly Deans of Westminster. Fully built up only *c.* 1830–40.

Coming from the Vauxhall Bridge Road end, past a little gabled SALVATION ARMY HALL of 1908 (No. 97, E side), *Chapman Taylor Partners*' Nos. 78–102 appears on the W side. Low chunky brick offices and flats of 1973–6, showing Neo-vernacular influence. Flat oriels, twice jutting out, break up the length. Then on the E side a large law-and-order complex, mostly disused in 2003: a courthouse (No. 69), with a front of 1904 by *J. Dixon Butler*, a police stable block, and a police station of 1900–1 (No. 63), also *Butler*'s. His customary free Baroque, red brick with fluent oversized stone details. The courthouse has a rounded pedimental gable, the police station a triangular one. The stable block, 1867–8 by *T.C. Sorby*, looks under-dressed between them. Above the stabling was a hayloft, then married quarters, then – a last-minute addition – a storey for single men. (For the former magistrates' offices behind *see* Vincent Square.) The MILITARY POLICE DEPOT opposite was built as the Grenadier Guards' Hospital, 1859 by *William Munt*: originally L-shaped, with a forecourt to the street, infilled by 1916. Three forbidding storeys all of yellow and white brick, with unpleasant flat rustication.

The next buildings on the E side belong with Vincent Square. Westminster Kingsway College and St Stephen follow (qq.v.). These face the UNITED WESTMINSTER ALMSHOUSES of 1880–2, by *R.R. Arntz*, completed after his death by *Cole A. Adams*. It merged several foundations, housed in separate blocks facing a small lawn. The central house is quite grand, with shaped gables. It contained offices, an infirmary, and accommodation matching the old Butler's almshouses, of 1675, formerly in Caxton Street. Two-storey side ranges, their gable-ends with busts and reset inscriptions: the r. one for Emery Hill's foundation on this site (1679, the plaque of 1708), the l.

for James Palmer's, 1656, which stood next to Butler's. Behind
and to the r., a tall but tactful addition of 1987–9 by *Ian Grant*,
with a prow-like turret. Next EMANUEL HOUSE, by *H. V. Lobb
& Partners*, 1964–8, incorporating a multi-storey car park
(demolition proposed). On the E side Nos. 17–19, much more
attractive offices in brick and caramel-coloured cladding.
1985–6 by *Lister, Drew & Associates*.
The N part of Rochester Row opens into GREYCOAT PLACE,
where the Grey Coat Hospital, S side, faces the Fire Station on
the N (qq.v.). W of the latter is GREYCOAT HOUSE, a former
grocery warehouse for the Army & Navy Stores, 1899–1900 by
Reginald Blomfield. Upper storeys spoiled *c.* 1960. Blomfield's
marvellous squat Tuscan columns remain below. Facing, the
former Girls' Friendly Society offices, Neo-Georgian with a
nice sweeping corner; 1924–6 by *Wills & Kaula* (demolition
proposed).

SMITH SQUARE

Called after Henry Smith, who owned the land to the N. His
father, also Henry, provided the site for the centrepiece, the
tremendous Archer church of St John, of 1713–28 (q.v.). The C18
enclosure was irregular and more spacious, with streets entering
only from the N and E. Later, probably in the 1810s, it was
built up more closely. The S and W entrances date from after the
Westminster Improvement Act of 1900 (*see* Millbank). After this,
commercial palaces began to invade the E and S sides. C18 houses
remain on the N side, amongst the first to be gentrified in
Westminster, while the W side and the streets around have some
superior early C20 private dwellings. p.
680

On the N SIDE Nos. 6–9 and 3–5 are the original houses, E and
W of Lord North Street. The date of No. 5 is indicated by its
tablet: 1726. The builder was *John Mackreth*. All have tiled
hipped roofs and dormers. Nos. 6–9 and 4 are nearly identi-
cal, of brown brick with storey bands and red brick dressings,
Nos. 6–9 with segment-headed windows. On Nos. 4 and 7–9
distinctive rusticated doorcases with thin pilasters carrying
carved brackets. Good ironwork outside, at No. 5 with a
lamp bracket rising from the railings. Its doorcase by contrast
has Ionic demi-columns, bulgy frieze and pediment; also a
side doorcase, of mid-C18 type. Interiors are mostly typical
1720s: timber stairs with Doric column-newels, rooms with
angle fireplaces and panelling variously enriched according to
status, and closet wings. Nos. 1–2, making good wartime
losses, are plausible imitations by *Clyde Young & Bernard Engle*,
1954–6.
The houses go on up LORD NORTH STREET, also built by
Mackreth or his men. Some of them had previously worked in
and around Cowley Street immediately to the N (q.v.). Of
doorcases No. 11, E side, has one like those in Smith Square,
No. 19, W side, one with carved brackets. No. 16 was restored
to an C18 plan type in 1988 by *James Dunnett*. More original

railings, with torch extinguishers; also fading wartime signs for air-raid shelters. No. 2 has a N façade of *c.* 1907, after old No. 1 was demolished to widen Great Peter Street. On the opposite, w corner is COLLEGE HOUSE, built as a pair of grand red brick houses by *Oliver Hill*, 1930–3. Exaggeratedly vertical sashes; one slim triangular pediment each. Two arched doorways in the middle, of which one led originally to a court-yard with garages. They were undertaken by Robert Hudson MP, who himself took the E house; the other, formerly with extravagant Vogue Regency interiors, was for the 1st Lord and Lady Mount Temple. Hudson's retains a marble-lined stairhall with Swedish-derived, quasi-Ionic columns. Part of the same group two smaller houses down Gayfere Street, w (Nos. 22–23 there).

GAYFERE STREET takes us back to Smith Square. Both its sides have small houses of *c.* 1800–20, showing how much less smart the area was then (Nos. 17–21, etc.). Of C20 houses, Nos. 14–16 are of 1954–6 and go with Nos. 1–2 Smith Square, No. 12 is by *Oliver Hill* again, and makes a smooth Neo-Georgian group with his No. 40 Smith Square. The l. part is of 1924–5, another two-in-one composition. The r. part, with closer-set sashes, was added in 1934–6. Reconstruction after bomb damage has disturbed the original arrangements.

The w SIDE of Smith Square carries on without a break. Nos. 37 and 36, also bomb-damaged, were reconstructed in 1951 as flats and offices respectively. No. 37 is of 1925, by *E.A. Remnant* for Viscountess Grey of Fallodon. Its horizontals and general mood derive from *Lutyens*'s No. 36, of 1911 for Reginald McKenna of the Midland Bank. This is of thin grey brick with red brick dressings, Gibbs surrounds on the ground floor, and a continuous stone band like a tide-mark just below the *piano nobile*. Some interiors remain, e.g. the butler's room, with reset panelling and Doric pilasters halved either side of the wall recesses. Behind it in DEAN TRENCH STREET No. 3, also with flush-framed sashes, but with shutters giving a Continental look. *Herbert Passmore* built it for A.D. Power, 1923–4. No. 1, flats by *H.S. Goodhart-Rendel* for Sir Michael Adeane, turn the corner to Tufton Street. The date is as late as 1951–5, the style an odd and charming reprise of the Arts-and-Crafts manner of *c.* 1900. Segment-headed or oval windows and white-painted timber oriels break its great flush cliff of fine purple-brown brick. It replaced a bombed house also by *Goodhart-Rendel*, of 1912. The s side of Dean Trench Street has very solid houses to one design, dated 1913 to the square (No. 34 there). Cornice and doorcase of stone, quoins of the same dusty rose brick as the walls.

Then the commercial blocks begin, and these are less distinctive. No. 32 (the Conservative Party office), 1956 by *Gunton & Gunton*, is exhausted Neo-Georgian. Rather better are *Morley Horder*'s tall offices at No. 30 on the s side, of 1926, of fine thin brick. Behind it in DEAN BRADLEY STREET, w side, is THORNEYCROFT HOUSE, 1923 by *A.A.H. Scott*, with reliefs showing activities of the Thorneycroft firm. On the opposite

corner is old Transport House, built 1925–8 as the Transport & General Workers' Union headquarters, for which the LCC insisted on a Neo-Georgian treatment. By *Culpin & Bowers*, a weak design with a concave-sided entrance bow. The SE and NE angles are the backsides respectively of Nobel House and Westminster House, for which *see* Millbank.

STAG PLACE

Named from the old Watney's Brewery site, six acres replanned in 1959–64 by *Howard, Fairbairn & Partners*. It was the first such non-domestic precinct scheme to be finished in inner London. Traffic was limited to the relief road across the SW corner (called Bressenden Place). The architecture, planning and public spaces were thought disappointing even when new. In 2003 a campaign of rebuilding and re-landscaping is under way, by *EPR Architects* for Land Securities.

The climax of Stag Place is PORTLAND HOUSE (1960–2), a tower of 334 ft (101.8 metres), tapered towards its ends, after Gio Ponti's Pirelli tower in Milan (1955–8). Through-storey arches below, fins to hide the services on top. *T.P. Bennett Partnership* added the curving entrance in 1993, with two glass pavilions for access to a giant underground restaurant. Portland House stands just within the SW corner of the piazza, which is mostly obscured by ELAND HOUSE (DEPARTMENT OF THE ENVIRONMENT, TRADE AND THE REGIONS), offices by *EPR Architects*, 1994–5 (engineers *Ove Arup & Partners*), replacing a 1960s block. A novel shape for London: a slab sloping up from N to S, with a rear wing. Elevations with modular horizontal panels, part-glazed. Near the middle a full-height entrance atrium, carried over the top like a giant mono-pitch greenhouse, and protected by solar-activated screens. At the S end a solid prow and mast. These outlines owe much to *Richard Horden*'s competition-winning design for the site, of 1987. To its S a giant free-standing wind-baffle called Big Painting Sculpture, designed by the painter *Patrick Heron* and realized by his son-in-law *Julian Feary*, 1998. Large paint-splash panels, linked by a spidery green web, fixed to a rather too noticeable scaffold some 60 ft (19 metres) high. Of the other 1960s blocks, on the W side of Bressenden Place are ELLIOTT HOUSE and THE STAG, a small octagonal pub, both by *Trehearne & Norman, Preston & Partners*, and behind the pub CARRIER HOUSE by *CLRP Architects*; in the main piazza; ROEBUCK HOUSE, E side, flats by *CLRP Architects*. Office slabs on the N and S sides were demolished in 2002–3; the S replacement block will extend up to Victoria Street. An elevated public space will be made in the centre, replacing mid-1990s hard landscaping.

The STAG BREWERY, founded *c.* 1641 by William Greene, grew to become the greatest in early C18 London. Rebuilt 1797–1807

by *George Saunders*; adapted 1860 for James Watney; closed 1959. For the workers' houses *see* Palace Street.

TOTHILL STREET

The major W street of medieval Westminster, developed in the C14 by the Abbey, on whose W gateway it was aligned. In the C16 and C17 favoured for aristocratic houses, but slummy by the C19; extensively rebuilt after the Metropolitan District Railway was cut through in 1864. Mostly C20 buildings, beginning at the E end on the N side with CAXTON HOUSE (Government offices, but built speculatively). An individual design by *Chapman Taylor Partners*, 1974–9. Large and symmetrical, rather extreme in proportions, with a Gothic air that dissolves on close inspection. Uprights clad in Portland roach, the infill very dark, with smoked glass. The end bay walls rise up sheer in parts, with slit windows and thin oriels which emerge from tall recessed slots. Top storeys projecting slightly, the piers coming out to support them, with pinnacle-like spikes on top.

Facing Caxton House on the S side, STEEL HOUSE, 1936 by *Burnet, Tait & Lorne*, stone-faced, with bands of windows and symmetrically arranged figure reliefs. Nos. 21–29, offices of *c.* 1980, more forceful. Big stone armature, bronzed infilling, upper storeys projecting. Down DEAN FARRAR STREET, No. 10, offices by *Michael Lyell Associates*, designed 1980. Ribbon windows, hard red brick bands, rounded stair-tower. On it a SCULPTURE by *Michael Marriott* called Split Form No. 9, 1987. Unequal stainless-steel wedges squashing a row of hemispheres. On the N SIDE of Tothill Street, two consequential classical office blocks of 1913–14 make the corners of Dartmouth Street: TELFORD HOUSE, E, by *Metcalfe & Grieg*, in Bath stone, and BROADWAY HOUSE, W (ENGINEERING EMPLOYERS' FEDERATION), by *Edgar Stones*, of Portland.

Next to Broadway House, in DARTMOUTH STREET, some gentle bow-fronted early C20 houses (Nos. 16–18); No. 16 is by *Frank Sherrin*, 1910. *Gerald Horsley*'s No. 9, dated 1896, was built for the Universities' Mission to Central Africa. Neo-Early Georgian, flush-fronted and economical. Dartmouth Street was laid out by *Nicholas Barbon* on part of the site of Lord Dartmouth's Carew House, demolished 1683.

TUFTON STREET

Built up slowly in the C17, from N to S. Mostly earlier C20 buildings, including some offices for Church bodies. At the N end, within the angle made by Church House (*see* p. 201), No. 7 (FAITH HOUSE), the former Parish Hall of St John Smith Square, little-known *Lutyens* of 1905. It shows him dipping a toe in Neo-Georgian or perhaps Neo-Serlian waters. Red brick, three round-headed lower openings, five windows above, and five dormers on a shallow pantiled roof. Aisled, church-like interior with a groin-vaulted central vessel. No. 11 is

WIPPELL'S the church furnishers, 1929 by *S.S. Yeo*. Plain, white-rendered Neo-Regency, with a carved shopfront.*
After Great Peter Street all is red brick. No. 37 (E side), of 1936, is the closest Westminster came to a full-blooded interwar Modern Movement house, a rather raw front with floors staggered either side of a tall staircase window. The architect is not yet identified. Nos. 57 and 57a are neat twin houses by *F.E. Williams*, 1925–6, his own speculation, with *Alfred Cox*. For the w side, *see* the former Ninth Church of Christ Scientist and Marsham Street. Further down, No. 81, a shallow-plan house with bows, 1929–31. By *A.S.G. Butler*, Lutyens's biographer.

VICTORIA STREET

Cut through the slums w of the Abbey in 1847–51, along lines first suggested in 1832. The plan was *Henry Ashton*'s, Surveyor to the Westminster Improvement Commissioners. It took until the 1890s to build up. What was most impressive about the result was its even height, five storeys up to eight, and imposing scale. The designs were on the whole done in blocks between side streets, often with shops on the ground floor, and had relatively little ornament. Some were of interest as pioneering examples of their type. Here in 1852–4 was London's first attempt at mansion blocks, or flats on the Scottish or Continental model. *Ashton* himself designed them, working with the engineer-builder *William Mackenzie*. The type caught on gradually, becoming the local norm for middle-class housing (cf. Carlisle Place). At Nos. 2–8 stood the Westminster Palace Hotel, a pavilion-roofed block of 1858–61 by *W. & A. Moseley*: the first grand London establishment to break free of the railway termini.

REBUILDING of this C19 legacy began in the mid 1950s, almost exclusively for big office blocks, and has not looked back since. Co-ordination was imposed by the *LCC*, succeeded after 1965 by *Westminster City Council*. There was no single master plan, though part of the N side was included with the new Stag Place (q.v.); a scheme based on elevated walkways, approved for much of the s side in 1963, was not proceeded with. At first plain or intersecting slabs were in favour, mostly with the dullest results. Many were taken by big oil companies, others by Governmental or public bodies. The square towers or broken modular outlines of the 1970s are more interesting, and in the 1980s–90s canted bays and polychromy were revived. So the rebuilt street has variety of a kind. The description is from E to W.

East Part, from Broad Sanctuary to Buckingham Gate

First on the N side is Nos. 2–8 (BARCLAYS BANK), six-storey stone-faced offices of 1975–9 by *N.D.N. Fairbairne*, consultant

* Opposite stood the Architectural Museum, French Gothic of 1869 by *Joseph Clarke* and *Ewan Christian*. In 1903–4 enlarged for the Architectural Association by *Leonard Stokes*; dem. *c.* 1930.

William Whitfield. The corner has canted bays caged in detached stone fins, their profiles reminiscent of the Tudor Perp of Parliament. Sides too suddenly plain by comparison. Next to it Nos. 10–18, by *Burnet, Tait & Partners*, 1954–6, with a butterfly entrance canopy. Facing them is the DEPARTMENT OF TRADE AND INDUSTRY (Nos. 1–19), a very large block by *Ronald Fielding*, 1959–64. Six storeys, followed by a recessed T-shaped range of nine storeys, turning a flat-nosed end towards the E. Odd decorative mini-motif of uprights faced with small white strips. A driveway in front was filled in 1993–5 by *DEGW* with a long glassy forebuilding, stopped by a stone-faced E end.

NEW SCOTLAND YARD, back on the N side, is the most memorable of these slab-type buildings. By *Max Gordon* of *Chapman Taylor Partners*, 1962–6, the firm's first really big commission. It was speculatively built (to a very high plot ratio of 1:7), but while still in progress was taken for the new Metropolitan Police headquarters – so it is really New New Scotland Yard, the heir to the old New Scotland Yard on the river (*see* pp. 248–50). A long flush nine-storey street front. Towards Broadway, l., it makes an excellent group with a twenty-storey tower, set parallel and close, with a short six-storey link. Their consistent vertical rhythm is based on an exceptionally widely spaced concrete frame; Gordon worked in Chicago with Skidmore, Owings & Merrill, whose influence is apparent throughout. Stainless-steel sheathing replaced the original polished grey granite in 1984–6. The famous revolving SIGN to Broadway, NW, dates from 1968. Near it and part of the same development a copper-clad cube, housing a restaurant.

More recent buildings on the S SIDE, not so large or so good. *Rolfe Judd Planning*'s Nos. 21–29, 1994–6, all bays and turrets, speaks of a Late Victorian context long since lost. BANK-BOSTON HOUSE (Nos. 31–59), 1983–8 by *Covell Matthews Wheatley Partnership* with *Tooley & Foster Partnership*, has a square façade unit of polished stone with inset black glazing bars, and a broken upper outline. *EPR Partnership*'s Nos. 61–71 of 1987–8 evokes a tamer Victorian mansion type, represented by *Bassett Keeling*'s big Nos. 77–93, 1885 (future uncertain). Between is ARTILLERY MANSIONS by *John Calder*, dated 1895, more characterful but also more forbidding. Plain red brick Gothic detailed in the hard fashion of *c.* 1870, with an exaggerated through-storey arched entrance. The rear wing appears aslant across a sunless courtyard. Flats of 2000–2 by *Hamilton Associates* replace the C19 back court.

Artillery Mansions looks across to a quite generous GARDEN with trees. At the back is a TELEPHONE EXCHANGE of 1959–62 by *W. S. Frost (Ministry of Works)*, a stone-faced slab with a one-storey post office behind. By the garden two MONUMENTS: Henry Purcell, 1995 by *Glynn Williams*, a bronze head fantastically periwigged with flowers, and the Suffragette Monument, a fibreglass curlicue by *Edwin Russell*, 1970. The garden began as land given in 1625 for a burial-ground for St

Margaret Westminster.* On its w side is No. 50, a smart square eighteen-storey tower of 1971–7 by *Seifert & Partners*, treated with crinkle-cut triangular bays of polished dark-brown stone. Three-storey rear range and eight-storey slab on Caxton Street. Past the tower is an honest pub of 1862, yellow brick, only four-storeyed, THE ALBERT. By *J. Carter Woods* for the Artillery Brewery, which stood opposite. Big cornice with lion masks, coloured to match the polychrome window trim. Rising behind is another dark and powerful office tower (*see* Buckingham Gate), a juxtaposition which for once works very well.

West Part: Buckingham Gate to Buckingham Palace Road

At first all is 1960s-70s. The N SIDE has a long sequence of 1960–6 by *Burnet, Tait & Partners*: the former Mobil House, WESTMINSTER CITY HALL, a nineteen-storey slab standing forwards at right angles, utterly mute in civic expression, and KINGSGATE HOUSE, another long range, this time with shops. On the s SIDE facing, first the ARMY & NAVY STORES, 1973–7 by *Elsom, Pack & Roberts*. A yellowing stone-faced box, spliced into smoked-glass offices of broken outline, and coming forward over a covered pedestrian passage. The previous store began as a distillery, built in 1864 and adapted for retail in 1872 and 1922. Down Francis Street, r., a detached EXTENSION by *Maurice Webb*, 1927, modernistic, with emphatic verticals and jagged jazzy tops. For the store's former warehouses beyond *see* p. 698.

Then an immensely long pair, ASHDOWN HOUSE and BP HOUSE. Also by *Elsom, Pack & Roberts*, 1971–5 (job architect *David Evans*), likewise with a colonnade and shops below, but much better handled. Both are built up from a single boxy unit, with polished granite framing and chamfered ends, the dark windows carried round the chamfer in little glinting strips. Between them a gap is left for a diagonal piazza in front of Westminster Cathedral (q.v.). The buildings draw back and up from this like the waters parted by Moses, rising from four to as high as fifteen storeys, stepped back in irregular stacks. The design lingers in the mind, unlike the boring slabs opposite. Another of that type, the former Esso House (1962) facing Ashdown House, was under demolition in 2003. Behind rises Portland House, for which *see* Stag Place.

Approaching Victoria Station, smaller and older buildings take over. The Frenchified No. 124, N side, was the westernmost pavilion of *Philip B. Lee*'s ALBERT MANSIONS of 1867–9, a composition 500 ft (152 metres) long. To its r. is the relief road for Stag Place. Next the VICTORIA PALACE THEATRE by *Frank Matcham*, 1911 (perhaps reusing walls from the Royal

* In *c.* 1638–42 it acquired a chapel of ease called the Broadway Chapel, Gothic externally, but with a cross-in-square plan anticipating St Matthias Poplar and some of Wren's City churches (*see* Peter Guillery in *London Topographical Record* 26, 1990). Its replacement, *Ambrose Poynter*'s Christ Church (1841–4), was an early attempt at asymmetrical, ragstone-built C13 Gothic. Blitzed 1941, dem. 1954.

Standard music hall, 1886). The front is all 'Penteliko' and 'Keramo', white faience products of *Gibbs & Canning*. Round-arched central recess, and statues and a Wren-like cupola on top. Foyer with paired marble columns. Stepped boxes towards the proscenium, a feature proclaimed as unique when new. Next the DUKE OF YORK, a big pub dated 1821, with later stucco dressings. The street here is older, laid out from 1816 as part of the Vauxhall Bridge approach. In the roadway to the s LITTLE BEN, a cast-iron baby clock tower of 1892 (why was there such a craze for clock towers in the late C19?). By *Gillett & Johnston* of Croydon. Removed 1964, reinstated 1981.

The N SIDE goes on with *Sidell Gibson Partnership*'s ALLINGTON HOUSE (Nos. 136–150), atrium offices of 1997. Butterscotch terracotta facing, with thin applied uprights reminiscent of Burnham's work in late C19 Chicago. Overdoor carved by *Barry Baldwin* with menacing heads of sharks, elephants, etc. The nondescript No. 152 was the front of one of *Alister G. Macdonald*'s newsreel cinemas, 1936, Nos. 160–162 the foyer block of a *George Coles* cinema of 1928–30. Painting has spoiled its pilastered front, which was marble-faced. Behind the upper window a glazed barrel-vaulted former tearoom. On the site of the auditoria, facing ALLINGTON STREET behind, a Flash Harry office block with squashed-in glass bays, called ALLINGTON TOWERS: 1985–6 by *Simpson Gray Associates*.

On the s SIDE a fairly low block (future uncertain), mostly Victorian and of brick. It sits over VICTORIA UNDERGROUND STATION (District Railway), opened in 1868. The VICTORIA ARCADE next door occupies a block of 1911, to designs by *George Sherrin* of 1909. One of several schemes made possible by the reduced need for ventilation once electric trains replaced steam. Heavy offices on top by *Trehearne & Norman*, 1922–5.

VINCENT SQUARE

Named from William Vincent, Dean of Westminster Abbey 1802–15, and before that Head Master of Westminster School. In 1810 he enclosed this area of Tothill Fields to protect its use by his pupils. Too large to be taken in as a square, it must be walked round to see the buildings. Semidetached houses came first, then terraces, then from the 1890s a succession of hospitals – now in other uses – and additional institutions.

Starting at the N apex, the NW SIDE is WELLINGTON HOUSE, built as a hostel for King's College Theology department in 1913 by *Arthur C. Martin*. Mixed Tudor and Georgian, U-plan, with tall grooved stacks and subtly patterned brick. The l. wing was added in 1928–9; round-headed ground-floor windows to a small Neo-Byzantine CHAPEL. At the rear angle a big hospitable mullioned-and-transomed window to the dining hall.

Continuing clockwise, the NE SIDE begins with Westminster Kingsway College (q.v.). Next door the old ROYAL HORTI-CULTURAL SOCIETY building, 1903–4 by *E.J. Stubbs*, tamely

composed but well-detailed Free English, showing the influ-
ence of Bentley's Westminster Cathedral. In 2000–1 recon-
structed by *Rick Mather Architects*, making better provision for
the society's notable library. The big exhibition hall remains
behind, with its glazed steel-lattice roof. It faces diagonally
across GREYCOAT STREET to the society's NEW BUILDING, III
1926–8 by *Easton & Robertson* (engineer *Oscar Faber*). This
additional hall was the first in England to use those bold,
sweeping concrete curves inside for roofing which were so
popular on the Continent. The prototypes were timber arches
in recent Swedish buildings, and reinforced concrete work by
Hennebique and Freyssinet in France, e.g. the Orly airship
hangars, 1921. Four stepped clerestories per side, the arches
coming down as thin, near-vertical piers. Their thrust is
absorbed by the aisle roof-slabs, reducing obstruction at floor
level. Over the entrance a raised dais or gallery. The front
is progressive too, with fluting to the top of the brick, and
a bowed porch. In Greycoat Street otherwise much recent
housing; ROWAN HOUSE by *Renton Howard Wood Levin*,
1985–7, has a bronze relief on the front by *Peter Thursby*.

Back in Vincent Square, ST GEORGE'S HOUSE (No. 82), plain
gabled red brick by *R.S. Ayling*, built in 1903–4 as a ladies'
residential club. Nos. 84–85, 1810s with later stucco, typify the
earliest houses here, of the type with two dwellings treated as
one under an open pediment. No. 86, detached, *c.* 1800, was
remodelled *c.* 1921 by *Oswald Milne* and *P. Phipps*, and later.
It incorporates a little house in MAUNSEL STREET, behind.
This has nearly complete three-storey houses of after 1823, a
speculation by the silversmith Paul Storr. Mostly one bay wide,
with elliptical-headed doorways. Of the interruptions, Nos.
18–20 of *c.* 1954 match carefully, No. 33, *c.* 1938, fumbles after
something Modernist. Back in Vincent Square, in the fields,
the half-timbered WESTMINSTER SCHOOL CRICKET PAVIL-
ION with steep sweeping roof, 1888–9 by *Richard Creed*. Round
the corner, thin classical GATEPIERS designed by *Bodley*, 1883,
transplanted *c.* 1930 from Ashburnham House (*see* p. 202).

On the SE SIDE of the square ordinary houses predominate.
Another pedimented pair at Nos. 3–4, latest C18, i.e. before
the square was enclosed. Behind them in FYNES STREET
Nos. 1–4, low-browed houses of *c.* 1815. Next some big ter-
raced houses of incongruously mid-suburban type (Nos. 5–6
and Nos. 9–20, dates 1866–78). Then VINCENT HOUSE,
pompous white-faience-faced offices of 1932, with Neoclas-
sical trim. By *Adrian Gilbert Scott* and *F.P.M. Woodhouse*, con-
sultant *Sir Giles Gilbert Scott*. More C19 terraces at Nos. 22–26,
1881 (and along the SW side, Nos. 38–45 and 48–53).

From the S corner, former HOSPITAL BUILDINGS are the main
interest. Last on the SE side is ADRIAN HOUSE (since 1981
Westminster Under School), 1896–8 by *Roumieu & Aitchison*,
built as the Grosvenor Hospital for Women and Children.
Very hard, with orange terracotta trim recalling the Burgesian
Gothic of the 1860s. Rear extension 2001. In the corner angle
HOPKINSON HOUSE, big lodgings of 1904–5 for the Brabazon
House Co., *R.S. Ayling* once again. Sparsely ornamented, with

corner turrets. The GORDON HOSPITAL at Nos. 46–47 is by
Young & Hall, 1939, blandly traditional. Further on, the front
of the former Infants' Hospital (No. 56), of 1906–7 by *Read &
Macdonald*. A turret hard against a gable in the New Scotland
Yard way, with a carved doorcase down Udall Street. Con-
verted to flats *c.* 1994, with a roughly matched extension. On
the opposite side of Udall Street an auxiliary block of 1913,
more in Hampton Court style. Both have majolica roundels of
infants after those on the Foundling Hospital in Florence.

Finally the NW SIDE. At Nos. 64–65 offices of 1958–60 by *A. V.
Farrier*, with thin mullions. Nos. 66–67 were magistrates'
offices, of 1845 by *Charles Reeves*. A battered two-storey
Italianate block, originally with a twin to the r. for a police
station. The rest of the complex goes with Rochester Row
(q.v.). Finally the former Empire Hospital for paying patients,
1912–13 by *W.E. Hazell* (now a hotel). Wrennish, and pleas-
ingly faced in red-trimmed silver brick.

BELGRAVIA

INTRODUCTION

Belgravia was built almost entirely on the Five Fields, part of the land acquired by Sir Thomas Grosvenor in 1677 on his marriage to the heiress Mary Davies. The name comes via Belgrave Square, named from Belgrave, a tiny settlement on the ancestral Grosvenor estates in Cheshire. It dates only from the early C19. Before that time building was confined to the older roads around the fringes, especially along Knightsbridge on the N. The oldest surviving houses, of *c.* 1720, are in Ebury Street, at the SW corner on the fringes of Chelsea. By *c.* 1810 terraces had also grown up along Grosvenor Place, facing the gardens of Buckingham House, along some new streets made off it, along Buckingham Palace Road, and at the NE end of Ebury Street.

The first scheme to open up the heartland dates from *c.* 1812. The royal removal to Buckingham Palace in the 1820s cannot therefore have been the spur, as is often claimed. The Grosvenors

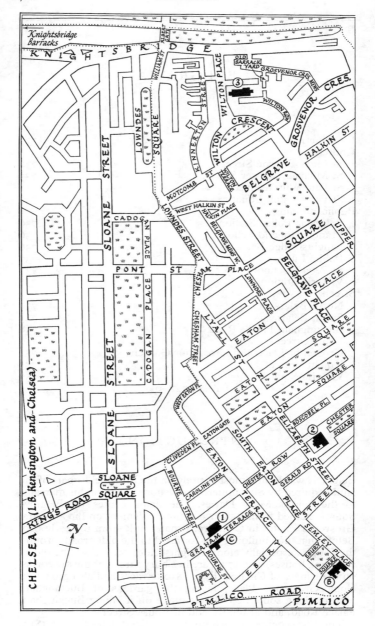

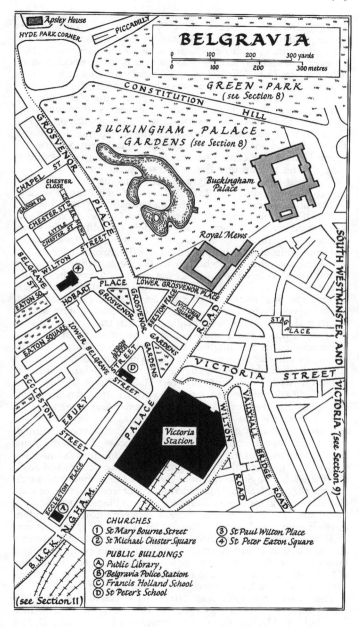

BELGRAVIA

| 0 | 100 | 200 | 300 yards |
| 0 | 100 | 200 | 300 metres |

HYDE PARK CORNER

Apsley House

PICCADILLY

CONSTITUTION HILL

GREEN PARK (see Section 8)

BUCKINGHAM PALACE GARDENS (see Section 8)

Buckingham Palace

Royal Mews

GROSVENOR ST

CHAPEL ST

CHESTER CLOSE

CHESTER ST

GROOM PL.

LITTLE CHESTER ST

WILTON STREET

GROSVENOR PLACE

BELGRAVE ST

EATON SQ

HOBART PLACE

LOWER GROSVENOR PLACE

GROSVENOR PLACE

GROSVENOR GARDENS

BEESTON PLACE

VICTORIA SQUARE

STAG PLACE

SOUTH WESTMINSTER AND VICTORIA (see Section 9)

EATON SQUARE

LOWER BELGRAVE STREET

WILTON PLACE STREET

VICTORIA STREET

ECCLESTON STREET

EBURY STREET

PALACE STREET

Victoria Station

WILTON ROAD

VAUXHALL BRIDGE ROAD

ECCLESTON PLACE

BUCKINGHAM

(see Section 11)

CHURCHES
① St Mary Bourne Street
② St Michael Chester Square
③ St Paul Wilton Place
④ St Peter Eaton Square

PUBLIC BUILDINGS
Ⓐ Public Library,
Ⓑ Belgravia Police Station
Ⓒ Francis Holland School
Ⓓ St Peter's School

must rather have been weighing up the capabilities of a smart new district between Chelsea and the West End. *James Wyatt* drew up the earliest PLAN. It already included the diagonal accent of the main square, with detached houses in the corners. In 1813 a larger and denser scheme was proposed as a speculation by *Alexander & Daniel Robertson*, the first in which Eaton Square appears, with the rambling country lane that was the old King's Road straightened out as its central spine. This plan remained in force even after the Robertsons themselves abandoned the project, subject to revision by 1821, by *William Porden* or *Thomas Cundy I*, who succeeded Porden as the Grosvenors' surveyor. These changes included a crescent N of Belgrave Square, the future Wilton Crescent. The first building agreements came in 1821, for the area around Eaton Terrace to the SW.

The great episodes of Belgravia belong to the next phase, signalled by the arrival in 1824 of *Thomas Cubitt*, the ambitious builder and contractor whose firm had already developed estates in North London and in Bloomsbury (*see London 4: North*). He was joined by other large-scale builders, notably *Seth Smith*, whose take included the enclave N and NW of Belgrave Square. In 1825 Cubitt and Smith passed on the Belgrave Square project to a separate syndicate, who got in *George Basevi* to design it. Cubitt was thus freed to take on even more land, both in Pimlico to the S (q.v.) and on the Lowndes Estate in the extreme NW corner. The plan mainly follows the principle of a diagonal grid, made interesting by a chain of loosely connected squares and by occasional crescents. The principle had been tried out most successfully in Bloomsbury and was just at that moment, in 1825–30, being applied in Paddington. Later revisions included the formation of Chester Square, in the SE pocket and outside Cubitt's empire, and two streets joining the corners of Belgrave Square, called Grosvenor Crescent and West Halkin Street. The last was made for easier access from the Lowndes Estate, where Cubitt eventually laid out another square, also on a very large scale.

Architecturally the HOUSES of Belgravia carry on from Nash and his most recent work on the Regent's Park terraces, though with much less drama in advance and recess. The same principle is employed of the very long unified front, mostly stuccoed all over, and given rhythm and dignity by various central and angle accents (Belgrave Square, Upper Belgrave Place, Eaton Square). After *c.* 1840 the Italianate fashion takes over from Grecian or Late Classical, and giant orders disappear (Eaton Place, Eaton Square, Chesham Place). Here and there a different note is sounded, quasi-Jacobean in Lowndes Square, fancy eclectic at the SW end of Eaton Square. Apart from the few big mansions, interiors are standardized, and generally conventional in plan. A greater mixture of smaller houses may be seen in the unpretending area W of Eaton Terrace, a very steep descent through the ranks finishing with the little one-bay workers' cottages of Bourne Street.

The district naturally had CHURCHES, classical at St Peter Eaton Square of 1824–7, Gothic at the 1840s St Paul Wilton Place and St Michael Chester Square, both by *T. Cundy II*, and at St Mary Bourne Street, built to serve the poor SW quarter in 1873–4. Other chapels, once numerous, have disappeared apart

from one odd fish in West Halkin Street, now in other uses. As for secular services, the bigger terraces were equipped with generous MEWS that remain important components of the Belgravian scene, though beyond their entrance arches there is rarely any building worth a second glance. An exception can be made for the little labyrinth off Kinnerton Street, which also features artisans' houses and well-judged post-war infillings. PUBS are mostly banished to spaces of this kind; SHOPS are concentrated in a few lesser streets, of which West Halkin Street also features a former bazaar or shopping arcade of 1830.

C20 ALTERATIONS to the heart of Belgravia are relatively few. Wilton Crescent was refaced in stone c. 1908–12. Early C20 fashions extended to less grand mansions built just behind the terraces of the squares (Belgrave Square), and mews also began to be chic (Belgrave Place, Boscobel Place). Only on the Lowndes Estate was wholesale rebuilding begun, from the 1930s onwards, with generally unappealing results. The German Embassy extension of 1972–8, off Belgrave Square, is the most interesting post-war building. More recent work generally aims to blend in, such as the understated Neo-Georgian scheme of 1979–81 in Bourne Street by *Chapman Taylor Partners*, the chief authors of an exceptionally searching plan for the Grosvenor Estate presented in 1971. In sensitive cases facsimile rebuildings have been resorted to (Elizabeth Street, Chesham Street). Such careful stewardship has restored Belgravia to something like its old snooty glory, after a prolonged low point after the Second World War, when Pevsner noted the headaches of coal and servant shortages (and when rebuilding in plain brick was thought acceptable, as witness Eaton Place and Chester Square). The Grosvenor Estate even specifies one precise shade of stone-coloured paint throughout. Most of the greater houses are now split into flats, though others have found uses as embassies and offices.

The busy streets on the margins are a different story again. Ambitious upper-class HOUSING was carried on in Grosvenor Place and Grosvenor Gardens, rebuilt with spectacular Second Empire terraces by *T. Cundy III* in 1865–71. SE of this strip lies Victoria Square, a stucco development of 1838–42, with a slightly different inflection from that of Cubitt. Cubitt's biggest houses of all are the twin 1840s monsters at Albert Gate in Knightsbridge. Plainer late C18 and early C19 houses remain off Grosvenor Place and along Ebury Street, which also has the one great concentration of Victorian model housing and post-war housing in the area. The highlights of Buckingham Palace Road are TRANSPORT BUILDINGS: Victoria Station, an involved but rewarding C19–C20 complex including *James Knowles Sen. & Jun.*'s swaggering Grosvenor Hotel of 1860–2, and the 1930s Victoria Coach Station and former Imperial Airways buildings. Buckingham Palace Road also has *Arup Associates*' outstanding office complex of 1988–91. Knightsbridge is well provided with mansion blocks and hotels. The latter include the Lanesborough converted from *Wilkins*'s imposing St George's Hospital of 1827–33. Knightsbridge also has the fiercest post-war building in the area, *Sir Basil Spence*'s Knightsbridge Barracks of 1967–70, at the extreme NW.

85

p. 738

122

The streets are arranged as follows: two perambulations of
Belgravia (N and S), followed by its margins, in alphabetical
order: Buckingham Palace Road, Ebury Street, Grosvenor Place
and Grosvenor Gardens, Knightsbridge, Victoria Square.

FURTHER READING. The essential work is Hermione Hob-
house, *Thomas Cubitt, master builder*, 1971 (reissued 1995). The
Knightsbridge strip is covered by the *Survey of London* vol. 45,
2000. The Grosvenor Estate's own survey of 1971 is entitled *The
Grosvenor Estate Strategy for Mayfair and Belgravia*. H.G. Davis,
Memorials of Knightsbridge, 1859, heads the list of older works. Of
the churches, St Mary Bourne Street has *Streets of Heaven*, 1991
(ed. N. Price), St Paul Wilton Place a *Short History* by M. Barney,
1967, St Peter Eaton Square a centenary history of 1927.

CHURCHES

ST MARY BOURNE STREET

1873–4 by *R. J. Withers*, as a chapel of ease to St Paul Wilton Place
(q.v.). Red brick, in an Anglo-French lancet style reminiscent
of James Brooks. Small flèche. The site had been cleared to make
the District Railway tunnel. Originally the entrance was from
Graham Terrace, S; buttresses were added on this side in 1947–8,
the vestry to their E in 1927, both by *H. S. Goodhart-Rendel*. The
way in now is through an ingenious polygonal NW porch also by
Goodhart-Rendel, 1925–8. The shape disguises the shift of axis
into his tunnel-vaulted N chapel, of the same date. These addi-
tions show an uncanny sympathy with High Victorian work, then
utterly out of fashion.* The chapel opens into Withers's N aisle via
an arcade of grey granite. Nave and chancel form a single volume,
emphasized by the ceiled and pointed roof. Five-bay arcades
on short round piers. The brickwork is exposed. PAINTINGS:
spandrels, prophets, attributed to *N. H. J. Westlake*, late 1890s;
flanking the altar, Annunciation and Visitation, slightly earlier.

FITTINGS. A superior assembly: much of the interwar Anglo-
Catholic Baroque associated with the Society of St Peter and St
Paul, plus some very individual things by *Goodhart-Rendel* and
Roderick Gradidge. – HIGH ALTAR. Originally Elizabethan, by *S.
Gambier-Parry*, c. 1909, classicized by *Martin Travers* in 1921, and
in 1934 topped with sunburst and cartouche by *Goodhart-Rendel*.
– PANELLING in the apse by *Gradidge*, 1974, gracefully lettered
by *Gavin Stamp*. – COMMUNION RAILS, mid-C17 style, prob-
ably by *Gambier-Parry*, c. 1910. – REREDOS of S aisle designed by
Goodhart-Rendel, 1929. A strange domed and painted Burgesian
Gothic statuary niche. – Flimsy PULPIT by *Laurence King*, 1972.
– W GALLERY and ORGAN CASE by *Gambier-Parry*, c. 1908–13.
Neo-Wren. – FONT by *J. Harold Gibbons*, 1973. A square stone
block. Openwork COVER, in a mixed style a bit like Cosin's C17

* His design for a Butterfieldian saddleback w tower was not built.

work in Co. Durham. – STATUE by it of the Baptist, C16 Spanish? – STAINED GLASS: W window by *Mary Lowndes*, 1897. N CHAPEL. REREDOS. The Seven Sorrows, painted by *Colin Gill*, 1929. The style suggests the influence of Significant Form and the rediscovery of e.g. the Lorenzetti. – FRAME by *Goodhart-Rendel*; also the openwork COMMUNION RAILS (maker *Betty Joel*). – CONFESSIONAL by *Goodhart-Rendel*, 1936, chunky and painted, more explicitly Neo-Gothic. – By the reredos a fine PAINTING of the Magdalen by the Sienese *Martino di Bartolommeo* (†1434–5). – STATUE of the Virgin by *Travers*, 1920, N wall. – STAINED GLASS. E window by *M.E. Aldrich Rope*, 1952, after the Litany of Our Lady. – By the entrance a second REREDOS, *c.* 1900, solidly Baroque. – COLUMBARIUM facing, 1999. Designed by *Gradidge*. Chamfered rustication of polished timber around three walls, with a central glazed cabinet (lettering by *Josephine Harris*) showing a reliquary by *Omar Ramsden*. Tympana above with paintings by *Anthony Ballantine* of tiny figures symmetrically resurrected across the empyrean. Columns by the entrance, Gradidge looking at Goodhart-Rendel looking at Rogue Gothic. – MONUMENTS. 2nd Viscount Halifax †1934, by *Goodhart-Rendel*. Baroque.

PRESBYTERY, corner of Graham Terrace and Bourne Street. Once a C19 pub called the Pineapple, adapted by *Goodhart-Rendel*, 1922–4. Blue slate-hung, like something from Devon.

ST MICHAEL CHESTER SQUARE

1844–6 by *Thomas Cundy II*. Late Dec style, with a broad transeptal plan of Low Church type. Squared coursed ragstone, of restless contour, with a NW tower (missing its pinnacles), and spire of Caen stone. In 1874–5 *T. Cundy III* added double chancel aisles, giving five gables towards the square. At the NE end *Sir Giles Gilbert Scott* appended a WAR MEMORIAL CHAPEL in 1920–1, in a different stone and a different style, with a polygonal apse. Its juxtaposition with the flat C19 E end recalls some churches by Scott's first master, Temple Moore. Originally treated, simplified geometrical tracery; aspiringly tall interior, with concrete groin vaults. Cundy's nave is broad and has only two bays. Transepts only slightly broader. Otherwise much reorganization: N chancel aisles enclosed as a meeting room *c.* 1970 by *A.F. Shannon*, nave stripped of all but vestiges of the galleries in 1993 (by *Thomas Ford & Partners*, with other modernization).

FITTINGS. Mostly later than the church. Ornate ALTAR and alabaster REREDOS of 1910. – PULPIT. 1878. Gothic, with stone base. – STAINED GLASS. Densely coloured E window of 1895, attributed to *Clayton & Bell*. W window 1951, unmistakably *Hugh Easton*. Two Morrisish S transept windows, 1882, perhaps by *Powells*, another †1894 by *Edward Frampton*. Solomon, N aisle, 1884 by *Clayton & Bell*. – War Memorial Chapel, light windows by *Powells*, 1920s. – FONT by *Scott*, 1934. Hard green stone, with unconventional carved panelling. – In the churchyard a FOUNDATION STONE of 1887 from St Philip Buckingham Palace Road, by *Demain & Brierley* of York (dem. 1954).

ST PAUL WILTON PLACE

By *Thomas Cundy II*, 1840–3. The second parish church on the Grosvenor Estate in Belgravia, and the first to use Gothic. Its first vicar, William Bennett, pioneered Anglican choral and ritual worship here (cf. St Barnabas, p. 764). Yellow brick, pre-archaeological in the material and in such forms as the equilateral-arched windows with Perp tracery and the W tower whose ground floor is developed as an open porch. *Bodley* made the stepped tower parapet in 1899. Stone portal by the road by *R.J. Withers*, c. 1871. Also pre-archaeological the airy interior, with galleries on cast-iron shafts and open Gothic brackets. Shallow queenpost roof, with angels on the hammerposts. Major alterations began in 1870–1, when *Withers* opened up the inner tower arch and lengthened the chancel. In 1891–2 *Bodley* lengthened it further and began to decorate it. S chapel of 1889 by *Sir A. Blomfield* (redecorated by *Donald Insall Associates*, 2000).

FITTINGS. Of the Westminster churches only St Barnabas can rival St Paul for late C19 Neo-Gothic embellishment. By *Bodley* and of 1892 the Perp SCREEN, rich REREDOS with statues in niches (enlarged 1895) and ORGAN CASE. – Contemporary ROOD, Oberammergau work. – The screen has GATES of 1895, by *Bodley*, and PAINTINGS of saints by *N.H.J. Westlake*, 1901. – Chancel PANELLING of 1908–10, designed by *W.J. Parker*, with painted figures by *Gerald Moira*, 1912–16. – Chapel SCREEN of iron, 1892, almost certainly *Bodley*'s. – REREDOS in the chapel painted by *Westlake*, 1890; the altarpiece is a copy after Perugino. – STATUES and their niches designed by *Bodley* (E wall): St Paul, 1902; Virgin and Child, 1896 (carver *R. Bridgeman*). Oberammergau CRUCIFIXION by the S chapel, given 1915. – Timber PULPIT carved with busts of the Evangelists. Probably 1843; cut down 1964. Tester of 1894. – Around the nave twenty-four very good sepia TILE PICTURES attributed to *Daniel Bell* with dates 1869–79, and STATIONS OF THE CROSS, 1920–2, painted by *Gerald Moira*. – FONT. 1842. Of Caen stone, carved with narrative reliefs by *Charles Physick*. Cover by *Walter Sarel*, 1935. – STAINED GLASS. E window, Tree of Jesse. Designed by *Bodley* and made by *Lavers & Westlake*, 1892. S chapel windows by the latter firm, nicely intimate. Aisle windows by *W. Wailes*, with mid-C19 boiled-sweet colours. Ten date from before 1858, six from after. W window by *T. Cleobury*, 1874.

CLERGY HOUSE, E of the church. By *Withers*, 1871. Tall, gabled and minatory, of stone-banded brick. In the garden, S, a subtly profiled MEMORIAL CROSS to Lt-Gen. Maude (†1917).

ST PETER EATON SQUARE

The first Belgravia church, 1824–7 by *Henry Hakewill*. Built as a district chapel of St George Hanover Square (p. 479). The Commissioners gave £5,556, a quarter of the cost. Partly and faithfully rebuilt by *J.H. Hakewill* after a fire in 1836, then twice remodelled: in 1872–5 by *Sir Arthur Blomfield*, and in

1988–91 by the *Braithwaite Partnership*, after another ruinous fire in 1987.

The church stands at the E end of the square, but not on axis, which, in such a classical design, is troubling. Giant portico of six Greek Ionic columns. The W bay is raised higher and crowned with pediments to N and S, on the pattern of St George Hanover Square. On this a yet higher attic, and on that the tower. Square stage with recessed columns, drum and dome. The stone is Bath, with Portland column bases, and plinth of granite. Within the portico and along the sides the facing is yellow brick, with tall round-headed windows. Different windows and brick of more lemony hue distinguish *Blomfield*'s transepts, added in 1872–3. These are pedimented, but have a few medieval touches. On the S transept a CRUCIFIX of *c.* 1920, from *Blomfield*'s St John Wilton Road, a daughter church (1873–4, bombed 1940).

The INTERIOR is reached between the 1820s stair-lobbies. The nave of 1988–91, a calm, forthright space five bays long, harks back to Hakewill's treatment, though dispensing with side galleries. Georgian proportions and column spacings, but no literal reconstruction: the columns are just slim steel cylinders with four detached brass-bound shafts. Flat ceiling with broad, minimal coffering. The colours are white and cream. At the E end an apse with half-dome, flanked by taller round-arched openings. The distracting galleries within these openings are the least successful feature. They serve meeting rooms and flats, made within the Victorian addition and above the new roof. The apse faces a small chapel E of the main sanctuary, which is defined by a marble dais, kept low to preserve the effect of a unitary volume. *Blomfield* had in 1875 introduced new arcades, clerestory and chancel in a fierce Italo-Romanesque style. Some of his work remains off a cross-passage behind the apse: the fire-scorched former chancel (now sacristy), and a marble-lined and barrel-vaulted CHAPEL to the S (now vestry), added in 1894–5 also by *Blomfield*.

FITTINGS. Of 1988–91 the W GALLERY on branching columns (ORGAN by *Kenneth James* of Dublin, 1992), well-made PEWS of pale oak, and ALTARS of white marble, in a Romanesque style nodding to Blomfield. – In the apse a copper and gilt AUMBRY from the chapel of 1895. Around it a golden MOSAIC with uncurling foliage by *Anna Wyner*. – In the former chancel MOSAICS (*Salviati*, 1878–9) and encaustic PICTURE, 1891–2. – STAINED GLASS. Oculus over the apse by *Harry Cardross*, 1991, with cloudy border and monogram. S chapel with good moody E windows of 1895 (by *Powells*, with other decoration), and bad S lights with saints, 1958 by *Frances Thornley*. – MONUMENT. Bishop Wilkinson of St Andrews (cross-passage), 1909. Designed by *W.R. Lethaby*, with damaged effigy by *J. Stirling Lee*.

PUBLIC BUILDINGS

BELGRAVIA POLICE STATION
Buckingham Palace Road

A decent, straightforward design by the *Metropolitan Police Property Services Dept.*, 1989–93. A lowish L-shape faced in tan-coloured brick. Upright windows on the outer faces; the inner part of stepped section, with windows in bands.

FRANCIS HOLLAND SCHOOL
Graham Terrace

A girls' school, founded 1881. The oldest building is of 1883–4, unobjectionable red brick (in the hall STAINED GLASS by *Powells*, 1897–8). Extension of 1960, l., with upright windows. Other blocks behind: Morison Wing, 1919–22 by *Victor Wilkins*; Jubilee Wing, 1978; Grosvenor Wing, 1996–9 by *Hans Haenlein Architects*.

KNIGHTSBRIDGE BARRACKS
Knightsbridge

By *Sir Basil Spence & Partners*, engineers *Ove Arup & Partners*. Designed for the Household Division in 1959–63, but not built until 1967–70. In 1973 Pevsner described it thus. 'This is a very impressive achievement. The site is long and shallow, and so there are very long façades to the street and the park. The composition is broken up into numerous units, culminating at the w in a slender tower, 320 ft [97.5 metres] high. The materials are red brick and variously treated concrete. But the whole suffers from a surfeit of motifs. Architects in reaction against the so-called International Modern of the 1930s are so much afraid of uniformity that they tend to jettison unity. In the Knightsbridge Barracks the architect has evidently felt that one ever-recurrent motif, the shallow concrete arch, would be enough to tie the whole together. In his University of Sussex that is indeed the case, where the same motif, derived direct from Le Corbusier's Maisons Jaoul, is applied to the majority of the buildings.' A more common criticism has been that the tower watches intrusively over the park. But this at least expresses a historical relationship, since there have been cavalry barracks here since 1792. The top, with flat fins slotted together, gives it more personality than the bland hotel towers of Park Lane (*see* p. 555). It houses two squash courts. The blocks to its w are the officers' quarters and mess, to its E the riding school, NCOs' mess and gym, barrack block, junior ranks' mess, and stables. A relic of the previous barracks, of 1878–80 by *T.H. Wyatt*, is incorporated into the parade-ground gateway, facing the park: a large PEDIMENT from the old riding

school, finely carved by *T. Earp* with horses' heads and foliage. Other salvaged sculpture includes BUSTS of commanders in the officers' mess entrance.

PUBLIC LIBRARY
Buckingham Palace Road

1892–4 by *A.J. Bolton*. Typical 1890s Northern Renaissance, now without its three gables.

ST PETER'S SCHOOL
Ebury Street and Lower Belgrave Street

By *Thomas Cundy III*, 1872. Red brick Gothic of the harder kind, with a flat-topped tower and insistent half-hipped dormers.

VICTORIA STATION
Buckingham Palace Road and Wilton Road

A large complex of different dates. There are really two termini, side by side. The prime mover, the London, Brighton & South Coast Railway, opened its station in 1860 (Act 1858, engineer *John Fowler*). The site was the main Grosvenor Canal basin (*see* Grosvenor Road, p. 777), conveniently set at the W end of Victoria Street. Also opened in 1860 was a separate terminus alongside to the E, for the use of the London, Chatham & Dover Railway. Both now have big early C20 blocks facing the forecourt, replacing the paltry original booking offices, etc. The Dover line, l., has a building of 1909–10 by *Alfred W. Blomfield* and *W.J. Ancell*: gaudy, typically Edwardian, with very Baroque big mermaids (by *H.C. Fehr*) carrying a very broken pediment. It sets forward from the Brighton half, of 1906–8, r., much taller and of red brick, but in a similar idiom. Designed by *C.D. Collins* of the railway's architectural department, with its engineer *Charles L. Morgan*. Huge high *porte-cochère*. The Dover side retains part of the building of 1860–2 along the l. flank, off Wilton Road. Plain yellow Italianate brick, of three storeys and complex near-symmetrical bay structure. Partly destroyed by bombing in 1944.

In a different class is the GROSVENOR HOTEL on the Brighton side, of 1860–2 by *J.T. Knowles Sen. & Jun.*, the greatest hotel London had yet seen. It was undertaken by and for the builder *Sir John Kelk*, the railway being too short of funds. It is heavy in general and in detail, of that demonstrative solidity which hotels of the date seem to aspire to (e.g. Charing Cross Hotel, 1863–5, p. 299). It also helped to popularize the French pavilion roof, first used in London at the Paddington Hotel of 1850–2 (*see London 3: North West*). Here they are of well-stuffed domical profile, with two storeys of dormers. Five tall storeys below that, of Suffolk brick and Bath stone, the honey colour again apparent after cleaning in 1978. The details combine foliage from

p. 738

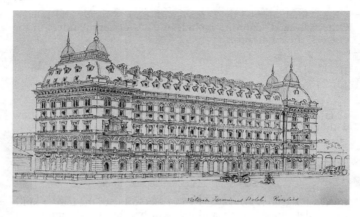

Grosvenor Hotel (Victoria Station).
Drawing by G.F. Sargent, *c.* 1862

various sources, classical or Italian Gothic, of cast rather than
carved stone. The window arches originally had eyelids of pierced
tracery, a few of which remain over the entrance. This mélange
is explained by Priscilla Metcalf, the Knowleses' biographer, as
an early instance of the Victorian quest for a new style using
mixed historic precedents. Non-repeating parts, notably the
portrait busts in the spandrels of the first and top floors, carved
by *Daymond & Sons* (Victoria, Albert, Palmerston etc., but also
Humboldt). INTERIORS include a proud stairhall with a colon-
naded upper gallery. Faience linings introduced by *Waterhouse
& Son* in 1900–2, after the railway bought the hotel. Originally
the first and second floors were planned as suites, with cheaper
rooms above. Further rooms in the terminal building of 1906–8.
 The TRAIN SHEDS show the same dualism. The Brighton
side (platforms 9–19) is of 1906–8, uninspired parallel ridge-
and-furrow glazing, crudely truncated by the air-rights block
above the platforms (*see* below). Big stainless-steel-clad TICKET
OFFICE, *c.* 1978. In a passage to the forecourt two tile MAPS of
the Brighton lines, *c.* 1908. The screen wall between the halves
was pierced only in 1924–5. Double-decked SHOPS by *McColl
Architects*, pushed through the wall in 1991–2, pick up the arch
motif. On the Dover side (platforms 1–8) are *Fowler*'s two glass
halls of 1860, on iron sickle-trusses. Within the r. hall a disrup-
tive mirror-glassed parcels office of 1984. On the concourse a
trim little two-storey former BANK, 1928 by *Palmer & Holden*,
faced in soot-resistant artificial stone. Diamond-patterned ter-
razzo FLOOR designed by *Tess Jaray*, 1985.
 Beyond the hotel in Buckingham Palace Road is a long formal
SCREEN WALL, built from 1905 (engineer *C.L. Morgan*). The
detail is said to be by *Vincent Harris*, then of the *LCC*. It has at
intervals columns and Neo-Gibbons carving by *G. Seale*. Behind
the nearer part rises a big air-rights development by *Elsom*

Pack Roberts, 1981–4 (engineers *Pell Frischmann & Partners*). A long shiny pile of stepped mirror-glass boxes, built over the Brighton line platforms, with escalators up into a shopping mall that disgorges also on to Eccleston Bridge. Offices above, with twin atria, approached through impressive jagged aluminium GATES by *Giuseppe Lund*, 1986. For Phase II of the station redevelopment, to the w, *see* Buckingham Palace Road.

STREETS

NORTH BELGRAVIA
Belgrave Square, Wilton Crescent and Lowndes Square

Belgrave Square

BELGRAVE SQUARE is the great showpiece of Belgravia. It is a true square, very large (nearly 10 acres, 4 hectares) and aligned diamond-wise. Detached mansions look in from all but the N corner, set diagonally to the square and separated by the entering streets. The motif is typically early C19, in that it breaks up the evenness of the square and heralds the restless individualism of Victorian building and planning. It appears already on the first plan for the area, drawn up for the 1st Marquess of Westminster by *James Wyatt c.* 1812. The combination of terraces and big detached villas may have owed something to Nash's proposals for Regent's Park; the executed terraces certainly do, though they were not built until *c.* 1826–1837. Their architect was *George Basevi*, working for a syndicate headed by two Swiss bankers, William and George Haldimand. They took over responsibility for all but a few houses in the square from the two chief builders of the area, *Seth Smith* (the NW side) and *Thomas & William Cubitt*, who were responsible for the garden and for the racetrack of roads around it. The result has a coherence unmatched in Belgravia, nicely set off by the different designs adopted for the corner mansions.

The TERRACES are four-storeyed, each of eleven or twelve houses. The top floor is above the main cornice, with a balustrade and urns. Engaged Corinthian columns stress the centre and ends. Otherwise they carefully avoid uniformity (though the planting has grown up so far that all four sides cannot be read together). The NE side has a six-column centre, the sw side one of eight, the NW of four and two square piers, the se again of six. The ground floors also differ: round-headed windows on the se, NE and NW, but at the sw some straight ones also appear. All four sides have a raised decorated attic above the centre, below which at the se are pedimented principal windows with reclining sculpted figures. Flanks are treated grandly, as at the Regent's Park terraces, with pilasters framing a big relieving arch. Two differences from Nash's work diminish the power of the compositions: the repeated small porches (some with

variant Corinthian capitals), and the relative shallowness in advance and recess.

The walk starts at the NW side (Nos. 1–11), begun earlier than the SE and SW terraces, and a little plainer than them. Behind No. 11, facing Wilton Terrace, is MÉNARD HOUSE, one of several smaller mansions fitted in later behind the main terraces. By *Arthur J. Davis* (*Mewès & Davis*) for Madame Koch de Gooreynd, 1934, Dixhuitième. The detached house in the W corner (No. 12, the PORTUGUESE EMBASSY), lower than the terraces, was built by *Smirke* in 1830–3 for the 1st Earl Brownlow. Five widely spaced bays, three storeys, porch of paired Greek Doric columns, with a triple window and balcony of Doric colonnettes over it. The SW terrace shows signs of alteration: a storey added in 1853 to No. 13 at its N end, rebuilding behind No. 18 for the AUSTRIAN EMBASSY, 1950s, by *W.H. Marmorek* (plain, un-English-looking brick), and large rear additions at Nos. 21–23, for the GERMAN EMBASSY. The first phase of these, of 1954–8 by the *German Government Buildings Department* (*Federal Ministry of Finance*) in collaboration with *Marmorek*, is of simple light brick. The second, of 1972–8 by *Walther & Bea Betz* of Munich with *W.H. Saunders & Son*, is more demonstrative. White-painted concrete and dark glass, horizontal in emphasis despite vertical recesses intended to echo the rhythm of C19 house fronts. Stilts over the mews entrance from Chesham Place; leaded top storey, a decided refusal of the mansard cliché. In front a bronze SCULPTURE like a giant seedling, 1978 by *Fritz Koening*. For the rest of Chesham Place *see* below.

The SPANISH EMBASSY (No. 24), S angle, is the most altered of the mansions. *Henry Kendall* designed it in 1826 for Thomas Kemp MP, the spendthrift founder of Kemp Town in Brighton (builder *Thomas Cubitt*). Still unfinished in 1833; drastically remodelled before 1853, heightening and extending forward the wings, making an Ionic *porte-cochère*, etc. Kendall's segmental bows remain on the sides, and a dwarf octagonal porter's lodge to the l. The columned Neo-Belgravian wing to the r. goes with rear additions by *Julio Cano Lasso* of Madrid, 1991–3, a courtly Bourbon riposte to the Bundesrepublik's sobriety opposite. Down BELGRAVE PLACE, l., No. 1, built by *T. Cubitt* after 1835 on land meant for Kemp's garden: very tall, and more Italianate than the rest of the terrace.

The SE terrace of Belgrave Square (Nos. 25–36) has on the nearer flank two *Coade*-stone reliefs with allegorical cherubs of 1796, installed 1968, from the former Danish-Norwegian consulate in Wellclose Square, Stepney. No. 31 was George Haldimand's own house. Behind No. 36 is CHESTER HOUSE, facing Upper Belgrave Street. 1911 by *F.W. Foster* with *Robert Atkinson & G.L. Alexander*. Up-to-date and somewhat grid-like elevations. Ionic porch of the Bassae order. Refurbished 1993–5 by *Quinlan Terry*, who added the smaller Doric-porched house, l.

The E mansion is No. 37, SEAFORD HOUSE, 1842–5 by *Philip Hardwick* for the 3rd Earl of Sefton, a big seven-bay palazzo built by *T. Cubitt* (now the ROYAL COLLEGE OF DEFENCE STUDIES). It might be a West End club, except for the two

bedroom storeys above the *piano nobile*. To each side a shallow projection with superimposed columns; along the front a columned porch, a post-war replacement for the original coupled Doric arrangement. Exceptionally large service wings behind, with a clock tower and servants' accommodation over stables.

The INTERIOR was remodelled after 1902 for the 8th Lord Howard de Walden, a costly, well-crafted and taste-less ensemble. STAIRCASE clad in shocking green onyx, approached through and overlooked by column-screens also of onyx. On the upper walls shields with reclining plaster women in relief. The style is loosely French C18, but the oval lantern with its gallery and caryatids are probably 1840s survivals. The DINING ROOM and DRAWING ROOM face the square. The former was given fine pilastered panelling, and a compart-mented ceiling painted Cinquecento-style. The Drawing Room seems 1840s, all Louis XVI white and gold, with a screen of square columns at the entrance. Behind it and facing s, the BALLROOM, pilastered, with fairy and astrological paintings in the coving, in divergent styles but all looking 1900s. On the ground floor, l. side, the MUSIC ROOM, with painted beams and a François I style fireplace, and LORD HOWARD DE WALDEN'S BEDROOM, ludicrous high medieval with a beamed ceiling. Surely no single designer created this whole compendium.

The last terrace, Nos. 38–48, includes a disruptive veranda'ed porch of 1876. In the N corner there is no big mansion, only the sweep of Grosvenor Crescent (*see* p. 754). On its r. corner is No. 49 (ARGENTINE EMBASSY), a large house built for Sidney Herbert, later 1st Lord Herbert of Lea, *c.* 1851. By *Thomas Cubitt*, his later manner, quoined and astylar with a canted bow. The octagonal hall and porch, l., were added in 1859 by *Mayhew & Knight*. (Interiors altered by *Mewès & Davis* for Otto Beit, before 1914.) Across the way a high stone plinth and bronze STATUE of the 1st Marquess of Westminster (1767–1845), by *Jonathan Wylder*, 1999. He struggles with a map, two dogs in attendance.

The GARDEN has more statues. At the N corner General San Martin, liberator of Argentina, by *J.C. Ferraro* of Buenos Aires, 1993; at the w corner Prince Henry the Navigator of Portugal, 2002 by *Simões de Almeida*, both facing their respective embassies. In the E corner Simon Bolivar, speechifying, by *Hugo Daini*, 1974. In the s corner Christopher Columbus, 1992 by *Tomas Banueles*. Inferior. Also a bust of George Basevi, 2000 by *J. Wylder*, and Homage to Leonardo, by *Enzo Plazzotta* (completed by *Mark Holloway*, 1982): Leonardo's Vitruvian Man, realized all too literally in bronze. Around the central circle four Tuscan-columned SUMMER HOUSES of the 1990s.

The Grosvenor Estate north and west of Belgrave Square

WILTON CRESCENT forms an embracing semicircle behind the NE side of Belgrave Square. Planned after 1821, when *Thomas Cundy II* took over as Surveyor to the estate, and built up by

Seth Smith from 1825. Starting from the N corner of the square, No. 32, l., is by *Philip A. Todd*, 1899–1900, Neo-Elizabethan and stone-faced, originally with gables. The s side of Wilton Crescent follows, built by *Seth Smith* (Nos. 34–50, leases 1827). It has typically Belgravian accents of giant pilasters, since compromised by non-balancing porches and heightenings. The two quadrants opposite were stone-faced *c.* 1908–12, to a mild design by *Balfour & Turner* with shallow giant pilasters in pairs. The early C19 type of house front still lines the w side of WILTON PLACE (various builders, 1824 onwards), which joins Belgravia to Knightsbridge to the N: round-arched doorways, stuccoed ground floors.* They face St Paul, q.v., and the Berkeley Hotel, for which *see* Knightsbridge.

An arm of KINNERTON STREET leads off the w side of Wilton Place between Nos. 8 and 9. It is a nice backwater of small mews and houses aligned N–S, undertaken by *Seth Smith*. The date is given by the WILTON ARMS on the w side: 1826. Its special attraction is the sequence of shallow closes off the w side, all different in shape and feel. From the N end, STUDIO PLACE is reached through Nos. 85–91, symmetrical brick with projecting ends. Hemmed in its end is the mysterious BRADBROOK HOUSE, a mutilated brick mansion of *c.* 1830 with an Ionic porch *in antis.* KINNERTON PLACE NORTH, especially nice and secluded, has tiny houses along the s side. In BOWLAND YARD, no less intimate, are eight houses of *c.* 1985 by *D. W. Insall & Associates* with boxed-out first-floor windows. KINNERTON PLACE SOUTH ends in an unusual stable complex probably of 1883 and by *R.B. Marsh*, with an access balcony to the upper level and flats on top. Back in Kinnerton Street, No. 35 was the house of *John Taylor* of Chapman Taylor Partners, 1975, a sturdy, pragmatic purple brick front with small asymmetrical leaded oriels. No. 31 goes with KINNERTON YARD, remodelled in 1980 by *Chapman Taylor Partners* as arch-windowed two-storey ranges, the upper flats reached by a spiral staircase hidden in a brick cylinder.

After that the w side of Kinnerton Street belongs with the large precinct of *c.* 1967–72 by *Robert Sharp & Son*, with residential ranges to the street, two baby tower blocks behind, and at the s end a block with canopied shops that extends to the corner of MOTCOMB STREET. On its N side is incorporated the stucco front of the PANTECHNICON, built by *Seth Smith* to designs by *Joseph Jopling* in 1830. It housed carriage showrooms, shops, and a large expanse of warehousing, with a bazaar in the block opposite. The main front has an applied screen of giant Greek Doric columns, as if it were a more austere Royal Institution. Round-arched entrances at each end. The supposedly fireproof warehouse behind burnt down in 1874, and its replacements went to make a shopping arcade and garden. Here an expressionistic bronze SCULPTURE by

*Much more modest brick-faced houses line OLD BARRACK YARD, built *c.* 1837–41 off WILTON ROW, the mews behind the E quadrant of Wilton Crescent. Next to them the GRENADIER, 1830, with an original pub front, very plain. The names derive from a guards' barracks that lay due w, in use *c.* 1762–*c.* 1835.

G.E. Wickham, 1971, called Fountainhead. The remarkably original HALKIN ARCADE opposite is also of 1830. Eight bays wide, of which three and seven are recessed and almost filled by one tall round-headed window. These lit the bazaars originally held on the upper floor. Converted for offices in 1979 by *Michael Haskoll*, with a shopping arcade under the l. window. This part is being reworked by *KSS Architects*, for a supermarket (2003). Its other entrance, on WEST HALKIN STREET, is more conventional, with giant pilasters, Greek porch and Greek decoration. Its neighbours here display unusual motifs for Belgravia. No. 11, l., *c*. 1830–40, is treated with a tall applied Grecian Ionic portico like those at the Adams' Adelphi, with in the pediment a superior relief tondo. The tall building on the r. is an intruder, a former PRESBY-TERIAN CHAPEL of 1881–2, probably by *J. Theodore Barker*. A funny cramped C13 Gothic front of Bath stone, with a little turret high up. In 1923 converted to a house for Mrs Zoe Oakley Maund, an occultist; since 1954 a private dining club. The interior, with an extravagant Neo-Early Georgian stair-case and gallery and a reset Jacobean stone overmantel, may retain features of 1923. Other houses, e.g. Nos. 14–16, *c*. 1839 by *Seth Smith*, are more conventional. His Nos. 4–6 on the s side, *c*. 1830, have engaged Greek Ionic columns below, apparently meant for shopfronts. No. 4 makes a corner with HALKIN PLACE, an especially attractive short street. Original houses include *Seth Smith*'s Nos. 1 and 3, with superimposed Grecian pilasters. The pretty mews-arch beyond leads to BELGRAVE MEWS WEST and the STAR TAVERN of *c*. 1830, four storeys of simple grey brick.

North-West Belgravia: the Lowndes Estate

The Lowndes Estate fills a broad band between the Grosvenor Estate, E, and the Cadogan Estate of Chelsea, w. *Thomas Cubitt* took out a building lease here in 1825, i.e. concurrently with those for elsewhere in Belgravia and Pimlico, but did little until the early 1830s. The chief difference from the Grosvenor area is the amount of C20 rebuilding, as immediately appears where West Halkin Street enters LOWNDES STREET to the w. The se corner is BOLEBEC HOUSE, by *Sir Lancelot Keay, Basil Duckett & Partners*, 1962, neat white and purple brick flats, incorporating a superior chromed bank front. Across the street appear much bigger blocks of flats, notably the semicircular CHELSEA HOUSE, flats over shops by *Thomas Tait*, 1934–5, at the oddly angled meeting with Cadogan Place. A plain, progressive design, faced with pale sand-lime brick. Only the NE corner is C19 and stucco, of 1838–*c*. 1842, with rounded corners and shops below.

From here Lowndes Street leads N to Lowndes Square, or s along the diagonal established by Belgrave Square, into Chesham Place. Heading N, the E side has the LOWNDES HOTEL, another part of *R. Sharp & Son*'s development on the Pantechnicon site (*see* above). LOWNDES SQUARE, ahead, is a long narrow space with streets entering asymmetrically, built

up 1836–49. Of *Cubitt*'s terraces Nos. 35–42 remain (W side), 1844–6, a five-storey composition with Doric porches, missing its N end. No. 35 at its S end, built for the 2nd Earl of Clare, is particularly big, with canted bays on the flank. Quite different houses on the S side, a speculation of 1837–9 by *Lewis Cubitt*, Thomas's brother. Here such disconcerting motifs as Jacobean balcony balustrades begin to appear, with the springy fat scrolls and brackets of extreme Early Victorian taste. *The Surveyor, Engineer and Architect* hailed them as 'the first houses in which the chaster part of what is called Elizabethan architecture is harmoniously blended with Tuscan'. No. 34, r., is original, the rest coarsened facsimiles of 1988–9. Big brick blocks of mid-C20 flats make up about half the remainder, too tall for the gardens they overshadow. Those by Messrs *Joseph* have grooved arches or piers high up: Nos. 43 and 44–49, 1933–4, W side, and Nos. 21–22, 1937, E; Nos. 10–19, with Greek Doric porches, are 1830s–40s. On the N side is a visual disaster for the square, the backside of the Grand Metropolitan Hotel of 1968–73 (*see* Knightsbridge). The NE exit is WILLIAM STREET, built up from 1831 with plainer four-storey houses over shops, which survive on the E side. At No. 4 a fine shopfront with Corinthian columns and column-slivers.

The S part of Lowndes Street has 1830s–40s houses, those on the E side with Greek Doric porches. The W side, a little later, is more Italianate. At the S end is CHESHAM PLACE, an elongated triangle around a garden. Its S side has Nos. 29–37, big and rather bland *Cubitt* products of *c.* 1840–50, much reconstructed. At No. 29, W, *Aitchison Jun.* added round the back an ornate conservatory like a giant iron woodlouse, for Sir Sidney Waterlow, 1895. Nos. 30–31 were combined for the Russian Ambassador, Baron Brunnow, in 1852, with a new entrance made in the rear yard. No. 37, the home from 1840 of Lord John Russell, has a five-bay elevation and solid square porch towards Lowndes Place, E. On the opposing corner is No. 38, a big detached house of *c.* 1843, with a good array of *Cubitt*'s standard square chimney pots. In LOWNDES PLACE some superior pedimented mews-end houses, with round-arched windows and segment-arched screens. The German Embassy extensions on the N side of Chesham Place belong with Belgrave Square, *see* above. On the W side (Borough of Kensington and Chelsea) are the SHERATON BELGRAVIA HOTEL by *Ted Levy, Benjamin & Partners*, 1969–71, with repeated square bays, the BELGRAVIA TELEPHONE EXCHANGE, 1958 by *G.R. Yeats* (*Ministry of Works*), with garish blue spandrels and a wavy top, and Nos. 26–28, pilastered Grecian of *c.* 1830–40. One of the last has round-arched rustication, Munich-fashion: presumably a later redressing. The W exit, N of the hotel, is PONT STREET, with a few 1830s brick houses with shops (cf. William Street, above). *Cubitt* built them to ensure a seemly approach from Chelsea to the W.

At the SW corner of Chesham Place, Lyall Street and Chesham Street branch off and merge into the terraces around the W end of Eaton Square. LYALL STREET, laid out in 1838,

was finished mostly after *Cubitt*'s death in 1855; the unusually lofty Nos. 3–4, 1847, served as his last residence and office. CHESHAM STREET has restrained Grecian houses on one side, twice broken by hurtful mid-C20 rebuilding; they may have been designed for Cubitt by *J.B. Watson*, who left drawings for Nos. 13–17. To their S a little close of smaller houses, of which No. 37 was built as a pub by *Cubitt* as early as 1829 (in 2000 heightened and given a house-type front).

SOUTH BELGRAVIA
Eaton Square, Chester Square, and the south-west

Eaton Place and Eaton Square

The S part of Belgravia has fewer notable buildings, and can be sampled more selectively. The start is in UPPER BELGRAVE STREET, the further E of the two S exits from Belgrave Square, built up by *Thomas Cubitt* in 1826–35. His terrace on its NE side (Nos. 3–11) is composed on the Belgrave Square principle, that is with a crescendo from individual porches to a joint porch for three houses, and above from giant Corinthian pilasters on each end to giant columns in the middle. At either end are detached pairs of houses also by *Cubitt*, nonmatching, but symmetrical in effect. Of these No. 1, N, with a pretty cast-iron balcony, is said to have been his first completed house in Belgravia (1826). No. 13, S, built 1829–31 for the 1st Earl of Munster, has a porch set troublingly off-centre. Inside, oblong staircase with classical reliefs and an elliptical glass lantern. The older, simpler brick terraces of Chester Street and Wilton Street run behind and between (*see* pp. 754–5).

The centrepiece of Nos. 3–11 makes the *point-de-vue* of EATON PLACE, a broad street of very grand houses, again by *Cubitt*. He himself lived in many of them, repeatedly moving as building went towards the SW, where work finished in 1850. The houses at the nearer (NE) end, of 1828–35, have exposed brick as well as a giant order. Nos. 1–31 on the NW side stretch too far for the symmetry of their seven separate emphases to register. The facing composition (Nos. 2–34) is more successful, with five emphases and a Doric colonnade linking the central porches. From here on the style becomes drabber, not helped by losses of stucco detail. The next block on the NW side, finished by 1840, is not symmetrical and drops the giant order; Nos. 37–43 here, perhaps by *J.B. Watson*, also show their brickwork. After this the SE side has Greek Doric porches, the NW side Roman Doric, and Italianate stucco, quoins and bracket-cornices become the norm. Compositions retain the slightly projecting ends and centre, painfully broken by Nos. 86–88 (SE side), mid-C20 red brick.

EATON SQUARE runs parallel to the SE. It shows a similar progression of styles on an even larger scale, too large to appreciate in any one view. The plan is a very elongated oblong, with the long axis is taken up by a main road, part of the same route as the King's Road of Chelsea. So the square also reads as one

80

prolonged street – a third of a mile long! – with generously set-back frontages (cf. Oxford Terrace and Cambridge Terrace in Paddington, *London 3: North West*). The gardens are inter-rupted by two cross-axes, making one enclosure for each of the three terraces on the long sides. Of these the NW side was by *Cubitt*, the SE side mostly by *Seth Smith*. Frontages are again composed with some variety, with the middle ones given the most pronounced motifs. Many were reconstructed as flats by *Raglan Squire* from *c.* 1952, some with obtrusive mansards. Winter, when the leaves are off, gives a view of both sides together; in summer the side roads must be followed.

Beginning with the NE side, the l. part has St Peter (q.v.), the r. part big brick houses of an older type, which continue SE down Lower Belgrave Street. Of the terrace compositions, Nos. 103–118 on the NW side (1826–30) are by *Thomas & Lewis Cubitt*, and resemble some of their joint enterprises on the Bedford Estate in Bloomsbury (*see London 4: North*): brick and stucco, four storeys with the cornice above the third, Corinthian pilasters on the end projections and the middle. Here they turn to engaged columns on the central seven bays, which project further still. Individual porches, those to the end houses placed on the flanks.* Opposite are *Seth Smith*'s Nos. 8–23, *c.* 1831–46, a similar but flatter composition, stuccoed all over. His Nos. 24–48 go further, with columns instead of pilasters and a pedimented central attic. They are out-pomped by *Thomas Cubitt*'s Nos. 83–102 opposite (design published 1829, first house built 1830, last one sold 1847). Here again is a giant Corinthian order on the centre and ends, but it breaks out in the middle of each with the only free-standing porticoes or column-screens on the terraces of Belgravia. They are rationed to four on each end and six in the middle – fewer than Nash would have managed – but the Greek Doric colonnade along the ground floor tightens the effect. The central portico had a pediment, since replaced by a balus-traded balcony like those on the ends. At the next division (Nos. 73–82), of 1841–55, *Cubitt* switched to astylar Italianate: handsome swagged frieze, Roman rather than Greek Doric colonnade, shallow canted bays on the flanks. Nos. 51–62 facing keep faith with the giant order (Corinthian three-quarter-columns), used on the ends only. They were begun after 1826 and finished (by *C.J. Freake*) after 1840, except for No. 52, rebuilt *c.* 1915 to an irritating shrunken Neo-1720s design.

Five-storey houses close the SW end. Nos. 67–71, r., 1851, are in *Cubitt*'s plainer Italianate mode. The similar No. 66a, on the opposite corner of Eaton Gate, is as late as *c.* 1877, on the site of a former school. To its l., Nos. 63–66, 1846–8 by *Freake*, more in a Pimlico style, with foliage embellishment and tripartite windows vertically linked (cf. St George's Drive, p. 772). The *British Almanac* thought they brought 'some degree of architectural improvement' to Eaton Square.

*Off to the NE in BELGRAVE PLACE, two small houses made by piercing and embellishing the C19 mews-end walls: No. 7, 1926 by *Easton & Robertson*, with a canted bay, and No. 8, *c.* 1985 by *Andrews Downie & Partners*.

South and south-west of Eaton Square, to Chester Square

The grandest effects of Belgravia end with Eaton Square. *Cubitt's* enterprises finished with the characteristic big Italianate block of *c.* 1845–55 behind Nos. 67–71 Eaton Square, bounded by West Eaton Place, NW, Eaton Terrace, SW, and EATON GATE, SE. On the opposite side of Eaton Gate, Nos. 2–10 are by *Balfour & Turner*, 1902–5 (builder *Willett*), big brick and Portland stone houses in a Byzantinizing style. They replaced *W. Porden's* Eaton Chapel, built in 1790 in the open fields. The streets S and SW of here were created by builders working on a smaller scale. The lead was taken in 1821 by *Samuel Archbutt*. By *c.* 1828 he had built Nos. 8–17 on the S side of CLIVEDEN PLACE, the continuation of Eaton Gate W into Chelsea and Sloane Square, and was busy in EATON TERRACE to the S, finished in the later 1840s. Many houses here have the familiar first-floor relieving arches of early C19 London.

The area SW of Eaton Terrace has its own character, with a rapid descent in size and ambition: see CAROLINE TERRACE, where *Archbutt* was also active, and GRAHAM TERRACE, parallel to its SE, mainly the creation of *W. Graham* from *c.* 1822 (since enlivened by St Mary, and the Francis Holland School, qq.v.). Two storeys are the norm here, still with the polite badge of stuccoed ground floors. BOURNE STREET, which runs N–S between, has cottages just one bay wide, e.g. *Archbutt's* Nos. 37–45, 1824. Also here the GROSVENOR CLUB (No. 35), built as a church hall for St Mary by *H. S. Goodhart-Rendel*, 1937–8. Economical but refined brick, with three tall Neo-Regency sashes. The block opposite forms part of a big Neo-Georgian enclave by *Chapman Taylor Partners*, built 1979–81, generously planned around a new pedestrian square called ORMONDE PLACE, with mews houses on the far side.

The houses NE of Eaton Terrace are more substantial: see the NE part of CHESTER ROW, and SOUTH EATON PLACE, which runs across it from the S corner of Eaton Square. CHANTRY HOUSE, on the E corner here, was remodelled by *John Simpson*, 1988–9, with a handsomely curved Doric porch and urns in Soane's early manner. Some houses on one side of GERALD ROAD, the parallel street SE of Chester Row, even have front gardens (leases 1844). No. 17 was home in 1930–56 to Noël Coward, who customized it for home theatricals; No. 1 is by *Liam O'Connor*, 1996, with a porch of heretical Grecian detail. Ahead, Gerald Road crosses ELIZABETH STREET, which points the way SE across the railway into Pimlico – a reminder that the two districts were much more one before the railway arrived. Here are good runs of terraces of *c.* 1820–40, most with shops, some with cast-iron anthemion balconies; Nos. 75–77 are facsimiles of 1985.* The line of Gerald Road goes on into Chester Square.

CHESTER SQUARE, an afterthought to the earliest plans, was projected in 1828 for 'second-rate' houses, started *c.* 1832,

* In BOSCOBEL PLACE off the N end, No. 48, a mews house vamped up with thin Neo-Regency trim by *Clough Williams-Ellis*, 1925.

and finished in the late 1840s. It is the most retired of the Belgravia squares, though crossed towards the NE by the busy ECCLESTON STREET, another street running SE into Pimlico, and overlooked from the SW end by St Michael (q.v.). The axis is parallel with Eaton Square, which it resembles in being much longer than it is wide. The SE and NE terraces, built by *Joseph Cundy* probably to designs by his brother *Thomas Cundy II*, are elegantly austere stucco with minimal paired antae on ends and centre. The NW side, built by *Seth Smith*, starts plain (Nos. 1–23, leases 1833–42) but turns Italianate further W (Nos. 24–32 and 37–39, leases 1842–5, separated by brick flats of 1963). The most individual design, at the SW facing the church, is Nos. 42–45. Single pilasters between the houses. A house by *John Pawson* is under way at No. 83a (2003).

BUCKINGHAM PALACE ROAD

Part of the old road between Buckingham Palace and Chelsea. It forms a busy buffer zone between Belgravia to the NW and Victoria Station and its railway approach on the SE, beyond which Pimlico stretches down to the river.

Starting at the NE end by the Royal Mews, a run of tame pilaster-strip façades of the early C20; Nos. 17–27 were built to designs of *c.* 1913 by *Leonard Martin*. Then an all too typical slab-and-podium product of 1961–5 (ROYAL WESTMINSTER THISTLE HOTEL), built in connection with the Stag Place redevelopment behind (*see* p. 719).* By *Morris de Metz*. It overlooks Nos. 8–30, the outer face of *Matthew Wyatt*'s little stucco oasis of 1838–42 (*see* Victoria Square). At Nos. 32–42 a handsome shop terrace of 1908 in Neo-Hanover Square taste. Then No. 87, a former Midland Bank of 1926 by *Whinney, Son & Austen Hall*, with a rounded and pilastered corner. A High Victorian interlude follows: the end of Grosvenor Gardens, W, and on the E side Victoria Station and its flanking wall (qq.v.). On the NW side plenty of big recent buildings and a few older survivors. Nos. 56–62, 1937 by *H.C. Constantine*, is a weak echo of its neighbour in Grosvenor Gardens. Next to it large new offices by *Michael Squire & Partners* are under way in 2003, replacing a block as recent as 1978. Nos. 92–98 are by *Read & Macdonald*, 1907, with sharp-edged gables and some Neo-C17 decoration in carved brick. At Nos. 126–158 a terrace of 1891–5 by *J.J. Stevenson*, a luminary of the early Queen Anne style, whose London works are mostly in Bayswater and Chelsea. Stone-dressed red brick, with gables, bays, or both together. Refurbished for offices in the late 1990s. Tamer contemporaries follow: the Library (q.v.), and No. 162, 1892 by *Edis*, the parsonage of the defunct St Philip (*see* St Michael Chester Square). Terracotta-trimmed, with a small church hall at the back. Behind is the former ST MICHAEL'S INSTITUTE

*It replaced GORRINGE'S, one of the lost department stores of London: by *J.T. Walford*, *c.* 1879–83, extended and largely rebuilt by *A.E. Hughes & Son*, 1908–14.

(No. 2 Elizabeth Street) by *N.F. Cachemaille-Day*, built in 1937–8 as a children's club for St Michael. Grey brick-faced, with a slit-windowed rear projection for the chapel and a slit-pierced screen wall on top of it. Down ECCLESTON PLACE, r., an early work by *Stanley Peach* (Nos. 23–27): big orange brick offices dated 1891, harshly ornamented.

Facing the late C19 sequence in Buckingham Palace Road is an office complex by *Arup Associates* (*Peter Foggo*), designed in outline in 1983, and built over the platforms in 1988–91 as Phase II of the Victoria Station redevelopment. They relate much more happily to the street than does the earlier Phase I, to the N (q.v.), and their structural and technological expression also sets them head and shoulders above the commercial norm. The plan is lucid: twin six-storey atrium blocks, with a pitched-glazed public passage in front and between, where it leads to the rectangular FOUNTAIN SQUARE, also 122 top-glazed. The passage is screened by the early C20 wall of Victoria Station, adapted with extra columns and openings, and ramps and steps within. At the back is a coach station. The office blocks continue Arups' exploration of external framing, here with paired projecting uprights. The dark infill is the outer of two glazed skins, with space left between for maintenance catwalks; it slopes outwards to cover the public passages, exposing the lower catwalks on the flanks. Skeleton and skin recall Arups' earlier complex at Finsbury Avenue (*see London 1: The City*), also built for the developers Greycoat, but to different effect; the diagonal tensioning and sombre patina of Finsbury are omitted, and the silvery girders with their hexagonal piercings have the look, at a distance, of Meccano. The weakest feature is the indented outer corners, which despite revisions from the first published design still relate uncomfortably to the screen wall. In Fountain Square 'Chalice' (1991), a wonderful FOUNTAIN by *William Pye*, who works mostly with metal and 122 water. A huge chromium basin, hung above head height from a circular wire curtain, and poised over a shaft and cone down which water flows. The wires are tied symmetrically into the roof, fusing with the architecture. The basin appears to hover magically in distant views. Each office block has a light and astonishingly pure atrium, clearly dependent on the structural grid. Twin glazed lift-shafts in the middle serve tiers of bridges to the upper floors.

Next two unusual transport termini of the 1930s, which use architectural fashions to trumpet the excitement of new ways of travel. On the NW the VICTORIA COACH STATION by *Wallis, Gilbert & Partners*, 1931–2 (*Oscar Faber* engineer). No large-scale coach station had then been built in England. The designers chose to cocoon its workings in a big solid building, leaving the buses to find their way out behind. These outlines were laid down by *Robert Sharp*, who was engaged in 1930 by London Coastal Coaches Ltd but was dropped for a firm better able to put a smart dress on things. At the angle a hieratic entrance tower with stepped and fluted detail. The sides, with their long over-emphasized bands of windows, are more obviously Modernist in manner. Vertical windows in the

Elizabeth Street wing, r., mark what was a 'first-class' restaurant and dance floor. sw extension by *T.P. Bennett & Son*, 1962. Its counterpart on the se is the former IMPERIAL AIRWAYS EMPIRE TERMINAL, of 1937–9 by *A. Lakeman*, assisted by *W.H. Williams* (now the NATIONAL AUDIT OFFICE). Art Deco Baroque, centred on a square-topped clock tower twice the height of five-storey wings, which curve forward to square lower towers. Between the wings a flat canopy and a portal, topped by huge stone super-beings carved by *Eric Broadbent* (called Speed Wings Over the World). From here passengers could board trains for the Southampton flying boats or coaches for Croydon Airport. Plain extensions of 1958–60 by *Charles Abell* and *Sir T.P. Bennett*. Passenger check-in ceased in 1980. Facing it, the Belgravia Police Station (q.v.).

The street ends at a crossroads set about with big C20 blocks. To the N where Pimlico Road starts, a tall Neo-Renaissance DRINKING FOUNTAIN of 1871 by *T.H. Wyatt* commemorates the 2nd Marquess of Westminster. Also in 1871, the 3rd Marquess gave the gardens of the little EBURY SQUARE just to the N, created after 1820 from the old Avery Green, to be a public park. The C19 layout remains, a St Andrew's cross with central fountain.

EBURY STREET

The name comes from the ancient manor of Eia, hence Eybury or Ebury. It runs just N of Buckingham Palace Road along the s edge of Belgravia, into the outskirts of Chelsea at the sw. Houses already appear at this end on Rocque's map (1746), when the rest was still just a lane through the Five Fields of the Grosvenors (*see* p. 727). This part was not filled with houses until *c.* 1790–1840.

The greatest episode is LYGON PLACE, on the NW side just behind Grosvenor Gardens. Six huge houses face a forecourt between two more, all of 1904–9 and by *A.F. Faulkner* of *William Willett*'s building firm. The multiplied gables, ironwork and big stone bows used with red brick take after Willett's work for Balfour & Turner in Eaton Gate (p. 747). Then on the se side St Peter's School (q.v.), on the NW the flank of an ambitious stucco terrace of *c.* 1842, with pilastered ends and centre to LOWER BELGRAVE STREET. Probably by *T. Cundy II*.

Back in Ebury Street, on the NW side, the former PIMLICO GRAMMAR SCHOOL of 1830, by *J.P. Gandy Deering*. This has a narrow frontage with an ambitious Greek Doric portico *in antis*, complete with pediment, rather crowded by later heightening of the outer bays. It later became a literary institute, then flats. Beyond it the long terraces begin in earnest, e.g. Nos. 28–50, later 1840s, of the Belgravian type with Tuscan porches. Large blocks of private C20 flats opposite, the zigzag-roofed BELGRAVE COURT by *Ronald Ward & Partners* of 1964–7, breaking the street line, and Nos. 55–75, brick-clad and more self-effacing, of 1975–8 by *T.P. Bennett & Son*, part of a larger scheme including offices on Buckingham Palace Road,

s (demolished). At Nos. 83–89 some straightforward houses of
c. 1796. More ambitious are Nos. 78–94 (NW side), survivors
of a composition built from 1825 by G. Watkins, of which the
centre and ends projected. Nos. 117–133 (SE side) are similarly
grouped, with round-headed windows for emphasis. Built from
1825 by George Harrison, probably to designs by his brother
Henry.

Detached blocks of mid-C20 flats take over soon after. JOHNSON
HOUSE on the SE side, 1953 by J. Innes Elliott, was built as
a police section house. Its flush yellow brick and projecting
window-frames are more up-to-date than the CUNDY STREET
FLATS that follow, four generously spaced blocks of 1950–2 by
T.P. Bennett. These funny creatures have the upright profiles
and coloured cylindrical columns of the fifties, with the long
rounded balconies of the thirties used to create a kind of ver-
tical crenellation, and sashes of early Georgian pattern.

Opposite (NW side) are two runs clearly of c. 1720–40 (Nos.
162–170 and Nos. 180–188), with segment-headed windows
and flush sash boxes. Between them is No. 176, the former
St Barnabas Boys' School, 1871 by Frederick Hunt: churchy
Gothic house, big gaunt classroom block behind. Nos. 180–182
are the grandest pair; the eight-year-old Mozart stayed in
1764–5 at No. 180. His STATUE by Philip Jackson, 1994, stands
at the junction with Pimlico Road. Plinth and setting by D.W.
Insall & Associates. Just to its E are the two white-brick blocks
of COLESHILL BUILDINGS, artisan housing of 1868–70, built
for Sir Sydney Waterlow's Improved Industrial Dwellings Co.
They owe their French pavilion toppings to the 2nd Marquess
of Westminster, who gave the land cheaply on condition that
they be 'as attractive as possible', and to the architect, W.W.
Lee. Other features, e.g. the iron-fronted access balconies,
follow the standard company model.* Shops below. The s
block faces St Barnabas (see p. 764) and the ORANGE pub in
PIMLICO ROAD, of c. 1846, with diamond-rusticated pilasters.
Further w in Pimlico Road, s side, No. 77 has a tablet (reset?)
inscribed 'Strumbolo House and Gardens 1765': a relic of tea
gardens established near here by 1762.

GROSVENOR PLACE and
GROSVENOR GARDENS
and streets off to the west

The E margin of Belgravia has a character all of its own: a
parallel series of Late Georgian streets, earlier than Cubitt's
stuccoland to the w, joined along Grosvenor Place and
Grosvenor Gardens by runs of extravagant quasi-Parisian town
houses of the 1860s. Grosvenor Place began to fill with houses
in 1767, after Buckingham House became a royal residence, and
the first streets off it soon followed. Things unfroze in the mid

*A more typical I.I.D. Co. project is LUMLEY BUILDINGS of 1875, in Pimlico
Road, just beyond the boundary with Chelsea (N side).

1860s, when over 200 house leases expired together. Grosvenor Place was widened and largely rebuilt, and Grosvenor Gardens laid out to its s as two contiguous triangles. The chief architect was *Thomas Cundy III*. As in Victoria Street the development was in large blocks, mostly from corner to corner; the style chosen was a version of the rich C17 French Renaissance which started in London at the Grosvenor Hotel (q.v. Victoria Station, the terminus for Paris). Its details are by no means correct for any period in French architecture, but the pavilion roofs are unmistakable, pyramidal as well as domed. The materials too are characteristically Victorian, mixing in granite trim, red Mansfield stone bands and terracotta cornices. Besides what the *Illustrated London News* called 'aristocratic mansions or rather palaces', one block of flats was also provided, in Grosvenor Gardens. Much of Grosvenor Place has been rebuilt for big mid-C20 headquarters, but the rest survives almost entire, including outriders in Grosvenor Crescent and Lower Grosvenor Place. The description is from N to s, with the streets off to the w following in order.

GROSVENOR PLACE. The first block, between Grosvenor Crescent and Halkin Street, is all stone-faced 1960s offices: Nos. 1–3 by *Stone, Toms & Partners*, 1963–9; Nos. 4–5 by *T.P. Bennett & Son*, 1958–61, fiddlier. Then Nos. 6–16, of 1867–9 by *T. Cundy III*. Ends and centre are emphasized with pavilion roofs and canted bays. End houses with porches in the side streets; at the N end also a big mews arch of Belgravian type. The view of Buckingham Palace gardens made these the most desirable houses, hence the superior INTERIORS. No. 6 was decorated for Henry Campbell-Bannerman by *George & Peto*, 1878, but the present Neo-late C17 English work looks *c.* 1910. At Nos. 8 and 9 the first-floor rooms are rich Louis XVI; staircases with arcaded upper landings. No. 11 has flamboyant first-floor saloons by Parisian craftsmen and a room below with imported Viennese panelling, noted in 1869. Splendid Dixhuitième interiors in enfilade at No. 16. No. 17 (IRISH EMBASSY) on the N corner with Chapel Street, built some years later, is of slightly different design. Fitted out *c.* 1890 for the shipowner Sir Arthur Wilson; the big open-well staircase may be earlier. Nos. 18–20, a trio of stuccoed Italianate mansions, are by *T. Cundy II*, 1842–4. Crammed elevations, with every window balconied. On their site was the Lock Hospital, founded to treat venereal disease in 1747. Nos. 21–24 (IRON TRADES HOUSE), 1937–9 by *A.A.H. Scott & W.L. Twigg*, stone-faced and quiet. Between Chester Street and Wilton Street, Nos. 25–35 (formerly AEI). By *Wimperis, Simpson & Fyffe*, 1956–8 (consultant *Sir Albert Richardson*). Called by Pevsner 'almost grotesquely reactionary', it now seems appealingly quirky. Six-storeyed, stone-faced, with corner pavilions with concave curves. Below the eaves in the centre sculptures by *Maurice Lambert* of angels treading down devils; on the ends tangled openwork bronze finials. Paired spindle columns below the roof, a late Richardson mannerism. Reconstructed internally by *EPR*, 1991–3, with a large atrium.

85

Finally Nos. 36–46, offices of 1996–9 by *HOK*, replacing Hobart House.* Stone-faced, with mullion-screens in a novelty mixture of stone and frosted glass. Spectacular atrium, with glazed steppings-down behind.

GROSVENOR GARDENS. The 1860s ranges line the long sides of the two triangular spaces, making a St Andrew's cross. Begun in 1865, they were substantially complete by 1867. In the N TRIANGLE the NE side is symmetrically composed at *Cundy*'s Nos. 1–17 (No. 1 altered 1929). The symmetry falters at Nos. 19–21, the former National Bank (1867–8 by *T. Chatfeild Clarke*), with its paired granite columns and rounded corner. The SW side is mostly symmetrical, with four pavilions and no stressed centre (Nos. 4–30). No. 2, r., lower and a little later, is red brick rather than stone; No. 32, l., has the complicated job of rounding the corner; the smaller No. 34 behind it, of brick, screens the mews. In No. 32 a show-stopping inlaid marble overmantel in the Italian style of *c.* 1600. In No. 5 a lavish Neo-Rococo saloon with painted overmantels. Rear parts of Nos. 12–18 rebuilt 1974. For the N side *see* Hobart Place, p. 755 below. The GARDEN and railings were restored in 1999–2000, and alarming naturalistic SCULPTURES by *Jonathan Kenworthy* of a lioness stalking a kudu set up. At the N end the RIFLE BRIGADE MEMORIAL by *John Tweed*, 1924–5: a curved screen wall with three standing soldiers in Peninsular or contemporary uniform. Also a late C19 CABMEN'S SHELTER. The *Cundy* mansions continue to the E in LOWER GROSVENOR PLACE, behind No. 1: Nos. 11–15, a symmetrical pavilioned group, of white brick rather than stone and with shops below. No. 10 was replaced in 1999 by *Michael Squire & Partners*: a pale, urbane block with curved end and oval glazed penthouse.

The S TRIANGLE is complete on the NE side (Nos. 23–47), built for the Belgrave Mansions Co., of red brick instead of all stone and also with shops below. It contained first-class flats, which in imitation of 'the Parisian mode of life' were let furnished, the earliest such in London. A restaurant within saved residents from having to cook. Nos. 36–50 (1867–9), SW side, are by contrast stone-faced; No. 36 has the best interiors. The composition is incomplete, the l. house having gone when TERMINAL HOUSE (No. 52) was built. This is of 1927–30 with elevations by *Lutyens*, the rest by *Yates, Cook & Darbyshire*. Entrances with big Doric columns *in antis*, the surrounds with Lutyens's favourite pilasters emerging from rustication. Also French the GARDEN, with two dear little shell and pebbledash lodges with pediments on all four sides, formerly with a parterre between. The gift of the French government in 1952, designed by *M. Moreux*, architect-in-chief of French national monuments and palaces. Just outside it an equestrian STATUE of Marshal Foch by *G. Malissard*, 1930, a version of one at Cassel.

* By *Howard & Souster*, 1937–40, later home to the National Coal Board.

Streets off Grosvenor Place, from north to south

GROSVENOR CRESCENT. Begun from the N corner of Belgrave Square in 1833, completed from 1865 across the site of Tattersall's famous horse market, to the NE. Nos. 11–15 here, *c.* 1867–9, are more of *T. Cundy III*'s big French Renaissance houses, this time without pavilion roofs. To their r. GROSVENOR CRESCENT MEWS runs back NW behind Knightsbridge, through a stuccoed Palladian ARCH of 1990, added in connection with work in Knightsbridge to the N (*Fitzroy Robinson Partnership*). GATES of 1996, based on the Grosvenor wheatsheaf motif. Mews houses mostly to one design of *c.* 1870, yellow brick with polychrome trim. To the l. Nos. 1–10, built by *Seth Smith* after 1836. Giant pilasters, and big Corinthian columns on the rounded l. corner, which faces Belgrave Square diagonally. Nos. 16 and 17, S side, are of *c.* 1852 by *Thomas Cubitt*, with stepped fronts and angled porches.

HALKIN STREET. A gap was left for this in the C18, but building began only *c.* 1808. Of this period Nos. 1–4, S SIDE. At No. 5 the HALKIN HOTEL, dismal sub-traditional (1988–90 by *S.K. Riddick & Partners*). Facing it, FORBES HOUSE (SOCIETY OF MOTOR MANUFACTURERS AND TRADERS), nine unenterprising terrace-house-like bays of yellow brick, behind a walled forecourt with trees. The five l. bays belong to the first house, of *c.* 1810 by *Sir Robert Smirke* for the 5th Earl of Oxford; the next three bays were added in 1824 for the future 3rd Earl Fitzwilliam (*Edward Trehearne* surveyor); the r. bay and the arched stone doorcase date from remodelling of *c.* 1912, for the 8th Earl of Granard and his wealthy American countess Beatrice (*née* Ogden Mills). The cast-iron balcony was probably done *c.* 1868 for the 1st Lord Penrhyn, who extended the house behind. Inside, the Granards' work subsumes all the rest. The decorators were *Lenygon & Co.*, with *Fernand Allard* of Paris; the architect may have been *F. W. Foster*, who later worked with the same firms at the Granards' Castle Forbes, Co. Longford. Entrance lined with French *stuc*, with an overmantel relief of Jason and the Golden Fleece. Column-screens lengthen the apparent distance before the full Imperial staircase rises at the back.

Further W No. 9, 1910–12 by *Blow & Billerey* for Sir Hugh Morrison; since 1946 the CALEDONIAN CLUB. Five bays of nicely rough rosy brick. Neo-Early Georgian style and proportions, but with a mid-C17-type doorcase, also of brick. Lame E extension for the club, of 1969. On the main site was *Sir R. Smirke*'s Belgrave Chapel of 1812.

CHAPEL STREET. Built up from *c.* 1787. Nos. 9–11 (S side) are of that time. Facing, No. 38, 1932–4 by *Etchells*, with six houses in Headfort Place behind. Red brick Neo-Georgian. Further W are runs of the 1800s–20s with pretty cast-iron balconies. Behind No. 30 (N side), the central house of a group of five of 1815, is an implausible timber-framed hall, said to be have been built *c.* 1890 to display a collection of armour.

CHESTER STREET was begun and finished later, from 1797 to

the 1830s. Nos. 8–14 (N side), 1810s, have door voids with Doric columns. Nos. 24–29 on the S side were built by *Seth Smith*, leases 1830–1. The smaller streets off Chester Street show a good selection of lesser houses. CHESTER CLOSE, N, has COBHAM COURT, flats of 1982–5 by *Davis & Bayne Partnership*. Pleasant enough, with external steps to the upper flats. Further W, GROOM PLACE, an early C19 mews. At its N exit a charming pair of houses with original shopfronts, one dated 1821. S of Chester Street is Chester Mews, and off it to the W LITTLE CHESTER STREET. On its S side Nos. 14–26, a natty little Neo-Georgian terrace by *Stone, Toms & Partners*, c. 1960. Nos. 4–10 opposite are modest *Seth Smith* houses of c. 1827.

WILTON STREET. Built up from c. 1813. After the mid 1820s organization into one composition begins to appear: Nos. 4–15, N side, and *Seth Smith's* Nos. 16–23 (S side), where the ends have Grecian pedimental attic blocks.

HOBART PLACE. The continuation of the King's Road route beyond Eaton Square, into Grosvenor Gardens. On the N side Nos. 11–14, 1907 by *Boehmer & Gibbs*, in a style of c. 1700 with a Dutch gable. Nos. 1–4 and No. 6 on the S side, Belgravian stucco, probably 1840s; the tiny No. 5, c. 1870, conjures ridiculously with the Grosvenor Gardens style.

KNIGHTSBRIDGE

Part of the main approach to London from the W, so named along its present length as late as 1903. The name comes from the *Kyngesbyrig* (king's bridge) recorded in the mid C11. It stood at the present Albert Gate, i.e. about halfway along. To its W was a hospital, originally a medieval lazar-house. By 1718 this was defunct, but its chapel lasted, rebuilt, until 1904. Most of the smart district familiarly known as Knightsbridge lies S and W of here (*see London 3: North West*). The street itself starts from Hyde Park Corner (*see* p. 657), and at first faces the park.

On the W side of Hyde Park Corner is the former ST GEORGE'S HOSPITAL (now the LANESBOROUGH HOTEL), a product of the Metropolitan Improvements, like the arch and screen on the traffic island opposite. It is a fine stuccoed Neo-Greek building by *William Wilkins*, 1827–33. The façade is tripartite with projecting wings (for ward blocks) and centre. The centre has a giant portico of four square pillars. Details come from the Choragic Monument of Thrasyllus. Top storey and pilaster surrounds to the second-floor windows added 1859, by *Arthur Mee*. The N front was restored in 1988–91, when the hotel conversion was done (*Fitzroy Robinson Partnership*, consultant *Anthony Blee*). It now has a central three-bay projection with pilasters (the porch not a Wilkins feature), rather than the spur wings added in 1868. Of INTERIORS the former entrance hall remains, of two storeys with upper galleries, severely Greek. The new public interiors are similarly treated, lightened by

a Gothick conservatory behind. Wilkins's building replaced Palladian premises just to the E, enlarged in 1733 by *Isaac Ware* from a house built in 1719 for the 2nd Viscount Lanesborough. The hospital decanted to Tooting in 1980.

Heading w, No. 1, 1988–91 by *Kevin Dash* of the *Fitzroy Robinson Partnership*, replaces early C19 houses taken over by the hospital. A good strong solid brick front with upright windows, playing off concave and convex. Nos. 11–13, originally Hyde Park Corner underground station, is unmistakably *Leslie W. Green*'s (1906); now a restaurant. On top a former hotel by *Delissa Joseph*, 1908–9, over-ornate stone. Nos. 15–17, a pair of town mansions by *George Legg*, 1870–1, already of brick and stone rather than stucco, and with eclectic trim. Nos. 19–23 (formerly Bank of Nova Scotia), with projecting marble-faced floorbands, is by *Julian Keable & Partners*, 1962–3. Then two symmetrical offices by *Hunter & Partners*, 1991–5: CARLTON (No. 25), buff brick and white stone with two big flat bays and simplified incised classical detail, and the larger ALFRED DUNHILL (No. 27), with a giant central bow. On the former two reset carved keystones from the becolumned Farmers' Union building formerly here, by *Ronald Ward & Partners*, of 1956. Nos. 37–39 are flats of 1935–6 by *Mitchell & Bridgwater*, in a Modernist idiom, but handled without grace (future uncertain). Then the big BERKELEY HOTEL, by *Brian O'Rorke*, 1965–72. Its entrance front to Wilton Place, w, is an appealing exercise in reductive classicism, faced in Clipsham stone. It took some courage at that time to use corner turrets, simple mouldings, a hipped slated roof and chimneystacks. Inside, a little silvery panelled room by *Lutyens*, 1913, brought from the previous Berkeley Hotel in Piccadilly. Rear extension 2001–2. Diagonally opposite the hotel is PARKSIDE, a long gabled brick mansion block, the first of the tall buildings that block the view of the park (by *Hart & Waterhouse*, 1906–7, carving by *H.H. Martyn*). Opposite, a comparable block by *W.D. Caröe*, more original in its details; 1902–3 (dated 'Anno Edw VII Coronationis'). Busts of notables of the day adorn the end parts.

We are now approaching ALBERT GATE. Here to the E and W of the carriageway two Italianate palazzi were built by *Thomas Cubitt* in 1843–5, the tallest private houses London had yet seen. Their windows match, but the w house has them set much more closely, so the effect is very different. The E house was taken by George Hudson, the Railway King, but soon became the FRENCH EMBASSY. A lower extension including a ballroom was made in 1899–1902 by *Olivier Carré*, r., matching externally, but using some reinforced concrete framing (*Hennebique* system), probably its first non-industrial use in London. Interiors mostly despoiled. Slightly more survives inside the w house (KUWAITI EMBASSY), remodelled after 1885 for A.D. Sassoon by *G. Jackson & Sons*, notably the marble-lined staircase with gilded balustrade. Next door is HYDE PARK HOUSE, offices by *Guy Morgan & Partners*, 1959–64. Premises for the Royal Thames Yacht Club in the lower storeys; in its entrance two melancholy stone lions

from a third, even larger *Cubitt* mansion on the site, of 1852–8.

Facing Albert Gate on the S SIDE the GRAND METROPOLITAN HOTEL by *Seifert & Partners*, 1968–73 (*Ove Arup & Partners* engineers). A fifteen-storey circular tower, arrayed with socket-like projecting windows clad in ochre mosaic. It all goes wrong at ground level, with its fiddly, shapeless podium. Next to it (actually in Kensington) is HARVEY NICHOLS, a rare instance of a late C19 department store still in use. By *C.W. Stephens*, 1889–94, rather boring brick and stone with weak pavilions and small detailing. SW and SE extensions by *F.E. Williams & Alfred Cox*, 1922–34, with giant pilasters of Selfridge type. Rooftop restaurant made 1992 (remodelled by *Lifschutz Davidson*, 2002). The shop was founded in 1831 by Benjamin Harvey, draper.

Back on the N SIDE, Nos. 62–64 is the former London & County Bank by *F.W. Porter*, with giant attached columns and a big porch, amazingly conservative for 1884–5. The HYDE PARK HOTEL (now MANDARIN ORIENTAL HYDE PARK) is of 1888–91, by *Archer & Green*. Much higher than the Italianate blocks, of brick, with French Early Renaissance decoration and pyramid roofs with lanterns, forming a jagged skyline. Built as gentlemen's chambers and a club, not unlike the architects' Whitehall Court (*see* p. 278), and with the same fraudulent promoter, Jabez Balfour of the Liberator Company. The partnership split in 1889, after which *Thomas Archer* joined *Francis Hooper* to finish the interiors; it became a hotel in 1902. The main STAIRCASE of 1889 remains, pilastered and lined with contrasting marbles. The rest, mostly later, include a white and gold BALLROOM of 1911–12 by *Mewès & Davis*, expert purveyors of Louis Quinze, and in the W part a BAR and interlinked RESTAURANTS of 1999–2000, by *Eric Parry Associates* and *Richmond International* (designer *Adam Tihany*), with contrasting, mostly dark colours and materials.

BOWATER HOUSE, a bloated office complex with a seventeen-storey tower at the W end, is also by *Guy Morgan & Partners*, 1956–8. Built for the developer Harold Samuel; the unusual height was his trade-off for giving up some land for street widening, with a roadway running below. Facing the park a SCULPTURE by *Epstein*, posthumously cast (1959–61). The god Pan urges on a running family group and dog. An embarrassing decline from his works of a few years before. Then more Late Victorian mansion blocks, starting with WELLINGTON COURT, 1893–5 by *M.E. Collins*. For Knightsbridge Barracks q.v. p. 64

VICTORIA SQUARE

An extremely pretty enclave just E of Grosvenor Gardens, composed in the style of the West Strand Improvements (*see* p. 364) but on a scale chiefly reminiscent of the seaside. Built in 1838–42 as a speculation by *Matthew Wyatt*, grandson of James Wyatt. Stuccoed façades with giant pilasters as the

main accents. Two recessed domed pepper-pot corners, also
with pilasters, mark the N access from Lower Grosvenor
Place. Some good shopfronts on that side. The E part faces
Buckingham Palace Road, E, where some houses turn their
backs on the square proper. To Beeston Place, SW, five houses
went in 1925–6 to extend the GORING HOTEL to the S. This
is by *Giles, Gough & Trollope*, 1909–10, a squashed-flat-looking
front with little Venetian windows here and there.

PIMLICO

INTRODUCTION

Pimlico is largely the creation of *Thomas Cubitt*. As his biographer Hermione Hobhouse writes, 'No other developer has had such absolute control over such a large area of London.' In Belgravia he was only the foremost of several developers; in Pimlico his hand was barely restrained even by the freeholders, who had the sense to let him get on in his own way. The foremost of these was the Grosvenor Estate, with which Cubitt's main building agreements were made in 1824–8, i.e. at the same time as for its Belgravian lands to the N. Other pieces were added over the years, and when Cubitt died in 1855 his broad new streets were fully laid out, and about half the projected houses built. The rest were finished by *c.* 1875, true to the end to Cubitt's conception of superior stucco Italianate terraces. The heart of Cubitt's

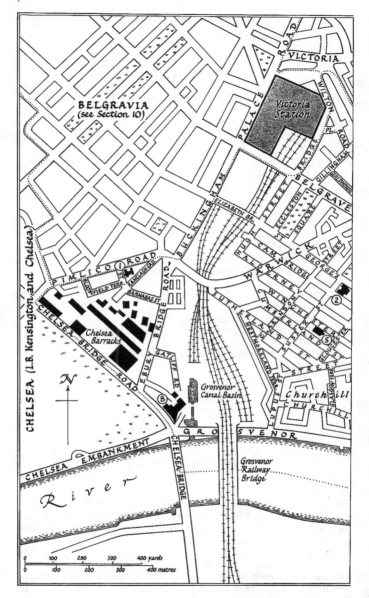

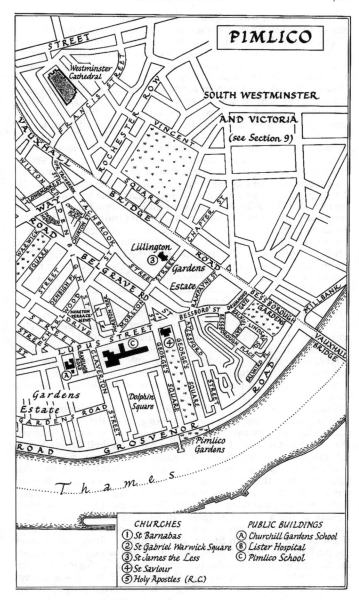

PIMLICO

SOUTH WESTMINSTER
AND VICTORIA
(see Section 9)

Westminster
Cathedral

STREET

FRANCIS ST

ROCHESTER ROW

VINCENT SQUARE

VAUXHALL

WAY

ROAD

WILTON

WARWICK SQUARE

WILTON ST TACHBROOK
LONGMOORE ST
CHITTERN ST
WINCHESTER ST

TACHBROOK STREET

BRIDGE

CHAPTER ST

ST

Lillington
③ Gardens
Estate

BELGRAVE RD

DENBIGH ST

WOOD ST

CLARENDON ST

MORETON STREET

MORETON TERRACE MEWS

DRIVE

CLIFTON ST

LAMPAYNE ST

BESSBORO' ST

BESSBOROUGH GARDENS

MILLBANK

STREET
STREET

ⒶLUPUS STREET
Ⓒ
CLAVERTON

④
GEORGE'S SQUARE

ST GEORGE'S SQUARE

WESTFORD STREET

BESSBOROUGH PLACE
DRUMMOND
GATE
BLUE
LINDSAY
SCOVALO

ROAD

VAUXHALL
BRIDGE

Gardens
Estate

GARDENS

Dolphin
Square

ROAD

STREET

GROSVENOR

ROAD

Pimlico
Gardens

T h a m e s

CHURCHES	PUBLIC BUILDINGS
① St Barnabas	Ⓐ Churchill Gardens School
② St Gabriel Warwick Square	Ⓑ Lister Hospital
③ St James the Less	Ⓒ Pimlico School
④ St Saviour	
⑤ Holy Apostles (R.C.)	

achievement, the three squares and the area to the NW, remains
one of the most architecturally consistent areas of London.

The name Pimlico is thought to derive from an inn near
Victoria Station, or from a brew served at the inn. It was current
from the 1620s, but was applied to the area further N and E. Most
of modern Pimlico was known before the C19 as the Neat
Houses. It was used largely for market gardens, interrupted at
the W by an arm of watery ground, which the Chelsea Water
Company formed into reservoirs after 1724. The Grosvenor
family owned most of the fields, which were crossed from E to W
by a track on the line of the present Warwick Way. This carried
on W to Chelsea across a wooden bridge at the NW angle of the
water, on the site of the modern Ebury Bridge. A small settle-
ment lay E of this bridge, just a scatter of cottages and pubs or
tea houses. The first attempt at large-scale development was by
the river, in 1807, and was mostly industrial. This lease was taken
over in 1817 by *John Johnson*, who added a few runs of houses
before selling out to Cubitt in 1825. By that time Vauxhall Bridge
Road had been made to the NE, and the reservoirs to the W and
NW were being remodelled as the Grosvenor Canal (1824–5),
which helped with the transport of building materials. But
Cubitt had so much on his plate elsewhere that he did not begin
in earnest here until *c.* 1840, save for dumping earth to raise the
ground. Meanwhile unambitious terraces by lesser builders were
going up around the fringes, around Bloomfield Terrace and
82 Ebury Bridge Road W of the canal, around Wilton Road, and
along Vauxhall Bridge Road. Cubitt aimed higher, both archi-
tecturally and in terms of optimum use of land. He not only
acquired extra acres to perfect his street plan (as at Bessborough
Street), but also undertook pressing public works at his own
expense, as in the embankment of Grosvenor Road after 1849.
From 1839 his own vast depot was close at hand, on Grosvenor
Road.

Cubitt's PLAN developed logically if unadventurously from
existing fixed points. The main NW–SE axes of Belgravia, carried
across the canal by two new bridges, were continued as Belgrave
Road and St George's Drive, parallel with Vauxhall Bridge Road.
Eccleston Square and Warwick Square lie between these two new
roads, from which a diagonal street grid extends laterally on both
sides. At the S the grid stops at Lupus Street, which follows an
older E–W route along the N edge of Johnson's riverside estate.
Between it and the river the streets lie N–S, including St George's
Square at the S end of Belgrave Road. Other infractions of the
diagonal grid represent routes established before Cubitt's time:
Warwick Way, Denbigh Street, and Tachbrook Street, made over
the curving line of the King's Scholars' Pond sewer. Mews streets
are fewer than in Belgravia, reflecting changes in habits as much
as any decline in ambition. For the *haut ton* Pimlico was always
second-best, however, and its bigger houses often proved harder
to sell than the three- and four-storey terraces of the side streets.
The placing of pubs on ordinary streets also shows a social
declension from Belgravia, where they are hidden in mews. Shops
were deliberately concentrated in particular streets or parts of
streets, as still appears.

Cubitt made the streets, sewers and some of the house vaults, but apart from some runs in the squares he built few HOUSES himself. The great formal compositions of Belgravia were not repeated. Fashion was turning against them, and they were also harder to achieve in stages over long years. The usual Pimlico street has instead long stretches of matching fronts, occasionally with the centre and end houses projecting. The designs are difficult to attribute: Cubitt certainly was closely involved, but he also employed architects or draughtsmen, and on Grosvenor land he worked under the eye of the surveyor *Thomas Cundy II*, whose own independent designs are not dissimilar. The builders or their architects may also have supplied some designs, or else have adapted existing ones. The earliest houses are in the restrained Late Classical idiom of much of Belgravia, e.g. at Nos. 1–3 Eccleston Square, after which quoins and Doric porches come in, and more use is made of pediments for windows. From *c.* 1850–5 fronts become more eclectic, though never fully 84 eclectic in the high 1860s fashion.

Other C19 buildings include CHURCHES, three designed by *T. Cundy II*: two on Grosvenor land (St Gabriel and St Saviour), the third, St Barnabas, intended as a mission church for the 71 area to the NW. Another is *G.E. Street*'s St James-the-Less, also 72 in a poor district, off Vauxhall Bridge Road. MODEL HOUSING was confined to land w of Cubitt's 'take', off Grosvenor Road and Ebury Bridge Road. The new railway to Victoria Station (1858–60) overran much land alongside the canal, which declined and was gradually infilled. Its s basin remains off Grosvenor Road. A BARRACKS built in Chelsea Bridge Road in 1861–3 was rebuilt a century later. INDUSTRY has almost disappeared, though some Victorian builders' offices remain from the wharves along Grosvenor Road.

The excitements of the TWENTIETH CENTURY are mostly post-war. Before then the main events were by the river, including the rebuilt Chelsea Bridge and Vauxhall Bridge and the huge 1930s complex of private flats at Dolphin Square. After 1945 the main effort went on new PUBLIC HOUSING, partly on bombed sites, partly at the expense of stucco terraces (the Grosvenor Estate anyway sold up after 1950). Two big and influential showpieces resulted: *Powell & Moya*'s Churchill Gardens in Grosvenor 5, Road (1947–62), a spacious pioneer of the mixture of tall p. slabs and lower terraces, and *Darbourne & Darke*'s Lillington 779 Gardens, Vauxhall Bridge Road (1964–72), heralding the change 116, to continuous structures on more intricate and introverted p. plans. PRIVATE HOUSING took longer to revive, apart from the 784 inevitable gentrification of C19 terraces. The first riverside flats on Grosvenor Road were finished in 1971, the best, Crown Reach 118 by *Nicholas Lacey* and *Maguire & Murray*, in 1983. The biggest development is *Chapman Taylor Partners*' rebuilding of the Crown Estate at Bessborough Gardens, Vauxhall Bridge Road, 1985–9, much of which takes after the stucco terraces it replaced. The stucco revival also appears in the heart of Pimlico, where underused sites and red brick post-war works are giving way to Neo-Cubitt reinstatement (Gloucester Street). In between, i.e. *c.* 1970, a few interesting small houses were built (Cambridge

Street, Winchester Street), since when innovative design has retreated into the mews (Moreton Terrace). OFFICE BUILDINGS are relatively few. The highlights are in Vauxhall Bridge Road, by *Avery Associates*, 1996–7, and *Whitfield Partners*, 1983. The one

p. outstanding Modernist PUBLIC BUILDING in the area is *John*
770 *Bancroft*'s glass-sided Pimlico School of 1966–70.

FURTHER READING. The starting point is Hermione Hobhouse's great study *Thomas Cubitt, master builder*, 1971 (reissued 1995). I. Watson, *Westminster and Pimlico Past*, 1993, and A. Stout, *Pimlico: deep well of glee*, 1995, are well-illustrated works that fill several gaps. Individual histories include K.F. Morris, *A History of Dolphin Square*, 1995.

CHURCHES

ST BARNABAS
St Barnabas Street

71 1847–50 by *Thomas Cundy II*, typical of his later church work.*
The *Ecclesiologist* saluted it as 'the most sumptuous church which has been dedicated to the use of the Anglican communion since the revival'. Of ragstone rubble, E.E. in detail, with NW tower and broach spire of Caen stone. It was built in what was a poor quarter, hence the picturesque ensemble of Cundy's CLERGY HOUSE, S, and SCHOOL, N, built in 1846–7. St Barnabas was also a pioneer church in the Anglo-Catholic movement, daily choral services being intended by its founder, the Rev. William Bennett of St Paul Wilton Place (*see* p. 734). A CHURCH HALL was added E of the clergy house in 1900, in similar lancet style. Behind these buildings are enclosed courts, of which the S one forms the approach to the church. Off the S aisle here a flat-roofed baptistery, added in 1902 by *Frederick Hunt*. The church consists inside of nave and aisles, the N aisle continued under the tower. Alternating circular and octagonal piers, exuberantly foliated capitals (*G.P. White* carver), arch-braced timber roof. Chancel long and very high, with sedilia and piscina copied from Preston church, Brighton. Beneath the chancel a vaulted crypt, intended to serve as a chapel for the clergy house.

FURNISHINGS. Mostly Late Victorian, by which time the Gothic Revival once more preferred archaeology over eclecticism, refinement over muscle, and English models over foreign. The chief designers were *G.F. Bodley* and his pupils *Kempe* and *Comper*, working for the Rev. Alfred Gurney, who embellished the church from the 1880s as a fashionable place of worship. T he E end is the chief glory. – REREDOS. 1893 by *Bodley & Garner*, with tiers of excellent carved figures. By them also the ORGAN CASE and marble PAVEMENT. – STALLS and PARCLOSE SCREENS made by *Jordan & Co.*, 1850, the latter richly painted

*No evidence can be found for the tradition that *William Butterfield* assisted him.

in the 1890s. – SACRAMENT HOUSE by *Comper*, 1890–6. – Chancel DECORATION, of 1890–6 by *Comper* below, the upper parts with brocade-like stencilling by *Kempe* and his nephew *Walter Tower*, after 1896. – SCREEN. 1906 by *Bodley*, a fine piece in Norfolk C15 style. In it brass GATES of 1850 by *Hardman*. ROOD above with figures by *Kempe & Tower*. – PAINTING over the chancel arch by *H.T. Bulmer*, 1850; the texts around the arcades also original. – PULPIT of stone, 1850, with figures painted on metal. – Brass eagle LECTERN, 1850. Designed by *Butterfield*, made by *Potter*. – MOSAICS in the nave. Venetian, to designs by *Booker*, 1870s–80s. – LADY CHAPEL, s aisle, with screens, stained glass, altar and decoration designed by *Comper*, 1900, as a memorial to Gurney. Particularly good the entirely unsentimental altarpiece of the Lamentation, style of *c.* 1500. – SCULPTURE includes a Calvary group under the tower, Oberammergau work given in 1910, and a tabernacle with statue of St Barnabas by *Tower*, w end; many other figures by *Comper*. – Purbeck marble FONT, 1850, with COVER probably of 1902. – Other STAINED GLASS. E window of 1956, showing *Comper*'s decline. Figures against clear glass. Oculus above, *c.* 1850 by *W. Wailes*. w rose, grisaille, also by *Wailes*. Nine windows by *Kempe* and successors, 1902–22: chancel s, N and s aisles, and N aisle W. s aisle W, 1900, style of *Henry Holiday*. Baptistery windows by *Martin Travers*, *c.* 1945. – CRYPT fitted up by *Bodley*, 1887; the iron SCREENS designed by *Comper*, 1889; STAINED GLASS 1865; PAINTING by *Frederic Shields*, *c.* 1900.

ST GABRIEL WARWICK SQUARE

1851–3 by *Thomas Cundy II*, conspicuously sited at the SW end of the square. Typical of Cundy's Pimlico churches, Dec style, of ragstone rubble dressed with Caen. NW tower and broach spire, the last shortened a little in repairs by *J.P. St Aubyn*, 1887–8. By St Aubyn also the large NE vestry. Gabled outer aisles, a SE chapel and W porch were added by *Arthur Baker* in 1895–7, when the galleries were removed. Arcades with piers with moulded capitals in the E.E. way, but above them very naturalistic corbels (carving attributed to *Samuel Cundy*, nephew of the architect). These support shafts on which the principals of the arch-braced roof rise. Aisles with pretty timber vaults of 1895–7, the inner aisles rising higher than the outer. Of 1895–7 also the W gallery on stone columns, interpenetrating Cundy's arcades.

FITTINGS. The most interesting are from the 1890s beautifications. HIGH ALTAR by *J.F. Bentley*, 1890, with painted front and marble footpace. The lavish chancel decoration, including the REREDOS, alabaster PANELLING, MOSAICS and wrought-metal COMMUNION RAILS, is by Messrs *Powell*, 1897–8. – Contemporary oak SEDILIA, carved by *R. Bridgeman* of Lichfield. – ORGAN CASE designed by *Sir Arthur Blomfield*, 1893. – PULPIT of brass openwork and granite, designed by *St Aubyn*, 1875. – In the SE chapel canopied NICHES, remains of the bomb-damaged former main reredos of 1869–77, designed by *G.E. Street* and made by *Salviati*. – FONT of 1853 carved by *Samuel Cundy*, the gift of his

uncle. – STAINED GLASS. E window and S chancel window 1896, good work by *Kempe*. W window a replacement of 1953 by *John Crawford*, the design too small for the space.

ST JAMES-THE-LESS
Vauxhall Bridge Road and Lillington Gardens

1859–61, the first work in London by *George Edmund Street*. One of his most important churches, and one of the finest Gothic Revival churches anywhere. Built at the expense of the three daughters of Bishop Monk of Gloucester in what was a poor neighbourhood, it rose, said the *Illustrated London News*, 'as a lily among weeds'. The materials, red brick with much black brick enrichment, speak their own mind and nowhere seem cheap. Details are otherwise simple and as Eastlake pointed out 'eminently un-English'; North Italian, German and Early French forms all appear, though generally as evocations rather than in quotation marks.* The church also makes an excellent group with the school, E, and with the later parish hall, W (*see* below). It has apse and transepts and lies back from the street, but reaches out with a passage and a porch. Over this porch the tower stands, in the manner of a campanile (Street wrote in 1855 that 'there are no features of Italian buildings which are so universally remembered with pleasure'). It is square and solid, strong and not at all elegant, and has a top-heavy spire, corbelled out to emphasize its mass. This begins as a single pyramid, modelled as it rises into four spirelets and a central spike. Globes of semiprecious stones on the wall face, above the bell openings. The church has a steep slated roof, broken by one gable on each side and carried round the apse as a half-cone. The buttresses die into the wall. On the N front they have carvings from Genesis. Over the main door carved roundels of the Wise and Foolish Virgins. Excellent RAILINGS to the N with tendril-like finials in three dimensions, derived from a screen in Barcelona Cathedral. Made by *James Leaver* of Maidenhead, 1866. The processional route of bollards from Vauxhall Bridge Road, S, was laid out *c.* 1970 in connection with the Lillington Gardens Estate.

72 The INTERIOR is broad, of three wide bays with clerestory, and with not too distant a feel to the chancel. The red brick shows and there is again decoration with black brick, and also with mastic and with *Maw*'s red and yellow glazed tiles, which carry on from floor to lower walls. Short, fat granite columns, with shaft-rings and stiff-leaf or figured capitals, support arcades of notched and moulded bricks. Nave windows with broader applied arcading overlaid. The clerestory has three-light windows in the first two bays, plate tracery in the third (in the gables of the roof), repeating the motif of the apse windows. Transepts of two unequal bays, creating mysteriously charged spaces at the crossing. This has a sexpartite brick vault, and the chancel is also vaulted. Here much marble lining and inlay. The CARVING was by *W. Pearce*, the best on the capitals at the nave ends, done

*Traced by Neil Jackson in *Architectural History* 23, 1980.

with Street's wonderful instinct for design. On the nave roof a PAINTING of the Tree of Jesse, by *Clayton & Bell*.

FITTINGS. PULPIT, heavily carved with figures and reliefs by *Thomas Farmer*, now rather battered. – MOSAIC of the Last Judgement above the chancel arch, 1880s, after a fresco of 1861 by *G.F. Watts*, which had deteriorated. – STAINED GLASS. Mostly by *Clayton & Bell*, good clear designs with upright figures. The apse and S aisle were done by 1861. One clerestory window designed by *Street* and made by *Powell* in 1865. S transept E window of 1892. – FONT, a great drum on five fat shafts. Ornate 72 domed iron CANOPY, shown at the 1862 Exhibition, an astonishing display of 'honest' structure. Made by *Leaver*, as were the wrought-iron SCREENS around the crossing, kept low as Street preferred, and COMMUNION RAIL. – Other good Street designs the STALLS and two POOR BOXES by the N door.

SCHOOL to the E, 1861–4, also by *Street*. Italianizing Gothic. In the rear angle an external stair and a loggia with short shaft-ringed columns.

PARISH HALL, 1890, attached to the W end. Built as an Infants' School by *A.E. Street*, son of George Edmund and a chip off the old block. Chequerwork end gable, stair-tower in the angle.

ST SAVIOUR
St George's Square

1863–4 by *Thomas Cundy II*, quite large and prosperous. Thomas Cubitt's executors gave the site, placed at the end of an oblong square like Cundy's earlier St Michael Chester Square (*see* p. 733) and St Gabriel Warwick Square (q.v.). Plan and detail recall St Gabriel, though in line with 1860s trends the composition is loftier and tighter. Of ragstone rubble, Dec style. NW tower with a rather starved spire and low corner turrets instead of pinnacles. Bunker-like NE vestry by *Nicholson & Corlette*, 1913–14, in a different stone. The nave has six bays, the chancel two, with a projecting sanctuary. E.E. arcades. *W.H. Romaine-Walker*, the son of the first vicar, overhauled the interior in 1882–3. He took down the galleries, and made blind arcading and a new REREDOS, carved by *T. Earp*, in the sanctuary. Earp also carved the enjoyable arcade capitals (stiff-leaf), headstops (squirming grotesques) and roof corbels (angels). Nave roof arch-braced; ceiled chancel roof, tastefully decorated perhaps by *Kempe*, c. 1891–2.

FITTINGS. Good TILES in the chancel, made by *J.C. Edwards* of Ruabon, 1882–3. – ROOD SCREEN by *Nicholson & Corlette*, 1913, rather flat. – By the same the pretty BALDACCHINO over the S chancel altar, c. 1919–20, Spanish late Gothic. – The SCREEN to this chapel was moved to a new chapel, S aisle, made c. 1950. Its REREDOS is a polyptych signed by one Sister *Mabel*, early C20; from a former mission church in Aylesford Street. – STAINED GLASS. E window, Christ in Glory, 1883. Designed by *Romaine-Walker*, made by *Clayton & Bell*. S chapel E, *Lavers, Barraud & Westlake*, c. 1870. S chapel S, *Clayton & Bell*, 1887. S aisle, from E: *Kempe*, 1898, *Powells*, 1913, *Clayton & Bell*, †1885. N aisle, from E: *Clayton & Bell*, c. 1880, *Heaton, Butler & Bayne*,

c. 1875, *Clayton & Bell*, †1879; the latter two enlarged when the galleries came out.

HOLY APOSTLES (R.C.)
Winchester Street

By *Hadfield, Cawkwell & Davidson*, 1956–7. Quietly Modernist forms, on a conservative plan: a typical mid-fifties church mixture. Brown brick, set longitudinally to the street, with a thin NW campanile. A presbytery is incorporated, and a church hall below. Aisled interior, divided by bony angled trusses. Slatted cedarwood ceiling. Baptistery behind iron screens, w, and screens too between chancel and chancel aisles. – STATIONS OF THE CROSS carved by *P. Lindsey Clark*.

PUBLIC BUILDINGS

CHELSEA BARRACKS
Chelsea Bridge Road and Ebury Bridge Road

1960–2 by *Tripe & Wakeham*. A successful composition. A long, impressive, five-storey range behind the parade ground, with an even, vertical rhythm of red brick panels. The messes etc. in separate buildings in front at either end. Behind the barracks married quarters in two fifteen-storey towers, on a different alignment. The capacity is 1,000 men. Its simplicity contrasts with Knightsbridge Barracks, conceived at the same time (*see* p. 736).

At the back the CHAPEL kept from the barracks of 1861–3, after *George Morgan*'s competition-winning scheme of 1855, which broke the military engineers' long monopoly on barracks design. Brick, free Italian medieval, with an E apse and W bellcote. S aisle added *c.* 1890. The chapel can be seen from Ranelagh Grove, via Pimlico Road or Ebury Bridge Road.

CHELSEA BRIDGE

A concise and functional design by *Rendel, Palmer & Tritton*, 1934–7, with *G. Topham Forrest* of the LCC as architect. Technically it is interesting as a self-anchored suspension bridge, the pull of the cables being taken by a thrust through the stiffening girders, which are also an early use of high-tensile steel. The 352 ft (20.7 metre) main span, small for a modern suspension bridge, is determined by the nature of the site. It replaced *Thomas Page*'s suspension bridge of 1851–8, which had elaborate cast-iron-clad towers.

CHURCHILL GARDENS PRIMARY SCHOOL
Lupus Street and Ranelagh Road

By the *LCC*, *c*. 1915. A tall compact block of dark brick. White-painted sashes of early C18 type, used sometimes formally, sometimes with absolute freedom.

GROSVENOR RAILWAY BRIDGE

Rebuilt in 1963–7 by *Freeman, Fox & Partners*; five open-spandrel steel arches ten tracks wide, the ribs of welded box section. The previous bridge, similarly arranged, was of wrought iron. Its oldest part was of 1859–60, by *John Fowler*. It carried the first railway to cross the Thames in central London, from Battersea to the London, Brighton & South Coast Railway's terminal at Victoria (*see* p. 737). The London, Chatham & Dover Railway doubled it to the E in 1865–6 (by *Sir Charles Fox*); the LBSCR extended it again in 1901–5, to the w. The phases can be distinguished in the old rusticated stone abutment.

LISTER HOSPITAL
Chelsea Bridge Road

Built as the British Institute of Preventive Medicine, 1895–8, by *Alfred & Paul Waterhouse*. Gabled Northern Renaissance, quite relaxed in the details. Of hard red brick, weathering to rose, dressed in friable yellow stone. Made more symmetrical by the l. wing added in 1909–10; beyond it an ugly precast-concrete-faced addition of 1970.

PIMLICO SCHOOL
St George's Square and Lupus Street

One of the weirdest 1960s buildings in London, built as a comprehensive school for 1,725 children by *John Bancroft* of the *GLC Architect's Department*, 1966–70. Its site covered only half the recommended area for so big a school, so a compact treatment was essential. The resulting building is very long, aligned on the middle axis of the site, with play areas to N and S. Four storeys, the lowest being below pavement level, with a spur wing coming forward to Lupus Street. Sides of raw ribbed concrete and patent glazing, the latter sloping out as in hothouses, but also sloping back on top. The frontages step forward and backward in a restless, aggressive, exciting way. Through the middle runs a broad concourse conceived as an internal street, a feature that the next generation of school architects was to make much of. Structurally the skeleton is a series of portal frames, with some cross-wall construction for the classrooms. The uniform size of these, rather than the flexible, semi-open plans in favour by *c*. 1970, is the

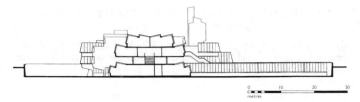

Pimlico School. Section, north to south
(R. Ringshall, Dame Margaret Miles and F. Kelsall, *The Urban
School, Buildings for Education in London 1870–1980*, 1983)

most conservative thing about the design. One serious defect, as
Pevsner anticipated in 1973, was the greenhouse effect of
the glazing. Vandalism soon wrecked the first, mechanical venti-
lation system, and computer-controlled louvres added in 1983
failed to solve things entirely. In 2003 a further refurbishment
was in prospect, after years of uncertainty over the school's
future.

VAUXHALL BRIDGE

Built 1895–1906 to a design begun by *Sir Alexander Binnie* for
the LCC, modified during construction by *(Sir) Maurice
Fitzmaurice* to have steel rather than concrete arches. There are
five of these, of two-pinned type. Concrete caissons clad in
Princetown granite, with steel-plated piers. Consultant architects
were *W.E. Riley* of the LCC and *Norman Shaw*, who both
favoured big pylons on the Westminster shore. Instead of these,
bronze female figures were fixed for ornament against the piers
after the bridge opened, by *Alfred Drury* (downstream) and *F.W.
Pomeroy* (upstream). The abutments reuse piled footings from an
earlier bridge, which was begun in 1811 as a stone-arched bridge
to designs by *John Rennie*. After construction of the N abutment
in 1813 the proprietors switched to a cheaper design in iron by
James Walker, which opened in 1816 as the 'Regent Bridge'. It had
nine cast-iron arches with vertical-ribbed spandrels, of only 78 ft
(23.8 metre) span, and was the first iron bridge in London.

STREETS

This section is organized like its equivalent for Belgravia, that is
with a description of the central, planned area first (here called
Cubitt's Pimlico), followed by the remaining streets around the
margins, treated alphabetically.

CUBITT'S PIMLICO

1. The Three Squares, and the Streets east of St George's Drive

The main armature of *Thomas Cubitt*'s Pimlico consists of BELGRAVE ROAD and the parallel ST GEORGE'S DRIVE, which continue two of the diagonal lines on which the squares of Belgravia were strung up. Around and between them lie three squares, ECCLESTON SQUARE, WARWICK SQUARE to its S, and ST GEORGE'S SQUARE, on a different alignment down by the river. All three are planned as elongated oblongs, like Eaton Square. Though scarcely inferior in scale to most of Belgravia, they tend towards repeated units rather than grand composition-making, with not a giant pilaster in sight.

ECCLESTON SQUARE is the starting place. The NW SIDE, begun first, is the most disparate. *Cubitt* on his own account built Nos. 1–3, 1836, and the taller and more ornate Nos. 4–5, 1842. The rest, taller still and more enriched, have the starting dates 1841 (Nos. 6–10), 1847 (Nos. 11–16), 1857 (Nos. 17–24, finished 1859) and 1855 (Nos. 25–26, by *Cubitt* again). A drawing exists by *Garland & Christopher* for houses in the square, closely resembling Nos. 8–10, but these differ only slightly from Cubitt's Nos. 4–5. Porches appear from No. 6, the characteristic Pimlico porch with Roman Doric columns and entablature; at No. 14 the storeys rise from four to five; No. 26 at the end has a canted bay on the return. The houses of the SW SIDE run on from St George's Drive to the N, with a modest increase in frontage width. The SE SIDE was built in 1842–55 almost entirely by *Cubitt*, more uniformly than opposite. Five storeys throughout, with quoins and shallow near-balancing end projections, and another canted bay on the flank of No. 53. The pattern breaks at Nos. 59–60, rebuilt in 1938 with grooved fronts. The NE SIDE has changed much more. Nos. 79–83, 1854–6, are another not quite symmetrical group, with a hefty Neo-Georgian extension behind Nos. 82–83 for the ECCLESTON HOTEL (1929–30). Nos. 84–89 are Neo-Cubitt offices of 1984–9 by the *Diamond Partnership*, but of six, not five storeys, which spoils the proportions. To its N an office slab by *J. Campbell-Smith* of *Stone, Toms & Partners*, 1964–6. Round the corner in BRIDGE PLACE, l., is a small stuccoed warehouse of *c.* 1830 which originally backed on to the main Grosvenor Canal basin (*see* Grosvenor Road), where Victoria Station now stands.

BELGRAVE ROAD continues this side of Eccleston Square to the SE. It has repetitious tall houses, mostly with the standard Doric porches. As a prelude on the NW side is No. 11, by *T.P. Bennett*, 1954–5. A good specimen of a commercial chequer-pattern façade, of orange brick with storey bands interrupting the stone uprights on alternating alignments. First floor, as usual, with its own rhythm. WARWICK WAY crosses further on, in origin an older route aligned obliquely to Cubitt's planning grid. The first building was the MARQUIS OF WESTMINSTER pub of 1838, SE corner, plainer and lower than the Belgrave Road terraces. To its E Warwick Way is a shopping

street, with simple brick houses of the 1840s; to the W it turns residential, the houses typically with two-bay balconettes, and with MEWS to Eccleston Square and Warwick Square branching off it and off the NE end of CLARENDON STREET to the S.

WARWICK SQUARE is the next incident off Belgrave Road, which forms its NE side. Begun in 1842, it was less than half-built when Cubitt died in 1855, though the completion is visually neater than at Eccleston Square. The houses are again similar to the later Belgravian type, with a relatively high proportion of blank stucco, which makes the windows seem smaller than they really are. Here too *Cubitt* got the job going himself, building Nos. 1–5 in 1842–50 on the NW SIDE. These make a composition with Nos. 6–7, *c.* 1851–5, with segment-headed fourth-floor windows on the end houses; but after that symmetry is given up. The rest of this side was not finished until 1865. The SW SIDE has St Gabriel (q.v.) at one end, on a site settled in 1848, i.e. an afterthought. The houses to its r. form a run with those of ST GEORGE'S DRIVE, built up from *c.* 1849. A little NW of the square these turn showier: Nos. 29–49, SW side, with a swagged cornice and shell-headed windows, Nos. 20–36 (opposite) with triple first-floor windows with pediments and Ionic column-mullions. But the real sore thumb lies S of the church at No. 33 Warwick Square, of 1860–1 by *George Morgan*, for the portraitist J.R. Swinton. The first true studio house in London, freely planned and almost style-less externally, of polychrome-banded brick with iron window colonnettes. The big blunt-nosed corner volume was the studio proper, with a picture gallery to its l. and living quarters behind. Opposite is Nos. 45–49 on the SE SIDE, built as one huge house in 1865 for Cubitt's daughter Lucy, the flank over-looking by far the largest private garden in Pimlico. Nos. 52–66 make a symmetrical composition, but with only a weak stress on centre and ends. Built 1850–69, starting from Nos. 64–66 at the Belgrave Road end, which *Cubitt* undertook himself.

Next in Belgrave Road, just SE of Warwick Square, is an elongated six-way crossroads, where DENBIGH STREET cuts N–S across the main grid. Its route was made after 1807, in connection with the first industrial development by the river. The N part, begun 1840, has simple three-storey houses, the upper parts of plain brick. In DENBIGH MEWS off the E side, offices by *Dave Hobday Designs*, *c.* 1980, a sharp smoked-glass box. CHURTON STREET, a shopping street running NE from the crossing, is also mostly 1840s. The CONSTITUTION pub on its N side is of 1845, with the extra storey typical of mid-terrace taverns in Pimlico. Further along is CHURTON PLACE, the only true close in Cubitt's Pimlico. TACHBROOK STREET crosses Churton Street at its N end. *Cubitt* created it in 1842–4 by covering over the King's Scholars' Pond sewer, hence its exceptional width and gently curving course. The NE side was cleared for the Lillington Gardens and Longmoore Gardens estates (*see* Vauxhall Bridge Road). The line of Churton Street continues S of Belgrave Road as GLOUCESTER STREET.

Nos. 1–47, NW side, are a very long four-storey stucco terrace of after 1848. The SE side has a facsimile front of 1990–4 at Nos. 14–26, by *Pryse Traynor Architects*, with a big garage ramp in the middle. Nos. 8–12, 1992, one of several medium-sized infillings or restorations by *Sanctuary Architects* (Sanctuary Housing Association), have summary blockish detail instead. The same body converted Nos. 29–33 in DENBIGH PLACE, parallel to the S, which were given a more attractive round-arched treatment (by *Jonathan Smith & David Burn*, 1981). At No. 3, facing, a nice big ex-pub of 1849. The next street to the S is CHARLWOOD STREET. It shows particularly well the 84 eclectic trimmings preferred even for smaller Pimlico houses by the 1850s: porches with sunk decoration (Nos. 43–65), windows with round-headed or lugged frames (Nos. 52–64), etc. From here we can return to ST GEORGE'S DRIVE, to the SW. On the S corner is Nos. 70–78, flats of 1983, *Sanctuary Architects* again, but here a convincing match for its mid-C19 neighbours. At the extreme S the more ornate post-Cubitt idiom recurs at Nos. 121–129, with thick dressings and Ionic porches. The acute corner with Denbigh Street, opposite, is of 1989, another *Sanctuary Architects* job. On the paved area beyond a bronze STATUE of Cubitt, of 1995 by *William Fawke*, shown in his element surrounded by building materials.

To complete the tour of the squares, the quickest way is E along Lupus Street (*see* p. 774), just S of the Cubitt statue, until it meets St George's Square. A diversion off the E side of MORETON TERRACE, E of Denbigh Street, for two resourceful mews houses. The SOUTH MEWS has *Jestico & Whiles*'s house for Jeremy Norman, 1982–4, at the N end. It has a rudimentary pedimented Baroque centrepiece facing a private courtyard. Discreet access through a plain wall, passing under a terrace for the adjacent house, r. In the NORTH MEWS No. 13a by *Nicholls Associates*, 1984. Screen wall with round openings, house askew behind, planned around courtyards on the same skewed axis.

ST GEORGE'S SQUARE was an afterthought by *Cubitt*, who laid out its sides as two streets S of Lupus Street in 1839, and decided later that he could afford a square on the land between. A triangle was also left on the N side, with its apex where Belgrave Road comes in, joining the square with the other two. It was planted in 1844, and four- or five-storey houses were started in earnest in the 1850s. The N triangle was finished first. Here Nos. 4–6, W side, are facsimiles of *c.* 1957. The S part, where St Saviour was built as another afterthought in 1863–4, was not completed until 1875. The leading builder was Cubitt's old foreman *George Dines* (agreement 1865). His houses mostly have bay windows, the only significant change from his master's idiom. The E side is otherwise quite coherent, with a cornice carried on from Nos. 39–77 at the N, built by *Cubitt* himself. On the W side Nos. 72–74 intrude, red brick flats of *c.* 1959. Houses further N were cleared for the Pimlico School (q.v.). For the gardens by the river *see* Grosvenor Road.

2. Bessborough Street and Lupus Street

An interesting mixture of *Thomas Cubitt*'s Pimlico and C20
rebuilding. Cubitt made BESSBOROUGH STREET after 1838,
to carry the line of Lupus Street across the Crown Estate to
Vauxhall Bridge Road (q.v.). Nos. 9–19 remain, s side, *c.* 1855,
four-storey stucco of standard type, and smaller houses round
their l. corner in BESSBOROUGH PLACE. Beyond, at an
angle, is a long range of three-storey houses of darker brick
(Nos. 46–66), plainer than usual for Pimlico, though still com-
posed with a projecting centre and ends. *Cubitt* built these
himself in 1842, chiefly to raise the tone by hiding a gasworks
from view, though he afterwards put some of his workmen in
them. *Chapman Taylor Partners* reconstructed all these terraces
in 1984–7 for the Crown Estate. Returning to Bessborough
Street, No. 1 is a MATERNITY CENTRE, 1936–7 by *F.M.
Harvey* for Westminster City Council, symmetrical stripped
Georgian.

LUPUS STREET is a broad street with shops, made on Grosvenor
land on the line of an earlier track, and built up after 1840. Its
N side is almost intact, its s side now largely C20. The first
houses were Nos. 1–7 on the s side, 1840–3, a plain group
including a pub. Nos. 2–8 facing, 1851, show an increase in
ornament. Then St George's Square (*see* p. 773) and St Saviour
(q.v.), after which the N side has mostly four-storey houses, the
s side the two big schools (q.v.) and the Churchill Gardens
Estate (*see* Grosvenor Road). At their greatest extent Cubitt's
own workshops covered the site of Pimlico School, but terraces
were built on this part *c.* 1860. C19 survivors lie immediately
w, Nos. 53–63, built after 1851 with the adjacent houses in
CLAVERTON STREET and RANELAGH ROAD. Next to the last
is EILEEN ATKINSON COURT, old people's flats of 1982 by
Levitt Bernstein Associates, four-storeyed with touches of Post-
modern pattern and colour. Further w along Lupus Street,
the E corner with Winchester Street marks the limit of work
before Cubitt's death in 1855. Beyond, the triangular block w
of Cumberland Street turns an ugly back on Lupus Street,
suggesting that his successors were less skilled in planning
awkward sites.

3. The west and north-west

The diagonal grid of smaller streets w of St George's Drive was
begun later and finished later than most of Pimlico. When *Cubitt*
died in 1855 none of the streets sw of Alderney Street was com-
plete, though his plan was already settled. The later date shows
itself in heavier and richer ornament, all-over stucco and full
porches on even quite small three-storey houses. There are also
fewer clusters of shops and slightly more C20 rebuilding than in
the area to the E. No individual building or space stands out, but
the quiet streets with their trees are pleasant to walk in.

Building began *c.* 1841 at the N end in HUGH STREET, where
the builder *Joseph Gordon Davis* was active. He undertook the

nicely fancy GREYHOUND pub and Nos. 55–63, along with
the N end of CAMBRIDGE STREET between them (agreement
1847), and most of Hugh Street E of St George's Drive
(Nos. 6–36 and 17–47, agreements 1841 and 1843). The hand-
some and distinctive ten-panel doors are his hallmark. Along
WARWICK WAY, to the S, houses are more elaborate, e.g.
Nos. 130–140 on the S side, *c.* 1847–52, of a much-repeated
three-storey type with Doric entablature, continuous balcony,
and Doric porches linked by a vermiculated frieze. Round
the l. corner, No. 52 Cambridge Street is another good big
pub, 1848, taller and richer than the houses around it. At
Nos. 76–78 an ingenious infilling by *Peter Foggo & David
Thomas*, 1968–9: a maisonette for each architect, set over two
flats. Smoked-glass front, screened by aggregate-faced con-
crete framing with waisted uprights, a motif introduced by
Gordon Bunshaft's Heinz headquarters at Hayes, Middlesex.
Back in Warwick Way, to the W on both sides is the ABBOTS
MANOR ESTATE by *Riches & Blythin*, on land partly cleared
by the bombs of 1941. It mixes six-storey housing of 1952–5,
with a tower block (GLASTONBURY HOUSE; alterations pro-
posed) and other buildings of 1964–9, in a harder red brick
and concrete style. The l. turning just before the estate
leads to CUMBERLAND STREET. Nos. 5–11 on its NE side are
credited to *James Yallop*, but scarcely differ from the houses
already noted in Warwick Way, or from Nos. 13–27 of 1857,
r. Presumably this elevation was a standard product of
Cubitt's office. Near the N end of SUTHERLAND STREET, the
next street to the SW, is the WHITE FERRY HOUSE pub of
1856, with a three-quarter-round corner. To its N and past the
entrance to Peabody's Pimlico Estate (*see* Grosvenor Road),
the former ST GEORGE'S ROW SCHOOL of 1898, a typical tall
compact Board School, then EBURY BRIDGE. This crosses
the railway on the line of the C18 wooden bridge, made origi-
nally over the reservoirs of the old Chelsea Water Works (*see*
Grosvenor Road). Adjoining the pub on the S is WESTMORE-
LAND TERRACE: shops of 1858 (Nos. 1–3), and a long three-
storey terrace begun by 1855, plainer than those to the E.
Between them, sheltered flats are proposed (2003), on the site
of a Methodist church of 1961–2 (successor to a chapel of
1858).
From Westmoreland Terrace, CLARENDON STREET runs back
NE across the grid. It has the unusual feature of pairs of broad
shallow houses slotted between the terrace ends. It meets
WINCHESTER STREET at No. 50, an interesting conversion
by *Stout & Litchfield*, 1971, signalled by plain chamfered bays
to the side. Two maisonettes were formed, making ingenious
use of the cellars below the pavement. Continuing SE down
Winchester Street, the l. side passes the end of SUSSEX
STREET, here with a cluster of shops and a pub of *c.* 1855, and
then Holy Apostles (q.v.). In ALDERNEY STREET to the SE is
RUSSELL HOUSE, an H-plan slab of council housing of
1946–50 by *A.J. Thomas*, on an isolated bombed site. Quite a
contrast with Churchill Gardens to the S: still sash-windowed,
with indented balconies. Nine storeys.

BLOOMFIELD TERRACE

A complete and charming composition of early Victorian houses, built from the early 1840s by *John Newson*. Mostly terraces, treated as semi-detached cottages of two storeys connected by recessed links, with plain pilaster strips and shallow hipped roofs. No. 39, S side, began as two houses, merged in 1922 by *Oliver Hill*. He added pediment and pilasters, and infilled the central bay. More orthodox 1820s–40s houses in the W part, where the street turns N, and in RANELAGH GROVE and ST BARNABAS STREET to the E. Many of the latter share a family likeness, with tall blank attics and round-arched stucco below.

EBURY BRIDGE ROAD

Laid out *c.* 1825 as Commercial Road, just W of the line of the Grosvenor Canal (*see* Grosvenor Road, W part). Now a study in working-class housing.

82 Coming from Ebury Bridge, N, RANELAGH COTTAGES (Nos. 20–42, W side), of *c.* 1825, is a survivor of the poorer kind of Late Georgian terrace, each house with just one window per storey. It faces the big EBURY BRIDGE ESTATE, built by Westminster Council on land recovered from the canal and its wharves, in part for its own employees. In the N part eight brick blocks by *Ashley & Newman*, 1929–31, with the usual gallery access and sash windows. The plan has two parallel pairs with four more to the E, set radially to the railway. The second phase, S, is of *c.* 1934–6 by *A.J. Thomas*, three blocks in a more attractive grey brick; EDGSON HOUSE, facing the street, is of 1953–5 by *Riches & Blythin*. On the W side the towers of Chelsea Barracks keep watch (q.v.). On the E SIDE next GATLIFF BUILDINGS, characteristic early working-class flats by *Thomas Cundy III*, for the Metropolitan Association for Improving the Dwellings of the Industrious Classes. Built 1865–7 (the date 1870 is false), to an irregular U-plan with gallery access behind. The architect was chosen by the 2nd Marquess of Westminster, who gave the site to house those displaced by the new Grosvenor Gardens (*see* p. 751); its Second Empire roofs are faintly echoed here. CHELSEA GATE APARTMENTS are private flats by *Holder Mathias Alcock*, 1996–8, long plain buff-brick slabs. Their neighbour is WELLINGTON BUILDINGS, a dense, harsh scheme of 1879 by the *Improved Industrial Dwellings Co.* Three six-storey ranges, near-parallel; the longest, facing Chelsea Bridge Road, with canted bays. Across the road and facing Chelsea Bridge, the CARABINIERS' MEMORIAL (Boer War), 1905, with a bronze relief of battle by *Adrian Jones*.

GROSVENOR ROAD
and streets to the north

Grosvenor Road is Pimlico's riverside. It runs between Chelsea Bridge, w, and Vauxhall Bridge, e. The first big attempts to develop land here began in 1807, but progress was slow at first. In 1825 *Thomas Cubitt* bought or leased most of the huge area n of the riverbank (*see* area introduction, p. 762). He began improving the road in 1834, but the full route and embankment were not built until 1849–*c.* 1860, up to the new Chelsea Bridge (q.v.). Cubitt again undertook much of this work, following a route set out by *Thomas Page* in 1845 for the Commissioners for Metropolitan Improvements. The e half runs inland, where it originally served a strip of wharves along the river; in the w part tunnels under the road were provided to several older docks and to the Grosvenor Canal. Industry began to give way to housing in the 1930s, a process almost complete in the early c21.

West Part, from Chelsea Bridge past Grosvenor Bridge

The Chelsea Bridge end begins with the Lister Hospital (q.v.). Further e are the remains of the GROSVENOR CANAL: a small, part-infilled RECEPTION DOCK, a LOCK, and a modest BASIN, together extending a little over 400 ft (122 metres) n of the foreshore. In 2003 the basin is set to become the centrepiece of a new development by St James Homes, masterplanned by *Broadway Malyan*, with six individual blocks by various architects including *Allies & Morrison*. The canal was a Grosvenor undertaking of 1824–5, to a plan of 1823 by *Thomas Thatcher*. Never part of the national canal system, it extended no further than a basin on the site of Victoria Station. The route traversed what had been a marshy expanse of reservoirs, held under a lease of 1724 by the Chelsea Water Company. The canal required less land, allowing the creation of wharves and warehouses along it. At first these operated symbiotically with the great building enterprises in Pimlico and Belgravia. Then in 1858 most of the e bank was taken for the approach to Victoria Station (*see* p. 737), built on the site of the basin itself. The rest lasted into the 1900s, when the railway engrossed the stretch along Buckingham Palace Road (q.v.), and Westminster City Council bought the remainder.*

Next, the buildings of the WESTERN PUMPING STATION, the last part of *Bazalgette*'s Low Level Sewer to be finished, in 1872–5 (*see* also p. 377). They are of pale brick, with the polite architectural dress then thought proper for great public enterprises. The designer is unknown; their builder *William Webster* may have contributed. By the road the PUMPING HOUSE, a big broad two-storey block, with a Frenchy convex roof of copper fish-scale tiles. It lifted sewage to run down to Abbey

*Until 2001 the council's Highways Department Depot occupied the w side of the basin, fronting on to Gatliff Road. It was a giant spreading structure of 1935–6 by *Grey Wornum*, detailed on Modernist lines and planned so that dustcarts could discharge from under cover into refuse barges.

Mills pumping station, where it was again lifted to run to the outfall at Barking Creek (*see London 5: East and Docklands*). Behind and to the l. the square CHIMNEY, elegantly tapered, with narrow round-headed recesses and decorated top. Also a small AUXILIARY PUMPING STATION, l., with a long low pitched roof, and SUPERINTENDENT'S HOUSE, r., hipped-roofed and pretty. Part of the site will be included in the new development around the Grosvenor Canal basin.

The boundary to the E is the Grosvenor Railway Bridge (q.v.). Against its further, E side is a STATION HOUSE of 1867 (No. 123a), which served a short-lived station on the tracks above. A gault brick box with two stone cornices of equal weight. From in front there is a fine view of the vast hulk of Battersea Power Station across the river (*see London 2: South*).

After the railway sidings the architecture turns domestic, organized in a long run of big developments. Some of these need diversions to see properly, though a general impression can be had without leaving Grosvenor Road proper. First comes the PIMLICO ESTATE, one of the larger C19 Peabody estates. Its heart lies to the N, a great grim parade of parallel ranges of 1874–6, almost exactly a thousand feet long. Originally there were twenty-six units, lettered from A to Z. They follow the standard design by *H.A. Darbishire*, of four storeys on the E side, five on the W. Bombing took away four blocks from the S end, but the impact is hardly diminished (infill rebuilding under discussion). The approach from the S is past two detached blocks of 1887 also by *Darbishire*, but with unusual terracotta enrichment.

Central Part: the Churchill Gardens Estate

5 The CHURCHILL GARDENS ESTATE begins E of Lupus Street. The architects were *Powell & Moya*, the dates of building 1947–62. It is specially important as the first English estate with tall slabs grouping with lower terraces, a type not adopted by the LCC until the early 1950s, and used thereafter for some of the best housing of the day. Some such scheme had been incubating in England since the 1930s (for instance the very similar 'Tomorrow Town' project by Architectural Association students, 1937–8), but the Second World War of course stopped anything being done. This significance was acknowledged by listing of the early parts of Churchill Gardens in 1998.

Westminster City Council first planned housing here in 1936, for a smaller area than the present estate. In 1943 the designated site was enlarged. The competition held for it in 1945–6 signalled a determination to break with pre-war municipal formulae for public housing. The winners were *Philip Powell* and *Hidalgo Moya*, of the next wave of Architectural Association graduates, both then in their mid-twenties. The 1,661 dwellings are spread over 31 acres (12.6 hectares), built as thirty-six blocks and in four phases. Density is 200 persons per acre, the maximum then recommended. The W and N boundary is Lupus Street, the extreme E boundary Claverton Street. From Grosvenor Road the general arrangement is clear enough, tall slabs of nine to eleven storeys

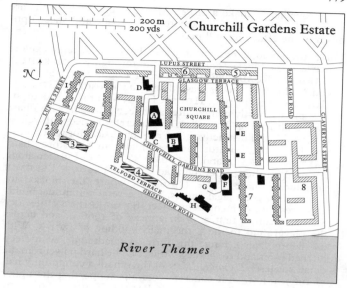

Churchill Gardens Estate

1	Gilbert House	A	Churchill Hall
2	Sullivan House	B	St Gabriel's School, 1861–5
3	Paxton Terrace	C	St Gabriel's School annexe, 1966–9
4	Telford Terrace	D	St Gabriel's Parish House, 1899–1901
5	De Quincey House	E	Dustbin shelters
6	Littleton House	F	Heating tower
7	Shelley House	G	Balmoral Castle pub, c. 1855
8	Main Block, phase four	H	Darwin House, c. 1980

NINE- TO ELEVEN-STOREY BLOCKS

SEVEN-STOREY MAISONETTE BLOCKS WITH SHOPS

OTHER BUILDINGS

MEDIUM-HEIGHT HOUSING

TWO-STOREY TERRACES

Churchill Gardens Estate. Plan

set N–S, enclosed on the N by seven-storey blocks along Lupus Street. Around and between are mostly three- and four-storey terraces of houses, flats and maisonettes, mainly also placed N–S, but in a few cases also E–W. Areas between are largely turfed, with some trees. Some older buildings were allowed to remain here and there in addition. The housing is all in a similar style, not too uniform in treatment, generally simple and self-effacing but with accents of strong colour. The whole has perhaps been overpraised of late, and some may agree with Ian Nairn's counter-verdict in 1964, that its 'good bits . . . nowhere quite

come together to make a piece'. All the same, the best bits are very good indeed, and the generosity of space and sheer optimism of the estate are still persuasive.

For a proper look one must leave the riverside and explore between the blocks. The main route through is CHURCHILL GARDENS ROAD, which turns E off Lupus Street at the W end.* The first blocks passed are the ten-storey GILBERT HOUSE and SULLIVAN HOUSE. These, with the blocks to the N, S and E (mostly named after architects), belong with Phase Two, built 1951–4. The tallest are concrete-framed with yellow brick infill, and distinctive giant rooftop drums for water tanks and lift-shafts. Towards the river high-rent two-storey flats, PAXTON TERRACE and TELFORD TERRACE. Further along the road on the N side, the road called GLASGOW TERRACE introduces Phase Three (1956–62), where the blocks are named after great legal figures. Here several communal buildings break in, to incoherent effect. ST GABRIEL'S PRIMARY SCHOOL comes first, a plain annexe of 1966–9, and across the playground to the E the main building of 1861–5. With its slightly later E range this forms a quadrangle, with steep pitched roofs and rough-hewn tracery. The hard polychromatic detail suggests *T. Cundy III*. N of the school a community hall of 1963–4, low, with concrete columns supporting the upper floor. Further N ST GABRIEL'S PARISH HOUSE, 1899–1901 by *W. Campbell-Jones*, brick, with a modicum of ornament. To its E is CHURCHILL SQUARE, a pleasing brick-paved space originally meant for a market, with blocks of maisonettes on its N side. These blocks were carried on from Phase One, immediately to the E, built in 1947–52. N of the maisonette blocks here is DE QUINCEY HOUSE, facing Lupus Street. This has six storeys also of maisonettes, set over shops to the street. Nice long canopy, with a segmental arch on the underside for each shop. (LITTLETON HOUSE, W, matches it but belongs with Phase Three.) The best part of Phase One is to the S, the four long blocks named after poets – the first to be finished, in 1950 – which are laid out parallel in the *zeilenbau* way. They have extruded glazed staircases all along one side, instead of the cheaper gallery access of later phases, and gently canted balconies on the other. The frame is monolithic concrete, with yellow brick used as cladding rather than infill (*Scott & Wilson* engineers). The two DUSTBIN SHELTERS in the N part are fun, concrete roofs over coiling screens of brick. Behind SHELLEY HOUSE at the SW a mysterious glass-faced TOWER, a tall faceted polygon with diagonal bracing showing within (engineered by *Kennedy & Donkin*). It served the first district heating system in Britain, supplied until 1983 by waste heat pumped across from Battersea Power Station. Marooned just to its E the BALMORAL CASTLE, a stucco pub of *c.* 1855 with the typical Pimlico rounded entrance corner. To its S DARWIN HOUSE, sheltered flats of *c.* 1980 by *Westminster City Council*,

*Staying with Grosvenor Road, the KING WILLIAM IV pub at No. 110 is basic brick by *George Legg*, 1880, Nos. 105–109, stucco cottages with pretty iron verandas, of 1826 (but probably agreed for before Cubitt took the ground in 1825).

showing the return of pitched roofs. On the site was All Saints' church, modest polychrome brick of 1870–1 by *T. Cundy III*. Phase Four lies further E, facing Claverton Street: a five-storey block of 1960–2, mostly white-tile-faced, that crosses over Churchill Gardens Road. The shift from repeated blocks to a continuous structure is typical of the 1960s (cf. Lillington Gardens, Vauxhall Bridge Road).

East Part, from Claverton Street to Vauxhall Bridge Road

In Claverton Street still some runs of big Cubitt-type houses (*see* p. 774). At its S end, Grosvenor Road turns away from the river-bank, so that buildings appear on both sides. The S SIDE is mostly expensive medium-rise private flats, a type now legion all along the Thames. First No. 128, by *Heber Percy & Parker*, 1985–8, strong rounded forms of brick, with darker bands designed to be legible from across the river. No. 129, 2000–1 by *MR Partnership*, cantilevers out against a giant prop-like pier on the riverside; *Leighton Carr*'s Nos. 130–131, 1996–7, like mansion blocks of c. 1900.

Opposite is DOLPHIN SQUARE, a gigantic quadrangle of 1,236 private flats, called when new the largest self-contained block of flats in Europe. Designed by *Gordon Jeeves*, built in 1935–7 by and for the builders *Costains*, then newly launched as a public company. It is concrete-framed and brick-faced, with large arched entrances facing Grosvenor Road. Eight broad shallow spurs face the large central courtyard. Pevsner thought it made a poor show alongside Churchill Gardens, 'a huge lump, seven to ten storeys, relieved only by an occasional strip-ing of brick and stone and a few motifs of no great vigour'. Nowadays its affinity with 1930s municipal housing is the most striking thing. The main differences are the use of spine corri-dors instead of external balconies, and the extensive built-in services: mechanical ventilation of bathrooms and rubbish cupboards, car parking and a private swimming pool in a base-ment under the garden, and a restaurant at the N end. The 7½-acre (2.8-hectare) site was previously the Royal Army Clothing Depot, housed in *Cubitt*'s adapted building works of 1839–56.

ST GEORGE'S SQUARE is the next great unit, one of the last parts of *Cubitt*'s great plan for Pimlico to be completed (*see* p. 773). The land between it and the river Cubitt left open, as PIMLICO GARDENS. Here a toga'ed marble STATUE of Huskisson by *John Gibson*, 1836. Made for Liverpool Customs House, but found too large, and set up at the Royal Exchange in the City; moved here 1915. His companion is The Helmsman, a bronze by *Andrew Wallace*, 1996, an Egyptianizing figure on a schematic boat, wheel and pole. On the bank the WESTMINSTER BOATING BASE, where children are taught sailing. Founded 1976; extended under rugged cor-rugated cladding in 1987–8 by *Colwyn Foulkes & Partners*.

To the E of Pimlico Gardens, No. 137, flats by the *John R. Harris Partnership*, 1994, within a strong controlling grid of large squares. Beyond it and in a similar stripped-down idiom

is EAGLE WHARF, four blocks of flats by the *Halpern Partnership*, 2000–2. They step down and become shallower as the site tapers. Overlooking from the N is the TACHBROOK ESTATE (now Peabody), built for the Westminster Housing Trust in 1931–55 by *F. Milton Harvey*. The post-war work, by the road, culminates in a powerful eight-storey block with six-storey wings splayed outwards. The pre-war part extends N along Aylesford Street.

After this the N side is filled by Phase 3 of the Crown Estate redevelopment (*see* Vauxhall Bridge Road). On the S side two baby houses built over the outfall arch of the King's Scholars' Pond sewer, reconstructed in 1986–8 incorporating some C19 fabric.

118 Next is CROWN REACH, the best of the private housing. *Nicholas Lacey* won a competition for the site in 1976, on an outlying finger of the Crown Estate. *Maguire & Murray* helped execute the scheme, which was finished in 1983. Mostly hard curved purple brick walls towards the road, small-windowed to exclude noise, and sliced back steeply on the main part to show steep leaded roofs. A public walkway runs along the river front, which uses different materials, tile and polished brown granite. First come four individual houses, then the main block of flats, convex, rising from a low centre to tall ends. In aerial views the shape resembles a big slice of hollowed-out melon; from the ground, it is the stepped and broken outlines that count, with deep balconies and ends jutting bravely out on raking struts. Ralph Erskine's Byker Wall in Newcastle is an obvious influence. Also part of the scheme are No. 146, a smallish office block, and the refurbishment of Nos. 147–150, E. These are relics of the C19 BUILDERS' WHARVES: two pairs of offices or managers' houses, each with a central archway to the former quay. Nos. 147–148, 1870–1 (misleadingly dated 1850), served Fabricotti's marble works, whose wares are shown off in dressy trimming of the red brick front. By *F.G. Widdows*, executed by *Woodzell & Collcutt*. For the tower beyond *see* Vauxhall Bridge Road.

VAUXHALL BRIDGE ROAD

Made in 1811–16, through what were still fields and gardens, to join the new Vauxhall Bridge with Grosvenor Place and the route up to Hyde Park Corner. Houses were built from *c.* 1822, and scraps of these unpretending terraces survive. C20 buildings include the most ambitious housing schemes in Westminster from the 1960s and 1980s, and some adventurous post-war office blocks.

Coming from the N, the first stop is on the SW SIDE, the APOLLO VICTORIA THEATRE, by *E. Wamsley Lewis* (executant *W.E. Trent*), 1928–30. Built as a ciné-variety hall; used as a theatre since 1980. One of the first buildings in which the Continental style of horizontal bands and windows appeared in England (Lewis admitted the influence of Poelzig's Schau-

spielhaus in Berlin). But the cast stone facing has too many flutings, openwork panels etc. for a purist effect, even without *Newbury Trent*'s giddy figure reliefs on the identical elevation to Wilton Road, behind. In the foyer more close-set fluting, and a relief by *Trent* personifying Cinema. Giant auditorium (the original capacity was 2,786), partly below street level, with the stalls gangways under the pavements. The fluted and faceted lights remain, but other fittings are stored, and the effect of a 'fairy palace under the sea' is lost. Nos. 279–295 is by *Michael Squire Associates*, 1997, forthright stone-faced offices with an atrium crossed by bridges.

Then No. 1 NEATHOUSE PLACE, offices originally by *Burnet, Tait & Partners*, 1959–62, drastically reworked by *Avery Associates*, 1996–7. Underneath the glittering skin the old composition remains, built of post-tensioned concrete so strong that retention proved easier than demolition. It forms a high slab cantilevered over a relief road. Little triangular aluminium-framed oriels make a continuous zigzag along the slab, dematerializing into reflections of each other, and the roadway passes under glazed screens designed to temper the wind. At the back the facing is of raked framelessly glazed bands, with a big glass drum for the entrance, S. Top like a big solid aerofoil. Next door the VICTORIA PARK PLAZA HOTEL, a Frankenstein's monster by *Igal Yawetz & Associates*, 1999–2001: Georgianish brick below, squat shiny black glass above.

On the NE SIDE the first 1820s houses appear at Nos. 278–282, in a typically woeful state. At Nos. 252–266 two lively mansion blocks by *Palgrave & Co.*, CATHEDRAL MANSIONS and ASHLEY MANSIONS, 1905 and 1907. Where Francis Street comes in, KING'S SCHOLARS HOUSE, 1993–7 by *Martin Hewitt*, shows the Postmodernist way with corner blocks. Upper storeys are treated as a giant cornice, with a clock at the apex.

Back on the SW SIDE, the acute angle with Upper Tachbrook Street is followed by the QUEEN MOTHER SPORTS CENTRE, 1978–81. Dark glass and black panelling, with windowless brick-faced ranges behind. It looks across to a PEABODY ESTATE of 1912–14, by *Victor Wilkins*. Red brick above brown, with a white-rendered top floor and rather pompous Beaux-Arts trim. Further on, Nos. 186–190, offices by *Berry Webber & Partners*, 1984. An interesting design. Lead-coloured mansard; floorbands also leaded, projecting as hoods within which external blinds are hung. It faces the largest 1820s group, a ragged regiment between Nos. 175 and 203, with gaps (future uncertain). At No. 172, opposite again, a former Westminster Bank branch, rather a jewel; by *Niven & Wigglesworth*, c. 1924. Just three bays, with engaged Ionic columns framing big windows, and a low attic. After Rochester Row Nos. 160–162, flats and shops by *Julian Keable*, 1958–62 (detailed by *Peter Ahrends*). Black brick-faced with concrete bands, reminiscent of Stirling & Gowan. Then a long stretch of backs of buildings facing Vincent Square, for which see pp. 724–6.

Opposite on the SW LONGMOORE GARDENS and LILLINGTON GARDENS begin, large housing enterprises of Westminster

116 City Council. LILLINGTON GARDENS, by *Darbourne &*
Darke, is the chief interest. Its special place in the history of
British housing was as a model of how low-rise dwellings could
reach the same high densities – here 210 persons per acre – as
tower blocks or uniform slabs. *John Darbourne* won the com-
petition for the site in 1961, aged twenty-six, and set up part-
nership with *Geoffrey Darke* to see it through. Construction was
in 1964–72, in three phases, mostly at the expense of ordinary
Pimlico terraces. Some two thousand people were housed, with
a high proportion of old people's dwellings, as well as pubs,
shops, surgeries, a community hall and a library.

LONGMOORE GARDENS comes first, between Warwick Way
and Charlwood Street. By *Westminster City Council Architects*,
finished 1980. Three blocks, set without finesse around a
triangular garden. The main difference from the Darbourne
& Darke manner is the shallow gabled roof-line, showing the
Neo-vernacular fashion.

LILLINGTON GARDENS proper begins to the s, bounded by
Tachbrook Street behind and Rampayne Street at the s. The
main facing of the blocks is brown Hastings-made brick, of
an unusually dark shade for the 1960s, but the effect is never

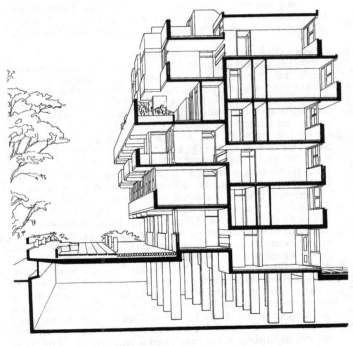

Lillington Gardens Estate.
Perspective section drawing of an accommodation block
(*Architectural Review* 148, 1970)

monotonous. They turn inwards towards green central areas, with a green border along Vauxhall Bridge Road (a road-widening scheme here was abandoned in 1982). The centre is traffic-free; the garages, which are underground, are placed on the perimeter. PHASE ONE and PHASE TWO come first, built in 1964–70. Here the parapets are flat, and the elevations show typical advanced 1960s forms: canting of the concrete slabs, broken skylines of up to eight storeys, and bay windows and balconies projecting for extra privacy. These seem without any overall system, reflecting the intricate internal planning, which makes use of scissor-plans and split levels. The general plan is no less ingenious, with internal courtyards and cross wings threaded through with paths and ramps. Higher levels are reached by brick-paved internal streets. In general the character is tough, not amiable – but then so is Street's church of St James-the-Less at the SE (q.v.), which is almost surrounded by the estate. It must have given the architects quite some inspiration. However, in the end toughness does not dominate, not least because of the exceptionally careful landscaping. The shared gardens are particularly spacious. The emphasis on landscaping also appears in the unusually broad upper access decks, with their semi-private gardens: an instance of the 1960s concern to ease the transition between public and private spaces. The same spatial complexity appears in microcosm inside the LORD HIGH ADMIRAL and PIMLICO TRAM on the perimeter, both rare survivals of 1960s pub interiors, with boarded surfaces and split levels. The Pimlico Tram is signalled by leaded oriels at the corner of Charlwood Street and Tachbrook Street.

The Vauxhall Bridge Road end of MORETON STREET, beyond the church, is not part of the estate proper. Its land formed the extreme SW part of the Dean and Chapter's Tothill Fields estate (*see* p. 667), here built up from *c.* 1822. Nos. 2–6 are relics of its inferior C19 housing (replacement proposed). Opposite, BRABAZON HOUSE, a big red brick hostel of 1901 by *R.S. Ayling*, for the Brabazon House Co. To its l. two small blocks for Westminster Council by *Lee, Goldfinger & Miles*, 1984–7: No. 9, one-room flats built to sell, and two-person flats behind. The same dark brick facing as the main estate, but with pitched roofs, and stepped Postmodernizing diagonals. PHASE THREE of Lillington Gardens lies to the SE, built 1969–72. Here more space was given over to small private gardens and the costly upper-level decks and split-level planning were omitted in favour of 'roof streets', invisible from below. Its upper storeys have slate facing, a very influential treatment. Part of Phase Two bridges Moreton Street at the opposite, SW end, next to which is a TRANSFORMER STATION of 1964–7 with what was a playground on top. The LIBRARY on the corner of Rampayne Street and Tachbrook Street, S, was built last, in 1973–4. Split-level interior with children's and young people's galleries: claustrophobic, but considered progressive when new.

A little further on, and the CROWN ESTATE scheme takes over both sides. The architects almost everywhere were *Chapman*

Taylor Partners, engaged by the Estate in 1971, whose general plan was settled in 1976. Completion was in 1989, with less new building or contemporary design than first planned, and more rehabilitation and imitation of C19 buildings. The scheme is essentially commercial, with private housing predominant. Its open spaces are nonetheless generous, and have mostly been kept within the public realm. There are three main parts: an office enclave between Rampayne Street and the realigned street called Drummond Gate, Neo-Cubitt terraces around an enlarged Bessborough Gardens, and a hinterland of smaller-scale housing to the SW, bounded on the S by Grosvenor Road. In addition some older terraces were refurbished, off Millbank and in and around Bessborough Street (*see* pp. 708 and 774), and the flats called Crown Reach built in Grosvenor Road (q.v.). Other architects were employed here and there, and monotony is avoided, though sometimes only narrowly.

The first two buildings encountered were finished in 1983. *Whitfield Partners'* No. 2 Bessborough Street ('Phase 1', first designs 1976) is a long low brick-faced wing, linked at the far end to a sturdy eight-storey tower like a castle keep, in plan an elongated octagon. This has load-bearing segmental arches, taller on the ground floor, in which is an entrance to PIMLICO UNDERGROUND STATION (opened 1972). Narrow window triplets on the two uppermost storeys, then a leaded mansard, notched with still thinner windows. The brick also refers to Lillington Gardens, just as the white-coated aluminium of Phase 2 next door (No. 1 Drummond Gate), by *Chapman Taylor Partners*, looks to the paler stucco of C19 Pimlico. This is relatively broad and low, with canted corners carried up as low towers. The frame is mostly exposed. Its big knuckle-like joints suggest the influence of Gunnar Birkerts' 1960s work, e.g. Tougaloo College Library, Massachusetts. Inside is one of the earlier atria in a London office block. It supplanted a scheme by the *GMW Partnership* for a U-shaped block for the CBI, towards which the little spur wings on the Whitfield block were meant to reach out. Between the blocks, facing Bessborough Street, a tall oblong AIR VENT for the Tube, sculpted by *Eduardo Paolozzi*, 1982. Relief panels below, breaking out above into grilles and chromed pipes.

Next the new terraces of BESSBOROUGH GARDENS, built 1985–6 on both sides of Vauxhall Bridge Road. In this area the local authorities urged rehabilitation of the old *Cubitt* terraces of 1843–60. The trade-off was a new set of buildings in Cubitt's later style but on a larger scale, and to a revised layout on the SW side. These form an L-shape around an extended town-square garden designed by *Sir Peter Shepheard*, 1980. The L-shape houses flats, with offices across the road. Details are well-observed and proportions mostly convincing, but as compromises go it is a dull one.* Less precedent-bound rear elevations, brick-faced and suggestive of mid-C19 industrial building. Greater freedom also appears in Phase 3, of 1987–9.

* On part of the garden site stood *J.L. Pearson*'s Holy Trinity Bessborough Gardens, 1849–52, in C13 English style; demolished 1954, after bombing.

This is reached through an open colonnade in the angle of the square, or via BALNEIL GATE, signalled by a little octagonal Tower-of-the-Winds-like lodge on Drummond Gate (designer *Robert Chitham*). First LINDSAY SQUARE and BALVAIRD PLACE, a great expanse of three- to four-storey housing on a complex plan that mixes elements of square and mews. More characterful detailing than the Postmodern average, e.g. the looped ironwork making ghost pediments. Further w is THOMSON HOUSE, angled red-brick-faced flats, completed a few years earlier and more simply treated.

Finally the post-war blocks by Vauxhall Bridge. The big square tower, originally Rank Hovis McDougall's offices, was built in 1969–71, again by *Chapman Taylor Partners*, but was remodelled as flats by the *Halpern Partnership*, 1998–2000. The result is glassier, bulkier and bittier. *Chapman Taylor*'s lower, brown-tile-faced block of riverside flats of 1969–71 remains. The stumpy RIVERBANK HOUSE on the opposite side, 1964–6 by *Farmer & Dark*, is an injustice to its prominent site.

WILTON ROAD

A jumbled street in the N apex of Pimlico. Made *c.* 1825 for access to the Grosvenor Canal basin, formerly to the NE. On the W SIDE No. 130, STOCKLEY HOUSE, 1984 by *Architech*. A forceful triangular office block with round-edged mushroom-coloured cladding, on stilts over a roadway. First-floor atrium in the angle. To the S, a medium-rise complex of supermarket, shops and flats by *Levitt Bernstein Associates* is under construction (2003). On the S side of GILLINGHAM STREET, to the E, a terrace of 1827. Modest in scale, but composed even so with projecting ends and pedimented centre. The smaller Nos. 1–6 in GUILDHOUSE STREET, s of Gillingham Street, must date from *c.* 1828–30. Further S and in LONGMOORE STREET to the E, terraces of *c.* 1840 with distinctive shallow-arched doorcases.

GLOSSARY

Numbers and letters refer to the illustrations (by John Sambrook) on pp. 798–805.

ABACUS: flat slab forming the top of a capital (3a).

ACANTHUS: classical formalized leaf ornament (4b).

ACCUMULATOR TOWER: see Hydraulic power.

ACHIEVEMENT: a complete display of armorial bearings.

ACROTERION: plinth for a statue or ornament on the apex or ends of a pediment; more usually, both the plinth and what stands on it (4a).

AEDICULE (*lit.* little building): architectural surround, consisting usually of two columns or pilasters supporting a pediment.

AGGREGATE: see Concrete.

AISLE: subsidiary space alongside the body of a building, separated from it by columns, piers, or posts.

ALMONRY: a building from which alms are dispensed to the poor.

AMBULATORY (*lit.* walkway): aisle around the sanctuary (q.v.).

ANGLE ROLL: roll moulding in the angle between two planes (1a).

ANSE DE PANIER: see Arch.

ANTAE: simplified pilasters (4a), usually applied to the ends of the enclosing walls of a portico *in antis* (q.v.).

ANTEFIXAE: ornaments projecting at regular intervals above a Greek cornice, originally to conceal the ends of roof tiles (4a).

ANTHEMION: classical ornament like a honeysuckle flower (4b).

APRON: raised panel below a window or wall monument or tablet.

APSE: semicircular or polygonal end of an apartment, especially of a chancel or chapel. In classical architecture sometimes called an *exedra*.

ARABESQUE: non-figurative surface decoration consisting of flowing lines, foliage scrolls etc., based on geometrical patterns. Cf. Grotesque.

ARCADE: series of arches supported by piers or columns. *Blind arcade* or *arcading*: the same applied to the wall surface. *Wall arcade*: in medieval churches, a blind arcade forming a dado below windows. Also a covered shopping street.

ARCH: Shapes see 5c. *Basket arch* or *anse de panier* (basket handle): three-centred and depressed, or with a flat centre. *Nodding*: ogee arch curving forward from the wall face. *Parabolic*: shaped like a chain suspended from two level points, but inverted. Special purposes. *Chancel*: dividing chancel from nave or crossing. *Crossing*: spanning piers at a crossing (q.v.). *Relieving or discharging*: incorporated in a wall to relieve superimposed weight (5c). *Skew*: spanning responds not diametrically opposed. *Strainer*: inserted in an opening to resist inward pressure. *Transverse*: spanning a main axis (e.g. of a vaulted space). See also Jack arch, Triumphal arch.

ARCHITRAVE: formalized lintel, the lowest member of the classical entablature (3a). Also the moulded frame of a door or window (often borrowing the profile of a classical architrave). For *lugged* and *shouldered* architraves see 4b.

ARCUATED: dependent structurally on the arch principle. Cf. Trabeated.

ARK: chest or cupboard housing

the tables of Jewish law in a synagogue.

ARRIS: sharp edge where two surfaces meet at an angle (3a).

ASHLAR: masonry of large blocks wrought to even faces and square edges (6d).

ASTRAGAL: classical moulding of semicircular section (3f).

ASTYLAR: with no columns or similar vertical features.

ATLANTES: *see* Caryatids.

ATRIUM (plural: atria): inner court of a Roman or C20 house; in a multi-storey building, a toplit covered court rising through all storeys. Also an open court in front of a church.

ATTACHED COLUMN: *see* Engaged column.

ATTIC: small top storey within a roof. Also the storey above the main entablature of a classical façade.

AUMBRY: recess or cupboard to hold sacred vessels for the Mass.

BAILEY: *see* Motte-and-bailey.

BALANCE BEAM: *see* Canals.

BALDACCHINO: free-standing canopy, originally fabric, over an altar. Cf. Ciborium.

BALLFLOWER: globular flower of three petals enclosing a ball (1a). Typical of the Decorated style.

BALUSTER: pillar or pedestal of bellied form. *Balusters*: vertical supports of this or any other form, for a handrail or coping, the whole being called a *balustrade* (6c). *Blind balustrade*: the same applied to the wall surface.

BARBICAN: outwork defending the entrance to a castle.

BARGEBOARDS (corruption of 'vergeboards'): boards, often carved or fretted, fixed beneath the eaves of a gable to cover and protect the rafters.

BAROQUE: style originating in Rome *c.*1600 and current in England *c.*1680–1720, characterized by dramatic massing and silhouette and the use of the giant order.

BARROW: burial mound.

BARTIZAN: corbelled turret, square or round, frequently at an angle.

BASCULE: hinged part of a lifting (or bascule) bridge.

BASE: moulded foot of a column or pilaster. For *Attic* base *see* 3b.

BASEMENT: lowest, subordinate storey; hence the lowest part of a classical elevation, below the *piano nobile* (q.v.).

BASILICA: a Roman public hall; hence an aisled building with a clerestory.

BASTION: one of a series of defensive semicircular or polygonal projections from the main wall of a fortress or city.

BATTER: intentional inward inclination of a wall face.

BATTLEMENT: defensive parapet, composed of *merlons* (solid) and *crenels* (embrasures) through which archers could shoot; sometimes called *crenellation*. Also used decoratively.

BAY: division of an elevation or interior space as defined by regular vertical features such as arches, columns, windows etc.

BAY LEAF: classical ornament of overlapping bay leaves (3f).

BAY WINDOW: window of one or more storeys projecting from the face of a building. *Canted*: with a straight front and angled sides. *Bow window*: curved. *Oriel*: rests on corbels or brackets and starts above ground level; also the bay window at the dais end of a medieval great hall.

BEAD-AND-REEL: *see* Enrichments.

BEAKHEAD: Norman ornament with a row of beaked bird or beast heads usually biting into a roll moulding (1a).

BELFRY: chamber or stage in a tower where bells are hung.

BELL CAPITAL: *see* 1b.

BELLCOTE: small gabled or roofed housing for the bell(s).

BERM: level area separating a ditch from a bank on a hill-fort or barrow.

BILLET: Norman ornament of small half-cylindrical or rectangular blocks (1a).

BLIND: *see* Arcade, Baluster, Portico.

BLOCK CAPITAL: *see* 1a.

BLOCKED: columns, etc. interrupted by regular projecting blocks

(*blocking*), as on a Gibbs surround (4b).

BLOCKING COURSE: course of stones, or equivalent, on top of a cornice and crowning the wall.

BOLECTION MOULDING: covering the joint between two different planes (6b).

BOND: the pattern of long sides (*stretchers*) and short ends (*headers*) produced on the face of a wall by laying bricks in a particular way (6e).

BOSS: knob or projection, e.g. at the intersection of ribs in a vault (2c).

BOWTELL: a term in use by the C15 for a form of roll moulding, usually three-quarters of a circle in section (also called *edge roll*).

BOW WINDOW: *see* Bay window.

BOX FRAME: timber-framed construction in which vertical and horizontal wall members support the roof (7). Also concrete construction where the loads are taken on cross walls; also called *cross-wall construction*.

BRACE: subsidiary member of a structural frame, curved or straight. *Bracing* is often arranged decoratively e.g. quatrefoil, herringbone (7). *See also* Roofs.

BRATTISHING: ornamental crest, usually formed of leaves, Tudor flowers or miniature battlements.

BRESSUMER (*lit.* breast-beam): big horizontal beam supporting the wall above, especially in a jettied building (7).

BRICK: *see* Bond, Cogging, Engineering, Gauged, Tumbling.

BRIDGE: *Bowstring*: with arches rising above the roadway which is suspended from them. *Clapper*: one long stone forms the roadway. *Roving*: *see* Canal. *Suspension*: roadway suspended from cables or chains slung between towers or pylons. *Stay-suspension* or *stay-cantilever*: supported by diagonal stays from towers or pylons. *See also* Bascule.

BRISES-SOLEIL: projecting fins or canopies which deflect direct sunlight from windows.

BROACH: *see* Spire and 1C.

BUCRANIUM: ox skull used decoratively in classical friezes.

BULL-NOSED SILL: sill displaying a pronounced convex upper moulding.

BULLSEYE WINDOW: small oval window, set horizontally (cf. Oculus). Also called *œil de bœuf*.

BUTTRESS: vertical member projecting from a wall to stabilize it or to resist the lateral thrust of an arch, roof, or vault (1c, 2c). A *flying buttress* transmits the thrust to a heavy abutment by means of an arch or half-arch (1c).

CABLE OR ROPE MOULDING: originally Norman, like twisted strands of a rope.

CAMES: *see* Quarries.

CAMPANILE: free-standing bell-tower.

CANALS: *Flash lock*: removable weir or similar device through which boats pass on a flush of water. Predecessor of the *pound lock*: chamber with gates at each end allowing boats to float from one level to another. *Tidal gates*: single pair of lock gates allowing vessels to pass when the tide makes a level. *Balance beam*: beam projecting horizontally for opening and closing lock gates. *Roving bridge*: carrying a towing path from one bank to the other.

CANTILEVER: horizontal projection (e.g. step, canopy) supported by a downward force behind the fulcrum.

CAPITAL: head or crowning feature of a column or pilaster; for classical types *see* 3; for medieval types *see* 1b.

CARREL: compartment designed for individual work or study.

CARTOUCHE: classical tablet with ornate frame (4b).

CARYATIDS: female figures supporting an entablature; their male counterparts are *Atlantes* (*lit.* Atlas figures).

CASEMATE: vaulted chamber, with embrasures for defence, within a castle wall or projecting from it.

CASEMENT: side-hinged window.

CASTELLATED: with battlements (q.v.).

CAST IRON: hard and brittle, cast in a mould to the required shape.

Wrought iron is ductile, strong in tension, forged into decorative patterns or forged and rolled into e.g. bars, joists, boiler plates; *mild steel* is its modern equivalent, similar but stronger.

CATSLIDE: See 8a.

CAVETTO: concave classical moulding of quarter-round section (3f).

CELURE OR CEILURE: enriched area of roof above rood or altar.

CEMENT: *see* Concrete.

CENOTAPH (*lit.* empty tomb): funerary monument which is not a burying place.

CENTRING: wooden support for the building of an arch or vault, removed after completion.

CHAMFER (*lit.* corner-break): surface formed by cutting off a square edge or corner. For types of chamfers and *chamfer stops see* 6a. *See also* Double chamfer.

CHANCEL: part of the E end of a church set apart for the use of the officiating clergy.

CHANTRY CHAPEL: often attached to or within a church, endowed for the celebration of Masses principally for the soul of the founder.

CHEVET (*lit.* head): French term for chancel with ambulatory and radiating chapels.

CHEVRON: V-shape used in series or double series (later) on a Norman moulding (1a). Also (especially when on a single plane) called *zigzag*.

CHOIR: the part of a cathedral, monastic or collegiate church where services are sung.

CIBORIUM: a fixed canopy over an altar, usually vaulted and supported on four columns; cf. Baldacchino. Also a canopied shrine for the reserved sacrament.

CINQUEFOIL: *see* Foil.

CIST: stone-lined or slab-built grave.

CLADDING: external covering or skin applied to a structure, especially a framed one.

CLERESTORY: uppermost storey of the nave of a church, pierced by windows. Also high-level windows in secular buildings.

CLOSER: a brick cut to complete a bond (6e).

CLUSTER BLOCK: *see* Multi-storey.

COADE STONE: ceramic artificial stone made in Lambeth 1769–c.1840 by Eleanor Coade (†1821) and her associates.

COB: walling material of clay mixed with straw. Also called *pisé*.

COFFERING: arrangement of sunken panels (coffers), square or polygonal, decorating a ceiling, vault, or arch.

COGGING: a decorative course of bricks laid diagonally (6e). Cf. Dentilation.

COLLAR: *see* Roofs and 7.

COLLEGIATE CHURCH: endowed for the support of a college of priests.

COLONNADE: range of columns supporting an entablature. Cf. Arcade.

COLONNETTE: small medieval column or shaft.

COLOSSAL ORDER: *see* Giant order.

COLUMBARIUM: shelved, niched structure to house multiple burials.

COLUMN: a classical, upright structural member of round section with a shaft, a capital, and usually a base (3a, 4a).

COLUMN FIGURE: carved figure attached to a medieval column or shaft, usually flanking a doorway.

COMMUNION TABLE: unconsecrated table used in Protestant churches for the celebration of Holy Communion.

COMPOSITE: *see* Orders.

COMPOUND PIER: grouped shafts (q.v.), or a solid core surrounded by shafts.

CONCRETE: composition of *cement* (calcined lime and clay), *aggregate* (small stones or rock chippings), sand and water. It can be poured into *formwork* or *shuttering* (temporary frame of timber or metal) on site (*in-situ* concrete), or *pre-cast* as components before construction. *Reinforced*: incorporating steel rods to take the tensile force. *Pre-stressed*: with tensioned steel rods. Finishes include the impression of boards left by formwork (*board-marked* or *shuttered*), and texturing with steel brushes (*brushed*) or hammers (*hammer-dressed*). *See also* Shell.

CONSOLE: bracket of curved outline (4b).

COPING: protective course of masonry or brickwork capping a wall (6d).

CORBEL: projecting block supporting something above. *Corbel course*: continuous course of projecting stones or bricks fulfilling the same function. *Corbel table*: series of corbels to carry a parapet or a wall-plate or wall-post (7). *Corbelling*: brick or masonry courses built out beyond one another to support a chimney-stack, window, etc.

CORINTHIAN: *see* Orders and 3d.

CORNICE: flat-topped ledge with moulded underside, projecting along the top of a building or feature, especially as the highest member of the classical entablature (3a). Also the decorative moulding in the angle between wall and ceiling.

CORPS-DE-LOGIS: the main building(s) as distinct from the wings or pavilions.

COTTAGE ORNÉ: an artfully rustic small house associated with the Picturesque movement.

COUNTERCHANGING: of joists on a ceiling divided by beams into compartments, when placed in opposite directions in alternate squares.

COUR D'HONNEUR: formal entrance court before a house in the French manner, usually with flanking wings and a screen wall or gates.

COURSE: continuous layer of stones, etc. in a wall (6e).

COVE: a broad concave moulding, e.g. to mask the eaves of a roof. *Coved ceiling*: with a pronounced cove joining the walls to a flat central panel smaller than the whole area of the ceiling.

CRADLE ROOF: *see* Wagon roof.

CREDENCE: a shelf within or beside a piscina (q.v.), or a table for the sacramental elements and vessels.

CRENELLATION: parapet with crenels (*see* Battlement).

CRINKLE-CRANKLE WALL: garden wall undulating in a series of serpentine curves.

CROCKETS: leafy hooks. *Crocketing* decorates the edges of Gothic features, such as pinnacles, canopies, etc. *Crocket capital*: *see* 1b.

CROSSING: central space at the junction of the nave, chancel, and transepts. *Crossing tower*: above a crossing.

CROSS-WINDOW: with one mullion and one transom (qq.v.).

CROWN-POST: *see* Roofs and 7.

CROWSTEPS: squared stones set like steps, e.g. on a gable (8a).

CRUCKS (*lit.* crooked): pairs of inclined timbers (*blades*), usually curved, set at bay-lengths; they support the roof timbers and, in timber buildings, also support the walls (8b). *Base*: blades rise from ground level to a tie- or collar-beam which supports the roof timbers. *Full*: blades rise from ground level to the apex of the roof, serving as the main members of a roof truss. *Jointed*: blades formed from more than one timber; the lower member may act as a wall-post; it is usually elbowed at wall-plate level and jointed just above. *Middle*: blades rise from half-way up the walls to a tie- or collar-beam. *Raised*: blades rise from half-way up the walls to the apex. *Upper*: blades supported on a tie-beam and rising to the apex.

CRYPT: underground or half-underground area, usually below the E end of a church. *Ring crypt*: corridor crypt surrounding the apse of an early medieval church, often associated with chambers for relics. Cf. Undercroft.

CUPOLA (*lit.* dome): especially a small dome on a circular or polygonal base crowning a larger dome, roof, or turret.

CURSUS: a long avenue defined by two parallel earthen banks with ditches outside.

CURTAIN WALL: a connecting wall between the towers of a castle. Also a non-load-bearing external wall applied to a C20 framed structure.

CUSP: *see* Tracery and 2b.

CYCLOPEAN MASONRY: large irregular polygonal stones, smooth and finely jointed.

CYMA RECTA and CYMA REVERSA: classical mouldings with double curves (3f). Cf. Ogee.

DADO: the finishing (often with panelling) of the lower part of a wall in a classical interior; in origin a formalized continuous pedestal. *Dado rail*: the moulding along the top of the dado.

DAGGER: *see* Tracery and 2b.

DALLE-DE-VERRE (*lit.* glass-slab): a late C20 stained-glass technique, setting large, thick pieces of cast glass into a frame of reinforced concrete or epoxy resin.

DEC (DECORATED): English Gothic architecture *c.* 1290 to *c.* 1350. The name is derived from the type of window tracery (q.v.) used during the period.

DEMI- or HALF-COLUMNS: engaged columns (q.v.) half of whose circumference projects from the wall.

DENTIL: small square block used in series in classical cornices (3c). *Dentilation* is produced by the projection of alternating headers along cornices or stringcourses.

DIAPER: repetitive surface decoration of lozenges or squares flat or in relief. Achieved in brickwork with bricks of two colours.

DIOCLETIAN OR THERMAL WINDOW: semicircular with two mullions, as used in the Baths of Diocletian, Rome (4b).

DISTYLE: having two columns (4a).

DOGTOOTH: E.E. ornament, consisting of a series of small pyramids formed by four stylized canine teeth meeting at a point (1a).

DORIC: *see* Orders and 3a, 3b.

DORMER: window projecting from the slope of a roof (8a).

DOUBLE CHAMFER: a chamfer applied to each of two recessed arches (1a).

DOUBLE PILE: *see* Pile.

DRAGON BEAM: *see* Jetty.

DRESSINGS: the stone or brickwork worked to a finished face about an angle, opening, or other feature.

DRIPSTONE: moulded stone projecting from a wall to protect the lower parts from water. Cf. Hoodmould, Weathering.

DRUM: circular or polygonal stage supporting a dome or cupola. Also one of the stones forming the shaft of a column (3a).

DUTCH or FLEMISH GABLE: *see* 8a.

EASTER SEPULCHRE: tomb-chest used for Easter ceremonial, within or against the N wall of a chancel.

EAVES: overhanging edge of a roof; hence *eaves cornice* in this position.

ECHINUS: ovolo moulding (q.v.) below the abacus of a Greek Doric capital (3a).

EDGE RAIL: *see* Railways.

E.E. (EARLY ENGLISH): English Gothic architecture *c.* 1190–1250.

EGG-AND-DART: *see* Enrichments and 3f.

ELEVATION: any face of a building or side of a room. In a drawing, the same or any part of it, represented in two dimensions.

EMBATTLED: with battlements.

EMBRASURE: small splayed opening in a wall or battlement (q.v.).

ENCAUSTIC TILES: earthenware tiles fired with a pattern and glaze.

EN DELIT: stone cut against the bed.

ENFILADE: reception rooms in a formal series, usually with all doorways on axis.

ENGAGED or ATTACHED COLUMN: one that partly merges into a wall or pier.

ENGINEERING BRICKS: dense bricks, originally used mostly for railway viaducts etc.

ENRICHMENTS: the carved decoration of certain classical mouldings, e.g. the ovolo (qq.v.) with *egg-and-dart*, the cyma reversa with *waterleaf*, the astragal with *bead-and-reel* (3f).

ENTABLATURE: in classical architecture, collective name for the three horizontal members (architrave, frieze, and cornice) carried by a wall or a column (3a).

ENTASIS: very slight convex deviation from a straight line, used to prevent an optical illusion of concavity.

EPITAPH: inscription on a tomb.

EXEDRA: *see* Apse.

EXTRADOS: outer curved face of an arch or vault.

EYECATCHER: decorative building terminating a vista.

FASCIA: plain horizontal band, e.g. in an architrave (3c, 3d) or on a shopfront.

FENESTRATION: the arrangement of windows in a façade.

FERETORY: site of the chief shrine of a church, behind the high altar.

FESTOON: ornamental garland, suspended from both ends. Cf. Swag.

FIBREGLASS, or glass-reinforced polyester (GRP): synthetic resin reinforced with glass fibre. GRC: glass-reinforced concrete.

FIELD: *see* Panelling and 6b.

FILLET: a narrow flat band running down a medieval shaft or along a roll moulding (1a). It separates larger curved mouldings in classical cornices, fluting or bases (3c).

FLAMBOYANT: the latest phase of French Gothic architecture, with flowing tracery.

FLASH LOCK: *see* Canals.

FLÈCHE or SPIRELET (*lit.* arrow): slender spire on the centre of a roof.

FLEURON: medieval carved flower or leaf, often rectilinear (1a).

FLUSHWORK: knapped flint used with dressed stone to form patterns.

FLUTING: series of concave grooves (flutes), their common edges sharp (arris) or blunt (fillet) (3).

FOIL (*lit.* leaf): lobe formed by the cusping of a circular or other shape in tracery (2b). *Trefoil* (three), *quatrefoil* (four), *cinquefoil* (five), and *multifoil* express the number of lobes in a shape.

FOLIATE: decorated with leaves.

FORMWORK: *see* Concrete.

FRAMED BUILDING: where the structure is carried by a framework – e.g. of steel, reinforced concrete, timber – instead of by load-bearing walls.

FREESTONE: stone that is cut, or can be cut, in all directions.

FRESCO: *al fresco*: painting on wet plaster. *Fresco secco*: painting on dry plaster.

FRIEZE: the middle member of the classical entablature, sometimes ornamented (3a). *Pulvinated frieze* (*lit.* cushioned): of bold convex profile (3c). Also a horizontal band of ornament.

FRONTISPIECE: in C16 and C17 buildings the central feature of doorway and windows above linked in one composition.

GABLE: For types *see* 8a. *Gablet*: small gable. *Pedimental gable*: treated like a pediment.

GADROONING: classical ribbed ornament like inverted fluting that flows into a lobed edge.

GALILEE: chapel or vestibule usually at the w end of a church enclosing the main portal(s).

GALLERY: a long room or passage; an upper storey above the aisle of a church, looking through arches to the nave; a balcony or mezzanine overlooking the main interior space of a building; or an external walkway.

GALLETING: small stones set in a mortar course.

GAMBREL ROOF: *see* 8a.

GARDEROBE: medieval privy.

GARGOYLE: projecting water spout often carved into human or animal shape.

GAUGED or RUBBED BRICKWORK: soft brick sawn roughly, then rubbed to a precise (gauged) surface. Mostly used for door or window openings (5c).

GAZEBO (jocular Latin, 'I shall gaze'): ornamental lookout tower or raised summer house.

GEOMETRIC: English Gothic architecture *c.* 1250–1310. *See also* Tracery. For another meaning, *see* Stairs.

GIANT or COLOSSAL ORDER: classical order (q.v.) whose height is that of two or more storeys of the building to which it is applied.

GIBBS SURROUND: C18 treatment of an opening (4b), seen particularly in the work of James Gibbs (1682–1754).

GIRDER: a large beam. *Box*: of hollow-box section. *Bowed*: with its top rising in a curve. *Plate*: of I-section, made from iron or steel

plates. *Lattice*: with braced frame-work.

GLAZING BARS: wooden or some-times metal bars separating and supporting window panes.

GRAFFITI: *see* Sgraffito.

GRANGE: farm owned and run by a religious order.

GRC: *see* Fibreglass.

GRISAILLE: monochrome painting on walls or glass.

GROIN: sharp edge at the meeting of two cells of a cross-vault; *see* Vault and 2c.

GROTESQUE (*lit.* grotto-esque): wall decoration adopted from Roman examples in the Renaissance. Its foliage scrolls incorporate figur-ative elements. Cf. Arabesque.

GROTTO: artificial cavern.

GRP: *see* Fibreglass.

GUILLOCHE: classical ornament of interlaced bands (4b).

GUNLOOP: opening for a firearm.

GUTTAE: stylized drops (3b).

HALF-TIMBERING: archaic term for timber-framing (q.v.). Sometimes used for non-structural decorative timberwork.

HALL CHURCH: medieval church with nave and aisles of approxim-ately equal height.

HAMMERBEAM: *see* Roofs and 7.

HAMPER: in C20 architecture, a visu-ally distinct topmost storey or storeys.

HEADER: *see* Bond and 6e.

HEADSTOP: stop (q.v.) carved with a head (5b).

HELM ROOF: *see* 1c.

HENGE: ritual earthwork.

HERM (*lit.* the god Hermes): male head or bust on a pedestal.

HERRINGBONE WORK: *see* 7ii. Cf. Pitched masonry.

HEXASTYLE: *see* Portico.

HILL-FORT: Iron Age earthwork en-closed by a ditch and bank system.

HIPPED ROOF: *see* 8a.

HOODMOULD: projecting moulding above an arch or lintel to throw off water (2b, 5b). When horizontal often called a *label*. For label stop *see* Stop.

HUSK GARLAND: festoon of stylized nutshells (4b).

HYDRAULIC POWER: use of water under high pressure to work machinery. *Accumulator tower*: houses a hydraulic accumulator which accommodates fluctuations in the flow through hydraulic mains.

HYPOCAUST (*lit.* underburning): Ro-man underfloor heating system.

IMPOST: horizontal moulding at the springing of an arch (5c).

IMPOST BLOCK: block between abacus and capital (1b).

IN ANTIS: *see* Antae, Portico and 4a.

INDENT: shape chiselled out of a stone to receive a brass.

INDUSTRIALIZED or SYSTEM BUILDING: system of manufac-tured units assembled on site.

INGLENOOK (*lit.* fire-corner): recess for a hearth with provision for seating.

INTERCOLUMNATION: interval be-tween columns.

INTERLACE: decoration in relief simulating woven or entwined stems or bands.

INTRADOS: *see* Soffit.

IONIC: *see* Orders and 3c.

JACK ARCH: shallow segmental vault springing from beams, used for fireproof floors, bridge decks, etc.

JAMB (*lit.* leg): one of the vertical sides of an opening.

JETTY: in a timber-framed building, the projection of an upper storey beyond the storey below, made by the beams and joists of the lower storey oversailing the wall; on their outer ends is placed the sill of the walling for the storey above (7). Buildings can be jettied on several sides, in which case a *dragon beam* is set diagonally at the corner to carry the joists to either side.

JOGGLE: the joining of two stones to prevent them slipping by a notch in one and a projection in the other.

KEEL MOULDING: moulding used from the late C12, in section like the keel of a ship (1a).

KEEP: principal tower of a castle.

KENTISH CUSP: *see* Tracery and 2b.

KEY PATTERN: *see* 4b.

KEYSTONE: central stone in an arch or vault (4b, 5c).

KINGPOST: *see* Roofs and 7.

KNEELER: horizontal projecting stone at the base of each side of a gable to support the inclined coping stones (8a).

LABEL: *see* Hoodmould and 5b.

LABEL STOP: *see* Stop and 5b.

LACED BRICKWORK: vertical strips of brickwork, often in a contrasting colour, linking openings on different floors.

LACING COURSE: horizontal reinforcement in timber or brick to walls of flint, cobble, etc.

LADY CHAPEL: dedicated to the Virgin Mary (Our Lady).

LANCET: slender single-light, pointed-arched window (2a).

LANTERN: circular or polygonal windowed turret crowning a roof or a dome. Also the windowed stage of a crossing tower lighting the church interior.

LANTERN CROSS: churchyard cross with lantern-shaped top.

LAVATORIUM: in a religious house, a washing place adjacent to the refectory.

LEAN-TO: *see* Roofs.

LESENE (*lit.* a mean thing): pilaster without base or capital. Also called *pilaster strip*.

LIERNE: *see* Vault and 2c.

LIGHT: compartment of a window defined by the mullions.

LINENFOLD: Tudor panelling carved with simulations of folded linen. *See also* Parchemin.

LINTEL: horizontal beam or stone bridging an opening.

LOGGIA: gallery, usually arcaded or colonnaded; sometimes free-standing.

LONG-AND-SHORT WORK: quoins consisting of stones placed with the long side alternately upright and horizontal, especially in Saxon building.

LONGHOUSE: house and byre in the same range with internal access between them.

LOUVRE: roof opening, often protected by a raised timber structure, to allow the smoke from a central hearth to escape.

LOWSIDE WINDOW: set lower than the others in a chancel side wall, usually towards its W end.

LUCAM: projecting housing for hoist pulley on upper storey of warehouses, mills, etc., for raising goods to loading doors.

LUCARNE (*lit.* dormer): small gabled opening in a roof or spire.

LUGGED ARCHITRAVE: *see* 4b.

LUNETTE: semicircular window or blind panel.

LYCHGATE (*lit.* corpse-gate): roofed gateway entrance to a churchyard for the reception of a coffin.

LYNCHET: long terraced strip of soil on the downward side of prehistoric and medieval fields, accumulated because of continual ploughing along the contours.

MACHICOLATIONS (*lit.* mashing devices): series of openings between the corbels that support a projecting parapet through which missiles can be dropped. Used decoratively in post-medieval buildings.

MANOMETER or STANDPIPE TOWER: containing a column of water to regulate pressure in water mains.

MANSARD: *see* 8a.

MATHEMATICAL TILES: facing tiles with the appearance of brick, most often applied to timber-framed walls.

MAUSOLEUM: monumental building or chamber usually intended for the burial of members of one family.

MEGALITHIC TOMB: massive stone-built Neolithic burial chamber covered by an earth or stone mound.

MERLON: *see* Battlement.

METOPES: spaces between the triglyphs in a Doric frieze (3b).

MEZZANINE: low storey between two higher ones.

MILD STEEL: *see* Cast iron.

MISERICORD (*lit.* mercy): shelf on a carved bracket placed on the underside of a hinged choir stall seat to support an occupant when standing.

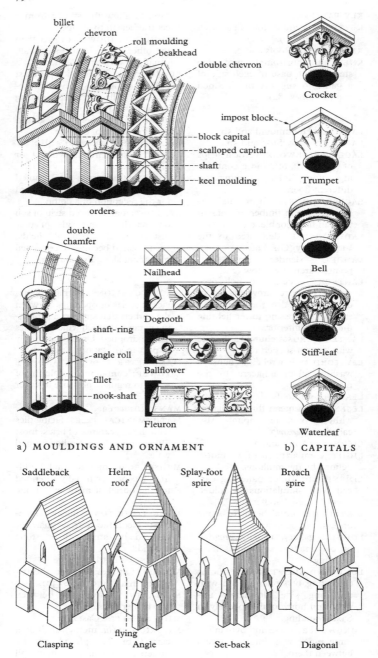

a) MOULDINGS AND ORNAMENT

billet
chevron
roll moulding
beakhead
double chevron
block capital
scalloped capital
shaft
keel moulding
orders

double chamfer
shaft-ring
angle roll
fillet
nook-shaft

Nailhead
Dogtooth
Ballflower
Fleuron

b) CAPITALS

Crocket
impost block
Trumpet
Bell
Stiff-leaf
Waterleaf

Saddleback roof
Helm roof
Splay-foot spire
Broach spire

Clasping
Angle
flying
Set-back
Diagonal

c) BUTTRESSES, ROOFS AND SPIRES

FIGURE 1: MEDIEVAL

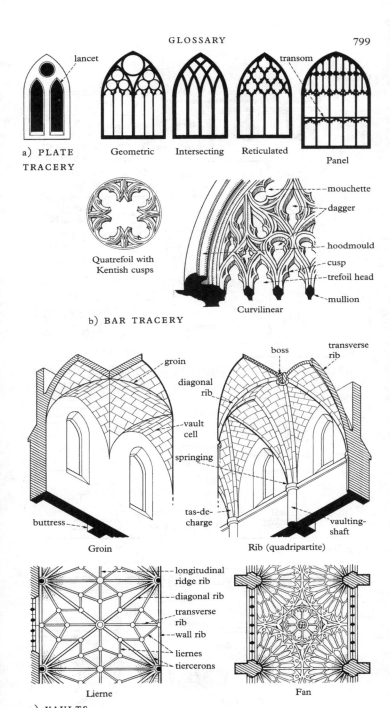

a) PLATE TRACERY

lancet

Geometric Intersecting Reticulated

transom

Panel

Quatrefoil with Kentish cusps

mouchette

dagger

hoodmould

cusp

trefoil head

mullion

Curvilinear

b) BAR TRACERY

groin

diagonal rib

vault cell

buttress

Groin

boss transverse rib

springing

tas-de-charge

vaulting-shaft

Rib (quadripartite)

longitudinal ridge rib

diagonal rib

transverse rib

wall rib

liernes

tiercerons

Lierne

Fan

c) VAULTS

FIGURE 2: MEDIEVAL

ORDERS

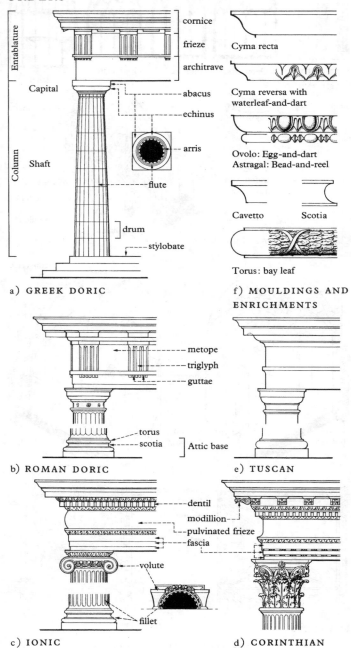

a) GREEK DORIC

f) MOULDINGS AND
ENRICHMENTS

Cyma recta

Cyma reversa with
waterleaf-and-dart

Ovolo: Egg-and-dart
Astragal: Bead-and-reel

Cavetto Scotia

Torus: bay leaf

b) ROMAN DORIC

e) TUSCAN

c) IONIC

d) CORINTHIAN

FIGURE 3: CLASSICAL

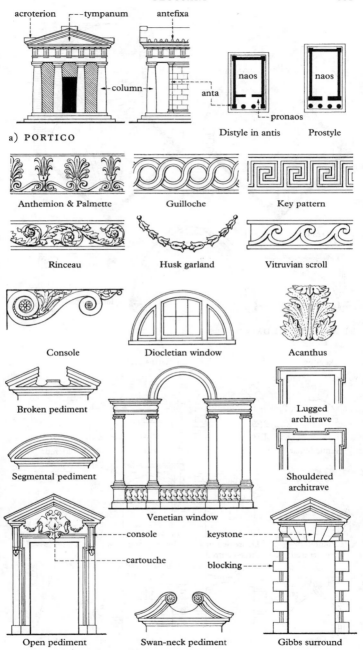

acroterion — tympanum — antefixa

column

anta

naos

naos

pronaos

a) PORTICO

Distyle in antis Prostyle

Anthemion & Palmette Guilloche Key pattern

Rinceau Husk garland Vitruvian scroll

Console Diocletian window Acanthus

Broken pediment Lugged architrave

Segmental pediment Shouldered architrave

Venetian window

console keystone

cartouche blocking

Open pediment Swan-neck pediment Gibbs surround

b) ORNAMENTS AND FEATURES

FIGURE 4: CLASSICAL

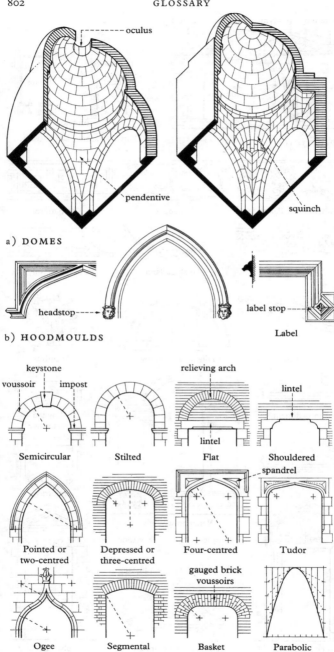

a) DOMES

b) HOODMOULDS

Label

c) ARCHES

FIGURE 5: CONSTRUCTION

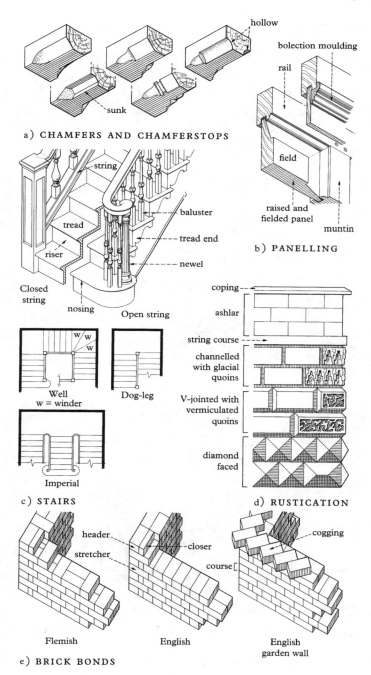

a) CHAMFERS AND CHAMFERSTOPS

hollow

bolection moulding

rail

field

raised and
fielded panel

muntin

b) PANELLING

string

baluster

tread

tread end

riser

newel

Closed
string

nosing Open string

Well
w = winder

Dog-leg

Imperial

c) STAIRS

coping

ashlar

string course

channelled
with glacial
quoins

V-jointed with
vermiculated
quoins

diamond
faced

d) RUSTICATION

header

stretcher

closer

course

cogging

Flemish English English
 garden wall

e) BRICK BONDS

FIGURE 6: CONSTRUCTION

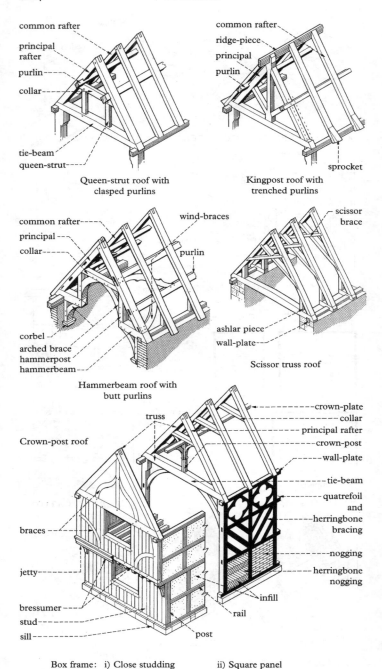

common rafter
principal rafter
purlin
collar
tie-beam
queen-strut

Queen-strut roof with
clasped purlins

common rafter
ridge-piece
principal
purlin
sprocket

Kingpost roof with
trenched purlins

common rafter
principal
collar
wind-braces
purlin
corbel
arched brace
hammerpost
hammerbeam

Hammerbeam roof with
butt purlins

scissor brace
ashlar piece
wall-plate

Scissor truss roof

Crown-post roof

truss
crown-plate
collar
principal rafter
crown-post
wall-plate
tie-beam
quatrefoil and herringbone bracing
nogging
herringbone nogging
braces
jetty
bressumer
stud
sill
post
rail
infill

Box frame: i) Close studding ii) Square panel

FIGURE 7: ROOFS AND TIMBER-FRAMING

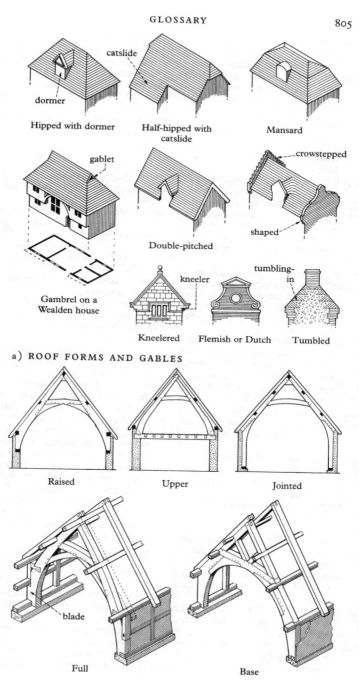

Hipped with dormer
dormer

Half-hipped with catslide
catslide

Mansard

Gambrel on a Wealden house
gablet

Double-pitched

crowstepped
shaped

Kneelered
kneeler

Flemish or Dutch

Tumbled
tumbling-in

a) ROOF FORMS AND GABLES

Raised

Upper

Jointed

Full
blade

Base

b) CRUCK FRAMES

FIGURE 8: ROOFS AND TIMBER-FRAMING

MIXER-COURTS: forecourts to groups of houses shared by vehicles and pedestrians.

MODILLIONS: small consoles (q.v.) along the underside of a Corinthian or Composite cornice (3d). Often used along an eaves cornice.

MODULE: a predetermined standard size for co-ordinating the dimensions of components of a building.

MOTTE-AND-BAILEY: post-Roman and Norman defence consisting of an earthen mound (motte) topped by a wooden tower within a bailey, an enclosure defended by a ditch and palisade, and also, sometimes, by an internal bank.

MOUCHETTE: see Tracery and 2b.

MOULDING: shaped ornamental strip of continuous section; see e.g. Cavetto, Cyma, Ovolo, Roll.

MULLION: vertical member between window lights (2b).

MULTI-STOREY: five or more storeys. Multi-storey flats may form a *cluster block*, with individual blocks of flats grouped round a service core; a *point block*, with flats fanning out from a service core; or a *slab block*, with flats approached by corridors or galleries from service cores at intervals or towers at the ends (plan also used for offices, hotels etc.). *Tower block* is a generic term for any very high multi-storey building.

MUNTIN: see Panelling and 6b.

NAILHEAD: E.E. ornament consisting of small pyramids regularly repeated (1a).

NARTHEX: enclosed vestibule or covered porch at the main entrance to a church.

NAVE: the body of a church W of the crossing or chancel often flanked by aisles (q.v.).

NEWEL: central or corner post of a staircase (6c). Newel stair: see Stairs.

NIGHT STAIR: stair by which religious entered the transept of their church from their dormitory to celebrate night services.

NOGGING: see Timber-framing(7).

NOOK-SHAFT: shaft set in the angle of a wall or opening (1a).

NORMAN: see Romanesque.

NOSING: projection of the tread of a step (6c).

NUTMEG: medieval ornament with a chain of tiny triangles placed obliquely.

OCULUS: circular opening.

ŒIL DE BŒUF: see Bullseye window.

OGEE: double curve, bending first one way and then the other, as in an *ogee* or *ogival arch* (5c). Cf. Cyma recta and Cyma reversa.

OPUS SECTILE: decorative mosaic-like facing.

OPUS SIGNINUM: composition flooring of Roman origin.

ORATORY: a private chapel in a church or a house. Also a church of the Oratorian Order.

ORDER: one of a series of recessed arches and jambs forming a splayed medieval opening, e.g. a doorway or arcade arch (1a).

ORDERS: the formalized versions of the post-and-lintel system in classical architecture. The main orders are *Doric*, *Ionic*, and *Corinthian*. They are Greek in origin but occur in Roman versions. Tuscan is a simple version of Roman Doric. Though each order has its own conventions (3), there are many minor variations. The *Composite* capital combines Ionic volutes with Corinthian foliage. *Superimposed orders*: orders on successive levels, usually in the upward sequence of Tuscan, Doric, Ionic, Corinthian, Composite.

ORIEL: see Bay window.

OVERDOOR: painting or relief above an internal door. Also called a *sopraporta*.

OVERTHROW: decorative fixed arch between two gatepiers or above a wrought-iron gate.

OVOLO: wide convex moulding (3f).

PALIMPSEST: of a brass: where a metal plate has been reused by

turning over the engraving on the back; of a wall painting: where one overlaps and partly obscures an earlier one.

PALLADIAN: following the examples and principles of Andrea Palladio (1508–80).

PALMETTE: classical ornament like a palm shoot (4b).

PANELLING: wooden lining to interior walls, made up of vertical members (*muntins*) and horizontals (*rails*) framing panels: also called *wainscot*. *Raised and fielded*: with the central area of the panel (*field*) raised up (6b).

PANTILE: roof tile of S section.

PARAPET: wall for protection at any sudden drop, e.g. at the wall-head of a castle where it protects the *parapet walk* or wall-walk. Also used to conceal a roof.

PARCLOSE: *see* Screen.

PARGETTING (*lit.* plastering): exterior plaster decoration, either in relief or incised.

PARLOUR: in a religious house, a room where the religious could talk to visitors; in a medieval house, the semi-private living room below the solar (q.v.).

PARTERRE: level space in a garden laid out with low, formal beds.

PATERA (*lit.* plate): round or oval ornament in shallow relief.

PAVILION: ornamental building for occasional use; or projecting subdivision of a larger building, often at an angle or terminating a wing.

PEBBLEDASHING: *see* Rendering.

PEDESTAL: a tall block carrying a classical order, statue, vase, etc.

PEDIMENT: a formalized gable derived from that of a classical temple; also used over doors, windows, etc. For variations *see* 4b.

PENDENTIVE: spandrel between adjacent arches, supporting a drum, dome or vault and consequently formed as part of a hemisphere (5a).

PENTHOUSE: subsidiary structure with a lean-to roof. Also a separately roofed structure on top of a C20 multi-storey block.

PERIPTERAL: *see* Peristyle.

PERISTYLE: a colonnade all round the exterior of a classical building, as in a temple which is then said to be *peripteral*.

PERP (PERPENDICULAR): English Gothic architecture *c.* 1335–50 to *c.* 1530. The name is derived from the upright tracery panels then used (*see* Tracery and 2a).

PERRON: external stair to a doorway, usually of double-curved plan.

PEW: loosely, seating for the laity outside the chancel; strictly, an enclosed seat. *Box pew*: with equal high sides and a door.

PIANO NOBILE: principal floor of a classical building above a ground floor or basement and with a lesser storey overhead.

PIAZZA: formal urban open space surrounded by buildings.

PIER: large masonry or brick support, often for an arch. *See also* Compound pier.

PILASTER: flat representation of a classical column in shallow relief. *Pilaster strip*: *see* Lesene.

PILE: row of rooms. *Double pile*: two rows thick.

PILLAR: free-standing upright member of any section, not conforming to one of the orders (q.v.).

PILLAR PISCINA: *see* Piscina.

PILOTIS: C20 French term for pillars or stilts that support a building above an open ground floor.

PISCINA: basin for washing Mass vessels, provided with a drain; set in or against the wall to the S of an altar or free-standing (*pillar piscina*).

PISÉ: *see* Cob.

PITCHED MASONRY: laid on the diagonal, often alternately with opposing courses (*pitched and counterpitched* or *herringbone*).

PLATBAND: flat horizontal moulding between storeys. Cf. stringcourse.

PLATE RAIL: *see* Railways.

PLATEWAY: *see* Railways.

PLINTH: projecting courses at the foot of a wall or column, generally chamfered or moulded at the top.

PODIUM: a continuous raised plat-

form supporting a building; or a large block of two or three storeys beneath a multi-storey block of smaller area.

POINT BLOCK: *see* Multi-storey.

POINTING: exposed mortar jointing of masonry or brickwork. Types include *flush*, *recessed* and *tuck* (with a narrow channel filled with finer, whiter mortar).

POPPYHEAD: carved ornament of leaves and flowers as a finial for a bench end or stall.

PORTAL FRAME: C20 frame comprising two uprights rigidly connected to a beam or pair of rafters.

PORTCULLIS: gate constructed to rise and fall in vertical grooves at the entry to a castle.

PORTICO: a porch with the roof and frequently a pediment supported by a row of columns (4a). A portico *in antis* has columns on the same plane as the front of the building. A *prostyle* porch has columns standing free. Porticoes are described by the number of front columns, e.g. tetrastyle (four), hexastyle (six). The space within the temple is the *naos*, that within the portico the *pronaos*. *Blind portico*: the front features of a portico applied to a wall.

PORTICUS (plural: porticūs): subsidiary cell opening from the main body of a pre-Conquest church.

POST: upright support in a structure (7).

POSTERN: small gateway at the back of a building or to the side of a larger entrance door or gate.

POUND LOCK: *see* Canals.

PRESBYTERY: the part of a church lying E of the choir where the main altar is placed; or a priest's residence.

PRINCIPAL: *see* Roofs and 7.

PRONAOS: *see* Portico and 4a.

PROSTYLE: *see* Portico and 4a.

PULPIT: raised and enclosed platform for the preaching of sermons. *Three-decker*: with reading desk below and clerk's desk below that. *Two-decker*: as above, minus the clerk's desk.

PULPITUM: stone screen in a major church dividing choir from nave.

PULVINATED: *see* Frieze and 3c.

PURLIN: *see* Roofs and 7.

PUTHOLES or PUTLOG HOLES: in the wall to receive putlogs, the horizontal timbers which support scaffolding boards; sometimes not filled after construction is complete.

PUTTO (plural: putti): small naked boy.

QUARRIES: square (or diamond) panes of glass supported by lead strips (*cames*); square floor slabs or tiles.

QUATREFOIL: *see* Foil and 2b.

QUEEN-STRUT: *see* Roofs and 7.

QUIRK: sharp groove to one side of a convex medieval moulding.

QUOINS: dressed stones at the angles of a building (6d).

RADBURN SYSTEM: vehicle and pedestrian segregation in residential developments, based on that used at Radburn, New Jersey, USA, by Wright and Stein, 1928–30.

RADIATING CHAPELS: projecting radially from an ambulatory or an apse (*see* Chevet).

RAFTER: *see* Roofs and 7.

RAGGLE: groove cut in masonry, especially to receive the edge of a roof-covering.

RAGULY: ragged (in heraldry). Also applied to funerary sculpture, e.g. *cross raguly*: with a notched outline.

RAIL: *see* Panelling and 6b; also 7.

RAILWAYS: *Edge rail*: on which flanged wheels can run. *Plate rail*: L-section rail for plain unflanged wheels. *Plateway*: early railway using plate rails.

RAISED AND FIELDED: *see* Panelling and 6b.

RAKE: slope or pitch.

RAMPART: defensive outer wall of stone or earth. *Rampart walk*: path along the inner face.

REBATE: rectangular section cut out of a masonry edge to receive a shutter, door, window, etc.

REBUS: a heraldic pun, e.g. a fiery cock for Cockburn.

REEDING: series of convex mould-

ings, the reverse of fluting (q.v.). Cf. Gadrooning.

RENDERING: the covering of outside walls with a uniform surface or skin for protection from the weather. *Limewashing*: thin layer of lime plaster. *Pebble-dashing*: where aggregate is thrown at the wet plastered wall for a textured effect. *Roughcast*: plaster mixed with a coarse aggregate such as gravel. *Stucco*: fine lime plaster worked to a smooth surface. *Cement rendering*: a cheaper substitute for stucco, usually with a grainy texture.

REPOUSSÉ: relief designs in metalwork, formed by beating it from the back.

REREDORTER (*lit.* behind the dormitory): latrines in a medieval religious house.

REREDOS: painted and/or sculptured screen behind and above an altar. Cf. Retable.

RESPOND: half-pier or half-column bonded into a wall and carrying one end of an arch. It usually terminates an arcade.

RETABLE: painted or carved panel standing on or at the back of an altar, usually attached to it.

RETROCHOIR: in a major church, the area between the high altar and E chapel.

REVEAL: the plane of a jamb, between the wall and the frame of a door or window.

RIB-VAULT: *see* Vault and 2c.

RINCEAU: classical ornament of leafy scrolls (4b).

RISER: vertical face of a step (6c).

ROACH: a rough-textured form of Portland stone, with small cavities and fossil shells.

ROCK-FACED: masonry cleft to produce a rugged appearance.

ROCOCO: style current *c.* 1720 and *c.* 1760, characterized by a serpentine line and playful, scrolled decoration.

ROLL MOULDING: medieval moulding of part-circular section (1a).

ROMANESQUE: style current in the C11 and C12. In England often called Norman. *See also* Saxo-Norman.

ROOD: crucifix flanked by the Virgin and St John, usually over the entry into the chancel, on a beam (*rood beam*) or painted on the wall. The *rood screen* below often had a walkway (*rood loft*) along the top, reached by a *rood stair* in the side wall.

ROOFS: Shape. For the main external shapes (hipped, mansard, etc.) see 8a. *Helm* and *Saddleback*: *see* 1c. *Lean-to*: single sloping roof built against a vertical wall; lean-to is also applied to the part of the building beneath.
Construction. See 7.
Single-framed roof: with no main trusses. The rafters may be fixed to the wall-plate or ridge, or longitudinal timber may be absent altogether.
Double-framed roof: with longitudinal members, such as purlins, and usually divided into bays by principals and principal rafters. Other types are named after their main structural components, e.g. *hammerbeam*, *crown-post* (*see* Elements below and 7).
Elements. See 7.
Ashlar piece: a short vertical timber connecting inner wall-plate or timber pad to a rafter.
Braces: subsidiary timbers set diagonally to strengthen the frame. *Arched braces*: curved pair forming an arch, connecting wall or post below with tie- or collar-beam above. *Passing braces*: long straight braces passing across other members of the truss. *Scissor braces*: pair crossing diagonally between pairs of rafters or principals. *Wind-braces*: short, usually curved braces connecting side purlins with principals; sometimes decorated with cusping.
Collar or *collar-beam*: horizontal transverse timber connecting a pair of rafter or cruck blades (q.v.), set between apex and the wall-plate.
Crown-post: a vertical timber set centrally on a tie-beam and supporting a collar purlin braced to it longitudinally. In an open truss lateral braces may rise to the collar-beam; in a closed truss they may descend to the tie-beam.

Hammerbeams: horizontal brackets projecting at wall-plate level like an interrupted tie-beam; the inner ends carry *hammerposts*, vertical timbers which support a purlin and are braced to a collar-beam above.

Kingpost: vertical timber set centrally on a tie- or collar-beam, rising to the apex of the roof to support a ridge-piece (cf. Strut).

Plate: longitudinal timber set square to the ground. *Wall-plate*: plate along the top of a wall which receives the ends of the rafters; cf. Purlin.

Principals: pair of inclined lateral timbers of a truss. Usually they support side purlins and mark the main bay divisions.

Purlin: horizontal longitudinal timber. *Collar purlin* or *crown plate*: central timber which carries collar-beams and is supported by crown-posts. *Side purlins*: pairs of timbers placed some way up the slope of the roof, which carry common rafters. *Butt* or *tenoned purlins* are tenoned into either side of the principals. *Through purlins* pass through or past the principal; they include *clasped purlins*, which rest on queenposts or are carried in the angle between principals and collar, and *trenched purlins* trenched into the backs of principals.

Queen-strut: paired vertical, or near-vertical, timbers placed symmetrically on a tie-beam to support side purlins.

Rafters: inclined lateral timbers supporting the roof covering. *Common rafters*: regularly spaced uniform rafters placed along the length of a roof or between principals. *Principal rafters*: rafters which also act as principals.

Ridge, ridge-piece: horizontal longitudinal timber at the apex sup-porting the ends of the rafters.

Sprocket: short timber placed on the back and at the foot of a rafter to form projecting eaves.

Strut: vertical or oblique timber between two members of a truss, not directly supporting longit-udinal timbers.

Tie-beam: main horizontal trans-verse timber which carries the feet of the principals at wall level.

Truss: rigid framework of timbers at bay intervals, carrying the longitudinal roof timbers which support the common rafters. *Closed truss*: with the spaces be-tween the timbers filled, to form an internal partition. *See also* Cruck, Wagon roof.

ROPE MOULDING: *see* Cable moulding.

ROSE WINDOW: circular window with tracery radiating from the centre. Cf. Wheel window.

ROTUNDA: building or room cir-cular in plan.

ROUGHCAST: *see* Rendering.

ROVING BRIDGE: *see* Canals.

RUBBED BRICKWORK: *see* Gauged brickwork.

RUBBLE: masonry whose stones are wholly or partly in a rough state. *Coursed*: coursed stones with rough faces. *Random*: uncoursed stones in a random pattern. *Snecked*: with courses broken by smaller stones (snecks).

RUSTICATION: *see* 6d. Exaggerated treatment of masonry to give an effect of strength. The joints are usually recessed by V-section chamfering or square-section channelling (*channelled rustica-tion*). *Banded rustication* has only the horizontal joints emphasized. The faces may be flat, but can be *diamond-faced*, like shallow pyr-amids, *vermiculated*, with a stylized texture like worm-casts, and *glacial* (frost-work), like icicles or stalactites.

SACRISTY: room in a church for sacred vessels and vestments.

SADDLEBACK ROOF: *see* IC.

SALTIRE CROSS: with diagonal limbs.

SANCTUARY: area around the main altar of a church. Cf. Presbytery.

SANGHA: residence of Buddhist monks or nuns.

SARCOPHAGUS: coffin of stone or other durable material.

SAXO-NORMAN: transitional Ro-manesque style combining Anglo-Saxon and Norman features, current *c.* 1060–1100.

SCAGLIOLA: composition imitating marble.

SCALLOPED CAPITAL: *see* 1a.

SCOTIA: a hollow classical moulding, especially between tori (q.v.) on a column base (3b, 3f).

SCREEN: in a medieval church, usually at the entry to the chancel; *see* Rood (screen) and Pulpitum. A *parclose screen* separates a chapel from the rest of the church.

SCREENS or SCREENS PASSAGE: screened-off entrance passage between great hall and service rooms.

SECTION: two-dimensional representation of a building, moulding, etc., revealed by cutting across it.

SEDILIA (singular: sedile): seats for the priests (usually three) on the S side of the chancel.

SET-OFF: *see* Weathering.

SETTS: squared stones, usually of granite, used for paving or flooring.

SGRAFFITO: decoration scratched, often in plaster, to reveal a pattern in another colour beneath. *Graffiti*: scratched drawing or writing.

SHAFT: vertical member of round or polygonal section (1a, 3a). *Shaft-ring*: at the junction of shafts set *en delit* (q.v.) or attached to a pier or wall (1a).

SHEILA-NA-GIG: female fertility figure, usually with legs apart.

SHELL: thin, self-supporting roofing membrane of timber or concrete.

SHOULDERED ARCHITRAVE: *see* 4b.

SHUTTERING: *see* Concrete.

SILL: horizontal member at the bottom of a window or door frame; or at the base of a timber-framed wall into which posts and studs are tenoned (7).

SLAB BLOCK: *see* Multi-storey.

SLATE-HANGING: covering of overlapping slates on a wall. *Tile-hanging* is similar.

SLYPE: covered way or passage leading E from the cloisters between transept and chapter house.

SNECKED: *see* Rubble.

SOFFIT (*lit.* ceiling): underside of an arch (also called *intrados*), lintel, etc. *Soffit roll*: medieval roll moulding on a soffit.

SOLAR: private upper chamber in a medieval house, accessible from the high end of the great hall.

SOPRAPORTA: *see* Overdoor.

SOUNDING-BOARD: *see* Tester.

SPANDRELS: roughly triangular spaces between an arch and its containing rectangle, or between adjacent arches (5c). Also non-structural panels under the windows in a curtain-walled building.

SPERE: a fixed structure screening the lower end of the great hall from the screens passage. *Spere-truss*: roof truss incorporated in the spere.

SPIRE: tall pyramidal or conical feature crowning a tower or turret. *Broach*: starting from a square base, then carried into an octagonal section by means of triangular faces; and *splayed-foot*: variation of the broach form, found principally in the southeast, in which the four cardinal faces are splayed out near their base, to cover the corners, while oblique (or intermediate) faces taper away to a point (1c). *Needle spire*: thin spire rising from the centre of a tower roof, well inside the parapet: when of timber and lead often called a *spike*.

SPIRELET: *see* Flèche.

SPLAY: of an opening when it is wider on one face of a wall than the other.

SPRING or SPRINGING: level at which an arch or vault rises from its supports. *Springers*: the first stones of an arch or vaulting rib above the spring (2c).

SQUINCH: arch or series of arches thrown across an interior angle of a square or rectangular structure to support a circular or polygonal superstructure, especially a dome or spire (5a).

SQUINT: an aperture in a wall or through a pier usually to allow a view of an altar.

STAIRS: *see* 6c. *Dog-leg stair*: parallel flights rising alternately in opposite directions, without an open well. *Flying stair*: cantilevered from the walls of a

stairwell, without newels; sometimes called a *Geometric* stair when the inner edge describes a curve. *Newel stair*: ascending round a central supporting newel (q.v.); called a *spiral stair* or *vice* when in a circular shaft, a *winder* when in a rectangular compartment. (Winder also applies to the steps on the turn.) *Well stair*: with flights round a square open well framed by newel posts. *See also* Perron.

STALL: fixed seat in the choir or chancel for the clergy or choir (cf. Pew). Usually with arm rests, and often framed together.

STANCHION: upright structural member, of iron, steel or reinforced concrete.

STANDPIPE TOWER: *see* Manometer.

STEAM ENGINES: *Atmospheric*: worked by the vacuum created when low-pressure steam is condensed in the cylinder, as developed by Thomas Newcomen. *Beam engine*: with a large pivoted beam moved in an oscillating fashion by the piston. It may drive a flywheel or be *non-rotative*. *Watt* and *Cornish*: single-cylinder; *compound*: two cylinders; *triple expansion*: three cylinders.

STEEPLE: tower together with a spire, lantern, or belfry.

STIFF-LEAF: type of E.E. foliage decoration. *Stiff-leaf capital see* 1b.

STOP: plain or decorated terminal to mouldings or chamfers, or at the end of hoodmoulds and labels (*label stop*), or stringcourses (5b, 6a); *see also* Headstop.

STOUP: vessel for holy water, usually near a door.

STRAINER: *see* Arch.

STRAPWORK: late C16 and C17 decoration, like interlaced leather straps.

STRETCHER: *see* Bond and 6e.

STRING: *see* 6c. Sloping member holding the ends of the treads and risers of a staircase. *Closed string*: a broad string covering the ends of the treads and risers. *Open string*: cut into the shape of the treads and risers.

STRINGCOURSE: horizontal course

or moulding projecting from the surface of a wall (6d).

STUCCO: *see* Rendering.

STUDS: subsidiary vertical timbers of a timber-framed wall or partition (7).

STUPA: Buddhist shrine, circular in plan.

STYLOBATE: top of the solid platform on which a colonnade stands (3a).

SUSPENSION BRIDGE: *see* Bridge.

SWAG: like a festoon (q.v.), but representing cloth.

SYSTEM BUILDING: *see* Industrialized building.

TABERNACLE: canopied structure to contain the reserved sacrament or a relic; or architectural frame for an image or statue.

TABLE TOMB: memorial slab raised on free-standing legs.

TAS-DE-CHARGE: the lower courses of a vault or arch which are laid horizontally (2c).

TERM: pedestal or pilaster tapering downward, usually with the upper part of a human figure growing out of it.

TERRACOTTA: moulded and fired clay ornament or cladding.

TESSELLATED PAVEMENT: mosaic flooring, particularly Roman, made of *tesserae*, i.e. cubes of glass, stone, or brick.

TESTER: flat canopy over a tomb or pulpit, where it is also called a *sounding-board*.

TESTER TOMB: tomb-chest with effigies beneath a tester, either free-standing (tester with four or more columns), or attached to a wall (*half-tester*) with columns on one side only.

TETRASTYLE: *see* Portico.

THERMAL WINDOW: *see* Diocletian window.

THREE-DECKER PULPIT: *see* Pulpit.

TIDAL GATES: *see* Canals.

TIE-BEAM: *see* Roofs and 7.

TIERCERON: *see* Vault and 2c.

TILE-HANGING: *see* Slate-hanging.

TIMBER-FRAMING: *see* 7. Method of construction where the structural frame is built of interlocking

timbers. The spaces are filled with non-structural material, e.g. *infill* of wattle and daub, lath and plaster, brickwork (known as *nogging*), etc. and may be covered by plaster, weatherboarding (q.v.), or tiles.

TOMB-CHEST: chest-shaped tomb, usually of stone. Cf. Table tomb, Tester tomb.

TORUS (plural: tori): large convex moulding usually used on a column base (3b, 3f).

TOUCH: soft black marble quarried near Tournai.

TOURELLE: turret corbelled out from the wall.

TOWER BLOCK: *see* Multi-storey.

TRABEATED: depends structurally on the use of the post and lintel. Cf. Arcuated.

TRACERY: openwork pattern of masonry or timber in the upper part of an opening. *Blind tracery* is tracery applied to a solid wall.

Plate tracery, introduced c. 1200, is the earliest form, in which shapes are cut through solid masonry (2a).

Bar tracery was introduced into England c. 1250. The pattern is formed by intersecting moulded ribwork continued from the mullions. It was especially elaborate during the Decorated period (q.v.). Tracery shapes can include circles, *daggers* (elongated ogee-ended lozenges), *mouchettes* (like daggers but with curved sides) and upright rectangular *panels*. They often have *cusps*, projecting points defining lobes or *foils* (q.v.) within the main shape: *Kentish* or *split-cusps* are forked (2b).

Types of bar tracery (*see* 2b) include *geometric(al)*: c. 1250–1310, chiefly circles, often foiled; *Y-tracery*: c. 1300, with mullions branching into a Y-shape; *intersecting*: c. 1300, formed by interlocking mullions; *reticulated*: early C14, net-like pattern of ogee-ended lozenges; *curvilinear*: C14, with uninterrupted flowing curves; *panel*: Perp, with straight-sided panels, often cusped at the top and bottom.

TRANSEPT: transverse portion of a church.

TRANSITIONAL: generally used for the phase between Romanesque and Early English (c. 1175–c. 1200).

TRANSOM: horizontal member separating window lights (2b).

TREAD: horizontal part of a step. The *tread end* may be carved on a staircase (6c).

TREFOIL: *see* Foil.

TRIFORIUM: middle storey of a church treated as an arcaded wall passage or blind arcade, its height corresponding to that of the aisle roof.

TRIGLYPHS (*lit.* three-grooved tablets): stylized beam-ends in the Doric frieze, with metopes between (3b).

TRIUMPHAL ARCH: influential type of Imperial Roman monument.

TROPHY: sculptured or painted group of arms or armour.

TRUMEAU: central stone mullion supporting the tympanum of a wide doorway. *Trumeau figure*: carved figure attached to it (cf. Column figure).

TRUMPET CAPITAL: *see* 1b.

TRUSS: braced framework, spanning between supports. *See also* Roofs and 7.

TUMBLING or TUMBLING-IN: courses of brickwork laid at right-angles to a slope, e.g. of a gable, forming triangles by tapering into horizontal courses (8a).

TUSCAN: *see* Orders and 3e.

TWO-DECKER PULPIT: *see* Pulpit.

TYMPANUM: the surface between a lintel and the arch above it or within a pediment (4a).

UNDERCROFT: usually describes the vaulted room(s), beneath the main room(s) of a medieval house. Cf. Crypt.

VAULT: arched stone roof (sometimes imitated in timber or plaster). For types see 2c.

Tunnel or *barrel vault*: continuous semicircular or pointed arch, often of rubble masonry.

Groin-vault: tunnel vaults inter-

secting at right angles. *Groins* are the curved lines of the intersections.

Rib-vault: masonry framework of intersecting arches (ribs) supporting *vault cells*, used in Gothic architecture. *Wall rib* or *wall arch*: between wall and vault cell. *Transverse rib*: spans between two walls to divide a vault into bays. *Quadripartite* rib-vault: each bay has two pairs of diagonal ribs dividing the vault into four triangular cells. *Sexpartite* rib-vault: most often used over paired bays, has an extra pair of ribs springing from between the bays. More elaborate vaults may include *ridge ribs* along the crown of a vault or bisecting the bays; *tiercerons*: extra decorative ribs springing from the corners of a bay; and *liernes*: short decorative ribs in the crown of a vault, not linked to any springing point. A *stellar* or *star* vault has liernes in star formation.

Fan-vault: form of barrel vault used in the Perp period, made up of halved concave masonry cones decorated with blind tracery.

VAULTING SHAFT: shaft leading up to the spring or springing (q.v.) of a vault (2c).

VENETIAN or SERLIAN WINDOW: derived from Serlio (4b). The motif is used for other openings.

VERMICULATION: *see* Rustication and 6d.

VESICA: oval with pointed ends.

VICE: *see* Stair.

VILLA: originally a Roman country house or farm. The term was revived in England in the C18 under the influence of Palladio and used especially for smaller, compact country houses. In the later C19 it was debased to describe any suburban house.

VITRIFIED: bricks or tiles fired to a darkened glassy surface.

VITRUVIAN SCROLL: classical running ornament of curly waves (4b).

VOLUTES: spiral scrolls. They occur on Ionic capitals (3c). *Angle volute*: pair of volutes, turned outwards to meet at the corner of a capital.

VOUSSOIRS: wedge-shaped stones forming an arch (5c).

WAGON ROOF: with the appearance of the inside of a wagon tilt; often ceiled. Also called *cradle roof*.

WAINSCOT: *see* Panelling.

WALL MONUMENT: attached to the wall and often standing on the floor. *Wall tablets* are smaller with the inscription as the major element.

WALL-PLATE: *see* Roofs and 7.

WALL-WALK: *see* Parapet.

WARMING ROOM: room in a religious house where a fire burned for comfort.

WATERHOLDING BASE: early Gothic base with upper and lower mouldings separated by a deep hollow.

WATERLEAF: *see* Enrichments and 3f.

WATERLEAF CAPITAL: Late Romanesque and Transitional type of capital (1b).

WATER WHEELS: described by the way water is fed on to the wheel. *Breastshot*: mid-height, falling and passing beneath. *Overshot*: over the top. *Pitchback*: on the top but falling backwards. *Undershot*: turned by the momentum of the water passing beneath. In a *water turbine*, water is fed under pressure through a vaned wheel within a casing.

WEALDEN HOUSE: type of medieval timber-framed house with a central open hall flanked by bays of two storeys, roofed in line; the end bays are jettied to the front, but the eaves are continuous (8a).

WEATHERBOARDING: wall cladding of overlapping horizontal boards.

WEATHERING or SET-OFF: inclined, projecting surface to keep water away from the wall below.

WEEPERS: figures in niches along the sides of some medieval tombs. Also called mourners.

WHEEL WINDOW: circular, with radiating shafts like spokes. Cf. Rose window.

WROUGHT IRON: *see* Cast iron.

INDEX OF ARTISTS

Entries for partnerships and group practices are listed after entries for a single surname.

INDEX OF STREETS, BUILDINGS AND MONUMENTS

Principal references are in **bold** type. References in *italic* are to buildings which no longer stand, and to defunct streets or street names. References in roman type within an italic entry are to remaining parts or furnishings. Buildings whose use has changed may be indexed under both present and former names.

Certain building types are indexed together: Board Schools; Christian Science Churches; Drill Halls; Fire Stations; Magistrates' Courts; Peabody Estates; Police Stations and Section Houses; Post Offices; Public Libraries; Salvation Army Halls; Swimming Baths; Telephone Exchanges.

Public monuments, statues and memorials are also indexed together under monuments; in addition the most important or conspicuous are entered separately.